REMBRANDT'S EYES

PENGUIN BOOKS

REMBRANDT'S EYES

SIMON SCHAMA

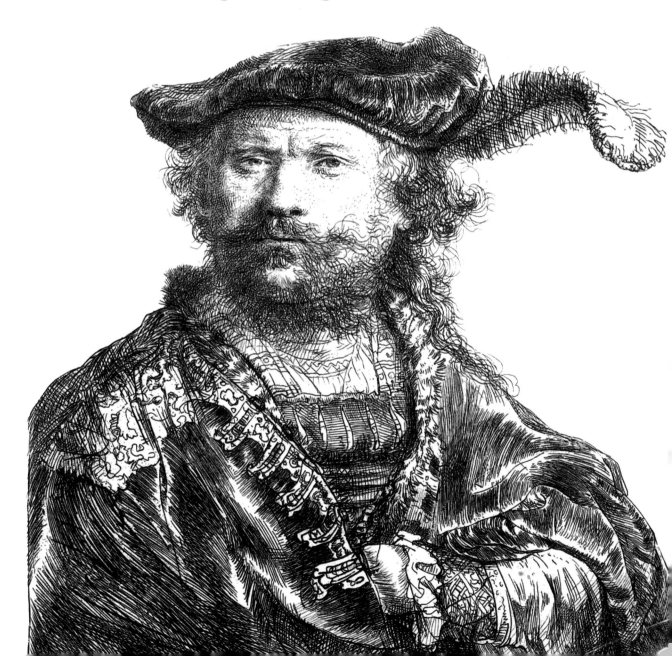

PENGUIN BOOKS

Published by the Penguin Group
Penguin Books Ltd, 27 Wrights Lane, London W8 5TZ, England
Penguin Putnam Inc., 375 Hudson Street, New York, New York 10014, USA
Penguin Books Australia Ltd, Ringwood, Victoria, Australia
Penguin Books Canada Ltd, 10 Alcorn Avenue, Toronto, Ontario, Canada M4V 3B2
Penguin Books India (P) Ltd, 11, Community Centre, Panchsheel Park, New Delhi – 110 017, India
Penguin Books (NZ) Ltd, Private Bag 102902, NSMC, Auckland, New Zealand
Penguin Books (South Africa) (Pty) Ltd, 5 Watkins Street, Denver Ext 4, Johannesburg 2094, South Africa

Penguin Books Ltd, Registered Offices: Harmondsworth, Middlesex, England

First published in the USA by Alfred A. Knopf, a division of Random House, Inc. 1999
First Published in Great Britain by Allen Lane The Penguin Press 1999
Published in Penguin Books 2000
1

Printed in Great Britain by Butler & Tanner Ltd, Frome and London

For John Brewer and for Gary Schwartz,
fellow lodgers in Clio's house

We should apologize for daring to speak about painting.
— PAUL VALÉRY

CONTENTS

PART FIVE THE PROPHET

PART SIX AFTERWARD

PART ONE

THE PROSPECTS
OF A PAINTER

CHAPTER ONE · THE QUIDDITY

i *'s Hertogenbosch, 1629*

After thirty salvos the cannon were obliged to cool off. So perhaps it was then that Constantijn Huygens thought he heard nightingales fluting over the artillery.[1] The windows in the headquarters of Frederik Hendrik, the Prince of Orange, commanded a remote but panoramic prospect of the siege. Had he been asked, Huygens would have been in a perfect position to draft one of those grandiose bird's-eye views of the operations of war, engraved to document the commander's genius, his worthiness to be remembered as the equal of Alexander or Scipio. Some liked to describe such scenes as theaters of valor. And to an eye as literary as Huygens's, the distant view from his tower chamber might well have seemed like a great masque, blazing with pyrotechnics and noisy with the work of contraptions; a flamboyance of banners. But he also knew that for all its appearance of a rout, such festive parades were actually conducted according to a strict program: first the pipers and drummers; then horses, fantastically caparisoned; then mountebanks and men in lion skins; the pasteboard dolphins and dragons; and finally triumphal cars *à l'antique,* pulled by garlanded oxen or the occasional camel.

This, however, was quite different: the appearance of a plan, the reality of chaos. Distance did not lend reason to the proceedings. There was much frantic hithering and thithering like rats in a storm. Mounted cuirassiers and harquebusiers would venture periodic sallies into the smoke, cantering over the gory wreckage of men and horses, discharging their carbines optimistically against the outer forts. Beyond them, in the low, wet ground, sappers crept tentatively through the trenches, understandably nervous of being hit by their own men's fire. And then there were those amidst the action who did nothing lively: who snored with their heads propped against a drum, threw dice, smoked a pipe, or, if they had been particularly unfortunate, swung from a discouraging gibbet. Every so often, at dusk, a mortar-launched grenade would snake into the inky light, find a rooftop in the city, and a small blossom of vermilion fire would unfurl in the Dog Star sky.

The junior of the two secretaries attending on the Prince of Orange, Constantijn Huygens was spending much of his time, day and night, deciphering coded intercepts taken from the Spanish and Flemish troops inside the besieged cathedral town of 's Hertogenbosch. When Frederik Hendrik commended him for his aptitude in this craft, Huygens, who had been expressly trained in the cipher while studying law at Leiden University, shrugged off the compliment. It was, he said, with cavalier modesty, "mere donkey work," mysterious only to those who had not been initiated into the art.[2] The truth was that it was sleepless toil, and Huygens later confessed to being proud of having deciphered every enemy document that had come his way. But occasionally he would allow himself a little variety, taking his goose quill and writing poems in Latin, Dutch, or French in his elegant hand, the tails from his *v*'s flicking like a whip, white fingers gliding over the sheet, a fine spray of white sand tossed on the paper when he was done to dry the dark and dainty lines.

This was 1629: the sixtieth summer of the war for the Netherlands. One hundred twenty-eight thousand and seventy-seven men were in arms for the service of the Dutch Republic.[3] The country which some foreigners supposed phlegmatic (even when they were busy enough buying munitions from its arms dealers) had been marshalled into an immense, bristling garrison. Dray horses, better used to being tethered to hay wagons, were now harnessed into teams of twenty or thirty to pull field guns and cannon. Troopers, many of them foreigners cursing in English, Schwytzertütsch, or French, packed the alehouses so tight that regulars were forced to roost with the pigeons on stoops and benches. Twenty-eight thousand of this mighty army had been mustered before 's Hertogenbosch, right in the heart of Brabant, the province of both Huygens's and the Prince's ancestors. Since May they had been laboring to take the cathedral city from the two-thousand-odd defenders holding it for the Habsburg Archduchess Isabella in Brussels and for her nephew King Philip IV of Spain. But the siege which had begun in the airy brightness of spring had, by the gray, sodden summer, turned into thankless, slogging work. The military governor of 's Hertogenbosch had flooded the low fields in front of his earthwork defenses, turning them into an impassable quagmire. Frederik Hendrik's English engineers, using portable horse-driven mills, would pump them dry, and the cumbersome machinery of the army would once again crank itself up for an attempted attack on the outer line of forts. Captains of pikemen and musketeers would make their dispositions. Armor would be burnished, sabers whetted at the grindstone. Sparks would fly. Some effort would be made to scrape at least one layer of the caked brown and yellow grime from the surgeons' tables. But then the army would awake before dawn to a July downpour that continued for days, dissolving strategy into a broth of streaming water and treacly mud. In the rear of the soldiers, a train of hangers-on remained encamped in the sopping mire, more numerous than the troops, a great fairground without

pies: wives and whores, seamstresses and laundrywomen; babes at the tit and snot-nosed urchins picking pockets or throwing back tankards of beer; vermin-catchers; piss-gazing quacks; bonesetters; plume-hatted sutlers demanding a king's ransom for a stony crust; tapsters; hurdy-gurdy men; half-wild dogs rooting for bones; and bedraggled lousy vagabonds who simply stood about, hollow-eyed and watchful, like gulls at the stern of a herring boat, drawn to the leavings.

It was mid-August before the ground was dry enough for the Prince to move forward. But by this time a diversionary army of ten thousand Spanish, Italian, and German soldiers had invaded the eastern frontier provinces of the Republic with the obvious aim of forcing Frederik Hendrik to break off the siege. Reports arrived from the countryside of the usual enormities: violated women; animals taken and butchered on the hoof; gangs of distraught villagers fleeing into the woods or rowing grimly into the bullrushes. The Prince's wife, Amalia van Solms, fearing that her headstrong husband might yet be a victim of his obstinacy, had a scholar-poet write a Latin poem in the manner of Ovid's heroic odes, directed at "Frederik Hendrik who, with too much steadfastness, fights right beneath the walls of 's Hertogenbosch."[4]

But the Prince, a small, stubborn man with sharply trimmed mustaches and a brisk, zealous air, was unmoved. Was he not, like Joshua, known to the people as "the Conqueror of Cities"?[5] Whatever it took, and however long it took, he would have his city. He would watch the papist bishop and all the monks and nuns depart with the humiliating courtesies due to the vanquished. Though he was no Calvinist fanatic, Frederik Hendrik still believed it proper that the Cathedral of St. John be cleansed of Catholic idolatry. The painful memory of the surrender of Breda, his father's city, four years before would be somewhat assuaged. For Frederik Hendrik, the capture of 's Hertogenbosch was not simply another trophy in the interminable carnage of the war. It was meant to demonstrate conclusively to the Spanish Habsburgs that they had no choice but to accept, unconditionally, the sovereignty and liberty of the Protestant Republic of the United Netherlands.

So the business of the siege began in earnest and men began to die behind the bastions and in the greasy clay. The *konijnen*, the coneys, burrowed away in the choking darkness, undermining the enemy's earthworks, setting slow fuses, and praying that they be preserved from the countermines arriving from the opposite direction. Above them, in the open ground, limbs were splintered by gunfire or hacked off on the trestles of the sawbones. Within the claustrophobic city, the common people were caught amidst scorched timber and mounds of smashed brick. In the chapels of the Gothic church of St. John, tapers were lit for the intercession of the Virgin. May Our Lady bring a speedy deliverance. . . .

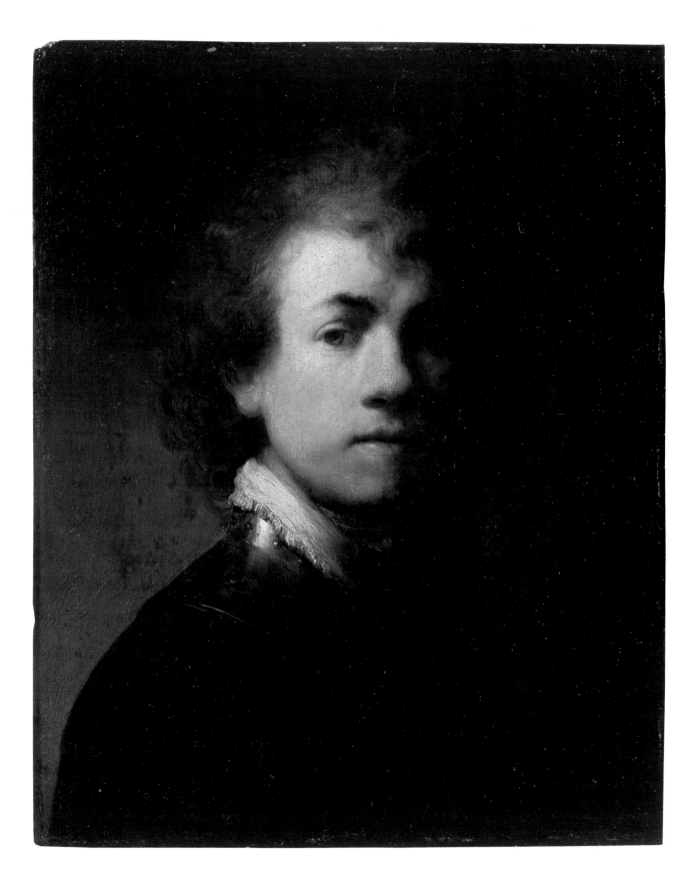

ii *Leiden, 1629*

Rembrandt had taken to painting himself in armor. Not
the full body suit. No one except cuirassiers, who were vulnerable to being
jabbed by pikemen below the crupper, went in for that anymore. But every
so often Rembrandt liked to wear his gorget. It was a hinged collar-piece,
covering the base of the neck, collarbone, and upper back, and it looked
good lying below a wound silken stock or scarf; a touch of steel lest he be
thought too much the dandy. It was not that he was about to report for
duty, even though, at twenty-three, he was of an age to serve in the militia,
especially since an older brother had had a disabling accident at the mill.
But this was social armor, military chic, not unlike the studiously worn
fatigues affected by twentieth-century politicians gone sedentary, or the
flak jackets of the urban paratrooper. Rembrandt's gorget with its glinting
studs gave him the bearing of a soldier without the obligations.

And then, quite suddenly, peril chilled the summer. In early August
1629, to general consternation, the city of Amersfoort, not forty miles from
Amsterdam, had fallen to the invading imperial army with scarcely a shot
fired in anger. Worse, the trembling city fathers had opened their gates to
the Italian and German soldiers, who swiftly set about reconsecrating its
churches to the Virgin. Censers swung. Nones and complines were sung.
The panic would not last long. A lightning counterattack on the imperial
citadel at Wesel had surprised the garrison at dawn and cut off the Catholic
army from its rear, dooming the whole invasion to sorry retreat.

But while it lasted, the sense of crisis was real enough. Companies of
part-time militia—brewers and dyers, men who, for as long as anyone
could remember, had done nothing more threatening than parade around
on Sundays in fancy boots and gaudy sashes, or who shot at wooden par-
rots atop a pole—were now being sent to frontier towns in the east. There
they were supposed to relieve the professional troops for active combat in
the embattled theaters of war. On the surface, much seemed the same.
There was still stockfish and butter for the table. Students at the university
still slept through lectures on Sallust and got tight in the evenings, braying
at the fastened shutters of the respectable. But the war had not bypassed
Leiden altogether. Propaganda prints reminding citizens, in literally graphic
detail, of the horrors endured when the towns of Holland were themselves
besieged fifty years earlier issued from patriotic presses. Students enrolled
in the school of military engineering were required to make wooden models
of fortifications and gun emplacements. Some were even taken to the bat-
tlefield in Brabant to see if their notions could stand the test of fire. On the
Galgewater and the Oude Rijn, barges rode low at the waterline, their
holds crammed with morion helmets and partisans alongside crates of
turnips and barrels of beer.

OPPOSITE: *Rembrandt,*
Self-portrait in a Gorget,
c. 1629. Panel, 38 ×
30.9 cm. Nuremberg,
Germanisches
Nationalmuseum

So it suited Rembrandt to get himself up as a military person. Of course, a "person" in the seventeenth century meant a *persona*: a guise or role assumed by an actor. Rembrandt was playing his part, and the deep shadow and rough handling of his face complicate the mask, suggest the struggling fit between the role and the man. No painter would ever understand the theatricality of social life as well as Rembrandt. He saw the actors in men and the men in the actors. Western art's first images of stage life— the dressing room and the wardrobe—came from his hand. But Rembrandt's drama did not stop at the stage door. He also painted historical figures and his own contemporaries in their chosen personae, rehearsing their allotted manners as if before an audience. And he cast himself in telling bit parts—the executioners of St. Stephen and Christ; a scared sailor on the churning Sea of Galilee—and just occasionally in a significant lead: the Prodigal Son, whoring in a tavern.[6] For Rembrandt as for Shakespeare, all the world was indeed a stage, and he knew in exhaustive detail the tactics of its performance: the strutting and mincing; the wardrobe and the face paint; the full repertoire of gesture and grimace; the flutter of hands and the roll of the eyes; the belly laugh and the half-stifled sob. He knew what it looked like to seduce, to intimidate, to wheedle, and to console; to strike a pose or preach a sermon; to shake a fist or uncover a breast; how to sin and how to atone; how to commit murder and how to commit suicide. No artist had ever been so fascinated by the fashioning of personae, beginning with his own. No painter ever looked with such unsparing intelligence or such bottomless compassion at our entrances and our exits and the whole rowdy show in between.

So here is the greatest trouper who never trod the boards playing Youngman Corporal, his I-mean-business gorget belied by the soft fringed collar falling over the studded metal, the slightly arched, broken eyebrow line (absent from the copy in The Hague), the deep set of the right eye, and the half-shadowed face, sabotaging the bravura, hinting at the vulnerability beneath the metal plate: the mortal meeting the martial. There is a touch too much humanity here to carry off the show. The light reveals a full, mobile mouth, the lips highlit as if nervously licked; large, liquid eyes; a great acreage of cheek and chin; and, planted in the center of his face, the least aquiline nose in seventeenth-century painting.

And then there is the *liefdelok*, the lovelock trailing over his left shoulder. Huygens, who would never be accused of indulging in frivolous exhibitionism, had written a long poem satirizing the outlandish fashions affected by the young in The Hague: slashed breeches, over-the-shoulder capes, and flying knee ribbons.[7] But flamboyantly long hair was being singled out by the Calvinist preachers as an especial abomination in the sight of the Lord. Rembrandt evidently paid none of this any heed. He must have taken great pains with his lovelock—also known from its origins in the French court as a *cadenette*—since of course it took immense care to produce the required effect of carelessness. The hair had to be cut asymmetrically, the top of the lock kept full while its body was thinned to taper along its length, ending in the gathered and separated strands.

And yet the picture is quite free of vain self-satisfaction. Rembrandt looks at himself in the glass, already committed to catching the awkward truth, trying to fix the point at which temerity is shadowed by trepidation, virile self-possession unmanned by pensive anxiety. He is Hamlet in Holland, an inward-outward persona, a poet in heavy metal, the embodiment of both the active and the contemplative life, someone whom Huygens was bound to commend.

iii *'s Hertogenbosch, 1629*

From his timbered quarters in the village of Vught, south of the town, Huygens must have heard the smack of the forty-eight-pound balls as they punched into the earthworks, sending up eruptions of dirt in which could be glimpsed rocks, palisading, and the occasional small animal. But it was a test of the true Christian stoic to remain studious amidst commotion. So Huygens stopped his ears to the din and began to write his autobiography.[8] He was only thirty-three years old, but this might be counted middle-aged; he was certainly old enough to reflect on his education and his extended apprenticeship in the world of public affairs. His father, Christiaan, in his own time secretary to the first Stadholder, William of Orange, had made the formation of his two sons as *virtuosi* his dearest project. To be a paragon-in-training meant starting early. Constantijn had been taught the viol at six, Latin grammar and the lute at seven. As the schooling proceeded, it added logic and rhetoric at twelve, Greek at thirteen, mathematics, ancient philosophy, history, law, and, throughout the years, a solid dose of sound Christian doctrine as laid down by the doctors of the Reformed Church.

And like all adepts of the liberal arts, Huygens had been assigned a drawing master. It was a commonplace of polite education, as the author of an English drawing manual put it, that the arts were "a polisher of imbred rudenesse and our informity, and a curer of many diseases our minds are subject unto."[9] And while no one ever accused Huygens of coarseness, he was, even when young, prone to bouts of melancholy. To those who might have read Robert Burton's *Anatomy of Melancholy,* this might suggest that the man had depths to fathom; to others, though, it indicated an errant imagination and an excess of black bile. Though artists were notorious for falling into the dark humor, the discipline of drawing was thought to set this to rights. In any case, picturing ran in Huygens's blood. His mother was Susanna Hoefnagel of Antwerp, niece of the great Joris Hoefnagel, whose topographical views of cities and miniatures of all the known beasts and insects of the world had been judged so fine that they had won him honor and riches from the likes of the Dukes of Bavaria and the Holy Roman Emperor.[10] Susanna had hoped that either Joris's son, Jacob Hoefnagel, or

her neighbor the graphic artist Jacques de Gheyn II, who had worked for the Stadholder's court and himself been a prolific sketcher of spiders and sycamores and the like, might take on Constantijn. But Jacob Hoefnagel was too busy in Vienna editing and profiting from his father's celebrity, and de Gheyn declared he had no inclination for the work. Instead de Gheyn nominated Hendrik Hondius, an engraver and publisher whom Huygens remembered, a little complacently perhaps, as "a good man, whose easy-going character made him a fine teacher for us well-brought up young men."[11] From Hondius Huygens learned anatomy and perspective; how to delineate the forms of trees and mountains; and, since this was another of Hondius's specialities, the design and construction of fortifications.[12]

To be an educated *amateur*—a lover of art, a *kunstliefhebber*—was one thing; to paint for a living quite another. It was inconceivable that someone with Huygens's family background and prospects should entertain thoughts of becoming a professional painter. Oils, wrote Henry Peacham, the instructor of noble amateurs, were unfit for gentlemen, being likely to stain your apparel and rob you of time.[13] Instead, Huygens would add the graceful practice of *miniatura*—watercolors—to the long list of his courtly accomplishments: theorbo, guitar, calligraphy, dancing, and riding. Occasionally, to maintain and perfect his drawing, he might take a sketchbook, a *tafelet*, out to the countryside and make pictures of trees, flowers, or even a figure or two.[14] He could even make something of a game out of this miniaturization of the world, engraving ingenious devices and inscriptions into the shells of hazelnuts and sending them as pieces of wit to his good friends.[15]

But there was another duty incumbent on a secretary to the Prince of Orange for which a sound education in drawing was an indispensable preparation. True gentility in the early seventeenth century required not just a flourish of the rapier or the confident setting of one leg at an angle to the other, *contrapposto,* just so. It also asked that a gentleman be a *kenner,* literally a know-all, a connoisseur. True *kenners* were not just men who advanced opinions that were little more than prejudices, or the parroted fancies of their seniors; they were men whose taste had been formed by disciplined practice and by study; by looking and doing, preferably in Italy. "It is not enough for an uninformed Gentleman to behold [the arts] with a vulgar eye—but he must be able to distinguish them and tell who and what they be."[16] A connoisseur worth his mettle ought to be able to make fearless separations between superior and inferior talents. He would know the best of painting because he had himself experienced the difficulty of making it.

Huygens's teacher, Hondius, had a line of engraved reproductions of the works of the masters of northern European art—Holbein, Dürer, and Bruegel—in his shop in The Hague, and there Huygens could have browsed the albums and played the critic. Although Jacques de Gheyn had not wanted to be his tutor, his son, Jacques de Gheyn III, also destined to be an artist, though an unproductive one, was Constantijn's friend-next-door. From the beginning, then, he was involved in the world of public imagery

and would have subscribed to the truism that the arts were a glory for the Netherlands, to be cultivated and encouraged. Hondius had himself published an allegorical engraving on *The Fortunate State of the Netherlands* in which, beneath a palm of victory, a painter sat sketching in the company of the liberal arts, doing his bit for the free commonwealth.[17]

On becoming secretary to Frederik Hendrik in 1625, Huygens, who had seen how these things were ordered in Italy, Paris, and London, viewed it as his commission to discover painters who might ornament a court that could hold its own with the Habsburgs, Bourbons, and Stuarts. His prince was a Stadholder, not a king, more, in fact, like a hereditary president, officially accountable to the States General of the seven United Provinces. But his pedigree was glorious and there was no reason why he should not be surrounded by dignified state portraits, edifying histories, extensive views. Huygens had read enough classical history to feel that republican grandeur was not necessarily a contradiction in terms. And it was fitting that a prince who had, after all, subdued commanders sent by crowned monarchs should be seen as a new Alexander; a ruler who attended as much to the fine arts as the martial arts.

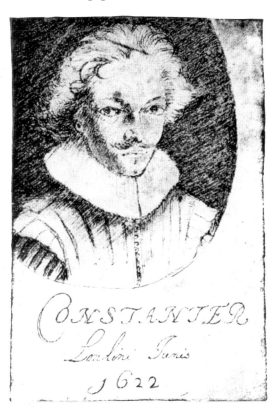

Constantijn Huygens, Self-portrait, 1622. Silver pencil on parchment

So Huygens went scouting for talent. The Dutch Republic was already thick with painters who could knock off landscapes, seascapes, vases of flowers, merry companies, belching boers, and strutting militiamen.[18] But that was not what was needed for the galleries of the palaces Frederik Hendrik was eager to build. What was wanted, Huygens made clear in his autobiography, were homegrown editions of Peter Paul Rubens: a producer of thrilling spectacle; a maker of magnificence. It was a maxim at court that princes were gods on earth, but only Rubens knew how to make them look immortal, transforming the physically unprepossessing specimens of the European dynasts, the short, the toothless, and the flabby, into so many Apollos and Dianas. In his hands, the most inconsequential skirmish turned into a Homeric battle. And Rubens could do all this because he was, in ways no one could quite put his finger on, noble himself. It had nothing to do with the blood, and everything to do with bearing. His entire demeanor defied the conventional wisdom that a painter could not also be a gentleman. There was his frightening learning, his unfailingly graceful courtesy. Even his Spanish masters, Huygens noted, who had condescended to Rubens for so long, had come to realize that "he was a man born for more than the easel." He was, in short, "one of the seven wonders of the world."[19] How regrettable, then, that Rubens also happened to work for the enemy, the Catholic Habsburgs.

It had not been easy to find what Huygens had been looking for: some

painter who, with the proper discipline and advancement, might yet turn out to be a Protestant Rubens. Oh, there were *able* talents, of course, in the Republic, some actually living in The Hague like Esaias van de Velde, the landscapist, who had also become something of a painter of battles and skirmishes. And there was still Michiel van Mierevelt in Delft, turning out production-line portraits of the mighty and the moneyed. He could always be depended on for decorum, and Huygens rhapsodizes about him as the equal if not the superior of Holbein.[20] And there was Lastman in Amsterdam, and Bloemaert in Utrecht, both painting histories, both, alas, Catholic.

It was only when he heard from someone in Leiden (perhaps his old student friend Johannes Brosterhuysen, with whom he regularly exchanged letters and who was himself something of a specialist in *miniatura*) that there were two highly esteemed youths there, and only when he took the trouble, toward the end of 1628, to see for himself, that Constantijn Huygens thought he might finally have found not one but two Dutch Rubenses. Though in his excitement Huygens called them "a young and noble duo of painters," neither could exactly be counted a gentleman.[21] Jan Lievens was the son of an embroiderer; Rembrandt the son of a miller. But as Huygens sat and wrote with guns booming in the distance, he sensed that he had stumbled onto something precious. What had been rumored, for once, had turned out to be true. In Leiden he had been amazed.

iv Leiden, 1629

Rembrandt was giving his full attention to the matter of painting, and in particular to a small patch of plaster in a corner of his walk-up studio. At the point where the wall met the upright beam of the doorjamb, projecting into the room, plaster had begun to flake and lift, exposing a triangle of rosy brick. It was the Rhine-water damp that did it; the oily green river which exhaled its cold mists out over the canals, insinuating itself through the cracks and shutters of the gabled alley-houses. In the grander residences of well-to-do burghers—professors and cloth merchants—that stretched along the Houtstraat and the Rapenburg, the invading clamminess was met, resisted, and, if all else failed, obscured by rows of ceramic tiles beginning at the foot of the wall and climbing upward as means and taste dictated. If means were modest, the householder could make a serial strip—of children's games or proverbs—to which further items could be added as fortune allowed. If he were already fortunate, an entire picture—of a great vase of flowers, an East Indiaman in full sail, or the portrait of William the Silent—could be constructed from brilliantly colored pieces. But Rembrandt's studio was bare of any of these conve-

niences. Unhindered, the damp had eaten its way into the
plaster, engendering blooms of mold, blistering the surface,
opening cracks and fissures in corners where the moisture
collected.

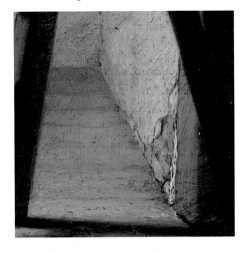

Rembrandt liked this. From the beginning, he was
powerfully drawn to ruin; the poetry of imperfection. He
enjoyed tracing the marks left by the bite of worldly expe-
rience: the pits and pocks, the red-rimmed eyes and scabby
skin which gave the human countenance a mottled rich-
ness. The piebald, the scrofulous, the stained, and the
encrusted were matters for close and loving inspection;
irregularities to run through his fingering gaze. Other than
the Holy Scripture, he cared for no book as well as the
book of decay, its truths written in the furrows scored on

Rembrandt, The Artist
in His Studio *(detail of
wall)*

the brows of old men and women; in the sagging timbers of decrepit barns;
in the lichenous masonry of derelict buildings; in the mangy fur of a valetu-
dinarian lion. And he was a compulsive peeler, itching to open the casing of
things and people, to winkle out the content packed within. He liked to toy
with the poignant discrepancies between outsides and insides, the brittle
husk and the vulnerable core.

In the corner of his room, Rembrandt's eye ran over the fishtail triangle
of decomposing wall, coming apart in discrete layers, each with its own
pleasingly distinct texture: the risen, curling skin of the limewash; the bro-
ken crust of the chalky plaster, and the dusty brick beneath; the minute
crevices gathering dark ridges of grunge. All these materials, in their differ-
ent states of deterioration, he translated faithfully into paint, and did so
with such intense scrutiny and devotion that the patch of crumbling fabric
begins to take on a necrotic quality like damaged flesh. Above the door
another veinous crack is making swift progress through the plaster.

To give his gash in the wall physical immediacy and visual credibility,
Rembrandt would have used the most precisely pointed of his brushes: a
soft-bristled instrument made from the pelt of some silky little rodent, the
kind the miniaturists favored, a brush capable of making the finest pencil
line or, turned and lightly flattened against the surface of the panel, a more
swelling stroke.[22] Slick with pigment—red lake, ocher, and lead white for
the brick; lead white with faint touches of black for the grimy plaster—the
squirrel-hair brush deposited perfect traces of paint over a scant few mil-
limeters of space on the panel, one set of earthy materials (the painter's)
translating itself into another (the builder's). It seems like alchemy.[23] But
the transmutation happens not in the philosopher's alembic but in our
beguiled eye.

Was the description of the patch of crumbled wall achieved in a matter
of minutes or a matter of hours? Was it the result of painstakingly calcu-
lated design or imaginative impulse? Rembrandt's critics, especially once he
was dead, disagreed on whether the *problem* with him had been that he
worked too impetuously or too laboriously. Either way, he is generally, and

not incorrectly, remembered as the greatest master of the broad brush there ever was before the advent of modernism: the bruiser's meaty fist slapping down dense, clotted pigment, kneading, scratching, and manipulating the paint surface as if it were pasty clay, the stuff of sculpture, not painting. But from the outset, and through his entire career, Rembrandt, quite as much as Vermeer, was equally the master of fine motor control; the cutter of facets of light; the tweaker of reflections, glinting minutiae like the beads of brightness swimming on the metal bar laid across the door, a mote of sunshine on the tip of the painter's nose. This was a talent that Huygens and Hondius, who both had goldsmiths and jewellers as forebears, might have been expected to appreciate. It was entirely logical for Rembrandt to believe that before he could aspire to be anything else, he first had to prove his credentials as a master craftsman. That, after all, is what his contemporaries meant by "art"—*ars*—manual dexterity in the service of illusion.[24]

Is *The Artist in His Studio* nothing more than a demonstration of this kind of "art": a practice piece, a mere jotting? It was painted on a small oak panel—scarcely bigger than this book turned sideways—which, before repriming with the usual mixture of chalk and glue, seems to have had another work on it; just a little bit of wood lying around the room, then.[25] So we are mischievously led to suppose that this is a casual, quite freely painted sketch of the painter's working space: a visual inventory of his tools and practices. There are the palettes hanging on the wall;[26] there the grindstone for preparing pigment, its surface scooped with use and supported on what looks like a crudely chopped slice of tree trunk. There are the pots of medium on the table behind it and perhaps an earthenware warming tray. We can smell the oils and emulsions, especially the astringent linseed. At first sight, the picture looks like the virtuoso flaunting his stuff: the bravura rendering of material surfaces, not just that plasterwork but the coarse-grained planking of the floor with its own web of cracks, stains, and scuff marks; the dull iron hardware on the door. But even as we discount the painting as a brag, a flourish, something cunning begins to register. The painter has chosen to show off his mastery of *ars* through the description of the materials of which it is constituted. With that anvil-like grindstone so prominent, we can almost see him making paint.

So how modest *is* this trade-card exercise in self-promotion? The words that Rembrandt means to bring to mind when we peer at the rough little rectangle are the same that recur when we look at his earliest face paintings, the *tronies*, featuring his shock of hair and rock-star stubble: *Zonder pretentie*, "unpretentious," both in what is being depicted and the way it's being depicted. But it gradually dawns on us that we are being pleasantly had. The panel is, in fact, brimming with pretensions: from the incongruous grandeur of the painter's elaborate blue and gold costume to the currant eyes planted in the gingerbread face. For all the ostensible stinginess of its pictorial language and the slightness of its dimensions, *The*

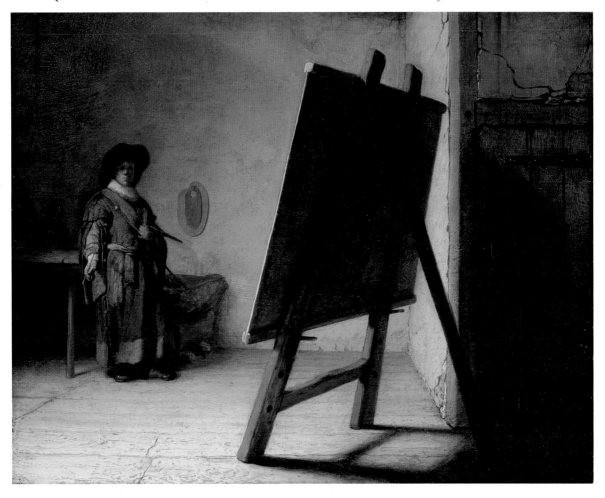

Artist in His Studio is as big a painting as anything Rembrandt ever did. Just as his earliest self-portrait etchings are postage-stamp minuscule in size but wickedly grandstanding in effect, this picture should also be thought of as Rembrandt's Little Big Picture: a grandiloquent letter of introduction, nothing short of a pronouncement on the nature of Painting itself. To pack all this meaning into an unassuming frame was a typical conceit of his generation. Make the largest possible utterance within the least possible space and you make a knotty little emblem; a mind-teaser, awaiting the work of wit to unravel its message. A picture full of evidence of the dexterity of Rembrandt's hand turns out, then, on closer inspection to be a demonstration of his shockingly original mind. For Rembrandt was seldom simple. He just took pride in looking plain. And if *this* was ever shown to Constantijn Huygens, one wonders just who was scrutinizing whom. Take a look at this, the cocky up-and-comer might have said in the provoking manner of the riddle-master, eyebrows arched beneath his felt hat. Now what do you see? Not much? Well, only everything you'll ever want to know about me and my trade.

Rembrandt, The Artist in His Studio, *1629. Panel, 25.1 × 31.9 cm. Courtesy Museum of Fine Arts, Boston; Reproduced with permission*

Or perhaps he thought that a real miniaturist would sense what he was up to? After all, Huygens's mother was a Hoefnagel; he himself had made the acquaintance of the English miniaturist Isaac Oliver, and he was the Dutch translator of John Donne, in whose economical sonnets lay entire universes of thought and feeling. Like any sophisticated connoisseur of his generation, Huygens would have known, and in all probability possessed, the extraordinary prints of the Lorraine graphic artist Jacques Callot. Callot's *Miseries of War* documented in merciless detail the butchery inflicted by soldiers on civilians, and in some cases vice versa, all etched in microscopic scale. Huygens must have grasped the irony of the French title—*Les Petites Misères de la guerre*—because it was not the miseries that were picayune but only the format of the etchings. So much grief and desperation contained in so tiny a frame had the uncanny effect of self-magnification. Such concentration was needed, such focus: ten men hanging from a tree in less than a square inch; an infinity of pain in a thimble. Copernican lenses had been polished in Italy that apparently allowed one to behold the universe, with its scattered stars, gathered in a little circle of glass. It was rumored that instruments were being fashioned through which one might view whole commonwealths of animalcules, microorganisms resembling crayfish, suspended in single droplets of water, or, better yet, homunculi in a pearl of semen.

So a clever patron like Huygens, attuned to these games of magnitude, ought really not to have been deceived by the unassuming size of Rembrandt's picture. And in his autobiography he does, in fact, notice that "Rembrandt concentrates all his loving attention on small painting [but] in this small format manages to achieve what would be sought in vain in the biggest works of others."[27] But what Huygens meant here by "small" was the *Repentant Judas Returning the Pieces of Silver,* six times bigger than *The Artist in His Studio.* For that matter, the little panel was obviously not a history painting; not the kind of thing Huygens had in mind for Rembrandt. But neither was it a conventional self-portrait, not with the features of the painter stylized into a gnomic caricature. So what was it?

It was a quiddity: the essence of the matter; the something that made things (in this case *schilderkunst*, the art of painting) just exactly what they were. And it was also a quiddity in the other sense in which the seventeenth century used the term: a subtle provocation; a riddling road to illumination.

Rembrandt is not usually thought of, first and foremost, as a profound and complicated intelligence, but rather as an orchestrator of emotion, a passion player. And that he certainly was. But from the very beginning he was also a cunning thinker; as much philosopher as poet.

How can we read his quiddity? To begin with, there is that painting within the painting: the same rectangular proportions, but magnified into an overpowering, even forbidding presence at the center of the composition.[28] The panel dwarfs the remote, oddly doll-like figure of the over-dressed painter. The disparity between *The Artist in His Studio* and the painting inside it means that, whatever else the picture is, it can't possibly,

as almost all modern readings assume, be a mirror image of the painter at work.[29] Why? Because it would have been improbable, if not actually physically impossible, for Rembrandt to have set his tiny panel on a standard easel and, bent forward, clutching his brushes and palette, to do the fine work exhibited on its surface. He is much more likely to have executed the painting seated, and at a table, as if it were a drawing, propped up against the folding support, rather like a library bookrest, as can be seen in the much later sketch of his studio in Amsterdam.[30] So this is not a picture of a painter catching himself in the act. It is, in fact, quite free of the narcissism of his armored dandy self-portraits. This time, Rembrandt is not lost in self-admiration; he is lost in thought. And the image he delivers is not one he has seen in a glass, but in his mind's eye. Insofar as one could ever be made, this is a picture of in-sight.[31]

The dominating oak panel is, then, at the heart of the enigma, both visible and invisible, massively present (its shadow falling over the door as if to repel the intrusion of the world) and yet elusive. Like all the rest of the material fabric—the plank floor, the peeling plaster, the easel with its pegs and holes—the physical character of the panel is exactly described. Initially it seems perverse for Rembrandt to have kept the most careful handling of paint for the ostensibly meaningless backside of the panel: the horizontal grain, the bevelled edges, and the outer edge so brilliantly lit that it seems to have sponged up every beam of illumination from an implied window at the left.

The drones wouldn't do it this way. They have no interest in being cryptic. On the contrary, they're only too eager to show us what they can do, making sure we have all the necessary information to complete the self-advertisement. We get to look over their shoulder and see they're painting a Bathsheba, a Mars and Venus, a vase of flowers, a lowlife, themselves. We get to see them sitting, or occasionally standing, always at enough of an angle to their work to allow them to bestow on us their most ingratiating or authoritative manner: gallant; soberly industrious; merrily debonair; silkily prosperous. We are asked to admire the cut of their slashed doublet; the pleats of their dazzlingly bleached ruff; the coat of arms discreetly but unavoidably visible behind them. They greet our examining gaze in such a way as to make it abundantly clear that their principal concern is (after themselves) us, the patron. They charm and they crow. This is what we do, and don't we do it well? How dazzlingly saturated is our vermilion, how snowy our lead white; how meltingly Venetian our flesh tint; how *expensive* our ultramarine. Admire us, buy us, honor us, and in so doing you will demonstrate to the world the rare quality of your taste.

But the little man in the sash and gown doesn't seem interested in striking a pose. Worse, he shows no interest in us at all; not the least bit. He can't even be bothered to display what's being pictured on the face of the panel because the demonstration of *his* credentials is, literally, beyond it: in the entirety of what we see in this naked room. The patch of flaking plaster; the whiplash crack over the door; the mottled stains on the wall; the

scuff marks on the floor—all argue irrefutably for his mastery of *ars:* the skill of painterly illusion. And the powerful line of perspective plotted along the floor testifies to Rembrandt's faithfulness to another necessary work habit—the *disciplina* expected of even the most independent-minded masters.

So Rembrandt is involved in something more ambitious than drumming up trade or repudiating any suggestion that he is a mere *pictor vulgaris.* He is presenting himself as the personification of painting: its skill; its discipline; and, not least, its imagination, its power of invention.[32] This is why he is dressed, or rather robed, with such ceremoniousness: the formal ruff; the impossibly grand blue tabard with its golden shawl collar and sash, a far cry from the shapeless and colorless working smock seen in a self-portrait drawing and a painting from the 1650s.[33] Not only the outside world is barred from his enraptured stare at the panel; so are we. He is monopolized by his mindful task; gripped by a transport of pure thought, the poetic *furor* which writers on Michelangelo believed to be at the heart of divinely engendered creativity.[34]

There has been too much fretting over the precise stage of painting supposedly represented in *The Artist in His Studio.* Some writers have argued that this is the moment of original conception prior to any stroke being laid on the panel. Others have insisted that since the painter is holding the small brushes and the maulstick used to steady his hand (in the manner of a billiard rest) when working up details, this must be a pause in the finishing process, the artist standing back for a chin-stroking consideration of a final dab here and there.[35] But this is not a genre scene; a snapshot from a day-in-the-life of young Rembrandt the working stiff. It's a compact grammar; an account of painting as both noun and verb: the calling and the labor; the machinery and the magic; the elbow grease and the flight of fancy.

Rembrandt's hands, the manual element of his art, grip his palette and brushes, a pinkie curled tightly around the maulstick. A shadow falls across his brow and cheek, perhaps marking him as another captive of poetic melancholy; Huygens's brother-in-gloom, but also temperamentally close to the most famous melancholic, Dürer.[36] A brighter light bathes the lower part of his face; not enough, though, to permit any kind of anecdotal speculation about what kind of man this might be. This is peculiar coming from Rembrandt, who enjoyed changing his face with every etching: Monday, beggar; Tuesday, roughneck; Wednesday, tragedian; Thursday, clown; Friday, saint; Saturday, sinner. But this is Sunday. And on Sunday the thespian has cancelled the matinee. His face is a closed book. It has no eyes.

We know from "model books," the drawing primers that were first published in Italy in the sixteenth century and then quickly adapted for use in the Netherlands, that the human face was the first assignment given to apprentices. It was, after all, closest to the instinctive apple-head or egg-head drawings of small children. The task of the master

was to educate instinct. So the youngest students were made to draw an oval shape, then bisect that oval down its length and then make a second, lateral line about halfway from the top. Along that simple grid the defining features of a human face would be methodically distributed: bridge of the nose at the center; eyebrows either side of the crossing. But when the student, child or adult, was given an exercise in drawing a specific feature of the physiognomy, first and always first came the eye. "First you must begin with the whyte of the eye," wrote Edward Norgate in his *Miniatura*, echoing model book after model book.[37] A late-sixteenth-century print by Jan Baptist Collaert from a model book illustrates a busy workshop where the master is painting a St. George, an older pupil painting a woman from life; the very youngest sits off to one side drawing an entire practice page of eyes. These were the eyes of classical art, the regulation-issue European almond, enclosing cornea, iris, and pupil with the budlike swelling of the caruncula lachrymalis at each corner, the flesh curtains of the lids, the sprouting fan of the lashes, and the arched superciliary eyebrows, all exactly delineated. Every detail, and the relationship between them, determined a reading of character, the sway of the passions. A pupil dilated so that its blackness seemed to swallow up the entire iris would suggest one kind of humor, a drooping superior eyelid another. An eye that was all white sclera with iris and pupil contracted into a pinprick might suggest horror, stupefaction, or devilish fury. Karel van Mander, who wrote the first Dutch manual for artists, in the form of a long poem, reminded his readers that the infernal boatman Charon (to which he might have added all the accompanying demons) in Michelangelo's *Last Judgement* displayed his eyes in exactly this way, as Dante had prescribed, "red wheels of flame about his eyes"; maddened and hellish. For van Mander eyes were the "mirrors of the spirit," the "windows of the soul," but also "the seat of desire, the messengers of the heart."[38] In 1634 Henry Peacham did his best to make sure that his readers properly understood that

> great conceit is required in making the Eye, which either by the dulnesse or lively quicknesse thereof, giveth a great taste of the spirit and disposition of the minde . . . as in drawing a fool or an idiot by making his eyes narrow and his temple wrinkled with laughter, wide-mouthed and showing his teeth. A grave or reverent father by giving him a dominant and lowly countenance, his eye beholding you with a sober cast which is caused by the upper eyelid covering a great part of the ball and is an especial mark of a sober and stayed brain within.[39]

So the utmost pains had to be taken with the depiction of eyes. The white of the eye, for example, could not be painted in unmixed lead white, which would have given it a strangely opaque cast suggesting an impending cataract, but rather in white mixed with a minute quantity of black. Similarly, the pupil was never painted dead black but with brown umber

Willem Goeree, Illustration from Inleyding Tot de Algemeene Teycken-Konst . . . , *first edition (Middelburg, 1668). Private collection*

Jan Baptist Collaert after Johannes Stradanus, Color Olivi *(detail), c. 1590. Engraving, from the series* Nova Reperta. *Amsterdam, Rijksprentenkabinet*

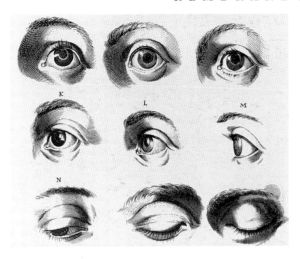

Engraved drawing models from Crispijn van de Passe, Van 't ligt der teken en schilderkonst *(Amsterdam, 1643). New York, Columbia University, Avery Library*

Rembrandt, The Artist in His Studio *(detail of head and shoulders)*

mixed with charcoal black and a flick of white; a dark iris with lampblack and a touch of verdigris.[40] Something apparently as insignificant as the tiny catchlights reflecting either pupil or iris or both, depending on size, shape, and angle of reflection, could make a face merry or disconsolate, lustful or haughty.

Making an eye was the beginning of art.[41] Tracing the contours of the organ of vision was both the apprentice's initiation into the mystery of his craft and an emblem of its purpose: a shorthand profession of the power of sight. The routine drawing of an eye was so fundamental that it may have imprinted itself on an artist's unconscious, returning long after he had become a master in the form of habitual doodles or sketches made on an empty pad or etching plate. Rembrandt's eyes sometimes appear on his most intuitively sketched copper plates, floating free of the faces they are supposed to inhabit. On one such plate, etched in the 1640s, Rembrandt has drawn on one side a tree, on another the right section of his upper face with one eye visible beneath a beret. But between hat and tree, altogether disembodied, is another eye, perfectly drawn, wide open, unnervingly watchful, a singular vision.

When Rembrandt made eyes, then, he did so purposefully. So how does he treat the eyes of the painter in *The Artist in His Studio*? He takes his finest brush, loads its neat point with black pigment, and makes the shape not of little almonds but rather of lead shot, or Malacca peppercorns, blackened o's that seem to absorb rather than reflect light. To make them, Rembrandt must have deposited a small, perfect dot and then moved his brush round and round, building the dot into circular pinheads. They have no convexity, these eyes. They are not gently protruded from their containing sockets like the black glass beads of a child's doll. They lie flat against the face, glitterless. They are, literally, black holes—cavities behind which something is being born rather than destroyed. Behind the drill holes, in the deep interior space of the imagination, the real action is going on, wheels within wheels; the machinery of cogitation whirring and flying like the delicately interlocking parts of a timepiece. An idea, *this idea,* is in genesis.

Rembrandt knew that nothing in the conventional repertoire of artist's eye-language was adequate to this moment, and certainly not some

glassy-eyed staring. So he opts instead for the blackout to convey a sense of creative reverie, the waking sleep which writers on art since Plato have characterized as a kind of trance. The word most commonly used for this visitation was *ingenium*, and the image used to symbolize it a female figure with winged heels, in flight from the mundane. *Ingenium* or *inventio* was the divine something without which skill and discipline were just so much hod-carrying. *Ingenium* alone distinguished the stupendously gifted from the merely accomplished. And unlike skill and practice, this was not something that could be studiously acquired. It was innate, and that made it literally awesome, a gift of God. Poetic visions came to those blessed with this inner eye, in states close to delirium, as they did to the "divine angel" Michelangelo. And though nothing seems, on the face of it, less Michelangelesque than

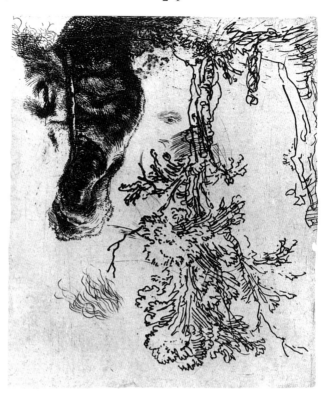

Rembrandt, Sheet with Three Studies: A Tree, an Eye, and a Partial Self-portrait of the Artist *(inverted to show eye), c. 1642. Etching. New York, Metropolitan Museum of Art*

our little potato-head in his upstairs room, it is as though Rembrandt had indeed read the pages in Giorgio Vasari's biography where he describes the isolation required by the authentic genius so that his ideas might ferment. "Whoever wishes," Vasari wrote, "to work well must distance himself from all cares and burdens because his *virtu* needs thought, solitude and opportunity, so as not to lead his mind into error."[42]

Was the miller's son, all of twenty-three, stuck in pious, professional Leiden, already presuming to present himself as the incarnation of Genius? No wonder a visitor from Utrecht, Arnout van Buchell, who encountered Rembrandt in 1628, thought him "highly esteemed but before his time."[43] But Rembrandt did not, of course, think of himself as a genius in the modern sense of a transcendent figure, embattled with the culture into which he arbitrarily happened to be born, answerable only to his inner muse and fed on alienation. Alienation would come to Rembrandt, all right. But it was not of his seeking. On the other hand, it doesn't do, either, to understate Rembrandt's precocious awareness of his own quirky ingenuity. *Ingenium* means something more than mere cleverness. It presupposes a divine spark, and the painter's power of conception, behind his black eyeholes, has evidently been kindled. Perhaps Rembrandt's pride in presenting himself in this way required an ostensibly humdrum setting and a throwaway manner to make its temerity palatable. Yet even this studied roughness was a pretense. Dürer, passionately admired and universally known to artists in the Netherlands, had observed that

an artist of understanding and experience can show more of his great power and art in small things, roughly and rudely made than many others can [show] in their great works. Powerful artists alone will understand the truth of this strange remark. For this reason a man may often draw something with his pen on a half sheet of paper or engrave it with his tool on a block of wood and it will be fuller of art and better than another's great work on which he has labored for a whole year. And this gift is wonderful. For God sometimes grants to a man understanding of how to make something the like of which, in his day could not have been found.[44]

So even if Rembrandt didn't think of himself as a "genius," he must have sensed his own budding originality. For nothing like *The Artist in His Studio*, so full of both handwork and headwork, could be found anywhere else in the Dutch painting of 1629. There had already been countless self-portraits of artists and there would be countless more, searching for clever ways to suggest, simultaneously, their presence in, and their absence from, the studio. They would appear as mirror reflections (like Parmigianino), or as their own likeness on an easel (like Annibale Carracci); in the glass bowl of a goblet, or in a print thrown carelessly amidst other artist's bric-a-brac. But they would not presume to appear as the personification of painting itself. And even Rembrandt has backed slyly into the role, his own mask, with its cut eyelets, oddly reminiscent of the mask described in the most famous emblem book of the seventeenth century as hanging from the neck of Pittura, or Painting. He has disappeared inside his Persona.

How much of this complicated, audacious performance did Constantijn Huygens, hardly an obtuse mind himself, take on board? Did he, for that matter, even see *The Artist in His Studio* among the more showy histories lying around Rembrandt's chamber? Might he have thought that the large panel seen in the painting was some sort of allusion to the grand histories he wanted out of the artist? Certainly there's no doubt that he was deeply taken with both Rembrandt and Jan Lievens, enough for him to make the extraordinary boast that in time they would surpass all earlier masters, both north and south of the Alps. But he can't quite avoid the literally patronizing impression that what he had found were two diamonds in the rough: brilliant but unpolished, intuitive rather than tutored. Huygens seems to have been deceived by Rembrandt's deliberately assumed guise of nonchalance, his resistance to being told what was good for him, into believing that he was somehow a kind of gifted primitive. But in fact, when he so chose, Rembrandt, who had been to Latin school and for a time at least to Leiden University, could trade erudition with any of the scholars. Did it ever occur to Huygens, for example, that the dazzling line that defined the lit edge of the panel might have been Rembrandt's allusion to the most famous game of one-upmanship in the history of art? It was one that Lievens and Rembrandt, who were themselves

engaged in an obvious competition, knew well, and which they could have expected others to discover with a happy shock of recognition.

The contest was told by Pliny in his history of the painters of the ancient world, and in particular in his biography of the favorite painter of Alexander the Great: Apelles of Cos. The story that everyone in the seventeenth century would have remembered about Apelles was of his painting Alexander's mistress Campaspe so well that the King gave her as a present to the artist. Painters, especially, treated the memory of Apelles as the patriarch of their craft, the perfect role model. He was, after all, the artist who became the familiar of the greatest prince of the world. The story of his life was a scripture of genius. On one occasion, according to Pliny, Apelles had heard of a serious rival, Protogenes, and journeyed to Rhodes to see what he was made of. "He went at once to the studio. But the painter was not there. There was, however, a panel of considerable size, on the easel, prepared for painting." Apelles left a visiting card in the form of "an extremely fine line" freely drawn across the panel in color, a knowing signature since the almost unbearably virtuous and prolific Apelles was also known for obeying his own stricture of "No day without a line" (*Nulle dies sine linea*), the motto which had become the Renaissance summons to self-discipline.[45] Protogenes returns, sees the challenging line, and rises to the bait: "He himself using another color drew an even finer line exactly on top of the first." With the uncanny timing usual in these apocryphas, Apelles comes back once more, finds the competition out, naturally, and applies the killer, a third, even finer line, cutting the other two. Protogenes throws in the towel and dashes to the harbor to find his rival, having decided that the panel "should be handed on to posterity as it was to be admired as a marvel by everyone, but especially by artists. I am informed," Pliny adds, rather lugubriously, "that it was burnt in the first fire that occurred in Caesar's palace on the Palatine; it had previously been much admired by us, its vast surface containing nothing else than the almost invisible lines so that among the outstanding works of many artists it looked like a blank space, and by that very fact attracted attention and was more esteemed than any masterpiece."

Suppose that this is what Rembrandt means by his brilliant line (and it is only supposition), the biggest possible brag made with the most economical of means; suppose again that Huygens worked all this out and understood *The Artist in His Studio* as a kind of cunning disquisition; would he have been impressed? He was not, after all, in the disquisition market. He was in the market for grandiose histories, decorous portraits; the pleasures of princes: images of themselves. Had he looked right through Rembrandt's production in 1629, he might have been made a little uneasy by what he saw, and perhaps come to the conclusion that for all his exceptional talent, this was a somewhat singular young painter. Bringing him on might not be an altogether straightforward business.

Now what was Huygens supposed to do with idiosyncrasy? He needed quality. He needed reliability. He needed a domestic Rubens. Genius? Who knew what that was?

v *New York, 1998*

One might say the same of modern Rembrandt literature. There was a time, not so very long ago, before the anachronism police had been sent out on monograph patrol, when "genius" and "Rembrandt" seemed to belong in the same sentence. For the unnumbered millions who respond intuitively to his painting, applying the G word to Rembrandt seems no more incongruous than awarding it to Shakespeare, Raphael, Cervantes, Milton, or Bernini, all of whom predate the Romantic recoining of the word. It was the way in which Michelangelo was referred to both inside Italy and beyond. Not long after his death, biographies of artists made a habit of identifying those who were inexplicably exceptional as prodigies whose gifts seemed so incommensurably greater than those of their contemporaries that they must have been marked by a touch of divinity. By the same token, such rarities were also prone to antisocial fits of melancholy and even madness. The isolated artist, eccentric in habits, mercurial in temper, embattled with the callow vulgarity of contemporary taste or the conventions of academic mediocrity, straining against the expectations of his patrons, was *not* a modern, nineteenth-century invention.[46] It was the way in which seventeenth-century writers wrote (and often complained) about, for example, Salvator Rosa, just nine years younger than Rembrandt and notorious for his arrogant indifference to the demands of patrons. Of course, acknowledging the eccentricity and obstinacy of genius was not the same thing as admiring it, and many critics who wrote of the truly peculiar painters thought such waywardness a symptom of deplorable self-indulgence.

But ever since one of the most penetrating of all writers on Rembrandt, the art historian Jan Emmens, published a ferocious attack, appropriately in a journal called *Tirade,* on what he took to be the vulgar glorification of Rembrandt, allergy to genius-talk has virtually become a professional obligation.[47] The postwar generation has been understandably cool toward cultural idolatry. In the Netherlands, mistrust of self-abasement before cultural folk heroes has a particularly poisoned history. In 1944 Dutch collaborators with the Nazi occupation thought it a bright idea to promote a national "Rembrandt Day" on the anniversary of his birth, as a popular alternative to the surreptitiously patriotic celebrations of the birthday of Queen Wilhelmina, then in exile in London.[48] Rembrandt's inconvenient habit of keeping company with Jews was overlooked (though not by all SS officers). This grotesque attempt to make over Rembrandt into a perfect specimen of Greater German culture, including a commissioned opera called *The Night Watch,* did not exactly catch fire in the public imagination in the Netherlands. But the episode might well have been re-

membered as the most egregious result of indiscriminate Rembrandtolatry.

Even without this obscene perversion of Rembrandt's memory, the postwar aversion to any kind of cultural heroism, which at its most extreme ended up in the endeavor to get rid of the idea of authorial originality altogether, was bound to discount the originality of his innovation. Emmens's doctoral dissertation, "Rembrandt and the Rules of Art," took the process of decanonization even further, arguing that the "myth" of Rembrandt the rule-breaker had been an invention of critics, who, after his death, projected back his apparent disdain for classical decorum onto his entire career. According to Emmens, judged by the earlier conventions of the century, Rembrandt had never been the notorious "heretic," as one late-seventeenth-century critic dubbed him. He had never really been a rule-breaker. On the contrary, he was, from the beginning, more interested in following norms than in violating them.

Instead of Rembrandt the rebel, we now have in place Rembrandt the conformist. This seems, to put it mildly, an overcorrection. *The Artist in His Studio,* with all its weight of learning and thought, might seem evidence of just how seriously preoccupied with the principles of his calling Rembrandt was. Certainly the picture is full of such commonplaces. But the *form* in which they are expressed, the manner in which they have become paint, is not in the least commonplace. Instead of the usual clutter of symbols and emblems alluding to this and that learned text, Rembrandt made the acts of conception and execution his little manifesto. Nothing whatsoever in the conventions of the day anticipated this: the knottiest thought in the simplest packing. Rembrandt in a nutshell. The quiddity.

These days we hardly have to worry about the exaggeration of Rembrandt's originality. Where once he was assumed to tower head and shoulders above his contemporaries, he has now been largely submerged within their company. The Rembrandt Research Project, whose original mission was to sort out, once and for all, the unmistakably authentic works of the master from those of lesser imitators, followers, and pupils, ended up, in the view of some (not me), making the distinctions less, rather than more, clear. The famous Rembrandt manner, muscular impasto, and theatrical lighting, it's said (not by me), could be imitated by others to a degree of plausibility that has made any serious differentiation between the real and unreal item all but impossible. Insofar as Rembrandt's painting is still thought distinctive, it is now fashionably reckoned to be the product of something else: his society, his culture, his religious confession (whatever that might have been); his teachers, his patrons, the nature of Amsterdam politics; the nature of the Dutch economy; the practices of his workshop; the literature of his day. And all these things *did* matter to his development, without ever, I believe, ultimately determining it.

But once the truism that Rembrandt's painting did not spring, fully armed, like Minerva from the head of Jupiter is taken as read, and once it is assumed that he was seldom isolated from the world which surrounded him, that he was, in fact, an intensely social, rather than antisocial, animal, it's impossible to look at his strongest work, either in painting, drawing, or

etching, and still not be struck by the simple truth that he achieved things which, as Dürer wrote in another context, "could not, in his day be found."

It didn't start this way, though, not at all. For all his inventiveness, the Rembrandt whom Huygens had discovered was driven constantly to measure himself against the mark others had set: his Amsterdam teacher Pieter Lastman; his Leiden friend and rival Lievens; perhaps even the great Renaissance master of his native town, Lucas van Leyden; against the grand array of Netherlandish masters pantheonized in Karel van Mander's biographies. Most of all, though, and for an entire decade, Rembrandt measured himself compulsively against "the prince of painters and the painter of princes": Peter Paul Rubens. To become singular, Rembrandt had first to become someone's double.[49]

Perhaps Huygens's obvious adulation of Rubens, his personal contact with the Flemish master, his intense desire, when the circumstances of the war allowed, to have him produce work for Frederik Hendrik's court, pricked Rembrandt's keen sense of emulation and envy. But in any case, it was quite impossible to avoid the great Paragon of Antwerp. A paragon (like a quiddity) had two meanings for Rembrandt's world: both the acme of perfection and the object of competition. Much of the history of art had been written in terms of such *paragones:* Apelles and Protogenes; two other ancient Greeks, Zeuxis and Parrhasius; Michelangelo and Raphael; and (soon) Bernini and Borromini.

For most museumgoers, the differences between Rubens and Rembrandt are likely to seem more obvious than any close similarities. Visitors to Rubens galleries, when they pause at all, tend to cower before the immense, obscure symphonies on the wall. Visitors to Rembrandt come close as if greeting a cousin. And certainly Rembrandt ended up being the kind of painter Rubens could not possibly have imagined, much less anticipated. But for the crucial decade of his formation, the years which saw him change from being a merely good to an indisputably great painter, Rembrandt was utterly in thrall to Rubens. He pored over engravings of Rubens's great religious paintings and struggled to make his own versions, at once obvious emulations and equally obvious variants. He borrowed poses and compositional schemes wholesale from Rubens's histories and transferred them to his own choice of subjects. And what he wished for came true. Huygens and the Stadholder entrusted Rembrandt with the most Rubensian project anyone in the Dutch Republic could have asked for: a series of paintings on the Passion of Christ. The work made him. And then it very nearly broke him.

And it still wasn't enough. He bought Rubens's *Hero and Leander* when it came on the market. Using the money he had been paid for the Passion paintings, he bought a house from the same family that had sold Rubens *his* palatial urban villa in Antwerp.

Rembrandt was haunted by the older master. He had become Rubens's doppelgänger. He began to dress like characters from his pictures, taking a

pose and costume from a turbaned figure in Rubens's *Adoration of the Magi* and transplanting both to himself. When, for the first time, he etched himself half-length, enveloped in a grandiose cape, it was as if he had superimposed his face on the body and deportment of his paragon. The face declared itself, unmistakably, to be Rembrandt. But everything else whispered "Rubens."

vi The Hague, Winter 1631–32

Something had happened to Rembrandt. He was no longer quite so peculiar. There were no more sharp little epiphanies featuring himself as the personification of painting, standing entranced in a bare studio room; no more ruffian *tronies,* the root-vegetable nose crowned by a mane of outlaw hair, expression unreadable in a pair of darkened slits. Increasingly, he was the object of refined self-admiration: the face becomingly well defined, almost bony; an ostrich plume in his hat, a jewelled hatband about its brim; a golden chain slung about his shoulders swagging down over his chest. The looking glass must have been put to heavy service. The manner of his painting was now sleek and glossy, as befitted a court-painter-in-waiting. Surfaces glimmer as if they were enamel or lacquer.

Prospects seemed good. Sometime toward the end of 1629, Constantijn Huygens, evidently enamored of Rembrandt's talent, had bought *three* of his paintings, including a self-portrait, for the Stadholder Frederik Hendrik. And the Prince had promptly made a gift of them to Robert Kerr, Lord Ancrum, a courtier to Charles I; the kind of Scot whom van Dyck liked to paint in watered silk. Ancrum was visiting The Hague to attend the obsequies for King Charles's nephew, the son of the Winter King and Queen of Bohemia. His own son, William Kerr, had been serving with the Stadholder's siege army at 's Hertogenbosch, so the Scottish lord joined the enormous throng of dignitaries coached to Brabant to witness the capitulation of the city on September 14. Endless carillons pealed; the conqueror was eulogized, interminably and in Latin; tanks of wine were consumed; raptures were made generally available.

Frederik Hendrik had every reason to want to make a serious impression on Ancrum. He knew that Rubens, of all people, had been appointed a special envoy from the King of Spain to the King of England and would be doing his best to bring about a peace treaty between those two countries, thus detaching a formidable power from the anti-Habsburg coalition. Since Frederik Hendrik was himself a devotee of Rubens's art (who was not?) and already owned six of his pictures, this must have hurt. Worse, it seemed that Rubens was already doing his job well enough that Charles I was reported to have broken down in tears at the news of the fall of 's Her-

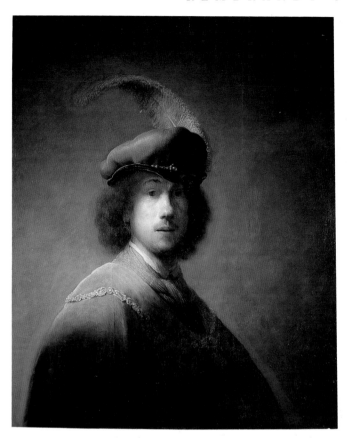

Rembrandt, Self-portrait in a Plumed Hat, *1629. Panel, 89.5 × 73.5 cm. Boston, Isabella Stewart Gardner Museum*

togenbosch. In The Hague, this was not at all what was desired. So a campaign of gentle but unsubtle counterpersuasion was mobilized. What better way to sweeten the Stuart King, who (whatever his other shortcomings) was famous for his cultivation of the arts, than with a prize parcel of pictures. Ancrum's gift from Frederik Hendrik duly found its way into the rapidly expanding royal collection in England. Doubtless Huygens was the orchestrator of this diplomatic offensive of good taste. Rubens is doing us an ill service, he might have told the Prince. Very well, let the Stuart King see that we have, in our country, painters who can match Rubens, stroke for stroke: our Lievens, our Rembrandt.

Of course, Rembrandt could have had no idea, when he painted it, that his own likeness was to end up in the collection of the King of England. But equally, Huygens might have thought it droll and fitting to include in the batch a self-portrait in which the young man had adorned himself with a great golden chain. It was known that one of the few self-portraits that Rubens ever painted of himself had been sent as a gift to Charles Stuart, when he was still Prince of Wales, in 1623. In that picture—copied at least once—a few links of a heavy chain were seen at the base of Rubens's collar. This was the way principled and modest gentlemen wore them. Such chains were bestowed as a sign of esteem from princes to their most honored subjects. They linked together sovereign and servant in a mutual bond. The subject acknowledged his golden fetters. In return he was marked as the favorite of his lord, almost an intimate. Just occasionally, painters were given this honor. The present King of Spain's great-grandfather, the Emperor Charles V, had given Titian such a chain. His son, Philip II, had given another to his own favorite Flemish painter, Anthonis Mor of Antwerp, said by van Mander to have been worth three thousand ducats.[50] Van Dyck would paint his self-portrait with a huge sunflower, an emblem of the radiance of royalty, his other hand trawling through a massive golden chain. But no one had more chains than Rubens. The cabinet in his superlative house in Antwerp was thought to be festooned with them.

But nobody, of course, had given Rembrandt any such thing. There were no kings in Holland, and the Stadholders were neither wont nor entitled to award such grandiose decorations. On the other hand, costume hardware was not difficult to come by, and since Rembrandt used the motif almost as much as he did armor, he might have had some sort of theatrical

prop available for his fanciful portraits. So he gave himself a chain of honor in the self-portrait given to Ancrum, unapologetically painting himself into gentility. No one seemed to take offense. Possibly it amused Huygens to think of his golden boy, his diamond in the rough, jostling Rubens for space in the gallery of Charles I. And for his part, perhaps Rembrandt thought Huygens would immediately understand this innocent pretension. Wasn't Huygens himself about to become an instant lord, the "Heer" of Zuilichem, the barony conferred along with the manorial estate he had just purchased?

By the winter of 1631–32, Rembrandt doubtless felt that he was on the verge of great things, a court-painter-in-waiting. He had moved from Leiden to Amsterdam. But he must also have been spending some time in The Hague, since he had been hired by Huygens's older brother Maurits, secretary to the States General, and his friend Jacques de Gheyn III to paint their "friendship portraits"—a pair which, when one or other of the friends died, would be reunited in the property of the survivor (in this case, Maurits Huygens). Constantijn, who had had his own portrait painted by Lievens (and possibly by Rembrandt as well), may not have been delighted to have his protégé moonlighting, accepting commissions especially from his own brother, which had not come through his own good graces. So naturally he found fault with the product. In 1633 Constantijn penned a tart little poem mocking Rembrandt for his failure to produce an acceptable likeness of de Gheyn. "Wonder on, then, O reader / Whoever's likeness is this / It's not de Gheyn's."[51] But Huygens was certainly not so miffed that he would get in the way of Rembrandt's prospects at court. And in 1632 the juiciest of all possible plums fell into the young painter's lap: a profile portrait of the Princess of Orange, Amalia van Solms, looking left, presumably to be paired with a picture of Frederik Hendrik looking in the opposite direction.

He was just twenty-five years old. Seven years before, he had still been a pupil of the Amsterdam history painter Pieter Lastman. If he now felt a little giddy with the rush of sudden success, this was understandable. He was knocking on the door of the cream of Dutch society; the world of moneyed nobility; the great officers of state and the high magistrates of the Republic. His fingers must have been itching to sample the weight of brocade.

The Hague was in its halcyon days. In the first decade of Frederik Hendrik's stadholderate, it had been transformed from an unpretentious place of administration and military barracks into an elegant, if still modestly sized, court city. The medieval Gothic Knights' Hall, where the States General met, had been enclosed in a courtyard of elegant northern Renaissance

Rembrandt, Self-portrait with Soft Hat and Gold Chain, *c. 1630.* Panel, *69.7 × 57 cm. Liverpool, Walker Art Gallery*

buildings looking out onto the lake of the Vijver. On the other side of the
pond, along the linden-lined boulevard of the Lange Voorhout, limestone
pilasters and pediments were starting to appear. Behind the traditional
quarters of both the Stadholder and the States General, Frederik Hendrik
had ordered the Count of Holland's ancient cabbage garden dug up and
turned instead into the Plein, a northern piazza custom-designed for the
open-air masques and ballets of which both the Prince and Princess were
inordinately fond.[52] By Dutch standards, The Hague was a self-consciously
aristocratic city: dotted with stables; expensive tailors; fencing academies;
and hunts in the surrounding woods. Along the Voorhout foreign diplomats
who dominated the population of The Hague fought proxy wars through
their equerries and postilions during the hours of the carriage drives; six-
horse teams, brushed to states of silky brilliance, competing for bragging
rights. Which ambassador had the handsomest equipage, the most gor-
geously liveried retinue, the most dazzling ladies: Naples? Poland? France?
It was a city of high boots, lace jabots, doublets of black satin threaded with
silver and gold; of exotically spiced pomanders, nautilus-shell goblets, and
pearl chokers; a place of brisk rapiers, fresh oysters, hooded sparrow
hawks, mischievous gossip, lightly worn piety, and dull suppers.

 And it was a culture where some artists knew very well how to get on:
by at least putting on a show of being themselves *virtuosi*. Hendrik Hon-
dius, for instance, Huygens's old drawing teacher, was known as a man of
cultivated enterprise as well as an artist: a publisher of fine editions and an
art dealer to the grandees of the court and city, whose own house was a
stone's throw from the Stadholder's living quarters.[53] In the winter of 1631,
two indisputable *virtuosi* dominated the world of painting in The Hague,
one of them without even living there. They were Gerrit van Honthorst and
Anthony van Dyck, and both, in their particular ways, had got where they
were because of Rubens.

 By the winter of 1631, Honthorst had become the court painter of
choice in The Hague. He had everything it took to be a smart success: a
prolonged stay in Italy at the right addresses, lodging with one famous
patron, Vincenzo Giustiniani, and working for another, Cardinal Scipione
Borghese, whose protégés also included the young Bernini. When he got
back to his hometown of Utrecht, he was already famous as "Gherardo
della notte" for the candlelit history and genre paintings which borrowed
frankly from Caravaggio's dramas of light and darkness. Turning out a
steady stream of histories and erotically suggestive genre paintings, Hont-
horst moved smoothly along. By 1631 he had been appointed dean of the
painters' guild of St. Luke in Utrecht four times. His workshop was,
according to one of his students, a virtual production-line enterprise with
no less than twenty-four paying pupils. He boasted a handsome face, an
elegant demeanor, and genuine flair and versatility as a painter.[54] He was,
then, the logical person for Rubens to seek out when he came to the Dutch
Republic in July 1627, ostensibly to talk to fellow painters but actually to
do some complicated diplomacy. Honthorst, who was in the process of
moving to an opulent house right in the center of the city, and who must

have been one of the very few painters to flaunt his own carriage, threw Rubens a lavish banquet anyway, complete with the usual exchange of toasts and eulogies.

The connection paid off. Honthorst began to paint fewer pictures of cow-eyed blondes with breasts like syllabubs being drooled over in "merry companies" while someone's fingers strummed an unsubtle lute. And he began to paint more of the kind of thing that would win him commissions from

Gerrit van Honthorst, Mercury Presenting the Liberal Arts to Apollo and Diana, 1628. Canvas. London, Buckingham Palace, Royal Collection

the great and lordly, the kind of pictures that had made Rubens famous and desirable—a *Death of Seneca*; a *Diana at the Hunt*. With Rubens himself so busy as a diplomat on behalf of the Catholic Habsburgs, it was natural for the anti-Habsburg princes and their talent scouts like Huygens to be on the lookout for tolerable substitutes. And the prolific, personable, and versatile Honthorst duly came to the attention of the *other* court in The Hague: that of the Winter King and Queen of Bohemia, who had been chased from their realm by the armies of the Holy Roman Emperor at the beginning of the Thirty Years' War. The Winter Queen happened to be the sister of Charles I, Elizabeth Stuart, who was pleased enough with Honthorst's portraits of her family, dressed in allegorical costumes, to cry up his talents to her brother in England. It made no difference at all that Honthorst remained a staunch Catholic. Wasn't King Charles's Queen Henrietta Maria of France a Catholic herself?

In 1628 Honthorst went to work for Charles I, painting portraits of the Stuarts and ending up with the most important commission the King could think of: a huge allegorical painting for Inigo Jones's new Banqueting House in Whitehall. The ceiling would be covered with Rubens's immense allegories of the improbable glories of the reign of Charles's father, James I (peace; union; justice). Beneath those same noisy alleluias, Charles would walk to the scaffold in 1649. But the wall facing Whitehall was dominated by Honthorst's picture of Apollo and Diana (a.k.a. Charles and his queen, Henrietta Maria) seated on the puffy upholstery of clouds while being graciously introduced to the Seven Liberal Arts by Mercury (a.k.a. the Duke of Buckingham, one of Rubens's most ardent collectors and admirers). The painting was such a tremendous success that the King redoubled his desperate attempts to have Honthorst remain in England, to no avail. It couldn't be said that Charles was churlish in disappointment. When he left, in

Anthony van Dyck,
Portrait of Frederik
Hendrik, *c. 1631–32.*
Canvas, 114.3 × 96.5
cm. Baltimore Museum
of Art

November 1628, Honthorst took with him a document proclaiming him an honorary subject of His Majesty the King of Scotland, England, and Ireland; a pension for life of a hundred pounds a year; three thousand guilders for his work (more than Rembrandt ever received for any work in his entire lifetime); a twelve-piece-per-setting solid silver dinner service including a pair of standing salts; and a thoroughbred horse from the royal stud. In other words, he was given the standard Rubens treatment.

Honthorst was now a made man. No one said anything about his being a Catholic. Though he continued for a while to live in Utrecht, the court patriciate lined up to have him paint them, along with their children and hounds, either in mufti or in the usual pastoral guise as swains and shepherdesses, gods and nymphs. Soon he had completely eclipsed the older, more austere Michiel van Mierevelt as the Stadholder's own portrait painter, and Honthorst was hired by Huygens to provide decoration for the Prince's palaces. When he did finally move to The Hague, it was as a great seigneur, complete with swaggeringly elegant house, servants, horses. And when his devotedly Catholic brother got into trouble in 1641 for religious offenses, it was nothing for the Stadholder to intervene personally on his behalf.

So when Rembrandt was hired to paint the profile portrait of Princess Amalia, quite possibly to face Honthorst's picture of the Prince, it must have been irresistible for him to imagine himself living the Honthorstian life: honor, fame, money, houses, carriages, golden chains.

During the winter of 1631–32, there was another presence in The Hague who might have quickened Rembrandt's ambitions to be the Rubens of Holland even more directly than Honthorst, and he was Anthony van Dyck. Van Dyck was, of course, Rubens's most gifted and famous disciple. But his relationship with his old teacher was not uncomplicated, for he endeavored to be something more than the Flemish master one went to when Rubens was, alas, politically unacceptable or merely otherwise engaged. Before 1630 van Dyck had only partly succeeded in developing a manner which was evidently all his own. His most important sacred work, a *St. Augustine in Ecstasy* done for an Antwerp church, bor-

rowed heavily from Rubens and was placed immediately to the left of a great painting of the Virgin and saints by the older painter. Try as he might, it was difficult (and perhaps undesirable) for van Dyck to avoid slipstreaming behind Rubens's long-established reputation in the courts. His patrons in Genoa were the same families Rubens had painted twenty years earlier. When he drew the portrait of the French classicist scholar Nicolas-Claude Fabri de Peiresc, it was probably with the self-portrait of Peiresc's dear friend Rubens in the room. Besides, there were some obvious advantages, as well as undoubted vexations, in being thought of as Rubens II, not least the scale of fees, his pension as a court painter for the Archduchess Isabella in Brussels, and the same relief from taxation that Rubens enjoyed.

The Hague in the winter of 1631 must have seemed a place where van Dyck could at last prevail in his own right as (Honthorst permitting) "the prince of painters." And the work he did there was, in fact, breathtakingly beautiful: a spectacular portrait of Frederik Hendrik as warlord, suited in magnificently decorated armor of black steel etched in gold; a voluptuous, Titianesque pastoral of the shepherd Myrtillo, disguised as a woman engaged in an adhesive kissing contest with the nymph Amaryllis. If the Prince and Princess of Orange (and their adviser Huygens) wished to make it incontrovertibly clear that they were not presiding over a halfhearted, dowdily Calvinist court, this was definitely the kind of painting to make the necessary, conspicuous splash.

It was while he was busily employed in The Hague that van Dyck made drawings of the leading lights of Dutch art and letters. They were to be added to the anthology of portraits he was collecting, and which he meant to publish in engraved form as an *Iconography,* not just of artists but of statesmen, generals, and princes. This miscellany was a deliberately loaded

LEFT: *Paulus Pontius after Anthony van Dyck,* Portrait of Gerrit van Honthorst, *1630s. Engraving. Amsterdam, Rijksprentenkabinet*

RIGHT: *Paulus Pontius after Anthony van Dyck,* Portrait of Constantijn Huygens, *1630s. Engraving. Amsterdam, Rijksprentenkabinet*

statement. It said that painters, *northern* painters, were no longer to be thought of as mere craftsmen; but rather, like *Sir* Peter Paul Rubens (and Sir Anthony van Dyck, as he would be), should be counted a natural nobility, fully the equal of the philosopher, the warrior, and the poet. Rubens, of course, had already been included in this gallery of the learned artists (along with van Dyck himself). In Holland he added, among others, the beauteous Honthorst and the not-so-beauteous Huygens, complete with the intense, slightly exophthalmic eyes that were to give him progressive trouble as the years went by. Huygens's hand rested on an enormous volume, representing his poetry and perhaps some of the eight hundred musical compositions he would write in his lifetime. In fact, van Dyck visited Huygens's house in The Hague, perhaps with an idea of making such a drawing. But it was not an ideal day for such precious business. For a storm had brought down trees, one of them on the roof of Huygens's own house, and it seems unlikely that van Dyck got quite as much of Huygens's undivided attention as he would have wished.[55]

Van Dyck's portraits were only published, in part, after his death. But it seems likely that the young Rembrandt, who must have had contact with both Huygens and Honthorst, would have known about the great project of the *Iconography*. Perhaps it even irked him that unlike, say, the landscape painter Cornelis Poelenburgh (whom Rubens had visited during his 1627 trip to Holland), he was not himself included. But perhaps the mere *idea* of a pantheon of contemporary artists—comparable to Vasari's lives of Italian painters and sculptors, or Karel van Mander's biographies of Netherlandish artists—triggered Rembrandt's own fantasies of what kind of figure he would cut, both to the present and to posterity.

For it was precisely at this time that Rembrandt began to make himself over in Rubens's image. He must have had the printed reproduction by Paulus Pontius of Rubens's great *Christ on the Cross*, which both he and Lievens had already taken as the starting point for their respective exercises in emulation. Perhaps he even knew of van Dyck's own variations on precisely the same work of Rubens, compulsively repeated in the years around 1630 and 1631. And it was just conceivable, since both Huygens brothers must necessarily have been involved in the arrangements, that Rembrandt learned the astounding news that Rubens was actually to be in The Hague for a few days in December 1631, in a predictably fruitless attempt to bring Frederik Hendrik around to more tractable terms for a truce. Rubens need only have taken a look at van Dyck's triumphal portrait of Frederik Hendrik as the modern Alexander to have saved himself the trouble. Just what van Dyck himself must have thought on hearing that his old master and rival was to show up on the very doorstep of his new patrons can only be imagined!

If Rembrandt knew anything at all of this sudden appearance and disappearance, it could only have been exquisitely tantalizing. So near, so far. But like everyone else, Rembrandt had the surrogate version of Rubens's presence to hand. It was an engraving, made by Paulus Pontius and published just the previous year, in 1630, of the Flemish master's self-portrait,

originally painted for Charles I in 1623. As
far as Rubens was concerned, this was his
prototypical self-image. When his antiquar-
ian friend Peiresc begged him for a portrait,
he made a copy of the 1623 painting. Unlike
Rembrandt's restless makeovers of his
appearance, Rubens's sense of himself was
constant. On the few further occasions that
he painted his likeness, it was in virtually the
same pose: the gentlemanly three-quarter
profile; the sober but aristocratic cape; a few
links of a golden chain exposed below the
throat—a persona that somehow managed to
be at the same time both formidably present
and winningly self-deprecating.

 This was what Rembrandt, a foot in the
door of the palaces of The Hague, badly
wanted to be: the gentleman intellectual. Per-
haps he had heard that Rubens had been
given an honorary degree at Oxford, pro-
claiming him before the world as *pictor
doctus*. And though Rembrandt, through the
generations, has been imagined more the
gypsy than the scholar, he too without ques-
tion wanted to be thought of as nobly
learned, not the common or garden *pictor
vulgaris*. Perhaps, too, Rembrandt knew that
when Rubens had been made Knight of the
Garter by King Charles, the King had slipped a diamond ring from his own
finger and given it to the painter, along with a diamond hatband and the
very sword which had tapped Rubens's shoulders, the gems glittering at
the hilt. Why should Rembrandt not have such things? Honor, fame,
wealth. Was it too much to fantasize about one day being *Sir* Rembrandt
van Rijn? After all, Huygens had actually been elevated to be *Sir* Constan-
tine by the last King of England at about the same age as Rembrandt
was now!

 Rembrandt was already deeply involved in his attachment to Rubens—
at once adopting him as his model and fighting to have the differences
noticed. His *Descent from the Cross*, also painted in 1631 for the Stad-
holder, was directly taken from the engraving after Rubens's greatest mas-
terpiece in Antwerp Cathedral, while at the same time being a calculated
Protestant response to the immense diapason of the Flemish master's altar-
piece.[56] Now he went one stage further by brazenly grafting his own like-
ness onto the best-known portrait of Rubens, as if his relationship to him
were as filial as van Dyck's. Putting himself up for adoption in this out-
rageous way was an act of both homage and effrontery; venerating and
confronting the father figure with one and the same gesture.

Peter Paul Rubens, Self-
portrait, *c. 1623. Panel,
86 × 62.5 cm. Windsor
Castle, Royal Collection*

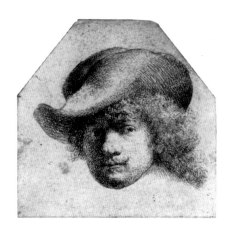

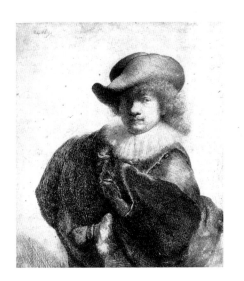

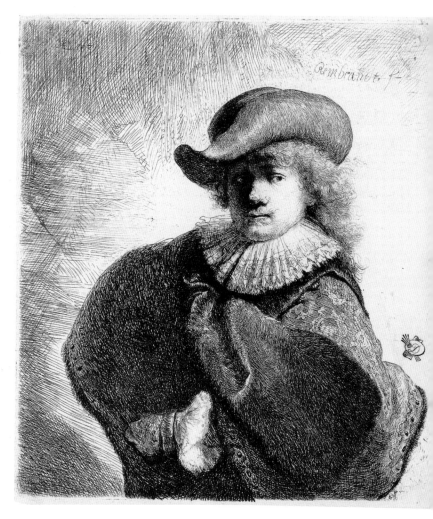

It was, unmistakably, a Statement. None of Rembrandt's previous self-portrait etchings had been made on anything like the scale of the so-called *Self-portrait in a Soft Hat*. It was, of course, *Rubens's* felt hat with the upturned brim. The etching was not only much the biggest that Rembrandt had made of himself; it was by far the most elaborate and intensively worked.[57] Though he began the etching in 1631, it seems likely that he fussed and worried and reworked the image over a number of years, coming back to it again and again, treating the copper plate to yet another round of covering up his last work with a new layer of waxy ground, scratching in the revisions, and dipping the plate in a bath of acid to let it eat through the new lines. This he did *eleven* times; eleven "states." It was a compulsion. It was his signature, his claim to be the new Rubens.

He began as Rembrandt, not Rubens, just an image of his head, the right side of the face shadowed as usual, and with his favored lovelock trailing over the shoulder. All that he had taken from Rubens was the hat, with the brim turned up on the right side rather more emphatically than on his model. But as he goes through further states, the petty larceny becomes more glaring. By the fourth state, head and shoulders have been turned at an identical angle to that of the Rubens portrait, but Rembrandt's fancy lace collar frames his face more formally, as if, on this occasion, to compensate for the absence of a golden chain. To have given himself a bogus chain when all the world knew of Rubens's authentic ones would have been an impertinence even Rembrandt could not have quite brazened out. The fifth state was the decisive moment in the hybridization of Rembrandt-Rubens, the twenty-four-year-old morphing into the fifty-four-year-old. By wrapping himself in Rubens's capacious cloak, Rembrandt is well aware that he has done more than steal the Flemish master's clothes. The folds and edging and drape of the fabric are made deliberately analogous with Rubens's famous personality: generous, gracious, thoughtful; a proper support for the intelligent dignity written on his handsome face. The cut of Rubens's cloth is, like the manner of his painting, expansive, voluminous, without ever coarsening into vulgar swagger.

Rembrandt takes this dress and does a little judicious tailoring, letting out the drapes to fit the more extravagant personality he is inventing for himself. At first glance, this seems like little more than a minor adjustment, giving a more pronounced lift to the cloak, filling out its edges with a generous, suggestively opulent fur trim. But in actual fact the alterations constituted a double challenge to the Rubens prototype. Rembrandt now stands in the pose and dress of a gentleman, a cavalier, his left arm held close to his side, the sleeve tightly gathered at the wrist, freeing his hand to rest on the hilt of an unseen sword. But it is the right arm, thrust sharply into lit space, that represents the most impudent act of borrowing. For, not satisfied with stealing the pose and costume of his model, Rembrandt, who, remember, is working from the engraving of Rubens's *Descent from the Cross*, has now made off with one of its most memorable details: the right arm and elbow of Nicodemus, similarly sharply outlined and projected against the white winding sheet of Christ.

By the tenth state of the etching, the sharp thrust of the right elbow beneath the cloak has been made still more theatrical by the darkening of the ground with a fretwork of lines, brightening as they reach the outline of Rembrandt's body, as if it were caught in a backlight. His lovelock has undergone a sudden growth spurt, in defiance of all the sermons. His dress is more grandly flamboyant: the fallen lace collar pleated and decorated; the shawled lining of his cloak given a complicated brocaded finish.

Rembrandt has literally taken Rubens's mantle (and gussied up its trimmings)—long before the garment had dropped from the shoulders of its owner. A commonplace of artists' manuals, repeated in Karel van Mander's *Schilder-boeck,* was the lawfulness, indeed the necessity, of theft, or at least liberal borrowing from envied models and masters. *Wel gekookte rapen is goe pottagie*—well-cooked pieces of this and that make the best soup. And Rembrandt in 1631 had certainly taken the advice to heart. He had done more than borrow pieces of Rubens's manner. He had lifted an entire identity, tried it on for size, walked about in it, and decided that it suited him uncommonly well.

There would be times, of course, when it wouldn't feel right. The incorrigibly peculiar Rembrandt, the maker of quiddities and visions, couldn't be contained within the grandiose habit of the Baroque master. But for ten formative years, Rembrandt struggled to make this new persona come to life, to replace *miniatura* with, as it were, *maximatura*—great Rubensian spectacles full of crashing, dazzling theater; terrifying, arousing; voluptuous and tormented. He would look to this and that of Rubens's masterpieces for inspiration after inspiration; for the Passion series he was commissioned to paint for the Stadholder; for an astounding *Samson* he gave to Huygens, the Rubens devotee. Many of these projects were sensational triumphs; some were miserable failures; and a few were badly damaged by the personality conflict working itself out in their execution. Only when Rubens died, in 1640, and Rembrandt had indeed become the supreme master of his time—not in The Hague but in Amsterdam—would he throw the weight of his emulation from his back.

But in 1631 he scratched—for the very first time—the words *Rembrandt f[ecit]* on the copper etching plate. He had to do this backwards, doubtless practicing in a mirror so that the reverse impression would come out correctly. Being "Rembrandt"—using his given, baptismal name as his signature—was itself a gesture loaded with self-importance, since it implied he belonged in the company of those remembered by their first name: Leonardo; Michelangelo; Titian; Raphael. But it seemed that he could only become this "Rembrandt" by way of becoming Rubens.

If only he had known how Rubens had become Rubens.

PART TWO

THE PARAGON

CHAPTER TWO · JAN AND MARIA

i Iniquities, March 1571

Now that he was shut up in Dillenburg Castle, Jan Rubens could see, with bitter clarity, that it had been a mistake to share the bed of the Princess of Orange. Of course, it was common knowledge that she was awash with drink. When deep in her cups, she was even capable of cursing her husband's name, threatening first his life and then her own. Attempts had been made by the princely in-laws to deny her wine. But Anna of Saxony, as he knew to his cost, was altogether undeniable: by sudden turns brazen or petulant. None of this, Rubens imagined, could be extenuation for his offense. It was not for the criminal to pass judgement. Yet when asked bluntly by Count Johan of Nassau, the Prince's brother, which of them had been the more forward in this unhappy matter, Rubens would reply, in his considered, lawyerly way, that "had he not been sure of his reception, he should never have dared to make an approach."[1] He could hardly add that it was much put about in the country that he had not been the first such transgressor. There had been tavern talk in Cologne concerning a captain and the son of a local money changer who had, in their respective fashions, offered their services and been well received. Who knew their fate? His own, alas, was all too plainly set out in German law and custom. Even had he not been so imprudent as to cuckold the preeminent nobleman of the Netherlands, Rubens would still have had to pay a capital price for his adultery. He could only hope to be granted the sword, as befitted his station as a learned doctor of the laws, and not be given to the hangman like a common cutpurse. He had sent such men to their death himself, heard the creaking gallows, observed the impatient rooks wheeling overhead.

When Rubens could bring himself to reflect on the consequences of his sinful trespass, it must have cut him to the quick to think of his four children, left fatherless, stained with disgrace, and sunk into destitution. His own father, Bartholomeus the apothecary, had died when Jan was still a child, scarcely breeched. But whatever the source of Rubens's misfortunes,

they could not be blamed on a grievous childhood. After his father's death, Jan's mother, Barbara Arents, mindful of her children and herself, had married again, wisely accepting Jan Lantmetere, a provisions merchant from one of the weightiest families of the weightiest city in the world: great, gabled, cargo-congested Antwerp, *mercatorum mundi,* the fast-beating heart of the Emperor Charles's empire, which stretched from Prague to Peru. Jan's new uncle, Philip, was already a power in the city: syndic, magistrate, and alderman; the kind of man who waited for others to doff their cap in the street. And his mother's family, the Arents-Spierincks, were well represented among the local magistracy. It was time that Jan Rubens acquire the learning and manners necessary to buff up mere riches into polished civility. Accordingly, the boy who at Latin school had declaimed his Cicero with precocious solemnity was sent off to Italy in his twenty-first year with instructions to drink deeply at the *fons sapientiae.* Seven years later, in 1561, and with little sense of urgency, Rubens returned to Antwerp, glorified by parchment bearing the august seals of the Sapienza College of Rome and attesting to his rank as doctor of both canon and civil laws.[2]

He was now fit for the patricians and they lost no time in making him one of their own. In October 1562, barely a year after his return to Flanders, Rubens was elected to the bench of Antwerp's eighteen aldermen: the *schepenen.* He would be reelected every year until the time of his sorrows. At thirty-one he had become a notable of the city, admitted to share their salt and their gossip. Now he would sup at the long tables of the truly moneyed, listen philanthropically (but firmly) to the importunate poor, and pray for the plague-stricken. On judgement days he would don his black gown and sit with his colleagues on the benches of the *vierschaer,* the capital tribunal, and, wearing a grave face, would dispatch rogues and ruffians to the gallows. The city was in its great glory, its face bright and rosy with limestone and brick, its inner rooms creamily marbled, the better to show off dark coffers and cabinets wrought from nut woods and ebony. At its heart, a great new Town Hall was rising, a palace really, utterly unlike anything to be seen north of Venice: a four-story triumphal statement, rusticated below, balustraded above; Ionic pilasters; all the Renaissance trimmings. Rubens must have been present at its inauguration in 1565, and from the surmounting tempietto that rose cockily above its pitched roof he could survey the swarming metropolis with satisfaction. Rubens stood among the masters of this fairest of places. In 1561 he had made a fine match: Maria, the daughter of Hendrick Pypelincx, a dealer in fine tapestries; demure, devout, and gratifyingly dowered. Standing before the altar of the St. Jacobskerk with his bride, Rubens must have supposed his life replete with blessings.

How could he know that in that year of his early splendor, 1561, another marriage was solemnized that would bring woe to Rubens, as well as to its unfortunate partners? In distant Leipzig, the twenty-eight-year-old widower William of Orange-Nassau, exceptionally rich and corre-

spondingly indebted, arrived with a retinue of eleven hundred knights,
squires, pages, heralds, and drummers, and the usual complement of wrest-
lers, fools, dwarves, and dancers, to marry Anna of Saxony. In the *alt-
deutsch* fashion, the pair were wedded and publicly bedded amidst
midsummer rose petals, country airs, and encouraging eructions. The
bride was sixteen: high-spirited and high-colored, her flax-blond hair
wound up in tight rolls beneath the bridal tiara to form the curving lobes
of a playing-card heart. Anna's high brow, large, slightly fishy eyes, and
irregular nose dividing white-dough cheeks had all been inherited from her
late father, the tirelessly pig-sticking, implacable Maurice, Elector of Sax-
ony, Germany's most obstinate Lutheran prince and the nemesis of the
Catholic Habsburgs.

From this ebullient paternity, as well as from the disconcertingly eager
manner in which Anna had responded to his formulaic letters of gallantry
(three love letters in a single day!), William might have guessed that their
union might want serenity.[3] But then, for all his courtliness the Prince was
an urgently sensual as well as uxorious man. Anna had been presented,
selectively, to him, and from the little that could be seen, he quite liked
what he saw. She seemed, perhaps, a little overexcited, but after all, she was
scarcely more than a child. There was every reason to assume that her occa-
sionally agitated manner would eventually be curbed by a consciousness of
high station, the supply of wise counsel, and the maturity of motherhood.
For the time being, William declared in a famously unguarded moment at
the wedding, she should put aside her Bible for chivalric romances like
Amadis of Gaul.

There were some ill omens. During the relentless jousts accompanying
the wedding festivities, her uncle and guardian Augustus, the present elec-
tor, fell from his horse in full armor, fracturing an arm.[4] And William had
barely gotten his bride to his palace in Brabant before general muttering
broke out in the courts of Europe. There were those, like Philip, Landgrave
of Hesse, the bride's grandfather, who believed the match to be a betrayal
of Lutheranism, and those, like King Philip II of Spain, who believed it to
be a betrayal of Catholicism. Complicated negotiations were entered into
regarding the confessional practices of the new princess. Philip of Spain
instructed his half sister, Margaret of Parma, the Regent of the Nether-
lands, to insist on Anna's speedy and unequivocal submission to Rome.
Philip of Hesse issued countercommands to the effect that she be allowed
full liberty to profess her Lutheran faith. William shut his ears to both
demands, preferring a more supple arrangement. Anna was to conform in
outward things to the Catholic Church but be permitted freedom of wor-
ship in her own chapel (public priests, private pastors). It was a typically
intelligent solution for shockingly unintelligent times, and it pleased no one
beyond the immediate circle of the Prince. At mid-century, Christendom
was ostensibly divided between Catholics and Protestants. But an even
deeper cleavage divided militants from pragmatists. The latter would let
men alone with their consciences provided their observances did not dis-

turb peace and propriety; the former detested such politic accommodations as courtesies to Satan.

By necessity and by moral inclination, William was a pragmatist, a *politique*, in the sixteenth-century term. His father, the Count of Nassau-Dillenburg, was Lutheran, but sufficiently relaxed in his attitude to be unperturbed by the continuing presence of Franciscans in his little hilltop town.[5] The Count's own brother Heinrich, after all, remained true to the old Church. So when, through a cousin's death in battle during the war with France, William suddenly inherited large portions of Brabant, Flanders, and Franche-Comté, as well as fifty baronies, three Italian principalities, the defunct kingdom of Arles, and the sovereign principality of Orange in the southern Rhône Valley, and was all at once transformed from a minor German dynast into the greatest seigneur in northern Europe, it seemed of not much consequence that the inheritance came with the requirement of Catholicism. Of more significance was the local joke that while the father was known about the Rhineland as "William the Rich," he was now a pauper beside his eleven-year-old son. As befitted his new fortune and rank, the boy was made to part from Dillenburg, where he had been born and had grown up: a medieval castle-town, with an old donjon sitting on the peak of a hill above an unruly nest of pitched slate roofs and timbered alehouses. William the Rich and William the Richer sat together in a closed carriage that trundled its way northwest to the Netherlands, to the boy prince's palace at Breda, and then on to gilded Brussels to be presented to the Emperor Charles V.

Uprooted from Gothic Nassau, William acclimatized quickly to the urbanity of Habsburg Brabant, learning the graces of the courtier and the disciplined arts of the young soldier. Speaking French to the mighty and Flemish to his servants, he was hard to dislike and rapidly became the favorite of the gout-racked Emperor, called to serve in his bedchamber. It was the Emperor-Father, not the Count-Father, who had chosen Anna of Buren as a fit wife for William in 1551, when he was eighteen. When, four years later, Charles decided to throw off the cares of state and retire to a monastery, he hobbled into the great hall in Brussels for the abdication announcement, leaning heavily on the right arm of the Prince of Orange. In a world where the body spoke, it could not fail to be observed that Prince Philip, to whom the kingdom of Spain and the government of the Netherlands were now formally entrusted, followed behind, screened from the assembly by the black-robed bulk of the Emperor and the trim Prince, whose slashed doublet glittered with silver thread.

Philip II and William of Orange were so entirely opposite in temperament and conviction that they might have been the conceit of an Elizabethan playwright. The lantern-jawed Spanish King was ascetic and severely single-minded in judgement, not least on himself; and though it was William who came to be called "Silent" (for keeping his own counsel), it was Philip who was the more ominously taciturn of the two. The Prince of Orange was delicately gregarious, and as much enamored of worldly

pleasures as Philip was afflicted by them. At the age of sixteen William had entertained Philip, then King of Naples, in his spectacularly handsome castle at Breda. The style was sybaritic—peacocks and pavanes—but for the fastidious Habsburg such occasions were a trial, as though the corruption of the flesh was grossly advanced with each nibbled dainty. Yet for all their incompatibility, William fully meant to be as loyal a servant of King Philip as he had been a devoted ward of the Emperor Charles, and was much given to elaborate declarations of loyalty to the Catholic Church. For his part, and whatever his private reservations, Philip had no alternative but to maintain the Prince of Orange in high office, if for no other reason than as a restraining influence on any of his fellow nobles who might be flirting with heresy. So William remained on the Council of State and was appointed *stadhouder,* or "lieu-tenant," literally place-holder on behalf of the sovereign, sworn to maintain and enforce the King's law in the provinces of Holland, Zeeland, and Utrecht. As far as the Prince was concerned, there was nothing in his Saxon marriage that compromised this duty. But when Lutheran pastors were reported attending on Princess Anna in her chapels at Breda and Brussels, Philip became confirmed in his suspicion that the union was a conspiracy, manufactured to smuggle German Protestantism into the Catholic Netherlands.

For King Philip, toleration was the herald of apostasy. It was well known that on his personal domains in Brabant, William of Orange was notoriously lax, going out of his way to protect Protestants from the Inquisition, introduced into the Netherlands in 1520 by Charles V. The local nobility there had protested that the tribunal had no legal standing in their provinces, but the Prince of Orange had no business giving that kind of insubordination aid and comfort. In his personal principality in Orange, in the Rhône Valley, with the great amphitheater of Augustus Caesar at its center, William had created a regime in which both confessions were allowed public worship. Pragmatic leniency, he had come to believe, was the only way to avoid an all-out war to the death between the mutually demonizing creeds of Catholicism and Protestantism (the latter given an even sharper edge by the growing popularity of Calvinism in southern France, England, and the Netherlands). But it was precisely this Manichean battle of light and darkness that King Philip was so hot to prosecute. Acutely conscious of his father's failure to reunite Christendom, Philip had sworn his own life to the sacred mission of extirpating heresy and vanquishing the Turks. The two were tightly interconnected in his mind with the realization of a true Christian peace. If the Ottomans could be stopped in the Aegean and the Adriatic, then he could turn his attention and forces to the heretics. If the heretics were brought to submission, nothing could stop a great crusade in the East.

The exasperatingly heterodox provinces of the Netherlands were a vital strategic element in this world mission.[6] Gold had to be choked loose from their usurious banks, supplies and levies from their wharves and trading houses, but at the same time, wicked literature had to be stopped up in

Joan Blaeu, Map of the
Seventeen Provinces of
the Netherlands, *from*
Atlas Major, *vol. 3
(Amsterdam, 1664).
New York, Columbia
University Libraries,
Butler Rare Book Room*

their printing houses. Under the Emperor Charles there had been a great
burning of heretical books in Antwerp in 1529, and the Inquisitors had
been given the authority of full imperial officers. But the publishers of that
cosmopolitan city were no better than the infamously godless Venetians.
Briefly sobered, they had continued to produce works, purportedly schol-
arly commentaries on classical history and philosophy, that were known to
be subverting loyalty and religion. It was time the Netherlanders were freer
with their funds and tighter with their opinions. This much Philip tried to
make clear to the landed magnates and city pensionaries who dominated
the representative assembly of the seventeen provinces of the Netherlands,
the States General. Most urgently, the crown needed three million florins in
subsidies to sustain the war with France. Startled by the unheard-of
demand, the States rejected it out of hand. Four years of grim bickering
between the King and the recalcitrant nobility ensued. Meetings of the
States General, summoned in 1556 and 1558, succeeded only in providing
a platform on which they could air their many grievances against the gov-
ernment. And since the royal finances had been based, for twenty years, on
issues of annuities guaranteed by the provinces, this abrupt change of direc-

tion toward fiscal centralism was unlikely to succeed. That his eventual victory over France was owed in no small part to men and money provided by the Netherlands did not make the King feel better disposed toward those provinces. In 1559 he exited Brussels, sour with chagrin. As a parting gesture, he had finally been allotted nine years of money, but only in return for promising the withdrawal of Spanish troops. Could he not be master, then, in his own lands?

If the prolonged wrangling with the States had been vexing, it had also been instructive. The heretically contaminated riches of the Netherlands had been put beyond the King's reach by a tangled forest of obscure and maddeningly parochial institutions. In muniment rooms throughout the Netherlands, in Mechelen and Douai, Dordrecht and Franeker, were stored great rolls of parchment, bound with silk, heavy with seals, and impressively black and crusty with time, in which were encoded the immemorial "liberties," "franchises," "immunities," "privileges," and charters of the towns and provinces, their great defense-works against the siege of monarchical government. For Philip these charters were medieval anachronisms that must yield to the modern reality of the worldwide holy mission. The parchment would be fed to the flames, his will would be done, and true congregations of the faithful would sing hosannas in his name.

Philip had left the details of this thankless task to the Regent, his illegitimate half sister, the stolid Margaret of Parma, who, despite her Italian marriage, had been born to a Flemish noblewoman and educated as her father Charles V wished, in the Netherlands. It was precisely this suspiciously native aspect of her character that made Philip wonder if she truly had the mettle to confront, head-on, the obstreperous resistance of the nobles and towns. To fortify her resolution, Margaret was to be assisted by a new type of handpicked loyalist: lowborn men who had risen through their wits and the King's good grace; university-educated, erudite in law and letters; bureaucratic in temper and uncompromisingly devoted to the absolute sovereignty of the monarch. The senior official cast in this mold was Antoine Perrenot de Granvelle, no servile fanatic but a sophisticated and learned humanist who was dependably unsympathetic to provincial traditions. The two goals of his planned reforms—religious uniformity and fiscal convenience—were meant to be mutually self-reinforcing. A new hierarchy of bishops, rationally consolidated throughout the seventeen provinces and centrally appointed from among the most reliable Inquisitors, rather than beholden to noble patrons, would ensure conformity. With webs of patronage swept away, the populace would be returned to their natural loyalty to the King and Church. And moneys raised from property and goods—everything from malt to salt—would fund the administration as well as any troops which (God forbid) might be required to protect it.

That, at any rate, was the idea. But it was one thing to decree the installation of government-appointed bishops, and quite another to make it happen. Protestantism had been acquiring converts among the Netherlands

nobles, some surreptitiously, some, like William's younger brother Louis of Nassau, unapologetically professing the Reformed creed. Such zealots could be assumed to be hostile to Granvelle's innovations. But the threat to their patronage also turned much more moderate figures like Prince William into personally aggrieved critics of the government. To represent the reforms as rational and tidy was a wicked masquerade. The truth was that they were the implements of despotism, the calculated ruin of their "old constitution." There was also an element of righteous snobbery in the nobles' discontent. Men like Granvelle were dismissed as parvenus, alien to the land and class of the natural rulers, determined to impose even lowlier nobodies on offices which properly belonged in the gift of the seigneurs. Where they could, the nobility persisted in placing their own men (and relatives, bearing familiar manorial names) in the bishops' seats; where they could not, they let pelting crowds do the work of obstruction. Who knows? Perhaps William really did believe that he could remain faithful to the King while repudiating His Majesty's officers. But gradually, almost by default, he allowed himself to become the focus of opposition to Granvelle and his loyalists on the Council of State. It was William who orchestrated the collective walkout of the most prominent nobles from the Council of State, disingenuously warning Margaret that they could not be held answerable for the peace of the realm as long as Granvelle and his policies remained. By March 1564 the centralizing reforms existed only on paper. Without the troops to make coercion credible, Margaret's only option was to concede to the noble demand to get rid of Granvelle. When he left (unwillingly), William and his colleagues graciously consented to return to the council.

If the Prince equated the removal of his adversary with the triumph of toleration, he was swiftly disabused. Granvelle's departure was a signal for many Netherlanders, highborn and low, to declare their allegiance to the Reformation, which in turn led Philip to dig in his heels and insist once again that the war against heresy would be redoubled rather than relaxed. The Inquisition would stay. The *placaten* (placards) stigmatizing Protestants as criminals would not be withdrawn. To William, the insistence on unswerving rigor unsupported by effective government was a policy destined for calamity. But in Philip's uncomplicated universe of good and evil, it made perfect sense. For the time being, there were no regiments to do his will. But that was no reason to betray his conscience and tarry from Christ's bidding. If he remained true and steadfast, Heaven would provide. He would live to see his soldiers, their pikes bright for the Lord, descend from the mountains and march into the low, green plains toward the cities of iniquity.

In the meantime, Hell had the upper hand. The winter of 1565–66 was memorably cruel. The river Scheldt froze hard, and the stevedores of Antwerp were condemned to penury. Grain was short and bread dear. The looms, dye vats, glass shops, brassworks, and tanneries of the town stayed idle, the familiar smells of the city workshops strangely absent from the biting air. While there was nothing in Calvinist preaching which directly laid

these misfortunes at the door of the royal government, the Lenten miseries were certainly thought of by many as the scourges of old Egypt, brought on them by their stiff-necked Pharaoh. Some, the artisans grumbled, ate well enough: the gluttonous monk drooling over his table could be seen in any number of woodcut satires that had begun to infiltrate the Netherlands from Germany and France. Complaining of the elaborateness of Church ornaments, a Reformed preacher told the erring priesthood that "you dress these wooden blocks in velvet but let God's children go naked."[7] Righteous anger was not the monopoly of the humble. Calvinist gentry returning from exile in England and Geneva, like Jan and Philip van Marnix, were freer with their psalms and opinions, and their unequivocal sense of right doctrine emboldened nobles like the Counts of Brederode and Culemborg. Grumbling at the hunt turned into godly intentions at the supper table and ended up as impassioned vows, sworn with hands on sword hilts. Noble bluster turned into a "confederacy" committed to ending the pernicious campaign against "heresy." A document professing to be the "Compromise" was drawn up and signed, but it required the Regent to annul and make void the entire religious policy of the crown. On April 5, 1566, some hundreds of mounted gentlemen, with Brederode, Culemborg, and William's younger brother Louis at their head, clattered into Brussels, with as much fanfare as they could contrive, to present their petition to the Regent. In the tense situation, William the Silent stayed prudent, ostensibly loyal to Margaret. But he found himself commonly assumed to be in sympathy with the confederates. The truth is that he was not entirely out of sympathy with them, either. Attempting to calm the agitated Regent, one of her counsellors, Berlaymont, had expressed sardonic surprise that she appeared so out of sorts for the sake of "*ces gueux*"—these beggars. Rumor wagged its many tongues about the streets of Brussels, and in a moment of inspired opportunism Brederode and his companions adroitly turned the insult into a badge of pride. Beggars indeed—well, better an honest beggar than a scoundrel government! Tailors were set in motion, happy for the work, to provide costume, and the troop of gentlemen rebels rode out of the city wearing the drab gray of mendicant friars, wooden begging bowls about their necks. In no time at all, Beggar songs, the *Geuzenlieden*, could be heard in the alehouses, where prints were nailed to posts and beams showing the clasped right hands of the *confoederatio* together with the clapper, stick, and begging bowl of the suddenly glamorous calling of the beggar. Wearing the bowl became à la mode among the circles of the opposition gentry, customized for the more fashion-conscious Beggar with silver rims and chains.

Somewhat to William's alarm, defiance bred disorder. Nothing he could do seemed to quell rumors that, for all his ostensible distance from the Beggars, the Prince was actually the Beggar-in-Chief. Among his many offices was that of Burgrave of Antwerp, leaving him no choice but to respond to Margaret's call to go to the city in July 1566 and attempt to calm a populace inflamed by anti-Catholic preaching. On his arrival, his

neutral stance was immediately compromised by an embarrassingly effusive public welcome by Brederode, dressed, of course, in Beggar gray. The two trotted through the city streets greeted by throngs cheering the Prince as if he had already accepted the role for which he would eventually be martyred: that of *pater patriae*, father of the country. Day by day Habsburg authority in the Netherlands was falling apart, and neither William nor, for that matter, Jan Rubens greeted the chaos with any joy. Like the Prince, Rubens had been sworn to uphold the King's law, yet he too had come to think of the Inquisition as an abuse of that law, rather than its legitimate expression. Nor could he be entirely unmoved by the Calvinist fervor gripping the city. Psalmbooks—suddenly a seditious form of literature—were everywhere. Preachers like Herman Moded and Guy de Bray attracted crowds to their sermons, thundering against the relics and rituals of the Roman Church as dross and trash, stinking abominations in the nostrils of the Lord. How was a conscientious magistrate to keep the peace?

In all likelihood Jan Rubens himself shared some of these equivocations and uncertainties, observing Catholic forms while flirting with the heresies he was appointed to repress. Before setting off for Italy in 1550, and like all sensible travellers faced with the many perils of the roads and mountain passes, Jan had made a will. The document commended his soul to "Almighty God, to Mary his Blessed Mother, and to all the Company of Heaven," and his "dead body to consecrated ground."[8] In 1563, when he revised that will to take account of his marriage, references to the Virgin had vanished in favor of the simple commendation to God. As for the bodies of husband and wife, they were to be laid simply "in a place to be determined." The banality of the language announces a momentous withdrawal from devotional ritual: the name of the Virgin replaced by a legal formula.

By Pentecost, 1566, the sound of massed Calvinist voices extolling the Lord and damning the Pope had become a fervent chorus. Outside Antwerp's city walls, beyond the reach of its magistrates, the crowds listening to the "hedge-preachers" denounce the Roman Antichrist had swollen from hundreds to fifteen, sometimes twenty, thousand. More ominous for the custodians of order, these congregations had begun to take on the look of an encampment. Food was cooked on open fires. And when the sermons and psalm-chanting refused to stop for darkness, families said their evening prayers beneath the summer sky and slept upon the trodden, muddy grass. Unlike on fair days, though, there were no players, no Gypsies, no quacks, just a solid mass of rapt humanity whispering, shouting, singing, praying. Immediately below the improvised wooden pulpit, and all about the perimeter of the congregation, stood armed men equipped with harquebuses and crossbows. Behind this protective shield, the preachers called for a great cleansing. For the moment, the violence remained rhetorical. There were even those among the magistrates who looked toward the hedge-flocks and saw a quiet and orderly troop, with well-to-do merchants and gentlemen reassuringly interspersed with stevedores, printers, and weavers.

Beyond Antwerp, especially in Holland and the northern Netherlands, matters had become rougher, not least because the more zealous members

of the Protestant nobility had themselves become patrons of image-breaking. Though the story of the Count of Culemborg feeding wafers ("baked gods," as the Calvinists called them) to his pet parrot in his local church may be apocryphal, Herman Moded certainly claimed that the Count had egged him on.[9] When the church walls had been stripped and covered with layers of chalk whitewash, designated squares were repainted black, over which the Ten Commandments were inscribed in gold. The first two—"Thou shalt have no other gods before me" and "Thou shalt not make unto thee any graven image, or any likeness of any thing that is in heaven above, or that is in the earth beneath"—were henceforth to be regularly brought to the attention of any congregants so impure as to hanker after the old images. Beginning on August 10 at Steenvoorde, churches and monasteries in the *westkwartier* of Flanders were invaded by crowds smashing statues, tearing down paintings, and inventively desecrating vestments.[10] In the Zeeland town of Middelburg, the artist Marinus van Reymerswaele turned on his own vocation by joining the image-breakers who broke stained glass and mutilated statues in the parish church. And with each unopposed attack, William's *via media* became more difficult to sustain.

On August 18 the cathedral chapter of the greatest and grandest of all parish churches, Onze Lieve Vrouwekerk, the Church of Our Dear Lady, processed through the city streets along a route that had been prescribed in 1399. At their center, a litter carried by twenty men bore a statue of the Madonna brilliantly painted, her face as white as a lily, gold thread embroidered through her gown. It was the Sunday after the Assumption of the Virgin, usually the most elaborate of Antwerp's public festivals. Besides the sacred images, the street processions usually featured spectacle for the people: floats of galiots and sea monsters; travelling towers and smoking dragons; giants, tumblers, and wild beasts—hippopotami carted by clowns. This year, however, the parade seemed more meager, the drums and pipes more subdued. The ranks of brilliantly costumed guildsmen, harque-busiers, and crossbowmen had been drastically thinned by companies who had already decided that the veneration of the wooden Virgin was shameful idolatry and who had asked to remove all statues, altarpieces, and relics from their respective chapels in the cathedral. The procession, then, had a self-conscious air about it, both defiant and nervous, facing crowds that sometimes did scandalous things, jeering at the Virgin as she passed, threatening that it would be "Meyken's last promenade." When the statue was finally returned to the Gothic annex of the church, it was railed off from would-be assailants. In other parts of the church, statues received the same precautionary protection as if awaiting a siege. Our Lady of Milan, with her long, loose tresses of hair, brilliant blue robe, and ears of wheat, and Our Lady on the Pole, who had once been a simple wooden manikin but who had been transformed into silver by the multitudes of the grateful who attributed healing miracles to her gracious intercession, were both screened from the ill-disposed.[11] The daily offices of the church proceeded as usual: laud, prime, terce, sext, none, vespers; the antiphons, litanies, lessons, and

responses echoing against the vaults. But prayers for the salvation of the faithful may have been offered with special fervor.

The Burgrave, William of Orange, believed the city to be on the point of tumult. He told the Regent as much when she summoned him to appear at a specially convened assembly of the Golden Fleece, the chivalric order of the Netherlands nobility sworn to allegiance to King and Emperor. If he left Antwerp now, the Prince warned, he could not answer for its peace. Nonsense, the Regent replied. The city is quiet. We are grateful. Come; you are needed to dissuade your fellow knights from the evil way of rebellion. Do not delay.

Margaret was obeyed. On August 19, the same day William rode through the city gates, a group of youths, some apprentices and some Latin school boys, made a noisy entrance into the cathedral where "Meyken" had been set up behind a guardrail for her own safety, and began shouting insults at the statue. Delighted with his own performance and egged on by the laughter and shouting, the ringleader climbed up the front of the pulpit and began to perform a parody of the Mass, until a sailor, beside himself with rage, grappled with the youth, throwing him to the church floor. Fighting broke out in the nave between mutually enraged crowds of the Reformers and the faithful and spilled over into the street. News of the brawl, making its way around the taverns and out into the preaching-fields, strengthened the conviction that with the Prince's departure, Antwerp was indeed an open city.

The next day, August 20, an immense crowd singing the praises of God assembled after vespers before the doors of the cathedral. It was liberally equipped with mallets, shears, knives, and hammers taken from workshops. Some from the docks and shipyards had brought grappling hooks, lanyards, and ropes, as if they were about to board an enemy vessel. Alarmed at the size of the gathering, Rubens and his colleagues decided to call out the civic guard, but their numbers had been weakened by defections to the iconoclasts. Nervous attempts to disarm the most aggressive among the crowd rapidly turned into scuffles, and might have been more serious had not the guard, at somebody's prudent command, rapidly abandoned their halfhearted attempt at police action. The church was defenseless. The chapter and choir had fled their lodgings. After the crowd forced their way past the barred and bolted gates and marched down the nave, Herman Moded, who had Hebraized his name of Strijker, entered the pulpit and yet again urged his flock to scour the temple of the idols and puppets that Satan had set within its precincts to tempt the eyes of the credulous and lead their souls into distracted perdition. *Strike* the abominations, he commanded; lay them low; pierce the Whore of Babylon to the heart. Praise be to God.

So the flock did as they were bidden and began indeed to smite. And because it was not fellow citizens who were on the receiving end of the hitting but dumb pieces of wood and stone and cloth and glass, the assaults could be joyfully unconstrained. Everything that had made Christian Flan-

ders bewitchingly beautiful, for that very reason, was marked for oblitera-
tion. Had not Calvin himself insisted that since God's majesty was invisi-
ble, anything that presumed to represent his works, or that of Christ and
the apostles, was idle blasphemy? Did not the catechism of Heidelberg
warn Christians against presuming to be wiser than God, who wished his
Gospel to be taught by the Living Word and not by dolls of wood and
paint?

Some of the chapels in the dimly glowing church had already been qui-
etly stripped of their art by the deacons of the guilds, so that the patron
saints of the coopers, furriers, tanners, and basketmakers now presided in
spirit, not image, over their respective sanctuaries. The stall within the very
precincts of the church from which artists sold retables, sculptures, and
paintings had been discreetly dismantled some weeks before and its ven-
dors dispersed. There remained, however, much for the iconoclasts to do,
and they scattered in busy gangs and teams through the church searching
for offending idols. Hooks and ropes were attached to statues of the cruci-
fied Christ above the rood loft, enabling four men to pull the work to the
cathedral floor in an eerie reversal of the elevation of the Cross. The rows
of apostles lining each side of the nave followed him to the pavement. Frans
Floris's *Assumption of the Virgin,* as well as other great altarpieces, was
plied out of its station with chisels and hammers, and the painting itself
smashed and splintered. The same master's *Fall of Rebel Angels* was ripped
from the wall of the chapel of the fencers' guild and sent tumbling, like its
subjects, into the dark space below. Though the great painting survived,
albeit damaged, the wings of the triptych went for good.[12] When the break-
ers were thwarted by the sheer weight and bulk of a painting, Bernard van
Orley's *Last Judgement,* for example, their frustrated energy redoubled
itself against targets that were more convenient for destruction. The richly
carved choir stalls were hacked about by assailants parodically dressed in
copes and chasubles taken from the vestry chest. Oil from the vessels of the
sacred unction was smeared on the heavy nailed boots that trampled relics
underfoot. And since God's splendor was to be extolled by nothing other
than the human voice, the *vox humana* pipe was the first to be torn from
the organ stall and the rest flung down shortly afterward. "I went into the
Church with ten thousand others," wrote an English merchant, Richard
Clough. "It looked like a hell, as if heaven and earth had gone together,
with falling of images and beating of costly works. . . . [It was] the costliest
church in Europe and they have so spoiled it that they have left not a place
to sit on."[13]

Even before the cathedral church of Our Dear Lady had been reduced
to its proper, chastened emptiness, the iconcoclasts had fanned out into the
city, making for the thirty churches and countless convents and monaster-
ies that had been Antwerp's glory. There they found Hubertuses, Willi-
brords, Geertruids, and Bavos to decapitate, sending heads deprived of
noses, ears, and eyes rolling down the aisles. Porches filled with the debris
of shattered statues, legs, arms, and trunks waiting like dismembered

plague victims for the death carts to carry them away. Monastic libraries were set ablaze, ancient illuminated manuscripts, missals, and chant books fuelling the flames.

The next day, with Antwerp made properly ashen with repentance, carts carried the iconoclasts to the villages beyond the city walls, where their energies revived. When, on August 23, the fury had ebbed enough for the city's magistrates to venture out safely and wander amidst the wreckage, they saw that none of Antwerp's holy places had escaped the purge. Color had been drained away from the churches. Vaulting that had been bright with flowered bosses and spaces where cupids had fluttered and lambs had carried the standard of Christ were now covered in chalky whitewash, clad in shrouds like penitent strumpets, the satisfied pastors said.

From their different places, William of Orange and Jan Rubens surveyed the disaster. Of the two, it was probably Rubens who had been more active among Calvinist circles (or so the Inquisition was to claim). But whatever the state of their shifting creeds, both must have understood that the *beeldenstorm*—the storm of images—had made moderation simultaneously essential and improbable. Shocked by the ferocity of the onslaught on the old Church, and nervous of retribution coming from Spain, cooler heads on both sides of the confessional divide attempted to return the country to reason. On August 23 a formal ban on ransacking churches was proclaimed, and the following day Margaret announced an "Accord" embodying the frail hopes of confessional coexistence advocated by both William and the pensionary of Antwerp, Jacob van Wesembeke. An embassy was to be sent to the King asking (optimistically) for understanding. Pending his response, the procedures of the Inquisition and the offending *placaten* would be suspended. Protestants were to be permitted their own places of worship, provided they relinquished the occupied churches. This partition approach had already been attempted in the cities and regions of France where Protestantism was strongest, but with the dispiriting result of turning local hostilities into all-out religious war.

If William feared that the Netherlands would fare no better, he did his best to conceal his trepidation. He spent the autumn of 1566 travelling about the three provinces of his stadholderate—Holland, Zeeland, and Utrecht—shifting flocks about from place to place and trying to calm their mutual anxieties. His own worries grew, and with good reason. Though Margaret claimed to want to abide by the Accord, she knew for a fact that Philip had already determined to use crushing military force. The Prince was also losing the struggle to restrain the Protestant zealots, not least his brother Louis of Nassau, who had committed themselves to rebellion. Early in 1567 he himself privately abandoned the attempt at compromise and steeled himself for the coming conflict. Anna and their younger daughter would be sent, in secret, to the Nassau ancestral home at Dillenburg, together with whatever money could be gotten from pawning plate and jewels.

Before he followed his family, William made a last, desperate effort to prevent slaughter in Antwerp. A few miles beyond the city, in the village of Osterweel by the Scheldt, on March 15, 1567, a badly armed, ineptly led Protestant army was surrounded, and then slaughtered, by government troops. Within the city gates, hysteria had understandably taken hold of the populace. Terrified of the retribution about to be inflicted on them by the Catholic troops, the citizens demanded that the Prince send an expedition to help the remnant of Protestant soldiers. This, said the Prince, facing the crowds together with Burgemeester van Straelen, would be merely a futile gesture, guaranteeing the defenselessness of the city itself. Suddenly unsure which course of action would do least harm, the crowd's leaders decided to take out their frustration on the city garrison and set up their own armed camp, complete with cannon, on the Meir Bridge. Only another speech from William, this time delivered from the steps of the Town Hall and including a promise to form a citizens' militia, defused the dangerous mixture of fear and rage.

At some point soon, William knew, this precarious balancing act was bound to fail, and he was not yet ready to be the most famous casualty of the ensuing debacle. On April 10 he formally resigned from the council, and a day later travelled northeast to Breda to collect his elder daughter, who had been extricated from the Regent's household. By the first week of May, the Prince was in Dillenburg with a company of 150 men, living off the hospitality of his younger brother Johan, who had succeeded his father as Count of Nassau. Anna, heavily pregnant, who had preceded him, was not especially welcoming. Dillenburg, she gave it to be known, was a prison. She was suffering cruelly beneath the weight of so many Nassaus: sisters, aunts, brothers, and especially the vigilant presence of her mother-in-law, the forbidding Juliana von Stolberg.

But for the Prince, now reduced to the status of a fugitive, his birthplace was blessed asylum. For all he had gone through, William was still undecided as to whether to join a rebellion, the very idea of which was repugnant to his ingrained instinct for peace and order. The Duke of Alva, who entered Brussels on August 22, 1567, swiftly decided this for him. Indictments of treason were issued against all the leaders of the opposition to Granvelle and Margaret, without nice distinctions between militants and moderates. The Prince's own position in this roll call of renegades was made absolutely clear by the seizure of his son, Philip William, from Louvain University, where he had been a student, to be sent straightway to Spain to be raised as the ward of his godfather and namesake, the King. When a deputation of faculty from the university made so bold as to protest the abduction to Alva's Spanish councillor, de Vargas, he replied with a chilling declaration of naked power intended to shock their pathetically professorial susceptibilities. "*Non curamus privilegios vestros*," he announced. "We care *nothing* for your privileges." Shortly after, the entirety of the Prince's possessions, estates, and property was declared forfeit to the crown. Nine barge-loads of furniture, tapestries, and paintings

were hauled away by canal from William's palace at Breda and stored at Ghent for the King's pleasure. Yet even now, when there could be no possible turning back, William's printed "Justification," the first great propaganda document of the revolt of the Netherlands, written with van Wesembeke, insisted that the King had been led astray by evil counsel and fervently hoped that more enlightened counsels might yet prevail in Madrid.

It was this same temporizing that made the Prince lose his best opportunity to make a military strike in the autumn of 1567, while anger over the Spanish military occupation in Flanders and Brabant was still raw, and before Alva's terror had successfully done its work of mass intimidation. By the time William, Louis of Nassau, and Brederode had managed to put together a military force, principally by recruiting German and French mercenaries, their task was more formidable, not least because the population of the Netherlands was understandably nervous about the consequences of giving assistance to their "liberators." There was a solitary victory in the north at Heiligerlee when Louis surprised the loyalist duc d'Aremberg (who had also been a friend of William's). But it was followed just two months later by a complete debacle at Jemminghen, where two thousand of Louis's men were killed or surrendered to Alva, and their commander was obliged to swim for his life. William attempted his own military incursion in the southern province of Limburg, where his army swiftly disintegrated for want of pay and supplies, spending most of its energy marauding local villages. Thereafter William was mostly reduced to trudging between Strasbourg, Duisburg, and Cologne, imploring the German and French princes to provide the men and the money that would allow him to challenge Alva's disciplined and well-supplied forces. Being a Beggar was no longer, if it ever had been, amusing. "We may regard the Prince of Orange," Alva wrote cheerfully, "as a dead man." Few disagreed.

In the spring of 1568, Wesembeke rode into the courtyard of Schloss Dillenburg in not much better condition than the Beggar Prince. He was able to give William a firsthand report of the miseries inflicted on the city by the new regime, though the Prince knew much of the bleak story already. Margaret of Parma had resigned the regency when she saw what was in store for the Netherlands. This was exactly what Alva had hoped for. Although Philip's intention had been to preserve the Regent while allowing the Duke to get on with an all-out campaign of repression, Alva's establishment of the principal instrument of his terror, the Conseil des Troubles (known to its victims as the Council of Blood) made her presence redundant. Gaunt, choleric, and extremely intelligent, the Duke of Alva set about his work with systematic zeal, assisted by an inner group of Spanish advisers and a trained corps of 190 prosecutors, together with the usual complement of interrogators, jailers, torturers, and executioners. The effectiveness of the Inquisition in Spain had trained many of these men in the operational methods needed to do their job: nocturnal seizures of papers; the persuasion (sometimes with the help of the block and the thumbscrew) of secretaries and servants to inform on their employers; the streamlined

production of confessions. There were big targets and small. Most of those caught in the net of Alva's terror were from the mercantile and trading classes, but the Duke understood perfectly the demonstrative effect of selectively victimizing the elite. The loftier the noble, the more shocking the attack.

On January 4, 1568, eighty-four nobles and high citizens of the Netherlands were sent to the block, and the following March another fifteen hundred were arrested, for whom hope was dim. Altogether, almost nine thousand were punished for heresy or treason or both, of whom about a thousand lost their lives.[14] The fortunate were executed forthwith on the scaffold. Common citizens who had been convicted of assaults on the churches were subject to breaking on the wheel or live quartering before being burned at the stake. If they were found guilty of blasphemy of the Word, their tongues were pierced with hot needles before they were taken to the gallows. Nearly nine thousand suspects were summoned to answer charges before the tribunals, many of whom were routinely tortured to extract confessions or left to rot in prison pending a final judgement. Eager to correct the simplicities of older, patriotic chronicles, modern historians have (rightly) been at pains to emphasize that for every casualty of Alva's terror, there were scores if not hundreds of equally complicit folk who were left quite alone. But this was a qualitative terror, deployed with brutal economy. "Everyone must be made to live in constant fear of the roof breaking over his head," Alva wrote to King Philip in January 1568.[15] After the Index of Forbidden Books, drawn up in Madrid and published in Brussels in 1569, it became possible to be arrested for reading (much less possessing) seditiously comic or satirical items like *Till Eulenspiegel*. Remembering the damage done to the authority of the Church not only by printed broadsides but by street theater, the new government also took care to ban "singing, playing, or divulging of farces, ballads, songs, comedies, refrains, or other pieces in languages old or new, which refer to our religion or ecclesiastical persons."[16] Lest the citizens of Antwerp ignore the noose waiting for their necks, Alva had a pentagonal citadel built south of the city, designed by two Italian specialists in military architecture, Francesco Paciotto and Bartolomeo Compi. Each side of its walls ran about 325 yards long, and from them projected arrowhead bastions armed with cannon, two of them pointing directly at the town whose citizens had paid through the nose for its construction—for their own *protection*, the Duke emphasized. The Spanish troops quartered there lived inside a miniature, self-contained city complete with chapel, governor's lodging, mills, foundries, butchers, bakers, and taverns. At the center, in the musteryard, was, of course, a larger-than-life statue of the Governor-Duke himself, armored and adamant.

As an alderman who had apparently stood by while the city had been surrendered to sacrilegious riot, Jan Rubens was a natural target for Alva's police. Even before the arrival of the Duke, Margaret had called for an accounting of the conduct of Antwerp's municipal officers. On the second of August 1567, a long document was presented to the Regent offering

detailed justification for their collective behavior. Alva brusquely swept it aside as disingenuous, and in December demanded a new report that could be checked against the information compiled by his own men from seized documents and informers. This second attempt at self-exoneration, eighty-five pages long with 293 arguments of proof, was delivered to Alva on January 8, 1568, and passed to the most ruthless of his prosecutors, Ludovico del Rio, for further examination. With good reason, Rubens must have worried about its persuasiveness, as three days later he asked a lawyer and friend, Jan Gillis, to represent his case before the judges. Then followed a long, sweaty delay. It was not until October 1568—the month in which William of Orange's little army was ignominiously routed in southern Limburg, leaving its commander to sell what guns remained and make his way back, disguised and alone, to Dillenburg—that Jan Rubens was summoned to appear in person at Antwerp's Town Hall to answer charges of heresy and sedition.[17] He could not have been optimistic about his chances of survival. The most popular of the city's burgomasters, the flamboyant impresario of the 1561 city festival, the *landjuweel,* Anthonie van Straelen, had been publicly decapitated the previous month on similar charges and with no more damning evidence than had been laid against him. His identification by a Catholic friar as "the first alderman of the city and the most learned of its Calvinists" was unhelpful, for erudition was no mitigation of heresy; better indeed to be thought of as credulous. Answering the probing questions posed by the Council of Blood's zealous interrogator, Rubens tried to make the best of it. He had listened to perhaps four or five sermons, he conceded, but had never attended the Reformers' assemblies or communions. What he had done was out of curiosity, not wickedness; indeed he protested that he was now, as always, a loyal son of the Catholic Church and an obedient servant of the King.

He also knew this would cut no ice with del Rio, or with the Duke himself. Earlier in the autumn Rubens had sent his wife and four children (aged six years to one year old) south through the rolling hills of Wallonia and Limburg, which were infested with mutinous mercenaries turned bandits, some of them the remnants of William's bedraggled army. Stopping to attend a baptism in Maria's family, the little group crossed the borders of the Habsburg Netherlands and entered the duchy of Cleve. Jan Rubens himself successfully temporized, slowing down the proceedings against him. But he was running out of time. Once he had in his hands a document from the municipal government of Antwerp certifying that he had for eight years properly and faithfully exercised the office of alderman, he slipped out of the city, taking the same route to a Rhineland exile. The family's destination was Cologne, where there was a large colony of fugitives from Alva's repression. Cologne was still very much a Catholic city, but its pragmatically minded authorities saw in the influx of Dutch and Flemish refugees (along with their bullion) commercial opportunities. They were admitted on sufferance and even allowed private places of worship, provided the public peace was not disturbed by their presence. Rubens, how-

ever, had been identified to the city authorities as just such a potential
troublemaker: someone "who does not go to church."[18] On May 28, 1569,
these suspicions resulted in a peremptory order to leave the city within
eight days. Rubens now played his best and only card. Two letters recited
his respectable history and confirmed that he had come to Cologne to prac-
tice his profession as an advocate. A further detail was meant to repel any
attempts at eviction. He was, he stated, in the employ of Her Serene High-
ness the Princess of Orange, who, on occasion when travelling, had even
entrusted him with the custody of her children.

The family was allowed to stay. For Jan's improbable boast was true.
On arriving in Cologne, Jan had sought out an old colleague from
Antwerp, Jan Bets, from a family of magistrates in Mechelen. Bets was
known as a legal counsellor to both Princes William and Louis, who relied
on him for his abstruse knowledge of German law and custom. In 1569 he
was especially occupied with the status of Princess Anna's dowry, trying
to build a case for its exemption from the general forfeiture that had
befallen the estate of her husband. And although Anna was forever plead-
ing poverty and blaming William for her own predicament, Bets's mission
was not necessarily an act of disloyalty. Under Netherlandish law, wives
retained a title to the dowry brought to a marriage even when it was
enjoyed in common throughout the life of the marriage. Given William's
desperate straits, it made sense to exploit the legal distinction in order to
rescue Anna's portion from the wreckage. At the very least, he must have
calculated, the provision of funds might muffle the shrillness of her recrim-
inations. Bets's charge was to try and enlist influential and sympathetic fig-
ures—the Emperor Maximilian; the Landgrave of Hesse; the Prince
Palatine—to voice their support for her claims in the hope of persuading
King Philip.

It cannot have been easy, working for Anna of Saxony. This being the
case, Bets may well have found it convenient, as well as necessary, to spend
much of his time away from Cologne travelling among the several princely
courts in Frankfurt, Leipzig, and Vienna. And it was this diplomatic absen-
teeism that opened up an opportunity for his friend Rubens to take care of
the Princess's domestic and legal affairs in his absence. Introduced to Anna,
he found immediate favor. Just when it was that counselling turned to
caresses will never be known. From the distance of the centuries, they make
an improbable couple—the sober Flemish advocate, excessively given to
quoting the classics, and the wine-soaked Princess bursting from her whale-
bones. But Jan's son, Peter Paul, would become, after all, the lustiest cele-
brant of female voluptuousness in the history of Western art. So beneath
the trim beard and prim demeanor of the father there may well have been
an equally strong animal nature. Whether it was her jewelled hand that
paused, so gratefully, a moment too long on his starched cuff, or his eyes
that travelled so nervously over her throat and bosom, the sheer reckless-
ness of their act bespeaks a consuming infatuation, the kind that maddens
its partners into illusions of invisibility.

Could it be that the unfortunate Anna of Saxony was actually desirable? To listen to the historians you would never think so. For ever since the revolt of the Netherlands was celebrated, in the eighteenth and nineteenth centuries (by Americans like John Adams and John Lothrop Motley), as the founding epic of liberal freedom, William the Silent has necessarily been its dauntless hero. In this long view, the burden he carried on his shoulders in the dark years between his flight from the Netherlands and the first stunning military success of the Beggar fleet at Brill in 1572 was not merely that of his country but that of the fate of Western liberal democracy. Those that made his burden still heavier, then, became traitors, not merely to the cause of the Prince but to the cause of the West. Alas for Anna, who had no inkling that her feckless self-indulgence was imperilling the fate of democracy. Woe to Anna, whose very name made the upstanding Dutch archivist who discovered her sorry history in the 1850s, Dr. Bakhuizen van den Brink, shudder with disgust and avert his eyes from the squalid details.[19] Described variously as without beauty, charm, or sense, afflicted with curvature of the spine, a spiteful, screaming shrew, a drunk with an itch in her linen, she occupies a prime place in the pantheon of Renaissance female infamy.

And perhaps she was all these things. The truth is that we know very little about Anna of Saxony, other than the relentlessly repeated opinion that, from the beginning, she was a handful. What we do know is that she quickly went from being an adolescent writing letters of unseemly ardor to her betrothed to being the mother of a series of children who, as so often was the case in the sixteenth century, hurried from the crib to the casket. There were exceptions—two daughters, Anna and Emilie, and the boy child Maurice, named for his Saxon grandfather, also sickly and given little chance of survival. Survive he did, though, and went on to become the second great Stadholder and general-in-chief of Dutch victory. The Maurician virtues—courage, intelligence, and discipline—must, say the historians, have descended to him exclusively through his father's line, miraculously unadulterated by the mother's vices. At some point, certainly, the marriage of William and Anna became a pathetic misery. Private wrongs, imagined or real, were turned by the Princess into public tantrums. Even before William's difficulties accumulated, Anna was given to accusing him of taking counsel from those who made no secret of their dislike for her, most obviously his younger brother Louis. She became restive, hysterical, a little paranoid. Her husband, she was only too aware, was himself no saint of marital fidelity, so a gracefully executed bow or an airy jest directed at one of the women of the court seemed to her overwrought imagination a calculated seduction. Like many other adolescent women destined to be dynastic broodmares and caught between dowager ladies-in-waiting and husbands wrapped up in political stratagems that were said to be beyond their understanding or concern, Anna struck out on her own, taking off for hunting parties or jousts where there was no shortage of courtiers eager to compare her in song and rhyme to Venus, Diana, Cybele, and Isis.

Why should a goddess have to live like a vagabond? Baffled by the col-
lapse of William's power and fortune and what must have seemed to her to
be his perverse appetite for misfortune, Anna thrashed about looking for
someone to blame. Before their marriage her husband had promised her
amusement and grandeur, but instead had brought her a cargo of sorrows.
The complete courtier had turned, before her eyes, into a haggard melan-
cholic, his head filled with incomprehensible stratagems, all of which
seemed to deepen their troubles. Increasingly, she kept her own company.
Even before William became a hunted man, his great estate ruined, robbed,
or pawned, Anna had determined that she would not be dragged down in
his train. Dillenburg was a penance, her pregnancy an ordeal, the infant a
howling inconvenience. She was sick of the Nassaus. Late in 1568 she
bolted for Cologne with a company of noisy hangers-on. Not that William
was under any illusion that his errant wife's motives were patriotic.
Cologne's fame as a market for precious stones and Rhine wine is likely to
have been more of an attraction than its piety or politics. He had good rea-
son to feel uneasy about Anna's liberty. Should she run true to form, his
military and political embarrassments could only be compounded by his
wife's notoriety. Sure enough, reports of the Princess's misconduct and
extravagant expenses soon arrived. William's response was a series of let-
ters to his *"liebe Hausfrau"* attempting to point out her wifely obliga-
tions.[20] Initially he hoped she could be persuaded to join him on his
wanderings through France and Germany. But when she bothered to reply
at all, Anna flatly rejected any thought of embracing such inconveniences.
On one notorious occasion she was said to have greeted the arrival of a let-
ter from William by publicly tearing it to shreds in front of the messenger
and her assembled company, shrieking with laughter at the mention of his
name.

Sorely tried and at the lowest ebb in his fortunes, William attempted
tenderness. In a touching letter written in November 1569, he gently
reminded her that "you have promised before God and the Church to
abandon the things of this world to follow your husband, whom, it seems
to me, you should hold closer to your heart than trivial and frivolous
things. . . . I do not say this to try and persuade you to come here, for if this
is contrary to your own wish, the remedy must be with you, but to remind
you that I am tied to you by the commandment of God as well as by
friendly affection [*amitié*]. There is nothing in the world which gives more
consolation to a man than to be comforted by his wife and to see with what
patience she demonstrates her willingness to bear the cross that the
Almighty places upon her husband, especially when it is for things that will
advance the glory of God and the liberty of his country. . . . To see [my
wife] for but a few days, it seems to me that I should be happy to suffer all
the miseries that God has sent me."[21]

When husband and wife did finally meet, between William's journey-
ings, recrimination was followed by tearful reconciliation. But as soon as
William disappeared, so did Anna's intermittent fits of loyalty. In the new

year, 1570, the Prince was addressing his neglected letters to "my wife, my own," but by the spring, with more reports from Cologne of her wild flirtations and public abuse of his own name, William had despaired of repairing the marriage. He was now more concerned with containing the damage its notoriety could inflict on his already battered standing in the courts of Europe. He had wanted to be happy. Now he was only concerned not to appear ridiculous. In April 1570 he wrote to her grandfather, the Elector of Hesse, begging him to admonish Anna to mend her ways. "The bad reputation my wife is acquiring redounds not only on her, but on me, on her children and all her relatives. . . . For to tell the truth, it is no longer possible for me to be patient. . . . [S]o many adversities, one coming after the other, may make a man lose sense and patience and respect; and in truth, instead of the consolation I should have from her, she must utter a hundred thousand insults . . . follies and outrageous nonsense." This, he continued, was all the more wounding since "I can swear to you, on the damnation of my soul, that for a long time I have wished that we could live together as God has commanded us."[22]

Anna, however, was no longer paying much attention to God. There was someone else on her mind. By St. John's Eve, 1570, the long night, so the village lore prescribed, when women were free to choose partners and men were bound to comply, Anna had chosen Rubens. He had evidently become indispensable to her as counsellor and helpmate. She had taken a grandiose house, where the lawyer went through her correspondence from Bets and explained its implications for the fate of her estate. Perhaps, while he did so, he took care to lavish flattery on a woman who drank it up as eagerly as Rhine wine. Perhaps his own head was turned by the exalted quality of his patroness. The doctor of laws was still the son and stepson of grocers and druggists. At some point, their tongues loosened by wine, their talk must have moved beyond entails and escheats. Rubens was asked to supper.

ii *Atonement*

Dear God, what had become of him? It had been three weeks since he had taken leave of the family. He had never been away for such a time on the Princess's business. And had he been detained in Siegen by some unexpected matter, he would have let her know. Perhaps there had been letters? Perhaps they had been taken on the road? Perhaps *he* had been taken on the road? Lord knows they were full of terrors: armies of beggars, some people said; soldiers who had fled the regiment and lived in the woods, preying on travellers. The Stoic philosophers counselled patience and fortitude, but Maria, even as she tried to reassure the children,

was brimming with apprehension.[23] Her friends, above all her kinsman Reymont Reingott, had asked questions in town, had written to fellow merchants in Siegen. She herself had written, many times, directly to the Princess, begging pardon for her presumption but imploring her to provide news of her husband's whereabouts and condition. Finally, and in desperation, she had sent two of Reingott's servants as messengers to Siegen to see if anything could be discovered. Much was suspected, nothing known for sure. Maria went through agonies of uncertainty. She moved among the *Bürgerfrauen*, her starched Flemish cap conspicuous amidst the strange forehead-plates with their dangling pommels that made the merchant women of Cologne look like a swarm of busy insects. Rosaries hung from silver belts slung about the black folds of their gowns. How long was she to be tried?

She was answered in the last week of March 1571. On the twenty-eighth, in the depths of the gray Lenten cold, a messenger arrived bearing a letter not from Siegen but from the castle of the Count of Nassau at Dillenburg. Perhaps, for a moment, Maria was relieved to learn that her husband was alive. But the news that followed was a sword-thrust passing clear through her body. Jan Rubens had been arrested the same day he had departed for Siegen, virtually on crossing into the Count's territories. He was imprisoned in the castle, his life forfeit to the Prince, whose honor he had violated as he had his wife's.

Strength came. On the twenty-eighth of March another man dismounted before her brick-fronted house with a letter from Dillenburg, this time in her husband's hand. It more than confirmed her worst fears. It added to them the dreadful sense that she was being addressed from the tomb by a man confessing his sins before meeting his end. He admitted everything, begged her forgiveness, declared himself base and unworthy of her. He had, he said, made a clean breast of everything before the Count. His position was especially black since the Princess, it seemed, was with child, yet had not seen Prince William for over a year. From the Prince's family he could expect no mercy. But from his wife he may have assumed some understanding, since amidst the professions of abject penitence and contrition, Jan made sure to provide careful instructions on how best to conceal the scandal from friends, the émigré community of Cologne, their relatives and business associates. He was, as ever, simultaneously culprit and lawyer, prostrate and pompous. But as little as he deserved his wife's forgiveness, he was right to suppose that she would offer it. Even before she had read his first letter, Maria had decided to pardon him, to do everything in her power to ensure their family's survival. He was still her "dear and most beloved husband," and she freely gave him "the forgiveness you asked for, now and always, *on the one condition that you will love me as you used to* [my emphasis]."[24] In that Flemish phrase "*dat gij mij zult liefhebben alzoo gij pleegt*" lay a whole world of wifely terror and doubt, for Maria had to have been wondering whether Jan Rubens would want her again. "If I have that," she went on, "everything else will follow." She

had sent her kinsman Reingott to Dillenburg with a petition but feared it might not find favor with the lords since "there is no art or learning in it, only my own wishes, expressed as well as I can."

More shockingly, Maria's response to her husband presupposes that he was at least as worried about news of his notoriety becoming public as her own reaction. For she goes to some lengths to reassure him that "I have said nothing of your matter to a living soul, not even to our friends, and have not asked for help, but have helped myself as best I could so that on our side, at least, your matter is kept secret." But, she added, "as to finding explanations for your absence, it is already too late for that, for where you are [the prison] has become common knowledge not just here but in Antwerp. We say what we agreed with Reingott, that you are coming home soon, and that has done much to stop the gossip. I have also written to our parents, who like all our friends have been stricken with unspeakable sorrow and cannot rest easy until they have news you are back home. You say in your letter that I should show no pain or dismay, but that is quite impossible since I have no moment without them. As people say, feigning gladness in sadness hurts the worst. Nonetheless, I do my best but I never go out of the house . . . and to those who come to talk to me I explain that I am distressed by the rumors and gossip that are being spread about you." The children, she added, prayed two or three times a day for him. He too ought to trust the Lord, who she hoped "would not punish me too harshly and keep us so woefully parted, for that would be too great a trial for me to bear patiently."

She must have set the pen down close to midnight, but before she could seal the letter a messenger arrived out of the darkness bearing another note from Jan, evidently overjoyed at her compassion and generosity. Judging from Maria's own response, written in the early hours of the morning, as soon as she had scanned her husband's words, Jan's almost inhuman selfishness and obsession with secrecy had now belatedly dissolved into grief, guilt, and fear. But even as Maria sought to console him and pull the shattered pieces of their marriage together, she herself, while writing, came close to a breakdown. "I am gladdened that you are happy with my forgiveness," she began, "[but] I never thought you could believe I would make any difficulties about that, as indeed I have not. How could I be so severe with you when you are in such perilous straits and when I would gladly give my life's blood to help you if it were possible? And . . . how could it be that hatred should have so replaced a long companionship that I could not forgive *a little misdeed against myself* [my emphasis] when not a day goes by when I do not pray to the Heavenly Father for forgiveness for the many great misdeeds I commit."

Jan's despondency made Maria herself "grieve so that I am almost blind and can hardly see to write." There was nothing in his letter, she wrote, that assured her. "I can scarcely read it for I think my heart will break since it shows me you have given yourself up for a lost man and speak as if you will die. I am so distressed I know not what to write. It

seems you think I desire your death since you wish me to accept it as satis-
faction. Ah, what an affliction it is for me to hear you say that; it passes all
endurance. If there is no mercy left, where shall I go, where shall I find it? I
must ask it of Heaven with my endless cries and tears. I hope the Lord will
hear me and soften the hearts of the princes that they may hear our prayers
and take pity; otherwise it is certain that in putting you to death I will also
die of heartache. The moment I hear the news my heart will stop. . . . My
soul is so bound up and united with yours that I feel and suffer exactly as
you. If the good gentlemen could see my tears, were they made of stone and
wood they would surely have mercy." If all else failed, she would go herself
to see Count Johan, the Prince's brother, even if everyone, the lords and Jan
himself, expressly forbade it.

At the end of the letter, perhaps when tears had calmed to sighs, Maria
gathered her strength again and urged hope on her miserable husband. "I
pray you not to think so much on ill things but be as brave as you can. Evil
comes soon enough of its own accord, and to be thinking always on death,
fearing death, is worse than death itself. So drive that from your heart. I
have hope and faith that God will treat us mercifully and bring us both
some happiness out of all this sorrow." And, she added in a postscript, "do
not write any longer '*your unworthy husband,*' for it is truly forgiven."

If Maria believed that the heavenly powers would hear her tormented
supplications, she was less sanguine about the earthly powers. When it
became clear that her friends' optimism that Rubens might quickly be
released was misplaced, she could not support waiting out the life-or-death
decision trapped in her house. So in spite of the strict instruction from the
Count's men that she should remain in Cologne, Maria took herself to
Siegen in the third week of May. From that place, marked forever with her
husband's transgression, she sent an impassioned letter to Count Johan
imploring forgiveness for Jan and taking the liberty of inquiring whether
she might be allowed to see him. Though she was in a world of Protestants,
she still acted instinctively as the intercessor whose name she bore: the Vir-
gin whose exposed breast implored the Father to be merciful to the iniqui-
tous. Maria would not go that far, but she would do everything in her
power to wring compassion from the lordly. When they disdained to
answer her letters, she moved herself closer to their anger, travelling to a
hamlet that was barely a mile from Dillenburg. More letters followed,
inquiring anxiously after Rubens's health. Emboldened by her persistence,
Jan then asked his captors whether they might not allow him a brief
moment with his wife, the paragon of steadfastness, so that he could hear
"from her own mouth the word *forgiveness.*"[25] Just a minute or two, in the
evening at the gate of the castle, would suffice. And if that could not be
granted, might she not at least be permitted to walk beneath the castle
walls so that he might see her through his barred window?

Hearts did not melt. Permission was harshly denied and Maria peremp-
torily ordered to remove herself from Dillenburg. It was a bad sign. Jan's
letters, once again, darkened. "If I receive my sentence of death, then you

should write to your parents that I have suddenly been sent to another country."²⁶ In October 1572 Maria Pypelincx's ordeal reached a critical point. Jan was brought from Dillenburg to another of the Nassau castles, Beilstein, where Anna had been locked away since the revelation of her crime. There the two sinners were made to confront each other, in a proceeding that was more tribunal than formal trial, and to confess their guilt. Both had been reduced to pathetic phantoms of their former selves: the lawyer no longer sententious, the Princess no longer uproarious. It had been otherwise in the days following Jan's arrest. Shown reports of her misconduct by Count Johan, Anna had admitted nothing and had written to William protesting her innocence and complaining indignantly about the "traitors" who had sullied her good name. Three days later, on March 25, she wrote secretly to Rubens in precisely the opposite vein, acknowledging her guilt. As late as June she was insisting to a French Protestant pastor that she had been falsely accused and had no scruples about comparing her plight to that of the apocryphal Susanna, slandered by the elders whose lust she had resisted!²⁷ But by the summer her belly must have been big enough to test even the most expansive farthingale's capacity for disguise.

Once she had owned up to her sin, Anna was taken to another of the Nassau residences, at Dietz, where she lived through the remaining months of her pregnancy, a prisoner and a pariah. Her Saxon family, mortified by the disgrace that her adultery had brought upon their house and on the marriage they had worked so hard to bring about, all but disowned her. Their awareness of her culpability did not prevent either the Landgrave of Hesse or the Elector of Saxony from being affronted by Anna's treatment and demanding the return of her dowry once it became clear that William was instituting proceedings for a separation and divorce. On the twenty-second of August 1571, Anna was delivered of an infant girl, named Christine von Dietz and immediately repudiated by Prince William. Like all of Anna's offspring, the baby was sickly and given little chance of survival. Inconveniently, though, she lived, and, grudgingly lodged at Dillenburg, was condemned to lead a melancholy and anomalous existence, referred to by her uncle Johan and her half brother Maurice as *la fillette*, the little girl.

After the confinement and the birth of her daughter, Anna was removed to Beilstein and kept under lock and key lest she contrive any further mischief. As soon as the divorce was enacted, she was packed off back to Dresden, where she lived but a few years more in close confinement before dying in December 1577, thus relieving all concerned of the burden of her wretchedness. Once safely below ground, she was at least allowed the dignity of being buried in the ancestral tomb at Meissen. Two years earlier William had taken another wife, Charlotte of Bourbon, fresh from the convent. It would be a happy union and would produce another prince: Frederik Hendrik.

It was the confession of guilt duly signed by Anna and Jan that had set the Prince free to remarry. Rubens's condition was now going to change, either for the better or for the worse. And despite her husband's fits of pes-

simism, Maria seems to have been convinced that, if only for reasons of
political expediency, William was unlikely to stage a public trial and execu-
tion. Advertising his chagrin as the most eminent cuckold in Europe was
not what was needed while the Prince was desperately attempting to
restore the fortunes of his political and military campaign in the Nether-
lands. Not long after the judicial hearing, Maria was for the first time
allowed to see Jan in his cell at Dillenburg. With help from her friends in
Cologne, she had been paying for his food and the other costs of his accom-
modation at the Prince's pleasure, but she could not have been under any
illusion that she would find the same man who had left their house that
March morning for the trip to Siegen. And her husband had indeed become
shockingly old and emaciated. Not long after the visit, she finally had the
news for which she had waited through two and a half years of uncertainty.
Johan's secretary, Dr. Schwartz, confirmed that the sentence of death had
been set aside. But while that was cause for rejoicing, it was still unclear
whether Jan would spend the rest of his days in prison, which, given his
physical condition, Maria now believed would be few.

On March 13, 1573, Maria was desperate enough to invoke the
impending Eastertide. She wrote the Count that she "could not let the Pas-
sion of Jesus Christ go by without praying for my husband's freedom. Will
Your Grace cast his merciful eyes on us all and bring us back together, not
just for the sake of my husband, who for two years has suffered great tor-
ment and passion, but also for myself, who during this time have been
innocent, and for the sake of my poor children, who have seen not only the
ruin of their father but their mother's grief and the distress of her senses."[28]
Shortly afterward, Maria received the long-awaited letter spelling out the
terms on which her husband would finally see the light of day. On payment
of a bond of six thousand thalers, Rubens was to be allowed to live in
Siegen, under the jurisdiction of the Count and subject to supervision by
one of his officers. Though he would be reunited with his wife and chil-
dren, their liberty was to be severely circumscribed. Rubens was strictly
forbidden to leave the house on any pretext whatsoever, including attend-
ing any kind of church. Those who might visit them had to be proved
acceptable to the Count. Since Rubens would be unable to exercise his pro-
fession, the family would receive interest on the six thousand thalers at an
annual rate of 5 percent, which it had been calculated would suffice for a
modest subsistence. The parties concerned—the Prince, the Count, and the
offended Landgrave and Elector of Saxony—all reserved the right to cancel
this arrangement at any time, to bring Rubens to trial once more or
demand his surrender for imprisonment. Any infraction of the agreement
automatically annulled his freedom and might well result in his immediate
death.

Harsh though these conditions were, Maria embraced them with un-
utterable relief and joy. On the tenth of May, Pentecost, the feast of the
Holy Ghost, the true consoler (as Jan of course had noted), the Dillenburg
Castle gate was opened to the prisoner, and a horse saddled for him. Once

settled in Siegen, Jan Rubens quickly found things to complain about. The city was a crowded, smoky little town of ironsmiths and metalworkers, a far cry from the grandeur and elegance of Cologne. Deprived of the street and the market, forbidden either to make or to receive visits, attempting to fit six children and two adults into a cramped set of rooms was, they discovered, truly another kind of imprisonment. Risking accusations of ingratitude, Jan lost no time in renewing his requests to the Dillenburg chancellery to be allowed to take walks by the city walls, where the air might assist the recovery of his enfeebled health. He also asked to be allowed to attend some form of church service "so necessary for a sinner." The second request was categorically denied, but Johan was prepared to allow Rubens to take the occasional promenade under the watchful supervision of an appointed official.[29]

Given his confinement, it was virtually impossible for Rubens to reestablish his old profession of advocate in Siegen. And since the war effectively cut off all possibility of help from their families in Flanders, the Rubenses were entirely dependent on the three hundred thalers that made up the promised interest payments on Jan's six-thousand-thaler ransom. All too often, though, the money failed to materialize at the half year, and sometimes it failed to materialize at all. Maria wrote letters complaining about this tardiness, but at the same time knew that her only weapon to nudge the consciences of the Count and his brother was her own blameless virtue. Her husband, though, came close to overplaying his hand. In December 1575 angry letters from Dillenburg accused him of all kinds of presumptuous wickedness: taking unsupervised walks hither and thither about the town; receiving unauthorized letters from Heidelberg and Cologne; and, most scandalous of all, going to sup with a friend on a Friday evening. Since he had so brazenly violated the terms of his release, the Count had now decided to impose harsher restraints. Leaving the house for whatever reason would henceforth be forbidden, on pain of renewed imprisonment; and he could put aside any vain hope of ever being permitted to attend public worship. The reports of his transgressions seemed regrettably specific, but Jan denied each and every allegation, protesting that the charges were without any foundation, and in all likelihood had been invented by ill-disposed persons. Aware that his wife carried a good deal more moral suasion than himself, Jan had her write to Dillenburg (at his dictation) asking if his little liberty might be restored.[30]

The answer, inevitably, was no. But even while rejecting the Rubenses' appeals for leniency, Count Johan's secretary held out some bare glimmer of hope. The Count, he implied, was not himself averse to clemency, but the Elector of Saxony and William, the Landgrave of Hesse, were still not in the forgiving vein. What Jan and Maria truly hoped for was an end to their Siegen house arrest; the possibility of removing themselves to some place further off where the husband could resume his profession and the wife be unafraid of whispered gossip in the market. By the end of 1577, an auspicious conjunction of events stirred their hopes again. Anna died in

December. Prince William had been contentedly and fruitfully married for
two years; and his political fortunes had been transformed for the better.
The center of the rebellion against Alva had moved north, to the seaports
and towns of Holland and Zeeland. For two years, through a campaign of
sack and siege, he had attempted to contain and crush the revolt and had
failed. Leiden, which had become a citadel of Calvinism after receiving an
influx of Protestant refugees from the south, resisted and starved for over a
year rather than submit to Alva's troops, and when the siege was broken by
the Beggar fleet, the Duke's policy of coercion broke with it. Alva left the
Netherlands in November 1573. The Spanish crown declared bankruptcy
in 1575, and without pay its troops turned to mutiny, with memorably ter-
rifying results in Antwerp. By February 1577 the new Spanish governor,
Requesens, had been forced to abandon all the elements of Alva's terror:
punitive taxation, the repression of heresy, and the quartering of soldiers.
Under the terms of a peace treaty between the provinces of Holland and
Zeeland (where William was Stadholder) and the States General in Brus-
sels, the toleration policy was to be restored, with Protestantism dominant
in the north, Catholicism in the south. In the autumn William made tri-
umphal entries into Antwerp and Brussels, the cities from which ten years
before he had fled as a fugitive and accused traitor.

With the political and military map of Europe changed, apparently for
the better, might the new peace bring with it a gentler future for the Rubens
family? Two more children had been added to the household: Philip in
1574; and on the feast day of St. Peter and St. Paul, 1577, another boy,
who was named for both the saints. That year, both Maria and her mother
Clara wrote the Count asking him to intercede once more with William,
suggesting that, now that the Pacification had come to their homeland, per-
haps they might be allowed to return. That much the Prince, with his
perennial anxiety that the old scandal might somehow find a way to seep
into public view, was not prepared to grant. But in the spring of 1578,
Count Johan was authorized to make a second agreement with Jan Rubens
that would license the family to remove themselves from Siegen to some
other place, provided it was not within the borders of the Netherlands.

By the end of 1578, seven years after Jan Rubens's arrest, the family
was back in Cologne. Whether they were able to put back together the
shattered pieces of their old life, it is still hard to say. Though Jan may
never have returned to the practice of the law, business letters to and from a
Frankfurt financier suggest that he was finding some way to support the
family, and it may be that in the interregnum between two periods of war-
fare, some of his lost funds and rents from the north were restored. The
tight restrictions on the family's freedom of movement no longer applied,
and they became practicing members of one of the Lutheran congregations
of the city. Even the ominous name of the house they rented in the Sternen-
gasse from a local merchant, "the House of the Ravens," cast no dark spell
on the air of normality, even respectability, which settled, once more, over
the family. Another child, the last, Bartholomeus, was born in 1581.

On the tenth of January 1583, an official document signed by Graf Johan van Nassau affirmed that, by the grace of himself and the Prince, Jan Rubens was hereby and henceforth free from any imprisonment and any further penalty.[31] He had at last served his term. In a private letter, the Count also affirmed that he had (as always) been moved to this last act of mercy by the "prayers of Rubens's *huysvrouw.*" There was, however, one last condition that remained attached to the long-sought, dearly bought liberty of Jan Rubens: that he would never, ever, by intent or accident, come within sight of His Grace and Highness, William, Prince of Orange, lest the said lord, reminded of a vile thing, become overmastered by passion, his reason succumb to his rage, and he be tempted to lift his hand against the malefactor. To avoid any such eventuality, Rubens was, for the remainder of his days, banished from the lands of the seventeen provinces of the Netherlands, north or south.

Eighteen months later, the sentence became academic (though it was never annulled). In June 1580 Philip II had proscribed William as "the chief disturber of our state of Christendom" and offered twenty-five thousand ecus to anyone who might venture to kill him. Between Catholic "Malcontents," who saw him as at least as infamous as the pagan Turks, and militant Calvinists disappointed by his failure to impose a Protestant theocracy, there was no lack of aspiring murderers. In March 1582 William was shot at point-blank range in Antwerp by Juan Jauréguy, put up to it by a Portuguese merchant. The gun had exploded in the assassin's hand, its discharge tearing away a side of the Prince's face. But although he lost massive amounts of blood and was twice given up for dead, William survived, his physician stanching the wound first with a lead pellet pressed to the opening and then by shifts of attendants holding their fingers to the site. The patient's endurance astonished many and disappointed his old foe Granvelle, who complained that "this pestilent Orange will never be done with his dying." Protestant ministers throughout Europe praised God for the miracle.

Two years later, in July 1584, after William had effectively given up Flanders and Brabant (including his hometown of Breda) as lost to Alessandro Farnese's Spanish army and had removed his headquarters to a modest former convent in Delft, the cabinetmaker Balthasar Gérard unloaded two pistols at the Prince as he was descending the staircase from his bedroom. Since Gérard's guns were aimed upward to hit the descending Prince, the bullets entered first William's stomach, then his lungs, and exited his body and lodged themselves in the plaster wall. "My God, take pity on my soul, and take pity on this poor people" was his last complete sentence, though when asked whether he died reconciled with Christ, the dying man answered weakly in the affirmative. Gérard was caught on the grounds of the Prinsenhof attempting to climb the garden wall. He had nothing on his person other than a pair of inflatable bladders with which he had hoped to swim the encircling canal.

Three years later, on the first day of March 1587 in a bulky house in Cologne, Jan Rubens died in his bed. Before his final sickness he seems to

have undergone a momentous change of heart, or perhaps, after all, he needed serious absolution. He returned to his old confession. Much restored to honor and even respectability, he was interred in the Church of St. Peter. His wife Maria had become accustomed, but not reconciled, to grief. Three of her children—Hendrik, Emilie, and Bartholomeus—had gone before their father. How heavy had been her load of misfortune, how painful the exile—from her country, her family, the church of her fathers. It was time now to go home, to make reparation as best she could.

i Painting in the Ruins

Saints everywhere.

Half of Antwerp's people had disappeared by the time Maria Rubens returned in 1587, the city of a hundred thousand shrunk to a mere town of fifty thousand, as if a contagion had swept over its bricks and gables. Daylight showed through the masts moored at the docks. Dust settled on abandoned looms and letterpresses. Room was available on the tavern benches and bolsters. But the saints (not to mention apostles, disciples, doctors, and fathers of the True Church; martyrs, patriarchs, hermits, and mystics) came flocking back, taking up station in naves and chapels, altars and choirs, mortified in print, exalted in paint. There were the saints familiar, whom the Council of Trent had especially commended as an antidote to heresy and doubt, none more ubiquitous than the penitent Francis, brown and mournful, stigmata-ready atop craggy Mount Verna. But there were also saints peculiar, dear to native tradition, who attracted fresh devotion after the publication in 1583 of the official index of Netherlandish holy men and women, Johannus Molanus's *Indiculus Sanctorum Belgii:* the blessed virgin Amelberga, whose body was said to have been pushed upriver to Ghent by a school of sturgeon; St. Wilgefortis (the English Uncumber), whose flowing beard protected her against would-be violators but not against her pagan father, who had her beheaded, whiskers and all. St. Dymphna's father, on the other hand, had threatened incest and had tracked his fugitive daughter all the way to the Flemish village of Geel, where he had her decapitated on the spot for Christian insubordination, a cleaner fate, at least, than that of St. Tarbula, who was sawed in half *prior* to her crucifixion, which had to be completed, perforce, on two crosses, the messiest martyrdom.[1] Nor did the new generation of Catholic image-makers flinch from featuring the particular anatomical item selectively extracted for martyrdom: the ripped-out tongue of St. Livinus (tossed to the dogs but miraculously reconstituted to wag censoriously at his persecutors); the shorn breasts of St. Agatha; the eyes of St. Lucy (self-gouged to

avoid violation elsewhere). The comprehensive and unsparingly gruesome martyrologies of Baronius's *Annales* and Biverius's *Sanctuarum Crucis*, for example, ensured that sacred illustrators would never run short of awe-inspiring examples. Painters were forbidden by the scruples of the Counter-Reformation to relate the more doubtful miracles, but popular engravers and sculptors continued to represent local prodigies like St. Christine or St. Trond, famed for miracles of healing performed during nocturnal flights, the personification of the good witch. And artists became ingenious at prompting memories of saintly legends by representing attributes, confident that their devotees, steeped in the printed hagiographies, would complete the story. It was enough to show St. Clare of Montefalco, for example, together with her attribute of the balance, to remind her devotees of the three balls posthumously discovered within her body, each of which weighed as much as the other two combined, a mysterious affirmation of the indivisible Trinity lodged in the saintly corpse.

First and foremost, holy Antwerp was Maria's city, protected by her namesake the Blessed Virgin, whose spirit still lodged at the great cathedral. One of Alessandro Farnese's first acts after taking the city in 1585 was to remove the statue of its mythological founder, Silvius Brabo, from the front of the Town Hall and replace it with the figure of the Virgin trampling on the serpent Heresy. (The truly knowledgeable would also have understood snake-stomping as a sign of the Immaculate Conception, neatly replacing a pagan founding event with a sacred one.) But Maria Rubens would have rediscovered the Mother in countless other personae, printed and painted and seldom vengeful. She appeared as *Maria mediatrix*, Mary the Intercessor, exposing her breast while her Son exhibited the wound in his side in a concerted appeal to the Father for clemency to the sinful. Passing her rosary to the apostles or saints (especially St. Dominic), Mary implored balm for the plague-stricken. The Benedictines and Cistercians, restored to their monastic houses, might yet prefer her as mammiferous Maria, engaged in holy *lactatio*, smiling as she hosed sweet milk directly into the thirsty mouth of Bernard of Clairvaux, the mellifluous doctor.[2] Or she might appear as gravid Mary, belly swollen tight like a hedgerow pod in August, the time of Virgo; or as grieving Mary, eyes shut in dolor as her Son's body was lowered from the Cross, its gray (or yellow or green) flesh flecked with meat-bright puncture drips; or as levitating Mary in mid-transport, eyes rolled heavenward, wrapped in celestial blue garments; or as Mary crowned, her throne resting on a floor of clouds, the seven angelical choirs (leaders Sophiel, Raziel, Mathiel, Peliel, Iophiel, Camael, and Haniel) raining hosannas on her nimbused brow.

The fact of the matter was that poor bloodied Antwerp needed all the intercession it could command. Disgraced by his failure to recapture the northern provinces of the Netherlands, Alva had returned to Spain in 1575. But little good came of his departure. The bankruptcy of the Spanish crown had stranded its troops without pay just as King Philip had become unconscionably high-minded on the matter of plunder, the traditional recom-

pense for intermittent and belated pay. Weary of waiting and of broken promises, in November 1576 soldiers in Flanders mutinied, resolved to take by force what they supposed was rightfully and traditionally theirs. As the richest city in the Netherlands, Antwerp was naturally their principal target of opportunity, and for three days was subjected to uncontrollable violence: hundreds were murdered, thousands assaulted, their houses and workshops plundered.[3]

No wonder, then, that when William of Orange entered Antwerp in the summer of the following year, 1577, he was initially greeted by the survivors as a savior. One of his first acts on taking full possession of the city in the name of the States General was to dismantle Alva's fortifications, including the citadel from which the Spanish garrison had issued to inflict mayhem on the citizenry. Scarcely two years later, he was having to rebuild the defenses against a fresh military onslaught directed by the new Spanish commander, the shrewd and resolute Alessandro Farnese. Within the city William was neither universally admired nor trusted. The most obdurate Calvinists recalled his temporizing in 1567, when they had wanted to raise a militia to come to the aid of rebel troops outside the city and had judged the Prince confessionally unsound. William protested uneasily that now he too was both *calvus et Calvinista*—bald and Calvinist (implying resignation rather than enthusiasm)—but the ministers failed to see the joke. When, in 1581, it was learned that the Catholics of William's town, Breda, had opened the gates to the Spanish, Antwerp's city council, composed entirely of Protestants, decided to brush aside any further pretense of religious coexistence and complete the great scouring begun in 1566. This time, the business was orderly and official—no self-authorizing gangs with mallets. But the result was the same. Paintings and sculpture commissioned by Alva after the first round of iconoclasm were in their turn removed and walls again covered in chalky paint. "Thou shalt have no other gods before me" reappeared in golden script, in Hebrew and Flemish, against a pitch-black ground where once the Virgin had stood in her mildness.

Twice-whitewashed Antwerp was not destined to stay Reformed. In 1584, doubtless heartened by the news of William's assassination, Farnese laid siege to the city again. Cut off from all hope of relief, it endured nearly a year and a half of famine before opening its gates in 1585. The Governor-General, who had been a child in Brussels before undergoing a properly solemn Spanish-Christian education, was less vindictive than Alva, but hardly the soul of tolerance. Closely watched by Spanish advisers, he ordered the immediate removal of all Protestants from office. Those who had been so misguided as to stray from the True Church were given four years to recant or suffer banishment. A heartbreaking exodus, one of the most momentous in European history, was the result. No fewer than a hundred thousand souls (including those who had fled Alva and the Fury of 1576) left the southern Netherlands for the seven free provinces of the Union of Utrecht, the pilgrim generation of the Dutch Republic. Many saw no point in waiting out Farnese's four years, since thirty-two thousand—a

full third of the mid-century population—left Antwerp in the months be-
tween its fall and the autumn of 1586 alone.[4]

It was no light matter, this devotional loyalty. But it was not the only
reason to go. For generations, children had been told that Antwerp took its
name from the *handt-werp,* the toss of a severed hand, into the waters of
the Scheldt. The hand belonged to the giant Antigonus, who had set himself
up as toll-master at the estuary, cutting off the arms of those who refused
payment. Only Silvius Brabo, the founding hero, had had the guile and
strength to tear off the giant's hand and cast it into the river mouth, guar-
anteeing for posterity the port's freedom from intimidation. But now it was
the stripling, not the ogre, that had turned bully, strangling Antwerp's free-
dom. The Beggar fleet of the northern provinces patrolled the estuary,
backed up by a new fort at Lillo on the right bank with guns reaching
across the span. Together the gunboats and the bastion put a choke hold on
Antwerp's trade. Cut off from overseas sources of raw materials and forced
to pay punitive prices for shifting to overland supplies and markets, local
manufacturers grew weak. Capitalists moved their funds away, leaving
their artisans with the choice of destitution or emigration. The city went
from affluence to indigence in a matter of months, the poorhouses shutting
their gates against the press of the ragged and the needy. Farnese, who
never doubted that economic want was a price worth paying for the victory
of Church and crown, at one point was moved to write that "it is the sad-
dest thing in the world to see what these people are suffering." Toward the
end of 1595, with winter closing in, carts and wagons loaded with essen-
tials—cooking pots, a wooden bed frame, chairs and benches—trundled
out of the city gates, moving north and east. Whole industries, especially in
the textile trades—linens and bays, woollens and tapestries—decamped,
journeymen and masters, looms and bobbins, capital and technology resur-
facing beside the canals of Leiden, Haarlem, and Delft, where they trans-
formed modest provincial towns into little economic miracles.[5]

The traffic was not all one-way. Catholic clergy who had fled the
Calvinist domination of 1579–81 responded eagerly to Farnese's aggressive
Counter-Reformation. Jesuits, Dominicans, and Capuchins made their way
back to Flanders and Brabant, hoping that their ransacked monasteries and
convents were still standing. The cathedral filled up again with chapter and
choir, the great organ, newly rebuilt, filling the nave with its adamant
chords. And what of Maria Rubens? In all likelihood she yearned for famil-
iarities: the tables of her kin; the prattle of old friends; vespers in the
Church of the Blessed Virgin. And after all her years of makeshift furtive-
ness, she evidently meant to have done with shamefulness and shuffling, for
she bought a house on Antwerp's most conspicuously grand street, the
Meir, number 24, and moved in with Blandina, Philip, and Peter Paul.
Where did the money come from? Some may have been restored to her by
the Pypelincxes, but it also seems likely that during the last years in
Cologne, when Jan had been allowed to resume his professional and com-
mercial career, something of the Rubenses' fortune may have been retrieved

from the ruins of his crime. Not that Maria would have been at all well off in Antwerp, merely less impoverished than she had been in Germany. In her will made out in 1606, she refers to the "sacrifices" she had made in the years after her return, especially to provide a dowry for her daughter Blandina, who was married to Simon du Parcq on the twenty-fifth of August 1590. At the time of her marriage, Blandina was twenty-six—not, by the standards of the time, an old maid, certainly, but perhaps old enough to make Maria nervous, always mindful as she must have been of unwelcome whispers that could suddenly make connections with the Rubenses a doubtful honor. It didn't hurt her daughter's chances, then, to be dowered with a sum that produced an annual income of two hundred florins—a modest, but not contemptible, little fortune.

The match accomplished, Maria immediately made some drastic changes. Perhaps the slice of her capital now allotted to Blandina's portion gave her no choice. The house on the Meir emptied; the two boys, Philip and Peter Paul, were placed with desirable patrons. Philip, now sixteen and studious, was sent to Brussels to be the secretary to Jean Richardot, himself famously rich and learned and a privy councillor, whose household was as grand as could be imagined in Counter-Reformation Brabant. Eloquent beyond his years, Philip would also act as tutor to Richardot's younger brother, Guillaume. Peter Paul was just twelve. He had been going to Romualdus Verdonck's Latin school in the cathedral churchyard, one of five such institutions expressly created by Farnese to train a cohort of literate clergy obedient to the dogma of the Church but armed with the rhetorical skills to hold their own against sophists, libertines, and, if need be, brazen heretics. Not that this necessarily dictated the boy's eventual career. The solid diet of Greek and Latin texts, mastered through the sturdy disciplines of grammar and rhetoric, in addition to the study of sacred scripture and books of devotion and contemplation, would stand him in good stead were he to end up in court, countinghouse, or confessional. Maria might well have felt that had he been alive, Jan (who must have begun the education of his two sons in Germany) would have approved of this kind of instruction. Latin schools, with heavy doses of Plutarch, Cicero, and Tacitus parsed on unforgiving benches, were the nursery of the next generation of Antwerp's Catholic humanist patriciate.

What was to be done with the precocious boy now that his brother was off to Brussels, his sister married and gone, and his mother moved into more modest and matronly quarters on the Kloosterstraat, comfortably close to the cathedral? Tall for his years, crowned with dark curly hair, his face animated by wide, intelligent eyes and softened by full, rosy lips, Peter Paul must already have suggested the easy grace and courteous charm before which, in the years ahead, patrons, prelates, and princes would uniformly melt. Rubens would always be the kind of man in whose presence most people found it difficult not to smile—a smile, moreover, not of irony or condescension but of convivial sympathy. In 1590 this unforced cordiality seemed perfect courtier material. So Peter Paul was sent to embellish the

little court of Marguerite de Ligne, Countess of Lalaing, at Oudenaarde, thirty miles to the southwest of Antwerp in the damp and grassy Flemish plain. The Count, who like many cow-and-castle barons boasted a long string of titles, lordships, possessions, and bailiwicks, had died in 1583, leaving behind two daughters and the handsome hôtel d'Escornaix in Oudenaarde itself, where his widow increasingly confined herself. Almost certainly the Countess knew something of the terrible scandal of which no one in Antwerp ever spoke these days, since nineteen years before, her kinswoman, another Lalaing, the widowed Countess Hoogstraeten, had been one of the first to visit and comfort Maria at her Cologne house during the desperate Lent of 1571. Now this post was something that could be done for Maria Rubens's boy, *tellement charmant,* the perfect page.

The biographers, beginning with the seventeenth-century author of the *Vita,* are quick to assume that Peter Paul must have hated it. All his life, Rubens would make a great show of complaining about the "golden chains" that fettered the courtier. But he would do so even while he wore them on his person. The experience at Oudenaarde might not have been a complete waste of time. The little courts of the Netherlands, especially those in country towns, were still stamped with the elaborate heraldry and ceremony they had acquired during th century when the country was ruled by the house of Burgundy, the codifier of late medieval courtliness. As a page or squire, Rubens would indeed have been required to attend on the ladies, prettily displaying a perfectly hosed length of leg, his jacket and coat disposed just so over the sword hilt; to keep up with the falconers and hounds; to look lively in the rabbit shoots; to dance *la volta* without gasping; to keep awake during the madrigals. Some of these rituals might indeed have been a trial to a boy with his mind on Virgil. But there were places in the hôtel d'Escornaix that would have spoken to his precocious thirst for history: the tombs of the Lalaings in the family chapels, smelling of penance and purgatory; the ancestors on their backs or their knees, their stony fingers pressed in prayer, costumed in long robes or the mail and helms of Crusaders. Though Rubens's own costume book was produced much later, he would already have known of the fashion for ancestor chronicles, with woodcut illustrations drawn from tomb effigies of long-interred counts and countesses. Perhaps it was in the sepulchral silence that he tried his first sketches?

Or was it still earlier?

Many years later, in 1627, when Rubens was fifty-five and already thought of about Europe as "the prince of painters and the painter of princes," he found himself on a tow-barge between Utrecht and Amsterdam. His host during this visit to the Dutch Republic, Gerrit van Honthorst, had fallen sick and had delegated the unnerving task of seeing to Rubens's welfare to his young apprentice, Joachim von Sandrart (who himself hailed from a family of Calvinist emigrants from Wallonia). Rubens talked; Sandrart listened, and told the story later in his own book of artists, the *Teutsche Akademie.*[6] In *his* youth, the Master said, he had taken plea-

sure in copying the little woodcuts of Hans Holbein and the Swiss artist Tobias Stimmer. Later in life, Rubens was still drawing figures copied from Stimmer's Bible scenes—Adam driven from Eden, sinking to one knee in awe of the pursuing archangel; and in another sketch, a sick man stretched out on his back beneath the brazen serpents.[7] It seems more likely, though, that it was the storytelling power of Stimmer's illustrations that first provoked his visual imagination when he was a boy. And this may well have happened before the family returned to Antwerp, since apart from being a prolific illustrator, Stimmer was also a fierce satirist of the Pope and the Roman Church. It was highly unlikely, then, that Rubens would have encountered the woodcuts in a school like Verdonck's, expressly created as a bastion of conformity. Stimmer's *Neue künstlicher Figuren biblischer Historien* had first been published in Basel in 1576, and was precisely the kind of Protestant teaching book that Jan Rubens could safely leave in the hands of his small children while he was still a professing Lutheran in Cologne.

It's possible, too, of course, that Maria brought the Basel Bible illustrations back with her to Antwerp, but whenever he first took a pen or pencil and followed Stimmer's swooping, densely shaded lines, it's evident that the woodcuts made a serious impression on Peter Paul, and for good reason. Framed by emblematic supporting figures, mythical and biblical, and supplied with both scriptural verses and homilies discoursing on their importance for the Christian tradition, the little prints are prodigies of dramatic compression. At his most inspired, Stimmer uses the tiny format to open up a broad landscape space against which he deploys big, sculpturally cut figures, twisting or falling, gesticulating. It's against one such pastoral of stony hills, weeds, and flowers, for example, that Cain stands like a Teutonic Wild Man, clad in animal skins, his hair demented and on end, a massively Herculean club over his shoulder, scowling down at the delicate torso of his murdered brother Abel. In another startling improvisation, Stimmer poses the boy Isaac, readied for sacrifice, from the *rear,* the soles of his feet and his bare neck, shoulders, and back vulnerably exposed against a cruelly bright, windy sky in which birds wheel above Mount Moriah. The young body kneeling before the laid sacrificial fire is, windswept hair aside, perfectly and obediently still, oblivious to the sudden, violent intervention of the angel, clasping Father Abraham's upraised sword by the blade, and the dark tangle of forms struggling in the left foreground space of the print.

So many of Stimmer's devices—the deployment of massive, animated figures through broad space; the strong torsion of trunks and limbs, twisting and groping in the air; the rhythmic orchestration of crowds; the expressive illumination of sharp brilliance or velvety shade; the *painterly* use of line—would all become so habitual a part of Rubens's own artistic vocabulary that it's difficult not to imagine Stimmer (and perhaps Holbein, too) as a moment of awakening. The exhilarating freedom with which the Swiss could conjure the folds of a robe, the mane of a lion, the maw of a whale, the feather of an angel's wing, furrowing the lines through the yield-

ing block as the pearwood shavings curled before his gouge—to do so much with so little—was this not precisely what might have registered most powerfully on a gifted little boy with a whittling knife and his own confident brush and pen?

So was there something, dashingly sketched, that convinced his mother that Peter Paul might be better suited to art than to courtly artifice? For after no more than perhaps six months, she removed him from the Countess's company at Oudenaarde and apprenticed him, probably in late 1591, to the Antwerp master Tobias Verhaecht, known mostly for his mannerist landscapes with figures. Verhaecht was by no means a preeminent figure in the Guild of St. Luke. But for Maria, still perhaps unsure of what best to do for her younger son, the mediocrity of Verhaecht's talent and fame may well have been less important than the fact that he was family: married to a granddaughter of Jan Rubens's stepfather, the spice trader Lantmetere. He had been to Italy (Jan would have approved), possibly in the company of Pieter Bruegel himself; had painted in Florence, where the productions of the Flemings, the *fiamminghi*, especially their rustic scenes, were always well received. Now he took pupils, and that, for the time being, was enough.

Perhaps Verhaecht, with his cosmopolitan pretensions and kinship connections, could reassure Maria, somewhat, that by taking Peter Paul, a son of the patriciate, presumed destined for the law or the Church, and making him a painter, Peter Paul would not be losing rank. She might not have been easily persuaded. Most Flemish painters (though by no means all) were themselves the children of artists or had even more modest ori-

LEFT: *Tobias Stimmer,* Cain and Abel. *Woodcut from* Neue künstlicher Figuren biblischer Historien *(Basel, 1576). New York, Columbia University, Avery Library*

RIGHT: *Tobias Stimmer,* Sacrifice of Isaac. *Woodcut from* Neue künstlicher Figuren biblischer Historien *(Basel, 1576). New York, Columbia University, Avery Library*

gins. The character of a trade still hung over the Guild of St. Luke, with its indifferently mixed company of gold- and silversmiths, glaziers, and painters. The very etymology of the word *schilder,* with its allusion to the "shield-painting" of medieval chivalry, advertised the modesty of the craft. Some of the most renowned of the older generation were famous for reasons other than artistic skill. The greatest of them all, Frans Floris, whose sacred histories had hung in Antwerp Cathedral, was also a notorious and incorrigible drunk who, according to Karel van Mander, liked to boast of drinking rivals under the table and who once claimed to have stayed on his feet after having double-toasted all thirty members of the Antwerp clothiers' guild, with whom he shared a table. "Even when he came home half or wholly drunk," writes van Mander with unconcealed admiration, "he would pick up his brushes and produce a great amount of work."[8] Jerome Wierix, one of the most prolific illustrators of sacred lives and scriptures, had an even more deplorable history. During one debauch in 1578, unusually abandoned even for Wierix, he had launched a pewter ale pot at a tavern hostess's head, killing her. It had been a year before his friends were able to extricate Wierix from prison, on condition that he make penitential reparation, in remorseful sentiment and hard cash, to the victim's family.

This was not the kind of company Maria Rubens had in mind for her younger son. But her circle of family and friends knew enough of an entirely different kind of artist for her to be confident that Peter Paul could aspire to become the epitome of refinement: the learned painter, or *pictor doctus.* The timing, moreover, was opportune. An entire generation of older artists had passed on. The great Pieter Bruegel had died in 1569; Frans Floris, a year later. Michiel Cocxie, who in his nineties had no business being on a scaffold in the new Town Hall, had been killed after falling from the planks. The tumults of war and religious persecution had taken a further toll. Hans Bol, the landscapist, had left Antwerp, as Karel van Mander related, "because of the disturbances caused by the malevolence of art-hating Mars," and with him to Holland went his gifted student Jacob Savery and his brother Roelant, both Anabaptists. Lucas de Heere had travelled to England to serve as propagandist for Elizabeth I's resistance to the Spanish-Catholic crusade.

Just at the moment when the Church had the greatest need to make good the damage done in the two iconoclasms of 1566 and 1581, Flanders and Brabant seemed to have been afflicted with a dearth of creative talent. Moreover, the prescription for sacred painting laid down in the very last session of the Council of Trent in 1563 presupposed pious and subtle artists capable of observing its fine distinctions between admissible and inadmissible subjects, yet without any loss of devotional power. The general rule of thumb was that acts that had been historically visible (the Sermon on the Mount; the Baptism or Passion of Christ) were legitimate subjects, while the representation of the ineffable (the countenance of God the Father) was not. Miracles and apocryphal wonders were to be treated with the utmost caution. Yet this prudent winnowing of the fabulous from

the miraculous could not happen at the expense of the Counter-Reformation's defining mission: the retention of the allegiance of the faithful (and the redemption of skeptics and heretics) through dramatically charged images that would speak to their deepest emotions. What was called for, then, was painters who were theologically versed dramatists, part scholar, part poet.

In the 1590s such paragons seemed to be in perilously short supply, and those with even a modicum of the needed qualities took advantage of the situation. Marten de Vos, for example, who made a career out of cultural vacuum-filling, had been dean of the Guild of St. Luke during Alva's terror, a sudden convert to Protestantism during William of Orange's return in the late 1570s, a favorite painter of the Calvinist patriciate in the early 1580s, and then a penitent back in the fold of the Catholic Church when Farnese's ultimatum reduced the choices to obedience or exit. The reward for this shameless confessional pragmatism was fortune and honor. He could depend on commissions for history paintings, portraits, and book illustrations. And in 1594 de Vos landed the best job of all: the designs for the temporary architecture that would adorn the triumphal entry into Antwerp of the Spanish Netherlands' new ruler, the Archduke Ernst.

The prolific success of Marten de Vos would have suggested to Maria Rubens that her son might indeed have an illustrious career producing work for both Church and state. And evidently, de Vos's reputation had been built, at least partly, on the strength of his being thought an impressively Italianate painter, someone who had indeed travelled there, who was said to have studied with Tintoretto himself, and some of whose most ambitious histories, like *The Virgin and Child Welcoming the Cross*, did display something of the livid, almost oversaturated color, all intense reds and smoky blacks, and edgy, mercurial movement of the Venetian master. It was well beyond the capabilities of Tobias Verhaecht to impart the level of instruction that would give an apprentice painter the opportunity to work his way into the kind of milieu represented by de Vos. On the face of it, Adam van Noort, Rubens's second teacher, hardly represented much of an improvement in his prospects. Van Noort was, like de Vos, yet another ex-Lutheran-turned-Catholic-of-convenience, and for this very reason may have had a direct line to an entire class of people (not least the Rubenses) whose confessional identity had swayed this way and that over the years. The year before Maria and her boys came back to the city, van Noort had been married to the daughter of one of Antwerp's best-known Protestant families, the Nuyts. Yet the wedding, in response to Farnese's ultimatum, was solemnized in Antwerp Cathedral according to the strictest Catholic rites, and to all intents and purposes, Adam van Noort was henceforth among the sturdiest pillars of the Counter-Reformation, rewarded, like de Vos, with a part in preparing the triumphal entry of 1594.

None of this, though, seems to have been an adequate substitute for inspired instruction, which was as conspicuously missing from van Noort's studio as it had been from Verhaecht's. Now fourteen or fifteen years old,

Rubens may already have sensed, through seeing reproductive prints of the greatest Italian masters, the clumsiness of his Flemish teachers' approximation of their manner. If he himself searched for a third master under whom to complete his articles of apprenticeship, the choice needed to be a figure whose credentials at translating the grave principles of Italian classicism were more credible than those of either Verhaecht or van Noort.

Such a person arrived in Antwerp toward the end of 1592, precisely the moment when Maria and her son were looking for a new teacher. Otto van Veen had been court artist to no less an eminence than Alessandro Farnese himself, painting the Governor's portrait and being rewarded with the vaguely defined post of *ingénieur-en-chef* in addition to his other official posts. He was a bird of a quite different feather from Verhaecht, van Noort, or for that matter Marten de Vos. His pedigree was patrician, his education classical, his manner cultivated, and his ambitions international. It may have been a friendly exaggeration for the humanist and geographer Abraham Ortelius (who himself had written a treatise on art) to write in van Veen's *album amicorum* that like Pamphilus, who was praised by Pliny as equally gifted in painting and literature, Otto was "the first in our world who has joined liberal letters with the arts," but in the late-sixteenth-century Netherlands there's no doubt that he was a cultural exotic, just the type that the Rubenses had been searching for, the very epitome of the *pictor doctus,* the scholar-artist.

The pedigree began with Otto's forebears. His father, Cornelis, like Jan Rubens a learned lawyer and magistrate, claimed descent from a bastard line of the Dukes of Brabant, even though at some point the family seemed to have settled in watery Zeeland. Cornelis van Veen had grown up in Leiden, where by 1565, with the great religious contention building like a storm out at sea, he had become burgomaster, his wealth and status proclaimed by the handsome house on the St. Pieterskerkhof into which he moved his family. Unlike so many of his contemporaries, though, Cornelis stayed uncompromisingly, recklessly, loyal to his Church and King (even when at least one of his ten children, Simon, resolved to turn Calvinist). With Alva's armies laying siege to Leiden and its citizens understandably in the grip of a violent reaction against the Roman Church and the Spanish King, Cornelis van Veen found it impossible to stay. In October of that year, he left Leiden, in some haste, one suspects, and made his way to Antwerp. It's possible, though, that the draconian Catholic reaction then in force there may have been just as unwelcome as its opposite, for by February 1573 he requested a passport, ostensibly to travel to Aachen, but in fact took his family to Liège, under the jurisdiction of the Prince-Bishop Gerard de Groesbeeck. It was here that Otto, now twelve years old, received most of his education, becoming a protégé of the poet-painter Dominicus Lampsonius.

To have been educated by Lampsonius was important. As a painter, Lampsonius was insignificant; as a writer, a biographer of northern artists, and tireless promoter of the independent dignity of northern art, he was incalculably influential.[9] He had himself studied in Rome with Fed-

erico Zuccaro, and after he returned to northern Europe corresponded with the elderly Titian. But it was Giorgio Vasari, the Florentine author of the *Lives of the Artists,* who, by omitting any mention of northern artists from his 1550 edition and in 1568 referring to them slightingly as "diverse Flemish *artifici* [imitators]," provoked Lampsonius into discovering his life's propaganda mission: the counterassertion of the value and virtue of Netherlandish art. Vasari's slight echoed the remark attributed to Michelangelo by Francesco da Holanda that Flemish painting was concerned primarily with "external exactness. . . . [T]hey paint stuffs and masonry, the green grass of the fields, the shadow of trees and rivers and bridges which they call landscapes . . . and all this, though it pleases some persons, is done without reason or art, without symmetry or proportion, without skilful choice or boldness, and finally, without substance or vision."[10] Turning defense into offense, Lampsonius's own biographies of northern painters, the *Effigies,* rejected the arrogant assumption that only history paintings truly counted; that landscapes were so much yeoman infill. Such rigid categories, he argued, might be all very well for Italians, steeped in the classical tradition, Lampsonius responded, but it had led to scholarly aridity, a loss of naturalness, which the Netherlanders, with their greater devotion to capturing the freshness of living forms, were better placed to supply. The very genres that Vasari and Michelangelo had written off as trivial—landscape and portraiture—genres that the Italians claimed called for the skills not of true *pittori* but of mere *artifici,* were those that Lampsonius insisted the Netherlanders had most reason to boast of. The artists he praised most fulsomely—Herri met de Bles, Joachim Patenir, Gillis van Coninxloo—precisely epitomized those skills.

Otto van Veen, Self-portrait, *1584. Drawing from* Album Amicorum. *Brussels, Royal Library*

In the same spirit, Lampsonius tried to ally this independently valid Netherlandish tradition with Venetian painting's passion for *colore,* for the active role played by color in the modelling of forms. In Titian's revolutionary hand, this amounted to a direct contradiction of the Florentine and Roman assertion that *disegno,* drawing, represented the direct transcription of the shaping idea behind any true work of art, its *dio-segno,* godly sign.

It would have been impossible, then, for Otto van Veen to have spent any time in Lampsonius's presence without being affected by this nagging sense of comparison and competition between north and south. Whether ultimately he would want to be placed in the camp of those who sought to refine northern art, to make it more Italianate, or would rather follow his teacher in affirming the distinctive qualities of Netherlandish painting, was as yet undecided. Either way, only by going to Italy could he discover what

he was up against. In 1575 van Veen travelled to Rome armed with an introduction from the Prince-Bishop of Liège to Cardinal Cristoforo Madruzzo that ensured his entry into the highest circles of the Roman humanist aristocracy. After five years of marinating in the wisdoms of the ancients and the sublimities of Michelangelo and Raphael, Otto van Veen resurfaced, thoroughly made over as "Vaenius" the genius: a virtuoso of the arts and letters, fluent in many different tongues, the essence of civility and refinement, yet still not detached from his northern roots. "Vaenius" now got the desirable jobs. From Rome he went to Prague, where he worked for a while in the self-consciously philosophical court of the Emperor Rudolf II, and thence to the court of Archduke Ernst of Bavaria at Munich, and since that Prince was also Elector of Cologne, it was conceivable that van Veen was there during the early years of Rubens's childhood.

Toward the end of 1583 or early in 1584, Otto van Veen returned to his native city of Leiden. Although the town was now unequivocally Calvinist, his father and mother had decided, possibly as early as 1576, to go back and spend their declining days in the grand house on the St. Pieterskerkhof, which their Protestant children had managed to keep out of the hands of the confiscators. But like so many other families, the van Veens had been divided by belief and scattered throughout the war-fractured territories of the Netherlands. Simon the Calvinist lived in The Hague; Gijsbert, the engraver brother (shown in Otto's painting of the van Veen family holding a drawing block), had remained Catholic and a citizen of Antwerp. Of the sisters, Agatha and Maria had moved north, married, and settled in Haarlem, but Aldegonda had stayed in Catholic Brabant. It would be good to imagine all of them them gathering in the family home in Leiden for Otto's family portrait, although it's entirely possible that he assembled the painting from individual sketches.

The picture is the most direct expression imaginable of van Veen's double identity: Italianate gloss and Netherlandish solidity. At its center, dressed in showy, silky clothes—a glaring contrast to the austerity of his Calvinist brother, Simon—is Otto himself. He is every inch the cosmopolitan gentleman artist, sandy hair trimly barbered, the beard close-cut à la *marquisetto;* his doublet dashingly pinked; the palette gripped by a refined, elegant hand. Like the squirrel that stares assertively from the gold-stamped leather hangings that adorn the room of the family reunion, Otto is becoming an agile climber: sleek, sharp-eyed, and acquisitive. Yet the painting, with its ungainly crowding of the generations, its sacrifice of plausible pictorial depth for family inclusiveness, could not have been executed anywhere other than the Netherlands. It's very much the work of a traveller come home.

He would not stay at home, though. In Leiden he filled his *album amicorum*—ostensibly a book of friends' personal greetings and mottoes, but often shown off as a kind of portfolio of recommendations—with the signatures of all the greatest and the best, Catholic and Protestant, among the humanist intelligentsia, philosophers, theologians, geographers. The time had come to put this impeccable curriculum vitae to work. Otto went back

Otto van Veen, Self-portrait of the Artist with His Family, *1584. Canvas, 176 × 250 cm. Paris, Musée du Louvre*

south, where he promptly became Farnese's court painter in Brussels and painted his first important altarpiece, *The Mystic Marriage of St. Catherine*, in a style directly borrowed from Bologna and in particular from Correggio. In 1593, resettled in Antwerp, he was registered as a master of the Guild of St. Luke, and important commissions promptly came his way: *The Martyrdom of St. Andrew* for the church bearing the saint's name, another for the Chapel of the Holy Sacrament, all executed with the cool gravity and slightly leaden deliberateness that was supposed to suggest the Bolognese and high Roman manner. In 1597 Antwerp's city council commissioned van Veen to prepare drawings for a tapestry that would commemorate the victories of the Habsburg Archduke Albert, shortly to succeed Ernst as co-regent of the Netherlands. His studio was busy with apprentices; his commission book was full; his marriage to Maria Loots had allied him with one of the notable families of the city.

In the mid-1590s it would have been hard, then, to imagine a more illustrious model for the young Peter Paul Rubens to follow than Otto van Veen: the very epitome of the *pictor doctus*, pious and poetizing, painterly and philosophical. Just as Lampsonius would have instructed Otto van Veen to study the Italian masters without slavishly emulating them, Rubens would have been encouraged to follow a similar course. His dutiful obedience to these precepts makes the task of glimpsing authentically Rubensian traits emerging from the pod of his Flamingo-Italianate apprenticeship frustrating, since as an apprentice he would have been conditioned to expect praise to the extent that he suppressed, rather than expressed, his own painterly personality.[11] Almost all of Rubens's paintings that can be dated from the late 1590s are, therefore, necessarily thirdhand productions, filtered either through van Veen's awkward efforts at synthesizing a

Rubens, The Fall of Man,
before 1600. Panel,
180.3 × 158.8 cm.
Antwerp, Rubenshuis

Roman and a Flemish manner or else through reproductive prints based on
Italian designs. Prints by Marcantonio Raimondi or by the Fleming Cor-
nelis Cort after Raphael or Michelangelo circulated widely in the Nether-
lands, and there was no shame in using them to work up paintings based
on the Italian originals, especially when the original was a drawing. Lamp-
sonius, in fact, had singled out Netherlandish engravers like Cort for spe-
cial praise as something other than merely dumb copiers of originals, seeing
them rather as authentic reinterpreters.[12] In the same fashion, Rubens
might have been expected to bring to his painted versions of recognizable
engravings something of his own northern sensibility. This was what the
discipline of "emulation"—*emulatio*—urged on all novice painters im-

plied: the copying of masters with a modest dash of personal manner added.

Rubens the emulator was most apparent in his version of *The Fall of Man*, based on Marcantonio Raimondi's engraving of a design by Raphael. Rubens closely follows Raphael's poses. Almost as if he had been reading Lampsonius, though, Rubens adds ingredients drawn from precisely the genres in which, it was commonly said, Netherlanders excelled: landscape and portraiture. In place of the summarily sketched and highly stylized Eden, Rubens has set down a true paradise garden, complete with that ubiquitous emblem of fecundity, the rabbit, and a lush collection of plant and bird life that came straight out of the Flemish passion for natural history. The depiction of an active nature, *natura naturans,* after all, had been said by Leonardo, among others, to demonstrate the almost godlike powers of the artist.

Likewise, even though he probably knew Dürer's prescription for the ideally proportioned Adam (the Apollo Belvedere) and Eve (a classical Venus), Rubens's two imminent sinners are a good deal less coldly sculptural and more amply carnal.

Rubens, Portrait of a Man, *1597. Copper, 21.6 × 14.6 cm. New York, Metropolitan Museum of Art*

Eve's profile, which in Marcantonio Raimondi's engraving seems to have been taken directly from a classical relief, is plumped and softened, the lips made temptingly apple-red, as if reflected from the fruit held close to her mouth, in sharp contrast to the alabaster coolness of her skin. Wound round the Tree of the Knowledge of Good and Evil, she seems caught in the serpentine coils of her impending fall. Adam's head is altered even more decisively: the full, virile beard and ruddy complexion turns Raphael's statue into a creature of flesh and blood; the palm of his gesturing hand no longer cups the fruit but is tracked instead with the lines of age and desire as it points ominously toward the serpent. Where is the mark of Rubens here? In the flushed tint he has applied to the inside of Adam's ear, and to his eyelids and lower lip; in the added swell of his belly, the beefiness of his hands and torso—the replacement of a decorative type with a convincing, fleshly portrait.

In 1598 Rubens's name was registered as an independent master in the Guild of St. Luke in Antwerp, allowing him, at the age of twenty-one, to enroll pupils. A silversmith's son bearing the glamorously Italianate name of Deodate del Monte and only five years younger than his new teacher became Rubens's first disciple. But though an officially acknowledged master, Peter Paul was not yet, in any persuasive sense, his own man, and probably continued to collaborate with Otto van Veen for another two years. He was full of gifts, promises, and expectations, not unlike the unknown

man whose face he had glossily painted on a copper plate in 1597, engraving his own name on the back. The portrait is executed with jewel-like brilliance, almost in the manner of a miniaturist, with telling details like the swept-up whiskers at the end of his mustache and the faint highlight on the bridge and tip of the nose rendered with fastidious pleasure. An inscription at the top of the little painting tells us that he is twenty-six years old, just five years the senior of the artist. Usually he is described as a "geographer," based on the assumption that the set square he is holding in his right hand is a tool of his trade, and this is certainly a possibility. But in his left hand the young man holds a closed watchcase, an allusion to the shortness of our days. This was a generation that loved emblems. So perhaps the pairing of the two instruments was meant to suggest the right-angled course to be set during one's allotted span of days. That would have been something the artist, as well as the sitter, would have taken to heart as he painted on the foxy face an expression uneasily caught between self-possession and wariness.

<div style="text-align:center">

ii *In Giulio's Shadow?*

</div>

It's never a good sign when processions are what a state does best. A quarter century of religious war had made the cities of Flanders, Brabant, and Hainaut scarred and sickly. Much of their populous prosperity was gone and would never again recover the splendor of 1550. But when, in 1599, the Archdukes Albert and Isabella (for so they were *both* to be titled) were installed as co-regents of the Netherlands, Brussels and Antwerp spared nothing for their triumphal entry. Pomp was stored in the civic memory. It needed only a ceremonious occasion for the guilds to draw their gaudiest costumes from the chests, for the silver trumpets to be polished. And for gilders, embroiderers, and carpenters, not to mention the artists (most notably Otto van Veen) commissioned to create ephemeral architecture for the *pompa introitus,* the occasion was a godsend. In Antwerp, arches, porticoes, stages, pavilions, and canopies went up to greet the archducal pair. Dolphins, giants, deities, and dragons celebrated the herculean prowess of Albert, his devotion to the Church, his invincibility on the battlefield. Virgins and water nymphs sang the praises of his bride.

Not all of the public enthusiasm was officially contrived. The Archdukes made a great show of coming to the Netherlands not as conquerors but as sovereigns, a show in which Philip II, his death drawing close, carefully connived. More than twenty years of bitter, inconclusive warfare had failed to bring the rebel Protestant provinces of the north to heel. It was now his duty to ensure that the "obedient" provinces of the south remained just that. In Albert, Philip had discovered a Habsburg prince who seemed

to embody the elusive combination of piety and martial competence. While still virtually an adolescent, he had been both cardinal and archbishop. In his young manhood (schooled by the grim Alva), he had proved to be a dependable field commander, with a pair of successful sieges to his credit. What more could the King ask for? In 1598 Albert was appointed Governor-General of the Netherlands and then promptly married to Philip's favorite daughter, Isabella Clara Eugenia. As part of the marriage contract, Philip then ceded sovereignty over the Netherlands to the couple. Ostensibly this gave the Archdukes greater autonomy than any rulers of the Netherlands since the beginning of the troubles. They could publish their own laws, mint their own coinage, appoint and receive ambassadors as if they were truly a sovereign state. Albert even promised to reconvene the long-redundant States General. Losing no time, he began to make diplomatic overtures to the provinces of the Union of Utrecht, offering to recognize Maurice (the son of William and Anna and a formidable military leader in his own right) as Stadholder of five northern provinces, and the de facto separation of a Protestant north from a Catholic south, in return for a formal acknowledgement of Habsburg suzerainty. But behind this elaborate show of devolution (as the Dutch well knew), Spanish power in the southern Netherlands was still formidably vested in pikes and powder. Before his death, Philip II specified that should Albert and Isabella fail to produce an heir, the Spanish crown reserved the right to reannex the Netherlands. Their enforcing ability was supplied by garrisons of Spanish troops whose commanders swore fealty not to Brussels but to the throne in Madrid.

The show of graciousness put on by Albert and Isabella, however, was seductive, the elated sense of a new beginning in Antwerp quite genuine. And for the first time in a generation, the festivities were sufficiently grand to attract visitors from all over Europe, as they had done in days long since past. Among those visitors in the late summer of 1599 was the Archduke Albert's cousin Vincenzo I Gonzaga, the Duke of Mantua, whose appearance in Flanders was, at least partly, dictated by his need to take the healing waters at Spa.

Vincenzo had much to heal. In 1582, while still the heir to the duchy, he had stabbed to death a young Scottish scholar, James Crichton, who had made the serious mistake of becoming Duke Guglielmo's court favorite. A few years later, Vincenzo became the object of one of the more peculiar judicial proceedings of the Renaissance when he was called on to demonstrate the competence of his manhood on a selected virgin before a papally authorized committee empowered to adjudicate the claim of his aggrieved ex-in-laws that the failure of marital consummation had been the groom's fault, not the bride's, as Vincenzo had alleged. With homicide and sexual farce clinging stickily to his name, Vincenzo was eager, on acceding to the dukedom, to repair the damage by cutting the grandest possible figure. A ceremony of Byzantine extravagance (for Vincenzo believed himself descended from the Paleologi emperors of Constantinople) marked the suc-

cession. Enthroned in Mantua Cathedral, Vincenzo was arrayed as if he were a full-blooded monarch, gowned in satin and ermine, bearing an ivory scepter, and capped with a custom-made crown, the setting for a ruby the size of a goose egg. Lest anyone imagine him a mere wastrel, Vincenzo also entertained fantasies of himself as the last of the great Crusaders, beating back the Turks from the gates of Christendom. His last will reflected these delusions, instructing the mourners to preserve his body seated on a throne, dressed in armor, his right hand resting on the hilt of a great sword. (Rigor mortis and common sense prevented his heirs from following these directions.) In 1595, at considerable expense, Vincenzo mobilized a toy army to fight alongside imperial troops in Hungary. The soldiers wore black uniforms emblazoned with Vincenzo's personal device, the crescent moon, and the motto S.I.C.—*Sic illustrior crescam:* "Thus do I grow ever brighter." Vincenzo's brightness shone dimly as he spent much of the time issuing commands from the interior of his velvet-lined carriage, and behind him trailed the usual retinue of cooks, mistresses, and a band of five musicians, including the new court composer, Claudio Monteverdi, which was required to play, at the appropriate moments, music that was, as occasion demanded, either martial or mistressy. Though he later complained bitterly of a mysterious skin disease contracted during the course of the expedition, Vincenzo led another, equally halfhearted campaign in Bohemia two years later. Its equally indecisive outcome led the Duke to ponder whether more decisive and expeditious weapons might not be deployed against the Muslims: typhus-infected lice, for example, or some kind of poison gas that the Mantuan alchemists might concoct.

By the time he arrived in Flanders, in the summer of 1599, Duke Vincenzo was no longer a joke, though he was still a memorable spectacle, behaving as if he were among the very greatest, rather than one of the most redundant, princes in Europe. The year before, he had dragged two thousand followers to Ferrara to congratulate the new pope, Clement VIII, on his acquisition of that coveted territory, and brought the same-sized retinue to the double wedding in Madrid of both Albert and Isabella and Philip III and his cousin Margaret of Austria. In Brabant and Flanders he made a princely progress through Liège, Antwerp, and Brussels, bathed his much abused and heavily diseased body at Spa, in what he hoped were the restorative waters, drank flagons more, and sent thousands of bottles of the mineral water home for future treatment.

It is also likely that while he was in the Spanish Netherlands, Vincenzo was shopping for painters. He had long wanted to restore Mantua's reputation as the most ambitious patron of art and architecture in northern Italy to the status it had enjoyed under his grandfather Federigo, when Giulio Romano had been the Duke's close adviser. Not a day could go by in Mantua without Mantegna's *Triumph of Caesar* and Giulio's astounding creation of the Palazzo del Te, a mistresses' retreat masquerading as a palace, reminding Vincenzo of the glories that, in his view, had been so humiliatingly sacrificed to Guglielmo's misguided parsimony. Not that anything

comparably splendid was to be expected from the Flemings, the *fiamminghi*. But Vincenzo thought of himself as an honorary Habsburg, and it was impossible to spend any time in Madrid or Vienna or Prague without being made aware of how highly the emperors valued the Netherlanders. The dense and swarming panels of Hieronymus Bosch had penetrated into the very bedroom of Philip II; Pieter Bruegel and Anthonis Mor were in fashion in Madrid and Vienna; and in Prague, Vincenzo would have encountered Emperor Rudolf II's favored Flemish mannerist, Bartholomeus Spranger.

Perhaps, confronted with striking evidence in the churches and patrician houses of Antwerp, Liège, and Brussels of a surge in Flemish creativity, Vincenzo, or his advisers, believed it would be timely to add *fiamminghi* to his stable of artists, where they might complement poets like Torquato Tasso, whom the Duke had extricated from the madhouse, and musicians like Guarini and Monteverdi. In the first instance, he needed someone capable of recording the splendor of his immediate family with the grandiloquence of a Titian or a Tintoretto, especially since his last daughter, Eleanora, had just been born. Frans Pourbus, an accomplished and delicate portrait painter, had already been presented to the Duke during his journey to Flanders, and would be summoned to appear in Mantua the following August. It seems entirely plausible, then (though undocumented), that Rubens might also have been either mentioned or even introduced to the Duke as an equally promising talent, someone who could fulfill his wish to have a gallery full of "portraits of beautiful women." (Vincenzo's taste, even in matters of art, was nothing if not predictable.)[13]

Whether or not Rubens had already been hired as the Duke of Mantua's glamorist, or whether, as the author of the Latin *Vita* states, he was independently "possessed with a violent desire to see Italy," eight months later, on May 8, 1600, the burgomasters and council of Antwerp provided him with an official clean bill of health, attesting that "by the benevolent Providence of God, this city and its suburbs breathe a clear and healthy air," free of plague or other contagious sicknesses. "Peter Rubbens," who had signalled his intention to go to Italy, ought therefore to be allowed to come and go freely with no suspicion of pestilence. Nor any other kind of suspicion, either. Thirty years after his father had fled Antwerp (to say nothing of other embarrassments), the councillors could now safely refer to him as "a former magistrate of this city" and assume that this reflected creditably, rather than the reverse, on the son. Armed with this certificate and probably a small selection of invaluable guides—Schottus's *Itineraria Italia*, which had just been published, and perhaps the *Delitiae Italiae*, which supplied indispensable tips on how to avoid being fleeced by the taverns or infected by the whores—Peter Paul was ready for the journey that would shape his whole life.[14]

Mantua in high summer is imposing rather than delectable: sultry, grandiose, and a little forbidding, dripping and sweating amidst its dark lakes and marshes formed by the muddy river Mincio. A fine place for a

courtier, it was bliss for the mosquitoes, which bred prolifically in the swamps and ponds and which, at dusk, flew in dense squadrons into the populous city to gorge democratically on patrician and pleb alike. Mantua's fevers became almost as legendary as its art and its horses. Benvenuto Cellini, the great loudmouthed goldsmith, was felled by an attack almost as soon as he arrived in town, and angrily laid his curse on "Mantua, its Lord and anyone who felt like staying there."[15] The turbid, vaporous air that hung over the city seemed to veil it with a kind of exotic peculiarity missing from sharper, drier, more reasonable places like Verona and Padua. There were Jewish physicians who could abbreviate the sweating sicknesses with potions of unknown formulae, and who were said to labor on behalf of the Duke's obsession with finding the philosopher's stone. And there were the great stables of Mantua mares and stallions, by common consent the purest-bred and fleetest in all of Italy, marvels of elegant brawn. Many who came to the city-state of the Gonzaga professing to pay homage to the masterpieces of Mantegna and Giulio Romano were there to admire the bays and sorrels, brushed brilliant and glossy, saddled and bridled with spectacularly worked pieces. Only in Mantua, indeed, was it possible to admire *both* art *and* horses in the formal halls where Duke Federigo had commissioned Giulio to paint his favorite beasts pawing the ground amidst assemblies of the gods.

Rubens, who was fond of riding, would undoubtedly have warmed to the Sala dei Cavalli. But he must have been still more impressed by the fortunes of its creator, Giulio Romano. Hired by the codifier of the courtly life, Baldassare Castiglione, then Federigo Gonzaga's ambassador in Rome, Giulio had swiftly become much more than a favored painter, rather the Duke's indispensable man, architect, and cultural impresario, officially known as "Superior of the Streets" and "Superior-General, within and without the city of Mantua." He designed and constructed palaces yet unbuilt; redecorated those that were; disbursed moneys; judged commissions; made himself responsible for everything from the stables to the silverware. In the Ducal Palace he had decorated rooms testifying not merely to the Duke's splendor but to his connections with the Caesars of old, since the most splendid of them was designed to show off the phenomenal Gonzaga collection of classical marbles. Giulio's Palazzo del Te, built beyond the city walls, was inventively conceived not merely as another aristocratic suburban villa but as a theater of recreation. Some of its rooms, certainly, were discreet enough to accommodate the Duke's sexual entertainment; others, where Giulio was encouraged to let his fancy run free, were designed as eye-popping spectacle. In the Sala di Psiche, Cupid and Psyche (much tormented by Venus) were united amidst riots of satyrs and sprites, the whole room swimming in erotic languor. Pleasure was replaced by anxiety and terror in the Sala dei Giganti, celebrating Jupiter's triumph over the Titans. The entire room—walls, ceiling, and doors—was covered with the inescapable, tumbling bodies of giants, thrown this way and that, like a downfall of boulders, the mass of the figures so bulky that the force of their

descent seemed (with the help of the artist's ingenious optical distortions) to make the room itself tremble and shift. No wonder Giulio was so handsomely honored by his patron: he was allowed to construct a house, the Casa Pippi, on a scale undreamt of even in Renaissance Italy, a building so grand and so elaborate that it astonished even Giorgio Vasari. Almost a lord himself, Giulio became the intimate of the Duke, "*nostro maestro carissimo.*"

The example of Giulio Romano's success must have impressed itself on the young Rubens, for when he in his turn came to build an urban villa, it would be unlike anything a Flemish painter had ever aspired to, and some of its motifs (a statue of Mercury, the presiding deity of artists, for example) were directly transferred from Giulio's Mantuan palazzo. But in 1600 could Rubens have presumed to such glory, especially in a Mantua governed by Duke Vincenzo, who rivalled his grandfather Federigo in the prodigality of his spending rather than in the elevation of his taste? The only judgement that the Duke is known to have allowed himself about his *pittore fiammingo* was that "he is not bad at painting portraits."[16] And since the documents are frustratingly silent on Rubens's work during his first year at Mantua, there is no reason to suppose that he was yet thought of as much more than an artistic drudge, doomed to turn out formulaically pleasing portraits of the ducal family in attitudes of pleasure or piety. It's possible (though by no means certain) that he was among Vincenzo's retinue at the proxy marriage of the Duke's sister-in-law, Maria de' Medici, to King Henri IV of France in the Duomo in Florence in October 1600. But even if he was present (as he indicated ostentatiously two decades later by including himself in a painting of the ceremony, conspicuously holding a processional cross), Rubens would merely have been one of the many hundreds of courtiers with whom the Gonzaga liked to announce their presence in a rival state, and who were obliged to show the livery at the endless rounds of hunting, jousting, quintain, mock battles, theatricals, feasting, and masking that marked the pseudonuptials.

What, then, changed his prospects? In a word, Rome.

At Mantua, Rubens had already begun to make use of the Gonzaga collection of antique art: vases, reliefs, cameos, and busts, much of it on exhibition in Giulio's great gallery. This was the beginning of an enormous trove of images and motifs stored up for later use in his own compositions.[17] But as rich as the Gonzaga holdings were, it was a truism for Rubens's generation that no self-respecting humanist could consider himself educated without direct experience of the remains of Roman antiquity. In the spring of 1601, Vincenzo was preparing to be off again on another (and final) campaign against the allied Turks and Hungarians in Croatia. Rubens decided that the moment was opportune to ask the Duke whether, during his absence, he might not profitably spend time in Rome making copies, principally of antiquities. The Duke's assent (albeit with the strict proviso that Rubens return to Mantua in time for the Easter carnival of 1602) suggests that by this time Rubens had done something to establish

Rubens after the antique,
Laocoön and His Sons,
*c. 1601. Black chalk
drawing, 47.5 × 45.7 cm.
Milan, Biblioteca
Ambrosiana*

himself as an artist with the potential to be taken seriously as a history painter. In any event, Vincenzo made sure in advance that Rubens would be received as befitted *"il mio pittore,"* and wrote to an eminence of the conclave, Cardinal Montalto, asking for his assistance. The Cardinal replied promptly and fulsomely, promising to be at the artist's disposal and asking in what ways he might possibly be of assistance.

By the end of June 1601, Rubens was in Rome and lost no time in seeking out the most affecting masterpieces of antiquity. There was no reason to be esoteric in his taste. In the Vatican he saw the tormented Laocoön, wrestling hopelessly amidst coils of writhing serpents, and sketched the figure from several angles, as if already aware that he might need to draw on different aspects of its drama for different subjects: the agonized face translated into a Passion; the twisted body used for a Flagellation. For some time, the papacy had been nervous about permitting access to pagan sculpture lest it somehow contaminate properly sacred iconography. But Rubens, in common with many of his contemporaries, had no qualms about adapting antique figures for Christian spectacle; it was as though his creative imagination had reconsecrated the ancient marble. For some years,

the private collections of the great Roman dynasts—the Borghese, Orsini, and Cesi—had been open for learned examination and copying, and Rubens threw himself into the activity, accumulating a hoard of models for later use. It's easy to imagine him in the gardens of Cardinal Cesi, the scent of thyme perfuming the summer afternoon, sketching the Crouching Venus, perhaps already imagining her transformation into the suddenly exposed Susanna. Copying antique marbles was an exercise at once seductive and studious. It had long been recommended as the proper way to grasp the celestial ideas that the ancients encapsulated, first in an ideal vision of the human body and then in stone. But Rubens's drawings are not fragments of sublimity. He seems to have seen the delicate modesty of the Venus Pudica, or the brutal muscularity of the Farnese Hercules, for example, as encapsulating the most essential of the human passions, the *affetti*. It became second nature for him, then, to use the upward-rolled eyes of the Laocoön for the face of Christ in his Antwerp *Elevation of the Cross*, the Farnese Hercules for the massive torso

of *St. Christopher* (also in Antwerp Cathedral), less as ideal forms than as vehicles of intense pathos. In his treatise on ancient statues (known to us only from the paraphrase of the eighteenth-century critic Roger de Piles), Rubens warned against mechanical transcription: "Above all," he wrote, "avoid the effect of stone."[18]

Rubens, Portrait of Philip Rubens, *c. 1610–11. Panel, 68.5 × 53.5 cm. Detroit Institute of Arts*

Stone made warm; immobility made vital; gravity infused with emotion: this was the authentic Rubensian temper, and it belonged not just to Peter Paul but to his brother Philip, who was himself in Italy by the end of 1601. Fraternity for these two was more than conventional sentiment. Instinctively strong, it was made more intense by their shared, secret knowledge of the family's black memory: the solemn, burdened father; the devout, patient mother. For all their carefully acquired gentility and cultivation, the two brothers had no inhibitions about expressing their strength of feeling. "I am not afraid to say, my brother," Philip wrote to Peter Paul, "that those who still believe that they can keep the human temper completely free from emotions are merely prattling in the manner of lunatics and fools and show their hardness and cruelty. Away with that apathy which turns men not into human beings, but rather into iron, into stone, a stone harder than the Niobic stone of mythology which overflowed with tears."[19] And what was the greatest object of their warmth? Each other. "More than anything," Philip wrote again in July 1602, "love in me *fraternity*."[20] Even when this brotherly love came garlanded with nosegays of

poetic self-indulgence, it was unmistakably passionate. While Peter Paul
had been working with Otto van Veen, he had been physically separated
from Philip, first when the older brother was Richardot's secretary in Brus-
sels, later when he had gone to Louvain University to study with Justus Lip-
sius. In May 1601 Peter Paul was in Mantua preparing to travel to Rome.
Philip wrote in a burningly ardent style which to modern ears would seem
more appropriate for a love letter to a mistress:

> Now that great distance separates us, my desire to be with you has
> grown. I know not what wretched stream of thought inclines us
> toward things we cannot have and makes us want them even more
> than things which are permitted. Today, in a burst of affection,
> my heart leapt to you across barriers of countries and, soaring
> high above the peaks, went to visit my loved one, but with a fresh
> tenderness.[21]

Toward the end of that year, 1601, the painful distance separating the
two brothers suddenly melted away when Philip managed, at long last, to
realize his own ambition of seeing Italy. For four years he had been the stu-
dent of Lipsius in Louvain, and not just a face in a schoolroom, either, but
the sage's favorite and prodigy, living in his house with a few other chosen
talents who together constituted a *contubernium*, a scholarly family. Help-
ing the old man prepare editions of Seneca and Tacitus must have engen-
dered the conviction that one day Philip and his friends should go in person
to Rome to soak up the lessons of the Stoics in the place where each fallen
stone and broken column vindicated their sober pessimism. Even the many
perils of the journey, Lipsius believed, were a sure way for a young man to
acquire the necessary qualities of prudence and self-sufficiency. Mindful of
the many allusions to the *Odyssey* planted in his head by Lipsius, Philip
wrote (in Latin verse) to the philosopher, as if reassuring a fretful father, "A
Song of Gratitude Offered upon Safely Landing," lines expressing his grat-
itude to his teacher for steering him safely through the treacherous seas and
directing him toward "the glory of ancient Italy."[22]

Philip was not travelling alone. Officially he was tutor and companion
for two younger Lipsian pupils, Jean-Baptiste Perez du Baron and Guil-
laume Richardot, the son of his old employer Jean Richardot. They spent
Christmas 1601 in a Venice so frigid that the canals were solid ice, and
doubtless took in all the *admiranda* required by the humanist itinerary.
Being serious disciples of Lipsius, though, meant that they were in Italy as
more than cultural tourists. Many of the places he had specifically recom-
mended, like Padua and Bologna, were famous for their learning, and all
three meant to crown their studies in Louvain with law degrees from an
Italian university. Philip himself settled on Bologna, where in 1603 he
became, like his father before him, a doctor of canon and civil laws.

It was not until the summer of 1602 that the brothers were finally
reunited, almost certainly in Verona, a short distance from Mantua, where

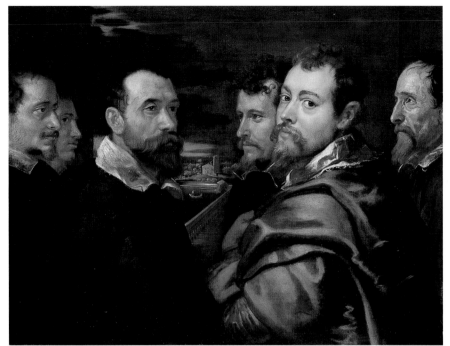

Rubens, The Mantuan Circle of Friends, *c. 1602. Canvas, 77.5 × 101 cm. Cologne, Wallraf-Richartz-Museum*

Philip had also met up with an old Antwerp friend and fellow student of Lipsius, Jan Wowerius. In 1606 Rubens painted a group portrait, set before the Ponte di San Giorgio and Mincian Lake, in which he appears with his brother, Wowerius, and two figures who are probably Philip's charges, Guillaume Richardot and Perez du Baron. It is the only self-portrait in which Rubens (in contrast to Rembrandt) chose to represent himself as a working painter, palette in hand. But the presiding spirit of the work is Lipsius himself, the absent scholarly mentor-father, who had died that year and for whom the picture is a memorial tribute.

The painting is conventionally known as *The Mantuan Circle of Friends,* and even though it gives the impression of a staged tableau rather than a spontaneous gathering of chums, it still testifies to Rubens's strong sense of the virtue of gregariousness. The brothers belonged to a generation that prized fraternity, fellowship, and friendship, and had trouble imagining the learned or the artistic life divorced from lively and articulate company. It doesn't do, then, to picture the northerners wandering desolately amidst weedy ruins or poring through manuscripts alone, by the light of a guttering candle. By the time he reached Rome, Rubens's Italian was graceful and fluent, and in the city he would have no difficulty at all in finding his way into the circles of young artists and students from Germany and the Netherlands working in the libraries and collections of the cardinals and the Vatican. Many of them, moreover, were not just tolerated but actively welcomed by the cardinals associated with the papacy of Clement VIII. During Rubens's first year at Mantua, Giordano Bruno had been burned at

the stake in Rome, and one of the Pope's closest advisers, Cardinal Cesare Baronius, Church historian, martyrologist, and hagiographer, made himself patron to a number of young northerners whom he believed to be enthusiasts in the reinvigorated crusade against heresy. Though not all of the Flemings and Germans were, in fact, equally ardent for the cause. Caspar Scioppius, the ex-Protestant prefect of the Vatican printing press, fervent with a convert's zeal, certainly lived up to the papacy's expectations, busily alerting the authorities to the presence of doubtfully lax compatriots, issuing militant diatribes against backsliders, and at one point attempting to convince Philip Rubens that he should become a subject of the King of Spain! The Pope's botanist and the curator of his garden of herbs and simples, Johannes Faber, on the other hand, was a much more broadminded and eclectic personality, whose own devotion to the Church did not preclude a friendship with Galileo. Faber was, among other things, a professor of botany at Jan Rubens's old college, La Sapienza; the owner of a natural history museum installed in his own house, close by the Pantheon; and the author of works on dragons, serpents (with special reference to venom), and the celebrity parrots of Rome, including a prodigy owned by a merchant who had tested its powers of mimicry to the maximum by teaching it to sing in Flemish.[23] Such men moved naturally amidst the Roman curia; kept company with prelates and cardinals; tended their libraries; offered expert counsel on antique gems and cameos; identified busts; and advised the Jesuits and Oratorians on artists who might produce work for their churches and chapels.

With his easy manner, lightly borne learning, and impeccable connections, Rubens walked right into the middle of this fashionable company. Dr. Faber recognized him not just as a painter but, like his brother, as a scholar, "an enlightened amateur of antique bronzes and marbles."[24] Though his Antwerp background might have been a liability in Florence, where Flemish painters could still be condescended to as crafty artisans, in Rome it was almost certainly an asset. His hometown's presses, especially the house of his childhood friend Balthasar Moretus, were already turning out albums of Roman antiquities and histories of the early Church that the cardinals hoped would resurrect its fervor. And Archduke Albert was seen in Rome as a paragon of enlightened piety.

It was Albert, in fact, who gave Rubens his first opportunity to prove himself as a serious painter of sacred histories. As the patron of the basilica of Santa Croce in Gerusalemme, he was responsible not just for a Roman parish church but for one of the city's seven places of pilgrimage, and one with legendary significance. The church of the "Holy Cross in Jerusalem" was said to have been built in A.D. 320 by the first Christian Emperor of Rome, Constantine, expressly to house the impressive haul of relics brought to the city by his mother, St. Helena, after her own pilgrimage to Jerusalem. The most resourceful of the early Christian scavengers, she was said to have retrieved from the site of the Crucifixion itself no less than three fragments of the Cross, one of the crucifying nails, a thorn (hard to

make out, one would imagine, amidst the Calvary rubble) from the Savior's crown, the original "INRI" inscription (Jesus of Nazareth, King of the Jews), and, surely her most impressive find, clods of Golgotha earth soaked with Christ's blood.

How better to recommend himself to the new pope, Clement VIII, than for Archduke Albert to give Santa Croce in Gerusalemme a decoration of sacred significance. And how painful to discover that the fragment of the True Cross assigned to his own custody was in fact being hawked about the streets of Rome! It didn't help matters to learn that unsettled goldsmiths' bills for work done in the church had brought further embarrassment to his name. This, for an erstwhile bishop and cardinal! Obviously, then, he leapt at the suggestion made by his ambassador in Rome that he restore his reputation by providing a new altarpiece and twin paintings for the side chapels, all alluding to the history of St. Helena and the relics. And since the ambassador just happened to be yet another Richardot—the son of Philip Rubens's old employer the privy councillor, and the brother of his present travelling companion, Guillaume—it's not surprising that the artist suggested for the commission was Peter Paul, the parties concerned agreeing that this was fraternity, not nepotism, in action.

The skills and sources that Rubens had been accumulating were now put to immediate practical use. It may be just because he so studiously assembled all the required sacred references and allusions (rather than intuitively conceiving a unified whole) that the finished work seems more like a program than a composition. The figure of Helena, while owing something to Raphael's *St. Cecilia*, was derived principally from an antique sculpture Rubens discovered among the ruins of the Sessorium which depicted a Roman matron who had conveniently acquired the legendary reputation of having been a convert, thus immediately winning devotees. Appropriately clad in a tactful combination of simply pious and aristocratically opulent dress, St. Helena stands before a triumphal arch holding the scepter of imperial power. Both the arch and the scepter were allusions to the victory of the new faith over the old pagan empire, a message with special significance at Santa Croce since the church stood on the ruins of the Emperor Septimius Severus's villa, the Sessorium. Philip Rubens's teacher, Justus Lipsius, had published a treatise, *De Cruce,* which promoted the cult of the Holy Cross as a sign of redemption, and Peter Paul's altarpiece spoke to the tradition that this particular church was a place where paganism had been redeemed by the acceptance of the new faith. The imperial mother Helena's right arm leans against an immense cross about which fly putti, variously holding both the imperial orb and objects that alluded to her Jerusalem dig: the crown of thorns and the sacred inscription. With his first serious show of understanding the critical relationship between an altarpiece and its architectural setting, Rubens cuts off the cross to imply its extension above the picture space to the ceiling of the church, where the cross was represented in mosaic, and to the point where Helena's upward-turned eyes are directed. Behind and to the left of the saint, the twisted "Solomonic"

Rubens, St. Helena Discovering the True Cross, *1602. Panel, 252 × 189 cm. Grasse, Chapel of the Municipal Hospital*

columns, embellished with winding vines, which legend imagined derived from the original columns of the Temple in Jerusalem (examples of which had survived in a screen at St. Peter's), tightened still further the connections between the old Holy City and the new.

Returned from annoying the Turks, did Duke Vincenzo perhaps hear of those great twisting columns and fancy himself as a new Solomon? Certainly he knew all about Rubens's work in Santa Croce in Gerusalemme, since Richardot had written to the Duke asking for an extension of Rubens's Roman residence so that he might finish the job. When, a few years later, Rubens painted the Duke and his entire family (including his late and unlamented father, Guglielmo, with whom, at least in pictorial piety, he was improbably reconciled) adoring the Trinity in the *capella maggiore* of the Jesuit church of Mantua, he placed the central group of the two Dukes and their wives on a balustraded terrace, flanked by theatrical Solomonic columns so tall that they appear to unite the earth with the heavens.

It was not a simple matter, of course, to create a celestial aura about the Gonzaga. Rubens borrowed the Venetian convention in which the Doge and his family were often portrayed as donors sharing pictorial space with patron saints or even the Virgin, and in particular used Titian's great Vendramin family portrait as a compositional model. But the Venetians were notoriously relaxed about doctrine, and the Council of Trent had laid down stringent principles governing celestial visions and the commingling of earthly and divine beings within a single picture space. Visions of the Trinity, it had decreed, could only be vouchsafed to the saints and apostles, among neither of which, it was safe to say, the Gonzaga or the Medici (or even Eleanora Habsburg, Vincenzo's genuinely pious mother) figured. But the church in question was the Santissima Trinità, and for the usual rea-

sons, Vincenzo very much wanted to be seen as the patron of his local Jesuits. It was left to Rubens, by 1604 clearly confirmed as a powerfully inventive history painter, to come up with an ingenious solution. Father, Son, and Holy Spirit are represented as if on a tapestry or rich cloth, so that the Gonzaga worship not the Trinity themselves but their likenesses, which appear miraculously vivid on the fabric. Rubens was borrowing from another native tradition: that of Flemish tapestry, unparalleled in northern, and perhaps in all of, Europe for its lustrous beauty. But the images of the Trinity in his Mantua painting do not, in fact, look at all "woven," or for that matter painted: they have the same corporal substance as the donors below, and, as was proper, rather more brilliance of feature. By this dazzling operation of his own *ingenium,* Rubens managed a discreet separation of the mortal and the sacred world and at the same time dissolved the invidious distinction between the *craft* of tapestry and the *art* of painting. This was precisely the difference which Michelangelo and Vasari had presumed would always separate out Flemish artisans from Italian artists, the workaday from the noble, and not for the last time Peter Paul Rubens triumphantly confounded that prejudice.

Rubens, The Trinity Adored by the Duke of Mantua and His Family, *c. 1604–06. Canvas, 190 × 250 cm. Mantua, Museo del Palazzo Ducale*

iii *Gift Horses*

By the time the brothers met in Verona in the summer of 1602, Peter Paul had been back in the Duke's service for three months. Perhaps he took the opportunity to let off steam about having to run around doing the bidding of the Gonzaga court, since Philip wrote him a sympathizing letter in which he expressed concern about Peter Paul's "good nature and the difficulty of refusing such a prince, a prince who makes constant demands on you. But be resolved to claim your complete freedom, something almost banished from the court at Mantua. You have the right to it."

Easier said than done. Philip's fighting words were straight from the neo-Stoics' playbook of noble constancy in the face of bullying and vicious princes. But the model philosopher for all students and followers of old Lipsius was Seneca, the tragedian who had bowed to the wishes of his very own vicious prince, Nero, to the point of committing suicide rather than inconvenience the Emperor with the prickles of his conscience. Grateful though he was for his brother's loyalty and concern, Peter Paul was not yet so successful or independent that he could risk a show of presumptuous assertiveness. And the work that occupied him in Mantua in 1602 was, in any case, not unworthy of his gifts: a series of grandiloquent and showy history paintings linked to the *Aeneid*, the epic masterpiece of Mantua's native genius, Virgil. These paintings fall a long way short of the perfect integration of heroic drama and sensuous fluency that would be the hallmark of Rubens's greatest histories. The multiple borrowings from Raphael, Titian, Veronese, Mantegna, and Giulio Romano (among others) show Rubens still stitching together the pieces of a personal manner, rather than seamlessly executing it. But there are passages within the big compositions that move away from this directory of sources toward something freer and more self-assured, as if Peter Paul, in his twenty-fifth year, were standing straighter before his Italian peers, looking them directly in the eye. The figure of Juno, for example, in *The Olympian Gods*, eyes brimful of raging jealousy, a perfectly judged foreshortened arm flung out, her body encased in a loose gown picked out with vernal green, generates an intensity that shoots across the crowded scene like a poisoned dart, straight to the heart of her hated rival Venus, lolling indifferently in her blond, half-naked vanity. It's the gesture of an artist unafraid to take major risks, to match himself against the masters. And when, at last, in the spring of 1603, we can hear Rubens's own voice, in a series of letters written to the Duke's secretary of state, Annibale Chieppio, its tone is startlingly candid and self-possessed, which, given the rite of passage directly before him, was perhaps just as well.

It must have seemed an honor, not a chore. On March 5, 1603, the Duke wrote to his ambassador in Spain, Annibale Iberti, that his painter, Rubens, was bringing an elaborate and precious offering of gifts for King Philip III and his first minister, the Duke of Lerma (the real power in the realm). For all Vincenzo Gonzaga's reputation for careless extravagance, the gesture was carefully considered, a diplomatic maneuver. From the south of Italy, where the Spanish Habsburgs held the kingdom of Naples, to the north, where they governed Milan, Spanish power was the dominant force in the whole peninsula. Whatever his other failings, Vincenzo was no fool. He was acutely aware of Mantua's strategic importance in the perennial hostilities between Spain and France. With a new king on the throne in Madrid, he was anxious lest his duchy be considered too slight or too fickle to be allowed indefinite freedom of action. Other Renaissance city-states— Ferrara most recently—had been swallowed up for less reason. The delivery of a stupendous gift, then, directly at the feet of the new king and his favorite was intended to impress Philip III with the bottomless resources of the Gonzaga and their undying and respectful homage to the mightiest of the Christian princes, and (rather improbably) to stake Vincenzo's own claim to succeed the disgraced Genoese Andrea Doria as admiral-in-chief of the Spanish navy.

It was Renaissance potlatch at its most calculated: an act of homage that conferred authority on the giver as much as the receiver. The composition of the presents was exquisitely thought out to match the known weaknesses of the Spanish court with the special strengths of the Gonzaga state: art, alchemy, and horses. From his agents in Madrid the Duke had doubtless heard that King Philip III was of an opposite temper from his great and gloomy father: sportive, elegant, and pleasure-loving, with a passion for the hunt that went well beyond the habitual pastime of princes. The heart of the gift, then, would be a pretty little coach, intricately worked and specially designed for rustic excursions, together with six of Mantua's greatest treasures: its bay horses. Whether he was off hunting stags or hares, the King of Spain would be seen magnificently equipped, courtesy of the Duke of Mantua.

It was notorious, however, that the light-headed King was not truly master of his realm. That power belonged to his favorite, the Duke of Lerma, the son of an emancipated slave who controlled access to the sovereign and the keys to the treasury, from which substantial sums found their way into his own pockets, as the people who called him *el mayor ladrone* well knew. But Lerma was a thief with pretensions, and the sweetener would have to reflect his inflated sense of cultural refinement. Hence Rubens. Hence the forty paintings, all—with the exception of a Pourbus full-length portrait of Vincenzo and a Quentin Metsys *St. Jerome*—copies of masterworks (with heavy emphasis on Titian and Raphael) from the Gonzaga collection, painted in Rome by the Mantua native Pietro Facchetti. What Lerma would be getting would thus be a synthetic version of the Duke's gallery, a reminder to a parvenu that the high taste of a dynasty like the Gonzaga was not lightly come by. And since the new Spanish court

was apparently as devoted to worldly pleasure as the old one had been to Catholic duty, Vincenzo also included, for both the King and the Duke, tall vases (silver and gold for the Duke, rock crystal for the King) filled with perfume. In the previous century, Muzio Frangipani had made the unlikely discovery that scents derived from essential oils could be dissolved in rectified spirit. Heady combinations of fragrances could now be stabilized in an alcohol medium and packed into magnificent vessels, stoppered with glass plugs and sealed with lead. For Lerma's sister, the Countess of Lemos, reputedly pious, there was a large cross and two candlesticks, all in rock crystal; for his most powerful councillor, Don Pedro Franqueza, a perfume vase and sumptuous damask and cloth of gold. And always on the lookout for additional musical talent to augment the already impressive ensemble at Mantua, Vincenzo sent a lavish monetary gift to the director of music in the Spanish chapel royal.

Elaborate gifts went to and fro between states all the time, as much the currency of diplomacy as treaties, marriages, and ultimata. But it's safe to assume that nothing this prodigious had ever made the thousand-mile journey between Mantua and Spain. To be personally responsible for its safe delivery was, of course, a flattering sign of the Duke's confidence in his young painter, a sense that he had in him qualities that made him more than a court menial. Equally, though Rubens knew that should anything go awry with the mission he would be held personally accountable to a lord not famous for his understanding of ill fortune, he must have been acutely aware of the honor and the risk involved when Vincenzo showed up in person to watch him packing up the works of art. Nothing could be entrusted to underlings. Peter Paul lovingly wrapped the paintings between double layers of heavily waxed cloth resembling modern oilcloth, and then set them carefully down in wooden crates that were lined with tin for added protection. The heavy rock-crystal pieces were cushioned with velvet and woollen wadding, then surrounded with layers of straw. No one imagined, moreover, that the bay beauties would be required to trot their way to the seacoast, so a special travelling stable was constructed for them, from which, at several stops along the way, they were to be brought forth for the wine bath that would ensure that they arrived in Madrid in prime condition. Likewise, a high-sided cart was made to take the little hunting coach, to be pulled by mules on the mountain roads, a progress that would inevitably be slow but, Rubens hoped, perfectly safe.

On March 5, 1603, the procession of horses, carts, and carriages made its way across the Ponte di San Giorgio, moving southeast toward Ferrara. Ten days later, after an epic crossing through the Apennine Pass at Futa which separated the Emilian plateau from Tuscany, Rubens and the convoy arrived in Florence. His first letter to Annibale Chieppio, written three days later, already reveals a high level of consternation that so little forethought seemed to have gone into so manifestly important an enterprise. At Bologna it had proved impossible to find any mules, and in any case, the muleteers who came to look at the contraption that had been designed to

carry the royal hunting coach judged it comically unsuited to crossing the Apennines. The only alternative was to leave it behind in Bologna and strap the coach into a cart that would then be laboriously pulled by oxen over the passes. Fretful about finding passage aboard ship from the Tuscan port of Livorno, Rubens had gone on ahead to Florence with the rest of the horses and wagons. What he heard on reaching Florence did nothing to allay his worries. The Tuscan merchants to whom he spoke with a view to booking passage from Livorno "crossed themselves in their astonishment at such a mistake, saying that we should have gone to Genoa to embark, instead of risking the roundabout route to Livorno without first being assured of a passage."[25] Rubens might well have been thinking the same thing, suspecting that Vincenzo must have had some ulterior, undisclosed reason for having him travel through Florence, perhaps nothing more sinister than a childish desire to show off the splendor of his gift to his in-law, Ferdinand de' Medici, Grand Duke of Tuscany. When Rubens subsequently discovered, at an after-dinner audience, that the Grand Duke seemed more completely informed about the details of the Spanish mission than he was himself, these suspicions deepened. "He told me, moreover, not without gratifying my pride, who I was, my country, my profession, my rank, while I stood there like a dunce."[26] Ferdinand's interest in the trip was not entirely a matter of courtesy. Through a Fleming in his own service, Jan van der Neesen, he had inquired whether Rubens might have room for an additional palfrey and a marble table to be delivered to a Spanish officer in the seaport of Alicante. Though Rubens must have had misgivings about adding to his cumbersome shipment, he agreed to do this, instinctively sure that it was worth the trouble to oblige princes.

There was nothing in return that Ferdinand de' Medici could do about the weather. Torrential spring rain frothed up the tan-brown Arno, creating floods that held up the already belated arrival of the coach and delayed Rubens's own efforts to get to Livorno to try to find a suitable ship to take him to Spain. In Florence he'd been given the depressing news that since no advance provision had been made for his journey, he would have to sail in two stages, first from Livorno to Genoa and thence by a second vessel to Alicante. But now that Duke Ferdinand had an interest in getting Rubens to Spain as quickly as possible, obstacles magically fell away. Livorno had become one of the busiest ports in the western Mediterranean: its wharves full of barks loaded with Tuscan produce, oil and dried fruit, and lagoon salt, sent from the little ports of Grosseto, Orbetello, Montalto, and Corneto; behind them bigger *galionetti* and the twin-masted, hundred-ton round ships that the Italians simply called *navi*. Some of these *navi* bore a distinctly foreign, northern rigging, and crews that spoke the rasping gutturals of Hamburg and Antwerp. It was on one of these unlovely but dependable, broad-beamed ships that Rubens found room for his precious cargo. On April 2, three days after Easter, he wrote that he was finally aboard with men, horses, and baggage and waiting for a fair wind for Spain.

Usually, those winds blew west–east, which made the journey from the Tyrrhenian Sea to eastern Spain a tremendous slog. Depending on the force of those winds, the voyage between Livorno and Alicante might take anything from seven to (in the worst cases) thirty days.[27] Rubens's ship docked at Alicante three weeks after sailing from Livorno, a slow but not disastrous progress given the heavy spring seas. Once ashore, he made sure to inspect the condition of the presents—from the bay horses to the crystal candlesticks—and was happy to discover nothing amiss. The Spanish authorities were courtesy itself, thanks to the chain of connections and favors he had been patiently linking together. Ferdinand de' Medici had found him Flemish merchants who had indeed helped ease his way at both ends of the voyage.

Even before he left Italy, Rubens realized that, once again, he had been a fool to trust the intelligence he had received in Mantua concerning the last stage of the mission: the overland travel from Alicante to Madrid. A glance at the map would have told him that 280 miles across rugged and often mountainous terrain up to the Castilian highlands would take considerably longer than the "three or four days" that had been budgeted in time and money. Rubens wrote fretfully to Chieppio that it seemed likely that he would be obliged to draw on the personal funds the Duke had allocated to him and perhaps borrow further to see the journey through to the end. He would, however, keep accounts of such care and integrity that Duke Vincenzo would see that he could not possibly be thought to have been prodigal with his money. Wine baths for horses did not come cheap.

As it turned out, money was the least of Rubens's problems. Not long after setting off north from Alicante, the Andalusian skies turned iron-dark and began to empty a steady, saturating rain on the long convoy that continued, uninterruptedly, for twenty-five days. The Spanish roads turned to muddy tracks that slurped about the hocks of the increasingly foul-tempered mules. Men fell sick with fevers and had to be left behind in remote village inns to survive on corn and chestnut gruels and black bread. Where could Rubens find the shelter to provide the horses with their ritual slathering: in sodden stables stinking of rats and bad cheese; in the tiled courtyards of obliging hidalgos impressed with their destination; in the cloisters of primitive but hospitable monasteries?

A week after leaving Alicante, the Mantuan train, now considerably bedraggled and bespattered, lumbered into Madrid, where Rubens's relief at arriving at what he had imagined to be his journey's end was short-lived. The court of Philip III, he was told, was no longer in Madrid but at Valladolid, another hundred miles further to the north, reached (of course) across miserably rocky and difficult country. Indeed, since it seemed well known in Spain that the Duke of Lerma had insisted on making the move, allegedly to appease the Castilian nobility by taking the King away from the Madrid bureaucracy, Rubens may have been forgiven for wondering why neither Duke Vincenzo nor Grand Duke Ferdinand had bothered to point this out. Before the weary caravan set off again, Rubens, unsure if he

would see Madrid again, wandered through the Escorial marvelling at the quality of the royal collection and making sketched copies of works by Raphael and Titian, the masters, respectively, of modelling by line and by color. To marry both those techniques, to make moot the choice between *disegno* and *colore*, was a challenge he would set himself, and was at least as daunting as catching up with the Spanish court.

The wagons and horses moved off north. On cue, the skies opened. On May 13, almost a month after leaving Alicante, Rubens entered Valladolid, where, he wrote Duke Vincenzo, "I have unburdened upon the shoulders of Signor Annibale Iberti my charge of men, horses and vases; the vases are intact; the horses sleek and handsome, just as I took them from the stables of Your Serene Highness."[28] Iberti, the Mantuan ambassador, on the other hand, was less than overjoyed to be the recipient of this charge and received Rubens with chilly correctness, not at all the warm welcome to which the painter thought himself entitled after all his troubles. But this cool reception was perhaps less surprising given that Iberti professed to know absolutely nothing about Rubens's mission. Horses? What horses? Faced with this show of blankness, Rubens (by his own account) was a model of concerned politeness. "I answered in surprise that I was convinced of the good intention of His Most Serene Highness, but that to recall a thing forgotten would be superfluous after so many other cases, for I was not the first envoy the Duke had sent him, and that for lack of advice the present necessities must serve as orders. He has perhaps his reasons." At least Iberti seemed helpful in extricating Rubens from his financial predicament, which had become serious. His own personal salary and the Mantuan expense float had already been exhausted, leaving him without a penny had not a local merchant provided a loan pending the Duke's reimbursement. This left him to the charity of Iberti, who supplied "Il Fiammingo," as he crisply called Rubens, with new clothes and lodgings, which he shared with his men, baggage, and horses.

As Peter Paul soon learned, his mission was neither home nor dry. The court had gone to hunt rabbits somewhere near Burgos, still further north. Another round of chase-the-king was out of the question. Rubens had neither the energy nor the money to consider it, and he was still waiting for the cart with the coach, which arrived in one piece on May 19. He would simply bide his time until the court returned from the shoot, be it weeks or months. Perhaps this little breathing space was just as well. He could unpack the gifts, groom the horses, polish the coach, buff up the vases, have everything just as Duke Vincenzo would wish it for the delectation of the King.

It's possible to picture the scene. A bright spring morning, at long last, the sunlight shining through young chestnut leaves. Peter Paul with his best broad-brimmed hat protecting his head (which was already showing a little pate through his receding hair) from the sun of León; a stick pointing at the crates to be opened; walking around the horses as they shook their manes and turned this way and that, within the fenced enclosure; the coach a little

way off, brightened and buffed, daintily elegant, fit for a Habsburg; a pleasant glow of vindication rising within him, an expectation of congratu-lations wrenched from the unwilling lips of Annibale Iberti. And then the paintings taken into an inner chamber, the boxes stood on their ends.

When exactly did he become aware of a dry mouth, the sudden loss of breathing room within his doublet? When precisely could he see the full extent of the disaster? When the wooden boxes were opened and the nails flew into the dirt; when a wave of blighted air, redolent of rain-sodden straw and mildew, rose to his face? Did he tremble, imperceptibly except to himself, as he lifted the rotten canvases from their tin casing? Did he roundly curse "malicious fate" like a tragedian, and did he do so in Flemish or Italian (reserving expressions of Latin lament for his letter to the Duke)? The paintings looked like plague victims, their surfaces swollen, blistered, and greasy. Elsewhere, the effect was more like leprosy: gobbets of paint hanging in loose flakes or collecting in crumbled slivers at the bottom of the box. When Rubens lightly fingered the surface, it peeled away as easily as a reptile sloughing its skin.

What could be saved from this ruin? Once he had caught his wind, Rubens, habitually methodical and not given to panic, could see that not everything was lost. The two original paintings—the Metsys *Jerome* and (as if his master's vanity had turned guardian angel) the Pourbus portrait of Vincenzo—were still in good condition. The casualties of the Spanish mon-soon were tenderly removed from their casings and frames, washed of mold and grime, and then set to dry in the long-awaited Castilian sun. Even where the pigment remained attached to the surface of the canvas, much of it had badly faded, but that could be restored by careful retouching. Of necessity, this was slow and painstaking work that might take months rather than days. Iberti had a quite different notion of how to cut their losses. Might not the matter be made more expeditious by hiring local painters who could help Rubens knock off a "half dozen or so woodland scenes" that could be substituted for the damaged canvases? As appalled as he was by his predicament, Rubens was even more aghast at this proposal. It echoed all too condescendingly Michelangelo's platitude that all the Flemings were good for was painting the grass of the fields. From what he had seen of contemporary Spanish painting ("incredible incompetence"), he had no intention whatsoever of "being disgraced unduly by an inferior production, unworthy of the reputation I have already made here."[29] His letter to Chieppio confessing the calamity, understandably anguished, allowed itself the luxury of a little sourness. He was already at work scrap-ing off the bubbled patches of paint and applying the first retouching and referred to this with a sardonic aside that he claimed, unconvincingly, was not expressed with any resentment: "To this task I shall not fail to apply all my skill since it has pleased His Most Serene Highness [the Duke] to make me guardian and bearer of the works of others, without including a brush-stroke of my own."

But Rubens was too close to his brother and his philosophy not to draw on the neo-Stoics' principle of constancy in tribulation. To thyself be true,

and good may yet come of evil. By spurning inferior assistance and refusing to compromise his own style, Rubens now saw a way in which his reputation as a prodigious talent might actually be enhanced rather than wounded by the crisis. Iberti had put it about that Rubens was grumbling that he would need nine months to finish his work and that all he was good for was some typically "Flemish" rustic entertainment. Very well, then, he would use fortune's challenge to confound everyone, beginning with the arrogant diplomat who seemed determined to cut him down a notch or two. Since the freshness of the paint would immediately alert any serious connoisseur to evidence of retouching, he would make Flemish candor a virtue, in invidious contrast to Iberti's clumsy ruse. And by working with skill and alacrity (though not with careless haste), he would be given credit for the restoration. Better yet, he would now get the opportunity to substitute freshly painted originals of his own design for two irreparably ruined canvases.

One of those two new paintings is known to have been a *Democritus and Heraclitus*, the merry and mournful philosophers of antiquity, seated beneath a tree and separated by a globe meant to symbolize the subjection of human ambition to the ways of the world. The choice of subject was, of course, not at all arbitrary. It was meant, in the first place, to parade Rubens's taste and erudition; to establish his connection with Raphael's *School of Athens*, where the two philosophers had most famously appeared, and with the printed versions by Cornelis Cort exceptionally popular in early-seventeenth-century Europe. Showing off this classical scholarship to the Spanish court (especially in the face of a Mantuan ambassador who kept referring to him as "the Fleming" as if he were a lower form of intelligent life), Rubens might evoke the tradition by which truth and action could be generated from the contest of opposites.[30] He would have calculated that the learned allusions to Stoicism—to the necessity of cheerful acceptance in the face of fortune's cruel buffetings—would be taken by the Duke of Lerma as a flattering reference to himself, since he was famous for a courtly manner that walked a tight line between gaiety and gravity. But for those who had the wit to see it, the painting was also pure autobiography. Given all the unforeseen crises and disasters that had been put in his path, Rubens might well have grimaced with the burly Heraclitus at the vanity of human pretensions to bend the world to their design. In his marrow, though, he was a modern Democritus: good-humored and self-possessed in the face of disaster; coolly amused rather than hot and bothered by fortune's caprice. It's Democritus, then, who literally has the world covered, draped in the capacious folds of his robe and secured with long, tapered Rubensian fingers.

Taken aback by "the Fleming"'s steely determination to do things his way, Iberti dropped his plan for quickly executed landscapes but resolved to make it quite clear to Rubens just who had precedence in the affairs of Mantua. For when the court eventually had had its fill of dead rabbits and returned to Valladolid in early July, it was Iberti, not Rubens, who presented the coach and horses to the delighted Philip III, notwithstanding Duke Vincenzo's instructions to the contrary. To the Duke, Rubens was

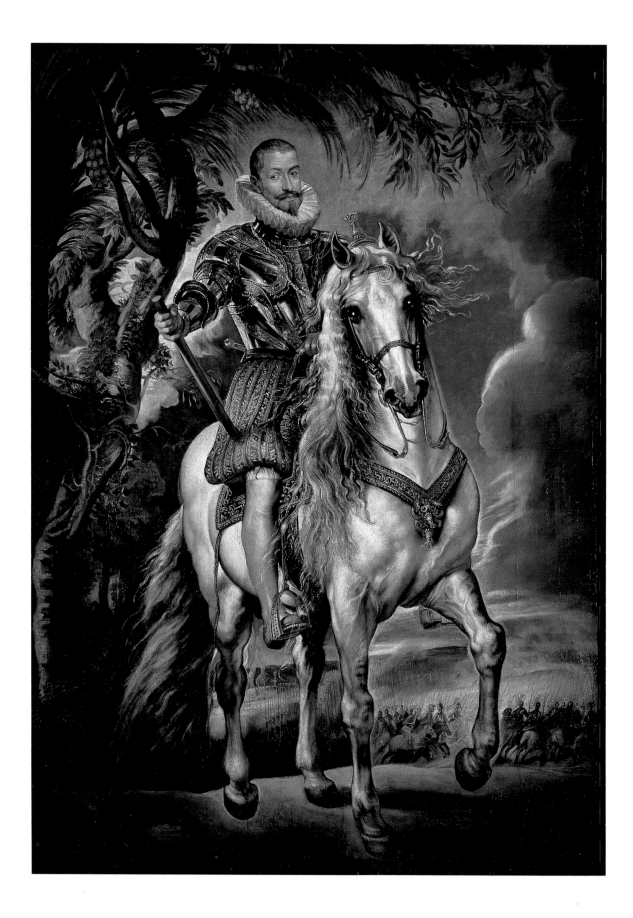

careful to report the ceremony with his anger muffled by the requirements of deference, simply adding that "I observed with pleasure the indications of approval which the King showed by gestures, nods and smiles." Even this account was meant to imply to Vincenzo what Rubens openly stated in a franker letter to Chieppio, namely, that he had been deliberately humiliated by being placed as far away from the King as possible during the proceedings, and that he had been forced to rely on body language for his assessment, as if he were craning his neck over a throng of courtiers. His letters on Iberti's conduct were by now predictably disingenuous. On his demotion at the presentation, for example, Rubens protested:

> I do not wish to interpret this [unannounced alteration of protocol] wrongly, for it does not matter, but I am surprised at such a sudden change. For Iberti himself had mentioned to me several times the letter of my Lord the Duke in which he expressly commanded my presentation to the King. . . . I say this not to complain, like a petty person, ambitious for a little flattery, nor am I vexed at being deprived of this favor. I simply describe the event as it occurred.[31]

Just so.

The second presentation, at the Duke of Lerma's house, was an entirely different story. Rubens installed the larger paintings in a grand hall, and the smaller pieces, along with his *Democritus and Heraclitus,* in an adjoining chamber. Enter the Duke, affable and informally gowned. Wearing his best connoisseur's expression, he toured the collection for more than an hour, muttering pleasantries, and finally announced that the Duke of Mantua "had sent him some of his greatest riches; exquisitely suitable to his taste."[32] Suddenly, Rubens and Iberti found themselves in a new and wholly unlooked-for dilemma, though not one with which they were going to unduly torment themselves. For Rubens had done his work so well that the Duke assumed that what he was looking at were *originals,* especially since, as the artist reported, "a number of the paintings (thanks to good retouching) had acquired a certain appearance of antiquity from the damage they had suffered."[33] Rubens emphasized that he had done nothing to lead the Duke (or for that matter the King and Queen, who joined in the general admiration) to make this assumption. But neither was he about to disabuse them of their error. Heraclitan candor stopped short of making a king and his first minister look like idiots.

His discretion paid off. Lerma was enraptured. What talent, what refinement, what thoughtfulness! He even supposed Rubens to have been especially considerate in gathering together so many paintings of sacred consolation as a particular solace for the loss of the dear Duchess, taken from him but a few days before! Such a prodigy as this could not be allowed to escape the greatest court in Christendom! So Lerma wrote Duke Vincenzo inquiring if he might not release Rubens from his obligations so that the Flemish artist might remain in Spain. Sensing a sudden rise in his

OPPOSITE: *Rubens,
The Duke of Lerma
on Horseback, 1603.
Canvas, 289 × 205 cm.
Madrid, Museo del Prado*

court painter's stock, the Duke, of course, regretfully refused, and urged
Rubens, amidst all this to-do, not to neglect his assigned job of painting
"the most beautiful women of Spain." Clearly Vincenzo had his own defi-
nition of a ducal collection.

Unwilling to surrender his new protégé without a struggle, Lerma came
up with a project which the Duke of Mantua could hardly overrule without
discourtesy: his own equestrian portrait. It was Rubens's greatest opportu-
nity yet to establish himself as more than an intriguing novice, but it also
carried with it complications, even risks, which Rubens's budding political
instincts could not have missed. It had been Titian, with his horseback por-
trait of Charles V at the battle of Mühlberg, fully armored, with the
knightly lance in his hand, who had set the standard for princely equestrian
portraits. The painting hung in the Escorial, and Rubens, during his brief
and sodden stay in Madrid, had made a copy of the masterwork. In turn, it
could not have failed to remind him of the prototype of all equestrian
emperors: the statue of Marcus Aurelius set high on the Campidoglio. In
that one heroic sculpture were compressed all the imperial ideals: stoic
mastery of the great horse, and thus sovereignty over the world, martial
strength, and philosophical composure.[34] To this imposing formula Titian
had added the quality of expressly Christian chivalry so that Charles, the
King-Emperor, astride his mount became also the *miles christianus,* the
quintessential Christian knight, armed to do battle against pagans, heretics,
and Turks. In innumerable engraved versions by the Netherlander Cornelis
Anthoniszoon, the Aurelian rider had been recycled to extol the regal
virtues of, among others, Francis I of France, Henry VIII of England, and
the Emperor Maximilian of Austria.

It had even been extended to Charles V's son, Philip II, despite his well-
earned reputation for fighting holy wars from his desk in the Escorial.
Though most of the Philippine portraits are more sedentary, perhaps delib-
erately refraining from comparisons with his permanently incomparable
father, there were exceptions like Tintoretto's *Entry of Philip II into Man-
tua,* which for obvious reasons Rubens would certainly have known. The
grandson, Philip III, though, suffered from no reluctance to show himself
off as the consummate rider-warrior, even though most of his campaigns
were waged against the stag and the pig.

Precisely because common gossip already ascribed the reality, rather
than the mere appearance, of royal power to Lerma rather than the King,
Rubens had to be careful not to reinforce the impression with a painterly
act of lèse-majesté. His solution was to turn the mounted figure ninety
degrees from Titian's profile to face the beholder in the manner of El
Greco's *St. Martin and the Beggar.* Lerma was in mourning for his wife
and had become uncharacteristically melancholy, even a little reclusive.
Rubens's challenge, then, was to provide an image of the minister-as-
warrior that would preserve this pious austerity yet convey the impression
of dynamic authority. What better way to do this than to play with contrast
(as he had already done in the *Democritus and Heraclitus*), posing the

black-costumed rider, with the silver-brown hair of a sage, on a spectacular gray mount, a veritable Pegasus equipped with huge black eyes, pricked ears, mane curled and flowing, the kind of steed encountered in chivalric fables. The wind blowing through the mane on the horse's left side suggests that it is in motion (at the least, a quick trot), but the Duke, mastering his mount with one hand, the other gripping the marshal's baton, is a picture of perfect stillness. It was a truism of riding academies in the age of the Baroque that the appearance of effortless control in the saddle was not merely an analogy for but an *attribute* of good government: power and wisdom in perfect balance. So Rubens was supplying Lerma with exactly what he wanted and needed: a glorious lie; the image of a dauntless commander, body poised, head held erect within its narrow Spanish ruff, cantering above the fray; the perfect rebuttal to all those infamous stories about him being nothing better than a parasite and a thief. The twenty-six-year-old novice had, in effect, reinvented the genre which, in countless princely courts from Whitehall to Versailles, from Stockholm to Vienna, would become the favorite icon of the omnipotent Baroque monarch.

As would be the case with all these studies of the "Great Horse," Rubens had to take into account its setting—in this case, high up at the end of a gallery in the Duke's house, dominating the entire length of the space, so that visitors would approach it from below, humbled and awed, as if entering the presence of an omnipotent Caesar. At a fairly late stage, perhaps when he was completing the painting at Lerma's country house at Ventosilla in the autumn of 1603, Rubens enlarged its dimensions with extra pieces of canvas, enabling him to add the conceit of the two trees, palm and olive, the emblems, respectively, of victory and peace, the twin attributes of the Duke's character. Rubens used them cunningly, in a way reminiscent of the overhanging vegetation he'd used in *Adam and Eve* and in the *Democritus and Heraclitus,* to emphasize aspects of the Duke's figure: a sturdy branch outlines the power of his right shoulder; a palm leaf frames the head like a Christian halo. Even the lighting was perfect propaganda—the storm clouds of war parting like a stage curtain to allow a dazzling radiance to bathe the heads of the hero and his snowy steed.

It took Rubens until late in November to complete Lerma's portrait to his satisfaction. He had begun the work in Valladolid, using a stand-in for the figure of the Duke, since in one of the preparatory drawings the bearded face of Lerma was subsequently pasted over the original model. While Rubens was putting on the finishing touches, Lerma was caught in the most important moment of his career. Queen Elizabeth I, the thorn in the side of the Habsburgs, had finally died, and the uncertainties of the succession had raised all kinds of questions over England's confessional future under King James, the son, after all, of the Catholic Mary Stuart. It would have been impossible to be so much in the company of the minister without being exposed to this political and diplomatic discussion. But at the same time, Rubens was being barraged with a series of letters from Mantua, increasingly exigent, all urging his departure from Spain. Vincenzo's plan,

however, was for Rubens to return via Paris and Fontainebleau, where he was required to paint the portraits of French beauties. As Rubens gloomily acknowledged in a letter to Chieppio, the Duke had made his intentions clear on this subject before the artist left for Spain. But the experience, to put it mildly, had been a transforming education. He had left Mantua a courtier-novice. He would leave Valladolid with the savoir faire of a diplomat, a politician, a travelling entrepreneur, and, not least, a painter with Caesars, not courtesans, for his subjects. How might he put all this with sufficient firmness to make his altered status clear, but without outraging his patron? By now Rubens was also a master of the disingenuous protest, and he used it once more to cunningly suggestive effect. To Chieppio (who had shown himself tolerant of this kind of thing) he wrote that "this mission is not an urgent one," and that since "contracts of this sort always result in a thousand inevitable [and unforeseen] consequences," who knew how long he might be detained in France? Why should the Duke suppose that the French would be any less interested in his art than the Spanish or the Romans, once they had a sample of it? If His Serene Highness really wished to have him back in Mantua, as he himself yearned to be, surely it would be wiser to commission Monsieur de Brosse or Signor Rossi, already at Fontainebleau, to do this sort of thing. Indeed, perhaps they already had portraits of Gallic *belles* available for the Duke's gallery? Clinching the case, Rubens went on to assume that Chieppio surely would not want good *money* to be thrown away "upon works unworthy of me, and which anyone can do to the Duke's taste. . . . I beg him earnestly to employ me at home or abroad in works more appropriate to my talent. I shall feel certain of obtaining this favor since you are always willing to be my friendly intercessor before my Lord the Duke. And in this confidence I kiss your hand with a humble reverence."[35]

The sauciness paid off. Orders to gather French beauties were not repeated. Rubens took ship, bound directly for Italy.

iv *Brotherhoods*

But could the painter, who could do *everything* else, swim? To look at his *Hero and Leander*, completed when he returned from Spain, one wouldn't suppose so. Deep in the billows of the Hellespont, Leander, the long-distance-swimming lover, lies drowned. This is the night when a storm, still raging in Rubens's painting, has extinguished the guiding light set in a tower by his beloved Hero, and taken his life. Leander's face has already turned pallid, while his body, still perfectly modelled, is borne up by a team of Ovidian synchronized swimmers: the Nereids. Only the leading pair of sea sprites seem to have much notion of aquatic propulsion,

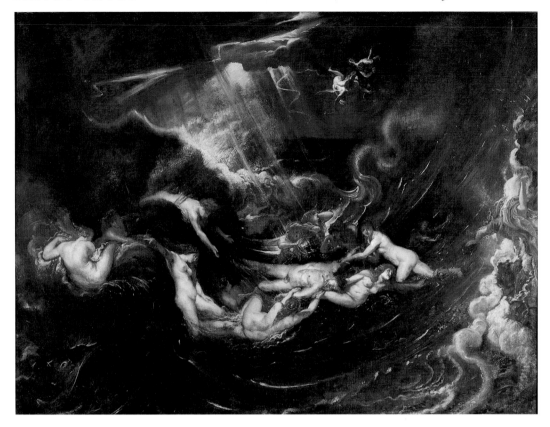

towing Leander with a functional sidestroke. Their sisters, supported by nothing other than their flotation-friendly Rubensian flesh, body-surf the crests and troughs, linked in an ornamental human wave that curls across the canvas. Some, like the Nereid on the left, recycled from Michelangelo's and Rubens's own *Leda,* seem to be modelling for fountains; others recline on the ocean as if it were a well-upholstered couch; still others tread water and stare in shock at rose-gowned Hero, plunging, in suicidal sympathy with her lover, into the sea. In the left corner, a sea monster, coal-bucket maw agape, confidently awaits his lunch.[36]

Perhaps Rubens has been looking at too many court masques and street processions, with their stylized, pasteboard renderings of Neptune's briny realm, since his figures are deployed choreographically as if in a horizontal water ballet. But the roiling sea is itself treated with such shocked respect that even if he had, as has been suggested, seen Leonardo's *Deluge,*[37] it's hard not to imagine him leaning against the side of his ship, between Spain and Genoa, sketching the heave of the tide and the ominous gathering of a slate-dark winter sky. A preparatory drawing for the *Hero and Leander,* now in Edinburgh, does indeed do justice to the banked-up waves with their scrolling, spumy tops. And for all the mannerism of the figures, the painting succeeds in rising above artifice, principally through Rubens's extravagantly forceful draftsmanship. The wreath of bodies bobs

Rubens, Hero and Leander, *c. 1605. Canvas, 95.9 × 127 cm. New Haven, Yale University Art Gallery*

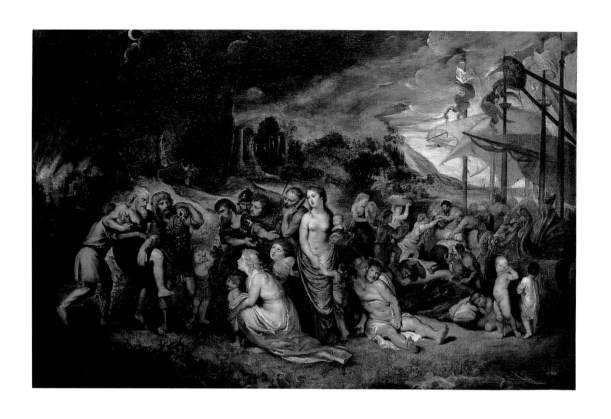

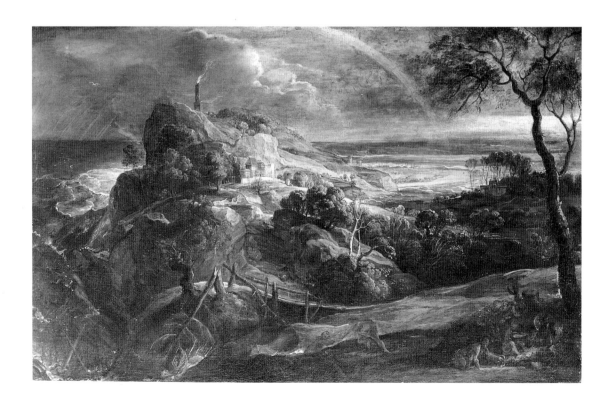

and tumbles through an inky tunnel of storm-thick air and surging water. Rills of foam and spray snake through the space like voracious eels, while the pitchy gloom is shot with bolts of shrieking, acid-bright light. The painting sucks, pulls, gulps, and swallows like the animal ocean itself. It is a patch of wildness, manic here, graceful there; a chancy effort like the most elemental work of Tintoretto, whom Rubens had already adopted as a counterfury to Titian's sensuous repose. No wonder Rembrandt liked it; valued its hectic riskiness, the violent illumination, the writhing, arabesque energy of the composition; and was prepared to shell out the princely sum of 440 guilders for it in 1637. For seven years it hung in Rembrandt's house on the St. Anthonisbreestraat, and when he sold it, in 1644, he made a nice little profit.[38]

Whether Rubens had fair or foul winds on his voyage home across the Mediterranean, sea changes seem to have been much on his mind. *Hero and Leander* was followed by a *Pharaoh and His Army Drowning in the Red Sea*, now preserved only in an impressive fragment featuring helplessly upturned faces and thrashing cavalry sinking below the waterline. A *Christ Calming the Sea of Galilee* (closely imitated by Rembrandt in his own composition of 1636, now hostage to an art thief)[39] also dates from this post-Spanish period, as do two scenes from Rubens's *Aeneid* cycle: *Aeneas and His Family Departing from Troy* and *Landscape with the Shipwreck of Aeneas*.[40] The Virgilian cycle ought to have been (with Vincenzo Gonzaga one could never tell) of special significance in Mantua, since he was the city-state's native-born poet, and Rubens brought to his two scenes a perfect sympathy for Virgil's calculated balance between disaster and hope. Both paintings are divided into realms of despair and realms of promise, with the sea itself playing alternate roles. In *Aeneas and His Family Departing from Troy*, the wind that fills the topsails of the waiting vessel also seems to blow through the bodies of the demoralized fugitives from Troy's disaster, stirring them to action. In the *Shipwreck*, roles are reversed. The ocean, black with rage like Leander's Bosphorus, smashes against the Ligurian coast, a promontory that the eighteenth-century enthusiast and biographer of Rubens, Roger de Piles, recognized as the notoriously rock-strewn Porto Venere near La Spezia.[41] The survivors cling to spars extending behind the wreck, while the central space of the painting is given over to Rubens's earliest pastoral: a lighthouse perched on a hill, surmounting a landscape bathed in welcoming light and cradled inside Rubens's compositional oval, the rainbow arching above, the road curving below: the womb-shape of Aeneas's Latin destiny.

The commonplace emblem of Fortune's caprice was Madama Fortuna, her hair and her drapery billowing in the wind like the sails of a ship. In some representations, like that of the mannerist Bartholomeus Spranger,[42] she was posed before a vessel, with the alternative fates of a stormy sea and a safe port indicated in the background. Philip Rubens, still in Italy while his brother was making the return voyage from Spain, saw visions of wrecked mariners and fretted over his brother's safe return. Being a

Rubens, he worried in Latin verse, imploring the gods who "inhabit the luminous temples of the sky and the seas sown with ships . . . who reign over the Tyrrhenian Sea" to "protect your ship against the redoubtable stars that excite tempests. May a favorable wind and a gentle zephyr carry you over the smiling surface of softly stirring waters so that your bark will arrive at its port, crown at the prow."[43] His anxieties were so sharp, Philip admitted, that even study, normally the dearest thing in the world, now filled him with aversion. Yet for two brothers so mutually and passionately devoted, the Rubenses suffered from peculiarly perverse timing. Hardly had Peter Paul's "bark" safely docked (probably at Genoa) when Philip, freed from anguish, decided that he must return to the Netherlands. And it was on his way north that the brothers met in Mantua in February 1604. It may be that Philip had no choice. He had completed his legal studies and was, like his father before him, a doctor of canon and civil laws. But he was also the Good Rubens: responsible and conscientious; obligated to deliver his two younger charges, fully educated, back to the Netherlands, and, in all likelihood, wanting to see his mother, Maria, whose health was beginning to give some cause for concern.

It was his surrogate father, though, who made no secret of wanting him back. On the last day of January 1604, just before the brotherly reunion, Justus Lipsius, feeling his age and the afflictions of the times, feeling, in fact, that the two sorrows were somehow ravelled up together, wrote to Philip almost pleading with him to return to Louvain before it was too late. "Come, come, converse with me, stay by my side. . . . I did not send you away, merely entrusted you to another for some time. But Italy holds you. I love it little because you love it so much." Shortly after, he wrote again, imagining their meeting. "I await you, I hurry to you, I open my arms to embrace you. Return when you can. I grow old, I grow gray. I cannot wait long. I must enjoy your presence now or never."[44] These were the heavy sighs of the father to his adopted son; and to make sure Philip heard them, Lipsius included, almost incidentally, the news that he had been thrown by a horse (a gift, in fact, from one of the Richardots, the Bishop of Arras). "I am passing well," he added with unconvincing stoicism.

There were many reasons why Lipsius wanted Philip back. He was about to publish a rather un-Lipsian collection of miracles attributed to the Virgin, but much more important, he was on the point of completing his life's major work: an exhaustive and authoritative edition of Seneca's writings, dramatic and philosophical. Had it not been for the riding accident, he was to have taken the final version to Balthasar Moretus's press in Antwerp. But even without the misfortune, he evidently needed his most trusted pupil to oversee the final stages of publication. Philip could hardly deny Lipsius this filial-editorial duty. The old man (as he seemed, though in his mid-fifties) was the patriarch Philip had long missed. His house in Louvain, where a few select students had shared meals, dwelling, and constant conversation with their teacher, had been, in some sense, a true home for Philip. But with this close and intense father-son relationship also came the predictable sense of guilt and suffocation. Remarkably certain that he had

little time to live, Lipsius badly wanted Philip Rubens to be his successor in the chair at Louvain and saw in him both the scholarly and moral qualities needed to perpetuate the principles of neo-Stoicism through the endless battering that war was inflicting on *miseram Belgicam*—unhappy Belgium.[45] Philip would be the standard-bearer of Catholic humanism in the hard times that lay ahead.

When it came to it, though, Philip flinched from the assignment, declining the appointment. Once he had seen his father-professor again, and seen off his works to the press, his heart turned again to Italy and to Peter Paul. It's hard to know what passed between the old and the young man as these painful things were settled. Lipsius, who had always set such public store by intellectual independence, could hardly now deny it to Rubens. There was a post available as librarian to Cardinal Ascanio Colonna, the son of the commander of the papal galleys at the battle of Lepanto and a man of serious learning who since 1602 had served in Spain as the Viceroy of Aragon. Returning to the great family palazzo at the foot of the Quirinal hill, Colonna needed a learned hand to oversee his famous library. Mindful perhaps of the Cardinal's reputation as a man so dyspeptic that he subsisted exclusively on a diet of chilled liquids that were inoffensive to his ruined palate, Lipsius omitted no possible compliment when writing on behalf of his protégé on the first of April 1605. Rubens, he declared, was "just what I would have wanted in a son if God had granted me one."[46]

Philip got the job. But he was not abandoning his old mentor and teacher entirely. He took with him a mint presentation copy of Lipsius's *Seneca*, to be delivered in person to the new Borghese pope, Paul V, together with a dedicatory poem and a portrait of the sage wearing his famous coat, trimmed with leopard fur. In one hand Lipsius held the book; the other rested on his black spaniel Saphyr, an emblem both of fidelity and stoicism in tribulation, since the little dog had met an unfortunate end by falling into a bronze pot of boiling water, a disaster that his bereft master had lamented with a Latin elegy: "O poor little one / You have gone to the threshold of dark Orcus / May brother Cerberus be kind to you."[47] When the books and painting were finally delivered to the Pope, both Rubens brothers attended the ceremony.

For after two years of work in Mantua, Peter Paul had managed to wrest from Duke Vincenzo another period of leave to make copies in Rome for the Gonzaga collection (no instructions this time on painting "beauties"). He had completed the great dynastic altarpiece for the Jesuit church in Mantua along with its companion pieces, a *Transfiguration* and the sublime *Baptism of Christ*. It was this second, exceptionally beautiful painting, in which Rubens effectively declared his wish to be taken seriously as the heir of the greatest Italian masters, self-consciously modelling his angels on Titian's soft manner, a group of athletically disrobing bathers on Michelangelo, and the figures of Christ and John the Baptist on Raphael, all of them set in a dazzling landscape with a Cross-evoking anthropomorphic tree at the center.[48]

Having made his point with the Gonzaga, Rubens might have wished

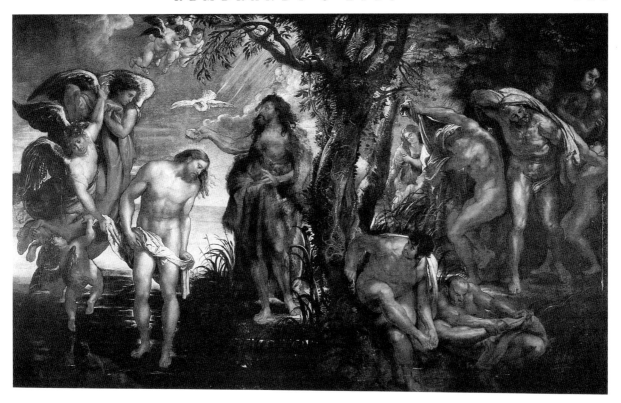

Rubens, The Baptism of
Christ, *c. 1605. Canvas,
482 × 605 cm. Antwerp,
Koninklijk Museum voor
Schone Kunsten*

to be rid of Mantua even had his brother's imminent presence in Rome not
been a powerful lure. It had been an ugly time in the duchy. A charismatic
monk of the kind that seemed to visit the Italian city-states with the regu-
larity of the pest, Fra Bartolomeo Cambi di Soluthio, had been screaming
at overflow crowds on the evils of the time and the punishments to follow,
strengthening his credibility with the usual dose of miracle cures. It was, of
course, Mantua's Jews who were held responsible for all the citizens' ills,
and the monk's answer to the Problem was, predictably, a brisk round of
expulsion and slaughter. The mood in the city became so hysterically
directed at the troops assigned to protect the ghetto that finally a few per-
fectly innocent Jews were picked at random, tried on a trumped-up charge
of assaulting a Christian, and publicly executed as scapegoats.

By December 1605 Peter Paul had removed himself to Rome. For the
first time since their schoolboy days in Antwerp, the brothers shared living
quarters, in a house on the Via della Croce, close to the Piazza di Spagna.[49]
Close by were a number of northern artists: Paul and Matthew Brill, with
whom Peter Paul went riding and sketching in the Campagna; and Adam
Elsheimer, the stunningly inventive artist from Frankfurt, who came to live
on the Via dei Greci and whose intensely compressed and ingeniously com-
posed histories-in-a-landscape may have reminded Rubens of Stimmer at
his most dramatic. When Elsheimer died prematurely in December 1610,
Rubens wrote: "I have never felt my heart more profoundly stricken with

grief [than] at this news."[50] It was not their only loss. The wildflowers were barely blooming in the ruins of the Forum when news came from Antwerp of two other deaths. The first, announced in a grieving letter from their friend Balthasar Moretus, was that of Lipsius, who had for so long been prophesying his own end and who had finally succumbed on March 26, 1606. A few days before his end, he had confided to a friend that Philip "alone had been the secretary who shared his own cast of mind, and that only those men should be loved to whom one's innermost secrets could be entrusted."[51] What the protégé felt at the loss of his closest mentor can only be imagined, but he agreed to contribute to a collective eulogy, in the Latin manner, to which the philosopher's most erudite pupils would all make a contribution. Less than a month later, the brothers heard that their only surviving sister, Blandina, had also died, perhaps taken by the plague then ravaging the cities of northern Europe, at the age of forty-two. Four of Maria Pypelincx's children had already preceded her to their graves: Bartholomeus, Hendrik, Emilie, and the oldest, Jan-Baptiste. Though she could still count on the support of her friends and the extended family of the Pypelincxes and the Lantmeteres, she now lived alone within the dark timbers of her house on the Kloosterstraat.

It was not enough to make her sons give up their Roman idyll, not yet at any rate. The summer of 1606 was a golden moment in their lives, a season of freedom cramped only by Philip's increasing awareness of Ascanio Colonna's irascible temper. But he worked away on his formidably strange compilation, the *Electorum Libri II*, a miscellany of observations and commentaries on all manner of Roman social minutiae: the precise trim (and color) at the border of the togas of different ranks and manners of Roman senators and nobles; the shape (and color) of the cloth flung into the circus to start charioteers' races; the sagum cloak favored by all ranks in the Roman army; the soft, ornament-studded footwear of noblewomen; the precise number and styles of tresses, braids, and ribbons favored by brides.[52] On all these and countless other sundry matters, Philip aimed to provide authoritative information, especially where Latin writers were confusingly contradictory. But he couldn't hope to propose his judgements without the clinching visual evidence offered by the equally dogged research of his brother, who carefully made sketches from sarcophagi, triumphal reliefs, busts, and statues wherever he could find them: standing in public sites; in the palazzi and gardens of the aristocracy; in the galleries of the Vatican; incised into the antique coins, gems, and cameos he was already busy collecting. Many of his sketches and transcriptions were meant to serve as illustrations for Philip's book, but equally Peter Paul was systematically accumulating a visual archive of historical detail which he would put to fruitful use in his own history painting. For Rubens the artist and storyteller, obsessing over the twist of an armlet, the clasp of a robe, was not trivial antiquarianism. It was the mark of an exacting narrator, the difference between historical credibility and the fanciful childishness of fable.

It was Peter Paul, then, who translated his brother's erudite nitpicking into visual archaeology. And this was the gift he used to brilliant effect in the commission he hoped would establish him as a true peer of the greatest Italian history painters of his time: the altarpiece of the Chiesa Nuova, the "New Church," of the Oratorian brotherhood.

The most important fact about the New Church was that it was very old, or rather that its site was said to date back to the earliest days of Christian Rome, the Church Primitive that many of Rubens's influential sponsors, like Cardinal Baronius, were committed to resurrecting. Under its old name of Santa Maria in Vallicella, the church had been built on the ruins of a Benedictine monastery founded by the late-sixth-century pope St. Gregory the Great. Gregory was remembered for any number of virtues and qualities: as an effective administrator of Italian provinces stricken with flood, famine, and barbarian invasion at a time when the Eastern Emperor's authority was present more in title than in reality; as the great patron of evangelical missions to Britain and Germany; as the codifier of plainsong and the promulgator of liturgy. But most important of all, it was Gregory who had most forcibly asserted and defended the supremacy of the succession of St. Peter, independent of the Byzantine Emperor and *his* Bishop, the Patriarch of Constantinople. This made Gregory the institutional (rather than nominal) founder of the papacy. It was apt, then, that it was Pope Gregory XIII who, in 1575, permanently changed the history of his church by granting it to the congregation of the Oratory.

The Oratorians were the disciples of Filippo Neri, a priest who had originally wanted to serve as a missionary to the Indies, but who had decided, rather, that "Rome shall be my Indies," and who in the 1550s had instituted a brotherhood to care for pilgrims to the Holy City. Increasingly, Neri was possessed by ecstatic visions, usually of the Virgin, that were so prolonged and so intense that priests accompanying him sometimes left the church while he was in the throes, and returned to continue the service once he had descended to reality. Naturally, Neri felt the need to share his visions with the laity, and the simplicity and passion of his preaching created a following that developed into a confraternity that was, in many ways, a striking alternative to the Jesuits: open and loosely organized while the Jesuits were tightly marshalled and secretive; proselytizing in public squares and calling the faithful to prayer through their "orations"; emotionally direct rather than intellectually driven; spontaneous and improvised rather than commanded along military lines. It was completely in character, for example, that Filippo decided to tear down the admittedly crumbling church which had been assigned to him and replace it with the most magnificent church in Rome before he had raised a single penny for its construction.

Such was the legendary sweetness, piety, and popularity of Neri that, especially after his death in 1584, funds poured in for the Chiesa Nuova. How could anyone resist a tribute to a priest who spent the last day of his life in May 1595 discussing points of faith with a long line of visitors

before announcing "Lastly, we must die" and then getting on with it? But while the body of Neri's church had been built by 1600, it was not until 1605 that the spectacular façade was finally completed and the Oratorians, led since 1593 by Baronius, could undertake its interior decoration. The work, conceptually as well as practically, was an extraordinary challenge, and for that same reason was without question the most prized commission in Rome. The successful artist needed to produce a scheme that would somehow contrive to bring together the complex history of the site and the simplicity of its most recent occupant (for Neri's remains had been interred in the church). It needed to invoke St. Gregory and the world of the early Roman saints and martyrs, many of whose remains (now preserved in the new church) had been discovered during the building excavations. And not least, the painting for the high altar, the Oratorians insisted, somehow had to incorporate a miraculous image of the Madonna (in actuality, a rather feeble fourteenth-century icon) said to stanch the blood of wounds, and which was the devotional focus of the brotherhood's cult of the Virgin.

It seemed inconceivable that a Flemish nobody, in Rome for less than two years, could succeed in winning the commission over the competition of the likes of Federico Barocci, before whose *Visitation* Filippo Neri was said to meditate every day. But Barocci, in his seventies, was probably thought too old; he was known to be brutally afflicted with digestive pains that had severely reduced his output, and in any case was unlikely to want to uproot himself from Urbino. Guido Reni, the rising talent, on the other hand, may have been thought too young and untried. Annibale Carracci suffered from apoplectic melancholia and had all but given up painting. Caravaggio was hidden away on the estates of his patrons the Colonnas, a fugitive from a charge of murder committed in May. This still left talents like Cristoforo Roncalli, who undoubtedly thought himself worthy of hire. But even had the competition been stronger, it's possible that Rubens might still have prevailed, as he wrote in a letter to Chieppio, "so gloriously against the pretensions of all the leading painters of Rome."[53]

For by the summer of 1606 Pietro Paolo Rubens was a figure to contend with. He could point to his first altarpiece in Santa Croce in Gerusalemme and the three great paintings that decorated the Jesuit church in Mantua. One of his major sponsors, Cardinal Giacomo Serra, was Genoese and in all likelihood knew the spectacular portraits that Rubens had painted of leading members (especially the women) of the Spinola-Doria dynasty in the Ligurian city-state. Whether he knew these works or not, Serra had enough confidence in Rubens to offer three *scudi* to the work on condition that it be awarded to the Fleming. And perhaps even more important, the *two* Rubenses were esteemed by the Oratorians as leading members of a Flemish-German circle boasting powerful scholarly and spiritual credentials. They were no longer, if they ever had been, outsiders, and Peter Paul was no longer thought of as a mechanical craftsman of the brush. When, on August 2, 1606, he was awarded the commission, Netherlandish artists could share the celebration and feel that Michelan-

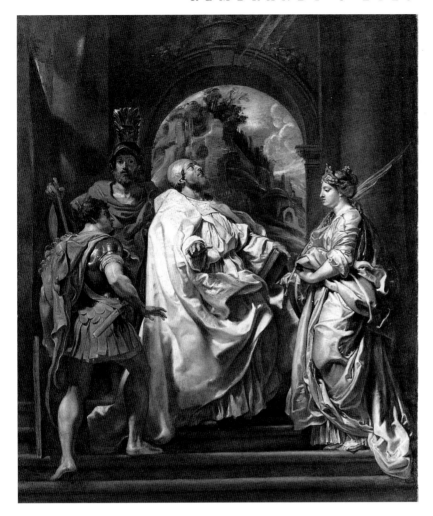

Rubens, Modello *for*
St. Gregory with Saints
Domitilla, Maurus, and
Papianus, *c. 1606.*
Canvas, 146 × 119 cm.
Berlin, Gemäldegalerie

gelo's jibe was at last off their backs.

Rubens's audacity may also have contributed to his success. To be seriously considered for the work, artists were required by the confraternity to submit recent proof of their skill and competence. Instead of delivering an earlier drawing, Rubens produced a large oil sketch (about five feet by four) representing what he had in mind for the altarpiece. It may be that he took full advantage of insider knowledge of the specifically prescribed subject matter of the altarpiece, but there is no doubt that this *modello* was a powerful demonstration of his fitness for the commission.[54]

Though at least three centuries separated the actual historical personae gathered on the steps before a classical arch, Rubens assembled them as witnesses to the moment when Rome turned from pagan power to Christian salvation. The arch frames a view of the eroded ruins of the Palatine hill with the little church of San Teodoro, long thought to have been the site of early Christian martyrdoms. Standing to Gregory's left, swathed in opulent violet-gray silk, is Flavia Domitilla, a relative of the Emperor Domitian who was burned to death in the second century for refusing to sacrifice to the gods and idols of the late empire. The two figures dressed in imperial armor are the early martyrs Maurus and Papianus, but they might easily have recalled the saints in whom Baronius and the Oratorians took special interest: Domitilla's eunuchs Achilleus and Nereus, both of whom had originally been soldiers before the sudden conversion that guaranteed their own martyrdom, and whose relics were preserved at the cemetery of Domitilla.[55]

As was his practiced habit by now, Rubens trawled through his archive of sources for both the specific figures and the overall composition: Gregory's hands, one outstretched and foreshortened, the other grasping a book, were taken from Raphael's Aristotle in *The School of Athens;* the heads of the bearded soldier-saint and Domitilla both owed their origin to

classical busts, and the gathering of holy figures about a sacred apparition (in this preliminary version, implied by the light streaming down toward Gregory's upturned face) to Titian's *Virgin in Glory with Six Saints*. But for the brilliant alternations of movement and repose, light and cast shadow (on the right leg of the smooth-faced soldier-saint, for example); for the shallow space on which the "drama" is staged and the deeply pierced recession of the land-scape; and above all for the dazzling play of intensely colored drap-ery, shifting and lifting as if moved by the force of the drenching radiance, Rubens owed nothing whatsoever to his prede-

Rubens, Saint Gregory with Saints Domitilla, Maurus, and Papianus, *c. 1606–07. Preparatory drawing for the Chiesa Nuova. Montpellier, Musée Fabre*

cessors. Here, incontrovertibly, he is the inaugurator.

Between early August and September 26, when the contract between Rubens and the Oratorians was signed, the artist refined his design further. The pen-and-chalk drawing now in Montpellier seems to have been the "draft" (*sbozzo o disegno*) required for the Oratorians' approval before the final version could go ahead. The arch and landscape remain, though the number of saints in addition to St. Gregory has increased from three to five. In other respects, too, Rubens has softened the Roman solemnity which made his first sketch so compelling. The bearded soldier no longer stares directly and challengingly at the beholder but converses with his col-league. Cherubim hold Gregory's holy book for him and fly overhead about the embellished frame, which would hold the miraculous Madonna. Only the head of Gregory has become more rather than less severe, much older and smooth-shaven, wrinkles and wattles carefully described, wear-ing a recognizable mitre rather than the interestingly strange cap (some-thing out of Philip Rubens's researches) of the oil sketch, its red and white bands soaking up the holy sunbeams.

The finished version was painted in the first half of 1607, during an

extension of the Roman leave requested by Rubens and granted by the
Duke, who doubtless was made aware of the reflected prestige of having
"his Fleming" execute the most important commission in Rome. It com-
bined some elements of both the earlier drafts but replaced their austerity
with an effect of startling sensuousness. The bearded figure behind Gregory
once again looks directly at the beholder, but he has suddenly become a
nude and his face has the full, rosy lips and gentle curls of the Rubens
brothers themselves. All the drapery has been made elaborately gorgeous:
Roman armor now trimmed with leopard skin; the overlapping steel plates
embellished with visibly chased images of bulls' heads and grimacing faces.
Domitilla has grown golden tresses that fall to her exposed shoulder and
whose intense hue is picked up in the loose robe slung over a dress of shim-
mering scarlet, blue, and imperial purple. Even Gregory's own robe is now
heavily brocaded and further ornamented by a brilliantly colored cope on
which the embroidered features of St. Peter, seated *in cathedra* and holding
the keys of the apostolic succession, are conspicuous.

The painting puts on a show, dazzles, perhaps a little too glaringly. Fi-
lippo Neri had been a great advocate of painting as a *Biblia Pauperum*—a
Bible for the poor and unlettered. But even he might have recoiled slightly
from Rubens's grandstanding parade of heroic textiles, the flamboyant
insistence on the compatibility of sumptuousness and saintliness. There is
an unavoidable impression here of a young prodigy determined to show off
his mastery of every skill in the painter's book, from architecture to cos-
tume, flesh tones to the perfect representation of steel plate and animal fur.
In one of the more outrageously gratuitous demonstrations of virtuosity,
Rubens makes the stone detail of a Corinthian capital exude the *real* foliage
of a eucharistic vine that descends the column as a luxuriant wreath, dead
stone transformed into living nature through the Madonna's miraculous
mystery. In the end, though, the disconcerting gorgeousness of the spectacle
is held in control by the calculated piety of the composition. At the right
and left, pairs of eyes are raised toward the image of the Virgin, from
whom illumination flows. And at the center, Rubens has succeeded in mak-
ing Gregory a figure that manages to combine virility with tenderness, a
princely bearing (appropriate for his forceful political history) with saintly
devotion. By replacing the Palatine hill with a sky of piling clouds and bro-
ken light, learned allusion has been sacrificed to purely pictorial drama.
Instead of being absorbed into the landscape, the saint's profile, with its
flickering whiskers and sympathetically luminous skull, is now sharply out-
lined against the celestial blue vault and touched (almost literally) by the
dove-white Holy Spirit.

No wonder Rubens would declare the work to be "by far the best and
most successful work I have ever done."[56] He had finished it by the late
spring of 1607, but had to wait for its installation in the Chiesa Nuova
until the sacred image of the Madonna had been moved to its new position
within his painting. In the meantime, he endured a prolonged period of
anticlimax. Alarmed at reports that their mother, Maria, now in her seven-

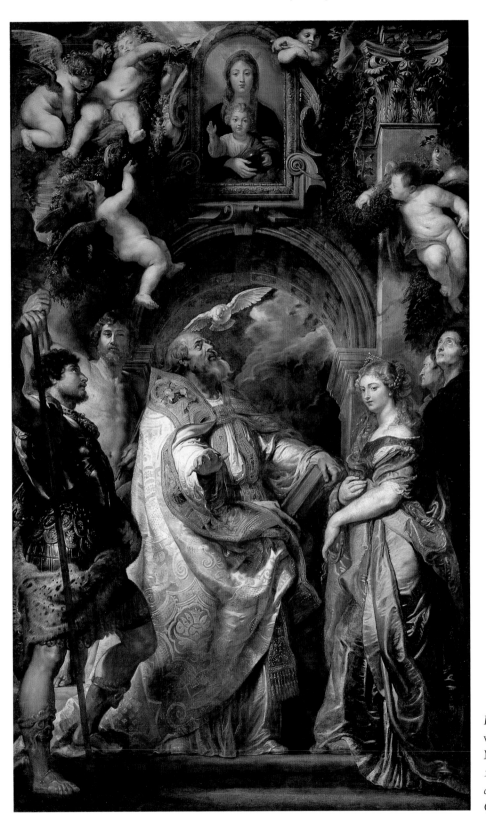

Rubens, Saint Gregory with Saints Domitilla, Maurus, and Papianus, *1607. Canvas, 477 × 288 cm. Grenoble, Musée de Grenoble*

ties, was suffering increasingly from bouts of asthma, Philip had returned in haste to Antwerp. Peter Paul's regular stipend from Mantua had been arriving only intermittently, and the second installment of his eight-hundred-crown fee due on the Chiesa Nuova altarpiece had been held up by the absence of his primary patron, Cardinal Serra, in Venice. Now it seemed Duke Vincenzo wanted his artist back for a summer visit to Flanders and Brabant, where he once again had need of the healing waters of Spa.

Worried about leaving the business of the altarpiece unresolved, Rubens nonetheless agreed to return to Mantua, and would certainly have been looking forward to a journey home when he suddenly learned of a change in the Duke's plans. Instead of Flanders, Vincenzo and the court would spend the summer of 1607 in Genoa, amidst the villas of San Pietro d'Arena, where terraces scented by orange blossoms and jasmine dropped steeply down to the indigo Tyrrhenian Sea. The real business of his life must have seemed strangely held in abeyance. Being Rubens, he used the time to make copious notes on the palatial villas of the Genoese patriciate, which were less grandiose and imposing than their Roman counterparts and more hospitably opened to the Ligurian sea breezes. He kept company with the Spinola-Doria and the Pallavicini, sipped iced fruit in their gardens, bowed his tall back in gallant deference to their ladies, patted the heads of their pet apes and dwarves, and clicked his tongue at their disdainful macaws. Some of the patricians had already sat for him; others did so now. Gian Carlo appears as a Knight of Santiago, performing the levade, his horse raising its front legs while being controlled by a single hand on the reins; a scarlet sash windblown above the Ligurian cliffs. Veronica Spinola's sharp little face, made sharper still by a blood-red carnation tucked into the tight curls at her ear, appears above its monstrous ruff like a pale sweetmeat set on a salver. Her upper body is punishingly corseted in the Spanish manner favored by the Genoese, but ever the master of sensual implication, Rubens allows her pearl necklace to hang with enticing unevenness.

The portraits of the Genoese princesses are, in their own right, stupendous formal inventions: controlled explosions of saturated color. They also reinvent a genre. For in the long history of portraiture, full-length grandiloquence had been strictly reserved for reigning sovereigns like Elizabeth I or Catherine de' Medici. Rubens gave his Genoese ladies the full royal treatment but opened their settings to the breath of living nature.[57] Draperies stir, albeit ever so slightly, in the light wind. July afternoon sunlight trickles over creamy skin and dark silk. Rubens's loaded brush moves smoothly across the canvas, rendering surfaces and textures with astounding exactness but also finding the flesh beneath the mannequin's costume. He possesses his subjects, reembodies them, makes them over into festivals of the senses.

But these were just summer satisfactions. Rubens's mind dwelled, not altogether quietly, on the fate of his great painting for the Chiesa Nuova.

OPPOSITE: *Rubens, Portrait of Veronica Spinola Doria (detail), c. 1607. Canvas, 225 × 138 cm. Karlsruhe, Staatliche Kunsthalle*

Rubens, Virgin and Child
Adored by Angels, *1608*.
Slate, 425 × 250 cm.
*Rome, Santa Maria in
Vallicella*

And when, at last, the day came to set it in place above the high altar, he knew at once that he was facing yet another of the disasters sent to try his stoicism. The problem was the light; not the weakness of it (as in many Roman churches), but the flood of radiance pouring through the high windows of a church specially designed to admit it in abundance. The entire effect of Rubens's work depended critically on subtle modulations of tone between brilliant and softer passages of color, and these were all but obliterated by the intense reflections that danced like quicksilver over his glossy finish. "The light falls so unfavorably on the altar," Rubens wrote grimly to Chieppio, "that one can hardly discern the figures or enjoy the beauty of color and the delicacy of the heads and draperies which I executed with great care from nature and completely successfully according to the judgement of all. Therefore, seeing that all the merit in the work is thrown away and since I cannot obtain the honor due my efforts unless the results can be seen, I do not think I will unveil it."[58]

The Oratorians themselves could see the problem. But a contract was a contract. Confident that he could find a more acceptable place for the painting, Rubens readily agreed to replace it with some sort of copy, painted this time on slate, a surface that ran no risk of reflection. But the gray stone seemed to contaminate the entire project with its dullness. For either in haste, resignation, or disgust, Rubens now proceeded to disassemble the elements which, tied together in his composition, had produced a genuinely miraculous encounter between the earthly and heavenly realms. Instead of a single, integrated work, there were now three discrete, though

related, paintings. The saints that had gathered about the heroically pivotal figure of Gregory were now divided into two separate groups set on the sides of the apse, as if heraldic supporters or donors. Gregory, no longer gorgeously garbed in white silk, stands with Maurus and Papianus on one side. Domitilla, who has had her imperially resplendent costume made sober, is accompanied by the eunuchs, all of them more aggressively statuesque and authoritative than in earlier versions. And as if he were answering a criticism that the Virgin had been upstaged by her saintly devotees, all the emotional force of the work has now been transferred to the Madonna and Child, swamped with cherubs and floating above a cloudy amphitheater of angels who act as intermediaries-in-adoration. This is what remains to be seen today in the Chiesa Nuova: an adequate and obedient work, but utterly missing the marriage of the sensual and the visionary that had made the original so magnificently peculiar.

Rubens now had one surplus-to-requirement altarpiece and was distressingly out of pocket. Cardinal Serra had paid some 360 crowns toward the agreed price of 800, but pending payment of the balance, Rubens himself had spent a further 200 in costs. He remained confident, though, that he had an alternative buyer in the person of the Duke of Mantua, who, as he wrote optimistically to Chieppio, had expressed an interest in having one of his paintings in his gallery. Of course, there would be Roman patrons lining up to relieve him of the redundant altarpiece, but he did not think it fitting for his reputation to have two virtually identical paintings in the same city. As the letter proceeds, a tone of anxiously strenuous salesmanship begins to intrude. Did the price seem a mite steep? "I should not base it on the estimate of Rome but leave it to the discretion of His Highness." Size? No problem at all, for the painting was tall and narrow, just right for the Mantua gallery. Knowing his patron's taste for glamour, Rubens emphasized the "rich dress" of the figures. Was not the subject matter a little esoteric? On the contrary, it was handily portable, since "though the figures are saints, they have no special attributes or insignia that could not be applied to any other saints of similar rank."

Even by Rubens's standards of polished disingenuousness, this was a bit much. No one knew better than he how precisely and painstakingly the painting had been matched with its site. Its brilliant evocation of the transformation of pagan into Christian power depended entirely on a strong awareness that beneath the polished marble of the Chiesa Nuova were layered relics and memories of the early Church, its Roman and Gregorian archaeology. Doubtless Rubens was relying on Vincenzo's ignorance of this complicated history to sell his painting as a saint-of-your-choice altarpiece.

Rubens may also have been betting that since the Duke had taken his advice the previous year and had bought a large sacred work on his recommendation, he would be prepared to act once more on the same principle. The painting in question, moreover, had not been an obscure item but Caravaggio's *Death of the Virgin,* intended as an altarpiece for the church of Santa Maria della Scala and then rejected by the Carmelite fathers who had

Caravaggio, The Death of the Virgin, *1605–06. Canvas, 369 × 245 cm. Paris, Musée du Louvre*

commissioned it. Quite apart from his notoriety as a murderer, Caravaggio had gone a little too far in his aggressive naturalism for the taste of the Carmelites. The artist had only meant well by giving prominence to the bare legs and feet of the Virgin, since it was, after all, the Discalced (or Barefoot) Carmelites who had commissioned the subject and with whose equally unshod feet the painter evidently wanted to establish Mary's close affinity. But the shock was such that it led to the usual anti-Caravaggio rumors that he had used a prostitute as a model. The uncompromising portrait of an emphatically defunct Virgin may also have given offense to those among the Carmelites who shared the popular view that Mary had merely fallen into an eternal sleep. It was precisely the courage of Caravaggio's physical boldness, together with the intensely emotional sculptural grouping, that is likely to have most appealed to Rubens, whose own work was moving in just that direction. His intervention in this case, notwithstanding the many scandals clinging to Caravaggio, was a strong statement of his belief in the transcendental virtue of art. That Rubens was himself so much a paragon of virtue only makes the testimony more eloquent. But given his paternity, Peter Paul could hardly help understanding the nature of human weakness even as he himself sought to master it.

Rubens not only managed to buy *The Death of the Virgin* for the Duke of Mantua, he proceeded to put it on display for a week, from the seventh to the fourteenth of April 1607, convinced that the profoundly reverent quality of the work would silence the mutterers. It was such a success that he proposed an almost comparably sensational promotion for his own work, unveiling the altarpiece in a public display where it too could be admired by the crowds. Their guaranteed acclaim, he assumed, would make it almost impossible for the Duke to decline.

This time, though, Rubens was sadly mistaken. Perhaps it was just because the Caravaggio had been bought for the Mantuan collection for

350 crowns, and at a time when the ducal treasury was more than usually empty of funds, that Vincenzo declined to buy his altarpiece. By the end of February 1608, Rubens changed his tune and requested, with understandable impatience, that the arrears of his stipend be paid up, as well as the moneys due to Cristoforo Roncalli, who had long since completed a work for the Duchess's private chapel and who was asking 500 crowns for it. Chieppio's view was that this was steep for a painting smaller than the Caravaggio. Rubens, who had arranged the commission, wrote that "I am alarmed at such indifference in matters of payment," suddenly sounding like an Antwerp banker.

When he returned to Mantua, sometime in the spring of 1608, the pleas of parsimony seemed transparently unconvincing. While his altarpiece sat in paper and cloth wrapping on the floor of his studio in the Ducal Palace, the court indulged itself in the extravagance expected when a dynastic son (Francesco) married a Habsburg (Margaret of Savoy). Monteverdi's *Arianna* and a ballet were performed; mock Turks battled with real Christians on the Mantuan lake; fireworks traced through the night sky; and the whole of Mantua was lit with thousands of colored paper lanterns. Gonzaga fairyland. It could never end.

Alas, the Duke was mortal. As summer drew on, Vincenzo, feeling his age, decided to depart once more for the healing waters of Spa. Rubens was not invited to accompany him. The letters from Philip concerning their mother's asthma grew steadily more disquieting, and when Vincenzo was in Antwerp he had been expressly asked, first by Philip and then, in a letter, by the Archduke Albert, whether Peter Paul could be allowed to return. Vincenzo responded that such was his painter's love for Italy, this would be very hard to accede to. But by the end of October, Maria's condition had seriously deteriorated. Writing from Rome, where he was still making preparations for the unveiling of the Chiesa Nuova painting, Rubens requested permission to return to Flanders, and while reassuring Chieppio that he would return to Mantua when the crisis was over, he nonetheless did not wait for a reply. "I kiss your hands in begging you to keep me in your favor and that of my Most Serene Patrons" was how he ended the letter, signing off, "Your devoted servant Peter Paul Rubens, *salendo a cavallo* [leaping into the saddle], October 28, 1608."

Other than during the winter snows, it usually took letters a little more than two weeks to travel from the Netherlands to Italy. A note from Philip relating Maria's death would have been crossing the Alps when Peter Paul took horse for Antwerp. He was, as we know, proud of his horsemanship, and it may well be that he rode all the way from Italy to Flanders, changing mounts at tavern stables and using mules for the mountain passes. But if the dust flew beneath his horses' hooves, it was in vain, for Rubens arrived to find his brother in mourning and his mother already interred in the Abbey Church of St. Michael, close to the house on the Kloosterstraat where she had spent her last years. It's not difficult to imagine the grief, certainly mingled with guilt, that Rubens must have felt on his tragically tardy

return. It could not have helped, sorting through Maria's belongings—beds, tables, chairs, hangings, linens, and books. Most of these things had been bequeathed to the two brothers, who were also Maria's executors. Peter Paul may have felt the sharpest pang on learning that she had made a point of exempting all her paintings,[59] other than family portraits, as "the property of Peter Paul, who has painted them," and which, she added, were especially fine.

Rubens assuaged his sorrow the only way he knew: by designing an elaborate altar in her burial chapel and setting above it the profoundly beautiful painting he had taken down from the Chiesa Nuova. The celestial Maria took up station over the remains of the earthly Maria; remembered, each of them, as a *Madonna mediatrix*, a compassionate intercessor for the sins of mankind.

CHAPTER FOUR · APELLES

IN ANTWERP

i *Honeysuckle*

It was not ideal, receiving the nuptial blessing beside her late mother-in-law's tomb. But Isabella Brant was unlikely to have complained. She was, after all, a few days shy of eighteen, thirteen years younger than the groom, and eighteen-year-old girls in Antwerp were expected to show respect for their husband's family, even had the tomb in question belonged to someone less famous for her saintliness than Maria Pypelincx. For that matter, St. Michael's Abbey, where the matron lay in her stone bed, was, in a manner of speaking, their neighborhood chapel, standing as it did on the Kloosterstraat, a few paces in one direction from the Rubenses' house, a few paces in the other from the Brants'. So Isabella was probably content. She was marrying her city's prodigy, scarcely returned from Italy before honors were heaped upon his head. And such a good-looking head, too, with its high brow and strong, straight nose, his chestnut beard and whiskers shot through with golden lights, a dashing ornament for his ready smile.

And what did Peter Paul see when he looked at his bride? First of all the eyes, enormous, feline; the eyes of the sharp-eyed lynx that his friends in Rome had taken for the emblem of their academy of the intellectually curious, the Lincei. Isabella's eyes, intriguingly turned up at the corners as if expecting a jest, her sharply arched eyebrows and the slight curl of her upper lip—all gave her face a quality of elfin playfulness. Her form was trim and delicately shaped, with nothing of the doughy heaviness that made so many Flemish girls resemble puddings in petticoats. And she was, even before the betrothal, family. Her mother's sister, Maria de Moy, had married his brother, Philip, just the year before. It was a sorrow that their mother had not lived to see them both wed. She would have had much satisfaction from the matches, seeing as they were made with good friends, people who were careful to remember only the best things about Jan Rubens. Like their late (and on these occasions at least) lamented father, Jan Brant was an advocate, but also a Latinist who found time between the

law and his duties as one of the city secretaries of Antwerp to write commentaries on Caesar, Cicero, and Apuleius; very much one of their kind.

The solemnities done, there would have been a feast in the Brant house. The Antwerp that mattered would have come: burgomasters, aldermen, magistrates, treasurers of guilds, officers of militia companies; men who had grown rich, or whose fathers had grown rich, on spices and textiles, diamonds and tapestry; men who chose not to flaunt their capital but to spend it instead on houses designed to contain their paintings, antiquities, and curiosities—exotic shells and coral; Roman cameos, intricately wrought; skeletons of armadillos and capybara—men whose conversation, peppered with well-travelled exclamations in Italian or French, turned less on the Bourse than on the edition of Marcus Aurelius they were preparing, or their latest correspondence with a French numismatist; an altogether uncommon company of friends.

Bride and groom might have worn their marriage crowns in the old Flemish fashion, but the music of the country, burping sackbuts and droning bagpipes, would have given way in this company to delicate Italian airs and singing viols. And since there could be no true rejoicing without poetry, Latin verse, of course, would have been declaimed with the exaggerated grandiloquence they had learned at school, but spiced at suitable intervals with the winking mischief of the bawdy stage. All best men who have risen to their feet and to the occasion will immediately recognize the formula. First, a greeting to Hymen, the god of marital consummation, only slightly off-color. "We call on you this night, this night so joyful for my brother and which he so ardently desires, as does your young bride. To be sure your virginal impatience must today be tempered, but tomorrow you will vow that the night has brought you the most beautiful day."[1] Next, the required, but slightly laborious, tribute to parents (which in the seventeenth century meant fathers), one living, one dead—Jan Brant, virtuous and learned: "[There is] no one better informed of the archives of our city and the customs of our ancestors"; and Jan Rubens, lauded noticeably more expeditiously: "Our father who sat in the Senate was no less [distinguished] whether explaining the enigmas of the law or giving advice with his eloquent speech." Then, warming to the work, a more excited tone; the naughtier the innuendo, the more melodramatic the manner, with much sweeping of arms: "Already, the God is impatient to light the nuptial flame and enter the domestic sanctuary where he sees the conjugal bed, the arena of Venus, appointed only for innocent battles."

Guffaws or sniggers must have sounded, followed by an outbreak of rib-poking and glass-clinking. The bride colors. The groom feigns despair. It's of no avail. The brother goes on, mercilessly merry: "Stay there alone, young bride, alone with your husband. He loves you with all his heart and he will tell you all the sweetest things that only the great master of love can teach. And even as he speaks such tendernesses, he will give you such kisses as Cupid gave to Psyche and Adonis to Venus. And you must give way. It is the law."

It was a springtime of flowers and pious wishes in the city of the Virgin. A cease-fire had been in place since 1607, but the official truce had been signed in the Staatenkamer, the Chamber of the States, in the Town Hall in April 1609. Fireworks had roped through the sky. Carillons had pealed through the night. Much wine was drunk and many pipe dreams smoked. The Scheldt would be reopened; the harbor would once more fill with sail; the fat years would come again to Flanders; the old metropolis would rise from its bier, more vigorous than ever, to greet its new golden age. Perhaps the old seventeen provinces of the Netherlands might even be reunited. Alas, most of those who fervently prayed for such a reunion did not (unlike Rubens) do so in a spirit of compromise, toleration, and reconciliation. The Jesuits, recently reinstalled in their new college, passionately wanted such an outcome, but only so that the heretics of the north might see the error of their ways and return to the true allegiance of Church and King. North of the river deltas, Calvinist preachers (who were none too happy about the truce) also prayed for a reunion, but only through a godly Protestant war that might recover the "lost" provinces of the south.

In the middle, the pragmatists who had actually crafted the truce were under few illusions about its prospects. The financial toll the war was taking on the Dutch economy had convinced the Republic's Lands-Advocate, Johan van Oldenbarnevelt, of the necessity of somehow halting it. For some time, the damage had been predominantly one-way, with Dutch warships inflicting heavy losses on the Spanish empire. Latterly, though, the strain had been felt acutely in the treasuries of the towns of Holland, to the point where it could be relieved only by punitive taxation. In Castile, Rubens's old patron, the Duke of Lerma, had come to regard the Army of Flanders as a vast sluice down which drained the Mexican silver that might otherwise have been used to rescue the Spanish crown from bankruptcy. The fact that he was supported in this conservatism by the Marquis de Spinola, the military hero of the Netherlands campaigns, must have weighed seriously with King Philip III. After much soul-searching, the King and his minister let it be known to Albert and Isabella in Brussels that they would be prepared to negotiate a truce, meeting the Dutch condition that the seven United Provinces be treated henceforth as "free lands." The quid pro quo was supposed to be that the Dutch would dismantle their military and colonial possessions in the Indies, where the Spanish crown was truly anxious that they would collapse in the face of further Dutch aggression. But this was never a political possibility for Oldenbarnevelt, nor indeed was meeting the Spanish fallback position of insisting on open toleration of Catholic worship in the Dutch Republic. In the end, the Habsburgs (as all Europe noticed) swallowed their pride and settled for an armistice, a breathing space that would allow the wounded Netherlands to stanch the flow of money and blood.[2]

For some of Rubens's old friends like Caspar Scioppius, the truce was an ignominious defeat. Military evidence notwithstanding, Scioppius still believed in the restoration of a Christian empire, absolute and undivided.

But he was far away in Rome, dreaming Jesuit dreams. In Antwerp, the seventy clans that governed the city, most of them friends of Rubens, openly rejoiced in the respite. It was air, light, life. They would have it. For the Archdukes Albert and Isabella, it was, at least, something to build on. And build they did. In 1605 they had already summoned one of the most gifted of the Flemish virtuosi in Rome, Wensel Cobergher, painter, engineer, and architect, to serve as court artist at Brussels. Together with the Archdukes, Cobergher planned an ambitious program of building: Jesuit churches in Brussels and Antwerp; new pilgrimage chapels on Marian miracle sites; and, since piety was supposed to be joined with prosperity, a canal joining the rivers Scheldt and Maas, thereby bypassing the Dutch blockade at the first estuary mouth.[3]

It was only to be expected that Rubens would be offered the same honors and privileges extended to Cobergher and Jan Bruegel, the son of the great Pieter. The Archdukes may even have been concerned that Rubens did not seem irreversibly committed to staying in Antwerp. As yet, he had given no indication to the Duke of Mantua that he would not be returning to Italy, and during the bleak Flemish winter of 1608–9 he may well have thought fondly of the skies of the south and of his good companions in Rome. To one of them, Dr. Johannes Faber, the "Aesculapius" who had cured his pleurisy, he confided, as late as the tenth of April, that "I have not yet made up my mind whether to remain in my own country or to return forever to Rome."[4] *Forever* was an enormous word, especially from someone who measured words as carefully as Rubens. But he had, he told Faber, "an invitation on the most favorable terms." "Here they also do not fail to make every effort to keep me by every sort of compliment. The Archduke and the Most Serene Infanta have had letters written urging me to remain in their service. The offers are very generous but I have little desire to become a courtier again."[5]

Albert and Isabella must have been aware of Rubens's reservations. They knew Vincenzo Gonzaga only too well and could have sensed Peter Paul's deep reluctance to surrender his liberty once more to princely beck and call; to ask permission where he might reside, what he might paint, how much he could, or could not, be paid. So they made it easy for him. Rubens would not have to reside at Brussels with their court but could remain in Antwerp. (They had, in fact, granted the same nonresidential privilege to Jan Bruegel.) He would be paid five hundred florins a year but, apart from initially painting their portraits, would not be expected, by the terms of his position, to do any particular work other than what he might decide for himself. Any further work done expressly for the Archdukes would be paid for per item. He was also freed from the regulations of the artists' guild of St. Luke, including the restriction on the number of pupils he might take and what he might charge them. And just in case this was not already enough, Rubens would also be exempt from all state and city taxes.

Whatever offer he might have had from Rome, it could hardly have matched this handsome opportunity, and in the third week of September it

was announced in letters patent that Rubens had been officially "retained, commissioned, directed and established" as "painter with our *hôtel*."[6] If, once resigned to staying at home, he still hankered after Italy, he could now enjoy it at a distance in the company of the "Romanists," an Antwerp society of artists and scholars, all of whom had spent time there and who met to discuss its antiquities and reminisce over its contemporary pleasures. In June 1609 Rubens had been welcomed into the society (which included his brother and his father-in-law) by its dean, Jan Bruegel, and he would have found there a number of other painters, like Sebastian Vrancx and his old teacher Otto van Veen, with whom he could share congenial memories of Rome. It may not have been quite like sharing his house with Philip on the Via della Croce, but it was at least possible to gossip about the cardinals and their libraries and mourn the deaths, in the same year, of their two great contemporaries, Caravaggio and Adam Elsheimer. In both cases, Rubens and his friends, in their neo-Stoic fashion, could allow themselves a little moralizing on the subject of great talent prematurely lost to art through personal failings. Caravaggio's weaknesses were only too well known. But "Signor Adam," as Rubens fondly called him in a letter to Faber, who "had no equal in small figures, landscapes and many other subjects," but who "died in the flower of his studies," had, Rubens believed, partly brought misfortune upon himself through "his sin of sloth by which he has deprived the world of the most beautiful things, caused himself much misery and finally, I believe, reduced himself to despair; whereas with his own hands he could have built up a great fortune and made himself respected by all the world."[7]

No one would ever accuse Rubens of neglecting fame and fortune, nor of frittering away his days. His personal regimen was a model of energetic orderliness. According to his nephew Philip (as recounted to the French critic Roger de Piles), he rose at 4 a.m, heard mass, then set to work as soon as there was light, listening to a reader recite from the classics while he sketched or painted. His meals, like most everything else about Rubens, were temperate, and especially sparing of meat "for fear that the vapor of meat should hinder his application and, having set to work, that he would fail to digest the meat." In a town awash with beer and wine, he drank little, and made sure to take his daily ride "on a fine Spanish horse" in the afternoon.[8] Yet for all this studied moderation, there was nothing about Rubens that seemed austere. To guests he was the soul of cordiality; to correspondents, a fountain of helpful information and counsel. Above all, an ascetic could hardly have produced the kind of works Rubens was painting during his first years back in Antwerp: sensuous, tender, drunk with color.

The Adoration of the Magi, specifically commissioned by the Antwerp city council in 1609 to commemorate the signing of the Twelve Years' Truce, while ostensibly a religious history, was as sumptuously processional as anything produced by Titian or Tintoretto for the doges of Venice. A spectacular oil sketch preserved in Groningen shows Rubens working with what a seventeenth-century biographer called *la furia del pennèllo*, the

Rubens, The Adoration of the Magi, *1609. Canvas, 320 × 457 cm. Madrid, Museo del Prado*

fury of the brush, laying in ideas, modelling, and color tones with phenomenal freedom and fluency. In the sketch, torches flare into a night sky, lighting a scene dominated by the kneeling King, clad in a rich, golden cape that reflects his offering to the Christ child. His two colleagues are equally regal, one given a prophetic white mane of beard that flows over a crimson velvet gown, the African Balthasar dressed in a pure white Maghrebi burnous and headdress. As in his *Baptism of Christ*, Rubens has imported into the scene a group of muscled Michelangelesque nudes, here made to do the work of carrying the royal gifts and luggage. Their bent and straining forms make a counterpoint to the gentleness of the scene around the crib, where a surprisingly sumptuously clad Virgin supports a naturalistically floppy-spined infant as he receives the adoration. In the final version, Mary has been given the more traditionally modest blue robe, and the visual center of the painting has shifted from the kneeling King to the standing crimson-dressed King, while their retinue is packed with a host of character types: long-nosed turbaned viziers deep in conversation, burly soldiers, and a herd of camels. But the painting was substantially altered by Rubens during a trip to Madrid in 1627, after it had been acquired by King Philip IV of Spain, not least to include a portrait of himself as a knight on horseback, complete, of course, with sword and chain of honor. In both versions, though, the air of oriental opulence, the great show of fabric and treasures,

threaten to drown out the innocence and simplicity of the Scripture. But this is, of course, precisely what the patricians of Antwerp, who themselves existed in a world where piety and gorgeousness were natural partners, wanted for their great ceremonial space.

Rubens, Samson and Delilah, *c. 1609. Panel, 185 × 205 cm. London, National Gallery*

Morality and sensuality were intuitively married in Rubens's creative personality, as if inherited, respectively, from his mother and father. From early in his career in Antwerp, Rubens (like Caravaggio) excelled in histories where physical force and psychological subtlety needed to be brought together. It seems to have been just what his friend Nicolaas Rockox, the burgomaster of Amsterdam, wanted for the *groot salet,* the great room, of his elegant house on the Keizerstraat, since he hung Rubens's *Samson and Delilah* directly above the fireplace as a showpiece. Once again, it's possible to make an inventory of the iconographic elements culled from Rubens's trove of sources for his great painting: the Roman head that must have served as the model for Delilah; the antique sculpture of Venus with a blindfolded Cupid set in a wall niche; the burning candle, an emblem of lust, gripped by an old procuress (reinforcing the popular convention that Delilah was a whore); the presence of Michelangelo looming behind the colossally muscled hero and his mistress, posed in the attitude of *Leda and the Swan.* But the painting is much more than an assembly of these commonplaces. It depends for its effect on calculated juxtapositions of delicacy

and brute force that are sometimes so startling they have led some commentators to conclude mistakenly that the painting could not be by Rubens at all[9]—Delilah's pink hand, with its slender, tapered fingers laid caressingly upon Samson's tawny back; the concentrated fastidiousness with which his captor awkwardly angles his hand to shear off a curl without waking the giant; the fierce look delivered by the captain of the Philistine guard at a soldier as if in warning not to make a sound; the perfectly smooth feet of Delilah, trapped and immobile beside the animal skin wrapped about Samson's hips. In this last fatal moment of repose, gathered beneath the heavy swag of a purple canopy, there are still the marks of animal action: the throes of sexual transport recapitulated in the liquid scarlet silk of Delilah's gown; the white chemise awkwardly disarrayed as if torn apart in Samson's hungry impatience to feed at her voluptuous breasts. Samson sleeps the sleep of the satiated, lips apart, nostrils slightly dilated, one hand curled back in utter relaxation, the other resting on his mistress's belly, a pillow for his own cheek. He is the pathetic brute, omnipotence made impotent.

Samson and Delilah were not the only pair of lovers Rubens painted around the year of his marriage. But if the Old Testament story is the most sensually direct account of the fatal results of unmastered passion, his own *Self-portrait with Isabella Brant* represents its exact opposite: the perfect contentment of a love that has been securely housed within the bonds of matrimony. Though the painting seems relaxed, the proper decorum for a marriage portrait has in fact been observed. Isabella sits at a dutifully inferior position from her husband, her right hand resting on his cuff in an informal version of the *dextrarum iunctio*, which even in antiquity symbolized the sacred and binding union of man and wife, and which in both Catholic Flanders and Protestant Holland appeared on betrothal rings, custom-struck "wedding coins" and medals, and countless other celebratory objects.[10] Even the honeysuckle which arches above their heads, forming itself into a bridal bower, could be considered a variation of the vine that in the moralizing emblem books of the time invariably twines itself about the sturdy trunk of a husbandly oak or elm. But Peter Paul is not only Isabella's stout support; he is also Isabella's *dappere ridder,* her brave knight, his left hand resting on a finely wrought sword hilt, the traditional chivalric gesture of protection. Never mind that Rubens was not yet knighted, and thus not yet entitled to wear a sword; his father and other advocates had long argued that families of the law were by definition gentlemen, and as far as Rubens was concerned, that went for court artists, too.[11]

Trawling through his visual and textual archives for the icons, associations, and images appropriate for his composition was merely the first stage in Rubens's conceptualization of his paintings. The real work of naturalizing those conventions, dressing them in credible flesh-and-blood human vitality, then followed. He had already gone far in this direction in the Genoese portraits, and the painting of himself and Isabella is ultimately less memorable

OPPOSITE: *Rubens,* Self-portrait with Isabella Brant, *c. 1610. Canvas, 174 × 132 cm. Munich, Alte Pinakothek*

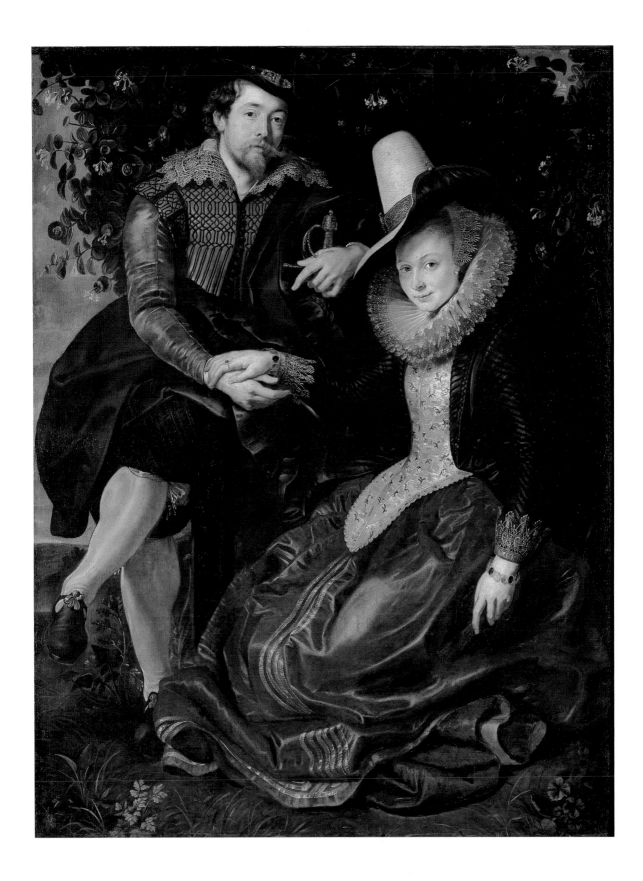

for the ways in which it mechanically repeats the conventions than for the ways in which it loosens and refreshes them. Earlier marriage portraits sometimes used the Garden of Eden as a background to counterpoint the sin of the first couple with the redemption of Christian marriage. But Rubens has reinvented the innocence of an Eden before the Fall for himself and Isabella. It is also a love arbor, but without the pergolas, fountains, and mazes that constituted the classic Renaissance garden of Venus, and for that matter without all the negative connotations that went along with it. Instead Rubens has created a lyrically unkempt place for himself and Isabella. Goat grass and ferns rustle at their feet; wild honeysuckle riots over their heads. The curling pistils and stamens project from the mass of dark foliage and are brilliantly lit at their very tips as though exuding radiance, a visual equivalent of the dense perfume saturating the country air. The blossom motif continues on through the embroidery patterning Isabella's stomacher, travelling down the golden trimming of her skirt and folding itself over her husband's foot. Playfulness and dignity are made companions here: Isabella's straw hat with its snappily turned brim sitting atop the maidenly lace cap that contains her curls; the dashing mustard hose on her husband's calves refined by the discreetly visible golden garter; the wife's pleasure in her state indicated by the merest whisper of a smile at the corner of her eyes and lips. Peter Paul's demeanor suggests that he had learned his lessons in Italy very well. He is all *sprezzatura:* the capacity to project authority without vulgar swagger; dignity softened and polished by effortless nonchalance. The sheen of his silken coat advertises Rubens's worldly success; the set of his jaw announces his seriousness. There is a forgivable air of self-admiration hovering about his figure: the elegant throat exposed between the wings of his lacy fallen collar, an advanced fashion statement in conservative Antwerp, where the millstone ruff died hard.[12]

The painting is imposing enough to have been hung in an almost ceremonial space. But its essential compositional device—the looping S that curls from the crown of the husband's head, down along his shoulder and right arm, over their linked hands, crossing the wifely bosom and dropping down her left arm to the crimson folds of her skirt—ties Peter Paul and Isabella together in a graceful but secure marital knot.

ii Tulips

On March 21, 1611, the first child of Isabella and Peter Paul, a girl named Clara Serena (after her great-grandmother), was baptized in the St. Andrieskerk. Five months later, on August 28, the baby's uncle and godfather, Philip, died. He was laid to rest in the Abbey Church of St. Michael, where he himself had interred his mother, Maria, three years before.[13]

How do you feel when your best friend dies? How do you feel when he is also your brother, and when the brother is all that remains, besides yourself and your infant daughter, of a family that once numbered nine? Historians like to tell us that we can know nothing of such things; that seventeenth-century grief is as remote from our sensibility as the mourning rituals of ancient Sumeria; that the ubiquitousness of plague and dysenteric diseases made for necessarily callused sensibilities. They caution us that a sudden passing that would render us distraught was accepted by our ancestors as the unchallengeable decree of the Almighty. And of course they are right, to some degree, in warning against projecting our own emotional sensibilities onto cultures still innocent of the raptures and torments of Romantic sentiment. Sometimes, though, they protest too much against the shock of recognition, the peculiar familiarity we register intuitively across the centuries. Historians, after all, have a vested interest in insisting that the past is a foreign country, since they like to claim a monopoly on translating its alien tongues. But sometimes they aren't needed. Sometimes the culturally conditioned response cracks apart and an emotion immediately recognizable to modern sensibilities makes itself felt.

Rubens, Portrait of Isabella Brant, *c. 1622. Black and red chalk drawing heightened with white, 38.1 × 29.2 cm. London, British Museum*

Such was the case in the summer of 1626, when Isabella Brant died in her thirty-fifth year, in all likelihood succumbing to the last stages of a cholera epidemic that had begun to ravage Antwerp the previous year. Observing the proprieties, one of Rubens's French friends, Pierre Dupuy, wrote offering the usual counsel to the bereaved: resignation to the dictates of an inscrutable Providence and trust to time to repair the wound. With his long education in the philosophy of the Stoics, one might suppose that Rubens would indeed have complied with its Christian fatalism. But he did not. Thanking Dupuy for reminding him "of the necessity of Fate, which does not comply with our passions and which, as an expression of the Supreme Power, is not obliged to render us an account of its actions," and for "commending me to Time," he continued, "I hope this will do for me what Reason ought to do. For I have no pretensions about ever attaining a stoic equanimity; I do not believe that human feelings so closely in accord with their object are unbecoming to man's nature, or that one can be equally indifferent to all things in this world. . . . Truly I have lost an excellent companion whom one could love—indeed had to love with good reason—as having none of the faults of her own sex. She had no capricious moods and no feminine weakness but was all goodness and honesty. And because of her virtues she was loved by all in her lifetime and mourned by all at her death. Such a loss seems to me worthy of deep feeling. Forgetfulness, Daughter of Time, I must without doubt look to for help. But I find it very hard to separate grief for this loss from the memory of a person whom I must love and cherish as long as I live. I should think a journey would be

advisable, to take me away from the many things which necessarily renew my sorrow."[14]

No letter survives to let us know whether Rubens experienced the same battle between philosophical composure and bitter grief when his brother died. But given the closeness and intensity of their relationship, it seems inconceivable that he would not have been prostrated by the disaster. Philip was just thirty-six when he died, at the height of his powers and good fortune; like Rubens's father-in-law Jan Brant, Philip was one of the four clerks of the city, an immensely prestigious and important office. Though he had turned away from the purely academic life at Louvain, Philip continued to be the scholar he had been for most of his life, editing ancient texts, refining the work that he and Peter Paul had collaborated on in Rome. The career of a cultivated patrician lay before him; an ideal marriage of the contemplative and the active life.

There is, however, a document by Rubens's hand memorializing his brother Philip. But it is a painting: the so-called *Four Philosophers*, now in the Palazzo Pitti and almost certainly painted around 1611–12. That Rubens meant something more by the painting than a mere group portrait is suggested by its size alone, and more significantly the assembly, within the same space, of the living (Peter Paul at the extreme left and Jan Wowerius at the right) and the dead (Philip, holding a quill pen, and his teacher Lipsius, pointing authoritatively to a text). Though none of the figures looks directly at the other, the work is nonetheless a conversation across the threshold of the tomb, an insistence on the intellectual and spiritual fellowship of the four. The tulips proclaim this, for the closed blooms, symbolizing the dead, and the open blooms, symbolizing the living, share the same glass vase. Together they also act as a brilliantly vivid reminder of one of Lipsius's greatest achievements: the creation of his botanical garden at Leiden, the immediate predecessor of the university's own Hortus Botanicus. In *De Constantia*, Lipsius had himself written on the wild dwarf species of *Tulipa tulipae* reputed to have been brought from Persia and Turkey by the ambassador of the Habsburg Emperor Ferdinand by another Antwerper, well known to the portrait group, Giselin de Busbeke, and eventually hybridized at Leiden by yet another transplanted Fleming, the most learned of all the Netherlandish botanists, Carolus Clusius.[15] The tulips, sharing the niche with a bust of Seneca, set the tone of the painting. Immortality denies death its due, refuses its severance, by affirming the ties that bind together brothers and friends, teachers and pupils, classical exemplars and modern disciples, and, not least, fellow tulip fanciers.

The perpetuation of the past is already announced in the landscape seen through the pair of classical pillars framing the group. In Rubens's day, the Palatine hill with the church of San Teodoro, viewed from the Capitoline, was thought to have been the original founding site of Rome, where Romulus and Remus were said to have been suckled by the wolf. In a more directly personal sense, it was also the place where the brothers Rubens recorded in their notebooks and sketchbooks the remains of its

OPPOSITE: *Rubens, Self-portrait with Justus Lipsius, Philip Rubens, and Jan Wowerius, known as* The Four Philosophers, *c. 1611–12. Panel, 167 × 143 cm. Florence, Palazzo Pitti*

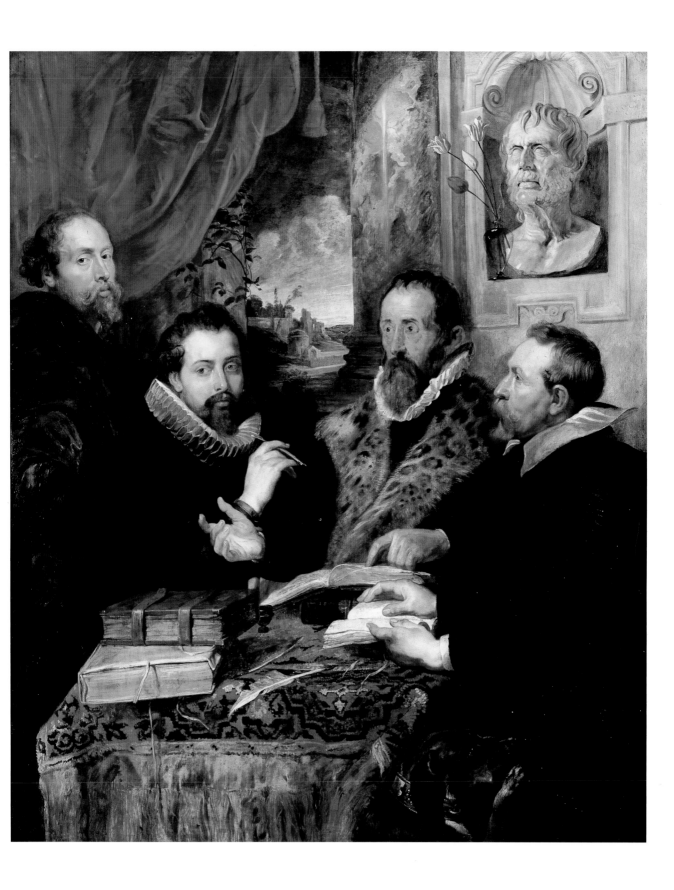

antiquity. And just as the four humanists share Rome as the cradle of their common culture, so they are bound together in a chain of memory whose invisible links run across the breadth of the painting. Peter Paul's devotion to his brother is expressed by another symbol, drawn from the natural world, the clematis, climbing about the pillar above Philip's head. His pen in turn points to the works of his master, Lipsius, whose left hand almost touches the right hand of Wowerius, the philosopher's designated executor.

The chain of connections does not end there. Philip had helped the ailing Lipsius complete the great edition of the works of Seneca, and in a poem included in the book *Electorum Libri II* (illustrated by Peter Paul) he had imagined a bust of the Roman Stoic coming to life and looking over Lipsius's shoulder as he worked. It was, moreover, a particular bust he had in mind, the one identified (purely speculatively) as the head of Seneca by the Italian humanist Fulvio Orsini, which in all likelihood Peter Paul saw in a painted illustration before he left for Italy in 1600. In Rome, though, he saw the bust itself in the Palazzo Farnese, and it moved him to make an extraordinary series of drawings of the head, seen from different angles. When he returned to Antwerp in 1608, he took with him a replica, and in his painting it sits in the niche with the memorial tulips, supplying yet another link between the classical past, the recent past, and posterity. The link is made even stronger by the fact that Seneca had long been imagined as a philosopher who had worn himself out in public service and in his struggle to reconcile his obligations to the Emperor with his duties to his conscience and to his students. (The pseudo-Seneca's haggard countenance, noble dome, and pinched cheeks seemed to correspond perfectly to this imagined type.) Lipsius was likewise thought of not just as the editor but as the inheritor of the Senecan dilemma, finding the task of squaring obedience and candor almost backbreaking. Lipsius's reputation as a latter-day incarnation of the silver-age philosopher is embodied in the painting by his seeming to speak and argue for the ages, precisely as Seneca had been recorded doing even as his wrists were being slit in obedience to the commands of Nero.

In fact, Rubens had painted precisely such a *Death of Seneca* just two years before. It is another of his studies in brutality and carefulness. The physician who, in Tacitus's account, had been deeply reluctant to carry out the philosopher's instructions is seen attending to him with exacting care, his right hand tightening the tourniquet while holding the knife that has already punctured the great man's artery. From the incision a bright, precisely painted thread of blood spurts into a golden basin, which is almost the size of a small bathtub. To Seneca's right, a student, inkwell and pen in hand, mouth agape with attentiveness, takes down every last word, as if he were writing with the great man's lifeblood. As with all of Rubens's masterpieces in these years, the still-life detail—like the notebook bent back over its spine so that it can rest on the young man's knee—is so precisely observed that it takes the story out of the realm of improving homilies and makes it instead a startling human drama. The soldiers sent by Nero are

anything but stock classical types; rather they are grizzled veterans, but men whose muscle is suddenly made obedient to the pure force of truth coming from Seneca's last moments. The parallels with the Passion are deliberate, and just this side of sacrilege—the martyr's loincloth folded very much as in a conventional *Ecce Homo* or *Man of Sorrows;* the pikeman's rapt and sudden conversion reminiscent of that of Longinus, the centurion who believed as soon as he had made a hole in Christ's side. One of the soldier's faces is literally illuminated by the force of his realization, much as in scenes of the Crucifixion.[16]

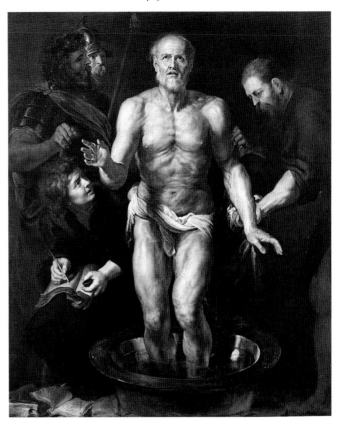

Rubens, The Death of Seneca, *c. 1608. Panel, 181 × 152 cm. Munich, Alte Pinakothek*

If Seneca was the father of the Stoic creed, Lipsius was his devoted apostle. And perhaps he is to be understood in Rubens's multiple portrait as pointing to the text for which he was probably best known throughout Europe: the treatise on constancy, published in Leiden in 1584. Skeptical critics of his could hardly forbear from noticing the audacity of a man who had taught in the Calvinist university of Leiden, the Lutheran university of Jena, and the Catholic university of Louvain, presuming to lecture others on the virtue of constancy. But for ardent Lipsians, it was the world, not Lipsius, that was fickle, and Rubens manages to proclaim the essential integrity of the philosopher through his gaunt face, the high cranium packed with verities, and the panther-trimmed coat which he habitually wore and which he bequeathed to the college at Halle.

And there is a final presence, completing the circle of devotees, possibly the most faithful of all to the memory of his master: the hound whose paw, raised beside Wowerius's chair, seems to be prompting him to be the loyal executor of Lipsius's legacy. The philosopher had, needless to say, written an erudite treatise on dogs, praising them for their constancy and devotion, as well as their strength and, by comparison with the rest of the animal kingdom, intelligence. He himself had kept several, and from his descriptions this hound can be identified as Mopsus, who, after the untimely death of Saphyr in the cooking pot, had inherited the coveted position of top dog to the Stoic. And anyone as familiar with Roman sarcophagi as Rubens was would have known of the tradition of representing, on the tombs of nobles, the likeness of a pet dog along with that of its master, that they might travel together to the afterlife.

At the opposite corner to the loyal Mopsus is the painter himself, the interlocutor between past and present. He now looks decidedly older than

the glittering dandy of the honeysuckle bower. His demeanor is grave and challenging; his whiskers thickened with the beard of maturity; his chestnut curls receded to reveal a great thinking brow like those of the brother, the teacher, and the martyr-philosopher in the stone niche. Rubens has once more designed a communion of figures, held together by a line that loops like a golden chain through the painting, travelling diagonally from the head of the hound to the head of the artist. They are a company of the like-minded, friends in life and death, but not a group whose concerns are confined to themselves. They look outward from their table, to us and to eternity, and they look as if they have something important to say. The undifferentiated black costumes of the two brothers seem to bind them together in a joint address to posterity. And of the two it is the survivor, the painter, who seems the more assertive, his elbow thrust out at us in the attitude of a noble or a soldier. Ostensibly and pictorially, Peter Paul stands modestly in the rear. But it is his presence that commands our attention. And he knows it.

iii *The Burden of Faith*

Oblivious to any hint of sacrilege, the merchant Jan le Grand had no hesitation in describing Rubens as "the god of painting" when recommending him as the best choice of artist for the high altar of the Benedictine Abbey of St. Winnoksbergen.[17] The encomium was written in March 1611, a mere two and a half years after Rubens returned to Antwerp. But there already seemed something Olympian about him; he was a marvel of learning, intuitive talent, and social grace. Yet none of these qualities would have been important to the devout Catholics of Flanders and Brabant had not Rubens also demonstrated a profound understanding of what was needed to carry the Gospel to the common people. For all his patrician bearing, he had the plebeian touch when it came to matters of faith. Johannus Molanus, Federigo Borromeo, Father Paleotti, and the other doctors of the Counter-Reformation who wanted to use images to create a *Biblia Pauperum,* a Bible for the poor and illiterate, were helpfully forthright about what was required. In the first place, the visual Scriptures had to be capable of being immediately grasped by the unlearned, not cluttered with obscure allusions and incomprehensible figures. If someone gesticulated or grimaced, the meaning of those gestures had to be made plain. No more enigmas. Second, the imagery had to be painted with the utmost realism so that the sacred stories would not seem remote in time and place but have an immediate, tangible presence in the life of the spectators who beheld them. Finally, religious paintings should attack the emotions powerfully enough to subdue any doubts and bring the believers into an exalted communion with Christ and his Church.

More than any of his predecessors in the Netherlands, or his own con-
temporaries, Rubens rapidly acquired a reputation for being able to fulfill
all these criteria. As a result, he painted no fewer than sixty-three altar-
pieces between 1609 and 1620: twenty-two for churches and chapels in
Antwerp alone; ten for Brussels; three for Lille, Mechelen, and Tournai;
and many others for churches in France and Germany.[18] And in none of
them did he ever treat his work formulaically, with production-line martyr-
doms available for the asking. On the contrary, Rubens was deeply atten-
tive (as he had been in Italy) to the specific architecture of the church; to its
local traditions and relics; to the particular interests and theology of the
patrons; and to all the elements he needed to turn his work into a unified
spectacle, a complete and integrated experience of sacred theater.

Nowhere was this more evident than in his first indisputable master-
piece, *The Elevation of the Cross*, painted for the Church of St. Walburga.
This was not just any Antwerp parish church. It stood close to the harbor,
not far from Jan Brant's house on the Kloosterstraat, where Peter Paul and
Isabella were still living in 1610. It was also one of the oldest churches in
the city, associated with the fishermen, sailors, and skippers who lived in
the crowded cobblestone alleys near the Scheldt. And it bore the name of a
saint, Walburga of Wessex, who had, during her flight from England to
Germany, miraculously calmed a tempest, and who thereafter had become
especially dear to the storm-racked seafarers of the North Sea. Local tradi-
tion had it that Walburga ended up in the crypt of the church in Antwerp,
where she spent most of her life in prayer and fasting. Initially the church
had been hardly more than a rudimentary chapel, but at the end of the fif-
teenth century it was enlarged by the addition of two aisles. Early in the
sixteenth century, a further expansion was meant to extend the choir, but
since there was no room in the packed streets immediately behind St. Wal-
burga's, the extension was added on as an elevation hanging over the alley
like the built-up stern of a Flemish cargo vessel—just right for a culture in
which the Church was often metaphorically described as a ship.[19]

This architectural peculiarity was something that Rubens immediately
sensed he might turn to theatrical advantage. As a depiction of the interior
of St. Walburga's by Anton Ghering makes clear, the high altar was now
very high indeed, approached by a flight of nineteen steps. So Rubens
decided to use the platformlike choir to advantage by conceiving a triptych
of striking verticality, having as its subject the moment of the Passion that
was itself about elevation—the elevation of the Cross. This was a relatively
rare subject in Netherlandish art, although Rubens himself had tackled it in
one of the side paintings to his *St. Helena* in Santa Croce in Gerusalemme
in Rome. That early version was itself based on a print representing the
subject by Jerome Wierix illustrating the most authoritative Counter-
Reformation treatise on sacred images, written by the Spanish Jesuit Jero-
nimo Nadal. But the print and Nadal's specifications were merely a starting
point. What evidently counted most, as Rubens began to think his way into
the composition, was that strangely lofty site. Why not create a tragic study
in uplift, with the composition pushing the beholder's attention up the

body of the Savior to his eyes, themselves rolled up in agony and supplication toward the Father, whose own image would be set into the space immediately above the painting.

Perhaps with the disaster of Santa Maria in Vallicella at the back of his mind, Rubens decided (unusually for him) to work on the site itself. So that he could work undisturbed by the routine of the church, one of the local sea captains had loaned an entire ship's sail, which a gang of sailors helped stretch around the painter's work area and over the choir, converting the space into a tented refuge from the eyes of curious worshippers.[20] Surrounded by sailcloth, Rubens decided that one of the subjects for the predella, running below the principal altarpiece, should be a sea piece representing the miracle of St. Walburga saving her ship from the tempest, a ferocious little painting that Rembrandt would take as a model for his own *Christ Calming the Storm on the Sea of Galilee*.[21]

Rubens could afford to take such risks in his characterizations because, in contrast to his Italian commissions, he could feel confident that he had the unqualified support of his patrons. The churchwarden of St. Walburga's was Cornelis van der Geest, like Rubens's stepgrandfather a wealthy spice merchant, a resident of the quarter in which the church stood, and, more important, one of Antwerp's most ambitious collectors and connoisseurs. Rubens later referred to van der Geest as "one of his oldest friends" and made it clear that he had been "the most zealous promoter" of the commission.

As was his habit, Rubens charged into the work with an unnerving combination of high-speed spontaneity and methodical experiment. Preliminary drawings were sketched out in chalk and pen; figures were lifted from his own past work, especially the painting in Santa Croce in Gerusalemme, and given fresh life and vigor. The construction of the new high altar had been completed at the beginning of 1610, and by June Rubens had sketched out enough of the elements of the composition to satisfy the church officers. Early that month, the contract was signed and—this being Antwerp—a feast was held to celebrate the occasion in a private supper room in the Klein Zeeland hostelry. Rubens himself had much to be cheerful about, since the work would bring him 2,600 guilders.[22] The oil sketch already suggests that something revolutionary was happening. Even in old-fashioned Flanders, triptychs had become virtually obsolete. Perhaps Rubens and van der Geest had deliberately decided to revive an archaic form in honor of the legendary antiquity of St. Walburga's (much as he had tried to allude to the imperial Roman ruins that lay beneath Santa Croce in Gerusalemme in his altarpiece there). At the same time, though, he wanted to pull together the three panels of the triptych so that they formed a single, integrated scene. The side panels would have their independent subject matter—the grieving Marys and St. John the Evangelist on the left, the Roman centurions and horsemen on the right—but through gesture and expression, their action would be directed at, and continuous with, the central spectacle of the elevation of the Cross itself.

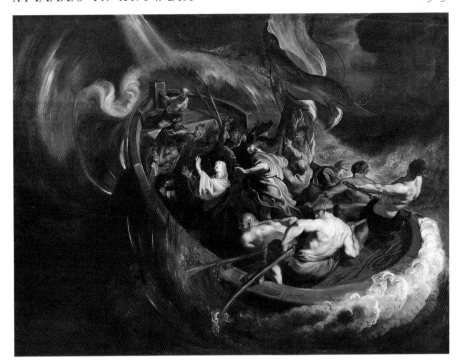

Rubens, The Miracle of
St. Walburga, *c. 1610.*
Panel, 75.5 × 98.5 cm.
Leipzig, Museum der
Bildenden Künste

The conceptual genius of the work is already there in the sketch. It occurred to Rubens that the full magnitude of Christ's sacrifice could be physically registered by transferring its literally excruciating burden to the very sinners on whose behalf it was being made: the executioners attempting to heave the Cross upright. How much easier it would be, especially for a congregation drawn from the ships, warehouses, and dockyards, to identify with the toiling transgressors, rather than with the Savior himself, not least because their labors resemble a ship's crew toiling to raise a mainsail. So Christ's body, still and luminous, the eyes turned upward in resignation toward the Father, was to be contrasted with the raw exertion of the sweating workers. Once again, Rubens had created a mysterious communion between violence and repose. To accomplish this, he had summoned his familiar team of half-naked, heavily muscled wrestlers, gladiators, athletes, and acrobats from their designated corners of earlier compositions like *The Baptism of Christ* and *The Adoration of the Magi* and brought them center stage, complete with swarthy skins, sweating torsos, and brows knitted with the sheer effort of their labor.

The side panels of the sketch also largely embodied Rubens's essential design: a great machine of furious, grinding energy. The only places of stillness are the body of Christ himself and the sober resignation of St. John and the Virgin, the latter depicted not in a tragic swoon but contained in her grief, Rubens having reverted to the medieval belief that she had long been made aware of her son's destiny.[23] In dramatic contrast, Rubens gathers in the corner of the same panel a group of desperate, horrified women: one unable to look; another unable to turn away; a third caught between

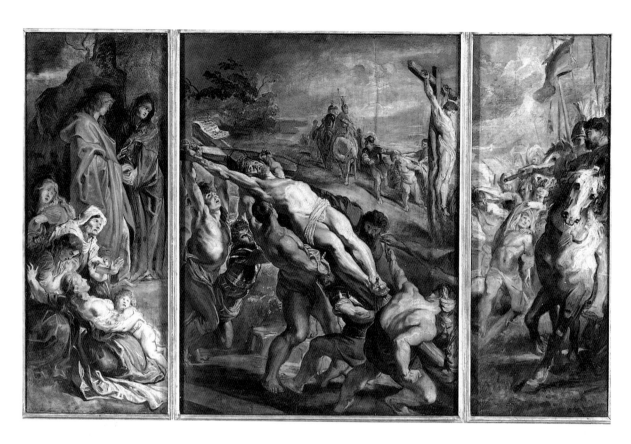

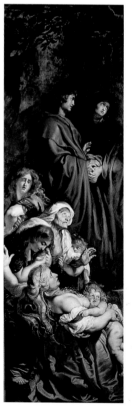

ABOVE: *Rubens, Oil sketch for* The Elevation of the Cross, *c. 1610. Three panels, 67 × 25 cm., 68 × 51 cm., 67 × 25 cm. Paris, Musée du Louvre*

LEFT: *Rubens,* The Elevation of the Cross, *c. 1610–11. Left panel, 462 × 150 cm. Antwerp, Cathedral*

RIGHT: *Rubens,* The Elevation of the Cross, *c. 1610–11. Right panel, 462 × 150 cm. Antwerp, Cathedral*

OPPOSITE: *Rubens,* The Elevation of the Cross, *c. 1610–11. Center panel, 462 × 341 cm. Antwerp, Cathedral*

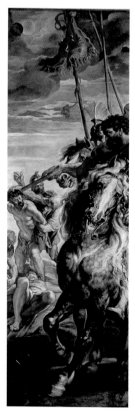

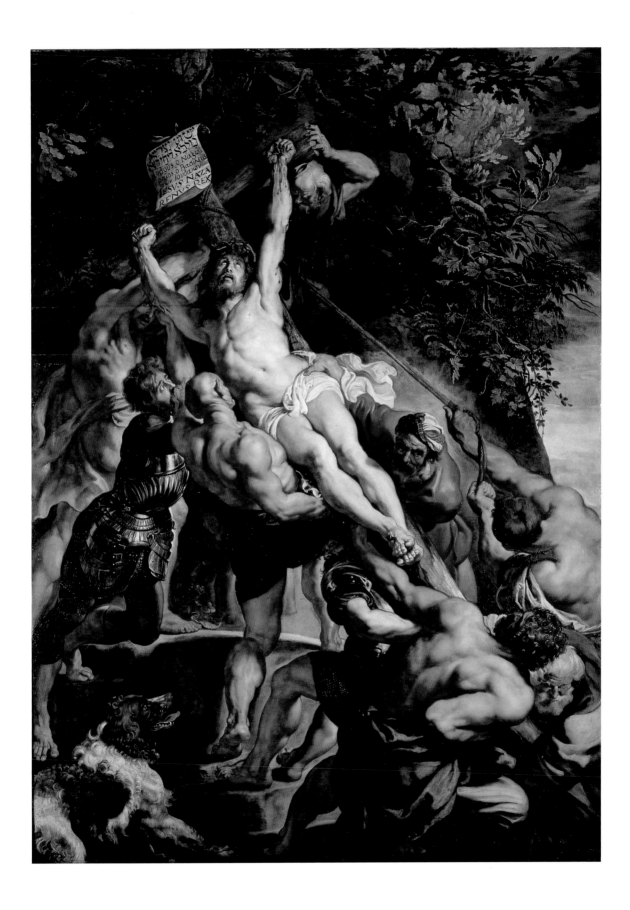

the two reactions; and at the bottom a startlingly voluptuous Magdalene, breasts exposed to a suckling infant, leaning back as if the Cross itself might fall upon her. In the right panel, a Roman officer, implacable and bearded (his head taken from the antique Hercules Rubens had sketched in the Palazzo Farnese), stretches out the baton of command to order the raising of the Cross.

And still, Rubens thought, it was not quite right. Something was missing from its compositional dynamics. In an athletic leap of his imagination, he caught it. By following the convention (in the great Tintoretto *Crucifixion* in the Scuola di San Rocco in Venice, for example) that set the Passion against the background of the Calvary hill, with distant views of the other crosses and the landscape beyond, Rubens had necessarily used perspective to open up a deeply recessed space. But this not only required filling the background with more soldiers and thieves, thus repeating the content of the right panel; it also surrounded the central violent action with wide-open air and light, weakening its concentrated impact. And Rubens had to consider not only those spectators of the work who would approach it from the porch end of the nave but those sitting below the choir whose angle of vision would be sharply acute. As usual, his solution was to turn a problem into an innovation. Suppose he were to do something unprecedented and represent only the immediate portion of Golgotha on which the Crucifixion took place, giving the scene an almost claustrophobic closeness to the spectators standing or sitting below the nineteen steps? Suppose, too, that he were to change the angle of elevation so that to be hauled into an upright position the Cross would now have to swing alarmingly *toward* the beholder? Could the experience of witness to salvation ever be made more overwhelming than to have the full weight of the sacrifice seem to rise from the earth and loom over the head of a kneeling worshipper?

So Rubens continued the narrow, rocky ledge on which he had set the Virgin, St. John, and the grieving women through to the central panel, which now is reduced to a terrifyingly shallow, suffocatingly crowded space. With less room to maneuver and a much steeper platform on which to set their load, the labor of the executioners becomes even more arduous, cramped, and savage. Their heads and bodies have been altered correspondingly, becoming as brutal as the rock face itself. The central figure, whose calves protrude toward the beholder, has become even more monstrously muscled and his head is now shaved. The armored and bearded soldier who in the sketch had scowled melodramatically at his job is now a more agitated presence, on the point of buckling at the knee while his partner (preserved from the sketch) lies *underneath* the foot of the Cross, taking the strain on his back. The thieves have been removed from the central scene and confined to the right panel, but in another stroke of dramaturgical inspiration, Rubens has replaced the usual auxiliary crucifixions with a horrifying detail: one felon who is being dragged by his hair to execution steps over the face of a fellow prisoner, flat on his back, as he is being fastened to the cross. Removing the crucified thieves from the central panel

leaves room for startling detail calculated to lock the beholder into the action: a fat teardrop gathering in the Magdalene's eye, another slowly descending her rosy cheekbone; the sun and the moon in apocalyptic conjunction, spreading tongues of bloody light staining a shockingly azure sky; a ferociously gnarled old character, inserted into a crevice of the rock, whose balding red head, ring of gray hair, and clawlike fingers direct attention to the spray of blood issuing from Christ's left hand, trailing dripping rivulets down the length of his arm; another rill of blood trickling into his eyes from the place where the crown of thorns has punctured his brow. No communicant with the Eucharist, his head bent forward to receive the Host and the cup, could possibly behold these terrible details and not be put in mind of the Church's doctrine of the Real Presence: the physical, corporeal existence in the bread and wine, of the flesh and blood of the Savior. Nor would he miss the inscription, in Latin, Greek, and Hebrew, of "Jesus of Nazareth, King of the Jews," its edge curled against the crossbar; nor the topographically unlikely combination of vines (again for the Eucharist) and oak leaves (for the Resurrection); nor, since this was a very doggy town, the spaniel witnessing the martyrdom, the four-legged Fido, the emblem of constancy and faith.

The boiling energy of Rubens's creativity poured itself into the delivery of the paint onto the panel. There are passages where a brush loaded with heavy, creamy paint models forms, especially where Rubens is suggesting a mass of dense and knotted muscle working beneath stretched skin. But there are far more passages where the *furia del pennèllo* makes itself breathtakingly evident: long, swift, almost recklessly applied lines, the dry bristles spreading a thinner medium flat to the surface; a storm of paint, flicking, turning, and curling, suggesting sprays of the finest gold-filament hair tumbling down the crimson back of the Magdalene, the rough white homespun of St. Anne's headdress, or the folds of the Savior's bloodied loincloth.

But even hurricanes have still centers, and within Rubens's whirlwind of paint his control of areas of sharp color was precise and calculated, working with, rather than distracting from, the motor force of the single great diagonal that extends from the top of the Cross all the way through Christ's body to the bare right shoulder of the executioner in the lower right corner. Any simple worshipper, beholding this pitiless stretching-rack of a line, would have felt its excruciating relentlessness in his bones. But for the more educated, perhaps a "Romanist" just back from the obligatory humanist tour of duty in Italy, there was much to engage with. Doubtless he could congratulate himself on recognizing that the tormented face of the Savior was a Christianized version of the snake-throttled Laocoön. Perhaps the single nail securing both of Christ's feet would remind him of the abstruse but fierce debates within the Church over the precise number of nails used in the Crucifixion. But as he mulled these erudite details, he might find himself unaccountably drawn to the precise point in the painting where the blue-loinclothed executioner's tensed bicep brushes against those impaled feet, and with a rush of recognition he would suddenly be re-

minded of the outstretched arm of the Creator giving life to Adam on the Sistine ceiling. And he would then sense an awesome connection. For if the creation of man is the beginning of the story, this is its preordained end: the drama of sin and salvation consummated in the groaning exertions of Calvary. Our Flemish gentleman returned from Italy might finally swell with satisfaction that in the plain old harbor church, with its poop-deck choir, the local Michelangelo had finally, and beyond all possible refutation, overthrown the Florentine's assumption that all his countrymen were good for was landscapes.

Contemporary pilgrims in search of *The Elevation of the Cross* will not find it in St. Walburga's Church. In 1794, when the troops of the French Republic "liberated" the Habsburg Netherlands, they also liberated Rubens's masterpiece, which, along with *The Descent from the Cross,* was shipped off as cultural loot to Paris. An official drawing commemorating the marriage of Napoleon to Marie Louise of Austria in 1810 shows the wedding cortège filing past the Rubens altarpieces in their secular captivity in the Louvre, though no one is paying much attention to them. After Waterloo, in which Dutch troops played a token role, the paintings were restored to the Netherlands and the seventeen provinces reintegrated (as Rubens always wished) as a single realm, but governed by a Dutch king from Brussels. In Antwerp a great festival was organized to celebrate their return and the decision taken to reinstall both paintings at the crossing of the cathedral, where they have remained (with some shifts of station) ever since. St. Walburga had been robbed of its prize possession, but the church fathers had already shown their indifference to Rubens's original conception of an integrated drama of painting and architecture when they pulled down the original high altar in 1733 and replaced it with a pompous, arcaded, and pedimented late Baroque structure. Although Rubens's standing in the critical circles of the academies of Europe had never been higher, the Catholic Church was beginning to find the raw, physical quality of his painting a touch sweaty as a visual primer for the faithful. So Rubens's three predella paintings, including the seafaring *Miracle of St. Walburga,* were sold off and replaced by a painting done by the new church architect. In 1797 the church itself was converted by the French into a customshouse, and in 1817 it was finally demolished, the bones of Cornelis van der Geest still resting below the vestigial remains of the old choir while the building was reduced to rubble.

Antwerp's cathedral became a symbol for nineteenth-century Belgian patriots of a country resurrected, so Rubens's two sacred masterpieces were necessarily housed there as if in a pantheon. Seeing the two great polyptychs at the left and right corners of the transept (separated at the altar by a much later Rubens *Assumption of the Virgin*), it's easy to assume they were conceived as twins, the *Descent* following on from the *Elevation.* But though obviously connected in Rubens's mind, the two works were drastically different in both conception and execution. Well before Rubens had finished his work for St. Walburga's, the diocesan synod of Antwerp had

decided in 1610 to commission a large history painting for the cathedral, at which point Rockox stepped in with a specific proposal. In 1609 Rubens had painted *two* major histories for Rockox, the *Samson and Delilah* for his house and *The Adoration of the Magi* for the Town Hall, where Rockox sat as senior alderman and burgomaster. But this still wasn't enough for the Rubens-besotted patrician, who wanted a grandiose sacred work for the cathedral to complete his own curriculum vitae as the Maecenas of Antwerp. The opportunity arose when the harquebusiers' militia guild, of which Rockox was the captain and chief officer, decided to commission an altarpiece for its own chapel within the cathedral. It just so happened that in the same year, 1610, Rubens had bought a property that came with a small linen-bleaching field abutting on the wooded yard of the harquebusiers' *doelen,* or meeting-and-drill house, on the Gildekamersstraat. It looked as though the painter was caught in the golden web that Rockox had spun around his career.

Not that he minded. To paint a history for the cathedral was to join a long list of great Antwerp masters: Frans Floris, Michiel Cocxie, Marten de Vos, and not least his old teacher Otto van Veen, whose most inspired work had been painted for its altars.[24] And the fact that some of the greatest works, like Floris's *Assumption of the Virgin,* had disappeared beneath the hammers of the iconoclasts was all the more reason for Rubens to jump at the chance of establishing his own presence in the most magnificent church in northern Europe.

The choice of subject, unlike the *Elevation,* was much more frequently represented in both the Flemish tradition and the Italian Renaissance canon. Living a stone's throw from Santa Trinità dei Monti in Rome, Rubens must certainly have seen Daniele da Volterra's version in the Orsini chapel and may also have known the intensely emotional painting by Federico Barocci in Perugia Cathedral, with its clambering ladder-workers and swooning Virgin. Much as he was bound to admire the stylized delicacy of the Italian masters, Rubens needed to reinvent the subject in an earthier, more physically assertive manner, not least because his patrons, the harquebusiers, were neither Italian aristocrats nor a monastic order but an institution that was rooted in the ancient and rowdy traditions of the city.

At the heart of that tradition was the folk cult of their patron saint, Christopher. His story, related in *The Golden Legend,* was exactly the kind of spurious mythology that the fathers of the Counter-Reformation were most anxious to expunge from a credible pantheon of saints. But it was precisely the bizarre richness of Christopher's story that made him so popular in the lives of the common people. Folklore made him an immense giant, possibly Canaanite, who (like all the best apocryphal saints) lived in Asia Minor, perhaps sometime around the third century. Some versions of the tale insisted that originally he had been born as one Reprobus, with a dog's head on his shoulders, only assuming full human form as he grew older. His vocation was to seek out the most powerful prince in the world and serve him with his superhuman strength. That prince turned out to be

Satan, until the titan noticed that even this mighty lord shrank at the sight
or mention of a crucifix. Searching for the Christ who was evidently the
Lord of Lords, he was given the office of carrying travellers on his broad
back across a deep river, guided by a hermit carrying a lantern. The child
whom he bore one day became, as he waded through the dark waters,
heavier and heavier, until the giant complained that his burden was unbear-
able, as if he were supporting the whole world. Indeed so, revealed the
Christ child, for you are carrying He who made it. Henceforth he was
Christophoros, the Christ-bearer.[25]

For all their eagerness to please the Church, Rockox and Rubens could
hardly ignore the devotion of the harquebusiers to St. Christopher, and in
any case their high-mindedness always made room for the earthy legends of
the common people. Colossal effigies of the friendly giant were all over the
Netherlands, and the militia company appointed one of its number to be
their "Christopher," parading on stilts in a pasteboard frame in the Pente-
cost and Lady Day processions with a little painted wickerwork doll-Jesus
on his back.[26]

The challenge for Rubens was to find a way to make the Christopher
respectably venerable or, better still, mysteriously connected with an irre-
proachably sacred motif. After he had transformed the Farnese Hercules
into a Christian giant trampling through the shallows, his brows knitted
and his muscles tensed in exertion while the cherubic Christ child hangs on
to his hair, the answer came to him. His theme would be the weight of faith
borne by *all* believers. Here he may have had some help from the fourth-
century commentaries of St. Cyril, published in a new edition as recently as
1608, which considered the reception of the blood and body of Christ in
the Eucharist as a kind of "carrying," since it was now "distributed to all
parts of the [communicant's] body."[27] Rubens thus needed a subject which
both foregrounded the body of the Savior in as dramatically immediate a
way as in his *Elevation* and also suggested the transfer of his substance to
his followers. This made *The Descent from the Cross,* with its tragic bur-
den at the center, an obvious choice, together with two other Gospel Scrip-
tures that related the bearing of Christ: the visitation of the pregnant Virgin
to her aged cousin Elizabeth, also miraculously fecund with the child who
would be John the Baptist; and the presentation in the Temple of the Christ
child to the high priest Simeon. So although Christopher was relegated to
the door of the triptych, the harquebusiers were free, of course, to shut it as
often as they wanted to make their patron saint more visible. And opposite
him, on the other door, was the image of the hermit and the lantern, not
just an incidental anecdote but the key to the crucial secondary motif of the
entire work: the transformation of weight into pure, celestial light.

Once he had conceived of the work in this way, Rubens must have sud-
denly grasped how astonishingly apposite the story was for its chosen site,
because whereas both the problem and the challenge in St. Walburga's were
height, in the relatively dim, recessed space of the harquebusiers' chapel,
the problem and the challenge were light. Hence the massive emotional

pathos of the great central panel is concentrated in the juxtaposition of Christ's pallid greenish-white corpse and the shocking blood-red robe of St. John the Evangelist that opens to embrace it like a cradle. It is as if the blood of the Savior had drained from his physical presence and flowed into the carriers of the Gospel. But though Christ's body has been emptied of earthly vitality, it seems, in Rubens's loving modelling, to have retained its anatomical integrity, and to be emitting a light which reflects on the brilliant winding sheet and the faces of Joseph of Arimathea, the Virgin, and the grieving Marys, Magdalene and Cleophas. So that in spite of the action unfolding at the dusky end of a Golgotha sunset, with darkness beginning to shroud the scene, Jesus is himself the source of illumination. He is, in fact, the "light unto the Gentiles" prophesied by Simeon as he holds the infant Jesus in the Temple, the light which now allows him to die in peace.

At first sight, Rubens seems to have paused in his headlong innovative rush, replacing the dramatically unified panels of the *Elevation* with the more traditional format for a triptych: three discrete narratives linked only by association. But if the experimental edge has been softened in *The Descent from the Cross,* something has also been gained, for in the three panels Rubens has created a marvellous dialogue between the southern and northern impulses in his own painterly personality. *The Visitation* and *The Presentation in the Temple* are his most elegant tributes yet to the Venetian tradition. The barefoot blonde with a basket on her head, a saucy look in her eye, and her sleeves rolled up is pure Veronese roll-in-the-hay sweet mischief, the kind of detail which, inserted into religious paintings, got the Venetian artist a date with the Inquisition. But a farm girl smelling of cows and summer sweat is only to be expected, since Rubens has Zacharias and Elizabeth living in a colonnaded villa somewhere in the Campagna or the Veneto, with a vine trellis over their heads and peacocks and poultry pecking beneath the terrace. The light is cerulean-rustic; beneath the arched steps a fowler can be seen stepping into an idyllic and bountiful countryside, and Joseph and Zacharias look like *messeri-contadini,* gentlemen farmers, about to exchange news of crop prospects. So they are, but the crop lies in the mysteriously fertilized bellies of Mary and Elizabeth. It is Rubens's special genius to have borrowed for the *Visitation* panel the conventions of the Italian bucolic pastoral (including the Virgin's fetching straw hat) to represent his third theme: that of divinely blessed fecundity, a theme that would sing in his ears for the rest of his life.[28]

The *Presentation,* on the other hand, is pure Titian-palatial, a sumptuous fantasy with the Temple made to resemble an ornately marbled palazzo with a coffered vault, profuse composite Corinthian capitals, and richly veined travertine that allows Rubens to show off his supreme skill at rendering surfaces. Simeon himself, with his velvet cap and embroidered tippet, seems a cross between a doge and a pope and looks toward Heaven in gratitude for granting his wish to see the Savior before the end of his days. Radiance pours from the shiny head of the little Christ as if it were a high-watt lightbulb powered by a spiritual generator, lighting the countenance

RIGHT: *Rubens*, The
Descent from the Cross:
St. Christopher Carrying
the Christ Child,
*1611–14. Panel (altarpiece
closed), 420 × 310 cm.
Antwerp, Cathedral*

BELOW: *Rubens*, The
Descent from the Cross,
*1611–14. Panel (altarpiece
open), 420 × 610 cm.
Antwerp, Cathedral*

OPPOSITE: *Rubens*, The
Descent from the Cross,
*1611–14. Center panel,
420 × 310 cm. Antwerp,
Cathedral*

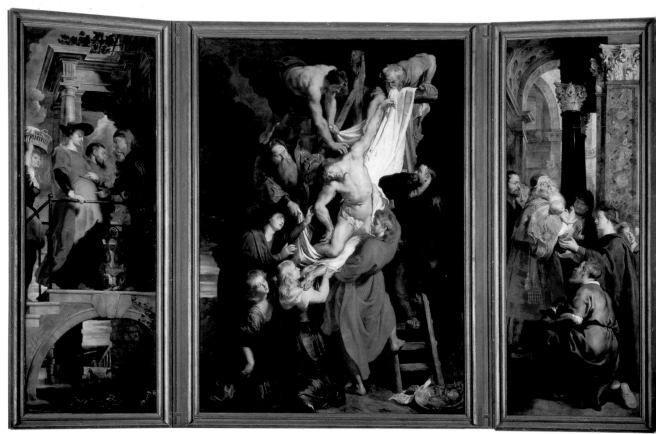

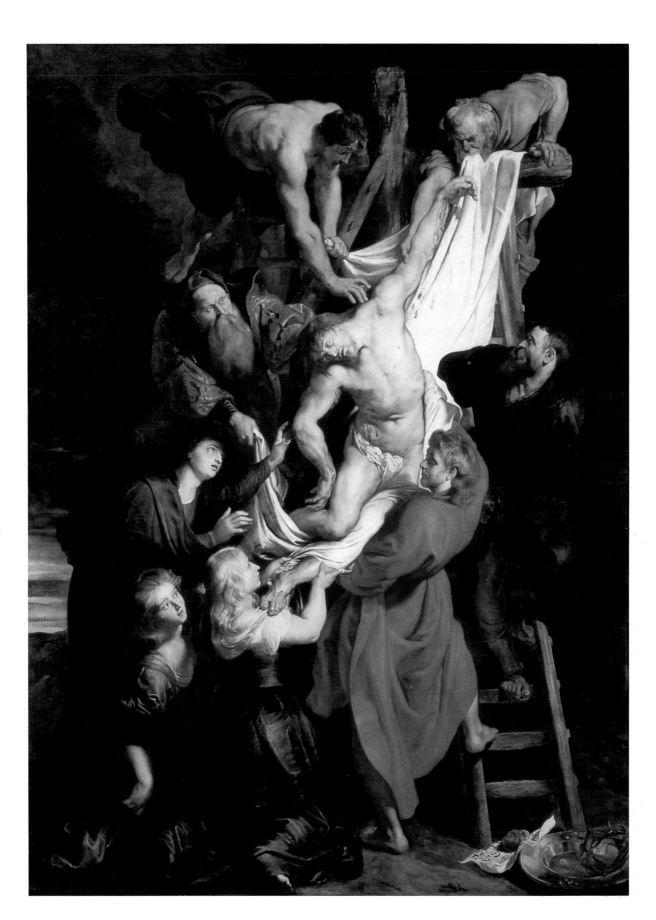

of the old man. Allusions to the Savior as the source of light are even reiter-
ated in the rays of the sun embroidered on the silken tippet covering
Simeon's shoulders. And this light, in fact, like that of the evangel, is both
strong and broadly diffused, able to reach the face of the Virgin in one
direction and reflect backward, behind Simeon, to the intelligent and gentle
bearded profile of Nicolaas Rockox. Between Simeon and the Virgin, her
old hands brought together as if engaged *both* in prayer *and* in playing
with the baby, smiling a toothless smile, is the prophetess Anna, who some
writers have speculated might bear the features of Rubens's mother, Maria
Pypelincx.[29]

In the *Presentation,* the sumptuousness of the setting and the domi-
nance of Simeon's red and gold robes are softened by the sobriety of the
costume and demeanor of the Virgin and especially Joseph, who kneels
before the old man and child. In the single, poignant detail of the underside
of the carpenter's right foot, shiny and callused at the heel, creased and
cracked at the sole, Rubens contrives to bring together those elements of
the Gospel that were most meaningful to the simplest worshippers: its cele-
bration of poverty, humility, and simplicity.

In the great central panel, the light-dark relationships of the side paint-
ings are reversed. Light is no longer airy or diffused but intensely focussed
in the tragic arc that extends from the winding sheet through Christ's livid
body to St. John. And unlike in *The Elevation of the Cross,* where the com-
position struggles to resist being rent apart by furious physical energies, all
the forms in this painting seem to coalesce, or to coagulate like Christ's
blood, into the dominating tragic center. For all its sharp physical impact,
there is a steady, regular motion, like a circulating pulse, beating through
the composition, the limbs patterned like the spokes of a wheel turning
about the central point, the punctured hub of Christ's wound. In the *Eleva-
tion,* the most powerfully tensed elements are at the base of the painting,
concentrated in the brutal laborers. In the *Descent,* they are isolated at the
top of the picture in two startling details as physically aggressive as any-
thing dared by Caravaggio. At top right, a corner of the shroud is gripped
by the teeth of the sinewy graybeard, his skin pulled tight over his jaws
with the effort. At top left, the foreshortened leg of the half-naked figure
swings out clear into empty, black space. Halfway down the ladder, this
muscular tension relaxes, somewhat, at the point where the richly cos-
tumed Joseph of Arimathea and Nicodemus act as flanking companion
supporters, resting places for the eye, a pause as the body continues its irre-
sistible descent. The complicated patterning of arms and legs that occupies
the middle left of the painting directs the eye toward the group of grieving
Marys. Rubens is not satisfied with tragic generalization here. Each Mary
must be seen to mourn in her particular way. The full throes of deathly,
inconsolable grief, a grief that has discolored her features, are written on
the face of the Virgin. A more histrionic, emotionally wild sorrow fills the
teary eyes of Mary Cleophas, while Mary Magdalene's expression seems to
reflect a more contained solemnity, the personification of *venustas:* the

quality of grace that unites outward beauty with inner spiritual radiance. Always the inventive dramatist, Rubens has transferred the force of tragic impact from the Magdalene's face to her shoulder, on which Christ's blood-ied foot rests, staining the threads of her blond hair caught beneath Jesus' toes. The shock, as always, is calculated, and instructive. It is meant as a reminder of the Magdalene's redemption from sin, when, as a token of her penitence, she had washed Christ's feet and dried them with her hair, the freed tresses of the reformed whore.

Until Rembrandt arrived, nothing could top this for sacred drama. *The Descent from the Cross* is all of painting in a single work. It is landscape, portraiture, history painting, and, not least, *nature morte*, astonishing still-life painting, figured in the carefully described rock which pins the super-scription to the earth, and in the bloodied crown of thorns staining the copper basin of water wine-red. It is northern painting and southern paint-ing, stunning draftsmanship and true, Titianesque *colore*. The shade of the greatest of the Venetian masters loomed over all of the most ambitious Baroque artists, but no one managed to honor his precedent more com-pletely than Rubens, who used areas of color not just as pleasing infill within a composition determined by line but to actually model his forms. Rubens understood, both intuitively and intellectually, the effect of differ-ent color values on optical perception, and *The Descent from the Cross* uses sharp contrasts of light and dark to carry the eye where the artist wants it to go. The dark blue of Nicodemus's right elbow, thrust abruptly out against the brilliant white shroud, pushes our attention down, along the edge of his forearm, to the point where it meets the intensely saturated red of St. John's arm and shoulder. The clarity and strength of this color path makes it impossible for the eye to end its route through the painting at anywhere but the broad chest and shoulders of the saint, stretched open to receive the pierced and torn body of the Savior. John's whole body is poised for this moment. His right leg is firmly planted on the second rung of a ladder for support, his pelvis thrust forward, his upper body bowed back to take the strain. On behalf of us all, he is ready to carry the burden of faith.

iv The Gentleman Completed

Here's an Antwerp room full of pictures and gentlemen. The gathering is impeccably well heeled, soft-spoken, soberly attired. It has pretensions to aristocracy, of a sort. Cornelis van der Geest, whose house this purports to be, has made sure that his painter, Willem van Haecht, has given due prominence to his coat of arms above the door. Never mind the

tattle of foreigners who liked to complain of the Flemish burghers' exces-
sive fondness for heraldry, as if their trading-house fortunes could be made
more respectable by the addition of a shield of lions argent on a ground of
sable. Ignore the scurrilous English stories of Netherlanders who changed
their coats of arms thrice a fortnight to please their capricious wives.[30] It is,
after all, not your common sort of gentry, with a timbered manor and a
weakness for broodmares and fowling, that van der Geest and his friends
aspire to, but rather the aristocracy of the eye. They remember the Roman
cardinals walking guests through galleries full of marbles and extending a
smooth white hand from a scarlet sleeve to point to this or that treasure—a
head, a torso, a cameo—and they see themselves as their northern counter-
parts, the eminences of the church of beauty. So here are their choice relics
(in replica), the votive pieces of the cult of perfection: the Apollo Belvedere
and the Farnese Hercules. So it is with some justification that the gentlemen
call themselves *kunstliefhebbers,* literally lovers of art—not just *schilderij,*
mind you, common or garden paintings, but *kunstschilderij,* fine art: histo-
ries and grand portraits. And they are so ardent and so knowlegeable about
their passion that they have sought, and been granted, admission to the
Guild of St. Luke in their capacity as collectors and connoisseurs.[31] An
extraordinary and unprecedented thing this is, gentlemen wanting to rub
shoulders with painters as if they were part of a common society. And if it
seems inconsistent that they should want to brag of both their armorial
bearings and their knowledge of art, the eminences do not see it that way.
Theirs is the principality of the mind. Is not their host's very name auspi-
cious? *Geest* translates into *l'esprit:* wit, intellect, imagination, *and* spirit,
an ideal union of the worldly and the pious. Very well, then let him exercise
it in a noble pun. Let the motto of the house be broadly writ: *Vive l'Esprit.*

Nothing exemplified this exalted union of the sacred and the painterly
better than Quentin Metsys's *Madonna and Child,* and as the host and
senior *kunstliefhebber,* van der Geest has the honor of showing it to his
most noble guest, the Archduke Albert. But if he gets to point a demonstra-
tive index finger proprietorially at the Christ child, it is another figure, at
the Archduke's right shoulder, who seems to be engaged in more active
explication. It is, naturally, Rubens, ever the tactful instructor, who is
present in the gallery in several guises. His warrior-glutted *Battle of the
Amazons* hangs on the back wall. And in the center foreground, some
sheets of graphic art sit on the lip of an octagonal table. The largest and
most prominent of those sheets is a drawing by Jan Wierix showing
Alexander the Great visiting the studio of the artist Apelles while he paints
the nude portrait of the King's mistress, Campaspe. In the history narrated
by Pliny, Alexander would show his esteem for Apelles by bestowing on
him all manner of favors, including Campaspe herself. This was not the
sort of thing to be expected from the ex-cardinal Archduke Albert. But in
the spirit of the identification-teasers that went along with these art-gallery
paintings, sharp-witted admirers would have been nudged to find pleasing
parallels between the visits of august patrons now and then. The cleverest

of the players might even remember that Wierix's drawing, faithfully repro-
duced in miniature here, gave Apelles the features of his local reincarna-
tion—curly hair, trim beard, strong nose: Peter Paul to the life. Perhaps van
Haecht tried himself to share some of the Apellian honors, since his own
signed version of *Danaë* sits beneath the drawing.

 At some point, Rubens himself could not resist trying the genre and
together with his friend Jan Bruegel painted a set of allegories of the senses
in the form of gallery pictures. *Sight* is a shameless anthology of their
favorite works, including the glorious collaboration the *Madonna and
Child,* in which Rubens painted the figures and Bruegel the flowers. Other
paintings, however, shamelessly advertise Rubens's versatility as reflected
by the distinction of his patrons: the equestrian portrait exemplified by
Gian Carlo Doria; the court pair portrait of Albert and Isabella. The ency-
clopedic collection of objects—the heads of philosophers and emperors,
including Marcus Aurelius and Seneca; the rare and precious shells at bot-
tom right; the globes, sextants, orreries, and compasses; the coins and
medals—corresponds not only to what we know of Rubens's own collec-
tion but also to the liberal arts required of every cultivated gentleman: his-

Willem van Haecht,
The Picture Gallery of
Cornelis van der Geest,
*1628. Panel, 100 ×
130 cm. Antwerp,
Rubenshuis*

Rubens and Jan Bruegel the Elder, Allegory of Sight, *1617. Panel, 65 × 109 cm. Madrid, Museo del Prado*

tory, human and natural; mathematics and architecture; cosmography and classical archaeology. No self-respecting gentleman could be complete without such schooling. But the learning and the moral nobility it conveyed had to be lightly worn. Hence the studiously careless pile of chains of honor thrown down amidst the scholarly treasures like a schoolboy's booty.

The salient virtue of such an education was its universalism. The background of *Sight,* left and right, shows two sharply different prospects. In the mind-set of the Flemish *kunstliefhebber,* though, they were complementary. At right is a view into an even grander gallery, loftily vaulted, its freestanding antique statues lit by a high circular window: the image of a great Roman prince's princely collection. The archway on the left, however, looks onto a port scene that is less Italian than Flemish; perhaps even an idealized view of Antwerp itself, with gabled roofs and a little tower at the entrance to the harbor. This is exactly how van der Geest, Rockox, Jan Brant, and Peter Paul Rubens saw their place in the world: built, conceptually, from both red brick and golden masonry, local sturdiness and distant splendor. Their place of residence was only factually moored at the mouth of the Scheldt. Culturally, they all dwelled in a brainy never-never land called Antwerp-Rome.

It seemed important to maintain this fiction just because it was at such variance with the facts. The great hopes that the Antwerp patricians had invested in the truce—that it might herald a new golden age—had hardly come to pass. The city's population had stabilized at around fifty thousand, but that number represented half the citizenry of the 1550s, the heyday of

Frans Floris and Pieter Bruegel. The shore forts of the Dutch States General remained on the eastern bank of the Scheldt estuary, their cannon making it impossible for North Sea ships to progress upriver to the port. So most of Antwerp's trade, profiting from the southern bypass canal, came and went, by land and river routes, to France, Germany, and Italy. It was a living, but not a fortune. Increasingly, the big money was in the Baltic and the Indies, in grain, timber, and spices, and it was being energetically harvested by the merchant fleets of Protestant Holland and Zeeland. Antwerp was now a world city mostly in the rarefied imagination of its painters and patricians. In September 1616 Sir Dudley Carleton, appointed English ambassador to the United Provinces, stayed for a few days in Antwerp. He was simultaneously impressed and depressed by what he saw. The city, he wrote to his friend John Chamberlain,

> exceeds any I ever saw anywhere else for the beauty and uniformity of buildings, height and largeness of streets and strength and fairness of the ramparts. . . . But I must tell you the state of this town in a word, so as you take it literally, *magna civitas, magna solitudo* [a great city and a great desert], for in the whole time we spent there I could never set my eyes in the whole length of the street upon forty persons at once: none of our own company (though both were work days) saw one penny worth of ware either in shops or in streets bought or sold. Two walking peddlers and one ballad seller will carry as much on their backs at once as was in that royal exchange. In many places grass grows in the streets, yet (that which is rare in solitariness) the buildings are all kept in perfect reparation. Their condition is much worse (which may seem strange) since the truce than it was before.[32]

In 1627 Rubens himself would compare the plight of Antwerp to a body eaten away by consumption: "declining, every day, little by little." But that later pessimism was a product of the renewal of the war between Spain and the Dutch Republic in 1621, a catastrophic blow to his hopes of a Netherlandish reunion. Ten years earlier, he, like his friends, had warded off any creeping sense of confinement with a burst of cultural exuberance. The militia companies strutted dandily, banging away with muskets and drums. Street processions, pious and profane, lost nothing of their old riotous élan; pasteboard monsters wobbled once more over the cobblestones. The chambers of rhetoric (in one of which Rubens was an honorary dean) continued to stage their booming performances, comical and tragical, and for the first time in generations, new buildings, private and public, went up all over town. Sometimes their façades spoke of an instinct to marry old Flemish manners with new Italian conceits, creating the mixed brick-and-masonry style known affectionately as *speklagen*, bacon rasher. Sometimes they were more uncompromisingly grandiose, as in the spectacular Jesuit church, the foundation stones of which were laid in 1614.

Named for St. Carlo Borromeo, with its marbled sumptuousness and pro-fuse painted decorations designed by Rubens, the Borromeokerk conceded nothing to its prototypes in Rome. Though the interior of the church was destroyed by fire, Rubens's cherubs can still be seen fluttering about its façade with no thought of civic retrenchment leadening their wings.

When it came to settling himself, Isabella, and Clara Serena, Rubens was determined that his house should present a bold face to the world, with nothing cramped or meanly parochial about it. There were precedents for handsome artist's residences in Antwerp in the houses of painters of the last century. Quentin Metsys's "St. Quinten" had been richly ornamented, and to judge by an eighteenth-century pen drawing preserved in the Royal Library in Brussels, Frans Floris had also created for himself a grandly clas-sicizing house in what is now the Arenbergstraat, complete with statuary niches and painted decorations.[33] But although his local predecessors could hardly have escaped his attention, Rubens obviously had on his mind Man-tegna's handsome house in Mantua, and especially Giulio Romano's Casa Pippi: the model of a patrician painter's mansion. Nor could he have for-gotten the airy, light-washed Ligurian villas of San Pietro d'Arena or the austere and elegant sixteenth-century palazzi of Genoa, whose descriptions he collected in a book published in 1622, based on notes taken during his stays there in Vincenzo Gonzaga's service. Their combination of quietly refined pilastered façades and spacious interiors obviously appealed to him as a model for his own accommodation.[34] But for all its "Romanists," Flan-ders was not northern Italy, and though Antwerp was a less populous place than it had been in his father's day, it must still have seemed unpromisingly cramped for the kind of virtuoso's villa that Rubens really desired.

In November 1610, he found just the property he was looking for: a solid and substantial house, albeit built in the sixteenth-century Flemish manner, with pitched roof and step-gables and faced in bacon-rasher brick with masonry edging. It opened onto the Wapper, a canal that had once been part of the girdling moat encircling the old city. The house itself was by no means shabby, but it was probably the land that came with it that was the major attraction for Rubens. For extending along the street, paral-lel to the canal, was an ancient laundry with boiling sheds. Rubens paid 7,600 florins for the property on the Wapper, and had he wished, he and Isabella could have moved into the standing Flemish house while a start was made on improvements and additions. But they chose instead to remain with Clara Serena in the Brant family house near the harbor, close by the sites of the two churches for which Rubens was doing major work. If the always studious Rubens stayed with his parents-in-law to escape the clouds of dust, carpenters' saws, and masons' hammers, he was wise to do so since construction work at the house on the Wapper turned into a five-year project. When it was done, though, Rubens could move into a house the like of which had scarcely been seen before in this city, and which was, moreover, the exact architectural expression of its owner's personality: ruggedly northern in one aspect, gracefully Italianate in another; elegantly

Jacobus Harrewijn after J. van Croes, View of Rubens's House and Garden, *1692. Engraving. Antwerp, Rubenshuis*

reserved on the exterior, sensuous and richly wrought on the interior. Throughout, it was designed both as a *locus amoenus,* a place of contemplative delight, and as a custom-built professional workshop. Like Cicero's villa, which Rubens certainly had in mind, the house was meant less as a simple dwelling than as a statement about the temperate and well-balanced life, its spaces accommodating both public instruction and private retreat. No wonder his friend Wowerius believed that it would "arouse the astonishment of foreigners and the admiration of travellers."[35]

What present-day foreigners and travellers see at number 9, the Wapper, is, with the exception of a grandiose masonry screen dividing the courtyard from the garden and a summer pavilion at the end of the garden, a simulacrum of the original house. After Rubens died in 1640, his second wife, Helena Fourment, continued to live there until 1645, when it was let to Lord Cavendish, a fugitive royalist from the defunct court of Charles I who found the premises ideal for both personal residence and a Spanish riding school. In 1692 the new owner, Canon Hendrik Hillewerve, himself something of a connoisseur of the arts, had Jacobus Harrewijn make engravings of the exterior, the gardens, and some of the interior rooms, and it was the survival of those prints that enabled the twentieth-century enthusiasts to re-create, for the Brussels World's Fair of 1910, what they imagined was a faithful replica, in painted plaster and cardboard. The walk-through make-believe was so successful with the Belgian public that after the devastating bombardments and occupation suffered during the First World War, the rebuilding of the Rubens House also seemed an ideal

symbol of national reconstruction. As Belgium clung to a nervous neutrality to avoid a repetition of its fate in the First World War, a bitter dispute between Rubenists divided the partisans of a more rigorously historical approach to restoration and those who wanted to transpose the World's Fair version of the house to the Wapper. The purists were loath to designate arbitrarily measured-off spaces as "kitchen" or "bedroom" without serious archaeological justification. What counted for the "populists" was creating a wraparound Baroque "Olde Flanders" atmosphere on the indisputable site of Rubens's house and using seventeenth-century furnishings— oak cabinets, blue-white tiles, pewter tankards, and brass candelabra—to give an evocative impression of the painter's professional, domestic, and scholarly milieu.

To the chagrin of the purists, the issue was decided by calendrical opportunism rather than archaeological integrity. The tercentenary of Rubens's death was fast approaching, and the architect to whom the work had been entrusted, Emile van Averbeke, was in a hurry to see the project through to completion. The small matter of the German occupation may, for the worst reasons, even have helped rather than hindered the enterprise. There had long been a strong, not to say passionate, scholarly tradition in *Rubens-forschungen* (Rubens research) in Germany, and in a debased version, this extended to his admirers in what passed for the cultural elite of the Third Reich.[36] Rubens's enthusiasm for well-upholstered blondes and violent action was taken as evidence of his ancestral sympathy for Nordic race theory, and the art historian Alfred Stänge chose for his address to the National Socialist organization of art historians meeting in Berlin in 1944 a lecture on *Rubens-Dämonie,* celebrating the painter's visceral energy as the antithesis of degenerate, overcerebral art.[37] While conclusive evidence is understandably hard to come by, the honorary membership accorded to Rubens as a member of the Aryan pantheon may have helped accelerate the restoration of his house during the occupation, not least because the occupation authorities may have hoped that it would win them points with the Flemish nationalists and fascists, whose active collaboration they eagerly sought. Whatever the reasons, in 1938 there was, to all intents and purposes, no Rubens House. And in 1946, there it was.

So poor Rubens, just like Rembrandt, was taken hostage by his most unwelcome admirers, and in a cause that could hardly have been further from his instinctive and principled cosmopolitanism. After all, what he had designed for himself on the Wapper was poison to cultural fascism: a happy cultural mongrel, an illicit product of a marriage between vernacular and international styles. The frontage of the house, when completed, stretched a full 120 feet, but it divided at a central gateway between the old house and the new. To the left, the Flemish façade was broken by narrow rectangular windows, lead-paned and quartered. To the right, the middle-story windows of the Italianate addition were handsomely arched and set in banded masonry frames, a textbook adaptation from Rubens's own Genoese designs.

It was a house designed for both industry and illumination. The large studio on the ground floor measured fully forty-six by thirty-four feet and was thirty feet high, giving the impression of a baronial hall as much as of any sort of workplace. There was room here for even the very largest Rubensian products, but the space, supplied with ample north light, was so theatrically grand that it is hard to avoid the feeling that Rubens treated it as a setting for a self-conscious spectacle of the Painter at Work. It seems unlikely that the serious conceptual work, executed in drawings or small oil sketches, would have been done in this great room. And Rubens's pupils and assistants were also supplied with an upper-story workshop, lit by a generous skylight, in which they could work up the paintings from the master's own *modelli*. So the large "studio" might more plausibly have been used by Rubens to retouch the work of those assistants so that the paintings might truthfully be said to have been "from his own hand." Of course, if those assistants were peers and colleagues like Jan Bruegel or Frans Snyders, or the most gifted of his student-protégés like Anthony van Dyck, it's entirely possible that they might have collaborated in the same space. But it's easy to envision Rubens, in the final stages of seeing a painting through to his satisfaction, standing at an easel in the midst of the elaborately paved, plastered, and panelled room listening to a reading from Tacitus, an Italian air played on the virginals, or a choice item of Antwerp gossip; not exactly striking an attitude, yet nonetheless acting somewhat the part of Philosophical Painter.

A Stoic? A selective Stoic perhaps. For while the house was free of vulgar glitter, Rubens would certainly have supplied it with furniture appropriate to its architectural grandeur, the same sort of thing he would have seen in the houses of his friends Rockox, van der Geest, and Moretus: gilt-stamped leather wall hangings; complicated brass candelabra; chairs with stern backs and twisted legs; Turkish rugs to cover the heavy oak tables; rosewood or ebony writing cabinets with tortoiseshell or pearl inlay; finials figured as saints, beasts, or gods; yet more elaborate *kunstkabinetten* (art cabinets) with doors that opened to display painted scenes of landscapes, peasant feasts, or epic battles. Brass-studded, leather-seated chairs would stand guard beside embellished travel chests and the great masterpieces of northern furniture: monumental linen presses, intricately carved with flowers, beasts, gods, and heroes. Throughout the house, the visitor would have felt an almost crushing impression of weight and worth, lightened and made bearable by the discretion and intelligence that crept in with the white northern light.

Tapestries, maps, and paintings would have thickly covered the walls, the latter hung in tiers if necessary. No braggart, Rubens was also not much overburdened by false modesty At his death in 1640, he still owned 156 of his own paintings, and without a dedicated storage space it seems likely that portraits of patrons, family, and friends, as well as smaller histories and perhaps his oil sketches, would have been prominently displayed. Interspersed among them would have been a veritable gallery of the mas-

ters he most admired, with the Venetians (Titian, Tintoretto, and Veronese) dominating, along with the greatest Netherlandish figures of earlier generations, from van Eyck and Metsys to Bruegel.[38] Some of these paintings would have been copies made by Rubens himself, others the originals. But visitors could scarcely have left the house without a strong sense of its transalpine confidence: that it proclaimed the irrelevance of cultural barriers, as though Rubens were guiding the visitor through a lofty mountain pass (the kind of place that had appeared in Bruegel's drawings and paintings). From the eagle's ledge it was possible to see Europe as a civilized whole, north and south, Low Countries and Italian hills, rolling together in a single, unfenced panorama. With the grim spectacle of clashing armies made remote, it was possible instead to command views of fields at harvesttime; village kermisses; skating parties; the strenuous exploits of mythical heroes; ancient bacchanals and modern flirtations within rosy pergolas; voluptuous Magdalenes and gap-toothed topers: the whole world in a single dwelling.[39]

And where in this little-big world did Rubens put his mummy? To judge by the drawing made by one of his assistants, it was a male figure from the Ptolemaic period, relatively well preserved and bandaged, complete with decorated neck and pectoral pieces and encased (like Osiris) in a cedar chest.[40] Egyptian antiquities were beginning to show up in the Netherlands, shipped by obliging merchants stationed in Near Eastern cities like Cairo and Aleppo to scholars and learned collectors in northern Europe.[41] But Rubens might easily have become interested in Egyptiana during his stay in obelisk-studded Rome, where the relics of that antiquity were coming to be seen by some church scholars (including the popes) as a prefiguration not just of pagan but even of Christian Rome.[42] Either way, it seems likely that he set it at the beginning of a display of classical sculptures for which he had custom-built his own museum. In Rome he would have seen such sculpture courts housing the collections of the Borghese and the Orsini, and though he had not yet visited England, he would certainly have known of the colonnaded gallery built at Somerset House by the most intellectually omnivorous aristocrat of his generation, Thomas Howard, the Earl of Arundel, whose figure, both martial and humanist, would provide him with arguably his greatest male portrait study of all. Many of these galleries were designed to suggest Roman antiquity, in particular the open atrium of a villa, with freestanding columns and illusionist ceilings painted to resemble the open sky. Rubens, of course, went one better by creating his domestic version of the Pantheon, complete with coffered vaults, niches to hold sculpture busts, and even an oculus, the eyelike aperture at the top of the dome that lit the display below. Admittedly, considerations of space only allowed for a hemispherical half-Pantheon rather than an entire rotunda, but with a rectangular, navelike approach leading to the vaulted chamber, the effect must still have been mightily august: a solemn procession of ancestral worthies, virtue frozen in marble.

When he originally designed his museum, Rubens would already have had a number of specimens of Roman sculpture, some authentic, some

copies, like his pseudo-Seneca head. But in 1618, three years after he and Isabella moved into the completed house, he was given the unexpected opportunity to make a respectable collection of antiquities into an unrivalled one, at least in the Netherlands. In March of that year, he heard through George Gage, an agent charged with acquiring art for the English ambassador to the Dutch Republic, Sir Dudley Carleton, that the diplomat might be interested in exchanging his famous and substantial collection of classical sculpture for a batch of works by Rubens. A delicate and surprisingly prolonged negotiation then followed, with Rubens trading rather heavily on the unequal status of the two parties. He would depend on Carleton's "knightly word" for the value of the marbles. For his part, he was "an honest man," one "*sed qui manducat laborem manuum suarum* [who lives by the work of his own hands]" and who could afford to indulge his "whim" only because he happened to have back inventory sitting in his studio. There was more than a trace of disingenuousness in this parade of his workmanlike humility. In 1631 Rubens would actively seek, and be granted, a Spanish knighthood, but well before that, his well-known pleasure in horses and swords and chains of honor already gave the strong impression of a genteel chevalier. But it was important on this occasion to pose as the chief of a workshop (rather than a solitary virtuoso) because only five of the twelve paintings Rubens was offering were entirely by his hand alone, though among them were the black and agonized *Christ on the Cross*, "life-sized, perhaps the best thing I have ever done."[43] Among the remainder were a number of stunning mostly-Rubenses, like the alarming *Prometheus*, "bound on Mount Caucasus," with the eagle painted by Frans Snyders lunching on the hero's realistically depicted liver, and a *Leopard Hunt* where Rubens, as was his general practice, had delegated the landscape to a specialist in the genre. In cases like the copies of the Duke of Lerma's *Twelve Apostles* that had been painted by his students, Rubens endeavored to convince Carleton that his retouching would be enough to make the work indistinguishable from a complete original.

In some cases he was credible; in others not. It didn't help matters that when the shipment of paintings arrived at The Hague, their measurements failed to correspond to Rubens's specifications. But the discrepancy ought not to have been a surprise to an old Netherlands hand like Carleton, who must certainly have been aware of the variations in standards of measurement from province to province and even city to city. The fact was that behind Rubens's modest description of himself as humble craftsman, the Englishman scented the desperate collector. So the artist topped up his offering of paintings with a cash payment, notwithstanding his lament that he had already spent thousands of florins on his house that year, and that in his eagerness to supply Carleton with perfectly retouched items, he had "for some time now . . . not given a single stroke of the brush except in the service of Your Excellency."[44] By June the ambassador had his pictures and Rubens his stones. The collection was stupendous in both quantity and quality: twenty-nine chests whose contents included burial urns, inscriptions, and tablets as well as heads and putti, some with dolphins, others

with dogs. When as much of it as could fit into the museum was installed, visitors could take a leisurely tour through the centuries of antiquity, past grinning satyrs and the weeping Niobe; allegories of Peace, Justice, Abundance; a chaste Diana and a hot-blooded Jupiter; and then along a procession of the wise and the merely powerful, Marcus Agrippa as well as Marcus Aurelius, Julius Caesar as well as Augustus Caesar (mortal and immortal), Claudius and Cicero, Drusus and Germanicus, Trajan and Nero, Caligula and Domitian, head after head after head, craniums judicious and craniums tyrannical, imperial noses and martial brows, the personifications of S.P.Q.R. in bleakly gleaming marble.[45]

This tremendous hoard was meant both for private contemplation and for public admiration. There's no doubt, from letters to his antiquarian friend Nicolas-Claude Fabri de Peiresc, that Rubens liked to spend an afternoon communing with his long dead companions as well as poring over his equally impressive collection of classical medals and gems—agates, ivories, cameos, and carnelians—all stored in vitrines in the anteroom to his Pantheon. But it's equally evident, from reports of visitors, that they were expected (and usually not unwilling) to do the tour and be suitably impressed. Among them must have been some mere mortals who wilted under the strain of remembering the right passage from Plutarch to match the relevant Roman bust, and who sought the courtyard and garden for a respite from learning. And at first sight, the enclosed space, with its little grotto and fountain tucked in one corner, the handsome portico screen, and the painted frieze that ran around the courtyard walls, might well have seemed like a welcome change from the chilly mausoleum of the great and the good inside the Pantheon. But if Rubens had followed his guest outside, he would have quickly disabused him of the notion that the exterior of the house was designed for idle pleasure. No such luck. The visitor was still surrounded, at every turn, by Instruction and Improvement. Over the side arches of the portico Rubens had set quotations from Juvenal's tenth *Satire:*

Leave it to the gods to give us what is fit and useful to us; man is dearer to them than he is to himself.

One must pray for a healthy mind in a healthy body, for a courageous soul which is not afraid of death . . . which is free of wrath and desires nothing.

That was all the visitor would see inscribed on the wall. But those who knew their Juvenal might have recalled that the passage continued by commending the labors of Hercules over a life of sensual self-indulgence. "What I commend to you you can only give to yourself, for it is assuredly through virtue that lies the one and only path to peace."[46] How many of those who stood gazing on these scoutmaster nostrums remembered Jan Rubens and buttoned their lip?

At this point, our visitor, his feet leaden, his head buzzing with

erudition-fatigue, might have felt well and truly trapped in allegory-land. But there had been, in fact, a subtle shift of emphasis from the museum to the courtyard. The Pantheon represented the public Rubens: the active citizen, Lipsian Man, deeply engaged in history and politics and devoted to the lofty ideal of a just Christian peace. (It was a bitter irony that 1618, the year in which his Cicero and his Seneca were installed in their niches, also saw the beginning of thirty years of religious and dynastic war in Europe that would make that ideal unattainable in Rubens's lifetime.) The courtyard, on the other hand, represented the realm of art—an art, to be sure, that was often at the service of princely and religious authority, but an art that was also seriously involved in the play of the passions and the senses.[47] Hence Hercules, who reappears so often in Rubens's work as to seem almost an alter ego for the painter himself: a child of a sensually driven father, but a man who, at the crossroads of life, chose the path of labor and virtue recommended by Juvenal. On the walls of the courtyard Rubens painted a faux frieze, in grisaille, representing episodes from both mythology and the lives of painters of antiquity. One scene has Hercules drunk, in the grip of the furious passion that would cause him to murder his own children. Not that Rubens supposed himself to be capable of such horrors. But some of the greatest of his paintings are full of shocking violence: severed heads; a tongue torn by the roots and fed to the dogs; epileptic seizures; full-blooded rapes; peasants groping and coupling. And he would not have been half the artist he was had he not understood, through his own sensuality, the power of the body's demons.

Against those maddening and destructive urges, the deities of wisdom and eloquence, Minerva and Mercury, stood sentry, right on top of Rubens's courtyard's triumphal archway. In the Greek version of their names, they were thought of as a single, androgynous defense unit, the "Hermathena," inspiring the painter and protecting him against envy and vice. Minerva's shield with the serpentine head of Medusa embedded in its center appears elsewhere in the courtyard on the arm of another hero of the painter, Perseus. Perseus was another important figure for Rubens since his own myth was connected, indirectly, with the birth of painting. His favorite mount, the flying Pegasus, had been born from the blood gushing from Medusa's head after Perseus had struck it off. And it had been Pegasus's hoof, striking Mount Helicon, that had created the Hippocrene stream in which the Muses, including Painting, had bathed. So the most venomous blood and the most limpid water both fed the well of artistic inspiration, and Rubens may have seen Caravaggio's startling version of the theme. He himself had painted another episode from the eventful life of Perseus (now in the Hermitage): the liberation of rock-manacled Andromeda from the sea monster, complete with the Medusa shield and the winged horse. But for his courtyard manifesto of the virtuosity of art, he went to the amazing length of reproducing it *in fresco,* on a solid wall, as a faux canvas hanging to dry in the sun. From his letters to Carleton we know that this was a regular practice of his, and one might readily imagine the old

bleaching field, once lined with sheets of snowy cloth, now filled with
lengths of canvas—a St. Sebastian, a lion hunt, a Bacchus—all pegged out
to take advantage of the unpredictable Belgian sun as it dipped in and out
of the scudding clouds.

Rubens's visual teases worked so well that when the restorers in the
1940s looked at the 1692 print with its details of the courtyard decora-
tions, they assumed that the Perseus and Andromeda had been an *actual*
painting hanging from a terrace, and that the rest of the frieze was in fact a
sculpted relief. The notion of cheat-paintings didn't seem to square with
the Serious Rubens, the acme of taste. But the play of illusion was all part
of the artful commentary on painting that travelled round the walls of the
courtyard. A number of the scenes in the faux frieze drew on stories of the
painters of antiquity and embodied virtues that were especially important
to Rubens. One scene showed Zeuxis (himself both praised and reproached
as a manipulator of optical illusion) selecting from among the maidens of
Kroton the particular features (this one's brow, that one's breast) that could
be combined into the perfect female nude. Thus Peter Paul Rubens, the
epitome of discrimination. Those who knew their Pliny and their Lucian
might also have remembered that Zeuxis was praised *both* for his ability to
work in illusions of monochrome (like the courtyard grisaille!) *and* for his
boldness in modelling forms through contrasts in color, rather than con-
tour and outline. Thus Rubens the virtuoso of *colore*. Another scene in the
frieze reproduced Apelles' *Calumny,* an allegory invented in response to a

rival's false accusation of political conspiracy, with the usual suspects—fraud, envy, deceit, and company—lined up before their ruler who, according to the story, had been given by Apelles the ears of an ass. Thus Rubens, the rock of integrity.

But was this nonpareil, this Apello-Herculo-Zeuxo-Perseus, human?

Walk through his triumphal arch and up the garden path and you can hardly conclude otherwise. For this was a third of Rubens's realms: his patch of the terrestrial paradise, his *hortus conclusus,* a domestic Eden, delicately patterned with low hedges of box and yew, like the embroidery on a fine length of silk. The gods and heroes were not entirely banished from this retreat, but here they wore a more affable demeanor. Their little temple, a colonnaded summer pavilion, was a votive shrine to nature such as Rubens supposed Horace, Pliny, or Cicero might have installed in their villas. Its presiding deity was the gentle Flora, mother of springtime, married to the Zephyr and made profuse with flowers. By her side, Hercules (again, modelled from the Farnese statue that haunted Rubens all his life) leaned contentedly on his club, finally at rest from his trials and labors.

As Rubens marched through the triumphal stages of his career, his garden became progressively more important to him (and expanded in size as he acquired adjoining properties on the Wapper). During the 1620s he went from acclaim as the local Apelles to international recognition as the greatest master of his age, the automatic choice of princes like Marie de' Medici, the Queen Mother of France, or Charles I of England to immortalize the virtues of their dynasties. His diplomatic touch with notoriously ticklish royal egos was such that it was merely a matter of time before it was utilized not just in painting but in political negotiations. And though there were initially complaints in Madrid that it was unseemly for the Spanish crown to be represented by someone who worked with his hands, the criticism evaporated when Rubens successfully negotiated a treaty of peace between England and Spain in 1629–30.

This was his high-water mark as a public man. The treaty gave him outward dignity and inner satisfaction. He was thrice knighted: in Brussels, London, and Madrid. But he could also stand in his Pantheon and look his philosophical ancestors—Cicero, Seneca, Marcus Aurelius—in their stony eyes, knowing that he too had done his utmost for an honorable peace. Before he left London, he had presented King Charles with an allegorical painting representing *Peace and War.* Mars is being decisively seen off by Wisdom, in the reassuring form of a Minerva with rolled-up sleeves. An opulently breasted Peace nurses a bonny little Ploutos, the god of riches, while a goat-footed satyr handles the fruits of prosperity spilling from a horn of plenty and a leopard on his back plays kitten with a hanging vine. Above their heads, a dark, storm-filled sky moves away, to be replaced by an azure-blue vault opening above the helm of Minerva.

Eight years later, Rubens repeated the subject, but in an exactly oppo-

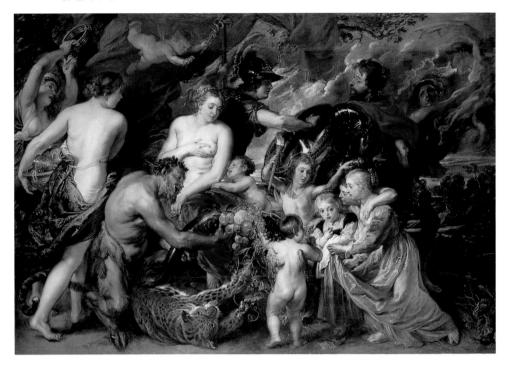

Rubens, Peace and War,
1629–30. Canvas,
198 × 297 cm. London,
National Gallery

site mood. This time the blue skies are overwhelmed by smoky darkness. Europa, wearing the turreted crown on her head, rushes from the open portals of the Temple of Janus, whose doors were firmly shut in peacetime. And despite support from the usual team of putti and her own spectacularly opulent charms, Venus is losing the battle for Mars's attentions to the Fury Alecto. "Nearby," as Rubens wrote to Justus Sustermans, his agent at the Medici court in Florence, where, safe conduct permitting, the painting was destined,

> are monsters personifying Pestilence and Famine, those inseparable partners of War. On the ground, turning her back, lies a woman with a broken lute representing Harmony. . . . [T]here is also a mother with a child in her arms indicating that fecundity, procreation and charity are thwarted by War, which corrupts and destroys everything.[48]

Rubens's hopes for a peaceful reconciliation between the warring confessions and powers in Europe had been cruelly disappointed. Spain's peace with England, which he hoped might have been a prelude to an accommodation with the Dutch Republic, uniting the two parts of the sundered Netherlands, had done nothing of the sort. Antwerp had sunk back into stagnation. His patrons Albert and Isabella were both dead, and although Rubens designed the triumphal ceremonies that greeted their successor, the Cardinal-Infante Ferdinand, he had been robbed of his earlier conviction

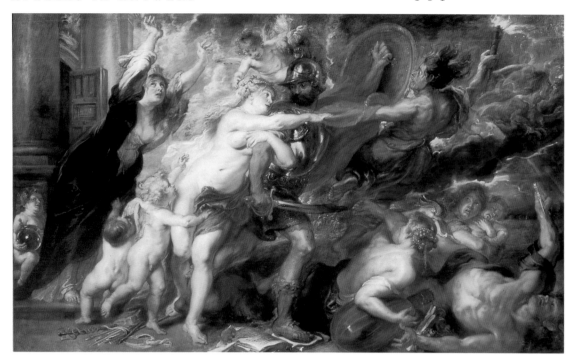

that an honest man might make a difference in a lamentable world. "I am by nature and inclination a peaceful man, the sworn enemy to disputes, lawsuits and quarrels both public and private," he wrote to his friend Peiresc in May 1635, and later that year he worried that unless the King of England, the Pope, "and above all the Lord God" could intervene in another bloody crisis, "a blaze which (not put out in the beginning) is now capable of spreading throughout Europe." But only the older, sadder Rubens could have added, "But let us leave the care of public affairs to those whose concern it is."[49]

Increasingly, Rubens sought in nature and in private life what he could not find in history or politics: the abiding redemption of love. In 1635 he sold off the Carleton marbles to the Duke of Buckingham, keeping for himself only the few antiquities that gave him particular pleasure: the pseudo-Seneca, for example; his collection of gems and cameos; and a classical porringer that he found perfect for his second wife, Helena Fourment, to use during her pregnancies, being "so light and easy."[50] Four years after Isabella Brant's death, he had decided to remarry since, as he explained to Peiresc, "I was not yet inclined to live the life of a celibate. . . . I have taken a young wife of honest but middle-class family although everyone tried to persuade me to make a court marriage. But I feared pride, that inherent vice of the nobility, particularly in that sex, and that is why I chose one who would not blush to see me take my brushes in hand. And to tell the truth it would have been hard for me to exchange the priceless treasure of liberty for the embraces of an old woman."[51]

Rubens, The Horrors of War, *c. 1637. Canvas, 206 × 342 cm. Florence, Palazzo Pitti*

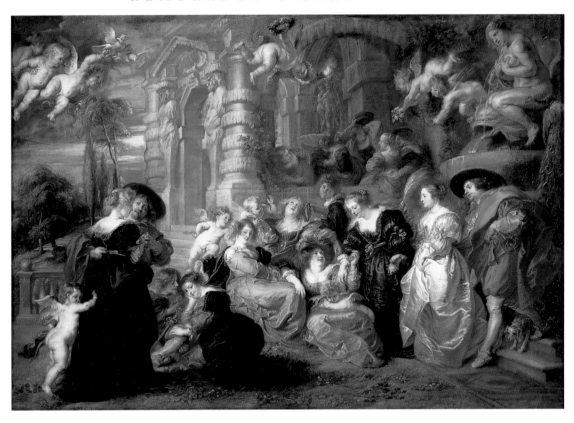

Rubens, The Garden
of Love, *c. 1630–32.
Canvas, 198 × 283 cm.
Madrid, Museo del
Prado*

Helena was the daughter of a silk merchant, Daniel Fourment, whom
Rubens doubtless knew through another of his daughters, married to a
brother of Isabella Brant's. When she married Rubens in 1630, she was just
sixteen. Her husband was fifty-three. No wonder he felt that life with her
was suddenly Maytime, when he had been expecting frost. Though Europe
might be a wilderness, strangled with tares and brambles, his own backyard
was a realm of peace, order, and abundance. In the sumptuous *Garden of
Love* now in the Prado, the painter and his adolescent wife seem to dance
toward a portico decorated exactly like Rubens's own, with banded
columns, a pediment, and a scalloped keystone amorously entwined with
roses. With his late rush of virility, Rubens's love gardens grew bigger and
bigger, straining to control a luxuriant riot of orgiastic humanity and fecund
vegetation. Often the nymphs and cherubs seem as much creations of the
vegetable as of the animal world: luscious fruit and bolting flowers, freely
fertilized by the artist's unstoppable creative flow. This was Rubens's answer
to a world that seemed consumed by mendacity and death: a procreation of
Edenic proportions, an immense horticultural hallelujah. Back in the Pan-
theon, Seneca, the epitome of the temperate life, must have been in shock.

In the sanctuary behind his house, the spite and savagery of the politi-
cal world were banished. But Rubens's *hortus conclusus* was more than
just a contemplative asylum. It was also a botanical projection of the
way the world ought to be. It comprised species that were diverse but har-

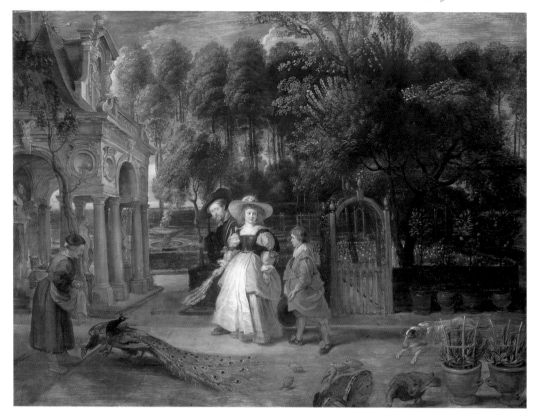

Rubens and workshop, Rubens in His Garden with Helena Fourment, *c. 1631. Panel, 97 × 131 cm. Munich, Alte Pinakothek*

monious—incomparably varied yet somehow all intricately connected through the sublime ingenuity of the Creator. Rubens's garden, then, was not just a recreational afterthought to his house. It was its consummation, densely planted with ideas and visions. It even embodied, in horticultural form, one of Rubens's most tenaciously held convictions: the belief in connections, between past and present, between the living and the dead, between entities that seemed unbridgeably separate yet were, in the omniscient vision of the Creator, part of a perfect whole. In common with other encyclopedically avid gardeners, Rubens thought of his yard as a place that reunited the scattered and richly various phenomena of the known world within a walled enclosure. There were tulips in beds and oranges in tubs, the exotic and the domestic, the golden apples of the Hesperides sharing space with the Turkish flower made Netherlandish. And if a painting of the Rubens family walking in the garden is to be believed, there were peacocks and turkeys, the fowl of Asia and America, strutting together. One of Rubens's last letters, written from the Château de Steen, asks his protégé, the sculptor Lucas Fayd'herbe, to remind his gardener to send him the first harvest of figs and of Rosile pears from the Antwerp garden.

In this way, Rubens managed to travel the world while staying at home; to follow the Herculean trail from the Hesperides to the Orient without any of the legendary discomforts. But if his understandable preference in middle age was for the comforts of domesticity, his reputation con-

tinued to travel. From Spain to the Baltic he was spoken of as the marvel of
the age, the paragon of talent and of virtue, pious and courtly, tireless in his
labors, gallant in his manners. No one had a bad word to say of him—
except, that is, a Dutchman, Rubens's quondam engraver, Lucas Vorster-
man, and he was widely rumored to be off his head.

v *Rubens for Export*

Just who was this Baudius person and what did he want?

In October 1611, quite out of the blue, Rubens received from Holland
an elaborate letter of condolence for his brother Philip's death, or, as the
writer preferred to put it, his "premature departure for the sojourn of the
fortunate." This was the sort of phrase that came naturally, or at least pro-
fessionally, to a professor of rhetoric like Dominicus Baudius, who was
also professor of history and law at Leiden University, the very same chair
that had been occupied by Justus Lipsius between 1585 and 1591. Perhaps
it was on the strength of that connection that Baudius implied some famil-
iarity with Philip Rubens, though he couldn't manage to say it outright.
Nor would he presume, heavens no, to offer the grief-stricken surviving
brother consolation from the Holy Scriptures, since Rubens would hardly
need such counsel (though he did select what he thought was an apt pas-
sage from Homer, along with the conventional piety that time, not reason,
"would gradually assuage the violence of our affliction and sorrow"[52]). But
these were just preliminaries. What Baudius really wanted, it transpired as
the letter continued, was Rubens's friendship, and he was prepared to
trowel on the compliments if that's what it took to get it. So the painter was
hailed (inevitably) as "the Apelles of our time" whom some new Alexander
would be sure to recognize. And lest Rubens think this proffered hand
belonged to some pushy nonentity, Baudius made so bold as to suggest
after his own *modest* and *humble* fashion that the position he held was not
altogether contemptible, namely (in addition to his university posts), the
title of official historiographer to the States of Holland in "this northern
Sparta."[53]

The occasion for Baudius's frenzy of epistolary hat-doffing was that he
had picked up an enticing rumor that Rubens was meaning to visit the
Dutch Republic, and he yearned to be able to impress the faculty by his
"friendship" with the genius of the age. So he finished the letter by shame-
lessly name-dropping a list of Rubens's closest acquaintances—Otto van
Veen, Wowerius, father-in-law Brant—and asking to be remembered to
them as if they were his own intimate familiars, men who might put in a
good word for him should they be consulted by a baffled Rubens.

Doubtless Rubens responded, as was his habit, with economical cour-

tesy. But Baudius wouldn't go away. The following spring of 1612, back he came with another letter, apologizing profusely for not having written sooner, his reason being that "I have been so preoccupied paying court that I have been entirely unable to attend to the other duties of life and friendship."[54] Again the unnerving presumption of comradeship: the fifty-year-old Baudius convinced that Rubens would want to share his joy at his own second marriage, to the extent of sending him a wedding present in the form of a painting! Lest Rubens think him a little forward in this suggestion, Baudius offered by way of a quid pro quo a few verses from his hand, eulogizing works "created by a brush so perfect that Nature herself rejoices in being conquered by such a rival." Baudius's poem then went on to describe three of Rubens's pictures, among them the terrifying *Prometheus*. Presumably he had seen the painting in Holland, for he relished describing its details: the "cruel bird ceaselessly devouring the liver . . . / yet still unsatisfied with his frightful meal tears with his talons and the face and thigh of his victim / . . . blood spurts forth from the breast, dyeing every spot where the bird sets his feet / And from the eagle's eye dart forth savage flames . . . / Neither Zeuxis nor Apelles equalled such works. No one can surpass you, your only rival is yourself."[55]

"I am not made for flattery," Baudius wrote unconvincingly. "[I]t is a stain which should not soil a noble heart, but I must say what I think: . . . that these masterpieces will live as long as art is glorified on this earth as the rival of nature and the essence of beauty." And though the exchange of a painting for a poem seems, in this case, hardly an equal trade, Baudius was relying on Rubens's erudite knowledge of the sisterhood, inherited from Aristotle and Horace, between poetry and painting to dignify his offer. And since he knew (or said he did) Otto van Veen, he must have known of the emblem in van Veen's book based on Horace's maxim *Cuique suum studium* (Each to his own discipline), which implied the parity of poetry and painting.[56] In the plate a poet sits at a table looking appropriately meditative, stopped in mid-pentameter while a painter at his easel works on a picture of a sphinx.[57]

Little came of this relentless self-promotion. Baudius never got his Rubens, either as friend or as picture. A few months after his second marriage, he died, though he was survived by a volume of poems which included his verse in honor of the Flemish painter. It's just possible, though, that just before his death Baudius might have gotten to meet the object of his effusions. For Rubens did in fact go to Holland in the early summer of 1612. His purpose was not to hobnob with literati but to find an engraver who could reproduce the pictures of his that were in international demand, in particular *The Elevation of the Cross*. Of course, Antwerp was not short of competent draftsmen or engravers. The Wierixes in particular continued to grind out plates for books of devotion, Bibles, and saints' lives. Rubens had enough confidence in local talent to use the brothers Theodor and Cornelis Galle to make some reproductions of his early works. But if some visitor from the north were to boast that there was no one in Flanders equal

to the great graphic artist Goltzius, who was living in Haarlem, it would have been hard to give him any kind of argument. And there was another practical reason for scouting for an engraver from the north. The Dutch were too enterprising (and, some would say, too unscrupulous) to refrain from making their own reproductions of Rubens's best pieces when there was both a domestic and an international market ready to snap them up. With no generally agreed copyright conventions operating in seventeenth-century Europe, it was impossible to prevent pirated editions of those prints from circulating in the marketplace.

Why not control the business himself, Rubens must have thought. Why not have his own Dutchmen? Even before he made the trip north, Rubens had borrowed Otto van Veen's Dutch engraver, Willem van Swanenburg, to make prints of some of his more celebrated histories, like *Lot and His Daughters* (groping and wine) and a theatrical Caravaggesque *Supper at Emmaus* (burly street types pushing chairs back in astonishment).[58] In van Swanenburg and his extended family, Rubens might well have recognized the same sort of clan as his own. They were an old Leiden dynasty, distinguished in law and city government, friendly with the van Veens. Many of them, including Willem, were officers in the militia. Though Calvinist, they were not hotheads or fanatics who thought any dealings with southern Papists tantamount to treason. They were men of the truce, men who were not shocked that it was Otto van Veen, the Catholic, who was commissioned by the States General to paint a cycle of twelve pictures representing the Batavian revolt against Rome (the classical analogy to their own rebellion against Spain) for their assembly chamber.

Alas, the gifted Willem van Swanenburg died, still a young man, in August 1612, but may have been ailing for much of that year. Aware that his chosen collaborator was not long for this world, Rubens may have wanted to seek his advice on a successor. Perhaps, too, he wanted to nose around this citadel of Calvinism in Leiden, take himself to the rooms where Lipsius had taught, poke with his cane at the patch of ground where he had made his medical garden? Watch the sails of the windmills, one of them by the Witte Poort, revolve in the breeze? He did find his way to Haarlem in June to see Hendrick Goltzius. Though separated in age by a generation, the two artists had much in common. Both could share memories of an early life of wandering across embattled borders in Germany and the Netherlands. They had ended up on different sides of the Catholic-Protestant frontier, and that was no small matter. In the desperate days of the 1570s, when the Rubens family had been in exile, Goltzius had produced propaganda prints representing William the Silent as a new Moses, leading his people from tyrannical bondage. And when William was assassinated, it had been Goltzius who was charged with the commission to produce a print of the funeral, an immense etching that required twelve separate plates, and that when printed extended for over fifteen feet. But still Rubens and Goltzius could talk to each other. They both hated fanatics; they shared a common pool of scholarship, poetry, and memories of

OPPOSITE: *Rubens and Frans Snyders*, Prometheus Bound, *1611. Canvas, 242.6 × 209.5 cm. Philadelphia Museum of Art*

Rome. Goltzius and his wife were, after all, still Catholics, and Rubens certainly admired Goltzius's fantastically inventive and theatrical manner, which was powered by the same muscular emotionalism that Rubens was pouring into his paintings.

Was the pleasure of reuniting the Netherlands in the symbolic form of their meeting a little *too* heady? In his memorial poem to Goltzius, the art dealer Balthazar Gerbier, who would become Rubens's most important contact in the English court, remembered an evening of happy drunkenness at a village hostelry just outside Haarlem notorious for this kind of entertainment. The group of revellers included, besides Gerbier himself and Goltzius, other Flemish painters then in Holland like Pieter Bruegel the Younger. The evening seemed clouded only by Rubens's own aloofness from the more riotous activity, which was just as well since the party ended abruptly with arrests for drunken disorder.[59]

Duly sobered up, Goltzius must have been of real help to Rubens. No one had more experience in the distribution of prints in the international market, nor in the move from reproducing the works of others like Annibale Carracci to specializing in the products of one's own studio. Goltzius had in fact trained up his own stepson, Jacob Matham, in this line, and had used him more and more as his health began to deteriorate. It was generous of him to allow Rubens to hire Matham and take him back to Antwerp on the return journey. There he made a number of prints, including Rockox's *Samson and Delilah*. But he wasn't as productive, nor the law as watertight, as Rubens would have liked. What Rubens really wanted was something like the establishment of Rubens Inc.—a diversified, fully integrated artistic corporation with the Master as chief executive and the ideas man originating sketches and supplying the finishing touches that would make the description "by my own hand" not a complete untruth. A team of pupils and assistants could then do the mechanical work of transposing the master design to a large panel or canvas. Colleagues and friends specializing in, say, flower or animal painting might be called on to produce custom work where it was called for. The difference to be preserved was between invention—the monopoly of the Master—and mere execution. Rubens Inc. would operate as a factory of Baroque production, complete with graphics and an export division servicing the international print market and armed with licenses forbidding the distribution of unauthorized reproductions.

In January 1619 Rubens wrote to yet another of the van Veens, Pieter, who lived in The Hague and himself dabbled in art as well as making a livelihood in the law. Could he put the copyright issue before the authorities? Rubens's timing was bad. The Dutch Republic had come close to civil war between militant Calvinists who wanted to renew the war with Spain and the defenders of the truce. The "peace" party had lost and lost badly. Grotius, the apostle of tolerance, was in prison; Oldenbarnevelt, the pragmatist, was tried and beheaded. Not surprisingly, the States General in May 1619 was not about to grant any favors to an Antwerp Catholic famous for his enthusiastic obedience to the Spanish crown. But Rubens

still had his friends in The Hague and did not give up. Perhaps Pieter van Veen reminded Their High Mightinesses that they had not objected to hiring his own Catholic brother, Otto, to decorate their chamber. And then there was the English ambassador Dudley Carleton, who now had a house full of great Rubens pictures, including the *Prometheus*, in exchange for his antiquities. Whatever influence was brought to bear worked. On May 11, 1620, Rubens was granted his copyright privileges within the Dutch Republic.

In confident anticipation of this outcome, Rubens had already hired his northerners: first Pieter Soutman and then, two years later, in 1618, Lucas Vorsterman from Zaltbommel, a true prodigy in his early twenties said to have been a skilled engraver since he was twelve.[60] From the beginning, no one doubted Lucas's innate gift. One of his first assignments must have been one of the Carleton pictures, an intensely erotic *Susanna and the Elders* which pretended morality while advertising desire. But Vorsterman proved to excel in both piety and profanity. During his first two years with Rubens, he turned out twelve large and spectacular prints (including versions of *The Descent from the Cross*), which represented the single most important diffusion of his master's work throughout Europe. Vorsterman developed a personal manner of working with the burin needle, building up dense but controlled layers of lines that somehow had the power to suggest the richness of Rubens's colors. For a year or two it seemed a harmonious working relationship, sealed, as these things so often were, with a ceremony, in this case the christening of Vorsterman's first child, Emile-Paul, with Rubens standing as godfather. In short order thereafter, Vorsterman became a citizen of Antwerp and master of the Guild of St. Luke.

Perhaps it was the smoothness of Vorsterman's rapid progress from apprentice to master that emboldened him to take on Rubens. The Master could hardly have seen it coming. He was, after all, unchallengeable, a grandee. Vorsterman, for all his native skill and years of scratching away, was, Rubens must have thought, a nonentity who owed his career to his trust and munificence. But here was the upstart ingrate presuming to demand, *demand*, mind you, that he should have some sort of independent recognition of his work, say a dedicatory inscription. The bald-faced effrontery of it! What should he have to print were it not for his master?

Rebuffed by Rubens in his attempts to receive both acknowledgement and a share of the proceeds, Vorsterman seems to have decided to act unilaterally, adding his own name or sabotaging the studio's production. To Rubens's undoubted fury, he even succeeded in turning the legal apparatus for copyright against his boss, seeking and acquiring his own privileges. And he was still unhappy. On the back of an oil sketch Rubens gave him to engrave he carved the inscription: "Through a bad judgment [presumably legal] this cost me many cares, anxieties and sleepless nights."[61] Then Vorsterman decided to hold the original work of art hostage, keeping under guard both the painting and his own copper plate. In other cases, Vorsterman simply went slow, endlessly delaying on a project Rubens had

Lucas Vorsterman the Younger after Anthony van Dyck, Portrait of Lucas Vorsterman. *Etching, from the* Iconography. *Amsterdam, Rijksprentenkabinet*

already pledged himself to. Finally, Rubens had had enough. In April 1622 he wrote to Pieter van Veen that for two years he had had no real work from his engraver, who had surrendered to the vice of *alblasia*—slothful arrogance and pride. What could be done with such a type? Nothing, he feared.

At stake here was much more than a personal feud. Rubens held to the position that it was the concept, the invention, that counted, and that therefore commanded the title to intellectual property. This was an essential element in the struggle northern artists had been waging to be taken seriously as learned thinkers. Vorsterman held the more down-to-earth position that some sort of title rested with the practitioner. At some point in the spring of 1622, matters went beyond dispute or even shouted recriminations. Rubens asked the magistrates for protection against the engraver, who had turned physically threatening. Astonishingly, his request was declined. Toward the end of April, a group of his friends petitioned the privy council in Brussels for intervention since Rubens's very life had been menaced by the "insolence" of Vorsterman, who, it was generally thought, had become deranged. Isabella took immediate steps, instructing the Antwerp magistrates to guard him against "one of his men, evil-intentioned and said to have sworn his death." Predictably, the stories, if not the aggressor, got out of hand. In the summer of 1622, it was rumored in Paris that Rubens had been attacked and wounded, if not slain, by the unhinged Vorsterman.[62] By 1624 Lucas had disappeared from the studio on the Wapper, replaced by the more amenable Paulus Pontius, who engraved Rubens's self-portrait. Perhaps Pontius's hand lacked Vorsterman's panache. But it was also less likely to be wielding a dagger.

The castoff was not entirely friendless. After 1624 he found some work with other Flemish artists and subsequently went to England, where he was hired by Rubens's old friend and patron, the polymath Earl of Arundel, to reproduce masterpieces from his collection. And there were still those in Antwerp—Adriaen Brouwer, Jacob Jordaens, and Anthony van Dyck—who promised him enough work to induce him to return to the city in 1630. When a daughter was born, it was van Dyck, not Rubens, this time who was the godfather to baby Antonia. The painter returned the favor by including Vorsterman some years later in his projected *Iconography*, along with Huygens and Rubens. It is one of the most troubling portraits ever to appear in that collection: a gallant Flemish cape surmounted by haggard cheeks, nervously sidelong eyes, and the worry lines of a tormented soul.

No wonder. Vorsterman was losing his sight. And when his eyes went, so did his income. He fell into distress and poverty, and those who contin-

ued to care for him believed he had always been a victim of poetic melan-
cholia. Vorsterman himself believed that his sight had been damaged by the
unrelenting and painstaking work he had done for Rubens; Rubens, whom
the world knew as the soul of Christian gentility, the pillar of virtue who
was taking the air amidst the pear trees while Vorsterman eked out a pit-
tance trying, through dimming eyes, to push a needle into copper. What
stuck in Vorsterman's craw must have been the sense, justified or not, that
without his prints Rubens would not have enjoyed his universal reputation
as the wonder of the age. Throughout the Netherlands and beyond its bor-
ders, there were novices, his prints on their table, beginning their labors
of emulation, seeing if they too could not become the Rubenses of their
generation.

One such prospective emulator in Holland must have had his own little
collection of Rubens prints: Pontius and the Bolswerts as well as Vorster-
man. In 1631 he did what emulators were supposed to do: copy a composi-
tion and add one's own touch. But the composition was Rubens's
self-portrait, and the "touch" was Rembrandt's irregular, confident face.
This was not exactly what the counsellors of instructive imitation had
meant. This was, some must have thought, a little much.

PART THREE

The Prodigy

i *O Leyda Gratiosa*[1]

The windmills were the first things you saw on the approaches to Leiden, whether you slid along the Rijn canals on the tow-barge, taking in the low, cow-grazed meadows through a screen of pipe smoke, or whether you spied the place on horseback, on the road from Leyderdorp or Souterwoude. There they stood, planted atop or just behind the city walls at sentrylike intervals, so many dumb automata, their arms slowly gesticulating in the breeze. Behind them, rising from the packed piles of gables, you could make out the humps of the thirteenth-century keep, the Burcht, and the two great Protestant churches, the Pieterskerk and the Hooglandsekerk, gray-brown and spiny like the dried blowfish exhibited in the university's garden. Depending on your mood and the temper of the skies, the ponderous motions of the phalanx of windmills could seem welcoming or threatening. As you came closer, you could hear the creaking and groaning of the wooden arms as they cut the cool air, the complaining sounds of creatures fastened to their labor. Bearing ancient, watery names like "the Ark" and "the Pelican," they seemed always to have been there, pumping water from the peaty water meadows or grinding meal for the city's bakers.

They had not always been there, though. There was a fancy, much written up by local chroniclers like Jan van Hout and his nephew Orlers, that Leiden had begun as Lugdunum, the tribal citadel of the ancient Batavians. They flattered themselves that these remote ancestors were, like their own generation, shrewd and watchful, and that they had determined their site of habitation as a good place to patrol the Rhine as it cut a path through the ridge of sand dunes and flowed, finally, into the North Sea. At the point where the two arms of the divided Rhine, the "old Rhine" and the "new," rejoined, just before making the last passage, these Batavians dug themselves in. From their first watchtowers, doubtless rickety timber structures, they could see that this was a perfect site to extract tolls from those wanting in (to the Rhineland) and those wanting out (to Britain). For centuries thereafter, the place was no more than a fort and a trading camp

wedged between the sandy shore and the river. To the south there were
low-lying boggy fields, sometimes flooded deep enough to allow flat-
bottomed boats to maneuver, poling between the wind-bent reeds for fish
and fowl.

But the rivers flowed swiftly, the traffic came and went, and by the thir-
teenth century the hamlet had become a town. As Leiden grew, it needed
mills, and the wind machines changed everything. They created food from
flood, grazing meadows from morass, and wrested a measure of freedom
from the tight grip of feudalism. Military muscle counted for less in a coun-
try where protection was needed from flood rather than from horseback
armies. So although there was a castle in the center of the town, the count
who held it shared his authority with the city fathers, who collected dues
and maintained the water defenses of the Rijnland. They ensured that trade
flowed freely and gave the Count a share of the tolls. He, for his part,
acknowledged their liberties. Within the red brick walls and timbered
rooms of the Gemeenlandshuis van Rijnland, the hydraulic councillors
considered the dredging of sludge and the shoring of dikes with the same
weighty sense of communal purpose that elsewhere in European cities
would have been reserved for the containment of brigands, heretics, and
pestilence.

At some point in the late Middle Ages, the windmills had been moved
out beyond the city walls into the surrounding meadows. Leiden was then a
modest town of about five thousand souls, but evidently confident enough

about its safety (despite periodic sieges by the rival armies of the Duke of Burgundy and the Counts of Gelderland) to risk placing the windmills on approach roads, especially to the west, where their sails might catch the strongest winds. They were sited beside canals and bridges where the boatmen dropped off their loads of grain or picked up sacks of flour for the return trip to the city. One of those windmills belonged to a certain Roelof Gerritszoon, whose father had been a miller before him, and whose great-grandson was to be Rembrandt van Rijn.[2] As the city grew, slowly but steadily, the millers prospered, along with the corn chandlers and the bakers, all of whom contributed to Rembrandt's family tree, and each of whom was capable of blaming the others in the difficult times when prices rose and fingers pointed. Millers somehow always seemed to survive the lean years, whether they ground flour for bread or, like Rembrandt's father, barley malt for beer. Both foods were the primary necessities of life for people of all ages and ranks, including children (for in this waterland no one dreamt of drinking the water); the sustenance of daybreak and supper. So the millers did well, many of them, including Rembrandt's paternal ancestors, buying up shares of other mills and the little houses and gardens around them. The mills themselves began to change from the old, crude *standaartmolen,* with open sails mounted atop a simple rounded base, to more imposing structures, sometimes octagonal and occasionally made of brick or, in rare cases, stone. Instead of occupying a simple habitation inside the mill, their masters now lived in houses in front of it, with a decent *voorkamer* (front room), a separate kitchen, and even upper chambers. Inventories of sixteenth-century millers list household possessions that mark them as substantial tradesmen, more than a cut above mere artisans. Their kitchens were solid with pewter tableware and copper kettles. Bulky oak chests were filled with linen, some of which went on curtained beds. There were chairs enough, *kamerstoelen,* some with turned legs and rush seats. And it was not uncommon for their white plaster walls to be covered by at least a few little "board" paintings (*bardekens*)—an Adam and Eve or a peasant landscape.[3]

All this well-being came at the price of a thick skin. For in Holland as throughout Europe, millers were the constant butt of jesting abuse, much of which turned on their ubiquitous reputation as cheats, extortionists, and adulterers, leaning on the scales and helping themselves to women. Beneath the jokes ran a streak of ugly resentment against the self-appointed lords of the village who had usurped the manorial droit du seigneur and thought nothing of deceiving maidens by sleeping in the place of their betrothed. "He could grind without wind, without wind in his mill, / He could grind double-quick with his girlie," sang the *Antwerp Song Book* of 1544.[4] The only consolation for the victims of the venal millers was that their drunkenness occasionally got in the way of their lust. Slimme Piet, the miller in Gerbrand Bredero's farce of 1618, is so tipsy that he fails to notice that he is sleeping with his *own* wife, not at all what he had in mind.[5] When the millers had had enough of all these bawdy slanders, they could console

themselves by praying for vindication to their patron saint, St. Victor, who had been martyred by drowning, a millstone tied about his neck.

For all the scorn, the millers knew how indispensable their windmills were to the city in time of war, making the difference between life and death. In 1420 the Duke of Bavaria, commanding an invading army, paid them the backhanded compliment of burning down the windmills in order to reduce the city to starvation and surrender. In 1572, with his insurrection failing, William of Orange instructed the city councillors of Leiden to destroy the village mills lest they fall into the hands of the enemy. Some, like the mill owned by Rembrandt's paternal grandfather, Gerrit Roelofszoon, were hastily torn down as the Spanish army advanced toward the city; others were mounted on platforms and rollers and resited immediately on top of the walls, high enough to catch the wind but safe enough to be protected by the armed gates, towers, and bastions encircling the city.

For a while, the tactic worked. By January 1574 eight of the rebuilt windmills were in operation and bread rations were speedily distributed to the citizenry. But protected mills were of no use should enemy action cut off the supply of grain. This is exactly what happened in May 1574, when a more formidable Spanish army, five thousand strong, occupied most of the strategic hamlets around Leiden and invested them with fortified stockades heavily manned with artillery.[6] Not only grain but hay for Leiden's horses and the cattle that had been driven into the city was now in critically short supply. The malt millers were more vital than ever as they ground barley into malted meal used to make gruel or coarse, unleavened bread. It was better, at any rate, than the boiled grasses and hide to which some believed they would be soon reduced. What the town endured, until its liberation the following October, would be recalled every year, on the third of that month, as the local epic of suffering and redemption. The siege was eventually lifted through a combination of deliberate self-inflicted inundations and a series of savage storms that confronted the Spanish troops with the possibility of being trapped within a swiftly rising inland sea over which the Dutch Beggar fleet sailed to the rescue. The Spanish commander, Valdez, hastily struck camp and retreated before he was cut off. William, who had lain sick through much of the siege, miraculously recovered and entered a jubilant city. Even the plague, which had become serious in the spring, now receded with the autumn mist. Bells rang from the church towers. Leidenaars gorged on loaves and fishes and thanked God for the wind and rain that had delivered them from peril. Rembrandt's grandmother, Lysbeth Harmensdochter, a widow since 1573, now sought, and was granted, permission to reerect her mill on the walls, by the tower called the White Gate.[7]

It was impossible to grow up in Leiden in the early years of the seventeenth century and not be marked, even at two generations' distance, by this traumatic and stirring history. Rembrandt's parents, both born in 1568, belonged to a generation that would have had the epic drummed into them by their elders, much as the Battle of Britain and the Blitz became the

patriotic scripture of Londoners growing up in the 1950s and 1960s: evil and tyranny defeated; self-sacrifice and courage rewarded. The immortals of the siege—Burgemeester Pieter van der Werff, who resisted any thought, even in extremis, of treating with the Spanish, and Janus Dousa, who led a platoon of volunteers out of the city to try to bring back some foodstuffs and livestock under cover of night—would all have been familiar as heroes, just as the *glippers,* the "bolters," who fled rather than share the city's trials, would be notorious as villains. Commemorations were everywhere: in Isaac Claesz. van Swanenburg's *Pharaoh Drowning in the Red Sea* hanging in the new Town Hall; or *The Distribution of Bread and Herring,* painted in 1575 by none other than the young native Leidenaar, Otto van Veen, as a contemporary Gospel scene with figures folding their hands together in prayer or sinking to their knees before the holy provender. In 1577 a precious blue stone altar on which, tradition held, Count William II of Holland had been baptized was taken from the St. Pieterskerk and attached to the façade of the Town Hall as if the seat of Scripture had passed from the ecclesiastical into the civic realm.[8] By the 1590s it had been joined by a matching blue stone plaque and both had been inscribed in gold letters with inspirational homilies. One emphasized both the suffering and the miraculous redemption; the other that both good and ill fortune should be submitted to as the operation of God's will, a sentiment that would have appealed to the sterner Calvinists in the city. On the level of popular instruction, countless prints and maps chronicling the epic could be bought at market stalls, bookstores, and fairs.[9] And every October 3, the entire city was given over to a great festival of rejoicing in which portions of herring and bread were the obligatory (but certainly not exclusive) items of consumption.[10] This was (and still is) Leiden's great fair, complete with parades of the *schutter* militia; freak shows (like the exhibition of sea monsters, some dried and stuffed, some purportedly live); rowdy street farces; pipers, acrobats, and barrels of ale. Each year the burgemeesters and the councillors of "the Forty" rode about the town, and though they now do it in top hat and black tie rather than in slouch hats and pleated ruffs, their progress still makes its way through a blizzard of bunting, the wheels of their carriages churning over the slurry that covers the streets—a mixture constituted, in equal parts, of beer, confetti, and horse shit.

Leiden's history divides, starkly, into before-the-siege and after-the-siege. Before 1573 the place was a modestly prosperous market town whose cloth manufacturers made a decent but not spectacular living by importing raw wool from England and reexporting the finished product to Germany or selling it for domestic consumption. It was a bustling little *waterstad,* less cultured than Haarlem, less elegant than Delft, less grandly ecclesiastical than Utrecht. But after 1574 it was, like Antwerp, history's playground. Leiden sat astride one end of the historical seesaw while Antwerp sat at the other, its fortunes swiftly rising as those of the great Flemish city fell. Leiden was not the only destination for the Calvinist exiles from the south, but they arrived there in massively disproportionate num-

bers, especially after Parma took Antwerp in 1585. For the most militant of the godly, Amsterdam, which had only belatedly changed its official confession from Catholic to Protestant in 1578, remained a suspect place, full of suspicious heterodoxies. But purged by its ordeal, Leiden had become a stronghold of the Reformed Church, and at the heart of that fortress was the university, founded by the Prince of Orange barely a few months after the end of the siege, in 1575. Its first quarters (still academically occupied) were in St. Barbara's Cloister on the Rapenburg canal, from which its former residents, the "White Nuns," had been evicted.

Calvinism and cloth transformed the city. Its population almost quadrupled over two generations, from twelve thousand in the 1580s to almost forty-five thousand in the 1620s, making it the province of Holland's second most populous city.[11] In short order, a gently churchy old market-textile town turned into a beehive: relentlessly busy, physically congested, humming with economic and cultural energy. But sometimes the bees stung each other. Inside the hive there was a short-tempered edginess which made relations between the old Leidenaars and the new Leidenaars tense, and not infrequently dangerous.

In this cramped immigrant town, wool was king and linen, another Flemish speciality brought north, queen, and their undisputed dominion was symbolized by the conversion of old monasteries and convents into cloth halls. The former Convent of the Sisters of Nazareth, for example, became the new Bay Hall, where the syndics of the cloth guild maintained quality controls on (and regulated prices of) their particular fabric. The raw wool, dense, greasy, and matted, came to the city in hanks of sheared fleece, shipped in not only from England but from the plateau sheep folds of the Spanish enemy. Some of the *stegen*, the alleys, stank of the fatty aroma of lanolin. The plank floors of workshops (often the front parlor of the smaller houses) where the raw wool was washed, carded, combed, and spun became sheeted in a fine snow of fibers. The doors of these little houses were left open to the street so that on breezy days the fluff hung over the street like dandelion seeds, clinging to hats and capes, finding a way into ears, nostrils, and lungs. The crowded back streets of Leiden clattered and clacked, spinning wheels turning, bobbins and shuttles flying to and fro beneath the deep eaves. Woven or knitted up, the cloth emerged as lengths of serge, baize (not the green stuff of our billiard tables but a fine twill cloth), or worsted, depending on how the fibers were laid and twisted and what the merchants said the clothiers in Paris, Frankfurt, and Cologne were currently seeking. Facing competition from the lighter "new drapery" fabrics being made up in East Anglia, the Leiden textile men introduced elegant mixtures of wool and silk: the sleek, delicate grogram that they hoped to sell in France and Italy. At the bottom of the heap there were the dyers, doomed to labor over acrid, steaming vats of indigo and exiled to the edge of town along with other stinking trades like the tanners, crucial for Leiden's shoemaking industry.[12]

Where were all these Brabanders, Walloons, and Flemings (not to men-

tion immigrants from other Dutch towns and provinces, from German Jülich and Cleve, and a handful of Puritan "Pilgrims" seeking a better Jerusalem than Stuart England) supposed to live? In 1611, with the city bursting at the seams, threatening to aggravate the usual menaces of fire and plague, "the Forty" decided on a major expansion to the north and west of the old town that would enlarge Leiden by almost a third.[13] Even this added supply of living space would not be enough to meet the pressing demand. Houses that were considered by the town council to be excessively large were demolished and the lot subdivided into anything from four to eight dwellings. Many other houses that were already modest now subdivided floors and rooms and let them to the most desperate. And Harmen Gerritszoon, the fourth-generation miller now specializing in grinding barley for malt, who evidently had a Carolus guilder or two to spare, promptly used it to buy up a number of promising lots and parcels in his neighborhood (or *bon*, as it was called in Leiden) of the North Rapenburg.

Harmen Gerritszoon's own house was on the Weddesteeg, the third house from the corner of the Galgewater, the street which took its unsentimental name from the gallows that were once dressed on its walls and which now boasted the elaborate, gabled residence of the city builder (literally carpenter), the *stadstimmerman*. In front of Harmen's house, on either side, were windmills, and beyond them the city wall, which dropped down into a branch of the Rhine that flowed through the town. To keep the approach to the walls clear, only one side of the Weddesteeg had been developed. So Harmen Gerritszoon's piece of Leiden was, by the standards of the time, an open space that allowed fresh air and light to come sweeping into the house. Until the building expansion of 1611, the view over the river would have been full of orchards and open fields.[14] Baby Rembrandt, taken out in his *rolwagen*, a wheeled walker, could have tottered a few feet from his house and seen the Rijn twice over: the weedy branch of the river known as the Velst, moving slowly past the gates and walls; and also the windmill his grandmother had bought, which, for obvious reasons, had come to be known as "De Rijn." And though his name would have, as we now like to say, legs, Rembrandt van Rijn would all his life be bound to this little corner of the world; the meeting of stone and air and water.

The Weddesteeg was not an imposing address. It had none of the pretensions of the patrician houses of the van Swanenburgs and the van Veens out by the Pieterskerk and the Rapenburg, or on the Breestraat, where the fine new Town Hall stood. But it was not a shabby locale, either. In all likelihood Rembrandt's parental home would have been much like the houses that appear in contemporary paintings of Leiden: brick-fronted, a narrow façade; the street-side rooms generously lit by tall leaded windows; three stories and a steeply pitched roof surmounted by the usual step-gable, with a sloping eave over the first floor to carry away the rain. No mansion then, and smaller than anything the young Rubens would have lived in, but big enough to hold the miller's considerable household. In 1581, while his grandmother, Lysbeth, was alive and married again to another miller, its

occupants included, besides the children, a maidservant; two mill hands, who were needed on the spot when there was wind enough to operate the grindstones through the night; and a university student from Friesland as a lodger.

Rembrandt was the eighth of nine children to be born to Harmen Gerritszoon and Cornelia Willemsdochter van Zuytbrouck. Two older children had died in their infancy, both buried in the same plague year of 1604. The precise date of his birth, however, is just the first of the many mysteries with which Rembrandt has enjoyed teasing his biographers. His first pocket biographer, Jan Orlers, writing in the second, 1641, edition of his history of Leiden, was unequivocal. The year was 1606, and the day to raise our glasses, should we feel in the mood, is July 15. Or is it? No official record of birth or baptism has ever been found, and as Rembrandt's mother and father were both dead by the time Orlers published his book, there was no means of checking his date. In May 1620 he is listed in the enrollment book of Leiden University as being fourteen, but the conventions of the time would have allowed this to mean either his fourteenth year, which would correspond to Orlers's date, or his fifteenth year, which wouldn't. And he himself contributed, mischievously or not, to the confusion. The self-portrait etching of 1631, the first on which he signed his name Rembrandt, clearly declares himself to be twenty-four, thus putting his birth year at 1607. Requesting the publication of his marriage bans to Saskia in June 1634, he indicates that he is but twenty-six, and in his notarized assessment of a painting by Paul Brill in September 1653, he gives his age at "about forty-six." All three documents fix the birth year as 1607, not 1606. It's possible, of course, that Rembrandt himself was unsure of the date. Not everyone in the seventeenth century, even among the literate classes, knew or even cared about such things. The trouble is that *none* of the date-markers supplied by Rembrandt himself actually corresponds to Orlers's information.[15]

Whenever it was, exactly, that Rembrandt made his appearance, he did so in a troubled place and time. A visitor to late-twentieth-century Leiden, walking by the handsome, placid canals, taking the even pulse of an old academic community, observing its apparently gentle manners—bicycles, beer, and bookshops—needs an imaginative stretch to recapture the violently partisan atmosphere of town and gown in the early seventeenth century. The years between Rembrandt's birth and his registration at the university in May 1620 were also those when both city and academy were so bitterly divided that they came to the edge of civil war. The cause was a particularly poisonous mixture of theology and academic politics. Leiden's troubles were, in essence, no different from those afflicting all the towns of Holland. But because Leiden had such symbolic importance in the Republic, and such a concentration of preachers, professors, and polemicists, all claiming a monopoly on wisdom, and all eager to speak about it, at length and with passion, mutually hostile positions were argued there with the most unsparing force.

At the heart of the matter was unfinished business left over from the

Dutch revolt. As long as keeping Spanish troops out of the northern Netherlands had been the provinces' most immediate concern, the divisions between the Dutch over what, exactly, they were fighting *for* could be safely left to one side. It had always been more obvious what they were fighting against: King Philip's Inquisition; the suppression of their local institutions by a centralized absolutist royal government; armed cantonments; arbitrary justice. But the military success of Anna and William's son, the Stadholder Maurice, in keeping the Spanish at bay, followed by the de facto recognition in much of Europe of their peculiar, confederated state, had made an argument about the domestic character of the Republic unavoidable. Was it to be a republic dominated by Calvinist Protestantism, or a place where no one single Christian confession had coercive power?

This had been William of Orange's foreboding. He had struggled to create a tolerant state that might accommodate both Protestant and Catholic worship. But that generous ideal had died with him on the stairway at Delft. Those who claimed his heritage were a good deal more cautious in their toleration. They were prepared to let Protestants and even Catholics and Jews live in the Republic and pray according to their respective conscience and fashion, but not to permit that worship in public. Defenders of this position, like Oldenbarnevelt and Hugo Grotius, accepted that there should be a dominant, Calvinist state church, but they refused to allow it theocratic authority, the power to rule. They also insisted that it was for the lay magistracy, beginning with men like themselves, to judge the *proprieties* of religious utterance, but only when its vituperation threatened the fragile civil order. At heart, they were patrician pessimists. They looked around Europe and saw murder done in the name of godliness. And they thought that only the stewardship of the enlightened—cool heads, dispassionate hearts, and (especially) philosophical minds—could preserve their country from the fate that had befallen France and Germany. In the name of such wisdom, they insisted that the Church be ruled by their prudence; that its preachers and ministers be appointed or dismissed by their hand; that they alone should have the right to convene national Church synods, where (Oldenbarnevelt hoped) the strictest Calvinist dogma might be moderated in the interest of domestic peace. From the quiet of their libraries, the patricians shook their heads at both the fury of the fanatics and the credulousness of the people and wondered what they could do to prevent their fatal collision.

To the strict Calvinists who believed themselves to be a godlier, much godlier, party, this was all spineless pragmatism, the amoral sophistry of men who had failed to understand that the cause of the Republic had been the cause of the Almighty; that He had chosen the Dutch, covenanted with them, to enact His special purpose and historical plan. Their opponents spoke of a "broad way" and enthused over the peace because they were little better than Papists; indeed they were *worse*, since, in the guise of being Protestants, they were prepared to open the gates of Zion to heathens, idolaters, the legions of the Antichrist. So in the diatribes of the militant preachers, the statesmen who had brought about the truce, and whose sup-

porters often dominated the councils of the great towns, were said to be adders, reptiles, demons; unclean, scaly bodies possessed by abominations, dispatched from the netherworld to bring woe to the new Israel.

All this bad-tempered vehemence could be heard in the pulpits of Leiden as the child Rembrandt's ears were opening to the world's noise. He may even have picked up some acute apprehension in the parlor of the house on the Weddesteeg, because his own family had special reason to feel nervous about the Calvinist rhetoric of retribution. Harmen Gerritszoon had become a member of the Reformed Church, though not, one suspects, a particularly enthusiastic or observant one, not least because his wife, Neeltgen van Zuytbrouck, came from an old Catholic family to which most of her relatives remained loyal. Harmen's confessional affiliation, then, like that of many men in his position, is likely to have been determined as much by prudence as by conscience. And the need to conduct oneself carefully became brutally apparent around 1610, when Leiden, then Holland, and then the entire Dutch Republic divided between "Arminians" and "Gomarists."

The argument, initially, was between professors. Never has the axiom that academic conflicts are so fierce because the stakes are so small been less apt. In Leiden at the end of the first decade of the seventeenth century, the stakes were life and death—indeed more than that, the welfare of the soul everlasting. Think of the argument as the nastiest possible row between neighbors, which Professor Jacobus Arminius and Professor Franciscus Gomarus in fact were, separated by their common garden wall, a barrier which one imagines as high and dauntingly brambly. On one side was the Hollander Arminius, the apostle of the more broad-minded and tolerant party, who took the position that the bestowal of grace might to some extent be affected by the faith and deeds of the believer. His colleague, the Hague minister Johannes Wtenbogaert, whose portrait Rembrandt would later paint and etch, believed in addition (and persuaded the Lands-Advocate Oldenbarnevelt to his view) that the *Confessie* of the Calvinist Reformed Church ought to be amended to reflect this. To his adversary Gomarus, the Flemish defender of Calvin's literal word, such presumption was heresy, scarcely to be distinguished from the Catholic doctrine of salvation through works. The essence of Calvin's doctrine, according to Gomarus, was that salvation had been predestined by God. The elect were numbered from the moment of their birth; the remainder were doomed to roast amidst the damned, and there was nothing in this world to be done about it. Humble acceptance of this human impotence before divine will was the first condition of a truly Christian life.

Between these two positions there could be no accommodation. Those, like Oldenbarnevelt, who followed Arminius's way of thinking, felt that as the southern Calvinists became more entrenched in the Republic their intolerant position would be bound to prevail unless something was done, and done soon, to preempt it. So the "Arminians" decided in effect to take advantage of whatever temporary domination they enjoyed in the councils

of cities like Rotterdam and Leiden to press for a national synod that would have the authority to amend the strictest Calvinist doctrine of the Confession. In 1610 they presented to the States of Holland their "Remonstrance" for those alterations. It was immediately denounced by a Gomarist document known as the "Counter-Remonstrance," which insisted, on the contrary, that a synod could only be convened if it granted in advance that the Confession would be left sacrosanct, *and* that all preachers should be required to subscribe to it. The labels that henceforth became attached to the parties—"Remonstrant" and "Counter-Remonstrant"—have a cumbersome, obscurely ecclesiastical sound, but in Holland in Rembrandt's childhood years, they defined the parties to an all-out conflict.

The year 1611 was when matters went from growling and snarling to roaring and bellowing. The occasion was (what else?) the succession to a professorship. The chair in question, it is true, happened to be the one that had been held by Arminius. Oldenbarnevelt, advised by Wtenbogaert, proposed a German minister called Vorstius, whose views on grace and toleration were generally thought, even by some Remonstrants, to be on the reckless edge of Protestant broad-mindedness, and who was himself not at all sure the appointment was a wonderful idea. When Vorstius got to Leiden, his misgivings were borne out. The storm of recriminations which had burst in the councils of the faculty rapidly spread to the lecturers and students, who cheered or reviled their academic heroes or villains and traded sword flourishes and curses with the other side on the doorsteps of taverns. Among the Flemish cloth workers and manufacturers, sympathies were overwhelmingly for strict Calvinism and against Vorstius. Gomarus himself had left Leiden for Middelburg, but there was no shortage of his partisans in the university and the pulpits to keep the fire of doctrine burning hard and bright. By the end of the decade, the whole city, the whole Republic, had been badly burned.

It was one thing for the Remonstrant oligarchs to muffle the voice of the preachers, and quite another to face the anger of their congregations, especially when that anger increasingly took the form of physical intimidation, peltings, and jeerings, and began to look like a threat to their monopoly not just on wisdom but on power. At this point, Oldenbarnevelt and his advisers like Grotius made a fatal tactical mistake. They decided to impose their reasonableness, if necessary, by force. Holland *would* be tolerant, whether it liked it or not. To contain the threat of assaults on Remonstrant preachers and patricians, they licensed the hiring of armed men, the *waardgelders*, in addition to the civic militias. This was taken by the Stadholder Maurice as a usurpation of the military authority conferred on him by the States General of the Seven Provinces. More than anything else, it was the creation of the armed companies which made the crisis political rather than theological and made it possible for Oldenbarnevelt and Grotius to be accused, ultimately, of treason.

Leyda gratiosa, gracious, graceful Leiden, rapidly deteriorated into one of the most dangerously polarized cities in the Republic. The Flemish com-

munity, ardently Calvinist in both its rich and poor elements, now wrapped itself in the black and white robes of uncompromising zeal. In the town council, the governing regents became nervous enough about their safety to construct a palisade in front of the Town Hall, within which the militia and *waardgelders* exercised with muskets and pikes. A climate of trepidation hung over the town. Old-time Leidenaars like Rembrandt's family were likely to have been more sympathetic to the Remonstrant side, especially given Neeltgen's Catholic family and the fact that none of Harmen's children were baptized in the official Calvinist churches of the Pieterskerk and the Hooglandsekerk. And their family notary, Adriaen Paedt, was one of the most visible Remonstrants in the city. In all probability the miller's family must have felt that they were suddenly living in a place where the "strangers"—the immigrants—had turned into a threatening majority. Leiden was no longer "their" Leiden.

Their worst fears were realized in 1618, when Maurice mobilized the army on the side of the Counter-Remonstrants, arrested Grotius and Oldenbarnevelt, and initiated a purge of all the town councils in the Republic, including Leiden, where the newly appointed sheriff (*schout*), Willem de Bondt, was known to be one of the most enthusiastic persecutors of Catholics and Remonstrants in Holland. The following year, 1619, the national synod, held at Dordrecht, enacted a farcical "hearing" for both sides of the theological dispute, merely a preliminary to declaring the Remonstrant creed the rankest and most damnable heresy and casting all who professed it out from the body of the Reformed Church. All Remonstrant assemblies or religious meetings were forbidden. At Leiden University, of course, the faculty was thoroughly cleansed, sending many of its most erudite and eloquent professors to other cities (like Rotterdam or Amsterdam) more hospitable to their beliefs. For the next three or four years, the only strictly Calvinist regime the Dutch Republic would ever see controlled the institutions of state, church, and learning, a theocratic revolution. And like all revolutions, it required its symbolic sacrifices. In 1619 Oldenbarnevelt was summarily tried for treason and beheaded; the local leader of the Remonstrants, the pensionary of Leiden, Rombout Hoogerbeets, sentenced to lifetime incarceration; and the university's most famous alumnus, Hugo Grotius, imprisoned in Loevestein Castle, from which he subsequently escaped, hidden in a book chest, the perfect exit, one supposes, for an unrepentant intellectual. The secretary of the States of Utrecht, Gilles van Ledenberch, was released from his imprisonment only through suicide, and even then his coffin was hung from a gallows outside The Hague along with the broken and mutilated remains of common felons.[16]

So while Rubens may have been born (involuntarily) into a history of religious war, Rembrandt was raised in it. It would always matter, deeply, to both of them. But somehow, amidst all this uproar, he was getting a schooling, an education, in fact, that (minus the Jesuits and the *Lives of the Saints*) would have been almost identical to Rubens's: Virgil, Horace,

Plutarch, and Tacitus; some contemplation of Homer, Euripides, and He-
siod. At the age of seven he would have filed through the arched doorway
of the Latin school on the Lokhorststraat, with its inscription carved into
the white limestone advertising the teaching within: "*Pietati, Linguis et
Artibus Liberales*"—Piety, Languages and Liberal Arts. For another seven
years his world would have been governed by the slate and the rod, a
wooden-bench world noisy with chanting, parsing, conjugating, declining,
and, unless it was unlike any other school there has ever been, the usual
back-row chuckling and schoolmaster fits of fury. During Rembrandt's
school years, the rector was a law professor, one Jacobus Lettingius, who
seems to have presided with special severity over the institution, at least
until 1625, when he was discovered to be taking more than the proper
share of *schoolgeld*. In addition to his classics and Bible studies, Rem-
brandt would have been taught calligraphy, and not least, again like
Rubens and Huygens, he would have taken drawing lessons, in his case
from Henricus Rievelinck, described rather ambitiously as a "teacher in
schilderconst [the art of painting]."[17] Here, in the brick-fronted house on
the Lokhorststraat, he would have made his first pair of eyes.

It was not unusual in the young Dutch Republic for the child of a fam-
ily in trade to receive a Latin school education. Rembrandt's archrival (and
perhaps friend), Jan Lievens, had a father who was an embroiderer, origi-
nally from Ghent. But at least two of Jan's brothers, including one with the
grandly Latin name of Justus Livius, received the classical education
needed for entrance to the university. Had not Jan been such a prodigy, he
too might very well have followed them. Rembrandt, though, was the only
member of his family's generation to have had any schooling at this level.
His oldest brother, Gerrit, had been destined to follow father Harmen into
the barley mill, and did so until he suffered some sort of accident, presum-
ably mechanical, around 1621. The next brother, Adriaen, became a shoe-
maker, but on marrying a miller's daughter, went into that trade himself. A
third brother, Willem, followed his mother's family profession of baker,
and there was yet another brother, Cornelis, about whom virtually nothing
is known. There were also two sisters, Machtelt and Lysbeth, the latter of
whom may have suffered from some kind of handicap, mental or physical,
since her father's will specified that she be put in the care of one of her older
brothers. Even had both girls been sound of mind and limb, it was not to be
expected in Leiden in the early seventeenth century that they would get any
but the most elementary and practical education. No Tacitus, and certainly
no Ovid, for the *meisjes*.

So Rembrandt was anything but a clumsily unlettered, poorly educated
boy. He had the best instruction that the most academic city in Holland
could give him. Throughout his life, his work would be marked by intense
literary passion, a hunger for texts as well as images. It's true that unlike
Rubens, Rembrandt did not conspicuously flourish the humanist's graces,
dash off lines of Latin verse, or pepper his letters with citations from Virgil.
When his possessions were inventoried in 1656 for the bankruptcy court, a

Rembrandt, An Old
Woman Reading, *1631.
Panel, 59.8 × 47.7 cm.
Amsterdam, Rijks-
museum*

great library was not listed among them. Even so, no painter of his time was more bookish, or, perhaps more accurately, more scriptural, than Rembrandt; none more obviously besotted with the weight of books, moral and material, their bindings, clasps, their paper, their print, their stories. If the books were not on his shelves, they would certainly be everywhere in his paintings and prints: piled high on tottering shelves; reposing authoritatively on the tables of preachers or anatomists; clasped in the hands of eloquent ministers or musing poets. No one would better describe the moment of imminent writing (for many of us, lasting too many hours of the day), the quill poised over the page. And though the subject of reading was popular with his contemporaries, no one would make it such an act of intense, transfiguring absorption as Rembrandt. One of his old women, usually characterized as his mother, Neeltgen, but certainly in the persona of the aged prophetess Anna, who frequented the Temple around the time of Christ's birth "day and night," is shown by Rembrandt in a painting in his Leiden manner deep in her Scripture. Anna mattered to Rubens, too. He had included her in the scene on the side panel of *The Descent from the Cross* together with the high priest Simeon, for she too had recognized the infant Jesus as the Savior. But for Rubens, Anna's source of light is of course the body of Christ. For Rembrandt's Anna, the radiance lies on the glowing page.

ii *Priming*

On May 16, 1620, the name "Rembrandus Hermanni Leydensis" (RHL, as he was to sign some of his early paintings) was inscribed in the register of Leiden University. He was certified as fourteen years old and still living with his parents, a student of literature. A good deal of trouble has been taken to find reasons why he should have enrolled and then departed so abruptly. His father, Harmen, had suffered an injury that prevented him not only from working but from doing his bit, as required, for the local militia, the *schutterij*. He had paid a small fee for his exemption,

but this would have been waived when one of the sons could take his place. Alas, around 1620–21, the oldest son, Gerrit, also had some sort of "mutilation" in the evidently perilous occupation of barley-milling. But before the brightest of the brood needed to be called on to serve, there were at least *three* other brothers—Adriaen, Willem, and Cornelis—who could have taken their place in the *schutter* ranks. So it seems hardly necessary to explain Rembrandt's enrollment at the university as a draft-dodging ploy.[18]

The explanation for both his presence and his subsequent absence at the academy is probably more banal. Erasmus of Rotterdam had prescribed a three-part education for the young and male—seven years of play, seven of Latin school, and seven of college—and Rembrandt almost automatically would have embarked on the last of these septennial terms. But he was an early dropout. Jan Orlers's 1641 account relates that "he had no desire or inclination" to study at the university, and that "his only natural inclination was for painting and drawing, so that his parents were compelled to take their son out of the School and following his own wishes to apprentice him with a Painter where he might learn the foundation and principles [of art]."[19] However tempting it might be to imagine Rembrandt sampling a lecture or two from the professors on the Rapenburg and experiencing an acute urge to be somewhere else, we have no real idea whether he took classes at Leiden University or how long he remained there. No one was taking attendance in 1620, and although Rembrandt spent three years with his first master, Jacob Isaacsz. van Swanenburg, followed sometime late in 1623 by a six-month study period in the studio of Pieter Lastman in Amsterdam, there seems no reason to assume that he might not, for a short time, have been both student and apprentice painter.

The possibility that Orlers was right, that Rembrandt was indeed possessed by an overwhelming desire to be an artist, has seemed too much of a sentimental fallacy to be allowed to remain unquestioned. But of course the annals of Renaissance painting and Karel van Mander's lives of Netherlandish and German artists are full of examples of painters driven by their *enthousiasma*. A trope can also be a truth. So it's not necessarily anachronistic to imagine Rembrandt following a similar impulse. In any event, becoming apprenticed in Leiden did not preclude the possibility of developing other occupations, either then or later. David Bailly, the son of a Flemish immigrant family (though born in Leiden himself), was, in addition to being an accomplished still-life and portrait painter, a teacher of fine calligraphy and fencing! He in his turn had been taught by Adriaen Janszoon van den Burgh, whose double life as both surgeon and painter (handy for battle and martyrdom scenes) was evidently no obstacle to his making a good match with the sister of another distinguished and successful artist, Jacques de Gheyn II. Bartholomeus Dolendo was a goldsmith who made die-stamps and seals, as well as an artist and engraver, and we have already encountered the example of Pieter van Veen, Otto's brother, who was both painter and advocate.

Calvinist Leiden was, above all else, a temple of the Word, yet it could

still offer a good career to the makers of images. The city's churches, like the Pieterskerk, were already bare of paintings and had been provided with the black and gold written version of the Decalogue that can still be seen there. But the visual culture of the town, and the attachment of its citizens to it, was too strong to allow another obliteration along the lines of 1566. The greatest of all men bearing the name of the town had been a master painter, Lucas van Leyden, the child wonder who at the age of nine had already produced marvels like the engraving of *Muhammad and the Monk Sergius*. Karel van Mander's pantheon of painters, the *Schilder-boeck*, had devoted more space (seven pages) to Lucas than to any other artist; and Rembrandt, like any child growing up in Leiden, would have known the great events in his life, like the meeting with Albrecht Dürer in 1521, much as a young Florentine would have been familiar with the life of Michelangelo. When he went to see Lucas's great *Last Judgement* hanging in the Town Hall, he would have been reminded of the history by which it was saved for his hometown. In 1602 Count Simon von Lippe, agent and art procurer for the Emperor Rudolf II, had made inquiries as to whether there was any chance of buying the triptych. The Stadholder Maurice, eager to do something that might divide the Spanish from the central European Habsburgs and aware of Rudolf's passion for collecting Netherlandish paintings and painters, saw another of those diplomatic openings through art. Maurice leaned on the local patricians and they leaned on the council to agree to the sale. But Goltzius and Karel van Mander, though settled in Haarlem, not Leiden, took it on themselves to mount a local campaign against letting the local masterpiece escape, doubtless making strong appeals to civic pride, history, and conscience. The campaign worked, and Lucas's triptych remained in the burgemeesters' chamber, from which no one, even at the height of the Counter-Remonstrant ascendancy, dared suggest its removal.[20]

Even if there was a brief hiatus in new commissions for religious history paintings around 1619–20, when the Calvinist polemics against idolatry were at their fiercest, inventories of deceased citizens (from small tradesmen to professors and lawyers) suggest that about a third of all paintings owned in Leiden during the first third of the seventeenth century still belonged to this genre. Each Testament had its favored and endlessly repeated episodes: the Sacrifice of Isaac, Lot and his Daughters, Judith and Holofernes, David, Moses, and Elijah, from the Old Testament; the Nativity, the Supper at Emmaus (good for kitchens), the parables of the Good Samaritan and the Prodigal Son (a choice of profane or penitential), from the New.[21] Those same inventories hardly suggest a culture which had suddenly turned hostile to painting, notwithstanding the Counter-Remonstrant ascendancy. There was even a type of domestic surrogate "altarpiece," known as a *kasgen*, small enough to stand on a table or buffet. One art-loving widow, Machtelt Paets van Santhoven, advertised her piety by displaying *eight* of these Bible paintings in a single room.[22] Even Jan Orlers, who was certainly on the more Calvinist side of the patriciate,

owned not just a *Temptation of St. Anthony* and a *Moses Striking the Rock for Water* but *een schoon Maryenbeelt*, "a beautiful picture of Mary"![23]

Impeccable Calvinists were not averse to sitting for their portraits, doubtless in properly forbidding black and white dress, and the city's most famous specialist, Joris van Schooten, was ready to oblige them. No self-respecting rector of the university, warden of the city orphanage, or militia colonel could pass up the chance to be immortalized in the full dignity and solemnity of his rank. Apart from formal portraits, many of Leiden's most important institutions also wanted visual documents of their activities, whether in the form of paintings supplied by Isaac Claesz. van Swanenburg of the wool manufacturers, or prints executed by Jan van der Woudt of the fencing room, anatomy theater, and botanical garden of the university. While still-life paintings would seem to be the epitome of what the preachers denounced as "idleness," the addition of images of transience like a skull or a smoking pipe (as in "For my days are consumed like smoke") to an array of glittering objects made moralists of materialists and protected both painter and patron from accusations of pandering to "idolatry."[24]

The Calvinist revolution in Holland did not *cause* the marked change to stripped-down, monochromatic compositions in both still-life and landscape painting. But the new gray-brown-green, sketchy, swiftly delivered manner practiced in Leiden by Jan van Goyen was certainly in keeping with the emphasis on sobriety and native virtue that marked literature as well as art in the early years of the renewed war with Spain. If there was to be art, it had better not be gaudy. The switch from woodland groves running with game, or languid, vaguely Latin scenery, painted by Flemish artists, many of them, like Paul Brill, Coninxloo, and Roelant Savery, favored by foreign courts, to fishermen hanging their nets beside drooping willows, or riders travelling rutted tracks beneath a wet and steely sky, was more than a substitution of a local for a fancy international style. It was also a replacement of a flamboyantly poetic manner with an unapologetically prosaic one; a coming down to earth. And the Leiden inventories nonetheless reveal that the older, "earthy" genres were still flourishing alongside newer ones. Parlors and kitchens still had genre paintings of the "five senses": peasant inn scenes; allegories of the fat and the lean kitchens; warnings (ambiguous) on the excesses of drink and (less ambiguous) gold; and scenes from the upside-down world of the Land of Cockaigne (Luilekkerland), where fowl flew through the air ready-trussed and houses were roofed in sweetmeat pies. These kinds of productions were swiftly done and cheaply sold, thought of, one suspects, as interior decoration, like ceramic tiles, rather than as Art. Some of Rembrandt's earliest efforts at painting were true genre pictures, like the eyeglass vendor in *The Sense of Sight*, earthy little products with a strong Flemish accent, the kind of thing one might have expected to find in a tavern as much as in a parlor.

So when the teenage Rembrandt asked his father, the wounded miller, if he might, perhaps, drop out of college and take up with a painter instead,

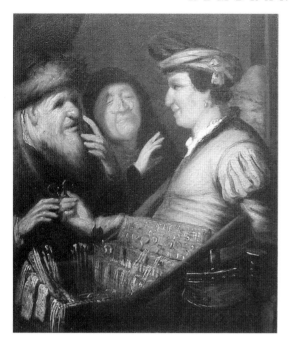

Rembrandt, The Sense
of Sight (The Spectacles-
Seller), *c. 1625. Panel,
21 × 17.8 cm.
Private collection*

he was not indulging in some sort of protobohemian act of defiance. He was opting for business. For pious, learned, partially sobered-up Leiden was packed with pictures. They decorated the houses of magistrates and innkeepers, bakers and builders, the mean and the mighty, and all in incredible profusion. For the more modest householders, paintings were actually a cheaper way of covering bare and often damp plaster walls than either tapestry or stamped leather wall hangings. So it should not be surprising to find the plumber and roof slater Cornelis van Couwhoorn, who was living in a fairly humble quarter of the city, leaving 26 paintings in his estate when he died. A confectioner owned 20, and a little further up the social scale a hosiery dyer, Tobias Moeyaert, had 64 paintings in his house when he died! At the top end of patronage, the professor of medicine François du Bois Sylvius, a regular Maecenas of Leiden, who lived at Rapenburg 31, had no fewer than 173 pictures in his house. The most valuable and sought-after masterworks were, of course, concentrated among the thirteen exceptionally wealthy "art lovers" mentioned in van Mander's *Schilder-boeck,* like the merchant and officer of a pawn-bank Bartholomeus Ferreris, who owned the great gold-drenched *Danaë* by Hendrick Goltzius as well as works by Lucas van Leyden, Quentin Metsys, and Pieter Bruegel the Elder.[25] The paintings (as well as drawings and prints) could be bought at booksellers, where they often shared space with the classical volumes and Bibles whose stories they depicted; at stalls set up in the Town Hall; or at the twice-yearly *vrijmarkt,* the fair that set up its booths in the middle of the city. There were the auctions, of course, virtually every week, where the estates of the defunct and the bankrupt could be picked over for bargains. And in the early decades of the seventeenth century, lotteries, held frequently to benefit charitable institutions, also began to feature paintings, as well as precious plate and tapestries, among their lists of desirable prizes.[26]

Who were the artists? If you visited the grand house of Matthias van Overbeke at Rapenburg 56–57 in 1628, you would have found a collection that would not have disgraced the Antwerp *kunstliefhebbers:* the Flemings Rubens, Coninxloo, Roelant Savery, and Sebastian Vrancx, but also local talent like David Bailly, the seascapist Porcellis, and the great landscapist and "merry company" painter Esaias van de Velde. But there seems to have been a genuine desire even among quite sophisticated collectors like Jan Orlers to favor local talent, such as Bailly, Pieter de Neyn, Aernout Elsevier, Coenraad van Schilperoort, and both Dirck and Jan Lievens, as well as works by van Goyen that could be described either as "pure landscapes" or as "history landscapes," like a *Hannibal Crossing the Alps* or a *Beach Scene with St. Peter.* And among his fifty-odd paintings there were also two

described as a "Naples market" and a *toverij*, a "sorcery." These last could only have come from one peculiar hand: Jacob Isaacsz. van Swanenburg. And it was to this unlikely sorcerer's cell that the fourteen-year-old Rembrandt went to learn about grinding and priming and dead coloring.

Just a few years earlier, an apprenticeship with a van Swanenburg would have made perfect sense as a short route to both artistic and social success in Leiden. The patriarch of the clan, Isaac Claesz., was the dominant painter of the post-siege generation, the closest thing Leiden had to an official civic artist, very much the kind of position held by his teacher, Frans Floris, in Antwerp before 1566. His apprenticeship there taught him the requirements of public versatility. To be a real presence, it was necessary not only to paint but to design an entire urban decor. And this Isaac Claesz. did with gusto, producing work that was turned into tapestries, seals, windows, and engravings. He could do the pompous and he could do the picayune. It was "Isaac Nicolay" (as he liked to be called) to whom the cloth guilds turned when they wanted both allegorical celebrations and accurate depictions of wool carding, combing, and weaving to decorate the Saaihal, the Serge Hall. But it was also Isaac Nicolay to whom the city councils in Delft as well as Leiden turned for their respective commemorative stained-glass windows in the St. Janskerk at Gouda: the former depicting the siege and relief (including a memorably beautiful portrait of William the Silent); the latter an obviously analogous version of the siege of Samaria.[27] But van Swanenburg was more than a painter; he was an oligarch, one of "the Forty" who ruled the city; thirteen times a *schepen*, five times a burgomaster, and all the time a senior officer of the militia. So like Rubens, he could claim to have lived the Ciceronian life: both active and contemplative. In 1568 he had painted his self-portrait in which he appears, in the Flemish style, as a dignitary of the palette: in manner and dress, fit to keep company with the shade of Titian.

No wonder it was to the van Swanenburgs that Rubens turned when he sought a Dutch engraver who would be less a printing drudge than a humanist collaborator. And his choice, the youngest of Isaac's three boys, Willem, looked fair to follow his father's fame in both public as well as artistic life, since he was already an ensign in a city militia company, often the first step to promotion through the patrician ranks. But Willem had died in August 1612, and his father followed him two years later. And by the time Rembrandt was looking for a master in 1620, the fortunes of the van Swanenburgs had drastically changed. Some of them were still Catholics; more were Remonstrants; none were on the side of the zealously Calvinist Counter-Remonstrants. Though their houses and fortune remained reasonably intact, their power and influence was gone. But there were still two van Swanenburgs left, Jacob Isaacsz. and Claesz., both mere shadows of their father in terms of reputation, but still a presence in the city. As the oldest brother and conceivably once seen as the most promising, Jacob Isaacsz. had been sent on the Italian tour, an indication that he showed potential for serious history painting. In fact, he could well have been in Rome in 1605

when the Rubens brothers were living on the Via della Croce. And since the Flemish-Dutch community was such a tight little group, it's not at all improbable that Jacob Isaacsz., Peter Paul, and Philip shared a table together. Unlike Rubens, though, Jacob Isaacsz.'s enthusiasm for Italy did not stop at ancient stone and parchment. He travelled further south, to Naples, then an outpost of Spanish power, and married a local woman, Margarita Cardona, reaffirming his Catholicism for the ritual. And perhaps it was the slightly embalmed quality of Naples, its sulfurous fascination with fire, death, and the underworld, that tempted Jacob into places a nice young patrician from Leiden probably ought not to have gone. He began painting phantasmagoria: elaborately detailed scenes of hell and witchcraft crawling with monsters and abominations, nasty things about to hatch, reptiles in flight, sinners skewered and broiled, the usual stuff. To judge from the few surviving examples of his work, these were the sort of thing that had become a slightly dated commonplace in printed versions of Bosch and Pieter Bruegel. But in superstitious Naples, with its unrivalled complement of tormented holy men, Jacob's phantoms and wizards must have seemed a little too enthusiastically depicted for his own, or the Church's, good, and he was duly called before the Inquisition for having painted a *Witches' Sabbath*. Not only that, but he had the temerity to sell it from his own booth on the premises of a church, the Santa Maria della Carità.[28]

No transcript of his interrogation survives. But the proceedings could not have gone well, as Jacob decided to leave Naples and return to Leiden, presumably in some haste since he initially left his Neapolitan wife behind. It was 1617. His father and younger brother were dead, and he found himself a Catholic in one of the angriest Calvinist cities in Holland. But resettled amidst the bulrushes and hanging clouds of the Rijnland, Jacob seems to have realized that he could actually trade, in a modest way, on his exoticism. So he continued to turn out both decorative townscapes and market scenes of Naples and, to service the market for black fantasies, his "ghost" pieces, his orgiastic sabbaths and gaping mouths of hell. The latter were what we would call novelty acts, and they may not have been quite as bad as they sound. As a chapter in the early history of the horror comic, they even had their entertaining moments. A surviving painting (although badly damaged and extensively repainted) is said to depict the passage from the sixth book of the *Aeneid* where the Cumaean Sibyl shows Aeneas the underworld from the lid of what looks like an ale pot. Immediately below, a demonic menagerie of gaping snouts and sharp-fanged maws gets ready for feeding time as lines of naked sinners are driven to the fiery pit, white and squirming, like pailfuls of fish bait.

Could Rembrandt have possibly spent *three years* learning this stuff? Or imitating the inspidly scenic little street and market scenes that were Jacob Isaacsz.'s other line? It would have been enough, surely, to drive him right back to the lecture hall. His own earliest work shows no more sign of van Swanenburg's influence than Rubens's bears the mark of Adam van Noort or Tobias Verhaecht. It's likely that, as young as he was, Rembrandt

Jacob Isaacsz. van Swanenburg, Hell Scene, *1620s. Panel, 93.5 × 124 cm. Leiden, Stedelijk Museum De Lakenhal*

must have thought Jacob Isaacsz.'s demon-infested obsessions an eccentric throwback to much older Netherlandish visions of the apocalypse. But if neither van Swanenburg's matter nor his manner seems to have made any impression on Rembrandt, the apprentice could not help picking up the "fundamentals and principles" of his craft simply by being in a studio and being obliged to carry out the routine drudgeries a master expected, and which were, in fact, a precondition of learning the more serious arts of composition.

So the novice Rembrandt Harmenszoon would have done the chores. He would have learned how to plane down the knots and bumps in a virgin panel; how to mix primer from lead white, chalk, and thin glue; how to produce the subtly different tints of "dead coloring," some brown, some gray, that would supply the tonal platform on which he would build his glowing layers of paint. He would have become expert in fingering the fine tail hair of squirrel and sable and the coarser hair taken from the ears of oxen or the backs of badgers and formed into flattish rectangles and tied to the wooden brush shaft with cord or thrust through a goose quill.[29] Sometimes he might have supposed himself to be apprenticed to an apothecary rather than an artist. It may have been possible in Rembrandt's day to buy slabs or chunks of dried and cleansed pigment which required only that they be ground down and suspended in the strong, meaty-smelling linseed oil to be ready for use. But the preparation of the basic pigments—lampblack, lead white, vermilion, smalt, and verdigris—was such simplicity that a workaday artist like van Swanenburg would have assigned the job to his apprentice.

It's good to think of Rembrandt, for whom the physical texture of paint was to be a lifelong obsession, *inhaling* his art, feeding it through his senses, absorbing the astringent odor of vinegar as it reacted with the strips and pretzel-shaped "buckles" of lead, yielding up the fine white powder basic to any kind of painting in the seventeenth century. If he was very unlucky, he might have had to refresh the piles of horse manure which generated the carboniferous heat needed to complete that reaction. Snow-white paint from steaming dung: another miracle of the painter's alchemy. Blacks were easier to come by. No one, thank God, robbed graves anymore for charring skeletons to make "bone black." Lampblack was gotten just by burning pitch or tar to create an obstinately oily soot. Smalt, the cheaper (but more unstable) alternative blue to costly lapis-lazuli-derived ultramarine, was just pulverized potassium glass to which cobalt had been added for color. And verdigris, that intense green that if made properly could be as deep and beautiful as any malachite, was nothing more than the brilliant crust that formed on good Swedish copper when it was brought into contact with an acetic concentration. The best kind of acid to produce this reaction was usually the fermented waste of wine, a dense sludge of mashed pips and skin. Better good green pigment than bad rotgut liquor. But the most miraculous, almost alchemical transformation occurred when cinnabar, mixed with sulfur and heated, produced a dull blackish baked-in lump which was then pounded underwater, turning an astonishing, brilliant red: the perfect vermilion. Together with a generous supply of earthen colors—ochers, yellow, and red—this was all the seventeenth-century painter needed for his basic pigments, though the more adventurous might have sought out masticot (lead-tin yellow), indigo, or the intense red cochineal that exuded from the crushed remains of female Mexican shield lice.

Aside from the aroma and the hues of paint, there was the marvellously protean quality of its texture to explore. Depending on the density of the medium (linseed, walnut, poppy oil), the paint might run as thin as a stream or as thick as a soup, a creamy weight on the bristles. Left awhile in sunlight, a pond of paint would soon coagulate into a multitude of forms: skins and crusts, clots, curds, and puddles; pearls, beads, warts, and pimples. If a curious finger or a pointed brush probed the sticky surface, it left minute wavelets, standing impudently up from the surface of the panel. The apprentice would have tested the different resistance of surfaces to the loaded brush: how, with the right priming, badger bristles could be made to slide glossily over the face of the panel or work pastily against the threads of a canvas warp. Drawing, the "nurse of art," as van Mander had called it, had its own changeable tempers to explore and respect. Red chalk was supposed to provoke gallant impulses, while pen and ink asked for more considered designs. But Rembrandt's economically suggestive hand would conjure a whole world of sky and water with three strokes of a raven's quill and change those academic assumptions forever.

This was all handwork. For headwork there was the Book: Karel van Mander's *Schilder-boeck,* published first in 1604 and then again in an

Amsterdam edition of 1618. For the first half of the seventeenth century, it was the *only* Dutch-language treatise on painting, so that any bright young apprentice wanting something more exalted than hands-on training would at least have pored through its stories of artists' lives and its detailed counsel about painting histories and landscapes, feasts of gods, and peasant dances. Van Mander, then, was an honored, almost revered name, though it did him little good in his lifetime, since he died in Amsterdam in 1606 almost penniless. Ah, but what a funeral his parting summoned—three hundred mourners in a long black line, following the bier to the Oude Kerk to the tolling of Michaelmas bells.

For those who want to believe that we should replace the myth of Rembrandt the Rebel with (the equally mythical) Rembrandt the Conformist, it must necessarily be van Mander's mighty Rule Book that he must have been heeding. So what did the erudite Mennonite have to say to the malt miller's son? When Rembrandt read the *exhortatie* which began the long poem *Den grondt der edel vry schilderkunst* (*The Foundation of the Most Noble Free Art of Painting*), he might have thought himself back in Dr. Lettingius's schoolroom. For after natural aptitude (without which, van Mander acknowledged, any attempt at training would be fruitless), the first requirement was wholesome moral discipline, the temperate personal regimen exemplified by Rubens. No drink, no gaming, no fighting, no idle distractions of any kind, and no whoring. Especially no whoring. But no early marriage, either, not for the monkish devotee of Pictura. Much of this depressing sternness was generated by van Mander's own distress at the dreadful reputation dogging Netherlandish painters (and to which, if he had been honest, he had contributed with his own little rogues' gallery of art). Van Mander made a great fuss about the ignominy of painters having to endure membership in a guild that also included low-life numskulls like tinsmiths when they ought to be honored like the Greek Pamphilus as learned and genteel; hence his emphasis on the most *noble* art of painting. You can almost see the sober, pinched-cheeked van Mander wince when he alluded, more than once, to the vernacular saying that summed up this bad odor surrounding the painter's studio, *Hoe schilder, hoe wilder*—"For painter, read wild man." No no no, he insisted, if you wish to be great, first be good, so that in future, generations could say instead *Hoe schilder, hoe stille*—"For painter, read calm man." Was Rembrandt Harmenszoon sitting up straight as he read this? Was he paying attention? Did he forswear the vices? Did he promise, in good conscience, to live the life of the cold-shower Stoics, appetites bridled by moderation, passion governed by cool reason? Would the "healthy mind in a healthy body" that Rubens had inscribed on his garden wall be adopted as his motto?

Did he, in fact, have the stomach to read on? If he did, he would have waded through thirteen verse chapters on painting, all of which have been treated lately as though they comprise a masterpiece of dense philosophical complexity and intellectual subtlety. The official entry on van Mander's life in the *Grove Dictionary of Art* even claims that the *Grondt* was almost

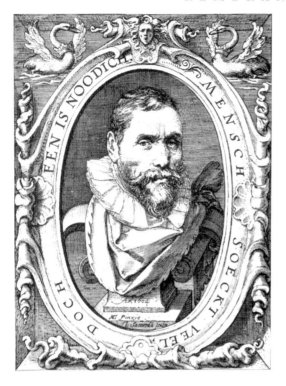

Jan Saenredam after Hendrick Goltzius, Portrait of Karel van Mander, *1604. Engraving. Amsterdam, Rijksprentenkabinet*

exclusively a theoretical, rather than a practical, guide.[30] But this is simply untrue. Its chapter on *ordonnantie,* by which van Mander meant something like composition, draftsmanship, the structural ordering of a painting, is full of highly specific advice about human proportions (the precise distance from elbow to shoulder, and so on). Van Mander offered step-by-step instruction on how to group figures so as to ensure that a history painting was built about a *doorkijkje,* a deep perspectival recession, that might be pictorially threaded together by a winding road or a winding river, like the stream that snakes through his *Crossing of the Jordan* of 1605 and which served, among other things, as an allegory of the boundary between the mortal world and paradise. In fact, the most glaring problem about gauging the influence that van Mander's rules had on subsequent generations is that they so very obviously describe his *own* output: classically statuesque at the beginning; elastically, writhingly mannerist at the end. So that when, for example, he insists on the importance of gestural variety in figure groups—some standing, some kneeling, some sitting, some climbing, a whole gymnasium of activity—it is a lot easier to be put in mind of the Flemish past than the Dutch future. Not for nothing are the heroes of the past age—Dürer, Lucas van Leyden, and especially Pieter Bruegel—to be found most often among his exempla.

There are passages in the text which actually do depart from the evidence of his own work, and which Rembrandt's generation may well have taken to heart. More than once, when speaking of the infinite variety of nature's colors, embodied for him in the plumage of a parrot, van Mander insists that Nature should be the great instructor, even though he himself was anything but a raw naturalist and actually disliked Caravaggio for his undecorous physical realism. Equally, although van Mander took the poet Jacopo Sannazzaro's pastoral poem *Arcadia* with a lot more seriousness than it deserves, his landscape chapter is full of native spontaneity and freshness; images of the artist planted out of doors in the fresh wet breezes sketching fishermen beneath the willow fronds or carters trudging along the rutted paths.

After *ordonnantie,* there was a chapter on *reflexy-const*—the treatment of light, shadow, and reflection, sunset, moonlight, firelight, and water mist; long passages on the rainbow and its revelation of pure, discrete bands of color—and Rembrandt would certainly follow van Mander's stricture that flesh tones ought to be subtly shaded with the reflection of bright clothes, or even the green of an outdoor setting. Perhaps he also took van Mander's observation that candlelight was the very hardest light source to master in painting as a challenge. He could learn which pigments to avoid for their fugitive impermanence (masticot yellow); the color com-

binations which worked (blue and gold) and those which didn't (purple and yellow, green and white, since the paler hue drained the stronger). And if he was not much interested in the detailed chapters on the precise rendering of the parts of a horse, it's likely that van Mander's elaborate concern for representing the behavior of different types of cloth—silk, linen, or wool—as they fell or folded, starched or softened, pleated or wrinkled, about the human form, would have made a serious impression.

Arguably, though, the chapter Rembrandt might have taken most to heart was van Mander's treatment of what he called the *affecten*, the passions. Here the Dutch writer was most indebted to Alberti, Vasari, and the Italians, yet he did bring something of his own culture's mind-set about the rendering of strong emotion, and that was its love of theater. Van Mander was himself a member of a famous chamber of rhetoric in Haarlem, the White Carnation, and certainly thought of himself not merely as a painter but as a poet. It's likely, then, that he himself may have acted or at least orated, and his instructions as to how the passions should be represented sound at times very much like a director instructing his troupe. Body language was itself a kind of eloquence. Tragic sorrow, for example, was to be indicated by a hand on the breast (or, better still, both hands crossed over the breast); a head should droop slightly down on one shoulder; and so on. But it was in the face that the painter might do things that might not be so easily seen by a theater audience: above all in the eyes, the messengers of the heart, the mirrors of the mind. Together with their auxiliary protectors, the eyebrows, and the broad theatrical space of the forehead, the eyes told the truth about the deepest inward states of emotion. Van Mander cited a print by Lucas van Leyden of David playing the harp before Saul in which the King's ostensible outward expression was one of regal composure. To attentive observers, though, it was apparent that Saul's eyes betrayed his true state of jealousy, hatred, and fear.

Though he despised portraiture as loathsome moneygrubbing and seems to have abstained from the character heads, the *tronies*, that were already an established Netherlandish genre, van Mander's text shows him to be an observant expert in emotive physiognomy. Laughing and crying, he points out, seem superficially to be amazingly alike in the effect they have on the human face. Until, that is, one notices that the laughing face expands, especially about the cheeks, while the crying face contracts into itself; that the merry phiz betrays itself in tiny wrinkles on the brow and half-shut eyes, the stricken phiz by a drooping, full lower lip. And in a moment of real poetic inspiration, van Mander compared the alterations in the forehead—its tightening, relaxation, smoothness, or wrinkles—to the passage of weather, from glowering and stormy to light and unclouded.

Did all this counsel—the learned allusions to examples in antiquity and in modern painting—add up to anything like a clear set of hard-and-fast rules? Hardly. Even van Mander himself, at certain moments in his relentlessly schoolmasterly survey, advised that the imagination, the *inventie* or the *geest*, be allowed to run free; that painters even explore color possibilities for themselves. On an issue that was to be of crucial importance to

Rembrandt—the deliberately and expressively "rough" manner of Titian's
last years—van Mander was very much of two minds, admiring it in the
great Venetian master but deploring it as a fashion followed by those who
had none of Titian's true talents.

If he read van Mander at all, Rembrandt might have done so more for
inspiration than for instruction. Far more of the work is biography than
technical manual: the lives first of the ancient artists (based nearly entirely
on Pliny); then those of the Italian masters (based nearly entirely on
Vasari); and, finally and most originally, the lives of the German and
Netherlandish artists from the van Eycks to Metsys, Bruegel, and Goltzius.
It was in these pages that a young Dutch artist might indeed see himself ris-
ing, like so many of them, from nothing to something and from something
to greatness, and convince himself that before too long the citizens of Lei-
den might own to having in their midst a second Lucas.

iii *History Lessons*

It seemed that the road to fame in Leiden lay through
Amsterdam. The smart little marvel Jan Lievens, the embroiderer-
hatmaker's son, had shown such precocious aptitude that he had been
packed off to the port city in his eleventh year, before there was fuzz on his
cheek, to study with the history painter Pieter Lastman, exchanging his
home on the Breestraat, Leiden, for his master's house on the Breestraat,
Amsterdam. When Lievens returned to Leiden around 1621, at fourteen,
according to the city chronicler Jan Orlers, he had already picked up the
knowledge and skills he needed to win a serious reputation in his native
town.[31]

There's nothing like envy to clarify one's career plans. Watching his
contemporary Lievens's star swiftly ascend, the student Rembrandt, stuck
in the antiquated world of apocalypse van Swanenburg, might reasonably
have wondered what a study term with Pieter Lastman might do for his
own prospects. The Amsterdam master was, after all, the epitome of suc-
cess, not just in the Dutch metropolis but in the wider European world,
winning commissions to decorate the King of Denmark's chapel at Fred-
eriksborg Castle, an assignment of Rubensian importance. Like Rubens,
Lastman parcelled these big jobs out to colleagues and assistants. The Dan-
ish commission was distributed among a group of artists, including the
Pynas brothers, Jan and Jacob, who between them had established Amster-
dam as a place to be contended with, not just as a great engine of riches but
as a site of cultivation and high taste. Its prolific theater and literary life had
already laid the foundation of an expressly Dutch, vernacular culture. Now
the group of artists associated with Lastman—Claes Moeyaert, François

Venant, and Jan Tengnagel as well as the Pynases—together produced a succession of brightly colored, energetically dramatic compositions in landscape or architectural settings that serviced both local and long-distance demand. From provincial Leiden, Lastman must have seemed to have the keys to fame and fortune, and the adolescent Rembrandt was impatient to unlock the door.

In all likelihood Rembrandt arrived in Amsterdam toward the end of 1624.[32] In the house on the Breestraat, in the shadow of Hendrick de Keyser's gracefully steepled Zuiderkerk, Pieter Lastman's formidable mother, Barber Jansdochter, was dying, full of years and money. It had been her property, paid for with the proceeds of her business dealing in secondhand goods and appraising paintings, plate, prints, furniture: the material residue of lives stopped short by death or disgrace. Before she was laid to rest in the Oude Kerk in December 1624, Barber had doubtless appraised her own estate and found it, to her satisfaction, worth not a penny less than twenty-three thousand guilders, not bad for a widow of twenty-one years saddled in her old age with the care of the four children of her dead son, Jacob the sailmaker.[33]

The making and breaking of fortunes, as unpredictable in Amsterdam as the skies, had kept her busy. Her long life had seen the city transformed, almost beyond recognition. When she had married her husband Pieter Segerszoon in the 1570s, the town had numbered no more than thirty thousand souls, jammed into the canals between the Oude Kerk and the Dam. The dock was filled with tubby little boats carrying the staples of Dutch life: herring, timber, and Baltic grain. By the time Pieter Segerszoon had gone to his Maker in 1603, there were twice the number of folk in the city and all manner of voices could be heard on the Dam: eastern accents, thick and yawning, from Gelderland and Overijssel; German gutturals; the soft glottals of Walloons and Brabanders; the singsong gurglings of Norwegians and Danes; and the legato run of Italian consonants that made the speakers sound as though they were on the verge of bursting either into a song or a fight. Barber Jansdochter and Pieter Segerszoon may themselves have hailed from the old Amsterdam, but they had no quarrel with the new, at least not with its cosmopolitanism. They appreciated the Portuguese Jews bringing with them the pepper, nutmeg, and clove trade from Lisbon, which now meant that the spices needed on tables throughout Europe had to arrive via Amsterdam. Every year seemed to convert luxuries into necessities: sugar and tobacco from the New World could be found in processing sheds along the Amstel. Even the strutting, vainglorious southerners, who had all but taken over the city with their coin and their catechisms, had, it must be admitted, created a mart for elegant wares—damasks and velvets, chased plate and gilt leather—that did no one any harm. There was silk and wine for those who cared for such things, and there was still cheese and fish, cabbages and ale, for those who clung to the older ways.

Lastman's father, Pieter Segerszoon, clearly had what it took to prosper in this mobile commercial culture: a willingness to travel and an eye for

appreciating property. He had begun humbly, living on the Pijlsteeg, a street busy with both workshops and whorehouses. It was the latter, though, which provided a livelihood for the sheriff's men responsible for policing them (and often taking a cut for their benign neglect). Lastman's father may have started as a sheriff's runner, but at some point he rose through the messenger hierarchy to the point where he became a dependable international courier, someone who could be relied on to know his way along the dangerous roads and rivers of the southern Netherlands and Germany, delivering papers not only to businessmen but to politicos like the Prince of Orange. In 1577 he was rewarded by being appointed official *bode*, or courier, for one of Amsterdam's most important institutions, its court of orphans. The times being what they were, orphans were abundant in Amsterdam, and Pieter Segerszoon conscientiously handled their money and the fortunes and property of spinsters and widows besides.

There was only one problem, and in 1578 it became a big one. Pieter Segerszoon and his wife, Barber Jansdochter, were both Catholics. Unlike Leiden and Haarlem, Amsterdam had remained obstinately loyal to King Philip, so that when the fortunes of war forced it to change sides and conform to Protestant Holland, the *alteratie* visited on it was particularly severe. All Catholics were removed from public offices, and that must have included Pieter Segerszoon. The family was diminished but hardly destitute. They moved to the St. Jansstraat, to a house perfectly named for their circumstances, "the Humble King," and all around them were similar princes in reduced circumstances making a living from trading in second-hand goods. This happened to be Barber Jansdochter's strong suit. A natural scavenger of estate and bankruptcy sales, she rapidly acquired both means and reputation as an eagle eye, so much so that the city came to depend on her as one of its most reliable assessors of property, especially the fine things—plate, paintings, prints, and tapestries.

Thus did the busily resolute Barber Jansdochter save her family and remake its fortunes. By the time her children grew to maturity, she had prospered enough to exchange the Humble King for the Golden Cup, a house that lived up to its name. Her children were well set up. One of the four boys became a sailmaker, a relatively humble trade, but there were worse crafts in the new shipbuilding center of the world. The other boys shone. Seeger Pieterszoon became a goldsmith and did so well that he rose to become deacon of the guild; another, Claes, also worked with metals, becoming an engraver. And between the older Seeger and the younger Claes there was Pieter the painter.

Now what should be done with a bright lad who showed an obvious gift with the pen and the brush? Send him to Italy, of course. Pieter, who now surnamed himself Lastman, was around twenty when he made the journey in 1603. So he would have been in Rome in 1605 doing much the same things and at much the same time as Peter Paul Rubens: smelling the thyme; gawping at Michelangelo; allowing himself a little swagger, renaming himself "Pietro"; sketching the ruins on the Palatine hill. With the Flemish-

Dutch circle so conspicuous in Rome, and so very tight with each other, Lastman, like van Swanenburg, would have run into Peter Paul, and perhaps felt a twinge of envy as the Antwerper got to work on the great commission for the Chiesa Nuova. And when he made the journey back north a year earlier than Rubens, in 1607, he took with him much the same luggage of impressions: the athletic audacity of Caravaggio; the sweetly balanced graces of the Carracci (especially Annibale); and the poetic simplicity of "Signor Adam" Elsheimer, whose elegant histories smoothly painted on copper were marvels of narrative compression.[34] He also learned much from the gently suggestive landscape style developed by Flemish painters in the Campagna like Paul Brill.

Rubens returned home to his mother's tomb. Lastman came back to the welcome of the new house on the Breestraat, bought by his mother expressly to house his studio. Though preachers might warn their flocks not to be beguiled by images, they had little effect on a demand for histories that was at its most robust precisely in the early decades of the seventeenth century when Lastman and his followers were in their prime. Classical histories would show off a wealthy patron's sophistication, testifying to his interest in matters beyond the warehouse and the countinghouse. The Scriptures were drawn from the old repertoire, much of it in engraved work by Lucas van Leyden or Maerten van Heemskerck, many of them chosen for their perennial moral lessons, often with a strong emphasis on family disasters: David and Uriah (adultery); Jephthah and Abraham (family sacrifices); Haman and Mordecai (hubris); Tobit and Tobias (fortitude, faith, and courage). Who could take exception to such visual homilies, hung on the walls of a *voorhuis*, the boardrooms of a hospital or an orphanage, the chambers of aldermen and burgomasters?

Family connections must have gotten Lastman off to a quick start. In 1611, probably through the influence of his older brother Seeger, just elevated to deacon of the goldsmiths, he won the commission to design a large window for the Zuiderkerk, the first church in the Dutch Republic to be custom-built for Protestant worship. It must have been a sign of Lastman's confidence or the relaxed temper in Amsterdam before the time of the confessional civil war that he could make the domed St. Peter's stand in for a Persian temple, before which King Cyrus is collecting precious plate that would go to the building of the Temple in Jerusalem. The elaborate display of silver and gold may have been a grateful nod to his brother or to the guild that may have paid for the window. But the combination of grand architecture, nobly drawn figures, and glittering still life was a virtual business card advertising Lastman's credentials as a history painter worthy of any hire.

It was also, of course, an attentive response to Karel van Mander's recommendations for success. Between 1611 and Rembrandt's arrival on the Breestraat, Lastman turned out a succession of paintings, some of them quite beautiful, some of them not, but all of which constitute a virtual inventory of the van Mander Rule Book. Group the figures in clusters ensuring that the essential action takes place in the middle ground, writes

Pieter Lastman, The Lamentation of Abel, *1623. Panel, 67.5 × 94.5 cm. Amsterdam, Museum het Rembrandthuis*

van Mander, with the dominant characters set on a prominence above the crowd. Place large but incidental characters at the very front of the painting, in part shadow, to set off the brightly lit action beyond or behind them. Provide a setting for the story worthy of its drama: a majestic arch or dome; a poignant ruin or a colossal bridge; or else a rocky or bosky landscape, whose strong contours, outlined against the sky, would provide the framing structure for the composition. Vegetation? Crucial. Decorate the work with faithfully observed botanicals, preferably (but not essentially) related to the subject: threatening growths of giant thistles; vines with a mind of their own; laurels of glory; oaks of veneration; a scattering of roses; a smattering of gillyflowers. Infants? Optional but desirable. Animals? Mandatory: horses for battles; cows for sacrifice (generally snowy white); goats and sheep (Old Testament Hebrew-herdsman flavor); asses (prophets and saviors); peacocks (classical-oriental flavor); and dogs (all-purpose tragical-comical-playful-loyal). In *The Lamentation of Abel*, everyone is, understandably, crying: Adam, Eve, two unidentified small boys. But it is the noble, smooth-haired sheepdog, made redundant by the murder of his master, the keeper of flocks and herds, sitting by the sacrificial altar, who best personifies the disaster.

Mind, too, that dress is correctly described with folds and rumples appropriate to the chosen fabric. Endeavor to include not only precious and intricately wrought plate but glistening armor or weaponry with its dull and threatening reflections. At the heart of every painting, establish the story through a repertoire of expressive gestures and grimaces supplied by the theater. Above all, make the eyes speak. Around the main action, especially if the subject (*Joseph Distributing Corn in Egypt*, for example) is a little short on thrills, compose a crowd scene with all manner of goings-on, the kind of human miscellany that invites the eye to work the picture space like a party. Give the customer clamor; give the customer bustle; give him, for God's sake, the whole damn *theatrum mundi:* oglers, idlers, jugglers, stragglers, girls in satin, men in rags, silky turbans, furry buskins, and let them perform to bright and brassy sound effects, drums and trumpets, a jangling triangle, a booming conch.

To be fair, this was not the only string Lastman had to his bow. Many of his histories (and certainly the most successful ones) were quieter compositions, concentrated on a much smaller cast of characters, often a pair of figures in intense relationship with each other (*Ruth and Naomi; Christ on the Cross with Mary Magdalene; David and Uriah*). With the noise level of the painting turned down, Lastman was able to make his dramas turn on the expressive communication of the eyes. In

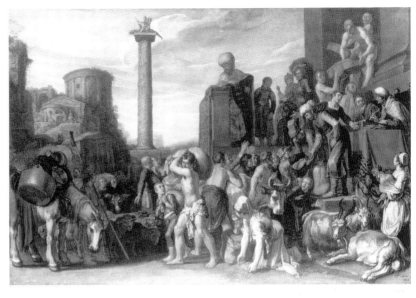

Pieter Lastman, Joseph Distributing Corn in Egypt, *1618. Panel, 58.4 × 87.6 cm. Dublin, National Gallery of Ireland*

these calmer works, landscape and still-life detail reinforce the narrative moral. The fate of Uriah, sent to his death in battle by David, who coveted his wife, Bathsheba, is announced in the plumed helmet that lies on the floor between the soldier and the King. The philosophical integrity of Democritus, being examined, sidelong, by Hippocrates for signs of insanity, is embodied in the massive open volumes lying on the ground beneath his bare feet. One of the most beautiful of all Lastman's works, now in St. Petersburg, *God Appearing to Abraham at Shechem*, has a full complement of gesticulating servants, donkeys, and the most confrontational billy goat in all Baroque art. But the landscape setting is so cunningly constructed and lit, with shadowed foreground and gently sloping background, as to perfectly frame the faces of Abraham and Sarah, radiantly illuminated by the providential sunbeams. The host of witnesses has been pushed into the background as if barricaded from the holy spectacle by the intensity of Jehovan light.

These lessons would not have been lost on the teenage Rembrandt. But if there was any single work of Pieter Lastman's that might have seemed the very definition of a grand history painting, something that could stand comparison with the Italian masters, it was his *Coriolanus and the Roman Women*, completed in 1625, the year of Rembrandt's own first dated painting. Loosely based on a composition by Giulio Romano, it depicted the erstwhile Roman general, now defected to the barbarian enemy the Volsci, standing before a domed tent at the top of a stepped dais draped in golden cloth, listening to the desperate pleas of his wife, mother, and children to spare his native Rome from destruction. Once again, Lastman has chosen an episode not of physical but of psychological drama, a lacuna between words where the outcome of the encounter hangs on the telling exchange of glances and gestures between mother and son. The mother, dressed soberly in red and white, holds out her arms as if to a lost child. Coriolanus

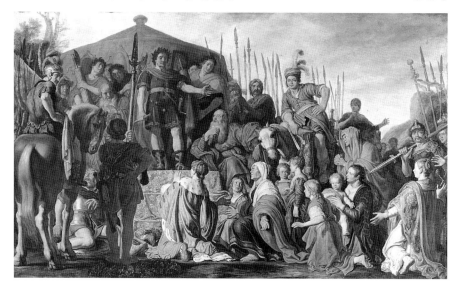

Pieter Lastman,
Coriolanus and the
Roman Women, *1625.*
Panel, 81 × 132 cm.
Dublin, Trinity College

extends his left arm both in filial response and as if holding back his warriors. The whole production is certainly rule-book van Mander, but done with the highest degree of narrative control. The actors are gathered as if on a shallow stage yet are easily distinguishable; the tableau is full of suggestive contrasts between graybeards and infants, sages and soldiers, the elaborately beautiful costume and fair skins of the women and the drooping whiskers and rough animal skin of a barbarian warrior (to Coriolanus's left) that Lastman took directly from engraved illustrations in a Dutch edition of Tacitus's *Germania*. For those familiar with the story, details of the scene would have announced the tragic outcome, in which the son relents only to be executed by the Volsci as a traitor. An ax and a spearhead converge toward the general's head. Behind him the captured fasces of the Romans fade into shadow. In the background row of heads, an old soldier looks meaningfully up at the grim fence of spears. But Lastman was content to imply the blood sacrifice, rather than show it.

The eighteen-year-old Rembrandt got back to Leiden sometime in 1625 with a drawing of Lastman's *Coriolanus* in his possession and a head full of lessons on how to do history painting. Yet his very earliest works suggest that he was of two minds about how to apply these models. Trying for emulation, he sometimes ended up in imitation. Rembrandt's 1626 *"History Painting,"* for example, with its martial figure similarly posed at the top of a flight of draped steps and a group of figures, male this time, gathered at his feet in attitudes of supplication while bearded counsellors and spear-carriers look on, is laboriously obedient to Lastman's prototype. Even Coriolanus's tent, with its nipplelike projection at the top, has been transposed to the vaguely classical background. And the subject, astutely identified by Benjamin Binstock as the Batavian chief Claudius Civilis welcoming his Gaulish prisoners to his side in the armed rebellion against the Romans, is, as in Lastman's painting, a scene of victory through magnanimity.

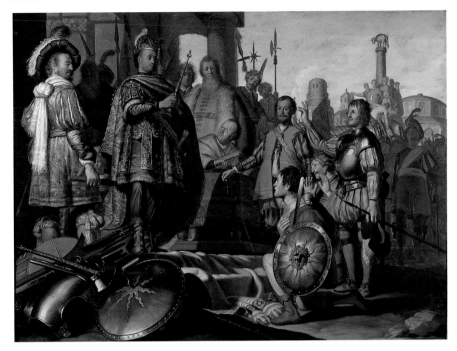

Rembrandt,
"History Painting"
(The Magnanimity of
Claudius Civilis), 1626.
Panel, 90.1 × 121.3 cm.
Leiden, Stedelijk
Museum De Lakenhal

For years, the subject of this *"History"* defied persuasive identification. The currently prevailing view, first proposed in 1963, was that Rembrandt was representing a scene from Joost van den Vondel's play *Palamedes, or Murdered Innocence,* in which a counsellor is unjustly accused of treason before Agamemnon and condemned to death.[35] The play was a thinly disguised version of the events leading to Oldenbarnevelt's trial and execution in 1619 and as a result caused great shock and offense when it was published in 1625. Vondel had presumably hoped that the death of the Stadholder Maurice that year and the succession of his half brother, Frederik Hendrik, a more pragmatic Protestant, might have made his appeal on behalf of the judicially murdered leader of the Remonstrants palatable. And the new regime had indeed changed in the direction of toleration, but not that much. The scandal sent Vondel into hiding, brought him a punishingly heavy fine, and ensured that the play would not be performed until many decades later.

If we suppose Rembrandt to have been nursing angry schoolboy memories of the confessional war in Leiden, then the *Palamedes* might have been an appealing subject. But this presupposes that he was, from the outset, a teenage rebel, burning for vindication for his Remonstrant friends or his mother's Catholic family, determined to say his piece and to hell with the consequences. But this would have been an inconceivably confrontational tactic for a nineteen-year-old unknown attempting to make his mark and find himself patrons on the strength of his Lastman-lessons. There were, it is true, some powerful potential Remonstrant patrons in Leiden, the most influential of whom would have been the historian Petrus

Scriverius, who would certainly have been sympathetic to a pro-Oldenbarnevelt reading of recent history. And it is also true that 1626 saw the triumphant return to Leiden and other towns in Holland of the leading Remonstrant preachers like Johannes Wtenbogaert, whose portrait Rembrandt later painted and etched.

Even were it the case that Rembrandt, an as yet unknown novice, was so rash as to throw in his lot with the returned exiles, what would have been the point of making a painterly statement of allegiance unless the propaganda message was unequivocally intelligible, which, as a *Palamedes*, this painting is not. Where *is* the tragic hero? If this were a *Palamedes*, it would be in violation of van Mander's cardinal rule, namely, that the dominant figure in the narrative should be unmistakably distinguished from the cast of supporters. But Rembrandt's group of supplicants or prisoners all seem much of a muchness, none of them particularly set apart by nobility either of fate or of rank.

Suppose, though, as Benjamin Binstock has suggested, that the figure of the Germanic primitive standing in the back row of Lastman's *Coriolanus* brought an entirely different story to Rembrandt's mind: the ancient history that meant more to Hollanders, Leidenaars, than any other: the rebellion of the Batavians against the Roman Empire. Scriverius himself had made the recovery of Batavian history and even archaeology his special discipline and had written a famous book on the subject that had already gone into two editions. So this would be a perfect subject, either for Rembrandt to ingratiate himself with the scholar or for Scriverius himself to have suggested. And if we also reasonably suppose that Rembrandt would have wanted to flatter, rather than defy, local susceptibilities with his first attempts at history painting, the tradition which believed Leiden to have been the ancient capital of the tribal Batavians made an episode from the uprising an appealing *local* subject. Though, to the modern archaeological eye, the costume of the kingly figure and his attendants scarcely suggest Germanic primitives, they do in fact call to mind the prints made by Antonio Tempesta chronicling the history of the Batavian revolt and used to illustrate the book *Batavorum cum Romanis Bellum*, published by none other than Rubens's teacher and native Leidenaar, Otto van Veen.[36]

So this is indeed a Batavian scene, but what's the story? If Rembrandt was following Lastman's cue from the *Coriolanus*, it's possible that this relatively quiet scene represents a story of reconciliation rather than confrontation or condemnation. In book 4, chapter 17, of the *Histories*, Tacitus describes Claudius Civilis (a reverse Coriolanus) endeavoring to win the loyalty of Gauls who had fought with the Romans by offering them presents "of crafts and gifts" and by "sending back the captured prefects to their own states and giving the soldiers of the cohorts permission to stay or go as they pleased. Those who stayed were given honorable service in the army, those who left were offered spoils taken from the Romans."[37] The spoils are the great heap of discarded martial hardware, the earliest evidence of Rembrandt's lifelong obsession with armor. And the combination

of salutations and awestruck expressions written on the faces of the benefi-
ciaries of this clemency seems exactly in keeping with Tacitus's account.
Even the ostentatious grandeur of Claudius Civilis's gesture is right for the
stirring speech Tacitus gives him on the subject of slavery, liberty, and
courage. "Liberty is a gift which nature has granted even to dumb animals,
but courage is the peculiar blessing of man."[38]

The year of the painting, 1626, is another crucial clue. The previous
year, Frederik Hendrik's personal domain in and around the city of Breda
had been lost to the Spanish general Ambrogio Spinola (the capitulation
later immortalized in Diego Velázquez's masterpiece). Strongholds in Flan-
ders and Brabant were under the most serious threat. So it might have been
a topical move (if also a piece of wishful thinking) to paint a history that
referred to the brotherly unity of the tribes of the Low Countries and their
fraternal interest in coming together to throw off the foreign yoke. That
was a message (unlike that of the *Palamedes*) that could win Rembrandt
friends and admirers in almost every quarter of the citizenry of Leiden:
Calvinist, Remonstrant, or Catholic. And he was, after all, attempting to
present himself as RHL, Rembrandus Hermanni *Leydensis*.

Of course, the prospective patron also needed to like the painting. And
even allowing for a contemporary taste for episodes of slightly stilted
solemnity, this might have been a stretch. Pieter Lastman it tried very hard
to be. Pieter Lastman it was not. In the first place, creating a genuinely cere-
monious scene peopled with elevated characters seems to have put the
teenage Rembrandt under some strain. He may have been no rebel, but
from the outset he was deeply interested in common, rather than refined,
physiognomy, including his own, which peeps from behind the royal
scepter dressed in a seventeenth-century collar as if he had just time-
travelled in from New Lugdunum. (Self-inclusion may well have been a way
of "signing" the painting without writing in his name.)[39] Claudius Civilis is
richly attired, yet his face, as befitted a warrior chief, has something of the
ruffian about it, a feature that almost forty years later, in another painting
of the Batavian leader, Rembrandt would glorify beyond all contemporary
propriety. If the standing bearded counsellor seems borrowed from Last-
man's gallery of sages—although perhaps with a slightly more druidical
tone, in keeping again with Tacitus's description of Germanic tribal types—
his face (and the piggy-nosed, cross-eyed little child seen behind the prince's
back) has more in common with the types seen in low-life tavern genre
paintings than noble histories. The demonstration of forehead-wrinkling
and brow-lifting that Rembrandt supplies for the seated scribe could very
well have been taken directly from van Mander's advice about the inscrip-
tion of the passions written on the upper face. But this is emphatically not a
face that either van Mander or Lastman would have dreamt of including in
his own elegant compositions. It is a face off the streets: coarse and knobly,
a root vegetable of a face with the kind of eyes and stubble that get gouged
and scraped clean before being dumped in a stewpot—in short, a real Rem-
brandt model.

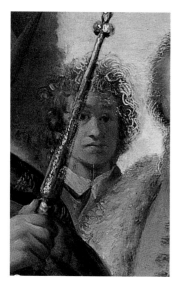

Rembrandt,
"History Painting"
(detail)

Rembrandt, Christ
Driving the Money
Changers from the
Temple, *1626.*
Panel, 43.1 × 32 cm.
Moscow, Pushkin
Museum of Fine Arts

For that matter, the entire company has a crudely dressed-up look, like a second-rate gang of actors hastily costumed in all-purpose "ancient" raiments and rags, less a company of gentlemen formed into a chamber of rhetoric than a scratch troupe ensemble doing the rounds of fairs and markets. But it's exactly in this raw, clumsy, slightly uncoordinated performance that we can sense the young Rembrandt discovering his own artistic persona. At about the same time, he was also painting crowded little genre scenes full of earthy, low-life character-sketching. And these raucous types, painted three-quarter length and crammed together into a tight vertical space, reappear in a startling little panel, *Christ Driving the Money Changers from the Temple,* also dated 1626. Of course, the wide-eyed shock and narrow-eyed avarice of the figures in that piece can easily be correlated with this and that item in van Mander's instructions about representing the passions. But, remembering the delicacy and refinement of van Mander's own figures, it's safe to say that he would have fainted in horror (or at least held his nose in disgust) at the intrusion of alehouse animals into the exalted realm of histories. In all likelihood, though, the young Rembrandt, so far from flattering himself that he was doing something new, might have believed he was returning to an older Netherlandish tradition (in Bruegel, for example) in which the painted Scriptures were peopled with recognizably common types: beggars and bandits, misers and merchants. Whether the move was conceived as traditional or daringly novel, Rembrandt was still violating the first precept of modern history painting, namely, that high tone and low life were kept strictly separate. Right from the outset, though, Rembrandt was a chronic and unrepentantly promiscuous mixer of genres, which is why it seems inappropriate to saddle Lastman and his followers with the collective designation of "pre-Rembrandtists," as if they were in the incipience business: warming the nest with as much dignity as they could muster until the cuckoo hatched.

This is not to say that Rembrandt's early creative awkwardness makes for especially appealing painting, or that all of these early histories are gems in the rough. Many of the 1625–26 paintings are just rough. Rembrandt's conceptual gutsiness, taking Lastman's horizontal format with its clearly defined spaces and groupings and turning them into narrow, upright, deliberately crowded scenes—in order, one assumes, to tighten the dramatic compression ratio of the scene—ran well ahead of his draftsmanship. But these early efforts are what they are: a fistful of bare-knuckled energy. And they are what they are not: the glossily finished, harmoniously balanced, exquisitely calibrated production numbers of Lastman and the Amsterdam history-men.

What, after all, could be rougher than *The Stoning of St. Stephen?*

Stephen was the "protomartyr," the first, after Christ

and the apostles, to suffer death (in the year A.D. 35) for the steadfastness of his faith.[40] "Full of faith and of the Holy Ghost," he was chosen as one of the "seven men of honest report" to bestow alms while the apostles got on with the work of preaching the Gospel. Stephen evidently interpreted his commission liberally, since he also "did great wonders and miracles among the people," pausing only for decisive victories in the usual synagogue debates. This understandably got under the skin of the elders of the Sanhedrin, who accused him of preaching against the Laws of Moses, a charge he refuted with a face "as it had been the face of an angel." Tact, however, was not Stephen's strong point; at the conclusion of his attempt to reconcile the old faith with the new, he asked, "Which of the prophets have not your fathers persecuted? And they have slain them which shewed before of the coming of the Just One; of whom ye have been now the betrayers and murderers."

This defense was not well received. "When they heard these things, they were cut to the heart, and they gnashed on him with their teeth." Stephen, however, "being full of the Holy Ghost," looked up and beheld a vision of Jesus in heaven standing at the right hand of God. Worse, he decided to tell everyone about it. The elders stopped their ears and then the deacon's mouth, casting him out from Jerusalem, where he was stoned to death while calling on God and Christ to receive his spirit.

The *Stephen* has been interpreted as another vindication of the Remonstrant martyrs. The stoned saint thus joins the *Palamedes* as another stand-

Rembrandt, The Stoning of St. Stephen, *1625. Panel, 89.5 × 123.6 cm. Lyon, Musée des Beaux Arts*

in for Oldenbarnevelt. But history paintings in the early seventeenth century were not required to be partisan editorials. And this particular episode from Acts 6–7 had been an immemorially popular subject for artists like Carpaccio and Fra Angelico, who, one can safely say, were well out of the news loop in Venice and Tuscany, both of them devoting whole cycles of paintings to the life and death of the deacon. More recently, both Annibale Carracci and Rubens had produced versions of the martyrdom, the latter for a patron nothing like Petrus Scriverius, namely, the Benedictine fathers of St. Amand at Valenciennes. It might well have been Annibale's version, seen during his Italian stay, that prompted Pieter Lastman to provide his own interpretation. That painting has been lost, but a drawing of it by another hand suggests that it was one of the Amsterdam master's strongest works, showing a dense knot of thugs fastened about their victim, with one of them turned in profile, both arms raised high at the point of bringing down the rock on Stephen's defenseless head. Off to one side, surrounded by false witnesses, is the seated figure of Saul the persecutor, "consenting unto his death."

What did Rembrandt do with his teacher's prototype? At first sight, not a lot. The basic elements of the composition—the gang of murderers falling on their victim, with the most grimly determined poised to deliver the crushing blow; the blood sacrifice set against the outline of the usual Romish ruins that stood in for Jerusalem—were all retained from Lastman's painting. On a second look, though, almost *everything*, or everything that matters, has been drastically changed, and done with the intuition of a dramaturge. The careful orchestration of groups has been replaced by a claustrophobic nightmare, the modulated space of Lastman's work retracted into a suffocatingly cramped corner of a Judean hill. Rubens's *Elevation of the Cross* with its little shelf of craggy torture comes to mind. Instead of the even light falling on the scene, Rembrandt has torn the painting into zones of darkness and light, with the turbaned soldier watching with Roman impassiveness from his horse. Saul, who was set in the middle ground in Lastman's work, has been literally enthroned on high over the execution as if to emphasize the spuriousness of his judgement. His head is turned, listening to lethal calumnies. Lastman's Stephen is about to succumb to a statuesque pair of louts, with a third lout about to pick up another stone; Rembrandt's martyr has sunk to his knees beneath a windmill of blows, falling inexorably, one after the other. As usual, Lastman suspends the action before the climax. With Rembrandt-the-director we are in the merciless thick of it. Stephen's face is bathed in holy light but swollen and puffy from the damage already done.

The faces of his tormentors constitute an opera of malevolence: twisted and sneering, demented with rage, lips pursed in spite. The eyes of the bearded assailant wide with rage are the eyes of Michelangelo's demons, black pits in distended white sclera. And at the center of the storm of violence, Rembrandt has done something shameless and strange, giving no less than *three* of his principals his own features, becoming, simultaneously,

witness, executioner, *and* victim. The central figure with the rock held above Stephen's head is perhaps the strongest likeness, but both the curly-haired figure immediately behind him with his mouth open and the saint himself have something of his physiognomy as well. It was not, of course, unprecedented for an artist to include himself in such history paintings. Karel van Mander had depicted himself as one of the Levite ark-bearers crossing the Jordan. But this, as with most cases of visual autograph, was intended as a statement of piety: the soul of the Mennonite painter preparing (only a year before his actual death) for the journey to the Promised Land; Scripture as personal testament. But it was, to say the least, unusual, if not brazenly presumptuous, for the nineteen-year-old to insert himself so aggressively into the very center of a large work.

If taxed with unseemly self-advertisement, Rembrandt could always invoke the impeccably Calvinist emphasis on personal witness to the Gospel, an identification so complete it

Rembrandt, The Stoning of St. Stephen, *1635. Etching. Private collection*

should be as though the believer had experienced firsthand the suffering and the salvation. And in the interests of direct witness and dramatic compression, he has done something he would often do in the most successful of his histories: collapse different episodes from the story into a single, concentrated frame. The clue is (of course) in Stephen's eyes, turned upward in the same direction as his outstretched hand. Doubtless we are meant to imagine him dying while calling, as the Bible says, on the Savior. But we are also meant to remember the moment that *led* to his death: the transfiguring vision of God in heaven with Jesus at his right hand. And it is from that celestial vision that the radiance pours down, on the martyr and the murderers alike, as the expired Stephen makes sure (in the manner of Christ at his end) that "this sin [be not laid] to their charge."

As a production concept, this is shockingly self-assured, even if the execution leaves a lot to be desired. In his eagerness to use the whole picture plane, piling up figures vertically as if they were standing on stepped platforms on a stage, Rembrandt overdoes the crowding, so that the relationship between close and distant space becomes difficult to read. The painting works, at best, in fits and starts. When Rembrandt revisited his composition in 1635 (exactly sixteen hundred years after Stephen's death), in a small but powerful etching, he had worked out a more effective economy of space and figures, removing the horseman, the figure of Saul, and much of the middle-ground detail. Instead he isolates the figures of Stephen and his executioners on a ledge with the ground dropping off sharply

Pieter Lastman, The Baptism of the Eunuch, *1623. Panel, 85 × 115 cm. Karlsruhe, Staatliche Kunsthalle*

behind them, the spectators furtively observing from a safe distance down the hill, and the walls of Jerusalem rising at the rear. Stephen's eyes are blank sockets, while above him an immense rock, its edges as cruelly sharp as the features of the man holding it, is poised to deliver the coup de grâce. Instead of being raised in innocent supplication, an arm hangs loosely by his side. A slipper stands poignantly empty. But this is nine years later and Rembrandt has a teacher other than Lastman. He has Rubens.

It's been suggested that the *Stephen* and the 1626 *"History"* were commissioned as a pair. But it's at least as logical to suppose that, in spite of their very different size, temper, and mood, *The Stoning of St. Stephen* might have been paired with another of Rembrandt's 1626 paintings, *The Baptism of the Eunuch*, since that story follows almost immediately on it in the Book of Acts and concerns another of the Christian deacons, this time Philip.[41] (It's not completely inconceivable that, given their association with practical charity, the "Deacon" paintings might have been executed for the administrator of one of Leiden's many almshouses.)

The Baptism of the Eunuch is as peaceful as *The Stoning of St. Stephen* is violent: the story of a journey to grace. A "eunuch of great authority under Candace queen of the Ethiopians" was returning from Jerusalem and reading the Book of Isaiah on the road. His attentiveness to the Scripture identified him to an angel as serious conversion material. The angel alerted Philip, who then made a missionary interception. The matter was clinched when Philip explained to the eunuch the significance of the lines "He was led as a sheep to the slaughter" as a prophecy of the Passion, and at the next available river the eunuch asked for, and received, baptism.

The story hardly seems rich enough in incident, let alone drama, to recommend itself to history painters, yet Lastman painted it no less than four times, the last in 1623.[42] This is the version Rembrandt would have seen in Amsterdam, and was one of his teacher's most successful paintings, in which all the elements of landscape and figures, story and setting, light and shade are perfectly integrated into a narrative whole. For once the rocky, wooded landscape from which water cascades into the baptismal river has

a functional rather than decorative role to play in the story, and accordingly, through fresh and vivid color and sure draftsmanship (the protruding, tree-capped rock leans toward both the echoing cloud and the parasol), he lavished his best attention on its details. Lastman's most inventive touch, though, is to make the empty coach, painted with loving detail down to the studs on the rim of the rear wheel, dominate the entire composition, recalling the journey the eunuch had made from paganism to salvation. For once Lastman has *not* placed his protagonists up high, but substituted the parasol as a suggestion of the eunuch's eminence, the better to contrast it with his humility as he kneels for his baptism.

It would be good to report that even here the pupil outshone the master, taking Lastman's design and somehow improving it beyond all recognition. But he didn't. The landscape is sketchy, the horses wooden, the composition banal. Yet the changes that Rembrandt does make are, once again, in their own way startling, and truly prophetic of his own later interests and obsessions. The upright panel lacks the elegance and Italianate harmonies that make Lastman's painting so sensuously pleasing. At the same time, though, Rembrandt's version has a quality missing from his teacher's original: reportorial immediacy. Typically, Rembrandt has brushed aside the innocuous conventions. He reads Acts 8:26–40 as the story of a Holy Land journey.

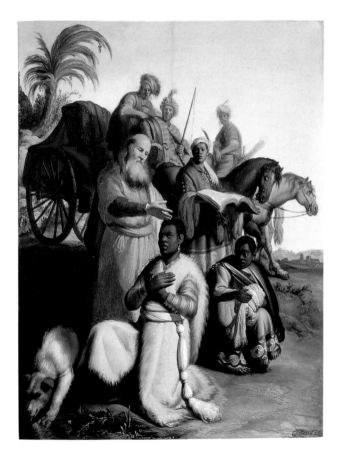

Rembrandt, The Baptism of the Eunuch, *1626. Panel, 78 × 63.5 cm. Utrecht, Museum Catharijneconvent*

Very well, it shall *look* like the Holy Land, not a corner of the Apennines. Hence the palm tree; though good graduate of his Latin school (if not the university) that he was, Rembrandt certainly knew as well that the palm, reputed to be immortal, had long been a symbol of the Resurrection.[43]

And there was another element in the story which Rembrandt seized on to supply all the drama that seemed otherwise to be missing: the transformation from black to white. Nowhere in the Bible is there any mention of the eunuch's dress, and an ermine coat seems hardly fitting for a journey across Judea, heading south. Yet it was impossible for Rembrandt to resist the pictorial fancy of translating African blackness into a snow-white second life. To accomplish this, he needed to make the whole *issue* of blackness not just a delicate, euphemized reference in the work, but to bring it right to the center. Typically, Lastman makes just the little page holding the eunuch's Bible an African child. Rembrandt, on the other hand, gives us *three* African faces, besides that of the eunuch himself, all, moreover, wonderfully individualized. Just as he scrapped the generic mountain land-

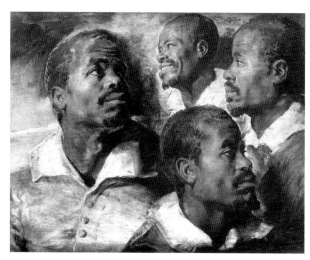

Rubens, Study of African Heads, *c. 1617. Oil on panel, transferred to canvas, 51 × 66 cm. Brussels, Musées Royaux des Beaux Arts*

scape for the palm of a plausible desert oasis, so Rembrandt also disposed of the insipid and tentative "Moorish" physiognomy in favor of an unapologetic, authentically described, and brilliantly individualized group of African portraits. Only Rubens in his intensely sympathetic multiple studies of a single African head, painted around 1616–17, anticipated Rembrandt's freedom from stereotype. This does *not*, however, make Rembrandt some sort of early civil rights advocate in the studio. On the contrary, at the back of all these sympathetic sketches is the standard Protestant race theory which made blackness a kind of damnation from which the eunuch's baptism would provide a redemptive bleaching. That Rembrandt should subscribe to the commonplace is hardly surprising. What *is* truly amazing is that Rembrandt should have had access to African models (were they slaves, house servants in Amsterdam or Leiden?), and that he should have seen their strong, dignified depiction as the key to his storytelling.

A final comparison between master and pupil will make Rembrandt's irrepressible instinct for upstaging Lastman still more obvious. In 1622 Lastman painted the history of *Balaam and the Ass*. Taken from the Pentateuch Book of Numbers, the Scripture concerned the Moabite prophet sent by King Balak to curse the Israelites, en route between Egypt and the Promised Land. Understandably, God, who had already taken the trouble to ward Balaam off, was not especially happy about this and sent an angel to stand in the way of, and only be visible to, the prophet's ass. Three times the ass took avoiding action, once crushing her rider's foot against a wall, and three times she was beaten for her pains before stopping braying and starting, miraculously, to speak to Balaam, complaining about her rough treatment. After some discussion, the Lord opened Balaam's eyes to the angel, who confirmed that had the ass not moved away, he would by now have dispatched the prophet with his sword. Balaam saw the light, prostrated, and repented.

It seems that no one had painted this subject before. Lastman's visual source, especially for the ass's head, with its mouth open, turned round to speak to its rider, was a drawing by the sixteenth-century artist Dirk Vellert.[44] But his real inspiration, at least for the formal composition, was certainly Adam Elsheimer, whom he closely followed in respect of the strongly outlined vegetation, echoing both angel's wing and prophet's turban, and the disposition of the protagonists in a relatively shallow, horizontal, friezelike space. Vellert's she-ass, with her curled-about neck, appears for the third time in Rembrandt's version, though, typically, he draws attention to her sudden power of speech by opening the animal's mouth wider, revealing an alarmingly prominent, and exactly rendered, set of equine teeth. And he has pulled forward a detail relegated to the back-

ground in Lastman's painting, namely, the Moabite princes described by the Scripture as accompanying Balaam, along with his servants, presumably to ensure that he carried out his cursing mission to the letter. But the most drastic alteration is, of course, the substitution, as in *The Baptism of the Eunuch*, of a vertical for a horizontal format. This allows Rembrandt to hoist the sword-wielding angel from his earthbound position and have him go airborne, so that the wings (again rendered astonishingly, as though they belonged to some great bird of prey) rise and fill the top left

quarter of the panel. Lastman's angel is a pedestrian with clip-on wings, a challenge, but perhaps not an insuperable one, for the club-wielding prophet. Rembrandt's angel, though fair of face, is credibly awesome and dangerous; and by making visual connections among pulled bridle, raised stick, and upright sword, the artist has set in motion, as with the execution-

ers of Stephen, a rhythm of dynamic, violent action. It is, of course, a completely Rubensian performance.

And then there are Balaam's eyes. Rembrandt's eyes. Lastman has followed the van Mander prescription. The prophet is amazed to hear his donkey speak. Follow the stage direction. Make his eyes pop with astonishment. Give the customers dilated pupils, white sclera, and lots of it. With a stroke of perverse genius (excuse the term), Rembrandt has done the opposite, painting Balaam's eyes as dark crevices. For this is, after all, the moment *before* God opens those eyes to the angel and the light of truth. The prophet, the man with the power of speech, has been struck dumb, eloquence given to his animal. And he is, for a minute longer, still blind.

Pieter Lastman, Balaam and the Ass, *1622. Panel, 40.3 × 60.6 cm. Jerusalem, Israel Museum*

Rembrandt, Balaam and the Ass, *1626. Panel, 65 × 47 cm. Paris, Petit Palais, Musée des Beaux Arts de la Ville de Paris*

All his life, Rembrandt would be fixated on the idea of spiritual, inner blindness, even among those who supposed their physical vision to be acute. This was but one of the qualities which set him apart so drastically from the mainstream of Dutch painting, which defined itself strikingly in terms of optical precision.[45] His own perception, even in his stripling years, was shockingly acute, as those donkey teeth bear witness. But he was already haunted by a paradox. The light that came to us in the clarity of the day, that led us to embrace the material, visible world, was a gift of immense power, but it faded into insignificance beside the other light, the interior light of the Gospel truth, the enabler of in-sight, especially strong in Protestant culture, though inherited from a tradition that went back all the way to Augustine, that the power of sight was spiritually dangerous: a sorcerer's spell.

Is it not astonishing that in the second year of his career Rembrandt painted not one but *three* histories exemplifying this force of interior vision? Stephen's eyes are opened to his celestial vision even as the light of this world dims Balaam's eyes, still dark with evil, at the moment of their angelic clarification; and in the same year of 1626 came his *Tobit, Anna, and the Kid,* the apocryphal Scripture which made blindness itself the core of the story.[46] In 1619 the Counter-Remonstrant Synod of Dordrecht had made it clear that the Apocrypha were no longer to be considered as true Scripture. But approved of or not, the books were too full of strange and stirring stories for Dutch artists or their patrons to turn their back on them. So there was no shortage of Susannas in Protestant Holland, as in Catholic Flanders, and the same was true of episodes from the Book of Tobit. The tale had everything: calamity visited on the righteous, faith under stress, angelic apparitions, an aquatic monster, a honeymoon horror story, and a happy ending. No wonder it became Rembrandt's favorite, or at least most compulsively revisited, book—painted, drawn, or etched twenty times.

Tobit himself is a good Jew in a bad place: Assyrian exile. He takes it on himself to ensure the proper burial of coreligionists who have been killed by Nineveh murderers. But instead of receiving a reward, he suffers a cruelly bizarre fate. Sleeping beside a grave and beneath a tree one night, he is blinded by a load of hot sparrow guano (some sources say swallow) evacuated right into his eyes. He is reduced to dependence on his son, Tobias, who is sent to the land of the Medes to recover some hidden money. On the journey Tobias is accompanied by a mysterious stranger who saves him from an attack by a monstrous fish that leaps, disconcertingly, from the Tigris. The stranger instructs Tobias to make sure to keep the heart, liver, and gall of the creature, which on a long journey in Iraq must have been something of an ordeal in itself. But if rotting fish remains were a penance for Tobias, they were a lot harder on the demons who had previously inhabited the body of his intended fiancée, Sarah, and who had been responsible for the wedding-night death of seven of her bridegrooms. Tobias's prudent gift to his bride, then, is to barbecue the offal, at which point the demons promptly depart the premises (and who can blame

them?). Tobias returns home with a wife, the money, and the fish gall, which he spreads on his father's eyes. Miraculous recovery follows, and in the light that suddenly enters Tobit's occluded eyes he suddenly sees his son's companion transformed into the archangel Raphael, who leaves the restored household in a blast of radiance.

The Apocrypha had been depicted many times before, but the favored scenes, not surprisingly, were those involving the fishy drama, not least because in traditional Catholic teaching the smearing of Tobit's eyes was thought to be a prefiguration of the Annunciation. Lastman, with his instinct for spectacle, had done paintings representing the *Jaws* moment and the wedding-night exorcism. But Rembrandt's choice of scene for his earliest Tobit was completely unprecedented as a subject for painting. The closest model was a print that he must have seen by Jan van de Velde after a drawing by Willem Buytewech (whose genre figures Rembrandt's earliest little panels often resemble). The van de Velde–Buytewech relates a sad episode that takes place during Tobias's absence, when Tobit's wife, Anna, returns home with a kid and, for her pains, is denounced by her husband for thieving it. The print shows the redoubtable Anna defending herself, arguing that it had been a gift and wagging an admonishing finger at her sorry husband. Once again, Rembrandt has altered the moment of emotional contact to extract maximum pathos, depicting the next moment when Tobit, stricken with remorse at his baseless accusation, prays to God for death to deliver him from his burden.

It is a terrible moment, the midwinter of Tobit's despair. The old man is a portrait of tattered grandeur, literally the remnant of his former respectability, his red fur-trimmed coat patched and ragged, his feet sticking through the toes of his shoes. (If books are Rembrandt's first fetish, shoes are the second, for no Baroque painter rivalled him in milking the emotive suggestiveness of footwear. And Leiden, as it happens, was the boot- and shoemaking center of the Dutch Republic.) At the troubled center of the picture are no less than four sets of eyes: the enormous glassy-black eyes of dumb innocence on the face of the sacrificial kid; the half-hidden doggy eye of loyalty; the wide-open eye of the falsely accused, much put-upon wife, turning from indignation to fearful dismay, the crow's-feet wrinkles deeply creased. Anna stares at Tobit's milky cataracts because she cannot, in turn, be seen. But Tobit's eyes, densely and carefully painted by Rembrandt as if his bristles were loaded with bird shit, are blind, not dead. Rembrandt hints at the moral life flickering behind the opaque lenses by having them exude tears of remorse.

He would certainly have been familiar with the medical literature on diseases of the eye, like Carel van Baten's popular Dutch editions of the works of Jacques Guilleumeau and André du Laurens, all of which retained much of the medieval tradition relating optical impairment to an excess of the melancholic humor.[47] And though, of course, Tobit's blindness was hardly of his own doing, something of the commonplace that the sickness was a moral, as well as a physical, condition entered into the earlier depic-

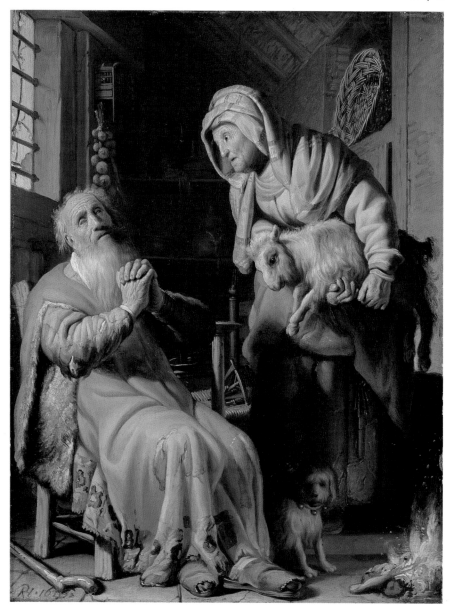

tions of his obtuse accusation against his wife.[48] But Rembrandt has
already become involved in the quite different tradition that associated
damaged sight with interior vision; hence his preference for Tobit's moment
of anguished truth, rather than his delusion. When he would etch the vision
of Raphael departing from the old man's house, he would make sure that
the cured Tobit would, again, momentarily lose his worldly vision in the
numen, the divine light streaming from the angelic presence.

Rembrandt is nineteen; twenty, if you like Orlers's birth date. By no
stretch of the imagination is he yet a master of any significance. In 1626 all
manner of artists in the Netherlands are painting more skillfully, more cre-

atively, more beautifully than he: Esaias van de Velde and Frans Hals are in their prime. Jan van Goyen the landscapist is getting under way; Willem Claesz. Heda is reinventing still-life painting; Jan Porcellis has done the same for seascapes. In Utrecht, a group of artists are imagining how Caravaggio would have painted had he been lucky enough to be Dutch. In Antwerp, Peter Paul Rubens is mourning the death of his wife and getting to work on the second half of his commission to decorate the Palais de Luxembourg with scenes from the life of the Queen Mother, Marie de' Medici, and her late husband, Henri IV.

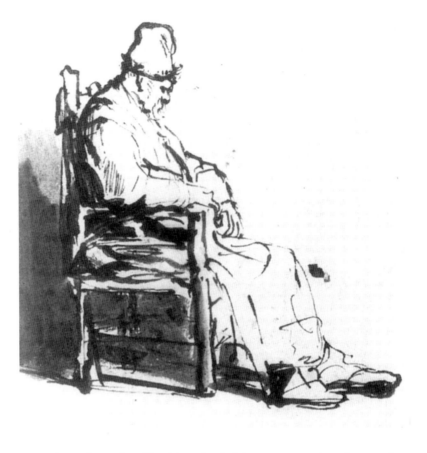

Rembrandt, Seated Old Man *(possibly Rembrandt's father), c. 1626. Pen and brush drawing. Paris, Musée du Louvre, Département des Arts Graphiques*

And yet Rembrandt is painting stories that have escaped everyone else's attention, or he is doing familiar histories in his own idiosyncratic fashion. His brush is not working quite as fluently as he, or his patrons, might like, as if one step behind the sprinting energy of his imagination and intellect. But he is not all mind. He is also feeling. Looking at his own old man, father Harmen, who himself seems to have gone blind, Rembrandt has already found his lifelong subject: the light that lives in darkness.

CHAPTER SIX · THE COMPETITION

i *Summer Candlelight, 1627*

Did he ever feel it was a farce, a detestable masquerade, all this creeping about in closed carriages and sorry little boats, pretending to do one thing but meaning all the while to do another? Rubens had been brought up, after all, on the cult of candor. His classical mentors, a succession of virtuous tempers—Cicero, Seneca, Lipsius—had all declared honesty the best part of nobility. And here he was, in Holland, doing his best to be edified by the pictures, pleased by the painters.[1] But always, like a stray dog nipping at his heels, there was the business of the state importuning. And he could not kick it away.

Rubens would not indulge himself in complaint. He had been told, predictably, that travel would dull the grief he felt for the passing of his wife Isabella Brant.[2] But he was fifty and had seen more than his share of dales and woods and the fly-plagued rumps of horses plodding on their way. The better counsel was to work—to paint, but also to pitch himself into the business of the other Isabella, the Infanta; to busy his brain with the ills of the commonwealth. The Lord only knew there were ills enough. Two years before, there had been rejoicing, even in the midst of the plague. Breda had fallen to the besieging army of his friend the Marquis Ambrogio Spinola, who had done the gentlemanly thing and allowed the Dutch garrison and its commander, Justinus van Nassau, the last of William's bastards, to march out with their standards. The same year, the lecherous old bachelor Maurice had finally given up the ghost, and his half brother Frederik Hendrik had become Stadholder in his place. It had been said that he was a more supple prince, and for a time there had been expectations in Antwerp and Brussels that an accommodation might be made. But as usual, hope had flamed fiercely and then spent itself into ash. Success in the field, and especially on the water, where Dutch fishing boats could scarcely put to sea before they were taken by the Dunkirk privateers, had excited the Catholic militants in Madrid. Once again, the party whom Rubens referred to bitterly as "scourges of God" were dreaming of holy triumphs, with the necks of heretics roped with the halter of the Church.[3] So the war had gone on.

The new Stadholder had already proven himself no less partial to cannon than the old, and no less resolute. Both sides in the war suffered. Precious lives were lost to amuse Mars. At the siege of Grol, the Stadholder Maurice's bastard son William of Nassau was killed by a fragment of pewter spoon, the defenders having been reduced to shooting kitchen utensils at their enemies. The treasuries in Europe were evaporating, so that, as Rubens wrote to his friend Pierre Dupuy, "they are not only deep in debt, with all their resources pledged, but can hardly find any new expedients to keep breathing."[4] But this hardly seemed to disturb kings and ministers intent on enduring any hurt (to their subjects) provided they could inflict equal or graver hurts on their enemies. Your guns, our pirates; who could do the most damage? All the herring boats in Holland might go to the bottom of the North Sea before the Dutch guns would release their grip on the Scheldt, and so Antwerp might yet perish from the blind obstinacy of the warriors. The twenty-league canal that Isabella wished to be called the Fossa Mariana[5] to bypass the obstruction of the blockade was being dug, but no one knew when it would be completed. Just as Isabella was coming to review the progress of her Virgin's ditch, the Dutch had made a raid on the work gangs, killing some of the laborers and taking off a hundred more as prisoners. Scarcely a week went by without yet another canal proposal, so that Rubens jested sourly to Dupuy that they hoped to win the war with shovels if it could not be won with guns. And while all this digging was under way, his city was dying, "languishing like a consumptive body, declining little by little. Every day sees a decrease in the number of inhabitants, for these unhappy people have no means of supporting themselves, either by industrial skill or by trade."[6]

Peace, as always, was the thing. Rubens's friends spoke of it constantly, ardently desired it. Yet it seemed further away than ever. But Rubens was not one to give up hope—not yet. The way to start was to break the ring of enemies—Denmark, England, and the United Provinces. If one could somehow be detached, the others, even the Hollanders, might yet be made tractable. Now there was a new English king, Charles I, at whose proxy wedding to the French princess Henrietta Maria in Paris in 1625 Rubens had met the royal favorite, George Villiers, Duke of Buckingham, along with his agent in matters of painting, the Dutch-born Balthazar Gerbier. Rubens's self-portrait was already in the King's collection and Charles was evidently avid for more. It seemed that the Duke, too, was passionately interested in having Rubenses added to the collection (already with its obligatory Titians and Tintorettos) hanging in Buckingham House on the Strand, where Gerbier had been made Keeper of Pictures. It would be especially delightful if Rubens could see his way to providing one of those handsome equestrian portraits of the Duke such as had been executed for the Spanish Duke of Lerma and the Genoese, with the rider effortlessly controlling his Great Horse *en levade*. Such a picture would stop the mouths of those who put it about that the Duke was nothing but an overdressed adventurer.

There was something else that the Duke wanted from Rubens: his mar-

bles. Buckingham had tried his best to appear a dashing commander (and had succeeded only in botching most of the expeditions he had planned and led). But he also needed to be regarded as a man of eminence, to be to Charles what Cardinal Richelieu was to Louis XIII. And no eminence was complete without a collection of antiquities attesting to his classical learning. How better to equip himself with instant erudition than to buy back the collection of antique busts and statues that had originally belonged to Dudley Carleton and which had been traded to Rubens in return for paintings? Gerbier was authorized to offer one hundred thousand florins for the lot (excluding gems, cameos, coins, and medals, which Rubens would not part with). This was a tempting sum, given the commercial doldrums in which Antwerp found itself and which Rubens felt would only worsen. But his true ambition was somehow to parlay the deal into something much greater: a stratagem for peace. This would not be easy. On the high seas, "the English are increasing their insolence and barbarity," Rubens wrote to Dupuy in June. "[T]hey cut to pieces the captain of a ship coming from Spain and threw all the crew into the sea for having defended themselves valiantly."[7] But incidents like this only increased the urgency of his own mission.

Rubens was also worried—with reason—about the good faith of the parties. The previous December he had gone to Calais to meet Gerbier, ostensibly to discuss the sale of his antiquities, but the Duke's agent had failed to appear, leaving him to endure the bleak Channel winds for three weeks. When they had finally gotten down to business in Paris, there were some promising signals. Buckingham's offer was this: If Isabella in Brussels could persuade her nephew Philip to sanction an armistice, the Duke on his side would do everything in his power to persuade the Dutch to accept a truce of two to seven years, during which a more formal peace might be negotiated. To Rubens this seemed too good to be true, and it was. Isabella and Spinola were both sincere about peace. Their reasoning was that if England and Spain could be brought together, the Dutch, left with only the Danes as allies, would have no option but to come round. It was a nice plan. The only problem was that although Philip IV pretended to go along with it, his actual policy, hatched in secret by his bellicose minister the Count-Duke of Olivares, was precisely the opposite. Instead of preparing for peace, Olivares was planning for all-out war in alliance with the power that Europe *least* expected to fight alongside Spain, their old enemy, France! Together the two Catholic powers would mount an irresistible onslaught on England and the Dutch Republic. A secret treaty to this effect had even been signed in Madrid in March 1627.

Rubens had no idea, any more than Isabella did, that he was being set up, sent to delude the English into illusions of peace while Spain actually prepared for war. He was still smarting from Olivares's insulting comment to Isabella that it was improper for a mere painter to be entrusted with business of state. Isabella had responded tartly that for his part, the Duke of Buckingham thought it well enough to be represented by a painter (for Gerbier was a practitioner of *miniatura* as well as a connoisseur), and that

the business of art, undertaken in Holland, would be a useful cover for the diplomacy. No one wanted the Dutch to be alarmed enough to scotch the Anglo-Spanish discussions before they ever made headway. The crucial intermediary was Sir Dudley Carleton, still the English ambassador at The Hague. With his own great collection of Rubenses installed in the embassy, and what had once been *his* collection of busts the subject of negotiation, Carleton was perfectly placed to obtain the necessary passport for Rubens to come to the Republic.

On July 10 Rubens arrived at Breda, where, after many years in the hands of the armies of the Dutch Republic, the standard of the King of Spain was again flying over its bastions. Gerbier was already in The Hague with Carleton, and Rubens wrote to him that they should meet in the small town of Zevenbergen, just across the battle-frontier. Gerbier's response was that a rendezvous so close to Spanish territory would give the regrettable impression that England was going out of its way to strike a bargain, making it seem supplicator rather than negotiator. Instead he proposed a meeting in some city deeper inside the Republic, say Delft or Amsterdam. Always scrupulous about never exceeding his brief, Rubens was obliged to travel back to Brussels for permission to go, literally, the extra mile, and duly got it. On July 21 he met with Gerbier in Delft, just a stone's throw from the house where William of Orange had been assassinated. For two weeks, the subtle Gerbier and the forthright Rubens travelled together around the Dutch Republic, speaking softly of the fate of Europe and loudly of the Rape of Europa.

Of course, put paintings, lots of them, in front of a painter and you will get his attention, whatever else he is supposed to have on his mind. Pictures were not exactly hard to come by in Antwerp, but even so, Rubens could never have encountered a world so thick with images, in a republic which, if Calvin had been followed religiously, ought to have abominated them. They were everywhere: on the walls of patrician parlors, in market stalls and print shops, in the boardrooms of orphanages and guildhalls, in the courtrooms of town halls—a universe of pictures, not just paintings but prints and drawings, hammered plate and engraved glass; merry companies, militia portraits, landscapes and pastorals, brothel scenes and breakfast pieces, and, probably to his astonishment, altarpieces.

Not, of course, in public but in the *schuilkerken*, the hidden churches that were being built and decorated at a considerable rate, now that it was plain that the new Stadholder had no intention of rooting out Catholics and Remonstrants by force. Instead a tacit arrangement had been made. Non-Calvinists were allowed to gather and worship according to their conscience and liturgy provided they made no public show of it. So spaces were scooped out of houses and those spaces made rich and glowing with decorated screens and organs, statues and paintings. From the outside they appeared to be private residences like any other. Step inside, go up some stairs, and you would enter a room crowded with pews, votive statues, sacred plate, and the lingering fragrance of incense. No place was more busily restoring the practicing life of a Catholic community than the

archepiscopal city of Utrecht, so it was no surprise that Rubens's visit there in the last week of July was the most elaborate and effusive event of his journey. No place else in the Dutch Republic could have made Rubens feel as much at home. There was a great cathedral at the center of the city (even if now shorn of its images), and right opposite its porch was the new house of Gerrit van Honthorst, who in every way—his Italian education; his passionate admiration for Caravaggio; his ambition to create a high style of portraiture and history painting for the court in The Hague; his workshop staffed with no fewer than twenty-five pupils, each paying a handsome hundred guilders a head for the privilege—was the kind of painter Rubens could appreciate. In its way, the cultural atmosphere in Utrecht was as Latin as anything in Antwerp or Brussels. The place took evident pride in its Roman antiquity and encouraged its study. There were priests in Utrecht who continued to administer what was left of the property and funds of the old Church for charity and education. Amazingly, there was even an apostolic vicar whose presence was hardly a secret. There were priests and congregations of *klopjes,* Catholic women who had taken vows of chastity, poverty, and piety and who were therefore nuns in everything but name.[8] And in Utrecht there was a host of artists who had all travelled south over the Alps to become painters. One of them, whom Rubens visited and admired, Cornelis Poelenburgh, had only just arrived back, bringing with him the drenching light of the Campagna to soak into his landscapes and pastorals.

For Rubens to go to Utrecht and to be celebrated there, then, was more than a routine courtesy. In Utrecht he could see how Italy might be brought north, right into the heart of the Dutch Republic, just as he himself had done without sacrificing a sense of native manner. This was not just a matter of importation but one of synthesis. Rubens's glowing color owed something to the Venetians, just as his muscular drama owed something to Michelangelo, but he had added to it an earthy naturalism that was entirely Netherlandish and created a Baroque style that was sui generis. He could see, in the taut-boned martyrs and voluptuous peach-skinned whores, in the candlelight glow that lit their antics and their agonies, that Dirck van Baburen, Hendrick ter Brugghen, Abraham Bloemaert, and Honthorst were all struggling to make Caravaggio Dutch, but with uneven success. Like Caravaggio, they all used unedited street faces for their sacred histories and musical parties, giving both the raw physical force of their great Roman model. And they all packed their big bodies bulgingly tight into the picture space so that they threatened to explode out of it into the beholder's room. But only ter Brugghen avoided a kind of claustrophobic, lumbering clumsiness and succeeded in building poetic monumentality. Only ter Brugghen seemed to grasp the difference between a smile and a leer. Only ter Brugghen controlled that numinous light so that it washed over his cool colors and perfectly described material textures so that his figures seem suspended in a mysterious state of grace. No wonder Rubens is said to have singled him out for special praise.

Utrecht must have seemed to Rubens a tantalizing vision of what a rec-onciled Netherlands *might* look like were his patient labors for peace to bear fruit. In the north there was Catholic worship with Calvinist domina-tion; why should there not, in the south, perhaps be some sort of de facto tolerance with Catholic domination? And he could hardly have failed to notice that confessional differences were no bar to collegial friendships and partnerships among the artists of the city. The patriarchs of the guild were Paulus Moreelse, a strict Counter-Remonstrant Calvinist, and Abraham Bloemaert, a devout Catholic whose *Adoration of the Magi* had been com-missioned for the Jesuit church in Brussels, where it stood at the high altar between Rubens's two masterpieces of holy ecstasy, *The Miracles of St. Ignatius Loyola* and *The Miracles of St. Francis Xavier.* Indeed, living in Utrecht had not prevented Bloemaert from painting his own *St. Ignatius* for the Catholic cathedral in 's Hertogenbosch, shortly to be the object of Fred-erik Hendrik's strategic attention. And Honthorst's Catholicism had not been an obstacle to his serving as dean of the Guild of St. Luke. So Rubens allowed himself to be handsomely entertained, flattered, and feasted in Italo-Dutch Utrecht. In return he showered the correct compliments on Poelenburgh's pastorals and Bloemaert's histories. In Honthorst's work-shop, according to Joachim von Sandrart, he was so taken with a *Diogenes* that he demanded to know who its author was and discovered—amazing to reveal—that it was Sandrart![9] Honthorst became mysteriously unavail-able to act as guide for Rubens on his travels, either because he was mov-ing, or because he was sick (1627 was one of the rare years he did not serve as dean of the guild), or just conceivably because he suspected the diplo-matic reasons for Rubens's visit and didn't wish to compromise his stand-ing in The Hague, which was especially delicate since he was a Catholic. But he deputed Sandrart to do the honors, an experience which must have made an indelible mark on the career of the young German-Walloon painter. In later years, when the magnet of creative energy had moved from Antwerp to Amsterdam, Sandrart unerringly spent some time in Rem-brandt's workshop, making him one of the few seventeenth-century artists to have a personal connection with both of the greatest masters of the northern Baroque.

But in 1627 Rembrandt's star still had a long way to rise before its brightness could be discerned by the many. Did Sandrart take Rubens to Leiden? It has always been assumed that the city of petulant professors and preachers was not on their itinerary, despite Rubens's visit there fifteen years before, and despite the continued presence there of his many friends and acquaintances, like Daniël Heinsius. The possibility, though, ought not to be categorically ruled out, since Sandrart, in his short account of the journey in the 1675 edition of the *Teutsche Akademie*, does not specify the towns, other than Utrecht, that Rubens and Gerbier visited.[10] One place that was quite deliberately given a miss was The Hague, so as to avoid any impression among interested ambassadors (like the French) that Rubens and Gerbier were up to something diplomatic. In fact, their entire mission

was so constrained by considerations of this kind that it was hard, if not impossible, to get much done. Returned to England, Gerbier complained that nothing firm, let alone definite, had been proposed, at least in writing. By late September they knew the worst: that instead of supporting his efforts at peace, Olivares in Madrid had been plotting war. The news of the Franco-Spanish alliance of aggression must have come as a thunderbolt, fatally undercutting Rubens's attempts to build trust with England, making a mockery of all the careful groundwork laid in his talks with Gerbier. Rubens must have burned with chagrin at having been used to mask a cynical deceit. His only hope, voiced in letters to Gerbier, was that an alliance between such traditional enemies as France and Spain would be as ill matched as "fire and water," with the inevitable result being a return to the wiser peace counsels of Spinola and Isabella. In the meantime, he declared, with a fatalism worthy of Lipsius at his gloomiest, "I know of nothing further I can do and trust in my own good conscience and God's will."[11] To Dupuy he confided, more bitterly, that "we are exhausted and have endured so much that this war seems without purpose," and that it seemed "strange that Spain, which provides so little for the needs of this country . . . has an abundance of means to wage an offensive war elsewhere."[12] Before his eyes now were visions not of some grand political pacification, nor of the businesslike religious coexistence of Utrecht, but of the plight of common soldiers faced with yet another round of the miserable, unending conflict. Three or four leagues beyond Antwerp, the Spanish were turning some godforsaken village into a huge fortress, so badly engineered that the soldiers had to wade waist-high in water to change sentry duty. Many were falling sick; many more disappearing furtively into the autumn rains.[13]

Perhaps, though, Rubens's visit changed some minds, not in the council rooms of the great but in the studios of its artists. It's often been suggested that even if Rubens did not go to Leiden, that city's two most ambitious and talented young artists were paying attention to his conspicuous presence in Utrecht. Rubens's flattery of the Dutch Caravaggists might have seemed a seal of approval. Ter Brugghen and Honthorst, the mark of favor implied, will be your Dutch Rubenses and will make their way as I did. Indeed Honthorst was just about to be called to the court of the King and Queen of Bohemia in The Hague and to the court of Charles I in England. The message was clear. The way toward recognition and prosperity for two young painters hungry for both pointed toward Utrecht, and so Rembrandt and Lievens began to retool their own style to look more like Honthorst than Lastman; the sharp colors and sculptured forms of the Amsterdam master replaced by the candelit glow of the Caravaggists.

Half of this story is true. Around 1627–28 Rembrandt did indeed drastically alter his manner of painting histories. His exteriors go indoors. The bright hardness of his colors melts away into monochrome bronzes and dusky velvets. Pools of glowing light pass through obscure, cavernous spaces like the moon escaping a shroud of clouds. But Rembrandt's experiments in illumination like *The Supper at Emmaus* owe little or nothing to

the shadow plays of the Utrecht Caravaggists. In fact, they owe nothing much to anybody, other than the intense mutual competition with Lievens. Only the Mission to Save Rembrandt from Himself, reinforced by the Horror Vacui Division of the art-historical academy, could work so hard to explain away the peculiarity of the 1627–29 history paintings as lessons learned from Utrecht.

To walk down the pictorial road to his *Supper at Emmaus,* with stops along the way in Rome, Antwerp, Utrecht, and Leiden, is to see how greedily Rembrandt absorbed the lessons of the masters, only to depart from them in a stroke of shocking conceptual bravery. The story had been painted countless times before. But it was perfect for the painter of the inked-in eyes, the reporter of interior sight, for it is a history that turns on the relationship between faith and vision. And since the panel is approximately the same size as the Boston *Artist in His Studio,* was evidently painted at about the same time, and repeats many of that other painting's visual motifs—the rough-grained planking complete with cracks and knotholes; a patch of shabbily peeling plaster—it might reasonably be thought of as its complement; another moment when the mind's eye has been flooded with realization.

Luke 24 relates the first reappearance of Christ on the third day after his entombment. Without disclosing his identity, Jesus joins a conversation between two of the disciples and offers the usual helpful instruction to the troubled and skeptical ("O fools, and slow of heart . . ."). Invariably, though, it is the moment of revelation, when he breaks bread with them at supper "and their eyes were opened, and they knew him," which past masters had found irresistible. Caravaggio had painted the scene twice. In the first version, of 1602–3, everything and everyone seems spasmodically electrified: foreshortened hands flung into space; a jaw-dropping, napkin-spilling epiphany. In the second version, done around 1605–6, when Rubens, Lastman, and ter Brugghen would all have been in Rome, the astonishment has been contained in the gesture of the apostle seen from the rear, while Caravaggio's strategically broken bread roll signals the eucharistic recollection of the Passion.

Most probably, Caravaggio painted this second version in the summer of 1606, on the lam from his tennis-court murder and holed up on the estate of Prince Marzio Colonna, south of Rome. It's not impossible that Rubens, the primary purchasing agent of Caravaggio's *Death of the Virgin* the following year, saw both versions of *The Supper at Emmaus,* since his own painting combined the energy of the earlier Caravaggio (one apostle pushing a chair back, the other thrusting his hand out) with the solid, sculptural mass of the latter (a calm Christ; the sympathetically concerned innkeeper's wife). Rubens's first Dutch engraver, Willem van Swanenburg, then produced a print of the Rubens, which must have circulated widely in Holland and which, since it issued from his teacher's brother's shop, would obviously have been seen by Rembrandt. The same print acted as a provocation in Utrecht. So it seems likely that the versions of the same subject

LEFT: *Caravaggio,*
The Supper at Emmaus,
*c. 1606. Canvas. Milan,
Pinacoteca di Brera*

RIGHT: *Rubens,*
The Supper at Emmaus,
*1610. Canvas, 205 × 188
cm. Paris, Église St.
Eustache*

turned out by the Caravaggists—Hendrick ter Brugghen's in 1616 and Abraham Bloemaert's in 1623—were in their turn responses to *both* Caravaggio *and* Rubens.

Rembrandt's essay in sacred stupefaction (page 252) is something else. It too struggles to combine the contradictory qualities of the two Caravaggios and the Rubens: explosive drama *and* frozen immobility. But it gets rid of the anecdotal fussiness of the dinner table and reinterprets the scene instead in terms of what mattered supremely to a painter: the issue of seeing. As he would do throughout his life, Rembrandt went back to the Scripture itself, but instead of pausing at Luke 24:30—"And it came to pass, as he sat at meat with them, he took bread . . . and gave to them"—he continued his reading to the following verse, 31: "And their eyes were opened, and they knew him; *and he vanished out of their sight*" (my emphasis), on the face of it an impossible challenge for a history painter since it seemed to call for a stare at a man who isn't there. Undaunted, Rembrandt reads on. The same chapter of Luke relates a subsequent, quite distinct event, when Jesus appears once more in the midst of the apostles, who, understandably, become "terrified and affrighted, and supposed that they had seen a spirit." As he would do time and again, Rembrandt collapses the two events into a single frame, concentrating on the spectral quality of the apparition. Jesus can now be simultaneously there and not there, discernible and fugitive, as if without the backlighting he would dissolve into celestial ether.

The painting is aggressively, evangelically simple, as though it, itself, had miraculously appeared rather than been fashioned, the thinned, almost monochrome paint laid on paper that was glued to an oak panel. The monochromatic, bitten-in feeling of the work makes the picture resemble a

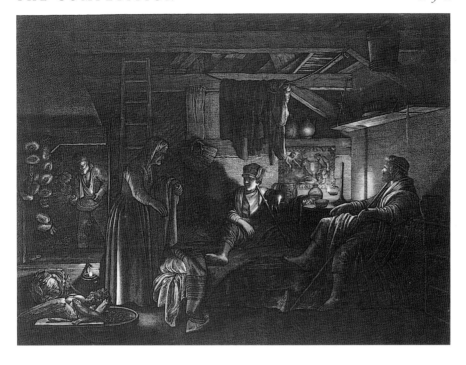

trial sketch for an etching, with areas of intense light and dense obscurity that seem more obviously appropriate for a print. At which point, enter the influence-sleuths exclaiming their *aha!* and flourishing *the very print* on which Rembrandt's work is purportedly based: an engraving by Hendrick Goudt after one of Adam Elsheimer's copper paintings, *Jupiter and Mercury in the House of Philemon and Baucis.* Sure enough, there is sufficient similarity between the positioning of the Jupiter figure at right and Rembrandt's Christ, and the detail of the cook-servant framed in the left rear, to bear out the assumption. But what does this iconographic "matching" actually explain? Nothing that really matters: the spur, not the substance, of Rembrandt's invention. It should put us in mind of Brahms's dismissive retort to the clever fellow who pointed out that the last movement of his First Symphony was, well, suspiciously like the last movement of Beethoven's Ninth: "Any fool can see *that.*" The formal similarity to the Goudt/Elsheimer engraving is just a starting point; not the most but the least interesting quality of Rembrandt's painting; a throwaway quotation in a painting that is already a revolution. More to the point is Rembrandt's eradication of all the anecdotal props and clutter in the Goudt/Elsheimer (the foreground still life, for example) in favor of a single, intensely focussed point of visual drama. Elsheimer makes a meal of the interior, detailing ladders, beams, hanging pails, and drapes. Rembrandt is content with that same brutally plain wooden planking that shows up in *The Artist in His Studio* and with the same phenomenal accuracy of texture. The difference is drastic: a clutter of anecdote against a moment of truth. And Rembrandt has found economical ways to deal with the tension between excitement and monumentality, embodying the latter—the gravity, as it

Hendrick Goudt after Adam Elsheimer, Jupiter and Mercury in the House of Philemon and Baucis, 1613. *Engraving. Amsterdam, Rijks-prentenkabinet*

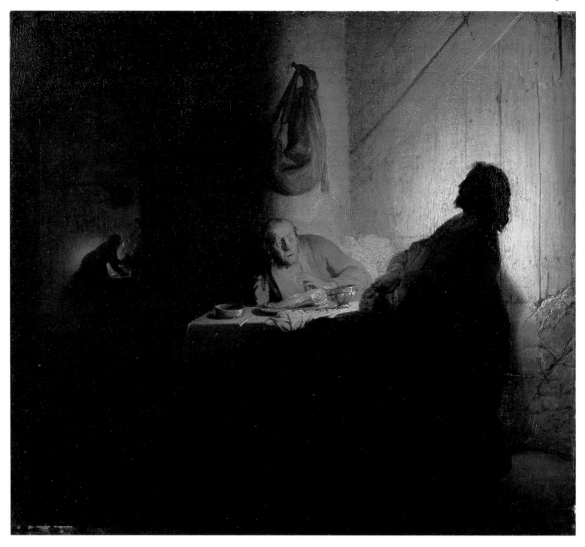

Rembrandt, The Supper at Emmaus, *c. 1628. Paper placed on panel, 37.4 × 42.3 cm. Paris, Musée Jacquemart-André*

were, of the moment—through a single architectural detail: the massive stone column that appears improbably in the hostelry at Emmaus.

The painting is sensational. Literally. A transformation of the knowledge conveyed by the senses; a transformation of the senses by knowledge. The extreme chiaroscuro is not there just as a cocky demonstration of technique: "Caravaggio? Really. Now watch what *I* can get away with." The chiaroscuro is the subject. Light from darkness; the Scripture reconceived of (once more) as a cure of blindness. The healer is himself barely visible, seen in silhouette, the backlighting coming from some source immediately behind Christ's head, construable as some sort of candle but in every important respect declaring itself as the light of revelation, the light of the Gospel. The disciple's eyes are at the opposite extreme to the painter's eyes in the Boston *Studio,* not sunk inside but popped out from their sockets, lizardlike, the iris and pupils contracted pinholes within great orbs of white

sclera. The disciple's skin is pulled tight over his brow, but his jaw is slack, the open mouth indicated with just a single, perfectly judged smear, almost cartoonish in its summary economy. And where Rembrandt wanted (again just as in *The Artist in His Studio*), he could produce passages of extreme precision, especially in the gesture of the disciple's hands, the fingers of the right hand foreshortened and spread wide apart as if caught in lockjaw, the left hand shaking in self-protection. This ambiguity between clarity and confusion is at the heart of the picture, impressed on us almost subliminally by the subtlety of Rembrandt's technique, hovering as it does between the linear and the sketchy. At first sight, for example, the silhouette of Christ's head seems sharply outlined against the lit wall planking. We can see acute details: the little fork in Christ's beard and the lock of hair falling over his brow. But in fact Rembrandt has laid in these details over the top of the original outline, and with soft, flying, almost smudgy strokes, the work of a hand with astoundingly fine motor control. The whole of the right side of Christ's body, ending in his serenely clasped hands, is done in half-lights, so that his figure seems to tremble in the sallow evanescence.

Like nearly all Rembrandt's best pictures, the painting has insignificant but eye-catching imperfections. The big pouch or saddlebag hanging from a nail on the stone column seems stagily hung over the head of the goggling disciple, an analogue of the suspension of disbelief, inserted as the one passage of painting that lies in both light and darkness. But then this is, after all, a picture of suspense, and Rembrandt the stage director found it impossible to resist bringing together glittering still-life detail—the knife handle with its shining highlight projecting over the edge of the table; the white napkin—with the almost invisible figure of the second disciple kneeling at Jesus' feet, the hair at the back of his head appearing to stand on end, and certainly to stand out against the white cloth, another reminiscence, in miniature, of the winding sheet of the Passion. The penumbra outlining the figure of the serving woman at the rear is needed to make her visible, and was presumably meant by Rembrandt to suggest the light of the Gospel already working its illumination. But the effect is disconcerting, a mild irradiation, like a watch face at midnight.

Not a perfect painting, then, Rembrandt's *Supper at Emmaus*, just a work of dumbfounding cleverness and originality, a piece of sacred narrative that vaults cleanly over any formal debts to this and that source and ends up in a realm strictly of its own painter's making. However deferential he might once have been to the rules laid out in the *Schilder-boeck*, Rembrandt, circa 1628–29, was already doing things undreamt of by the likes of van Mander or Honthorst or Lastman. Or not doing the one thing he was supposed to, namely, "finish." Perhaps he remembered the praise given by Pliny to Apelles for knowing "when to take his hand away from a picture."[14] For the roughly fashioned, apparently incomplete work invites the beholder's faculties to work with the picture, to become engaged in it, far more emphatically than any ostensibly finished product. It's as if Rembrandt were already refusing the slick brush in favor of the urgent eye.

ii The Partnership (Limited)

There was, in fact, a young painter in Leiden who had his sights set on becoming the hometown Honthorst, and he was Jan Lievens. His *Pilate Washing His Hands* from around 1625 betrays careful study of what it took to be a success in Utrecht, and thus what it would mean to be a success in Frederik Hendrik's new court. Bulky, oversize figures, seen in half-length, crowd the front of the picture plane like an audition in Brobdingnag. Their flamboyant dress and the prominent cup caught in strong light advertise the painter's talent for *stofuitdrukking,* the sensuous depiction of materials like metal, silk, and fur. As always, there is shadow play, some whimsical, some serious. The more playful detail is the face of the soldier seen between Pilate and the serving boy, arbitrarily divided at the nose into zones of light and dark. The result is odd, the "auspicious" and the "drooping" eye at odds with each other as if in undecided amusement. (Slightly off-key humor, awkwardly integrated into a narrative, threatened to become something of a nervous tic in Lievens's work, although many of the Utrecht painters' genre scenes also feature toothy cackles at uproarious jokes we are doomed never to get.)[15] On the other hand, the serious shadow play is an inspired invention. In the background right corner of the painting, Christ, seen only from the rear, is led by his guards from the darkened interior, through an archway, into the cruelly blinding light of a Jerusalem square. This is a good example of the narrative cunning which made Lievens, not Rembrandt, an early reputation as the fresh Leiden prodigy.

Some father somewhere in Leiden must have begun a lecture to his own son with the question "Why can't *you* be like Jan Lievens?" For the boy was unquestionably a pacesetter. Rembrandt had become apprenticed at the conventionally tender age of fourteen, but Lievens had been sent to study with the portraitist Joris van Schooten when he was *eight.* Rembrandt arrived at Lastman's studio when he was about seventeen or eighteen; Lievens had been there when he was *ten.* He was, then, the most obvious reincarnation of the original boy wonder of Leiden, the immortal Lucas, whose "toys and jacks were . . . charcoal, chalk, pens, brushes and burin."[16] At twelve, Orlers (who owned nine Lievenses but no Rembrandts) relates, Lievens was able to copy a *Democritus and Heraclitus* by Cornelis Ketel (the finger-and-toe marvel) so precisely that no connoisseur could distinguish it from the original. In case this were not enough, he was also a junior Stoic, working right through the commotions of 1618, never allowing a trifling matter like civil war to interrupt his assiduous drawing of prints by Willem Buytewech.[17]

There was a time not so very long ago when Jan Lievens was consid-

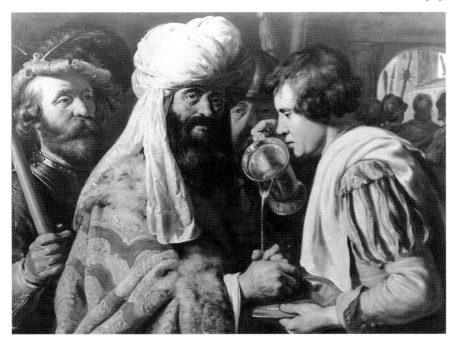

Jan Lievens, Pilate Washing His Hands, *c. 1625.*
Panel, 83.8 × 106 cm.
Leiden, Stedelijk
Museum De Lakenhal

ered a pale reflection of his fellow Leidenaar's strange and strong talent. Not anymore. If anything, it is Rembrandt who is now more often classified as the derivative follower, slipstreaming himself behind Lievens's genius. This, it seems to me, is an excessive correction. That the young Lievens was gifted, especially perhaps in graphic art, there's no doubt.[18] But that he was the senior partner, in creativity and technical quality, seems much more debatable. It's also become a commonplace to argue the indistinguishability of Lievens's and Rembrandt's paintings during the period when they were certainly working closely together. It's true that those who made inventories of the Stadholder's art collection sometimes mistook the work of one for the work of the other, perhaps based on Huygens's pairing of their names. But we need not. In some of the most famous instances where a direct comparison can be made between their respective treatments of the same subjects—*Samson and Delilah, The Resurrection of Lazarus,* and *Christ on the Cross*—the differences between the two, as Huygens himself pointed out, are glaringly obvious. More interesting than adjudicating the order of follow-my-leader in the competitive partnership between Rembrandt and Lievens is the *fact* of its intensity and mutual creativity.

Because the past two centuries have made a lot of the autonomy of the painterly vocation, we're overly accustomed to thinking of the lives of painters as an odyssey of self-discovery. And for all the excesses of Romantic imagining, we should not be entirely wrong in charting this course for Rembrandt. In its different way, self-interrogation, especially spiritual self-interrogation, was as much a seventeenth-century as a nineteenth-century

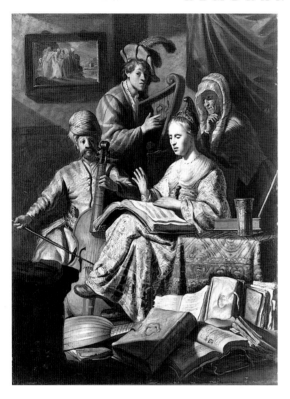

Rembrandt, Musical
Allegory, *1626. Panel,*
63.4 × 47.6 cm. Amster-
dam, Rijksmuseum

preoccupation.[19] But as idiosyncratic as Rembrandt revealed himself to be in paintings like *The Supper at Emmaus* and *The Artist in His Studio*, he was certainly not out to celebrate his uniqueness. On the contrary, he was, at the beginning, compulsively needy for role models, rivals, paragons. And competitions were, after all, the stuff of art history, if not of art practice, going all the way back to the contest of illusionists recorded in Pliny between the Greek painters Zeuxis and Parrhasius. Zeuxis's painting of grapes was so lifelike that birds flew up to the stage where it was painted to peck at them, "whereupon Parrhasius himself produced such a realistic picture of a curtain that Zeuxis, proud of the verdict of the birds, requested that the curtain should now be drawn and the picture displayed; and when he realized his mistake, with a modesty that did him honour, he yielded up the prize, saying that whereas he had deceived birds, Parrhasius had deceived him, an artist."[20]

Were Lievens and Rembrandt the Zeuxis and Parrhasius of Leiden, smitten with mutual admiration to the point where they actually shared their models and their best ideas: the painters-as-buddies?[21] Or were they deadly serious rivals who took each other's latest history as a challenge to outsmart and surpass, with an eye to standing first in line for work with the Stadholder's court in The Hague? Which mattered more: mutual emulation or jealous competition? Perhaps, as in any robust working collaboration, there were elements of all of the above: envy as well as reciprocity. That they shared some techniques is certain: sketching in the basic lines of the composition over the ground in *doodverf,* a dark brown or dark gray monochrome; or the use of the stub end of the brush to scratch in details of hair. They both tended to indulge, sometimes to excess, their virtuoso handling of the arched eyebrow and the deeply furrowed brow. And they evidently shared models who would give them the physiognomic expressiveness they liked to exploit, like the imposing old man with the high bald forehead, patriarchal growth of gray whiskers, and a little cleft beneath the lower lip who did duty as Paul (for them both), Job (Lievens), Jeremiah (Rembrandt), and Jerome (Lievens). His ubiquitous counterpart on the distaff side is the heavily wrinkled, large-eyed old woman whom Rembrandt painted as the prophetess Anna, and Lievens as Job's wife, and later as an exotically turbaned soothsayer. Even more intriguing is the popeyed young man who plays the viola da gamba in Rembrandt's early *Musical Allegory* of 1626, and who makes a clumsy appearance as the tiptoeing Philistine soldier in Lievens's grisaille sketch of *Samson and Delilah*. And not least, they introduced each other into their own pictures. The standing harpist in Rembrandt's *Musical Allegory* is sometimes thought to be a self-

portrait, but in fact much more closely resembles Lievens with his long, thin nose, pointed lower jaw, and fishily exophthalmic eyes.

Around 1629 Lievens painted a sympathetic portrait of Rembrandt as the sitter would have wanted it, as both softy and tough guy: the shock of wiry auburn curls is crowned by a black velvet cap; Rembrandt's already ample chin rests on a wound white scarf; and the challenging glint in his eye is echoed in the steely reflection of the gorget, our combat-ready painter. For his part, Rembrandt produced a wonderful drawing of his friend that manages to be both free and intensely concentrated: Lievens's face is shadowed by thoughtfulness much as Rembrandt's own is in the Boston *Artist in His Studio,* but his body is hunched forward toward the panel rather than standing back from it, one hand gripping the top of the chair from which he has just risen to examine his work. At first sight, the space in which he stands even seems the same as the studio described in Rembrandt's painting, suggesting that they did indeed share working space. But there are in fact telling differences. The grindstone in Lievens's studio is close to his easel, rather than propped against the wall. (No one is going to be casually moving grindstones with each day's work.) And Lievens's easel is set a good distance from the door in what looks like a considerably bigger room than Rembrandt's. Lievens's family house, after all, was in a slightly but decidedly grander part of town than the Pellecaenshouc end of the Noord-Rapenburg/Galgewater where Rembrandt's father had his house and rental properties.

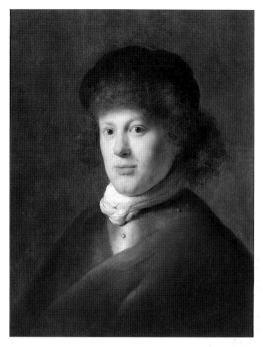

Jan Lievens, Portrait of Rembrandt, *c. 1629. Panel, 57 × 44 cm. Private collection*

Rembrandt, The Artist in His Studio, *c. 1629. Pen drawing. Los Angeles, J. Paul Getty Museum*

Whether or not they actually occupied the same studio, or whether one of them took the walk (perhaps fifteen minutes from Lievens's original house on the Pieterskerkchoorsteeg, ten minutes from the new house on the Breestraat) to sketch a model or just see what the other was up to, there's no question that Rembrandt and Lievens used each other as creative tinderboxes, striking sparks. For Huygens, the *duo,* their oddly interlocked relationship, was undoubtedly part of the attraction, guaranteeing, as he thought, that they would each strive to outdo the other, leapfrogging their way to excellence.

For if Huygens was to realize his goal of finding painters (in addition to Honthorst) who could do for the Stadholder's palaces and residences what van Dyck and Rubens were doing for the Habsburgs and Stuarts, he needed *both* the qualities which were embodied, separately, in the two young men: narrative grandeur and brilliant show in Lievens; poetic imagination in Rem-

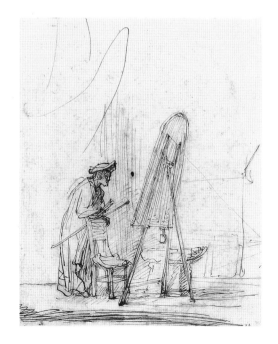

brandt. Only Rubens had married those two gifts in the one painterly personality. And Huygens needed portrait painters. In 1628 Michiel van Mierevelt, who had something of an industrial assembly line in Delft, with the master deigning to paint only faces and hands and leaving the remainder to a corps of assistants, was beginning to lose favor. Perhaps offering a portfolio of poses to prospective clients and then fitting the face to the number, while admirably economical, was bound to seem, after a while, formulaic. Honthorst was in England flattering the King and being flattered back. It seems likely that it was Lievens, rather than Rembrandt, who was first sought out by Huygens, together with his older brother Maurits, who, as secretary to the States General, also had a potential prize of patronage to dispose of. And why not begin with a portrait of himself? The offer was grasped with almost disconcerting eagerness. "He was seized with the desire to paint my portrait," Huygens wrote in his autobiography. "I assured him that I should be only too pleased to grant him the opportunity if he would come to The Hague and put up at my house for a while. So ardent was his desire that he arrived within a few days, explaining that since seeing me his nights had been restless and his days so troubled that he had been unable to work. My countenance had lodged so firmly in his mind that his eagerness brooked no further delay."[22] Taken aback (and doubtless charmed) by the young painter's ardor, Huygens gave him some time in between his official duties. Not enough time, though, especially as the sittings took place in the short daylight hours of winter. Lievens had to content himself with painting his eminent sitter's hands and clothes, letting it be known that he would return in the spring to complete Huygens's face. "Once more," notes Constantijn, relishing his protégé's eagerness, "he appeared well before the appointed date." Though drawing life studies at different times for a portrait must inevitably have been a common challenge for painters, Lievens's picture of Huygens does seem to suffer from the staggered phases of its development. Those hands, folded rather self-consciously together, seem out of proportion to Huygens's head and almost dominate his face—a head, however, which in its expression of philosophical thoughtfulness much pleased the sitter, though he added that his friends thought it did little justice to his vivacity. "I can only respond that the fault is mine. During this time I was involved in a serious family affair [his wife's advanced pregnancy, perhaps?] . . . and as is only to be expected, the cares which I endeavored to keep to myself were clearly reflected in the expression of my face and eyes."[23]

Initially, then, it was Lievens who made an indelible impression on the man who was arguably the most strategically influential patron in the Dutch Republic. But once Huygens had encountered Lievens's doppelgänger, he must have quickly realized that Rembrandt was, at the very least, his match. He certainly observed that they were far from being indistinguishable. "Rembrandt is superior to Lievens in his sure touch and in the liveliness of emotion [*iudicio et affectuum vivacitate*]; Lievens surpasses him in the loftiness of his concepts and the boldness of his subjects and

forms. From his youthful spirit, he does nothing which is not magnificent and grand. Rather than depict subjects in their true size, he chooses a larger scale. Rembrandt, on the other hand, devotes all his loving care and concentration to small painting, achieving on a small scale a result that one would search for in vain in the largest works of others."[24]

In other words, and without prejudice to either, expressive grandiloquence versus dramatic compression, the big gesture or the giveaway glance? In three and a half centuries, no one has managed to improve on Huygens's concise and telling contrast. And he was at pains to give both Lievens and Rembrandt their due. There are, in fact, a few works, like *The Raising of Lazarus*, where Lievens's approach, both in the painted and the etched version, gives Rembrandt (at the very least) a good run for his money.[25] But that may be because, for the one and only time, the painters seem to have traded roles. Rembrandt's panel is uncharacteristically large and

Jan Lievens, Portrait of Constantijn Huygens, *c. 1628. Panel, 99 × 84 cm. Amsterdam, Rijksmuseum*

perhaps the more histrionic of the two. It is Lievens's painting, with the Boris Karloff fingers appearing at the lid of the tomb as if pulled by Christ's own hands, clasped in prayer, that achieves maximum dramatic force from small details. Lievens has selected (with the kind of precision more usually associated with his rival) a telling moment in the Scripture, when Jesus is himself communing with God to give him the strength to perform the miracle. As a result, he has deliberately isolated the figure of Christ in a pool of intense, supernatural radiance. Rembrandt's painting, on the other hand, emphasizes the astonished witnesses, including Mary Magdalene and Martha, and gives Lazarus a semicadaverous, greenish phosphorescence. Rembrandt's aim, obviously, is to break drastically with the tradition, conspicuous in the Italian masters like Tintoretto, as well as Rubens and Lastman, of representing Lazarus as a well-modelled body, resurrected in peak condition, looking as though he has just returned from a rest cure. Rembrandt's point is, as usual, well taken, if overdemonstratively made. But as good as his painting is, the great dark space that Lievens has allowed Christ, even more evident in the etching he made directly from the painted composition, has the effect of concentrating attention on what, for the Protestant devotee, mattered: the force flowing directly from the Almighty through His Son in the miracle of a second life.[26]

But Lievens's *Lazarus* is the *only* such history painted in this manner, with small figures gathered in deeply recessive, tenebrous spaces and lit with theatrical chiaroscuro. It came at the end of years of competition in

Jan Lievens, The Raising of Lazarus, *1631. Canvas, 103 × 112 cm. England, Brighton Museum and Art Gallery*

specific subjects, in which, for the most part, Rembrandt's painterly economy had more consistently achieved the compelling drama that had eluded Lievens's more cumbersome rhetorical manner. The three paintings, two by Lievens and one by Rembrandt, on the Samson and Delilah Scripture, all of them with Rubens's great painting (accessible in Holland as an engraving) done with Rockox's house in mind, tell the story. The chronology of the three pictures has exercised art historians eager to establish some sort of pecking order for the "duo." Was Lievens's little grisaille panel the prototype to which Rembrandt responded with the medium-size panel now in Berlin, and which was in turn answered by Lievens's big canvas? Or was the canvas the initiator of the competition, with Rembrandt's panel the startling reply and Lievens's little panel an attempt at a final retort? It remains difficult if not impossible to sort this out. But it doesn't, in the end, matter very much. What does matter is that *both* of Lievens's efforts, big and little, were ponderous attempts at visual theater compared to Rembrandt's calculated rendering of a moment of high tension and nervous betrayal.

The large Lievens is the most unfortunate of the three versions in its strenuous attempt to outdo Rubens in presenting Samson's body as simultaneously hulking and vulnerable. Lievens has gone to a great deal of trou-

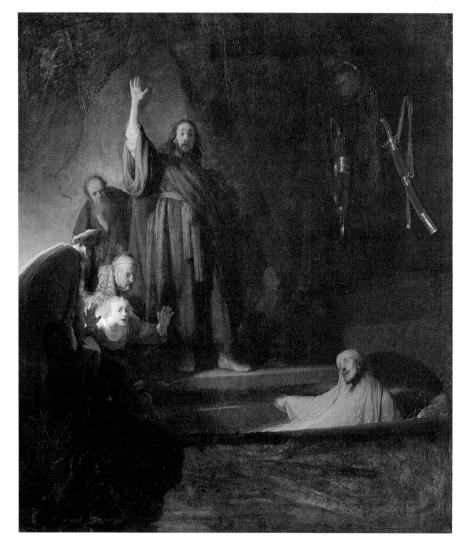

ble in detailing, with his signature stub-end scratches, the whiskers at Samson's jaw and cheek and the slightly creased brow of a deep sleep. All this is to the good, but any impression of a morphic lion is fatally undone by the big, pallid, fleshy body, and especially the left arm on which his face rests, which seems to be strangely attached to Delilah's elbow, as if the temptress boasted, along with the rest of her charms, an additional limb.[27] Given the generous size of the canvas, the upper and lower halves of Delilah's body seem awkwardly squashed together. Lievens has obviously tried to make the scissors the dramatic center of the painting, with their blades pointing ominously at Samson's neck. But the effect of impending disaster is wrecked by the clumsily nervous expression on the Philistine soldier's face, and by his raised hand, a glaring match for Delilah's, as though they were lining up for a high five over the neck of the unsuspecting giant.

There was nothing Lievens could do to get this crucial figure of the

LEFT: *Jan Lievens,
Samson and Delilah,
c. 1630. Canvas, 129 ×
110 cm. Amsterdam,
Rijksmuseum*

RIGHT: *Jan Lievens,
Samson and Delilah,
c. 1628. Grisaille panel,
27.5 × 23.5 cm. Amster-
dam, Rijksmuseum*

Philistine soldier right. It seems likely that he *began* with the big painting, which was, after all, in his then customary Caravaggist format, with large figures brought up tight to the picture plane, and subsequently produced the little panel, with its much more clearly articulated space, as an attempted response to Rembrandt.[28] But even supposing that Lievens's little panel preceded Rembrandt's, it is conspicuously devoid of the latter's emotional and psychological complexity. Instead we have silent-movie melodrama, dangerously close to inadvertent burlesque, with the pop-eyed, creaky-booted soldier being cautioned by Delilah with a finger to her lips. Samson, this time much reduced in scale, is slumped against her knee, his hair pulled back from the neck by Delilah's left hand, giving the unhappy impression that she has been searching for nits.

Rembrandt's Delilah, though, is evidently not engaged in grooming. But at the very heart of the painting he has managed to give her some business which miraculously suggests much *more* than this immediate moment in the story. For while her right hand lifts a lock of Samson's copper hair (its waves glinting in the golden raking light), ready to be shorn away, her right hand almost idly strokes his tresses. Thus Rembrandt does indeed go after the core of Rubens's success: the tragic inseparability of amorous tenderness and brutal betrayal. This was what Rembrandt would become supremely good at: the capacity to suggest an entire story encapsulated in a single moment.

The particular qualities of Rembrandt's Berlin *Samson* document the distance between his own inventiveness and Lievens's more workmanlike gifts. Rembrandt's answer to the naked Greco-Roman beefiness of

Rubens's Samson was to cover him up: clothing him in the rich golden apparel that soaks up the light and suggests the splendor he is on the verge of losing. The painter has mobilized all his plaster-peeling skills of material description on the costume—the blue-red and gold sash tied about his waist, the elaborate threads and stitches rendered by heavy blobs and raised beads of yellow paint that Rembrandt has then scratched back with the back end of the brush. Onto this already intricately built-up pattern he has then unloaded drips and spots of brilliant blue. And the reason why he has taken such pains with these virtuoso passages of painting, repeated in the area of Delilah's embroidered hem, is to weave, as it were, the two bodies together at the precise point where they would be ripped asunder. For unlike in the Lievens sketch, Samson's whole upper body rests between Delilah's thighs. A preparatory chalk drawing, quite rare in these early history paintings, suggests how much thought went into the rendering of the thigh and leg, originally perhaps exposed, later, with typical Rembrandtian countersuggestibility, made *more* sensually suggestive by being covered with shimmering colored fabric. And unlike the Rubensian models, this Delilah is not some glamorously devouring courtesan; she's just a tavern girl on the make with zaftig breasts and dirty toenails. Her victim's body has been correspondingly robbed of mythic power, a body drastically unlike any other Baroque Samson: neither giant nor titan, pathetically boyish as it lies against Delilah's maternal bosom. The only signature of Samsonian force is supplied, as it often would be in Rembrandt's histories, by an aggressively lit still-life detail: the great potent curve of the hero's sword, unlike the weapon of the soldier in the background, deeply sheathed and hanging slackly beneath his buttocks. It doesn't take a higher degree in Freudian analysis to understand what Rembrandt is up to here: the narration of sexual drama through signs and euphemisms. It's the array of naked *feet,* for example, that speaks most eloquently of intimacy and betrayal: Samson's hard-soled and roughly sketched; Delilah's pale, shining, and unwashed.

Rembrandt has caught the trepidation of the instant to perfection, down to the veins bulging in the Philistine soldier's right arm as he tenses his muscles and the tiny catchlight in his right eye that reveals his mixture of vigilance and fear. Unlike the indeterminate gesticulation of Lievens's soldier, this fellow's left hand is simply engaged in the involuntary gesture of cautious motion as he gingerly advances, knowing he is about to take the decisive all-or-nothing move down the last potentially creaking riser of the wooden stairway. Rembrandt depicts the enormous boot on the back leg as though the soldier were struggling for balance in his efforts to avoid waking his victim, whereas Lievens's pantomime observation has his figure put all the weight on the front foot.

It's this feeling for imminence, the construction of uneasiness through details made slyly ominous, then gathered together in the burnishing light flickering over the figures, that marks Rembrandt as a dramatist rather than a melodramatist. He is already the economist of trouble, measuring it

in drops rather than bucketfuls. Where both Rubens and Lievens felt the need to indicate Samson's eventual fate by a whole troop of soldiers waiting at the door or making an entry, Rembrandt has made do with the single emblematic figure of the man emerging from behind the heavy drape. His face is summarily sketched, half in deep shadow, his ugly resolve suggested only by the grimly clenched mouth. But the sketchiness of the physiognomy only serves to draw attention to the lit edges of iron and steel around him. At the very end of his labors, Rembrandt has quickly traced the highlights that make these details so compulsively sinister: the rim of the soldier's helmet; the circular iron door-pull; and, with delicate decisiveness, the fine, gleaming line along the top of the sword, as if freshly honed for the kill.

This instinct for the emotive weight of *things* was deeply ingrained in Rembrandt. The inventory of his possessions taken at the time of his bankruptcy in 1656 shows him to have been a compulsive pack rat, accumulating armor, weapons, skulls, and shells as well as the more conventional complement of busts and plaster casts.[29] There's no way of knowing when he began to collect objects in this omnivorous way, though the recurrence of certain obvious props like oriental turbans and curved sabers suggests that he started the collecting habit in his Leiden years. But the skill to translate their material texture into paint was a talent he acquired, at least in part, from studying contemporary still-life painting. And although Rembrandt painted barely one or two pictures that we would properly classify as still lifes, he was in fact one of Dutch art's most exacting practitioners. The metallic, polishing light which he has raking over selected objects is close to the radiance used by specialists in the genre like Pieter Claesz. during the 1620s. Like them, Rembrandt opts for a somber, near monochrome palette, laid on over a chalk and glue size, brushed with a thin layer of yellow-brown and lead-white imprimatura. The transparent luminosity he achieves seems, simultaneously, to reveal the material texture of metals while paradoxically suggesting their insubstantiality. This was one of the commonplaces of the Protestant culture of the time and served well for patrons who evidently enjoyed both the display of precious objects and the tut-tutting pieties that affected to disapprove of them. And Leiden, with its abundance of goldsmiths and workers in rich fabric, may have been the perfect place to develop these crafty skills. Rembrandt's first pupil, Gerard Dou, who came to work with him in 1628 at the age of fourteen, would become famous as a master of luminosity, the first so-called *fijnschilder*. But in Dou's case, the glossy rendering of material surfaces became something of an end in itself. For Rembrandt, on the other hand, it was always a tool of his storytelling.

The gleam of precious metal is certainly at the center of the painting Huygens singled out as a masterpiece to be "compared with all Italy, indeed with all the wondrous beauties that have survived from the most ancient of days." This was *Repentant Judas Returning the Pieces of Silver*, and the coins (all thirty, count them) thrown violently on the wooden floor are scattered in a puddle of light in front of the thunderstruck Sadducees. A

OPPOSITE:
Rembrandt, Samson and Delilah, *1628. Panel, 61.4 × 40 cm. Berlin, Gemäldegalerie*

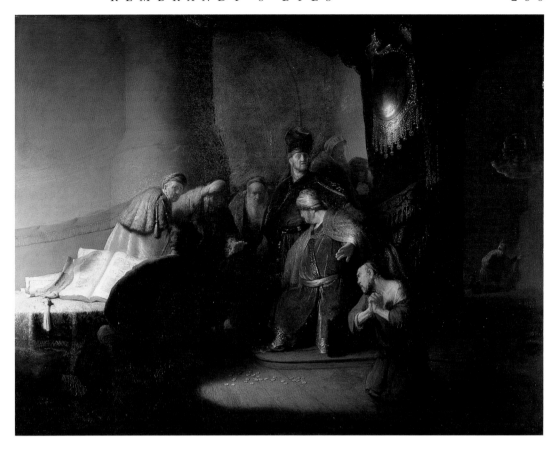

Rembrandt, Repentant Judas Returning the Pieces of Silver, *1629. Panel, 79 × 102.3 cm. Private collection*

telling pentimento beside Judas's right knee suggests that Rembrandt had initially painted a money bag but then painted it out to avoid any distraction from the fatal silver. The light of revelation which enters, as usual, stage left illuminates, with Rembrandt's typical indifference to optical logic, the things he wants to connect with the coins: the emblems of unholy wealth—the richly embroidered cape and turban of the seated priest; and, most glaringly, the gold and silver Torah shield with its hanging chains and ornaments. Perhaps this was another kind of autograph, akin to his self-inclusion, since the Dutch word for painter—*schilder*—had its etymological root in the word for shield, apocryphally, the first kind of work that painters in the Netherlands were said to have done. A preliminary sketch makes it clear that Rembrandt originally thought of the *Judas* sharply divided into a dark left and a bright right side.[30] The late introduction of the dazzlingly lit table with the great Talmud or Bible laid on it was an inspired change of heart, since it seems to throw light onto the figures and faces of the astounded priests, one of whom looks directly at the beholder with a single bug-eye and a gaping mouth.

The painting is more ambitious than, and, in some places, not quite as successful as, the Berlin *Samson*. The architectural setting, as is often the

case with Rembrandt, is indicated for atmospheric effect rather than spatial precision. The fringes that extend from the leaning priest's back seem to have no connection with the architecture, and the relationship of the canopied area to the big column and back wall seems strangely incoherent, an effect aggravated by the cracked surface of the background area immediately to the rear of the priests. The foreground figure seen from the rear, whose darkened silhouette serves to highlight the table and book even further, has by now become rather formulaic, having been used twice in 1628, for the figure of Joseph in *Simeon in the Temple with the Christ Child* and for St. Peter in *Two Old Men Disputing*.

But all these imperfections matter very little compared to the quality that Huygens himself singled out as the painting's heart and soul: the extraordinary figure of Judas, pushed to the edge, about to hang himself in despair, abjectly wringing his hands, his body twisted in a paroxysm of self-hatred and remorse, unable to take his own eyes off the money—according to Huygens, "screaming, begging for forgiveness, but devoid of hope, all traces of hope erased from his face; his gaze wild, his hair torn out by the roots, his garments rent, his arms contorted, his hands clenched until they have lost circulation. A blind impulse has brought him to his knees, his whole body writhing in pitiful hideousness."[31]

Now this is precisely the kind of emotionally charged, intuitively visceral subjective reading for which modern commentators—not to mention unguarded museumgoers—are taken sternly to task by the academy as naïvely unhistorical. Yet Huygens's outpouring is by far the most extended commentary on any single Rembrandt painting that survives from his lifetime, and it was supplied by one of the most sophisticated of all the painter's contemporaries. But all of Huygens's philosophical coolness became disarmed in the face of the elemental tragedy of the scene, and even led him into projecting details onto the painting which are not there. Nothing in the picture suggests "hair torn out by the roots." But Huygens is free-associating, just as Rembrandt surely wanted, Judas's brutally shorn, stray-cur-like appearance conjuring up the Judeo-Christian convention of hair-tearing grief. By taking enormous risks, Rembrandt had triggered in Huygens a reaction completely at odds with the polite norms of scholarly decorum. Looking at Judas, the courtier had stopped being courtly and had instead reverted to his other persona, that of the Christian poet, the translator and friend of John Donne, responding to the scene before him as though it had pitched him into its world, making him and by extension the reader-beholder a direct witness of the scene of bitter remorse. At the end of his description of Judas, Huygens added the astonishing comment that he contrasted it "to all the elegant works of the centuries [*omni saeclorum elegantiae oppono*]." This was precisely the immediacy that Rembrandt was aiming at. And Huygens grasped that he had achieved it only by departing sharply from the smooth refinements and statuesque grandeur of classical history painting. It was this imaginative leap that Huygens responded to, a leap usually too daring for Lievens to

follow without falling flat on his face. And that was why Huygens urged
Lievens to concentrate on his strength—portraiture—since "in what we are
accustomed to calling history pieces, his astonishing talent notwithstand-
ing, [Lievens] is unlikely to match Rembrandt's vivacious invention."

The recognition that two apparently parochial and *relatively* untutored
young artists had already produced work that could compete with bona
fide, internationally acclaimed geniuses like Rubens and Goltzius threw
Huygens into a quandary. Part of him, a strong part at that, swelled with
native pride. Rembrandt and Lievens were living proof of the absurd belief
in "nobility of the blood." And though, of course, Huygens hardly meant
to boast that the Dutch Republic was a commonwealth of equals, he does
seize on his prodigies' *natural* talent to suggest that it was no accident that
such instinctive genius could be nurtured in his homeland. In fact, he makes
more of their common origins and mediocre training than was strictly the
case. But his repeated insistence that they owed "nothing to their teachers
and everything to their natural aptitude" was meant to take Rembrandt in
particular *outside* the classical tradition of mere *ars* (skill) and *disciplina*.
Huygens could hardly have been more categorical about this. After admir-
ing Rembrandt for conceiving his desperate, tortured Judas as the antithe-
sis to the "elegant works of the centuries," he went on:

> This is what I would have those naïve beings know who claim (and
> I have rebuked them for it before) that nothing created or
> expressed in words today has not been expressed or created in the
> past. I maintain that it did not occur to Protogenes, Apelles or Par-
> rhasius, nor could it occur to them were they to return to earth,
> that a youth, a Dutchman, a beardless miller, could put so much
> into one human figure and depict it all. Even as I write these words
> I am struck with amazement. All honor to thee, Rembrandt! To
> transport Troy, indeed all Asia, to Italy is a lesser achievement than
> to heap the laurels of Greece and Italy on the Dutch, the achieve-
> ment of a Dutchman who has never ventured outside the walls of
> his native city.[32]

The choice of hyperbole is significant. Alluding to Virgil's *Aeneid*, Huy-
gens, going right over the top even for a classical poet, claims Rembrandt
to have surpassed Aeneas's achievement in "transport[ing] Troy . . . to
Italy," that is, in *founding Rome*! Part of Huygens was exhilarated by the
sheer temerity of his protégés, their exhilarating disregard for the conven-
tions of tradition. It seemed to him of a piece with the salvation epic of his
homeland, which was also rewriting history in so bold a fashion as to stag-
ger the ancients and cry out for its own Homer, its own Virgil. Another part
of him, though, couldn't help tut-tutting at the arrogant indifference to
self-improvement displayed by the duo. Lievens was stubborn, and touchy
to a fault, "either roundly rejecting all criticism or, if he accepts its validity,
taking it in bad spirit. This bad habit, harmful at any age, is absolutely per-

nicious in youth." Neither of them would hear of a journey to Italy. "This is naturally a touch of folly in figures otherwise so brilliant. If only someone could drive it out of their heads, he would truly contribute the sole element needed to perfect their artistic powers. How I would welcome their acquaintance with Raphael and Michelangelo. . . . How quickly they would surpass them all, giving the Italians due cause to come to Holland. If only these men, born to raise art to the highest pinnacle, knew themselves better!"

Well then, ought they to be *more* like Rubens or less? Huygens could not make up his mind, secretly admiring the confidence with which they rejected out of hand an Italian-classical tour of instruction and appreciation while regretting their sophomoric obstinacy for the very same reason. The dilemma inadvertently opened up by Rembrandt and Lievens had actually exposed a fault line in his own intellectual temperament. He was, at one and the same time, Huygens the humanist cosmopolitan, planning a Palladian town house on the Plein, where the Count of Holland's cabbage patch had once been, and Huygens the Calvinist patriot, the eulogist of native simplicities. Shifting nervously in his seat from one role to the other, he does at least know that he is dealing with two strange and marvellous birds. He could scarcely hold their mistrust of Abroad against them, since he knew very well that Hollanders of their generation, however regrettably parochial, tended to believe already that they were the center of the world, or at least the world's mart. He understood, too, given the proliferation of reproductive engravings and the rapid accumulation of art collections, including the cream of Italian painting, within the Republic, their resistance to spending the time and trouble to cross the Alps when they had their hands full with work in Leiden.

> I feel it incumbent upon myself to state that I have never observed such dedication and persistence in other men whatever their pursuits or ages. Truly these youths are redeeming the time. That is their sole consideration. Most amazingly they regard even the most innocent diversions of youth as a waste of time, as if they were already burdened with age and long past such follies.

This unflagging concentration on their work was to Huygens both admirable and a little frightening, accustomed as he was to reiterating the humanist mantra of moderation in all things. Rubens, the very personification of temperance, had shown it to be the condition of a consistently productive career. But these two seemed to be driven by furies. Huygens trembled when he suspected them to be already possessed by the vocational wasting disease of painters—the melancholic humor said by writers on art to govern their talent, and which, after the light of *ingenio* had flared, would return them, inevitably, to darkness and grief.

iii *By Faith Alone*

There were travellers and there were stay-at-homes. The
Dutch, who had become the world's geographers, mapmakers on paper
and map-changers on ships, were, at the same time, the most puzzlingly
domestic of all the nations of Europe. Rubens, too, yearned for the tran-
quillity of his house and the repose of his garden even as he was setting out
on yet another journey on behalf of an unattainable peace. He had spent
years either on his own or at others' behest traipsing the length and breadth
of Europe. He knew the quays of Ostende and Calais, the brigand-happy
passes through the Alps and the Apennines, the ferries and fords across the
Rhine and the Meuse, the roads of England and the roadsteads of Holland.
Though he now longed to sit in his summer pavilion, and although he was
grievously disenchanted with the machinations of princes and their minis-
ters, he had not quite given up on peace. So a carriage was kept in good
order in the stables on the Wapper. Huygens and Honthorst, van Dyck and
van Veen were all travellers. Lievens would seek his way in England and
Antwerp, and his younger brother Dirck would die in the East Indies.[33]
Rembrandt's family, on the other hand, never moved from Leiden, and
until he became seriously interested in Saskia van Uylenburgh, the extent of
his travels was bounded by Amsterdam, Leiden, and, in all probability, The
Hague. This did not make him, in any meaningful sense, parochial. Even
his early work shows signs of a peripatetic intellect, more deeply fascinated
by oriental cultures than any of his contemporaries. This was not just a
matter of turbans and elephants. Rembrandt would collect Mughal minia-
tures and make his own versions of them in prints and drawings. There are
Africans and Slavs in his work, Muslims and Jews, Javanese daggers and
Polish stirrups.

And if he resisted Huygens's strong recommendation to go to Italy if he
truly wished to realize his potential as a painter of the first rank, it was not
for lack of passionate curiosity concerning the Italian masters. There were
precious few of them—not Raphael or Michelangelo, not Correggio or
Leonardo—who did not, in some form or other, show up in Rembrandt's
work, and Titian would become as important to his maturing as Rubens
had been to his formation. Nonetheless, if it seems impossible to think of
Rembrandt sketching amidst the dandelions of the Palatine, or assiduously
copying the antiquities of the Capitoline, it's for a good reason. In one fun-
damental respect, Rembrandt was profoundly unmoved by classicism. This
disengagement was not historical. The epic and literary remains of antiq-
uity stirred him immeasurably. Apelles of Cos lived as close to him as
Lievens. The disengagement was philosophical. The premise of academic
classicism presupposed that art's profoundest ideals were embodied in the

sculpture of antiquity; hence the requirement for all serious students to copy them at an elementary stage of their training. Those sculptures in turn were the tangible expressions of a philosophical idealism, set out in the aesthetics of Plato and Aristotle, which held art to be the visible approximation of a celestial Idea. Its task, then, was to edit nature so that the impurities of mundane life were cleansed from it; to push the real toward the ideal, the material toward the ineffable, the flesh toward the spirit. Art was not a report from the world, it was a transformation of it.

Rembrandt would never be in the transformation business, at least not in the manner the classicists understood it. In this sense, the critics who attacked him later in life for his coarse indifference to aesthetic decorum were quite right, and Jan Emmens was quite wrong to assume that this was merely a retrospective and anachronistic judgement. Throughout his career, Rembrandt was less interested in finding the god in the man than the man in the god.

That went for kings and shepherd boys too. His David is not Michelangelo's perfectly muscled dream of male beauty. He is a nervous adolescent strumming his harp for a paranoid king. This is a drama of hands as well as eyes. David's fingers run liquidly over the strings, a delicately suggested diadem set on the crown of his head. Despite heavy retouching in this area of the painting, the fingers of Saul's left hand seem to grip the arm of his throne as though holding on for dear life, while the fingers of his right hand, set at the dead center of the painting, are clenched so tightly about the spear he would hurl at the offending shepherd boy that the knuckles seem on the point of cracking along with the King's equanimity. Rembrandt had evidently paid attention to Karel van Mander's description of Lucas van Leyden's treatment of the eyes of Saul, so stricken with "inward fear" that they could not look properly outward.[34] And indeed the eyes on Lucas's Saul do seem to sink into their sockets and narrow between the lids as he looks away from the oddly nondescript David, standing while he strums. But Lucas's King is a grotesque, already stooped with malice. Rembrandt's Saul, on the other hand, stares sidelong, both at and beyond the harpist. His head is disconcertingly at odds with the regal costume. Rembrandt has, as usual, taken immense pains with material detail: the silken strands of Saul's turban, a construction of little lines of yellow, blue, and white paint, the better to contrast with the coarse treatment given to the unbalanced face of the paranoid King. Dabs of pink and red line the rims of the eyes, giving them the appearance of insomniac shiftiness, and the royal face is fringed with scruffy stubble. The impression is of violent mental turmoil, the meditations of a cutthroat.

Rembrandt's painting was popular enough for a copy to have been made, probably in the 1630s, after which a print was subsequently engraved by the Antwerp artist Willem van der Leeuw. Just how exacting were the skills needed to contrive Rembrandt's visual impression of nervous disorder is demonstrated by the crudeness of the print, in which Saul's expression of half anxiety, half calculation, has been replaced by gangster-

Rembrandt, David Playing the Harp to Saul, *c. 1629. Panel, 61.8 × 50.2 cm. Frankfurt, Städelsches Kunstinstitut*

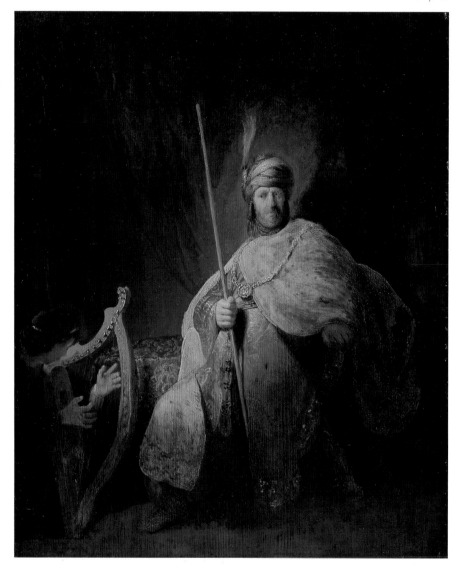

ish ruthlessness. A poem added at the bottom of the print, written by Cornelis Plemp, piles on the melodrama: "His eyes bulge with his bile; / evil and bitter is the mind of Saul; / putrid ruin eats at his bowels."[35] Plemp's poem, though a gratuitous reinforcement of what is already evident in the painting, is nonetheless a reminder that dramatically humanized Scripture in the Netherlands was not the sole province of painting or prints. Apart from Bible poems, stage plays frequently made over favorite episodes from the Bible, like the stories of Samson and Esther, into popular dramas. And the object of both art and literature was to bring Christians into as immediate a relationship with Scripture as possible. The "States Bible," the officially authorized Dutch edition, was being translated and edited in Leiden between 1626 and 1635, and no city in Holland could come close to its reputation as the paramount fortress of the Word. From the perspective of

the Calvinist worthies and preachers of Leiden, Amsterdam was suspiciously worldly, and Utrecht brazenly easygoing toward Catholic ritual.

It's hardly surprising, then, to see how frequently Bibles and Bible commentaries feature in the Leiden history paintings of Rembrandt and Lievens. Both artists linger lovingly on the textures of aging vellum, yellowing parchment, crumpled paper, and cracking hide. In the Rijksmuseum *An Old Woman Reading* (see page 208), the antiquity of the text and the ancient, wrinkled skin of the prophetess Anna (probably modelled by Rembrandt's mother, Cornelia) seem to share the same venerable character. But neither the book nor the prophetess is moribund. The paper seems to have a life and a light of its own, a page lifting its corner without any apparent benefit of breeze. But giving the physical presence of the Bible its due in such a strongly Protestant culture was not just a matter of literal depiction, of inserting it as a pious prop in an otherwise conventional history painting. It was also a matter of what got stripped away: icons, attributes, legends—the entire ancient theological clutter of Catholic representation. Images of the saints, prophets, and apostles in Baroque churches were supposed to do their work mystically, bringing the worshipper into a state of trancelike exaltation. Together with the ritual of the sacrament, the flood of sacred music, and the dizzying architectural manipulations of light and space, those paintings were part of an immense effort to realize Christian ecstasy here on earth. As Rubens well understood, this demanded life-size or outsize figures, spectacular color saturation, a seething commotion of bodies.

Calvinism demanded the opposite. The proper task of religious paintings was to make believers aware of their submission to the word of God as revealed in the Bible. Huygens, whose devotion to Protestant doctrine was unswerving, fully subscribed to its dictum: *Sola Scriptura, Sola Gratia, Sola Fide.*[36] And since salvation came by faith alone, the only tolerable Christian art was that which brought individuals as close as possible to the truth of Scripture, and which above all else acted as a spur to the essential Protestant act: prayer. The paintings, to be hung in houses as visual accompaniments (for no right-minded preacher could consider them *enhancements*) to these devotions, were necessarily smaller, the figures less violently agitated or exalted, than in their Catholic counterparts, the distractions of elaborate ornament and complicated architectural settings all brushed aside. The challenge for temperamentally theatrical painters like Rembrandt and Lievens, then, was to invent a kind of Bible painting that would somehow avoid vulgar spectacle yet make Scripture concrete and immediate in the lives of believers. All Rembrandt would have had to do was to attend supper at the Huygens household in The Hague, with its prayers

Lucas van Leyden, David Playing the Harp to Saul, *c. 1508. Engraving. London, British Museum*

and graces written by Constantijn himself, and the whole household, including servants, gathered after the meal for the daily Scripture reading and common prayers, and he would certainly have gotten the point.

But there was another consideration. In Holland in the late 1620s, Scripture was politics. With the accession of Frederik Hendrik, many of the leading Remonstrants, in particular Johannes Wtenbogaert and the eloquent theologian Simon Episcopius, who in 1619 had had the thankless task of arguing the Remonstrant case before the Synod of Dordrecht, had returned from exile. And they had no intention of letting sleeping dogs lie. Once the new Stadholder made it clear that, unlike his predecessor Maurice, he would not use military force to disperse Remonstrant assemblies, the Remonstrant leaders, including Hugo Grotius (at a safe distance from France), returned to the cause of Christian toleration.[37] The lines of battle were starkly drawn. The fiercest of the Counter-Remonstrant propagandists, Henricus Arnoldi, continued to insist that absolute discipline must be imposed, coercively if necessary, by the state, and that to tolerate, for example, Lutheran worship, much less the Catholics and Jews, was tantamount to destroying the Reformed faith from within. With such laxity, the war against the Spanish tyrant and the legions of the Antichrist might as well have never been fought. Episcopius, on the other hand, in his tract *Vrye godes-dienst* (*Free Religion*) argued that since there was an essential core of beliefs common to all Christians, and that the differences were only about relatively minor matters, it was unnecessary to seek rigid uniformity on issues where there could be no real agreement. From this premise, Episcopius proposed that toleration of widely varying readings of Scripture, and of differing forms of worship, was not only possible but actually desirable since it would preempt the kind of schismatic rage that had brought the Netherlands and other states into all-out religious war.[38]

Though Arnoldi was a minister in Delft and Episcopius an Amsterdamer, Leiden, as the greatest center of academic theology, was hardly exempt from this impassioned renewal of confessional debate. And since both the university and the town council were still more dominated by entrenched Counter-Remonstrants than elsewhere in Holland, any young history painter in Leiden needed to navigate with some caution between the reefs of theological argument. Rembrandt, of course, had been taught by Catholics and had connections to the Remonstrants. This does not mean, though, that his histories of the late 1620s ought to be seen in any sense as blunt instruments of confessional propaganda. In fact, their general style was capable, perhaps deliberately, of elastic, cross-confessional interpretation. After all, his father, his brothers, and he himself may well have belonged to the sizable proportion of the population that, even in this famously religious country, were not active participants in any specific confessional congregation, and unless a theocracy triumphed in Holland, such families were left in peace. So Rembrandt's narrative tactics in his religious paintings of the late 1620s could be seen as instances of principled theological versatility. On the one hand, his spontaneous use of a universalized lan-

guage for religious histories dovetailed neatly with the kind of ecumenical appeal made by Episcopius for a common core of Christian belief. But on the other hand, Rembrandt's prophets and apostles, inhabiting cells or bare rooms, dark, bald spaces shot through with the pure light of Scripture and revelation, could hardly be objectionable to mainstream Calvinists.

How, for example, did he manage to invent a Protestant St. Peter? In Rome, of course, the cult of the apostle was undergoing a spectacularly elaborate revival built around his purported tomb and the great throne, the *cathedra Petri,* which Bernini would conceive as a miraculously levitating seat carried on the fingertips of the doctors of the Church and flooded by a wash of celestial light. Around 1616 Rubens had painted Peter, three-quarter length and life-size, grandly attired and heroically posed. And in 1637 Rubens was commissioned by the city of Cologne to provide an altar-piece on some subject associated with the life of St. Peter. (How long had it been since he had given a thought to Cologne and the house on the Sternen-gasse from which his father had seldom strayed?) And the particular subject he chose—perhaps with Caravaggio's masterpiece in Santa Maria del Popolo in mind—was the crucifixion of his saintly namesake "with the feet turned uppermost." Traditionally, Peter's specially requested upside-down crucifixion had proved a popular image because of the tradition according to which he believed himself too humble to share the manner of Christ's death. And the lingering dispute as to whether Peter had been attached to his cross by ropes alone or with nails provided painters like Marten de Vos (ropes) and Rubens (nails) with exactly the kind of controversy guaranteed to work up interest in their interpretations. There had been other Petrine favorites: the miraculous draft of fishes; the denial of Christ; and the receipt of the keys to heaven from Christ. Peter had twice been imprisoned, once at the hands of Herod, once in Nero's Rome. But when the prison theme was chosen, as in a 1621 work by Hendrick van Steenwijk, it was almost always to depict his miraculous liberation by an angel.

But Rembrandt's Peter is not the Roman but the Leiden Peter. He had, in fact, been the patron saint of the city since at least the thirteenth century.[39] And notwithstanding the fierceness of the Reformation there, the city coat of arms still bore the crossed keys (which were also taken to represent the twin arms of the Rhine) and its grandest church was still, of course, the St. Pieterskerk. Inside, though, the church had been scoured of any kind of Petrine paraphernalia, so Rembrandt's apostle, too, had to be utterly alone—no ropes, no rooster. His most important attribute, the keys, lying on the straw, receive almost as much attention as the saint's face. But this is surely a Herodian, not a Roman, prison. And the subtle alteration of a distinctively Roman motif into a universal Christian one is managed by making the keys as much an ironic commentary on Peter's confinement as an allusion to his appointment as heaven's gatekeeper. Compared with van Swanenburg's engraving after Abraham Bloemaert in which the saint is surrounded by attributes and is seated in the rocky landscape where he was said to have received the "New Law," Rembrandt's Peter, down on one

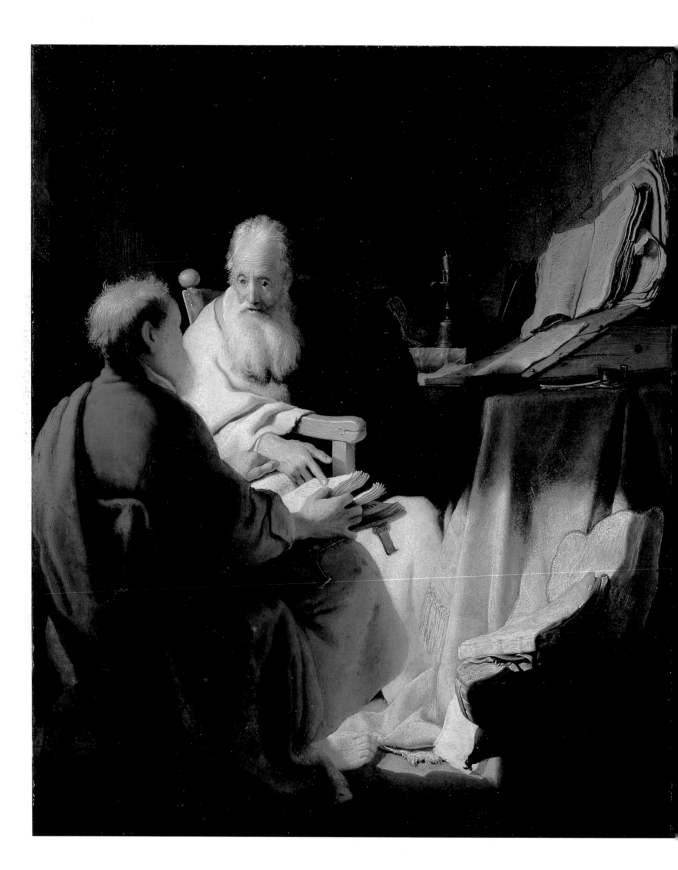

knee, concentrates entirely on pathos and penitence. Bloemaert, for example, adopts the standard gesture for repentance, the same wringing of hands that Rembrandt had used for his Judas. Here, though, Rembrandt has Peter clasp his gnarled hands, one huge, grimy thumb squeezed against the other as if in prayer, an impression strengthened by the lips parted between the white down of his whiskers. An entire book of remorse is written in the nine rows of wrinkles and frown lines creasing the saint's brow, carefully, elaborately, almost excessively highlighted by a network of minute strands of fine white paint. That Rembrandt succeeded perfectly in creating a Peter attuned to the formidable load of Calvinist guilt can be judged from the fact that it was owned by Jacques Specx, the powerful East India Company merchant, the inaugurator of Dutch trade with Japan, and the Governor of Batavia.

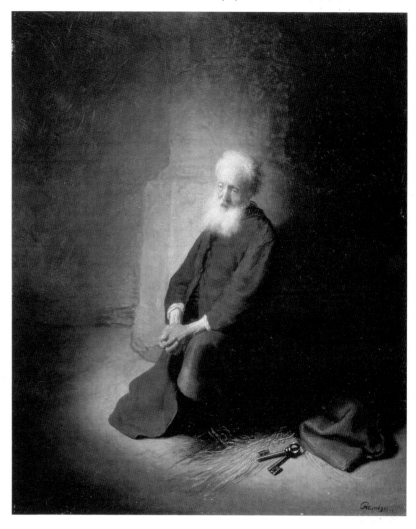

Rembrandt, St. Peter in Prison, *1631. Panel, 59.1 × 47.8 cm. Private collection*

In the Leiden Town Hall, Peter appeared together with Paul on the wings of Lucas van Leyden's *Last Judgement* as the two apostolic pillars of the Church. In 1527 Lucas had also engraved Peter and Paul, sitting in a landscape, engaged in animated argument. And this has been persuasively identified as the subject of Rembrandt's superb painting in Melbourne known as *Two Old Men Disputing*.[40] The bone of contention, debated in public at Antioch, was Peter's willingness to conform to the Jewish prohibition against eating with Gentiles, as recounted in the second chapter of the Epistle to the Galatians. To Paul, the gesture of obedience to Jewish law was a shameful retreat from the universal mission of the Gospel, and he "withstood him [Peter] to the face, because he was to be blamed." Rembrandt has moved the scene indoors, and since there is no sign of either keys or sword, the usual attributes of the saints, it's not surprising that the 1641 will of the painting's first owner, the artist Jacques de Gheyn III, whose portrait Rembrandt later painted, describes it merely as "two seated

OPPOSITE:
Rembrandt, Two Old Men Disputing, *c. 1628. Panel, 72.3 × 59.5 cm. Melbourne, National Gallery of Victoria*

old men disputing, one with a large book on his lap, while sunlight enters."[41]

Perhaps, though, as Christian Tümpel and John Gregory have perceptively argued, the apostles have been euphemized precisely because they were intended to stand as surrogates for the opposing parties in the toleration debate then raging in Leiden as elsewhere in the Republic.[42] The more aggressively ecumenical position of Paul at Antioch would then correspond to Remonstrant inclusiveness; Peter's emphasis on the primacy of Law to hard-line Counter-Remonstrant orthodoxy. The fit is not perfect, since Paul had for many years been an unquestionable Calvinist hero, and his whole resonance in Protestant theology was hardly that of relaxed toleration. Perhaps, though, Rembrandt was making the painting for a patron of Constantijn Huygens's stripe: officially an unequivocal Counter-Remonstrant, but in practice a more pragmatic and tolerant Calvinist. In any event, the two figures are certainly the two pillars of the Church. Peter is depicted this time according to the traditional iconography, as a stocky man with tonsured head and short, squared-off beard. And since no one got the better of Paul, Peter is seen in shadow, from the rear, the attentive listener rather than the instructor.

The two figures are diagonally separated by one of Rembrandt's invariably meaningful shafts of brilliant light illuminating Paul's face, with its parted, speaking lips, and the index finger that points to the clinching passage in the Bible. Peter's countergestures are more defensive: fingers wedged in the book, keeping his place in the chapters that might avail him a counterpoint. The sharp contrast between radiance and darkness functions, not for the last time in Rembrandt's work, not merely as a formal but as a narrative device; the visual analogy of an argument.[43]

Both Lievens and Rembrandt returned repeatedly to the subject of Paul in the act of writing the Epistles. And if Peter, for obvious reasons, was a more problematic fit with Dutch Calvinism, Paul was its obligatory patriarch. Since Luther, he had virtually been adopted as the founding ancestor of the Reformation because of his doctrine of justification by faith alone. The crux of the debate at Antioch over the priority of Law versus faith had profound meaning for Dutch Protestants, who had rejected any notion that either mere ritual or legal obedience could confer grace. As the persecuting Saul, he had appeared in the very earliest Rembrandt known to us, *The Stoning of St. Stephen,* where he had been seated in judgement on the summit of the Jerusalem hill. It might have been expected, then, that the traumatic conversion drama in which he falls from his horse, blinded by the light of truth, would have appealed to Rembrandt, who was so deeply interested in the paradox of sight lost and found. Instead, though, he painted the saint in the act of creating the fundamental theology of the Church: lost in thought, pen resting in his hand.

Between them, Rembrandt and Lievens produced three such images. The earliest, probably by Rembrandt, posed the apostle in his prison cell with his attribute of the sword (with which he would be decapitated) and

the book conspicuous behind him, a foot escaped from his sandal as he broods on the sacred truth. Lievens's version retained the moment of reflectiveness, but characteristically made the moment highly specific by making the text on which Paul is working the opening verses of the second chapter of the Second Epistle to the Thessalonians, warning against false prophecies of the Second Coming of Christ (conceivably a visual polemic against contemporary millenarians in Holland). Rembrandt's version in Nuremberg goes in the opposite direction, replacing both his own rather hard-edged style of the earlier painting and Lievens's velvety brushstrokes with a bold, free style which somehow makes the figure *more* solidly present, even though it is less sharply and literally described. Compositionally, the Nuremberg painting is based on a print by Jacques de Gheyn III of Chilo, one of the seven sages of ancient Greece. But it's precisely where Rembrandt differed from de Gheyn, and from his own, earlier painting, that this Paul is so telling. Instead of the hand-on-chin, pen-on-book pose, Rembrandt's painting has the apostle swing his right arm loosely over the back of his chair. Instead of the fixed gaze into space of the prison painting and the abruptly shadowed profile of the de Gheyn print, Rembrandt turns the old man's head so that his slightly downcast eyes turn away from his book and come to rest on nothing in particular. It is the replacement of a highly self-conscious, rather stagey pose by an absolutely unselfconscious moment, a philosophical transport. And instead of Lievens's precisely identified text, chapter and verse are withheld from us, yet the Scripture, of course, radiates the light unto the Gentiles that gave Paul his life's mission. Light falls on the saint's formidably strong cranium, but with special intensity on his left hand, which tenses itself against the book, beneath the hanging scimitar. This golden corner is the locus of Pauline forcefulness: the hand and book against which the persecuting sword would prove dull and impotent.

Imposing old patriarchs, deep in thought, sleep, or melancholy, are everywhere in the work of both Lievens and Rembrandt toward the end of their years in Leiden. Once it was assumed that all these hirsute venerables either were modelled on, or were actual portraits of, "Rembrandt's father." And there is, in fact, an exquisite pen drawing in the Ashmolean Museum in Oxford with an inscription, apparently in Rembrandt's own hand, identifying this particular old man as "Harman Gerrits van den Rijn," the retired (and perhaps blind) miller. The earliest of all Rembrandt's drawings, from around 1626 (see page 241), also of a large man, a soft hat on his head, shoulders slumped forward as if he is asleep, seems to be a portrait of the same figure. But the model used by Lievens and Rembrandt for their saints, apostles, and Old Testament prophets, while also old and bearded, is quite different: less plump in the cheeks and with a longer, straighter nose. And rather like their picturesque interest in the heroically half-ruined quality of old books, the eroded features of their favored ancient seem to have been inexhaustibly fascinating to both artists. For quite apart from the paintings, they sketched him, especially in chalk drawings, head bowed, almost always seated, innumerable times.[44] Rather than conceive a particular sub-

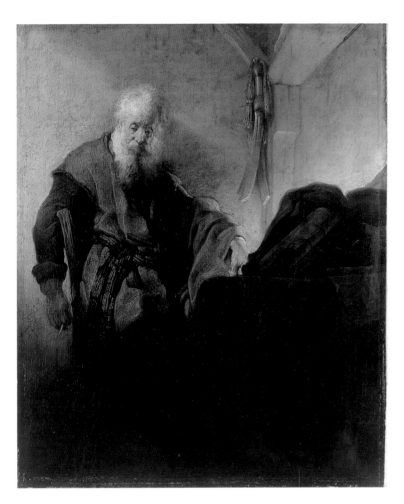

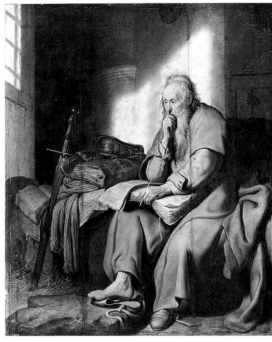

LEFT: *Rembrandt, St. Paul at His Desk, c. 1630. Panel, 47.2 × 31.6 cm. Nuremberg, Germanisches Nationalmuseum*

RIGHT: *Rembrandt,* St. Paul in Prison, 1627. *Pan̄ 72.8 × 60.3 cm. Stuttgart, Staatsgalerie*

BELOW: *Rembrandt,* The Artist's Father, *c. 1630. Red and black chalk drawing with brown wash, 18.9 × 24 cm. Oxford, Ashmolean Museum*

ject and go look for the old fellow to sit once more, they may have been stirred by his availability as a model to think of subjects where they could, once again, milk the pathos of his shining dome and nobly wrinkled brow.

Around 1630–31, for example, he shows up in Lievens's work as St. Jerome, and later in a very large and magnificent canvas as Job on the dunghill, as naked as the Scripture specified, being smitten by Satan's devil (with as yet unerupted boils) and told by his wife to curse God and die. But both the little *Jerome* and the large *Job* clearly owed their inspiration to the work that is arguably the most haunting of all Rembrandt's solitary patriarchs of this period: *Jeremiah Lamenting the Destruction of Jerusalem.* Once again, Rembrandt's aversion to signpost literalism has not helped the precise identification of the subject. For although it recycles the pose used for the lamenting Jeremiah in the woodcut illustration to the 1532 Vorsterman Bible, variants had been freely borrowed for other famous melancholics, like Heraclitus in Raphael's *School of Athens,* for example.[45] But the tiny background detail of a figure apparently running from the flaming ruins with his hands over his eyes does indeed seem to suggest Zedekiah, the King of Judea, who, Jeremiah 52 relates, was blinded by the Babylonian King Nebuchadnezzar following the sack of Jerusalem and the destruction of the Temple.[46] It was exactly in keeping with Rembrandt's habit of collapsing together two separate texts for him to have created a visual equivalent of the opening of Lamentations—"How doth the city sit solitary, that was full of people! how is she become as a widow! she that was great among the nations"—with the prophet sitting by the plate inventoried in the last chapter of Jeremiah, "the cauldrons . . . and the shovels, and the snuffers, and the bowls, and the spoons, and all the vessels of brass," which would be taken into exile along with the Jewish captives.

The destruction of Jerusalem was one of the most relentlessly repeated homilies of Dutch Calvinist preachers attempting to alert the sinful to the fatal consquences of the idolatrous worship of gold and other worldly vanities. The fate of Sodom was, of course, equally chastening, and for some time the melancholy figure in the Rijksmuseum painting was thought to be Lot, notwithstanding the missing pillar of salt. But Jerusalem, raised to glory and prosperity by God as long as the children of Israel held fast to their covenant, and then brought low as retribution for its violation, was a much more commonplace analogy. The poet and playwright Joost van den Vondel, who had written a play about the *second* destruction of Jerusalem by the Romans, also published a series of monologues, put into the mouths of Old Testament prophets, including Jeremiah grieving over the fulfillment of his prophecy that the Holy City would be sacked and its king blinded.[47]

Rembrandt's brushwork responded instinctively to the nature of the theme: the mortality of finery. For unlike Job, Jerome, or for that matter Peter and Paul, Jeremiah is richly attired in a tabard of dove gray, trimmed with fur, worn over an elaborately embroidered doublet. To achieve the desired contrast between riches and ruin, Rembrandt has made his own brushwork in the passages of Jeremiah's dress unprecedentedly silky and

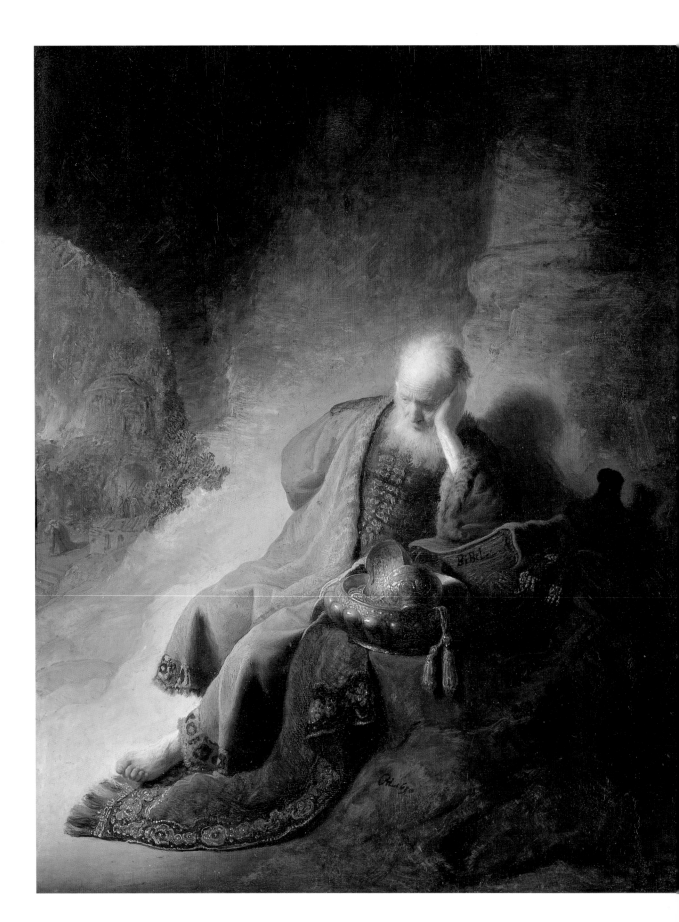

smooth. The extreme care taken with the tactile representation of fine fabric displays the fashion-attentive skills he would want to offer to well-heeled sitters in Amsterdam the next year. But Rembrandt also demonstrated in the *Jeremiah* his shrewd understanding of the psychology of the Protestant patriciate. He knew they were in the market for still-life paintings scintillating with plate, nautilus-shell goblets, and embossed drinking horns, but which, with the judicious addition of the usual *vanitas* symbols—a skull, an hourglass—might communicate their owner's aversion for the very treasures the picture glitteringly advertised. Likewise, whoever was the lucky owner of the *Jeremiah*, a modestly sized panel, got to enjoy its exquisite, gemlike finish without risking accusations of luxury.

Beyond these pieties, there was something prophetically moving about Jeremiah, as Josephus described him in *The Antiquities of the Jews*, a book Rembrandt owned, preferring to dwell amidst desolation rather than accept the offer of the King of Babylon to live in exiled splendor. In Josephus's text, he is given "rich gifts" by the Babylonians and allowed to take them wherever he pleased. So here is Jeremiah, alone in his sanctuary of grief, with a pile of golden vessels heaped on a rock at the base of a ruined column, their overwrought surfaces lit with the fires of destruction. The punishment for following false gods, and the transience of worldly fortune, were, of course, clichés of contemporary culture, relentlessly invoked in verse and image. But while others were paying lip service to the nostrum, Rembrandt would be living it.

iv *Dogging the Nonpareil*

Life was unjust. That's what Constantijn Huygens must have been thinking on the subject of Rubens, whom, for one reason or another, he was unable to shake from his mind. Here was "the Apelles of our time," not merely the greatest of all living painters but also the wisest; learned, humane, and, in his deplorable Catholic fashion, devout. Huygens worshipped his art, hungered for his friendship. For all that had divided them, were they not both Netherlanders? His father, Christiaan, had been one of William the Silent's secretaries while Rubens's father had been adviser to Anna of Saxony. Well, perhaps best not dwell on *that*. But there were other, less scandalous connections. Constantijn had been named (as had his sister Constantia) not just for the first of the Christian Roman emperors but in deference to the virtue of constancy itself, which had formed the center of Justus Lipsius's creed and works.[48] His education had been a duplicate of Rubens's, with the one critical difference: their form of Christian confession. And though he detested Catholicism and, for that matter, the Remonstrance, Huygens liked Catholics (some, at any rate)

OPPOSITE:
Rembrandt, Jeremiah Lamenting the Destruction of Jerusalem, *1630. Panel, 58.3 × 46.6 cm. Amsterdam, Rijksmuseum*

and, for that matter, Arminians (or some, at any rate). He, Huygens, like Rubens, had a great library already three thousand volumes strong. He too was thinking of building an Italianate villa for himself in the center of The Hague. What might they not speak of together? "My desire to enjoy your wonderful conversation is not a passing thing," he would write to Rubens. "I don't know what demons have robbed me of your company."[49]

But regrettably, Rubens was also the enemy—an agent, worse, a *successful* diplomatic agent, of the King of Spain. From the letters of the Dutch ambassador in London, Albert Joachimi, Huygens must have known all about Rubens's English triumph in 1630—not just the treaty which had robbed the Republic of its English ally, but also the uproar of admiration: the honorary degree at Cambridge; the natural friendship resumed with the great English aristocratic humanists and antiquarians Sir Robert Cotton and the Earl of Arundel. He himself *knew* these men. Rubens had even been to see Cornelis Drebbel, Cheapside publican and inexhaustible projector, the inventor of the solar-powered harpsichord and the torpedo, whom Huygens had befriended on one of his London embassies earlier in the decade. Rubens had scrutinized (skeptically, so the reports said) Drebbel's plans for a *perpetuum mobile*. And now they were both of them English knights, Sir Peter Paul and Sir Constantine.

Huygens undoubtedly knew, too, that the English King had engaged Rubens to execute a sequence of triumphal paintings for the ceiling of his new Banqueting House at Whitehall celebrating the Solomonic wisdom and Caesar-like power of his late father James (for whom the young Constantine had been obliged to play the lute at Bagshot). Once those labors were completed, Rubens would be the perfect choice for the task of creating something comparable for the Stadholder. But that could only come to pass once the two states of the Netherlands, divided by faith and war, had been brought to peace, or at least a truce.

This, he knew, was also Rubens's heart's desire. He further understood that after the predicted collapse of the Franco-Spanish alliance (a bitter satisfaction to Rubens), Isabella had managed to persuade Philip IV to allow the States General in Brussels to treat *directly* with its counterpart in The Hague. The problem this time was not in Spain but in Holland. For in 1630 neither the Stadholder nor Their High Mightinesses in The Hague were especially of a mind to be tractable. The fall of 's Hertogenbosch had proved to be just the first of a series of triumphs that had come Frederik Hendrik's way. So the premise behind Rubens's negotiations with Gerbier—that once the English were detached from the Dutch, the Republic would be forced to make peace—was now moot. If it must, the Dutch Republic would fight on its own. This was the message that old Joachimi had delivered to Rubens when the painter came to see him on March 5 before leaving England. There was but one way for peace to be concluded in the seventeen provinces of the Netherlands, he had been crisply informed, and that was "by chasing the Spaniards from thence."[50]

The matter was not quite at an end. Isabella, who since the Archduke

Albert's death had taken a nun's habit in the order of the Poor Clares, had all but despaired of ever bringing about peace in the Netherlands between north and south, Protestant and Catholic. Her most trusted adviser, Spinola, the man whose own martial record entitled him to a view on the matter, had shared her fundamental pacifism but had been ignored in Madrid. Now he too was dead. There was one other person whose standing was sufficiently influential across the lines of battle to be heard, and that was Rubens. In December 1631, Balthazar Gerbier, now Charles I's agent in Brussels, reported that "Sir Peter Rubens is gone on Sunday last, the fourteenth of this month, with a trumpeter, toward Bergen op Zoom, with full power to give ye fatal blow to Mars and life to this State and the Empire."[51] A few weeks later, Hugo Grotius wrote to Rubens's correspondent Pierre Dupuy, "Our good friend M. Rubens, as you will have heard, has accomplished nothing, having been sent back by the Prince of Orange almost as soon as he arrived."[52]

Huygens, constantly at Frederik Hendrik's side, must have been there for this abrupt encounter, when his paragon was sent away with a flea in his ear, informed, punctiliously but firmly, that only the States General was empowered to enter into negotiations concerning a truce. Perhaps he knew that Rubens would reach down deep into his Stoic education so as not to be so personally stung as to abandon all his diplomatic efforts. There was much to keep him at home in Antwerp: his sixteen-year-old flax-blond, cow-eyed, voluptuous new wife Helena Fourment; his paintings, his coins and gems, his fruit trees. But throughout 1632 he continued to bustle back and forth across the siege emplacements in further efforts to bend the Stadholder's ear toward peace. Huygens found himself in painfully formal correspondence with his paragon concerning the issuing of passports.[53] Four days after the great fortress town of Maastricht surrendered to the Dutch army, Rubens showed up yet again in Frederik Hendrik's camp and yet again was sent away empty-handed. No matter; whatever the procrastinations and tergiversations, whatever the personal affront, there was nothing he would not do to achieve a blessed peace.

In December 1632 the Dutch States General finally agreed to receive ten emissaries from its counterpart in Brussels. It seemed like the moment everyone had desired. Rubens found himself in the thick of it, though not in the way he would have wished. The Spanish government in Madrid was unhappy with the diplomatic opening initiated by the Brussels States General rather than by itself, and had forbidden any further negotiations without the King's express authorization. To appease the court and to make sure that the Flemish deputies did not exceed their brief, Isabella once more asked Rubens, whom she hoped was a friend of all parties, to go to The Hague one last time. But as what? A tame spy on behalf of the Spanish, so it seemed to at least one of the Flemish deputies, the Duke of Aerschot. Livid at the implication that he and his colleagues needed careful watching, Aerschot did his best to ensure that Rubens's mission would be sabotaged. In January 1633 his formal application for a passport was duly refused.

It was the last straw. Peter Paul resolved henceforth to stay home, paint, graft trees, and produce children. He was fifty-six. It was time to tend his garden.

If Rubens was denied entry into Holland in person, his prints did his travelling for him. In the early 1630s, engravings and etchings by all of his graphic artists—Andries Stock, van Swanenburg, Vorsterman, Pontius, and the Bolswert brothers—could be bought at fairs, bookstores, and markets throughout the towns of the Republic. The pleasant face with its reflective half smile and dashing whiskers would have found its way into the libraries and studies of art lovers and collectors from Middelburg to Groningen and everywhere in between. Dutch artists themselves had mixed feelings about this. On at least one occasion, the Utrecht connoisseur Arnout van Buchell reported the painters of that city grumbling that the prints by Vorsterman in particular were overpriced, though acknowledging at the same time that Rubens's fame in the Netherlands had been carried by the reproductive engravings of his paintings. Perhaps they were anxious about competition, for as the town councils in Holland increasingly took a "broad" view of the forms of worship they would countenance, the market for those religious prints was bound to grow.

One of the most sought-after prints was Paulus Pontius's engraving of Rubens's painting of *Christ on the Cross,* itself based on a crucifixion in Cologne by another Flemish refugee in that city, Goltzius Geldorp. If it was the "Crucifixion, life-sized" which Rubens offered to Carleton in the batch trade of 1618 (and which Carleton declined, complaining it was too large to fit in his low-ceilinged house in The Hague), Rubens thought it "perhaps the best thing I have ever done."[54] Unlike the masterpieces done for St. Walburga and Antwerp Cathedral, the Savior appears here brutally and tragically alone, his white body set against a thunderously dark sky filled with storm clouds. In the background is the (inevitably European-looking) landscape, with the dome of the Temple in the distance. At the top of the tau, or T cross, Rubens, always the correct scholar, painted the superscription in Latin, Greek, and Hebrew. And he added to Pontius's engraving verses from Luke 23:46, "Father, into thy hands I commend my spirit," making absolutely clear that he meant to depict Jesus' very last extremity. For the Counter-Reformation theologians who ardently promoted the cult of the Cross, this same moment was, unequivocally, a triumph; and the printed version of the painting added angels who are laying out both the Devil and Death. The last was especially important since the Crucifixion was seen, inseparably from the Resurrection, as the death which defeated death: a new life.

At some point in 1631, both Lievens and Rembrandt (signing the picture "RHL") painted their own versions of *Christ on the Cross,* based directly on the Rubens, which they must have seen in Pontius's engraving. It is possible, of course, that these pictures were commissioned by Catholic patrons, but it's certainly not necessary to assume this in order to account for their execution in Calvinist Leiden. Around the same time, Huygens

would ask Rembrandt to paint six scenes from the Passion expressly for the Stadholder—the most prestigious commission imaginable in the Dutch Republic. Were these earlier paintings some sort of trial assignment to see which of the two prodigies was best fitted for the series? Were they another exercise on Huygens's part in having his two favorite young protégés compete with each other to see if they could outdo the elusive, peerless Antwerp master?

Whatever the precise nature of the work, and for whomever it was painted, both Rembrandt and Lievens took up the challenge of producing a painting that could somehow be altered from a Counter-Reformation icon to an aid to Protestant devotion. And however comparable, to this point, Lievens and Rembrandt might have seemed to dispassionate judges, when faced with this daunting challenge, it was Rembrandt who now put clear water between himself and his competitor.[55]

How did he do it? Both his and Lievens's paintings stripped away all the paraphernalia of winged victories. Both set the Crucifixion against a black ground, the "darkness that covered the earth," with absolutely nothing else to distract from the intensity of the redemptive pathos. In keeping with the Calvinist doctrine of the frailty of human flesh, and especially compared to Rubens's triumphant torso with its Greek muscles and heroic rib cage, both of the Leiden Christs are emaciated, weak, and torn. Both make Christ's wounds vividly gory. A river of blood flows down the side of Christ in Lievens's picture from the wound where it had been pierced by the centurion Longinus's lance. In Rembrandt's painting, blood drips from Christ's punctured feet, minute highlights appearing on the drops, staining the Cross and collecting at the point where bark has peeled away from the wood. And both paintings use the arched format to powerful effect, the Savior's arms almost pressing against the edge, lifting the body.

Why, then, is Rembrandt's painting, in the end, more remarkable? The answer is the head. Rubens's crucified Savior, in his painting as well as in the earlier *Elevation of the Cross*, had been taken from his exquisite red chalk draw-

Rubens, Christ on the Cross, c. 1613. *Panel, 221 × 121 cm. Antwerp, Koninklijk Museum voor Schone Kunsten*

LEFT: *Paulus Pontius after Rubens*, Christ on the Cross, 1631. *Engraving. Amsterdam, Rijksprentenkabinet*

Rembrandt, Christ on
the Cross, *1631. Canvas
placed on panel, 92.9 ×
72.6 cm. France, Le Mas
d'Agenais parish church*

ings of the head and upper torso of the Laocoön, made long ago in his days
in Rome with Philip. Constantijn Huygens had actually seen a copy of the
famous sculpture in the Earl of Arundel's gallery at Somerset House when
he was in London in 1618. His friend Jacques de Gheyn III had made a
sketch of it, later engraved as a print for which Huygens himself had added
a little verse. Now if Rembrandt wanted to make a serious impression on
Huygens, he had two choices: subtly flatter Huygens's connoisseurship by
making his own Christ's head Laocoön-like, or strike out confidently on his
own and produce something drastically *unlike* the noble Laocoön and its

Rubensian version, which had survived intact in the Pontius print. His friend Lievens was a little less countersuggestible. His Christ is certainly a picture of torment, but the features are still finely chiselled, the mouth just wide enough for uttering the Seven Last Words. Rembrandt, on the other hand, has opted decisively for raw pain. His Christ's head is broad, unidealized, rough to the point of being brutish, with any traces of sublimity wiped from its features. (It is, in fact, startlingly like the head of *Judas*!) The mouth is wide open in an agonized rictus, the top lip pulled back to expose the upper jaw and teeth, painted with little stabs of gray-white paint. The nostrils are fully dilated, the skin over and between the eyes taut and deeply lined in acute suffering. The sound is an animal howl; the grimace that of a torture victim. A little self-portrait etching of Rembrandt's face contorted in the same shout of pain tells us he had practiced the look of torment in an attempt to make his own face register its spasms.

It is as if Rembrandt had changed Gospels, from the lines of resignation written by Luke and adopted by Rubens and Lievens, to the Gospel of Matthew's famous protest, made in anger and despair: "*Eli, eli, lama sabachthani* . . . My God, my God, why hast thou forsaken me?"

If this is indeed a triumph, it is hard, at this moment of crisis, to discover. What Rembrandt offers instead is a Calvinist image of the body: pathetically slight, broken and bleeding, its arms pitifully thin and frail; come, at last, to the end of its ordeal. It is, evidently, a human sacrifice of the most unsparing kind, and Rembrandt's treatment of the base of the Cross, the supports crudely hammered together, is in keeping with the coarse brutality of the act. Where Catholic teaching necessarily glorified the perfection of the human body as the chosen form of the Incarnation, the fusion of divinity and humanity, in Rembrandt's Protestant Crucifixion, that body is simply not up to the demands placed on it. With its little belly, meager rib cage, and skinny arms, it is, in the literal sense, a pathetic spectacle, a flimsy book of grief. Even the peeled-away bark, another of Rembrandt's typically learned allusions to the tradition of the "Tree of Life," from which, in some Church teaching, the Cross was said to have been made, deviates sharply from Catholic norms.[56] Most of those images would have incorporated vines (Jerome Wierix), apple trees (Hendrick Goltzius), or, in Rubens's own *Elevation of the Cross*, oak leaves—in any event, the greenery that proclaimed the second *life* brought about by the Passion. Rembrandt's tree is not in leaf. It is a crude stump, blasted by lightning, the living dermis of the tree peeling away, poised itself between life and death. Green hope is not to be found.

Suppose, then, that the two versions of *Christ on the Cross* were painted in response to Huygens's interest in seeing which of his two Leiden protégés could come closest to emulating, and perhaps even surpassing, the nonpareil Rubens. If the Master was still precluded from working for the Stadholder's court in The Hague, one might at least supply Frederik Hendrik's palace in the Noordeinde with paintings from the hand of his closest Dutch competitor, however precocious. And not just history paintings,

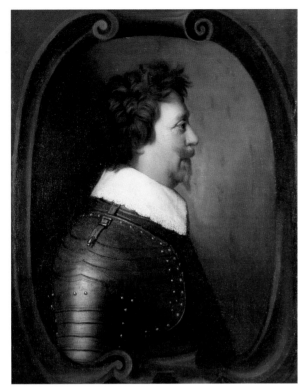

LEFT: *Gerrit van Hont-horst*, Portrait of Fred-erik Hendrik, *1631. Canvas, 77 × 61 cm. The Hague, Huis ten Bosch*

RIGHT: *Rembrandt,* Portrait of Amalia van Solms, *1632. Canvas, 68.5 × 55.5 cm. Paris, Musée Jacquemart-André*

either. Perhaps the most astonishing sign of Rembrandt's dizzy rise from provincial obscurity to fashionable court patronage is the fact that, notwithstanding the praise that Huygens had showered on Lievens as a portraitist, it was *Rembrandt* who got the job of painting the Stadholder's wife, Amalia van Solms, probably as a pendant to Honthorst's portrait of Frederik Hendrik. He must have imagined himself stepping into Hont-horst's shoes: the coach, the grandiose house, a score and more of paying pupils; the dean of the guild; the entrepreneur of *international* commis-sions. Honthorst, after all, would be paid thirty-five *thousand* guilders for the thirty pictures adorning the Danish court. What could possibly arrest Rembrandt's ascent to similar heights of fame and fortune?

Except unwanted candor. The portrait of the Princess of Orange was conceived in left profile to defer, in a becomingly wifely fashion, to the patriarchal authority of the Prince, who looks, in Honthorst's portrait of 1631, in the opposite direction. But in 1632, when an inventory of the col-lection was taken, it seems that the Princess chose to hang Rembrandt's portrait "between her two galleries *without* a companion." This may not have been a good sign. Amalia was already famous for being strong-minded and "difficult," not least with Huygens, though fanatically devoted to her husband. But she had been a lady-in-waiting to the Winter Queen of Bohemia, Elizabeth Stuart, and she must have wanted something more along the lines of van Dyck's airbrushed cosmetics than Rembrandt's exces-

sive attachment to physiognomic truth with its pasty face, mouse-fluff hair, and beady eyes. Of course, Rembrandt would not have wanted to offend. Not the least of his gifts was his instinctive—and educated— understanding of how his contemporaries wished themselves to be seen and known. In Amalia van Solms's case, he evidently thought that the key to her public self-consciousness was Calvinist piety and aristocratic dignity. So he quite deliberately set out to produce a likeness devoid of vanity, qualities the head and shoulders attempt to capture, with the strong set of the jaw (with no more than a trace of overbite), and the pearl tiara, necklace, and earrings, and the elaborately described triple-layer lace collar, allowing him to reconcile nobility with humility, not unlike in Rubens's utterly unglamorous portraits of the aging Isabella as a Poor Clare. But Rembrandt may have taken Amalia's reputation for pious severity just a little further than she or certainly the Prince wished. Art, that is to say, court art, was not about truth. It was about the modification of truth in the interests of beauty. So another pair of portraits of the Prince and Princess, glitteringly got up, were commissioned in due course, and they were *both* by Honthorst.

Perhaps Rembrandt was not, then, the court portraitist Huygens was looking for, especially when he saw the notorious picture of his brother Maurits, and that of his friend Jacques de Gheyn, which he judged so little resembled the man. But he was, surely, the history painter they had been looking for. He had shown how he could follow Rubens and at the same time transform him. Now let him do the same with an even more ambitious challenge: an acceptably Protestant version of Rubens's greatest masterpiece, *The Descent from the Cross*.

Both the *Descent* and its companion, *The Elevation of the Cross*, entered the Stadholder's collection sometime between August 1632 and 1636. In that latter year, Rembrandt himself mentions them in a letter to Huygens concerning three further paintings he had been commissioned to execute representing scenes from the Passion. But there is no reason to assume that his *Elevation* and *Descent* were originally conceived as the first two items in an ongoing series.

In all probability Rembrandt reversed the order of Rubens's conception, painting the *Descent* first and seeing if it met with the approval of Huygens and the Stadholder. It sustained the poetic inspiration of the *Christ* by representing Jesus' body as a collapsed and dislocated sack of organs rather than as a heroic torso modelled after the antique. More important, it was the engraving by Lucas Vorsterman (now back in Antwerp, befriended by Anthony van Dyck and presumably keeping his distance from his old boss) which was Rembrandt's starting point. Vorsterman's personal notoriety had been balanced somewhat by his early reputation as the most painterly of engravers, using the burin needle to build up close strata of lines that had the power of suggesting, in black and white, the range and saturation of color in Rubens's paintings. Or so it was said.[57] The truth, though, is that no print twenty-two inches by seventeen, how-

LEFT: *Lucas Vorsterman after Rubens,* The Descent from the Cross, *1620. Etching and engraving. London, British Museum*

RIGHT: *Rembrandt,* Descent from the Cross, *c. 1633. Panel, 89.4 × 65.2 cm. Munich, Alte Pinakothek*

ever spectacularly accomplished (as Vorsterman's certainly is), had the faintest hope of approximating even a particle of the chromatic power of the huge painting in the Kloveniers' Chapel of the Onze Lieve Vrouwekerk. It wasn't just a matter of the dress of St. John being blood-red or that of the Virgin being cool blue, but that Rubens, as we have seen, used color in these works as the principal engine of his draftsmanship. Rembrandt, then, was responding to a monochrome ghost of the original painting. What Rembrandt had in front of him was a dense knot of figures, histrionically impacted together about the body of the Savior. Very sensibly, then, he resolved to strip and simplify, not just in the interests of a composition that would be satisfyingly legible within a much smaller format but also because it was presumably intended for prayer and devotion in the Stadholder's private apartments. So where the emphasis in the Rubens is on action and reaction, in Rembrandt's version it is on contemplation and witness, the properly Calvinist response. In Rubens's original, there are virtually no figures who are not somehow in direct bodily contact with the Savior—touching his flesh, stained by his blood. This was precisely right for a church in

which the eucharist was of fundamental importance; where the communicant was meant, physically, to *experience* the martyrdom of Christ, the Real Presence, through the sacrament. Indeed, this was one of the most serious issues dividing Catholics and Protestants. In Rembrandt's version, doers are perforce replaced by watchers (or swooners and cringers). The figure draped across the top of the Cross who, in Rubens's painting, grips the winding sheet in his teeth is reduced here to the top man in the lowering machinery, a human pulley. X-radiographs have revealed that originally Rembrandt was, in fact, tempted to follow Rubens more closely by having the figure of the Virgin stationed behind the standing Joseph of Arimathea, grasping Christ's arm with one hand and reaching toward his leg with the other—in other words, almost precisely the same position in which she appears in Rubens's work. In the end, though, he decides on distance and resignation rather than bodily proximity: he removes the Virgin some distance from the Cross, and she is now seen swooning in the left foreground.[58] Helplessness before the ineluctable execution of God's will is the keynote of the scene.

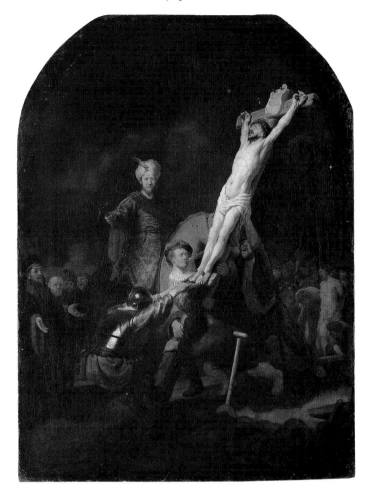

Rembrandt, The Elevation of the Cross, *c. 1633. Canvas, 96.2 × 72.2 cm. Munich, Alte Pinakothek*

Though light shines from Christ's body (as in the Rubens original), reflecting on the faces of the immediate supporters (including one who has something of Rembrandt's own younger features), there are as many witnesses as participants to the event.[59] While the painting is incomparably smaller, it actually feels more spaciously composed, the arched gateway and the trees establishing a middle ground and a background, reducing the sense of sacred claustrophobia that Rubens was aiming for in both his great Antwerp altarpieces. A barrier of space and depth separates the ring of onlookers from the Cross, and their tragic stillness and resignation in the face of the martyrdom speaks of helpless contemplation rather than interaction.

The same stillness hangs over *The Elevation of the Cross* even in the midst of its exertions. Since an engraving of this painting was not available until 1638 and Rembrandt had no opportunity to see it in situ in Antwerp, Rubens's work in this case is unlikely to have been the direct source of the composition. There have been alternative suggestions, in particular a

woodcut by Albrecht Altdorfer. Yet while the picture is obviously much less close to Rubens's version than the *Descent,* the central diagonal axis of the composition, in the continuous extended line between the soldier's arm and Christ's left arm, seems too close to the Antwerp painting to be completely fortuitous. So perhaps Rembrandt was relying on someone's sketch or memory—van Dyck's, for example—as his starting point. And, of course, a mounted witness *is* in fact present in Rubens's original, but only on the right panel. In Rembrandt's painting, the Calvinist weight of shared guilt, of collective responsibility, is signalled by the turbaned horseman looking directly at the beholder. Once again, it's a pair of eyes that establishes the essential connection between painting and beholder. The work of implication is made more shockingly serious through the artist's decision to cast *himself,* dressed in beret and doublet, as the executioner, jaw set, hands wrapped around the Cross, about to heave the Savior upright. In fact, although the shining armor of the soldier draws attention to his part (though not nearly as decisively as the massive naked torso of the bald executioner in the Rubens), it's Rembrandt himself who is *literally* the dramatic fulcrum of the entire work. The great Rubens is filled with violent strenuousness, the work of demonic titans, a trembling of the earth. In the Rembrandt, there is a soldier and a pair of shadowy laborers, and in the middle a painter whose hands, meant for the palette and the maulstick, are guiding the Cross to its position.

There was nothing novel about this self-inclusion. In 1627 Rubens had gone back to *The Adoration of the Magi* he had done to celebrate the Twelve Years' Truce and painted himself in as a mounted knight, the *cavaliere* which he had in fact officially become. From the beginning, Rembrandt had included his own likeness in *The Stoning of St. Stephen* and the 1626 Batavian *"History Painting."* But there was no precedent for a self-portrait which drew attention to his own presence, simultaneously, as the maker of the work of art (indicated through the beret) and the instrument of Providence (the fulcrum of the Cross). Extraordinary as this was, it shouldn't be taken as the artist blasphemously imposing himself on the Scripture. Nothing could be further from the truth or the possible range of Rembrandt's intentions, however daring. Instead of *intruding* himself into the sacred spectacle, Rembrandt was attempting to do something like the opposite, namely, *immerse* himself as completely within it as all those who wrote about history painting advised. He is, literally, shouldering the guilt, become the medieval figure of *Elk*—Everyman—taking on himself the sins of mankind. Cast as *Elk* the Painter, Rembrandt manages to equate the act of painting itself with the Crucifixion of the Savior, an oxymoron only a Dutch Calvinist in the golden age could possibly take on board.[60]

That said, Rembrandt was not wholly devoted to self-effacement.

v Making Faces

When Rembrandt superimposed his face on Rubens's self-portrait, he was not out to steal his paragon's persona so much as to try it on. It was as if he had stolen into the house on the Wapper while the Master was away at his country estate and, confronted with a case of golden chains, could not, somehow, prevent himself from fingering their links, having the weight settle just so about his neck and shoulders.

Rubens, of course, seldom tried anything on. His self-image, like his character, was what his brother's mentor, Lipsius, had insisted should be at the center of every upright Christian gentleman's life: he should be constant, temperate, unswerving through good and ill fortune, whether well or ill used by princes and patrons. Accordingly, there are just *four* solitary self-portraits of Peter Paul, and all of them, irrespective of the time of his life, look pretty much the same, some with more of a hint of a balding brow than others, but for the most part a document of how *little* damage the passage of time had affected the *echte* Peter Paul. Rubens appears in a number of other paintings, but in the company of friends, his brother, his wives, his children, *amicitia et familia,* the humanist's kin. And often he is not the most obviously important figure in the group.

Rembrandt, of course, did not stop at four images of himself, nor four and twenty nor forty-four. No other painter before the twentieth century, perhaps no other artist *ever,* has left us with such an exhaustive archive of his face, from the very first of his dated paintings, *The Stoning of St. Stephen,* to some of the very last, in 1669, the year of his death.[61] And unlike in the case of Rubens, these appearances are seldom gregarious. Rembrandt only ever appears (outside of the histories) in the company of one person: his wife, Saskia van Uylenburgh. Essentially, this is a forty-year soliloquy, and its inexhaustible, bravura quality inevitably led to the adoption of Rembrandt as the archetype of the self-obsessed artist. Even during Rembrandt's own lifetime, Italian artists like Giovanni Benedetto Castiglione shamelessly aped the "Rembrandt-Type" in order to present themselves as the modern Michelangelo: fiercely self-possessed; indifferent to the obtuse whims of patrons; accountable only to the sovereignty of their own muse. It was a version of the artistic personality cut loose from, or even hostile to, social convention that much pleased the nineteenth-century Romantics. And even when Picasso was at his most egregiously fashionable and feebly formulaic, he could still wheel out the Rembrandt-Persona to convince himself that his own flinty integrity had remained uncorrupted by glamour.

But Rembrandt had not the slightest idea of casting himself as the First

Rembrandt, Self-
portrait, *c. 1628. Panel,
22.5 × 18.6 cm. Amster-
dam, Rijksmuseum*

of the Farouches, much less the "angry young man" who Kenneth Clark assumed appears in his early self-portrait etchings.[62] The reason for the multiplication of his self-image was not a relentless, almost monomaniacal assertion of the artistic ego but something like the exact opposite, Rembrandt's experimental *dissolution* of his self into countless other personae: the soldier, the beggar, the bourgeois, the prince, the Antwerp master.

Peter Paul was, when all was said and done, the One and Only Rubens.

And Rembrandt? Rembrandt was, as we have already noticed, Everyman.

Everyman was not just the universal Sinner. He was also cast in the theater as a modern Proteus, able, as his name suggested, to adopt the persona of any and every character he encountered. Rembrandt was this protean updating of Everyman, driven by the need to burrow inside his subjects' skins (and this went for his portrait sitters as much as his historical characters), to understand, from the inside out, how it was they wished themselves to be seen. He was no exhibitionist, and his self-inspection ought not to be confused with compulsive self-exposure. In fact, the earliest paintings of his own face are more remarkable for what they conceal than for what they disclose. And what they hide, of course, are the artist's eyes. If indeed, as van Mander had suggested, the eyes were the window to the soul, Rembrandt had closed the shutters.

The deep shadow falling across his brow, or a side of the face, has been read by Perry Chapman as a declaration of melancholy,[63] the physiognomic signature of creative genius. There is no doubt that Rembrandt's fuse was short; that he was prone, especially later in life, when, after all, he had much to contend with, to fits of cranky irritability. Whether, however, he imagined himself to be afflicted with a surfeit of black bile in the way that, for example, Constantijn Huygens supposed himself to be, is much more debatable. Of course, if the *pose* of the melancholic genius seemed to Rembrandt to be worth striking, if only to conform to the profile of natural genius, he might well have reached for a pictorial manner to suggest this poetic moodiness; hence his chiaroscuro self-portraits. But there might be an additional explanation for the almost perverse obscuring of the artist's demeanor: the projection of the *power* of the painter's eye.

All gazes, all acts of staring, are, to some extent, trial expressions of strength, and we often assume that the more direct and unflinching the gaze, the stronger the person behind it, like an arm wrestler's upright fist.[64] But right from the beginning, Rembrandt decided to play a different game with the beholder, a cat-and-mouse game, a painter's cunning peekaboo, now-you-see-me, now-you-don't. Look at the mesmerizingly beautiful 1628 self-portrait in the Rijksmuseum. By definition, it was impossible for Rembrandt to have positioned himself in the deep obscurity necessary to

OPPOSITE: *Rembrandt,*
Self-portrait, *1629.
Panel, 15.5 × 12.7 cm.
Munich, Alte Pinakothek*

ABOVE: *Rembrandt*, Self-portrait, Bareheaded with White Collar, *1629. Etching. Amsterdam, Museum het Rembrandthuis*. OPPOSITE, TOP LEFT: *Rembrandt*, Self-portrait Leaning Forward, *c. 1630. Etching. Amsterdam, Rijksprentenkabinet*. TOP RIGHT: *Rembrandt*, Self-portrait Frowning, *1630. Etching. Amsterdam, Museum het Rembrandthuis*. BOTTOM LEFT: *Rembrandt*, Self-portrait Wearing a Fur Cap, in an Oval Border, *c. 1629. Etching. Amsterdam, Museum het Rembrandthuis*. BOTTOM RIGHT: *Rembrandt*, Self-portrait in a Cap with Eyes Wide Open, *1630. Etching. Amsterdam, Museum het Rembrandthuis*

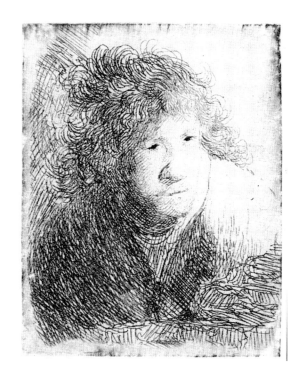

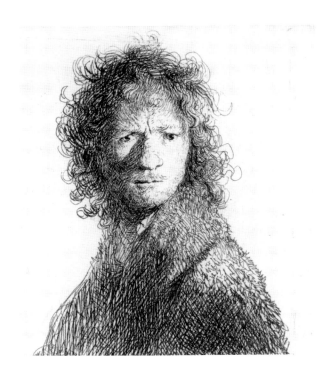

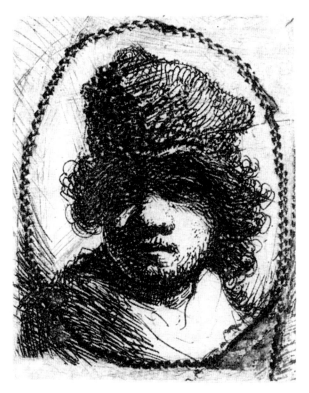

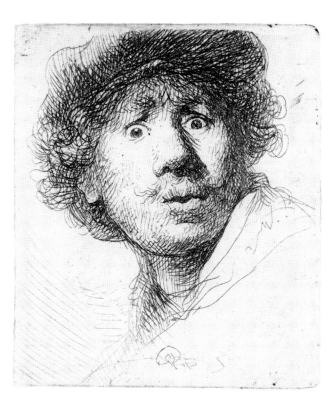

have produced the shadow that falls over his eyes and upper face and still create a legible image. So whatever else this picture may be, it cannot be a simple mirror image. It is, in fact, the antithesis of the *icon vera*, the "true image" associated with the mysteriously spontaneous apparition of Christ's face on shrouds and cloths, which Joseph Leo Koerner has seen as the dominant source for Albrecht Dürer's great self-portrait of 1500.[65] Even while it borrows from the Savior-face, Dürer's self-portrait is unflinching in its precision, as though *no* hand had fashioned it, as though the icon, like the artist's persona, were itself a creation of a higher Agent.

The Rembrandtian self-portrait, on the other hand, is *all* frank invention: literally made-up; the curls and split ends clawed in; the eyes cut like holes in a mask. In the amazing Munich self-portrait of 1629, the self-designing hand of the painter is made confrontationally apparent. His collar is daubed in with the thick white paste usually associated with a much later style; the highlights on his shoulder are brushed in with broad, dashing strokes. The scratches that describe his wiry curls are made wilder still by the scraped and hatched and dabbed-in ground, a little paint-storm all of its own, not to be repeated at this level of aggression until van Gogh.

It's dashingly put on, this makeup, but it is a mask applied with almost disingenuous transparency. For the Rembrandt-face, however made-up, is still evidently subject to the pranks and indignities suffered by all mortal flesh. Unlike Dürer's mystically objective apparition, unlike Rubens's carefully edited generic humanist-patrician released in print for wholesale distribution, the Rembrandtian face is rubber, not wood: clownishly elastic, now tense, now slack; a phiz over which even the owner seems to have imperfect control. It performs but it seldom ingratiates. In its more decorous incarnations—the bourgeois fop, the bright-cheeked officer—it conforms to certain social conventions and expectations, but in such a way as to invite us immediately to mistrust the struck pose, to suspect the dress to be costume rather than uniform, to see the player beneath the role. It is, in fact, the *unfixed* quality of the Rembrandtian self-portrait—its resignation to puffings-up and hollowings-out, to bruised skin and broken veins, swellings and discolorations; its helpless picturing of the work of time and fortune—that accounts for its legendary power of sympathetic connection, its tender correction of vanity. With Rubensian constancy is how we should like to behave; with Rembrandtian inconstancy is how we do behave. Rubensian nonchalance, Baroque cool, is how we should like to picture ourselves, full-length in the mirror showing a trim leg. But Rembrandtian hamming, sucking in our cheeks, tensing our abdominals and checking for the ostrich plume, is the reality of our antic condition. And this is why, notwithstanding all the sneering allusions in modern commentaries to the fatuously naïve Romantics, nineteenth-century writers were absolutely correct to liken Rembrandt to Shakespeare as a comparably profound archivist of human self-delusion.

The Everyman-Player-Artist, then, is after variousness, including his own. So his early self-portraits, the etchings especially, are strikingly *unlike*

each other, the paint handled in drastically different styles. The Gardner Museum portrait of the artist in his feathered hat (see page 28) was painted in the same year as the raw, freely handled Munich self-portrait, yet it could hardly be more different in its manner, the paint carefully laid on with a slick, lacquered glossiness designed to emphasize the softness and smoothness of the materials in which Rembrandt is dressed, while the three-quarter length and low viewpoint accentuates the lofty formality of the pose. Many of the paintings that seem to be slight variations of an early Rembrandt "type" in fact turn out to be copies painted by other hands, possibly his first students, Isaac Jouderville and Gerard Dou.[66] The only undisguisable physiognomic signatures are his rounded jowly chin and the exuberant Rembrandt nose, a heroic proboscis on which the artist will sculpt the effects of age and temper over the next forty years. (It was, of course, well beneath Karel van Mander to say anything at all about the nose in his catalogue of the expressions of the face.) But even with these basic elements of the phiz, Rembrandt can model astonishingly different *tronies*, or character types. He can make his nostrils dilate and the skin on the bridge crease up, his eyes narrow and his mouth open in a feral snarl, or he can tighten the nostrils, purse his usually fleshy lips into a tight slit, furrow his brow, and turn his head about as if staring us down over a can of beer. The cackling simian and the famous "seen-a-ghost" pudding-face seem to belong to different bodies altogether. Occasionally Rembrandt's self-portraits actually seem closer in resemblance to some of his *tronies*, or face paintings, that use other models than to his own features, as if he were rehearsing or understudying their pose: Rembrandt the available face-of-the-day.

Often, in both his drawings and etchings that have been dated from between 1629 and 1631, Rembrandt's *age* seems to differ far more widely than can be accounted for by a mere two or three years. At times, in his fallen collar, his more developed and trimmed mustache, his features evenly lit, he presents himself as a young burgher, a solid citizen, a Rubens-in-the-rough. At other times, his hair is flamboyantly awry, the dress unbuttoned. But these two kinds of self-image correspond, more or less, to the two models of a painter which Rembrandt was trying to graft onto his own peculiar personality.

One of these models was Lucas van Leyden, or rather the pseudo-Lucas, the etching by an unknown hand which for generations had been supposed (on the most speculative grounds) to be a self-portrait of the hometown genius. Rubens, who for all his classical and Italianate refinement never abandoned the more earthy, northern vernacular vision associated with Lucas, himself made a drawing after the engraving, adding a laudatory inscription of his fame. It is inconceivable that Rembrandt would not have known this almost ostentatiously simple and direct face, unapologetically different from the courtly poses struck and elegant costumes worn in the self-portraits of Anthonis Mor and Isaac Claesz. van Swanenburg. There were a few other assumed self-portraits in this homespun, conspicu-

LEFT: *Andries Jacobsz. Stock*, Portrait of a Man, *called* Portrait of Lucas van Leyden, *c. 1620. Engraving. Leiden, Stedelijk Museum De Lakenhal*

RIGHT: *Rubens*, Portrait of a Man, *called* Portrait of Lucas van Leyden, *c. 1630–35. Brush and bistre drawing. Paris, Frits Lugt, Institut Néerlandais*

ously unpretentious manner that could have added to the precedents, perhaps Pieter Bruegel the Elder's *Artist with Patron*. In any event, the rude simplicity of the image wasn't quite enough for Rembrandt, who was tempted to build on top of it, as we have seen, an entire theater of bravura. But that Rembrandt produced an image of aggressive earthiness, in defiance of the more courtly versions of the artist's persona, seems indisputable. And the fact that by 1634 his gifted pupil Jan Joris van Vliet had already produced engraved copies of the light-dark face seems to suggest that he had succeeded in creating a popular demand for the New Lucas image, simultaneously artful and candid, melancholy and sanguine.

In fact, Rembrandt went even further in this direction by following Lucas van Leyden's and especially Pieter Bruegel's fascination with true social outcasts: beggars.[67] Like all other Protestant cultures in the early seventeenth century, the Dutch liked their rogues and vagabonds to be confined strictly either within the boundaries of plays, poems, and pictures or within the four high walls of the local houses of correction.[68] By the first decade of the seventeenth century, brutally sharp distinctions were being made, not least by Jan van Hout, the town clerk of Leiden, between, on the one hand, the deserving local poor, for whom collections were taken up in church and who were the objects of charitable attention unrivalled in Europe, and the floating pools of semicriminal vagrants, who were treated by the city fathers as a kind of infestation to be expelled from the body

politic (in carts if necessary), or whipped and preached at until they submitted to a decently industrious Christian life.[69] The Amsterdam artist Werner van den Valckert painted a series of panels documenting precisely the process by which the destitute were made proper wards of the civic and church communities. And in some towns a limited number of indigents were licensed to beg in specified places. But the policy of confining, correcting, and expelling was so successful that foreigners often commented enviously on the astonishing absence of beggars from the centers of Dutch towns. "It is as rare a thing to meet with a beggar here," wrote James Howell, "as rare as to see a horse, as they say, in the streets of Venice."[70]

Perhaps it was precisely because of the relative *invisibility* of Dutch beggars that as literary, picturesque, or even pseudoreligious types, they could actually become objects of exotic fascination. Adriaen van de Venne's *Tafereel der belacchende werelt (The Tableau of the Ridiculous World)* included in its anthology of follies a Dutch version of a genre that travelled the length and breadth of Europe, from Spain and England to Bohemia and Italy: the encyclopedia of rogues and vagabonds.[71] Van de Venne lists forty-two established types of con men and women, including the *loseneers*, who pretended to be escaped captives of the Turks; the *iuweeliers*, who specialized in fake gems; *swijgers*, who smeared themselves with a mixture of horse shit and water to simulate jaundice; *schleppers*, who were (mirabile dictu) phony Catholic priests; and the seriously annoying *nachtbehuylers*, who lay with their children in front of houses and moaned all night until they were let in. Van de Venne's text was, without question, meant as a cautionary manual. The description of each class of rogue had a suitably stern moral epigram appended to it in a separate column. And both the accompanying illustrations and the extraordinary grisaille paintings he made of his crooks and beggars depict a bestiary of human grotesques, physically deformed by their vice.

The series of prints likely to have been Rembrandt's principal source for his beggars—the *Gueux* etched in 1622 by the great Lorraine graphic artist Jacques Callot—retain something of this demonization. One figure in a tattered cape holds out a hand on which the nails have grown into threatening talons; another with a staff stares back at the onlooker with an expression of roguish mischief. But Callot's riffraff were, for the first time, recognizably human rather than subhuman, even when, as in the mock pilgrims, they correspond to figures in the dictionary of vagabonds. Rembrandt, who owned some of Callot's prints, took the process of

Jacques Callot, Beggar in a Cape, *1622. Etching. New York, Metropolitan Museum of Art, Gift of Henry Walters, 1917*

humanization much further. In his hands, they are no longer blunt instru-
ments of moral correction or objects of picaresque curiosity. They are,
unmistakably, kindred beings. All of the nightmarish deformities that twist
van de Venne's types into repellent rat-men, vermin in tatters, have been
removed. But he has also avoided the kind of self-congratulatory style of
van den Valckert's panels, where the indigents have been satisfactorily con-
verted into the grovelling, grateful recipients of Christian alms.[72] There is,
already, something about the spectacle of human ruin, the type that is at
the opposite extreme to the classical hero, that Rembrandt found authenti-
cally heroic. So heroic, in fact, that in more than one etching his own face
appears in the company of beggars. And in one of the most memorable of
the self-portraits, he becomes a beggar himself. And not, moreover, the
tamely deferential pauper of the charity houses and Sunday preaching, but
the real thing: crook-backed, panhandling, foulmouthed, and scrofulous;
ungrateful, unrepentant, dangerous—the kind of starveling whose appear-
ance brought out the *schout*'s men and had respectable burghers bolting
their shutters and unloosing the dogs. Rembrandt's fascination with this
underclass, his encouragement to van Vliet to turn out further sheets of
beggar prints in addition to his own, goes well beyond ethnographic
curiosity and comes eccentrically close to celebration. By putting himself in
the company of the unwashed, Rembrandt seems to want to flout van
Mander's strictures about moral respectability, to revel in precisely the low-

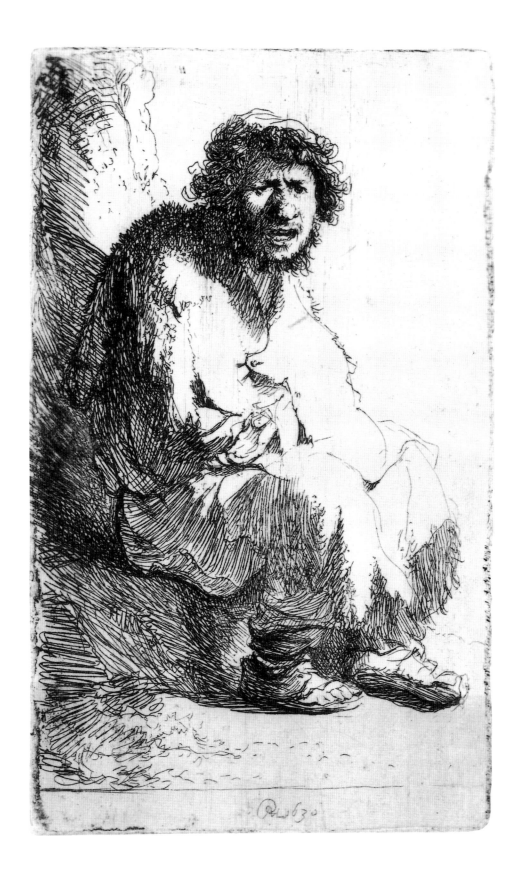

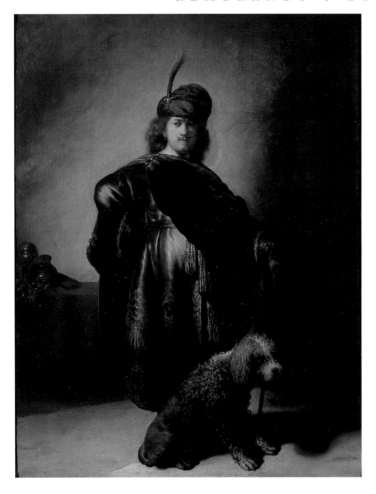

Rembrandt, The
Artist in Oriental
Costume, with
Poodle, *1631.
Panel, 66.5 × 52
cm. Paris, Petit
Palais, Musée des
Beaux Arts de la
Ville de Paris*

life beastliness of the painter—*Hoe schilder, hoe wilder*—that the moralist had abhorred. And it's not necessary to fall back on Romantic stereotypes about Rembrandt spitting in the eye of bourgeois conventions to acknowledge the audacity of what he's doing here. For there were plenty of precedents for the selective slumming of the Rabelaisian artist, the most obvious in Holland being the great Amsterdam playwright Gerbrand Bredero, who had been trained as a painter and who in one famous declaration, about his use of street slang, announced, "Fat lot I care whether I learn my mother tongue from a mighty king or from a beggar." In the same sense, one can imagine Rembrandt insisting, "What do I care whether I learn about the faces and bodies of men from princes or paupers?" Huygens's complaint about the arrogance of the young Leiden painters comes to mind—an "excess of self-confidence," most glaring perhaps in Lievens's case, but which, he made sure to add, "Rembrandt shares."[73]

And yet this cheeky beggar, this full-of-himself Lucas-Bruegel-Bredero-Rembrandt, the rogue virtuoso of rags and stitches, of bent limbs, wooden rattles, and begging bowls, is also the Rembrandt who still could not quite leave off wanting to be Rubens. At the same time that he created the hybrid Rembrandt-to-Rubens self-portrait etching and signed it "Rembrandt f," he also committed another mild act of larceny on the body of the Flemish master's work. He went to another reproductive print made by Lucas Vorsterman, this time of an *Adoration of the Magi,* and extracted from it the figure of an oriental potentate, swathed in a robe of glistening satin tied at the waist with a sash. With this figure in front of him, Rembrandt had no need of mirrors. He set one arm on a hip, the other on a cane, and planted his feet in an elegant, virile contrapposto. At some later date, a poodle was added, perhaps by another hand. For the moment, he stood there, satin-draped elbow and prosperous belly catching the light, Rembrandt Pasha, warrior, Magus, bringer of gifts.

PART FOUR

THE PRODIGAL

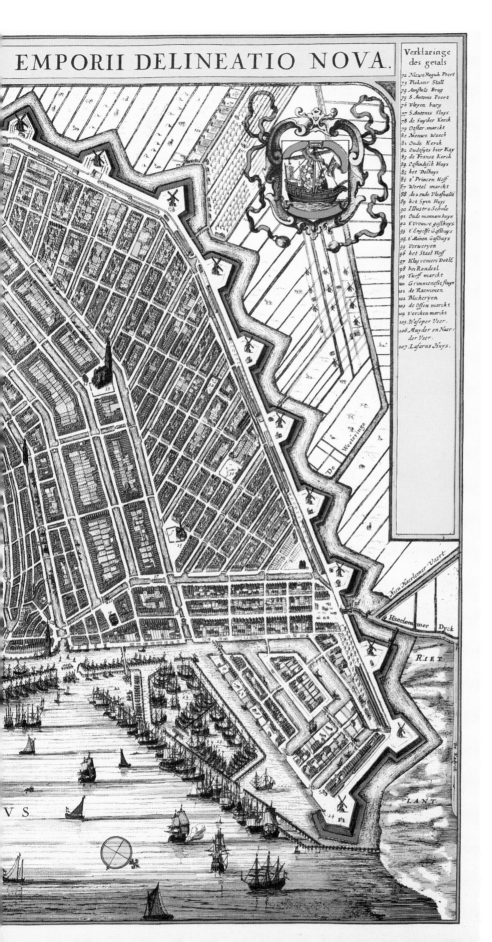

Joan Blaeu, Map of
Amsterdam, *1649.*
Private collection

i *The City in Five Senses*

From a seagull's gliding altitude, the great city resembled: a half-moon; a rat-gnawed cheese; a cradle lying with its base to the southern meadows, the top open to the dark waters of the IJ; the tubby hull of a *noordvaarder* awaiting masts and sail, sheets and shrouds, so that it might be off about its business; a straw-filled bolster indented with the weight of heavy heads.

And somewhere amidst its more than hundred thousand souls there would have been a workaday painter turning out yet another *Allegory of the Five Senses.*

De Reuk

First, the Zuider Zee itself, sucked through the inlet of the IJ, washing against the slimy double row of palings separating the inner from the outer harbor, carrying with it a load of tangled wrack and weed, worthlessly small fish, and minute crustaceans generating a briny aroma of salt, rotting wood, bilgewater, and the tide-rinsed remains of countless gristly little creatures housed within the shells of periwinkles and barnacles. In the yards behind the first row of houses facing the docks there were better things to smell. Lengths of green timber were stood on end to season, some already bent to form a rib in a ship's hull. A man might walk down the alleys parallel to the harbor, inhale the sharp tang of fir (for masts) and oak and beech (for hulls), and for a moment think himself in a fresh-cut wood in Norway.

The illusion would not survive the taverns and brothels. Behind the seasoning yards, in the alleyways around the Jan Rodenpoort and the Haarlemmerpoort, columns of heavy odor arose from the slops. The base

of this olfactory architecture was supplied by layers of mussel shells; above them rose the sickly sweet ossuary of discarded parts of shrimp, crab, lobster, and prawn, the remains picked over by cats. Even this was better than the night-soil boats, moving slowly but profitably through the Amstel locks, heading out into the IJ toward the strawberry growers of Aalsmeer and the carrot growers of Beverwijk to the west and Hoorn to the north, who would pay a pretty penny for the manure. The *vuilnisvaarders,* the dung shippers, were, in their way, carefully specialized in their supplies, taking sheep shit to the tobacco growers around Amersfoort; horse shit to the horticulturists, who would constitute from it the magically fertile soil, from which cabbages, cole seeds, and beans sprang with a copious regularity unseen anywhere else in Europe. If the playwright Bredero was to be believed, there were even some Amsterdammers prepared to buy urine for resale to the tanneries.[1] In Holland, waste was a contradiction in terms. Even industrial residue like the soap-boilers' potash could be recycled as fertilizer. The rich cargo of the dung boats was supposed to travel by night, but those along the route still made sure to fasten their shutters before dark, anxious that the awesomely potent stench would find a way through vents and cracks.

The worst was the smell of death hanging over the Karthuizerkerkhof in the summer months of a plague year—1624 or 1635—when there were too many bodies to bury and not enough arms to dig graves and the little yard was full of black-garbed processions, formed up two by two, in absolute silence, waiting to go in and out of the enclosure, traffic jams of grief. When there was room, the linens of the dead were laid out to dry on the ground, decently saturated in vinegar to avoid adding to the contagion. No one who gagged easily would want to work there, or for that matter among the tanners or tallow renderers or the pig-gut packers, who stuffed tripe, liver, and lard along with a filling of groats into intestinal casings to make winter sausages.

Against this foulness, Amsterdam countermarshalled fragrance in quantities, intensity, and variety to please the most demanding nostrils. On spring mornings, a walker, selecting his route carefully and avoiding the sections between the Prinsengracht and the harbor that had been set aside for dye vats (the Bloemgracht) and soap-boiling (the St. Jacobskapelsteeg), might even deceive himself into supposing that the whole city had turned into a pomander. In the herb markets there were dittany, lavender, rosemary, and cicely plant packed into little "sweetbags" to be hung about the wrist or the neck as a nosegay keeping contagion at bay, just as well since the cadavers of dead animals—dogs, cats, pigs, the occasional horse—rose without warning to the scummy surface of the canals. For wealthy men, the Turkish rosewater that scented their calf or kid gloves helped somewhat to mask the odor of putrefaction. And around the warehouses of the East India Company there hung invisible clouds of spicy vapor: cinnamon and cloves, nutmeg and mace. Morningtime the bakers' ovens near the Nes gave off the thick, yeasty scents of those same nails, powders, and studs,

darkening and cracking to release their aroma into the breads, tarts, biscuits, and sweetmeats cooked for the tables of the high-hats and opulent ruffs.

Fastidious noses sniffed daintily from their tall flutes at the bouquet of green Moselle or dark Malmsey. Common noses, young and old, smooth and warty, were tickled alike by the malt ales served up in dull pewter pots or green glass *roemers* day and night. Come morning, slops and puddles which had taken on a smell all their own were banished by the astringent, cleansing soaking lye, the alkalized solution of vegetable ashes used to wash down the floors and walls of both modest and grand houses. But try as they might, even the most conscientious servants and the most fanatical *huisvrouw* found it difficult to expel entirely from their rooms the musty air of mildew that crept with the Amsterdam damp into the best-lined linen chests and the most thoroughly aired curtains and rush mats. Remedial or defensive measures might be taken. In fastidious houses, parcels of dried flowers and herbs, especially lavender, were set in bed linens before night-time. Elsewhere in the house, bookcases began to be custom-designed with glass fronts to prevent the invasion of the fungus that foxed and freckled fine paper even when the books were stored in the heaviest chests. Turkey-work rugs were kept on tables, not floors, for the same reason.

Against the dankness there were remedies to hand. In the spring and summer, fleshy damask or musk roses might be set on the buffet in ceramic pots, perhaps in the company of gillyflowers and candy-smelling spotted lilies. In the wintertime (or, its devotees claimed, anytime), long pipes of tobacco "sauced" with spices or narcotics like black henbane seed, belladonna, or even the "Indian berries" which we know as coca produced fumes said to desiccate the aguey dampness. Come spring, as the days brightened and lengthened, an hour's saunter south along the banks of the river Amstel, past the fishing rods and trotting dogs and the white rumps of swimming boys, would bring the walker to pastures and shallow coppices. A little further and the air would be freshened by linden blossom and mown hay, and the occasional stand of poplars or sycamores could be discovered, edged with oxlips and harebells. If the excursionist was mounted and rode back at sunset toward the city gates and walls, he might find his horse sniffing and pricking his ears as Amsterdam's tower-punctured skyline came into view, as if already scenting the whiff of humanity sweating in its layers of serge and linen.

Het Gehoor

A ticktock city, ruled by the unforgiving government of timepieces: clocks and watches, pendular, circular, mounted in towers with faces of Arabic or Latin numbers, set high in church steeples and painted gilt against black as if God himself were keeping strict time and expected no less of good Christians. At night, within solid houses of brick and timber, the stillness would

be broken only by the regular movement of precisely balanced brass machinery vigilantly measuring the passing of darkness into thin, gray light. Outside: the slap of canal water against the bridges; the creak of masts, of the little boats moored along the Damrak and, further off, bigger ships lying at anchor in the IJ; the balletic patter of rats' feet along the timbers; and, not infrequently, a shout, curse, or cackle, since with a thousand and more inns in the city and the streets full of sailors, no one was very far from a fight or a whore or both. Finally, then, at ten o'clock, the sheriff's drumroll and the reassuringly slow, deliberately heavy tread of the boots of the watch.

And yet, foreigners accustomed to the bedlam of Rome or London thought Amsterdam a very quiet place indeed were it not, of course, for the bells. Which was like saying Paris was a plain enough city were it not for the silk. For there was no escape from the bells, nor could any Amsterdammer imagine why, in any case, one should want to flee them. Across from the Breestraat and Pieter Lastman's house, one could see Hendrick de Keyser's tower on the Zuiderkerk, with rows of thirty-five bells hanging like magpies on a fence. Come the hour and the half hour, they tolled their changes to the harmonies of psalms and hymns; and across the city, in exuberant discordance, they were challenged by brother and sister bells on the Oude Kerk, the Noorderkerk, and especially Assuerus Koster's massive bell on the high towers of the Westerkerk. During the day, the business of the city was measured in carillons. At one o'clock the clock chimes of the Beurs, at the end of the Damrak, opened its galleries for negotiation. A mere hour later, the same chimes announced the close. Bells by the harbor welcomed the return of fleets from Batavia or Spitsbergen or Recife; muffled bells, tolling slowly, marked the interment of a notable.

And though the ministers had (at the very least) grave misgivings about church music, Amsterdam was full of it. The city organist, Jan Pieterszoon Sweelinck, and his pupils were contractually obligated to fill the city churches with sound, twice daily at noon and in the evening, and so they blasted away on the vox humana, attempting to turn the attention of burghers toward sacred matters while many of them were strolling amiably about the aisles, taking shelter from the rain, gossiping and doffing their hats to neighbors.[2] In better weather, when shutters were opened along the Keizersgracht or the Oudezijds Voorburgwal, light voices, countertenor or soprano, perhaps in emulation of Francisca Duarte, the "French [but actually Marrano] Nightingale," would float over the street, singing, in Italian or Dutch, of heartless shepherdesses and lovelorn swains, arpeggios skipping over the green canal water. Worse still, children, who knew no better, were being taught the lute, the dulcimer, or even the viol, and were sent to dancing masters to mince, caper, spring, and sway like the impenitent heathens of old Gomorrah.

Amsterdam not only wantonly delighted in this music, it manufactured it. Walk down some streets and you might hear the steady thudding of drum makers testing the tightness of their skins; others resounded with the

tremendous clanging of foundry sheds where the cast bells were hammered into perfect pitch. Relegated to the outer, eastern sections of the city or to the artificial islands that had been built in the IJ, principally for shipbuilding, other foundries cast the weapons of war. This was the clanging zone: hammers striking red-hot gun muzzles or beating strips into the pliable thinness that would wrap around another of Amsterdam's absolute necessities—casks and barrels, or tin hammered finer still into foil used for the spuriously "gilt" leather hangings that went on merchants' walls. And beyond the clanging and banging was sawing and rasping. In the Lastage, where vessels were assembled from separate parts sent down from the yards on the river Zaan, the saws were alarming instruments, sixteen blades working at once, operated by teams. But Amsterdam—with its urgent need for massive timber pilings to support houses in the boggy mud, for beams, and for chairs and closets, chests, buffets, and beds—was built on carpentry. The tavern floors would never run short of sawdust, and the sound of metal teeth rhythmically biting into wood could be heard almost anywhere in the city, even in the mournful enclosure of the men's house of correction, itself known as the Rasphuis, where the toughest wood of all—brazilwood—was chosen for the inmates' labors.

On the Sabbath, the delinquent and the idle would be preached at by a *predikant* whose voice was trained to rise and fall with the severity of his admonitions. Elsewhere, within the walls of other charity houses, orphans' voices chorused hymns or recitations from Scripture, and in the big barn-like churches of the city, obedient flocks attended to the *voorlezer* reading passages from the Bible from his own little stall, preparing the way for the theatrical moment when the preacher himself would mount the pulpit and, with the fire of Amos and Micah and Ezekiel and Paul and John the Evangelist filling his lungs with holy heat, bellow sulfurous imprecations at the stiff-necked transgressors for hours on end. From elsewhere in the city came different sounds of veneration. Behind locked doors, false walls, in cellars and attics, the chant of the Catholic Mass was sung in secret chapels; in rooms with bare plank floors and benches, with a small cupboard for the ark, a Hebrew *kedusha* was intoned, its responses inflected with the nasal ululations of Moorish Iberia.

Papists and Jews, Remonstrants and Lutherans were not the only voices over which the *predikants* struggled to make themselves heard. There were the chambers of rhetoric, the "Old Chamber" of the Egelantier, the Eglantine Rose, lodged above a butcher's establishment, where burghers who, according to the preachers, ought to have known better, strutted and boomed between pots of ale. And now there was a rival chamber, the Wit Lavendel, the White Lavender, which brought to its rooms Brabanders and Flemings. And now that men of notorious laxity were governing the city, who knew what kind of ungodly theatricals they might tolerate next? *Women* like the Papist Roemer Visscher's immodest pair of daughters were known to recite poetry and sing before admiring circles of dilettantes like common strumpets. The next thing would be to have *juffers*

brazenly walking the boards of Coster's theater pasted with ceruse and pink-face, giggling and flouncing their skirts above the eyes of the greedy and the depraved.

Out in the markets and exchanges, Amsterdam threatened to turn the new Jerusalem into the new Babel. Portuguese, Italian, Polish, German High and Low, Danish, Swedish, Turkish, Ladino, Spanish, Flemish, Friesian; greetings, complaints, inquiries, barters, insults, felicitations; the cries of street vendors; the bellowing of actors and storytellers; the solemn assurances of quacks; the shrieks of clowns; the carefully orchestrated oohs of crowds watching a tightrope-walker; the barking of penned hounds at the Monday morning dog market; the ugly chorus of crows roosting in the plane trees. Not such a quiet town after all.

Until, that is, the sudden drop of darkness, when the hubbub was muffled as if a black cloth had been thrown over a parrot's cage.

De Smaak

De gustibus non est disputandum. . . . In matters of taste there can be no dispute—not, at any rate, if your weekly wage was counted in stuivers, not guilders.[3] Then you woke with the night's thickness in your mouth and made it starchier still with a heel of rye bread moistened in a bowl of beer or sour milk. On the tables of the fortunate, the milk would be (relatively) fresh, the butter bright, the bread wheaten or made with semolina flour, the ale sharp with the tang of barley malt, and there might be a smoked or pickled cod, and a slice of ham on a pale earthenware platter.

Should life seem too sweet for a Calvinist palate, bitterness could be served with a *middags sallet:* wild chicory, purslane, burnet, borage leaf, *dent-de-lion,* buttercup, catnip, and calendula. Sharp enough? Then the sting on the tongue could be sweetened with a scattering of forget-me-nots and softened with a stream of melted butter. One would try to eat this as the books of etiquette recommended, without opening the mouth too wide, smacking the lips, licking or spitting on one's fingers, or packing one's cheeks like a rodent.

The afternoon meal was the time to taste one's fortune. Under the arches of the old city walls where the destitute camped (courtesy of the sheriff), it tasted rancid and moldy: a rind of cheese with a little something, left behind by the rats, to gnaw at; perhaps a smear of lard on a stale crust. In the old people's homes and in the orphanages where the wards of the city sat down, dressed in its colors of red and black, it smacked, satisfyingly, of respectable austerity: dried beans and peas, gruel and bacon. On the new *grachten,* it tasted of cornucopia: fish and fowl and fruit and greens: a pike's tail spit-roasted; a bream stuffed with its own roe and sharpened with mace, anchovies, and *verjus* of unripe grapes; a carp simmered in Rhenish, pinked up with its own blood, carefully reserved; a *pastei* of finches boiled with sugar and pine nuts before they were locked within a

golden crust. It also tasted of the sweets of empire. A favorite drink, *kandeel*, was a gift of the Indies: cinnamon, nutmeg, cloves, and sugar dissolved in a pot of wine. Calf's-tongue tart, another favorite dessert, needed sugar and ginger to make it even more appetizing.[4]

Grandmothers and great-aunts were old enough to remember when the "fine" vegetables—savoy cabbage and spinach, artichokes, salsify, and asparagus—found their way only to the tables of the rich. More modest burghers made do with the roots: turnips, parsnips, radishes, beets, and white carrots. Now they arrived in such profusion at the Groentemarkt that they were sold at prices the many rather than the few could afford. New varieties like the "underearth" (Jerusalem) artichoke had become widely available, and the carrots now came in many colors: not just the traditional bright yellow kind or the new orange varieties grown in the north near Hoorn, but purple and dark red as well.[5]

And however sated one was, it was virtually impossible to walk through the city and not have one's taste buds crying for mercy. There were two fish markets—freshwater by the bridge over the Oudezijds Voorburgwal, seafood in the great market on the Dam—and two meat halls with separate markets for game and fowl. For Amsterdammers were great birders and devoured their poultry from the spit on the hearth or baked in pasties and pies, now liberally peppered thanks again to the fleets of the East India Company. The tour de force of a great feast might be the famous pie of boned birds, each nesting cozily within the body of its bigger relative, so that the diner could chew his way from heron to lark (via swan, capon, wild goose, pintail, widgeon, shoveller duck, lapwing, pigeon, plover, woodcock, and snipe, the last with its innards removed, ground into fine paste, and then reinserted into the cavity), an entire aviary devoured at one sitting.

As the *predikants* tirelessly warned, gluttony would receive its just desserts. Amsterdam's sweet tooth, fed by its merchants' control of Brazilian sugar, was an ugly, cary-pitted thing. The rich attempted to stave off rotting molars with dentifrices composed of pulverized cuttlefish, coral, dried roses, and cream of tartar, and rubbed the saliva-moistened paste into the teeth with their fingers. And when the dull, ominous throb began to make itself felt and the cheeks to swell, they could apply oil of juniper or cloves against the inevitable day when an appointment with the surgeon's pliers could no longer be postponed. If the victim was (in spite of the preachers' warnings) a little vain about smiles, false dentures could be made from hippo-tusk ivory and fastened with gleaming silver wire.

Three or four days of feasting (the usual form) would take its toll on even the most devoted gourmand. And the purges and emetics tendered to those in gastric distress still came from the medieval pharmacopoeia and were literally bitter pills (and potions) to swallow, compounds of herbs and roots like licorice and sassafras, but not infrequently mixed with the kind of ingredients that all self-respecting purveyors of physics commanded: fresh urine, pulverized antler and coral, secretions from toads and newts.

The resulting concoctions were such that they could scarcely pass down the gullet without a helping of Amsterdammers' favored strong spirit—brandywine—so that the burn took away the instinct to gag.

And if the physic, however foul to the palate, did its work properly, why then the suffering Amsterdammer might swiftly be made fit to indulge once more the taste for *luxuria* in its two most alluring local forms: the hard bite of gold and the meeting of lips sweetened and softened with a drop of cordial.

Het Gevoel

It seemed like a city that worked hard to keep its edge. The grinders and sharpeners were never at a loss for custom. There were sabers and pikes, halberds and partisans, ice skates and picks, daggers and peat-diggers, razors and scalpels, saws and axes, all of which needed constant attention against dullness and rust. So fingers ran along the honed blades with knowing alertness, feeling for the slight pull against the skin, a stretch just short of a cut.

And yet Amsterdam was not all straight edges. The three new residential canals, the Herengracht, Keizersgracht, and Prinsengracht, looped gracefully round the old city core like a three-string necklace, and the gables that topped the handsome houses built along their banks had abandoned the stepped forms, with their faintly castellated air, for the flowing curves of a bell. Even when they remained right-angled, in "neck" gables, their lines were relaxed by curling scrolls and swags that made the limestone seem as soft as chalk.

Sharpness and delicacy, the tough and the tender, were always proximate. To remove cataracts, the surgeon-Tobiases of the city used needlelike tools with long, spirally twisted handles, often handsomely embellished, so that they could more easily turn the point to dislodge the hardened occlusion without rupturing the cornea. The engravers who kept their incising tools—the burin and the drypoint—keen did so so that they might, if the subject and mood called for it, create lines of velvety softness on the print. Pressing the drypoint into the yielding copper plate produced a grooved furrow, the edges of which formed minute ridges of displaced filings. If those ridges were left intact, on contact with the ink they would produce the soft and smudgy "burrs" that gave a fluid, voluptuous feel to the printed line. It was the same with the silversmiths. Johannes Lutma, the most inventive, understood the city's taste for irregularity and satisfied the demand with ewers and basins that were scalloped, lobed, and furled like the waves of the sea and the shells on its bed; metal that seemed to resist its own solidity, to have been frozen in fluid undulation.

With no call for statues of saints and apostles, sculptors were not much in evidence in Amsterdam, though chisels and mallets chipped away at ships' figureheads and the little reliefs that could be set into the façades of

houses or up on the gables. But fine fingering was needed everywhere in the city, nonetheless. Papermakers attempting to compete with the soft, doughy papers imported from the Orient ran their hands over the sheets to see if they had the absorbent density the most demanding etchers sought. In the textile guilds, syndics appointed to monitor quality control refused to trust entirely to the evidence of their eyes and carefully passed the camlets and damasks and grograms through their fingers, feeling for telltale knots and frays. Velvet weavers brushed their cloth with the back of their hands to feel the glide and the resistance of the nap. And those who supplied painters with panels and canvases needed fingertip confirmation that the oak surface or the warp and woof of the canvas would take up primer and pigment in the required manner.

The city's sensations were not purely manual and dextrous. Warming pans hung at the end of the curtained box beds to ease the entry of bodies into the linen on biting winter nights. Servants in the best houses saw to it that silk hose was properly rid of dampness and chill before smoothly sheathing the pale calves and thighs of both the master and mistress. And though the preachers had condemned the habit as the most unspeakable whorishness, Amsterdam was a city of pearls and diamonds, and strings of them were set about the neck of *vrijsters* so that they rested just so, between throat and bosom.

What could be tethered could also be loosed. At night, the necks of ladies and gentlemen were at last freed from their encircling ruffs: the fiercely starched millstones for the older generation; the softer *fraises de confusion* with their wavy pleats or lacy fallen collars for the younger. Imprisoning whalebone corsets and chest-hugging doublets gave way to the gentler embrace of house robes of taffeta and fur; boots and buckles to slippers and mules. And some way off (although not *that* far), in a whorehouse or a *musico,* a soldier would fumble sweatily with a girl's chemise while two pairs of hands would reciprocate his advances, one applying friendly pressure to his breeches, the other darting, quick as a mouse, in and out, a purse nimbly retrieved between finger and thumb.

Het Gezicht

What might be seen in Amsterdam? The wide world, naturally, and even more than that if one found an ingenious lens-grinder who might supply a telescope to view the endless, star-mottled heavens and the blotched moon discolored like a dish of moldy curds.

The city was full of neck-craning; a horizontal place that strained for the vertical. Timber cranes around the harbor were busy lifting mainmasts into position on the decks of great *retour* ships, East Indiamen, their forecastles and prows riding high in the water; or loading and unloading cargo into the little, lighter boats that would take the goods to the wharves. Some of the warehouses were many stories tall, and the merchant residences built

on Amsterdam's new rings of canals were themselves often six floors high, conspicuously loftier than their counterparts in Leiden or Delft. Their façades were crowned by gables, the newest faced in Bentheim limestone or sandstone, not just bells and "necks" but entire little temples complete with pediments and pilasters, caryatids, globe-bearing Atlases, and freestanding obelisks. Above the dormers, dolphins, and sailing ships rode the sky while masonry and plaster eagles and pelicans stared at them from the opposite bank of the canal. When a new line of fortifications was built to accommodate the three-canal city expansion, the old bastions, along with their gatehouses, became functionally redundant. But de Keyser and his associate the city builder Hendrik Staets decided to retain them as lofty belfries, northern campaniles, along with the names that gave them distinctive personalities: the Schreierstoren, named for the iron hooks, the *schreier* set into its walls; the Haringpakkerstoren, for the fish-salting done beneath its brick spire. When the Westerkerk opened its doors to congregations in 1631, its steeple was the highest structure in the Republic, some 283 feet tall with a golden crown at its top, the emblem of the heraldic crown said to have been granted to the city by the Emperor Maximilian.

There was nothing in the world that escaped the Amsterdammer's possessive gaze; not the beasts of the tropics—elephants and tigers from the Indies; capybara, tapir, and armadillos, the plated pigs, from Brazil; apes as little as a fist or as big as a soldier; and, most astonishingly of all, the bird that could not fly, the dodo, from Maurits-eiland, alive and wondrous ungainly, first put on show in 1626. Where entire live specimens were unavailable to the paying public, pieces of them likely to excite admiration were displayed, especially protuberances and excrescences like the penis of a whale and the horns of the great *renoster*, the rhino, and the spiral narwhal (so that the knowing could instruct the credulous that the *een-horn*, the unicorn, was, in fact, a fish). Pickled reptiles, especially immense coiled snakes and some indecipherably scaly object authoritatively certified to be a dragon's belly, could be seen at the Botermarkt (now the Rembrandtsplein), as well as abnormally colossal vegetables; fantastically shaped tumors; or living monstrosities like children joined at the hip, midgets and giants, Laplanders and Inuits who smelled (as Trinculo had already observed) more like fish than men, and Indians in breechclouts painted indigo and cochineal with their faces terribly pulled and pierced and their bodies heavily scored like scrimshaw—so far sunk into savagery, it was said, that their choice cut of meat was human thigh.

For those who flinched at the jostling of the unwashed, it was possible to see the world in the serenity of a library. Once, it was true, the world had been limned in Antwerp, when, so their elders told them, that city had commanded an empire that girdled the continents. But that was long ago. Now it was just a sorry lackey of Spain, full of monks and short of money. If you wished to see King Philip's American silver treasure, you had better come to Holland, where Piet Hein's ships had brought it captive three years before, in 1628. Once it had been Antwerp that had supplied Europe with globes and maps and charts and had provided mariners and geographers

with the limits of continents and the edges of the seas. No more. The Fleming Gerard Mercator now had his maps, collected in batches that he called "atlases," printed up by the firm of Hondius in Amsterdam, though he struggled to compete with the acknowledged master, Willem Jansz. Blaeu, who also made the beautiful and exact globes without which no gentleman could expect to be regarded as cultivated. With each subsequent edition, the maps brought new and unsuspected lands—like the mysterious southern *terra australis*—into view, as if under license from God to disclose the last secrets of creation. And if a *schipper* went to Blaeu, he could purchase the means to seek them out: besides the charts and maps, his guide to navigation and the latest optical instruments designed to figure position with unprecedented accuracy.

To see the earth's extent unscrolled, it was necessary to trace with a fingernail the edges of every archipelago and littoral surveyed by the Republic's distant captains, and sometimes the threading lines tantalizingly trailed away into open, oceanic indeterminacy. Those short of both imagination and patience could, if they wished, take in everything *tout à coup*, by holding the world entire in the palm of their hand, figured by ingenious carvers on a single nutshell or a cherry pit, or incised into the surface of a pearl. Passionate collectors of curiosities boasted mysterious pictures inscribed in nature without the least intervention of a human hand: a pastoral complete with cloudy skies and distant groves, all discerned in the patches patterning a moss agate or a bezoar, the creamy stones, like small moons, taken from the stomachs of ruminant beasts. Other patterns were of such wonderful intricacy and brilliance that they far exceeded the imaginings of men: shells as big as cats, mottled purple or umber on the outside, pink and furled on the interior like the entrance to a woman's body.

Anthonie van Leeuwenhoek had not yet invented the optical device that would bring an unimagined, teeming world of microscopic organisms into vision. But magnifying glasses strong enough to reveal the hairs on a whale louse's legs or the sprung segments of a scorpion's sting were already available to the first explorers of the microcosmos. One's eye might be set against the velvet edge of such a glass and find another eye staring dead back: delicately filigreed and cross-hatched, the alarmingly omniscient eye of the drone fly, or the little button-eyes of the crayfish and the crab, stuck out on the ends of stalks. And in a city that lived so much of the year in low light, there were bound to be those who dreamed of perfect lucidity: gem polishers who sought rock crystal so pure that they might make a sphere that would seem to emit, rather than absorb, radiance; spectacle makers who promised to give the most stumbling myopic the eyes of a lynx.

Twenty years after Amsterdam's grudging conversion to the Reformed faith in 1597, as the first Dutch ships were bringing grain and salt into the lagoon, a disaffected Venetian, Antonio Obissi, took the techniques of glassmaking from Murano to Amsterdam. The North Sea dunes provided him, and those who were instructed by him, with all the silica they could possibly want, and by the second decade of the seventeenth century Amsterdam glaziers like the former butter maker Jan Janszoon Carel were

turning out all kinds of products. Raspberry-prunted, hollow-stemmed *roemers*, colored green or gold by the addition of iron to the molten silica, now appeared alongside the more familiar pewter flagons. For more refined tastes, tall flutes and *bekers* designed to be held in place in claw bases by silver screws were available. Amsterdam glass could still never hope to compete with the most elaborate products of Venice and Nuremberg, but it brought glass to the middling sort. The narrow, deep façades of canal houses were now cut open, on three or four stories, by generous windows that admitted as much light as possible to their dim interiors. And for those who could afford it, the lightening effect was enhanced even further by a generous supply of mirrors, oval, round, or rectangular. For the first time, many of these mirrors were flat rather than convex, the glass ground to a degree of regularity that could accept a backing of tin or mercury. Hung from pins and rails, often canted forward a little to catch light from facing windows, these mirrors confronted, delighted, or disconcerted Amsterdammers with what appeared to be the truth of their own features. And though the *predikants* damned idle vanity as self-idolatry, it was difficult to resist one's own reflection, if only to adjust, by a slight touch, the tilt of a slouch hat or the drop of a necklace.

Ex tenebris Lux! An empire of merchants that saw the light, the first perhaps to eye itself quite plainly. But even as it admired or worried about what it saw caught in the glass, it knew that the image was deceptive in its apparent stability. In truth, it was as fugitive as if it had been spied from a bridge on the surface of the canal on a rare windless morning. To *truly* see themselves, and to have generations after them see what it meant to be an Amsterdammer, they needed the eye, and the hand, of the painter.

ii *Movers, Not Shakers*

Constantijn Huygens had told Rembrandt and Lievens that they really should go to Italy. So Lievens went to England, and Rembrandt went to Amsterdam.

Leiden was just too narrow a place to contain Rembrandt's ambitions. For all its paintings and patrons, it still had no Guild of St. Luke and would not get one until 1648. The lack of a guild meant that artists theoretically might have been freer to sell their work. But if Utrecht was the model, where a powerful dean might organize an informal syndicate of painters to undertake great court commissions, Leiden's informality might have seemed a disadvantage. Then again, Rembrandt might have gone to The Hague to profit from the connections Huygens had made for him at the Dutch court. But beyond the squares and avenues around the Vijver, The Hague was still, in its way, a small town. Amsterdam, on the other

Rembrandt, View of Amsterdam from the Northwest, *c. 1640. Etching. New York, Pierpont Morgan Library*

hand, was a metropolis, teeming, rich, and easygoing. When Rubens had been made a court painter, he had expressly chosen to stay in Antwerp so that he might paint for merchants as well as princes. Besides, great port cities like Antwerp and Amsterdam were magnets for pupils and apprentices. In Leiden, between 1628 and 1631, Rembrandt had had four paying pupils: Dou, Jan Joris van Vliet, Jan de Rousseaux, and the innkeeper's orphan Isaac Jouderville, the last of whom he may well have taken to Amsterdam. Already his studio must have been thought of as a workshop, perhaps specializing in *tronies* of "orientals," old folk, soldiers; low-life prints; and small histories. But the encounter with Huygens had changed his life. His histories and his ambitions got bigger.

And Pieter Lastman had not lost touch with his old pupil. He had continued to advise Rembrandt after he had returned to Leiden. Amsterdam was the place to make a name in the great world. The commission for the Danish court had proved that Utrecht did not have a monopoly on lucrative history assignments. Besides, every day another splendid house went up on the canals, its owners eager to have their likenesses ornamenting its rooms. All this said the same thing: Come to the money. Come to the beehive.

So he did. In Leiden he left behind a much altered family. The blind patriarch, Harmen Gerritsz., had been buried in the Pieterskerk in April 1630, followed eighteenth months later by the eldest of his children, Gerrit, who perhaps had never recovered from his accident at the mill. There were now four brothers left to take care of the family fortunes: Rembrandt; his two older brothers, Adriaen and Willem; and the mysterious younger

brother, Cornelis (address unknown). After Gerrit had become disabled, Adriaen had left his shoemaker's trade to become, once again, a miller, perhaps doing business with Willem, the baker and grain merchant. It was Adriaen who now took charge of managing the van Rijn household. The house on the Weddesteeg was now full of single women: mother Neeltgen, now in her sixties, and the two unmarried daughters, Machtelt and Lysbeth. After Neeltgen's death in 1640, Adriaen moved back into the parental house, but the family property had already been allocated so that if the women outlived the men (as so often happened), they would have enough independent means to survive. Some of that income would come from rents. In March 1631 Rembrandt bought a "garden" lot beyond the Witte Poort gate, a further fence against misfortune of the kind to be expected in Holland in the 1630s. By the time he decided to leave Leiden, toward the end of 1631, he need have no doubts that the family would be adequately taken care of.

To move from Leiden to Amsterdam in 1631 was more than a change of address; it was a passage across enemy lines. At the height of the toleration debate in the late 1620s, the major towns of Holland had become polarized into two bitterly unforgiving camps. Calvinist Leiden was still governed by staunch Counter-Remonstrants adamantly intolerant of Remonstrant assemblies, much less religious gatherings of Catholics. Though the Stadholder and the trading cities of Amsterdam, Rotterdam, and Dordrecht all now favored negotiating a truce with Brussels, the preachers in Leiden continued to describe such a prospect as spiritual and political treason. Proposals, especially from Rotterdam, that Hugo Grotius might now be amnestied and allowed to return made the soldiers of God apopleptic.

Amsterdam was, in every respect, a different universe. The Counter-Remonstrant domination of the town council had suffered a critical setback even before the death of Prince Maurice, in 1622, when its most militant spokesman, Reynier Pauw, was defeated in the elections for burgomaster. A year after the accession of Frederik Hendrik, the council had moved decisively away from Calvinist coercion with the election of Andries Bicker and Geurt Dircksz. van Beuningen to two of the four burgomasterships. Before very long, Bicker would become the godfather of the Amsterdam oligarchs: ruthlessness veneered with reason. But Andries Bicker, with his heavy jaw and long nose, was already the formidable head of a colossally rich mercantile family firm. He and his three brothers, Jacob, Cornelis, and Jan, had taken the brewing fortune they had inherited and turned it into a monstrous trading empire that divided the world into Bicker-colonies. Andries's share was Indian spices and Muscovy furs; Jacob's the breadbasket trade of Baltic timber and grain; Cornelis's the hot, drenched, and dangerous realm of American-Brazilian sugar; which left Jan, poor fellow, with Venice, the eastern Mediterranean, and a substantial shipyard. The Bickers were not, then, to be taken lightly. Andries, in particular, brimmed with contempt for the Calvinist zealots. They were the ones

whose hotheaded theocratic temper he held at least partly responsible for
the hard economic times that had befallen the city. No Remonstrant him-
self, he saw nothing wrong with allowing them private worship in their
own fashion, or even admitting Remonstrants to municipal office. The
business of Amsterdam was business. And it had no interest in ostracizing
men of substance and enterprise, nor for that matter honest Remonstrant
artisans, forcing them to take their dearly needed skills and capital else-
where. Sound minds already rued the day that the city had let itself be dic-
tated to by fanatics and mob-raisers. It was his work and those of like
minds to see that it never happened again. In the first years, Bicker, van
Beuningen, Jacob de Graeff, Anthony Oetgens, the hugely wealthy Jacob
Poppen (whom the preachers denounced as a virtual Catholic), and their
colleagues acted subtly, altering matters by *failing* to do certain things, *fail-
ing* to forbid offices to certain people.

The inner ring of councillors could hardly have expected the Guardians
of the Straight Way to stay oblivious to their circumventions. Nor did they.
The most violently wrathful of the Counter-Remonstrant preachers, Adri-
aan Smout, took the regents to task every week in the pulpit, denouncing
them as "libertines," "Mamlukes," and base hypocrites who pretended to
be loyal children of the Reformed Church even as they were in the process
of subverting it from within. They were worse than heretics or apostates;
they were knaves, "disturbers of Israel" who would lay waste to the holy
places of the Lord. In these all-out harangues, Smout was supported from
other pulpits around the city by his fellow Jeremiahs, Jacobus Trigland and
Johannes Cloppenburg.

As long as this was just a matter of words, Bicker and his friends
shrugged them off as if they were nothing more hurtful than children's
snowballs. But in 1626 matters took a much rougher turn. On Palm Sun-
day Smout preached an inflammatory sermon commanding those obedient
to the word of the Lord to rise up in indignation against the godless burgo-
masters and their henchmen. A riot duly followed, and two in the crowd
were shot during its suppression by the city militia companies. But the loy-
alty of those companies began to seem dangerously frayed, especially in the
lower officer ranks, where Calvinist fervor was strongest. When, in 1628, a
Remonstrant from one of Amsterdam's wealthiest families, the van
Vlooswijks, was appointed to replace a Counter-Remonstrant as captain of
one of the militia companies, a considerable number of the ranks and some
of the junior officers threatened to mutiny. The crisis was serious enough
for the city fathers to ask the Stadholder to make an appearance in Amster-
dam to calm the agitation. This he did, in the carefully staged company of
both a Remonstrant and a Counter-Remonstrant minister. But the perfor-
mance was neither convincing nor effective. It may, in fact, have pushed the
rebel militia leaders to take their case directly to the States of Holland in
The Hague, where they knew that the delegations of Haarlem and Delft
as well as Leiden would side with them. They argued that the government
of Amsterdam ought to be actively committed to defending the "True"

Church, not countenancing its corruption by all kinds of pseudo-Papists, and that they, the *schutters*, were the true voice of the people and should never be used to suppress righteous indignation.

This was a bad mistake. Frederik Hendrik was not interested in hearing from jumped-up corporals and God-knows-who presuming to lecture him about the Rights of the People and the ways of righteousness. Instead of supporting the *schutter* leaders, he sent troops to Amsterdam to arrest them and purge the ranks. Henceforth, matters in that city would be left to the good Lord and to Andries Bicker (who certainly seemed to have a sound working relationship with the Almighty). In January 1630 he and his colleagues on the council, the *vroedschap*, decided, after a particularly violent outburst, that they had had enough of *predikant* Smout. He was banished from the city, and with him in protest went Trigland and Cloppenburg, all of which suited the burgomasters very well. In future, they or their representatives sat in on meetings of the Church consistory to guard against inflammatory statements or action. It was seldom necessary for them to say anything at those meetings. Their presence, hands folded, tight-lipped, hats on head, was warning enough.

Where did the militant ministers go? To Leiden, naturally, where the council, like its counterpart in Haarlem, acted in calculated defiance of Amsterdam, enforcing the ban on Remonstrant assemblies with greater severity than ever. The polarization between the two cities could not, then, have been more extreme. They represented diametrically opposite views of the political and religious nature of Holland: on one side, single-minded, orthodox, belligerent; on the other, pluralist, heterodox, pragmatic. And Rembrandt, as we have seen, was much inclined to variousness.

Not that his family was, or had become, formally Remonstrant. His father and brother Gerrit must have at least outwardly conformed to the orthodox Reformed Church since they were both buried in the St. Pieterskerk. But his mother's family remained Catholic, and Rembrandt himself certainly associated with notorious Arminians like Petrus Scriverius. By the time Rembrandt arrived, the power struggle in Amsterdam was over. In 1631 a Remonstrant church had opened its doors for public prayer for the first time since the upheaval of 1618. There were (at least by the count of appalled Calvinists) *forty* secret Catholic churches around the city. There was also a Jewish prayerhouse, not quite yet a synagogue; and places that would be left undisturbed for Lutheran and Mennonite services. Rembrandt's first wave of patrons and sitters included members of all of the above confessions, including Catholics, and for four years he would lodge with one of the best-known Mennonites in the city, the art dealer Hendrick van Uylenburgh.

There were countless other ways in which the tolerant regime, which all but waived the right to censorship, transformed Amsterdam's culture. The city's college of higher education, the Athenaeum Illustre, was instituted by the "libertine" councillors expressly as an alternative to Leiden University, which after a tremendous struggle consented to its foundation on condition that whatever-it-was did not refer to itself as a "college,"

"academy," or "university." Its first two professors, Gerard Vossius and Caspar Barlaeus, were the two most famous Remonstrant exiles from the Leiden faculty who had remained in Holland. On its inaugural day Vossius lectured on "The Use of History," addressing himself as much to his Leiden antagonists as to his distinguished audience. The following day Barlaeus, who would specialize in custom-designing Latin rhetoric for the commercial classes, spoke on the subject dearest to the hearts of the Bickers, Poppens, Oetgenses, et al.: *mercator sapiens*, the wise merchant.

No work more emphatically proclaimed Rembrandt's adoption into this community of tolerance than his heroic three-quarter portrait of the patriarch of the Remonstrants, Johannes Wtenbogaert.[6] Before the disaster of 1618–19, Wtenbogaert had been adviser to Oldenbarnevelt, but also personal preacher to the Stadholder Maurice and tutor to his half brother Frederik Hendrik, evidently making more of an impression on the younger than on the older prince. To avoid the fates of Oldenbarnevelt and Grotius, he had fled to France only to return in 1625, when his princely student had become Stadholder. Wtenbogaert quickly made it apparent, however, that he had no intention of leading a quiet life. He decided to live in the thick of the political action in The Hague, and, with Simon Episcopius, he became once more the leader of a reinvigorated campaign for tolerance. Rembrandt painted him in April 1633 when he was visiting Amsterdam for a few days, at the request of his host, a wealthy Remonstrant merchant, Abraham Anthoniszoon, whose daughter was marrying the son of the late revered Arminius. It was an occasion, then, to do both the man and the cause proud. Wtenbogaert would have been well into his seventies, but Rembrandt depicts a man still vigorous, imposing, even combative. Above all else, the pose, with one open hand pressed against the heart and another clasping a pair of gloves (a conventional emblem of fidelity), is meant to suggest honesty and unswerving loyalty, two characteristics even his enemies might have conceded to Wtenbogaert. Loyalty to what? The answer is, of course, supplied by the book.

Presumably it is a Bible, although Rembrandt, as was his practice, makes the script illegible. It is, however, brilliantly lit, as is Wtenbogaert's face: the philosophically prominent temples and the extraordinarily challenging, book-worn eyes with their suggestion (a dab of carmine) of exhausted eyelid-rubbings; their every wrinkle and frown line, like tree rings on an indomitable oak, the score of endurance. Even though Rembrandt could only have had the briefest time to sketch in the essentials of his sitter—and may in fact have left some details, like the lower right hand, to a pupil—the composition is constructed with prodigious cunning without ever seeming laborious. The ruff rising over Wtenbogaert's chin draws attention to the strong set of his jaw and mouth, while the cast shadow falling on the other, left inner surface of the ruff suggests movement, the head abruptly turned to confront the beholder. Even the slightly awkward arrangement of the space in which the book and hat rest on a table has the effect of propelling the subject forward. It is, in other words, a treatment which belies any notion of venerable frailty. Instead Rembrandt provides

Rembrandt, Portrait of Johannes Wtenbogaert, *1633. Canvas, 130 × 103 cm. Amsterdam, Rijksmuseum*

an image of the thinking man as hero, marked, but not at all damaged, by his tribulations: the contemplative and the active life united in a rugged frame.

By the time he got to paint Wtenbogaert, Rembrandt was already a master of portraits that said "dynamic, yet thoughtful." For he had quickly discovered that this was a pose favored not just by intellectuals and divines but by the hard-boiled captains of commerce who dominated the Amsterdam patriciate. He had arrived in 1631 when they were savoring their successes and congratulating each other on their godly good fortune, prodigious common sense, and proven political intelligence. They were also keenly interested in exhibiting their good taste, notably in likenesses of themselves, and fancied themselves quite distant from their forebears, who had traded in the humdrum ordinaries of daily existence: fish, grain, timber, hides, and beer. Their warehouses were stocked with the conveniences rather than the necessities of life: silks, furs, velvets, diamonds, wine, spices, and sugar. And they were rich beyond the most fantastic dreams of their grandfathers. In 1631 the ten wealthiest Amsterdammers counted

their fortunes in *hundreds* of thousands of guilders. Many had taken a commercial fortune and multiplied it by the judicious and timely acquisition of real estate. They had owned lots on the edge of the city which—mirabile dictu—had suddenly turned into priceless building lots when Amsterdam's limits expanded. And they had bought worthless bogs and inland seas in the Noorderkwartier north of the city, invested capital in pumping bills, converted wetland to dry, and then sat back and waited while the new land appreciated to four or five times its purchase value.

Everywhere you looked, there was evidence of the raw self-assurance of its ruling oligarchs. More remarkable to Amsterdammers than the unnoticed arrival of Rembrandt van Rijn would have been the publication in 1631 of Salomon de Bray's folio volume, the *Architectura Moderna*. Consciously modelled on the building books of the Venetian architects like Serlio, and perhaps even on Rubens's compilation of Genoese palazzi published in 1622, de Bray's handsome work was ostensibly a tribute to the most prolific and inventive of Dutch architects, Hendrick de Keyser, who had died eight years earlier. But it was impossible to praise the man who had reinvented vernacular and church buildings in Holland without simultaneously advertising the splendor of the houses in which the richest Amsterdammers lived. The book carried with it the strong implication that, brick-fronted and gabled though they still might be, these were more than mere merchants' houses. They were the first Dutch palazzi. And the impression of magnificence would have been reinforced on the Keizersgracht, right opposite the gleaming new Westerkerk, which held its first public services on Pinksterdag—Pentecost Sunday—1631. On the bend of the canal, another on the "ten richest" list, Balthasar Coymans, had the daringly classicizing architect Jacob van Campen build a true urban palazzo for himself and his brother, faced in stone and topped with an elaborately ornamental gable.

The outside of such mansions spoke of the refined pretensions of the new patriciate, expressed in the swags and scrolls and scallops festooning the upper stories. On the inside, their sense of civic indispensability (just this side of hubris) was supplied by portraits.

The poet Charles Baudelaire memorably described portraits as "models complicated by artists." In fact, portraits are a *three*-way negotiation: among the sitter's sense of identity; the painter's *perception* of that identity, which may be mischievously or creatively imaginative; and, finally, the social conventions that the portrait is expected to satisfy.[7] In seventeenth-century Holland, it goes without saying, artists were required to supply a good likeness of the sitter. But despite the common use of the term *conterfeitsel* (counterfeit), which to a modern ear suggests a replica, portraits, if only by virtue of their two-dimensionality, could not possibly be pure copies of an original. As it was, iconoclastic preachers pointed to the sacrilegious arrogance of artists presuming to violate, as it were, God's copyright over His creation. Even the artists who gave little thought to such matters assumed that a "likeness," however seemingly close to the features of a sitter, would be something other than a facsimile.

That "something" was supposed to be a visual distillation of the essential personality of the sitter. Before the Romantic period, this persona was a social, rather than a psychological, construction—a gentleman, a soldier, a scholar, a husband, a landowner. And these qualities were to be conveyed through pose, gesture, demeanor, costume, and attributes: a sword for a gentleman; a book or classical bust for a scholar. Yet even before the flowering of the modern culture of personality, portraitists were also asked to represent *something* of the sitter's distinctive humor: flamboyant or contemplative; demure or courtly. To attempt this, of course, meant risking producing an image that failed to correspond to the features that the sitter imagined he spied in his new Amsterdam tin-backed mirror. Understandably, then, the artists who dominated the portraiture market in the city before Rembrandt by and large restricted themselves to a narrow range of expression. When asked to paint the portrait of a prominent figure, artists like Cornelis Ketel or Nicolaes Eliaszoon Pickenoy began with the formulaic type (hand on hip for the gentleman; another hand at the hilt of a saber for the soldier) and then attempted to individualize the portrait through a mildly expressive treatment of face or hands, aiming to bring physiognomy and pose together in an idealized whole. Very often, in fact, the most successful of such artists had their assistants and students paint in background architectural settings or interiors and the bulk of the body, economizing their own efforts by supplying hands, face, and perhaps strategically important framing elements of costume like the ruff or cuff. Assembling a portrait in this way was much like assembling a ship from the parts (hull, masts, sails, anchors, and rigging), all made in separate workshops in towns on the river Zaan and then put together in the Amsterdam shipyards.

Perhaps it was boredom with this kind of mechanical production that led Cornelis Ketel to astonish his patrons by producing brushless portraits executed entirely with his bare fingers, or in some cases, if we are to believe the sober van Mander, with his *feet*. Despite Ketel's fancy footwork, most of the portraits turned out in the first two decades of the century are statuesque in posture and contained in their gestures. Which is probably just what that generation of Amsterdam patricians wanted: nothing reprehensibly flashy; sober costume relieved with an occasional touch of color supplied by a bloom in the hand or a gem at the throat. By 1630, however, the inclination of the canal-house oligarchs was for a slightly bolder immortalization; something that better matched their conviction that they were the rulers of the new Tyre, the commanders of the world's goods.

What manner of styles was available for this bolder, grander kind of portrait? In Haarlem, Frans Hals had been painting the local patricians and militia officers with a painterly freedom and brilliance of color that had never before been seen in Holland. They were fleshy and exuberant, painted so dashingly and lit so sharply that even the doughiest model seemed to be leavened into vitality. But while we recognize the universal quality of Hals's élan vital, in 1630 it probably seemed merely the best specimen of a parochial Haarlem-style, one that owed a lot to the anima-

tion and immediacy of Hendrick Goltzius's pictures and to the earthy and rumbustious manner of Judith Leyster and her husband Jan Miense Molenaer. The Hals style certainly appealed to some Amsterdammers, since they would commission him to paint one of their militia companies.[8] But it's not hard to imagine the plutocrats who now disdained the bulk for the "fine" trades considering Hals's brassy ebullience as fit for the brewers and linen bleachers of Haarlem, but not for what they supposed to be their own more elegant fashion.

If Hals was bolder, not grander, Anthony van Dyck was grander, not bolder. And unlike Hals, he would have been thought of in Amsterdam as the epitome of high portraiture, less Rubens's pupil than his successor, a specialist in extravagantly elegant full-length figures where the superficial informality of the heads, complete with delicately ruffled locks, was meant to suggest its opposite: the studied nonchalance that signified gentility. The costumes were given the grandest treatment, flowing and furling as if they were the banners of cultivation. And the hands, as always in van Dyck portraits, were miracles of graceful attenuation, like pale blooms drooping from slender stalks. Since van Dyck's presence in The Hague, it would have been known that he had added Dutch figures to his album of drawings intended for the printed pan-European *Iconography*. Nothing could have been a surer sign of the fitness of the Republic's patriciate—and their artists—to stand alongside the grandees of princely and aristocratic society. It was time that they too were figured between Corinthian columns, or standing dressed in shining silks, sleek hounds at their sides.

And van Dyck had included in his pantheon those painters he presumably thought best adapted to this high portraiture: van Mierevelt, of course, but also Jan Lievens. Lievens had left Leiden *after* Rembrandt had departed for Amsterdam, which might suggest that once their competitive collaboration had been broken, he needed to find a distinctively different painterly milieu. Perhaps he might have been stung into seeking his own court patronage after Rembrandt's conspicuous success at placing his *Descent from the Cross* with the Stadholder. In the glossy, self-regarding, poeticizing world of the Stuarts, he must have thought he had found his golden opportunity. And though little is known in detail of Lievens's three years in England, it's evident that he had chosen a drastically different society than Rembrandt: the most refined aristocratic culture in Europe, one that had astonished Rubens with the sophistication of its connoisseurship. The most spectacular of van Dyck's Stuart portraits are, of course, gorgeous lies, Titian brought to the shires: the cosmetic makeover of nondescript faces and bodies into idealized pastoral and classical beauties; lissome figures languidly draped about lengths of veined travertine, ringlets curling over their brows and down their necks; loosely clad in liquidly flowing satins, their eyes dark, lips moist and unnaturally crimson like the inside of a wound, glaring against complexions deadly pale and laid in with the faintest color as if painted with pulverized opal. And they are supported, in the Venetian idiom, by delicately golden landscapes, ennobling classical columns, purebred fine-muzzled dogs, and high-hocked steeds.

This was evidently too much of an embarrassment (as yet) for the likes of the Bickers and the de Graeffs. But Lievens seems to have been seduced by the sheer spectacle of the van Dyck manner, as perhaps he was by the not inconsiderable elegance of the man himself. It paid off. Lievens was introduced to the orchidaceous circle of the Stuart court and, for a while at least, became one of its painterly glamorists.

So the respective paths of the two Leiden friends and rivals had diverged about as completely as they could. Rembrandt was making his reputation among the hard-boiled Amsterdammers, attempting to portray them as men in action. The first requirement of a successful court portraitist in England, on the other hand, was the ability to portray men and women doing absolutely nothing and doing it beautifully. And when commissions in England ran dry, by 1635, it was not to Holland that Lievens returned, but to Antwerp. Rembrandt had merely purloined Rubens's pose and dress, the better to advertise the distinctiveness of his own credentials; Lievens had decided to become Rubens's neighbor and acolyte, perhaps hoping to fill van Dyck's shoes while that artist remained in England. To some extent he must have succeeded, since Lievens painted a large altarpiece for the most demonstrative Counter-Reformation church in Antwerp, the Jesuit St. Carlo Borromeokerk, designed, partly by Rubens, to resemble the Chiesa Nuova, and with a majestic sequence of ceiling paintings, also by Rubens. Even Lievens's most unorthodox work in Antwerp—his startlingly expressive woodcuts—owed their origin to a Rubens connection, the woodcut prints made by Christoffel Jegher after the Flemish master's paintings.

In 1638 Lievens married Susanna de Nole, the daughter of a prominent sculptor, Andries Colijn de Nole, whose major work was the decoration of the Catholic churches of the city. It was a fateful moment in his career. The embroiderer's son had decided to dissolve his own considerable originality within the expansive world of the Catholic Baroque. On the terms of aristocratic and Catholic culture, he would enjoy some success and reputation (though less than he hoped). But he would never again paint with the audacity and emotional force he had shown in the best of his Leiden paintings, like his *Job on the Dunghill* and *The Raising of Lazarus*. When the time came for Lievens, a decade after Rembrandt, to move to Amsterdam, it was on other people's terms since he was escaping his creditors in Antwerp. In Holland he continued what he had begun in 1632, when he had left for London: a cool and courtly manner; bulkily imposing histories and stonily elegant portraits.

This was not Rembrandt's way. For Rembrandt, Amsterdam was not a fallback but a main chance. Just as the laureates of Amsterdam sang its praises as the new global emporium, evidently the "next" Antwerp, yet making its own distinctive way in the world, so Rembrandt seized the opportunity offered by its patronage to do something other than imitate Rubens. Specifically, he would excel in a genre which Rubens had largely given up on: portraiture. He would make it as prestigious and, doubtless important to him, as lucrative as history painting. He would pose the

burghers of the city three-quarters, even full-length, giving them the grandeur of Italian or English aristocrats but without the vanity. And then he would charge them a hundred guilders per piece.

He would reinvent the form. And he would do so by investing these big portraits with the dynamism and energy of history paintings. Throughout his career, Rembrandt would make it difficult for art historians to know whether to classify a figure study like the spectacular *Man in Oriental Dress* in the Metropolitan Museum as a portrait, a history, or a *portrait historié:* a commissioned likeness of an individual got up as a character from Scripture or mythology. This is because he was consciously engaged in dismantling the barriers separating the genres. The figures in his histories were given the recognizable immediacy of men and women in the street (which, of course, they often were), while portrait subjects were invested with the urgency and energy of characters caught in a personal drama—their own.

Rembrandt, Man in Oriental Dress, *1632. Canvas, 152.7 × 111.1 cm. New York, Metropolitan Museum of Art*

Dramatizing the humdrum was an approach that decisively separated Rembrandt from more conventional portraitists like Nicolaes Eliaszoon and Thomas de Keyser, who had made a living from lending their patrons an air of statuesque solidity. Rembrandt did, in fact, adopt many of their standard working procedures: figures posed crisply against a neutral gray or brown ground, dressed relatively plainly with little or nothing in the way of background props. But he turned all of these routine features into kinetic techniques designed to free the figures from any kind of entrapment inside the picture space, and instead thrust them forward toward our attention. The lighting is aggressively uneven, travelling from spotlit intensity, through sharply cast shadows, into hollow obscurity. The ground, which in lesser hands is merely a kind of nondescript backdrop, Rembrandt builds from layers of thinned, almost transparent gray-brown paint, most radiant at the edge of the head and body, and steadily darkening as it moves toward the edges of the painting, suggesting the eternities of space against which the sitter stands or sits, making his or her mark. Imagine such paintings hung in the entrance hall or over the mantel of a patrician house. They would have the force of a living presence even after the sitter was long dead.

Which was the case with Nicolaes Ruts, probably Rembrandt's very first commissioned portrait, executed in 1631, his first Amsterdam year. It was a jaw-dropping debut, arguably the most perfectly realized of all his portraits of the 1630s, and presumably a painting that had prospective sitters flocking to his door on the Breestraat.

At its center is one of his most spectacular demonstrations of *stofuit-drukking*. Rembrandt had already been perfecting this skill in the best of the Leiden histories like the *Samson and Delilah*, but it never counted for as much as in this commission. For Nicolaes Ruts is literally wearing his stock-in-trade: sable. It would be good to imagine Rembrandt using sable-hair brushes to produce the sensuous impression of this softest and most precious of furs, but however he managed it, the illusion is spectacularly convincing: on the velvety surface of Ruts's hat; the individual hairs on his right sleeve shown standing up, as if freshly brushed or stroked, through a

series of minute white lines; the varied thickness, color, and glossy softness
of the fur on his shoulder and down the length of the coat, suggested by
touches of ocher that seem almost combed rather than painted into the pre-
dominant brown. It is as though Rembrandt, who all his life relished the
sensuous pleasure of fabric, retained a precise recall of the tactile experi-
ence of his fingers roaming through the softly enclosing fur even as he
applied the paint.

No fabric of any kind—not Persian silk, not Indian calico, not French-
worked damask—was more precious than sable. Ruts's long tabard is
trimmed with the fur that was used by the Muscovite tsars as diplomatic
gifts and treaty-sweeteners. It had ingratiated them with the Stuart court,
pacified the Mongol khanates, and flattered the Ottoman sultans. And yet
for all the unparalleled magnificence of the coat that sits on the shoulders
of the fur trader, Rembrandt has managed to avoid the least impression of
vanity or idle opulence. On the contrary, with his brilliantly lit face, sharp
eyes (almost as sharp, indeed, as those of the animals from whom the pelts
were taken), and fastidiously combed whiskers, his head slightly inclined
and turned *against* the direction of the body, which is itself stopped in a
three-quarters turn, Ruts's glance is that of a slightly impatient, edgy intel-
ligence, angled diagonally away and past the beholder. He is the epitome of
the entrepreneur-as-man-of-action—not a complete fiction, since the Mus-
covy fur trade was certainly one of the more heroically risky of the "fine"
trades.[9]

Though it could yield fabulous profits, the fur business was not for the
faint of heart or tight of wad. The White Sea approaches to Arkhangel'sk,
the great fur entrepôt, were ice-free only during the summer months, from
late June to the third week of August. The voyage from Amsterdam, with-
out mishap, took four to six weeks in ships specially designed to withstand
the rigors of the Arctic and to carry the maximum cargo. Though it had
been the English who had first opened up the domestic Russian trade for
export through the White Sea in the 1550s, it had been the Dutch who had
asked for Arkhangel'sk to be built at the mouth of the Dvina River, as a safe
haven from Norwegian pirates. By the second decade of the century, it had
become a virtual Netherlandish colony, and all other European traders
were being outspent, outorganized, and outshipped by the Dutch. Amster-
dam dealers retained resident agents in Arkhangel'sk through whom huge
sums of coin were routed to buy up advances of the next winter's stock of
sable, marten, ermine, wildcat, mink, wolf, arctic fox, and even squirrel.
And since Amsterdam now virtually controlled the freight trade in all the
manufactured articles wanted by the Russians—needles; sabers; church
bells; saffron; whale fins; dyed woollens and horsecloths; mirrors; writing
paper; pewter tankards and glass goblets; pearls and playing cards; incense;
tin and gold foil—it was in a position to dominate the international trade.[10]
By the time Nicolaes Ruts posed in all his sable-swathed glory for Rem-
brandt, Dutch merchants were sending thirty or forty ships each year to
Arkhangel'sk. What the Amsterdammers and Dordrechters didn't want—

like the young sables that had gorged themselves on a particular type of
Siberian berry that punished them with an irritation that made them
scratch their fur against the bark of trees—the Germans and the English
and the Greeks were welcome to. But if they advanced so much cash and
goods to buy the cream of a future year's pelts, their competition had
nothing to do the next summer except lament that there was nothing to
buy. Conversely, when a Russian dealer, Anton Laptaev, had the temerity to
try to sell his pelts direct in Holland, he was confronted by a prior no-
purchase agreement among the Amsterdam merchants that forced him to
take the furs back to Russia and sell them on the usual terms.[11]

Nicolaes Ruts had been born in Cologne in 1573 into a family of Flem-
ish exiles. The chances were, then, that his family knew the Rubenses—and
perhaps their story. Unlike the Rubenses, though, they had remained faith-
ful to the Reformed Church. Nicolaes was raised as a Mennonite but had
become a member of the orthodox Reformed Church, perhaps to ease his
way into the brotherhood of the thirty-six who made up the furriers' guild
in Amsterdam. He was not, however, among the big players. He could
hardly have competed with the Bickers and the Bontemantels, and he did
not yet have his own warehouse on the quays of Arkhangel'sk. Most likely
he was a partner in one of the *rederijen,* or syndicates, that put their capital
together for a specific voyage and then divided the profits according to their
shares. It was just because he was among the smaller dealers that he doubt-
less wanted an image from Rembrandt that would make him seem almost
regal in his command of the business; hence the unusual choice of a timber
for the panel support: precious mahogany rather than dependable oak. And
it was part of the promotional nature of the image that it posed Ruts as a
man of sound credit, exemplified by the note or letter that he grasps securely
with his left thumb. Once again, the script is indecipherable, Rembrandt
avoiding the vulgar literalism of details for an impression of the dependabil-
ity of Ruts's word and bond. The right hand, too, resting on the corner of a
table, placed parallel to the picture plane and between Ruts's body space
and our own, reinforces the sense of trustworthiness and security. These are
large, firm hands into which one might surely commit one's capital.

Or so Nicolaes Ruts wanted someone to believe. Was that someone
perhaps Russian? For in November 1631, precisely when Rembrandt
painted the portrait, a Muscovite embassy had arrived in Holland. Sybrand
Beest painted them at the Binnenhof in The Hague dressed in their long
coats and high fur hats, a good insulation against the Holland damp. The
nobles on such delegations were notoriously partial to all manner of gifts
(which, it must be said, they always returned in Muscovite luxuries). Was
Ruts trying to impress himself on the Muscovites as someone rather more
important than he in fact was; someone who merited an establishment at
Arkhangel'sk, perhaps with the special customs exemptions that the biggest
merchants already enjoyed?

If the portrait was meant to play any part in Ruts's business fortunes, it
failed to have the desired effect, since notwithstanding all the allusions to

his soundness, some months before his death in 1638 he was obliged to file for bankruptcy. Well before that date, the painting had passed into the house of his daughter, Susanna, for whom, it's been speculated, the painting might have been executed as a gift on the occasion of her second marriage. And despite Nicolaes's problems, his son did, in fact, succeed in opening a factory-warehouse in Russia. So Susanna could loyally hang the great painting in a prominent place without too much embarrassment.

And why not? For the word which seems to sum up the entire work is *confidence*: the decisiveness of the painter neatly transferred to his subject. Here is a man whose body fills the space but whose face is alive with commercial acumen.[12] As he was to do in all his strongest portraits of the 1630s, Rembrandt has used different techniques of brushwork to suggest the different, but complementary, qualities of the man: his energy embodied in the free and brilliantly lit treatment of the ruff, the fashionable *fraise de confusion,* and in the extremely free and thick painting of the right cuff, gray and white strokes laid rapidly over a gray underlayer. His fastidiousness is registered in the precisely rendered whiskers, mustache protruding over the upper lip, individual hairs quite deeply gouged into the panel with the back end of the brush. Thoughtfulness is suggested by the deep shadow cast by the side of his head and the catchlights dancing in the pupils between slightly pinked inner eyelids as though Ruts had sacrificed his sleep for the good of the investors.

No wonder J. P. Morgan bought the picture. For if there has ever been a better portrait of the businessman as hero, there certainly has never been one that achieved more spectacular results with such apparent economy of means.

Apparent is the operative word here. A superficial economy was often forced on Rembrandt by his Protestant sitters' aversion to the kind of drapery, magnificent costume, and grandiose architectural detail acceptable in court and Catholic portraits. Ostentatious plainness was an especially compelling virtue among the Mennonite community of Amsterdam, who supplied some of Rembrandt's earliest and most important patrons since his partner and landlord, Hendrick van Uylenburgh, was himself a Mennonite. Marten Looten, for example, whose portrait was painted in 1632, was another Flemish émigré, a cloth merchant like those Rembrandt had known in Leiden, but one who had actually converted from orthodox Calvinism to the more exactingly austere and scripturally saturated Mennonite faith. Ostensibly, then, Rembrandt had little to work with, yet managed to transfer an astonishing richness of interest onto elementary details, like the delicately looped edge of Looten's linen collar, used (like Ruts's sable-trimmed tabard) as much as an attribute of character as of a profession, and the sympathetic visual rhyme established between the crease in the brim of his hat and the gentle frown marks lining his brow.

Rembrandt's economy of eloquence was of a piece with his approach to history painting, where he had already stripped away the clutter of detail distracting from the essential core of a narrative. In portraiture, the rejec-

Rembrandt, Portrait of
Marten Looten, *1632.
Panel, 91 × 74 cm. Los
Angeles County
Museum of Art*

tion of elaborate ornament allowed him to concentrate the awesome arsenal of his techniques on what really mattered: the summation of character through body language and the illumination of animated faces and hands. Costume is no longer treated decoratively, or painted with indiscriminate evenness throughout the picture. Instead Rembrandt isolated certain elements—ruffs and cuffs, of course, but also hats, buttons, bonnets, and gloves—and made them expressive elements of personality: exuberantly dramatic or contained and demure, as the occasion required.

So while all the strongest portraits of the 1630s have the air of spontaneous freshness, they are, even when finally executed at dashing speed, the result of fine calibrations of pose, pigment, and lighting.[13] Rembrandt's flesh tones, for example, are constructed from a wide range of colors, from carmine reds to dense yellow ochers and even shades of green, and are laid down with an amazing sensitivity to the differential wear and tear of age on different parts of the face. No one among his contemporaries paid anything like the same detailed attention to the topography of a middle-aged upper eyelid; the oiliness of a prosperous nose; the overlapping folds of a jowl or wattle; the wateriness of the eye's vitreous membrane; the shiny tightness of a forehead pulled back into a linen cap. Nor did any of his contemporaries take so much care to register the subtle reflections that would be cast by lit areas of the face on unlit areas like the underside of the nose or jaw.[14]

Though it's difficult to avoid the impression that no painter of his century looked at the human face harder, longer, or more observantly than Rembrandt, his painstaking face-mapping was never done in a spirit of physiognomic pedantry. Though his heads and bodies are rendered with utterly convincing precision—that is, they seem in some undeniable sense to have the look of vital *truth*—they are seldom described literally, by sharp-edged lines and contours. On the contrary, only Frans Hals approached the freedom and versatility of Rembrandt's brushwork; in some places applied in short, dashing, dabbed marks, in others with long, fluent arabesque curves. What he was after, of course, was not some sort of additively built-up delineation, a composite of physical features as in a police profile, but rather a decisive illumination. Paradoxically, then, Rembrandt's most powerful works, like the *Portrait of an Eighty-three-Year-Old Woman* in the London National Gallery, have the force of extreme clarity even when their technique is most audaciously loose and suggestive. For that clarity occurs in the vision crystallizing in the painter's mind as much as in the dexterity of his hand. To look, for example, at the brilliant evocation of the translucent fine lawn fabric of the bonnet's "wings," their edges painted with a single bravura stroke, the brush turning in his hand as he completes it, or the

detail of the woman's right eye, is to see a painter marrying the fastidious exactness of the miniaturist to the exhilarating freedom of a modernist. In one incredibly complicated passage, a fleshy fold of the eyebrow overhangs the upper eyelid, which itself droops slightly to reveal the root ends of the eyelashes, all of which is described by an astonishing thicket of jabbing strokes, some fine, some coarse. The effect of slightly unfocussed melancholy that comes from this moist and weaker eye being set on the brighter side of the face is crucial to Rembrandt's effort to create, through the slightly downcast gaze, a mood of poignant venerability. And this painter knew instinctively what would become a modernist platitude: that the sketchier and more suggestive the hand, the more potent its invitation to sympathetic projection.

Rembrandt, Portrait of an Eighty-three-Year-Old Woman *(Aechje Claesdr.), 1634. Panel, 71.1 × 55.9 cm. London, National Gallery*

Rembrandt, Portrait of
Joris de Caullery, *1632.*
Canvas, 102.2 × 83.8
cm. San Francisco,
M. H. de Young
Memorial Museum

Though there is an unusually strong hierarchy of importance operating within the details of Rembrandt's portraits, *all* the elements, however broadly or tightly painted, needed to be resolved into a single coherent image if the impression of a living presence was to be sustained. This was more than merely a matter of reconciling different manners of brushwork. To work properly the portrait needed an *allover* quality apt to its subject—what might be called the "atmospherics" of the work, akin to the tonal mood established in landscapes by the predominance of warm or cool colors. The portrait of Marten Looten, for example, is dominated by a cool and clean air exactly right for the pious Mennonite cloth merchant, whereas *Joris de Caullery,* the portrait of the marine soldier gripping the stock of his small musket, is bathed in a warmer, more bronzed light that encourages the slightly theatrical martial pose of the figure to stand forth. Some of the desired effect could be realized by slight but decisive alterations in the composition of the thin layer of imprimatura Rembrandt laid over his initial white chalk ground. For the most part, this was an oil mix of lead white with earth pigments and traces of black so that it could be adjusted along a range between a golden-yellow ocher to a much darker gray or brown tone, and that in turn would affect the luminosity of subsequent layers of pigment. To make all these techniques work harmoniously together required decisive judgements, and there are times, especially in one or another of his paired marriage portraits, when Rembrandt's commitment to fine-tuning every element in the composition seems less than total and he seems to go through the motions of representation. This halfhearted (or hasty) approach to *one* of a pair (in, for example, the Boston Museum of Fine Arts and the Metropolitan Museum in New York) has led the Rembrandt Research Project to reject *both* portraits in the pair as necessarily the work of another hand.[15] It's entirely possible, though, that a pupil or assistant working with Rembrandt at Hendrick van Uylenburgh's establishment on the Breestraat was delegated to finish a portrait after its principle elements had been blocked in by the artist himself, or that, being not only a genius but a fallible human being, Rembrandt devoted more attention to some portraits than to others, even within a linked pair.

The disparity between the perfect and the imperfect works *is* jolting only because the best synchronized portraits have such phenomenal vitality

that their subjects seem not so much posed as caught. The calligrapher sharpening his quill and the scholar at his writing desk, head turned at a sharp ninety degrees away from his body, appear to have been interrupted in the midst of their personal routine rather than made to "sit" and assume the social mask required for dignified immortalization. Everything about the Hermitage painting of the scholar goes against the grain of convention for "scholar portraits." Instead of the crisp-edged, meditative, almost monkish profiles in which, for example, Holbein caught Erasmus, Rembrandt's writer, captured life-size, glows with the robust warmth of a full-blooded life. His cheeks are rosy, his fingernails buffed, his eyes bright, his lower lip moist (with a carefully painted highlight) as though habitually licked in reflection. The great foaming pile of his ruff encircling and illuminat-

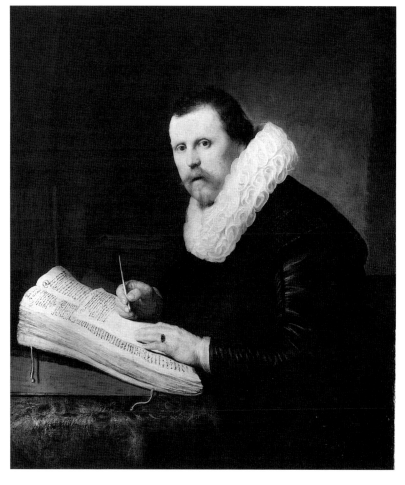

Rembrandt, Young Man at His Desk, *1631. Canvas, 104 × 92 cm. St. Petersburg, Hermitage*

ing his face adds still more energy to his alert features. But the almost disconcerting illusion of a real presence is indicated in incidental details made strategically inescapable, like the open mouth addressing the intruding beholder, the wrinkled, stubby fingers securing a writing sheet on the book, and two perfectly observed cast shadows. One of those shadows is thrown by the underside of the ring finger on his writing paper; the other falls from the book tie against the wooden side of the reading desk, as ephemeral as the book itself is massive, a touch as delicately poetic as anything in Vermeer.

The notion that an identity might be most candidly exposed when caught *in medias res*, in the midst of things, is itself startlingly fresh. It anticipates photography not in any crude sense of duplication but in the faith that the entirety of a character can be implied by the revelation of a single instant. Freeze-framed, this single moment has the power to suggest the continuum of a life from which it has been selectively shorn away. At their most sharply focussed, such caught moments can do still more, offering inklings of posterity, a consoling connection between the instantaneous and the eternal.

iii Autopsy

Rembrandt, it turns out, had a hand or two to spare. Two days before his death in October 1669, he was visited by the genealogist and antiquarian Pieter van Brederode, who cast a hunter-gatherer's eye over what remained of the painter's famous collection of "rarities and antiquities." The greater part of the prodigious assortment of busts, helmets, shells, coral, weapons (Western) and weapons (Indian), the porcelain cassowaries and the stag antlers, had all been auctioned off in 1656 as part of Rembrandt's bankruptcy settlement. But among the items which remained were, according to Brederode, "four flayed arms and legs anatomized by Vesalius."[16] In the first, 1543, edition of his master-text *De Humani Corporis Fabrica Libri Septem,* the founding father of modern anatomy, Andries van Wesel, better known as Vesalius, had provided a frontispiece showing himself dissecting the forearm. Rembrandt, who, unlike Rubens, never bothered to amass much of a library, was, however, notoriously partial to peculiar mementos, especially when they could be turned to practical use. So it is not out of the question that one of those "Vesalian" arms seen by Brederode, floating muscle-pink and pickled in its glass jar, had been used, some thirty-seven years before, as the model for the forearm being dissected by Dr. Tulp in Rembrandt's masterpiece of 1632, *The Anatomy Lesson of Dr. Tulp.*[17]

Supposing this was the case, it's hard to imagine Nicolaes Tulp not being flattered by this remote association with the great Brabander author of the *Fabrica* through the improbable relic of his own public anatomies. It may be going too far, with William Heckscher, to say that Tulp wanted himself to be depicted as the reincarnation of Vesalius, especially since he was a *doctor medicinae,* a general practitioner rather than a professional anatomist.[18] But we know from his erstwhile student Job van Meekeren that Tulp did in fact use the dissection of the forearm and the demonstration of the flexor muscles as an exemplum of the God-created ingenuity of the body.[19] It might be precisely because he was the part-time praelector in anatomy to the surgeons' guild of Amsterdam that he chose the pose which connected him most directly to the most illustrious of all Renaissance anatomists. What better way to advertise his own authority, in the chamber of the guild, than by associating himself with the master who first insisted that true understanding required direct inspection of the human body rather than book learning or animal dissection?[20]

Though Rembrandt had painted other masterpieces before 1632—in particular *The Supper at Emmaus* and *Repentant Judas*—none had quite such a public airing as the *Anatomy.* So in some sense, Dr. Tulp made Rembrandt, and Rembrandt returned the favor. Of course, the doctor might

reasonably have taken offense at the implication that he needed a group portrait to establish his reputation. Long before he had become "Dr. Tulip," he had set his sights on the learned and noble art of medicine. He had been born as plain Claes Pieterszoon, the son of a linen merchant, and was raised in a house on the corner of the Gravenstraat and the Nieuwendijk, in the center of the oldest section of Amsterdam.[21] Like Rembrandt, he had gone to Latin school and Leiden University, where in 1611 he was enrolled as a medical student. The faculty there was small but impressively distinguished. Claes Pietersz. would have heard lectures from Reinier de Bont (physician to Maurice and later Frederik Hendrik) and Aelius Vorstius and would have received anatomical instruction from the famous Dr. Pieter Pauw. Pauw's anatomical lessons would normally have been given with the aid of illustrated manuals or skeletons. But on a few occasions during the winter months, he would perform public dissections in the university's anatomy theater on the cadavers of freshly executed criminals. These anatomies were eagerly anticipated events in the calendar of Leiden's spectacles. All the eminences of town and gown—senators and curators and rectors from the university; burgomasters and aldermen from the city—were in attendance, along with crowds of students and professors. But the back rows of the amphitheater's benches were filled with the ticket-paying public, who, notwithstanding mounted skeletons (including a skeletal rider on a skeletal horse) holding up signs requiring them to contemplate their own mortality, thoroughly enjoyed themselves. There was music; there was food and drink and gossip; there were intestines and brain matter and a heart to see, only partly obscured by the smoke of incense burned to mask the unpleasant aroma of the body. And we can be sure that Claes Pietersz. paid good attention.

Near the anatomy theater there was another, quieter place where he and his fellow students got their essential learning: the university garden, the Hortus Botanicus. Under the administration of Outger Kluyt, the garden was carefully fashioned not just as a botanical collection, a horticultural *wonderkamer,* but as a place of fundamental biological and medical instruction. It was there, on the paths of crushed seashells and amidst the pergolas and geometrically ordered beds, that knowledge was imparted of the herbs and plants essential to the modern druggist, and which in 1636 the doctor would himself incorporate into his own handbook for physicians, the *Pharmacopoeia Amstelredensis.* But even while he was paying close attention to Kluyt's medical botany, Claes Pietersz. could hardly have failed to notice, in other beds, the novelty flower from the East, transplanted and cultivated by the botanist Carolus Clusius, known in Turkey (for its resemblance to a pointed turban) as a *tulbend* and rechristened in Holland *tulp.*

The bright young student had not yet turned into Dr. Tulip. In 1614 he successfully defended his dissertation on the disease of *cholera humida* and left Leiden, diploma in hand, a fully licensed *doctor medicinae.* This entitled him to practice in the top tier of a profession sharply divided into three connected but strictly separated métiers. Like his colleagues who had

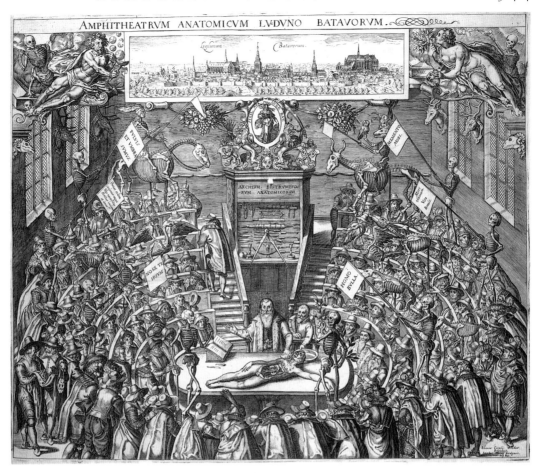

Bartholomeus Dolendo after Jan Cornelisz. Woudanus, The Theatrum Anatomicum in Leiden, *1609. Engraving. Amsterdam, Rijksprentenkabinet*

obtained degrees from one of the few great medical colleges of Europe—Padua or Paris—Tulp had become, in effect, a consultant, called on to diagnose ailments and prescribe either surgical or medical treatment. In the case of the former, he would send the sufferer to surgeons, who were the active sawbones (and who had long been forced to share their guild with clog and skate makers, and tripe preparers).[22] The range of procedures was extremely narrow, confined for the most part to the removal of gallstones, cataracts, and some external tumors, as well as the "lightening" of what was judged to be morbid obstructions or coagulations, either by trepanning the skull (drilling a hole to relieve pressure between the brain and the cranial cavity), cupping (setting a hot glass vessel quickly on the skin to "draw out" an infection), or slitting a vein or applying leeches to allow a steady flow of blood to ease a constricted pressure. They might also administer enemas and remove, as best they could, painfully obstructive rectal fistulas. If the patient could be treated mercifully and medically, he would be sent by the doctor to an apothecary with a prescription for the correct type and dose of drug or simple.

When he returned to Amsterdam and set up his practice, the young

doctor could expect throngs of the sick to gather on his steps each day, from early light to dusk, wanting help for whatever ailed them, and to make regular consultation calls to the city's old-age homes, hospitals, and leper and plague houses. He could also expect to make a solid, if not spectacular, livelihood, be treated as an honorable and important figure in the city, and, as a result of the first two conditions, make a respectable match. In 1617 he married Eva van der Voech, a choice which displeased his ambitious mother, for the doctor, it seems, had chosen for beauty rather than connections. What connections there were were dubious, even for good Calvinists, one of Eva's uncles having taken great pride in smashing church paintings in the iconoclasm of 1566.[23] But Claes Pietersz. was not to be dissuaded, and after his marriage moved into a house on the Prinsengracht which boasted a signboard painted with a tulip and which was thus known as "De Tulp." When the couple moved a second time to a more permanent dwelling on the Keizersgracht, the tulip reappeared on their gable, and in 1622, when the doctor was admitted to the council of the city and made one of its nine aldermen, he took the flower as his personal coat of arms: a single golden bloom set on an azure ground with a star set in its upper left corner. Little by little, he was turning into the figure whose identity could hardly be separated from his house, his town, his native world: Doc Tulip. And Doc Tulip he would stay for the next fifty years, riding around to make house calls in his specially authorized coach decorated with the flower; the gracious recipient and inspiration of one of Johannes Lutma's most astounding fantasies: a wine goblet in solid silver in the form of a tulip, the stem not a simple, regular, straight-sided support but a living, bending stalk transmogrified into shining metal, complete with bladelike leaves and an indented crown at the bloom-head.

When Rembrandt got the commission to paint Tulp and his seven colleagues in the surgeons' guild, the doctor had become a man of serious weight and substance in Amsterdam. In 1628, the same year he was appointed praelector in anatomy to the guild, thus being given the responsibility to conduct the annual Amsterdam public anatomy, Tulp's wife died. In a plague culture where mortality was so regular a visitor, no one, however devoted to the memory of the deceased, stayed single for very long if a suitable replacement could be found. And in Margaretha de Vlaming van Outshoorn, Tulp had a spouse whose connections could give no grounds for complaint, even to his mother. She had herself grown up in the same neighborhood as Tulp, amidst Calvinists as devout as the doctor himself. Margaretha's late father had been *kerkmeester,* a deacon of the Nieuwe Kerk, a member of the inner circle of the city council, and, during the heyday of the Counter-Remonstrant ascendancy, four times a burgomaster.[24] They were married in 1630 and lived for another half century in the house of the tulip.

So it was as a magisterial as well as a medical presence that Tulp decided to have his second public anatomy, performed in January 1632, commemorated by a group portrait. It would not be the first in the genre.

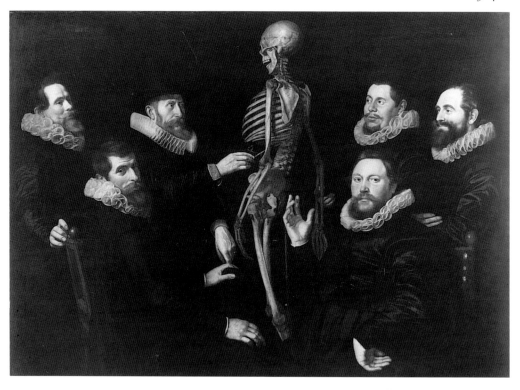

Thomas de Keyser (?), The Osteology Lesson of Dr. Sebastiaen Egbertsz., 1619. Canvas, 135 × 186 cm. Amsterdam, Amsterdams Historisch Museum

In 1603 Aert Pieterszoon had painted no fewer than twenty-eight members and officers of the surgeons' guild gathered around the praelector, Dr. Sebastiaen Egbertszoon de Vrij, as he stood poised, scalpel in hand, above the faceless cadaver of an English pirate. Thomas de Keyser[25] was probably the artist who subsequently painted the same doctor in the less claustrophobically mobbed setting of an "osteology," or bone demonstration, performed on the skeleton of a *subiectum anatomicum* that had already been dissected. Finally, Nicolaes Eliasz. Pickenoy had painted an anatomy of Egbertsz.'s successor, Johan Fonteijn, during the winter of 1625–26. But little or nothing in these dutiful antecedents, nor even, I suspect, his own careful instructions to Rembrandt about what and whom he wanted depicted, could possibly have prepared Dr. Tulp for the painter's revolutionary refashioning of the "anatomy."[26]

Like all the great cities of Holland (only more so), Amsterdam was a corporation town. It was a regular beehive of capitalism, but the bees liked to buzz together, not as isolated individuals. So it was natural that the group portrait had flourished there since the mid-sixteenth century. And lately it had come to be in enormous demand, not just among the surgeons but also among the militia guilds (who had inaugurated the genre as early as the 1530s) and the innumerable regents and regentesses of charitable institutions. And since it was possible to charge a tidy sum—as much as a hundred guilders a head in some cases—group portraits had become the bread and butter of any ambitious painter, not to mention a prime source

of advertisement for their skills, since the paintings were meant for semi-public display in the guild chambers or boardrooms. So Werner van den Valckert, Jan van Ravesteyn, Thomas de Keyser, and Nicolaes Eliasz. Pickenoy (whose family were patients of Dr. Tulp) all established themselves as dependable masters of the genre.

And an infernally difficult genre it was, too. On the face of it, the artist was being paid to reconcile two hopelessly contradictory tasks: provide recognizable likenesses of the individual figures, yet also provide a strong sense of the collective character of the group.[27] Ideally, then, the painting had to depict not just a plurality but a fellowship. And then there were other requirements basic to the commission. The group had to be differentiated by rank and function, especially important in the case of the militia officers. By the 1620s, with portraiture as a whole struggling to escape the stony formalism of statuesque poses, there was an additional demand to show the figures in the group interacting in a plausibly lifelike manner, preferably in some way specially associated with the institution's character. Thus some regents might be shown by van den Valckert visiting the sick or admitting orphans, or the militia might be shown mustered for drill or at their annual saint's three-day binge. And when all these requirements had been taken into account, the group portraitist had better not forget to have at least some of his figures address the beholder with a meaningful gesture or glance so that those who saw the painting would be personally reminded of the importance of the institution and its leading figures in the life of the city.

The simultaneous need to establish, as Alois Riegl, the analyst of Dutch group portraits, put it in 1902, an "inner, closed unity" (between the figures) and an "outer unity" (between the figures and spectator) posed a severe challenge to group portraitists to which most of them signally failed to rise. Inevitably, their first obligation was to those who were paying the bills, so that, as in the Aert Pietersz. anatomy of 1603, the painting became monstrously elongated in order to accommodate all twenty-eight surgeons, who are lined up in three rows along a single axis, their most senior officials identified by their holding a basin or a list of the sitters. Only the slightest variation in the angle of the head or a hand placed on a shoulder relieves the monotony of a relentlessly two-dimensional and repetitive composition that was criticized, even in its own day, as being hopelessly stilted. In response to this awkwardness, the group portraitists of the next generation, like de Keyser and Pickenoy, made a conscious effort both to have the figures communicate with each other more credibly and to give the composition as a whole greater dramatic coherence. In the case of the surgeons, they were helped by the far smaller number of surgeons willing or able to have themselves portrayed along with the demonstrating praelector.[28] This meant that de Keyser, for example, could use a much less eccentrically elongated format for *The Osteology Lesson of Dr. Sebastiaen Egbertsz.* and so establish the physical center of the composition, with the anatomist and the superbly rendered skeleton at its moral and didactic

FOLLOWING PAGES: *Rembrandt,* The Anatomy Lesson of Dr. Tulp, *1632. Canvas, 169.5 × 216.5 cm. The Hague, Mauritshuis*

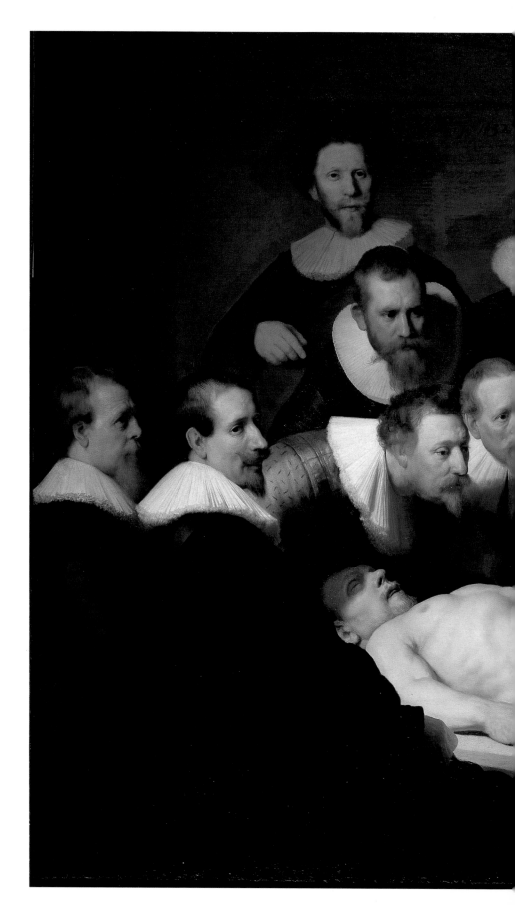

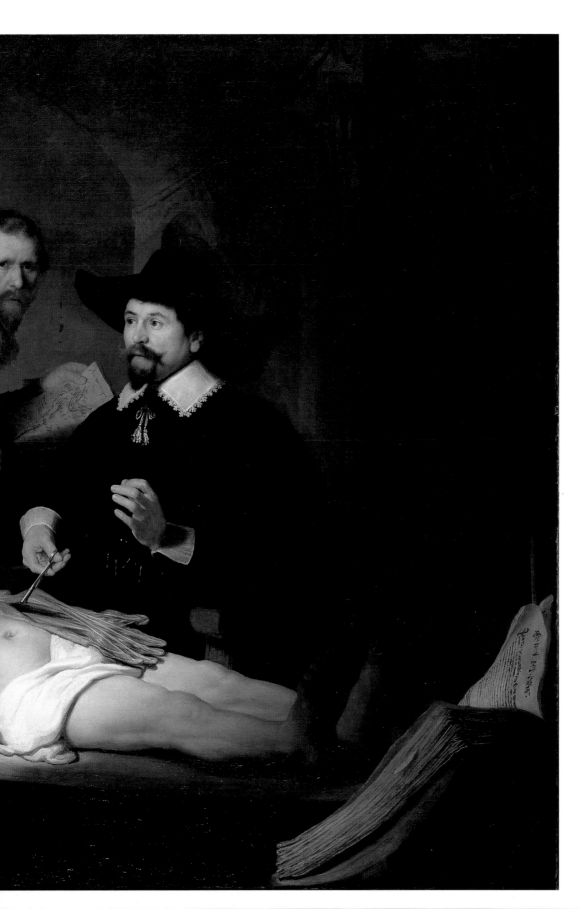

core. A modest concession to depth helps give the impression that the group is standing in something like a "real" space, rather than stacked up on tiers like fairground cardboard cutouts. The three surgeons at the back give their attention (though not altogether undivided) to Dr. Egbertsz. The two at the front address the beholder, one of them significantly gesturing toward the skeleton, reminding us that in the human condition, divinely bestowed ingenuity must coexist with chastening mortality. The skeleton itself (which in the Leiden theater would have been holding up a placard to this end) is ingeniously rotated so that it too reiterates the message, "looking" directly back at the doctor with something of an attitude in its empty socket.

There's little doubt that the devout Dr. Tulp would similarly have asked Rembrandt to incorporate this conventional double meaning into his own anatomy. And a pentimento around the head of Frans van Loenen, the figure at the apex of the pyramid, suggests that originally he wore a hat, giving him unusual significance almost on a par with that of the praelector himself. Van Loenen's gesture, pointing with his index finger toward the corpse, performs the same function as Dr. Fonteijn at the front of the Pickenoy of 1625–26: a reminder of our common mortality. Together with the fact that van Loenen is also the only figure to look directly at the beholder, his posture has convinced William Schupbach that Rembrandt's *Anatomy Lesson of Dr. Tulp*, so far from being any kind of breakthrough in the genre, is actually an obediently traditional specimen of it.[29]

But this is to discredit the evidence of one's eyes. For the fulfillment of his patron's wish to include a memento mori in the painting is the *only* conventional feature of this stupendously original work. Rembrandt has often, and mistakenly, been cast as the rebel, the "heretic," in the words of one of his contemporary critics. But he was grievously misunderstood. He never wished to fly in the face of his patrons' basic requirements, but rather sought to transform them into something impossible to envision from antecedents. In this case, he understood, possibly better than Tulp himself, that the subject at the heart of the work was the relationship between vitality and mortality. But he was not satisfied with merely illustrating a concept, as if he were the engraver for an emblem book. As was his wont, he aspired to turn the commonplace into a drama.

Who better to turn to as a drama teacher than Rubens?[30] At some point Rembrandt must have seen Lucas Vorsterman's engraving of *The Tribute Money*. For most painters, Rubens's crowded composition might have prompted another history. But Rembrandt looked at the rows of peering faces and, in a leap of the imagination, saw how those expressions, wound up even tighter, might transform an anatomy from a picture of studious contemplation to one in which visual concentration has become a dynamic physical response. At the center of the composition is the arrowhead of figures pointing both toward the dissected arm and toward Tulp's own hands. Even when Rembrandt, during the process of making the picture, added an extra figure—that of Colevelt on the extreme left—he aligned the head so as not to break the thrusting lower line of the ∨ or > formation. And the

cadaver itself is unusually set at a diagonal from the picture plane, not exactly aligned with either row of heads but still at an angle designed to arrest our attention. Which is not the only extraordinary quality of the body. As the earliest commentators on the painting like Joshua Reynolds recognized, Rembrandt went to extraordinary lengths to fix the precise tone and bluish pallor of dead flesh, using a finely adjusted tint of lead white mixed with lampblack, red and yellow ochers, and a trace of vermilion[31]—in effect another of his virtuoso demonstrations of *stofuitdrukking,* the *stof* in this case being

Lucas Vorsterman after Rubens, The Tribute Money, *c. 1621. Engraving. London, British Museum*

the cadaver's waxy skin. Earlier anatomies like Aert Pietersz.'s 1603 painting, or Michiel and Pieter van Mierevelt's Delft anatomy of 1617, had hardly bothered to register in color the startling difference between the rosy complexions of the living breathing surgeons, working in midwinter, and the stony object on which they were performing. They also observed the usual decorum by partly or wholly masking the face, lower trunk, and legs. The body was thus properly reduced to its role as the *subiectum anatomicum,* no longer a human but rather an arrangement of organs conveniently awaiting the anatomist's instructive hand. But Rembrandt, who was almost certainly present at Dr. Tulp's anatomy on January 31, 1632, does something quite shocking. Instead of concealing the cadaver's face, he fully reveals it, shadowing the eyes much as he did with his own image. In fact, he devotes almost as much detailed attention to the dead man's head as to the paying customers, tucking it between two of them as though it were very much part of the company. As a result, despite the pallor of the cadaver, he manages to rehumanize, rather than dehumanize, that body, forcing the beholder into an uncomfortable kinship with the dead as well as with the living.

Rembrandt may himself have felt something of "There but for the grace of God go I," since the anatomical subject was, like him, a native Leidenaar who had migrated to Amsterdam in search of better pickings. Unlike Rembrandt, though, the pickings gleaned by Adriaen Adriaenszoon, alias "Aris Kindt" ("the Kid") belonged to other people. He had had a long history of petty theft and criminal assault; just another of the countless thugs who hung around the pubs and alleys looking for an easy mark. This time he had been caught in the act of trying to relieve a burgher of his cape, presumably having a tough time of it since he was also beating the victim into surrender as he did so. He was hanged for the offense on one of the gibbets by the IJ that faced the harbor, so that a row of them would have greeted incoming ships much as the Statue of Liberty does in New York. The sur-

geons had to retrieve the corpse before it suffered damage, not least from the superstitious eager to detach the teeth or blood or bones of a hanged man, which were said, by rather different medical advice from that which Dr. Tulp was accustomed to dispensing, to be a sure cure for any number of ills. Thus would the criminal fully pay his debt to civil society. For as Caspar Barlaeus later noted in his poem dedicated to the construction of a new anatomy theater in 1639, "Evil men, who did harm when alive, do good after their deaths: / Health seeks advantages from Death itself."[32]

Had the painting been a faithful representation of the dissection, the Kid would have been a mess: the stomach cavity opened and the intestines drawn and displayed long before Tulp got anywhere near the muscles and tendons. In fact, the lower digestive tract was the doctor's speciality; he was the first to identify and fully describe the operation of the ileocecal valve, which, in a nice burst of patriotic metaphor, he felicitously compared to the locks and sluices of the canals of Holland, opening and shutting to allow one-way traffic. Joshua Reynolds thought that Rembrandt refrained from displaying the reality of the dissection to avoid making the picture prohibitively "disagreeable." But as vividly immediate as the painting appears, it was not, of course, meant to be a literal record of the proceedings of the thirty-first of January. Instead Tulp had selected that element of the anatomy which most spoke to his association with predecessors like Adriaen van den Spieghel and perhaps Vesalius, and more particularly to the capacity which was the most emphatic sign of God's providential ingenuity in differentiating man from beast: dexterity.

In fact, Tulp is seen at the precise moment of demonstrating two of the unique attributes of man: utterance and prehensile flexibility. With his right hand he is lifting and separating the flexor muscles (both carpal and digital), while with his left hand he is actually demonstrating precisely the action enabled by the relevant muscles and tendons.[33] As Schupbach noticed, the surgeons about him respond to this marvellous double display *not* uniformly but rather in a sequence corresponding to the stages of the demonstration itself. Adriaen Slabberaen, second from the left in the front row and seen in profile, looks out at the book, perhaps an anatomical text, propped up at the end of the table, projecting through the picture plane. Hartman Hartmanszoon, who sticks out from the "arrowhead" and whose upper *body* is in profile while his head is sharply turned (in the manner of the portrait of the scholar), holds a paper which at some later stage was inscribed with the names of the surgeons, but which originally bore the discernible outline of a flayed "Vesalian" man. He is staring at the bending finger joints of Tulp's left hand, and Rembrandt means us to think of him as having just been glancing at the anatomical illustration, but now entranced by the *actuality* of the living muscle. The surgeon immediately to his right (our left), with the pale brow, fiery pointed mustaches, and the pink ear of extreme excitement, is Jacob Block, and his gaze, both at and over the lit edges of Tulp's fingers, seems to be travelling also between book and hand. The remaining two surgeons, bent forward, are closest of all to the action. Jacob de Witt, with the gray hair, is intently watching the action

of Tulp's instrument on the muscles and tendons; Matthijs Calkoen, to his right, follows its consequence, the doctor's fingers moving at the joints in and out of the light.

But where is Tulp's gaze? And where are his thoughts? Had this been a painting by anyone else, he might well have been facing forward, directly addressing the beholder as if inviting congratulations on his ingenuity. But the real subject of the painting is only secondarily the ingenuity of Dr. Tulp, and *primarily* the ingenuity of his Creator. So Rembrandt has had the brainstorm of having him look not at his enthralled colleagues but off into the distance, away from both the company and ourselves, as if rapt in Christian meditation. Just what kind of meditation this was was evident at least to Barlaeus, whose 1639 poem was specifically about Rembrandt's painting.

> Dumb integuments teach. Cuts of flesh, though dead,
> for that very reason forbid us to die.

> Here, while with artful hand he slits the pallid limbs,
> speaks to us the eloquence of learned Tulp:

> "Listener, learn yourself! and while you proceed through the parts,
> believe that, even in the smallest, God lies hid."[34]

Dexterity, then, is divinity. But to know that is to know, alas, only a partial truth. And this work of Rembrandt's is, in the literal sense, from the Greek, an *autopsia,* an act of direct witness or seeing for oneself. But what they see, what we see, is that the same body which is stamped with the genius of godly engineering is also chasteningly limited by its fleshly housing. Besides discoursing on the lock-gates of the intestinal tract and the flexor mechanism of the arm, Tulp would also deliver an oration in 1635 on another favorite seventeenth-century topic for which he might as well have referred his listeners to Rembrandt's masterpiece: the metaphysical sympathy between the body and the soul.

What Rembrandt has painted, then, is a moment of truth, another instant in which both the immediate and the eternal stand simultaneously illuminated. Both he and Dr. Tulp would have seen the placard held in the bony grip of a skeleton mounted at the back of the Leiden anatomy theater and commanding *Nosce te ipsum*—Know thyself. It was a motto which both painter and physician would, in their respective ways, adopt for the rest of their lives. To know is to see is to know: both the husk and the kernel, the body and the soul. Thus stands Dr. Tulp, left hand in the air, right hand gripping his instrument. Thus stands Rembrandt painting him, left hand holding his palette, right hand gripping the brush, the two of them mutually immortalized.

i Pairing Off and Dressing Up

What was she doing in Amsterdam anyway, this Saskia van Uylenburgh, with her butterball chins, lopsided grin, and coppery curls? A nice Frisian girl certainly; a catch, one might reasonably assume, being the daughter, after all, of a burgomaster of Leeuwarden, bred up from good solid stock like the cattle up there, famous for their copious flow of milk. Her father, Rombertus, had been a provincial Person of Consequence: a harvester of offices and dignities, a founder of Franeker University with connections to the Friesland Stadholder, Willem Frederik, and exceedingly prolific besides, the begeter of eight children. Saskia grew up in a household of petticoats, the littlest of four girls, though the big petticoat, her mother, Skoukje Ozinga, had died in 1619, when she was just seven years old. The older sisters, Antje, Titia, and Hiskia, all married well, though to very different types of suitors. To the gossips and money-bag watchers, Titia had perhaps done the best, marrying into a patrician clan of Zeeland Calvinists, the Coopals. Her husband, François, was a man of commercial substance in the port of Vlissingen, where his brother Anthonie liked to cut a figure as something grander than a mere merchant: rather, as he lost no chance of announcing, the "Grand Pensionary of Vlissingen in Zeeland and Former Ambassador to the Courts of Poland and England."[1]

Not that the other two sisters had done poorly. Antje had married a Polish professor of theology, Johannes Maccovius, who had risen in the academic ranks at Franeker to become the university's *rector magnificus.* Hiskia's husband, Gerrit van Loo, was the secretary-clerk of the *grietenij,* or township, of

Rembrandt, Saskia Wearing a Veil, *1634. Panel, 60.5 × 49 cm. Washington, D.C., National Gallery of Art*

Het Bildt: actually a group of villages scattered about the country northwest of Leeuwarden that had been reclaimed from the sea in the previous century and settled by farmers shipped in from Holland. Their descendants now spoke a peculiar dialect, half-Frisian, half-Dutch, so that sometimes they called their village Tzummarum and sometimes Tsjommarum, sometimes Vrouwenparochie and sometimes Froubuorren.

It was just as well that there were all these sisters and brothers-in-law to concern themselves with Saskia van Uylenburgh, since her father's death in 1624 had made her a twelve-year-old orphan. She must have been shuffled between Hiskia's and Antje's homes in St. Annaparochie and Franeker, where she helped to keep house, shaking the linen or carrying baskets home with the servants through lanes bordered by low-eaved farmhouses. On Sunday afternoons after church, when the men went off fishing or fowling, she might have walked the muddy paths beside willow-brushed streams or out into the fields, garishly bright with stands of rape and linseed, flags of gold and blue stretched out under the bulging cumulus clouds.

Rembrandt, Portrait of Johannes Cornelisz. Sylvius, *c. 1633. Etching. Amsterdam, Museum het Rembrandthuis*

So why *was* she in Amsterdam in 1633? Saskia was twenty-one and blessed with a portion of her father's estate. But it was a modest portion. Rombertus had been eminent, but he had not been rich, certainly not as wealthy as the envious gossips imagined. And there were, after all, the other children's shares. There was still no question of her being free to do as she pleased with her portion. There was a cousin in Amsterdam, Aeltje, who had married the minister Johannes Cornelisz. Sylvius, the *predikant* of the Oude Kerk, and he would see to it that Saskia ran no danger of going astray. He was Frisian himself, this Sylvius. He had preached the Word in Het Bildt, and he had spread the Gospel in Firdgum, Balk, and Minnertsga. Perhaps the dominance of the Reformed Church in that province had kept him safely clear of the excesses of Counter-Remonstrant zeal. Thus he came to Amsterdam as the protégé of one of the richest and least zealous of the Calvinist regents: Jacob de Graeff. By the time his wife's young cousin, Saskia, arrived in the city, Sylvius was already close to his allotted life span of three score and ten and had hung on to his ministry for more than twenty of them. He had been the subject of Rembrandt's very first portrait etching in Amsterdam, a densely cross-hatched image of the old man seated, his hands folded over his Bible, light falling on the left side of his gravely reflective face. A second etching, executed in 1646 as a memorial for Sylvius, who had died in 1638, included a poem by Caspar Barlaeus which alluded, in the most delicate way, to the preacher's unusually long tenure in his post. He put it this way: "Jesus can be better taught/By living

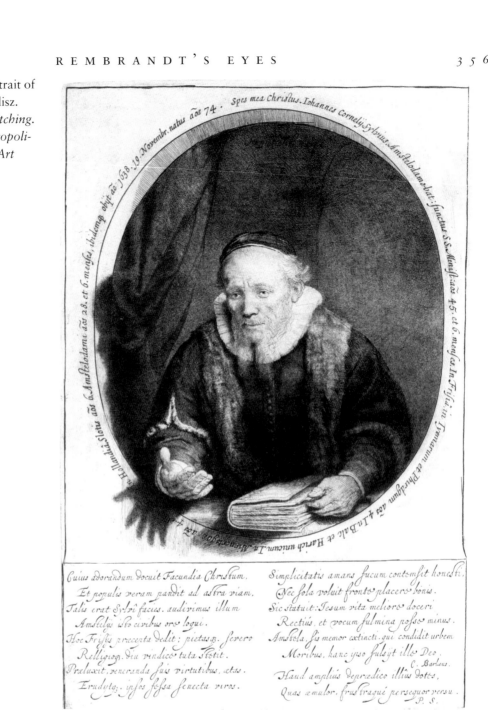

the right life/Than by the thunder of the voice." (In other words, Sylvius, unlike the Counter-Remonstrant martinets Smout and Trigland, had preached the Word judiciously.) Rembrandt's print somehow needed, then, to suggest smoke-free eloquence. So the minister's lips are barely parted. But he leans forward through the oval picture frame as if it were a curtained pulpit, the cast shadows of his silhouette and gesturing hand, as well as the Bible, projecting into our own space, literally the shade of the preacher.[2] The velvety shadows are themselves done with painterly finesse,

not to mention almost unbelievably fine motor control, the forehead traced with minute loops as fine as Velcro, the hatching broken into random strands where he wants to suggest the stringy outline of the shadowed beard.

Aeltje and Sylvius provided one kind of family house for Saskia: godly, watchful, sober. Which may be why the twenty-one-year-old girl with the crinkly smile might have wanted to seek out her other cousin, who lived on the Breestraat. Not that there was anything conspicuously disreputable about Hendrick van Uylenburgh the art dealer. He was a Mennonite. But then, the founder of that mildest sect among the Baptists, Menno Simons, had himself been Frisian. Now that Mennonite Baptism was tolerated in the Dutch Republic, it had taken root in the sand-blown villages and dune-islands along the North Sea coast of Friesland. There was an aura of quiet solemnity about the Mennonites that contributed to their reputation as solid citizens, a far cry from the outlandishness of the original Anabaptists. Under the messianic spell of another native of Leiden, Jan Beukelsz., the Anabaptists in the previous century had instituted communism and polygamy in their millenarian "kingdom" in the Westphalian town of Münster in 1534. This "Jan of Leiden" and his concubines and apostles, all freshly baptized, had lusted devoutly for the apocalypse and were duly rewarded, eighteen months later, with a bloody consummation. The prophet-king had swung from an iron cage on the walls of Münster Cathedral, ecstatically embracing his torment while his followers were put to the sword. In Amsterdam, a like-minded company of Anabaptists had run naked through the city in the slicing March winds, waving swords in the air above their white bodies. At the end of the month, the same bodies were hanging from gallows on the Dam. A year later, another armed band of Anabaptists had attempted to storm the Town Hall. After a street battle, there were more beheadings and hangings. The women, reviled as harlot-heretics, little better than witches, were pulled to the river, stones at their necks, and drowned.

Perhaps it was the fate of Menno Simons's own older brother, Pieter, who had perished in a siege while defending an Anabaptist holy commune in Friesland, that turned Menno into a pacifist. Simons's followers continued to reject the concept of original sin, predestination, and infant baptism as a violation of the letter of the Gospel. They continued to require adult baptism and a voluntarily entered covenant as the precondition of grace. And they had no intention of acknowledging the authority of any state or church. But unlike the first generation of Anabaptists, they no longer saw themselves as obliged to overthrow "godless" institutions. After the spilling of so much blood, they were now prepared to submit passively to the power of magistrates not of their own creed, always provided that they were not asked to bear arms. This was not enough, however, to dispel the suspicions of Catholic, Lutheran, or Calvinist governments, which for most of the sixteenth century continued to look on the various creeds of Baptists as carriers of both sedition and blasphemy (especially in their denial of the

Trinity). The exception to this intolerance was the kingdom of Poland and the grand duchy of Lithuania. This had almost nothing to do with principle and everything to do with the peculiar politics of that elective monarchy. Candidates hoping for election were prepared to offer toleration to Polish nobles who had been converts to Protestantism in exchange for their support. So the Compact of Warsaw in 1573, guaranteed by the new Valois king, turned Poland into the most heterodox and tolerant state in Europe.

Driven from Germany, Switzerland, and the Netherlands, Mennonites and other kinds of Baptists moved east in large numbers, settling in two distinctly different regions. Some families, including the van Uylenburghs, made a home in the turreted city of Kraków, the capital of the elective monarchy and the home of Jagiellon University, where Mennonite theologians were as free to debate and defend their confession as anyone else. Others established themselves around the delta of the Vistula, facing the Baltic Sea, a marshy, low-lying country, a place of cattle and fishermen that may well have seemed a sort of Friesland transplanted to the northeastern shores. In one respect, though, that country was quite different from their native land. Its interminable fields of rye and wheat were cultivated not by free tenants but by bonded serfs who belonged, body and soul, to the great Polish and Lithuanian feudal magnates. By the end of the sixteenth century, Dutch shippers had already arrived in Gdansk with cargoes of desirable imports—Italian silk, Turkey rugs, and Leiden cloth—as well as chests full of cash to buy up, in advance, the entire grain harvests of the Polish nobility. The rye and wheat was then shipped across the Baltic (at costs a third less than those of any other trading competitor) and reexported from Dutch ports to the grain-poor countries of the rest of Europe. Satisfying their own domestic needs from cheap eastern European imports in turn freed Dutch farmers to do what they did best: raise cows, and grow cattle feed and market gardens.[3] All of these intricately bound connections meant that one set of van Uylenburghs (the Polish-Mennonite branch) were, at least indirectly, subsidizing the other set of van Uylenburghs (the Frisian-Calvinist branch).

Not that the van Uylenburghs appear to have been directly involved with the grain trade. But their success at establishing themselves as craftsmen in the luxury trades meant that they were likely to have had ties to the likes of the Potockis, the Czartoryskis, and the other great granary dynasts. One of Hendrick's relatives, possibly his father, had been a royal cabinet maker, and his own brother Rombout was a successful enough painter to have made a career at court.[4] But around 1611 Hendrick and Rombout moved to Gdansk, the port that was rapidly becoming the hub on which the massive bulk trades of the Baltic turned.[5] Hendrick underwent his adult baptism there and, taken into the local Mennonite community, was in a perfect position to be an intermediary between Poles and Hollanders, traders and aristocrats. Doubtless one of the commodities that he began to import to cater to cultivated taste were paintings from the Netherlands, shipped in bulk.

At some point, Hendrick van Uylenburgh, who for virtually all of his life had known only Poland and the Baltic, must have decided to "go home." His journey to Holland may have been as early as 1625, as soon as the Stadholder Maurice died and it became apparent that his successor, Frederik Hendrik, would refuse to enforce Counter-Remonstrant intolerance. Along with all the Remonstrants who returned to the Netherlands were tens of thousands of Mennonites. It's even possible, as B. P. J. Broos has suggested, that Rembrandt first encountered Hendrick van Uylenburgh in Amsterdam when he was studying with Pieter Lastman on St. Anthoniesbreestraat, a short walk away from the Mennonite's rented house on the corner of the street.[6] Three years later, van Uylenburgh was going to Leiden to buy work from Rembrandt.

It's conceivable that on one such trip van Uylenburgh himself suggested the arrangement by which Rembrandt eventually came to Amsterdam toward the end of 1631. By that time, Hendrick had established himself as a prominent and versatile entrepreneur in the Amsterdam art market, at one and the same time producer, marketer, and instructor. His business did just about everything that could be done with works of art. It sold old paintings as well as freshly commissioned works and supplied a line of copies of both the old and the new works, turned out by teams of assistants and students working under instruction from a master (like Rembrandt). The firm also sold new prints and the etching plates from which they were struck.[7] This ambitiously comprehensive art business needed constant infusions of both operating capital and skilled labor, and it got both from Rembrandt. While he was still in Leiden, in June 1631 Rembrandt had found the means to lend van Uylenburgh the considerable sum of a thousand guilders.[8] In return Rembrandt got access to van Uylenburgh's wide circle of potential portrait sitters and may even have been contracted to supply portraits for the "firm." And not least, working with van Uylenburgh gave him a way to paint while residing for the two years that the artists' guild of St. Luke in Amsterdam required before he could set up shop as an independent master.

On van Uylenburgh's part, the arrangement had obvious attractions. When he moved into studio space at the back of the house on the Anthoniesbreestraat, Rembrandt brought assistants and pupils like Isaac Jouderville with him who staffed the copy-production line and were actually prepared to pay van Uylenburgh for the privilege as part of their apprenticeship. Rembrandt's rapidly growing reputation in Amsterdam was in turn likely to attract another wave of pupils eager to be instructed and work alongside him. Imagine, then, a hive of activity inside the van Uylenburgh house: a showing gallery in the *voorhuis*, with storage for prints and drawings as well as paintings; a printing press and working studios toward the back, with good northern exposure, all busily expanding the van Uylenburgh inventory. In some of these rooms, lessons would have been given in all of the branches of the visual arts, not least by Rembrandt himself. There would have been life classes with models young and old,

Rembrandt pupil, Studio Scene with Sitters, 1650. Drawing. Paris, Musée du Louvre, Département des Arts Graphiques

male and female, dressed and nude; the older pupils sat on stools in a circle, the master moving around to inspect the drawing, lean over, add a touch here and there. The younger boys would have been busy at the back smoothing panels, sizing canvases, rubbing down lump mercuric cinnabar, pouring linseed oil, trying to get good looks, instructive eavesdropping. It was this bustling, dynamic enterprise that the Danish artist Bernhard Keil had in mind when he described it to Filippo Baldinucci, Rubens's biographer, who in turn immortalized it, rather more grandly than it deserved, as *"la famosa Accademia de Eeulenborg."*[9]

For a while at any rate, the partnership between van Uylenburgh and Rembrandt was genuine. The dealer undoubtedly brought the painter his first batch of portrait commissions, but very smartly the painter brought the dealer kudos. Even by the end of the summer of 1632, when a notary responsible for checking that the parties to a tontine were still alive came to van Uylenburgh's house and had the painter called from a back room, and attested that he was indeed "thank God fit and in good health," Rembrandt had already become the necessary man: investor, instructor, magnet for future recruits to Hendrick's talent pool.[10] Between them, van Uylenburgh and Rembrandt could even overcome the misgivings sober parents might have had about their child turning painter. "Have I been spared by God," asked the horrified Anthony Flinck, a bailiff in Cleve, "so that my son should lead a dissolute life among men who frequent whores?"[11] He resolved instead that his boy should go into some nice safe trade among his

fellow Mennonites in Amsterdam. But he must have been persuaded by his fellow Mennonite Lambert Jacobsz. that the gates of hell did not, after all, lie at the entrance to a painter's studio since Lambert was himself both an impeccably devout itinerant Mennonite preacher *and* a painter in Friesland. Govert was first taken in charge by Lambert as apprentice, and then, when the time was right, in 1635, sent on to Amsterdam to spend a year with Rembrandt to finish his training.[12]

So within a few years of Rembrandt's arrival from Leiden, spectacular works like *The Anatomy Lesson of Dr. Tulp* had made him sought-after: the smartest and sharpest of the city's painters; a known miracle-worker, someone who could breathe gusts of fresh air into stale genres without ever threatening their essential decorum. The idea was to transform his patrons' expectations without alarming them: flattery, not mockery. And the patrons flocked to the Breestraat. They included not just traders from the middling ranks but young swells, dripping in ribbons and lace, many tiers up in the patrician pecking order. It was with this swiftly inflating sense of himself as a person of substance that Rembrandt painted his own likeness in 1632, for the one and only time, as a true burgher. Here he is, spruce in his *zondagspak*, his Sunday best, complete with pleated fallen collar and the same soft hat he used in the "Rubensian" self-portrait etching of 1631. He had not yet resided long enough in Amsterdam to qualify for his *poorterschap*, the certification of domicile and possessions which would enable him to join the Guild of St. Luke. But the painting, with its conspicuous lack of self-dramatization, the broad features turned frontally to the viewer, the whisper of a mustache, seems like an earnest application for admission to the class of honest citizens; a refutation of the suspicion of the likes of Anthony Flinck that artists were, for the most part, a bunch of ne'er-do-wells. Its elegance is carefully economized, limited to a few discreet touches: the red ribbon fastening the collar; the line of gold buttons. Pushed right to the front of its allotted space, the picture is a declaration of what the seventeenth century called *honnêteté*: candor, dependability, integrity. "Think well of me and my prospects," it says. I am not like the notorious Torrentius, imprisoned for heresy and fornication. Truly, I am sound, I am solid: a businessman, a teacher, an Authority. In the *album amicorum* of a visiting German, Burchard Grossmann, probably one of van Uylenburgh's customers, Rembrandt added a further touch of gravitas, writing, "*Een vroom gemoet / acht eer boven goet* [A pious character / values honor above possessions]."

The commonplace was recorded just a few weeks before he married Saskia van Uylenburgh in Friesland on July 4, 1634.[13] Though none of his future in-laws may actually have seen the inscription, Rembrandt might

Rembrandt, Self-portrait as a Burgher, *1632. Panel, 63.5 × 46.3 cm. Glasgow Museums, Burrell Collection*

still have written it for their benefit, since Hendrick van Uylenburgh's own little homily, "*Middelmaet hout staet* [Moderation endures]" followed immediately on Grossmann's album page.[14] The painter might reasonably have supposed, then, that his pious self-advertisement would reach the family. And even if the gesture was not quite this calculated, the motto was the kind of sentiment that would have come instinctively to someone trying hard to disabuse his future in-laws of the slightest suspicion that he was some sort of adventurer after the orphan girl's estate. The Frisian van Uylenburghs knew something about painters. A second cousin of Saskia's had married the painter Wybrand de Geest. Still, he was very much a local figure and they might have pondered van Mander's cautionary tales of famous painters in grand cities sodden with drink and made destitute by their own spendthrift folly. But there could be nothing to fear from the solid, dependable, *personable* Rembrandt van Rijn, he of the prolific brush, favored by the rich and mighty, court-painter-in-waiting. No, he was to be compared with the great Hendrick Goltzius, whose own motto (a play on his name) had been "*Eer boven golt* [Honor above gold]." Yet, perhaps, not *quite* indifferent to it either, since in two other self-portraits (both in the Louvre and executed in 1633) Rembrandt appears with a massive gold chain and medallion, chunkily painted, slung about his neck and shoulders, and a studded military gorget at his throat: the epitome of worldly success.

Rembrandt, Self-portrait with a Gold Chain, *1633. Panel, 60 × 47 cm. Paris, Musée du Louvre*

So how did he present himself to Saskia and the van Uylenburghs—as the worthy, sober burgher or the dashing courtier; the dependable steward of their fortunes or the plumed popinjay? Marriage-advice books like Jacob Cats's *Houwelijk* (*Marriage*) were full of solemn counsel about solid virtues taking precedence over transient qualities like good looks and merry dispositions: charms that faded like the rose. They also warned against surrendering to the passions (while making sure to describe, in mouthwatering detail, the results should they not be held in check). But in gallant, seductive Amsterdam, other less prim messages abounded: in the little anthologies of amorous poems and songs that could be bought for a few stuivers at market stalls; in the theater where a lovelorn suitor could pour out his passion (usually unrequited) before his inamorata; and in the streets where young couples strolled and flirted, sometimes (to the horror of foreign visitors) without chaperones. And Rembrandt was not always going to put on his please-the-in-laws face. One of the most beautiful self-portraits from the year of his marriage, 1634, has the air of a lover primping himself in the glass. His hair is fluffed and brushed; he wears fabrics soft to the touch:

velvet and fur. The hairs on the fur trim
stand erect, brushed against the nap. A silk
collar is raised over his chin and cheek,
firming the usually pudgy jawline. Rem-
brandt's mustache is fine and light; his eyes
unusually soft, liquid, and receptive, as if
stirred by desire. His lips are parted; his
throat shadowed. The demeanor of his
face is both serious and welcoming, the
head moving from shadow into light. The
paint flows thin and free, laid on with a
gentle hand. The face speaks of life's hand-
some design.

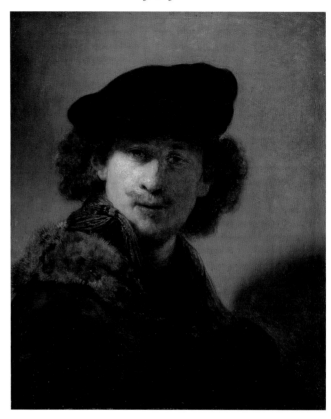

 But it is also the face of a city dandy,
and Saskia, who had spent all her life in
Friesland, might have had country expec-
tations. On the offshore islands of Fries-
land, after all, *kweesten,* or night visits,
were still common practice, when bache-
lors climbed into the bedrooms of their
betrothed, and in some places into the
bed, for a night of tantalizing, tormented
proximity, but were expected to leave at
dawn with their beloved's virtue still invi-
olate.[15] Though they might have exchanged lingering glances and tentative
smiles, hurriedly withdrawn, in the parlor of the minister Sylvius, most of
the courtship took place in the cool, wet light of the Bildt. Rembrandt
might well have first set eyes on his future wife during an early visit to
Friesland since he evidently had close relationships with the two local
painters, Lambert Jacobsz. and Wybrand de Geest. And he must have gone
back to St. Annaparochie in the late spring of 1633 to advance his cause
with the family, sit with Saskia in a front room, propose the sharing of par-
lor and bed, settle the details of the betrothal with the sisters- and brothers-
in-law.

 In his drawing, inscribed "the third day after our betrothal," Saskia
wears a straw country hat (identical to the one worn by Rubens's model
Susanna Fourment in his *Chapeau de paille*), the kind put on for walks.
And the drawing was executed in the materials—silverpoint on prepared
vellum—that were used in the portable, erasable sketching tablets that
artists habitually carried around.[16] The drawing tool was a stylus, the pre-
decessor of the graphite pencil, in which the point was made from an alter-
native soft metal, in this case fine silver. The paper was covered with a
mixture of ground bone white and gum water so that the sheet surface
became grainy enough to take up the delicate silver lines and fix them on
the surface. Exposed to the air, the silver lines have gradually tarnished so
that Rembrandt's drawing of Saskia has developed a brownish-black tone.

Rembrandt, Self-portrait
with a Soft Hat and a
Fur Collar, *1634. Panel,
58.3 × 47.5 cm. Berlin,
Gemäldegalerie*

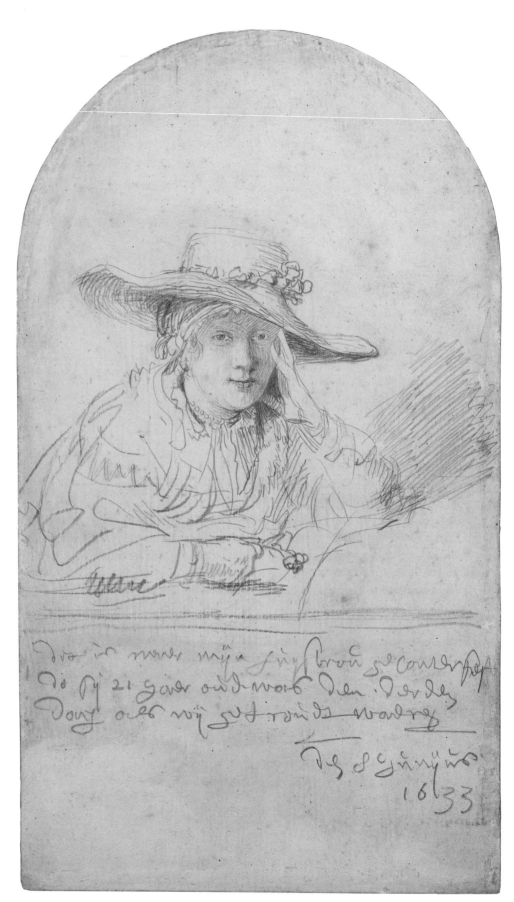

Rembrandt, Saskia in a Straw Hat, *1633. Silverpoint on white prepared parchment. Berlin, Kupferstichkabinett*

But what Saskia would have seen that June day would have been a drawing in the most delicate silver-gray, the line faintly glinting off the page.

It is a little act of adoration. Perhaps they stopped somewhere on a country stroll amidst the June-bright trees. Or perhaps it was when they had returned to the village that Rembrandt saw her sidelong and pulled out his *tafelet*. Saskia's face and upper body are caught in a fresh, early summer light. She sits at a table, her elbow resting on an inclined surface that looks much like an artist's sketching support, leaning forward toward her betrothed, self-consciously the love object. Her features are lightly but exactly described, as if by fingertip exploration. Intimate details are quickly traced with the attentiveness of a lover carefully registering an inventory of small treasures: a wisp of hair lying against her right cheek; the puppy-fat folds at her throat circled by a pearl necklace (the

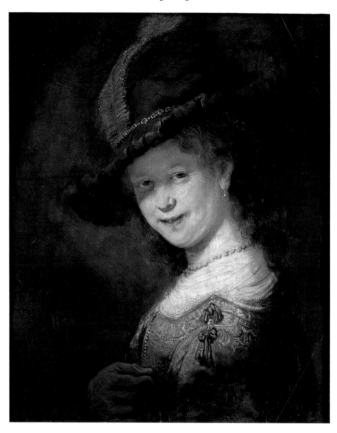

Rembrandt, Saskia Laughing, *1633. Panel, 52.5 × 44.5 cm. Dresden, Gemäldegalerie*

same one that appears in the Dresden portrait); the slight rise of bone at the tip of her retroussé nose; the gathered fabric of her blouse, filled with the bosom that rests on her right arm; the faint pressure of her tapered index finger against her left cheekbone, the underside of her thumb propping up her head. And at the center, dramatized by the dashing sweep of the wide-brimmed straw hat, is Saskia's heart-shaped face with its faintly snub nose; its Cupid's-bow mouth, the shaded join between the upper and slightly drooping lower lip exactly described, sketched; and its almond-shaped eyes, amused, flattered, good-humoredly tolerating the examination. Flowers encircle the crown of her hat; another is held by the stalk, its head drooping slightly. She is his bloom, a child of nature, the Frisian meadow girl, the bringer of springtime fertility, bright and dewy. "*Dit is naer mijn huijsvrou geconterfeit do si 21 jaer oud was den derden dach als wij getroudt waeren den 8 junijus 1633* [This is the likeness of my wife Saskia made the third day after our betrothal, 8 June 1633]" reads his inscription. But it seems less a statement of possession than of amazed delectation. See this. This *schatje*, this precious little piece of work; she is my wife-to-be, my great good fortune.

In the manner that his time understood it, in the way Donne and Hooft versified it, Rembrandt was in love. A head-and-shoulders portrait of her, also painted in 1633, followed Karel van Mander's prescription for

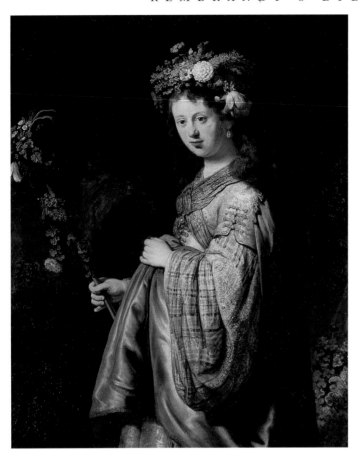

Rembrandt, Saskia as Flora, *1634. Canvas, 125 × 101 cm. St. Petersburg, Hermitage*

depicting a blithely loving face: mouth slightly open in a "sweet laughing merriment," eyes half-closed.[17] He has dressed Saskia elegantly, not outrageously, with a decorated bodice and plumed hat with slashed brim. Her head is sharply turned, almost at ninety degrees to the body, as if in sudden greeting. A ray of light picks out the pearl hanging from her ear. She is a picture of innocent seduction.

Rembrandt's anticipation of their nuptial pleasure may have been quickened by separation. Her sister Antje had died in November 1633, and Saskia, as the last remaining unmarried sister, was required to look after the widower, the apparently difficult Professor Maccovius, in his house in Franeker. During their time apart, Rembrandt secured formal permission from his mother to marry, without which the banns could not be read for the third and final time. But as he became more and more involved with the van Uylenburghs, he seems to have drifted further and further from his family in Leiden. When he and Saskia "went through the red door" of the Oude Kerk sacristy on June 10, 1634, to register their marriage with the civil commissioners of the city, their witness was Johannes Cornelisz Sylvius.[18] And when the bridal couple finally crossed the choppy Zuider Zee in late June 1634 for the wedding, his company on the sailing ferry, besides the preacher and his wife, were Hendrick van Uylenburgh and Hendrick's wife, Maria van Eyck. Titia and her husband François Coopal had also travelled up, all the way from Zeeland, for the marriage. But there were none of Rembrandt's own family: no brothers, no sisters, no mother, even though Neeltgen was in good health. A month after the marriage, Rembrandt went to Rotterdam to paint the wealthy brewer Dirck Jansz. Pesser. The route could easily have taken him through Leiden. But if he did take Saskia with him and stop at the house on the Weddesteeg to introduce her to his family, the records are silent about it. The fact is that Rembrandt had become one of the van Uylenburghs now; and with the wedding feast at the house of Hiskia and Gerrit van Loo in St. Annaparochie, he was brought within the clan. One sister had been sent to her grave; another was now sent to her marriage bed. Such was the way of the Almighty. The Frisian wedding would have been noisy, copious, gener-

ous: none of the elegantly com-
posed Latin verses that celebrated
the union of Rubens and Isabella
Brant, perhaps, but tables piled
with sweetmeats and tawny spiced
breads, wine, ale, and marigolds.
The bride would have worn a
crown of flowers; the groom an
expression that he seldom permit-
ted himself on paper or panel or
canvas: unforced pleasure.

It was early summer, *hooi-maand*, the month of haymaking in
the meadows of Friesland. Rem-
brandt and Saskia were in no hurry
to get back to Amsterdam and
stayed at least until the first week
of July in Hiskia and Gerrit van
Loo's house. But since this was an
unsentimental culture, honeymoon
pleasures were usefully combined
with practical matters arising out
of Saskia's share of her father's
estate. There were debts to be col-
lected, her share of a local farm
property to sell off.[19] And even

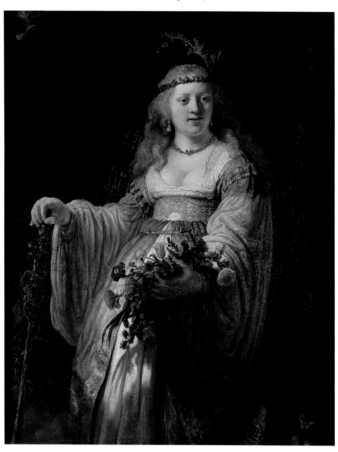

Rembrandt, Flora,
c. 1634–35. Canvas,
123.5 × 97.5 cm. Lon-
don, National Gallery

after they had both moved back to Hendrick van Uylenburgh's house on
the Anthoniesbreestraat, Rembrandt brought country to town, *rus in urbis*,
by painting two three-quarter-length versions of Flora, the goddess of
springtime abundance and fertility.[20] A long tradition has identified both
these paintings (in the Hermitage and the London National Gallery) as por-
traits of Saskia. And for all kinds of reasons, it would be pleasing to sup-
pose this were true. Around the same time, Rubens painted his new wife,
Helena Fourment (who certainly lived up to his expectations of fertility), in
the garden of their Antwerp house, dressed country-style in straw hat and
open bodice, as his rustic muse. The Hermitage *Flora*, dating from 1634
and likewise set in some imaginary arbor, might just be reconciled with the
features of Saskia, known from the betrothal drawing and the two Dresden
paintings, especially since Rembrandt was notorious for a very free attitude
toward literal likeness.[21] But the London *Flora* is without question a com-
pletely different model. She is the heavyset, moonfaced woman, with
slightly protruding eyes and forehead and fleshy, prominent nose, who
reappears in a number of Rembrandt's works in the mid-1630s. She is the
(not very successful) *Bellona* in New York. She is the Madrid *Sophonisba
Receiving the Poisoned Cup*, and she is the Tokyo *Minerva*. Not least, she
is the model for the 1636 etching known as *Woman on a Mound* whose

unedited cellulite later so distressed the self-appointed guardians of classical good taste. She is not, however, Saskia.

No matter. It could hardly have been coincidental that with his Frisian wife established in the city, Rembrandt chose this moment to go pastoral, to freshen the air with flowers and the green, rather cool vernal light that bathes both paintings. But it was, as usual, a shrewd move, since rustic idylls had been made fashionable in Amsterdam by the popularity of pastoral plays like Pieter Cornelisz. Hooft's *Granida and Daifilo* and Jan Harmensz. Krul's *Diana and Florentius,* both of which featured stricken shepherds and bewitching shepherdesses.[22] By 1630 stage costume had spilled over into love poetry, vocal music, and painting, where in Utrecht Paulus Moreelse, for example, was producing Arcadian shepherdesses with the straw hats and loose shawls that had been designated standard pastoral uniform. In turn, the theatrical vogue had affected actual dress modes, so that fashionable women could get themselves up as sheep-girls, in low-cut, high-waisted bodices, fine "Arcadian" veils, and the ubiquitous straw hats, for an occasional expedition into the surrounding country.

For Rembrandt, the line between playacting and life was habitually blurred. And to judge from his elegantly full-length portrait of Jan Krul, the painter may well have been on personal terms with the Catholic pastoral poet. So it would have been entirely in character, as well as in fashion, for him to have dressed both himself and Saskia in Arcadian outfits, in exactly the way his student Govert Flinck painted their respective portraits. But the two big three-quarter-lengths seem too gorgeously and fantastically arrayed to have strayed off the pastoral stage, where simplicity and modesty was the hallmark. The London *Flora* seems every inch a goddess rather than a shepherdess, and she conspicuously displays the low-cut bodice in keeping with Flora's reputation as the patroness of courtesans. Initially it seems that Rembrandt had an altogether different subject in mind, a *Judith with the Head of Holofernes,* closely based on a stunning 1616 painting by Rubens that he would have seen in Leiden in the 1620s, in which the heroic murderess was also depicted with spectacularly bared kiss-me-and-die breasts. It's possible that well before 1635 Rembrandt had already blocked in the original features of the composition with Holofernes' gruesomely decapitated head held in the position where the *Flora* now carries her bouquet of marigolds and tulips. Perhaps his own Arcadian fantasies, refreshed by a trip back to Friesland in that same year when he stood witness with Saskia to the baptism of one of Hiskia's children (named for their dead sister Antje), spurred him to make the substitution. Or did perhaps the conception of their first child, in the spring of 1635, prompt Rembrandt to make a benign alteration from homicide to horticulture, from an avenging angel to the goddess of fertility? In any event, the altered *Flora* sparkles with color, especially in the waistband and in the floral necklace made of interlaced scarlet pimpernels and forget-me-nots. Both these details are built up from little nodules, beads, pellets, and blisters of brilliant paint, resembling nothing so much as a meadow spattered with the color of ran-

domly growing wildflowers. Could the *learned* Rembrandt have been thinking of Karel van Mander's beautiful analogy between a painting and a field of multicolored flowers, in which the eyes dart as busily as bees seeking honey?[23] If so, then his Flora becomes the patroness not just of physical but of conceptual fertility; a personification of painting itself.

In the antique tradition, Flora blossoms when visited by Zephyrus, the sweet, moist breeze. Suppose, then, that the painter was the zephyr and Flora his color field; it would not have been amiss for Rembrandt to represent the goddess as in a state of ripe gestation. And since he and Saskia together would produce both paintings and progeny, he has invoked the blessings of the guardian of twofold abundance. In the Hermitage painting, Rembrandt has even reached back to the medieval Flemish convention of the thrust-out abdomen. But in 1635 the perfume of spring flowers was overwhelmed by the stench of death; Flora bowing her neck to the scythe. It was the worst plague year in living memory, more horrifying than any Amsterdammer could recall. One in five of the population perished in the contagion. Those who could fled into the countryside. Those who could not waited for the angel of death to pass and prayed that their groins and armpits would not begin to mark with fatal purple, like the stain of sloes. The littlest were the most vulnerable of all. Rembrandt and Saskia's first child, named Rombertus, after Saskia's father, survived barely two months. He was buried by his father and mother in the Zuiderkerk, close by Hendrick's house, on February 15, 1636, just another baby to add to the hecatomb of innocents taken by the monstrous epidemic.

Not long after, the whole ménage on the St. Anthoniesbreestraat broke up. Hendrick van Uylenburgh moved to the opposite side of the street; Rembrandt and Saskia belatedly moved into their own home in one of two houses constructed on the Nieuwe Doelenstraat, facing the river Amstel. They had been built by Willem Boreel, the pensionary of Amsterdam, a notoriously difficult oligarch but important enough in the city for Huygens to seek him out whenever he wanted some sort of opening to, or favor from, the Amsterdam regents. Boreel lived in one of the houses and rented the other to Rembrandt's landlady, herself a wealthy widow. So that although Rembrandt was in effect occupying a sublet, when he wanted to seem important (not least to Huygens) he could give his address the grand air of being "next door to the Pensionary Boreel."

It was during their stay in the house by the broad gray river that Rembrandt made a double-portrait etching of himself and Saskia (page 372). If the quasi-history painting of the two of them dressed as the Prodigal Son and a whore is assigned to a class other than simple portraiture (as it must), this is the only image Rembrandt created of their marriage.

Once again, Rembrandt threw convention to the winds, or at least reinvented it. For the etching has no precedent and no successor. He was certainly not the first Dutch artist to paint himself with his wife. In 1601, for example, the mannerist painter and wealthy Utrecht flax dealer Joachim Wtewael painted portraits of himself and his wife, Christina van Halen,

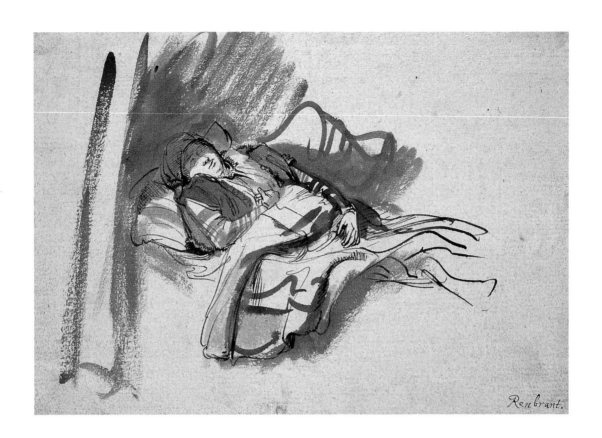

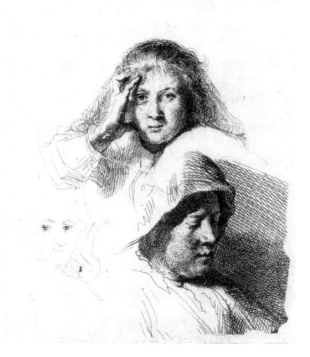

ABOVE: *Rembrandt,*
Saskia Asleep in Bed,
*c. 1635. Pen and brush
in bistre. Oxford, Ash-
molean Museum*

LEFT: *Rembrandt,*
Sheet of Sketches with
a Portrait of Saskia,
*c. 1635. Etching.
Amsterdam,
Rijksprentenkabinet*

that like many such pairs were meant to be seen together: the wife holding a Bible in one hand and gesturing deferentially toward her husband with the other. Wtewael, painted as dynamically as his wife's face was painted smoothly, shows himself at work, holding palette, brushes, and maulstick.[24] In his cartwheel ruff and black satin doublet, Wtewael is the essence of the gentleman artist: upright and correct, very much the peer of Otto van Veen and Peter Paul Rubens, not least in his affecting indifference to renown. Behind both the painter and his wife is a self-explanatory inscription reading, "*Non gloria sed memoria* [Not for fame but remembrance]."

Rembrandt, one feels sure, craved *both* fame *and* posterity. Wtewael's pair portrait was meant for his own household and stayed there. An etching, on the other hand, is meant to be seen by many eyes, and a self-portrait etching thus necessarily becomes an advertisement of the artist's persona. And as with the *Self-portrait in a Soft Hat*, Rembrandt has finely calculated (through three states this time) the effect he wants to make. The compositional novelty was to align husband and wife not parallel to the picture plane but at near right angles to it. On the one hand, this preserved the customary hierarchy of the marriage portrait, with Saskia notionally seated "behind" her husband. Yet, not least because of the brilliant lighting that falls on her rather solemn features (a far cry from the laughing bride-to-be of the Dresden portrait), Saskia can also be read as seated *opposite* Rembrandt on the far side of the table. The visual implication is that once he is

LEFT: *Joachim Wtewael*, Self-portrait, *1601. Panel, 98 × 74 cm. Utrecht, Centraal Museum*

RIGHT: *Joachim Wtewael*, Portrait of the Artist's Wife, Christina van Halen, *1601. Panel, 98 × 74.5 cm. Utrecht, Centraal Museum*

Rembrandt, Self-portrait with Saskia, *1636. Etching. New York, Pierpont Morgan Library*

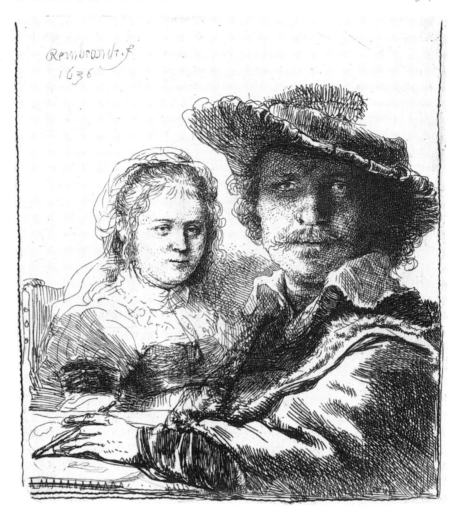

done with his work, he will turn to face her. For the moment, however, the work is everything. And the alignment of arm and head at right angles to each other also has the additional, all-important effect of engaging a third party—the beholder—in this work. Rembrandt's sketching arm, cropped at the bottom, is pushed so far forward to the picture space that his whole presence threatens to project through it, through the looking glass on which his stare is intensely concentrated as he works, his hand moving in "blind" obedience to the instinctive instruction of his eye. It is as though we were behind a two-way mirror, with the artist staring simultaneously at us and at himself. Surreptitiously, the beholder becomes both observer and object of observation; and Rembrandt's wife looks (from an angle) at us looking at him looking at us. This is as intimate as it gets.

Even had these not been Rembrandt's honeymoon years, he would still have been commissioned (through van Uylenburgh) to paint Amsterdam pair portraits. Some of those paintings are routine head-and-

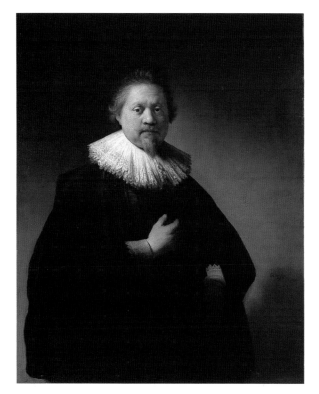

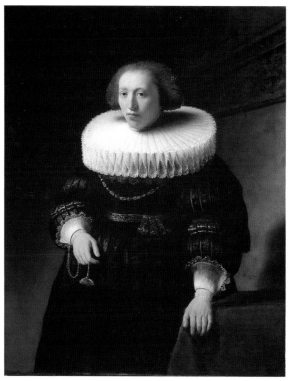

shoulders likenesses, enlivened occasionally with a brightly lit forehead or a gallantly glossy set of whiskers. There are others, though, that, as usual, shake up the conventions of the genre, converting standard pendant portraits into images of dignified but affectionate companionability: a representation of the *friendship* that was touted in contemporary marriage manuals as one of the principal virtues of the conjugal union.[25] And without assuming any simple connection between life and art, it's hard not to see Rembrandt's own pleasure in his young household as contributing something to the freshness and spontaneity of the best of these married-couple portraits.

Which is not to say that Rembrandt could afford to ignore the generally understood conventions of decorum governing marriage portraits. The institution, after all, was said by the preachers, then as now, to have been instituted by God, not merely for mutual succor but also for the more sober purposes of procreating children and raising them in the fear of the Almighty, and, it need hardly be added, for the extirpation of debauchery. So while traditional Dutch marriage portraits were meant to register a firm connection between the partners, any sign of mutual affection came a long way behind the visual assertion of authority and the clear indication of the separate and unequal realms of husband and wife. In any pair portrait of this period, the man is always seen to the left of his wife (or on *her* right hand). He is dexterous, a-droit, *rechts*, all terms that semantically equate right-handedness with the law, for the husband was indeed the supreme

LEFT: *Rembrandt,* Portrait of a Man, *1632. Canvas, 111.8 × 88.9 cm. New York, Metropolitan Museum of Art*

RIGHT: *Rembrandt,* Portrait of a Woman, *1632. Canvas, 111.8 × 88.9 cm. New York, Metropolitan Museum of Art*

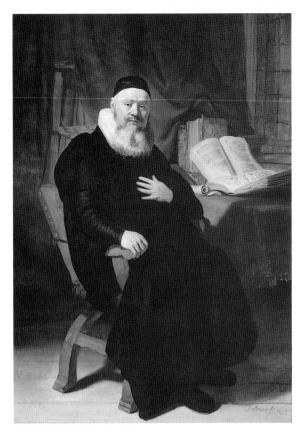

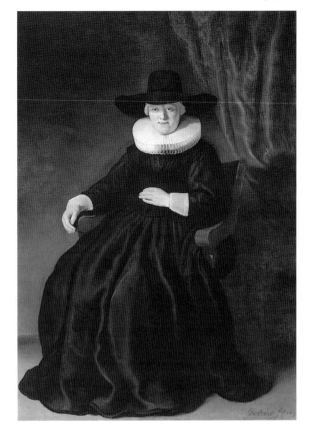

LEFT: *Rembrandt, Portrait of Johannes Elison, 1634. Canvas, 174.1 × 124.5 cm. Courtesy Museum of Fine Arts, Boston; Reproduced with permission*

RIGHT: *Rembrandt, Portrait of Maria Bockenolle, 1634. Canvas, 175.1 × 124.3 cm. Courtesy Museum of Fine Arts, Boston; Reproduced with permission*

magistrate in the little commonwealth of the family. He is also its minister of external affairs, so that the gestures or movements of the male side of marriage portraits are invariably more open and vigorous than the female side. When his hand gestures toward his wife, as if in introduction to the beholder, she is generally posed in passive stillness, in acceptance of his mediation between the home and the outside world. Often the man is seen standing, indicating a more worldly and open manner, while his wife remains seated, the queen of the domestic hearth. He may hold a pair of gloves, the emblem of the *dextrarum iunctio,* or the nuptial joining of right hands, a detail which, in Catholic culture, had originally signified the sacramental nature of marriage, but which had survived into seventeenth-century Protestantism as a symbol of the marital bond. In more courtly pictures, the husband might hold a single glove by one finger as if poised to drop it gallantly at her feet. Wifely props are generally more passive: a fan tightly shut or, if open, held close to the body, rather than fluttering through the air.[26]

Despite his later reputation for restive inventiveness, Rembrandt was perfectly willing to observe these proprieties if the commission called for it. The authenticity of the "Beresteyn" portrait pair in the Metropolitan Museum of Art, New York, has been called into question partly because the wooden pose and demeanor of the wife seems at odds with the painter's

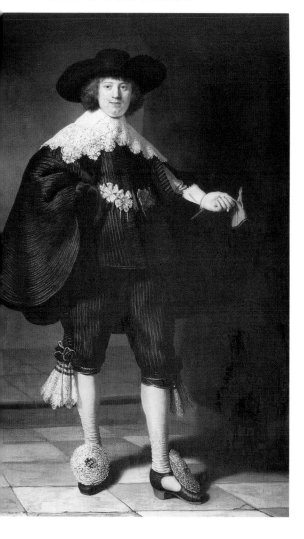

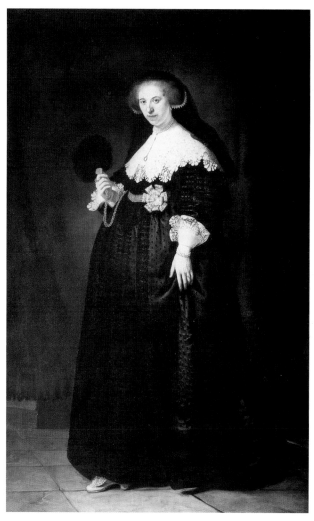

preference for animation.[27] But much of the unfortunate impression of a decapitated head that has been surgically reattached to the body is the result of the brutally old-fashioned millstone ruff abruptly separating chin and neck. The formidably bullish face of her husband is painted with typically Rembrandtian attention to detail around the eyes, and his own ruff is actually a tour de force of the painterly rendering of layered fabric, using precisely the same techniques that the artist used in his own *Self-portrait as a Burgher*: the lead white laid on in thick, almost foamy density. The brilliant ruff not only frames the face above it but casts light onto it, investing its heavy features with heft and vitality.

In another portrait, the life-size, full-length canvases of the minister of the Reformed Church at Norwich, Johannes Elison, and his wife Maria Bockenolle, Rembrandt is once more on his best behavior, dutifully attending to the requirement of making a document of an ideally pious Calvinist marriage. His patron was the couple's son, Johannes Jr., an Amsterdam

LEFT: *Rembrandt, Portrait of Maerten Soolmans, 1634. Canvas, 209.8 × 134.8 cm. Private collection*

RIGHT: *Rembrandt, Portrait of Oopjen Coppit, 1634. Canvas, 209.4 × 134.3 cm. Private collection*

merchant whose wealth created something of a problem for Rembrandt since it seems to have spurred the younger Elison to demand pair portraits on a pretentiously monumental scale, unusual in paintings of a minister. Rembrandt needed all of his skills—highlighting the skullcap, for example, along with the usual dramatic treatment of the books and Elison's hand-on-heart gesture of marital sincerity and loyalty—to prevent the paintings from becoming dourly statuesque, especially when the sobriety of the couple precluded the use of any enlivening props. Though he does everything he can with the faces of the dauntingly exemplary couple, Elison's large head and frame suggesting the weight of his piety, Maria Bockenolle's sympathetically painted eyes and right hand gently resting on her stomacher proclaiming her as a paragon of wifely mildness, the portraits stubbornly refuse to come to life. But perhaps Johannes Jr. was less interested in vivacity and more in large icons of the family patriarch and matriarch seated on their thrones of righteousness. This he certainly got.

Happily for Rembrandt, some of his other married sitters must have wanted something more animated, or at least raised no objections when he represented their marriage as an active rather than a passive partnership. This was no more than the most respectable marriage manuals of the time prescribed. Jacob Cats, in a vivid if unfortunately chosen metaphor, compared husband and wife to two millstones who must perforce grind against each other to achieve their life's satisfaction.[28] But instead of mutual grinding, Rembrandt has at least two of his young couples appear to come together across the wall space separating their pendant portraits. In the most ornately debonair of all his pairs, Oopjen Coppit, the distaff side of the literally well-heeled patrician marriage, her wedding ring hanging conspicuously from a pearl choker, appears to move toward her pretty-boy spouse, Maerten Soolmans. Her body is turned to face her husband as she lightly lifts her skirt, its hem casting a shadow on the tiled floor that serves as a unifying common ground for both pictures, and puts her exquisitely shod right foot forward. This may be the first full-length Dutch pair portrait in which as much attention is focussed on the couple's feet as on their hands, since Rembrandt has reserved his most spectacular brushwork for the outrageous rosettes on Maerten Soolmans's shoes, planted at aristocratic right angles to each other.

The portrait of Oopjen Coppit reverses the convention by which the husband in pair portraits was given the more physically demonstrative role. But just as Rembrandt was able to suggest the tranquillity thought desirable in a model wife even as she moves across the floor, so in another brilliant piece of painting (page 377) he contrived to make an ostensibly still wife seem alive with energy. Her husband, yet another young fashion-plate regent, fancily got up in figured black satin embellished with rosettes and hung with gold needle-pegs or aiguillettes, rises smartly to his feet, leaning and motioning toward his wife. Although she makes no comparably dramatic movement, the slight backward lean of her body and its subtle counterclockwise twist, as well as the shadow below her right fan-holding hand,

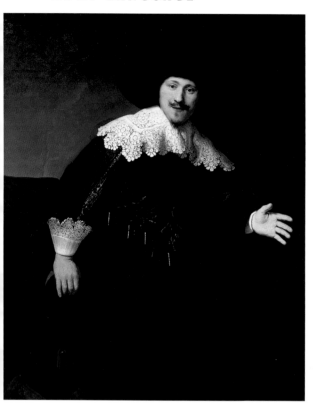

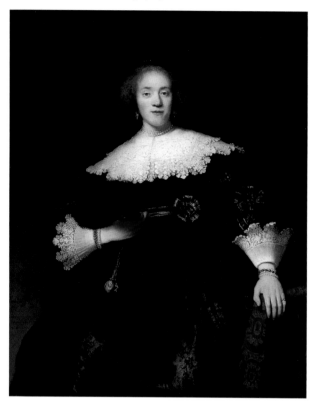

give her pose a kind of edgy vitality. Rembrandt has made the elaborately layered and scalloped lace collar and cuffs curl and rise like the crests of little waves, so that the entire personality of the woman seems to be running on a gentle electric charge. Even her lips and eyes and brows at their corners betray the faintest beginnings of an impending smile.

These were all subtly informal alterations to the standard genre of the pair portrait. But a third painting, *The Shipbuilder Jan Rijksen and His Wife Griet Jans,* was an utterly unprecedented invention, not so much a unified "pair portrait" as an episode from married life. Its originality was all the more startling given that only the most restrained and severely formal poses were considered appropriate for the depiction of an elderly married couple. As usual, Rembrandt's innovations begin as a creative reworking of a tradition: in this case, the sixteenth-century paintings of husbands and wives seated together at a table, the man preoccupied with business, usually monetary; the wife with spiritual devotions.[29] He may have been thinking in particular of one of the most famous and much imitated of all Netherlandish paintings, Quentin Metsys's *Money Changer and His Wife* of 1514, which might have been the "portrait of a jeweller by Master Quintinus" listed in the inventory of Rubens's own collection on his death in 1640.[30] Metsys's double portrait exemplified the traditional division of spheres into the masculine worldly, active life and the female contemplative, pious life, reinforced by the illumination of the Virgin and

LEFT: *Rembrandt, Portrait of a Man Rising from His Chair, 1633. Canvas, 124.5 × 99.7 cm. Cincinnati, Taft Museum*

RIGHT: *Rembrandt, Portrait of a Young Woman with a Fan, 1633. Canvas, 125.7 × 101 cm. New York, Metropolitan Museum of Art, Gift of Helen Swift Neilson, 1943*

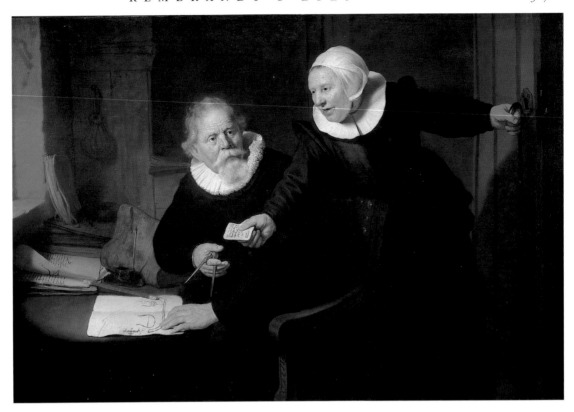

Rembrandt, The Ship-
builder Jan Rijksen and
His Wife Griet Jans,
*1633. Canvas, 114.3 ×
168.9 cm. London,
Buckingham Palace,
Royal Collection*

child in the wife's devotional book. The particular cunning of Metsys's
composition, the complication that would undoubtedly have appealed to
Rembrandt, was its subtle erosion of the watertight separation between the
worldly and unworldly realms, indicated by presenting the wife as dis-
tracted from her devotions by the clink and glitter of the money changer's
coins. Suspended between one world and the other, she ponders the scales
as if they were measuring both the respective weights of the material and
immaterial worlds and the partners in a consecrated marriage.[31]

 Rembrandt neatly upends these stereotypes. It is Jan Rijksen who
seems dreamily preoccupied, not in any spiritual exercise but in the concen-
trated consideration of his ship design, sketched out on the paper in the
shape of a stern seen from the rear. He is lost, in other words, in his *inge-
nium,* the idea at the moment it takes wing, the instant of conception that
Rembrandt had himself represented in the Boston panel of 1629, so that we
should not be surprised to see the artist's signature inscribed, sympatheti-
cally, on Rijksen's sketch. Unlike in the Flemish "banker" paintings, it is
the architect's wife who bursts in on this interior contemplation. With his
typically free approach to combining old and new genres, Rembrandt has
grafted the modern interruption scene, almost always featuring a manser-
vant, maidservant, or soldier bringing a letter to his or her master, mistress,
or officer, onto the Flemish husband-wife painting. But the synthesis
amounts to something completely new: a sympathetic enactment of

another axiom from contemporary marriage manuals, namely, that the ideal wife should be a true partner in the affairs of her mate, helping him to shoulder its burdens—a notion not too far-fetched in this case since Griet Jans herself came from a family of shipbuilders.[32] The subtle allowance of a more active role for the female side of the marriage implied in Oopjen Coppit's move-

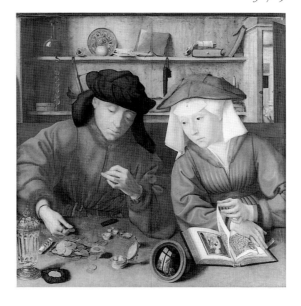

Quentin Metsys, The Money Changer and His Wife, *1514. Panel. Paris, Musée du Louvre*

ment toward her husband has here been developed into something incomparably more uninhibited and vigorous. Though the painting is in fact divided at its center between the two figures, Griet Jans seems to dominate the composition, through the extension of her arms all the way from the door to her husband's desk, through the angle of her upper body leaning dramatically forward, through the dramatic shadow cast by her cheek and chin against the brilliant white ruff, and not least because she is clearly *speaking* to Jan as she hands him the letter. Despite this compositional daring, Rembrandt has been careful to preserve the familial hierarchy. The wife, after all, remains deferentially wifely. She leans on the back of her husband's chair, much as wives (like Isabella Brant) were conventionally represented leaning against the male governor of the household. And she makes sure to keep her left hand on the iron door handle, as if signalling her intention to depart as soon as her errand is accomplished, returning Jan Rijksen to the privacy of his business.

Cunningly, Rembrandt has even preserved, right at the heart of the painting, one of the formal, symbolic attributes of marriage, the *dextrarum iunctio*, the joining of right hands. But instead of its being euphemized in a pair of gloves, he has dissolved the emblem into a moment of imminent contact between husband and wife: the compass and the letter. It's a stroke typical of his determination to honor the traditional conventions of marriage portraits while drastically altering their representation. Though Jan Rijcksen was seventy-two at the time he posed for Rembrandt, and his wife presumably at least in her middle sixties, nothing could be further removed from the rigid icons of patriarch and matriarch, respectfully hung on the walls of their children's house as objects of ancestral respect and veneration. Instead of representing the *institution* of marriage, Rembrandt has painted the lived reality of it. A single moment has been torn from the long calendar of familiarity; an entire double history visualized in a split second.

Rembrandt, Three Sketches of the Prodigal Son with a Whore *(detail)*, *1630s. Pen drawing. Berlin, Kupferstich-kabinett*

And what of Rembrandt and Saskia's own double history? That he painted a portrait of them both at some point isn't in doubt, since an inventory of their son Titus's former guardian Louis Crayers, drawn up when Crayers's wife remarried in 1677, lists "*een contrefeytsel van Rembrandt van Rijn en sijn huysvrouw,*" a likeness of Rembrandt van Rijn and his wife.[33] It's long been assumed that this must have been the painting in Dresden depicting a mustachioed gallant trailing a long sword from his bandolier, guffawing toothily as he puts his arm round the waist of the richly dressed girl whose plump, silkily modelled derriere is solidly planted on his lap. A mid-eighteenth-century etching after the painting, made by the *Inspektor* of the Elector of Saxony's art collection, came to be labelled *La Double Jouissance,* and an anecdotal tradition grew up around the canvas in which it was seen as an unapologetic celebration of the couple's notorious appetite for high-roller living: sex, wine, and peacock pie. For the Romantic biographers, the painting's hedonism exactly matched their need for an image of Rembrandt's shameless dissipation: the moment of hubris before the fall into debt, widowerhood, and bankruptcy. The later discovery of complaints from Saskia's Frisian relatives about the squandering of her portion of Rombertus van Uylenburgh's estate only seemed to reinforce the image of heedless prodigality.

But whatever else it is, the Dresden painting can't possibly be autobiography, at least not of a straightforward kind. For if Rembrandt is posing as the Prodigal Son, frittering away his fortune in a place of ill repute,

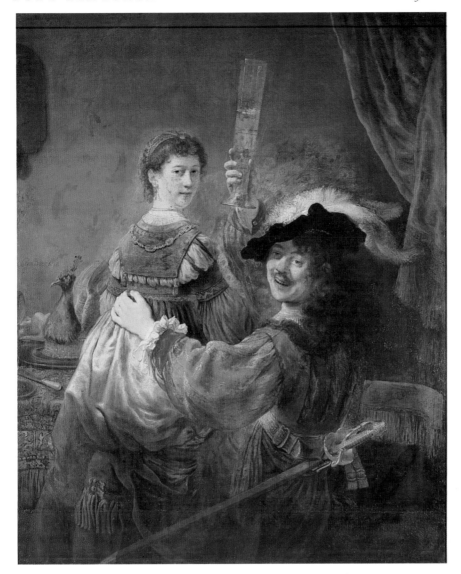

Rembrandt, Self-portrait with Saskia (The Prodigal Son with a Whore), *c. 1635. Canvas, 161 × 131 cm. Dresden, Gemälde-galerie*

that makes Saskia his dimpled whore, an unlikely role for the wife of an ambitious artist "next door to the Pensionary Boreel" and patronized by the Stadholder and the cream of the Amsterdam patriciate. But there is no doubt at all that the parable is, in fact, the subject of the painting. A long iconographic tradition represented the Prodigal Son precisely in this manner, carousing with one hand round a prostitute and the other round a glass of wine.[34] Two related pen drawings from this period, both stunningly candid, make Rembrandt's deep interest in the subject graphically plain. In the more complete drawing, the Prodigal Son, dressed in a hat and doublet very similar to those of the figure in the painting, fondles the breast of the girl on his lap while a second girl, semidressed and seated, looks on and a third, completely nude, strums a lute, a standard visual innuendo for copu-

lation, especially when connected with an ostentatiously tall *fluit* glass. X-ray images of the Dresden painting (which was extensively overpainted and clumsily retouched at a later date) reveal that originally a grinning, lute-playing woman was standing between the two figures, with the neck of the instrument pointing to the right in precisely the manner indicated in the drawing. A second sheet experiments further, with one rough sketch showing the Prodigal planting his hand between the whore's thighs, and another showing him facing forward and grinning, much as in the painting, while he brings his right arm round the back of the girl and under her arm to fondle her exposed breast. She is riding his lap, her skirt pulled up over her thigh, and she is smiling.

Which is, of course, the difference between drawing and painting. Saskia-dressed-as-tart shows scant enthusiasm for her raucous client. In fact, she shows precisely the kind of bemused tolerance that generally goes with the obligations of her profession. And here's the problem. The earlier, naïvely uninformed tradition of seeing this scene as one of innocently lusty merriment has now been replaced by its antithesis: the naïvely *erudite* assumption that Rembrandt must, without question, have intended this as a scene of moral warning. The requisite emblems are all there: the peacock, a standard emblem of vanity; the tally board at the back, the emblem of ominous *reckoning*! And how could anyone mistake the expression worn on Saskia's face, one of the few passages in the painting where Rembrandt's own hand has been left relatively intact, as anything but a solemn reprobation. But a careful look at that expression reveals it to be tantalizingly equivocal, neither colluding nor disapproving, the corners of her lips turned up, the light in her right eye as bright as her pearl drop earring.

None of which necessarily means that Rembrandt is, after all, relishing his role while pretending to frown on it. What it might mean, however, is that to make the history spring to fresh life out of the mass of clichéd images inherited from the past, he needed to do more than a casual dress-up modelling job. Instead he buries himself in the part, makes the Prodigal uncomfortably recognizable, a street dandy with his ostrich-plume hat, crooked teeth, and flashy gold-hilted saber. Once seen as *both* a biblical parable *and* a contemporary genre painting, the discrepancy between the Prodigal's drunken, lecherous cackle and the self-contained *knowingness* of the courtesan's face becomes shockingly telling (much as it would in the similar paintings of Jan Steen where the artist also poses as a tavern girl's liquored-up trick). So this is not Rembrandt. And then again it is. Or rather it *is* Rembrandt insofar as it is also a personification of all of us. Just as he did when he impersonated the executioners of St. Stephen and of Christ, Rembrandt has once more turned into *Elk*, Everyman, the epitome of sinful humanity, doing us all a favor by sponging up our iniquities, mercifully oblivious to the reckoning.

ii *Violations*

Fast-forward three and a half centuries to June 15, 1985. White nights are coming on fast in Leningrad (as it still was). In the afternoon brightness, by the river Neva, a nondescript young Lithuanian walks into the long Rembrandt gallery on the second floor of the Hermitage. The first painting to greet him is *Danaë*, stretched out on her bed, propped up on her left elbow, her skin bathed in golden light, her breasts, belly, and thighs turned hospitably to the beholder. The man walks up to the painting and stabs the girl in the groin, slicing through the canvas and extending the tear a full four inches as he pulls the knife from the wound. He punctures her once more and moves swiftly to a second assault, throwing a bottle of sulfuric acid at her face, torso, and legs. Photographs taken after the vandalism show three violent impact sites, so that it must have taken three big swings to empty his flask. All this evacuation of hatred happens in a few seconds, before guards can get to him.

Within minutes, the painting is cooking, carbonizing the oils. No water and no guidance is available to the guards, who might, in any case, have been understandably nervous about drenching a Rembrandt.[35] It is still, after all, year one of glasnost. By the time distraught curators arrive, the acid has eaten right through layers of Rembrandt's pigment and "dead-color" sketch, leaving scarified bald patches over the central area of the picture. A dark, bubbling, viscid mess, like simmering molasses, is streaming down the surface of the canvas and onto the wooden floor of the gallery, where it coagulates into a bad-smelling black puddle.[36]

The devastation inflicted on the *Danaë* has been only partially reparable. Just a third of the total area of the painting was affected by the vandal's onslaught, but it was, of course, the critical central section, the body of the woman. It took twelve years for the understandably anxious and still grieving restorers and curators to show the painting to the Russian public. What happened in the interim itself constitutes an act of considerable bravery and integrity. Immediately after the crime, in June 1985, Communist party officials, lapsing into Chernobyl disinformation mode, wanted to conceal the full nature of the disaster from the public and ordered the painting to be fully restored. "The picture must not become a monument to barbarism," declared one official. "It must be returned to the museum's halls as an example of the progress of Soviet art restoration." The museum staff were less sanguine. The painting was no more capable of "integral restoration" than the USSR itself. They were conscious that what was being demanded was not merely local retouching but a repainting so extensive that the canvas would, to all intents and purposes, cease to be a Rembrandt at all.

Instead of inflicting this "integral" restoration on what was left of the *Danaë* and pretending that the damage had been slight, the curators and restorers took their courage in their hands and proposed something truly revolutionary: admitting the truth, and retouching only in areas of the painting where the acid had not bitten clear through to the ground. Rembrandt's habit of coating layers of paint with varnish and semi-transparent thinned pigment before proceeding to work up the color detail had had the effect of protecting some of the deeper layers from maximum damage. It was these lower layers, now exposed, that the more conservative approach to restoration was endeavoring to preserve, even at the cost of accepting a radical and irreversible alteration of the painting's basic tonal quality (not least the golden light which, as we shall see, is at the heart of the depicted story). Doubtless some delicate and anxious negotiation followed, but the professional museum staff held fast to this position and won the argument. So although it is still a heartbreakingly beautiful work, the painting returned to the gallery is not the same painting that was seen before June 15, 1985. Important details have disappeared forever: the lower end of the sheet originally covering her legs; much of the coral bracelet on her left wrist; the heavy bunch of keys held by the old maidservant; and, not least, the flood of golden light that poured over Danaë's flesh and made it shimmer as if irradiated by a kind of sublime possession.

And yet, even in its ravaged state, the *Danaë* still emits the intense sensuality that may have provoked the Lithuanian to his slash-and-splash attack. His motives were mixed. An apocryphal story has it that he asked the guard which was the most important (or most expensive) Rembrandt in the gallery. Interviewed by a Dutch journalist, the assailant claimed his

Rembrandt, Danaë *(detail, after being vandalized), 1636. Canvas, 185 × 203 cm. St. Petersburg, Hermitage*

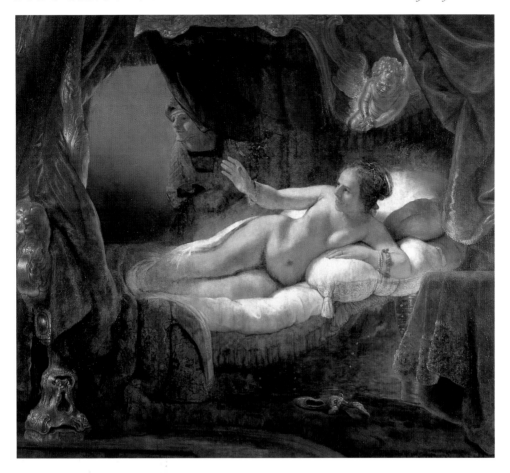

attack was an act of nationalist protest. But Irina Sokolowa, the curator at the Hermitage, believes he was deluded by religious indignation, out to obliterate profanity. Was it an accident that his knife-thrust landed on the pubic triangle which Rembrandt had deliberately designed not just as the intersection of his three heavily curving outlines but as the precise center of the painting?

Well, she was asking for it, wasn't she? After all, the picture's almost disturbing, palpable earthiness had gotten it in trouble before. It had been bought by the Empress Catherine the Great, whose own famously well-developed erotic instincts would presumably have been much pleased by it. In the reign of her son, Tsar Paul, who cordially detested almost everything associated with his mother, the painting had been removed from the delicately decorative small Hermitage and taken to a darker gallery. The strait-laced reign of Nicholas I isolated it even further from ogling eyes, so that by the time the French critic Louis Viardot visited St. Petersburg in the mid-nineteenth century, what he described as a painting of "an indecent subject painted in a still more indecent manner" had been "relegated far from the crowds of visitors" in the depths of the palace.[37] How, Viardot added, sub-

Rembrandt, Danaë *(after partial restoration)*

scribing to a long tradition of disgust at the forms of Rembrandt's nudes of the 1630s, "can one possibly conceive of the passion of the Master of the Gods [Jupiter, that is] for a creature so evidently unworthy to please?" The painting, he concluded, could be summed up in two phrases: "horrible nature, incomparable art."

But why, in what was the biggest history painting he'd yet tackled, would Rembrandt have gone out of his way to create a perversely repellent nude? And why should the *subject* have been thought indecent? The story of Danaë is taken principally from Horace and turns on the favorite Roman truism of the futility of self-protection against the decrees of fate. The King of the Argives, Acrisius, sought to avoid the fulfillment of a prophecy that he would be killed by his own grandson by incarcerating his only daughter, Danaë, in a "brazen" tower. This was, of course, a risible challenge to Jupiter, who duly penetrated both the prison and the princess in the form of a rain of gold. Having a hard time crediting her pregnancy to an eighteen-carat downpour, Acrisius decided to take no chances and cast Danaë and the love child into a chest which was then thrown into the sea. Needless to say, both survived, the infant growing up to become the hero Perseus, who between more celebrated exploits was casually throwing the discus one day when a fateful zephyr diverted its trajectory straight to the head of his grandfather, Acrisius. Prophecy fulfilled. Served him right.

The story had been irresistible to artists since antiquity because it so neatly embodied both senses of *luxuria:* lust and opulence. In Greek ceramics Danaë is often seen opening her dress to admit the golden shower, but in Pompeian painting she was, predictably, nude. The Roman writer Terence mentions a Roman youth who attempted to defend himself against charges of rape by blaming the whole matter on an unbearably alluring *Danaë* that had excited his passion. Since Jupiter had himself been aroused by the spectacle of the locked-up girl, he pleaded, how "as a mere man could I do otherwise?" (Though the defense was probably not strengthened by his continuing, "In fact I've done the same and enjoyed myself.")[38] The erotic charge emitted by Danaë's nude body became a standard feature of Renaissance painting, although artists like Correggio, Titian, and Tintoretto differed in the emphasis they placed on the rain of gold itself, not least because it had begun to be associated with the venality of courtesans. In some versions, cupids accompany Danaë and harvest the lucre; in others, she is attended by an old maidservant (represented in the manner of a procuress). Rembrandt's conspicuous omission of the kind of heavy shower of coin that appears in most Italian versions has even led some writers to doubt the subject. But there were some precedents for euphemizing the rain of gold as a shaft of light, not least in the great Correggio painted for Federigo Gonzaga in which the Jovian presence was represented by a potent, sacklike golden cloud from which a mere drop or two falls on the maiden's receptive body. But in any case, Rembrandt was often quite undeterred by lack of precedent in his impulse to stray from literal representations in the interests of dramatic subtlety. Rembrandt may have followed one of Titian's several

versions of the history when he replaced the material manifestation of Jupiter with a numinous golden light, though he went much further than the Venetian master in reducing the god entirely to his auric aura. It's this supernal radiance whose arrival is heralded by Danaë's gesture of greeting and which (before the vandalism) pours through the parted curtain, illuminating the maidservant's face. When Rembrandt returned to the *Danaë,* at some point in the late 1640s or 1650s, and strengthened the fall of golden light on her body, he also turned the maidservant's face from profile, providing a bigger surface area—both cheeks, the nose, forehead, and tip of the chin—to catch that brilliance.

The conversion of the rain of gold into something more ethereal has led the more pious-minded writers on Rembrandt to argue that his *Danaë* was meant less as a love song than as a hymn, a deliberate throwback to the medieval tradition which made the chaste princess, inseminated by golden light, a prefiguration of the Virgin.[39] So this is apparently another work from the hand of Rembrandt the Puritan *pretending* to celebrate the pleasures of the world when he was, in fact, scowling at them. And for enthusiasts of this devout reading, the meaningful presence of the shackled cupid, weeping at his inability to consummate fleshly love, at one end of the bed, and the golden parrot, a bird associated by Conrad of Würzburg with the Virgin Mary, at the other, puts the whole matter beyond doubt.

A pity, then, that the Hermitage slasher who was so enraged by the wickedness of Rembrandt's *Danaë* that he decided to destroy it did not have access to this erudition. Had he but known that the painting embodied virtue, not vice, he might have spared himself the trouble and the rest of us the masterpiece.

But then again he might have taken a second look and found the Christian interpretation a bit of a stretch. He might have said to the learned iconographers, Look, maybe Rembrandt knew all about Conrad of Würzburg, but I'm damned if *I* can see the parrot. For that matter, the elaborately wrought decoration at the end of the bed is hardly self-evidently a *bird.* And the tears of the chained cupid, as Erwin Panofsky pointed out a long time ago, can more obviously be understood to represent Danaë's enforced *chastity* rather than any regrets about its impending loss![40] Insisting that Rembrandt's woman, lying warmly and heavily on her sheets, is a personification of the victory of Platonic over sensual love requires the blinkers of erudition to be clapped so firmly over the evidence of our own eyes that they blind us to the most obvious fact about the entire painting: the uniquely earthy imprint of her body. It's obvious that Rembrandt has wanted to follow Titian in creating an overpoweringly desirable nude. But Venetian eroticism, even in Titian's directly sensual rendering, is the lust of Ovidian dreams: shimmering, perfectly opulent bodies that simultaneously offer themselves while remaining tantalizingly unavailable to mortal touch. Rembrandt's eroticism, on the other hand, draws on the heart-pounding excitement of immediate, complete availability. His *Danaë* is a memory bank of close-up physical inspection, from the dark line stretching from

Rembrandt, Danaë
(detail of shoes)

navel to groin, to the heavily rounded belly whose weight creates the shad-
owed declivity between waist and hip that asks to be traced with the gentle
caress of the back of a hand. We see things unfit for the gods: the short neck
and trunk; the little beadlike nipples; the irregular teeth appearing above a
slightly protruding lower lip; the shiny forehead. And the shadows on her
body are calculated not as a poetic veil but as an erotic route map: the
crease at her armpit; the little indentation at the base of her throat; the
underside of her fleshy arms; and the darkened, triangular valley of her sex.
The lower edge of the mattress, its swelling line (like much else in the paint-
ing) unusually reinforced with a contour-stroke, and Danaë's left hand, its
upper surface resting on the underside of her breast, its palm flat on the
smooth pillow, are all details meant to lead us across the golden threshold
from vision to touch, from fantasy to possession.

Even the still-life details work the senses. Rembrandt's pleasure in
incorporating the elaborately curvy, "lobate" style of worked gold and sil-
ver made popular by the likes of his friend Johannes Lutma into the histo-
ries of the mid-1630s has been noticed often enough. But the reinforcing
effect it has on sexually charged histories, where the fluid, almost liquid
lines of the plate echo the voluptuous curves of a nude, is usually only made
inadvertently apparent when, for example, a solemn entry in the *Corpus*
mentions the characteristic "re-entrant cavities" of the foot of Danaë's
bed.[41] It shouldn't take Dr. Freud to notice that "re-entrant cavities" are all
over this picture: Danaë's mule, whose opening faces us and which rhymes
with the curious openings of the bed foot; and, not least of course, the cur-
tains themselves, which have been boldly parted to allow the penetration of
the god.

And although Rembrandt decisively altered the angle and attitude of
Danaë's upraised right arm when he later returned to the painting, so that it
became much more welcoming, it seems utterly implausible that he should
ever have meant this woman, painted this way, as a representation of spiri-
tual, rather than carnal, love. For that matter, Rembrandt's own near con-
temporaries had already begun to treat the medieval tradition of Virginal
Danaës rehearsing the Immaculate Conception as a great joke. Karel van

Mander's biography of Cornelis Ketel, for example, tells the story of the peasant who, upon looking at his version of the *Danaë*, "lying naked with her legs apart," claimed to recognize the subject as "the Annunciation of Mary."[42] Later in the same book, the chapter on his friend Goltzius describes his famous *Danaë* as "wonderfully fleshy." Later, the Dutch poet Joost van den Vondel wrote a poem on a *Danaë* painted by Dirk Bleker (who was associated with Rembrandt's workshop in the 1640s) which leaves no doubt that the picture represents physical rather than spiritual love, since it begins, "This naked body could entice a god."[43]

Vondel goes on to treat Bleker's *Danaë* as if it were clearly an attack on women's weakness for glittering objects, their notorious *snoeplust*. The last line of his poem explicitly warned of the evils that necessarily followed when women meddled in matters of money! But the originality of Rembrandt's masterpiece was, as usual, his *avoidance* of all these hackneyed stereotypes. His Danaë is neither virgin nor gold digger, and for that matter neither a coolly classical model (in the manner of Correggio) nor the poetically voluptuous torso of Titian's treatment of the same subject. She is something altogether more startling: a resolutely unidealized, flesh-and-blood contemporary woman. It was, in fact, something very like this painting that Jan de Bisschop, one of Rembrandt's fiercest later critics, had in mind in 1671 when he attacked the painter for putting nature before the classical ideal, painting "a Leda or a Danaë . . . as a naked woman with swollen belly, hanging breasts and garter marks on the legs."[44] Ten years later, the dramatist Andries Pels waxed even more indignant at Rembrandt's habit of taking "a washerwoman or peat-treader from some barn [and] calling his whim the imitation of Nature and everything else decoration."[45]

When they upbraided Rembrandt for spitting in the eye of classical decorum, these critics undoubtedly also had in mind the two extraordinary etchings known as *Woman on a Mound* and *Diana at Her Bath*, both published by Rembrandt in 1636, around the time he was completing the *Danaë*, offending garter marks and all. These images seemed to the horrified guardians of taste (generation after generation) an incomprehensible lapse of manners. In the eighteenth century, François-Edmé Gersaint, the first cataloguer of Rembrandt's prints and therefore by definition a great admirer, threw up his hands when it came to contemplating his alarmingly unedited bodies. "I don't know why Rembrandt was so often determined to make both male and female nudes," Gersaint wrote, "when it appears that he never succeeded [at this]. I don't believe there is a single one that can be cited that is not disagreeable to the eye."[46] Two centuries later, Kenneth Clark, who pronounced the same prints "some of the most unpleasing, not to say disgusting, pictures ever produced by a great artist," thought that Rembrandt's perverse devotion (as he saw it) to recording in unflinching detail the folds and swellings, dimples and wrinkles, sags, bags, and pouches of a woman's body could be explained either by the deliberate intention of sabotaging the classical ideal or by a clumsy attempt at

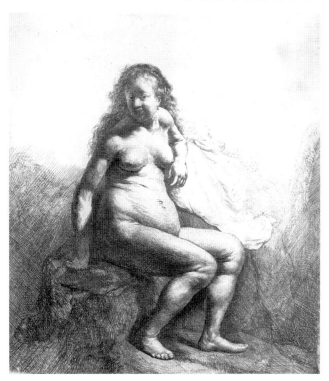

ridicule.[47] In all these respects he was to be set sharply off from Rubens, who not only had recommended copying classical statues for the ideal model of a nude but had also chosen for one of the decorations of the garden façade of his house the episode from Pliny in which the painter Zeuxis has a procession of naked girls file in front of him so that he can choose five from whose best features (number one: breasts; number two: behind . . .) an ideal figure of the goddess Hera could be synthesized.[48] To Rubens's most ardent admirers, like the late Baroque French critic Roger de Piles, this selection process epitomized the Flemish painter's commitment to discrimination. Rembrandt, on the other hand, whatever his many other virtues, had no idea when to avert his gaze. Put a nude in front of him and he was a greedy vulgarian.

Rembrandt, "Woman on a Mound," c. 1631. Etching. Amsterdam, Museum het Rembrandthuis

RIGHT: *Rembrandt, "Diana at Her Bath," c. 1631. Etching. Amsterdam, Museum het Rembrandthuis*

But *were* Rembrandt's nudes, in fact, all that different from Rubens's, and especially from the ample Rubensian bodies of the mid-1630s, with their voluptuously fleshy overspill and their heavy horticultural ripeness? For all Rubens's admonitions to study the antique, nothing in his celebrations of cellulite remotely resembled fifth-century Greek Aphrodites or Dianas. In one of the most sensually overloaded of his late paintings, *The Three Graces,* blooms of summer, full-blown and rosy, hang over the heads of his nudes. Not only has Rubens lovingly modelled every pleat and corrugation in the breasts and buttocks of his beauties, he has one of them press her thumb into the copious flesh of another's upper arm as though testing its abundance, a gesture, one suspects, that gave the artist himself intense, gleeful

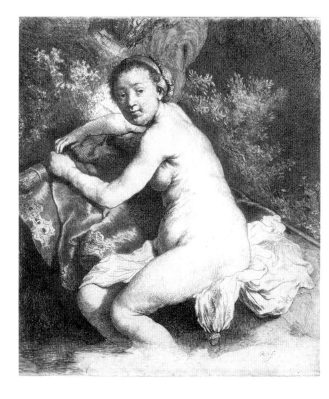

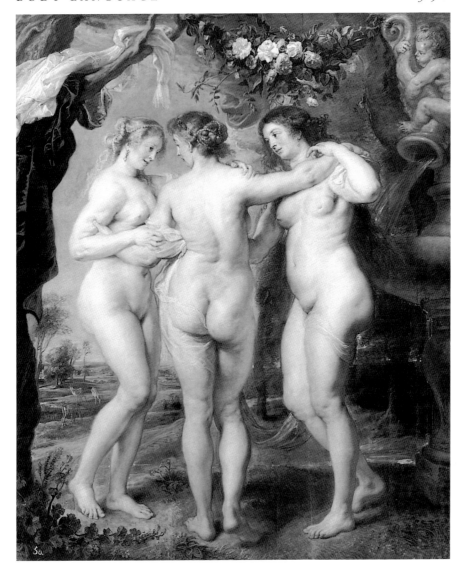

Rubens, The Three
Graces, *c. 1635. Panel,
221 × 181 cm. Madrid,
Museo del Prado*

pleasure. The sketch that Rubens made in 1636 for his *Origins of the Milky
Way* shows a startlingly squat Juno with an enormously thick waist and
belly and a peasant girl's stocky feet planted on the clouds. Though Rubens
deferred to classical taste by giving his goddess a more conventionally Ital-
ianate face in the final version, the upper body remains identical with the
one in the sketch.[49] Was Rembrandt's Diana, whose lumpy breasts and bal-
looning belly provoked such disgust, so very far from these Rubensian
models? For that matter, *Woman on a Mound*, which appalled critics,
ought to be recognized as the unclothed and unadorned model of the Lon-
don National Gallery *Flora*; as a fully costumed pseudo-Saskia, she wins
the beauty pageant in many commentaries on Rembrandt's female figures.
The fact that the print was swiftly copied by an artist as important as

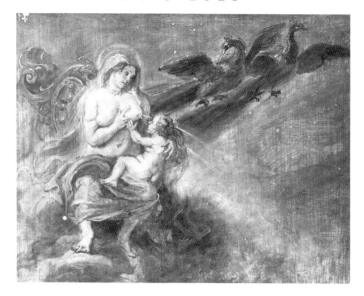

Rubens, Sketch for the Origins of the Milky Way, *1636. Panel, 26.7 × 34.1 cm. Brussels, Musées Royaux des Beaux Arts*

Wenceslaus Hollar tells us that whatever subsequent generations might have thought, in the 1630s *Woman on a Mound* must have been a popular image, and certainly not as a joke. It's inconceivable, in fact, that Rembrandt should have designed these nudes, as Clark imagined, either as figures of fun or as standard-bearers of revolt against the classical tradition. It's odd that in his excellent book *The Nude*, Clark didn't notice the resemblance between the plates in Albrecht Dürer's *Book of Proportions*, with their broad hips and thighs, and many of Rembrandt's figures, especially since this was one of the fifteen books listed in the painter's inventory in 1656. Elsewhere in the inventory was "a book full of [Rembrandt's] drawings of nude men and women"[50] that must have documented his initial debt to Dürer, Titian, and Rubens and, at the same time, displayed the development of his own independent manner.

In the 1650s, when Rembrandt returned to nudes in painting, drawing, and etching, he would add something, as we shall see, to the standard repertoire that no one before had dreamt of. But in the 1630s there was no reason why the up-and-coming Rembrandt should have gone out of his way to make his nudes a calculated offense against seemliness. He was, after all, working for the Stadholder, and by extension for his secretary Constantijn Huygens, the pillar of classicism. He is anxious for important and lucrative commissions. Why, then, would he want to present himself as a malcontent, a violator of good taste? On the other hand, no one could call the nudes of Rembrandt's history paintings exactly conventional either. A glance at the (relatively few) nude figures produced by his Dutch contemporaries like Caesar van Everdingen in the 1630s, with their secondhand reproduction of a cool Italian style, all alabaster flesh and carefully modelled contours, only makes the peculiarity of his unclothed figures more striking. The difference, though, needs to be measured by something other

than the buxomness gauge or the pucker count. Rembrandt is, once more, up to something. But what he is up to presupposes not the ugliness of his models, as the critics assumed, but the very quality that is hardest for our generation's airbrushed-standard-of-beauty culture to grasp, namely, their *desirability*. For only if we can see these bodies as palpably, sexually desirable can we also see them as vulnerably exposed, or, in a word, naked.

Not nude then; naked. In fact, seventeenth-century Dutch had no word for nude, signifying a classically undraped figure as oblivious as a statue to being looked at. The nearest it got was *naakt*, or *moedernaakt* (or, if not quite naked, *schier naakt*), all terms which presuppose exactly the embarrassment and awkwardness that Rembrandt, alone among Baroque artists, was irresistibly drawn to explore. What evidently fascinated him was the quasi-nude, the imperfect conversion process by which live models were made over into mythological or biblical figures. Certainly he knew he was supposed to draw statues. But at some point, at least for Rembrandt, stone-gazing had to be replaced by flesh-gazing. And he found himself looking at plump and rumpled women who held his attention only to the degree that they could *not* quite manage the required transformation into Dianas or Venuses. This ambiguity (is she a goddess, or is she a girl with her clothes off; is she a *nude*, or is she *schier naakt*; does she belong to the ages, or does she belong to me?), is also at the erotic center of Rubens's most famous nude: his wife Helena in her fur coat and nothing else. But Rembrandt was the only artist daring enough to make the relationship between exposure, embarrassment, and desire a recurring *subject* of his work.

So off he goes and makes dramas of undress: *Danaë; Diana Bathing, with the Stories of Actaeon and Callisto; Andromeda; Susanna and the Elders.* These are not stories in which the subjects happen to wear no clothes. They are episodes in which naked exposure *is* the story.[51] They were also, of course, a standard item in the repertoire of mannerist and Baroque history painting, but featured there as a thinly disguised erotic convenience. In keeping with the double standard that was expected of both patrons and artists, the Dianas and Susannas, even as they were ostensibly being ogled by figures inside the history, were lavishly displayed to the beholder. For this elaborate peep show to work satisfactorily, it was essential that the viewed body not betray any signs of self-consciousness or shame. So, for example, Goltzius's *Andromeda* of 1583, chained to her rock, is turned and twisted to offer maximum visibility while Danaë's love child, Perseus, now grown up to heroic stature, is off yonder dispatching the monster. Rubens painted the same subject twice: initially in 1618, a rather stately version which he copied as the trompe l'oeil painting on his garden wall; and again in the last years of his life, with Perseus diminished to a background detail, the better to avoid any distractions from the spectacle of Helena Fourment's copious flesh offered up to the appetite of the ravening beast, which is to say, us.

Rembrandt's little *Andromeda*, on the other hand, is no showgirl. Her helpless pose, arms chained above the head, is probably borrowed from a

painting by Joachim Wtewael.⁵² But where the Wtewael Andromeda grace-
fully bends her elbows to preserve the flowing line of her body, Rembrandt
pulls them painfully taut. This is a real captivity and without much hope of
reprieve, Perseus being nowhere to be seen. Our heroine, moreover, is not a
pretty sight. She has a coarsely sketched face and a frankly unidealized
body constructed from overlapping circular and ovoid forms, the egglike
belly visually rhymed with the left breast, drawn dead on, the navel with
the nipple. Though he may have taken the half-robe, fallen and swagged at
her hips, from classical motifs (as well as from Wtewael), Rembrandt has,
for the first but certainly not the last time, seen that by *adding* a stitch or
two of dress and getting rid of other figures, he has added to the impression
of painful vulnerability.

Diana Bathing, with the Stories of Actaeon and Callisto, probably
painted in 1634, is even more explicit about the costs of nakedness. Rem-
brandt undoubtedly knew the many prints of the two separate stories, both
from Ovid's *Metamorphoses,* but combining them in a single painting was
so complicated a challenge that it could only have come from his obsessive
need to focus attention on the theme of tragic undress. On the left, Diana,
with a crescent moon in her hair, has caught the hunter Actaeon glimpsing
her bathing. He is already paying a high price for his accidental glimpse of
the divine form: drops of water splashed on his body are turning him into a
stag that will be torn to pieces by his own hounds. On the right, the nymph
Callisto, pregnant by Jupiter, is revealed to be in violation of the chastity
clause in her contract as Diana's handmaid. Her allotted fate was to be
turned into a bear by the jealous Juno (and before long a bearskin, were it
not for the intervention of Jupiter, who preemptively turns Callisto into a
constellation of stars). Most of the known versions of the Callisto story
before Rembrandt depicted either the seduction or the alteration of the
nymph. Rubens, for example, had already painted Jupiter's wooing of Cal-
listo, and would choose the revelation of the pregnancy as the subject of
one of his decorations for Philip IV's hunting lodge of the Torre de la
Parada in 1637–38. In keeping with the poetic and pastoral feeling of the
ensemble of paintings, he would turn the scene into something delicately
poetic and gentle, with Callisto's abdomen completely hidden from the
viewer. Rembrandt's mood is unsentimental, more in keeping with an ear-
lier brutal version by Rubens. The unfortunate Callisto is pinned down
from the back by one of Diana's attendants while another tears aside her
concealing robes to reveal her distended belly. The unsparing cruelty of the
exposure is written on the cackling face of the nymph behind her.

If you were a painter interested one way or another in dramas of
undress and exposure, there was one story you could hardly avoid, and
that was *Susanna and the Elders.* The story, based on a first-century apoc-
ryphal addition to the Book of Daniel, concerns the virtuous wife of a mag-
istrate who was spied on while taking her bath by a pair of "elders."
Excited by the spectacle, they demand sexual favors from her, threatening
to slander her as an adulteress should she refuse. Even more than in the

OPPOSITE, CLOCK-
WISE FROM UPPER
LEFT: *Hendrick
Goltzius,* Andromeda,
*1583. Engraving.
Amsterdam,
Rijksprentenkabinet*

Rembrandt, Androm-
eda, *c. 1630. Panel,
34.5 × 25 cm. The
Hague, Mauritshuis*

Rembrandt, Diana
Bathing, with the
Stories of Actaeon and
Callisto, *1634. Canvas,
73.5 × 93.5 cm. Anholt,
Museum Wasserburg*

case of the *Andromeda,* Baroque artists conspired with their patrons to put on a good show of moral indignation while turning the heroine's nakedness into a calculated gazing opportunity. In 1607, for example, Jan Govaerts not only commissioned a *Susanna* from his friend Goltzius but shamelessly had the painter depict him as one of the elders feasting his eyes on her body.[53] Eleven years later, when Rubens was painting one of his many *Susanna*s, his friend the English ambassador at The Hague, Dudley Carleton, wrote to him drooling at the prospect that the picture would be "beautiful enough to enamour old men." Rubens replied reassuringly that it was indeed a "*galanteria.*"[54] So paintings which ostensibly had been made as a reproof to the viciousness of old men were now used as aphrodisiacs to revive their jaded libidos. *Susanna*s which purported to make voyeurism their subject actually colluded in the spectator sport. No wonder, then, that the crusader against indecent pictures, Dirck Raphael Camphuyzen, in his Dutch translation of an older text by Geesteranus attacking paintings, singled out *Susanna*s as a "cancer for morals and venom for the eyes."[55] That this righteous polemic had little effect might be judged from a poem by Vondel on "an Italian Painting of Susanna" which begins and ends with the required expressions of outrage, but which in between translates the arousal effect of the painting into a visual grope: "happy is the mouth, which such a mouth may kiss / see the shoulders, neck, back and arms; the living alabaster. . . ."[56]

Rembrandt, once again, takes his cue from Rubens but refuses any kind of parade. He pushes Susanna's half-crouch, which Rubens had borrowed from an antique Venus he had seen in Rome and which had also been used by Lastman, much further forward, implying sudden panic. The goatish figures of the elders, hidden in the shrubbery, are made so shadowy that they completely fail in their assigned role of displacing voyeuristic guilt from us to them. Their invisibility makes *us* feel awkward. An uncomfortable feeling arises that we are the looker looked at.[57]

There's no reason to suppose that Rembrandt was any more moral than Rubens, Lastman, or any of the many conventional Susanna painters. His graphic images of women pissing in fields or copulating with monks hardly suggest a prudish Calvinist acutely sensitive to bodily shame. But Rembrandt never met a convention he didn't like to complicate. He may not have been the "heretic" of later academic criticism, but he was certainly a troublemaker, a disturber of lazily repeated formulae. In place of an unproblematic relationship between the invited and the uninvited gaze, Rembrandt set down the issue of tragic embarrassment. It was a narrative opportunity he couldn't resist.

So his Susanna becomes something more than a pleasure object disguised as a heroine. She is a body in distress. Just as he used Danaë's glowing bed sheets to convey the physical sensation of a flesh warmly pressed against fabric, Rembrandt carefully traces the texture of drapery and garments not just as visual filler but as pictorial elements crucial to the story. The fragile defense of the left arm, pressed against the breast, is echoed in

OPPOSITE:
Rembrandt, Susanna
and the Elders, *c. 1634.*
Panel, 47.2 × 38.6 cm.
The Hague,
Mauritshuis

the empty sleeve hanging from Susanna's discarded shift. The Apocrypha made it clear that the elders had initially become aroused by seeing the *dressed* Susanna strolling in her garden, so Rembrandt makes her dress conspicuous, the better to suggest, simultaneously, both her draped and her undraped states. The complicated travel of the garment—beneath her thigh, wrapped about her behind, and pulled forward to her groin—makes us feel its presence *on* her body. And our greedy, wandering little minds are then led to the moment of disrobing, the beginning of the assault by staring. As if all this were not enough, Rembrandt has added (as he would in the *Danaë*) two bracelets and a necklace, enhancing the impression of objects laid on her skin. With the elders obscured, Susanna's gaze is turned toward *us*, the intruder, the violator of her privacy, as though we had clumsily stepped on a twig. The response to this tip-off of a sudden noise is the body language of sexual panic: uncoordinated movements of hand and feet. At which point, enter the iconographer, armed with emblem book, to point out the erotic analogy, known to contemporaries, between sheathing a foot in a slipper and the sex act. But Rembrandt is in fact the last painter to use emblems mechanically. He was much more likely to point to the allusion by turning it upside down, using the misstep as a gesture of innocence, the fumbling foot a reproof to the slavering gaze.

Rembrandt's fascination with naked embarrassment and blackmail was not exhausted by his *Susanna*. His equally original and alarming etching of *Joseph and Potiphar's Wife,* also made in the first year of his marriage, 1634, is the obverse of the painting from the Apocrypha, since in this case it is the female body which is the instrument of sexual extortion and the clothed male figure who is the victim. The penalty for Joseph refusing his patron's wife is to be accused (like Susanna) of the very crime he has virtuously resisted. The composition is loosely based on a print by Antonio Tempesta, but without any of the moderating classicism of that much more conventional image. Rembrandt's disturbing etching is a picture of two ferocious struggles. The first tug-of-war is between the animal appetite of Potiphar's wife, her gross torso twisted like the satanic serpent of Eden, and the virtue of her husband's protégé. But in keeping with the most famous contemporary recitation of the story as an example of the mastery of desire, Jacob Cats's *Self-Stryt* (*Self-Struggle*), Rembrandt has complicated the Scripture by designing a *second* interior struggle taking place within Joseph.[58] His mouth is oddly slack, the eyes dark and narrowed as if feeling the tension between arousal and revulsion. Should he or shouldn't he?

No seventeenth-century Dutch viewer would have missed the erotic obviousness of the monstrously phallic bedpost. Nor, given the contorted twist of the woman's lower torso and her fist clutching at Joseph's coat, would they have needed the additional detail of the chamber pot beneath her bed to register the force of her lasciviousness. And the body of Potiphar's wife is not just big, like Rembrandt's *Diana* and *Woman on a Mound:* it is perversely dislocated as if constructed of cartilage, the casing of something demonic. Joseph's hands, with their strongly cast shadows,

shield him from the offering of the shaved pudenda beneath the great belly. But we, poor sinners, can hardly miss the sight.

No wonder Kenneth Clark was put off his port. For we are a long way from the marble purity of the classical nude. As a story-telling device, it's apparent that Rembrandt thought brutal nakedness altogether more compelling than deco-rous nudity. Nowhere was this more obvious than in his graphic treatment of the Scripture in which bodily innocence and sinful self-consciousness are again the core of the story. This was *The Fall of Man*, the subject

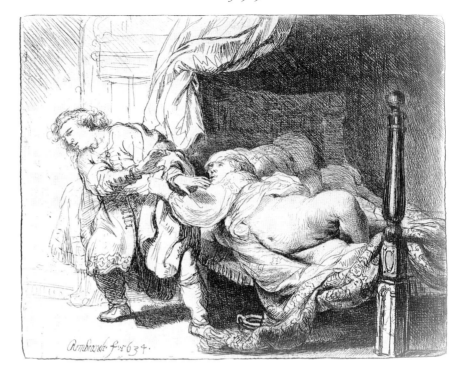

Rembrandt, Joseph and Potiphar's Wife, *1634. Etching. Courtesy Museum of Fine Arts, Boston, Harvey D. Parker Collection; Reproduced with permission*

with which Rubens had inaugurated his own career in an homage to Raphael. Rembrandt's disconcertingly savage etching, dated 1638, was at the furthest possible remove not only from Rubens and the Marcantonio Raimondi print after Raphael but also from other classically inspired versions closer to home, like Cornelis van Haarlem's smoothly beauti-ful painting of 1592, commissioned for the Stadholder's residence in Haarlem and rightly characterized by van Mander as "very grandly done."[59]

After his death, this was the etching most often cited by Rembrandt's critics as a prime instance of his perverse preference for raw nature over the classical ideal, or a graceful form that would exemplify the refined taste of the Creator. To do otherwise was not only to commit an offense against decency; it was to commit blasphemy, to suggest that somehow the Almighty had botched the design job. The early-eighteenth-century biogra-pher and critic Arnold Houbraken wrote that no one should "gape at, much less follow, such an ill-made likeness of Adam and Eve as can be found in Rembrandt's print."[60] Even for enthusiasts like Rembrandt's first print-cataloguer, Gersaint, the etching was yet further evidence that he "had no understanding of working with the nude."[61] What easily scandal-ized ministers like Camphuyzen, who had actually warned in his Dutch translation of *Idololenchus* against the indecency of Eves shown *resur-rected* nude on the Day of Judgement, must have thought, one can only imagine.[62] But in one sense at least, Rembrandt's etching was in perfect accordance with Calvinist teaching since it deliberately harked back to the

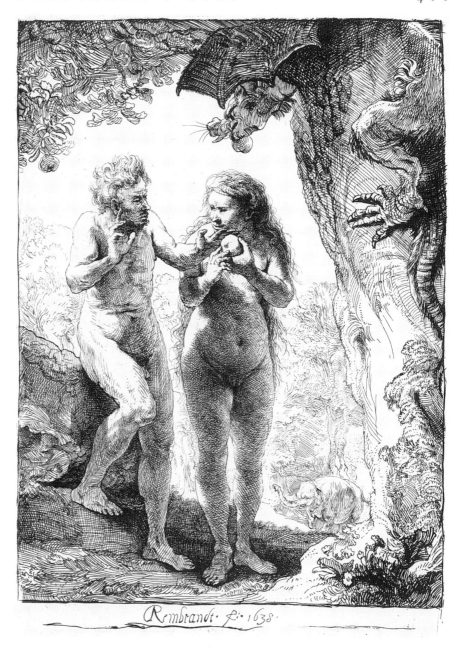

more primitive forms of Gothic carving and the engravings and woodcuts
of the late Middle Ages and early Renaissance, all of which had imagined
Adam and Eve not as smoothly sculpted by the hand of Divinity but rather
as roughly fashioned, grotesque vessels of shame. In particular, Rembrandt
borrowed the strangely hairy, dragonlike serpent from the menagerie of
reptilian creatures in Albrecht Dürer's 1512 print of *Christ in Purgatory.*[63]

But Dürer's Adam and Eve were themselves taken from the medieval
tradition of hirsute "wild men" who, during the course of the sixteenth
century, had been transformed from cannibalistic satyrs into paragons of
natural innocence.[64] And Rembrandt has co-opted his bearded Adam and

coarsely drawn Eve from wild-man imagery to suggest *both* the time before *and* the time after the Fall: Adam and Eve as Edenic creatures *and* as incipient humans with a dawning awareness of their shame. This collapsing of consecutive moments in a story was of course a favorite device of his, but in this case he uses the technique of the etching itself to strengthen the effect. While conventional mannerist or classical representations of Adam and Eve, still secure in paradise but at the point of committing the original sin, make their bodies unself-consciously nude and therefore intact in their innocence, Rembrandt is deliberately *inconsistent* by drawing their bodies complete with the marks of shame. The shadow of Adam's outstretched arm falls across Eve's upper body and breast. But most conspicuously of all, Rembrandt has scored the whole of her lower body with heavy cross-hatching, and certainly not out of any deference to the preachers. For Eve's genitals, the site of sin, remain scandalously visible through all the dense marking. This deliberately inadequate veiling, the opposite of the opaque fig leaf, is certainly not an accident on the part of the etcher, cutting his way out of embarrassment or uncertainty. It is evidently designed to offer the sharpest contrast with the brilliantly lit areas of the plate, in particular the radiance of Eden itself shining on the elephant trumpeting through the garden in the background. The concentrated scoring forces us to regard Adam and Eve as *both* unself-conscious *and* self-conscious humanity; both bodies of blissful ignorance and the shameful vessels of guilty knowledge. We are all nudes before the act; and we are all naked afterward.

iii *Furies*

Rembrandt van Rijn became a great history painter just at the moment when Peter Paul Rubens was wondering if, after all, he had not had his fill of it: history, that is.

The crucial years were 1635 and 1636. Plague shrouded Amsterdam, but Rembrandt, in his late twenties, was robustly alive, the throttle of his creativity kicked wide open. It roared and surged. An entire procession of masterpieces appeared at a phenomenal rate over the next two years: big, violent, visceral things packed with lurching, lunging, bone-crunching action. Bodies are pitched about. Fists are clenched. Knives are out. A baby screams, emptying his bladder. A face is clawed. An eyeball is punctured with malice aforethought. The colors are hotter and sharper than anything yet seen from Rembrandt's hand. His canvases emit noise: a shriek of pain; a crash of golden vessels; the beat of angel's wings. They are celestial and they are infernal. They are as emotionally histrionic, as physically operatic as anything Rubens had ever done. They are eye-openers, heart-stoppers, mind-benders.

Rubens never flagged in his production of histories. By the 1630s his

workshop had become a painting factory, industrially processing images of myths, saints, and Scriptures. The boss did the design, the hired help got on with working it up into pictures, and the boss returned to retouch and sign off. But Rubens was frankly tired of being expected to execute commissions on demand *and* run thankless diplomatic errands for princes who (the Archduchess Isabella always excepted) showed him scant grace in return. Understandably, Rubens still smarted at the boorish treatment he had received from His *Grace* the Duc d'Aerschot, the leader of the States General of the southern provinces in Brussels, during abortive peace negotiations with the Dutch Republic in 1632. For all his diplomatic experience and courtly manners, not to mention his elevation to the knightly order of Santiago, Rubens was still deemed by the Duc too socially incompetent to be the Archduchess Isabella's adviser. The new dignity had, in effect, publicly acknowledged Rubens to be the indisputable heir of Titian, who had himself been knighted by Charles V.[65] But Rubens had had to petition for the favor, and was certainly not so secure in his chivalric self-confidence as to be immune to the slights of the nobility. When Rubens attempted, as courteously as he could, to pacify the Duc d'Aerschot's irritation concerning his privy access to Isabella, his efforts were brusquely rebuffed. "It is of very little importance to me how you proceed," the Duc wrote, "and what account you render of your actions. All I can tell you is that I shall be greatly obliged if you will learn henceforth how persons of your station should write to mine."[66]

Understandably, then, as he told his friend Peiresc, Rubens had "decided to force myself to cut this golden knot of ambition in order to recover my liberty. Realizing that a retirement of this sort must be made while one is rising and not falling; that one must leave Fortune while she is still favorable . . . I seized the occasion of a short, secret journey to throw myself at Her Highness's feet and beg, as the sole reward for so many efforts, exemption from such [diplomatic] assignments and permission to serve her in my own home. This favor I obtained with more difficulty than any other she ever granted me. . . . Now by God's grace . . . I am leading a quiet life with my wife and children and have no pretensions in the world than to live in peace."[67]

History had not quite done with Rubens. After the death of Isabella in 1633, her successor as Governor of the Southern Netherlands, King Philip's brother, Ferdinand, the Cardinal-Infante, the victor of the great battle at Nördlingen in 1634, was to receive the ceremonial *joyeuse entrée* in Antwerp that would signify the institution of his rule over the city, and over the province of Flanders. Naturally, Rubens was called on to supply the elaborate decorative scheme of triumphal arches and stages, all with monumental paintings at their center, that would greet the new governor's progress. The commission was both a great honor and a great trial. For despite its overtones of a Roman triumph, the joyous entry was not a celebration of conquest or of the *imposition* of authority so much as a mark of the city's *acceptance* of its legitimate governor.[68] Allegorical language had

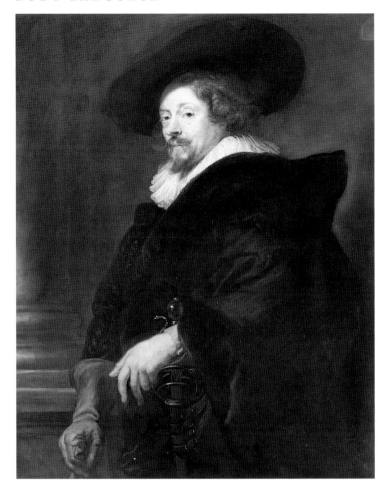

Rubens, Self-portrait,
*c. 1639. Canvas, 109 ×
83 cm. Vienna, Kunst-
historisches Museum*

to be found for this hint of a contractual trade-off: panegyrics for the
Cardinal-General (who had won an important battle the year before), com-
bined with a statement of Antwerp's continuing economic sufferings at the
hands of grim-visaged Mars. At a speed which was daunting even for some-
one of his facility, Rubens was asked to supply the designs for four stages
and five triumphal arches. Though he could rely on his scholarly friends for
help with the allegorical program and his workshop for assistance in fabri-
cating them, he still became so "overburdened" with the work that, as he
told Peiresc, "I have neither time to live nor to write. I am therefore cheat-
ing my art by stealing a few evening hours to write this most inadequate
and negligent reply to the courteous and elegant letters of yours."[69]

The result of all his labors was one of the few moments of public glory
allowed to beleaguered Antwerp. Out came the silver trumpets once more,
the drums and carillons, the flags and floats, the horses and the barges, on
one of which arrived the Cardinal-Infante himself. No doubt he thought
Rubens's *Stage of Welcome* featuring his own figure riding triumphally on
horseback pleasing. But the mood of the allegories was not one of unmixed

jubilation. The painter's own exhaustion made itself felt as a plea for the enervated city. As he arrived by way of the Scheldt, Ferdinand would have seen one of Rubens's ensembles depicting Mercury, the patron deity of both art and commerce, *departing* Antwerp! Another stage represented the terrible spectacle of the opening of the doors of the Temple of Janus, customarily closed during times of peace. Through its doors charges the cutthroat personification of war, bloody sword and burning torch in his hands, a blindfold over his swarthy, bearded, not un-Rubensian face. On the right-side wing is the helpless image of Antwerp at peace; on the side sinister, the image of death trampling on prosperity.

No wonder, then, that during the summer of 1635 Peter Paul was preparing to lend his personal efforts, one last time, to the cause of peace by undertaking yet another secret trip to the Dutch Republic. He must have felt the timing was unusually auspicious, since an invasion of the Catholic south mobilized by a joint Franco-Dutch alliance had just ignominiously collapsed. That war plan, pushed through with the help of lavish bribes from Cardinal Richelieu doled out among the Stadholder's advisers, was meant to exert enough military force to persuade the southern provinces to rise in rebellion against Spanish rule. In that event, the provinces would be granted freedom of religion, either Catholic or Protestant, and their own autonomy. But should they fail to defect from Spanish rule, a conquest would partition the territory between France and the Republic. Ghent, Bruges, and Antwerp would become Dutch (and Saskia's brother-in-law Anthonie Coopal would become hereditary "marquis" of the city, Rubens's overlord).

None of this happened. Instead of the French and Dutch rolling over the defenses of the south, the Army of Flanders, now seventy thousand strong, resisted the onslaught, then emerged from their fortifications to pursue the enemy across the territory of the Republic itself. The fort of Schenkenschans, said to be impregnable, actually fell to Spanish troops in late July 1635. Needless to say, Rubens was relieved, even delighted. But being Rubens, he also wanted to profit from the good fortune (which he, as a good neo-Stoic, knew would be temporary) to press the cause of peace. Plans were laid. He was to travel north in the late autumn under the usual pretext of some art business and undertake negotiations with members of the States of Holland sympathetic to a peace and alienated by Frederik Hendrik's commitment to an invasion of the south. Though he was trying to outflank the Stadholder's war party, he was nonetheless preparing to meet with Huygens in The Hague, much to the latter's uncontainable excitement. "I do not know what demons have kept me from your presence up to now," Huygens wrote the painter.[70] Rubens's cover was the inspection of a shipment of paintings from Italy, a subject calculated to bring together the artist with the secretary-virtuoso. But the location of those pictures—and, presumably, of the secret talks—was . . . Amsterdam.

When Rubens had first come to Holland in 1614 in search of an engraver, Rembrandt had been a snub-nosed schoolboy, a little bench-

sitter. When he had next come, in 1627, Rembrandt was still a novice, a brilliant nobody, a Lastman acolyte. Eight years later, he had become, unquestionably, the most important painter in Amsterdam. Is it conceivable that they would have met? Is it conceivable that they would *not* have met?

They never did. The Arminian majority of the Amsterdam council was all for peace. Indeed, some of them were covertly supplying the enemy with munitions to *ensure* a military stalemate! But the circle around Frederik Hendrik, committed, not least through the obligations of their French bribes, to the war in the south, bridled at any possible settlement, even in a year of stunning military reverses. The quarrels boiled down to a single pressing question: Should Rubens be given a passport? Unable to agree, the council left the matter to the Stadholder himself, who decided against it. Rubens never went north of the Scheldt and Maas again.

His pictures did, both as engravings and as originals installed in the houses of some of Amsterdam's wealthiest merchants, like Nicolaes Sohier. That Rembrandt had the most passionate interest in Rubens can hardly be in doubt. Fired, as he had been, by alternating senses of emulation and competition with the Apelles of the north, perhaps he felt a pang of jealousy when he surveyed Rubens's impossibly grand achievement. Of course, he too was being patronized by a court. But what was the patronage of the Prince of Orange beside Rubens's long list of royal and princely commissions—Spain, France, Britain? What was The Hague beside Madrid, London, Paris?

Whatever his complicated mix of sentiments toward Rubens, the Flemish master was seldom far from Rembrandt's mind in the mid- and late 1630s. Though he had not come to Amsterdam in person, Rembrandt brought him home on October 8, 1637, in the shape of the *Hero and Leander*, purchased for 424½ guilders. But for at least two years before Rembrandt acquired a work of Peter Paul's, his big histories became so strongly imprinted with Rubens's presence that it was as if the two artists were sharing studio space. For a few years the Amsterdam artist's passionate canvases are driven by the same Baroque furies that had long inhabited Rubens's greatest works: a storm of raging emotions and bodies.

Even before he turned to the sequence of big-figure epics, some of Rembrandt's most ambitious histories had been based on models supplied by Rubens, in particular *The Abduction of Proserpine* and *Christ in the Storm on the Sea of Galilee*. The *Prosperpine* was painted around 1631–32, at just the time Rembrandt was creating his variation on Rubens's *Descent from the Cross*. The painting was listed in the Stadholder's inventory of 1632 (albeit as a Lievens!), so that it may well have been commissioned by Huygens, which would explain its peculiar fusion of classical and Rubensian motifs. Its basic composition was modelled on an etching by Pieter Soutman after a Rubens painting which was itself modelled on a relief from an antique sarcophagus.[71] Rembrandt borrowed one of the figures holding on to Proserpine's train beside a basket of spilled flowers from Rubens's

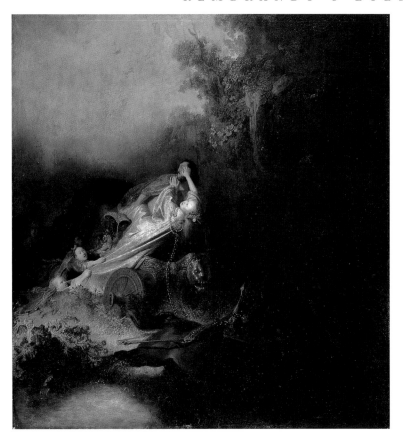

painting. Although the Flemish artist's version is a good deal more sedate than Rembrandt's painting, the conflict of opposites expressed as a physical tug-of-war is an authentically Rubensian motif. Everything else, however, Rembrandt has made more grimly bestial. His painting is not just an "abduction" but a rape, well under way, with Pluto's hands planted under Proserpine's thighs, wrenching her upward while she claws at his cheeks. The brutally fanged bronze lion decorating Pluto's chariot, bearing an entire row of spiky canines suggesting the feral nature of the assault, along with the imprisoning chain, is pure Rembrandtian metallic melodrama. And Rembrandt needed no tutorials from Rubens or Huygens to remind him that the story of Proserpine's seizure was also an allegory of the cycle of the seasons.

Rembrandt, The Abduction of Proserpine, *c. 1632. Panel, 84.8 × 79.7 cm. Berlin, Gemäldegalerie*

Stricken by the loss, the nymph's mother, Ceres, withdrew her natural bounty from the world, plunging it into wintry desolation until Jupiter listened to her lament, sent Pan to discover her whereabouts, and finally persuaded the god of the underworld to release his bride for part of the year, restoring life and light to the earth. So the painting becomes a battle between the forces of sunlight and gloom, bright meadow flowers giving way to weedy vegetation bolting in dimness: burdock, nettle, and thistle. Beneath the car, a watery abyss opens with sedge marking the damp fissure.

The roiling, sea-green *Christ in the Storm on the Sea of Galilee* (as of this writing, still hostage to the thief who stole it from the Isabella Stewart Gardner Museum in Boston) owed even more to Rubens, since it borrowed from *two* of his paintings: the *Hero and Leander,* which was probably in Holland even before Rembrandt bought it in 1637; and his 1610 predella, *The Miracle of St. Walburga* (page 153), another storm scene showing the saint riding serenely through the North Sea trough. It's possible that Rembrandt also knew a similar *Storm on the Sea of Galilee* by Marten de Vos through an engraved reproduction.[72] The Rubensian passages are obvious: the fury of the wind-whipped waves; the spumy water smashing over the boat, indifferent to the harpoon projecting from its prow (whale hunting in Galilee?); the tensed muscles of the sailor wrestling to secure the sail around the bottom of the mast as the halyard flies free into the engulfing

Rembrandt, Christ in the Storm on the Sea of Galilee, *1633. Canvas, 160 × 127 cm. Boston, Isabella Stewart Gardner Museum (stolen)*

gloom; the helmsman's struggle with the rudder against the bucking waves. But there are also passages of pure Rembrandtian invention—and not just the miserable figure slung over the left-hand side of the boat, retching into the churning sea. Rembrandt has sought to emphasize the *impending* miracle by contrasting figures of agitation and calm. As he had done with *The Elevation of the Cross,* Rembrandt has again inserted himself into the action, as the figure gripping the stays with one hand, hanging on to his hat with the other, and looking directly out at the beholder. The color juxtaposition of his blue coat with the yellow of the figure immediately behind him (blue and yellow being recommended by van Mander as an especially compatible combination) draws attention to the latter's hunched stillness in the midst of the roaring commotion of men, wind, and water. To the immediate right, the fears of the disciples are played out in the kind of hand drama

Rembrandt, St. John
the Baptist Preaching,
*c. 1634. Canvas on
panel, 62 × 80 cm.
Berlin, Gemälde-
galerie*

in which Rembrandt specialized. One pair of hands is brought together in
prayer; another hand, sharply foreshortened, is thrust out in gesticulation.
Another hand roughly pulls Jesus round to face the anger and perturba-
tion. (Stunningly, his profile bears the same physiognomy as that of the
model for Pluto in *The Abduction of Proserpine*!) But in telling contrast,
the hands of the Savior are at rest: one on his lap; the other at his heart in
avowal of the faith with which he tries to still the terror of his disciples.
Even the weather itself wears two faces: that of dark ferocity and clearing
calm, suggested by a patch of open sky appearing in the boiling clouds.

In the history paintings of 1631–33, all this drama is tightly concen-
trated. The *Christ in the Storm on the Sea of Galilee* and *The Abduction of
Proserpine*, as well as *Diana Bathing, with the Stories of Actaeon and Cal-
listo* and *The Rape of Europa*, all featured bunched groups of small figures,
carefully threaded through a spacious, turbulently lit, and fantastically
imagined landscape. Since the canvases were themselves quite large, the
effect was of a telescopic concentration of drama played out on a stage seen
from the back row of the gallery, the knots and heaps of characters moving
in and out of flickering light. Occasionally, the young Rubens had himself
used this kind of format, with the *Hero and Leander,* for example. But the

Flemish master was much better known for pushing his action into the face of the beholder: clambering, life-size figures filling and spilling through the huge picture space, looming over its threshold, pulling the spectator into the arena of a violent muscular and emotional struggle.

Rembrandt did not entirely abandon his earlier format. His stunning monochrome *St. John the Baptist Preaching* of 1634–35 is Amsterdam turned Israel, a fair of the world swarming with exotics: a turbaned Turk, an African in full headdress, and an American Indian complete with bow and arrow. But like a small number of other grisailles from this period, including an *Ecce Homo* and *Joseph Telling His Dreams*, it was executed as a study for an etching. Rembrandt's intention, modelled on Rubens's long practice, was to prepare detailed oil sketches which would then be turned into prints by etchers and engravers directly working for him. But for whatever reason, Rembrandt never found a Vorsterman or a Pontius to whom he could reliably delegate this work. Two of the monochrome studies—*The Descent from the Cross* and the *Ecce Homo*—did become etchings, but the *Joseph* and the great *John the Baptist* survived only as oil sketches. If Rembrandt ultimately felt that no one could be depended on to produce an etching with as much flair, subtlety, and daring as himself, he was quite right.

Rembrandt, St. John the Baptist Preaching *(detail)*

In 1635, then, and quite abruptly, Rembrandt's history paintings turn Rubensian. They become big not just in dimensions but in the concentrated shock of their physical force. Like Rubens's strongest dramas, they are twisters: gyroscopic body-manipulations; acrobatic torso-turners. Not surprisingly, at the back of both Rembrandt and Rubens stands the ultimate corkscrew draftsman: Caravaggio. Rubens had certainly seen Caravaggio's great St. Matthew cycle in the Contarelli Chapel of the church of San Luigi dei Francesi in Rome, and transferred the whirling arc of seraphic wings and robes in *St. Matthew and the Angel* to his own two versions of *The Sacrifice of Isaac*. In the later version, done as a ceiling painting for the Jesuit church in Antwerp, the patriarch's impending butchery of his boy, already laid out on the faggots, one foreshortened foot extending beyond the sacrificial slab, invokes the *two* Michelangelos (Buonarroti and Caravaggio) in the great skyburst of angelic energy that arrests the slaughter. Rembrandt knew (or even possessed) the 1614 engraving by Andries Stock of Rubens's earlier painting of *The Sacrifice of Isaac*,[73] and he might also have remembered his teacher Pieter Lastman's version of 1612, in which

the Caravaggio angel gesticulates, rather than actually laying his hand on Abraham's wrist, and in which the sacrificial fire is smoking ominously in the background.

Although at first sight his own version of the sacrifice of Isaac in the Hermitage appears close to Lastman and Rubens, Rembrandt's alterations are strokes of pure theatrical genius. Once again, there is manual performance at the center. The angel's right hand, painted in Rembrandt's most liquid smoothness, is laid on Abraham's enormous, darker paw, and instead of positioning Abraham's hand on his son's head, a blindfold conveniently slipped to allow us to see the expression of Isaac's terror, Rembrandt turns the hand itself into a bandage, fully covering, indeed almost smothering, his son's face, at once a gesture of tenderness and suffocating brutality. Between the hand-play, the sacrificial knife, on which Rembrandt has lavished his usual elaborate attention, hangs suspended in free fall, its blade still pointing at the exposed throat of the helpless boy.

Rembrandt would have been as much aware as his Catholic predecessors (Caravaggio, Lastman, Rubens) that Christian tradition treated the sacrifice of Isaac as a prefiguration of the later blood offering by the Father of His Son: the Crucifixion. Whoever commissioned the painting (and its copy in Munich) would have understood this subtext to be an important element in its devotional appeal. But as always, the challenge Rembrandt set himself (and in this respect he was indeed truly the heir of both Caravaggio and Rubens) was not with abstruse confessional iconography. His work was to make sacred history credibly human. The test of a father commanded to kill the son of his old age had horrible seriousness in a Calvinist

world where unquestioning obedience to the inscrutable plans of the Almighty was said, over and over, to be the mark of true faith. But Rembrandt's passion here is paternal before it is Protestant. His own infant had died. He needs no sermons on the necessity of yielding to God's iron law. But he also wants to believe in God's compassion and gives Abraham's wrathful, anguished face the look of a madman unexpectedly paroled from hell.

Whatever his own particular confession, Rembrandt was well versed in the ways in which Christian doctrine had annexed not just the Old Testament but even the literature of pagan antiquity for its own teaching. "Moralized" versions of Ovid's *Metamorphoses*, for example, circulated in the Netherlands, attaching Christian homilies and epigrams even to the most unlikely subject matter. Rubens's teacher Otto van Veen had himself produced a whole book of emblems representing the triumph of divine over profane love.[74] And Karel van Mander had included a Dutch-language version of Ovid, properly cleaned up and made Protestant-friendly, in his

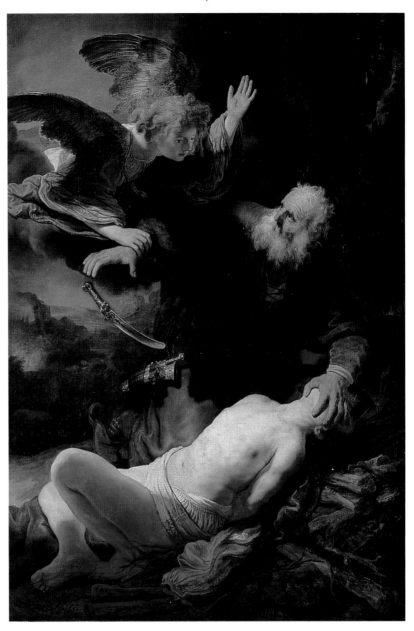

Rembrandt, The Sacrifice of Isaac, *1635. Canvas, 193 × 133 cm. St. Petersburg, Hermitage*

Schilder-boeck of 1604. Even so, it's hard to imagine a myth less suitable for Christian instruction than the story of the Trojan shepherd-prince Ganymede, carried off by the Jovian eagle to be Jupiter's cupbearer and catamite. Happily for the Christianizers, there was also a minor Platonic tradition which imagined the flight of Ganymede as the departure of a pure soul from the corrupted earth to the celestial heights.[75] It was, then, but a slight adjustment to substitute the Heavenly Father for the insatiably lustful Jupiter. Ganymede, gathered to his Father, was still pure; perhaps even the Savior himself! For the made-over Ganymede, a pretty, well-chiselled

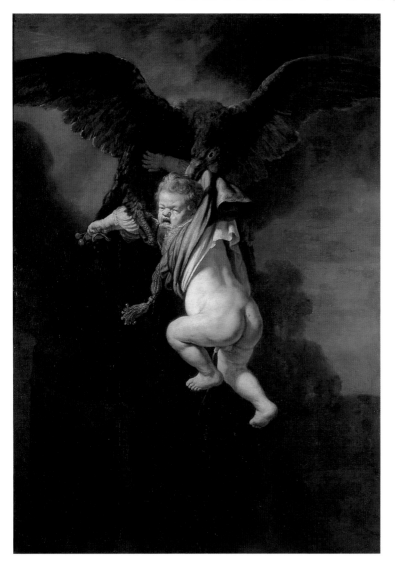

Rembrandt, The Abduction of Ganymede, *1635. Canvas, 171 × 130 cm. Dresden, Gemälde-galerie*

youth would hardly do. Instead he appears in the Christian emblem books as a cherub out for a gentle ride on a benevolent bird, his legs hanging over the eagle's body like a child on a merry-go-round.

Rembrandt's *Ganymede* does not seem to be enjoying the trip. His mouth is open in a howl of protest, and he is arcing an impressive stream of urine down toward the rapidly receding earth. For Kenneth Clark this was yet another case of Rembrandt's mugging the classical tradition, although this time he thought the painter was posturing as a puritan rather than a roughneck. The 1635 painting, he believed, was "a protest, not only against antique art, but antique morality and the combination of the two in sixteenth-century Rome," exemplified by that notorious Ganymede-fancier, Michelangelo.[76] But Rembrandt is doing something more here, I would say, than pissing on the mythic glamorization of pederasty. His encyclopedic knowledge certainly took in the astrological legend in which the kidnapped Ganymede was subsequently transformed into the constellation of Aquarius the waterman. One can sense Rembrandt's mischievous relish at pointing out this arcane detail to anyone shocked by the most memorable micturation in northern history painting. It's quite likely, as Margarita Russell argued, that he would have known François Duquesnoy's famous statue of the *manneken pis* in Brussels, or have seen a print of it, and his bankruptcy inventory actually included a pissing putto as well as a carving of a weeping cupid that some writers believe could have served as the model for the Ganymede as well as the chained Eros in the *Danaë* a year later.[77] In Flanders Rubens might well have drunk a draft of angel's pee, for favorite drinks of beer or wine were already being praised as *pipi d'ange,* or even *pipi de Jésus.*

So Rembrandt knew his classics as well as his Scripture. But he was no more governed by pedantry than by piety. If his imagination spent a good

deal of time in antiquity, it kept company with the earthy Plautus rather than the metaphysically lofty Plato. He had, after all, already made two etchings of a woman and a man urinating, and there was nothing remotely spiritual about those extraordinary images of the crude squat or the standing piss. The whole business of Rembrandt's profanity, inserted, with quite deliberate incongruousness, into scenes that are supposed to be edifying, paradoxically sends scholars rushing and blushing for primly learned explanations. The dog conspicuously (and copiously) voiding his bowels in the brightly lit *foreground* of Rembrandt's 1633 etching of *The Good Samaritan*, for example, has inevitably been seen as a symbol of the polluted life cleansed by the good deeds of such as the Samaritan.[78] But the same scholar who felt obliged to find "a plausible iconographic explanation" for the dog's presence also registers Rembrandt's obvious scatological relish, noticing that "in its precarious balance, its straining sides and earnest obliviousness to all else but the job at hand, the dog in *The Good Samaritan* remains one of the most engagingly true-to-life creatures the artist ever depicted."[79]

Rembrandt, The Good Samaritan, *1633. Etching. New York, Pierpont Morgan Library*

Defecating dogs
and urinating Gany-
medes were precisely
the kind of detail
that upset the self-
appointed guardians
of good taste in Dutch
art later in the cen-
tury, including Rem-
brandt's own student
Samuel van Hoog-
straten. They saw
Rembrandt's insis-
tence on gross obser-
vation as an act of
puerile vulgarity, quite
out of keeping with
the exalted vocation
of art. And they were
right in seeing the
painter as a throw-
back to an older
northern Rabelaisian
tradition which had
no scruples about mix-
ing base and elevated matter within the same work. In all likelihood,
Rembrandt (like the playwright Bredero) clung to that older tradition not
because he was thoughtlessly attached to old ways, but because he
respected its more complete sense of humanity: its candid regard for the
animal as well as spiritual qualities. In such a tradition, the earthiness of
life was nothing to be furtively ashamed of. On the contrary, it could be a
cause for glee. A preparatory drawing for the *Ganymede* shows his parents,
the father holding what seems to be a telescope up to the sky, suggesting
that Rembrandt had in mind the origins of Aquarius, the bringer of winter
rain. So Ganymede's silver stream is a blessing. He pisses on the earth and
makes it live. Jupiter's golden ejaculate, spilled upon the virgin Danaë, is
the seed of the heroic age.

Mortals and immortals are promiscuously at play here. So Rembrandt
not only saw nothing wrong with mixing up faces from classical antiquity
with faces from the streets of Amsterdam; he supposed it essential for the
enduring vitality of the myths, their presence within contemporary life.
This too was a lesson from Rubens. For although the Flemish master could
not have painted as he did without his archive of drawings from ancient
sculpture and Renaissance art, their power would have been dim had he
not also brought into his histories the personae he saw about him in the
markets and taverns, the churches and the streets of Antwerp. Rembrandt

went further, dissolving epic iden-
tities within the immense encyclo-
pedia of the human comedy he
was compiling in his drawings.
Ganymede's scrunched-up mask
of woe owed something to carv-
ings of weeping cherubs, but
something as well to sketches
done *naer het leven*—after life. At
the time he was painting the
myth, Rembrandt was, once
again, a prospective father. So
while it's necessary to beware of
any crude lines of connection
between life and art, it would
nonetheless have been perfectly
natural for him to take a fresh
interest in the facial and body
language of small children.[80]

Around 1637, when Saskia
was again pregnant, Rembrandt
made a beautiful etching known
as *Jacob Caressing Benjamin* in
which the arms of father and son
cross on the former's lap while

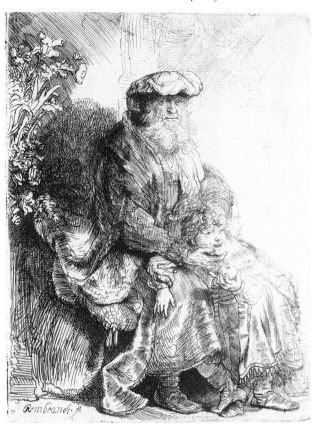

Rembrandt, Jacob
Caressing Benjamin,
*c. 1637. Etching, first
state. New York, Pier-
pont Morgan Library*

the little boy, sweetly drawn by the artist, laughs at something unseen and
wrigglingly plants his stocky foot on the older man's boot. It's the work of
an artist whose interest in the world of the very young (like his interest in
the world of the very old) went well beyond standard iconography. The
infant Ganymede is described with an exactness and a candor that were
missing from classical carvings, urinating fountain-boys, the spiritualized
cupids of the emblem books, and the representations of dead babies as
winged cherubs hovering over their parents in family portraits. Rem-
brandt's *Ganymede* smells of little boy; from his impressive scrotum,
chubby thighs, and stomach amply layered with puppy fat, to his squashed
nose, puffy cheeks, and curly topknot. Ultimately, it's the earthy relish of
the image which makes it impossible to read the *Ganymede*, any more than
the *Danaë*, as a straightforward allegory of unalloyed virtue. At the back of
Rembrandt's mind could well have been the directly sensual versions of
Correggio and Rubens. But just as he took the traditional love object,
Susanna, and complicated it with overtones of shame and resistance, so the
hoisted infant *is,* after all, unreconciled to his fate. He may be cast as
the Pure Soul, hanging on to his cherries for dear life. He may be Aquarius
the life-giving rainmaker. But Rembrandt shows him protesting his destiny.
If this is the ride to transfiguration, he wants to get off.

iv *The Moving Finger*

The tide of death rose higher. Back in Leiden it swept away fully a third of the city; in Amsterdam, before it receded, nearly a quarter. Plagues, said the preachers, were a visitation of a justly incensed Jehovah. They were rods laid across the backs of the iniquitous, a chastisement for their idolatry, their impious lust for gold. The preachers read from the Scriptures to their heedless flocks of the fate of Israel and of Judah, which had been beloved of God but had paid the price for their wantonness. They had made themselves fat and licentious; they had taken vessels from the Holy Temple and profaned them with their whorish gluttony. They had been inebriates of pride. Look to thine own conduct, the sermons warned. Examine thy stained soul in the reflection of thy goblets. Put aside the peacock pie.

Jan Harmensz. Krul, the poet and dramatist who sat for his portrait by Rembrandt, published works attacking the lust for the high life and warning of the consequences.[81] So perhaps it was for a like-minded client, who wanted to be reminded in the most spectacular manner of the contingency of worldly power and riches, that Rembrandt painted his sensational *Belshazzar's Feast* in 1635. The story, from Daniel, chapter 5, had traditionally been invoked as a cautionary tale against the habit of excessively sumptuous feasts. Jan Muller's mannerist version, for example, painted in 1597–98, had borrowed from Tintoretto's *Last Supper* in San Giorgio Maggiore in Venice for the long candlelit tables that dominate his composition.[82] In Rembrandt's painting, there is even more gold than in the *Danaë*, which was painted at about the same time. But this gold comes to its history not as a blessing but as a curse; not as radiance but as a kind of leprous contamination, covering the King's ornate costume, shining ominously from the vessels seized by the Babylonian prince from the Temple in Jerusalem and desecrated as his banqueting plate.

The Bible describes Belshazzar drinking before "a thousand of his lords." To suggest the immensity of a vast hall, Rembrandt might well have reverted to his older style, with crowds of small figures packed into a cavernous space. But by isolating a few exemplary figures, including the King himself, and pushing them suffocatingly close to the edge of the picture space, Rembrandt actually manages to increase the sense of ominous claustrophobia. This is a party with no emergency exit.

It's also a very Utrecht-looking Babylon. Rembrandt has gone to the "Caravaggisti"—van Baburen, ter Brugghen, and Honthorst—for his pagan revellers: the King's "princes, wives, and his concubines." The plumed and pearled courtesan seen at the extreme left sits silhouetted against the garish brightness, her stillness (as in the case of the hunched fig-

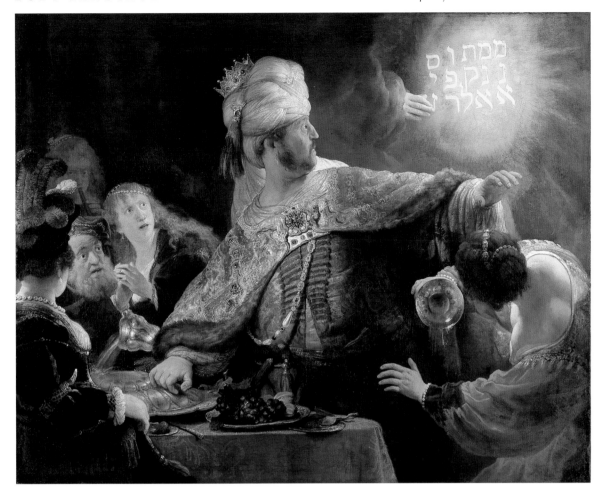

Rembrandt, Belshazzar's Feast, *c. 1635. Canvas, 167.6 × 209.2 cm. London, National Gallery*

ure seen from the rear in the *Storm on the Sea of Galilee*) pointing up the agitated stupefaction of the rest of the company. The shadowy woman at left in Rembrandt's preparatory "dead-color" monochrome fingers her recorder and eyes the rest of us and is likewise extracted from the basic repertoire of the half-sexy, half-sermonizing Utrecht artists. But the velvety vermilion gown and naked shoulders of the woman at right leaning away from the vision and letting the wine spill from the mouth of the golden flagon comes directly from the lushest passages of high Italian Renaissance painting, specifically from a *Rape of Europa* by Veronese in the Ducal Palace in Venice, a copy of which Rembrandt saw in the Amsterdam collection of his patron Joan Huydecoper.[83]

Everything else, though, is the product of Rembrandt's own pictorial operatics, especially the hand-play, which, even more than in the *Abraham*, is crucial to the story. Belshazzar's gesture of horror, as if pushing away the phantom writer, is the mirror image of both Danaë's raised arm of greeting, especially at its originally lower angle, and of Abraham's arm, poised for the kill. The most powerful action (other than the "moving fingers" them-

selves) occurs along the parallelogram formed by Belshazzar's right hand resting on the golden dish, the elaborately painted finery of his turban, his outstretched left hand, and the scarlet sleeve and hand of the serving girl. The painting (like many of these histories) has been cut down in size, and the surviving version in the London National Gallery needs to be imagined rotated slightly clockwise to register the full effect of collapse, figures and wine falling from their proper place.

The painting is also one of Rembrandt's most flamboyant exercises in representing the *affecten,* or passions, written in the drop-jawed astonishment of the banqueters and especially in the face of Belshazzar himself, shot through with spectral illumination, his eye (like the disciples at Emmaus) almost popping from its socket. Faithful to the biblical message, Rembrandt has gone all out to suggest the perishability of things: precious metals, the pleasures of appetite, the longevity of empires. To accomplish this, he needs, paradoxically, to turn still-life painter, beginning with an unusually dark brown underpainting against which the surface textures of both solid and liquid objects—the cascade of wine, the bursting figs and grapes (emblems of debauch), the richly brocaded cloth—could be rendered with sparkling sensuousness. Not for the last time, Rembrandt turns artisan, like his friend the silversmith Lutma, whose elaborately punched and scalloped plate he used in many of his histories, manipulating the paint surface like a craftsman, working the dense ochers, lead-tin yellow, and lead white on the King's robe and crown into a brilliantly reflective fabric. The turban glitters with iridescent strands of pearly color. Dazzling gemstones—onyx, rubies, and crystals, and especially the large gem at the head of the turban tassel—are built from thickly constructed dabs of pasty paint. But amidst this rush of dense color Rembrandt is also subtle enough to include delicate details like the crescent-moon earring hanging from the royal lobe and highlighted along the edge facing the apparition. Even the fur trim of the King's robe stands on end in the oracular light, as though bristling with providentially generated static.

This electrical effect of solid matter disturbed, of the *liquidation* of power into spilled wine, the meltdown of literally brazen effrontery, is all the more earthshaking because the dread letters are *not* written on the plaster of the wall, as specified in the Scripture. Just as he had altered the commonplace rain of cash in the *Danaë* into a shaft of golden light, so Rembrandt has made the prophetic hand of doom, painted with significantly greater smoothness than the hands of the King, emerge from a cloud and inscribe the letters within a nimbus of fiery light. The Sephardic Jewish scholar and publisher Menasseh ben Israel, who also lived on the St. Anthoniesbreestraat, almost certainly supplied the painter with the additionally esoteric effect of having the Hebrew/Aramaic letters read in vertical columns rather than horizontally from right to left. The hand is depicted just *before* it completes the final letter, thus sealing the fate of the King, who would perish the same night Daniel interpreted for him the meaning of the vision. The hand vanishes into air, and with it the entirety of Belshazzar's worldly dominion.

v *Samson's Eyes*

The painting is the evil sibling of *Danaë*. It has the same dimensions, the same compositional scheme with curtains parted to admit strong light, a face outlined against the brilliance, a body stretched out full-length toward us. But this is a light of extinction, not conception. It is so hard and intense that it reveals Delilah's delicate forearm within the gauzy sleeve of her blouse. Her eyes, wide open with sadistically aroused elation, fill up with its radiance. But it falls on Samson with a vengeance, and he cannot see it. One eye is shut fast in agony. The other is spiked with a Javanese kris, sending out a brilliant gout of blood, each spurting drop pedantically formed and highlighted by the painter, leaning on his maul-stick to finesse the details. Samson is already dead to this glare. He has been caught in the slumberous darkness of lust and wine, and now he will see nothing more of the world.

There had been countless *Samson and Delilah*s before, including, of course, one by Rembrandt himself, two by Jan Lievens, and two by Rubens. But there had never been anything like this; not a single painting that had concentrated so mercilessly on the moment of the strong man's triple destruction: sexual, optical, and muscular.[84] You feel the weight of the moment in Rembrandt's ironmongery. Chains cut into his wrists so cruelly that they too begin to bleed. The kris, which Rembrandt, a great collector of weapons and exotica, may have bought for himself, is lavishly embossed on its handle, its sinuous, elegant blade described with clinical precision, and appears to be turning as it sinks deep into the eye socket. The scissors held by the triumphant Delilah glitter in the brilliance. Manacles await their helpless prisoner. An armored fist grabs at the fallen giant's beard. A helmet falls from a soldier who has positioned himself underneath Samson, fastening his body to his back and securing him with a choke hold about the throat.

Seventeenth-century imagery, of course, dripped with edifying gore.[85] Painters like Rubens who had seen both Caravaggio and the Laocoön took the latter to be the classical case of virtue through torment: the *exemplum doloris*. And Rubens was by no means alone in producing images of such elaborate grisliness that they are hard to look at today, even in the age of celluloid slash-and-splat. It's nonetheless difficult to resist the impression that this gentlest of men quite enjoyed his more gruesome inventions, like the huge painting of St. Livinus executed for the Jesuit church in Ghent that shows the martyr, blood dripping through his beard, watching as his own tongue, already torn out from the root, is dangled in a pair of tongs by his persecutors above the heads of a pack of hungry hounds. The eloquence of the savagely stopped mouth drew from Rubens some of his most memo-

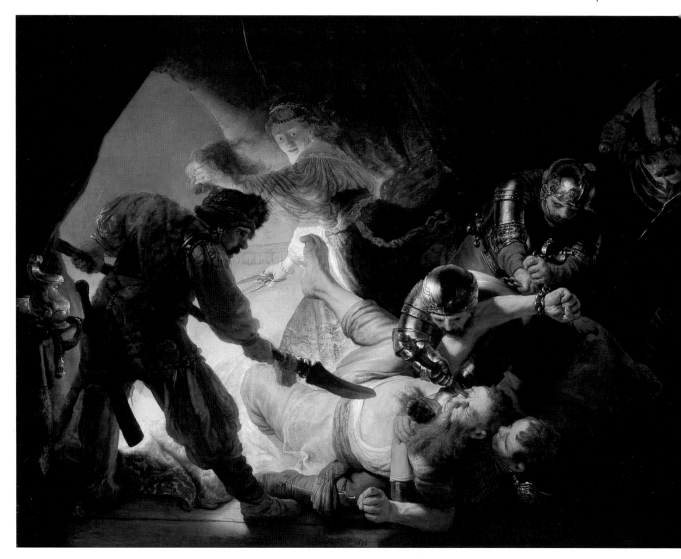

Rembrandt, The Blinding of Samson, *1636. Canvas, 205 × 272 cm. Frankfurt, Städelsches Kunstinstitut*

rably horrible images. In addition to the St. Livinus, he painted an unforgettable St. Justus of Beauvais, the boy martyr who held his own severed head, the decapitation wound made elaborately visible, the horrific effect only slightly undermined by the fact that the saintly head continues to address the understandably astonished pagans. The memory of one of Caravaggio's most macabre paintings, his *Head of Medusa*, seen by Rubens in the collection of the Medici Duke of Tuscany, provoked him to outdo his Italian *paragone* by depicting a stickily severed head, complete with a mass of snakes (possibly painted by Frans Snyders, his partner-in-horror) spontaneously generated from the gory ooze and busy writhing, copulating, striking, and dying, or sometimes managing all four activities at once. Constantijn Huygens mentions in his autobiography that between 1629 and 1631 a copy of the famously alarming picture was in the collection of his

Amsterdam merchant friend Nicolaes Sohier. Given two Dutch cultural passions—the taste for the macabre and the taste for puns—it's not unlikely that the gruesome *Medusa* was thought especially suitable for a merchant who, since his marriage to the sister-in-law of the poet-playwright Pieter Corneliszoon Hooft (or "Head"), lived in "the House of the Heads," named for the heads which decorated its façade. Huygens is often quoted (correctly) as commenting that he was glad that it was in his friend's house rather than his own. But he also says that while the viewer was bound to be shocked when the protective curtain was pulled back, the combination of the beautiful woman's face with the hideous serpents was so "elegantly executed that it was hard not to be affected by the natural liveliness and beauty of . . . the cruel work."[86]

Rembrandt's *Samson* was closely modelled on another sensationally violent painting jointly executed by Rubens and Snyders, Rubens's *Prometheus,* the painting that had been singled out for lavish praise by the verse eulogy of Dominicus Baudius in Leiden.[87] The chain of admiration, in fact, went back even further, for Rubens's masterpiece was in its turn based on Titian's dramatic rendering of the fate of the Titan Tityus (engraved in 1560 by Cornelis Cort). Punished for attempting to rape the nymph Leto, the mother of Apollo and Diana, Tityus was doomed to lie pinned to a cliff in Hades, with his liver, according to the ancients the seat of the libido, continuously devoured by (depending on the source) a pair of serpents, vultures, or eagles. (The punishment, as with Prometheus, involved the perpetual replenishment of the organ just to the point where it once more became bird food.)[88] Rubens took as much care in depicting the sacrificial organ, curled and foreshortened, as Rembrandt would with the internal musculature of Aris Kindt's forearm. And perhaps Rembrandt noticed, from the print after Rubens's painting, that he and Snyders had set one of the talons of the eagle in the midst of Prometheus's eye. His sin had been the attempted theft of fire from the gods. But Platonic theory, reiterated in a number of contemporary ophthalmological manuals like Carel van Baten's *Chirurgie,* had argued that sight was, in fact, a fiery quality (unlike Aristotelian theory, which insisted, correctly, that it was vitreously watery). Baudius's verse eulogy had singled out the detail of the eagle eye, filled "with consuming fire." The juxtaposition of the glittering avian eye with the extinction of Prometheus's own optical fire would have been just the kind of sharp move that would not have been lost on the observant Rembrandt and which might have kindled his own narrative spark.

All these antecedents—Titian, Caravaggio, Rubens—featured a Herculean figure thrown backward, his feet thrust into the air, body turned at a

Rubens and Frans Snyders, Prometheus Bound, *1618. Canvas, 242.6 × 209.5 cm. Philadelphia Museum of Art*

tortured diagonal across the picture space, head projecting toward the
viewer. But Rembrandt has used light and color in ways which not only
didn't occur to his predecessors but contradict all the basic assumptions
about the shaping of pictorial depth. Every history painter worth his hire
assumed that light passages had the optical effect of advancing toward the
viewer, while darker passages created the impression of recession.[89] But in a
stroke of daring, Rembrandt has set the most brilliant areas at the rear, so
that Delilah seems to be fleeing the carnage out of the dazzling back of the
painting. (Indeed, he made that passage still brighter in subsequent alter-
ations to the painting.) Gripping the trophy of Samson's shorn locks, in her
vindictive rush she moves, in other words, in the opposite direction from
the great fall of the giant's body, with his annihilators throwing themselves
on his trunk and head. The result of these two opposing movements is to
generate a kind of manic energy within the painting. And all the other
clumsinesses of its construction—the odd foreshortening of the soldiers'
arms; the apparently slapdash handling of paint on the fur-trimmed coat of
the figure with the partisan—add to this quality of whiplash ferocity. Even
more than the obvious precedent of Rubens's *Prometheus*, the picture has
something of the snarling violence of Peter Paul's many paintings of lion
hunts. In 1629 Rembrandt had made an etching of just such a Rubens-like
hunt, with a spear poised for a downward thrust through the head of a
beast in a manner reminiscent of the action in the *Samson*. (Lions, after all,
played a crucial part in the Samson story.) But the handling of paint in
Rembrandt's picture is itself more aggressively brutal than anything
Rubens would have owned to. Rembrandt went back to the painting many
times, altering the positions of some of the figures and apparently actually
roughening the finish, all surely with the object of making a fit between

brushwork and narrative. There are details in the depiction of Samson's agony—the curl of the tormented toes, the clenching of the teeth in the rictus of pain—where the paint seems to have been stabbed onto the canvas.

The raw physical urgency of the *Samson* was at complete odds with the glossier finish of the standard Baroque histories, which looked more slavishly to the masters of Antwerp and Italy. Rembrandt's aim, of course, was not just to make a new kind of butchery drama but to do so in the service of the essential message: redemption through suffering. It has long been thought that *The Blinding of Samson* is the painting which, on the twelfth of January 1639, Rembrandt offered to Huygens in an attempt at ingratiation, and to expedite payment for his work on the Passion series, together with the advice to "hang it in a strong light so that it might be appreciated from a distance."[90] If this was indeed Rembrandt's gift to Huygens, it would certainly have been understood and appreciated by its recipient as a scene of redemptive immolation: the moment when a tragic hero pays the price for hubris, vanity, and the sins of the body.

Or, to put it another way, Samson was being punished for his moral blindness. Now that his eyes were out, he could, at last, see things right.

This was the sentiment that ran through Huygens's own poem on blindness, *Ooghen-troost,* published eleven years after Rembrandt painted *The Blinding of Samson,* but written, in fact, during the 1630s. The title is itself a typical Huygensian conceit since it was the familiar Dutch name for the herb euphrasia, or eyebright, whose bright blue flower, according to the medieval "doctrine of signatures," in which the visible properties of a plant advertised its particular healing function, was a cure for the occlusion of vision. A typically doubtful late medieval prescription, for example, had recommended that eyebright be mixed with agrimony, sage, burnet, betony, and "the urine of a chaste youth" for maximum effect.[91] But *ooghen-troost*'s other meaning, a balm for the eyes, referred not just to the lotion but to the kind of consoling advice which Huygens offered in the form of his poem to the daughter of an old friend, Lucretia van Trello, who was suffering, probably due to glaucoma, from a loss of vision in one eye.[92]

The comfort Huygens offered to Lucretia we might think pretty cold, if impeccably neo-Stoic. Accept your lot. It is God's inscrutable design. What may seem like a cruel affliction has within it the seeds of self-enlightenment. The particular blessing within the curse was the capacity to distinguish between *falsa bono* and *falsa mala,* false good and false evil, between outward and inward sight. Partial vision, Huygens told Lucretia, meant being deprived of precisely those things which on the surface might seem most delectable, but which, like the glitter of gold or the allure of a body, were provocations to grief and sin.

At the heart of Huygens's poem was a long roll call of the "ranks of the blind," all those who were most deluded by the sorcery of sight: misers, lovers, "blind" power-seekers, and, not least of all, painters, who came in for especially stinging criticism. They were, said Huygens, thrice reprehensible: first, for presuming to represent the reality of things when in fact they

merely imitated surface appearance; second, for the temerity of presuming to ape God's creation; and third, for the sacrilegious absurdity of calling a landscape or a comely person *Schilderachtigh*, or picturesque. It was, Huygens added tartly, for the picture to show itself worthy of the Lord's creations, not the other way about, in order to win praise. Damaged sight paradoxically relieved mortal humans of all these optical delusions and instead reinforced (much as, it was said, the loss of one faculty strengthened another) the capacity for *binnenwaarts zien*—inward sight.

It might seem odd, on the face of it, that Huygens, who in his detailed comparison of Lievens and Rembrandt had shown himself to be such a visually acute connoisseur, should here seem to be slighting the sense of vision.[93] But it was not at all uncommon for Protestant humanists to combine the keenest interest in the explorations of the eye, and the pleasures of the optically surveyed natural and material world, with a chastening sense that this pleasurable inspection was, ultimately, of a lower order than the truths to be gained from inward contemplation. Their deepest suspicions were reserved for the Catholic Counter-Reformation, which gave positive encouragement to visual spectacle as a route of mystical transport to divine revelation. Huygens himself was echoing an ancient tradition that had begun with St. Paul and which had been especially pronounced in Augustine's *Confessions*, where the saint rejects the temptations of the eye. "The eye," he wrote, "delights in beautiful shapes and colors. I would not have these things take possession of my soul. Let God possess it." The demon was light, or what Augustine called corporeal or bodily light, "the queen of colors that pervades everything I see wherever I am during the day" and which distracts the good Christian from the path of devotion. The *true* light, he continues, is "the light that Tobit saw when his eyes were blind, [the light by which] he taught his son the true path to follow."[94]

So it should not surprise us to find Rembrandt continuing his long fascination with the Book of Tobit at much the same time that he was painting his three Samson pictures, including the terrible and unforgettable *Blinding*. Rembrandt's entire career was a dialogue between outward and inward vision, between the glitter of the hard, unforgivingly metallic surface of the world and the vulnerability of mortal flesh, between the vulgar *spectacle* of Belshazzar's golden kingdom and his sudden *vision* of its destruction. It would be another twenty-five years before both Joost van den Vondel and his friend John Milton would write their own respective versions of the insight finally vouchsafed to the blinded Samson. In much the same vein and in the same year, 1660, that Rembrandt was producing his shockingly confrontational one-eyed Claudius Civilis, Vondel wrote two plays in which sighted but morally blind heroes achieve a state of grace and truth through blind self-destruction: *Samson's Revenge* and his own version of Sophocles' *Oedipus Rex*.[95] In the Samson play, Samson expressly refers to his "blind love" for Delilah laying him low, and later to the "blind idolatry" of the Philistines that would, in their turn, seal their doom. Ten years later, the blind Milton has the chorus of Danites in *Samson Agonistes* describe the hero's final redemption:

But he though blind of sight,
Despis'd and thought extinguish't quite,
With inward eyes illuminated
His fiery virtue rous'd
From under ashes into sudden flame.[96]

In the 1660s Rembrandt would arrive at a manner of painting that was itself a kind of outward-inward vision, a manner that owed almost as much to touch as to sight, and which certainly ran directly against the coming vogue for sharp-focussed, hard-edged, brilliantly colored, crisply modelled forms sparkling with reflected light.[97] But a quarter century earlier, he was already experimenting, compulsively, with both techniques and histories that turned on the occlusion and clarification of vision.

A drawing in the Cleveland Museum of Art showing *The Healing of the Blind Tobit* suggests that Rembrandt, who had already demonstrated a more than amateur interest in anatomy, was also conversant with the oph-

Rembrandt, The Healing of the Blind Tobit, *c. 1645. Pen and brown ink drawing corrected with white gouache. Cleveland Museum of Art*

Rembrandt, The Angel
Leaving Tobias and His
Family, *1637. Panel,*
68 × 52 cm. Paris,
Musée du Louvre

Rembrandt, The Angel
Leaving Tobias and His
Family, *1641. Etching.*
New York, Pierpont
Morgan Library

thalmological literature on the removal of cataracts. For instead of following both convention and Scripture by showing the moment when Tobias smears his father's eyes with fish gall, as instructed by the angel Raphael, Rembrandt had decided to show him (in all likelihood in a painting of which only a pupil's copy survives) manipulating the optical surgeon's needle, turning and twisting the point to dislodge the callused matter from the surface of the cornea and pushing it to the inferior part of the eyeball. The procedure by which the old man's head is grasped, the eyelid pulled firmly back, and the needle carefully inserted is taken directly from works like the Utrecht physician Carel van Baten's Dutch translation of Oswald Gabelkower's *Medecynboek* and the German surgeon Georg Bartisch's *Ophthalmoduleia.*[98] It's even been suggested

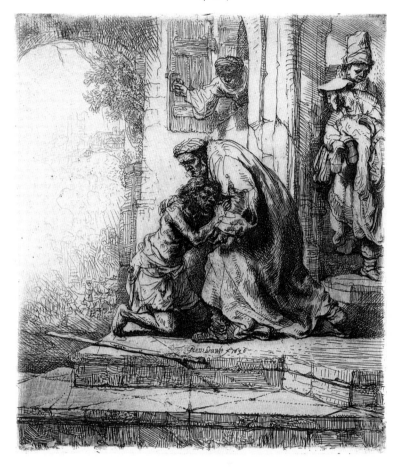

Rembrandt, The Return of the Prodigal Son, 1636. Etching. New York, Pierpont Morgan Library

that Rembrandt might have drawn directly on the advice of the Amsterdam optical surgeon Job van Meekeren for his careful representation of an operation that could not be left to the common run of surgeons, whose expertise was limited to the excision of gallstones and the repair of fractures.[99] As with Dr. Tulp's dexterous dissection, it's probable that Rembrandt (as a master of fine motor skills himself) admired the delicacy and steadiness needed for the risky procedure.

But his version, as represented in the drawings, is also a document of filial tenderness—the obverse not just of *The Sacrifice of Isaac* but also of Rembrandt's overwhelmingly moving 1636 etching of *The Return of the Prodigal Son,* where the pathetic, bedraggled, and emaciated creature, reduced to rooting for swill in the pig trough, returns to the bosom of his father. Though there is no mention of it in the Bible, Rembrandt seems to suggest (as he would again in his painting from the 1660s) that the father, whose eyes are shut fast, has become blind in his old age, just like the miller Harmen Gerritsz. All of these filaments running through Rembrandt's life and his favored choice of histories become woven together in the *Tobit* drawing, all the more poignant since in this case it's the father who must put his blind faith in the benevolent strength of his son. Tobit's involuntary

combination of slackness and tension is touchingly suggested by his mouth, which has dropped slightly open as the eyelid is pushed up, and by his hands fearfully gripping the ends of the chair arms. Rembrandt has taken liberties with the text to make this a family scene. Tobias's wife, Sarah, who stands in quiet profile, her hands resting on her stomach in the medieval attitude of fruitful wifeliness, was, according to the Apocrypha, not present at the scene but was left at the gates of Nineveh while her husband returned to his father. And Anna, the faithful wife, has been turned into a nurselike figure, peering through her spectacles at the operation while holding a bowl of water to swab and cleanse the eye. Over Tobit's right shoulder, the figure of the angel Raphael has been inked in and then made more spectrally faint with a light whitewash, as though to emphasize his immateriality.

This sense of the guardian angel being a quality of light rather than solid matter is at the center of Rembrandt's concerns when he turns to the final episode from the Tobit story, when the mysterious stranger Azariah reveals himself as the archangel Raphael and, his mission done, leaves the house, ascending to the heavens in a great burst of radiance. Rembrandt's painting may be dated to around 1637, and in 1641 he repeated the subject in an etching, further developing his favorite paradox of the blinding light. In the painting, the two generations react in different ways: the younger, in the person of Tobias and his miraculously exorcized wife Sarah, being able to look directly in astonishment at the departing angel, while the older couple, in their separate ways, shield their gaze. Tobit, in particular, prostrates himself in prayer, his eyes summarily indicated with a dark smudgelike line as if still bearing the outward signs of the years of his blindness. In the later etching, Raphael's own form has become faceless, while the great numen of light now dazzles all the members of the family, including the eye doctor Tobias, who bows his head in its radiance.

Even then, Rembrandt had not quite finished with the Book of Tobit as his favorite parable of inward and outward illumination.[100] For in 1651 he cut one of his most moving etchings, depicting the old man, alone in his kitchen, suddenly aware of his son's presence at the door and moving with affecting clumsiness, his right foot rising in his slipper as he shuffles as fast as he can toward the door, knocking over the spinning wheel, the emblem of his long-suffering wife's domestic virtue, and colliding with the faithful dog. Tobit's eyes are marked by deep black lines, suggesting that Rembrandt used the burin to make a velvety burr on the etching plate. Nonetheless, Rembrandt has managed to give them the appearance of both sight as well as blindness, or rather to treat them as organs of direction and purpose, of inner rather than outer vision.

It is not enough, though. For Tobit moves, in fact, not toward the half-open door, which we can see plainly to his right, but toward a collision with his own shadow.

OPPOSITE: *Rembrandt,* Tobit Going to Greet Tobias, *1651. Etching. New York, Pierpont Morgan Library*

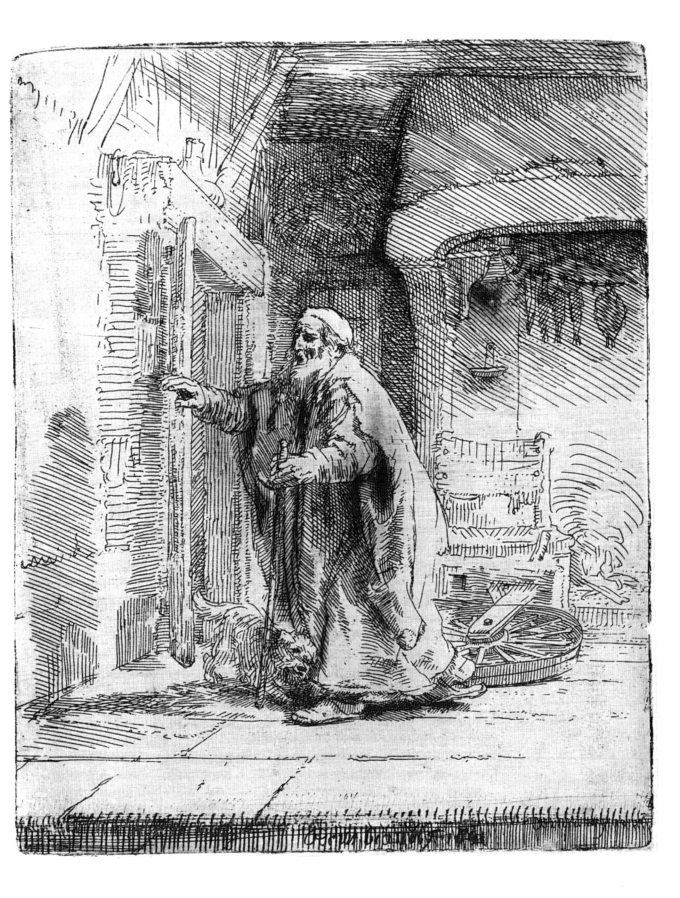

Down the inner alleys, the *stegen en sloppen*, of Vlooienburg, the Jewish world grew much denser and poorer. The houses here were wooden, since the whole island not long before had been occupied by carpenters, lumbermen, and shipwrights, cutting and framing parts for vessels made in the Amstel yards. Now those ships were made up, in large part up the Zaan, and assembled on the outer islands of the river in the big admiralty docks. Sawdust had been replaced by the finer powder from polished gems or by cast-off hanks of tobacco. There were chickens and goats, butchers and bakers, old-clothes men, surgeons, and wig makers. Peer through one pair of shutters and you would see men moving movable type in Hebrew, Aramaic, Spanish, and Ladino; peer through another and a pair of shears would be out cutting lengths of fabric to be died yellow and made into prayer shawls. Dig deeper in the neighborhood and you might come across the occasional *tedesco* from some barbarous German or Polish burg, who struck the Portuguese Sephardim as ignorant and unclean with their horrible long beards, even longer coats, and gobbling gutturals. Further in still, of a night, in the sallow gleam of an oil lamp you might find an inn, a fiddler, a smoke, and, though no one admitted it, a girl.

It was hardly a ghetto that Rembrandt and Saskia made their home in. They only had to cross a bridge going north and continue for a block and they would emerge onto the Breestraat, turning left to Hendrick van Uylenburgh's old house. And many of the faces that have been thought and called Jewish on the strength of dark hair or a flowing white beard presuppose a "Semitic" physiognomy that belongs more to the cliché and caricature book of the nineteenth century than to the reality of seventeenth-century Amsterdam, where the vast majority of Jews dressed precisely like their Christian neighbors.[104] Many of the ancients, long labelled "rabbis" in the museums of Europe and America, were in all likelihood venerable Protestants. A skullcap, for example, was no indicator of race or religion, nor even the soft felt Polish *kolpak* hat, which was more likely to be worn by Mennonites from Gdansk like the van Uylenburghs than by Jews from Kraków. Even the portrait etching of a man with a broad nose and thick lips usually identified as Menasseh ben Israel bears almost no resemblance whatsoever to the secure likeness we have in a print by the Jewish artist Salom Italia. Conversely, were we not to know for sure that the elegant gentleman descending a staircase was in fact the Jewish physician Ephraim Bueno or Bonus, there would be no way at all to identify his religion from dress, face, or demeanor.

And yet it would have been impossible for Rembrandt to have lived on Vlooienburg in the late 1630s and not to have soaked up some of the richness of Portuguese Jewish culture. He was, after all, an enthusiast of the exotic, and his instinctive sense of the Scriptures, not least the Old Testament, as a living book of stories could only have been reinforced by his closeness to the people of the Book. For Rembrandt was one of nature's ecumenicals. His mother's family had been Catholic; his father's desultorily Calvinist. His friends, patrons, and sitters were all over the map—Remon-

strants, Counter-Remonstrants, Mennonites, and at least two Jews. For that matter, he may have fallen into the unnumbered many in the Dutch Republic who chose to belong to no particular confession at all, save for baptisms and funerals, but whom the state left unbothered. Which is not to say that Rembrandt did not feel his faith as intensely as Rubens did his. But it was a faith of dramatic interruptions, agonizing temptations, unresolved struggles, and gnawing anxieties, not one of saintly callings and ecstatic martyrdoms. Uncertainty, anger, disbelief, and betrayal were at the heart of it.

This feeling for humanly embodied Scripture gave Rembrandt, on the brink of a breakthrough as Holland's great history painter, both opportunities and headaches. When he painted two further large Samson stories from the Book of Judges, he was in his element, for they were both dramas of treachery and wrath. *Samson Posing the Riddle at His Wedding Feast,* painted in 1638, shamelessly borrowed from Leonardo's *Last Supper,* which Rembrandt had drawn from a print, but with the sumptuously dressed and crowned Philistine bride substituted for Christ. To her right, amidst much giggling and overdressed groping, Rembrandt has repeated the leaning Veronese figure in red velvet and bare shoulders whom he had used in the foreground of the *Belshazzar.* And to her left, Samson poses the riddle of the sweetness to a group of listeners, making the point with his fingers while also supplying the answer of the honey in the lion's carcass with his own maned, leonine appearance.

The earlier Samson painting was much more peculiar. The episode, from Judges 15, when Samson's Philistine father-in-law refuses to let him into his house to see his wife and give her a kid, gives the old man, not the young man, the action, saying, "I verily thought that thou hadst utterly hated her; therefore I gave her to thy companion: is not her younger sister fairer than she? Take her, I pray thee." The Scripture only says that Samson resolves to do the Philistines "a displeasure" as a result. But this doesn't stop Rembrandt from inventing a scene of fabulous fury, his mouth open, showing his teeth in shouted anger, the great fist moving up toward the father-in-law's face while the old man's right hand grips the iron ring of the shutter, in both fear and defiance, emphasizing the incarceration. The impact of the confrontation depends entirely on the disconcerting quality of the isolated head, seen in profile, framed by the studded shutter, but detached from the rest of the body as if retractable, like the paper-pull illustrations in a children's book. Ultimately, the gesture is perhaps too self-consciously posed to work dramatically, but it was still another startlingly original exploration of spatial illusion, and one which must have been carefully noticed by Rembrandt's student Hoogstraten when he painted his own illusionistic exercises in apparently disembodied heads.

It was, though, exactly this quality of unpredictable inventiveness, the instinctive capacity to reinvent a genre, to see round conceptual corners, that seems to have deserted Rembrandt when he worked on the commission which became, upsettingly, both the most and least desirable of his

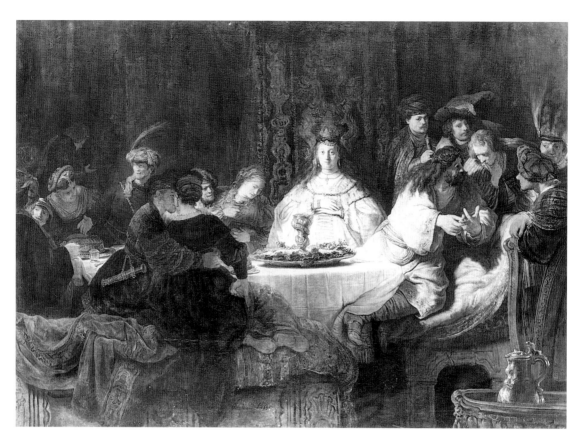

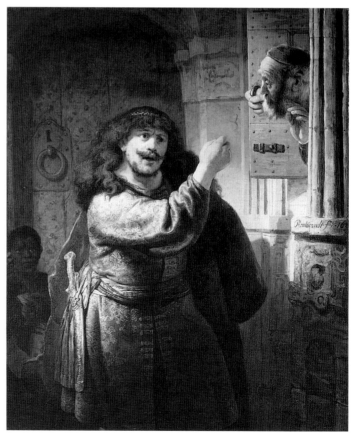

ABOVE: *Rembrandt,
Samson Posing the
Riddle at His Wedding
Feast, 1638. Canvas,
126 × 175 cm. Dresden,
Gemäldegalerie*

RIGHT: *Rembrandt,
Samson Threatening
His Father-in-law,
c. 1635. Canvas,
158.5 × 130.5 cm.
Berlin, Gemäldegalerie*

career: the Passion series for the Stadholder Frederik Hendrik. To begin with, the invitation to paint a further three scenes to be hung together with his *Elevation of the Cross* and *Descent from the Cross* in the Stadholder's private gallery in the Oude Hof palace in The Hague must have seemed an unqualified prize, the official seal on his bid to be the Dutch Rubens. With this feather in his hat, who could be said to be his master in history painting? Lievens was in England. Pieter Lastman had died, and the surviving members of his circle—Jan and Jacob Pynas, Claes Moeyaert, Jan Tengnagel, and the like—might well have been green with envy. Should the work go even routinely well, Rembrandt's unapologetic gesture of painting himself decorated with a golden chain of honor would look less like an idle brag and more like a prophecy.

The trouble was that the lessons he had learned from Rubens, which he had mobilized in the great powerhouse histories, with their stabbings and swoopings, were of no avail at all in this job where he needed to return to the more restrained and contemplative manner he had left behind in Leiden. Sure enough, the most important commission in his whole career evidently turned into a laborious, painful creative struggle, perhaps, at times, even a chore. In February 1636 Rembrandt wrote Constantijn Huygens, as always the prime mover in such assignments, using a tone in which a veneer of confidence barely disguised a note of procrastination. It seems likely that the commission had been awarded in 1633, following the success of Rembrandt's second painting of the Passion, *The Elevation of the Cross*. Three years had passed without much sign of progress, for Rembrandt's letter, full of declarations of his own diligence and perseverance, sounds very much like a defensive response to a courteous but perhaps slightly restive inquiry from Huygens. Rembrandt wrote that he had now finished the first of the three commissioned paintings, an *Ascension of Christ*, and as for the other two, an *Entombment* and a *Resurrection*, they were "easily more than half done."[105] (This, as tardy writers as well as painters well know, could mean, say, nine-sixteenths done.) "Should it please His Excellency to receive the finished piece first, or all three together, I pray my lord to let me know concerning this matter so that I may oblige the wishes of His Excellency the Prince to the best of my ability."

One must hope, for his own sake, that Huygens decided to see the *Ascension* without more ado, since it would take another three years before the remaining two pictures actually got delivered. An ominous silence followed (although Huygens's letters to Rembrandt, which might well have been less intermittent than the painter's, have not survived). It's not beyond the bounds of reason to suppose that Rembrandt might actually have *deliberately* set the commission aside after his attempts to raise his fee for the paintings had been rebuffed. A second letter from the artist, written in 1636, is another off-putting mixture of ingratiation and high-handedness. On the one hand, Rembrandt is all eagerness to ensure that his new paintings match the first two in the Stadholder's gallery, and offers to come to The Hague to guarantee a good fit. On the other hand, he asks for two hun-

dred Flemish pounds for *each* of the new paintings, the equivalent of twelve hundred guilders per work, or twice the rate he had been paid for *The Descent from the Cross* and *The Elevation of the Cross*. Rembrandt might reasonably have felt that a higher rate of pay was merited by the transformation of his status and reputation since the submission of those two earlier works in 1632–33. He was now the renowned painter of *The Anatomy Lesson of Dr. Tulp*, the portraitist of grand patricians and venerable preachers. Even more to the point, he was no longer merely a partner in the van Uylenburgh concern, but was now the master of an independent workshop with a procession of gifted pupils, the most important center of art production in Amsterdam.

And yet there were limits to his brassy temerity. Rembrandt must have been uncertain how his request would be received, since he added that although "I certainly deserve two hundred pounds . . . I will be content with whatever His Excellency [chooses] to pay me." Perhaps, too, he was not completely confident of Huygens's own advocacy when it came to supporting his claim to a double rate of pay. Huygens's abundant admiration of Rembrandt, remember, had not precluded that cutting little verse about the artist's failure to paint Jacques de Gheyn III with any semblance of close likeness.

The stinging lines remained unpublished—until 1644, when Huygens collected some of his occasional verses in a published anthology. But they may still have hit their target. The circle that Rembrandt moved in, especially during his dealings with the court in the 1630s, was small. Gossip and ridicule, polite and impolite, was its food and drink. The temptation for some not entirely well-intentioned party to bring Huygens's unflattering verses to Rembrandt's attention must have been irresistible. Whatever Rembrandt's many capital qualities, good-humored forbearance was not high on the list. So although he had tried to sweeten the request for double pay by presenting Huygens with an example of "my latest work" (perhaps an etching), he was perhaps not completely surprised when the claim was declined and the same rate of remuneration—six hundred guilders per item—was specified for the remainder of the commission.

It may have been enough to poison the cup. On his side, Rembrandt may have felt humiliated by the rejection and recognized that, after all, the position of the courtier-painter was more slavishly deferential than perhaps he cared for (something Rubens had keenly felt on more than one occasion). For his part, Constantijn Huygens (or the Stadholder) may have thought that the painter whom they had plucked from obscurity in Leiden was getting decidedly above himself, giving himself the airs and graces which even Rubens might have blushed at. An inevitable comparison must have been glaring. Contemplating paintings that would "agree," as his letter put it, with the earlier Passion paintings, Rembrandt could hardly have avoided being put in mind of the Rubens models which he had self-consciously quoted and competed with in making his own sacred histories. And his repeated tic of quoting Rubens's works—the *St. Walburga*, the

Prometheus, The Sacrifice of Isaac—suggested that he had not yet shaken free from the urge both to emulate and surpass his paragon.

For his part, Huygens could scarcely have been indifferent to Rubens during the late 1630s, even after the abortive attempt to have the Flemish painter come to Holland in 1635. In 1638, after all, Rubens's most famous (and politically most notorious) patroness, Marie de' Medici, the Queen Mother of France, exiled for her part in a botched coup d'état against Cardinal Richelieu, had taken asylum in the Netherlands, partly at Rubens's behest. From the Catholic south she travelled north to the cities of the Dutch Republic, a tour culminating in a grand entry in Amsterdam itself. Wherever she went, the ghost of her more triumphant past followed her, in the form of engraved reproductions of Rubens's cycle of paintings eulogizing her life. For that matter, it would have been impossible for the masters of the ceremonies in Amsterdam not to have been acutely conscious that Rubens's designs for the triumphal entry of the Cardinal-Infante three years earlier represented the last word in allegorical panoply. And predictably, although the cast of characters was different and the mood decidedly more cheerful, the Amsterdam ceremonies borrowed extensively from the much older and better-tested Antwerp playbook.

Nor could someone with Huygens's international connections have been ignorant of Rubens's astounding rate of production of paintings for the Torre de la Parada, King Philip IV's hunting lodge outside Madrid. In rather less than two years, Rubens and his workshop had produced more than *sixty* mythological paintings for the King (and for his friend Frans Snyders, another sixty of animal and hunt paintings). To meet the King's impatient demands, Rubens had had to mobilize no fewer than eleven of his Antwerp colleagues, including Jacob Jordaens, Cornelis de Vos, and Erasmus Quellin, to work up the finished paintings, especially since he himself was increasingly afflicted with attacks of gout that made it hard for him to grip his brush. But the little oil sketches on panels that set out the basic composition of the mythical scenes, mostly taken from Ovid, were entirely the work of Rubens himself and are among the most beautiful things he ever created. The astonishing burst of poetic energy from a gouty old gent with arthritic joints must have reminded Huygens that whatever his earlier predictions, it seemed very much as though Apelles still lived west of the Scheldt and Maas.

In fact, Huygens was in direct contact with Rubens during the years he was trying to extract the Passion paintings from Rembrandt. Eager to win the approval of the Flemish artist, who was himself famous for building the perfect house of a humanist gentleman scholar and was the published authority on Genoese palazzi, Huygens sent Rubens illustrations of his own brand-new urban villa, built in the center of The Hague to the most fashionably Italianate specifications. At the end of the letter, almost casually, Huygens added a commission from Frederik Hendrik for a painting to be placed above the hearth in his palace, the subject to be of Rubens's choosing, but with three, "at most four" figures, "the beauty of whom

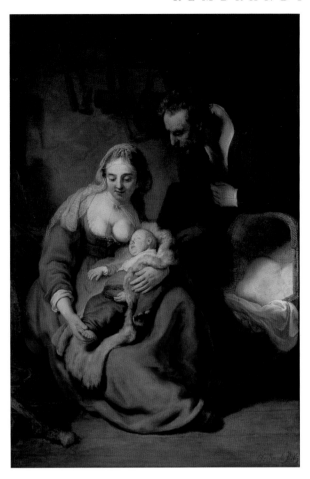

Rembrandt, The Holy Family, *c. 1634. Canvas, 183.5 × 123 cm. Munich, Alte Pinakothek*

should be elaborated *con amore, studio e diligenza.*"[106] The specification of number was presumably an indication that the Stadholder did *not* want a nude-choked *Garden of Love* in the manner to which Rubens, in his ripe middle age, had become famously partial. So Rubens eventually sent the Stadholder a large and colorful *Crowning of Diana*, full of obedient beasts, a perfect spectacle to preside over a banqueting hall following a successful hunting party.

Rembrandt, too, knew something about painting for palatial spaces, in particular Frederik Hendrik's gallery in the "Oude Hof," the Noordeinde palace. And he could assume enough knowledge of Huygens's own gallery to advise that the painting he was giving him should be placed "in a strong light" for best appreciation.[107] But for all his surface self-confidence, Rembrandt was still very much in the grip of influence anxiety, shopping around among the Catholic paragons for models for his Passion paintings while trying to please a Protestant patron. The most frequently cited source for Rembrandt's *Ascension of Christ* is Titian's great altarpiece of *The Assumption of the Virgin*, executed around 1517 for the Franciscan church of I Frari in Venice. But unless Rembrandt had access to a drawing of Titian's painting, this could not have been his prototype, since it was not engraved until well *after* he had delivered the picture to the Stadholder in February 1639. There were, however, a great number of *Assumptions of the Virgin* and an *Ascension of Christ* available for him to study in the form of engravings by Schelte à Bolswert after paintings by Rubens. Taken singly, none resembles Rembrandt's composition for his own *Ascension* as closely as the Titian. But Rembrandt was adept at borrowing from different models and creating his own synthesis, and this is just what he did with the Rubens paintings, taking the flight of cherubs from one painting, the gesticulating figures below from another, even perhaps the Holy Ghost from yet another Rubens, *The Descent of the Holy Ghost* engraved by Pontius.

But this laboriously additive collection of Catholic motifs only points up Rembrandt's painful difficulty in converting the conventions of the public, inspirational Catholic altarpiece into a Protestant, private devotional painting. The most acute problem turned on the place of sacred spectacle in the strengthening of faith. For Catholics, pictures had to be powerful enough to give the beholder a bodily sense of participation in the Passion, so that the boundary between their own persons and that of the Savior, the Virgin, and the apostles all but dissolved. But that was precisely the bound-

ary which Protestantism insisted on respecting, believing the Catholic
ardor for physical, rather than symbolic, communion an act of presumptu-
ous sacrilege. Luther and Calvin had both dismissed as deluded, if not actu-
ally blasphemous, the notion that salvation could depend at all on the
actions of Christians. Instead, it was argued, salvation was bestowed by
grace alone. Faith, as St. Paul had taught, became essentially a passive con-
dition: the meek acceptance of sin and unworthiness; the hope that God's
abundant mercy would redeem the sinner. Protestant painting, then, ought
to have no pretensions to transport the communicant into the material
presence of Christ. It should instead point up the virtues of watching, wait-
ing, believing; it should illuminate not the *closeness* between mortal man
and the Son of God but the insuperable distance between them.

The only trouble for Rembrandt in the mid- and late 1630s, of course,
was that his greatest efforts were invested in close-up action painting:
bringing Abraham's beefily murderous hands, Danaë's glowing breasts,
Raphael's flying feet, or Belshazzar's popping eyes right into the face of the
beholder; making the experience palpable and concrete. Even in New Tes-
tament scenes like the tender *Holy Family* of 1634, Rembrandt's emphasis
is on direct, intimate physical experience, on domestic details which bring
the figures within the compass of human experience. Here, too, Rembrandt
remains bewitched by the earthy beauty of Caravaggio and Rubens. Like
any new mother's, the Virgin's left hand plays with the Christ child's toes;
her breast touches his forehead. Joseph, at once part of the mystery and
separated from it, leans carefully toward the baby, his hand going no fur-
ther than the crib blanket. And all around the room are the tools of his
trade as well as a cut branch—allusions, for those searching for them, to
the Crucifixion, the ultimate meaning of the birth of the Savior, but embod-
ied in the commonplace clutter of a carpenter's shop.

The Holy Family was Rembrandt's largest history painting to date.
Paradoxically, though, the Passion series had to fit bigger, more sensational
episodes into a *smaller* format, the same size as the original pair of paint-
ings from 1631–33. And the dimensions were the least of his problems. He
also needed somehow to continue paintings that were spectacular yet con-
templative; which combined sacred apparitions with this-worldly witness,
divine emanations with solidly mortal clay.

It's hard now to see, with any clarity, how manfully Rembrandt strug-
gled to resolve all these thorny problems, thanks to the misplaced enthusi-
asm of an eighteenth-century restorer at the court of the Elector of
Mannheim, Philipp Hieronymus Brinckmann, who added insult to the
injury of his overpainting by attributing to himself godlike powers. Pre-
sumably it was not fortuitous that it was the back of *The Resurrection* on
which the proud artist-restorer chose to crow about his work by inscribing
(in Latin), "Rembrandt created me; P. H. Brinckmann brought me back to
life."[108] So although Rembrandt has been wrongly accused of being slap-
dash in his paint handling and of doing nothing at all about completing the
series until the sudden need to come up with money for his new house in
January 1639 forced him to pay attention to the job in hand, the evidence

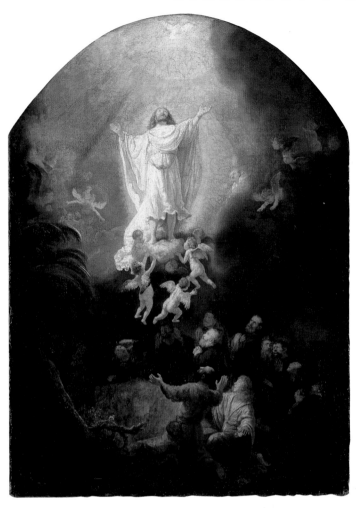

Rembrandt, The Ascension of Christ, *1636. Canvas, 92.7 × 68.3 cm. Munich, Alte Pinakothek*

of painterly sloppiness is almost all Brinckmann's, not Rembrandt's. Long delays there certainly were, and even were the works in the Passion series undamaged, I suspect they would still not rank among Rembrandt's most coherent achievements. But the delays were more the result of his having taken the commission *seriously* rather than lightly, and more the result of his wrestling with the contradictions implicit in Protestant painting than of a casual and dishonest investment in the commission.[109] After all, the grisaille of *The Lamentation over the Dead Christ,* now in the National Gallery in London, shows similar evidence of the artist battling to reconcile sacred grandeur with human detail. Rembrandt began the work in 1637, at the same time that he was working on the Passion series, but fiddled with it even longer, for seven years, adding strips and pieces of canvas here and there to the original paper center. The writer Jonathan Richardson the Younger claimed (dubiously) to have counted, with his father, seventeen such strips, so much had Rembrandt "labour'd this study . . . and had so often chang'd his mind in the disposition of the clair obscur."[110]

Even in the miserable condition in which the Passion series has been preserved, it's possible to see Rembrandt thrashing around, trying different, and often inconsistent, solutions to the problems inherent in the commission. One can almost feel the insomniac tossing and turning, the gnawing anxiety that he would never get it right. The *Ascension,* full of unresolved dilemmas, is constructed around what, even for Rembrandt, were starkly divided zones of light and dark, thus preserving the Protestant requirement to separate the celestial and the mortal worlds. But in this painting more than any others he ever executed, Rembrandt went as far as he dared toward Catholic apostasy, delivering an abbreviated version of an inspirational altarpiece which would have suited any Roman church. The palm tree at left, a symbol of the Resurrection, is drawn directly from Catholic devotional iconography. More significantly, X-radiographs reveal that originally Rembrandt intended to paint the Holy Trinity, including an image of God the Father receiving his Son into heaven, as well as the dove of the Holy Ghost. In his *Institutes of the Christian Religion,* Calvin had expressly warned against attempting any likeness of God, since "the

majesty of God, being too high for human view, must not be corrupted by phantoms which have nothing in common with it."[111] But in fact, even the fathers of the *Catholic* Counter-Reformation, following the Council of Trent, had frowned on attempts to represent the theologically immaterial presence of the Divinity. And here is Rembrandt offering the sight of the ascending Christ in plain view of the assembled throng who for once are *not* blinded by their vision. To make matters inadvertently worse, he observed in his second letter to Huygens that the *Ascension* would "show to the best advantage in Her Excellency's gallery where there is a strong light."

It was an appallingly tactless and obtuse move. Frederik Hendrik had begun his stadholderate with a show of leniency toward Christians beyond the Reformed Church. But in 1633 he had swung, decisively and calculatedly, toward a political alliance with the Counter-Remonstrants, whom he trusted would support his more aggressive war. At some point, Rembrandt must have realized that he had gone well beyond the bounds of acceptable Protestant iconography, went into sharp theological reverse, removed the face of God, replaced it with the Holy Ghost, and made all the elements of the picture more this-worldly than would have been the case with a truly uninhibited Catholic altarpiece. The figure of Christ, while much more idealized than in either of his two earlier paintings (possibly in response to delicately constructive criticism by Huygens?), is still very much a Savior *incarnate*, especially at the level of his sturdy calves and feet. His ascent to heaven seems less a levitation than a hoist, his body strenuously pushed aloft by a hardworking team of dove-winged cherubs. Never were clouds so inconveniently solid a platform for their miraculous purpose.

If Huygens and the Stadholder liked the painting, they evidently were not so enthralled by it as to grant Rembrandt his request for a double rate of pay. When Rembrandt finished sulking over his rejection and returned in earnest to the two unfinished canvases, *The Entombment* and *The Resurrection*, he also returned to the qualities that had been singled out by Huygens as his greatest gift: the representation of *human* emotion and action. In his grisaille study of *St. John the Baptist Preaching*, through artful lighting Rembrandt had contrived the impossible, bringing together his cast of thousands, from Turks to Pharisees, snoozing bystanders to evacuating dogs, with the central drama of the apostle's speech. Evidently he tried something of the same with his *Entombment*, attempting to evoke a whole world of emotional response. By placing the three grieving Marys at Christ's feet (one of those feet resting on the hair and shoulder of Mary Magdalene, precisely as in Rubens's altarpiece), Rembrandt removed them from the main centers of human action in the painting. The women are illuminated by the weak light coming from the lantern on the right, while the more anonymous figures immediately around Christ's body are lit much more strongly, the illumination coming more from the *lumen Christi*, the light unto the world, than from the single candle shielded by the hand of the bearded figure on the left. The principals are themselves a microcosm of the saved: two burly workmen lowering the body into the tomb; a richly

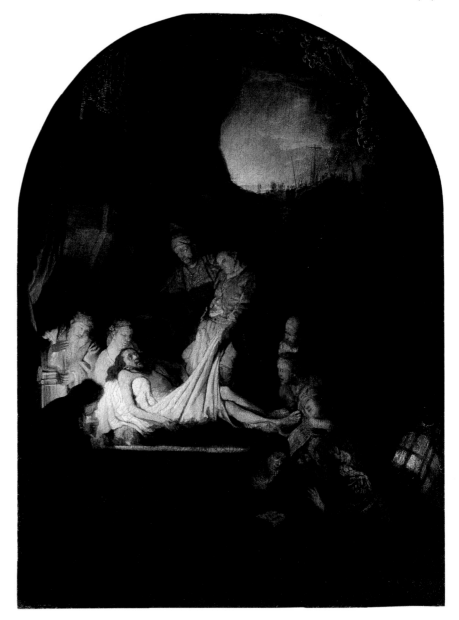

dressed figure, perhaps Joseph of Arimathea, standing between them; an
old woman, her clasped hands resting on the lip of the tomb, silhouetted
against the radiance of the shroud. Behind the principal group, easier to
make out from a reliable contemporary copy of the painting, is yet another
large cast of characters, filling the space between the tomb and the mouth
of the cave. In the middle of them, visible between two backs leaning in dif-
ferent directions, is a face looking sternly and directly toward us, wearing
the flat beret and the unmistakable features of the Everyman-artist. Behind
him is the kind of Golgotha any contemporary would have recognized, its
instruments of execution—stakes and wheels as well as crosses—spiking
the murky brown horizon.

It had been the pains he had taken to depict "the greatest and most natural movement," Rembrandt wrote to Huygens on the twelfth of January 1639, that were "also the main cause why they have been so long in my hands." And although this solitary surviving statement of Rembrandt's on the characteristics of his own art explicitly referred to *both* of the final two pictures in the Passion series, his use of the word *beweechgelickheit* was, for a long time, thought to refer to the avalanche of bodies tumbling down the left-hand corner of *The Resurrection*. But "movement" is a misleading translation of a term, which to Rembrandt's contemporaries would have denoted emotion as well as motion, inner as well as outward agitation. In fact, "*die naetureelste beweechgelickheit*" presupposed exactly the correspondence between interior feeling and body language (including facial expression) that Rembrandt had so famously mastered, and could just as easily have applied to the bent old lady of *The Entombment* as to the guard, flung backward, feet in the air, by the force of the opened stone lid, in *The Resurrection*.[112]

So, however belated and possibly intermittent his efforts, by early 1639 Rembrandt had unquestionably committed all the skills at his command to trying to satisfy the most influential commission of his career. He used theatrical manipulation of light. He used the full range of facial and physical characteristics that he had explored in his contemporary etchings like the reworked *Stoning of St. Stephen* or *The Return of the Prodigal Son*, and he manipulated space, especially in *The Resurrection*, to try to engineer the same drama of explosive collapse that he had used in *The Blinding of Samson* and *Belshazzar's Feast*. But it was (and it still looks) a strain. Changes made to *The Resurrection* in particular suggest signs of desperation. Initially, perhaps in the period around 1636 when he assured Huygens that he had "more than half done" the last paintings, Rembrandt concentrated on the blazing angelic apparition and the "great consternation of the guards," as he described it, a contrast between the calm leverage of celestial force and the chaotic implosion of panic. In keeping with the scriptural text in Matthew 28:1–5, Rembrandt had refrained from showing the figure of Christ. At some point before he delivered the picture, he changed his mind. Perhaps he thought of his teacher Lastman's *Resurrection*, in which an ecstatic, triumphant Christ, eyes rolled heavenward, arms outstretched in the manner of the Crucifixion, rises through the vault. But Lastman was, of course, a Catholic, almost certainly producing the image for a coreligionist. Once Rembrandt had saddled himself with the decision that he too must include a representation of the risen Christ, he needed to make sure it conformed to the quietist Protestant vein. He ended up plagiarizing himself, recycling the imperfectly risen, oddly *mortal*-looking figure with his fingers on the edge of the tomb which he had used in his *Resurrection of Lazarus*. Perhaps Huygens had admired that painting and the etching Rembrandt had subsequently made, and this encouraged Rembrandt's alteration. But it was a fatal move for the compositional integrity of *The Resurrection*. Instead of being (as Rembrandt must have intended) a counterpoint to the intense light and hurtling motion of the other sections of the painting, it

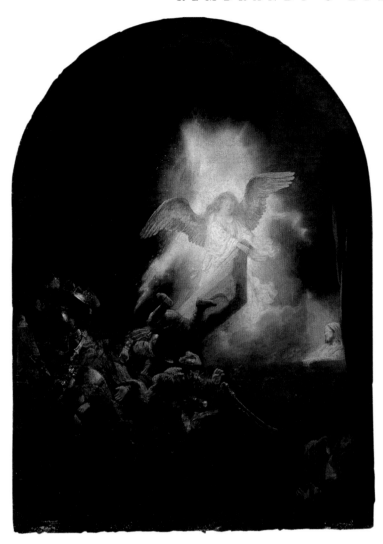

Rembrandt, The Resurrection of Christ, *c. 1639. Canvas transferred to panel, 91.9 × 67 cm. Munich, Alte Pinakothek*

just complicates and muddles them.

The Passion paintings were certainly not an out-and-out disaster. All of Rembrandt's agonizing about how far he dared go toward a quasi-Catholic iconography of revelation paid off in that the Stadholder was prepared to commission another two religious works from him in the 1640s—an *Adoration of the Shepherds* and a *Circumcision of Christ*. He had not botched the job. But neither had he done so well, in this most important commission of his life, to win for himself a secure place at court. He would not be van Dyck. He would not be Rubens. Amalia van Solms would pass him over when looking for a great talent to memorialize her husband in a palatial mausoleum painted in his honor.

It's hard to imagine Rembrandt delivering the last paintings in the cycle and basking in the glowing satisfaction of a work supremely well done. His calligraphy betrays deadly knowledge of their shortcomings. The hand which had written to Huygens in 1636, full of swooping flourishes, had retreated into a small, neat, slightly crabbed manner. He surely knew that this time he had fallen short of the stunning reinventions of a genre which mark his greatest early accomplishments, the *Anatomy Lesson of Dr. Tulp* or the *Susanna and the Elders*. The Passion paintings swing nervously between costive circumspection and vapid spectacle. And they betray the signs of having been built rather than conceived and fluidly executed. The very last words that normally come to mind in thinking of Rembrandt—laborious, additive, anecdotal—seem apposite here. Most unexpected of all, at the very point in his career when the dream of becoming the Rubens of the Dutch Republic had drawn tantalizingly close, the genie, the *ingenium* of his originality, deserted him. He had the house. He had painted in the chain of honor. But the part, the persona, would not fit any better than his shrunken Rubensian altarpieces would fit into the cabinets of Protestant princes and patricians.

Something else, someone else, was called for. And in the years that followed, set free by this comparative failure, Rembrandt would find a different way to conceive sacred spectacle; something quite beyond Rubens's

most exalted imaginings. Rembrandt's deepest feeling for salvation would come not from shows of mystical transport or from the throes of bodily torment, but rather in acts of quiet repossession: reading, praying, atoning.

For the time being, though, he had to make the best of it, and pressed on Huygens the most Rubensian of all his histories, *The Blinding of Samson,* as a token of his "gratitude" for "becoming involved in these matters for a second time."[113] The gesture might have been better received had not Rembrandt immediately followed it with another letter expressing the hope that when his two last Passion paintings would be seen by the Stadholder, they would be "considered fine enough to warrant His Highness paying me no less than a thousand guilders for each of them."[114] In other words, Rembrandt had lowered his asking price by two hundred guilders per item but was still seeking four hundred more than he had been paid for the first three. By this time a marked note of petulance, perhaps on account of his struggle to overcome the built-in difficulties of the commission, crept into the otherwise properly deferential letter. "Should His Highness not deem them worth that, let him pay me less, according to his pleasure."[115]

But His Highness, or someone advising His Highness, demurred. That someone was not necessarily Constantijn Huygens, unless he was being peculiarly duplicitous, since in the letters that followed, Rembrandt, as if slightly embarrassed about his fit of petulant resentment (but still resentful all the same), went out of his way to thank Huygens for his best efforts to secure the higher payment. "I discern your kind inclination and affection," he wrote the secretary, "which I feel deeply obliged to requite with service and friendship"; hence the presentation painting, and the advice on how best to display it. "My dear Sir, hang this picture in a strong light so that it can be viewed from a distance where it will sparkle at its best."[116]

Cordial or cross, the result was the same. Six hundred guilders, plus forty-four for the ebony frames and packing crates. Not a penny more. Two weeks after he had sent *The Entombment* and *The Resurrection* off to The Hague, Rembrandt had yet to see any money. Into the breach between the artist who had taken six years to deliver three paintings and the Stadholder who was two weeks late in paying him stepped a third party: Johannes Wtenbogaert—not the Remonstrant preacher whose portrait Rembrandt had etched and painted, but his nephew and godson. In all likelihood Rembrandt had known Johannes when the latter had been a student in Leiden between 1626 and 1631—the days of Rembrandt's local glory— and now he was living with his father, Augustijn, in a house very close to the painter's first lodgings in Amsterdam on the St. Anthoniesbreestraat. Wtenbogaert fancied himself something of a collector and connoisseur and had paid a call on Rembrandt to inspect the two Passion paintings (and perhaps the gift to Huygens as well) before they were crated up. Yet more important, he had become, in 1638, receiver-general of taxes levied on the province of Holland for the States General.

So Wtenbogaert was well placed to expedite payment, and when he paid the visit to Rembrandt in the last week of January, he suggested that perhaps the painter might be reimbursed directly in Amsterdam. Up until

Rembrandt, Portrait of Johannes Wtenbogaert, *1635. Etching. New York, Pierpont Morgan Library*

this suggestion, the funds were to have come from the accounts of one Thyman van Volbergen, a secretary of the General Accounting Office in The Hague who had been claiming not yet to have the necessary receipts from which payment could be made. On February 13, the painter, by now resigned to getting no more than 1,244 guilders, asked Huygens to intercede for him and see if Wtenbogaert's proposal to short-circuit van Volbergen's delay could be acted on: "I would ask My Lord most kindly if he could see to it that I might be paid as soon as possible here in Amsterdam, and so through your kind efforts on my behalf I should be able to enjoy my pennies, and I shall remain eternally grateful to you for all such acts of friendship."[117]

Evidently Wtenbogaert had been able to enlighten Rembrandt about the true state of van Volbergen's coffers. And when Rembrandt heard what Wtenbogaert had to say, he did a lot more grumbling, this time to Huygens. As a result of the information, Rembrandt could state categorically that more than four thousand guilders had already been deposited in van Volbergen's office. "I beg you, good Lord," he wrote to Huygens, "to have my order for payment promptly made out so that I might at last receive my well-earned 1,244 guilders. I shall eternally recompense you with reverence, service and evidence of friendship. With this comes my heartfelt regards and wishes that God long preserve you in good health and blessings."[118]

Rembrandt had good reason to be grateful, then, not just to Constantijn Huygens but to Johannes Wtenbogaert. And the large etching he made in that same year, 1639, of the receiver-general at his table is usually described as a token of the artist's gratitude. But while it is one of the more extraordinary of Rembrandt's etchings, it can hardly be read as a simple

token of thanks. Perhaps a *complicated* token of thanks, though, the complication coming from Rembrandt's perfectly natural hunger for fame and fortune and the stinging sense that somehow he had not been well served by his connection with the Stadholder's court. The angle of vision is, after all, grovellingly low. A servant kneels obediently before the figure of Receiver Wtenbogaert, magnificently got up in a fur-trimmed coat and the kind of fashionably raked cap that Rembrandt etched himself in shortly after. It is unclear whether he is taking or receiving funds. But cash flow is evidently not a problem in his domain, since another bundle is being set on the great scales which dominate the center of the etching. He is surrounded by coffers, casks, and money bags. At the outset of his career, around 1626, Rembrandt had painted a little panel in which an old man sits by candlelight inspecting a coin while an immense, overhanging tower of books threatens to fall on his money bag. The painting has been interpreted as the parable, related by Christ in Luke 12:19–20, of the rich fool who "layeth up treasure for himself, and is not rich toward God." And Rembrandt, with his precocious and encyclopedic knowledge of art, especially northern art, would certainly have known of the Netherlandish tradition, exemplified by the "banker" pictures of Marinus van Reymerswaele and Quentin Metsys, which juxtaposed the love of coin with the true redemption of grace and faith.

But if both the early painting and the etching are statements about money, they are anything but simple. For it is, after all, *books,* not coin, which threaten to topple down on the old man with eyeglasses. But he seems more neutrally rendered than the usual knuckle-cracking personifications of avarice. Conversely, is the image of the lordly Wtenbogaert, who had indeed done Rembrandt a great favor, a bouquet of unmixed flattery and gratitude? Behind the receiver is a painting of an unusual subject in Dutch art: *Moses and the Brazen Serpent.* The story, related in Numbers 21, was of a plague of fiery serpents sent by God as a chastisement against the wandering Israelites for complaining about their lot in the land of Edom, being "much discouraged." The snakes bit the grumblers and they died. Survivors repented their sins, and seeing their contrition, God instructed Moses to make a serpent of brass and set it on a pole, "and it came to pass, that if a serpent had bitten any man, when he beheld the serpent of brass, he lived."

In Catholic tradition the brazen serpent hanging from the Greek tau cross was seen as a prefiguration of the Crucifixion. But Protestant commentaries had turned to another Scripture, in which King Hezekiah commands the destruction of the serpent as an idol. Not for the first or last time, Rembrandt wandered slyly across confessional lines. Wtenbogaert, if he chose, could fancy himself the savior of the artist, snakebitten by the Passion series. But if others who saw the print noticed the serpent and were suddenly aware of a touch of excessive *idolatry* in the kneeling servant, well that of course was none of Rembrandt's business, was it?

CHAPTER NINE · CROSSING THE

THRESHOLD

i *Painting the Sun with Charcoal, May 1640*

Rubens was dying, and he knew it. It was hard to die in spring, with the trees hectic with songbirds. But he had been given sixty-three such seasons, and now that it had pleased God to take strength from his hands, so that his fingers could not grip a brush, he had no choice but to make his peace. His passing would be judged an inconvenience by the Cardinal-Infante Ferdinand and by his brother the King of Spain, both of whom seemed to fear his death more than he did himself. He had barely finished the great work of sixty-one paintings for the hunting lodge of the King than they had hastened to ask for another eighteen pictures, this time hunting scenes, meant for the great vaulted hall of the royal palace in Madrid. Perhaps it had been a mistake to complete the Torre de la Parada pictures within a year. The princes now supposed him capable of anything: another Titian, who was still in his oily smock in his eighties, and whose portrait as an old man hung in Rubens's house, both reprimand and reassurance. Well, he had done his best to oblige them, finishing the sketches for the palace in a month or so, his mind still humming with invention. There were days when his fingers could race over the panel, as fleet as the fallow deer he had painted in one of the little panels.[1] There is no trace of arthritic lameness in that sketch. The action leaps across the length of the picture, Rubens's brush nimbly tracing the shadow on the neck of the three-point buck, the arched back of a hound as it strained against the tether, the billowing cheek of a nymph blowing the hunting horn. Uncertainty about what time was left to him had taught Rubens to economize his efforts, using the lightest dabs of color—a touch of purple or pink to suggest the brilliance he wanted in the drapery, or a flash of chalky white to point up the dappled light falling on the breasts of the nymphs. Nor had his memory failed. From the great archive of images in his cabinet and in his mind, Giulio Romano provided him with the arm of the nymph slung

round a tree trunk as she attempted to hold on to her dogs. The *furia del pennèllo* had not left him yet.[2]

Perhaps he had tried too hard to please, remembering how much he had been pestered by the Cardinal-Infante over the Torre de la Parada paintings. For when he had done with this new series and had taken himself to Steen, he suddenly suffered a relapse of the gout, the iron caliper of pain fastening itself around his feet and wrists, his fingers as brittle and crooked as dry twigs. Physicians were sent for from Mechelen, who had fussed about his bed and applied themselves to his condition in the usual manner, bleeding and bandaging, grinding up powdery, vomitous potions, and smearing greasy ointments over his inflamed joints. But the affliction came and went as God allowed. All those many years ago, Lipsius had instructed the Rubens brothers to submit to the will of the Almighty with fortitude and humility. And he had always done his best to heed the counsel, especially when ill used by the mighty. But there were times when the winds of Fortune blew deathly cold and the pieties of Seneca seemed a meager shroud to wrap his grief in. When Philip, his other self, and his good Isabella had been taken from him, he had found it hard not to rail against the cruelties of Fortune.

But he would not rail now. Death would relieve him of the endlessly importunate princes better than if he hid himself away in the deep woods at Steen, with the secretive badgers for company. How could he complain against the numbering of days, seeing as how even those of great kingdoms themselves were numbered. The body of the Spanish monarchy seemed itself at death's door, its limbs and members falling away as if leprous. In Catalonia both nobles and commons were rising in revolt against the Habsburg crown of Castile. And last year, while King Philip fretted over the delivery of Rubens's paintings of the hunt, his great Armada, the hope of the Catholic Netherlands, was being splintered apart by the Hollander Marten Tromp somewhere off the chalky coasts of southern England. King

Rubens, Diana and Her Nymphs Hunting Fallow Deer, *c. 1636. Panel, 23.5 × 52.6 cm. Collection of Mr. A. Alfred Taubman*

Rubens, Self-portrait, c. 1638–39. Black chalk drawing heightened with white. Windsor Castle, Royal Library

Charles, who had sent Rubens a golden chain of honor for the peace he had made between the two crowns, had sworn he would never suffer Spanish ships to be attacked within his waters. But Charles no longer seemed master of his own realm, seemed no more able to impose his will on a truculent Parliament than King Philip could coerce the Catalans into submission. Seventy of the Spanish fleet's seventy-seven ships had been sunk or taken in the calamitous sea battle with the Dutch. Now, instead of Spanish soldiers coming to the aid of Flanders, the King was imploring the Cardinal-Infante for help at home! And England seemed likewise on the brink of calamity. There had been talk of Rubens doing some pictures for the Queen's Closet at Greenwich. But 1640 did not look to be a year to indulge the whims of kings.

Rubens had begun to resign himself to his end. But as the barren winter began to thaw, the sickness released its bony grip and he seemed to revive. He managed to write letters once again, and could sign his name instead of having his eldest son, Albert, do it for him. But the painter was not deluded. The letters were, in their delicately indirect way, adieux. The sculptor François Duquesnoy, then living in Rome, had sent him models of work done for a tomb monument, and Rubens praised them with his usual expansive generosity as being formed "by nature rather than art," adding that were he "not detained here by age and by the gout which renders me useless, I should go there to enjoy with my own eyes and admire the perfection of such worthy works." He hoped, at any rate, to see Duquesnoy, properly celebrated in Flanders for his "illustrious works," and prayed that he might himself "look upon all the marvels of your hand . . . before I close my eyes forever."[3] A few weeks earlier, he had made sure that he seconded the interests of his favorite pupil, another sculptor, Lucas Fayd'herbe, who specialized in ivory miniatures, by writing a fulsome recommendation declaring that "he has done for me various works in ivory, very praiseworthy . . . and carried out so remarkably well that I do not think there is a sculptor in all the land who could do better. Therefore I believe it behooves all the lords and the magistrates of the city to favor him and encourage him with honors, franchises and privileges, so that he may take up residence with them and embellish their dwellings with his works."[4]

At the very end of Rubens's life, Lucas Fayd'herbe had virtually become the adopted son of the painter. His own older children, his sons by Isabella Brant, Albert and Nicolaes, both showed promise, but little of it was artistic. Albert, in particular, seemed to take after his uncle Philip, his nose in classical texts. But neither of the boys exhibited the eagerness to be

a painter which he himself had displayed in his early youth. Rubens still hoped that his little ones, Frans (now seven) and Peter Paul (three) might, in the fullness of time, follow their father, and with this possibility in mind he expressly forbade the dispersal or sale of his great collection of drawings, his treasury of the classical tradition, lest someday the younger children take up the brush or chisel, or even in case his daughters married painters. The thought that the girls might themselves have become artists did not seem to have crossed his mind, though such a thing was certainly known both north and south of the Alps.

So Fayd'herbe became the artist-son he never had, "my dear and beloved Lucas," a familiar in the household, trusted with looking after the Antwerp house and garden when Rubens, Helena, and their children were away in the country, welcome to come and go from Steen, bringing the painter the things he needed, whether prepared panels or fruits from his little orchard. "Take good care," Rubens wrote to him in August 1638, "when you leave, that everything is locked up, and that no originals remain upstairs in the studio, or any sketches. Also, remind William the gardener that he is to send us some Rosile pears when they are ripe and figs when there are some or any delicacy from the garden. . . . Come here as soon as you can. . . . I hope that you have taken good care of the golden chain [recently sent by Charles I] following my orders so that, God willing, we shall find it again."[5]

On May 9, 1640, Rubens wrote the last letter that survives, to Fayd'herbe congratulating him on his marriage to Maria Smeyers.

> Monsieur:
> I have heard with great pleasure that on May Day you planted the may in your beloved's garden; I hope that it will flourish and bring forth fruit in due season. My wife and I, with both my sons, sincerely wish you and your beloved every happiness and complete, long-lasting contentment. There is no hurry about the little ivory child; you now have other child-work of greater importance on hand. But your visit will always be very welcome to us. I believe that my wife will, in a few days, go to Malines on her way to Steen, so she will have the pleasure of wishing you good fortune by word of mouth. In the meantime please give my hearty greetings to your father-in-law and your mother-in-law, who will, I hope, rejoice more and more every day in this alliance, through your good conduct. I send the same greetings to your father and also to your mother, who must be laughing in her sleeve now that your Italian journey has fallen through and, instead of losing her dear son, she has gained a new daughter who will soon, with God's help, make her a grandmother. And so I remain ever, with all my heart, etc.[6]

The letter is quintessential Rubens: the considerateness of temper; the unstinting expression of affection; the endearing conviction that there were

moments when the timetables of art should yield to the timetables of love (making an ivory child could be postponed in favor of making a flesh-and-blood child); the unembarrassed enthusiasm for fruitfulness. It was the way he had lived. It was the way he wanted those dear to him to keep him in their recollection.

He would do his best to prepare himself for what must come. Albert was sent to Balthasar Moretus's bookstore to buy a *Litaniae Sacrae,* a book of prayers, and the *Officium Beata Mariae,* which would instruct him (not that he needed it) on how to die a good and faithful son of the Church. But it is hard to imagine Rubens easily reconciled to parting with the things of this world. He had, after all, defied the somber introspection expected of grave old men by painting, in the middle and late 1630s, a veritable festival of flesh. And if anything, his capacity to describe the play of the senses had become more, not less, acute with advancing years. The oil sketches he had done for the Torre de la Parada were full of sensuality. Bright light edged the tresses of a Nereid as she leaned against the scaly back of the sea god Triton. The scorch of the sun burned white on Clytie's face as she metamorphosed into a sunflower. Lightning rends the black clouds of a violent sea tempest as Fortuna, her big body twisted in the wind, balances precariously on her crystal globe. Great Bacchus, a lake of flesh pouring over his triumphal car, crams a bunch of grapes into the gobbling mouth of a cloven-hoofed satyr boy.

Rubens was not going quietly. For nearly three years he had worked on the rustic debauch of his *Kermis,* turning up the volume of the country music until it became a deafening, roaring rout, drowning the politely pastoral airs that passed for country scenes on the walls of Antwerp parlors. He had evidently wanted the rich barnyard stink of the thing, the whole engorged mess: the dogs rooting in the dirty cups; the shiny backfat of the slumping drunkard snoring on his bench; the slurping pull of the babe on the mother's tit; a skirt riding high up the grimy thighs of a stomping dancer; the grip of brawny arms locked about a waist; the cushions of wheat sheaves pricking the backside; the grass flattened by the soles of the feet planted on the earth, steadying the hips, as a visiting body descended. Rubens wanted nature's roughness.

But he also cherished its seductive caress: the whispered *conversations à la mode* of silkily dressed gallants and their sweethearts, accompanied by the languid trickle of a stone fountain carved with satyrs. Out in the countryside at Steen, he had painted the buttery moonrise reflected in a pond edged with alders. He had sat in his tower and inhaled the sun-warmed air at haymaking time, and surveyed his patch of Brabant as if it were the world entire, the incomparable glory of God's creation. And he had painted sunsets and rainbows, valedictions and covenants of hope. He would miss the horses he could no longer ride, the letters he could no longer write. He would miss his cameos and his agates and his books and his marbles. He would miss his good-natured, learned friends: Rockox (who would follow Rubens to the grave that same year), father-in-law Brant, Gevaerts, and

Moretus, the companion of his school days and ever since. He would miss, from afar, the gentle wisdom of Peiresc. And he would find it hardest of all to part from his dear ones at home. Long ago he had marvelled that God, who had stripped him of his brothers and sisters, had recompensed him for his trials with such abundant progeny: Isabella's boys were now grown to men. (It was just as well he could not have imagined Albert's terrible end, dying in inconsolable misery after his own son had been fatally attacked by a rabid dog.) And there were four little ones, sprung from Helena's fertile womb. Since a fifth child, Constantina, would be born eight months after Rubens's death, it seems certain that he would also miss his wife, the plentiful bounty of her

Rubens, Kermis *(detail), mid-1630s. Panel, 149 × 261 cm. Paris, Musée du Louvre*

body and her corn-bright hair. During the last five years of his life, it was as though Rubens could not bear to take his eyes off Helena. There was hardly a history, save the martyrdom of saints and apostles, in which she did not appear in some guise or other, most often nude. She was Venus and she was Callisto; she was Susanna and Syrinx, Ariadne and Eurydice, Bathsheba and Hagar. And more than any other mythical figure, Rubens returned constantly to his wife in the form of Andromeda. In the last version, painted in 1638, her snowy body chained and fully exhibited, a faint smile arriving on her lips, as she felt her savior Perseus at hand. Rubens, the *cavaliere,* had made Perseus his own hero: the love child of Danaë and the golden semen of Jove; the ward of Minerva and Mercury, the guardian deities of painters; the slayer of monsters and tyrants; the rider of the winged horse; wearer of the winged sandals of invention.

Helena may have felt awkward about her husband's fixation, submitting, rather than exhibiting, herself to his hungry gaze. After he was gone, she destroyed a number of nudes that she judged indecent, although this still left innumerable images of her body, posed this way and that, in the collections of princes and patricians, as if Rubens had offered it to selective eyes as a form of cordiality. There was one painting of Helena, possibly the most famous and certainly the most sexually charged, which he had always meant to be kept as a private possession, and which he specifically assigned to her in his will. *Het pelsken* was, among other things, a document of Rubens's painterly as well as personal passions, taking as its prototype Titian's *Lady in a Fur Cloak,* even repeating the pose of the right arm cradling the breasts, and invoking the Venetian master with the rich crimsons of the rug and cushion and the exceptional freedom with which material textures are evoked: fur, gauzy muslin, bare skin.[7] For the erudite it might even be taken to be a demonstration of Rubens's own conviction that antique statues should be used as exemplary models by painters only if they were, in the end, able to transform cold stone into warm flesh. Predictably

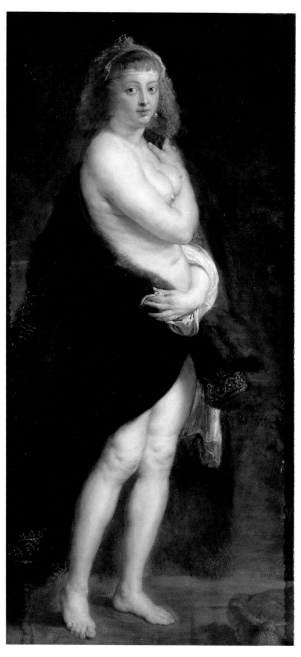

Rubens, Het pelsken, *c. 1638. Panel, 176 × 83 cm. Vienna, Kunsthistorisches Museum*

demure efforts have been made to integrate the painting into the mythological conventions of Rubens's history paintings by calling it an *Aphrodite*. But the tingling sensuality of the painting is of course owed to the *incompleteness* of Helena's transformation into an art nude. There is a spellbinding uncertainty in her pose, caught precisely between display and modesty, innocence and knowledge. The woman, confident of her beauty, rests with one foot flat on the floor. The self-conscious girl, uneasily shifting her weight, rises on the other foot, her heel casting a shadow on the rug. Everything about the way she holds herself signals the ambiguity of intimate knowledge, something to be simultaneously concealed and shared: the opulent breasts, with their erect nipples, both protected and displayed; the soft pleats of flesh beneath; the touch of the black animal pelt against her own blond skin; the big, dark, heavy-lidded eyes, lit so that she appears both self-possessed and vulnerable. We are on the same indistinctly defined boundary line between the naked and the nude which Rembrandt also felt the urge to map, and to which, in the 1650s, he would return, enlarging it into an entire territory of vision and expression.[8]

Whatever Helena's mixed feelings about her husband's ravenous appetite for images of her body, pride, respect for his wishes, and, perhaps, tender memory prevailed over any primness or embarrassment, so that *Het pelsken* survived her puritanical purge. She must have been happy enough with the many paintings that Rubens produced of her with her children, often enough with her generous décolletage on full view, but with the aim, this time, of celebrating her maternal fecundity. It would have been hard for her to take exception, for example, to the gloriously colored portrait in Munich, painted with a blithely loose and sketchy brush, of her with her hands clasped about the bare, chubby waist of the three-year-old Frans, their dark eyes, pink cheeks, and dimpled chins a perfect match. It's impossible to think of *any* Baroque (or for that matter Renaissance) master who celebrated the lives of his own children with such uninhibited delight as Rubens, seeing in them his futurity as his own days became shadowed by illness and the chill of impending mortality. His family was like his garden: sturdy, lovingly tended, a place of both exuberant

vitality and melting calm. He would have been content to know (although since she was only one month pregnant when he died, this seems unlikely) that he had left Helena with yet another seed planted in her fertile womb.

It mattered a great deal to Rubens that his family should continue to live in harmony after he had gone. On the twenty-seventh of May, he must have felt his sickness worsening, since he called for a notary and made a new will. Helena received as much as the laws of Flanders and Antwerp allowed: half his estate, with the château and land at Steen divided between her and his two oldest sons. The greater part of the other half was distributed equally between his six children, together with pious provision for the poor and the churches of Antwerp. Small portions were thoughtfully set aside for ordinary people who had done him some particular service, like his grooms. Albert, the promising classical scholar, was left his library, and his pride and joy—the collection of cameos, agates, coins, and medals— was shared with his brother Nicolaes.[9]

In the days that followed, his condition became grave. Physicians went back and forth from his bedchamber: the Antwerp doctors Spinoza and Lazarus; and two additional surgeons to care for his feet, now agonized by the implacable progress of gout. The Cardinal-Infante sent his own doctors from Brussels. Apothecaries delivered potions, all to no avail. The fever rose and Rubens sank. On the thirty-first Gerbier wrote to an English correspondent, "Sir Peter Rubens is deadly sick," but by the time he added another letter to King Charles himself, he had learned that the painter had died the previous day, "of a defraction which fell on his heart, after some days indisposition of ague and gout."[10] He had left the world at noontime on the last Wednesday of May, the hour of the day when he would have been attending to works in progress in his studio, inspecting his assistants' work, retouching details, standing back to look at the finished painting. The aroma of baking pies, announcing a temperate dinner, would have begun to creep through the house. The skies over his garden would have been bright with midday light. There must have been blossom and the regular clack of horses' hooves on cobblestones.

And then the bells tolled. Rubens's body was set in a hardwood coffin. At evensong, a company of monks from six different monasteries around the city—the same institutions that Jan Rubens had watched being pillaged seventy-four years earlier—followed his bier west along the length of the Wapper, then across the Meir, where Maria Rubens had first lived on returning to Antwerp, and to the St. Jacobskerkstraat, where Peter Paul was laid in the family vault of the Fourments. Three days later, on June 2, a sixty-taper funeral took place, with crosses covered in red satin and the singing of a Miserere, the Dies Irae, and the Psalms. The façade of Rubens's house was draped in black cloth while inside a banquet was given in honor of the dead man, as Flemish custom prescribed. All over Antwerp, glasses were raised in his honor: in the Town Hall, where his *Adoration of the Magi* still hung, amidst a full company of magistrates, aldermen, and burgomasters; in "the Golden Flower," the meeting place of the Society of the

Romanists, where his brother and he, along with Rockox, Gevaerts, Moretus, and the rest, had exchanged elegant Latin verses; in "the Stag" tavern, where his brother painters of the Confraternity of the Gillyflower and St. Luke drank to their acknowledged master. Masses continued to be chanted by the hundreds by the Dominicans, the Capuchins, the Augustinian friars, the nuns of the Discalced Carmelites, and out beyond the city by the Black Sisters in Mechelen and the Jesuits in Ghent. In the little church at Elewijt where Rubens had worshipped when staying at Steen, twenty-four masses were said for the repose of his soul.

Rubens had been right. There was some audible disappointment in England and in Brussels that the painter had departed the world before he was able to supply yet more pictures for their galleries. The Cardinal-Infante wrote to his brother King Philip, "Rubens died about ten days ago and I assure Your Majesty I am very sorry because of the state the pictures [being made for the vaulted hall of the palace] are in."[11] But the abbot of St.-Germain hit a more sensitive note, writing to Rubens's old school friend Balthasar Moretus that the artist had gone "to see the original of the fine paintings he has left behind." Moretus replied that "in truth our city has lost much by the death of Mr. Rubens and myself in particular for he was one of my best friends." Better yet were the last lines of Alexander Fornenbergh's verse tribute, which praised the painter's preeminence even as they dismissed the poet's competitors in eulogy. "The rhyming geniuses who have celebrated Rubens in bold verses / and who have composed learned poems in his honour, / all imagine that they have carried off the palm, / but they have taken charcoal to paint the sun."[12]

In the days before he died, someone, perhaps Lucas Fayd'herbe, asked Rubens whether he would care to have a memorial chapel placed in the St. Jacobskerk. His response had been typically, studiously, laconic, the opposite of posthumous self-aggrandizement. *Should* his widow, his grown sons, and the guardians of his children who were not yet grown to majority consider it appropriate, well, they could certainly do so and use a picture of the Holy Virgin for decoration. In November of the next year, the magistrates of the city gave the family their permission, and a chapel, costing five thousand florins, was built behind the choir. Set into the floor is an inscription by Jan Gevaerts praising "Peter Paul Rubens, Lord of Steen, who among the other gifts by which he marvellously excelled in the knowledge of ancient history merited being called the *Apelles* not only of our, but of all time, who made himself a pathway to the friendship of kings and princes."[13] Above the tomb altar, surmounted by a delicately beautiful marble sculpture of the Virgin with a pierced heart, is Rubens's *Madonna and Child with Saints*, embodying within its glowing colors virtually his entire personality: virile and energetic in the figure of St. George; simple and austere in St. Jerome; above all, tender and sweetly informal in the exchange of loving looks between mother and infant son.

By the middle of July 1640, a "Specification" of the works of art remaining in Rubens's house and not expressly bequeathed was completed.

It listed some 330 pieces, of which 319 were paintings. There were more than a hundred by Rubens himself, including many copies after Titian and other masters, as well as originals by Titian, Tintoretto, Veronese, and northern painters like van Dyck. Needless to say, the agents of the courts instantly smelled a buying opportunity, and before the end of the year much of Rubens's collection had been shipped off to Madrid and Vienna and The Hague.

Helena Fourment herself bought nine of her late husband's works, for the most part family paintings as well as a poetically amorous *Conversation à la mode*. She was, as Gerbier crisply wrote to Inigo Jones, "a rich widow with rich children." In fact, she was rich beyond the wildest dreams of a painter's wife, having half an estate which was valued in its entirety at some 290,000 guilders, a colossal fortune for any burgher of Antwerp, much less one who had come into the world with his own father's worth, moral and material, in utter ruin.

And among the great piles of paintings propped against the walls of the house on the Wapper, awaiting the many auctions and sales that continued through the 1640s, was an

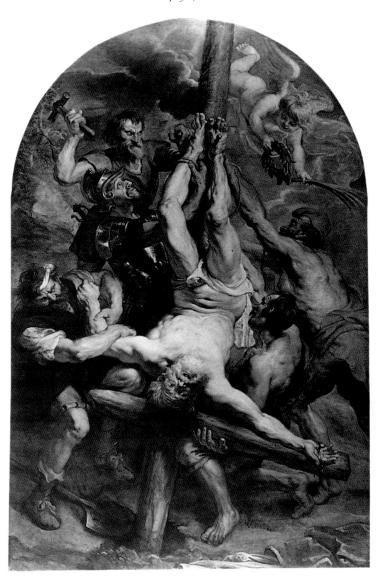

unfinished *Crucifixion of St. Peter*. It had been commissioned, quite out of the blue, by a London merchant named George Geldorp, originally from Germany, from the venerable episcopal city of Cologne. In 1637 he had asked Rubens for a painting that might be presented to the Church of St. Peter in that city on behalf of the family of one of its art-loving merchants, Everhard Jabach. Cologne—Rubens had had nothing to do with the place for countless years, had heard nothing from it. But his response to Geldorp was, of course, all cordiality. He would leave the subject to "the one who will pay the expenses," but he did have in mind a crucifixion of the most penitent of the saints, a half-namesake. "I have great affection for the city of Cologne," he added, "because it was there that I was brought up until the tenth year of my life. I have often wished to see it again after so long.

Rubens, The Crucifixion of St. Peter, c. 1637–39. Canvas, 310 × 170 cm. Cologne, St. Peterskirche

However, I am afraid that the perils of the times and my occupations will deprive me of this and many other pleasures."[14]

Always the gentleman. Could he have had the slightest interest in returning to the Rhineland? Cologne, it was true, was not Siegen; and by stating that he had spent all of his childhood in the former place, Rubens had blotted out that other more shameful town from his memory. Nonetheless, he not only did not go to Cologne, he also could not somehow manage to finish the painting. An oil sketch, with the martyred Peter in upside-down agony, survives, and the painting itself, completed by other hands and neither the worst nor the best thing to come from Rubens's workshop, did finally make its way to the church in Cologne where another penitent, all those ages ago, had knelt in contrition.

ii Crossing the Threshold

Amsterdam must have been full of people who claimed to have known Rubens, and some of them actually had. Anthonie Thijs, for example, could boast a credible connection. His father, the gem merchant Johan Thijs, had sold the property on the Wapper canal, complete with a defunct laundry, that had become Rubens's urban villa. Like so many others, the Thijs family was all over the map, confessionally and geographically. Some of them, presumably more devoted, or more prudent, Calvinists, had migrated north to Holland during the troubles. But they left enough of the family behind in Antwerp to avoid forfeiture of their real estate. So despite being long settled in Amsterdam, Johan Thijs was in a position to sell his property to Rubens in 1609 through the good offices of a fellow jeweller, one Christopher Caers.[15] Apart from the asking price of 8,960 florins, Johan Thijs made two further conditions, one customary, the other quite unusual. Rubens was to supply him with a painting, and he was also to accommodate his son, probably Anthonie's brother Hans, as a pupil in his studio, gratis. The going rate for apprentices was around 100 florins, so father Thijs was saving himself 500 to 700 florins, and in addition ensuring that one of his sons, whatever his talent, could thereafter boast of having been in the workshop of the greatest master in the world.

Whether it was Anthonie or his brother Hans (later a buyer of art) who spent time in Rubens's studio, by the time that Anthonie Thijs married in 1621, his glamorous address on the Herengracht hardly suggested the kind of milieu inhabited by painters. His bride, Lijsbeth, on the other hand, had grown up in a house on the Breestraat, a street shared by diamond merchants (and other kinds of traders), artists (like Pieter Lastman), and dealers. The marriage was brutally short-lived. Lijsbeth gave birth to a son barely ten months after the wedding. Four days later, she was taken to her

grave in the Oude Kerk. Anthonie Thijs was evidently not accustomed to looking far for his partners. His first wife had also been his niece. Her replacement, five years on, was his ward, the seventeen-year-old Magdalena Belten. She too came from a family of Flemish immigrant merchants living on the Breestraat, in a handsome, solid house, the second from the corner of the St. Anthoniesluis, ornamented with a step-gable and a pedimented doorway. The couple lived there for about six years before moving off again, to what must have been a still grander address on the Keizersgracht. A year later, in 1634, Anthonie himself died, and following the close-knit marriage strategies of the Beltens and the Thijses, his widow, still in her twenties, lost no time in finding a new husband from within the family, settling on her dead husband's nephew, Christoffel.

Magdalena shared ownership of the house on the Breestraat with her brother, Pieter Belten, but after her new marriage she transferred the title to her husband Christoffel Thijs. In 1636 the two male owners put the house up for auction, but withdrew it when the price failed to move beyond 12,000 guilders. For two years the house was let, and then, in 1638, it was put on the market for 13,000.

The buyer was the upwardly mobile Rembrandt van Rijn. So while he was locked in the coils of the Passion cycle, attempting to turn himself into the Rubens of Holland, Rembrandt bought a house from the very same family that had sold Rubens *his* property! It seems unlikely, given the gossipy closeness of the Breestraat families, that Rembrandt would not have known this. Was it part of the irresistible attraction? A house, *this* house on the Breestraat, was more than just brick and mortar. It was a mansion of associations, which spoke of all those who had mattered most to his life as a painter: Lastman, van Uylenburgh, and now, as it turned out, Rubens. How could he possibly *not* buy it?

Rembrandt's house, now Museum het Rembrandthuis, Jodenbreestraat, Amsterdam

Did Rembrandt, at thirty-four, imagine himself, at last, living the Rubensian life—horses, grooms, house servants, cooks, his own paint-grinders? At any rate, he must have thought himself well enough off to afford a house that was incomparably grander than anything he had yet lived in, and for that matter considerably more expensive than anything his peers and colleagues aspired to. In the same year that Rembrandt bought his house, Michiel van Mierevelt, the veteran court portraitist, bought a house in Delft for a mere 2,000 guilders, slightly higher than the mean for the city.[16] But then, in comparison with Amsterdam, in 1639 the most desirable and elegant city in Europe, Delft was a provincial backwater, and house values, as well as portraiture fees, may well have reflected the difference. Even so, a portrait painter as eminent and successful as Nicolaes Eliasz. Pickenoy ultimately found the Breestraat beyond his means. Around the same time as Rembrandt, he bought the next house along on the

Breestraat, the third from the corner, a property that had belonged to the regent Adriaen Pauw. Five years later he was forced to sell it again for 9,000 guilders to the Portuguese Jew Daniel Pinto.[17]

But Rembrandt felt rich, and was not shy of saying so to the court in Friesland which heard his suit against members of Saskia's sister Hiskia's husband's family, the van Loos. Dr. Albertus van Loo and Mayke van Loo, he contended, had libelled him and his wife by putting it around that she had frittered away her legacy by *pronken en paerlen*—flaunting and showing off.[18] He might, of course, have chosen to defend himself against the charge of being a prodigal by claiming that, in fact, he and Saskia led lives of exemplary modesty and sobriety. But whatever Rembrandt's failings, mealymouthed hypocrisy was not among them. Instead he asserted that they were too *wealthy* to be accused of squandering away their fortune. "The plaintiff stated (and without boasting) that he and his wife were richly and superabundantly endowed (for which the Almighty can never be enough thanked)."[19] Perhaps unbeknownst to him, Rembrandt had actually been drawn into a long-standing feud between some of the Frisian van Uylenburghs and some of the van Loos, since the artist's advocate in this case, Ulricus van Uylenburgh, had already tried unsuccessfully to sue Albertus van Loo. One can easily imagine Rembrandt provoked into enlisting in the van Uylenburgh camp through a combination of indignation and husbandly loyalty. It did him no good. The court found that whatever the defendants might have said about some of the van Uylenburghs, they hadn't said it about Saskia or her husband. No retraction. No damages. Both sides paid costs.

The painter probably shrugged off the annoyance. He had, after all, asked for only 64 guilders' damages, hardly a sum to make much difference either way to a man who would, a few months later, contemplate paying 13,000 guilders for a new house. The terms, though, were not especially benign. The purchase agreement was signed on January 5, with exchange of contracts agreed for May 1, on which day the first payment of 1,200 guilders came due. No wonder, then, that Rembrandt was so insistent about getting paid the 1,200 owed to him for the last two paintings in the Passion series. In November 1639 a second 1,200-guilder payment was payable, followed by another 850 on May Day, 1640. The remaining three quarters of the purchase price—9,650 guilders—was to be paid in unspecified installments over the next five or six years. But the outstanding balance was, in effect, treated as a mortgage, financed by the previous owners, carrying a 5 percent rate of interest. This might (in New York in 1999) sound like a bargain. But commercial interest rates in Holland in the middle of the seventeenth century were generally between 2 and 3 percent. So Rembrandt's debt load was not insignificant.

Nor, on the other hand, was his self-confidence. He may well have calculated, like his new neighbor Nicolaes Eliasz., that should the repayment schedule become too much, he could always resell the house and make a profit into the bargain. The problem with this contingency plan, however,

was that Christoffel Thijs had deferred full conveyancy of the property pending timely payment of the promised installments. Even so, it is unlikely that Rembrandt in 1639 was cowed by this kind of foreboding. He was at the height of his powers and reputation. In 1641 the new edition of Orlers's history of Leiden would include an account of his career suggesting that he was indeed the successor to Lucas, and in October of the same year the dean of the Leiden artists' guild, Philips Angel, in his St. Luke's Day speech, would refer to him as the "widely renowned Rembrandt [*wijt-beruchten Rembrandt*]."[20] So there was no question about his fame. And since he was in demand in the most moneyed city in the world, how long could it be before fortune followed?

So although the Breestraat was changing, with conspicuous numbers of foreigners, especially Portuguese Jews, migrating across the bridges from Vlooienburg to live there, Rembrandt could still savor his return to the street as a little triumph. He was not even beyond gestures of largesse, signing on with a group of investors, including some fellow artists, who lent money to the chronically cash-poor Hendrick van Uylenburgh. Saskia must also have been happy to live, once more, a stone's throw from her cousin. Though a few minutes' walk from Vlooienburg, the house on the Breestraat represented, in almost every way, a fresh beginning for Rembrandt and Saskia: an elegant residence in a prosperous neighborhood, not as fashionable, perhaps, as the ring of new canals, but still a place that advertised the substance and style of its occupants. Laid out in the standard Amsterdam manner of the turn of the century, their new house was tall and deep, with a relatively narrow frontage to the street. The classicized stone doorway (which may have reminded Rembrandt of his old Latin school) led directly into the *voorhuis*, the entrance hall, where one would have been greeted by plaster casts of what the inventory drawn up at the time of Rembrandt's bankruptcy described as "two naked children."[21] There would not have been much in the way of furniture in this room: just six chairs, four "Spanish with Russian leather," and a step stool to see out of the window (should the master not want to be at home). But the hallway was full of pictures, generally "cabinet" paintings—small landscapes by Rembrandt himself and Lievens; pictures of animals; some *tronie* heads; and genre paintings by the Flemish artist Adriaen Brouwer, who specialized in low-life, smoke-filled, drink-sodden tavern scenes and whose raw earthiness Rembrandt obviously much admired.

Off the *voorhuis* was the *"sydelcaemer,"* the side chamber, with a walnut table, a marble wine cooler, seven more Spanish chairs with green velvet seats, and no less than *forty* paintings, including some by the artists who meant the most to Rembrandt: a fellow student of Lastman's, Jan Pynas; Lievens once again; the extraordinarily original landscapist Hercules Seghers; and the marine painters Simon de Vlieger and Jan Porcellis. Porcellis, whom Rembrandt's pupil Samuel van Hoogstraten later described as "the Raphael of sea painters," had won a famous painting contest, held in Leiden around 1630, probably when Rembrandt was still

there, besting the landscapists Jan van Goyen and François Knibbergen.²²
So the "side room" was virtually a small art gallery. Beyond it were two
further rooms, the *binnenhaard* and the *sael*, or parlor. While the *sael*, with
three "antique statues," served as the main receiving room of the house,
none of the rooms in these houses yet had strictly defined functions, so that
cedar linen presses and cupboards, tables and chairs would have been
present in both, and there was a "sleeping corner" complete with a box bed
in the *sael*. Taken together, the enfilade of rooms would have given the visi-
tor the impression of solid comfort—*gezelligheid*—with brass chandeliers
and sconces and ebony-framed mirrors reflecting the cool, wet daylight.

It was on the next floor up, though, that Rembrandt imprinted his per-
sonality on the house. There were four rooms including another entryway,
then a "large" and a "small" painter's room, and on the interior—in other
words, over the ground-floor *sael*—a room described as a *"kunstcaemer."*²³
To walk through those rooms was to be confronted with an astounding
array of objects, comparable to the encyclopedic collections in the houses
of Rubens's friends in Antwerp, and designed to encompass virtually the
entirety of known global culture, past and present, exotic and domestic.
The "large painter's room" was, in all likelihood, Rembrandt's own work-
place. From the 1656 inventory prepared for the insolvency commission-
ers, it is evident that he no longer painted in the bare wood-planked
emptiness of the little studio in Leiden depicted in the 1629 panel. Now he
had for company a complete pair of South American Indian costumes, male
and female; "a giant's helmet"; five cuirasses; a "wooden trumpet"; and "a
little child by Michelangelo."²⁴ That room was relatively uncluttered so as
to give the painter working space, but the "little painter's room" and the
"kunstcaemer" were crammed with every conceivable kind of object, from
antique and Indian weapons, including longbows, arrows, darts, and
javelins, to American bamboo musical pipes, Javanese shadow puppets,
African calabashes and gourds, and a Japanese helmet (possibly the one
used for a figure in his grisaille of *St. John the Baptist Preaching*). A single
shelf in the *kunstkamer* held Rembrandt's sizable collection of shells and
coral, a Turkish powder horn, two "complete nude figures," a death mask
of the Stadholder Maurice, two handguns, an array of walking sticks, and
sculptures of a lion and a bull.²⁵

Casually listed like this, as if the bailiffs were shoving their way
through the detritus of a spendthrift's ruin, bumping here into an elephant's
tusk, there into a Carpathian saddle, Rembrandt's collection is bound to
seem an Olympus of junk, indiscriminately acquired, chaotically displayed,
of a piece with his impulsive, greedily omnivorous personality. But just as
the *apparent* freedom and spontaneity of Rembrandt's painting disguises
an immensely painstaking and calculated technique in both composition
and execution, so his compendium of objects was something more than a
magpie's nest. It may not have rigidly followed the studious classification
system of scholarly collectors, yet Rembrandt's miscellany nonetheless
reflected his instinctive, Aristotelian, belief that from the infinitely pleasing

variety of the world would appear, unforced, a revelation of the Creator's design.

His *kunstkamer,* at any rate, was divided into classical and scientific knowledge and into *naturalia* and *artificialia.* The world of antiquity was just as well represented as in Rubens's collection, though Rembrandt had to make do with plaster casts where Rubens had the means to buy, occasionally, original antique sculptures as well as his famous collection of gems and cameos. Nonetheless, it was Rubens, not Rembrandt, who voluntarily sold the major part of his sculpture collection to the Duke of Buckingham. It took the insolvency commissioners to force Rembrandt to part with his classical pieces. And he had them all—the Twelve Caesars, from Augustus through Caligula and Nero right through to Vespasian, Galba, and Marcus Aurelius. And as in any true gentleman scholar's cabinet, they kept company with the illustrious poets and philosophers of the ancient world: Homer, Socrates, and Aristotle. Rembrandt even possessed a bust of the figure that more than any other had formed the young Rubens—the bearded Seneca, dolorous and tragic. He also had a Laocoön and a group of heads of "antique women." It also seems likely that along with these sculptures Rembrandt also had a collection of coins and medals, though certainly not one as compendious or as discriminating as the Flemish master's.

It's a mistake to judge from slight impressions. Rembrandt the profligate, Rembrandt the *wilde,* was also Rembrandt the scholar, Rembrandt the virtuoso of universal knowledge, every bit as anxious as Rubens to demonstrate that he was no crude artisan, but a *pictor doctus,* an intellectual painter, a philosopher of the brush capable of competing with the poets at the highest level of taste.

While his knowledge may not have been as deep as Rubens's, Rembrandt's roaming mind more than made up in breadth what it lacked in profundity. If anything, his intellectual curiosity, as his globes, terrestrial and celestial, attested, was *more* encyclopedic than Rubens's. Intrigued, like so many in his empire-city, by the marvels of the far distant world that had been brought to the docks of the IJ, Rembrandt accumulated specimens from the depths of the ocean and from the tropical forests: precious shells, sponges, little mountains of coral, but also a stuffed bird of paradise from New Guinea. This was not only an eye-filling wonder of dazzling plumage but the object of intense debate, among those who concerned themselves with such matters, as to whether the creature had legs, since those who had treated it in the Indies before sending it to Europe seemed always to have skillfully removed these lower appendages. Hedging his bets, Rembrandt drew his own specimen on two separate sheets, one with legs and one without.[26] Among the *artificialia,* there were the works of exotic hands: Chinese and Japanese costumes and ceramics; swords and helmets, things with horns and things with turrets to set on the head; Turkish and Persian textiles where thrushes hopped in meadows of lilies. There were Caucasian leathers, musical instruments, zithers and bells, gongs and nose flutes oriental and medieval.

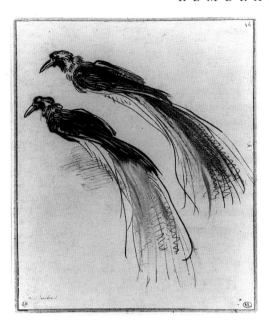

Rembrandt, Two Studies
of a Bird of Paradise, *late
1630s. Pen and brown
ink drawing with brown
and white wash. Paris,
Musée du Louvre,
Département des Arts
Graphiques*

Largely missing from this fabulous array were books. The 1656 inventory lists only fifteen "of various sizes." In addition, there was a copy of Flavius Josephus's history of the Jewish War, illustrated by Tobias Stimmer, the very same graphic artist who had made such a deep impression on the young Rubens. But the indispensability to Rubens of his library and Rembrandt's apparent lack of interest in a literary collection is something that genuinely separates their sensibilities. This is even odder given Rembrandt's evident passion for the physical quality of books, which he painted over and over again as if they were monuments, massive, eroded, and authoritative. Of course, the fifteen books may well have constituted the irreducible core of Rembrandt's narrative passions: the Bible, a Tacitus, certainly an Ovid, perhaps a Horace, and a Pliny. And just as one might see Rembrandt following the example of Apelles, who, Pliny related, used just a four-color palette to create the most diverse effects of form and color, Rembrandt may well have distilled his bookishness down to its essence. And this included Dürer's book on proportions and possibly Jacques de Gheyn II's drill manual (in a German edition), on which he would draw for certain figures in *The Night Watch*. It's also quite possible, of course, that before the bankruptcy men arrived in 1656 he decided to sell off part of what may have originally been a much more extensive library.

But what he lacked in volumes Rembrandt more than made up for in art, as his collection of works on paper was evidently enormous, of high quality, and wide-ranging, from Mughal miniatures through the greatest masters of northern graphic art—Lucas van Leyden, Pieter Bruegel, Hendrick Goltzius, and Jacques Callot.[27] Needless to say, there were also a number of pieces by Rubens—proofs of engraved versions of his landscapes corrected in his own hand, as well as a volume of printed portraits. There was also a heavy representation of the Italian masters. The inventory makes it quite clear that for years Rembrandt was systematically engaged in creating his own complete archive of Renaissance art, so that he had access to virtually the entire corpus of Michelangelo, Raphael, and Titian in the form of reproductive engravings. There was also a "precious book" of Mantegna, which might suggest drawings. But he did not stop there, since the "moderns" were also represented by the work of all three of the Carracci (including Agostino's notorious erotica, the *Lascivie*) and Guido Reni.

Rembrandt had been haunting the Amsterdam estate auctions in the late 1630s with the devotion of a compulsive collector. The habit cost him, but he couldn't help himself. At the auction of the estate of Jan Basse on the Prinsengracht, which took place over three weeks in March 1637, fifty lots of prints, drawings, and shells were knocked down to Rembrandt. At the next great event of this kind, the sale of the collection of the Russian mer-

chant Gommer Spranger at his house on the Fluwelenburgwal in February 1638, he took another thirty-two lots, including works by Dürer, Raphael, Goltzius, and Lucas, ceramic pots by Caravaggio da Polidoro, and yet another collection of rare shells, clearly a serious passion. He would have run into van Uylenburgh there, and other artists like Nicolaes Eliasz. Pickenoy and Claes Moeyaert, and their acquisitive itch didn't do much to calm Rembrandt's buying fever. Even he recognized, though, that there were limits to what he could afford. Like his fellow painters, Rembrandt would often have to content himself with items available to a modest bidder, paying only a few guilders for each group of prints. Occasionally, though, when he saw a unique buying opportunity arise, Rembrandt surrendered to the urge to have the item, whatever it cost. So he paid 106 guilders, roughly his going rate for a portrait, for three drawings by Goltzius, and 127 for the rare Lucas van Leyden print known as *Uylenspiegel,* but which in fact shows a company of beggars (including owl).[28]

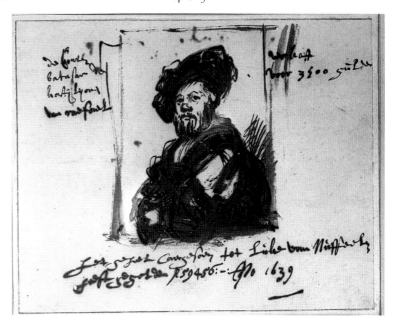

Rembrandt, Copy after Raphael's Portrait of Baldassare Castiglione, *1639. Pen and brown ink drawing with white body color. Vienna, Graphische Sammlung Albertina*

In the auction rooms, Rembrandt was competing not just with his friends and colleagues in the Amsterdam art world but with the heavily moneyed merchants and patricians who were themselves sophisticated collectors. There were some sales where the choice items fetched thousands, rather than hundreds, of guilders, and here Rembrandt knew when he was beaten, settling for the galling role of covetous spectator. At the sale of Lucas van Uffelen's estate in April 1639, for example, he could only watch while Raphael's famous and very beautiful portrait of Baldassare Castiglione fetched 3,500 guilders. Rembrandt sketched the portrait, noting the price and the additionally impressive information that the whole of van Uffelen's collection went for 59,456 guilders—a tremendous fortune. The buyer was Alphonso Lopez, a Portuguese Jew who had made a fortune in diamonds and who was, in addition, an arms procurer in Amsterdam for Cardinal Richelieu. Out of his league as a competitive bidder, Rembrandt must nonetheless have been amazed (and perhaps galled) to see another painter, Joachim von Sandrart (Rubens's designated travelling companion during the Dutch trip of 1627), as the underbidder, going as high as 3,400 before surrendering the painting to Lopez! Sandrart may have been acting as a paid price-hiker, a common practice on these occasions and one to which Rembrandt himself would stoop on occasion. But there is no way to know.

In all probability, Rembrandt knew Lopez personally and visited his grand house on the Singel, known as "the Gilded Sun." After all, Rem-

Titian, Portrait of a
Gentleman *(formerly
called* Ariosto*), c. 1512.
Canvas. London,
National Gallery*

brandt was familiar with the notables of the Sephardim like Ephraim Bueno and Menasseh ben Israel from his days in Vlooienburg, and besides, Lopez was an avid collector of Indian and oriental art, a specialty which also attracted Rembrandt, both as connoisseur and as collector. In all likelihood, then, he went to Lopez's house to see another enviable masterpiece in his collection: the *Portrait of a Gentleman* by Titian. In the seventeenth century, the gentleman was assumed to be a likeness of the Italian poet Lodovico Ariosto, the author of the epic poem *Orlando Furioso,* widely known in Holland after the appearance of a Dutch translation in 1615 and the kind of thing, in its blood-and-guts rumbustious uproar, certain to have appealed to Rembrandt.

The two pictures, seen together, obviously cast an immediate spell on Rembrandt, not only for what they were as paintings but also for what they said about the nobility of art and artists. Raphael's portrait of Castiglione was known to be much more than simply a likeness of the author of *The Book of the Courtier.* It was also a document of the friendship and mutual esteem in which the writer and the painter held each other. In his own writing, Castiglione had taken care to give painters their due, seeing in figures like Leonardo and Raphael the natural peers of poets. Raphael himself had produced poems, and the legendary grace and delicacy of his style had often been compared to the verses of Petrarch.[29] All those qualities were clearly on display in the portrait of Castiglione, which thus became a statement of the sympathetic affinity between painting and poetry, rather than of their antagonistic competition for supremacy.[30] Other painters had been well aware of the case that the portrait made for the poetic eminence of painting, not least Rubens, who was himself much concerned to transcend the contest between the two arts, and who had seen and copied Raphael's portrait when he was at Mantua. Indeed, Rubens was one of the few artists who could actively identify with both the painter *and* his subject. Raphael, after all, had also been compared to Apelles for the "graceful charm" with which he carried himself in the company of princes, a quality which Rubens had had to acquire early, and which he had learned, at least in part, from a careful reading of Castiglione's book on courtly self-conduct. But Rubens also knew something about the painful diplomatic exertions Castiglione had been required to make on behalf of his patron, the Duke of Urbino. When it had all been too much, Castiglione had himself retreated to Mantua to the hospitality of the Gonzaga.

The second painting, Titian's supposed portrait of Ariosto, had an even more direct impact on Rembrandt's own chosen manner of self-presentation. Once again, the poet and the painter were known to have been friends and mutual admirers and in no sense competitors. Both were associated with courtly cultivation (in Ariosto's case, the Este court at Fer-

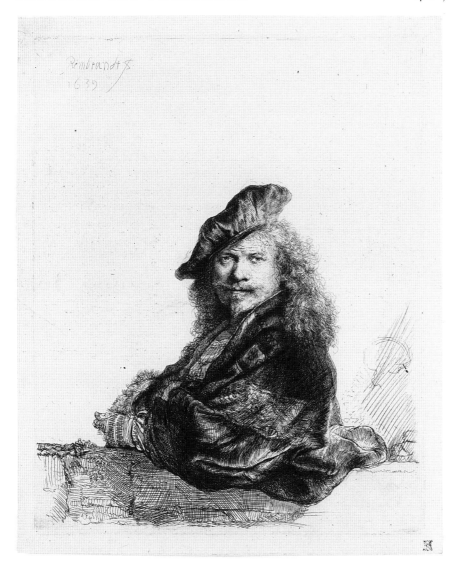

Rembrandt, Self-portrait Leaning on a Stone Sill, *1639. Etching, first state. New York, Pierpont Morgan Library*

rara), but without any sense of grovelling deference to their patrons. Titian's portrait was imagined, then, to be of a fellow artist who, with his arm slung nonchalantly over a parapet, was as much an embodiment of the Renaissance virtue of easy grace as any noble of high blood. With his body turned toward the right and his head facing the beholder, Ariosto also seemed to embody another important element in genteel behavior: sympathetic approachability qualified by polite restraint. In its ability to be *both* formal *and* relaxed, the portrait exemplified the quality Titian's admirers had characterized as *disinvoltura:* the harmonious occupation of space without any sense of statuesque inertia. The figure at the stone parapet seems only momentarily still. But the folds of his shirt, the glittering band at his throat, the rich glossiness of his dark hair, and not least the great swell of his quilted sleeve, all suggest a powerful vitality, a chest rising and falling within the handsome apparel.

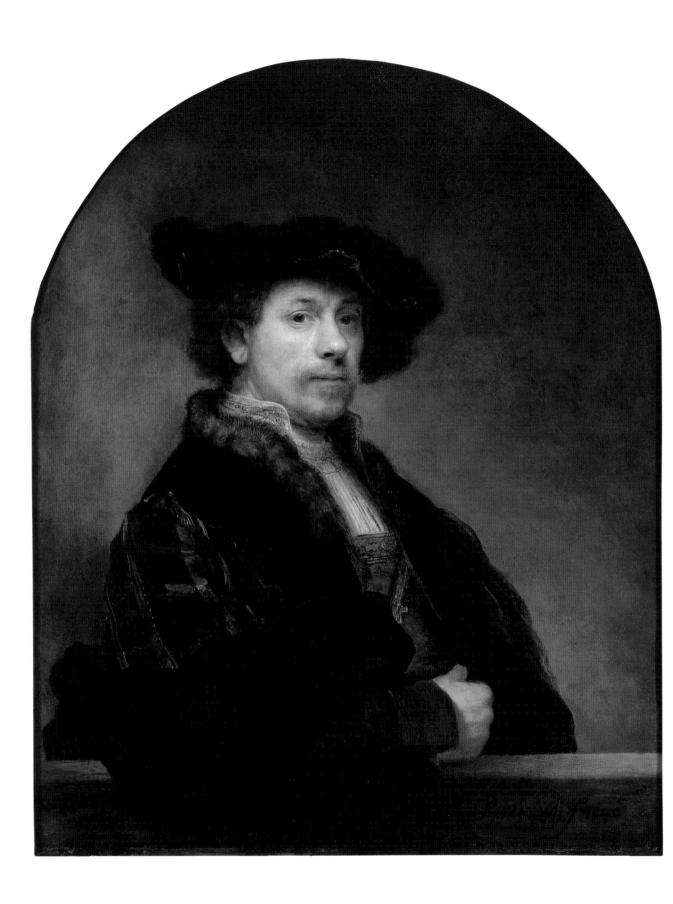

Rembrandt not only admired these two paintings in Lopez's collection. He decided to become them. In 1631 he had become a pseudo-Rubens by making the Flemish self-portrait his own. The Rubens of Rembrandt's fascination had already absorbed Raphael and Castiglione into his persona by making his copy. Now Rubens was expiring and Rembrandt in his turn borrowed the identities of the paragons of the High Renaissance, *both* the sitters (the courtier and the poet) *and* the artists (Raphael and Titian). His sketch of the Castiglione portrait is not, in fact, an exact description of the original. Rembrandt has cocked the head slightly and set the hat at a higher, more rakish angle. It is as if he were already trying out the pose for his own etched *Self-portrait Leaning on a Stone Sill,* where his beret is set at the same jaunty angle. While the arm slung over a stone wall is obviously taken from the Titian, the elaborate flow and folds of his sleeve owe more to the Raphael. At the same time that he wraps himself in the mantle of the Renaissance masters, though, Rembrandt's portrait is not in the least bit deferential. The set of the mouth and the steely gaze have very little of the softness of the Italian paintings. And by posing himself outdoors, with tufts of grass poking through the stone and his own hair tumbling luxuriantly down his back, Rembrandt has made his own person seem deliberately *less* classically composed and more a force of nature.

Some of that edgy vitality is still there in the self-portrait "at age thirty-four" that Rembrandt painted in the following year, 1640. But it now takes second place to a courtly, even princely self-presentation. He is, at last, relaxed in his sense of mastery. Rubens is dead. He will make sure he is no mere Elisha. Costumed in the grand manner of the sixteenth century, with a slashed sleeve and a fur-edged tabard, a gold chain fastened about his chest and another decorating his hat, Rembrandt is the embodiment of noble self-possession, the uncontested Apelles of Amsterdam. In his painterly manner he made the case for his succession to the great Renaissance traditions of *disegno* (drawing) and *colore,* respectively embodied in Raphael and Titian. Raphael had been praised by Vasari as the superior of sculptors for his legendary ability (in the *Portrait of Pope Leo X*) to render the material textures of velvet, damask, and silk, and on this occasion Rembrandt used his own self-portrait to demonstrate his unparalleled mastery of those same descriptive skills. At the same time, though, the tonal unity of the painting, the fluid brushwork, and the perfectly judged way in which his figure is positioned within its allotted space made his claim to be Titian's heir not entirely presumptuous. Above all, Rembrandt had mastered Titian's technique of making his portrait subjects come alive through the fine adjustment of countless subtle details. There is, for example, a fine line of white paint that extends from the corner of the right eye where it meets the bridge of the nose down toward the lower edge of the cheek. That line both defines the cheekbone and, together with the white accent on the tip of Rembrandt's nose, gives a slightly glistening tone to the skin, as though the sitter were lightly perspiring in his heavy clothes. The self-portrait owes its uncanny sense of Rembrandt's fleshly presence to any number of these

OPPOSITE: *Rembrandt, Self-portrait at the Age of Thirty-four, c. 1640. Canvas, 102 × 80 cm. London, National Gallery*

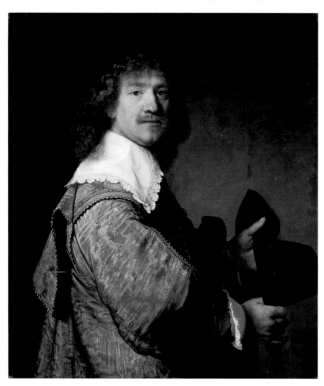

Rembrandt, Portrait of
a Man Holding a Hat,
*c. 1639. Panel, 81.4 ×
71.4 cm. Los Angeles,
Armand Hammer
Collection*

nuances: the shadow cast by the edge of his cuff against the back of the hand; the tiny wisp of gingery hair at the extreme left end of his mustache, visibly flicked up against the darker edge of his hair; his decision (after the painting had been finished) to give himself a raised collar, so that its delicate crease could be reconciled with the line of his jaw, as if the stiffened material were very slightly pressed down against the underside of Rembrandt's chin as his head moved. Though the degree of attention verges on the zoological—the glossy plumage and glittering eye of the rara avis leaving nothing omitted—there is no danger of this creature being seen as taxidermically inert.

X-ray images have revealed that originally Rembrandt posed himself with both hands visible, the fingers of his left hand resting on the wooden sill. Overpainting his left hand as though it were covered by the black sleeve must have been an improvement since it leaves his right hand, with its foreshortened thumb and knuckles, in sole commanding possession of the balustrade, the generous billowing sleeve coming right through the edge of the picture space. The impression of authority is important because, more than any other self-portrait up to this point, Rembrandt is representing himself as equal not only to his illustrious predecessors in the Renaissance tradition but also to his own patrons. Ten years before, Huygens had noticed in both Lievens and Rembrandt (and with mixed feelings) their confident air of a "natural" nobility. Now Rembrandt made no effort to disguise his loftiness.

All the same, it took some temerity to make this claim in 1640, because the kind of patron who sat for Rembrandt no longer came from the ranks of the merely comfortable but from the cream of Amsterdam society. There was a world of difference between merchants like Nicolaes Ruts, with his high-risk and intermittently secured prosperity, and the great plutocratic dynasts—the Trips, de Graeffs, and Witsens: the kind of people whose fortunes were measured in the hundreds of thousands of guilders, who made up the core of the governing regents of the city, and who were thought magnificent enough to play host to visiting princes. If such people went visiting painters for a sitting, they took with them a little retinue of maids, secretaries, and black pages got up in satin breeches. Though it's impossible, for example, to identify the subject of *Portrait of a Man Holding a Hat,* painted around 1640, with any certainty, the splendor of his apparel and the transfer of the planed-down panel to an expensive mahogany support suggest that he either came from this upper crust or

had aspirations to join it. Certainly the spectacular taffeta of his doublet, with its matching cape hanging down his back and the exquisite raised and braided frogging at its seams, makes it clear that he was not from the run-of-the-mill black-wool-costumed *burgerij*.

As society portraitist, Rembrandt's task was to emulate van Dyck rather than Rubens; to celebrate the cool elegance of these young patricians on the rise. And he further refined his already impressive mastery of the rendering of fabric to even sleeker and more convincingly illusionistic heights to service their self-admiration. In his hands, linen, lace, and silk become correlates of character, dropping and twisting, curling and folding, as though performing an elegant slow dance along the lines of the body. Unlike van Dyck and his aristocratic sitters, though, Rembrandt and the merchant princes had to beware of the vanity trap. For they were not living in the shires or amidst the Italianate town houses of

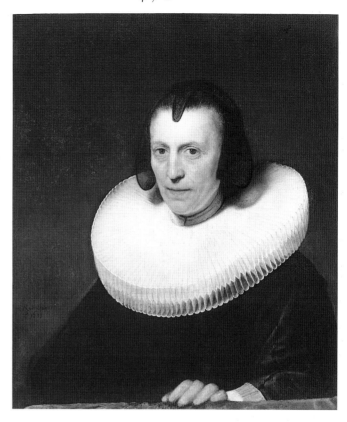

Rembrandt, Portrait of Alijdt Adriaensdr., *1639. Panel, 64.7 × 55.3 cm. Rotterdam, Boymans van Beuningen Museum*

London. During the 1640s, denunciations of the extravagance of fashionable dress and tumbling hair in the Calvinist Church synods became exceptionally heated. So while he went out of his way to make the sumptuous details of costume exquisitely tangible, Rembrandt must also have appreciated that he was still required to pay attention to an overall impression of modesty and self-control. Hence the hat. Grasped by both hands, it makes the sitter appear caught on the verge between his private and public self (as if either about to make an exit or having just made an entrance), and its simplicity is in appealing, almost homely contrast to the heroic glamour of his coat.

Rembrandt brought some of the same tactics to bear on a number of his other wealthy sitters in these years. Alijdt Adriaensdr. was the widow of Amsterdam's most formidable businessman, the stratospherically rich Elias Trip, originally from Dordrecht, who had built a colossal multinational pan-European iron and munitions empire at a time, of course, of continuous war. Rembrandt needed to advertise the widow's authentic piety and modesty, so that she seems to have emerged straight from the pages of one of Jacob Cats's sententious morality manuals for the Stages of a Woman's Life. The spectacle had to lie in the detail. So at the same time that he pays attention to the costume of old-fashioned virtue—the millstone ruff—Rembrandt manages to make a painterly meal of it, devoting more care to its depiction than to anything else in the painting. Its purity is of such intensity

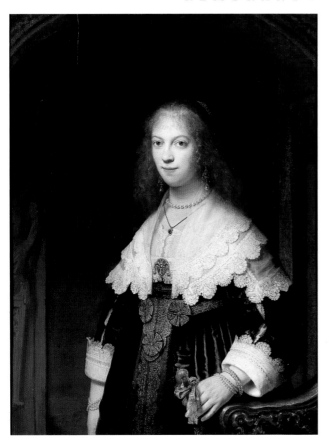

that it actually throws light on the bony plainness of her features, washing them in a pale gleam of righteousness.

As befitted someone of her stature, Alijdt Adriaensdr. lived in one of the most substantial houses on the Herengracht, where her portrait probably kept company with that of her daughter, Maria Trip. As a marriageable girl of the next generation, around twenty when Rembrandt painted her, Maria wears a costume that is appropriately more lavish and more self-consciously fashionable. She is dressed in a spectacular fallen collar of multilayered, scallop-edged lace, rendered with stunning authenticity. Yet there is nothing slavishly descriptive about Rembrandt's technique here. On the contrary, Rembrandt's skill at conveying a three-dimensional sense of surface is beginning to come from the boldness of broken or loose brushwork loaded with pigment. Slickness is departing; rough energy arriving. And he is also becoming more experimentally diverse with color, so that the shimmering all-over gold quality of Maria Trip's costume is actually constituted of dabs and short strokes of gray, green, orange-brown, and black as well as ocher. Still,

Rembrandt, Portrait of Maria Trip, *1639. Panel, 107 × 82 cm. Amsterdam, Rijksmuseum*

Rembrandt knew that he needed to do something more than present Maria Trip as a glossy clotheshorse. The rules of plutocracy always pretended that less is more, and demanded that the display of rank be crushingly subtle. She stands in the classical archway that proclaims her patrician pedigree. But Maria's face is as simple as her costume is ornate. She wears her fortune but her virtue is her gold. Behind the embroidery she is her mother's daughter, a good Christian maid.

How to make these people *live*, how to make them move when they wished to be enthroned or stand commandingly observing their portraitist? Increasingly, Rembrandt found himself experimenting with framing devices that, instead of containing the subject within a conventional picture space, could make it appear that they were emerging through it, entering the "real" space of the viewer. He was certainly not the inventor of the optical illusion. It was a commonplace of Renaissance portraiture and in the Netherlands had been used to brilliant effect by Gerrit Pietersz. in a portrait of his brother, the composer and organist Sweelinck, and by Werner van den Valckert and Frans Hals.[31] But most of these antecedents involved the subjects projecting through a window frame or niche, or over a balcony or balustrade. Rembrandt took the process a stage further by displacing the picture frame from its assumed role as a solid object *outside* the representation to its position as an element within it. Instead of acting as a

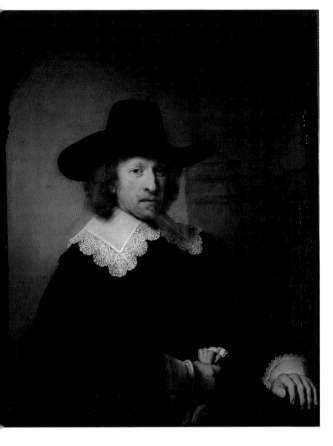

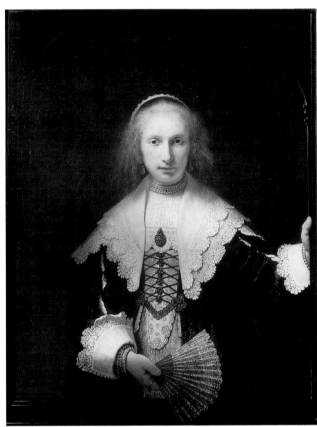

clear boundary between the concrete world of the viewer and the world of images, the frame disconcertingly turns into a self-dissolving threshold, like Alice's looking glass, through which both the beholder and the beheld may unnervingly pass.[32]

Rembrandt had already attempted something of this effect with the hand of Alijdt Adriaensdr. resting on the nether edge of the painting. But it was a clumsy and tentative effort compared with the marriage pair of Nicolaes van Bambeeck and Agatha Bas. Van Bambeeck was a reasonably well-off cloth merchant, dealing primarily in Spanish woollens, who had also lived on the Breestraat and who may have met Rembrandt as a fellow investor in the new Uylenburgh loan of 1640. His wife, however, was from a different social tier entirely, the eldest daughter of Dirck Bas, one of the more formidable politicians among the Amsterdam regents, many times a burgomaster, and a member of the governing board of the East India Company. In 1634 Bas had had his family painted by Dirck Santvoort in a sober, formal, friezelike group portrait elongated sufficiently to include all seven of the children, the whey-faced Agatha standing demurely by her mother. The prominence of the Bas clan in the upper echelons of Amsterdam society made the concern to balance display and reticence within the portraits of the married couple an even trickier calculation than usual. The husband had to appear the authority figure, but Agatha Bas's illustrious pedigree

LEFT: *Rembrandt*, Portrait of Nicolaes van Bambeeck, *1641. Canvas, 105.5 × 84 cm. Brussels, Musées Royaux des Beaux Arts*

RIGHT: *Rembrandt*, Portrait of Agatha Bas, *1641. Canvas, 105.2 × 83.9 cm. London, Buckingham Palace, Royal Collection*

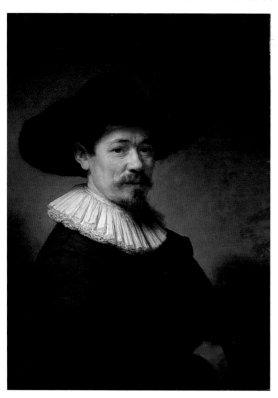

Rembrandt, Portrait of Herman Doomer, *1640. Panel, 75.2 × 55.2 cm. New York, Metropolitan Museum of Art*

made it imperative that she should show off the splendor of her fortune and rank, yet without going beyond the bounds of wifely duty.

Rembrandt, as usual, knew what had to be done. Van Bambeeck's right arm rests, in the *Ariosto*-Titian manner, on a support, but instead of a stone wall or a wooden rail, it is the frame of the picture itself. His clasped glove, the conventional emblem of married fidelity, protrudes over the edge, and the fingers which Rembrandt would black out in his own self-portrait remain lodged on the frame as though ready to greet an oncoming visitor. The fact that van Bambeeck stands within the framed space but still in front of another wooden door behind him gives a sense, simultaneously, that he is both master of his house and yet hospitably approachable.

His wife's portrait, one of Rembrandt's most subtly powerful achievements, retains this strong sense of a figure both inside and outside the domestic space. Like Maria Trip, Agatha Bas faces the beholder square on, rather than turned, as if eschewing any kind of elegantly posed effect for an impression of disarming candor. She is both plain and fancy. Her dress is dramatically elegant, the gold flowers on her stomacher glowing against the white silk, the black-crossed bands of her bodice, and the figured satin of her outer coat. By contrast, her face, with its weak chin and long nose, is what it is. But the painter brings a rippling light to play on her awkward features, shining through the filigrees of her fine hair and casting delicate patterns of shadow and half-shadow. Instead of being a liability, Agatha's milky face becomes the very picture of artlessness, the unpretentious saving grace of her fortune. Both her hands, like those of her husband, protrude through the frame, and they too carry simultaneous messages of modesty and show. The blue and gold fan, shining at its top surface and delicately shadowed below, is opened like a peacock's tail. But it nonetheless intervenes between the viewer and any presumption of undue familiarity. And even more arrestingly, her left thumb is curled about the picture frame, each joint precisely modelled and shaded by Rembrandt, the rest of the hand left in unseen space both behind and beyond the picture edge. That flat, fat thumb is one of the most extraordinary things Rembrandt ever painted, for it manages, in its utterly convincing solidity, to make its owner uncannily three-dimensional, materially present in some place between here and there, between reality and illusion.

Perhaps Rembrandt was tempted into his framing games by his familiarity with an actual maker of frames: Herman Doomer, whose portrait he painted in 1640 along with that of his wife, Baertje Martens. Doomer had been born in Germany but had come to Amsterdam in 1611 and special-

OPPOSITE: *Rembrandt,* Portrait of Herman Doomer *(detail)*

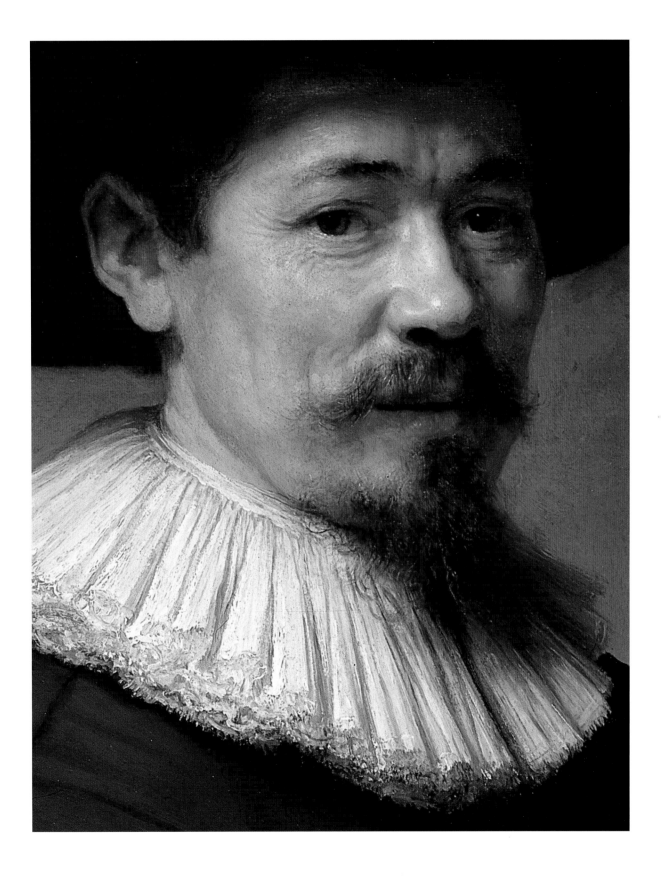

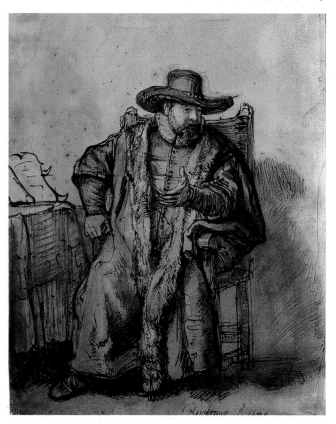

Rembrandt, Portrait of Cornelis Claesz. Anslo, *1640. Pen drawing with black chalk and brown wash. Paris, Musée du Louvre*

ized in working the hard ebony frames, as well as the blackened whalebone versions which were a less expensive substitute. He must have been fairly well-off, but hardly to be counted among the seriously rich who constituted most of Rembrandt's clientele in the early 1640s. But Rembrandt took Doomer's son Lambert on as an apprentice and it's possible that the pair portrait was done as an act of friendship. When Baertje made her will (she survived her husband by twenty-eight years), she made sure that the painting would remain in the family, and the simplicity and gentle forthrightness of both portraits certainly seems to speak of a warm relationship between artist and sitters.

Being a work by Rembrandt, though, the painting of Doomer, in particular, is not without its subtleties. For while the artist has respected the perfect simplicity of his sitter's dress and demeanor, Rembrandt has posed Doomer in the identical fashion to his own Titianesque self-portrait. Herman Doomer, then, has been co-opted into this lofty company, a position for which he is all the better qualified given his utter lack of social pretensions. And Rembrandt, of course, knows exactly how to lend grandeur even to the most modest image. For the most part, the paint is applied with even, fluid thinness to Doomer's face, each crow's-foot and wrinkle beneath the eye, each wispy strand of the beard, carefully and sympathetically described. But when Rembrandt arrives at the collar, his handling turns into a bravura performance, the loaded brush laying down a dense, sticky paste to suggest the layers at the bottom edge of the collar, the flat edge of the bristles stabbed into the wet pigment to achieve the raised ripples and frills of the gathered fabric.

None of his contemporaries came close to Rembrandt's instinctive ability to inject drama into simplicity and still manage not to compromise the integrity of the subject. And nowhere did he demonstrate that skill more conclusively than in the double portrait of the Mennonite lay preacher Cornelis Claesz. Anslo and his wife. A cloth merchant and shipowner, he had moved a number of times, his address becoming steadily grander until he was ready to move into a new house on the Oudezijds Achterburgwal that had been completed for him in 1641. Anslo had the wherewithal to pay off the enormous debt of sixty thousand guilders accumulated by one of his children (evidently not a model Mennonite), and when he died in 1646 he was still worth a cool eighty thousand. The fur trim on the coats of both

him and his wife manages to advertise
this substance without violating too
blatantly the Mennonite aversion to
conspicuous display.

Their double portrait was un-
doubtedly intended for the new house.
But it was meant to celebrate Anslo's
piety, not his property, in particular
his fame as the preacher of the Grote
Spijker church of the Waterland Men-
nonites, the most scripturally devoted
and literalist of the confession. At the
same time, Anslo also wanted a single-
portrait etching, perhaps to be distrib-
uted among his flock, and Rembrandt
supplied a *modello,* or drawing, for
his patron's approval, showing the
preacher seated at his desk, his right
hand holding a pen (for he was also a
writer of theological tracts), the palm
resting on the pages of a book, while
his left hand gestures meaningfully at
another book, presumably a Bible.
With two telling modifications, per-
haps suggested by Anslo himself, the

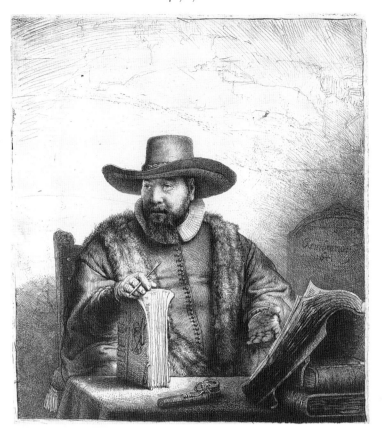

drawing became transferred to the etching plate. The etching shows a
nail hammered into the bare wall, and beneath it a painting with an arched
top which evidently has been taken down and set with its face against
the wall.

Rembrandt, Portrait of
Cornelis Claesz. Anslo,
*1640. Etching, first state.
New York, Pierpont
Morgan Library*

Once again, Rembrandt found himself in the thick of the perennial dis-
pute between the claims of the eye and the ear. It might have struck him as
paradoxical that in Anslo he had a patron who wanted a large painting of
himself and his wife *and* an etching into the bargain, both of which were
nonetheless supposed to promote the dignity of the Word over that of the
image. At some point, possibly after seeing the *modello,* the poet Joost van
den Vondel weighed in on behalf of the Word with the following quatrain:

> *Ay, Rembrant, maal Cornelis stem,*
> *Het zichtbre deel is 't minst van hem:*
> *'t Onzichtbre kent men slechts door d'ooren.*
> *Wie Anslo zien wil, moet hem hooren.*

> O Rembrandt, paint Cornelis's voice,
> The visible part is the least of him:
> The invisible can only be known through the ears.
> Who Anslo wants to know must hear him.[33]

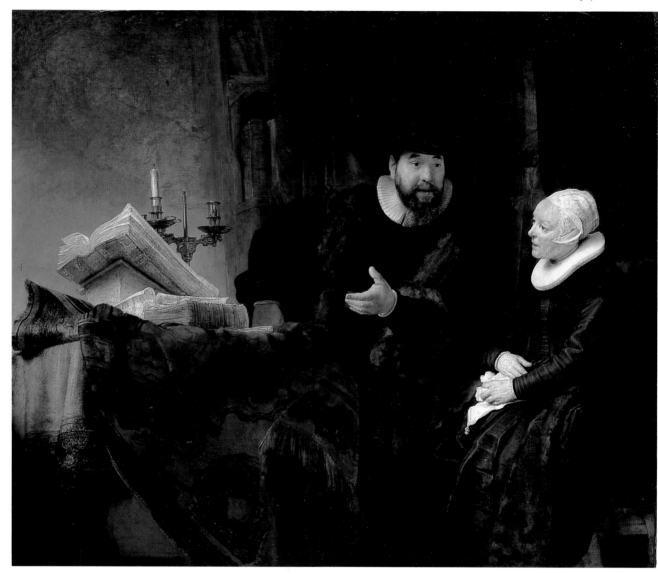

Rembrandt, Portrait
of Cornelis Claesz.
Anslo and His Wife,
Aeltje Gerritsdr.
Schouten, *1641. Canvas,
176 × 210 cm. Berlin,
Gemäldegalerie*

With the full-scale painting Rembrandt duly obliged. But then, he had
long been interested in the possibilities of painting diction, something hith-
erto assumed to be impossible. The rapt observers of Dr. Tulp's anatomy
are, after all, responding to *both* sight *and* sound, and Rembrandt certainly
meant those who saw that painting to imagine the doctor in the midst of a
verbal as well as visual demonstration. A year after painting Anslo, he
would likewise open Captain Frans Banning Cocq's lips just enough to sug-
gest, along with the gesture of his hand, the command to his lieutenant to
have the company move off. Anslo's own gesture, with his foreshortened
hand brilliantly lit on the palm side, seems a direct rehearsal for the manual
command in *The Night Watch*. The interaction between husband and wife
also recalls the dynamic pairing of *Jan Rijcksen and Griet Jans*. But where

that couple, through the wife's two extended arms, had reached across the whole length of the painting, in this case the preacher and his dutifully attentive partner only dominate the right half of the composition, with the left half given over to the towering still-life treatment of books and candle. The extremely low angle of vision, the corner of the table thrust out at an angle to the picture plane, the intensely colored display of the two cloths covering the table, one of them an oriental rug, all combine to give the impression of something like a high altar, atop which rest the sacred books. And those books, which catch the full illumination coming from the left, are not mere heaps of parchment and paper. The pages stir, rise, and flutter with light and life. The books, like Ezekiel's dry bones, respire. The Word lives.

This astounding capacity for transforming the ordinary into the sublime, for creating a temple from a stack of books and a candle, was what rescued Rembrandt from his thwarted career as a pseudo-Rubensian maker of angel-choked altarpieces. His instinct for simple illuminations had always been there, radiantly evident in the two masterpieces of 1629, *The Artist in His Studio* and *The Supper at Emmaus*. But, with the seductive life of a court painter crooking its finger at him, Rembrandt had concentrated instead on the production values of epic drama, sacred and profane, and on the ingratiation of fashion. Now, in the year of Rubens's death, with the vexations of the Passion series behind him, *Anslo* announces a new Rembrandt—a Rembrandt who could make the things of this world hymn the sanctity of the world to come, yet manage, somehow, not to trespass impiously across its borders. He had created what the preachers had said was impossible: Protestant icons. And he had finally taken his leave of his Flemish doppelgänger.

Manipulations of viewing angle were as important for the Protestant icons as they had been for Rubens's *Elevation of the Cross*. Anslo must have been gratified to have so commanding a view of his authority, communicated through Scripture, reinforced by the low angle of vision. It's tempting, then, to speculate that Anslo might also have indicated to Rembrandt that his own large double portrait was also to be hung in some relatively commanding position, as, perhaps, an overmantel. At the top of the pyramidal composition, he occupies an almost Moses-like position of authority, and, according to one scholar, is actually in the process of administering a "fraternal admonition" to his wife.[34] The key to this interpretation is said to lie in the pair of snuffers sitting in the drip tray of the taller candle, which are supposed to allude to the "brotherly admonition which trims away the dribbling wax of the errors of the soul." But even if he had known this obscure allusion, Rembrandt was seldom, if ever, given to this degree of literal specificity. It's always possible, of course, that Anslo himself might have directed him to indicate the admonition with this particular symbol, and it's certainly true that the painter took great pains to get the detail of the *two* candles just right, including the congealed trickle of wax. But it still seems curious that there is a strong suggestion of a

recently snuffed candle, with a dark trace of sooty smoke barely detectable above the wick. Smoking candles, especially when set against extinct stubs, often alluded to the brevity of earthly life in still-life compositions, so it's not beyond the realm of possibility that Rembrandt and/or Anslo meant the juxtaposition of book and candle to suggest things immortal and things worldly, the spirit and the flesh.

The painting, though, is more than a bundle of symbols; more than a painter trumping a poet by executing a work that is *both* vision *and* diction. More than any of these cerebrally conceived matters, Rembrandt's work is still, at its heart, a portrait of a Dutch marriage, specifically a Mennonite marriage. The preacher garbed in his fur-trimmed wealth and doctrinal certainty leans heavily toward his wife, benevolently overbearing, just short of bullying, and looks directly at her as if expecting acknowledgement of some error. Rembrandt has lit Aeltje Gerritsdr.'s face more brilliantly than anything else in the painting, as if it were illuminated by her correction. A little cowed, the wife stares at the book rather than at her husband, her head slightly cocked like an obedient pet or a contrite child, the little shadow cast by her chin falling on her millstone collar, a picture of patient and, Rembrandt makes us feel, accustomed compliance. But if her face speaks of patient resignation—the skin scoured pure, the hair pulled, skull-tight, into the cap, the thin-lipped mouth set against idle gossip, her hands say something else. The left hand in particular, with its veins standing out, the knuckles tensed, kneads and crumples the handkerchief, conveying the *hard work* of being perpetually on the receiving end of the Word.

Which is not to say that there is anything even mildly skeptical or subversive about Rembrandt's painting. The mood he has conjured up, it's true, is a long way from the mutual companionship implied in the double portraits of Maerten Soolmans and Oopjen Coppit or even that of the ship's architect and his wife. But it is nonetheless a portrait of a partnership, even if a markedly unequal one. More to the point perhaps, Rembrandt has once again sized up the essential human truth in a relationship and made it monumental.

iii *Propulsion*

What was it, exactly, about the harquebusiers, the *kloveniers*, that made them the patrons of masterpieces? Although Rubens's *Descent from the Cross* and Rembrandt's *Night Watch* could hardly be more different in purpose and effect, they were both responses to a commission from the shooter militias of Antwerp and of Amsterdam. So, to the already improbable thread twisting around and through the lives of these two men, we must add yet another skein of fate and fortune. They were

both immediate neighbors of the harquebusiers. Rubens's garden backed onto the yard of the Antwerp Kloveniersdoelen, their meeting place and shooting range. During much of the 1630s, the militia guild was slowly and laboriously building itself a new assembly house, and the inevitable noise and dirt of the construction, intruding on his sheltered yard, may well have increased Rubens's pleasure in his bucolic country retreat at Steen.

When he had been living on the Nieuwe Doelenstraat after leaving van Uylenburgh's house, Rembrandt probably hadn't minded the work under way at the Amsterdam Kloveniersdoelen at all. It was an auspicious address for a man on the rise. From across the Amstel, the new building immediately created one of the city's emblematic views: an architectural union between the medieval and modern commonwealth. The medieval conical Gothic tower of Swych Wtrecht (Silence Utrecht), once part of the city fortifications, now abutted a handsome classical building with a row of six tall windows separated by pilasters on the ground floor and another row of double columns dividing the high windows on the upper story. By the time he was hired, probably around 1640, to paint the company of Captain Frans Banning Cocq, he was two houses further on in his career. But the experience of having lived virtually in the backyard of the *kloveniers* could only have added to his appreciation of the importance of the job.

Both Rubens and Rembrandt, in their very different ways, sought to make something that would enshrine the sovereign *idea* of their respective militias. In devoutly Catholic Antwerp, that idea was bound to be pious. The harquebusiers, commanded by genteel officers like Nicolaas Rockox, were still what they had always been: an elite organization drawn from the wealthiest and most cultured citizens. As such, they remained the loyal auxiliaries of the magistrates, who in their turn were the steadfast servants of the Archdukes ruling on behalf of the King of Spain. So Rubens's painting was bound to be a work of reverence, an altarpiece whose subject was prompted by the mythical history of the militia's patron saint, Christopher: the carrying of Christ; a sacred burden made light, in the doubled sense of alleviation and illumination.

In Calvinist Amsterdam in 1640, on the other hand, the cathedral had been replaced by the Town Hall and the *doelen* itself as the sites of hallowed civic values, none more cherished (even when it had largely ceased to correspond with military reality) than that of the citizen soldier, the *schutter*. In the lore of the Dutch revolt, the shooters had been eulogized as the heroic defenders of the towns of Holland: starved in Leiden, martyred in Haarlem. Never mind that Amsterdam's own history during the early years of the Dutch revolt was conspicuously free of epics of sacrifice and siege; its militiamen were still at the core of the city's belief in its independence and liberty, a bulwark *against* the despotic pretensions of the princes, foreign and even (some said) domestic. Although the senior officer corps, as much as in Flanders, was recruited from the most substantial burghers of the city, the rank and file of the militia companies were legally open to any citizen. So the three guilds—the crossbowmen, the longbowmen, and the harque-

busiers—came to be thought of as in some sense representing, symbolically rather than politically, the community of the whole city. When they were mustered en masse at the city gates to greet a foreign prince, or even to provide a ceremonial escort for the Stadholder, the crowds lining the streets watching the rows of pikes and muskets, with the blue and gold or red and white banners flying overhead, must certainly have felt an identity with the *schutterij* as the guardians of Amsterdam's freedom.

Their presence was not all show. Though the pan-European war meant, overwhelmingly, the mutual slaughter of mercenaries and professional men-at-arms, there were still some occasions when companies of Dutch *schutters* did actually go off to fight in the war against Spain (and the troops of the Catholic Netherlands). In 1622, for example, companies of the Amsterdam militia—some two hundred men—marched out in defense of the Overijssel town of Zwolle. In 1632, two companies had been assigned to the Gelderland city of Nijmegen. And with a muster roll of four thousand men divided among twenty precinct companies, the militia was an indispensable underpinning for the political independence of the Amsterdam regents. They had been used decisively in 1629 to suppress Counter-Remonstrant disorders which the magistrates saw as fomented from elsewhere in Holland, in particular from the more militantly Calvinist cities of Leiden and Haarlem. On that occasion, the mobilization of the militia had the blessing of the new Stadholder. After 1633, though, Amsterdam and Frederik Hendrik parted company on the most critical issues dividing the Republic. Betting on the success of the alliance with France, the Prince had become an advocate of belligerence, while the regents of the trading metropolis not unnaturally wanted a negotiated peace and a sharp reduction in the size of the army.

At some point in the late 1630s, Rembrandt had himself become involved as a propagandist in this serious dispute. His notoriously dense allegorical painting *The Concord of the State (De eendragt van het Land)* probably alludes in some manner to this division within the Republic over the deployment of its arms. Precisely what it means to say, though, has been hard to decipher, a task made no easier by the fact that Rembrandt's grisaille seems to have been a *modello,* or trial sketch, intended for the approval of a patron but, in the end, never worked up into a finished painting. To add to the mystery, a partially obliterated date, *164,* has been judged to be inauthentic by the authors of the *Corpus.* Its bias, however, seems to lean more decisively toward the House of Orange than to the city of Amsterdam, since the equestrian figure of the Stadholder is depicted riding valiantly against the massed hordes of the Habsburg armies while the lion, usually an emblem of the United Provinces, lies snarling and fettered in the foreground, conspicuously tethered to a ring immediately below the arms of the city. The contrasting attitudes of the right foreground riders, some gesturing toward the battle, some turned away from it, also appear to suggest the division of opinion between the several towns that made up the province of Holland.[35] Is it entirely coincidental that the features of the

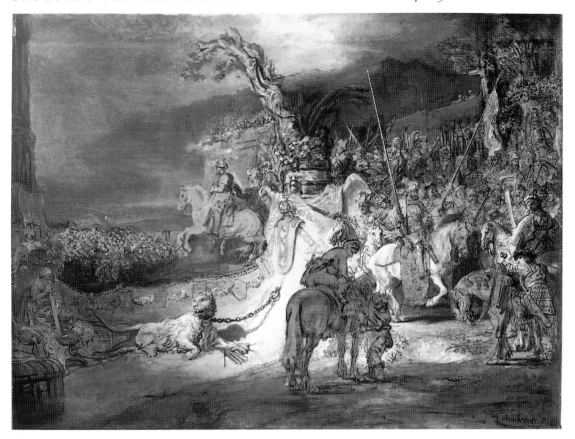

dominant rider, burly and bearded, have more than a passing resemblance to the supreme arbiter of power in Amsterdam, Andries Bicker?

At first sight, it seems perverse that Rembrandt should have been prepared to paint an allegory that took sides *against* the rulers of the city where he was rapidly making his fame and fortune. But the real magnates of the city, the Bickers, were not, in fact, among his immediate circle of patrons, and around 1640 there was no reason at all why Rembrandt would have abandoned his old dream of being a court painter. For all of his procrastinations and difficulties involved in producing the Passion pictures, the payment he received for the two additional religious paintings, *The Adoration of the Shepherds* and *The Circumcision*, ordered by the prince was in line with the inflated Rubensian tariff he thought he merited—2,400 guilders for the pair.

Something did go wrong, though, with *The Concord of the State.* Perhaps it was too obscure for The Hague, or too tactless, after all, for an Amsterdam artist, since it suggested the aloofness of the city's government from the war, could well have been seen by the burgomasters as offensive to themselves. At any rate, the grisaille was still in Rembrandt's possession at the time of his bankruptcy inventory in 1656. Someone didn't want it.

The overcomplicated density of the allegory might be evidence of Rem-

Rembrandt, The Concord of the State (De eendragt van het Land), *c. 1642. Panel, 74.6 × 101 cm. Rotterdam, Boymans van Beuningen Museum*

brandt's nervous uncertainty, around 1640, as to which place—Amsterdam or The Hague—offered the best prospects. The sheer extravagance of the ceremonies laid on for the exiled Marie de' Medici in 1638 might well have given the artist the distinct feeling that his bread would be much more thickly buttered in the city than at court. What were the little houses dotted about The Hague—hardly palaces at all really—compared to the metropolitan swagger that was everywhere around him? There had been great parades, masques and banquets, theatrical performances on the streets and on the river, fireworks and carillons. And there had been the three guilds of militia, the *schutters* brilliantly turned out en masse with banners and drums, formed up to welcome the Queen Mother at the city gates and escort her through the city. Their republican ebullience seemed to embody the demeanor of the greatest metropolis in the world: splendor and ceremony without any servile deference; martial flamboyance without dynastic intimidation. They were the guards of the commonwealth of *mercator sapiens,* the wise merchant, and their city was a fixed hub of an empire on the move.

It helped, of course, that the dynastic guests were damaged absolutists. Marie de' Medici (who had also been received by Rubens's friends the Antwerp *kloveniers* in 1631) was in permanent exile from France, having botched an attempt to dislodge Richelieu. In 1642 she was followed in Amsterdam by her own daughter, Henrietta Maria, another queen-on-the-run, this time from England, now fully embroiled in civil war. Charles and Henrietta Maria had just married off their daughter Mary to William II, the son of Frederik Hendrik and Amalia van Solms, so the Stuart Queen was able to find friendly shelter at the Stadholder's court in The Hague. But Henrietta Maria needed something more than the courtesies of court to sustain her. She needed hard cash, and she had brought the crown jewels of England to pawn them to Portuguese Jewish gem merchants or Mennonite bankers—whoever would take them as security for a sizable loan needed to bankroll her husband's war against Parliament. In the spring of 1642, a full-dress "entry" complete with massed companies of militia was staged for the English Queen, together with her daughter and son-in-law, in Amsterdam, notwithstanding the frosty relations then prevailing between the city and the Stadholder. In fact, an elaborately pompous reception for the fugitive Queen, hated in her own country, was a perfect opportunity for the "magnifico" Andries Bicker and his fellow oligarchs to make an obvious cautionary point to *their* prince on the power and dignity of Amsterdam's own citizens-in-arms.

Where could Henrietta Maria have been regally entertained? Not, at any rate, in the old Town Hall, which was too mean and too quaintly Gothic a space to do justice to the grandeur of the city, but perhaps in the *groote sael,* the great hall of the handsome new Kloveniersdoelen, with its six tall windows overlooking the Amstel. By Amsterdam standards, the room was palatial: sixty feet long, thirty feet wide, and fifteen feet high. Until the new Town Hall on the Dam was built with the enormous Bur-

gerzaal at its center, the *groote sael* was easily the most spacious chamber in the city and was let by the *kloveniers* to the city for all manner of feasts and entertainments. To the Queen of England, of course, it may have seemed hardly more than a pitiful closet, grossly unfit to be compared with Inigo Jones's great Banqueting House in Whitehall Palace, where Rubens's painted eulogy to the godlike strength, virtue, and wisdom of her deceased father-in-law, King James I, triumphed on the ceiling. Beside such celestial visions of divine kingship, the paintings of Amsterdam merchants, vendors of wool and wine, dressed up as soldiers must have seemed laughably common. Seven years later, her husband would be led to his execution through that same Banqueting House, with the guardian deities of the Stuarts coolly indifferent to his fate. While Charles I was a captive of Parliament, the Amsterdam patricians would be relishing their own triumph: the formal recognition by Spain of the sovereign independence of the Republic of the United Provinces.

It seemed, then, that the gentlemen officers of the Amsterdam militia, for the time being at any rate, had the better of history than their princely adversaries. Eyeing the main chance, Rembrandt had no trouble thinking of himself as a city painter as much as a court artist. Hadn't Titian been both? Hadn't Rubens filled his pockets with fees supplied by the patricians of Antwerp? Why would he want to be left out of the most important and grandiose commission that had been seen in Holland for many years: the decoration of the new Kloveniersdoelen's *groote sael*? To stand aside on the strength of faint and uncertain prospects in The Hague when all his rivals in Amsterdam were grabbing the opportunity would have been absurd.

When, six years hence, in 1648, the time came to celebrate their hard-won peace with Spain (won, of course, more by mercenaries than by any citizen soldiers), the *kloveniers* would repair to their *doelen* and gaze with satisfaction at their own likenesses, mustered amiably about their drums and banners, pikes and muskets. In the Kloveniersdoelen in particular, there were four (out of an eventual seven) large paintings already installed in the *groote sael*. At one end of the long room, on the short lateral wall, was a painting of the governors of the militia guild by Govert Flinck, who had been Rembrandt's pupil in 1635–36 and who had succeeded him in van Uylenburgh's establishment as instructor to paying pupils and assistants. The remaining six were group portraits of each of the precinct companies that made up the *kloveniers*. Flinck and Rubens's old travelling companion and guide Joachim von Sandrart provided two relatively compact pictures that hung on either side of the fireplace on the facing short wall, respectively for companies commanded by members of the Bas and Bicker clans. The rising star of group portraiture in Amsterdam, Bartholomeus van der Helst, admired by his happy clients for the slickly brilliant manner in which he depicted them, was allotted the most difficult space to work with—a narrow area above the fireplace on the entry wall—and duly obliged by producing one of his letterbox specials, a monstrously elongated line of figures, though undoubtedly enhanced by one of the very best

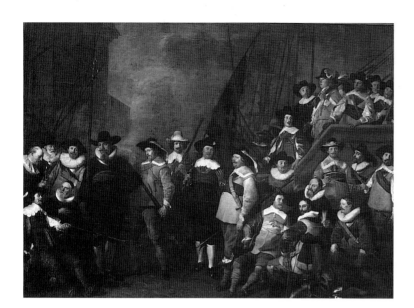

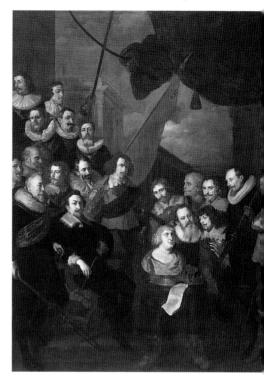

LEFT: *Jacob Backer,*
The Company of Cornelis
de Graeff, *1642. Canvas.
Amsterdam, Rijks-
museum*

RIGHT: *Joachim von
Sandrart,* The Company
of Cornelis Bicker, *1638.
Canvas. Amsterdam,
Rijksmuseum*

and shaggiest dogs in all of Dutch painting, obediently lying down in an encouraging show of martial discipline.

The remaining three paintings were designed for the long wall facing the second-story windows that looked out onto the river. The light flooding in might suggest that these were the prime positions, but this high degree of reflectiveness carried potential problems as well as opportunities and certainly needed to be taken into account by the artists assigned the long-wall spots. Both had connections with Rembrandt. The space nearest the entry door, to the right of the wall facing the river, intended for *The Company of Cornelis de Graeff,* was given to Jacob Backer, who for years had been turning out group portraits of the regents and regentesses of old-age homes and orphanages, but whose superb portrait of the Remonstrant preacher Johannes Wtenbogaert suggests that he was, in his own right, an artist of considerable power and subtlety. In the center space was the work of Rembrandt's briefly residential neighbor on the Breestraat and long-time competitor, Nicolaes Eliasz. Pickenoy. In the left-side space was Rembrandt's contribution, celebrating the company of Captain Frans Banning Cocq, a work so explosively animated that it threatened to march across the room, through the windows, and out into the thin air over the Amstel; a picture that was at one and the same time a colossal anomaly and the crowning glory of the Kloveniersdoelen, of Amsterdam, of Dutch painting, of all of Baroque art.

Contemporaries—and critics of later generations—clapped their hands and scratched their heads. The hoary myth, perpetuated in the biopics, that

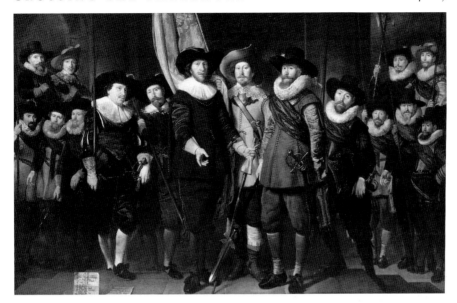

Thomas de Keyser,
The Company of Allart
Cloeck, *1632. Canvas.*
Amsterdam, Rijks-
museum

the sitters demanded their fees back for obscured, imperfect, or partial like-
nesses is indeed entirely spurious. Rembrandt was paid a hundred guilders
for each of the junior officers and men, sixteen hundred guilders in all. But
the number of names inscribed on the plaque attached to the archway is
eighteen, making it likely that he charged the two foreground principals,
Banning Cocq and the lieutenant Willem van Ruytenburgh, on a higher tar-
iff. But there is no sign that Frans Banning Cocq, the captain, Willem van
Ruytenburgh, his lieutenant, or indeed any of the other depicted figures
were anything but happy with the painting. Banning Cocq was sufficiently
satisfied that he had *two* copies made for himself, one by the artist Gerrit
Lundens and another as a watercolor in a two-volume family album com-
memorating the art patronage of himself and his wife's family.

All the same, it's possible, here as elsewhere in Rembrandt's work, to
overcorrect the "myth." By the 1670s, there were already voices of qualifi-
cation and criticism, and some of them came from artists who had them-
selves been at the center of things in 1642. Joachim von Sandrart, for
example, the German painter who went on to have an illustrious interna-
tional career, was the first of Rembrandt's severe critics, accusing him of
"not hesitating to oppose and contradict the rules of art." Sandrart was not
referring directly to *The Night Watch,* but since his own contribution to the
Kloveniersdoelen was also the most aristocratically grandiose and stat-
uesque, with the company of Captain Cornelis Bicker obsequiously gath-
ered around a bust of Marie de' Medici against a background of a
pretentiously imposing classical palace, it seems safe to assume that his
reservations would have applied to this most brazenly unclassical work of
Rembrandt's. *The Night Watch,* after all, flouted two sets of conventions:
the rules of art and the rules of muster. In a work supposed to commemo-
rate discipline, it seemed a garish chaos.

Not everyone in the community of critics and painters later in the cen-

tury felt this way. No one drafted a better balance sheet of the splendors and difficulties of the painting than Samuel van Hoogstraten, who had been Rembrandt's pupil during the late 1640s. In his treatise on painting published in 1678, Hoogstraten compared the necessity of unifying the several elements of a painting to an officer marshalling his troops. Which led him, rather surprisingly, to *The Night Watch*, where, he wrote:

> Rembrandt has observed this requirement [of unity] very well . . . though in the opinion of many he went too far, making more of the overall picture according to his individual preference, than of the individual portraits he was commissioned to do. Nonetheless, the painting, no matter how much it is criticised, will, in my opinion, survive all its rivals because it is so painterly [*schilderachtigh*] in conception and so powerful that, according to some people, all the other pieces in the *doelen* look like playing cards alongside it.[36]

Nothing could testify more strongly to Hoogstraten's acute visual intelligence (as well, perhaps, as his direct knowledge of Rembrandt's working manner) than for him to take *The Night Watch*, which, whatever its many other recognized virtues, few either in the seventeenth century or after praised for its *orderliness*, as an example of fine calculation disguised as spontaneous vitality. Much more typical was the reaction of the nineteenth-century critic Eugène Fromentin, a besotted admirer of Rubens, who thought it incoherent, self-consciously violent, disarrayed, and wounding to "that logic and habitual rectitude of the eye which loves clear forms, lucid ideas, daring flights, distinctly formulated."[37] When Hoogstraten, on the other hand, praised Rembrandt's *painterly* conception, he meant not just a felicitous interlocking of color and form, the credible manipulation of figures in space, but precisely the virtue that Fromentin thought was missing: the crystallization of the entire work around a strong, dominant organizing idea. The idea that Fromentin couldn't see, even though it strode right by him, was propulsion: the irresistible forward action of Frans Banning Cocq's company, a gathering of scattered and diverse figures marching as a single body out from the obscure depths of a great arched gateway, past our viewpoint, and specifically a little way off to our left. Despite what the critics imagined, it was an idea meant to celebrate not Rembrandt's own genius but the genius of the city, the genius of citizen soldiers. For the idea was freedom *and* discipline, energy and order, moving together. *The Night Watch*, then, was to be painted ideology, as triumphantly unambiguous as *The Concord of the State* had been muddily obscure. And in committing his fortunes to that ideology, Rembrandt had switched sides, replacing the courtier of princes with the flag-waver of republican liberty. Now he would make the paint itself work with the exhilaration of freedom.

It would be harder now. In his studio in Leiden, all that there had been to bring his idea to life were himself, his lit panel, and the peeling plaster.

Now he had to deal with another paradoxical idea about the unity of the multitude. But he clung to the notion of men on the move coming together like wandering beads of quicksilver slipping into a silvery mass. And nothing could have been a greater contrast to the other group portraits in the *doelen,* most of which followed the conventional practice of lining up their figures around a horizontal axis. (Only Jacob Backer made a concerted effort to break the monotonous line with a semicircular grouping and a massing of figures below and on a staircase.) But this idea of Rembrandt's was also, to some extent, a reversal of the practice which had established his reputation and which specialized in stoppings, not startings, in moments of arrested action. For *The Night Watch* is designed to be a Cornelis Drebbel machine, a thing in perpetual motion, a group perpetually forming up, firing off, banging a drum, barking like an officer, barking like a dog, waving a flag, marching out. It's a movie frame that refuses to freeze.

It's also an act of brinkmanship played out between painter and patron that is breathtakingly scary, for Rembrandt junks all the conventional practices of draftsmanship and bets that Banning Cocq and his fellow officers, instead of admiring themselves in the even light and tranquil pose of Sandrart's or Pickenoy's paintings, might actually prefer to see themselves caught up in a rush of martial adrenaline. He gambles that they might be prepared to trade frosty clarity for blazing dynamism.

Oh come now, it wasn't *that* different, the Horror Vacui Brigade (Antecedent-Hunting Division) protests. Cornelis Ketel and Thomas de Keyser, you know, had already made the break from the friezelike militia portraits, lined up horizontally in such a way that, as Hoogstraten deliciously put it, "one could, in a manner of speaking, behead them all with a single blow."[38] But although one of the principal officers in de Keyser's *The Company of Allart Cloeck* (page 487), painted in 1632, does indeed make a (limp) forward gesture with his hand, the differences between this painting and *The Night Watch* utterly overwhelm any resemblances. What do the virtually motionless, statuesque figures gathered in a semicircle, or the unconvincingly recessed ranks behind them, have in common with the mad commotion of Rembrandt's picture?

Mad but not crazy. As always, Rembrandt's idea was to confound, not to confront. The last thing on his mind was to deliver to the *kloveniers* something they would find unintelligible, daring them to figure it out and then chuckling to himself at their obtuseness. He wanted the fee, he wanted the praise, he wanted more jobs. As with *The Anatomy Lesson* and all his most ambitious works, Rembrandt meant, if anything, to flatter his patrons, to sweep them off their feet so convincingly that, however startled their initial reaction, they would end up feeling sure that this was, after all, what they had wanted from the outset. He wanted them to feel dazzled by his ingenuity and elated by their fabulous taste. In particular, he was gambling that Banning Cocq and his colleagues would be ravished to see themselves as if caught in the flickering light of a great drama rather than in an

additively contrived, formulaic group portrait. This was, after all, only an extension of his working practice throughout the 1630s, in which portrait subjects, singly or in pairs or groups, were dramatized as if they were enacting a history. But there was no getting around the riskiness of Rembrandt's idea. Though the title was a later misnomer that came from an impression of a nocturnal scene that owed itself to darkening varnish, Rembrandt *was* bringing his cast of characters out from shadow into blazing light, asking the men of Banning Cocq's company to participate in an apparition, a vision that might obscure as much as it illuminated. Even Hoogstraten, who so admired the picture, confessed that he wished the master had allowed it just a little more light.[39]

Doubtless Rembrandt set to work with confidence. His *Anatomy*, after all, which had been, in its way, no less revolutionary, had been thought acceptable, and the officers of *The Night Watch* were hardly a bunch of oafish philistines. Banning Cocq may have been no Bicker or de Graeff, but he was both well heeled and well educated. His father, Jan, had been an apothecary, which is not to say a mere street-corner druggist, since he had amassed a considerable fortune in the trade and had married well into the Banning family. The family had been ambitious and sophisticated enough to send Frans to law school at Poitiers, and when he returned with a doctorate, he married into the Overlanders, a family famous for its political clout and serious money. It was a brilliant alliance. The clan patriarch, Frans Banning Cocq's father-in-law Volckert Overlander, was one of the great power brokers of the city: shipowner and international trader; the owner of one of the most spectacular houses in Amsterdam, "the Dolphin," originally built by Hendrick de Keyser for the poet-scholar Hendrick Laurensz. Spieghel; many times a burgomaster; and a founding director of the East India Company. Like many of his kind whose position helped them make shrewd investments, Overlander had put money into real estate in the Purmer area north of Amsterdam, where substantial land reclamation had inflated land values. Sitting on these juicy assets, Overlander in due course aspired not just to wealth but genteel title, building himself a castellated manor to which he gave the Gothic name "Ilpenstein" and in which he could play the squire as "Lord of Purmerland and Ilpendam." When he died in 1630, his daughter Maria, Frans Banning Cocq's wife, inherited the lot, passing on the grand title to her husband, who thus instantly became a natural candidate himself for high civic office (in the first instance as commissioner of marriage contracts). More significant for Rembrandt, Banning Cocq rapidly rose through the officer corps of the militia, becoming lieutenant of the first precinct company in 1635 and, at some point between 1638 and 1640, captain of the second precinct, the district just north and east of the Dam.

While not quite as exalted as Banning Cocq, his lieutenant, Willem van Ruytenburgh, was not exactly hoi polloi either. His family had done well as *kruideniers,* grocers—well enough to buy themselves the house and the few acres needed for a position in the patrician gentry of Holland (for, contrary

to the lofty assumptions of other European nobility, this was *not*, any more than Venice was, a nation of mere bourgeois). Indeed, the van Ruytenburghs had purchased their property in Vlaardingen from the aristocratic clan of the Ligne-Arenbergs, the same dynasty that had made Rubens its page and which had long occupied a place at court in Brussels. But to be a "Heer," a gentleman, in Holland meant to be able to show off both fine stables in the country and a magnificent façade to the city canals. And van Ruytenburgh had both, living as he did in one of the most sumptuous palazzi on the Herengracht. There is something, in fact, wonderfully subtle in Rembrandt's grasp of the niceties of the pecking order of the patriciate, and the ways in which it both connected and separated van Ruytenburgh from Banning Cocq. Van Ruytenburgh gets the more dazzling costume: a stunning buff coat, in brilliantly yellow hide, ornamented with fancy French bows and richly patterned at its edge. The outfit was complemented by cavalier riding boots. The entire getup, beside the relatively sober apparel of the captain, was outlandishly glamorous. But there was, after all, no standard uniform for the officers of the militia. They appeared in whatever manner they chose, equipped at their own cost, and in appearing in van Dyckian splendor, van Ruytenburgh was certainly choosing to advertise, possibly a little too loudly, his station and fortune. His narcissism was, however, moderated by his local patriotism, for the rich decoration that edges his coat actually includes details from the arms of Amsterdam, and the braid at the base of the crown of his hat, as well as at the tassel at his shoulder, is blue and gold—the colors of the *kloveniers* and of the city "War Council" (Krijgsraad), the high command of the militia of Amsterdam.

Somehow, though, the showiness of the lieutenant only strengthens the sense of command reposing in the figure of his captain, costumed in black but ablaze with the fiery orange-red sash wound about his chest. The entire force of the foreground of the painting depends critically on this stunning color contrast. But Rembrandt manages to work exactly against the received wisdom concerning the optical effect of color in space, which held that light colors must necessarily advance and dark ones recede. Banning Cocq, costumed principally in black, not only dominates van Ruytenburgh's canary yellow but demonstrably moves in front of him, making the lieutenant, as was proper to his station, seem markedly smaller than his senior officer. Nothing is more eloquent of the relationship between the full-face commander and his profiled subordinate than the shadow of Banning Cocq's ordering hand falling on van Ruytenburgh's tunic, the pictured echo of his captain's spoken order.

The Night Watch, though, is not just an homage to two isolated patrician figures, with a crowd of undifferentiated extras falling in behind. Besides the senior officers, there were sixteen men of the second precinct, many of them cloth merchants, who paid for their portraits, and Rembrandt, contrary to his critics then and since, certainly meant to honor his commission, but without the drearily cumulative format of conventional

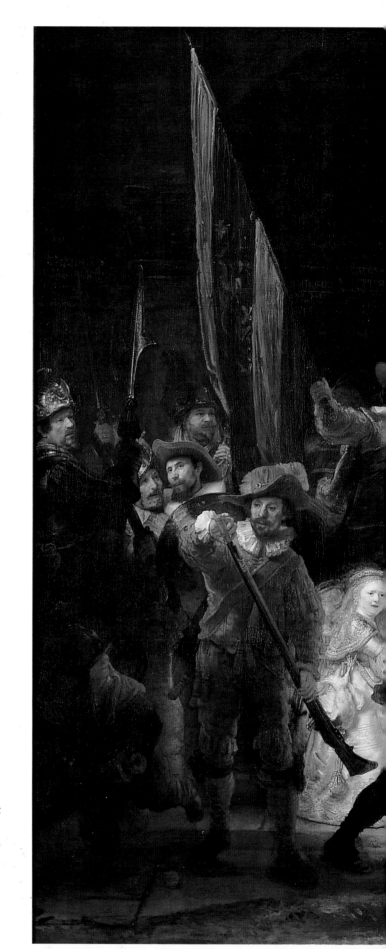

Rembrandt, The Night Watch, *1642. Canvas, 363 × 437 cm. Amsterdam, Rijksmuseum*

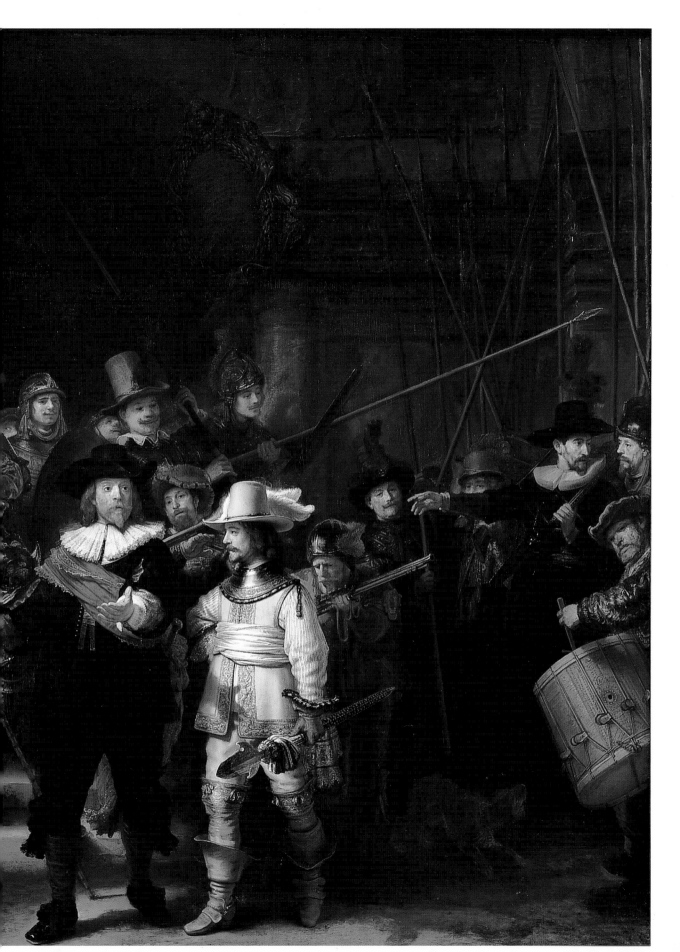

militia pieces. In fact, it's hard to resist the impression that Rembrandt, while respecting the ranks of the depicted officers, was consciously attempting to bring to life the *kloveniers* as a little commonwealth, with each of the figures emblematically representing a distinct social type, each of which was needed for the unity of the company, and by extension for that of the metropolis.

Hence the two sergeants at the extreme right and left of the painting: Rombout Kemp and Reijnier Engelen, their heads both brightly lit, captured by Rembrandt in the midst of making broad, dramatic gestures. Unlike Banning Cocq and van Ruytenburgh, both were very much men of the district, earning their living from the cloth business. As his sober dress and demeanor suggest, Rombout Kemp was a pillar of the community, a deacon of the Calvinist Church and a governor of a local poorhouse. Reijnier Engelen, on the left, must have been pleased by being portrayed in a flamboyantly heroic attitude, dressed in an antique warrior's helmet and holding a grandiose halberd while seated athwart a parapet, since he was burdened with a slightly shady (if forgivable) past, having been fined for lying about his age when signing a marriage contract with a much younger bride.[40]

Has central casting been at work here? Are these the types we expect to see in any military company where the men are made visible beneath the uniforms? It begins to look that way. Here are the upper-crust, stiff-upper-lip officers, one peppery and laconic, the other expensively glamorous; here are the no-nonsense, salt-of-the-earth sergeants dressed in anachronistic costumes, as if personifying veteran virtues. And no platoon of this kind would ever be complete without the impulsive rah-rah bachelor, perhaps an only child, pampered at home, more mouth than brawn, noisily eager to wrap himself in the regimental flag. And there he is, in the center of the back row, dressed in the blue and gold of the *kloveniers,* their most youthful personification: Jan Claesz. Visscher, ensign. Precisely because they led infantry advances in the battlefield and were correspondingly vulnerable, ensigns in the militia, as well as in the regular army, were actually required to be unmarried. Visscher, thirty-one when Rembrandt painted him, lived alone with his mother and grandmother on the Nieuwezijds Achterburgwal as something of a dilettante in a house full of paintings. Occasionally, he too would draw or dabble in music. Eight years later, he would die, without ever marrying but also without ever seeing any kind of combat, just before the troops of the Stadholder William II began their march on Amsterdam. It takes only a brief look at the way in which the ensigns of the other *kloveniers* companies were depicted, with just a touch of bravura but nothing too theatrical, to appreciate the full force of Rembrandt's marvellously vital image of the standard-bearer. It owed something to the flamboyant images produced by Goltzius of standard-bearers, whose great sail-like flags seem almost to have a life of their own, imparting martial energy to their carriers. And it also owed something, in spirit if not in precise pose, to the 1636 three-quarter-length

of a standard-bearer, arm akimbo like the grandest aristocrat, stuck out at ninety degrees to the picture plane, the straggly whiskers extremely reminiscent of engravings of the virtuous barbarians illustrating editions of Tacitus's *Germania*. Although, at first sight, the whole of Visscher's lower body is hidden and he seems to be one of those figures standing in obscurity, he and his flag are thematically at the very heart of the painting. Here, as elsewhere in the painting, Rembrandt makes partial concealment a way to arrest, not distract, our attention.

The Night Watch is not just a gathering of officers. Unique among militia pieces, it evokes a company on the move, almost like a troupe of street performers with all its players along for the show—the drummer hired for the day; the powder monkey (clownlike in an oversize helmet); pikemen and musketeers. Some of these role-players—the more decorous figures—must have been among the eighteen names Rembrandt was hired to portray. Others, like the little girls, also dressed in the *kloveniers'* blue and gold, obviously were not. But a strong element of the painting's power is the breadth of its human ensemble, a microcosm not just of the militia but of the whole teeming city.

Classicist critics were right to be appalled by *The Night Watch* because, despite its fine calculations of color, tonal values, composition, and form, it pays such scant attention to the rules of decorum. It was the most immodest thing Rembrandt ever did, not in self-advertisement but in terms of what he thought he could achieve in a single work. It is the acme of Baroque painting because it does so much, because it *is* so much. It is group portrait, quasi-history painting, emblematic tableau, visionary apparition, and, not least, I think, a personal statement about the transcendent, living quality of painting itself. All this happens on one canvas. It is a painting of Rabelaisian inclusiveness, one that mocks the academic hierarchy of genres in favor of a display of social performance. It is a noise, a brag, a street play. It is how we all are. But because it's all that, it's a picture that keeps threatening to disintegrate into incoherence. For it takes the chance that all the picture types that it wants to bring together will end up, not in agreement, but at war with each other. Instead of a sublime synthesis, there might be a dissonant rout. And that is exactly how its hostile critics through the centuries have written it off as the most overrated painting in seventeenth-century art.

Rembrandt was aware he was playing for high stakes. Here was the moment where he could cancel out all the frustrations and confusions of the Passion series, where he could take his leave of the anxiety of influence: where he could do more, be more, than Rubens. A triumph would make him. A disaster would break him. (In the end, what he got was customer satisfaction, which did neither.) He certainly must have known that to achieve success in pulling together all the disparate pieces of his great unruly engine of a painting, in making the rods and pistons of the thing work as they should, he needed the strongest possible compositional scaffolding on which to assemble the complicated interlocking parts. The

nineteenth-century French critic Fromentin, who wrote with poetic subtlety about Rubens and *The Anatomy Lesson of Dr. Tulp*, completely failed to see this, *assuming* that "it is agreed that the composition does not constitute the principal merit of the picture."[41] It's true that Fromentin saw *The Night Watch* as all succeeding generations have been obliged to see it: with a broad strip at the extreme left cut away and another strip from the bottom of the painting also removed, presumably so that it would fit the new space to which it was allotted when it was relocated from the Kloveniersdoelen to the Town Hall in 1715. Though it's been argued that the far left of the painting was its least important area, the preserved copy of the original and intact composition, made by Gerrit Lundens, shows just how critically important those additional spaces were to Rembrandt's intention of situating his figures in a credible urban space. The additional length of the canal railing at left (alongside which the powder monkey runs) together with the edges of the flagstones are, in fact, the orthogonal lines of Rembrandt's perspective, leading to a vanishing point in the center of the great arched doorway from which the company is emerging. Those lines at left also give a far stronger sense of the concrete location—a bridge over a canal in front of the Kloveniersdoelen—than is possible in the reduced painting we now see. This is crucial not just for the formal energy of the painting but for the reinforcement of its moral raison d'être: the personification of a company entrusted with the protection of Amsterdam, with guarding its gates, bridges, and canals.

Even with this truncated composition, though, it's amazing that Fromentin (and others) managed to miss the heavy engineering of Rembrandt's pictorial machine, since its armature is so completely exposed. It is both radial and axial, centrifugal and centripetal. The axial spine extends from deep in the obscurity of the arch and projects forward, through Banning Cocq's figure along the line of his foreshortened hand and striding legs, out into our own spectatorial space. But the complicated élan of the painting, with its dashing movements and countermovements, is pinned together by the radial spokes, or parallelograms, marked toward the left by Banning Cocq's cane, the muzzle of the red musketeer's gun, and the staff of Ensign Visscher's flag. To the right, they are marked by the barrel of the musket immediately behind van Ruytenburgh, by the direction of Sergeant Kemp's partisan, and by the long pike in the rear. It's possible to see this intricate yet strongly skeletal arrangement as a fan, or as the marvellous unfurling of a peacock's tail (a bird in which Rembrandt had a strong interest). But it's also immensely tempting, especially when looking at the original composition in Lundens's copy, to see Rembrandt lining up his painting as a St. Andrew's cross. Three black crosses on a red field formed the arms of Amsterdam. And that same cross reappears in the pattern of pikes in the right background of the painting.

A gesture this cunning can hardly be ruled out in a painting so complex and so sly. For aside from building a formal structure strong enough to contain an explosion of action without risking complete disorder, Rem-

brandt has clarified in his own designing mind the essential if paradoxical purposes he wanted to fulfill. First and foremost (because most instantly recognized by the militia officers themselves), there was the effort to represent the company as an energetic band in full forward motion, striding from darkness into light; the epitome of disciplined liberty. But then, Rembrandt also wanted to incorporate some sort of emblematic or allegorical representation of the historical *meaning* of being a *klovenier*, a citizen-in-arms, yet without sacrificing the sense of a living human assembly. So it became important for him to connect the darkness-into-light motif with that of past-into-present. Indeed, if one takes the lit space of the stone bridge across which the company passes before us as a passage into the future, then Rembrandt is completing the sense of his historically costumed citizens-in-arms as striding into their own posterity. If he can do all of this, of course, he also ends up satisfying what I believe to be his own personal ambition, something to make the shade of Rubens green with envy, namely, creating a work that exploded right through the most obvious limitation of any painting—its two dimensions—a work that was, in fact, a repudiation of flatness. The critic Clement Greenberg once defined premodernist paint-

Attributed to Gerrit Lundens after Rembrandt, The Night Watch, *c. 1650. Panel, 66.8 × 85.8 cm. Rijksmuseum, Amsterdam*

ing by its struggle against the confinement of two dimensions.[42] (Modernist painting, for Greenberg, began with the frank acknowledgement and celebration of flatness as the quality irreducibly peculiar to painting.) If he is right, then the Rembrandt of *The Night Watch* is indeed the exemplary paradigm of the premodern artist, fighting to transcend the two-dimensional limits of his medium, wanting to beat not just Rubens and Titian at their own game but Michelangelo, Caravaggio, and Bernini as well, embracing with his brush the operational freedom allowed to sculptors and stage directors, those who worked with animation, volume, noise, bodily presence.

In the first place, he needed action. So the flying tassels on Banning Cocq's black breeches, the shadow cast by his back foot, and, most wonderfully, the raised fabric of his flaming red sash, which is itself moving into the light, all declare someone already on the march as he gives his order. Van Ruytenburgh himself is literally but half a step behind, his back foot raised on its heel, his partisan properly lowered, in deference to the captain but pointing also in the direction in which the company is to move. As Ernst van de Wetering has argued, through looking at the way Rembrandt anticipated the kind of startling rewriting of the rules of art that subsequently became codified in Samuel van Hoogstraten's treatise, the artist had to employ an array of optical illusions in order to have the mostly dark figure of Banning Cocq seem clearly in advance of, rather than behind, his more brightly lit lieutenant. Foremost, literally, is of course the spectacularly foreshortened left hand, which contemporaries all noted and admired. But it was equally important that to achieve just the right degree of projection for van Ruytenburgh's partisan, Rembrandt painted its blue and white tassel with thick impasto, laid on with confident freedom and "roughness." Here he does indeed seem to be following the daring practice, invented by Titian, of painting passages closest to the beholder in a rough and broken manner and those further back more smoothly, precisely the reverse of what might be conventionally expected.[43]

Immediately behind the two principal officers, Rembrandt made another startling, indeed to some bewildering, innovation, combining ostensibly realistically depicted figures like the red musketeer with other more fantastically theatrical types, like the brilliantly lit little girl, an inverted chicken suspended from her waist, and the dwarfish figure of a mostly invisible, helmeted figure discharging his weapon right behind the captain and lieutenant. It's been recognized that these figures, along with the third, helmeted shooter over van Ruytenburgh's right shoulder blowing powder from the pan of the musket, are emblematic rather than naturalistic figures. (There is, in fact, a similar musketeer equally unrealistically shooting behind an officer in van der Helst's painting for the *kloveniers*.) The three men in Rembrandt's painting are incarnations of the illustrations by Jacques de Gheyn II from a famous drill manual, *The Exercise of Arms*, first published in 1607 for the Stadholder Maurice and since translated into virtually every European language, internationally known as an indispens-

able handbook for the modern army. Which is very much the point, since the *kloveniers* are, after all, *not* a professional army but a citizen band, flattered by Rembrandt as if they were performing their duties as shooters to the perfect letter of the instruction book: one, two, three, *LOAD, SHOOT, BLOW!* The actions were not entirely imaginary or optimistic, though, since at each Sunday parade, at kermis-time and at the city entries, a company of *kloveniers* would indeed halt in the parade to shoot their weapons while another rank behind them would get ready in their turn to repeat the exercise.

The oak leaves adorning the helmet of the little shooter are, together with the girls, the most emphatically emblematic pieces of the painting: symbols of victory, of course, but also of virtue, martial strength, and even of resurrection; the harquebusiers once and forever triumphant. The two little girls likewise are certainly an abstract personification of the *kloveniers,* the *klaauw,* or raptor's talon, which appeared on their drinking horns and ceremonial coats of arms transformed here into a chicken's foot. This might indeed have seemed an impertinence to the officers who commissioned the painting. But here, as elsewhere in the picture, Rembrandt is evidently wanting to make his figures flesh-and-blood types rather than purely allegorical personifications. And it may be the case that such children, dressed in the colors of their militia guild, did in fact appear in parade along with the officers and men, rather like batboys and mascots of our present-day urban warriors—professional sports teams. Since dogs appear in other militia paintings, it's even possible that the hound tearing wildly around at the right of the painting (carefully balancing the powder monkey in the composition) was similarly not a complete fiction on Rembrandt's part, even if the animal is less nobly idealized than the hound that appears in van der Helst's painting. The mix of costumes, some contemporary, some antique, including the extraordinary worked helmet of Sergeant Engelen, perhaps an item from Rembrandt's collection, as well as the combination of time-specific and timeless figures, all served to create precisely this union of past and present in which Rembrandt wanted to enfold the company. This promiscuous mingling of modes—symbolic, naturalistic,

Jacques de Gheyn II, A Soldier Loading His Musket. Engraving from The Exercise of Armes (Wapenhandelinghe van Roers, musquetten ende spiessen), *1607. New York, Columbia University Libraries, Butler Rare Book Room*

Rembrandt, The Night
Watch *(detail)*

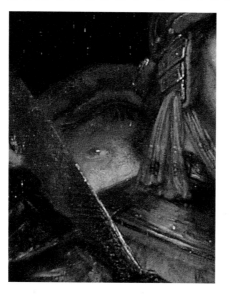

emblematic, and social—was yet another instance of Rembrandt pushing a perfectly acceptable manner beyond its expected limit. For the "historiated portraits" in which sitters got themselves up in the guise of figures from mythology or history were a standard part of the conventions of the day. Rembrandt, however, does something much more daring, sensing the ways in which men dressed up expressly (and, by 1642, often from their own wardrobe) for the public gaze felt themselves, as they strutted by the lines of ogling burghers, to be the contemporary incarnations of something bigger than themselves: the spirit of the citizen soldier, past and present; the pride of Amsterdam, which from nothing, from reeds and fishes, from storms and floods, God had raised to be the new Carthage, the new Tyre.

They felt themselves, in fact, to be a living flag. Which is why the great azure and gold banner raised by Ensign Visscher is much more than a rhetorical flourish. It too is painted by Rembrandt in broad strokes, but without the dazzling brilliance which would have given it crude dominance over the whole field of the painting. (Its yellow is principally composed of ocher, rather than the sharp lead-tin yellow of van Ruytenburgh's costume.) Nonetheless, the topmost gold band of the *kloveniers'* flag seems to soak up the light mysteriously originating from some unseen source on the left and falling on the ensign's face and the sash wound around his breast. The gently raking light does not rest there. It seems to drift along the lines of heads at the rear of the painting, illuminating what Rembrandt presumably hoped would be seen as a hundred guilders' worth of countenance.

One of those faces, though, was certainly painted gratis. True, it's not that much of a face at all; more a nose and a flat hat and an eye. There's just enough of the nose to suggest a familiar fleshiness at the unseen tip. There's enough of the hat to suggest a painter's flat beret. There's enough of the sharply lit eye to announce Rembrandt himself, coyly standing at the very back of his sublime tumult, his single watchful eye directed sideways and upward, over Jan Visscher's shoulder to the streaming blue and gold. It's more than a wink and less than a nudge. It's the eye of a commander.

iv Fallen Birds, June 1642

Here's what needs to be imagined. The painter is busy fin-
ishing his militia piece in the gallery he has enlarged at the rear of his
house.[44] In a primitive form, this narrow covered walkway existed when he
bought the property, not much more than the usual lean-to, commonplace
in Amsterdam's courtyards, erected against his neighbor's back wall and
supported by wooden piers. *The Night Watch* must have needed more
space. So Rembrandt raised the height of the roof up to the second-story
level of his house, enclosed its open side, put in some windows, and
punched a hole in the wall of the back room of his *kunstkamer,* giving him
access to what was now a workshop studio from the inside of the house.

Rembrandt, Saskia
Holding a Flower,
*1641. Panel, 98.5 ×
82.5 cm. Dresden,
Gemäldegalerie*

At the other end of the house, in the box bed in the *sael,* Rembrandt's
wife Saskia is deathly sick, wasting away from tuberculosis.[45] It's a bad way
to die, the diaphragm shaken by spasms of bloody coughing. Rembrandt
is the only artist of his day to
whom it naturally occurred to
depict his wife both as princess and
as invalid, in her finery and in her
nightshirt. He too, like Rubens,
cannot quite take his eyes off her,
but he has little interest in painting
Saskia in some imagined world of
Ovidian fantasy. For the most part,
he likes to draw her when she can-
not see him: her eyes shut, her
hand resting on the counterpane.
He does just one more *Flora:* ten-
derly arousing, Saskia posed with
her chemise unfastened, her hand
at the breast sweetly ambiguous, at
the same time concealing the open-
ing and intimating the body
within. Like all good wives, she
proffers a bloom, the emblem of
fidelity, of loyalty unto death, to
her husband.

In 1639 Rembrandt had made
an etching of a married couple,
costumed *à l'antique,* in which the

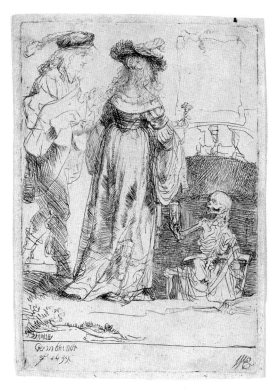

Rembrandt, Death Appearing to a Wedded Couple from an Open Grave, *1639. Etching. New York, Metropolitan Museum of Art, Gift of Henry Walters by exchange*

wife also holds a flower. But she tenders it not to her husband but to the energetic figure of Death, clambering out of an open grave, an hourglass cupped in his skeletal palm. Confronted with the spectacle, the couple is not, in fact, standing still. The man is caught in mid-stride, walking *toward* the grave. His wife, seen from the rear, blond hair tumbling over her neck and shoulders, stands on the lip. Neither of them shrinks from this encounter. It is as though they were greeting a familiar.

It must have felt so. By the end of 1640, there were three little stones between the columns of the nave in the Zuiderkerk: for Rombertus; for the first Cornelia, who had died in August 1638; and for the second Cornelia, who had died almost exactly two years later. Neither of the baby girls was more than two weeks old. The deaths of small infants were, of course, so common in seventeenth-century cities that we might suppose Rembrandt and conceivably even Saskia to have been hardened against grief. And so it may have been. But *no* artist of his day produced quite so many drawings and etchings of small children, either done directly from life or from memory. Babies suckled at their mother's breast, babies carried in arms, squirming, or toddlers taking their first steps. Dutch art was full of images of children. But they were very often posed in particular roles—seen in attitudes of obedient instruction or mischievous play, mere illustrations of qualities the moralists attributed to them. Rembrandt, on the other hand, who until Titus was born had almost no opportunity to draw his own infants before they were carried off to the grave, took every opportunity he could to simply observe them as spontaneously as possible.

Barely a fortnight after the second Cornelia joined her namesake under the church floor, Rembrandt's mother, Neeltgen Willemsdr., for whom the baby girls had been named, died in Leiden in her seventy-third year. A sensitive portrait of her done around 1639 suggests that Rembrandt had not been entirely absent from his native city. And he must have returned, however briefly, immediately after her death, since a legal document dated in November 1640 gives power of attorney to third parties on the grounds that he was not able to "remain" in the city. Neeltgen had made sure, in any case, that there would be no grounds for any ill will between the four heirs—Rembrandt's two surviving brothers, Adriaen and Willem, and his sister Lysbeth. Adriaen got the "garden" lot beyond the Witte Poort and the family house on the Weddesteeg; and after he moved in, Willem moved into Adriaen's old house on the Rijn. The unmarried Lysbeth was taken care of by the rent from other properties around Leiden and got some of her mother's jewels and gold chains. Whether or not she was disabled in

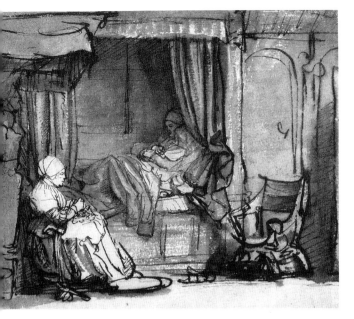

CLOCKWISE FROM TOP LEFT:

Rembrandt, Saskia's Bedroom, *c. 1639. Pen drawing and brown ink with brown and gray wash, heightened with white. Paris, Frits Lugt, Institut Néerlandais*

Rembrandt, Portrait of Titia van Uylenburgh, *1639. Pen drawing with brown wash. Stockholm, Nationalmuseum*

Rembrandt, Four Studies of Saskia, *c. 1636–37. Pen and brown ink drawing. Rotterdam, Boymans van Beuningen Museum*

Rembrandt, Studies of a Child Pulling Off an Old Man's Cap, *c. 1639–40. Pen and brown ink drawing. London, British Museum*

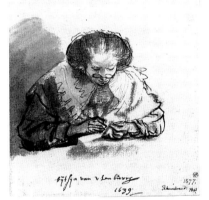

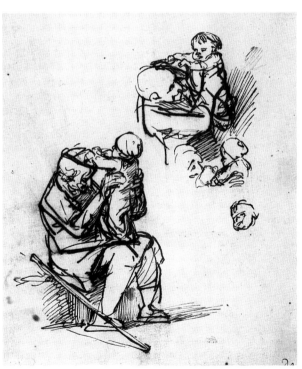

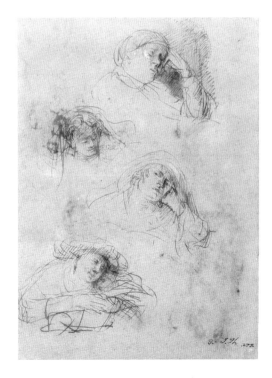

Rembrandt, Girl with Dead Peahens, *c. 1639. Canvas, 145 × 134.8 cm. Amsterdam, Rijksmuseum*

some way, she was certainly being looked after by Adriaen, who would pay her an allowance out of the estate for the rest of her life. And Rembrandt? He was bequeathed half the mortgage on the mill Adriaen worked, worth the quite serious sum of 3,565 guilders.[46] But the mill had neither a sentimental nor a commercial hold on him, and he took steps to sell it as soon as he could. His home was on the Breestraat now, and there were payments to be met. It seems unlikely Rembrandt ever went back to Leiden again.

In June 1641 Saskia's sister Titia, the wife of the Zeeland patrician Coopal, died. An exquisite drawing, done from life, of Titia sewing, her spectacles poised on the end of her nose, her neat head bent over her work, suggests that although she lived with her husband in Vlissingen, in the far southwest corner of the Republic, Titia was a visitor to the Breestraat. She died when Saskia was pregnant with their fourth child, a boy, baptized in September 1641 and given the name Titus in memory of his aunt.

Saskia herself seems to have suffered from all these births and deaths, although tuberculosis would have killed her even had she been in otherwise good health. Death's sear hand, as all good Christians knew, could stretch out and chill the warmest body. Had not the Preacher, Ecclesiastes, warned how man might be caught, all unsuspecting, in the midst of his vain vigor? "As the birds that are caught in the snare; so are the sons of men snared in an evil time, when it falleth suddenly upon them."[47]

Around 1639–40 Rembrandt painted two large and equally mysterious paintings of dead birds. Ostensibly, both of them belonged to familiar genres in Dutch painting: the *Hunter with Dead Bittern*, to hunter's trophy paintings; and the *Girl with Dead Peahens*, loosely reminiscent of the much older genre of "kitchen" pieces, where cooks and maids surrender pride of place to piles of food heaped in the foreground. But only the most relentless classifiers could be determined to fit either of these paintings into their respective conventions. To "bird" (*vogelen*), in contemporary slang, it's been said by learned iconographers, meant to fuck.[48] So a hunter holding up a dead bird by the feet must have been painted to raise a smirk. But for

this to be an even faintly plausible reading requires two elements: a hunter (usually grinning) and a girl to whom the bird can be presented, the proposition made. Rembrandt has the girl. He has the hunter with the bird. But they're in different paintings. It seems even less likely that with these paintings, despite the presence of a gun in the *Bittern,* he was staking a claim to be considered among the landed gentry, a kind of painted application to the Gun Club. (In fact, fowling was a popular Sunday pastime through a broad section of the population. Hear the preacher, watch the *schutters,* shoot the birds or rabbits, or dangle a hook for the fish.)

The real trouble with thinking of these two wonderfully strange paintings as having anything to do with sporting or screwing is the profound air of melancholy which hangs over both and seems a lot closer to the lines from Ecclesiastes than to a dirty joke or a huntsman's brag. Even by the normal standard of his chiaroscuro, Rembrandt has cloaked his features in deep shade (the gun almost completely obscured), with only the far right side of the face lit.

Rembrandt, Hunter with Dead Bittern, *1639. Panel, 121 × 89 cm. Dresden, Gemäldegalerie*

But there is enough light to make out the solemn expression on his face— somewhat akin to Saskia's in *The Prodigal Son.* And the Rembrandt of both those paintings is wearing an ostrich plume. Now Rembrandt, undoubtedly from earlier self-portraits, was partial to his feathered caps and the way he looked in them. But in these two paintings, the plumage (with the peacock at the back in *The Prodigal Son*) is meant to summon up somber thoughts, of transience, of mortality, of the downy ephemerality of earthly pleasures. For meaning-hunters, Rembrandt leaves clues in both these paintings: the disconcerting, gallowslike wooden structure at the left on which he inscribes his name; the extraordinary realism of the blood (painted in thin carmine) oozing from the body of one of the peahens, which is completely at odds with the proper decorum of either kitchen or game pieces. But the lit center of both pictures concentrates on the feathers (very much as Rembrandt would later exhaustively explore the innards of a slaughtered ox). The bittern's underside, in particular, is painted with an

extraordinary froth of dashing strokes, at once phenomenally strong and free yet absolutely faithful to the downy surface. And though the wings of both bittern and peahens appear to be more laboriously described, they are, in fact, sketched with just as much dashing freedom and confidence. The wings of birds may have had an especial appeal for Rembrandt, as they did for Leonardo, as both miraculous machinery and poignant emblem of the brevity of life. He had, after all, a bird of paradise in his *kunstkamer*. His birds in these paintings hang upside down (the position, as any poultry worker will tell you, that renders even a living fowl helpless), quite crestfallen, the beautiful fretwork of their wings useless, the skinny feet bound together with twine, rubbery and ridiculous. A pudding-faced girl (quite unlike the scampering imp of *The Night Watch*) ponders the fate of the pea-brained peahens, while the artist, his tightly gloved hand held high, confronts us from the shadows.

Rembrandt, Saskia Sick, with White Headdress, *c. 1642. Etching. New York, Pierpont Morgan Library*

Euphoria and sorrow were advancing toward each other like two dancers from opposite sides of a room. Rembrandt was on the point of completing the most profoundly improbable masterpiece in seventeenth-century painting, a work that contrived to be, at the same time, deeply parochial and wholly universal, flooded with the light of tradition and ventilated with the air of modernity. There would have been a spring morning when *The Company of Captain Frans Banning Cocq*, properly shielded against grime and weather, would have been trundled on a cart to the Nieuwe Doelenstraat, carried through the courtyard and up the stairs of the Kloveniersdoelen, and set on the brightly lit wall facing the river.

But a short time after, perhaps a matter of days, on the fifth of June 1642, the notary Pieter Barcman was called to the house on the Breestraat to draw up Saskia's will. Her breathing must have been labored, her energy too slight to pull the reluctant air through her ragged lungs. He arrived in the morning, while she still had strength to listen to the reading of the document. It was a ceremonious moment. Two witnesses, Rochus Scharm and Joannes Reijniers, were in attendance. "*In den name ons Heren Amen . . .*"

> In the name of our Lord Amen . . . Saskia van Uijlenburch, wife of the Honorable Rembrant van Rhijn, residing in this city, well known to me, the notary, although sick in bed, yet in full control of her memory and understanding, as it outwardly appeared, after commending her soul to God Almighty and her body to Christian burial, before me declared and appointed as her heirs Titus van Rijn, her son, as well as any other lawful child or children she might bear. . . .[49]

And so on, the forms and manners prescribing that Saskia look to *both* her burial *and* her birthing bed! But anyone who took a pitying glance at her—the cheeks hollow, the eyes sunken—could not have imagined she would bring any more babies to the baptismal font.

They had evidently thought about what was to be done, Rembrandt and Saskia, and they had done it together. Saskia's marriage portion had been of the kind that legally remained her own property throughout the marriage, although the usufruct had been in common. And so she had the freedom to bequeath it, in its entirety, to Titus. The widower was given use of the estate to "trade, consume or do anything else" with it as he saw fit, provided only that he "scrupulously bear the cost of the aforementioned child or children's board, clothing, schooling and other requirements" until they came of age or married. Rembrandt's freedom to do what he wanted with the inheritance, though, would lapse in the event of his remarriage, a condition which in

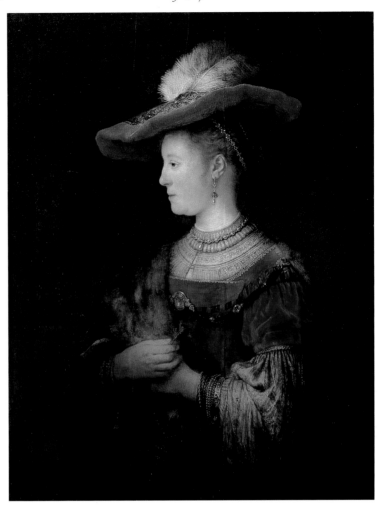

Rembrandt, Saskia in a Red Hat, *c. 1634–42. Panel, 99.5 × 78.8 cm. Kassel, Gemäldegalerie*

the days of mourning may have been the furthest thing from his mind, but which would come to play a fateful role in the painter's future. Should he remarry (or for that matter die), he or "his flesh and blood" was still entitled to half of the remaining estate, with the other half going to Saskia's surviving sister Hiskia, who had just lost her own husband, Gerrit van Loo.[50] And there were other clauses in the will that, even in this extremity, suggested the couple's freedom from expected legal convention. Normally, a surviving minor had two legally appointed guardians. But Saskia instructed that Rembrandt, and Rembrandt alone, would be their son's guardian and the sole executor of the estate. The Amsterdam Weeskamer, the Chamber of Orphans (which one was required to inform when a parent of a minor died), was expressly excluded from any role whatsoever in administering the bequest. "Confident that he will acquit himself very well in all good conscience," Saskia also waived the requirement that her husband provide any kind of inventory of her property "to anyone in the world."

It was a testament typical of a seventeenth-century marriage: hard-

headed rather than softhearted. In an earlier will, Rembrandt had been named sole beneficiary of the twenty-thousand-odd guilders that represented Saskia's share of their common property. Now he inherited nothing but controlled everything. But Rembrandt's trustee status may well have been a prudent legal stratagem designed to protect his wife's legacy from his own creditors. Yet there is something odd, something preemptively cautious, about the document, as if, in the blazing year of *The Night Watch*, the optimism of their marriage had caught a sudden chill.[51]

Ten days later, on June 14, 1642, Saskia departed the world. Another silent procession, the body wrapped, as Calvin had ordered, in a simple cloth. Though her dead babies were in the Zuiderkerk, close to their house, Rembrandt buried Saskia in the Oude Kerk, the church of her sister's husband, Sylvius, who was still *predikant* there. Perhaps he helped find a grave for the painter to buy, a few weeks later, quite close to the organ and behind the pulpit, in the plain little space known as the Veerkoperskapel. There was no epitaph.

Not in the church, anyway. But somewhere in the house her husband had a portrait he had begun many years before, at the playful beginning of their life together, in 1633 or 1634.[52] A drawing of this original painting made by Govert Flinck suggests its relative simplicity. The famous hat was unplumed. Saskia's shirt was quite unadorned and only broadly described, and she wore no fur cape over her shoulders. At some point, either while she was sick or perhaps even after she died, Rembrandt returned to the portrait, transforming his wife into a bejewelled Renaissance *principessa*. Though the overpainting of a later and different hand subsequently altered the picture yet again, making the lit edge of the famous red hat much more coarsely brilliant than was originally the case, Rembrandt's own ornamentations are themselves spectacular. His wife is now draped in layers of the painter's favorite materials: fur, feathers, silk, and velvet. She gives off an air of both innocence and luxuriance: the densely embroidered and braided shirt, with its immense, falling sleeve, partly covered by an old-fashioned, richly colored, but demurely tailored bodice with a slashed and puffed upper sleeve. And unlike all of the portraits of Saskia completed when she was still alive, there is something oddly removed about her in the Kassel painting. Her body remains in three-quarters profile, but the face has been turned to a full profile, its contour much more sharply delineated than that of almost any other portrait in Rembrandt's entire output, its gaze away from any sought encounter. There is a slightly enamelled quality to the head, more reminiscent of Florentine or even German painting than of the Venetian softness Rembrandt was following through the late 1630s and 1640s. It is as if Saskia, weighed down with all those ropes of pearls, had become crystallized into a gem, put away with the other treasures in her husband's upstairs *kunstkamer*.

PART FIVE

The Prophet

i *The Real Thing?*

Well then, Saskia had gone, and it was as if a peal of bells had been abruptly stopped, the clappers wrapped in a muffling cloth. The public showiness of Rembrandt's painting, its clangorous din, yielded to something quieter. Suddenly, with the exception of the carpenter Joseph's ax, there was a noticeable shortage of metal in Rembrandt's painting and a good deal more wood and stone.

It's a truism, I know, that art should never be naïvely read from life. And it's another truism that in the seventeenth century grief had perforce to be economically measured out, for there would be so many occasions to call for it. Death was everywhere, and Calvinists trained themselves in dry-eyed acceptance of the will of the Almighty. So you may, if you want, suppose that Rembrandt was not distracted by sorrow at the loss of Saskia. But the fact is that nothing in the culture precluded it, either. There were some good Calvinists who gave themselves over entirely to grief when they lost their beloved—Constantijn Huygens, for example. When Susanna van Baerle, his wife, died in May 1637, Huygens wrote a mourning Latin quatrain ending with the lines: "The white day breaks, the black night dies, you die with them / Stella, my star, my days all perish in your death."[1] A year later, roiling in an oceanic trough of misery, Huygens wrote one of the most moving poems in all of seventeenth-century European literature, *Daghwerck (The Day's Work)*, a two-thousand-line elegy documenting his struggle to bear with the daily round by somehow keeping his lost wife in his company: "As the buds which end the branches / As the wax fused by the seal / Such will be our discourse silent / As we take our daily meal."[2] But as the poem goes on, Huygens's efforts to reconcile the routines of life with his "companionable solitude" become increasingly desperate. His fortitude crumbles away, and his eloquence fails. "Who, this time, is my reader? / How shall I stand my trial in the court of this world / Without you, Stella, the sharer and guide of my pen? . . . / We talk in the dark now." And eventually it collapses altogether, the poet imploring his friends to console him, to give

voice while his own stammers into mute misery. "*Tot spreken hoort noch kracht; de mijne gaette niet / Spreeckt vrienden ick besw*——... [Speech needs strength; I have none left / Speak, friends, I succ(umb) . . .]"

Perhaps the protégé was not as prostrate as the patron. About the needs of his body, Rembrandt was certainly unsentimental, taking little Titus's dry nurse, Geertje Dircx, a bugler's widow from Edam, into his bed. And *his* eloquence did not fail him, at least not to the point of stopping his own *daghwerck*. On the contrary, his days were still full to overflowing: running the studio; instructing pupils; turning out prints and drawings, even some histories for exigent dealers like Johannes de Renialme. But things did change after 1642, and it would be obtuse not to acknowledge this out of some fear of surrendering to "Romantic myths" about the life of the artist. Sometimes the Romantics are right. Starting in the mid-1640s, Rembrandt's art did turn aside from its dazzling representations of surfaces and exteriors—the outward face of society and individuals—and began to move toward mapping the interior of things, even the body cavities of slaughtered animals. He stopped producing grandiose, dynamic histories on the scale of the theatrical barnstormers of the 1630s. The best of the religious paintings, like *Abraham Serving the Three Angels*, known from an oil sketch, and the St. Petersburg *Holy Family*, draw their emotional power from their domestic scale and intimacy, the conventions of Dutch genre painting (meals, scenes of work) imported into the sacred histories. Even the most grandiose exception to these generalizations, *Christ and the Woman Taken in Adultery*, which seemed to revert to Rembrandt's late Leiden style, painted on a panel and with its crowd of small figures set in an immense temple interior, light gleaming off piles of gold, nonetheless has at its center the intensely still figures of Christ and the kneeling adulteress garbed in penitent white.

And if he was still producing occasional histories for the rich and powerful, Rembrandt was no longer painting their likenesses. For a decade between 1642 and 1652, society portraits disappeared entirely from his repertoire, and this at a time when they were in great demand from his former pupils like Govert Flinck and Ferdinand Bol. More serious, *both* of the career trajectories he had set himself in the 1630s and 1640s seemed to have petered out. When Amalia van Solms planned the decoration of the Oranjezaal in the Huis ten Bosch palace, a mausoleum-cum-hall-of-honor glorifying, in allegorical paintings, the life and career of Frederik Hendrik, who had died in 1647, Rembrandt was conspicuously missing from the list of painters commissioned for the work. Instead the Dowager Princess went to Antwerp—the city against which her late husband had waged war—to recruit the painterly heirs of Rubens like Jacob Jordaens and Thomas Bosschaert; Dutch classicists like Caesar van Everdingen; Gerrit van Honthorst, of course; and, to cap it all, Jan Lievens, now back in Amsterdam!

Rembrandt was still hailed in many quarters as the new Apelles. But being Apelles, he was discovering, was not all nectar and laurels. In 1642, at the height of his triumph, it had still taken a committee of adjudicators—

goede mannen—to oblige the powerful Andries de Graeff to hand over the five hundred guilders Rembrandt claimed he was owed for a portrait. The reluctance of the colossally wealthy patrician to pay up could only have been on account of some dissatisfaction with the likeness. De Graeff's rejection was a fateful turning point in Rembrandt's career. It was also a deep wound inflicted on a painter more accustomed to appreciation. Salt was then rubbed into the wound in 1644, when Huygens published an anthology of verses that included the caustic ridicule of a certain painter's inability to depict the features of Jacques de Gheyn III. The line including Rembrandt's name was omitted, ostensibly to spare the painter's blushes. But since all kinds of people in The Hague, not least Huygen's brother Maurits, who owned the painting, knew perfectly well who was the butt of scorn, Rembrandt's humiliation was still likely to have been deep and bitter.

But then, as all readers of Lucian knew, the original Apelles had had to suffer the injuries of the envious, the peevish, and the malevolent. The worst of them all had been an artist called Antipholus, so consumed with jealousy that he had accused Apelles of fomenting a conspiracy against the Egyptian king Ptolemy. When the slander was revealed, Ptolemy offered to compensate Apelles for the hurt by giving him his accuser as a slave as well as a sum of gold. The painter, however, spurned the gifts, preferring, as he said, to make a picture that would express in vivid allegory the injustice that had been done to him. Painters through the ages had done their best to imagine Apelles' image of self-vindication, with the credulous ruler sprouting the ears of an ass, twitching as they listened to the lies concocted by Envy, Ignorance, and Sloth. Rubens had included the scene, based on a painting by Federico Zuccaro, in the decoration of the garden façade of his house. And Rembrandt would later himself make a copy of Mantegna's famous version of *The Calumny of Apelles*.

There would come a time when every plum job seemed to be going to rivals or ex-pupils and Rembrandt might well have felt somehow victimized, too. But for the moment, stung by the humiliation of having to submit the matter of the de Graeff painting to an arbitration of his peers, Rembrandt delivered his opinion of the critics in a startlingly abusive drawing,

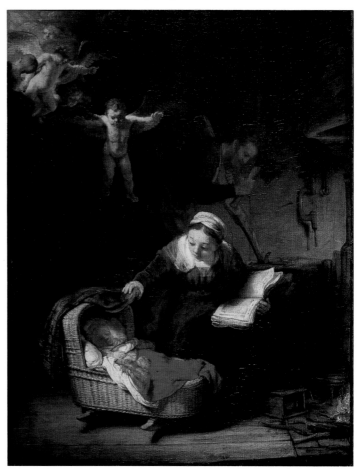

Rembrandt, The Holy Family, *1645. Canvas, 117 × 91 cm. St. Petersburg, Hermitage*

the graphic equivalent of a finger (or two) jabbed indelicately in the air. The artist squats, bare-assed, in mid-evacuation, wiping his rear with paper that looks suspiciously as though it were torn from the Collected Wisdom of the critics.[3] He is, of course, the only figure in the crowd looking directly at the spectator, his jaw set in a knowing expression, half grin, half grimace. The principal target of the artist's contempt is seated on a barrel, a pair of ass's ears sticking through his hat, an arm akimbo, delivering judgement with his pipe before a painting of a figure framed by a niche, door, or window, very much Rembrandt's favored pose in the early 1640s. The venom of his opinion is implied by the snake coiling around his right arm. The acuteness of *his* eye can be gauged from the pair of spectacles at his feet. Four other figures seem to be hanging on every word, one seated, courtier-like, at his feet; another, wearing a chain and therefore most likely the servant of the painters' guild, supports the painting and leans forward attentively. Behind the defecator stand two figures, rather more grandly dressed, one stroking his chin, gazing thoughtfully at what might be either another picture or, conceivably, a mirror held up for them.

In the opinionated dolt with the ass's ears, Rembrandt, as was his custom, seems to have gathered together a number of associations, all of them negative. One story of Apelles may even have prompted another, related by Pliny: that of the painter's greatest patron, Alexander, delivering judgements on paintings so glaringly crass that even the servants who ground the artist's pigments could scarcely control their laughter.[4] And although the seated critic is plainly dressed, his features—a rather chubby face and a slightly hooked nose—do bear some resemblance to known likenesses of Andries de Graeff! It's even been suggested that the principal object of ridicule might be none other than Huygens, although since Rembrandt was still being commissioned by the Stadholder to produce history paintings, this seems unlikely. Ernst van de Wetering, however, quotes Samuel van Hoogstraten, a pupil of Rembrandt's during the 1640s, as later describing the "laughable" antics of the "asses" who were "conceited or pedantic connoisseurs" and who "not only deceive ignorant art lovers by selling ragged copies for true originals, and this seemingly cheaply and for a low price, [but] also deceive themselves being pleased when putting the worst faults and shortcomings, instead of the virtues, as miracles before their eyes and praise what deserves only contempt, thus belittling the master of the original."[5]

It seems likely, then, that Rembrandt was thinking not so much of any particular individual as of whole classes of jackasses as the butt of his derision. At the top of his list of targets of contempt were empty-headed windbags whose opinions ran ahead of their knowledge, as well as their victims, the gullible "name-buyers" (*naem-kopers*) on the right, who mistook poor rags (*vodden*) for the real thing.

The sly expression on the face of the artist might best be described as knowing. As the master of the busiest and most influential workshop in Holland during the late 1630s and 1640s, Rembrandt was well placed to know all about copies, both honorable and dishonorable. Copying the

Rembrandt, Satire on Art Criticism, *1644. Pen and brown ink drawing. New York, Metropolitan Museum of Art*

works of both past and present masters was, of course, not only not discouraged in the studio, it was assumed to be an indispensable part of a young artist's training. Drawn copies, done with brush and gray wash, copies of Rembrandt's own work—of the London *Flora,* for example—have survived, and near literal transcriptions of paintings like the Louvre *Angel Raphael Leaving Tobias* and the Munich version of *The Sacrifice of Isaac* were so successful that they have caused headaches for modern connoisseurs attempting to distinguish what the seventeenth century knew as *principaelen* (originals) from their doubles. The Munich painting, which added a sacrificial ram and had the angel intervening from the right rather than the left, is unique in bearing the candid inscription "altered and overpainted by Rembrandt," almost certainly by a hand other than the master's. But there were at least a few cases of paintings which, while essentially based on a design by Rembrandt, were executed principally by pupils or assistants like Barent Fabritius and Samuel van Hoogstraten, but which were nonetheless known as "Rembrandts" even in his lifetime.[6]

This is surprisingly close to the division of labor in Rubens's workshop, where the Master supplied the invention, retouched the painting at the very end, but left everything in between to his "staff." There are too few surviving quasi-Rembrandts in this manner to suggest that Rembrandt was guilty

of the deceptions he ridiculed in his drawing. He would have been the first to make an indignant distinction between deliberately fabricated copies (the "rags") purporting to sell as *principaelen* and the works overtly described as "after Rembrandt" (*nae Rembrandt*) offered to customers unable to afford the originals.

On the other hand, though, there was nothing to stop him from *assigning* literal copies of his own work as study projects to his pupils and reaping the profit from the results. Arnold Houbraken commented in the early eighteenth century that, not content with taking his fee from pupils, Rembrandt made two and a half thousand guilders a year from the sale of such work, which also undoubtedly included works in the Rembrandt "vein": *tronies,* small histories, portraits, and even perhaps still lifes. The workshop on the Breestraat, after all, was both business and school, a fact that might have offended later high-minded critics who believed that art and commerce ought to be kept strictly separate, but which, in the middle of the seventeenth century, was perfectly acceptable practice.

From the mid-1630s onward, Rembrandt's fame drew students from all over the Netherlands and from Germany and Denmark. Virtually none of these prospective pupils would have expected him to provide their basic instruction in drawing or painting. Rembrandt was already too important and too expensive for that, charging a hundred guilders a year for his teaching. Virtually all of them would have been sent on from another master. Govert Flinck, for example, had been sent by the Frisian painter Lambert Jacobsz., who managed the Leeuwarden branch of the van Uylenburgh art firm. Ferdinand Bol, who studied with Rembrandt for a number of years in the late 1630s, was the son of a master surgeon in Dordrecht, and would also have had some prior instruction. Gerbrandt van den Eeckhout, who was in Rembrandt's studio around the same time as Bol, specializing in history paintings with relatively small figures set in landscapes (rather in the manner, in fact, that Rembrandt had left behind with Lastman), was the son of an Amsterdam goldsmith whom Rembrandt, with his enormous interest in decorative plate, is likely to have known personally. So while Joachim von Sandrart might have exaggerated when making his assertion that "countless young men of the foremost families" came to study with Rembrandt, it certainly was the case that most of his pupils and assistants were from relatively well-off and reasonably well-connected families who could afford the hefty annual fee. Some of them may only have come to Amsterdam to round out a liberal education with the most important master of the city, intending, like Constantijn van Renesse, eventually to return to their native town (in his case, Eindhoven in Brabant) and lead the life of a patrician, or, like Rembrandt's second cousin Karel van der Pluym, to continue to practice a wholly different profession: that of city hydraulic engineer of Leiden.

Many more, though, must have come to the Breestraat in full earnest, determined to make themselves into masters in their own right. Samuel van Hoogstraten was no more than fourteen when he arrived in Amsterdam

from Dordrecht. His father, a genre and landscape painter who had given him his first instruction, had died in 1640, and Samuel had resolved to go to Amsterdam over the strenuous objections of his family. Why would any reasonably gifted young fellow dream of choosing someone else as his master when he could have the priceless opportunity of being instructed by Rembrandt? Hoogstraten's own pupil, Houbraken, in his potted biography of Govert Flinck, wrote that because

Rembrandt school, Rembrandt with Pupils Drawing from the Nude, mid-1640s. Pen drawing with wash and brown ink over black chalk. Darmstadt, Hessisches Landes-museum

"Rembrandt's manner was so generally praised . . . everything had to be based on it [so that] to please the World he [Flinck] found it advisable to go and learn from Rembrandt for a year, where he became accustomed to that handling and manner of painting."[7] It was the mark of Flinck's talent, Houbraken goes on, that after only "this brief time" his own work was taken "*and sold*" (my emphasis) as the "true brushwork of Rembrandt."

Some of the most proficient of the students, like Bol, Hoogstraten, and Carel Fabritius, stayed on in the studio well beyond any period of instruction, becoming, in their own turn, teachers and assistants, passing on to another cohort of pupils the essential elements of Rembrandt's manner: his dramaturgy of light and obscurity; the subtle interlocking of color so that it modelled, rather than merely delineated, form; the manipulation of the face and the body to indicate both the inner and the outward movement of the passions. Rembrandt's own etchings of nude youths posing for a life class, and a student drawing showing the master with a diverse group of pupils including an older bespectacled man and a group of younger apprentices, document the regular practice of drawing from models, both male and female.[8] Crispijn van de Passe's drawing book of 1643 shows a group of pupils sitting sketching a model posing in the manner of a Jupiter, and Willem Goeree's instruction manual published in 1668 suggested that students find a master or recruit an informal gathering of eight to ten artists who would make up a *collegie,* or academy, specifically for this purpose. It is quite possible that independent artists in Rembrandt's circle, like Govert Flinck and Jacob Backer (both Lambert Jacobsz. protégés), who were not formally part of the "school" would have actively shared these life drawing sessions.[9] And given the special importance of selective lighting in Rembrandt's art, it also seems likely that they would have met for night draw-

*Crispijn van de Passe,
Frontispiece from*
Van 't ligt der teken en
schilderkonst *(Amster-
dam, 1643). New York,
Columbia University,
Avery Library*

ing sessions, again as indicated in Goeree's manual, working beneath oil lamps hung strategically to create the most pronounced play of shadows.[10]

It's easier to reconstruct the physical circumstances of Rembrandt's "school" than to imagine what he must have been like as a teacher. Presumably based on what his own teacher, Hoogstraten, told him, Houbraken described pupils working in small cubicles, an impression confirmed by the assessors who came to Rembrandt's house in 1656 and whose inventory mentions areas on the upper stories partitioned into small spaces. Houbraken's portrait is of a rather cantankerous, compulsively avaricious master whom the students would deliberately deceive by painting coins on the floor which Rembrandt would then stoop to collect. Writing a generation after Rembrandt's death, Houbraken anthologized the many anecdotes circulating about Rembrandt, most of which portrayed a cranky and disagreeably eccentric figure, short-fused and obdurate, someone whose incomprehensible partiality for recording ruined, ungainly, and generally unappetizing aspects of nature, human and otherwise, was of a piece with his own intemperate personal and work habits.

By the time Houbraken wrote his biographical sketch, Rembrandt's manner of painting was under severe attack from the avatars of a purified classicism, and the misfortunes and transgressions of his personal life had made him notorious (though no more so than many others recorded in the annals of van Mander and Houbraken). Unlike his pupil Jacob van Loo, who would have to flee to France after murdering an innkeeper, Rembrandt had not actually done anyone in. And in the 1640s, at the height of his fame and powers, there is nothing at all to suggest the foul-tempered martinet of the posthumous caricatures. One of the relatively few surviving drawings that graphically document his teaching, an *Annunciation* by Constantijn van Renesse, shows the master's drastic enlargement of both Mary's reading desk and the angel Gabriel, transforming the latter from a delicately drawn and human-scaled youth into a true apparition, the emanating light being all the more dramatic for Rembrandt's other alteration—the emphatically closed shutters. It's easy enough to imagine Rembrandt leaning over his understandably nervous young pupil, seizing his pen and chalk, and making, in a few decisive lines, the difference between a passable and an excellent drawing.[11]

Much depended, of course, on the kind of talent Rembrandt had to work with, which, even among the figures known to have worked in Rembrandt's

studio (a very small proportion of those who actually did), was extremely various. Almost all of them had *some* sort of aptitude. Rembrandt's students of the 1630s— Flinck, Bol, and Johannes Victors—were all quick to pick up the skills of rendering textures of both fabric and precious metals that had won Rembrandt commissions for both histories and society portraits in a city which, for all its Calvinism, was increasingly infatuated with its glittering reflection. The result is a large batch of "Rembrandt-brand" imitations: of young men in steel gorgets; old men in turbans; couples got up, Arcadian fashion, with flutes and flowers; matrons wrinkled and leathery; ruffed burghers, heavily starched and imposing. Sometimes the pupils or ex-pupils like Bol appropriated details from Rembrandt's most successful paintings (just as he had taken details from Lastman). The exotically overwrought bed on which Danaë reclines to receive her golden insemination, for instance, turns up again in a more pious vein as the bed from which Isaac bestows blessings on Jacob and Esau.

Constantijn van Renesse (corrected by Rembrandt), The Annunciation, *late 1640s. Pen drawing with brown wash and red chalk. Berlin, Kupferstichkabinett*

Some of these knockoffs of the 1630s and 1640s are, in their way, pretty good. Govert Flinck's histories and portraits in particular show the makings of an independent style which by the 1640s, as his contributions to the Kloveniersdoelen suggested, would increasingly diverge from his master's, becoming more sharply lit and brightly colored. Many more, though, are mediocre, and some, now reverently overappreciated, are conspicuously dreadful. But even when they were performing competently, *none* of Rembrandt's pupils, associates, or assistants ever came close to the *conceptual* originality which produced *The Anatomy Lesson of Dr. Tulp, Jan Rijksen and Griet Jans*, and the Anslo double portrait.

For the most assiduous pupils, the trouble was that as quickly (or laboriously) as they grafted Rembrandt's techniques onto their own native skills, their master was busy altering the fundamentals of his own style. By the early 1640s, when a new cohort of pupils had arrived, including some of the most gifted of his followers—Carel Fabritius and his brother Barent, and Samuel van Hoogstraten—Rembrandt was moving away from the strongly colored, animated Baroque history style of the previous decade

Ferdinand Bol,
Historiated Portrait of
an Eighty-one-Year-Old
Woman, *1651. Canvas,*
129 × 100 cm.
St. Petersburg,
Hermitage

(*Belshazzar's Feast* and the *Samsons*) and toward a much denser, more sculptural handling of paint and a more meditative and poetically self-contained choice of subjects. His palette, for the most part, becomes stripped down to the famous four-color range (black, white, yellow ocher, and earth reds) which was all Apelles himself had been said by Pliny to need, even to paint Alexander at the Temple of Artemis at Ephesus holding a thunderbolt.[12] But during the 1640s, Rembrandt seemed less interested in furious spectacle and metallic brilliance. Instead, an absorbent earthiness comes to dominate the pictures, the paint itself made more pasty and opaquely solid, often with the addition of gritty material like crushed quartz and silica. Panels, for the most part, disappear, with Rembrandt using the coarse weave of his canvases as an intrinsic element in the composition, the thickly loaded bristles of his broad brush allowed to spread the creamily viscous paint unevenly over the surface.

Now that Rubens was gone, Rembrandt was going back to one of Rubens's most admired *paragones,* Titian, for lessons in the suggestiveness of the broken surface. While the feathery, agitated motion of late Titians is not mechanically reproduced in Rembrandt's experiments with paint in the 1640s and 1650s, the profound paradox by which the *solidity* of things—bodies, costumes, still-life detail—could be better suggested by loose, open, and free painting than by hard-edged linear description makes itself powerfully felt. This "rough" style with its deliberately *non-finito,* unfinished, appearance had long been considered a subtle miracle of illusionism, but a dangerous lure for those seeking to emulate the Venetian master. While professing admiration for Titian's late manner, Karel van Mander (who certainly never tried it himself) expressly cautioned against imitating it, warning that those who had made the attempt without Titian's own skills risked embarrassing failure.

The more spectacular passages of *The Night Watch* had already shown that Rembrandt was fully capable of emulating Titian's paradoxical gift for making the most roughly painted areas appear, from a distance of course, the most three-dimensionally projected. (Apelles's painting of Alexander at Ephesus was also admired for the way in which both the King's fingers and the thunderbolt appeared to project from the surface.) In the decade after *The Night Watch,* Rembrandt experimented with strikingly different manners of painting within the same composition, using broadly dabbed-on

strokes for both dark backgrounds and the textured surfaces of cloth and stone. His figures and faces—often of deceptively simple subjects like kitchen maids—and still-life material manage to seem, somehow, softly modelled and enduringly monumental. To emulate *that* achievement took more subtlety than most of Rembrandt's pupils, with the possible exception of Carel Fabritius and Samuel van Hoogstraten, had at their command.

To see the Rembrandt of this period both closely imitated and yet elusively inimitable, one has only to look at the Dulwich Picture Gallery *Girl at an Open Door.* The painting is another of Rembrandt's experiments with proximity, an arm turned parallel to the picture plane, as in his *Self-portrait at the Age of Thirty-four* and the portrait of Herman Doomer. The girl's pose is at once simple and disturbingly seductive. The shirt, thickly painted in Rembrandt's broadest manner, seems, like its wearer, the essence of homespun, yet the girl's fingers toying with the gold necklace doubly wound about her neck draw attention to the opening at her throat and between her breasts, darkened by the shadow cast by the wrist. The shadowing between the edge of the rolled-up sleeve on her right arm, or cast by the end of her nose on the upper lip, and even the tiny shade of the stray curl falling over her forehead (and touched in with Rembrandt's *finest,* lightest brushwork) are all done with extreme subtlety and delicacy. Together, though, they combine to give an uncanny sense of the living presence of the girl, leaning ambiguously toward us. The same combination of a more broadly and roughly painted fabric against which to juxtapose the soft sensuousness of flesh and skin is evident in Rembrandt's *Young Woman in Bed,* ostensibly an image of Tobias's demon-infested bride, Sarah, awaiting her groom on her wedding night, and thus an image poised precisely on the borderline between carnality and innocence.

The Dulwich painting is signed and dated 1645. In the same year, or very close to it, another three paintings of extremely similar subjects, all posed either at half-open doors or at windows, were painted by artists in Rembrandt's studio or his immediate circle. Each of the imitative paintings, while trying to be faithful to Rembrandt's style at this time, even copying the strong highlights at the tip of the nose or the fine flicked-in hair, demonstrates a wide range of skills at approximation. The Bedford painting is the most obviously laborious, the light sharper, the shadows unsubtle, the flesh pinks rather porcelainlike without any of the fresh effect of "ruddy good nature" admired by nineteenth-century essayists. Reasonably, then, the painter is thought to have come from the second rank of pupils at this time—perhaps Karel van der Pluym, Christoph Paudiss, or Constantijn van Renesse. The Washington, D.C., *Girl with a Broom,* with her Cupid's-bow lips and crossed hands, however, is much more strongly executed, perhaps, in fact, a little too strongly, with inadequate transitions between the brilliantly lit and shadowed passages of the face—rather as though a flashlight were being shone from the left. The painting is currently given to Carel Fabritius, who of all the pupils was perhaps the one who best mastered the solidity of Rembrandt's forms at this time and who was certainly interested

in experiments in optical illusion. But by 1645 Carel, unlike his less skilled younger brother Barent, had returned to his native village of Midden-Beemster.

The third painting (page 525), which also bears a plausible though subsequently altered Rembrandt signature and 1645 date, is now called a Samuel van Hoogstraten. It's been argued that a progression of motifs leading to the *Young Woman at an Open Door* begins with a Hoogstraten in the Hermitage of a young boy leaning at just such an open door, continues through a self-portrait of the eighteen-year-old painter, finally arriving at the maid with the sidelong glance in Chicago. But this is a shaky syllogism. For although Hoogstraten's two paintings clearly demonstrate his unbounded confidence in trying out Rembrandt's broadest manner of brushwork, it's actually the *fine* work of the Chicago girl's hair and the exceptionally beautiful shading on her face, especially at the corner of her mouth as well as the subtle highlight on her right upper eyelid, that are completely beyond Hoogstraten's style at that time. There is also the matter of the half-turned, watchful, almost suspicious head, avoiding the usual ingratiating gaze at the beholder and *never*, in all

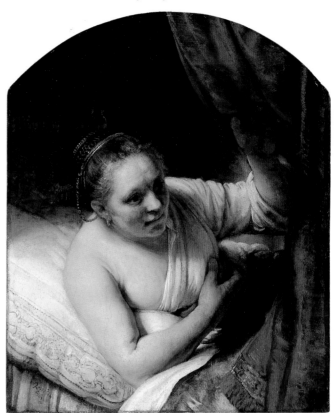

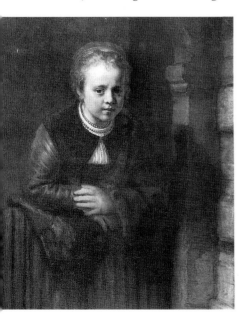

the countless imitations and variations of "servants at the door" that appeared later in the seventeenth century and through the eighteenth and nineteenth centuries, ever recurring.

Could it be that the Chicago painting is a case where the master and his student collaborated on the same composition? It's quite easy to imagine Hoogstraten sketching in the essential design in "dead color," perhaps taking a good look at Geertje Dircx as he did so, for the woman wears a dress characteristic of the Waterland villages from which Rembrandt's mistress came. Then he may have worked the sketch up to some point where the master provided the crucial finishing

ABOVE: *Rembrandt, A Young Woman in Bed, c. 1647. Canvas, 81.3 × 68 cm. Edinburgh, National Gallery of Scotland*

LEFT: *Pupil of Rembrandt, Girl at an Open Door, 1645. Canvas, 75 × 60 cm. The Marquess of Tavistock and the Trustees of the Bedford Estate*

OPPOSITE: *Rembrandt, Girl at an Open Door, c. 1645. Canvas, 81.6 × 66 cm. London, Dulwich Picture Gallery*

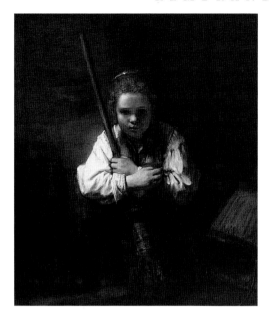

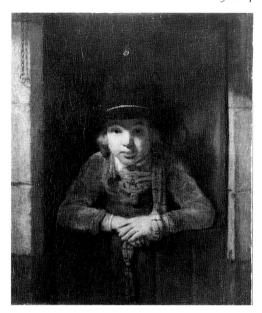

LEFT: *Carel Fabritius,
A Girl with a Broom,
c. 1651. Canvas,
78 × 63 cm. Wash-
ington, D.C., National
Gallery of Art*

RIGHT: *Samuel van
Hoogstraten,* Young
Man at an Open Door,
*c. 1647. Canvas, 42 ×
36 cm. St. Petersburg,
Hermitage*

touches, and thus, with some real justification, in the Rubens manner, put his own signature to it.

In any event, Hoogstraten, who was on his way to becoming an accomplished poet as well as a painter, was not one likely to hide behind his master for very long. Around 1647–48 he had the temerity to do what Rembrandt had done to Rubens in 1631: steal his paragon's pose. He painted himself in a classical niche in virtually the identical pose Rembrandt had adopted for his *Self-portrait at the Age of Thirty-four,* but if anything decked out in even grander style, his arm resting not on the stone sill but on a sumptuous pillow, a steel gorget about his neck (of the kind that Rembrandt had worn for his own earlier self-portraits), and with a grand chain of honor, complete with medallion, slung across his breast. What made the gesture even cheekier was the fact that Hoogstraten was not only announcing his competition with the master but appropriating for himself all those other shades—of Raphael and Titian—that Rembrandt had incorporated into his own self-portrait. No one, then, could possibly accuse the twenty-year-old Samuel van Hoogstraten of false modesty.

Hoogstraten would go on to become famous at the court of the Habsburg Emperor in Vienna as a master of illusionism. And although we never think of Rembrandt as especially interested in optical deceits of the literal kind that would make Hoogstraten's name (and actually earn him the medal he prematurely displayed in his self-portrait), it's entirely possible that the master taught him a trick or two. For *one* of Rembrandt's painted girls at a window—perhaps the much later and more freely painted picture of 1651 now in Stockholm, but more likely the Dulwich College painting—features in an anecdote told by the French critic and art theorist Roger de Piles. In the introduction to the published version of his lectures at the Académie Royale, in which he awarded points to the Zeuxises and Apelles

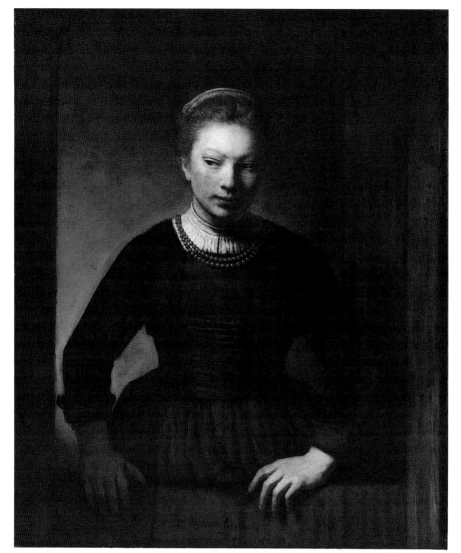

Samuel van Hoogstraten and Rembrandt (?), Young Woman at an Open Door, *1645. Canvas, 102 × 84 cm. Chicago, Art Institute of Chicago*

and Protogenes of the past century, Rembrandt getting a mere six (out of twenty) for drawing, though a seventeen for color and eighteen for composition, de Piles told the story of the artist

> amusing himself by painting the portrait of his servant girl. He wanted to arrange it in front of the window so that the passersby should think that she herself was really to be found there. He succeeded, as the optical illusion was discovered only several days later. As one can imagine, in Rembrandt it was neither the beautiful drawing nor the nobility of expression that caused the effect.[13]

Roger de Piles may have had a special interest in the innocence of deceit. Understandably, he omits from a reference to his "stay" in Amster-

Rembrandt, Kitchen Maid, *1651. Canvas, 78 × 63 cm. Stockholm, Nationalmuseum*

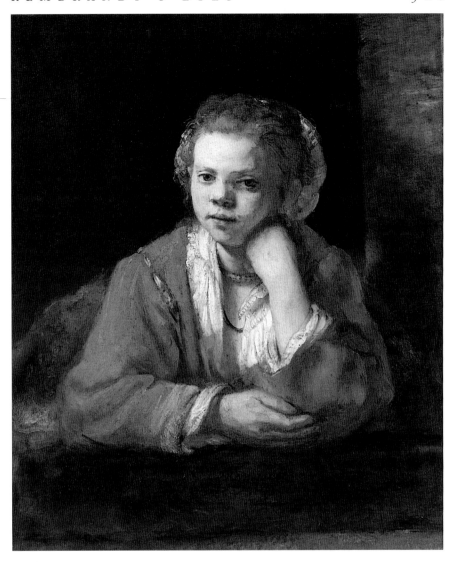

dam in 1693 that he was there as the secret agent of Louis XIV, charged with making contact with a potential "peace party" in Amsterdam. Unluckily for him, his letters from Versailles were intercepted and he was arrested and thrown into the prison at Loevestein Castle. Unlike Hugo Grotius, he failed to make his escape in a book chest or even a painting crate and was released four years later when a peace treaty was signed between France and the Dutch Republic. But before he was banished forever from the Republic, he managed to make one crucial acquisition which perhaps he sent home before his embarrassing detention. It was the painting of the girl playing with the gold chain about her neck, her snub nose and lips shining and the dark eyes looking directly at the spectator. The high-minded critic kept it with him for the rest of his life.

ii *The Mutable Line*

To look at Rembrandt's little *Winter Landscape* of 1646, you might suppose that, as usual, he was going quite the wrong way. Not in his country walks, which took him, like most Amsterdammers, south along the banks of the Amstel toward the bend in the river called the Omval, or even further to the manor house known by the unconvincingly self-deprecating name of Kostverloren, or "Write-off." Or he might walk east along the raised embankment of the IJ called the Diemerdijk looking one way at the boats, the other at the cows and cottages huddled behind the dike. It was not his strolling habits that went against the grain so much as his chosen manner of painting, which seemed perversely old-fashioned. The little panel, with its bone-biting blue sky, skeletally stripped winter trees, and humdrum single figures plodding about their business or seated, skates up, on the grimy snow, seemed a direct throwback, if not an explicit homage, to the artist who had pretty much invented the native, local, pure-and-simple Dutch landscape: Esaias van de Velde.

Esaias had been the first artist to translate a direct and unliterary view of his own countryside from the drawings and prints that had been made by Goltzius, the unknown limner known as the Master of the Small Landscape, and the topographical album makers like Claes Jansz. Visscher into *paintings*.[14] The achievement was all the more unlikely since Esaias van de Velde was himself no boor turned artist but a sophisticated and learned figure, another displaced Antwerp Protestant who eventually settled in The Hague and had the Stadholder as one of his patrons. Like his teacher David Vinckboons, another Fleming, he had made a living from painting "merry companies" of egregiously overdressed youths feasting and fondling in love arbors; crowded and sometimes terrifying scenes of bands of marauding soldiers attacking villagers; and finally densely anecdotal landscapes, each little incident (a cow on a ferryboat) picked out with patches of bright local color. But then, around 1614, came a great alteration in which both subject matter and color were flattened out; the angle of vision drastically lowered; the painting reduced to a sketchy, raw economy; the figures eerily isolated from each other rather than clustered in the social groups required by artistic convention; the eye acute but dispassionate, the whole vision deeply averse to the charm of the bucolic.

And this was the manner Rembrandt had chosen to emulate precisely at the point when the most sought-after and prolific Dutch landscapists like Esaias's pupil Jan van Goyen were moving *away* from simplicity and toward a more heroic vision of their native habitat. The angle of vision was rising once more, the horizon sinking, the better to fill the top two thirds with the thundering opera of the Dutch sky.

Rembrandt, of course, was not averse to landscape operatics himself. During the 1630s, no one had been more extravagantly melodramatic in his landscape pictures than Rembrandt himself.[15] They had been of a piece with the muscular histrionics of his histories, full of flashing, fitful illumination, and always seeming to enclose some obscure history, even when they did

not. The *Mountain Landscape with a Thunderstorm,* done around 1640, was also reminiscent of Rubens's early landscape-histories, like the *Landscape with the Shipwreck of Aeneas,* using the same eagle's-eye airborne view and the combination of multiple topographies, mountainous and lowland, unified by tonal atmospherics. The tradition of such "world landscapes" was, in fact, even older, going back to Herri met de Bles and Joachim Patenir at the beginning of the sixteenth century and consummated a generation later in the landscapes of Pieter Bruegel the Elder, in which not only diverse but actually startlingly incompatible scenery—soaring Alpine

crags and Brabant wheat fields—were accommodated in the same composition as though they were adjacent topographies.[16] This Olympian vision was an expression of rapture at the Creator's universal design, his infinite capacity to pattern the rich variousness of the visible world. It was of a piece with the passion of humanist scholars to bring the infinitely diverse, but ultimately complementary, phenomena of nature into a single space—be it a botanical garden or an encyclopedic *kunstkamer* of the kind Rembrandt himself had cre-

Rembrandt, Mountain Landscape with a Thunderstorm, *c. 1640. Panel, 52 × 72 cm. Braunschweig, Herzog Anton Ulrich-Museum*

ated. It was orderly omniscience, this intellectual and instinctive acquisitiveness; philosophical plenitude, Aristotle's appetite ruled by Plato's regimen.

Rembrandt had this hunger to digest the world in trencherfuls. It was the same instinct that Karel van Mander ascribed to Bruegel when he wrote of him "swallowing the Alps whole and spewing them out onto his canvas."[17] So the travellers in Rembrandt's own storm-tossed paintings of the late 1630s trudge laboriously through theatrically zoned passages of obscurity and brilliance, pass beside craggy keeps, beneath jutting, vertiginous cliffs or over ancient bridges, and onward, like pilgrims, to a lit horizon punctured by the beckoning salvation of a church spire. But Rembrandt added to this picturesque overload a distinctly different sensibility—the feeling for ruins, for landscapes full of crumpled, eroded, fallen-in and thrust-up things, stumps of half-collapsed masonry or softly crumbling rock, all of which he had discovered in the sensationally original artist (and Flemish Mennonite refugee) Hercules Seghers, eight of whose paintings he owned at the time of the 1656 inventory, one of which (now in the Uffizi) he actually retouched. This apparently perverse pleasure in the scarred and pitted face of nature was, of course, the topographical equivalent of Rembrandt's favored taste in *tronies*, where, from a very early age, he had loved to linger over every crease and wrinkle in an ancient face, or of his unembarrassed preference for the irregular, pleated, and corrugated bodies of naked women over the polished, perfectly proportioned, and pock-free classical body, or of his delight in the tatterdemalion splendor of vagabonds. Pitifully insignificant travellers wandering their way through mountainous peril were a platitude of Baroque landscape both north and south of the Alps, especially well known in the work of Joos de Momper.

Hercules Seghers,
Abbey at Rijnsburg,
1620s. Etching.
Amsterdam, Rijks-
prentenkabinet

But in his graphic work, Seghers had taken the commonplace and made from it something unearthly. And he had done so by using etching techniques no one else had imagined: printing his writhing, stippled, speckled, and abraded lines in colored ink on a ground prepared in a different color, and then, on occasion, covering the finished print with yet a third tone. For one version of the ruined abbey at Rijnsburg, for example, Seghers used yellow ink on a black ground and then hand-colored details of the bricks in red. For another, he would use a blue-tinted paper. Each impression was thus a quite distinct work of art with the individuality of a painting rather than a mechanically duplicated print.[18] The effect of Seghers's coloring, when taken together with his densely wrought lines, was to dissolve the ostensible subject matter—claustrophobically cultivated plateaus or valleys packed into the hollows between immense and threatening mountain ranges, ruined abbeys, or moss-bedecked pines—into an elementally expressive mood-space, neither quite of this world nor beyond it. It is as though Seghers knew of the budding debates on the origin of mountain ranges, thought to be the shattered remnants of a primordial world destroyed by the Great Flood, and was trying to convey the enormity of the geological drama.

No wonder, then, that Rembrandt was so drawn to Seghers's imaginative overdrive and technical wizardry. He may have especially admired Seghers's creative audacity in deliberately leaving the marks of accidents (like a darkened area of sky made by a piece of cloth straying onto the plate) on his impressions. And if he believed the stories, he may not even have been completely surprised at the trouble Seghers had apparently brought on himself by his disturbing inventiveness. According to Samuel van Hoogstraten, who was himself an admirer and avid collector of the colored prints, Seghers had prospered enough (partly through a well-connected

marriage) to buy a grand house on the Lindengracht in Amsterdam, whose name he changed from "the Duke of Gelders" to the more aptly picturesque "Falling Water." But then, he himself had fallen into a lake of debt, black and deep. Forced to sell up and leave the city, Seghers had resettled first in Utrecht and then in The Hague, dealing in art as well as making it. Though he attempted to strike a compromise with current taste by making relatively realistic panoramas, his fortunes failed to improve and his life was ended, again according to Hoogstraten, in a drunken fall down a staircase sometime between 1633 and 1638.[19]

Rembrandt needed no cautionary lessons. His habit was not to go looking for trouble, even if sometimes he failed to avoid it. And while some of his paintings, like *Mountain Landscape with a Thunderstorm* and *Landscape with the Good Samaritan* are very Seghersesque in both composition and atmospherics, others like *The Stone Bridge* contained their elemental drama within a local and more familiar topography: an inn by a riverbank; fishermen; a group of cottages with roofs caught by a shaft of sunlight. In some of his earliest etchings, Rembrandt transferred his affection for the staved in and the tumbledown to subjects which had already appeared, twenty years earlier, in paintings turned out by the cartload by the likes of van Goyen, Pieter de Molijn, and Salomon van Ruysdael: cottages with subsiding timbers and piebald thatch; massive windmills raised up on defensive bastions with their timbered sides weathered, the sails slightly ragged, like old soldiers recovering from one campaign too many. All these

Rembrandt, The Stone Bridge, *c. 1637. Panel, 29.5 × 42.5 cm. Amsterdam, Rijksmuseum*

Rembrandt, Het Molentje, *c. 1649–51. Pen, brown ink, and wash with touches of white on oatmeal paper. Cambridge, The Syndics of the Fitzwilliam Museum*

scenes were unlikely to offend or baffle anyone, even if their loving survey of rustic dilapidation was by now likely to seem quaintly nostalgic.

The first generation of Dutch landscape printmakers—Jan van de Velde II, Willem Buytewech, and especially the prolific, commercially shrewd Jan Claesz. Visscher—had catered to a public that was just beginning to indulge itself in something shockingly new in European culture: the country walk.[20] In fact, the frontispiece inscription on Visscher's "Pleasant Places" series of etchings of scenery around Haarlem still advertised itself as suitable for "art lovers who have no time to travel." But Visscher's collection was published in 1612, the third year of the truce, and as more settled conditions established themselves in the Dutch countryside, so the opportunity to take excursions—by boat or wagon, or on foot—became both more possible and more desirable. It was encouraged in the 1620s and 1630s by the pastoral craze which began as the importation into Dutch urban culture of the Italian, especially Venetian, fancy for dressing up (like Rembrandt and Saskia) as shepherds and shepherdesses and going to see musical and theatrical entertainments featuring lovelorn swains and merciless maids.[21] Parties of would-be Silvias and Corints, Granidas and Daifilos, made their way, often in *speelreisje* wagons, into the villages around Amsterdam, especially to the south (their servants following with the victuals), and took their playacting into the meadows and copses. Doubtless the *real* peasants became grimly accustomed to these gangs of preposterously got-up town kids crowning each other with *bloemenkransen,* flowerchaplets, reciting poetry, and getting drunk among the cowslips. They may even have made a few pennies out of them if they needed shelter in a rainstorm or a *kan* of beer in a broken-down *langhuis,* whose "quaintness" they noisily enjoyed.

By the time Rembrandt became seriously interested in sketching and etching the country around Amsterdam in the early 1640s, the day-out-in-the-country (which would have had to be a Sunday), or the afternoon walk, was no longer the privilege of the hooting and shooting classes. Amorous songbooks like Jan Starter's *Friesche lusthof* (*Frisian Pleasure Court*), Rembrandt's friend Jan Harmenszoon Krul's *Minnelycke sangh-rympies* (*Lovers' Rhyme-Songs*), and the *Spiegel der Nederlandsche ieucht* (*The Mirror of Dutch Youth*) were all published cheaply and in small format and could be taken along for the excursion. And since the newly established passenger barges, the *trekschuit*, had put the ferrymen and rowboat oarsmen of the Amstel out of business, they got some of their livelihood back by hiring themselves out as pleasure boats, one of which can be seen in Rembrandt's etching of *The Omval*.[22] The passion for country outings and the threat they represented to the chastity of the young people of Holland was such that by the late 1630s Calvinist moralists like Jacob Cats were regularly denouncing the wagon and boating trips, and even unchaperoned country walks, as fraught with moral peril.

Rembrandt's biographers have sent him off on walks in the countryside around Amsterdam drinking in nature's consolation for the loss of Saskia. And there's no reason to suppose that he was any less affected by the death of his wife than Rubens and Huygens were moved by the loss of theirs. It's also true that seventeenth-century poetry often did draw on nature imagery as a balm for affliction. But it seems to me to be a mistake to conjure up an image of the painter tearfully trudging the towpath, fleeing the town, and hiding his wretchedness in the woods and the water meadows. His etchings of the 1640s and early 1650s are not at all Arcadian in the sense of a dream landscape from which all urban presence has been banished. On the contrary, they usually feature a recognizable urban skyline (usually, of course, the towers, church spires, and windmills of Amsterdam, but occasionally, as in the so-called *Goldweigher's Field*, Haarlem—see page 568).[23] In fact, the drawing by a follower of Titian featuring a pair of lovers shaded by a tree which was copied by Rembrandt and has sometimes been invoked as the prompt for his own pairs of concealed lovers in the prints of *The Three Trees* (1643) and *The Omval* (1652) appealed to the Dutch artist precisely because of the *close proximity* of a row of imposing buildings, including a large church, and the amorous landscape.[24]

Most of Rembrandt's landscape etchings are strikingly marked by a gentle human traffic that presupposes the interpenetration of the urban and rural worlds, not their opposition. Even when Rembrandt, for example, etches, most beautifully, an empty boat moored by the side of the canal, the image is loaded with the implication that its passengers, perhaps lovers, are happily parked some ways off out of our sight, but not out of our imagination. Elsewhere, there is all kind of activity: fishermen dangling hooks in the water, other fishermen taking the catch home in baskets. The house beside the windmill and aptly called "Het Molentje," seen from across the Amstel in one of Rembrandt's most exquisite drawings, done on

oatmeal paper, was likewise not simply a picturesque miller's habitation
but one of the most famous inns south of the city. As quiet as the drawing
is, Rembrandt means us to hear the faintest echo of pleasure, like distant
song, drifting across the still water. All these things are, to be sure, idylls.
But they are, in the seventeenth-century sense, suburban idylls.

And they record the observations of a walker, not a rider. Rubens, on
the other hand, recorded the horseman's view of the countryside around
Steen: manorial, proprietary, bucolic; the eye of the squire watching *his*
peasants in their carts, his beaters and shooters stalking the bracken for
partridge. Who knows? Perhaps Rembrandt, at the height of his prosperity
and social pretensions, might also have coveted a house like Kostverloren,
Banning Cocq's fake Gothic "Ilpenstein," or the country property of a new
friend and patron, the gentleman poet Jan Six. But he would never get him-
self a Château de Steen. He would always be the guest, not the host; the
pedestrian, not the equestrian. And he may have liked it that way. Even
before Saskia's death, he had already begun to sketch his walks. One light-
ning drawing, almost scribbled, on prepared vellum suggests that, like
many artists, he took with him a silverpoint "pencil" and an erasable tablet
and then worked the sketches up in the studio, either as a pen-and-brush
drawing or as an etching.[25] This allowed Rembrandt to bring together the
two manners of drawing—*uyt den gheest* (from the imagination) and *naer
het leven* (from life)—in whatever combination struck him as most pleas-
ing. Sometimes it's the immediacy and obvious spontaneity of the land-
scape that is its most striking feature, as in the lightning etching of *Six's
Bridge,* done in 1645 (it was said by the first cataloguer of his prints,
François-Edmé Gersaint) on a wager that he could complete the composi-
tion in the time it took Six's servant to go to the village for mustard and get
back to the house.[26] At other times, the poetic conceit prevailed, as when he

Rembrandt, The Wind-
mill, *1641. Etching.*
New York, Pierpont
Morgan Library

set unexceptionally Dutch cows drinking in a pond (but with very un-
Netherlandish hillsides as a backdrop), or when he showed himself in 1648
sketching, perhaps even making the etching we are looking at, but with a
gently rising and wooded hill seen in the window frame over his right
shoulder.

Seghers had himself taken liberties which would later seem shocking to
the guardians of consistency, planting a row of step-gabled houses—the
very same houses that he could see from his own house on the Linden-
gracht—into the midst of a wild and rocky valley.[27] Rembrandt was less
brutally incongruous, but he was radically inventive nonetheless. In the
1640s, he began to take familiar and simple objects and places and project
onto them a poetic or (in the case of *The Windmill*) a bluff heroic aura. His
techniques were not at all the same as Seghers's, but it seems likely that he
was emboldened by the example of the older artist, as well as another great
graphic artist whose work he collected, the Lorrainer Jacques Callot, to
experiment with the etching medium so as to extract the maximum atmos-
pheric and expressive power.[28] And even this is to summarize his ambition
as an etcher too drily, as if these prints announced a mere modification of
technique instead of a revolutionary reinvention. For at his most resource-
ful, Rembrandt wanted to transform what was, by virtue of its metallic
medium, necessarily a sharp-edged and linear form of representation into a
soft, elastic, almost liquid medium. It was precisely the opposite of what he
was doing with paint. While his paint was becoming more sculpturally
coagulated, thickening into something that could be palpably worked, that
asked to be touched, his etching experiments were meant to belie the
unyielding hardness of its material character.

Rembrandt, The Three Trees, *1643. Etching. New York, Pierpont Morgan Library*

This urge toward aesthetic metamorphosis, the transformation of the working fabric of art into something which was, on the face of it, alien to it, was shared by all the very greatest designers of the Baroque, who were bewitched by the interchangeability of substances—solids into liquids; liquids into vapors; base into precious metals. In their several ways, some more solemnly philosophical than others, they fancied themselves wizards of the senses akin to magi or alchemists. At the back of their minds, perhaps, was the ultimate magus, Michelangelo, who alone had created painterly sculpture and painted forms with the exacting precision of marble. But Gianlorenzo Bernini, for example, took it as a challenge when still very young to do what had been said by the wise men to be impossible: to make hard stone appear as though it were the curling flames of fire as they rose from the gridiron on which the artist's namesake, San Lorenzo, was being slowly barbecued. Similarly, I think, Rembrandt was drawn to this conquest of what the Italians called *difficoltà,* and resolved to transform etching into not merely an *alternative* but the *opposite* to engraving, with its undeniably linear precision. He wanted to make it poetically sensuous, infinitely malleable, disarmingly mutable.

What better way to test this transformative skill than by supposing he could make visible, without paint, the fickle temper of the Dutch weather?

The great etching known as *The Three Trees* does precisely this, registering the passing of a rain shower through elaborate diagonal hatching. But Rembrandt also discovered ways to evoke merely the impression of a moist, overcast sky using sulfur tone on his plate. This involved applying a corrosive paste directly to the copper, which created a pitted or slightly scoured surface that then printed up as a faintly darkened area, as if a light wash had been brushed over the print. Rembrandt did not go as far as Seghers, who was known on occasion to use cut-up linen for his print surface (a choice of material that Hoogstraten assumed had been dictated by his inability to afford paper!), but he did vary the kind of paper he used, not only from etching to etching but in different states, sometimes using fine French or German rag, made of pulped linen or hemp; sometimes the more coarsely woven *cardoes,* Dutch oatmeal cartridge paper; sometimes the absorbent Japanese *gampi,* shipped from Nagasaki and Deshima, faint gold or pearly gray and sometimes a soft white that would take the ink so gently that the entire etching seemed bathed in delicate light. And just as he had begun to manipulate the paint on his canvases with the kneading and building energy of a sculptor, so Rembrandt began to play with all kinds of handwork in his prints, sometimes leaving his plates only partially wiped, sometimes wiping them with a rag or even his fingers and allowing the marks of his work to show in some states of the impression. It was not just that he was consciously dissolving the boundary between what was painterly and what was graphic—though that was clearly part of his intentions. It was also that he was becoming instinctively fascinated by the possibility that the process of the work itself—the labor of making the exhaustively explored textures of the medium—could be the subject of his compositions as much as (if not more than) the ostensible objects of representation. Thus the same Rembrandt who was deeply attached to native graphic traditions was also, in the marrow of his creative imagination, a modernist.[29]

Of course, to be a modernist also meant to follow Aristotle, in particular his dictum that "art loves chance and chance loves art." And Rembrandt undoubtedly knew of Pliny's story of the great autodidact Protogenes, the ship painter turned artist who got himself lathered up while attempting to catch the effect of foam on a panting dog's muzzle, rubbing away layers of paint with a sponge and still not getting the right result. "Finally he fell into a rage . . . and dashed a sponge against the place in the picture that offended him, and the sponge restored the colors he had removed . . ." and eureka—canine drool—"chance producing the effect of Nature."[30] Rembrandt, too, was becoming increasingly fascinated by the ways in which the materials of art could themselves generate visual sensations and impressions, with only the most minimal intervention of the artist's hand. Some of his most stunning drawings, done with the more pliable and sinuous instrument of a reed pen (rather than the more precisely indicative quill), involve the *unfilled* and uninscribed paper as an active agent of illusion. What might be called subtractive expression— to take away is to fill up—is most amazingly recorded in the Fogg *Winter*

Rembrandt, Winter Landscape, *c. 1649. Drawing. Cambridge, Mass., Fogg Museum of Art*

Landscape where an expanse of bare paper somehow precisely registers the blanket of snow and the muffled, decelerated hibernation of a Dutch village.

While the uninscribed paper itself seems to produce the picture, Rembrandt precisely calculated the effect, however intuitive and swift his strokes of the pen. But the technical device which more than any other worked to scramble and creatively jeopardize those graphic calculations was drypoint. Drypoint involved working the surface of the copper plate with a cutting instrument that produced a deep and (relative to the engraver's burin) quite broad furrow. The cut threw up minute ridges of metal filings that would be left to sit on the edge of the groove and which would print out as a dark, velvety "burr." The burr might merely strengthen, soften, or deepen a contour, or it might, if heavily inked, flatten and spread to produce an impression of texture and mass—of foliage, for example. Or it might do something which the etcher could not completely anticipate. Scholars of Rembrandt's etchings discuss his use of drypoint, usually added to the plate after the acid-bitten etching had been done, in terms of the artist grappling to control the wayward darkness of drypoint burrs. But it seems to me that it was precisely the unpredictability of drypoint, its escape from the controlling hand, which made it so attractive to Rembrandt.

So on some few occasions, he held his breath and worked *only* in drypoint, for example, in the justly famous and unromantically named *Clump of Trees with Vista.* Here expressive tone completely overwhelms any kind of literal, linear description of the scene. But the tone in each of the two states is as different as, perhaps *more* different than, a photographer's choice of exposure during development. In the first state, the little cabin seems to float on a meadow with just the merest impression of vegetation filling in at the back and a foreground tree indicated with the barest minimum of lines. The plate is full of a watery light created by Rembrandt's cal-

culation in leaving a thin film of ink on the plate, with the densest area immediately behind the cabin. The direction of his wipe (with the palm of his hand or a moist cloth) upward and out from the dark smudge behind the cabin gives an uncanny illusion of the foliage pushed by the breeze. The whole effort is as close to pure black-and-white painting as he ever came. The second state is more conventional—and perhaps more marketable—with the expanse of foreground cropped away, the layering of the foliage more exactly

detailed, and the recession into space toward a distant horizon made more legible. It's still a work of considerable power, with the grassy hummock in the foreground and the tree at left still imaginatively sketched rather than literally described. And it suggests just how liberated from convention the Rembrandt of the 1640s and early 1650s really was.

Rembrandt, Clump of Trees with Vista, *1652. Drypoint, first state. Amsterdam, Rijksprentenkabinet*

There's no need to turn Rembrandt into some sort of proto-Romantic, winging it on the strength of his muse, in order to credit properly the extent of his daring as an etcher. Unlike with painting or drawing, after all, there were no rule books for etchers which practitioners were supposed either to observe studiously or defy self-consciously. The medium itself was barely a century old and younger still as an established artistic practice. So the most inventive etchers like Seghers and Callot and Rembrandt were indeed free to shape the possibilities of the form. And instead of smoothly integrating the different styles of graphic expression—etching and drypoint—Rembrandt on occasion actually chose to emphasize, quite deliberately, their *dis*continuity. Never more so perhaps than in *The Omval*, which looks disconcertingly like two entirely discrete compositions that have been awkwardly joined in the same print. The right side of the large print shows a contemporary scene of work and pleasure. The Omval was a spit of land dividing the Amstel from the old lake of the Diemermeer, now reduced to a working canal whose mouth has to be imagined between the two windmills on the far bank, partly hidden by the back of the standing

Rembrandt, Clump of Trees with Vista, *1652. Etching with drypoint, second state. New York, Pierpont Morgan Library*

Rembrandt, The
Omval, *1645. Etching.*
New York, Pierpont
Morgan Library

peasant. The rowboat with its little party of trippers is one of the excursion boats about which the ministers became so upset. But it's the left-hand side of the etching which has the action to provoke the preachers. For although it is ostensibly an outcropping of trees extending right down to the river-bank, Rembrandt has in fact knowingly created a completely different world, an alternative to the suburban commonplaces of the river. The smudgily dark drypoint has been used to create a sense of enveloping obscurity: a hollow in the wildest of woods, a space in the deepest forest, for once a genuinely Arcadian sylvan cell surrounded by flowers and ferns thick enough to provide a hideaway for lovers. Who are they, in their little tabernacle of passion to the left of the tree stump, the man crowning his beloved with a *bloemenkrans,* the woman seated on the ground with her back to the tree, her profile a little solemn, Saskia-like perhaps, her bodice availably loose at the neckline, the upper part of her face in shadow.

Of course, it is not physically inconceivable that such a place might have existed directly across from the Omval. But it is unlikely. What Rembrandt has in mind is a sweet harmonization of *naer het leven* (on the river)

and *uyt den gheest* (in the tree hollow), the *two* ways of experiencing nature, happily prosaic and suburban on the one hand, infatuated, poetic, and magically sylvan on the other. He is also, of course, playing his favorite game of using obscurity to draw our attention to things, much as he deepened the shadow over his own eyes in self-portraits or lured the eye toward the forbidden areas of a woman's body, by challenging us to penetrate his dark scorings and cross-hatchings, to make us consciously aware of the searching gaze. Our own seeking, then, is counterpointed with the *boer* in his flat hat standing precisely between the two country worlds of the suburban and the sylvan, the polite and the passionate. But it's the more restrained of those two worlds which takes his attention—the boating party—while behind him, deep in the dense greenery, a more unruly nature rules.

There is another figure with his back oddly turned away from the principal action in Rembrandt's other large etching of the 1640s, *The Three Trees* (page 536). He is the figure of an artist, seen minutely drawn on the hill at right (where, customarily, the lines of a church are often made out), sketching in bright light while the great stormy drama unfolds behind him. The drama of the skies, moreover, is not all that passes him by, since deeply buried in the drypoint blackness of the foreground vegetation at right is another pair of lovers. Rembrandt fully means them to be scarcely visible since their own love play has gone well beyond the poetic stage of the pair in *The Omval,* the woman reaching between her lover's legs. At the same time, at the left of the etching, a pair engaged in angling would also have tripped the snicker-alert for seventeenth-century audiences, since contemporary poems very often referred to either men or women as fishing for more than their dinner.[31]

The Three Trees is, of course, much more than a game of erotic peekaboo. It uses every etching technique at Rembrandt's command to offer something like a world-image, but not one in the sixteenth-century tradition of the Alps brought to Flanders. Instead, since the three trees would certainly have carried with them overtones of the three crosses, carrying in their luxuriant foliage the promise of resurrection, Rembrandt has brought together not just etching and drypoint but the sacred and profane, the world of spiritual and embodied experience, and the two aspects of Virgil's pastoral—the world of idle *otium,* or leisure, and the Georgic round of agricultural labor. There is play in the foreground and in the wagonload of *speelreisje* passengers on the brow of the hill, to the left of the artist. And there is work in the middle ground: cattle and herdsmen standing in the pasture. And most of all, there is the marriage between town and country embodied in the left horizon, the Amsterdam skyline and beyond it, mostly brightly lit, the source of its wealth, the IJ, stretching on out into the Zuider Zee. Over all this, Rembrandt's hand passes, creating the billowing clouds, the sheets of rain, and up, over the trees, indicated with just a few flicks of the etcher's needle, the very simplest of all representational marks, something every child can do: a flock of birds.

iii *Exposure*

Never confuse a genius with a saint.

On October 1, 1649, Rembrandt's young housekeeper, Hendrickje Stoffels, doubtless with some trepidation, appeared before the notary Laurens Lamberti. She was twenty-three years old, dark-eyed, fair-skinned, a trim little figure. Hendrickje was a child of the military, the youngest of six children of Sergeant Stoffel Jegers from Bredevoort, near the embattled eastern border of the Dutch Republic. Her two brothers were both in the army, one a drummer, and her sister Martina was married to another soldier.[32] So Hendrickje Stoffels was probably well used to the company of men, their alehouse laughter and their clay pipes. But this was different. There were two other men there, another notary and a witness, observing her carefully. How could she not have been apprehensive, as if somehow this whole matter was her fault. At least the proceedings were brief. She was asked by notary Lamberti to affirm under oath that something said by her master to have happened last June 15 had indeed happened and that the agreement set down in writing on that day had indeed been accepted by all concerned. She so affirmed. She could go home and tell Rembrandt she had done as he had asked.

Of course, some said that all this could have been avoided if her master had answered the summons of the commissioners of matrimonial affairs to appear in the matter of the complaint of Geertje Dircx, instead of brushing their paper aside and submitting to their fine. But how could such a great man stoop to such low things, and with him so busy, having to run the printing presses and the studio? Hendrickje was honored that she could do him this service really. She was the keeper of his house now, the one with the keys who locked the doors last thing at night.

Still, if she thought back to June and before June, it was a bad business, no denying it. She had come to the house with Titus's mother not long in her grave. Then the orders were given—what to buy, where to sweep—by Geertje Dircx, the bugler's widow who had been taken in to care for the little boy. Pretty soon she was tending to the master too, and for his part he seemed glad enough of it to give her some of his dead wife's jewels. By the standards of the times, it was not unreasonable for Geertje to take this as a sign that Rembrandt would treat her in a proper Christian way now that she came to his bed and that he would marry her.[33] But that was not how things came to pass. Who knows when and how the heat of lust turns lukewarm? How the routine of desire begins to chafe? Or when Rembrandt looked at Geertje wearing, once too often perhaps, Saskia's pearls and felt a twinge of remorse and then turned remorse into anger, finding fault with

this and that: a supper spoiled; a door left open when he had said it should be kept shut; pieces in his collection tidied away, unasked for, vexing. Or when he stopped talking kindly to her. Or when he started talking kindly to Hendrickje, looking at the younger woman an instant longer than was quite necessary between a master and a maid.

No artist of the seventeenth century pictured the sexual act quite like Rembrandt. Despite the vigilance of the censor, erotic prints, most of them originating from France and Italy, still circulated in the Netherlands, and Rembrandt had his own collection of them, probably including the choicest items, Agostino Carracci's *Lascivie* and Marcantonio Raimondi's extremely graphic *I modi* (*The Postures*), done after Giulio Romano's illustrations for Aretino's comprehensive manual of sexual positions. But the energetic coupling in all these images was invariably enacted by figures from the realm of art: curly-phallused satyrs or Pans taken right off Greek vases, or (in Marcantonio's case) strapping, bearded heroes and receptive nymphs modelled along the lines of antique Venuses.[34] Rembrandt's startling prints of fornication, on the other hand, all executed

Rembrandt, Woman in North Holland Dress (Geertje Dircx?), *c. 1645. Pen and brown wash. Haarlem, Teylers Museum*

in the mid-1640s during his relationship with Geertje, *The Monk in the Cornfield* and *The French Bed* (*Het Ledikant*), don't belong to this statuesque tradition at all. It's not only that, particularly in the case of the large etching of the *Ledikant* (page 545), Rembrandt features a couple in recognizably contemporary dress copulating with their undershifts still on; it's also that in both cases it's the heavy animal clambering of the act, rather than the graceful erotic athleticism of Italian pornography, which is the most obvious feature. Paradoxically, it's only when the female body (in Carracci's *Lascivie*, complete with penetrated vulva) is made *visibly* available to the male gaze that the pornographic aim of arousal is possible, with the fantasist inserting his own phallus into the composition.

It's precisely this visibility, and therefore the voyeur's arousal, which Rembrandt's bodies obstruct, interposing themselves between the woman's body and the male gaze. In fact, what *is* visible of the woman in the *Ledikant*—her eyes, softened and darkened with a touch of drypoint but raptly turned toward the face of her lover—makes this exclusion of the voyeur even more emphatic. And Rembrandt's famous "error" of doubling her left arm actually works in the same way. Initially left passive on the sur-

Rembrandt, The Monk in a Cornfield, *c. 1646. Etching. Amsterdam, Rijksprentenkabinet*

face of the bed, her arm has been moved so that both hands now clasp her lover's waist, pulling him more deeply into her. The effect of a lightly adjusted position is cinematically actual and, I think, intentionally provoking to the outsider, alternately teased and resisted. This is a threesome in which the looker can never exchange places with the doer. All he has are banal surrogates for the sex act: a background figure scything rhythmically away at the tall wheat in the one print; the phallic bedpost covered by the plumed hat, its opened interior carefully shaped and darkened, in the *Ledikant.*

These prints, as well as the etching of a grimly lecherous flute player staring up the skirt of a shepherdess while a strangely demented-looking goat strays into a flock of sheep, were executed in the early and mid-1640s, while Rembrandt was in the throes of his sexual relationship with Geertje Dircx. The flute, the goat, all this leering and peering amount to something like a fixation on Rembrandt's part in these years of sex and solitude. He would never be quite this preoccupied with the machinery of lust in this way again, although he remained, for a long time, fascinated by the complex connections between looking and arousal, reverie and action.

Had Hendrickje blushed that first time when she felt him looking at *her*? It wasn't long, at any rate, before he wanted her in his bed, and Geertje out of it. And then out of the house. Which is when the serious trouble started, the bad feeling between the two women, one of them spurned, the other flattered, both of them on the edge between safety and ruin. Like so many bad household quarrels, it began with gold and diamonds. At some moment along the stony path of his estrangement from Geertje, Rembrandt must have repented, especially of his rashness in letting her have Saskia's jewels and even more perhaps of giving her a silver

marriage medal, though left carefully unengraved.[35] Whether she had asked or he had freely offered made no difference. And though there could be no taking back, he needed to make sure that on Geertje's death, the jewels and the silver would come back to the family. So, in January 1648, he had Geertje make a will, bequeathing her

Rembrandt, The Flute Player, *1642. Etching. New York, Pierpont Morgan Library*

clothing to her mother and "all other property, movable and immovable, securities and credits," to Titus.[36] Her only condition was that her portrait and a hundred guilders be given to Trijntje, the daughter of one Pieter Beets of Hoorn, presumably a relative or perhaps friend of her dead husband, the ship's bugler, Abraham Claesz. It was made clear in the will that jewelry was not to be considered as "clothing" so that Rembrandt could at least feel assured that after Geertje's death (and who knew how soon that might be), Saskia's property would revert to her son. That way, the painter could convince himself, Geertje had the use, the *usufruct*, as the lawyers liked to say, of the jewelry, rather than the outright ownership; that it was no more, really, than a sort of loan.

Still, it lingered, this bad conscience, not about Geertje but about Saskia. After all, he had given the bugler's widow a home for years, fed and kept her, given her all manner of things. He was sorry that she had to go, but it was impossible now, having her and Hendrickje under the same roof. He would be generous. He would make sure she was not cast out into the streets without a penny. She could keep the jewels provided she promised never to sell or pawn them, or to change her will bequeathing them to Titus. And he would give her 160 guilders a year for the rest of her life. And if this were not sufficient, he would "help her yearly, at his discretion and according to her honorable needs."[37] In return she would promise not to "make any further demands." Now, Rembrandt, must have thought, through the summer of 1649, what could be fairer than that?

Rembrandt, Het Ledikant, *1646. Etching. New York, Pierpont Morgan Library*

But although, as Hendrickje affirmed in her statement before the commissioners of marital affairs, Geertje had assented to that agreement on June 15 and, in the presence of witnesses, had put her mark on it, once she was out of Rembrandt's house her bitter sense that she had been used badly began to eat at her. She was living in a miserable room in the Rapenburg and was getting desperate, perhaps even panic-stricken. Had she managed to bear Rembrandt a child (as Hendrickje would), her claims on him would have been stronger, perhaps decisive. But her womb had been barren in her first marriage to the bugler, and it had proved no more fertile in her years with the painter. Still, he had given her a betrothal coin, even if it was unengraved. What was she supposed to have thought of that? And what was she supposed to do now? Be turfed out with just a pittance? Was that all the thanks she got for years of service, tending to his son, giving him her body? How was she supposed to live on the paltry sum he had given her? So notwithstanding Rembrandt's guilty obsession with the fate of Saskia's jewels (or just possibly in spite of it), Geertje found a barge skipper's wife who lent money, and put sixteen of the most valuable objects—three gold rings, including one with a diamond cluster—in pawn. To do this she had to travel back to Edam, where the bargewoman-moneylender lived, no doubt in an effort to hide the transaction from Rembrandt. But she may have thought: If he should find out about this, well, too bad! Just let him try and do something. She would show him. She would *sue* him for breach of marriage contract. Let's see how the *eersame en wijtvermaerde schilder,* the *honorable* and renowned painter, liked that!

One can only imagine Rembrandt's amazed fury at this defiant challenge to his authority, thrown in his face by the illiterate, cast-off housekeeper. He must have felt that he was, in effect, a victim of blackmail, threatened with public scandal if he did not yield to Geertje's demands. And also, if he was at all honest with himself, that this predicament was entirely his own doing. But Rembrandt also knew that he had to make another offer to Geertje, to buy off her rage. She would be given 200 guilders to redeem the pawned jewels and to clear her present debts. He would, as already promised, make the annual payment of 160 guilders. But should she ever try again to violate their agreement, either by alienating any part of the jewels or by making any more demands on Rembrandt, not only would the arrangement become null and void, he would demand back all the moneys he had advanced to her. Geertje was brought to the Breestraat on October 3 and asked, in the presence of one of her neighbors, the shoemaker Octaeff Octaeffsz., acting as witness, if she would now agree to these terms. She said she would. But exactly a week later, Geertje changed her mind. Back in the house to sign the document, she began to shout and rail against Rembrandt that she would not hear the thing read out by the notary, much less sign it.[38] Finally the notary got her to calm down, somewhat, and even to acknowledge that the document contained only the terms to which she had already agreed. But what if she got sick? she said. (And perhaps she was already ill.) She might need a nurse. How

could she do that with just 160 guilders a year? Well, then, Rembrandt said, presumably struggling with self-control, let us see. We can amend this agreement to take care of your concern. No, said Geertje. I will not sign this thing.

A week later, on October 16, Rembrandt was fined a second time (3 guilders) for refusing to appear before the commissioners of marital affairs. On October 23, however, he did finally answer the summons and the two antagonists faced each other across the room in the Oude Kerk. At the table sat men like Cornelis Abba, the brewer who lived in the grand house called "the Pentagon" on the Singel, and Hendrick Hooft, from a famous family of burgomasters, the sort of men whom Rembrandt might have reasonably hoped to paint and whose good opinion he could ill afford to lose. But he had to sit and listen while Geertje stated with no equivocation or inhibition that Rembrandt had made "verbal promises of marriage and has given her a ring; and that furthermore he had slept with her on numerous occasions, and so she demands that the defendant marry her or undertake to support her."[39] Rembrandt's retort was legally considered and brutally candid. He flatly denied ever having proposed marriage to Geertje, nor was he obliged, he said, to admit ever having shared his bed with her. That was for her to prove. Let her try.

The three commissioners must have heard this sort of thing before, many times. They undoubtedly believed at least some of Geertje's story. But she too had acted in clear violation of her agreement with the painter, and they were not, in any case, about to force a housekeeper into the bed of the Apelles of Amsterdam against his clear repugnance. So the terms of the most recent agreement were upheld, but with Rembrandt now obliged to pay Geertje 200 guilders a year instead of 160—a 25 percent increase in maintenance. With that judgement, they had provided for the unhappy woman without imposing an impossible marriage on the painter. Done and done fairly.

But it was not done, not as far as Rembrandt was concerned. Whether it was the damage to his good name or the irritation at having to pay Geertje 40 more guilders a year over and above a sum he already thought generous, Rembrandt evidently seethed with anger at what had been done to *him*—and by whom? By a no one, a hoyden, a shrew. Consumed with vindictiveness, Rembrandt plotted something wicked. The man who had created so much beauty showed himself, in this one matter, capable of great moral ugliness.

Geertje must have had a sense of what was coming, because even after the judgement of the commissioners she took steps to make sure she could collect the maintenance due to her from the painter. In April 1650 she assigned legal authority to collect all debts owed to her to her brother, Pieter Dircx, a ship's carpenter, and to a cousin, Pieter Jansz. Geertje must have supposed that her family, at least, would prove loyal and dependable. But she was cruelly disabused of this trust. When Pieter Dircx came to the Breestraat to collect the first of his sister's maintenance payments, he evi-

dently got into a rewarding conversation with the painter. Rembrandt needed Pieter Dircx because, with power of attorney invested in him, he had to be the one to redeem the pawned jewels, and he might well have offered him, as an enticement to carry out the rest of his plan, a commission on the recovery of the gold and stones. After Geertje had been expeditiously disposed of (with the brother's collusion), Pieter was duly sent with the money that was supposed to have been allotted to Geertje for this purpose to the bargewoman in Edam to redeem the rings, coins, and gems. Perhaps, too, there was an understanding between Pieter Dircx and Rembrandt that the jewels would sooner or later get returned to the Breestraat (rather than be held "in trust" by Dircx for his sister). In any event, it was the kind of understanding that gets broken, since in 1656 Pieter Dircx filed a complaint with a notary that he was being unjustly detained by Rembrandt from going aboard his ship.[40]

The treacherous brother was not the worst of it. Early in 1650, Rembrandt used Pieter Dircx and a butcher's wife called Cornelia Jans to collect malicious gossip from some of Geertje's neighbors and get them to swear before a notary that she was of unsound mind and—it must have been implied—morals. For in July of that same year, that deposition was reaffirmed, again under oath, before the burgomasters of Amsterdam.[41] This was to prove the weapon that would put Geertje away, Rembrandt evidently hoped, for long enough and distant enough that she could do him no further harm. For there were places of confinement and correction for women judged unstable, and before the year was out the unhappy Geertje found herself in one—the Spinhuis in Gouda. Just why she was committed to a house of correction in another city remains unclear. Rembrandt had paid Cornelia Jans to have Geertje transported to Gouda and had given her the necessary money, some 140 guilders, to pay for her admission and, one suspects, to strengthen the persuasiveness of the Amsterdam certificate of her incompetence.

Perhaps there was a shred of truth in the story. A passage in the notary's record witnessing the assignment of legal powers to her brother refers to the "*allercrachtigster forme*"—the "most vehement terms"—in which she stated her intentions. So she may, indeed, have continued to nurse a violent grievance against Rembrandt. But the Spinhuis was a pitiless place, smelling of lye and pease porridge and occupied mostly by whores and vagabond women, imposing a regime of ferocious austerity in which the fallen souls were morally and physically chastised and set to work spinning until their fingers were numb. And there were relentless sermons, prayers, Scripture readings, all meant to scour the filth out of these iniquitous creatures' bodies and souls.

This was what Geertje Dircx endured through five long years as a consequence of her temerity in taking on the great Amsterdam master. But even five years seemed to be not long enough for Rembrandt. He wanted to be sure that she could not return to haunt him for at least *eleven* years. Which is when he overplayed his hand. At some point after Geertje's committal to the Gouda Spinhuis (most likely, I think, in 1651), he sent his trusty, the

butcher's wife, Cornelia Jans, to see some of her family in Edam, including her godmother and a cousin, as well as two acquaintances of hers, both widows. To go to this length, Rembrandt must, one supposes, have been convinced that Geertje was, in fact, unhinged, and that he could extract supporting information on the matter even from those who had been close to her before she moved to Amsterdam. Or perhaps he supposed that his name, power, and wealth would overawe the widows into collaboration. If so, he was seriously mistaken. Not only did the two Trijns (Trijn Jacobsdr. and Trijn Outger, the slaughterer's widow) refuse to have anything to do with the attempt to extend Geertje's term of incarceration, they were clearly shocked to learn that she had been confined in the first place. In 1655 the younger of the two, Trijn Jacobsdr., made up her mind to go to Gouda and attempt to get Geertje released. Amsterdam was on her route (most likely by the tow-barge), so she actually decided, perhaps to avoid any accusations of underhanded action, to go to see Rembrandt and announce her intention. The visit, as might have been predicted, was not a success. In the deposition she made before a Haarlem notary in favor of Geertje, Trijn Jacobsdr. described the painter threatening her, pointing his finger and warning that she would rue it if she went ahead with her plan.[42]

Rembrandt, Self-portrait in Work Clothes, *c. 1656. Drawing. Amsterdam, Museum het Rembrandthuis*

Another interfering, presumptuous old bat, Rembrandt thought, and hastened to write letters to the magistrates in Gouda insisting that Geertje Dircx should not be released from the house until her brother Pieter had returned from a voyage with the West India Company. But by February 1656, almost certainly with the help of Trijn Jacobsdr., Geertje had already recovered enough of her liberty to be able to appear before a notary and fire the treacherous brother from his role as her legal agent. And in the spring of the same year, "after great trouble," as the good Trijn put it, she managed at last to persuade the magistrates of Gouda and the governors of the Spinhuis to release Geertje.

By this time Rembrandt was himself in serious financial difficulties, and actually defaulted on the maintenance payment he was supposed to make to Geertje under the terms of their court settlement of 1649. His prisoner had now become his creditor. No doubt Geertje, whose health must have suffered badly during her years in the Spinhuis, would have traded her satisfaction for the money. It was too late for the both of them, Rembrandt descending into a pit of debt and disaster; Geertje dying in the second half of 1656, before she could witness the painter's humiliation as a bankrupt.

And what of Hendrickje Stoffels, who succeeded Geertje Dircx in Rembrandt's bed? The light shone on her as it passed from Geertje. She was established as the mistress of the grandest painter in Amsterdam, whose praises were being sung by poets like Jan Vos and Lambert van den Bos.

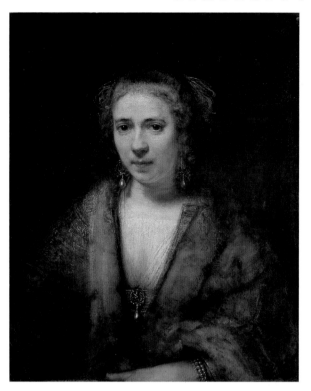

Rembrandt,
Hendrickje Stoffels,
*c. 1655. Canvas, 72 ×
60 cm. Paris, Musée
du Louvre*

The house was filling to the rafters with students, statues, paintings, strange-looking weapons, stuffed animals and birds. Persons of importance were always coming and going. Titus was growing into a beautiful boy, with his mother's curly auburn hair. Even with the plague prowling Amsterdam, and the war with the English going badly, and the marketwomen complaining of the hard times, and the painter himself much troubled by his expenses, and the hammering that seemed to go on endlessly from Mijnheer Pinto's house next door until their heads throbbed with it, how could she fail to be happy, the sergeant's daughter, to bless her fortune and ask forgiveness of those hurt by it?

Of course, there were always the busy tongues of the neighborhood muttering that she was a lost woman, that she had prostituted herself to the infamous reprobate, Rembrandt. But until 1654 she could afford to ignore their poisonous prattle. Then Hendrickje got with child, and after a while, even the most voluminous skirts could not conceal her condition from the pious and the censorious. In June, five months pregnant, she received a summons to appear before the Church Council to answer reports that she was "living in whoredom with the painter Rembrandt [*in Hoererij verloopen met Rembrandt de schilder*]."[43] Rembrandt received the same summons to admonition, but when it was realized that he was no longer an active member of the Reformed Church, no further attempt was made to have him appear in person before the council. Hendrickje was another matter. She received two more notices, her belly growing more conspicuous, before she finally mustered the courage to appear on July 23, 1654. There she was given the usual frightening dressing-down for her sins, informed of the full depths of her depravity and wickedness, admonished to do proper penance, and formally banned from the Lord's Supper, the Calvinist communion.[44] Whether she was contrite or not, three months later a daughter was born and baptized Cornelia, after Rembrandt's mother, on October 30 in the Oude Kerk, where Saskia was buried. And unlike her two dead namesakes, the third Cornelia would survive.

Though there is no securely documented portrait of Hendrickje, it's all but certain that she was the model who posed for him, four or five times, in various states of undress and half-dress between 1654 and 1656: a full oval face with heavy-lidded dark eyes, and a graceful, broad-shouldered, amply rounded body. At least three of those paintings—the *Bathsheba* in the Louvre; the oak panel called *Hendrickje Bathing* in the London National Gallery; and the *Woman in a Doorway* in Berlin—are all set in an ambiguous space between seductiveness and innocence. This was a theme Rem-

brandt had explored in the 1640s with his kitchen-maid paintings. But using Hendrickje as a model made this new series of paintings a statement about intimacy.

This was true even of the most historical of the pictures, the *Bathsheba*. For although Rembrandt did not of course display Hendrickje's pregnancy and presumably began work on the painting (dated 1654) before her body had begun to swell, anyone who saw the masterpiece would have known the fateful significance of pregnancy to the story, related in the Second Book of Samuel. Rembrandt has collapsed together two consecutive moments from the Scripture. Bathsheba is caught in a state of poignant meditation, head slightly downcast, holding the letter from King David which summons her to his presence, and, she evidently realizes, for more than a royal audience. Her tragic predicament, then, is to be made to choose between disloyalty to her king and disloyalty to her husband, Uriah the Hittite. But by displaying her very beautiful body so fully, Rembrandt again implicates the beholder in the covetous voyeurism of David, who is spying on her bathing from a window of his palace. Twenty years earlier, Rubens had posed Helena Fourment in the same way, both in the midst of her ablutions (her upper body, thighs, and legs exposed) and on the point of receiving the royal letter from an African page. But the expression on the face of Rubens's Bathsheba is more that of the coquette than that of the sacrifice. Painting his wife as though she were expecting a date, Rubens was, in fact, following an iconographic tradition of representing Bathsheba as seductress, conniving at her adulterous liaison. And Rembrandt's student Willem Drost, who painted his Bathsheba glossily half-naked like an advertising courtesan, demonstrated that this more crudely sensual tradition was still in fashion in the middle of the century.

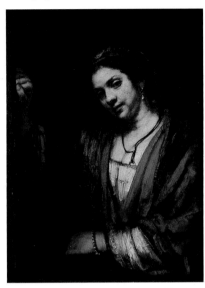

Rembrandt, Woman in a Doorway, *c. 1656. Canvas, 88.5 × 67 cm. Berlin, Gemäldegalerie*

Rembrandt, on the other hand, makes the most beautiful nude of his career, in fact, the *last* nude painting of his career, a vessel of pure tragedy. In the 1640s, he had made a much smaller version of the same subject in a sharply different temper. The smile on the face of that Rubensian blond Bathsheba speaks of naked complicity. It's the expression of a mindless flirt, a come-on. But the 1654 Bathsheba is burdened by thought, the lines of the body evoking, for once, the self-containment of classical friezes to suggest Bathsheba's fatalism; the mood intensely self-interrogatory. Rembrandt's brushwork has as many calm passages as agitated strokes, limpid cool tones as well as Venetian warmth and softness. And it is heavy with telling contrasts—between the richly brocaded gold robe (painted with loaded strokes of yellow ocher and black), the garment of her royal destiny, and the pure white shift of her betrayed innocence; between her own dewy, roselike beauty and the knowing, shaded countenance of the old servant washing her feet.

The stain was on Bathsheba's pregnancy. For once David realized she was with child, he attempted, as forcefully as he could, to persuade Uriah

to sleep with his wife so as to conceal his own adultery. Inconveniently, though, Uriah turns out to be an even more exemplary patriot than he is a model husband, and refuses to return home while a battle in which he had been fighting for the King is still raging. The strategy of his sexual convenience sabotaged, King David's fallback tactic is to ensure that Uriah is sent to a place on the battlefield where death is guaranteed. After Uriah's demise and a year of mourning, David takes Bathsheba as his queen, but as the Bible puts it with ominous economy, "the thing that David had done displeased the Lord."[45] The prophet Nathan admonishes David for his wickedness and warns that henceforth "the sword shall never depart from thine house," and that although the King would not die for his sin, the child born of his illicit union would perish.

Two years before, with this story evidently much on his mind, Rembrandt executed one of his most powerfully compressed little etchings, of David kneeling in prayer. The Bible speaks of David fasting for the life of his newborn son (in vain, since the boy dies seven days after his birth) and "lying on the earth." But Rembrandt often felt at liberty to depart from the strict text of the Scripture while keeping faithful to what he felt to be the essence of the story. The etching was made in the same year as the *Ledikant* and repeats the sense of its opened interior as an allusion to the sex act. The fact that Rembrandt has made the contrite King, his face deep in shadow, atone at the very site of his transgression makes it all but certain that the Bathsheba story is Rembrandt's subject here. The curtain gathered and folded over the bedpost recapitulates his adultery even as he prays for the life of his child. And he kneels between the two emblems of his own sacred history: the harp and the book. The harp was especially significant in Protestant Holland, where the Psalms were at the heart of the liturgy and could be heard sung in every Sunday church service, the most direct form of address between the congregant and God.[46]

The *Bathsheba* preserves this deep contemplative inwardness even while it is painted on the same scale as Rembrandt's energetically extroverted histories of the 1630s. At the emotional—and compositional—center of the painting is the letter on which not only David's fate but the fate of the whole House of Judah seems to be inscribed. The implications of the disaster for the political history of the children of Israel would not have been lost on the Dutch, who were repeatedly likened by their poets and preachers to the Chosen People, their blessings guarded by a watchful Providence on the condition that they obey His laws. As the hinge of disaster, the letter receives Rembrandt's closest attention, a corner curled back to reveal (indistinctly, as usual) the King's own hand, the paper casting a light shadow on Bathsheba's thigh. But she is not reading the thing. She has already understood, too well, its content. So Bathsheba stares beyond it, toward the servant washing her feet. But this ostensibly anecdotal detail itself becomes weighted with tragic implications, and Rembrandt means us to see it. For the Bible relates that David lay with Bathsheba after "she was purified from her uncleanness," in other words, after her postmenstrual rit-

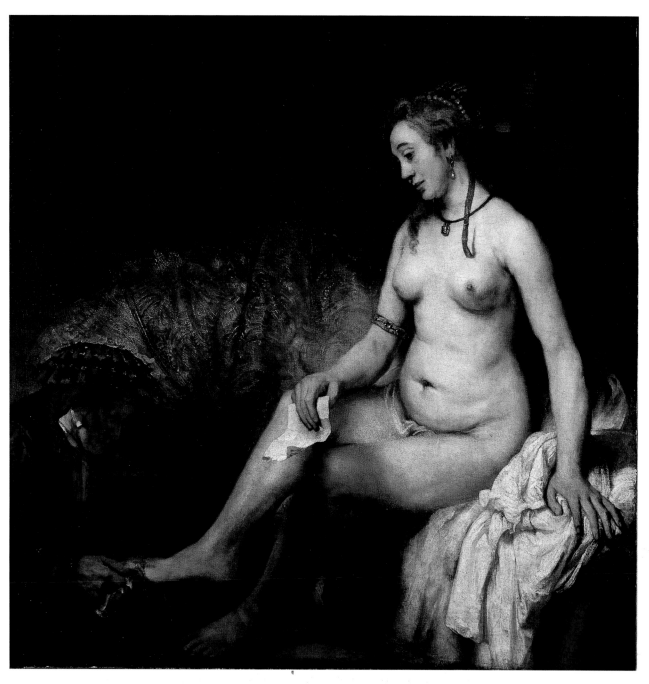

Rembrandt, Bathsheba,
*1654. Canvas, 142 ×
142 cm. Paris, Musée
du Louvre*

Rembrandt, David at
Prayer, *1652. Etching.*
New York, Metropolitan
Museum of Art

ual bath.[47] So that Bath-sheba is, in effect, watching an act of cleansing turn into an act of pollution, and the reaffirmation of her conjugal purity turn into the preparation for her adultery. No wonder, then, that her gaze is both concentrated and distracted, the lips soft and loose, on the verge of trembling, the eyebrows tightly arched as though battling against the onset of tears.

But at the same time that Rembrandt was painting Hendrickje posing beside the water of guilt, he was also sketching her wading into the water of innocence. Not complete innocence, of course, since the same heavy and ornate crimson and gold fabric he had used for Bathsheba's robe also lies on the bank beside his stunningly beautiful *Hendrickje Bathing* (page 556). And the combination of her deeply plunging décolletage, exposing the delicate cleavage between her breasts, and the shift lifted above and in front of the deep shadow at her upper thigh and groin gives the painting an extraordinarily powerful, though tender, sensuality. In all likelihood a work so intimate, and in its way so daring, was painted by Rembrandt for himself and Hendrickje, a personal celebration of their intimacy akin, in this respect at least, to Rubens's *Het pelsken,* to which it's often been compared.[48] But in fact, it's those features which are most *unlike* Rubens's work which, in the end, give Rembrandt's little panel its revelatory power. Helena Fourment is carefully, if insecurely, posed somewhere between an Ovidian myth and her husband's bedroom. Rubens decides on the degree to which she should be presented as the wife or the goddess, toying erotically with her unease, the black fur sliding about her opal, glowing skin. She is his to represent, to be stared at, her body entirely his possession. And as befits the fetishized beloved, he lavishes his most careful painterly technique on the detailed objects of his desire: the breasts, the fleshy legs, the full lips and shining eyes.

But Rembrandt paints Hendrickje *not* looking at him. He admires her evidently not as a possession but for her self-possession, and he catches her, sidelong as it were, in an act of self-absorption. Readings of the painting

that like to make it a literal record of a specific concrete action tend to imagine Hendrickje testing the waters, or rather the riverbed, for a secure footing. And perhaps Rembrandt did want to inject a note of caution in what is otherwise a gloriously incautious act of painting. More likely, though, Hendrickje is looking, the suggestion of a smile playing about her lips, into the watery mirror of her own reflected body, privy to a view denied us, and emphatically obscured by the black depth of that shadow below her shift. The most elaborately calculated passage in the entire painting is the area where her calves meet the water line, the minutely rippling break in the surface indicated by tiny lines of pure lead white, the reflected legs painted in transparent dabs of ocher and red earth.

The painting is an amazingly unforced synthesis of solid forms modelled

Rubens, Het pelsken, *1638. Panel, 176 × 83 cm. Vienna, Kunsthistorisches Museum*

with the most liquidly spontaneous brushwork. The entire thing seems to have been done at speed, the rich *primuersel* colored a warm yellowish brown (exposed at the bottom edge of her shift), the outlining edges of Hendrickje's neckline and right forearm and the crucial shadows at elbow and thigh and beneath her chin indicated in the "dead color" of charcoal black. The covering paint was then laid on with a creamily loaded brush, often wet-in-wet, a bristle-load of lead white mixed with just a trace of black or ocher where Rembrandt wants to describe the falling creases of the shift, following the lines of the upper body, lit and faint on the left side, a series of broad darker strokes at the right. There are exquisitely precise things—the corkscrew curl hanging over her neck; the faint, slightly oily glistening of her forehead, a minute highlight on her upper right eyelid. And there are passages of whirlwind suggestiveness: the white smear at the

left sleeve; above all, Hendrickje's right hand, treated so freely and broadly, with a dry, loaded brush dragged across the surface of the panel, that generations of connoisseurs assumed this to be a damaged passage.

A look at the famous hands of Jan Six in Rembrandt's portrait painted a year earlier might have suggested otherwise. For in both paintings, but especially perhaps in *Hendrickje Bathing,* Rembrandt is beginning to do something shockingly and movingly original. He is inventing the antipose, consciously disassembling the elements of a smoothly integrated representation, exposing rather than concealing the painterly hand itself. He was doing this, moreover, at precisely the time when his contemporaries, including Jan Lievens, returned to Amsterdam and belatedly prospering, and ex-students like Bol and Flinck, were actually *refining* their manner in the direction of a glossier, slicker finish, the hand of the painter dissolved inconspicuously into its assigned subject, be it a portrait or a history.

In other words, fashion was increasingly demanding exuberant outwardness: a clear line, a bright light, and a smooth finish. Rembrandt was, increasingly, absorbed by a dashing, thickly applied, suggestively broken line, a flickering light, and a provocatively unfinished finish. Of course, the old Titian had also won admiration for the indifference to finish displayed in his own late broken manner. But Rembrandt's late style, prefigured in the apparent incoherence of Hendrickje's left hand, has little or nothing in common with the feathery, mistily lyrical atmospherics of the Venetian artist, whom he certainly admired to the point perhaps of adulation. The viscous smears and dabs that sacrificed delineated form to the sheer intoxication of gestural painting owed nothing to any "rules of art" or precedent. Nor was it, as is sometimes argued, perversely *old*-fashioned, since, significantly, those same accounts invariably fail to identify the particular old fashion to which Rembrandt was allegedly returning. To admit that Rembrandt was *interested* in the ancient and the ruined doesn't mean that his own manner was sentimentally nostalgic. To claim Rembrandt for the respectable past has always been a position of tortured smartness, erudite

Rembrandt, Hendrickje Bathing *(detail)*

OPPOSITE:
Rembrandt, Hendrickje Bathing, *1655. Panel, 61.8 × 47 cm. London, National Gallery*

Rembrandt, Seated Nude, *1658. Etching. New York, Pierpont Morgan Library*

countersuggestibility. The truth is really much simpler. It is what countless generations of his admirers have always innocently supposed to be the case. That his experiments with paint were, in the profoundest sense, creatively disobedient, instinctual, free.

Rembrandt's inward turn—not, as most writers suppose, exclusively toward his own philsophical or spiritual preoccupations but into the material and conceptual interior of art-making—took him to areas undreamt of, much less essayed, by his contemporaries. It occurred to no other artist until Courbet and Degas, for example, to make the business of nude modelling *itself* the subject matter of art. In an extraordinary series of etchings all dating from the middle and late 1650s, Rembrandt drew his models not in the course of their painterly transformation into heroines or goddesses, and not simply disingenuously displayed for erotic gratification, but instead sitting by the "warm stoves" described by Hoogstraten in his account of Rembrandt's studio. Rembrandt's purpose in sketching in the actual physical circumstances in which these women posed was much more than simple social anecdote; he was creating another kind of genre, much like images of women making lace or sitting at a spinning wheel. Paradoxically, by situating them halfway between dress and undress— with their caps still on, their skirts in place—and by having them feel the cold, Rembrandt is quite knowingly disrupting art's authority to make those bodies its representational property. Instead of being the passive vehicles of art's great makeover (from a working girl called Trijn to a goddess called Diana), Rembrandt restores to these women their bodily reality; implies the goose bumps from their closeness to the stove, the numbed circulation from the pressed-down arm. The models nearly all assume the pose of Bathsheba, as if presenting themselves for a tryout in the part. Taken together, the etchings reveal more than the unidealized features of women's bodies. What gets unclad are the working processes of Rembrandt's vision as he feels his way toward the painting. But ultimately what obsesses him is not the neatness but the awkwardness of the fit between Amsterdam flesh and biblical heroine.

It's precisely this *resistance* to visualizing them as art objects which has so irritated and bewildered Rembrandt's critics from the seventeenth to the twentieth century. Kenneth Clark, for example, assumed that the 1658 etching of a solidly built woman shown with her feet in a pond or a river must have been "an *old* woman" or "the Gothic hulk of an old body" since she so little resembled the conventional Renaissance or classical nude.[49] Clark's assumption that Rembrandt has here depicted "the obstinate unde-

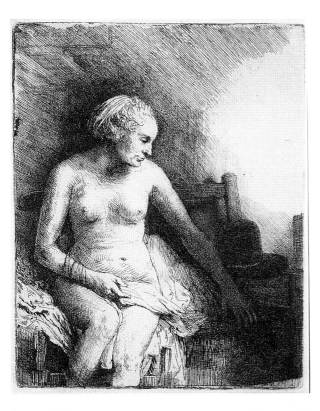

Rembrandt, Seated
Nude with Hat,
*1658. Etching.
New York, Pierpont
Morgan Library*

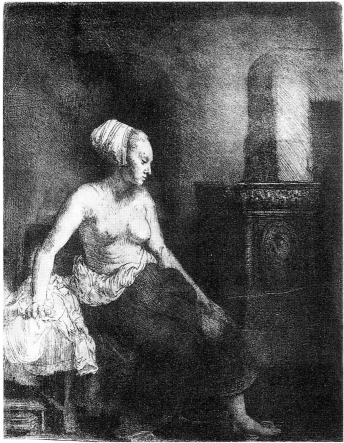

Rembrandt, Half-
Dressed Woman Sitting
Beside a Stove, *1658.
Etching. New York,
Pierpont Morgan Library*

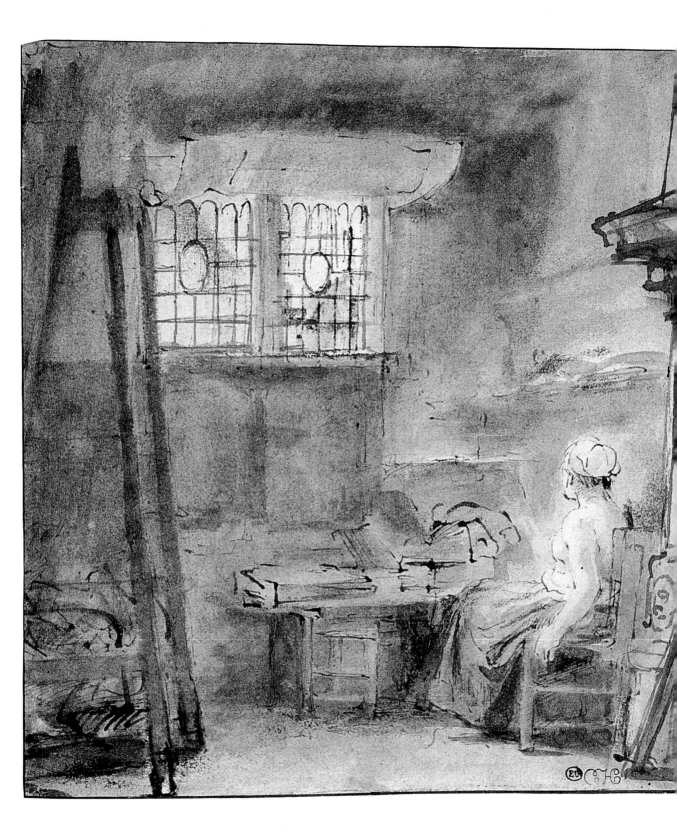

feated shape of an old boat" says more about his own fastidiousness, or possibly his greater familiarity with varieties of sailing craft than with unidealized naked bodies, for there is absolutely nothing in the etching to suggest the veteran matron whom he mistakenly assumes Rembrandt displays as an object of curiosity or compassion. An Old Master, it's felt, has no business giving ideas to the likes of Francis Bacon or Lucian Freud.

The real problem is Rembrandt's inability to keep the high realm of art and the low realm of physically felt life properly separate, as the books of painterly decorum required. A *half*-dressed woman with her cast-off clothes all around her could not, by definition, be a nude, and therefore her depiction in this transitional state must immediately become an embarrassment or an indecency. But for Rembrandt, this wandering across the boundary between art and daily life could *itself* be a wonderfully rich subject, never more sweetly rendered than in a drawing in the Ashmolean Museum in Oxford. The setting is Rembrandt's studio on the first floor of the house, with the presence of the painter announced in proxy by the tall easel at the left. The room is almost completely in shade, except for the light allowed to stream in through the upper part of the window by having the curtain pulled up and fastened at the rod. It falls almost exclusively on the head and naked upper body of the model, Hendrickje, though a little of the economical radiance trickles onto her lap and hits the edge of Rembrandt's working materials—stacks of paper—shelved around the room. But Hendrickje is seen not just as an object of the artist's observation. There are reminders everywhere of her bodily presence. The lower shutters of the windows have been closed, the better to concentrate the light source but also, surely, to protect her from prying eyes. She is seated by the fireplace to keep warm, and her pose—broad shoulders pushed forward, cap on head, her shirt down around her waist, skirt still on, a hand gripping the seat of the chair—show us the woman rather than the model. Not just a woman, but a mother. For in a stunning indication of the entanglement of life and art, Rembrandt has used a reed pen to emphasize the *two* objects set on the table: on the left, the raised and slightly banked surface of his sketching and etching desk; to the right of it, with the cloth thrown back from its opening, a little cradle just big enough for a newborn—in fact, for Rembrandt and Hendrickje's infant daughter, Cornelia. So Hendrickje has taken her shirt off to be both mother and model, to nurse as well as to pose. Milk as well as ink has flowed in this little room.

Is it possible to imagine *any* other artist of the seventeenth century doing this, wrapping up together the most intimate domestic scene and a description of his place of work? Bernini? Velázquez? Vermeer? Van Dyck? Guercino? Guido Reni? Poussin? Only one perhaps had even come close, with a bare baby's bottom planted on his mother's lap. The uxorious, endlessly fertile paterfamilias, Rubens.

OPPOSITE: *Rembrandt, Hendrickje in the Artist's Studio, c. 1654. Drawing. Oxford, Ashmolean Museum*

CHAPTER ELEVEN · THE PRICE

OF PAINTING

i The Pulled Glove

In the late 1640s, Philips Koninck, a gifted and slightly peculiar landscape painter, began to paint panoramas, his canvases divided in half, horizontally, between equal measures of earth and sky. Koninck had married the sister of one of Rembrandt's pupils, Abraham Furnerius, and though never a student himself, he was evidently much affected by Rembrandt etchings like *The Goldweigher's Field*, which looked across a broad sweep of country layered with bands of shade and light. Impressionable and single-minded, Philips Koninck began to paint like this for the next decade, almost all his panoramas pieced together as if narrow ribbons of darkness and brightness had been laid across the canvas. He was a great success, enough of one, at any rate, to buy and operate a barge line that ran between Amsterdam and Rotterdam via Leiden, so that his business could travel through his landscapes. The countryside surveyed by Koninck's paintings, tracked by narrow, parallel courses of water fields, somehow seemed both familiar and fantastic, parochial and grandiose, which is precisely how the Dutch patriciate, at mid-century, liked to think of their *vaderland*. In 1657 Koninck married again, and his wife's name was Margaretha van Rijn.

Likewise, Dutch history seemed caught in alternating moments of brightness and gloom during the late forties and early fifties. A peace had finally been signed in Münster between Spain and the Dutch Republic, ending the eighty years of conflict that had begun with the splintering of images in Antwerp Cathedral in 1566. Had he survived to see this long-yearned-for peace, Rubens would have been both pleased and saddened by its terms. Flemish artists could, at last, come and go across the border, and some, like Jacob Jordaens and Artus Quellin, quickly won important commissions in the Dutch Republic. But Münster had also killed off Rubens's dream of reunifying the old seventeen-province Netherlands. The cultural

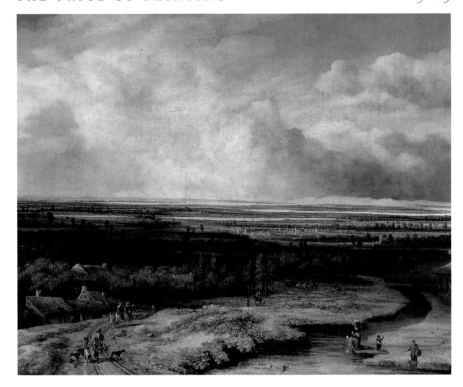

Philips Koninck, An
Extensive Landscape
with a Hawking Party,
*c. 1650. Canvas,
132.5 × 160.5 cm.
London, National
Gallery*

border, porous even in times of war, now virtually dissolved away alto-
gether. But the political and military border remained. The Catholic south
and the Protestant north had crystallized into two very different, and in
many ways irreconcilable, states. And when an attempt was made, in 1815,
to unite them as the kingdom of the Netherlands, ruled by the House of
Orange from Brussels, the union lasted just fifteen years.

There were no heavy hearts in Amsterdam, though, in 1648. Banquets
and parades, fireworks, muskets, and drums marked the peace. On the
Dam, a foundation of white Bentheim sandstone was laid for a new Town
Hall, now that the old Gothic structure seemed quaintly inadequate for the
pretensions of the new Tyre. The first batch of timber pilings were driven
into the sodden subsoil, stabilizing the foundations. Thirteen thousand five
hundred more would follow. Was there anything Amsterdam could not do?
Was there anywhere its fleets could not go? Was there anything at all the
world had to offer that would not be brought to its markets? In that same
year, 1648, Bartholomeus van der Helst, much the busiest of group por-
traitists in Amsterdam, painted an enormous militia piece depicting no
fewer than twenty-five members of the company of crossbowmen, feasting
in their *doelen*, on June 18. They are literally drinking in the triumph of the
moment, their faces ruddy with victorious self-satisfaction. The glittering
plate is adorned with vine leaves; the ensign at the center leans casually
against the table. To his right, Captain Cornelis Witsen, a plume in his hat,
receives the heartfelt congratulations of his lieutenant. Witsen, who would

play his own part in the unfolding of Rembrandt's destiny, glows with self-satisfaction, his beefy hand firmly gripping the stem of the enormous silver guild drinking horn, figured with an image of their patron saint, George. One writer later described Witsen in an unflattering epitaph as "a gentleman somewhat too fond of the grape."[1] And he does, indeed, have the air of a man who expected his cup to run over.

For a moment in the summertime of 1648, it did seem as though the dragons threatening Amsterdam, both foreign and domestic, had finally been disposed of. It had been plenipotentiaries from the States General, dominated by the delegates of the province of Holland, not some envoy of the Stadholder, who had negotiated the peace, and the patrician regents of Amsterdam now saw no further need for a large, expensive standing army of the kind insisted on by the Princes of Orange, especially since it now consisted mostly of foreign mercenaries. They could afford to lower their pikes and their muskets. Even before Frederik Hendrik's death, Holland's obstruction of funds needed for the army had dictated a reduction in its size and a corresponding dilution of the power of the stadholderate. So the Prince had died, therefore, in a state of exasperation, and bequeathed this dangerous irritability to his son, William II, just twenty-one when he succeeded as Stadholder. The son lacked the pragmatism of the father. Headstrong and intemperate, William looked to the plight of his father-in-law Charles I of England and thought that he had better seize the moment before it seized him. Threats were made against Holland, and in particular against Amsterdam, should they persist in their aim of demobilizing the army. When funds destined to pay troops were halted, William's threats were followed by action. In 1650 he had a number of his most conspicuous opponents arrested and imprisoned. His relative Willem Frederik of Nassau, the Stadholder of Friesland, was ordered to mount a secret military expedition against Amsterdam. Suddenly, the outlook, so fair in 1648, grew murky. A wave of trepidation swept through the patriciate. Calvinist preachers strongly pro-Orangist in their sympathies let it be known that God was about to punish the Dutch for their abandonment of the righteous crusade against the Spanish Antichrist.

But it turned out that Jehovah had a wicked sense of humor. The night before the attack, planned for the early morning of July 30, Willem Frederik's cavalry got lost in the fog somewhere on the Gooi moors. A mail carrier bringing letters from Hamburg to Amsterdam saw the companies of horses and armored musketeers stumbling around in the bracken and galloped to Amsterdam to sound the alarm. The city gates were slammed shut, the bastions armed, and the city government prepared for a siege. But before a shot was fired, a political accommodation was made. Andries Bicker, who had been burgomaster ten times since the 1620s, and his brother Cornelis were sacrificed from the inner circle of regents and funds restored for the Prince's militia. In place of the expelled "league of Bickers" came a group of men, many of whom had once been patrons of Rembrandt's: Nicolaas Tulp, Frans Banning Cocq; Joan Huydecoper van

Maarsseveen, and not least the brothers de Graeff. Whether they would be his patrons again, though, was in doubt. As he considered the unpaid eight thousand guilders on his house, Rembrandt may have been beginning to regret his disastrous falling-out with Andries de Graeff.

Rembrandt, View of a Camp, *c. 1650. Drawing. London, British Museum*

The new men were scarcely any less devoted to the interests of Amsterdam than had been the Bickers. Their ascendancy was immediately blessed by a disaster for the House of Orange. In November 1650 William II died of smallpox, leaving his wife, Mary Stuart, pregnant with the future William III (born eight days later) and throwing the place of the dynasty in the Republic into uncertainty. In Amsterdam no one seemed to mind very much. A local wit put a gold coin in one of the church's collecting boxes together with the rhyme:

> The Prince deceased
> My alms increased
> No word so dear
> In eighty year.

A "Great Assembly" was convened to fill the vacuum, dominated by Holland and steered by the State's Advocate, Johan de Witt, whose father had been one of William II's prisoners. The assembly reaffirmed that full sovereignty lay in the seven provinces alone, and resolved that the stadholderate in all (except Friesland) was to remain indefinitely vacant.

Fitful thunderbolts, coup and countercoup, thus inaugurated the "stadholderless" epoch of the regents in the Republic of the United Provinces. Though centuries of gallerygoers have looked at scenes of housemaids folding crisply starched linen, thick-necked cattle chewing the cud in bright pasture, citizens taking their ease on dune-lined beaches or walking between rows of ripening wheat and have imagined this mid-century Hol-

land as the perfect bourgeois idyll, the reality, in the 1650s, was not espe-
cially tranquil. Now that the old enemy, Spain, had been pacified, new foes
immediately appeared. In 1651 the English Parliament passed a Navigation
Act designed to break the Dutch domination of the international carrying
trade. Henceforth, herring, mackerel, and cod would be shipped to
England in English boats. Other cargoes destined for British ports would
have to be carried either by vessels from their place of origin or, again, in
English ships. To make their intentions clear, English warships began to
harass Dutch vessels. Failure to offer a formal salute to British warships in
the "British Seas" invited seizure or sinking. One hundred and forty Dutch
merchant vessels were taken by English warships in 1651.[2] Parliament had
another, more purely political, motive for this aggression. Charles I's
widow and her children were living in asylum in the Dutch Republic. Now
that Charles I had been beheaded, Cromwell wanted a guarantee from the
States General not only that they would never countenance any kind of
support for a Stuart restoration in England, but also that no Prince of
Orange (married into the British dynasty) would ever again become Stad-
holder and thus be in a position to threaten a kingless Britain. He even
went so far as to propose a political union between the two countries: an
improbable vision of a maritime Protestant League.

But the States General understood quickly enough that what was being
proposed was a polite form of blackmail. Forgo your political indepen-
dence and we will leave your ships alone. What was at stake, they knew,
was the principle of the *mare liberum*, the freedom of the seas—unre-
stricted shipping, unrestricted cargoes—on which they had built their
immense national fortune. Faced with the demand to relinquish this liberty,
the States General chose war instead. For the most part, it went very badly.
The Dutch fleets were courageous, but too dispersed in their firepower to
prevail in battle over the big English warships. During 1652 they watched
(sometimes literally from the shore) while their navy was torn apart, great
ships pounded, holed, dismasted, sunk. At the climactic battle off
Scheveningen, the naval commander Marten Tromp was killed along with
four thousand men, and eleven warships sunk or taken prize. The commer-
cial lifelines on which all Holland's prosperity depended were severed like
arteries and the Republic began to hemorrhage money. Many investors in
trading syndicates were driven to the wall. A terrible slump descended on
the country. Additional taxes were levied to raise funds for the restoration
of the battered fleets. Bread, butter, and beer were dearer. Riots broke out
in many of the towns of Holland, from Dordrecht in the south to
Enkhuizen in the north. The patriciate bolted their shutters against the
ominous din or headed for their country houses.

For a while, the news was unrelentingly bleak. In 1653 a concerted
Dutch naval counteroffensive began to turn the tide, taking as many
English vessels as had been taken from them. But even when the Treaty of
Westminster ended the naval war with England, the Dutch seemed sud-
denly on the defensive elsewhere. Brazil, which had been taken from the

Portuguese crown and which promised great riches for the West India Company, had been forfeited back to Portugal when Johan Maurits of Orange and his troops had been withdrawn. In the same year, 1654, a catastrophic powder-house explosion in Delft destroyed the entire northeast of the city and took with it the most gifted of all Rembrandt's pupils, Carel Fabritius. And as if there were not enough afflictions laid across the back of the Republic, in the mid-1650s the plague revisited its cities with almost unprecedented ferocity. Rembrandt's Leiden lost a quarter of its population in a single year, the artist's elder brother Adriaen, who died in 1652, perhaps among the victims. In Amsterdam, the paupers' graves in the Karthuizerkerkhof were dug and redug and then there was no further room, so the carts kept trundling out toward and beyond the Pesthuis into the villages of the Amstel and along the shoreline of the IJ.

It was in this somber time that Rembrandt's own manner became more contemplative; the action in his paintings, whether portraits or histories, less strenuously physical and more philosophically metaphysical. Of course, there was no crude correspondence between the gloomy temper of the times in the early 1650s and his choice of style and subject. He may have been concerned (as well he might) when the St. Anthonis Dike, not that far from his own house, broke in 1651, sending water crashing down into the villages below it. The Breestraat remained dry, but the floodwater coming up against the St. Anthonis Lock at the end of the street may have unsettled the foundations of some of the houses, as often happened anyway in the saturated subsoil of Amsterdam. One of the affected houses belonged to Rembrandt's neighbor, the Portuguese Jew Daniel Pinto, the Levant trader who had bought it from Nicolaes Eliasz. Pickenoy in 1645. The damage required Pinto to raise the level of his floor, and since Rembrandt shared a common wall with him, the painter's house was also forced to undergo some structural alterations.[3] The construction work—done for thirty-three guilders and a keg of beer—lasted (as construction will) far longer than either Pinto or Rembrandt had anticipated. The hammering and crashing never seemed to stop. Tempers frayed.[4] Rembrandt and Pinto had agreed on separate billing for lumber supplies, but inevitably got into disputes with the suppliers and with each other, Pinto going to court when he believed he had been charged for Rembrandt's timber.[5] How could a painter work? The noise was a torment. Dirt and dust were everywhere, hanging in the air inside and out. Rembrandt produced not a single picture through the first nine months of 1653 and only one in the last three.

It was not a good time to go dry. The seller of his house, Christoffel Thijs, was beginning to make demands for the payment of the outstanding balance of eight thousand guilders. Rembrandt was already deeply in arrears on his repayment schedule. In 1651 he had tried to mollify Thijs by producing one of his best and most ambitious landscape etchings of his country house, "Saxenburgh." And until his house had begun to collapse metaphorically and literally, he had tried to paint his way out of debt. And evidently he was talking to Thijs about his predicament. On the back of a

Rembrandt, The Gold-
weigher's Field, *1651.*
Etching. Amsterdam,
Rijksprentenkabinet.
Thijs's house, "Saxen-
burgh," is in the center,
middle ground.

pen-and-sepia drawing of two women and an older sister guiding an infant
in those first tottery steps, Rembrandt had written himself a reminder note
for the next meeting "to ask ourselves if [the issue] will remain with the
arbitration men and to Thijs if he wouldn't like one of two pictures to be
finished . . . or if he wants neither of the two."[6]

So when the hammering paused, there was still much to keep Rem-
brandt awake at night, for all the comfort of Hendrickje Stoffels's solid
body in his bed. Even if he had no guilty conscience about what he had done
to Geertje Dircx, he could not rest easy about the eventual outcome of the
affair. Too many people knew too many things, and not all of them could be
bought off. If only he could feel confident that a fresh and moneyed group
of patrons would come to him, then all would be well. But it was far from
clear in the early 1650s that those patrons were beating a path to his door.
Whatever the *schutter* officers felt about the painting of the company of
Frans Banning Cocq, Rembrandt was conspicuously missing from the
artists asked to paint the huge commemorative group portraits celebrating
the Feast of Münster. In fact, he would not get another group portrait com-
mission of any kind until *The Anatomy Lesson of Dr. Jan Deyman* in 1656.
In his anxiety Rembrandt must have been bitterly ruing his dispute with
Andries de Graeff, for the magnates of the most powerful faction in the
city government had made it clear that Flinck, rather than Rembrandt,
was their preference. He was at a crossroads, and the way ahead was not
obvious.

He ignored the signposts. As the future grew murkier for him, Rem-
brandt redoubled his experimental determination in the face of increasing
evidence of its unpopularity. In the most fashionable echelons of patrician
society, it was becoming evident that Rembrandt's rough manner of paint-
handling, and his still rougher attitude to sex and money, was not for

everyone. Still-life painters, landscapists, and portrait painters were working toward a more colorful, brilliantly lit, and smoothly painted manner; and while history painters were becoming more self-consciously classical, with crisply defined contours and sharply chiselled forms, Rembrandt was moving toward a painterly essentialism unencumbered by anecdote or gratuitous touches of local color. Clarity of surface description was becoming less important to him than expressive suggestion made through the manipulation of paint. Since *The Night Watch*, Rembrandt had decided that a "rough" rather than a "smooth" manner was more likely to establish an active engagement with the spectator, with the viewer participating in the imaginative "completion" of the work rather than simply being confronted with it. Perhaps the *conterfeitsel* of a young girl that he painted for the Portuguese Jewish merchant Diego d'Andrade in 1654 and which was rejected, once again, as "showing no resemblance at all to the head of the young daughter,"⁷ was also compromised by an apparently "unfinished" and broken manner of painting. Both d'Andrade and the girl seemed to have abruptly broken off sittings, perhaps after taking a look at what Rembrandt was doing, since the deposition announced that she "would be leaving at the first opportunity." D'Andrade demanded that Rembrandt immediately take up his brushes and finish the work to his satisfaction before the girl left, or else refund the seventy-five-guilder advance he had received for the job. Rembrandt, who had been forced to listen to these humiliating criticisms in front of a notary, responded furiously that "he would not touch the painting, nor finish it unless the claimant pays him the balance due or guarantees it by giving a security." After it was done, he was prepared to submit it to the Guild of St. Luke and let them decide whether or not the likeness was good. Just how those arbitrators would rule, both on "likeness" and finish—a notoriously ticklish matter in Amsterdam in the 1650s—was far from obvious, since fashion and taste in the style wars were not going Rembrandt's way, but toward ever smoother and cooler slickness. Any way he looked at it, the dispute was a smarting blow.

And still he refused to be seduced by vain surface effect. Since the mid-1640s, Rembrandt had been conducting a sustained, poetic inquiry into the relationship between the skin of things and the heart of the matter. He was ever the metaphysician. So he appears before us in the great Vienna self-portrait of 1652 socially naked, stripped of attributes: no plumes, no chains, no steel gorget or fancy turban; just the oversmock and cap of the working artist. (Though the cap is, perhaps, still very reminiscent of Raphael's *Castiglione*.) For once Rembrandt's eyes are entirely legible; indeed the slightly shadowed left eye, if anything, is even more arresting than its opposite on the brightly lit side of the face. There is no attempt to attract through obscurity. In fact, these eyes, with their reddened lids, divided by a deep vertical furrow on the brow, together with the pursed lips and set jaw, speak of intense intellectual concentration; the demanding labor of the painterly vocation. Rembrandt's pose in this painting, with his thumbs tucked forcefully inside his belt, his elbows stuck out, has been mis-

read as aggressively confrontational: the Painter against the Public. Certainly there is nothing ingratiating about it. But when taken together with his pupil Carel Fabritius's similarly plain self-portrait, painted not long before his death, we can see that Rembrandt's aim at this time, expressed in the terse confidence of his brushstrokes down the coat and the summary depiction of his big, muscular hands, was to try to register the unadorned truth: the independent master clad only in the garment of his work.

The same impression of sympathetic simplicity, of the prized seventeenth-century quality of *honnêteté*, a paradoxically calculated artlessness, was applied to some of his other sitters in this period: to the three-quarter-length portrait of Nicolaes Bruyningh, for example, whose handsome face is turned into the concentrated light while his body drapes itself over a solid chair. Little is known about Bruyningh, but it seems likely that he or his family must have had genteel pretensions, since Rembrandt has supplied him with the seated equivalent of the aristocratic contrapposto, the head turned in elegant opposition to the upper body. And Rembrandt substantially darkened the backgrounds of his portraits so that selectively illuminated areas of the face would glow out of the space, as if encountered in candlelight. And this impression of faces and figures emerging from, and dissolving back into, infinity was strengthened by Rembrandt's deliberately setting himself (as with the portrait of one of Dr. Tulp's apparently rather elderly sons-in-law, Arnout Tholincx) the virtually impossible task of making *black* costume—hat and coat—legible against a near-black ground.

In the portraits of the 1650s, Rembrandt adapted his painting technique to express his perception of the sitter. So the brushwork in the portrait of Bruyningh is relatively free and fluid, giving the sense of an animated, rather

Rembrandt, Portrait of Nicolaes Bruyningh, *1652. Canvas, 107.5 × 91.5 cm. Kassel, Gemäldegalerie*

OPPOSITE: *Rembrandt,* Self-portrait, *1652. Canvas, 112 × 81.5 cm. Vienna, Kunsthistorisches Museum*

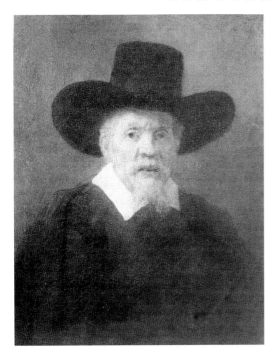

Rembrandt, Portrait of
Arnout Tholincx, *1656.*
Canvas, 76 × 63 cm.
Paris, Musée
Jacquemart-André

debonair figure; while for Tholincx, especially in the
collar and lit cheek, it is dense and rather rugged,
emphasizing the stolid virtues of the persona.
Nowhere, though, did the strokes of Rembrandt's
brush *themselves* supply a complex and perfectly
described character sketch to more revolutionary effect
than in his 1654 three-quarter-length of Jan Six (page
579), without any question the greatest of all his por-
traits, and arguably the most psychologically penetrat-
ing of *all* seventeenth-century portraits. Why? Because
it pictures, at one and the same time, our street face and
our mirror face, the way we choose to be seen and the
way we know we are.

Though nothing could have anticipated a painting
so completely cut free of precedent (or for that matter
without much progeny, at least until Goya and
Manet), Rembrandt's portrait of Jan Six could only
have been the result of a close knowledge of the sub-
ject. Though they would not remain friends for very
much longer, after he had completed the portrait Rem-
brandt's acute understanding of both the outward and
the inward aspects of the man presupposes something closer than the usual
patron-artist relationship. If a portrait of a plain and pious middle-aged
woman, dated 1641, is indeed, as has been speculated, a likeness of Jan
Six's mother, Anna Wijmer, then Rembrandt might have met the son when
he was just twenty-three, freshly returned from his Italian tour, handsome,
well off, fashionable, his head full of Italian poetry, Tasso and Ariosto, his
conversation doubtless peppered with talk of Bernini and fountains, cardi-
nals and libraries. Since he was thirteen, Six had lived with his widowed
mother in some style in the house called "the Blue Eagle" on the Klove-
niersburgwal, next door to "the Glass House" of the mirror manufacturer
Floris Soop. His grandfather had come to Amsterdam as a Huguenot in
1586, and his sons, Jean and Guillaume, had established themselves in a
trade in which French Protestants excelled: the weaving and dyeing of silk.
Jean Six had died in 1617 while his son was still in utero, so that Anna had
taken charge of the boy's education, doing the usual things to ensure that
the next generation would replace the grit of commerce with the polish of
learning. Jan was duly sent to Leiden University to study the *vrije kunsten,*
the liberal arts, and may have gone on to further studies at Groningen
University.[8] Certainly he would have acquired a decent knowledge of the
classical languages as well as Spanish, French, and Italian before being
dispatched over the Alps.

The campaign of refinement worked. Returned to Amsterdam, Jan Six
cut a dashing figure as a poet-patrician, complete with his very own rustic
Arcadia, a country estate at Ijmond. The tradition that he played host to
the artist (hence the story of the wager over *Six's Bridge* and the mustard)[9]
is almost certainly apocryphal, although a nicely poetic match between

the gracious dilettante and the notoriously difficult painter. But the first documented encounter was in 1647, when Rembrandt made a portrait etching of Jan Six, a work exactly calculated to gratify his self-image as a gentleman-virtuoso.

What did the two men of unequal age, background, and ambition see in each other in 1647? Rembrandt had many pupils, assistants, and patrons, but few friends, least of all of the elegantly cultivated kind personified by Jan Six. Rembrandt was certainly aware of the old *paragone*, the endlessly rehearsed rivalry between painting and poetry, which was particularly keen in Amsterdam. He routinely featured in the lists recited by Amsterdam's poets singing the praises of their city, and playwrights like Jan Zoet would mention his name when they wanted to invoke the acme of art.[10] But the two major poets of their generation—Huygens and Vondel—had both referred to him in a slightingly oblique fashion: Huygens teasing him for his failure to produce a recognizable likeness of Jacques de Gheyn III; Vondel challenging him to depict

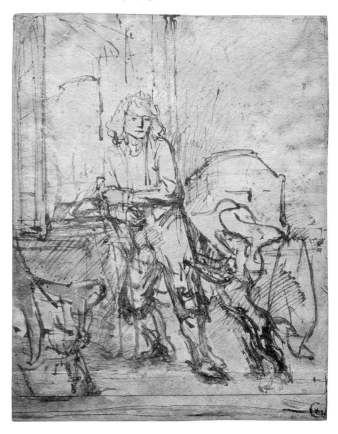

Rembrandt, Portrait of Jan Six, *1647. Pen and brown ink, brown and white wash. Amsterdam, Six Collection*

the great Anslo in the act of speech. Vondel's failure to praise Rembrandt might have been especially niggling since he was free enough in his praise of other artists. (Even when, later, he praised the portrait of Jan Six, Vondel actually omitted the name of the artist!) So Rembrandt was doubtless flattered to discover one young poet of indisputable cosmopolitanism and classical erudition who seemed to want to cultivate his company. For his part, Jan Six, who was as avid a collector of both Western and oriental art as Rembrandt himself, and who shared very similar tastes—Titian, Palma Vecchio, Dürer, Lucas van Leyden, Chinese drawings, and classical sculpture—may well have consulted the master on his own purchases.

Despite the age-old competition, the *affinity* between poetry and painting was much in the air at mid-century. A society meant to bring the two muses together outside the auspices of the Guild of St. Luke—the Society of Apollo and Apelles—in October 1653 held a banquet of mutual self-celebration (from which, however, Rembrandt was conspicuously and significantly absent).[11] But the sense in which the young writer and the middle-aged painter shared a common culture was evident in the pains Rembrandt took with the portrait etching. Preparatory drawings for etchings were relatively rare for Rembrandt, but for this commission he produced *two* such drawings for Six. Both were meant to suggest Jan Six's *sprezzatura*, the quality of refined nonchalance which Castiglione had required of all true gentleman courtiers. Such was the general impression

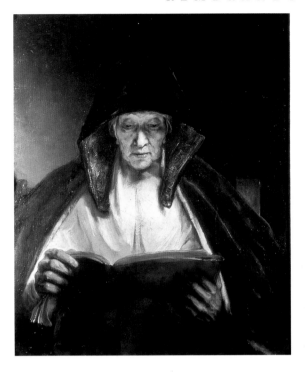

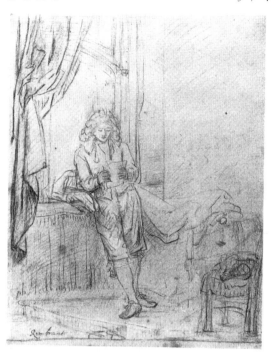

LEFT: *Rembrandt*, An Old Woman Reading, *1655. Canvas, 80 × 66 cm. Private collection*

RIGHT: *Rembrandt*, Portrait of Jan Six, *1647. Drawing. Amsterdam, Six Collection*

that Jan Six was the very model of politeness which the Italian writer had in mind, that the first Dutch edition of *The Book of the Courtier* would be duly dedicated to him. Rembrandt's two drawings, on the other hand, emphasized quite different aspects of the gentlemanly character. The first drawing featured a dog jumping up toward his master. The hound, of course, suggested Six's pretensions to be counted among the hunting classes, but it also alluded (as dogs often did) to qualities of loyalty and friendship, and even perhaps to the learning of the master as well as his pet, since all these values had been attributed to dogs in Lipsius's treatise on them.[12] But the extreme informality of the pose must have come as something of a surprise to Jan Six, and perhaps not an especially welcome one, either, since Rembrandt's second drawing, sketched rapidly and from life on the back of another image of a beggar receiving alms, was more the kind of persona that Six himself liked to think he had created for himself: the beauteous young writer, his nose stuck in a manuscript, standing, contrapposto, by a window, the light flooding in on his fine-boned face.

Rembrandt had long been obsessed with books. Yet he could hardly be called bookish. As deeply engaged as he was in the stories they told, he was also fixated on books as physical objects: on their casings, paper, and vellum; their piled-up, packed-in, gathered-and-bound authority. Over and again, his eye and his painter's hand wandered over their bindings or dwelled on the uneven, yellowing pages. He used books theatrically, with figures like St. Paul gesticulating at them; like Jeremiah resting mournfully beside the Lamentations; or like Anslo and Sylvius uttering their gospel truths. And unlike for Rubens, book illustration had been an almost

insignificant part of his work.
Before he met Six, a frontispiece
for a book on navigation and sea-
manship had been his only contri-
bution to the genre. Until the late
1640s (and with the exception of
the painting of *The Prophetess
Hannah*, possibly modelled by his
mother), Rembrandt had been less
interested in depicting *reading* fig-
ures, that is, figures lost in their
opened books. In the late 1640s
and 1650s, though, he etches and
paints faces literally illuminated
by the opened page. And unlike
the tradition of "scholars in their
study" in which the figure (like
Holbein's Erasmus) was conven-
tionally seen in profile, parallel to
the picture plane, and thus in
some way removed, these figures,
like the old woman (perhaps Six's
mother, Anna Wijmer) and Rem-
brandt's son Titus, are turned
about to face the spectator, so that
we become deeply drawn toward

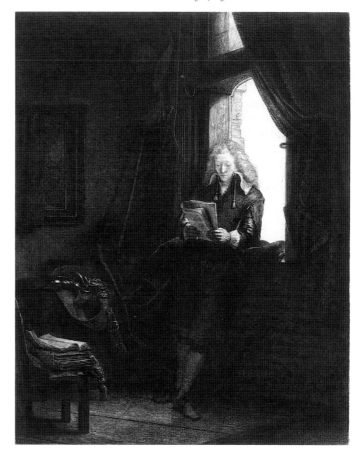

Rembrandt, Portrait of
Jan Six, *1647. Etching,
second state. New York,
Pierpont Morgan Library*

their own absorption, observing the light reflected from the books to their
faces.

A third drawing poses Jan Six precisely in this way, face-on, deep in his
reading, the pages of his book folded back, the pose that would be repeated
in the etching. There is, of course, a bright exterior light behind him as if he
were standing by the window on a sunny day. But with his back to the win-
dow, one would normally expect to see at least some of his face in shadow.
Rembrandt, however, has taken care to make Six's features brilliant, as if lit
less by the outdoor sunshine than by the literary illumination. The entire
etching, in fact, is a tactful synthesis of the spirit of the *two* drawings: the
doggy outdoors feeling of Six's role as an exemplar of the *vita activa*, signi-
fied by the elaborate sword and scabbard, the dagger and the cape; and, on
the other hand, the radiant light of the *vita contemplativa*, the life of the
imagination and mind. Buried in his reading matter, Jan Six stands pre-
cisely on the margin between the outdoor and the indoor worlds, between
the street and the study.

In the same year that Rembrandt executed his etching, Jan Six's first
dramatic effort, *Medea*, reached the stage. That he was an avid classicist is
not in doubt. In 1649 Six would buy (doubtless to the chagrin of less
monied scholars) the priceless ninth-century Carolingian minuscule manu-
script of Caesar's *Gallic War* at an auction.[13] So it seems likely that on his

Rembrandt, Marriage of Jason and Creusa, *1648. Etching, fourth state. New York, Pierpont Morgan Library*

Italian travels Six would have seen the famous pseudo-Seneca bust. Perhaps, like Rubens and Rembrandt, he had even provided himself with a replica. (There must have been a steady living for sculptors of *Seneca* knockoffs in Baroque Rome.) In any event, he would certainly have read Lipsius's definitive edition of Seneca's tragedies (completed by Philip Rubens). But in the spirit of free emulation endorsed by Aristotle and Horace, Six certainly felt at liberty to go ahead with his own version, part homage, part independent variation. The play was at least successful enough for its author to publish the text the following year, 1648, and to commission his new friend Rembrandt to etch a frontispiece. How odd, then, that Rembrandt chose as his illustration the scene of the wedding of Jason and Creusa, which was not actually part of Six's text. It was, in fact, possible for such scenes to be interpolated into the performance, in the manner of a masque, even when they were not expressly set down in the text. And Rembrandt's picture, with Jason kneeling beside his crowned bride before a mitred priest, clouds of incense rising to the vault of a lofty

half-Gothic, half-oriental temple, very much of the kind Rembrandt had favored in histories like *Christ and the Woman Taken in Adultery,* does indeed suggest some sort of tableau. But what tricks the subconscious plays! For the wedding was, of course, a fateful crime, or at least a tragic error. Jason had come to Corinth with his wife Medea, and when he had tired of her had simply cast her off in favor of the young princess. The rejected wife would have her revenge. After she had delivered her thoughtfully selected wedding gift (a poisoned gown) to the bride, Medea set about slaughtering her children. Now, the consequences of Rembrandt's own rejection of his concubine would not become apparent until the following year, 1649. And poor, slighted Geertje would turn out to be no Medea. But did, one wonders, Rembrandt look at the inscription on his etching for *Medea* with its solemn warning of the consequences of infidelity— "Unfaithfulness, how dearly you cost"—and cringe just a little?

And Jan Six? Oh, he was above such little unpleasantnesses. Rembrandt was a friend. For the time being. And as a friend, he was invited to contribute to Six's *album amicorum,* called *Pandora,* in 1652. He provided two pen drawings, one of which represents the first (but not the last) time he depicted Homer, reciting his verses, the blind eyes blank, the mouth open, before a rapt audience, some seated at his feet, some standing by and between trees. Homer, was, of course, a figure for whom both men must have shared a reverence, Six for the lyric poet, Rembrandt for the sightless yet visionary bard. The second drawing showed Minerva in her study,

LEFT: *Rembrandt, Homer Reciting Verses, 1652. Pen and brown ink drawing. Amsterdam, Six Collection*

RIGHT: *Rembrandt, Minerva in Her Study, 1652. Pen and brown ink drawing with brown and white wash. Amsterdam, Six Collection*

complete with shield hanging on the wall, deep in a book, wearing a head-dress very much like that of the 1655 *Old Woman Reading*. And if that old woman was in fact Six's mother, Anna Wijmer, then the drawing becomes another gallant allusion to the legendary wisdom of the matron. In the same year, Six bought two major works from Rembrandt, both, however, from the 1630s, a *Simeon in the Temple* (presumably the *Simeon* of 1628) and the stupendous 1634–35 grisaille of *John the Baptist Preaching*. A year later, when Christoffel Thijs began to pressure Rembrandt for the balance owing on his house—7,000 guilders plus another 1,470 in interest and "costs"—Six lent Rembrandt 1,000 guilders toward the outstanding sum.[14]

The loan was interest-free. But Rembrandt's portrait of his younger friend, painted a year later in 1654, repaid the obligation with a master-piece, the greatest portrait of the seventeenth century.

The painting is life-size but a three-quarter-length, creating a startling impression of an immediate, living presence. When Rembrandt, in 1641, painted the figure of a patrician (either Andries de Graeff or Cornelis Wit-sen) leaning nonchalantly against a classical column, the full-length format, in the van Dyck manner, dictated a necessary aristocratically calculated dis-tance, a length of floor, between observer and subject. Jan Six, on the other hand, is *in* space, so close we can see the small cleft in his chin and the fas-tidiously exposed measure of pink skin between his mustache and upper lip. Normally, a three-quarter-length would have suggested a rectangular canvas support. But Rembrandt's painting is nearly square. And almost the entire left-hand third of the canvas is occupied by nothing except a thickly painted blackness, from which Jan Six projects himself into the light. Through a calculation of the optical effects of color as careful as in *The Night Watch,* moving diagonally from the dark pigeon-gray of the coat through the ocher of his chamois gloves and finally toward the dazzling, saturated scarlet of his cloak, Rembrandt manages to make Jan Six seem to move through space, toward us, out of the anonymous darkness into the cordial, warming light of recognition.

His motions, as befits the gentleman virtuoso, are not unduly brisk. His regard is steady, directed at us, the business with the hands and the glove instinctively elegant. But what *is* that motion painted by Rembrandt as an astonishing wet-in-wet, unresolved blur of ocher, brown, gray, and white? It has always been assumed that Six is pulling his left glove more firmly onto his hand, preparing, as it were, to assume his street persona. But Rem-brandt has taken the greatest care to show the thumb of that same left hand skintight snug in the glove, even to the extent of outlining the upper edge of the thumbnail beneath the soft chamois. It is just as plausible, then, to read the motion of the bare *right* hand as beginning to pull the glove off, rather than putting it on. It's not, of course, that we need to change the direction of Jan Six's movement from a going-out to a coming-in, from a departure to a greeting. It's rather that Rembrandt means to catch his subject pre-cisely at the ambiguous margin between the home and the world. Ten years

OPPOSITE: Rembrandt, Portrait of Jan Six, 1654. Canvas, 112 × 102 cm. Amsterdam, Six Collection

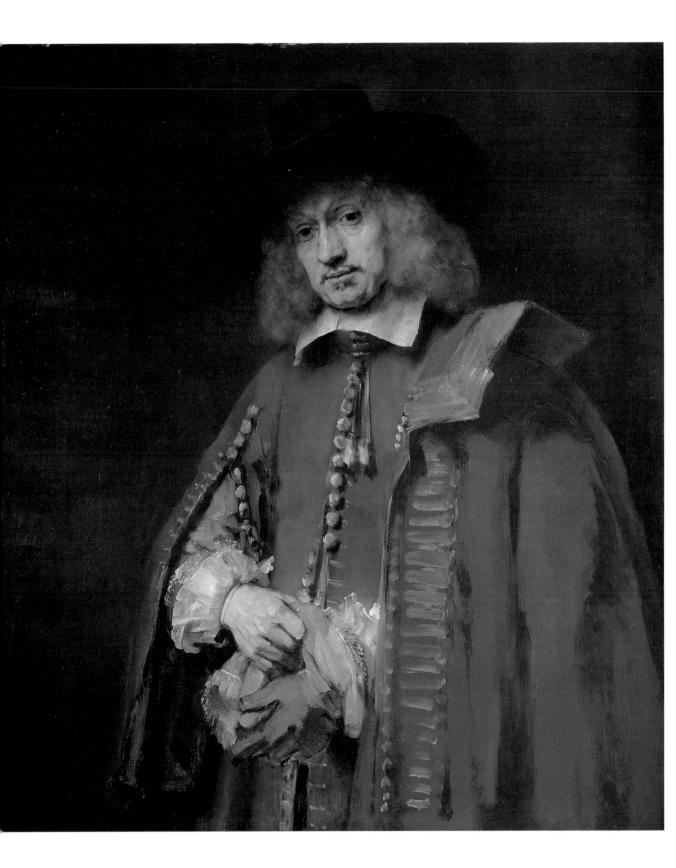

ago, David Smith very observantly noticed that in the Latin *chronosticon,*
or little epithet, which Six himself wrote of the portrait in his *Pandora*
album, he referred to himself as "IanUs."[15] So that when Six goes on to
affirm (considerately, given d'Andrade's complaint that same year) that
"this is the face that I, *Janus* Six, wore, who since childhood have wor-
shipped the Muses,"[16] he implies punningly two faces rather than one: the
face worn for the world and the face worn for his friends, for himself.
Which is why Rembrandt has done everything he possibly can to make us
look at those two hands: the bare hand of personal, familial greeting (the
precise indication of the knuckles and even the veins, for all the loose free-
dom of the brushwork, heightening this sense of intimacy) and the gloved
hand of social rituals. For that matter, the joining of hands or gloves was a
commonplace emblem of friendship and mutual devotion, so that Rem-
brandt was, in effect, once again making another allusion to the amity
existing between painter and poet. The greatest compliment Rembrandt
could pay his patron, though, was to deliver the paint to the canvas with
the appearance of pure *sprezzatura,* all his fine calculations disguised as ele-
gant spontaneity, just as Castiglione had urged.

The brushwork, then, *is* the personality of its subject, calling attention
to itself as an astonishing act of fluent self-possession. It is the most breath-
taking demonstration of what Dutch writers on painting would have called
lossigheid, looseness, giving the impression (belied by Rembrandt's
preparatory drawings) of paint having been laid on, wet-in-wet, at speed,
very much as in the painting of Hendrickje bathing in a stream, from the
same year (1654 must rank with 1629 and 1636 as one of Rembrandt's
most mind-bogglingly prolific years). But even if he did paint the portrait
relatively quickly, the exceptionally subtle handling of details, and the
amazing variety of brushwork, even in adjacent passages, testifies to the
tremendous care Rembrandt took with the conception of the painting, and
above all with what art theorists of the day called the *houding* of the piece:
the precisely interlocking relationship of colors to create credible pictorial
illusions in space.[17]

Wherever one looks in the painting, there is startling evidence of this
instinctive marriage between exact calculation and liberated handling. As
Hoogstraten noticed, the passages *closest* to us receive the freest brush-
work of all—the cloak with its broad strokes of black indicating the nat-
ural fall of the material following Six's shoulder and the amazing single
dabs of yellow describing the facings and buttons; the slightly more loaded
bottom edge of the brush, mixed here and there with a trace of white, man-
aging to suggest the way in which the light might catch the fabric, just as it
does more sharply on the more heavily faced gold lapel. Crucial to the
overall composition is that sharp right angle, repeated in the white collar,
anchoring the pose amidst all the movement of the brush. The shadows
beneath the collar are exactly calculated to give the linen lightness and lift
so that it seems to float over the dove-gray coat, the right corner given an
exquisite little curl. And where in the 1630s Rembrandt would have

Rembrandt, Portrait of Jan Six *(detail)*

painted his sitter's hair with almost pedantic care, scratching in the individual bristles with the back of his brush handle, here he manages to suggest Jan Six's full reddish mane with cloudy, almost airy brushwork, dabbed in except in the locks overhanging the white collar, where he indicates the hair ends by a web of minutely hatched vertical lines.

The picture is, then, a virtual encyclopedia of painting, from the loosest handling to the dry brush, sparely loaded with yellow, dragged over the surface at the edge of Six's right cuff; from the finest detail to the most impressionist daring. Yet Rembrandt manages to bring all this diversity of technique into a totally resolved single image. So that Jan Six does indeed stand before us much as we would dearly wish to imagine ourselves, all the contradictions of our character—vanity and modesty, outward show and inward reflectiveness, energy and calm—miraculously fitted together.

But was it what Jan Six really wanted? For when he married Dr. Tulp's daughter, Margaretha, two years later, it was Govert Flinck, not Rembrandt, who was hired to paint the bride. At some point, Jan Six sold off his loan note to a third party, Gerbrand Ornia, a rich patrician deep in the highest circles of the Amsterdam regency. He made sure, however, to keep his erstwhile friend's paintings. Janus, it seemed, was indeed two-faced, but not quite in the way the poet meant.

ii *Apelles Contemplating the Bust of Homer?*[18]

Between Scylla and Charybdis, the rocks and the whirl-
pool, the seawater looked beguilingly beautiful, dark like lapis lazuli,
flecked with sun-glitter. Scylla, the she-monster with the wolf's head and
the dolphin's body, rearing up from the surface as shredding rocks, was bad
enough. But it was Charybdis, on the Sicilian side, that the helmsmen,
steering a cautious course to Messina, all feared. They knew about the
garofano, the carnation, the sucking blossom that patterned the dark
water, each petal, ruffled with light foam, opening to welcome a ship into
the vortex of the flower. They had seen with their own eyes, or had heard of
it from men who had seen it, vessels first becalmed and then driven help-
lessly into the whirlpool, the ships turned upright, bowsprit pointing to the
sky, before disappearing forever. There were songs the beggars, the *lazza-
roni,* in Sicily sang about whole fleets eaten up in this way by the hungry
garofano. A good pilot, though, knew how to steer clear of the monster's
maw. And once well clear of the straits, the ship could take a safe position
by an estimation of its distance from the lighthouse and could sail toward
the curling spit of sand enclosing Messina's lagoon, the Tantane, where the
water became idle, flat, and green. For centuries the port had been called
Zancle, or the Sickle, after the curved shape of this outer strand, its "blade"
deceptively slight, but strong enough, all the same, to whittle tempests
down to size and protect the ships moored in the harbor.

On July 20, 1654, one of those ships, the *Bartolomeo,* which had made
the long, gusty monthlong journey from Texel, at the northern end of the
Zuider Zee, down the western coast of France and all the way around
Spain to the Tyrrhenian Sea, was docked in Messina's lagoon. The *Bar-
tolomeo* had been carrying a cargo of raw silk from Amsterdam to Naples.
But one of its charterers, a well-to-do merchant, Cornelis Gysbert van
Goor, had written his commercial contact in Messina, Giacomo di Battista,
that he had taken advantage of the ship's route to include, along with the
rest of the cargo, a four-sided box containing a painting destined for Bat-
tista's friend Don Antonio Ruffo Spadafora di Carlo, one of the port city's
senatori, Duca di Bagnara and (since 1650) Lord of Nicosia.[19] It's quite
possible that the painting was shipped on from Naples in another, smaller
coastal vessel. But there would have been a good commercial reason in
1654 for the *Bartolomeo* to have continued on through the straits. For sky-
high sugar prices on the Amsterdam Beurs, caused by the interruption of
Brazilian muscovado supplies when the Dutch were evicted from Recife
and Pernambuco, might easily have tempted the merchant entrepreneurs of
the voyage to pick up a load of Sicilian sugar which could then be prof-
itably unloaded on the return journey.

So we would not be far from the truth in imagining the cargo being taken off the ship by stevedores, beneath the inflammable sky, bearing much of it on their oily backs down onto the quayside. If, for a moment, the captain took his eyes off the business at hand, wiped the sweat from his dripping forehead, and looked over the tops of the crowded white houses, he would have seen a daunting range of mountains rising behind the walled city, parched dun and umber by the midsummer heat. On the scrubby slopes, a few tenacious chestnut and olive trees clung to the soil, defying the worst that nature could inflict on them, their trunks buckled, twisted, and knotted, but the roots secure, even when the earth, as it did from time to time, heaved a little and shook granite boulders from the hillsides. A few wispy clouds hung over the peaks, too thin and weak to amount to anything, unless a wet mistral was blowing in from the Tyrrhenian. Donkeys, in twos and threes, baskets slung over their backs, threaded their way down the ravine-cut hills into the outlying villages and on toward the great port city, *la nobile Messina*, currently enjoying one of its intermittent periods of prosperous enthusiasm between earthquakes, plagues, and tax riots.[20]

When a cargo from Amsterdam was judged valuable, the Dutch commercial consul in Messina, Abraham Casembroot, would have come to the harbor in person to make sure the goods were in order and were properly seen on their way to the merchants for whom they were consigned. In all likelihood this would have been one of those occasions. Beside bales of cloth from Holland and chests of iron and steel goods from Germany and Spain lay a square wooden crate containing a painting. Since Consul Casembroot was himself a painter (of quite elegant little scenes of the Messina waterfront, among other things), engraver, and architect who had supplied works of art to the local patriciate, he would have been paying particularly close attention to the fate of this shipment.[21] And he would have been joined by the grandly dressed merchant and connoisseur Giacomo di Battista, acting for the buyer. One can imagine the two men, shaded by parasols, giving directions to load the wooden box carefully onto a cart and following behind in a carriage as it set off at a sleepy pace along the harborside. The little convoy would have trotted past Montorsoli's statue of Neptune, holding a trident with one arm and with the other commanding Scylla and Charybdis, one screaming with rage, the other clawing vainly at the air, to cease their racket, and would have proceeded toward the *palazzate*, three-story Baroque houses with grandiose porticoes leading into shadowy courtyards where water dribbled reluctantly from the verdigris-stained mouths of dolphins and lions. Lemon trees stood in tubs and jasmine climbed the walls.

The cart would have turned into one of these fine entrances, doubtless greeted by an onrush of servants. The master of this house, Don Antonio Ruffo, a trimly mustachioed figure, would have descended hurriedly from the piano nobile with its frescoes of Ovid's *Metamorphoses*, past the rows of busts of Roman emperors lining the stairwell,[22] greeted his friend Gia-

como di Battista, and stood in front of the crate as its contents, a large painting, arched at the top, about six and a half feet long and five wide (or eight *palmi* by six, the Sicilians preferring to measure by the breadth of their hands than by the length of their feet), were removed. There would have been shouted commands to the servants to exercise great care with the dark, gleaming canvas, even though, with Ruffo's collection increasing every week, his men must have had plenty of experience at this work. When the last layers of protective sacking and wadding and oilcloth were removed, Ruffo found himself, at last, looking at Rembrandt's painting. It depicted a three-quarter-length figure of a thickly bearded, late-middle-aged man, his face and upper body lit, costumed in a black tuniclike sleeveless vest beneath which a capacious white gown flared out into enormous pleated sleeves cascading down from his shoulders and forearms, gathered only at the wrist. On his head he wore a flattish broad-brimmed hat which shadowed his creased forehead but left the strong nose and cheekbones and the dark, rather melancholy eyes all visible in the golden light. The man's right hand was placed upon the skull of an antique bust, which Ruffo, though a connoisseur of antiquity, initially at least, failed to recognize as Homer.[23] His left hand, a golden band glinting on the little finger, seemed to be playing with the enormous, weighty golden chain that hung across his chest and from which a medallion bearing the likeness of a helmeted head depended down his right side. The chain was painted in an extravagantly dense impasto, crusts, clots, beads, blisters, knots, and ridges of thickly mixed paint, white and yellow slathered together on the brush itself, rising from the canvas, in some passages, to a quarter of an inch.

Behind the bust was a pile of books. So Don Antonio Ruffo assumed that Rembrandt had sent him a philosopher of some sort, and the painting was duly entered in his inventory on September 1, 1654, as a "half-length of a philosopher made in Amsterdam by the painter Rembrandt (it appears to be Aristotle or Albertus Magnus)."[24] Rembrandt's painting was not the only picture whose precise subject Ruffo was unsure of. Another work was described in the inventory as depicting "either St. Jerome or a philosopher with the index finger of his left hand pointing to a skull resting on a book."[25] But from the two entries, it certainly seems that Ruffo was creating a gallery of scholars or philosophers, ancient, medieval, and modern, much like the one that Rubens had created for his friend the publisher Balthasar Moretus. By the time he referred to the painting again in 1661, when he was commissioning a companion work from Guercino, Ruffo had decided that it was indeed an Aristotle.

The original commission went back to 1652, probably along the same route, in reverse, that the painting had taken when shipped. Ruffo had asked his friend Battista, who had commercial contacts in Amsterdam, to see if Rembrandt would paint him a half-length figure. That he sought out the artist is itself powerful evidence of how far Rembrandt's reputation had travelled by the 1650s. His own pupils would have created one route of fame. Samuel van Hoogstraten, for example, was making his own name as

OPPOSITE: *Rembrandt, Aristotle Contemplating the Bust of Homer, 1653. Canvas, 143.5 × 136.5 cm. New York, Metropolitan Museum of Art, Lehman Collection*

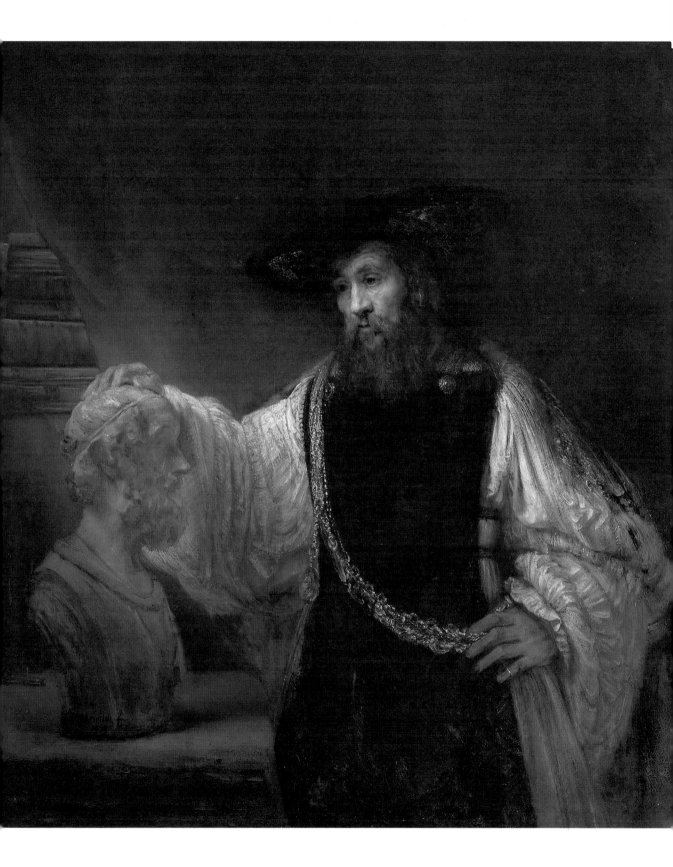

a court painter in Vienna specializing in extraordinary optical illusions, known in Holland as "deceits." But it was also likely that he, like others who had gone through Rembrandt's workshop, would have had many stories to tell of their master. Filippo Baldinucci, for example, who provided the first Italian account of Rembrandt's life, got his information from the Danish artist Bernhard Keil. And there were other equally far-flung outposts of the Rembrandt empire who might have spread the word.

However dismissive Michelangelo might have been of the capacities of northern artists, there's no doubt that by the mid-seventeenth century there was a strong taste for their work in Italy. Van Dyck had worked in Naples in 1624, painting, among other things, a *St. Rosalia with Eleven Angels* (now in the Metropolitan Museum in New York), and reproductive engravings had spread the fame of Rubens's masterpieces as much through Italy as anywhere else in Europe. Antonio Ruffo, who had moved into his grand palazzo in 1636 and who by 1649 had accumulated a spectacular, comprehensive collection of 166 paintings, also owned prints by Lucas van Leyden, the same artist whose works Rembrandt had been prepared to spend considerable sums of money to acquire. Rembrandt's own paintings, though, could only have been known to a select few among Italian patrons. The great Roman collectors—the Barberini, the Giustiniani, and the Orsini—as well as the Florentine Medici are all supposed to have owned examples, including self-portraits. But Rembrandt's fame, in Italy as throughout Europe, lay in his etchings, which were hugely admired, sought-after, and copied. The Genoese artist Giovanni Benedetto Castiglione, for example (who had also worked for a period in Naples), was sufficiently taken with the bravura of the Dutch artist's self-portrait etchings of the 1630s to depict himself as an Italian Rembrandt, complete with dashingly plumed hat, piratical mustachios, and confrontational countenance.

Castiglione's unmistakably Rembrandtesque self-portrait draws on what may have been an already established image of the Dutch artist as someone who would certainly oblige, but not fawn on, his patrons; the kind of persona, in fact, adopted by the notoriously difficult Salvator Rosa, another painter admired, and subsequently hired, by Ruffo. Whether Ruffo took this into account in the specifications for the original commission of 1652 is hard to say. In fact, it's not at all certain that he specifically requested a philosopher rather than merely a "half-length" from Rembrandt. (What he got was closer to a three-quarter-length, both longer and wider than the present, reduced canvas in the Metropolitan Museum.) Many other guesses as to the identity of the figure have been made over the years, from the seventeenth-century Italian poet Torquato Tasso to the Dutch poet Pieter Corneliszoon Hooft.[26] (Though why Rembrandt should have supposed his Sicilian patron wanted a portrait of a Dutch writer is hard to imagine.) In a justly famous article, Julius Held argued that the helmeted head on the medallion hanging from the golden chain, long recognized as a stylized image of Alexander the Great, embodied a third presence in the painting, and one, moreover, which linked the philosopher to the

poet.[27] For Alexander, who as a child had
been Aristotle's most famous pupil, was
known to have revered the blind bard so
much that he kept copies of his works by
his bed. It was also commonly supposed,
from the biography written by Plutarch,
that Aristotle had actually prepared a new
edition of the *Iliad* expressly for Alexander
so that the young ruler would learn the arts
of war from the poet. The relationship
between the bust and the philosopher, the
dead immortal and the living scholar, sym-
bolized by the touch of his right hand,
would, then, be akin to that between the
bust of Seneca and the equally somber fig-
ure of Justus Lipsius in Rubens's *Four
Philosophers*.[28] And the golden chain, seen
by Held as an allusion to a reference in the
Iliad to the "golden chain of being," thus
seems to link all three figures in mutual
admiration.

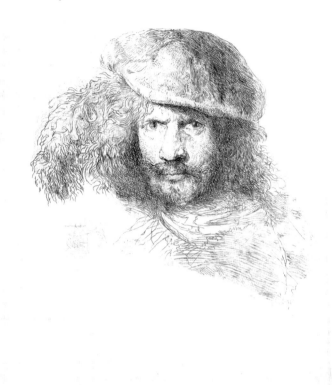

*Giovanni Benedetto
Castiglione*, Self-portrait,
*c. 1650. Etching. Private
collection*

Neither Homer nor Aristotle was
thought to have ended his life in peace and
prosperity. Homer, whose very name signi-
fied blindness and whom Rembrandt had
sketched in Jan Six's *Pandora* album the
same year that the commission arrived
from Ruffo, was often imagined suffering
all kinds of ordeals, the most famous being
his humiliation at Cumae, when, after he
promised to make the town famous with his verses if it would grant him
patronage, the locals declined the offer out of fear that they would be inun-
dated with a horde of destitute and infirm poets panhandling for bread.
Aristotle also suffered bitterly after Callisthenes, his friend or perhaps
nephew, had been put to death for treason by Alexander. Though Aristotle
himself survived, he was persecuted after Alexander's death for having
been too close to the Macedonian dynasty and was condemned to die by
the Areopagus. He died in exile on the island of Euboea.

The melancholy expression on Aristotle's face could, then, be plausibly
understood as his "contemplation" of the brevity of fame and the fickle
character of worldly fortune. His fingers trawling through the heavy gold
chain seem to "tell" his story from Alexandrian honor to disgrace and
repudiation. And given Rembrandt's increasing ambivalence about the
relationship between artists and their public, expressed most pithily in his
scatological satire against the "asses" of art, Held's reading continues to
make a lot of sense. It could even encompass a typically Rembrandtian

tragic conceit played off between two kinds of blindness: Homeric vision and the blindness of public opinion.

But *is* he, in fact, as Ruffo eventually assumed, really Aristotle? Paul Crenshaw has noticed that there was, after all, another major figure with whom Rembrandt identified (as his scatological drawing showed) and who also suffered from the caprices of the powerful, and that, of course, was Apelles. Apelles had been Alexander's personal favorite as an artist and was far more commonly coupled in the seventeenth century with Homer than was Aristotle, the two of them celebrated (by van Mander, for example) as the epitomizing geniuses of, respectively, poetry and painting. If there are no attributes of painting present to indicate his profession, the same had been true for those other "painters of princes" Titian and Rubens, both of whom (unlike Rembrandt) had famously been awarded chains of honor. For that matter, Rembrandt was quite as likely to portray himself without brushes as with. The handsomely silky, almost regal black-and-white attire in which Rembrandt has costumed his figure is quite as suitable for an honored royal favorite as for a philosopher. The presence of books (as in Rembrandt's etching of the artist Jan Asselijn) just as often indicated a *learned* painter, the *pictor doctus,* as a scholar. Bear in mind, moreover, that 1653, the year in which Rembrandt executed the painting, was also the year in which the Society of Apollo and Apelles, instituted to celebrate the mutual admiration of poetry and painting, held its banquet, and one can begin to see the pieces of Rembrandt's daring inspiration coming together.

The fact that Rembrandt seems to have been missing from the inaugural festivities of "Apollo and Apelles"—perhaps because the guest of honor, Joan Huydecoper, belonged to a political faction opposed to most of Rembrandt's patrons—scarcely weakens the possibility that the brooding figure in Rembrandt's picture might well have been a painter rather than a philosopher, as Ruffo assumed. It would have been exactly like Rembrandt to use the occasion to make the claim that he, and not the nonentities claiming to personify "classical" taste—Govert Flinck, Nicolaes van Helt Stockade, and the like—truly embodied the inheritance of Apelles. For while the brightly lit and sharply contoured painting style was gaining ground in Amsterdam, Rembrandt might have deliberately chosen to demonstrate that it was *his* manner of painting, not theirs, that was closer to the Greek master. The way he did this was to paint a portrait of Apelles incorporating precisely the characteristics singled out by Pliny as the signs of genius in Apelles and which were starting to be attacked as self-indulgently "rough" and obscure. The matching between subject and painterly technique was, of course, to be repeated again in the following year, in both the liquid informality of the brushstrokes in *Hendrickje Bathing* and the "loose," calculated nonchalance of the portrait of Jan Six.

In his various stories of Apelles' career, Pliny evokes the particular qualities of his technique which established him as the supreme painter of Greek antiquity. All of them are glaringly present in the painting at the Met. First, Apelles' portrait of Alexander holding a thunderbolt (for twenty

talents of gold) has the fingers of the King appearing to "project from the surface" of the painting. Rembrandt has made the gold itself, in the form of the chain, and his image of Alexander "project" through his densely worked impasto. Second, Apelles is said also to have achieved his effects while restricting himself to the four-color palette—black, white, ocher, and earth red—the palette to which Rembrandt had also mostly confined himself in the 1650s. Third, Apelles was said to have used a thin, almost invisible black varnish which helped soften the garish brilliance of colors and even make them somber at a distance. Rembrandt used no "black varnish" but with his carefully thinned grounds certainly was concerned to make the contrasts between darks and lights, as brilliant as they appear in this painting, subtly modulated. Finally, Pliny relates that while Apelles admired the "meticulous and laborious" style of his rival Protogenes (read, perhaps, in Rembrandt's mind, Govert Flinck, who himself was already being spoken of as "Apelles Flinck"), "in one respect he stood higher, [namely,] that he knew when to take his hand from a picture."[29]

Nothing could have been more expressive of Rembrandt's "unfinished" or "rough" manner than the stupendous handling of the great sleeves, the paint dabbed on in precisely the broad, slashing strokes which the advocates of high-finish classicism most disliked. One of the earliest and most pungent attacks on Rembrandt's late style, in fact, came in 1670, a year after the painter's death, from the great-grandson of Pieter Bruegel the Elder, Abraham Breughel, living in Rome, contrasting the "great painters" who "try to show a beautiful nude body in which one can see their knowledge of drawing" with "an incompetent who tries to cover their figures with dark clumsy garments . . . a kind of painter who does the contours so that one does not know what to make out of it."[30] Just whom Breughel had in mind is not in doubt, since five years earlier, in May 1665, he had specifically told Ruffo that in Rome, while they were well thought of as portrait heads, "the paintings of Rembrandt are not held in high esteem."[31]

Rembrandt had heard *that* already in the complaints of Andries de Graeff and Diego d'Andrade (echoing those of Huygens) that he had failed, yet again, to produce an acceptably clear likeness of his sitter. What better way to vindicate himself, without surrendering the least measure of his painterly power, than by representing Apelles as an alter ego, his hand touching the head of Homer, famous for the expressive roughness of his own poetic manner, and reflecting poignantly on the transience of fame, the shallowness of taste. And the pendant medallion of Alexander might, after all, have a different significance than if the figure were Aristotle. For Apelles outlived his great patron, travelling to places in his former empire like Ephesus and Alexandria where the King had made his mark, but becoming dependent on patrons like the Ptolemys, who were but a feeble shadow of the great Alexander. So that, among its many other meanings, the painting might well be taken as a meditation on the fleeting quality of imperial power.

Of course, once Ruffo had made it clear that he was happy with his

philosopher and indeed paid Rembrandt the five hundred guilders he was owed for it, there was no reason at all for the Amsterdam artist to disabuse his patron of any misunderstanding. (It's even possible, as Paul Crenshaw argues, that since Ruffo's correspondence dealing with the subsequent pictures and explicitly mentioning an "Aristotle" was sent not to Rembrandt but to the Dutch ambassador at Messina, Rembrandt never actually knew of the Sicilian's misidentification.) For that matter, the two subjects Ruffo subsequently ordered from Rembrandt—an Alexander the Great and a Homer, disaggregated, as it were, from the original painting and given their own half-length treatment—could as easily be reconciled in his mind with an Apelles as with an Aristotle. Since by the time Rembrandt shipped his *Alexander,* along with a sketch of a proposed *Homer Instructing His Pupils,* he had been bankrupted and lost his house and most of his collection, one would suppose that he wouldn't risk losing so important a patron as Ruffo for the sake of clearing up some sort of misidentification. Other risks, however, Rembrandt was perfectly prepared to take. For when Ruffo examined his *Alexander* (possibly, though by no means certainly, the painting now in Glasgow),[32] he could see that the canvas had been stitched together from four separate pieces. In fact, just like Rubens, Rembrandt had enlarged his canvases before, as his ideas about a composition developed, without any sense of compromising quality. Both *The Night Watch* and the great *St. John the Baptist Preaching,* owned by Jan Six, had been expanded in this way. It may be that Rembrandt, again following Rubens, prided himself on being able to make the unity of the whole so compelling that the joins would become virtually invisible.

For a while, this must actually have been the case, since Ruffo's letter complaining bitterly of the patchwork canvas was sent only fifteen months after he received the *Alexander.* Once the defect of the material had been noticed, though, it probably did not help that Rembrandt had attached to his invoice a note airily remarking that because the painting was of a good size, six by eight *palmi,* "the price [500 guilders plus another 123 for packing, shipping, customs, and insurance] should not unduly overburden the Gentleman."[33]

Perhaps when he discovered what he assumed was sharp, or shabby, practice on Rembrandt's part, Ruffo became particularly incensed because he had already commissioned from Guercino a companion piece for the *Aristotle.* Shown a sketch of the first painting, Guercino assumed he was looking at a "physiognomist" since there appeared to be a man advertising his calling by feeling a skull, and painted for Ruffo a *Geographer* as a pendant, the mapping of the earth thought to be a good match for the mapping of the human head! In contrast to Rembrandt's perceived laboriousness, Guercino, who undoubtedly valued and perhaps owned Rembrandt's etchings, had completed his painting in just a couple of months, and had especially obliged Ruffo by reverting, anachronistically, to his earlier, chiaroscuro manner, the better to fit in with the Amsterdam artist's style. Since Ruffo had flattered Rembrandt by treating the *Aristotle* as the center-

piece of a small gallery of heroes and thinkers of the kind the Prince of Liechtenstein had commissioned from Jusepe de Ribera, he might have been especially galled to be so casually treated by the Amsterdam painter the second time round.

When it was sent on November 1, 1662, the letter minced no words about Don Antonio's displeasure. It was dispatched through the Dutch consul in Messina, Jan van den Broeck, whose name was conveniently Italianized as "Vallembrot" and who was on his way to Amsterdam. Once there he was to inform Isaac Just, presumably the intermediary between Rembrandt and the Messina patrician, of the intense dissatisfaction of the latter at the work he had received. The *Alexander,* he complained, being unacceptably stitched together from four separate pieces, showed seams which were "too horrible for words." Among his collection of two hundred of the very best paintings in Europe, there was not one which was put together from such patches. It was apparent that originally the painting had been nothing more than a head, not the half-length which had been commis-

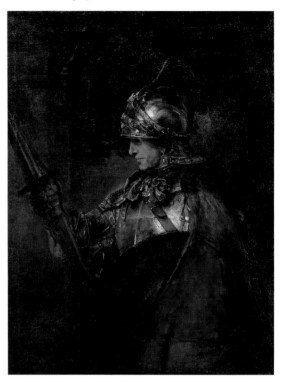

Rembrandt, Man in Armor (Alexander?), *1655. Canvas, 137.5 × 104.4 cm. Glasgow Art Gallery and Museum*

sioned and paid for. And this head, who knows, perhaps painted earlier, had merely been lengthened by the addition of canvas at the foot. Then, to avoid the unfortunate impression of a long narrow piece, it had been enlarged once again by the addition of two further strips at each side. To compensate for all these imperfections, Rembrandt had seen fit to include with the cobbled *Alexander* a Homer which had at least been painted on a fine, single canvas. But not painted enough. In fact, it was plainly *mezzo finito,* half-finished.[34]

So what was to be done with such faulty goods? The *Homer* would be shipped back forthwith to Amsterdam to be finished. If Rembrandt seriously expected Don Antonio to accept the *Alexander* in its present condition, he should at least be prepared to cut the price in half since the sum asked for was "more than four times the amount the best Italian painters would ask for." But since Rembrandt could not really expect "such an expensive painting with so many defects" to remain in Ruffo's house in a gallery of fine masterworks, he should be prepared to do the painting over again or else take it back and refund the money already paid.

Rembrandt's retort, evidently made after the *Homer* returned to Amsterdam, has been preserved only in the Italian version made for Ruffo, but it loses nothing of its own force in translation. It was not exactly a grovelling apology.

I am most astonished by what has been written about the "Alexander," which is so well done that I must suppose there are not many

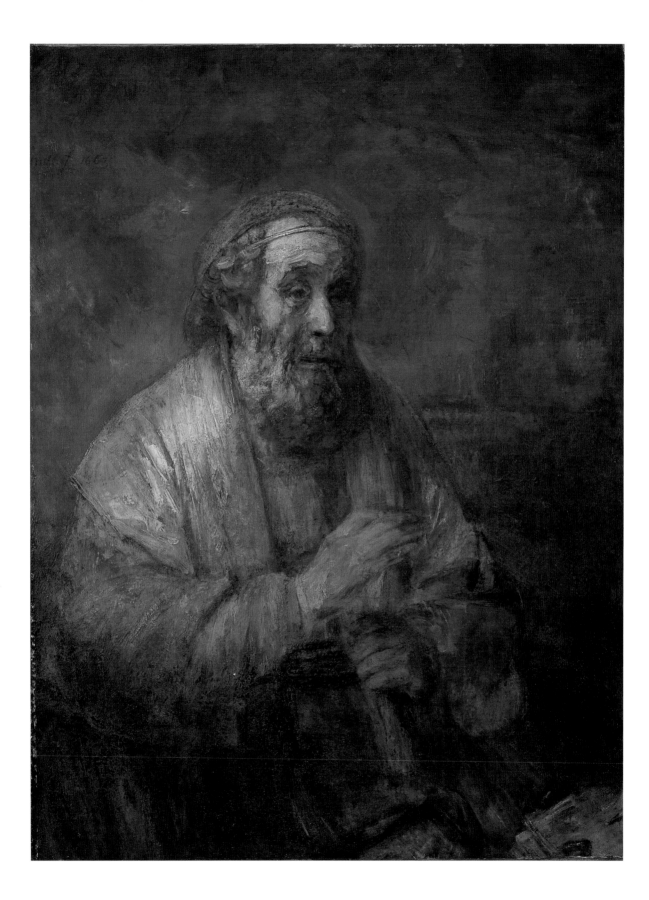

lovers of art [*amatori*] at Messina. I am also surprised that Your
Lordship should complain as much about the price as about the
canvas, but if Your Lordship wishes to return it as he did the sketch
[*schizzo*] of Homer, I will do another Alexander. As for the canvas,
I did not have enough of it while I was painting and so needed to
lengthen it, but if it is hung well in daylight, one will not notice
anything.

If Your Lordship likes the Alexander as is, very well. If he does
not want to keep it, six hundred florins remain outstanding. And
for the Homer five hundred florins plus the expenses of canvas, it
being understood that everything is at Your Lordship's expense.
Having agreed to it, would he kindly send me his desired measure-
ments. Awaiting the response to settle the matter.[35]

One might imagine that if Ruffo was mortified at what he thought was
the shoddy work from the painter generally thought to be the greatest of
his generation, he would have been apoplectic on reading Rembrandt's
retort. But in fact, there was not a breakdown in the relations between
painter and patron. Perhaps Rembrandt explained his working methods a
little more fully to Ruffo, since the *Alexander,* however unsatisfactory, did
not get returned to Amsterdam. And presumably Ruffo was well satisfied
when he received the completed *Homer.* From Rembrandt's reference to a
"sketch," one might assume that Ruffo had, perhaps understandably in
view of his exasperation at the Alexander, mistaken a trial *modello* for the
finished painting.

But when he received the *Homer Instructing His Pupils,* Ruffo was
pleased enough to continue commissioning paintings from other artists, all

Rembrandt, Homer
Instructing His Pupils,
*c. 1661–63. Pen and ink
drawing. Stockholm,
Nationalmuseum*

OPPOSITE: *Rembrandt,*
Homer Instructing His
Pupils, *1663. Canvas,
108 × 82.4 cm. The
Hague, Mauritshuis*

relating to the theme of instruction: a *Diogenes the Schoolmaster* from Mattia Preti; *The Philosopher Archytas with His Dove* from Salvator Rosa; and the painting listed as a "St. Jerome or a philosopher with the index finger of his left hand pointing to a skull resting on a book" from Giacinto Brandi. None of those paintings, nor indeed the Guercino *Geographer,* has survived, and the *Homer* only exists now as a fragment, severely damaged by fire as well as cut down on all four sides.

It's possible to reconstruct the way the painting originally looked from a preparatory drawing sent to Ruffo for his approval. Done, unusually for Rembrandt, in brown India ink with heightening in white, it shows the blind bard, one hand on his stick, the other making a chopping movement through the air, perhaps keeping the rhythm of his chant. A bright light falls across Homer's right shoulder and onto his face. But it also travels on in the drawing through to the student sitting at his desk, his eyes turned attentively toward the old man, in one of Rembrandt's beautiful visualizations of the idea of "illumination."

The poor, mutilated piece of canvas in the Mauritshuis has lost a great deal, but it has also preserved a good deal of what matters, not least Rembrandt's inspired idea for the depiction of the storyteller he evidently revered. Once again, the brushwork is meant to convey the essence of the subject: rugged simplicity; his hands big and demonstrative; the body patriarchal; the mantle of the bard shapeless and unembellished but lit with a poetical glow. As with his rendering of the bust of Homer in the *Aristotle/Apelles,* Rembrandt deliberately keeps his eyes in shadow. But there is enough light for us to notice that in contrast to the hands, painted with broad, sketchy strokes, Rembrandt has taken great pains with these eyes. The sunken sockets are deeply modelled, the rims of the eyelids sore; the upper lids hooded; a tiny highlight appears at the very edge of the lower lid. The eyeballs themselves are black and lifeless, repelling any kind of reflection. But above them, within the shining skull of the poet, visions are nonetheless forming.

iii *Sacrifices*

Rembrandt's troubles had come to him unremarkably, like the first heavy drops of rain striking a dry windowpane, a momentary distraction.

And then it turned into a storm. On February 1, 1653, a notary showed up at the house and formally presented Rembrandt with a statement of the balance owed on his property. It had been prepared for Christoffel Thijs, who evidently had not been pacified by Rembrandt's etching of his country house, nor by the proffered paintings. He had been patient, he must have thought. Rembrandt had undertaken to pay the balance owed in a period of five or six years, though there had been some additional words about "or as shall seem convenient." Fourteen years had unreasonably stretched any definition of convenience, and the patience of Christoffel Thijs had now expired. Earlier in the year, in January, he had already demanded the conveyance tax before transferring the deed to Rembrandt. The entire bill came to 8,470 guilders and 16 stuivers, interest and taxes included. "In the event of further delay," the statement ominously warned, "a protest will be lodged because of the most urgent reasons, and steps will be taken, as deemed advisable, with the intention to claim from Your Honor all costs and further interest plus damages."[36]

To meet at least some of these obligations, Rembrandt contracted for two serious loans. The first was from Cornelis Witsen, the patrician captain who had appeared so prominently in van der Helst's group portrait of the company of crossbowmen celebrating the Peace of Münster. He lent Rembrandt 4,180 guilders, which in a sworn statement before the magistrates the artist pledged to repay inside a year. His collateral was the entirety of his possessions. Though Witsen was outside the charmed circle of regents who dominated the Amsterdam regency after 1650—the de Graeffs and Huydecoper—his star was once again on the rise; he was elected to one of the four burgomasterships just a few weeks after lending Rembrandt his money. And since those other magnates had conspicuously dropped Rembrandt from their favors (certainly in respect of commissions to decorate the new Town Hall), it may just be that Witsen, as Gary Schwartz has suggested, was deliberately adopting Rembrandt as a way of making the kind of statement about his taste that might promote his political prospects.[37] To go anywhere as a patrician in mid-century Amsterdam, it had become important to play Maecenas. But Rembrandt should have been wary of Cornelis Witsen. The same sharp epitaph writer who had described him as a drunk also thought him a bloodsucker and hypocrite, "unpopular as

sheriff because he bled the community white . . . while claiming he was not after the money at all and that the office was forced on him."[38]

But in the spring of 1653, Rembrandt did not have the luxury of being choosy about his creditors. Six's 1,000-guilder interest-free loan had certainly been a statement of friendship. But he was still strapped. He took out a new loan of another 4,200 guilders with one Isaac van Hertsbeeck, which like the Witsen loan would be due in a year.[39] No wonder he was painting fast and furious throughout 1654!

Perhaps all would still have been well had his ship come in. Instead, as his application for a *cessio bonorum,* or voluntary surrender of property, to the insolvency commissioners stated, he had suffered "losses at sea" as well as "losses at business."[40] What had happened? Had he invested unwisely in a merchantman that had been taken prize in the war with the English? Had it sunk with a cargo of spices somewhere in the Bantam Straits or in the howling winds off the Cape of Good Hope? For that matter, how had Rembrandt managed to spend his way through Titus's share of Saskia's legacy, a full 20,000 guilders? How much had those porcelain cassowaries *cost*? After all, despite his being knocked off a rung or two from the most sought-after painters, Rembrandt had not exactly slipped into total obscurity. His paintings were being handled by the dealer Johannes de Renialme, and one of them, *Christ and the Woman Taken in Adultery,* had been assessed as worth 1,600 guilders, a fabulous sum. But that painting had been done in the jewel-like manner of the early 1640s, packed with anecdotal detail and curious, intricately wrought architecture and costumes. Other things, less fancy things, interested him now. Early in 1654, with the help of Renialme and another dealer, Lodewijk van Ludick, an effort was made to try to sell some other picture to a Delft notary.[41] The sale fell through when it turned out that the buyer was himself relying on funds due to him from a bankruptcy action, which cast doubt on whether the sellers would ever see their money. But they had attached, in any case, a strange condition to the sale, namely, that none of the parties concerned should breathe a word of it to anyone, and "*especially* not to Jan Six." This in spite of the fact—or possibly because of it—that the dealer van Ludick had stood guarantor of Six's generously interest-free loan to Rembrandt!

The fishy nature of this transaction suggests the beginning of financial panic. As a result of the three loans, Rembrandt could pay off the conveyance tax and the deed to the house as finally his. But now he was in debt up to his neck to a fresh batch of creditors, some of them, like Witsen, unreliable in their magnanimity. The coils of his ruin began to rope themselves around him ever more tightly. As he thrashed around looking for some way out, some sort of deliverance, he could feel the constriction pressing harder. Toward the end of 1655, he began to take cautionary steps to protect his family should the worst happen. Titus, now fourteen, was made to write his will specifying that if he predeceased his father, what was left of Saskia's legacy would go to Rembrandt. "The testator does not wish," declared the document, "that any of the goods he leaves behind

should be inherited by any relatives on his mother's side, unless his father so wishes."[42]

In December Rembrandt rented a room at the Emperor's Crown Inn on the Kalverstraat, an imposing three-story building with coats of arms and sculptures on the façade, and put some of his possessions, presumably principally artworks, up for sale. The amount realized was a bitter disappointment, the first of many in the grim years that followed. Ruin stared him in the face. No Huygens, no Stadholder, no Jan Six, and certainly no Cornelis Witsen would save him from the debtors' prison.

In May 1656 Rembrandt transferred ownership of the house to Titus in an attempt to protect the property from liability for his own debts. The maneuver, legal but frowned on, instantly provoked his creditors into threatening further legal action before they saw their collateral vanish. In July Rembrandt turned his face upward to the catastrophe like Stephen to the stones. To preempt further legal action on the part of the creditors, he applied to the High Court of Holland in The Hague for a *cessio bonorum*. This was a form of bankruptcy granted to persons deemed sound citizens who were judged blameless in the manner in which they had incurred financial losses. Rembrandt's claim that he had lost a fortune at sea must, then, have been believed, since the *cessio bonorum*, shielding him from further personal claims, was allowed. It was, however, a stony mercy. The artist was now to surrender all his goods and property, movable and immovable, into the hands of the Chamber of Desolate Boedels, the insolvency commissioners, who would use the assets accumulated in a special account to make a settlement with the creditors. Henceforth, he was, in effect, their ward, his liberty as well as his dignity in pawn. Twelve days after the granting of the *cessio bonorum*, the five commissioners—merchants, lawyers, magistrates, solid citizens all—appointed the *curateur* into whose hands the insolvent artist would now relinquish his goods. His name, Henricus Torquinius, was itself virtually a reproof to the prodigal, and he arrived one morning in late July 1656, in the company of clerks, to begin the work of making an inventory of everything in the house, starting with "a small piece by Adriaen Brouwer of a pastry cook" hanging in the *voorhuis*, and ending, 363 items later, with "a few collars and cuffs" in the laundry.

Did Rembrandt look up while they were marching around the rooms pulling open closets, cabinets, and chests, throwing open albums of drawings and prints, the quills scratching industriously on their paper, the clerks throwing sand on their inky lists? Did he secrete himself inside his workshop and carry on as though it was all beneath him? Or did he confront the list makers, arms akimbo, wearing his studio coat, high hat, and the adamant, faintly contemptuous expression he gave himself in a drawing made around this time (see page 549)? For, amazingly, the great deluge of misfortune which now broke mercilessly over him did nothing to slow Rembrandt's creativity. The years 1655 and 1656, while the creditors were knocking at the door and the bankruptcy commissioners taking deadly note of the extravagant house and the impossible accumulation of objects,

Rembrandt, The Slaugh-
tered Ox, *1655. Panel,
94 × 69 cm. Paris, Musée
du Louvre*

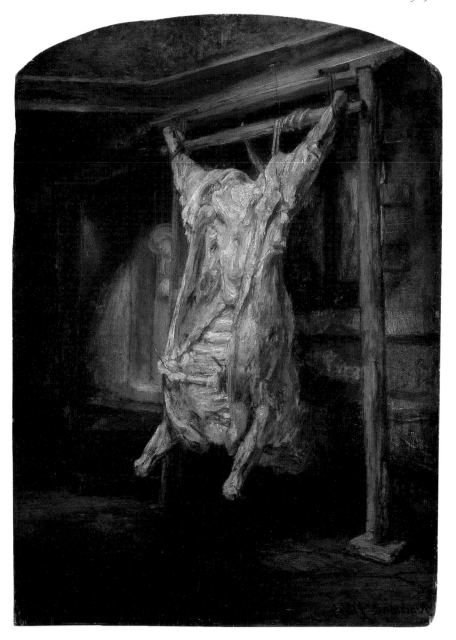

were also years which produced a group of Rembrandt's most originally
conceived and hauntingly powerful paintings.

The most powerfully affecting of these pictures dwelled in the shadow-
land between optimism and mortality. A disembowelled ox carcass is
spread-eagled, lashed to a wooden crosspiece, while a kitchen maid peers
from behind the carcass—perhaps the same juxtaposition of life and death
that Rembrandt had laid out in the *Girl with Dead Peahens*, but with even
greater sacrificial force. Someone in Rembrandt's circle had painted a very
similar *Slaughtered Ox* before, in the late 1630s. But while the earlier

painting describes the ribs, viscera, fat, muscle, and membrane with stu-
diously forensic care and gives the whole carcass a ghastly gleam, Rem-
brandt attacked his *Ox* with his brush as if it were a butcher knife. His
short, dense strokes slash, strip, hack, trim, and pare. The eerie result of all
this furiously energetic brushwork is both to bring the creature to *life* as
well as to display its death, like a flayed and mutilated martyr captured in
the throes of his agony. The painting, after all, is dated 1655, not a good
year for Rembrandt, at least outside the studio. Was he thinking of a print
by Maerten van Heemskerck (which Rembrandt may himself have owned)
of the Prodigal Son returning to his father's forgiveness, symbolized by the
slaughter of a fatted ox?[43] Or was he just indulging in a case of tragic pro-
jection (as he had done with his *Hunter with Dead Bittern*): a martyr in the
making, suspended between life and death. The autumn sale of his house-
hold property had brought in just 1,322 guilders and 15 stuivers. He owed
13,000; and there was the 20,000 of Titus's legacy to account for as well.
No wonder he felt the flayers in the wings, the hooks in the bone.

In *The Polish Rider*, the same disturbing sense of an animal phantom,
both apparently alive and yet somehow moribund, is present in the bony
gray nag that trots along in the sallow, gleaming light with an impossibly
handsome youth sitting high and forward in the narrow saddle, knees
sharply pulled up to set his feet in the short stirrups. Some sort of skin, its
corner curled in a pawlike shape, has been thrown over the horse's
haunches as a saddlecloth. The beardless boy-man looks in the direction of
his outthrust elbow, past us, the right side of his face catching some
momentarily apprehended happening. Is he too a sacrificial innocent?

He is, at any rate, certainly Polish (or Lithuanian), and he was certainly
painted by Rembrandt.[44] We can also be sure that whoever commissioned
the work can hardly have meant it to be imbued with the air of poignant
fatefulness, the rosy-cheeked flower of youth trotting gamely toward some
obscure destiny, that has drawn generation after generation to the picture
in the Frick. For although *The Polish Rider* has been interpreted variously
as the image of the Prodigal Son on his wanderings, as a theater portrait of
an actor playing the lead in a drama about Tamerlane (in leftover Polish
costume), and as the incarnation of the *miles christianus*, the perfect gentle
knight sallying forth to confront the enemies of Christendom, it seems
much more likely that a family of Lithuanian nobles commissioned Rem-
brandt to make a portrait of one of their young sons then studying in the
Dutch Republic.[45] Only a gentleman of the horse would have known how
to sit on the mount, Polish style, not erect but leaning forward, the right
hand curled backward to grasp the head of the *buzdygan*, the battle mace,
left hand on the reins.[46]

Dutch patricians of good birth and fortune were themselves wanting
horseback portraits by the 1650s, and artists like Aelbert Cuyp in Dor-
drecht were starting to oblige them. But none of those paintings, nor the
equestrian painting that Rembrandt and a pupil painted of Frederik Rihel
in 1663, resembled, in costume, armor, or horse, *The Polish Rider*. This

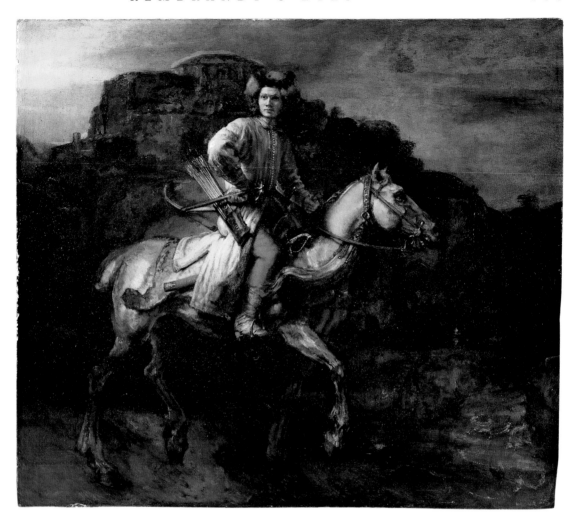

Rembrandt,
The Polish Rider,
c. 1657. Canvas,
116.8 × 134.9 cm.
New York, Frick
Collection

must have been a special, rather peculiar, commission, and it must have been Hendrick van Uylenburgh, born and raised in Poland and still with many trade and family connections there, who found Rembrandt the commission. Van Uylenburgh, now in his late sixties, was himself no model of financial prudence. Since moving from his house on the Breestraat, he had led something of a gypsy existence, renting a house near the Dam until the building of the new Town Hall forced him out and into another rental at the corner of the Westermarkt and Prinsengracht. At the time of Rembrandt's insolvency, he himself owed the city 1,400 guilders in arrears of rent. From steering some business Rembrandt's way, he might himself earn a commission on the transaction, much as he had done when they had been partners twenty years earlier.

Van Uylenburgh's understanding of Polish would have made him a natural contact for the many east Baltic merchants living in Amsterdam, some of them trading on the Beurs.[47] Perhaps he also knew the resident of the Schapensteeg whose house was known as "the Polish Cavalier" and boasted a decorative stone representing a rider in a long quilted and but-

toned coat, the *zhoupane,* an elbow thrust out from his waist.[48] The patron responsible for commissioning *The Polish Rider,* though, is likely to have been a rather different class of Pole, with its own contingent of representatives living, not inconspicuously, in the Dutch Republic: namely, the landed nobility. It was a member of one of those clans, Michal Oginski, Grand Hetman of Lithuania, who in fact presented the painting in 1791 to Stanislas Augustus, the King of Poland, together with a droll letter: "Sire, I am sending Your Majesty a Cossack whom Reimbrand has set on his horse. This horse has eaten during his stay with me 420 German gulden. Your Majesty's justice and generosity allows me to expect that orange trees will flower in the same proportion."[49]

Hendrick van Uylenburgh knew these people well. His father Gerard and his brother Rombout had dealt directly with the *szlachta* both in Kraków and Gdansk; had supplied them with the fine things of life. They were the lords of serfs and of ancient Baltic forests, domainial masters of thousands of acres of golden wheat and silver rye; long-coated magnates who continued to fancy themselves as Sarmatian warriors, horseback princes, hunters of the lynx and the bison, even while they also built themselves pilastered Italianate villas and stocked them with Flemish tapestries, Dutch gilt leather and tile, and Turkish rugs. Their assent was needed to crown the elected Kings of Poland and the Grand Dukes of Lithuania, and it was a point of pride for them to send sons and unmarried brothers on light, swift eastern mounts to make up the cavalry musters put in the fields against the Turks. A significant number of these magnate households had remained Protestant (some of them even Socinian Baptists), and it was those families, not least the Lithuanian Oginskis themselves, who sent their sons, along with valets and tutors, to study at the Dutch universities, especially in Leiden and Franeker in Friesland, where Rembrandt's brother-in-law, the reformed drunk and brothel-goer Johannes Maccovius, had been the great luminary of the theological faculty.[50]

The Oginskis seem not to have been exemplary students, at least not in the way the academic authorities would have liked them to be. At Franeker, in 1643, two of the family, Jan and Szymon Karol, were accused of being involved in a violent gang fight that broke out between the Polish and German students, on one side, and the Frisians in the streets of the city. The Frisians got the worst of it, one of the theology students dying of a deep dagger thrust, another badly sliced up at the shoulder while trying to protect his friend. Szymon Karol Oginski was tried but acquitted of the murder, managing to turn the evidence of the prosecution's German witness against the German student himself.[51] But once he had redeemed himself by translating Castiglione's *Book of the Courtier* into Latin, Szymon Karol was apparently good enough to marry the daughter of a burgomaster of Leeuwarden just two years later. In 1655, when Rembrandt painted *The Polish Rider,* the controversial brothers Oginski would have been much too old to be the subjects, but they did have a cousin, Marcyan Oginski, then enrolled in Leiden University, who would still have been in his mid-twenties.

It would be good to suppose that *The Polish Rider* was actually commissioned by the same family in whose hands it ended up at the end of the eighteenth century. But even if it was not one of the young Oginskis depicted on the sinewy gray, the almost fanatical care with which Rembrandt has represented the specific costume and armor details of a contemporary Polish-Lithuanian cavalryman, from the wool and fur *kutchma* cap to the *buntschuk*, the severed horse's tail, tied beside the mane as an ornament, makes it certain that he was answering to the requirements of a real patron, rather than to those of a figure conjured from his imagination.[52] Of course, with his passion for exotic dress and weapons, Rembrandt did his work lovingly, making the low twilight glint off the hilt of the Sigismund saber, and the head of the *buzdygan* war mace. And the flashes of brilliant vermilion on the horseman's cap and tight breeches not only set off the silvery silk of his coat but carry the figure forward along the narrow, low-walled road. Though the middle ground and background are only roughly sketched in (so roughly, in fact, in contrast to the broadly sketched but precise impression of the horseshoes, that this passage of the painting might indeed have been supplied by a pupil), the road seems to border a river from which a hillside ascends on the opposite bank. At its crown is a grim citadel with a flattened dome, the kind of rocky pile Rembrandt had used as background for his Leiden histories thirty years before. Some sort of smoky fire seems to have been lit in the lower right background.

There *is* a sense of theatrical show about the rider. But it was precisely the kind of show which the Lithuanian nobility liked to put on at home and perhaps conceivably abroad, too, down to the yellow pointed, spurless riding boots and the anachronistic quiver full of arrows. Some of the clans still rode to war, along with Hungarian hussars, against the Turks, and the epitome of the Polish cavalry warrior, Jan Sobieski, would earn immortality saving Vienna from the besieging Ottomans in 1683. As an image of undying chivalry, then, Rembrandt's painting could have been expected to be just the kind of thing to hang in the halls of an Oginski house, either in Holland or back in the woods of Lithuania.

All through his career, though, Rembrandt had been executing portraits in ways that transcended the specifications of the commission without doing violence to them. And the sense of sweetly heroic melancholy that seems to hang over the smooth-faced youth trotting along beneath a smoky, livid sky is not imaginary. Whether he was painting Jan Six caught between his public and private selves or his next-door neighbor, the elderly ensign Floris Soop, the statuesque rather than the dashing bachelor standard-bearer, Rembrandt tried to distill something universal out of the particular and immediate presence of his subjects, to catch an ethos as much as a person. The way he did this was by focussing attention on some tellingly expressive detail: the wood grain, surely polished birch, on Floris Soop's flagpole; the blur of motion of Jan Six's pulled glove. And in *The Polish Rider*, it's the unmistakably strange fit between rider and mount that gives the painting its temper of mortality. It's quite true, as Polish scholars have

argued, that east European cavalry mounts were much thinner than the Spanish horses used for hunting and war in the west. And the head and neck of the horse are, in fact, quite beautiful. But even if Rembrandt did not actually evoke the horse skeletons used in the anatomy theaters as his model, as Julius Held has suggested, it is true that he has outlined the legs of the horse as if every bone were visible through the skin. It's as though the horse, with its pulled-back bit and exposed teeth, unlike its rider, was walking, under some sort of fatally irreversible obligation, toward its last roundup.

Rembrandt, Preliminary Drawing for "The Anatomy Lesson of Dr. Jan Deyman," *1 6 5 6.* *Pen and ink drawing. Amsterdam, Rijks-prentenkabinet*

Oddly enough, this same unsettling sense of the cohabitation of the living and the dead lingers over Rembrandt's *Anatomy Lesson of Dr. Jan Deyman,* completed about a year after *The Polish Rider,* in 1656. A fire in 1723 destroyed all but a small central fragment of the painting, but what survived, together with a preparatory drawing, makes it clear that this must have been one of Rembrandt's most powerful and, in its own way, disturbing works. The magnificent strangeness of the work is all the more courageous when one realizes that this was Rembrandt's first group portrait commission since *The Night Watch,* a recognition from the institutional arbiters of fame and fortune in Amsterdam that he desperately needed.

Looking at the drawing, in fact, suggests at first that the insolvent Rembrandt has been careful to do exactly what his patrons expected. Unlike the electrifying drama witnessed in *The Anatomy Lesson of Dr. Tulp,* the 1656 work seems magisterial and gravely, almost pompously, monumental, with figures grouped symmetrically on each side of the anatomist. The corpse, one Joris Fonteyn, arrested after attempting to rob a draper's store and then attacking those who tried to stop him with a knife, is represented in mid-dissection more realistically, with the stomach cavity already emptied of the alimentary and excretory organs, the lobes of the brain now exposed for examination.[53] All this seems much *less* challenging to convention than Rembrandt's earlier painting, and perhaps it also seemed so to the surgeons.

In fact, this later anatomy was as startlingly unconventional as the earlier one. But the focus of Rembrandt's vision had changed from animated action to interior self-examination. *Dr. Tulp* had been all about the divinity of dexterity, with the instruction to reflect on mortality indicated only by the meaningfully pointing finger of Dr. van Loenen. In the Deyman anatomy, the mortal element, as well as sense of judgement, conveyed by

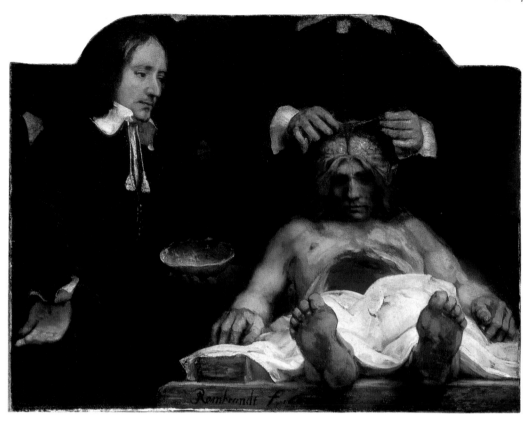

Rembrandt, The Anatomy Lesson of Dr. Jan Deyman, *1656. Canvas, cut down to 100 × 134 cm. Amsterdam, Amsterdams Historisch Museum*

the solemnly gathered figures is overwhelmingly present. The exposure of the brain of the *subiectum anatomicum* suggests that thought, even more than dexterity, the sapient mark of humanity, was both a mass of viscous, blood-filled matter and a supreme marvel of God's work. For Rembrandt has made a church of this anatomy theater lodged in the upper story of the Meat Hall, and the painting is its altarpiece. The low angle of vision in front of the painting hung up in the chamber of the surgeons' guild would have obliged the beholder to look up over the startlingly foreshortened feet and directly into the deep shadowy cavity of the eviscerated stomach, still supported like a tent by the intact rib cage. The foreshortened large hands and trunk and the incongruously serene face, painted as though shrouded in a veil of grace, are unmistakably reminiscent of the depiction of dead Christs, in particular those of Borgianini and Mantegna. And the body has been lined up (at ninety degrees to the picture plane) directly with Dr. Deyman himself, who stands, paternal and godlike, over the head of the miscreant, lovingly peeling back the dura mater membranes and separating the two cerebral hemispheres as if administering a benediction. The touching but unsettling sacramental quality of the scene is completed by the assistant surgeon, Gijsbert Calkoen (the son, no less, of Matthijs Calkoen, whom Rembrandt had shown leaning close to Dr. Tulp's right hand in his earlier anatomy), holding the detached skullcap tenderly in his palm as if it were the cup of the Eucharist.

The end of the dissecting table is inscribed with Rembrandt's signature, painted on the wooden edge, once again as if the hand of the anatomist and the hand of the painter were in instructive collusion. A striking number of the masterpieces of the mid-1650s are composed in the same way, with some sort of barrier—Titus's reading desk, Jacob's bed, Dr. Deyman's table—lined up parallel to the picture plane but continuing right to the bottom edge, that is, the extreme "front" of the picture. One might expect this to get in the way of us and the depicted scene. In fact, the compositional device works in exactly the opposite way, *advancing* us into the immediate presence of the figures. How does Rembrandt do this? By completely filling up the foreground space with the bed, the desk, and the table, he removes any kind of "frame" separating us from the figures. Instead we have the illusion of being admitted, like silent witnesses, to the very interior of the scene.

This sense of privileged eavesdropping is heightened in the case of Rembrandt's heartbreakingly beautiful *Jacob Blessing the Sons of Joseph* by the opened curtain, as if the patriarch's bed were set within a canopy. But the bed actually projects *through* the space bordered by the curtain, so that we ourselves seem to be positioned at its elaborately worked foot watching the action unfold. The story, told in Genesis 48, related how the patriarch Jacob, still living in Egypt with his son Joseph and sensing the end of his days approaching, offered to bless his grandsons, Manasseh and Ephraim. Joseph took his elder boy, Manasseh, with his left hand toward Jacob's right hand so that he should receive the first blessing, but to his dismay saw Jacob place his right hand on the head of his younger son, Ephraim, as the Scripture says, "wittingly." Joseph attempted to intervene: "Not so, my father: for this [Manasseh] is the firstborn; put thy right hand upon his head." And his father refused and said, "I know *it,* my son, I know *it:* he also shall become a people, and he also shall be great: but truly his younger brother shall be greater than he, and his seed shall become a multitude of nations."

The apocryphal Book of Barnabas, written in the early Christian era but freshly published in a Dutch translation in 1646, had seized on the story of the reversed order of blessings as a momentous prophecy. Ephraim, the younger son, was the forefather of the new Church of Christ within which would indeed be gathered a "multitude of nations," while the Jews would spring from the seed of the older Manasseh.[54] Artists working in this tradition had imagined Jacob's hands crossing, in defiance of Joseph's expectations, in prophetic rehearsal of the form of the Savior's sacrifice. And many of them had depicted Joseph in various states of bewilderment or chagrin at his father's error.

It's easy to imagine the Rembrandt of the 1630s, the virtuoso of interruption, painting the scene very much as convention expected, with a mortified Joseph rushing from an adjoining room, seizing his father's crossed hands, and attempting to correct the error. But this is Rembrandt twenty years later. Reconciliation, not conflict, is foremost on his mind. He is also beginning to dwell sympathetically on moments of family intimacy and affection. So Joseph's face is free of any trace of indignation; instead he

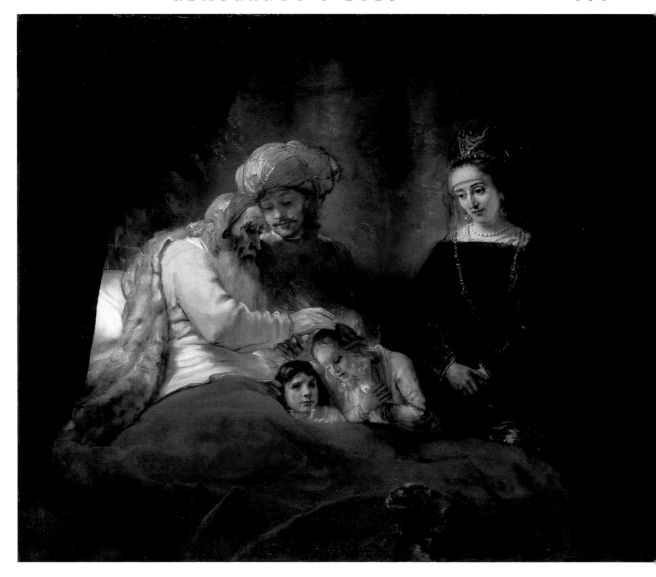

Rembrandt, Jacob
Blessing the Sons of
Joseph, *c. 1656. Canvas,
175.5 × 210.5 cm.
Kassel, Gemäldegalerie*

looks down on his father with tender filial concern and attempts to move
his hand from underneath with only the gentlest of gestures. Perhaps
Joseph even manages to see the crucial detail that is almost obscured from
view, of three fingers of Jacob's left hand resting not on Manasseh's head
but against the hair that falls down his cheek—not exactly a formal bene-
diction but a gesture of grandpaternal assurance that may explain the
child's expression of innocent contentment.

In this same spirit of binding things together, Rembrandt also adds
the figure of Joseph's second wife, whom Jewish tradition identified as the
daughter of an Egyptian high priest who had converted to Judaism and
repudiated the idols of her forefathers, looking appreciatively toward the
scene at the old man's bed. The same Jewish tradition, which Rembrandt
may well have known through Menasseh ben Israel, gave Asenath a critical

role in the family drama. For when Jacob realized he could not bless the boys in the conventional order, he is supposed to have refused any blessing at all, relenting only when Joseph asked him to do it "for the sake of this righteous woman." But Rembrandt, with his instinctive love of the inter-weavings and cross-stitchings among different but related Scriptures, has included Asenath as a deliberate reminder of an earlier story, related in Genesis 27, when the blind Isaac is deceived by Rebecca into supposing that he was bestowing his blessing on his older son, Esau, instead of the younger, Jacob.[55] Asenath stands, her face brightly illuminated, as the art-less, innocent mother, in implied contrast to Rebecca, the artful and culpa-ble thief of Esau's benediction. For she had accomplished the deception by supplying her "smooth" son, Jacob, with the skin of a goat, which he wrapped around his arm and neck, so that when Isaac felt him he supposed he was touching the "hairy" Esau. And sure enough, Rembrandt has given the dying Jacob a shawl of animal skin wrapped around his neck and falling down his back as a further reminder of the earlier story.

And then, of course, there are the eyes of the patriarch, unmistakably darkened. For it's often forgotten that the Scripture says of Jacob, too, that his eyes "were dim for age, so that he could not see." The ribbon of mem-ory winds itself around all these sad gropings in the dark, all these fateful misapprehensions and atonements enacted between fathers and sons. Blind Jacob, possessed of a strong interior light, the light of grace that falls on his pillow, this time made of feathers, not of stone, the same light in which he saw angels ascending to and descending from paradise. So he reenacts and, as best he can, redresses the sin committed against his father Isaac's blind-ness, and against his older brother, by blessing in his turn *both* his grand-sons. Perhaps, too, Rembrandt is remembering his own blind father and wondering, since it is 1656, what blessings, what portion will remain to him, in his gathering ruin, to bestow on the head of his son Titus.

The paradoxical figure of Jacob was much in Rembrandt's mind in 1655. For in that year he also made an etching of Jacob's dream of the angels ascending and descending their celestial ladder while his head rested on the stone pillow at Bethel. The little etching was one of four made for Menasseh ben Israel's kabbalistic treatise, the *Piedra gloriosa, o Estatua Nabuchadnosor* (*The Glorious Stone, or the Statue of Nebuchadnezzar*).[56] Rembrandt may not have been the philo-Semite beloved of sentimental leg-end, outcast speaking to outcast, communing in melancholy. Though he had certainly gotten on well enough with figures like Ephraim Bueno (also painted by Lievens!), proximity had been no guarantee of amity, and Rem-brandt had been in bitter fights with his Jewish, as well as non-Jewish, patrons and neighbors. He was not, we have to conclude, the neighborly type. But the relationship with Menasseh was real and it was serious. How could he not have responded to the story of Menasseh's father tortured three times by the Inquisition; the son vindicating the father by establishing himself as a prodigy of Hebrew learning? And Menasseh's intellectual nomadism, his passion to find Jews lurking in the remote antipodes so that

they could fulfill the prophecy that only when they were truly distributed throughout the world would the Messiah come, was exactly the kind of feverish ecumenism that would have found a response in the mind-wanderer Rembrandt.

If this mutual sympathy and curiosity did not in the end produce anything especially profound or any masterpiece of painting, it did at least result in the very first collaboration in print between a learned rabbi and a Protestant artist. Rembrandt's introduction of the Asenath figure in the glorious *Jacob Blessing the Sons of Joseph,* as well as his own lifelong fascination with Islamic, Indian, and Persian culture, pointed to his sympathy for an ecumenical view of monotheistic religion. And for the same reason, he may well have been drawn at just this time (when he needed to look for a new kind of divine succor) to the startlingly radical teaching of Adam Boreel denying the existence of a single church and embracing the heretical notion that every church, including Judaism, was possessed of its fragment of the revealed truth. Boreel was a friend of Menasseh ben Israel's and shared his fascination for postbiblical Hebrew commentary.

The *Piedra gloriosa* linked together four episodes from biblical history through the mysterious presence of a messianic stone which turned up providentially, from time to time, to change the course of history—rather like the basalt obelisk of *2001*. In addition to Jacob's pillow, Rembrandt's etchings illustrated: the stone which struck the feet of the statue of Nebuchadnezzar before transforming itself into a mountain; David's slingshot pebble which caught Goliath right between the temples; and the peculiar vision of Nebuchadnezzar in which four "great beasts came up from the sea," decoded by Daniel to mean the empires (Persia, Macedonia, and Rome) that would supersede Babylon. All these episodes delivered a clear message as to where the Power really lay. Abstruse as these were, they were irresistible to Rembrandt's appetite for visions, and alterations he made in the states suggest that he and the rabbi worked closely together. No, no, Menasseh must have said on looking at a pull of Jacob asleep, positioned logically at the foot of the ladder, he must be, you see, in the *middle*. "Halfway up?" Rembrandt might have responded. "Surely not." "Oh yes," Menasseh would have said, "for asleep, he is in Jerusalem, and Jerusalem is in the center of the world."

Menasseh ben Israel, like Rembrandt, did not have a happy future awaiting him. Later in 1655, in pursuit of his mission to restore Jews to countries from which they had been expelled, he crossed the North Sea to England to plead their cause before Oliver Cromwell and the government of the Protectorate. Two years later, he was back in Holland, convinced his mission had failed and bearing the body of his son, who had died in England. Menasseh himself fell into poverty and died in despair. Rembrandt's etchings for his book were replaced by more feeble and less fantastic prints by the Jewish artist Salom Italia. But since Menasseh had sent the Rembrandt edition to the dedicatee of the book, the Leiden theologian Gerard Vossius, there was no question of him repudiating the strange and

OPPOSITE: *Rembrandt, Four illustrations from* Piedra gloriosa *by Menasseh ben Israel, 1655. Etchings. Amsterdam, Rijksprentenkabinet*

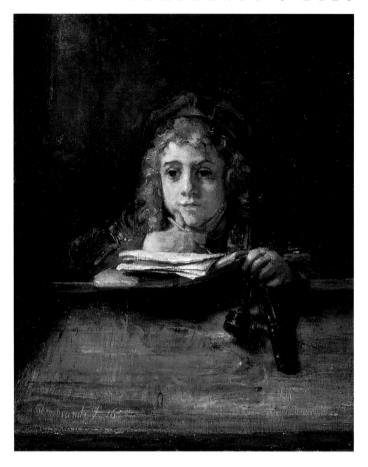

Rembrandt, Titus at His Desk, *1655. Canvas, 77 × 63 cm. Rotterdam, Museum Boymans van Beuningen*

haunting images made by his friend.

Rembrandt must have been moved by the fate of Menasseh and his son. Father-son images recur in his own work in the mid- and late 1650s with striking frequency. In 1655 Rembrandt painted Titus caught in momentary reflection while writing his exercises, chin on hand, a thumb pressed into his cheek, his look dreamy, his curly hair sweetly tousled. But there is also something distinctly odd about the picture. For the face is not the face of the 1655 Titus, who would have been fourteen, but that of a much younger child, perhaps ten or eleven, as if the father was lingering over the fondest memories of childhood much as parents open old photo albums. Even more striking evidence of Rembrandt's preoccupation with father-son feeling at this time is a little pen-and-brush drawing, done around 1656, one of a number of copies of Mughal miniatures. He has faithfully reproduced the likeness of Shah Jehan in profile, much as it would have appeared in the original, a version of which Rembrandt the keen oriental collector may have seen or even owned. But he has also added an additional face to the drawing: the face of a chubby-cheeked little boy, the little prince Jehangir, seated at what very much looks like *his* writing desk. The little boy is an anomaly in what is otherwise a careful copy of a Mughal painting, and is evidently a later addition, since his features are lightly sketched in with a flowing reed pen, rather than in the more studious hand that drew the father. In fact, Rembrandt has covered the bottom of the drawing with a bister wash so as to obscure the original position of Shah Jehan's left arm, which originally must have been held straight down. With a few strokes of the reed pen he has made the arm bend at the elbow, so that even while the Lord of the World looks straight ahead, his index finger chucks his son's fat little chin.

Standing helplessly to one side as he watched his father's house gutted and stripped to the bone, Titus, for all his fifteen years, doubtless could have used the occasional chin-chuck himself. Bankrupts' children feel wounded in the same way as the children of an ugly divorce do. However

much they know themselves to be innocent, helpless parties to the ruin, they somehow hold themselves accountable for it. Any sense of shame that Titus may have had would have been compounded by the provisions made for him, with mostly benevolent intent, by the law separating him from Rembrandt's estate. For Titus, with only a ruined father and a common-law stepmother to care for him, was now deemed an orphan, and shortly after the granting of the *cessio bonorum* was required to have a guardian appointed to protect his own interests. Since no close relative was able or willing to undertake the responsibility (indeed Hiskia van Uylenburgh was herself suing Rembrandt), the Chamber of Orphans appointed one Jan Verwout. Perhaps this Verwout failed to take his duties

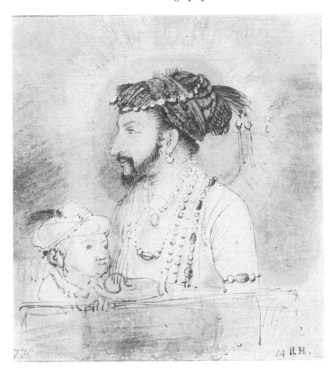

toward Titus seriously enough, since two years later, in 1658, he was replaced by Louis Crayers, who certainly did. This meant treating Titus as yet another unsatisfied creditor of his own father. For Rembrandt did indeed legally owe the lad the vanished twenty thousand guilders of his dead mother's legacy. So if the family was, as the moralists were always saying, a little commonwealth, the order of things in the van Rijn republic had been utterly overthrown.

Rembrandt, Shah Jehan and His Son, *c. 1656. Pen and ink drawing on Japanese paper. Amsterdam, Rijksprentenkabinet*

And yet if Titus was now his father's creditor, he was also his accomplice, drawn into Rembrandt's increasingly desperate tactics to salvage something from the wreckage of their fortune. Between 1655 and 1657, he made Titus draw up no fewer than *three* wills, each one designed to ensure, more effectively than the last, that Rembrandt would, despite his bankruptcy, fully control all the property nominally and legally belonging to his son, even in the event that, as sadly came to pass, Titus predeceased him. Thus Titus's little half sister Cornelia was named as his heir and Hendrickje was provided for from the "benefits accruing to this property." And since Rembrandt must have been busy attempting to transfer as much property as possible into his son's name, shielding it from the liquidators, he included a clause in the last will specifying that "the testator's father need not give access to anyone in the world to the property left behind by the testator, nor give account or provide an inventory thereof, even less to use it as security or guarantee."[57]

So Titus understood, somehow, that he was involved, now on one side, now on the other, tangled in the coils of the calamity. He was fifteen. It was

time he was an apprentice. His father had kept drawings by his son, mostly of dogs. So it is likely that Rembrandt, like so many other artist fathers, had meant for Titus to join him in the workshop, to take instruction from his hand, be shown how to design the languages of the face and the body, how to create depth and the subtle plays of light and shadow. But now Titus looked on as men came and carted off his father's great collection, halberds and helmets sticking out of the boxes like trophies captured from the enemy's field; Roman busts suffering indignity as they were carried to the auction room; heap after heap of things he had known since his childhood in the great lair of wonders upstairs—coral and nautilus shells, lion skins and bird plumes, turbans and nose flutes—and with them the treasures of Rembrandt's "academy": the Flemish pictures and the Italians, Brouwer and Palma Vecchio, drawings by Dürer and Holbein all off to the sale rooms, where they fetched insultingly paltry sums. Rembrandt's own works went with them: the *Negro Heads* and *The Descent from the Cross*, a *Jerome*, an *Ox*, and a *Bittern*, a *Danaë* and *The Concord of the State*, fifty or so paintings fetching altogether less than a thousand guilders. How could this be, since the *ten* Rembrandts sold from the estate of Joannes de Renialme, the dealer, made two thousand? Had there been some sort of foul play, some sort of advance agreement among the buyers, avid for bargains, to divide the spoils without competitive bidding? It was the kind of thing gentlemen did; not so shocking, really. Apelles seemed to be done for. What a pity. But then such a notorious prodigal. Now their duty was surely to his works, not his person.

The ordeal went on and on, all through 1657 and 1658, creditors haggling and bickering between themselves on the priority of their claims, adjudicated by the commissioners of insolvency sitting in their chamber in the new Town Hall, the one with the rats, padlocked chests, and worthless bills carved in stone above the entrance. Gerbrand Ornia, indecently rich himself, now decided he wanted the thousand guilders back of Six's original loan and demanded them not from Rembrandt, protected by his insolvency, but from the guarantor Lodewijk van Ludick. Witsen, too, whose loan had been registered before the aldermen, which put it at the top of the creditors' reimbursement line, was clamoring for his due. From time to time Rembrandt had to appear before the commissioners, or their cashier, receiving proceeds from the sale of his goods, money that had to be immediately handed over to the most pressing and powerful creditor. It did not help that he knew these people presiding over his humiliation. The brewer, Cornelis Abba, who seven years before had listened to tales of his adultery and bad faith, now picked over the details of his financial disaster. He even knew the insolvency auctioneer Thomas Haringh; he had etched his son's portrait in 1655 and had made a not altogether unsympathetic face out of the lawyer's big rabbity nose and wide, shallow-set eyes.

But now Haringh's hammer was slamming down on the successive chapters of his life, set down in paint and panel and canvas and so carefully kept by Rembrandt: the *Tobias* by his old teacher Lastman, dead these

twenty-five years; and figures by Lastman's disciple Jan Pynas; nine paintings by his old comrade Lievens, who had come back to Amsterdam no grander (until now) than Rembrandt himself for all his years away in England and Flanders. They had come to something, both of them. Not perhaps what Constantijn Huygens had prophesied. Did Huygens, living off in The Hague or in his country villa, no longer with the patronage of a Stadholder to dispense, know of his old protégé's predicament? Down went the hammer on the proofs, retouched by the hand of Rubens. Well, he had not made himself, after all, the Rubens of the Republic. Something else, though; something different. It was all going, the springs of his inspiration: the colored landscapes of Hercules Seghers; the little cherub's head of Michelangelo he had used for the *Danaë* and the *Ganymede*; the merrily fornicating nymphs and satyrs of Agostino Carracci; the album of Lucas van Leyden's prints for which he had paid so dearly; and the "very precious book" of drawings by Mantegna with the sketches for *The Triumphs of Caesar* and *The Calumny of Apelles*. Now he would have to make do without his museum. Or rather he would have to find his museum within his *gheest,* the word some of us would translate as imagination, some as spirit.

Early in 1658, it was grimly apparent to Rembrandt that none of the proceeds from the sale of his personal property and collection would make anything close to satisfying his creditors. At the end of January, in a last-ditch attempt to protect his house, he renewed his earlier transfer of title to Titus. He was supported in this move by the orphans' court, acting as guardians for Titus and concerned that he would never see his share of his mother's estate. But the bull-like Witsen charged and charged, and he was now firmly established in the Amsterdam regency, with the power to make his interests felt. On February 2, 1658, Witsen was reelected to a second term as burgomaster and within hours had appeared at the insolvency court to demand they overrule the transfer of the Breestraat house to Titus. They did.

The house went on the auction block. The first buyer turned out to be a sheep. A *schaep* was someone who was serious only about getting his hands on the premium awarded to a high bidder. Really, they should have known. This Pieter Wybrantsz. was, after all, a bricklayer, and where would a bricklayer get the 13,000 he had offered? But the sheep seem to come in flocks. The next offer, of 12,000, came from a nail maker, and he, like his predecessor, failed to post the bond needed to secure the purchase. On a third try, two brothers-in-law, a shoemaker, Lieve Symonsz. Kelle, and a seller of silk goods, Samuel Geerincx, who had offered 11,218 guilders—or two thousand less than Rembrandt had paid—got the house on the Breestraat knocked down to them.

There was another little farce to be played out according to the rules of insolvency. On February 22 Rembrandt finally saw some money—4,180 guilders—from the house sale. He took it from the cashier of the court and without more ado gave it to the man standing next to him: the resolute, merciless Cornelis Witsen. In no time at all, Kelle and Geerincx had divided

the house on the Breestraat in two, knocking down the gallery Rembrandt had built adjoining the house. The shoemaker and his family moved into one half; the silk seller may have briefly occupied the other half before moving to grander lodgings on the Herengracht. Well, the Breestraat was not what it had been. No Lastman, no van Uylenburgh, no Pickenoy. Even the argumentative neighbors, Pinto and Belmonte and Rodrigues and most of those Portuguese Hebrew gentlemen, seemed themselves to be moving on to bigger houses on the *grachten.*

But it was all that Titus had known as home, this neighborhood: the Jews with their dark hats and diamonds; the vegetable market on the Houtgracht; the bridge over the Amstel where he could idly watch the barges and the pleasure boats sail south into the green countryside. Now they would have to go somewhere else; his father, Hendrickje, and his little sister had to be packed off to the Rozengracht, some small place to rent with a room where Rembrandt could work. The Rozengracht, he knew, did not live up to its flowery name. There were precious few roses, but plenty of backyard pigs and stray dogs running about in the *stegen en sloppen,* the back alleys between the crowded rows of little houses. Still, they would take themselves away from the gossiping tongues and the pitying glances. With the help of those who still counted as their friends, the Francen brothers and the good Crayers, they would eventually escape from the serpent coils of the courts. Well, why not go? There was not much left in the house on the Breestraat anyway. Emptied of everything familiar, the things that had made up his childhood life, the rooms had seemed to grow, becoming bigger and bigger as they themselves shrivelled up like old snails in a shell.

Now they could help, Hendrickje and himself. They were both free of the chains that bound Rembrandt. Hendrickje had managed to save some bits and pieces, claiming (over the protests of Torquinius) that the big old oak cupboard was hers alone and could not be sent to sale, and she had packed it with linen and silver and things they could use in the house on the Rozengracht. And he could help, too. His father had said he could go to the Lommerd, the city pawnbroker, and redeem some things with the little left of his mother's money.

There was something in particular his father wanted. A great mirror framed in the finest ebony, silvered and flat, beautiful, the kind of thing that came from Floris Soop's factory. So on April 18, 1658, Titus went and retrieved it, pleasing everyone no end. Outside the Lommerd he found a bargeman willing to carry the heavy piece back to the Breestraat, and set it on top of the man's head. But it was an awkward thing to carry and, as Titus must have seen, the bargeman's step was unsure. As the crowds milled about him going this way and that, the sweat must have started, making his hands slippery, his grip shaky. Near the Rusland bridge, where the night lotteries were held, he was heard to cry out, "Friends, please be careful, don't let anyone bump into me; I am carrying this expensive piece here."[58]

And then, as he stepped off the bridge, as two witnesses reported it,

eene groote knack, a great cracking and snapping, was heard. The witnesses were testifying on behalf of the carrier, who swore it was not his fault. He had neither fallen nor bumped into anything. The mirror must, well, have just smashed of its own accord. But there it was in front of Titus, shivered into a thousand pieces, the shards and slivers glittering on the brick paving, leaving the boy to carry back to his father a frame without a center, a picture of nothing.

i *Rough Treatment*

Disgrace lowers the eyes, breaks up conversation. The dispossessed shrinks from the direct gaze lest it offer patronizing consolation. Carrying his contamination with him, the bankrupt slinks off into the shadows, out of the way of inspecting stares.

So Rembrandt naturally paints himself in 1658, at the nadir of his fortunes, godlike, enthroned, mantled in lustrous gold, staring down presumptuous mortals, his lips pursed, a suggestion of lordly amusement playing about his eyes. There is not the least trace of defensiveness, much less self-pity, in the great Frick self-portrait. Instead of being diminished by his misfortunes, Rembrandt seems to have become augmented by them, visibly expanding before our eyes like a genie, pressing hard against the perimeter of the picture space as though challenging it to contain the force of his authority. Somewhere Rembrandt has seen van Dyck's portrait of the one-armed Flemish landscape painter Martin Rijckaert (probably in the engraving done for the *Iconography*), similarly seated, with his right and only hand holding the end of the chair arm, his girth decorated with an elaborate sash, a fur-edged coat falling to the floor.[1] Van Dyck posed Rijckaert in a generously capacious space, his body leaning backward at an angle from the picture plane in an attitude of grandiose relaxation, an avuncular slouch. But there is nothing relaxed about Rembrandt's pose. He has pulled himself upright, so that his great barrel chest, rather than his belly, takes the light, thoracically intimidating, an adamant bulk. The lower part of his golden gown hugs the imposing mass of his flesh so that we can see that he sits like a king, with his thighs apart.

And then there are the hands, large and meaty, painted with enough brutal drama to force us to look hard (and nervously) at them. Van Dyck, who liked to paint hands as elegant, delicately drooping things, the fingers exquisitely tapered, the skin lily-pale, deliberately gives Rijckaert's sole

hand, the basis of his fame, proper prominence, lighting it as strongly as his face. But it lies on the chair arm, the terminus of the rest of him, out of proportion to his trunk. Rembrandt's right hand, though, emerges dramatically from the slather of white paint that defines his sleeve and cuff, each knuckle joint glaringly highlighted, the joints and bones (especially of the thumb) precisely indicated, so that an unavoidable connection is made between the strength of *what* is being painted and the instrument that has painted it. His left hand is treated still more coarsely, the better to display the knobbly, glinting silver cane. The rounded head, similar to the pommel end of a maulstick, is the only suggestion of this figure's profession. But no maulstick could ever have been this irregularly shaped. It is as if a tool of the trade had been replaced by an attribute of sovereignty: the baton of a commander; the wand of a magus; the scepter of a ruler.

Perhaps, in fact, the ruler of the gods. For although the Frick self-portrait has always been seen in isolation, it may, as Leonard Slatkes has suggested, actually be one half of a pair. Its opposite number, the equally extraordinary *Juno*, for which Hendrickje Stoffels posed, is not, strictly speaking, a pendant, since it was painted at least three years after the Frick self-portrait. It's tempting, in fact, to believe that it was Rembrandt's memorial to Hendrickje, as unearthly and idealized as his posthumous portrait of Saskia (see page 507). The fact that the picture was pledged to one of Rembrandt's most dogged creditors, Harmen Becker, may even have provoked Rembrandt to find a way to paint his second wife in a manner that matched the honor he had bestowed on himself. Mortal Hendrickje, dying in 1663, was transfigured into celestial Juno, keeper of Jupiter's house. So like Rembrandt, she too is enthroned, and holds a great staff in her hand. She has the emphatic, frontal, imperial expression; the encrusted, stupendous costume, the ermine-trimmed robe, a massive jewelled swag below her regal bosom, and, more unequivocally than her mate, the Olympian crown and Juno's attribute, the peacock.[2] Rembrandt, then, is Jupiter to Hendrickje's Juno. The insolvent and the fallen woman proclaim themselves as the king and queen of the immortals, invulnerable to the wounds inflicted by mere men.

This is not exactly a mea culpa. Every brushstroke sweeping thickly down over the canvas, or coiling a ropework of pigment in Rembrandt's embroidered collar, or in the dark, roughly applied impasto of Juno's bodice and stomacher, proclaims the painter's Jovian impenitence.[3] Even had he not been ruined, this would still have been a turning point in the painter's career. For it marked the moment at which he took his leave, for good and all, of the agitated theatricality of Rubens, at the same time that he must have abandoned much hope of ever attaining a Rubensian degree of rank and respectability. At the corresponding point in his career, Rubens had been a country squire, the owner of nine properties in and around Antwerp. He had been knighted by three courts and universally extolled as the greatest history painter of the age. Rembrandt, on the other hand, was a bankrupt, living with a maidservant as his common-law wife,

FOLLOWING PAGES, LEFT: *Rembrandt, Self-portrait, 1658. Canvas, 133.7 × 103.8 cm. New York, Frick Collection*

RIGHT: *Rembrandt, Juno, c. 1661–65. Canvas, 127 × 107.5 cm. Los Angeles, Armand Hammer Collection*

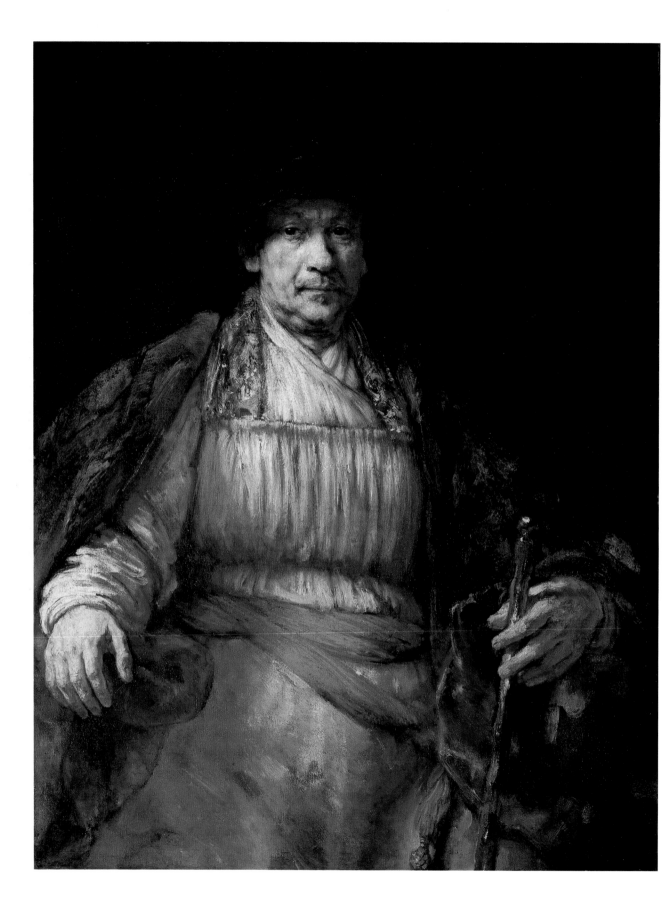

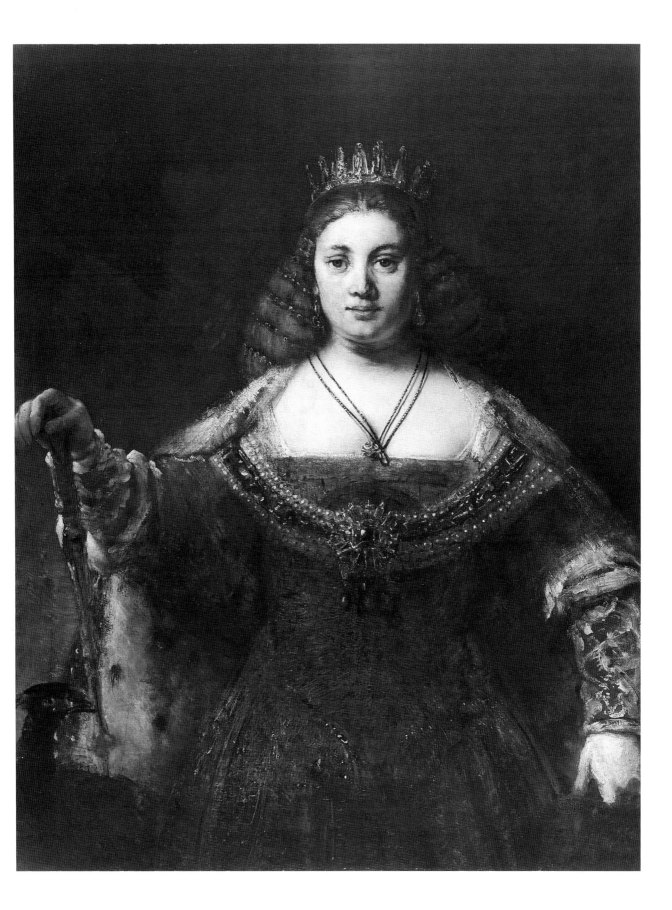

cast out by the Church, in a modest house in the Jordaan, a neighborhood of bell foundries, sailors' taprooms, and saltpeter works. But even as he was beginning to be written off, or condescended to, as hopelessly "picturesque" by artists who were taking Rubens or Poussin as their models for Baroque histories, Rembrandt was reinventing or, as William Hazlitt would later, and acutely, write, becoming the *legislator* of art.[4]

Relieved—involuntarily—of the weighty substance of the world, Rembrandt transferred it to his canvases, working the paint layers to create a micro-universe of unprecedented richness and complexity. Instead of the act of painting disappearing into the subject matter, or echoing the subject matter, Rembrandt went so far, in the most radical pictures of his last decade, as to make paint itself the subject.[5] Cut free from the obligation to describe form literally (as all his contemporaries insisted it should), Rembrandt's paint-handling went off to lead a life of its own; an amazing vagabond life of daubing, dragging, twisting, dabbing, drizzling, coating, sloshing wet-into-wet, kneading, scraping, building into monumental constructions of pigment that had the mass and worked density of sculpture, yet which shone with emotive illumination. The great masterpieces of the 1660s managed, at one and the same time, to be physically weighty but spiritually weightless; solid and earthbound, but leavened by the redeeming light of grace.

This is how he paints *Jacob Wrestling with the Angel,* less a struggle than an embrace. The action, which in the 1630s would have been a furious whirl of muscular energy, is quiet and slumberous, heavy with the kind of eerie deceleration experienced in dreams. Though the Bible says only that Jacob wrestled "until the breaking of the day," Rembrandt has given it the quality of a somnambulist encounter, intensely felt yet physically immaterial. The angel, to whom Rembrandt has given the most beautiful face in all of his painting (perhaps an idealized version of Titus), framed by a crown of thick, springy curls, one of which corkscrews down his neck, looks tenderly from beneath shiny eyelids at Jacob's shut eyes and clasps him about the neck and waist with a lover's urgency. Damage is being done, all the same. The angel's right foot is braced against a rock, and the strain of Jacob's body against him is written in the tensed muscles of his upper back and shoulders bulging through the crimson garment. The angel's left hand is set decisively on Jacob's hip, or rather "the hollow of his thigh," about to dislocate it from its socket. The blindly groping, maimed, but obstinate man presses tight against the luminous, snowy bosom of the angel, helpless yet determined not to relinquish his grip: "I will not let thee

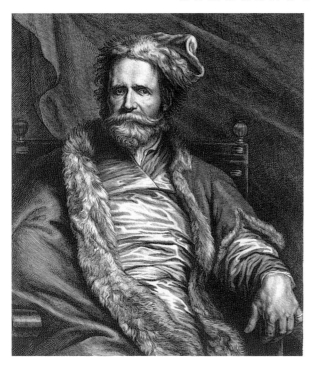

Jacob Neefs after Anthony van Dyck, Portrait of Martin Rijckaert, *1630s. Engraving, from the* Iconography. *Amsterdam, Rijksprentenkabinet*

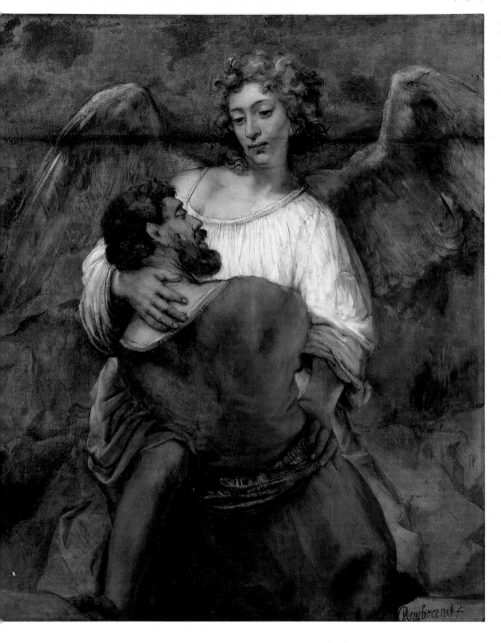

Rembrandt, Jacob Wrestling with the Angel, *1658. Canvas, 137 × 116 cm. Berlin, Gemäldegalerie*

go, except thou bless me." He is so blessed, and carries with him the mark of grace in a limp, the sign that he is now Israel, not Jacob; that he has "seen God face to face" and "[his] life [is] preserved."

Mortal gravity touched by celestial illumination also colors Rembrandt's *Moses with the Tablets of the Law,* painted about the same time as the *Jacob* and perhaps even with an eye to its being used to decorate one of the chambers of the new Town Hall on the Dam. Both paintings show evidence of having been reduced in size, and in their original dimensions would have been even more imposing, life-size figures, set in a steep, shallow space and seen from a low angle of vision, the better to convey a sense

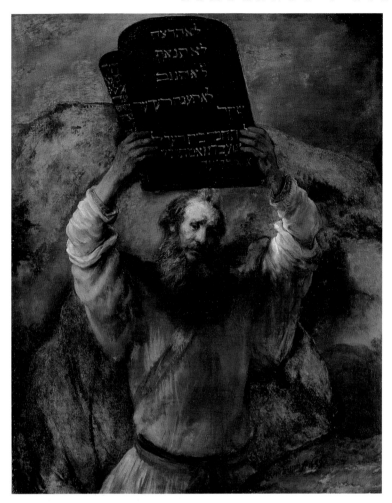

Rembrandt, Moses
with the Tablets of the
Law, *1659. Canvas,
168.5 × 136.5 cm.
Berlin, Gemäldegalerie*

of awesome vision from on high. Both use a palette stripped down to the four colors of Apelles. But the *Moses* is even sparer than the *Jacob*, virtually a tawny brown monochrome, the smoldering rocks of Sinai evoked with bituminous patches and dabs of paint, indeterminately contoured forms, the figure of the prophet coarsely clad and rough-cast as though extruded from the stone himself. The very darkness of the place only makes such light as there is shine with greater intensity, which is right, since Exodus 34:29 makes a point of saying that as he came down the mountain, Moses "wist not that the skin of his face shone." Christian commentators on the Pentateuch had assumed the Hebrew word *keren* to mean horns, when it actually also means a ray of light. Thus had arisen the tradition (in Michelangelo's tomb for Pope Julius II, for example) of depicting Moses with a pair of horns sprouting from his head. Rembrandt both retains and euphemizes that tradition by transforming the actual excrescences which were commonplace in seventeenth-century prints of Moses and the Ten Commandments into tufts of hair in the center of his pate. With his arms and face radiant with sublime light, Moses stands on his stony ledge, transfigured by revelation, precisely at the margin between the mortal and immortal worlds. Like Jacob, who, after his encounter with the angel, also became "a prince" invested with "power with God and with men," Moses is the appointed intermediary between Divine Will and the stiff-necked Chosen People, burdened (as he often complained) with the thankless negotiation between sinfulness and salvation.

Rembrandt depicts Moses on his second descent from Mount Sinai, carrying the tablets imprinted with the Ten Commandments (in the black and gold in which they were customarily painted in Calvinist churches in Holland). An attempt has been made to suggest that the painting actually represents the earlier moment (Exodus 32:19) when, on seeing the golden calf, Moses smashes the tablets.[6] But the Bible makes it clear that Moses breaks the tablets not when he is on the mountain, but after he has come

"nigh unto the camp" and seen "the calf, and the dancing." As he had done in *Jacob Blessing the Sons of Joseph* and countless other histories, Rembrandt certainly implies an earlier event in the Scripture while painting a later one. So the corners of Moses's mouth are turned down and his brow furrowed in stern and censorious authority. It is as if he is recalling the idolatry and debauchery he had seen on his first descent from the mountain. But Rembrandt also means us to imagine, at the foot of Mount Sinai, the gathering of penitent sinners who, despite their wantonness, had been given, through the favor that Moses found with the Lord, their covenant. It's the bestowal of divine mercy even, or especially, on the heads of unworthy sinners, after all, which most closely corresponded to the Calvinist doctrine of salvation by grace alone, and which in his last years especially preoccupied Rembrandt, as well it might.

Sometime in 1662, a painting of *Moses with the Tablets of the Law* was indeed installed in the Aldermens' Chamber (Schepenkamer) of the Town Hall.[7] But it was not Rembrandt's painting. It was, instead, the work of his former pupil Ferdinand Bol, and its

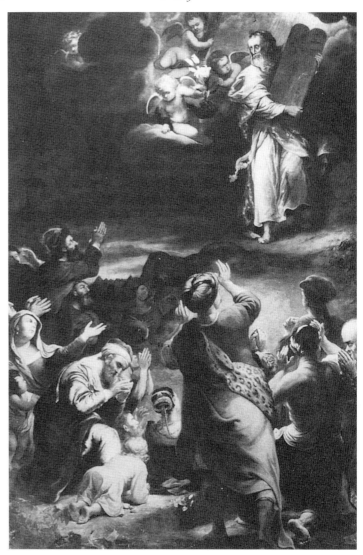

Ferdinand Bol, Moses with the Tablets of the Law, *1662. Canvas. Amsterdam, Koninklijk Paleis*

sharp vermilions and deep azurite blues, hard edges and histrionic poses, demonstrated just how completely the student had separated himself from his master. It was not that Bol had strayed so very far from the lessons he must have had from Rembrandt in the 1630s; it was rather a measure of the distance that *Rembrandt* had travelled from the days when all of his energies had been committed to beating Rubens at his own game of visual theater. Bol's *Moses,* in fact, takes its composition directly from Rubens's *Assumption of the Virgin,* substituting the prophet with the commandments for the ascending Mary and transcribing with dogged literalness a number of the reverential penitents gathered below. It's a picture that takes the business of hand-language, which Rembrandt was certainly not above using, to absurdly excessive lengths, so that pairs of hands implore, pray, beseech, attest, exclaim, and greet, rather as if Bol was thumbing through John Bulwer's dictionary of manual gesture, the *Chironomia* (published

Nicolaes van Helt Stockade, Joseph Distributing Grain in Egypt, *1656. Canvas. Amsterdam, Koninklijk Paleis*

around 1650), picking this and that pose and then attaching bodies to match. It seems unlikely that Rembrandt and Bol were in any kind of explicit competition for the commission to decorate the Schepenkamer, although the older master may have painted his *Moses* in the hope that it might find some sort of auspicious home. If he did, he was bound to be disappointed. It was pictures in Bol's manner, rather than Rembrandt's, that now answered to fashionable demand.

Ferdinand Bol was one of a group of Amsterdam history painters mobilized by the city fathers to fill the grandly appointed and spacious chambers of the new Town Hall with solemnly didactic art. Each subject was meant to be a dignified commentary, drawn either from the Bible or from classical history, on the virtues of the respective offices.[8] Hence the office of the city treasurers-ordinary, who were responsible for public works, was decorated with *Joseph Distributing Grain in Egypt* by Nicolaes van Helt Stockade, where the high-and-mighty benevolent patrician directs his clerks to bring succor to hollow-cheeked matrons and anguished nursing mothers while the usual ensemble of nudes struggle calisthenically with overloaded baskets of corn. The Council Chamber (Raadzaal), where the inner core of Amsterdam's government, its thirty-six councillors, deliberated, got a *Solomon's Prayer for Wisdom* by Govert Flinck.

Flinck and Bol competed aggressively with each other for each of the big commissions, and no wonder, since the former was paid the princely sum of fifteen hundred guilders for his painting for the Burgemeesterskamer, more than Rembrandt ever got for a single work other than *The Night Watch.* In the end, the two favorites of the burgomasters were each given facing overmantel spaces where they supplied, respectively, exemplary demonstrations of incorruptibility and fortitude. Centuries later, both large paintings have become unintentionally comical in their gravity, featuring at their respective dramatic centers a turnip and an elephant. Flinck's turnip, a specimen big enough to win prizes at agricultural shows, belongs to the homespun consul Marcus Curius Dentatus, who clutches his veggie as though he were in danger of losing it to the sybaritic Samnites (dressed by Flinck suspiciously like Venetians), who have deluded themselves into imagining they might undermine his integrity with bribes of gold plate. On the opposite, northern wall, a trumpeting elephant in Bol's painting is unleashed by the turbaned King Pyrrhus in a last-ditch effort to cow the intrepid (and, it goes without saying, incorruptible) Gaius Fabricius into

submission. You can tell from the consul's flinty expression that this strata-
gem is not going to work, and that the honor of the Roman Republic will
remain uncompromised. Rest assured, the paintings say to the burgers of
Amsterdam, the custodians of your government are similarly inflexible in
their civic virtue. The seventeenth-century Dutch translation of "consul"
was, after all, "burgemeester." And in case the message was in danger of
understatement, it got repeated in crushingly sententious verses supplied by
the likes of Vondel, Huygens, and the relentlessly prolific Jan Vos, often
installed beneath or beside the pictures.

Virtually all of these large paintings, so prized, praised, and richly
rewarded in their own day, seem unhappy embarrassments in ours: plod-
dingly conceived, ponderously statuesque, clumsily modelled (despite their
pretensions to classicism), and claustrophobically overcrowded, contriving
somehow to be both shrilly melodramatic and stonily bloodless. Sometimes
(as in the case of Flinck's putti-infested *Solomon*) they resemble altarpieces
without a church. Sometimes they seem like pious memorial paintings
without a mausoleum. It's become obligatory, in much recent scholarly lit-
erature, to give these feebly additive paintings a great deal more than their
due, by reiterating seventeenth-century judgements that they were nobly
"modern" pictures in contrast to Rembrandt's supposedly reactionary per-
sistence with chiaroscuro drama. The innocent view, that the Town Hall
paintings are, in fact, third-rate tableaux devoid of any kind of persuasive
vitality, neither tragically grand enough to be compared with Poussin nor
theatrically exuberant enough to be compared with Rubens, is, by the same
token, written off as ignorantly unhistorical, naïvely anachronistic. The
unfortunate vulgar obsession with Rembrandt, Rembrandt, and Rem-
brandt again is blamed for blinding us to the solid independent virtues of
the work of van Helt Stockade and Ferdinand Bol.

Only the countersuggestibility of academics could manage to produce
this kind of topsy-turvy perversion of common sense, so that Rembrandt is
made to seem dog-in-the-manger rearguard and the classical painters
courageously avant-garde, thus confusing fashion with invention. Flinck,
Bol, van Helt Stockade, and the rest of the Town Hall brigade doubtless
saw themselves as the true history painters of their generation. Many of
them had left the Guild of St. Luke to form their own Fraternity of Painters,
who might associate as equals with the poets, untainted by the oily stain of
craft. As a group they managed to exploit, in all sincerity, the natural crav-
ing of the Dutch oligarchs of the 1660s to be treated like court aristocrats
of neighboring states whose history painters and portraitists reeked of cul-
tivation. As a result, their high-tone work was bound to gratify patrician
taste far more consistently than that of Rembrandt, who was increasingly
indifferent to it, and who, far from running away from the traditions of
craft or from displays of painterly work, was unapologetically wrapping
himself within it. The classicizing painters might well have felt that Rem-
brandt's past successes actually set back the efforts of their profession to be
taken as a true academy. So they proceeded to turn the clock back to the

Govert Flinck, The Incorruptibility of Marcus Curius Dentatus, *1656. Canvas. Amsterdam, Koninklijk Paleis*

decorous conventions established by van Mander and Pieter Lastman forty and fifty years earlier, which Rembrandt had decisively forsaken in 1629. Their own work once again featured (as in Lastman's *Coriolanus*) august, isolated, brightly costumed figures high up on platforms or steps in front of grandiose, vaguely Roman architectural settings (columns, flattened domes, arches, loggias, and statuary obligatory), with crowds of posturing extras, some modelled on classical sculpture, distributed in the space beneath them, and always the odd animal—dog, horse, goat, or sheep—guaranteed to amuse.

This was just what the governing patricians of Amsterdam wanted to congratulate themselves on: their coming-of-age as a city worthy of comparison with the great empires of the past—Athens, Tyre, Rome, and Carthage. They were not interested in darkly glowing profundity, figures shrouded in gloom or blanketed in glaring light, still less in obscure conflicts between the outward world and the inner spirit. They *were* the outward world, its unchallenged masters from Formosa to Surinam, and metaphysical meditation pieces were not high on their list of collectibles. Such matters were best left to their private consciences. As for their public conscience, they knew very well what they needed: nicely defined, instantly intelligible, worthily wordy histories; lofty rather than deep; inspirational or cautionary stories from the texts they had been forced to read at Latin school, seldom bothered with again, but liked to revisit at the theater. For ceilings they needed, likewise, generic allegories singing the virtues of their governance and invoking the guardianship of the usual gods—Mercury, Minerva, Apollo. And they knew very well who would deliver the goods: the painters who specialized in pictures that were lucid, literal, and literary, who bathed their figures in bright light (for the Town Hall was designed to admit generous amounts of light wherever possible); artists who would give good value for their fee by stuffing the canvases with lots of ornate dress, ceremonious architecture, and stagy gesticulation. Desirable credentials were some experience working with Rubens himself, hence the presence of Jacob Jordaens and the brothers Erasmus and Artus Quellin; or with van Dyck, hence the inclusion of Jan Lievens, who since his return to Amsterdam in 1643 had been doing his very best to emulate the Flemish master, rather than his old comrade of the Leiden atelier. Lievens's contribution was to paint "Burgemeester" Fabius Maximus ordering his father to get off his horse to pay respect to the office held by his son.

To be a successful artist in the shiny hard world of mid-century Amsterdam meant not only painting to formula but also carefully cultivating a network of important social and political connections. Despite the success of *The Night Watch*, it was Flinck, a painter of whom dependability, not surprises, could be expected, who got the best commission: to paint the militia celebrations of the signing of the Peace of Münster in 1648. In 1652 he went from patricians to princes, painting the portrait of the Elector of Brandenburg. Two years later, Flinck painted Amalia van Solms mourning for Frederik Hendrik. One notch down in the hierarchy of the desirable were artists like Bol and van Helt Stockade, who had received portrait commissions from the great merchant oligarchs of the city, had had no complaints from them about the accuracy of the likeness, and who had managed to establish something like a personal or even familiar relationship with these high-and-mighty patrons. Bol, after all, painted his own portrait as if he were already a patrician, clearly aspired to join their ranks, and saw work in the Town Hall as a way of advancing that possibility. He would not be disappointed. On the day Rembrandt died, October 8, 1669, in circumstances of desperate penury, his old student Bol, the surgeon's son from Dordrecht, was negotiating a contract for a second marriage with the fabulously rich Anna van Arckel, a match that allowed him to stop painting altogether and join the ranks of the regents. Finally there was a group of more workmanlike hands—Willem Strijker, otherwise known as "Brassemary," or "Feastface"; Cornelis van Holsteyn; and Jan van Bronckhorst—all of whom could be relied on to produce ceiling and decorative painting in keeping with the sober ceremoniousness of the building.

All through the 1650s Rembrandt watched as the Town Hall, the "Eighth Wonder of the World," rose miraculously from its pile-supported boggy foundation, knowing that the plum commissions were passing him by. On a midsummer night in 1652, the Gothic pile of the old Town Hall, slated for replacement since 1639, burned to the ground, and Rembrandt, who was always more interested in staved-in things (including his own face) than in spanking new monuments, sketched the burnt-out ruins. There was something fundamentally incompatible between his passion for dark, cavernous spaces in which objects glowed and the glistening, geometrically calculated, stony-white interiors of the new Town Hall, with their dazzling marble floors, the cold, precisely cut sculpture, all flooded with light admitted through rows of tall windows. None of which is to say that he could have been indifferent to the fact that lesser talents, many of them originally taught by him, were now reaping the rewards of the most lucrative commissions the city had to offer, jobs worth hundreds of guilders, even a thousand and more. But if this pained him, perhaps Rembrandt was not, after all, surprised at the way things had turned out. His very first pupil, Gerard Dou, who had come to him in Leiden as a twelve-year-old *leerling*, a chit of a boy, had now made a colossal international reputation and a fortune to match, turning out exquisite genre paintings of lacquerlike slickness: alchemists in their cells; serving girls with deep cleavages leaning

Gerrit Berckheyde,
The Town Hall on
the Dam, Amsterdam,
1672. Canvas, 33.5 ×
41.5 cm. Amsterdam,
Rijksmuseum

out of windows beside pots of meaningful rosemary; gleaming little things you wanted to turn in the light like a buffed-up gem. Now, in 1659, Rembrandt had no pupils at all. And Govert Flinck, the Mennonite from Friesland who had come to him from Lambert Jacobsz. all those years ago, was now cried up by every hack poet in town as "Apelles Flinck," hired to paint portraits of the men whom Rembrandt had first pictured—Dr. Tulp and Andries de Graeff.

Flinck had carried off the grand prize of all the Town Hall commissions: eight huge paintings depicting scenes from Tacitus's history of the Batavian revolt against the Romans. These were to decorate the gallery around the great ceremonial court of the Town Hall, the Burgerzaal, the center of the building, which was itself thought by its governors to be the center of the world—a belief reflected in maps of the celestial and terrestrial worlds. It was a project of Rubensian magnitude to be compared with the cycles celebrating the life of Marie de' Medici in the Luxembourg Palace or allegorizing the reign of James I on the ceiling of Whitehall. But unlike all those paintings, this would be a truly *republican* history; a celebration of the *ware vrijheid,* the "true liberty," that had no need of princes, not even from the House of Orange, the freedom that had always been in the bones and blood of the Dutch, from their Batavian antiquity to their modern splendor. Though Otto van Veen's twelve small panels were in the States General, the Town Hall paintings would dwarf them, just as the great and free commonwealth of Amsterdam now dwarfed The Hague and its vestigial court. These paintings would be of properly epic scale, masterpieces to match the immense figure, set on the rear roof pediment, Atlas supporting the world, much as Amsterdam carried its trade. When future generations wanted to see how Amsterdam revered the ancestry of its freedom, all they would need to do would be to come to the Town Hall and marvel at these paintings.

And Rembrandt would be shut out from it. He was now treated rather like the eccentric uncle, soiled by disgrace, a little cracked, and with a poor sense of manners, kept out of sight in the upstairs apartment lest he embarrass polite society. But on February 2, 1660, Flinck suddenly died, universally mourned. Vos and Vondel laid poetic garlands on his bier, and the *vroedschap* confronted the daunting problem of what to do with the immense project now that its master had gone. All that he had left behind were preliminary drawings, which could indeed be a guide for his successor. But it was judged that no other single Amsterdam painter was capable, by himself, of filling his shoes—not, at any rate, if the project was to be completed within a reasonable time. So the work, now reduced to

decorations for the four great arched lunettes by the staircases leading down from the Burgerzaal, was farmed out to three artists. Two of them, Jacob Jordaens and Jan Lievens, had worked on the Oranjezaal in the Huis ten Bosch and could therefore be depended on to do decorous histories. Jordaens was assigned two of the paintings; Lievens, the painting of the chief of the Canninefates, Brinio, raised aloft on his tribal shield. The third artist—assigned, with whatever trepidation and reluctance, to paint the immensely important history of the Batavian leader Claudius Civilis swearing his confederates to an oath of resistance in the "sacred wood"—was Rembrandt van Rijn.

Rembrandt, Ruins of the Old Town Hall, *dated July 9, 1652. Pen drawing. Amsterdam, Museum het Rembrandthuis*

Going back to Tacitus was a return to his beginnings. Thirty-five years before, with the whole world before him, the "beardless miller's son," as Huygens had called him, had meant to impress Scriverius and Leiden with his first history painting, of Civilis granting clemency to captured Roman and Gaulish soldiers. He had come to the painting with van Mander's rules and Pieter Lastman's *Coriolanus* fresh in his mind. So he had done his best to please, according to all the rules and conventions, filling the panel with strong color, imposing architecture, a stepped platform for the leader, plenty of face-and-hand gestures, and he had not blushed to sign it with his own likeness painted behind Civilis's scepter.

And if he still wanted to please his patrons, all he had to do was to recover that decorous temper, especially since so many of the paintings already in the Town Hall looked as though they had come directly from Lastman's workshop! And Flinck's drawing, which followed, in spirit, the solemn scene painted by van Veen and etched by Antonio Tempesta, showed him how he might do this. Around a neatly dressed table, covered by white linen as though a lord were picnicking in the woods, the ritual handshake was being consummated. Civilis was seated at the end of the table, naked from the waist up, his face seen in profile, thus decently hiding his blind eye, just as Apelles had hidden the hollow socket of King Antigonus,[9] and a plumed turbanlike hat on his head. His hand was clasping the arm of a figure dressed like a Roman soldier, as if encouraging a defector to join the alliance or perhaps taking one of the young Batavians drafted in the levy that sparked the revolt into his camp. Around them were fellow banqueters, become coconspirators, leaning toward each other in collusion. The mood, as befitted the Town Hall, and as had been the case in the earlier versions of the scene, especially those printed in Tempesta's plates for Otto van Veen's book, *Batavorum cum Romanis Bellum,* where polite gentlemen, many of them rather elderly, locked their hands together in solemn bond, was one of great sobriety.[10]

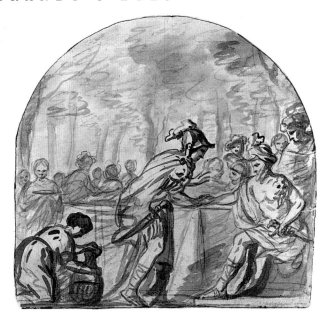

But Rembrandt, whose three books of Tempesta prints listed in the 1656 inventory must have included van Veen's version of the Batavian war, noticed that Tacitus specifically referred to the "revelry that had fired their spirits," and conjured up in his mind something other than stoic resolution; rather an orgiastic inebriation of liberty, a freedom-feast. Then he read that it was not merely the elders and betters of the Batavians but also "the boldest of the common people" whom Civilis had brought to the conspiratorial table, and he imagined something other than a country club of worthy gentlemen trading dignified handshakes. Of course, Rembrandt would have known that the handshake had been, since the earliest days of the Dutch revolt, the symbol of the *confoederatio*—the alliance of free men and sovereign provinces—which ever since had given the Republic of the United Provinces its distinctive character amidst the absolute monarchies of Europe. But he read Tacitus's reference to *barbaro ritu*, to barbaric rites, and again, something other than this handshake came to mind: a clash of swords, a calyx slop-full of wine or blood or both. And he must also have known that with the burgemeesters' aversion to any glorification of princely heroes, he had to be careful not to make too much of the barbarian chief, especially since Claudius Civilis had long been thought of as a kind of prototype of the Prince of Orange. But then again, how could he avoid giving Civilis, a lion among heroes of old, his due? Had not Tacitus written that he had been of royal stock? Had Civilis not suffered heroically, dragged in chains before Nero, tormented by the spectacle of his brother-in-arms, Julius Paulus, wrongfully accused of rebellion and executed? Above all, did he not wear his disfigurement not furtively or shamefully but as a boast, as Tacitus had said, "like a Sertorius or a Hannibal"?

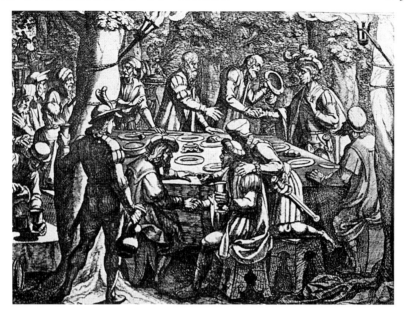

Antonio Tempesta after Otto van Veen, The Meeting in the Schakerbos. *Etching from* Batavorum cum Romanis Bellum, *1612. London, British Museum*

So Rembrandt gambled once again that he could violate the conventional expectations of a commission but so astonish the patrons with the incontrovertible excellence of the result that they would forgive him the inventions and discover that, yes, this was, of course, what they had wanted all along. He would be congratulated once again for so intelligently divining their true intention. So Rembrandt ignored Flinck's drawing, and for that matter wiped his imagination clean of any of the iconographic precedents: of handshakes and plumed hats; of a dining room in a glade; of servants tidily pouring goblets of wine. Instead he dreamt up a scene of barbarian uproar, hot with revelry, as Tacitus had said, drunk on freedom, burly plebeians mixed among the lords, something beyond the wildest fancies of the likes of Feastface Strijker. And he visualized this happening not directly amidst the trees but in a vast hall. In fact, Rembrandt did not completely abandon the association between woodland and primitive liberty, since the arches and columns of the meeting place frame an enormous tree and other vegetation lines the walls, both inside and out, so that the conspirators seem to be gathered before a kind of screen, or within some sort of tent or tabernacle.[11] The great company, some seated, some standing, evidently inspired by Raphael's *School of Athens*, was to be seen from a low angle of vision, with the eye climbing steeply up a great processional flight of steps toward a pyramid of massed figures in the deep middle ground until it reached the focal point in Civilis's immense, fearsome figure: the royal stature of the chief made even more loftily imposing by his stacked-up tiara headdress (adapted by Rembrandt from a Pisanello medal), his one eye staring darkly out into space, the other a gashed cicatrice, a cyclopean history of suffering and redemption.[12] Civilis's face was to be made, like that of Moses, to burn with an ethereal glow, suffused with

the spirit of liberty. For the Batavian leader was depicted just as he had finished making the great speech, recorded in Tacitus, setting out the brutality of the Roman levy, "separating children from parents and brothers from brothers as in death,"[13] had listened to the applause that rained down on him, and was now calling upon his brothers to swear their solemn, binding oath with a clash of steel.

The shocking, Shakespearean grandeur of Rembrandt's barbarian vision for the painting is known only from a drawing of the entire composition that survives in Munich, summarily sketched on the back of a printed funeral invitation dated October 25, 1661. The painting in its original form presumably stayed in its place in the assigned lunette of the gallery surrounding the Burgerzaal for merely a few months, during the summer of 1662. But by the late summer of that year, Rembrandt's painting had been returned for alterations, and it may well be, as Svetlana Alpers has suggested, that the drawing is not a preliminary study at all, but the kind of sketch that Rembrandt often did while he was working through problems and revisions.[14]

At some point, it must have dawned, queasily, on Rembrandt that this time he might have lost the gamble; that the daring of his conception had alienated, rather than won over, his patrons. And perhaps all the mythical scenes invented for biopics of indignant burghers recoiling at *The Night Watch* might actually have happened in the sad case of the rejected *Claudius Civilis.* Perhaps there was no outbreak of chortling or cries of disgust. Perhaps instead, as the regents of the *vroedschap,* the custodians of the Eighth Wonder of the World, stared upward at a cavernous space and looked at a barbaric, perhaps blasphemous, mélange of *The Last Supper* and *The School of Athens,* and peered further and saw that their republican hero, Civilis, had been rendered as a brigand king and that the faces about him, barely discernible in the flickering, sallow light, resembled Jews or ancient, stump-toothed drunks, mouths open in hideous guffaws, they were, indeed, confounded, but not in the way that Rembrandt hoped for. Perhaps they let it be known, always while offering here and there a polite note of admiration for the extraordinarily *interesting* and *spirited* fashion in which he had chosen to depict the Batavian ancestors, a little note of regret that not everything could be clearly made out in the *fascinating* and tremendously *bold* composition.

Rembrandt's optimistic conviction that the *Claudius Civilis* would, after all, make him the chronicler of Holland's liberty, much as Rubens would be recognized as the supreme panegyrist of absolutism, must have been brutally short-lived. His immense, twenty-foot-wide painting was still hanging in its corner lunette at the end of the Burgerzaal gallery when Melchior Fokkens described it in his 1662 guidebook celebration of Amsterdam. But then, someone perhaps from within the governing circle who still knew and admired the master, Joan Huydecoper van Maarsseveen or Dr. Nicolaes Tulp, let it be known that, however admirable it was, in its way,

and so very faithful to nature, it was not exactly in the spirit of Flinck's design and thus, regrettably, not really what was wanted, if he took their meaning?

By September a cart would have brought the huge canvas, rolled up, to the little house at the southern end of the Rozengracht. Where did Rembrandt put it? Propped against the wall in a corner of his studio? For that matter, who would want the enormous painting, arched at the top expressly to fit into the lunette, its foreground precisely calculated to extend the long approach of the gallery *into* the picture space itself, giving the beholder an uncanny sense of moving toward the high table of the conspirators? Even Rembrandt's lighting, with its white-forge glare, had been carefully thought out to radiate from *beneath* the faces of the figures, as though lit by the sconces of the gallery itself.

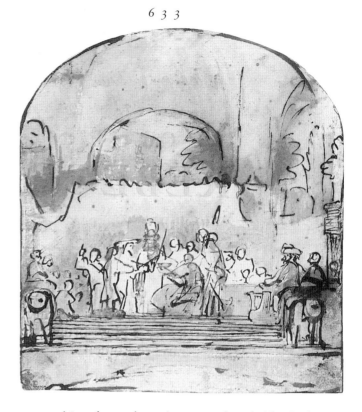

Rembrandt, The Oath-Swearing of Claudius Civilis, *c. 1661. Pen drawing with wash. Munich, Staatliche Graphische Sammlung*

And yet he desperately needed to salvage something from the ruin. There was rent to pay, bread to be put on the table. Otherwise all his herculean labor would go for nothing; no fame and assuredly no fortune. His only hope was to try somehow to turn the white elephant into a salable commodity by cutting it down to a size that might be suitable for someone's house. Perhaps he could manage to find a buyer who could set it at the top of his own staircase, or over a grand mantel, if it were cut down. So there was nothing for it but to roll the twenty-foot masterpiece out on the floor (for Rembrandt could not have had any kind of table big enough to hold it) and have Titus secure one end while he knelt down with his knife and sliced through it, the tight weave fraying as he sheared, cut-away lengths falling on the floor like strips of shoddy in a tailor's shop. He must have crawled over it until the painting was pruned to the long, relatively narrow fragment that survives today in Stockholm.

It's true that seventeenth-century artists would have been much less squeamish than we might suppose about chopping, trimming, or for that matter splicing and stitching works to make them more salable. Even so, Rembrandt could not have set about the mutilation of what must have been the greatest, certainly the boldest, of all his history paintings with anything but the deepest anguish. But he attempted, as best he could, to convert his most humiliating defeat into some sort of victory, reimagining the entire composition, repainting large sections of what was left. Instead of figures in the middle ground set in a deep, lofty space, he created an

FOLLOWING PAGES: *Rembrandt*, The Oath-Swearing of Claudius Civilis, *c. 1661–62. Canvas, cut down to 196 × 309 cm. Stockholm, Nationalmuseum*

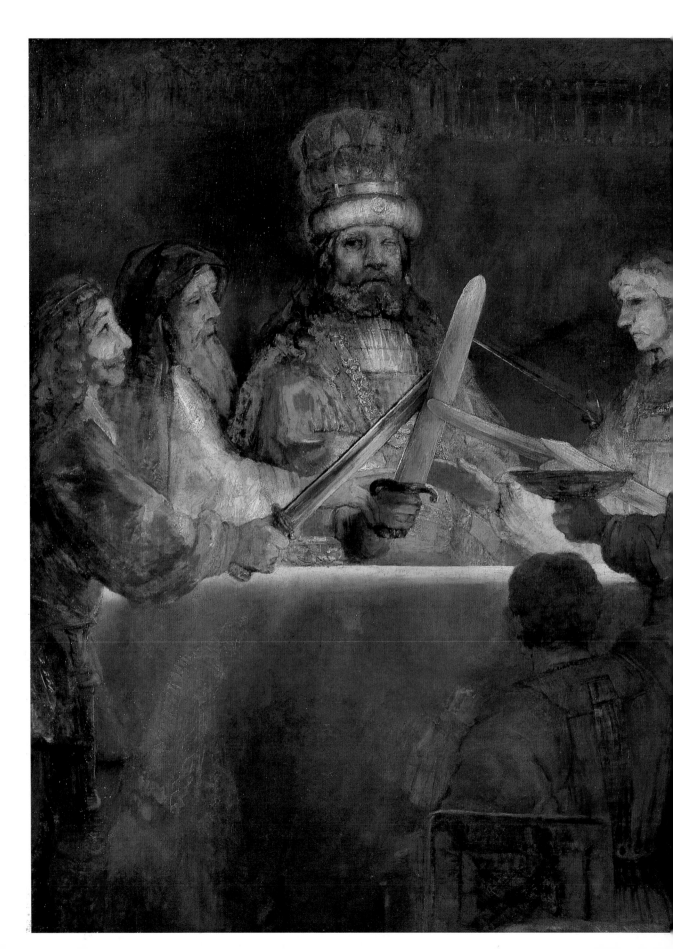

extraordinarily concentrated group, pushed threateningly close to the beholder; a confrontation of barbarian energy.

The painting we can see in Stockholm is, then, a cruelly truncated and heavily reworked fragment of the original. But even so, it remains a very large painting and certainly ambitious enough to be judged as one of the most revolutionary acts of painting in the entire history of seventeenth-century art. More recently, the failure of the *Claudius Civilis* to win acceptance by the worthies of the Town Hall has been explained by politics and history. Margaret Carroll, in particular, has argued that the massively uncouth hero figure of Claudius Civilis, regally enthroned at the heart of the picture, offended a staunchly republican regime in Amsterdam, committed to doing away altogether with the stadholderate as a hereditary institution.[15] It is true that during the early 1660s the campaign arguing for Holland's republican sovereignty was at its most uncompromising. Vondel was writing his last play (performed in 1663), *The Batavian Brothers, or Freedom Suppressed,* in which the tyrannical Roman governor of the ancient Netherlandish homeland who provoked the rebellion was described as a "stadholder."[16] But while the circle around the Grand Pensionary of Holland, Johan de Witt, was certainly fully committed to this republican offensive, the regents of Amsterdam in the same period were, as usual, a more pragmatically assorted group. Prominent among them, for example, was the notoriously slippery Gillis Valckenier, who was becoming more, not less, of an Orangist. But in any case, Rembrandt might well have displeased *both* the adversaries *and* the champions of the House of Orange by his treatment of Claudius Civilis, since the former might have been dismayed by the dominant position given to the warrior prince, seated in somewhat the same position as Jesus in Leonardo's *Last Supper* (a painting Rembrandt had drawn), and the latter unhappy about his resemblance to a one-eyed bandit chief.

Aside from all these historical encumbrances, the issue of Rembrandt's manner of painting could hardly have been trivial. Anyone who goes to Stockholm and stands before the remnant painting, even at the distance which Rembrandt assumed would separate the beholder from the original canvas, is dumbstruck by the uncompromising attack of the brushwork, which in many of its passages bears no resemblance to any kind of contemporary painting, least of all to the licked finish of the other painters of the Town Hall. In all likelihood those who had to pass judgement on the painting would have shared the later judgement of Gérard de Lairesse that Rembrandt was prepared to allow his "colors to run down the piece like dung."[17]

Once again, Rembrandt has not done this out of any sense of self-conscious aggression. He needed this job, badly. And in fact, he has just taken two of his working principles—the transformation of a familiar genre, and making the brushwork speak to the story—and pushed them to hitherto unimagined extremes. No one, not Rubens, not Titian, had ever painted quite like this.

Somewhere at the back of his dangerously fertile imagination, Rembrandt had conceived the *Claudius Civilis* as a deformed militia-feast, a *schuttersmaal*, with a company of part-time warriors gathered about a table, bonded together by their devotion to the "true freedom." To be sure, they hardly look much like the bluff and boozy militiamen painted by Frans Hals, still less the civic guards painted by the accomplished flatterer Bartholomeus van der Helst: gorgeously got-up weekend warriors, plumed and sashed, their baldrics burnished, their whiskers smoothly combed. But, Rembrandt might have reasoned, *The Night Watch* had not been what its patrons might have anticipated either. Just as in *The Night Watch* Rembrandt had tried to recover the original ethos of the militia—its martial energy—at the expense of obeying the formal conventions of that kind of painting (to represent each and every individual in their correct status and rank), in the *Claudius Civilis* he has similarly subordinated the expectations of literal-minded Roman history painting to the power of an idea. But where that dominating idea had, in the case of *The Night Watch*, been flattering to its patrons—that of the disciplined propulsive energy of the *kloveniers*—in this case the idea was less easily digested. For it was barbarian liberty, enacted with the solemnity of a pagan, even druidical rite, a compact of freedom or death, wine and blood, a rum sort of militia banquet to be sure. Worse, it violated the first principle of militia-feast paintings, namely, that they depict only gentlemen, with an occasionally deferential servant and perhaps the odd respectably pious or sober sergeant. But Civilis's crew is outlandishly motley—swarthy orientals, belching dotards, a druidical priest. You can hear them yell and guffaw, smell their foul breath and unclean bodies, all pressing in, crowding the spectator, sticking their faces in his space. The paint is distressingly apt: screaming masticot, sour greens, all stuck on the canvas as if the savages themselves were clutching it in their fists. It was as though Rembrandt had forgotten that the general had been a Roman soldier before he had become the rebel leader, a loyal subject pushed, only in extremis, to revolt, just like Moses, just like William of blessed memory. But this! This person was an un-Civilis.

As far as Rembrandt was concerned, though, he had merely been continuing to paint as he had in the past: in the portrait of Jan Six, for example, where the brushwork did not just describe but *embodied* its subject. His paint-handling was no longer the routine tool of narration. It was itself akin to a kind of visual diction, less literal but more dramatically suggestive than an open mouth or a wave of the hand. Elegant nonchalance—*sprezzatura*—had been perfect for Jan Six, whom one imagines with a silvery, refined tongue. Civilis, though, must declaim with brute power, grim resolution, and with the clipped decisiveness of the rough-cast hero sworn to bloody insurrection. So, more than in any other painting in his career, at least to date, Rembrandt has let his brush-hand jab and thrust, almost as though it were Civilis's broadsword. And just as he has painted his own defiant self-possession into other histories of this period, the painter has

projected much of his own adamant defiance into the image of the chieftain-general. In fact, Civilis even wears a garment very like the golden robe of Rembrandt's commanding self-portrait of 1658. So he goes at it, depositing glowing color in raw, unmodulated patches and gobs onto the surface of the canvas and then going back, applying second and third layers of strong lights or deep shadows, kneading, scratching, piling the paint high, scraping it back. This did not necessarily mean the entire painting was uniformly opaque. Some famous surviving passages—the exquisite glass goblet on the right—have a luminous transparency achieved, paradoxically, by intensely worked color and, even for Rembrandt, an ingenious calculation of highlights. But other passages, like the two figures *above* the goblet, are painted in with the most summary coarseness imaginable, palette-knife slaps of paint indicating a nose or a cheekbone, a sharp dab of black suggesting an eye socket. Then again Rembrandt varies the fury of his brushwork according to the character depicted: softer and more carefully descriptive for the high priest seen to Civilis's immediate right, and for the glowing features of the young mustachioed man who again seems to resemble Titus; a dense screed of raised paint for the face of the leader himself.

For a painting in which Rembrandt wanted to create an atmosphere both of riotous revelry and of solemn stillness, he has also managed, as usual, to invest it with a tremendous jolt of action, through the straining figures seen from the rear, one of them stretching out his arm in the salute of allegiance, the other holding out the ritual libation cup. At that center, at the base of the man-mountain that is the prince of the Batavians, the light, still fiercely golden even after the centuries, is at its most intense along the horizontal line of the table itself, pouring *upward*, gathering the conspirators into a bowl of radiance.

At what would have been the center of the painting, in its original state, one of those pools of light settles at the headband of Civilis's crown, becoming most intense at the medallion in its center. The headband becomes a nimbus for the grimly scarred face, turning the figure into seer and saint, as well as warrior prince, his nobility not belied by, but *exemplified* by, the brutish head and massive upper body. It frames those two eyes: one, as in so many of Rembrandt's figures, black; the other a dead slit. But there is, in fact, something very like a third eye, that gleaming oculus on Civilis's brow, concentrating the light of freedom in the seat of his inner vision.

ii Mixed Company

Rembrandt was living opposite an amusement park. The Nieuwe Doolhof, or the New Maze, was run by one of Amsterdam's great showmen, David Lingelbach. Originally a tavernkeeper from Frankfurt, Lingelbach now described himself, much more grandly, as a *kunstmeester,* a professional title that had more to do with fountains and fireworks than brushes and easels. He had been married three times, and one of his sons was the painter Johannes Lingelbach, who made a decent living from pseudo-Neapolitan harbor scenes or Roman pastorals in which Gypsies or huntsmen wandered fetchingly through the sun-soaked Campagna. But the Nieuwe Doolhof, leased by David Lingelbach from 1636 on, was another kind of Arcadia altogether, and a lot more fun. Its array of fountains—including an allegorical waterworks of a rampant Dutch lion with water spouting from the bunch of arrows held in its paw—had been created by the Huguenot master of hydraulic spectacle, Jonas Bargeois. Lingelbach had expanded the gardens, turning them into an indoor and outdoor palace of wonders. There was a wooden and stone house in which visitors, welcomed by a green parrot, could explore the curiosities—the usual things: elephants' skulls; a tableau of the "Samaritan's Well" with plaster figures—and a series of open-air hedged enclosures, some with doves and guinea fowl and peacocks wandering about, and each featuring at its center some sort of mysterious, intricately carved, and magnificent spectacle.[18] In the center of one such squared-off enclosure was another great four-sided fountain ornately carved with representations of everything that came in fours—seasons, elements, and (with some editing) cardinal virtues and deadly sins. At its top was the people's favorite giant, the holy piggybacker St. Christopher. Another enclosure boasted at its center a spectacular clock featuring a motion of fabulous beasts, and a tremendous carillon sounding on the hour. There was also an elaborate organ featuring a Judith and Holofernes and the always popular "Wife Who Wore the Trousers" with her husband meekly sitting at a spinning wheel.[19] And at the very center of the park was the feature which gave it its name—the maze of high box hedges in which lovers could giggle, stumble against each other, and judge how seriously they would get lost.

Everyone in Amsterdam—well, almost everyone—loved the Nieuwe Doolhof, an outdoor Chamber of Curiosities for the people. They loved it even more than the original Oud Doolhof, which David Lingelbach had begun decades before, but which had started to attract too many women, so the sheriff said, of easy virtue (in competition with the brothels, from

Rembrandt, Self-portrait, *1660. Canvas, 80.3 × 67.3 cm. New York, Metropolitan Museum of Art*

which he and his men got a cut). So the Nieuwe Doolhof was built at the southern end of the Rozengracht ostensibly as a more domestic place. On warm Sunday afternoons, crowds poured into the pleasure gardens to stroll, drink (if they chose) from the cool fountains, and eat Deventer *koek.* There would have been dogs and small children, rolling carts and hobbyhorses, hurdy-gurdy players and soap bubbles, young men got up in flirting costume—hose of shocking brightness, scarlet, mustard, or kingfisher blue—their hair (either natural or bewigged) elaborately curled to fall over their shoulders in the new fashion that the preachers thought was a sure sign that Amsterdam was turning, irreversibly, into the new Sodom. Men paraded in long coats nipped in at the waist, flaring out over breeches which were tricked out with ribbons and rosettes in the French manner. The girls would have shameless chokers of pearls at their throats; silk bows in their short ringlets; their bodices tightly laced to push out their breasts, which might or might not be decently covered with a soft fabric. Through the avenues of the Nieuwe Doolhof strolled or staggered sailors and musketeers, Turks and Jews, matrons and babes-in-arms, fiddlers and hurdy-gurdy men. And since there was no way to stop this, save a perpetual patrol, something for which the sheriff and his watch had no time or inclination, there would also have been an inevitable contingent of overdressed professional women, arm in arm in twos and threes, scanning the men for business.

There must have been times when the painter's concentration would have been tested by the piercing shrieks of peacocks and thundering chimes of the great garden clocks. And since Lingelbach had also planted an ornamental trellised vineyard leading to a place of refreshment, there was also, inevitably, the uproar of drunks. Fights broke out with regularity along the Rozengracht, at least at the wrong, southern, end of the canal, where Rembrandt lived and where the Nieuwe Doolhof was located. In October 1661 Hendrickje, who must have been much pleased to be summoned, officially, as the "*huysvrouw*" of the "artist [*fijnschilder*] Sr. Rembrant van Reyn," was called as a witness, along with some of her neighbors—a sailor's widow, the wife of a gold-wire maker, and an innkeeper—to testify that she had seen a drunken surgeon lurching about with a glass of wine in his hand, accosting anyone who passed to share either a drink or a fight with him. This was the sort of thing that must have spilled over from the park all

the time. Crowds gathered. Pleased to have an audience, the drunk got drunker, louder, and nastier. Hendrickje and her two friends posted themselves a little up the street, attempting to alert innocent oncoming pedestrians to take a detour that would steer them clear of trouble. Eventually the sheriff came and dragged the pest away.[20]

It was certainly a different life from the St. Anthoniesbreestraat. But it was not a hole-in-the-corner existence. If anything, the Breestraat was on its way down as a fashionable address, and the Rozengracht, and the area around it, if not exactly on its way up, was by no means the poorest or meanest address in central Amsterdam. One canal away to the east, on the other side of the Nieuwe Doolhof and parallel with the Rozengracht, was the Lauriergracht, where a whole crowd of artists and dealers had made their residence, including the peripatetic Hendrick van Uylenburgh and his son Gerrit, also a dealer; the Italianate landscapist Bartholomeus Breenbergh; the game-piece painter Melchior d'Hondecoeter; and Juriaen Ovens, Rembrandt's former student, hired to replace the rejected *Civilis* of his old master.[21] Another former pupil who had overtaken the master, Govert Flinck, had bought two adjoining three-story houses on the Lauriergracht which after his death in 1660 were valued together at eighteen thousand guilders, and which, packed solid with grandiose sculpture and painting, he called the "Schilderhuis," as though it were the urban villa of the Rubens of Amsterdam.

In fact, the neighborhood must have been full of living memories for Rembrandt, some fond, some painful. Halfway along the Rozengracht, between the more solid and the humbler houses, there was one painter in particular whom Rembrandt knew very well: Jan Lievens. Forty years on from the Leiden days when the two of them had shared models, ideas, and the praise of great patrons, they had both ended up on the Rozengracht. In the 1620s, Rembrandt and Lievens had shown themselves capable of *both* rough *and* smooth painting, sometimes within the same composition. But now they had clearly parted company: Lievens struggling to please the taste of the grandees by painting ever more slickly, Rembrandt taking the rougher road.

In December 1660 Rembrandt's insolvency account was finally closed by the insolvency commissioners. On the same day, Hendrickje and Titus appeared, along with Rembrandt, before a notary to constitute formally a business partnership to trade in "paintings, graphic arts, engravings, and woodcuts as well as prints and curiosities."[22] All the movable property belonging to the family was now assigned to the business, with each of the partners sharing the profits and losses equally. Since "they are both very much in need of aid and assistance in this enterprise" and because "no one is more suitable for this purpose than the aforementioned Rembrandt van Rhijn," he would live with them, board and lodging supplied, paid for by supplying artworks for the inventory. All of his possessions, whether pictures or furniture or household utensils, everything, now belonged to his son and common-law wife, who would lend him some money for his mate-

rials, again, on the security of his work. Should any of the partners smuggle something out of the house in violation of the business agreement, fifty guilders was to be docked from the sums owed them by Rembrandt—a rider which suggested that he was not quite free of the suspicions he seems to have nursed about human behavior much of his life.

Rembrandt put Titus and Hendrickje through this elaborate charade to limit his liability from claimants left over from the mess of his financial ruin, or any future creditors. And though his account with the insolvency commissioners was closed, Rembrandt still owed sums to private individuals, not least the money for which the guarantor of the original loan from Jan Six, Lodewijk van Ludick, had stood liable when Rembrandt went belly-up and from which other creditors were trying to recoup their own money.[23] But perhaps, after everything he had gone through, an act of willed self-dispossession of the kind formalized by the terms of the partnership was not, after all, so deeply uncongenial to him. The inventory taken at his death suggests that he lived very simply in the house on the Rozengracht: earthenware dishes on the table, pewter to drink from, enough clean linen not to feel like paupers.[24] The playing-card maker, Jacques van Leest, who owned the house, which was, like most of those round it, narrow and deep, charged him 225 guilders rent for the few rooms. The front door opened onto a little *voorhuis* facing the canal where he put a few chairs and some of his pictures. The parlor was where they kept a few fine things that Hendrickje had preserved from the ruin: a fancy bed with bolsters with silk curtains, more for show than use; a big oak table. Behind was a simpler *binnenhaard* where they could sit, read, talk; further back the kitchen and a little room for sleeping and dressing. It was a far cry from the grand "Schilderszaal" of Flinck on the Lauriergracht, crowded with pupils and works of art, where models had sat "mothernaked" for the artist in the late 1640s.[25] But Rembrandt had no need of a large workshop now since he had only one pupil, the sixteen-year-old Arent de Gelder, who had been sent to him by Hoogstraten and who doggedly endeavored, for the rest of his days, to emulate Rembrandt's dense impasto, rough finish, and sharp contrasts of darks and lights. Titus himself painted now and again and modelled for his father, as did Hendrickje and a few other types from around the Jordaan, who show up over and again as apostles, Old Testament patriarchs, sages, and heroines.

With his ambitions to cut a fine and swaggering figure in the world so completely fallen away, and with a rent that was not, after all, such a fortune, Rembrandt must have still thought he could do enough to make ends meet. Sometimes his optimism flared up like a freshly greased torch, and the naughty old prodigal, unchastened by disaster, reappeared, as when he actually offered a *thousand* guilders to buy a Holbein![26] But then, he might have seen yet another reference to the "wide-renowned *Reimbrant*" in the verses of the city's poetizers and supposed that it would only be a matter of time before he climbed back to fame and favor. Even in Antwerp, where the memory of the great Rubens stood unchallenged as the colossus of Nether-

landish painting, the poet Cornelis de Bie, in a 1661 verse tribute to all the great painters of his day, sang Rembrandt's praises. To those who were beginning to denigrate him as an undisciplined slave of nature, de Bie retorted extravagantly that "Nature stands abashed—red faced / For never before has she been so well rendered / By any artist. . . ."[27] Very well, then, he was not going to withdraw into his shell in the Jordaan like an old snail, not yet.

These were not the fantasies of a has-been. In his last years, in the 1660s, Rembrandt was not so much written off as written about, less a discard than a figure of fierce controversy whose immense reputation attracted both champions and denigrators. It may even have grated on the nerves of his domestic critics that Rembrandt, whom they patronized as indecently quaint, and whose coarseness stuck out like a sore thumb among the decorous, academic hands of the practitioners of the "clear" style, seemed still to have so many admirers from abroad.[28] For the advocates of a refined and solemn style, adherence to classicism was not just a matter of social or aesthetic propriety. It was an issue of philosophy. In their eyes, the fastidiousness of classicism, its erasure of the ill-formed and unseemly, its aversion to the indeterminate and the willfully obscure, supplied a *definition*, a justification, of the high moral purpose of art: the crystallization into matter of spiritual beauty. The essence of clarity itself, it necessarily required brilliant light for its display. Even when they looked at Rubens, the champions of classicism found something a little excessive and histrionic, something that was a little overgenerous in its efforts to turn stone into flesh. But Rembrandt was much much worse—incomprehensibly perverse, obstinately bent on limning ugliness, claiming that everything to be found in nature was worthy of painting, and unhealthily obsessed with dusky obscurity. Joost van den Vondel, obviously with one particular master in mind, used his poem praising an exemplary Venus by Philips Koninck to attack "sons of darkness / who like to live in shadow like an owl / those who follow life can forgo beautifying gloom / And as a child of light need not hide in the dusk."[29] A distaste for clarity, Vondel thought, was necessarily a symptom of a confused or diseased mind.

But the champions of the clean line, the nobly chiseled form, and the heroic, cloud-scudded sky did not yet have the field to themselves. A famous verse anthology, *The Dutch Parnassus* (*De Hollantsche Parnas*), published in 1660, included at least two poets, Jan Vos and Jeremias de Decker, both of whom were, in their different ways, spirited defenders of the Rembrandtian style and of the painter himself. Jeremias de Decker had, in fact, been Vondel's student, but had made his own reputation not from elevated classical dramas but from spiritually intense little meditations, inward and self-admonishing, with death and the vanity of the world as a repeated theme. In one telling poem called "Shadow-Friendship" ("Schaduw-Vrindschap"), de Decker equates bright light with fair-weather friendship. As long as the sun shines, this kind of friend follows along just like a shadow. But when the sunny sky gives way to gray and fair outlook is replaced by the damp

Rembrandt, Portrait of
Jeremias de Decker,
*1666. Panel, 71 × 56
cm. St. Petersburg,
Hermitage*

and fog of adversity, the shadow-friend promptly disappears.[30] De Decker wanted to make it clear that he was not among Rembrandt's "shadow-friends," expressly addressing himself in a poem describing the painter's *Christ Appearing to Mary Magdalene* to "Friend Rembrandt" and praising it for its astonishing power of resurrection—"dead paint so brought to life," as if Christ were actually speaking to Mary—but also for exactly the kind of features the classicists most disliked: a towering rock-tomb, and a composition "rich with shadows, spirit and majesty."[31]

Rembrandt reciprocated the poet's appreciation by painting de Decker's portrait, and did so as an act of personal friendship, asking nothing by way of payment, even at a time when he was still desperately hard-pressed to make ends meet. And he repeated the gesture in 1666, the year of the poet's death, in a portrait that is one of the most moving and powerful studies from his last years. The painting is itself dominated by the deep shadow that falls from de Decker's broad-brimmed hat over his brow and eyes, giving him precisely the cast of mournful spiritual thoughtfulness inscribed in his poems. It is as if de Decker were contemplating his own end, poised between light and dark, a temper which Rembrandt himself would continue to explore to the end of his own days. In its utter simplicity—the old-fashioned collar, taking the strength of the light, floating over the dark coat; de Decker's face modelled with thick, solid paint as if hand-sculpted by the painter—the picture is a fraternal valediction. Its sadly sweet elegiac quality gives it the feeling of a memorial done in the immediate aftermath of a friend's passing. The picture is Rembrandt's condolence to himself, the artist lingering sensitively over each feature of the deceased as if inspecting a privately cherished treasure—the cleft chin, the wispy mustache, the gently cogitating brow—all put together in a physiognomy of endearment. Too late for its subject to contemplate, the picture personi-

fied de Decker's claim that the true Apelles of Amsterdam was capable of conquering death itself through the immortality of his genius.

Jeremias de Decker was not the only poet who saw in the aged, battered Rembrandt a vanquisher of death. In 1654 Jan Vos, who was as brashly exuberant as de Decker had been inward and metaphysical, had published a poem called *The Battle Between Death and Nature, or The Victory of Painting*. Nature, sorely beleaguered by Death, eventually finds succor in Painting, who is discovered in a curious chamber or studio decked out with piles of books in ancient bindings, rusty swords, old shields, human limbs, a lion pelt and a skull, things which had been cast off, despised, but which in the lair of Painting are restored to value.[32] The room might have been Rembrandt's own *kunstkamer,* and when, following her deliverance by the allied forces of Painting and Poetry, Nature is suddenly possessed of a prophetic vision imagining an Amsterdam burgeoning with artists, it's not surprising to find Rembrandt's name at the head of a list that also included Flinck, van der Helst, Bol, and the still-life painter Willem Kalf.

The inseparability of Art and Nature, which for his critics was precisely the problem with Rembrandt, was, for Jan Vos, his chief claim to glory. Though he certainly had ambitions to be counted in the pantheon of poets, Vos's background and personality made him an unlikely candidate for the Amsterdam Society of Apollo and Apelles. Originally an illiterate glazier, he still kept the business going. Condescended to by the loftier muses of the city as a part-time and vulgar bard, he was, everyone was bound to concede, an inexhaustible versifier. What was more, for all the bouts of eye-rolling they provoked among gentlemen with Italian educations and French valets de chambre, Vos's thudding lines were immensely popular. He had become the manager, the *curator,* of the Amsterdam city theater, and had made his own name there by displaying a sure instinct for giving the gallery what it wanted: blood, hysterics, malice, vengeance, remorse, and more blood, and he had packed the lot into *Aran and Titus,* his version of Shakespeare's *Titus Andronicus,* which made the original, human pie and all, look quite demure by comparison. Flat-footed in his meter, Vos nonetheless gave his readers and audiences something that more refined poets disdained: an earthy connection to the world of the old farces and street-market playwrights. No wonder he saw in Rembrandt, who was himself fond of drawing actors strutting in their costumes, a kindred spirit, a thespian of the canvas: someone who revelled in picaresque figures and booming declamation; someone who could never be accused of being stingy with passion. For Vos as for Rembrandt, it was not art's work to trim human nature of its undignified irregularity, to correct the unfortunate accidents of nature, the pockmarks, the flabby rumps, and the warts. Why, he was warty himself, a great fat hairy one, a veritable monarch of warts, enthroned beneath his blubbery lower lip, the wart and the lip overhung by a grandly simian proboscis.

So the ill-favored, supremely fortunate Jan Vos continued to defend and extol Rembrandt van Rijn even when the painter had become some-

thing of an embarrassment among his ex-pupils, who were attempting to turn themselves into a brotherhood of high-minded muses. What was worse, however much they might cringe at his writing, Vos was unavoidable, ubiquitous. He even had patrons in high places, like the perennial burgemeester Huydecoper van Maarsseveen, who had been one of Rembrandt's earliest patrons and whose house on the Singel was packed with art, all of which was dutifully described in Vos's eulogistic verses. Somehow he had made himself indispensable. When anything of importance happened—a battle, a notable death, a wedding, or a disaster—there was Vos to pen an occasional poem, as indefatigable as the automata in David Lingelbach's park. And the fact that, say, Vondel had gotten there first was no deterrent. Vondel saw fit to write a long poem on the inauguration of the new Town Hall. Vos wrote a long poem on the inauguration of the Town Hall. Vondel wrote a few lines on Bol's *Moses* in the Chamber of the Aldermen. Vos wrote a few lines on the *Moses* in the Chamber of the Aldermen.

How could such a person *not* be useful to Rembrandt, to defend the principles of his naturalism and to sustain his reputation against the noses-in-the-air? Vos's evocative description of Rembrandt's *Esther, Haman, Ahasuerus, and Mordecai,* with the Haman (the kind of villain Vos loved), "his breast full of regret and pain," in the house of Jan Jacobsz. Hinloopen, one of the most powerful of the city councillors, must have helped reestablish the fitness of Rembrandt's kind of history painting, roughly painted, somber, and glowing, for the collections of the patricians.

Rembrandt, then, was not alone. Extolled by the gregarious, loud-mouthed, thespianic, oratorical Jan Vos and the mournful, metaphysical, evangelical Jeremias de Decker, respectively, the Carnival and the Lent of Dutch poetry, he was, despite his personal and public notoriety, despite his not entirely undeserved reputation for being obstinate, unpredictable, and generally impossible, still a logical, and even desirable, choice for some of the more important patrons in Amsterdam, even after the tragic fiasco of the *Claudius Civilis.* In fact, the drastic and enforced alteration of his great history painting from a spacious composition on the scale of Raphael's *School of Athens* into a banquet scene may actually have focussed his mind more sharply on another crucial commission which had come his way at around the same time: *The Sampling Officials of the Drapers' Guild,* known ever since as *The Staalmeesters.*[33]

The *staalmeesters* were quality-control men, appointed annually by the burgomasters to ensure that the blue and black cloth made in the city was well enough made and dyed to pass its certification, indicated with a lead seal attached to the sample. Traditionally, they had had their portrait painted at the end of their term and hung in the building, the Staalhof, where they conducted their business. The group which commissioned Rembrandt was an extraordinarily complete (though selective) cross section of the merchant elite of the city: two Catholics, a Remonstrant patrician, a Calvinist, and a Mennonite—an exemplary instance of the businesslike

attitude toward religious confession which made Amsterdam unique in Europe.

 If Rembrandt thought to himself (as he had done in all his previous group portraits), What is the essential ethos of the *group*? he would have seen the challenge right away, since the qualifying credential of each of the masters was, after all, his *judgement*, his sense of being able to determine excellence. It was exercised, it's true, on bolts of blue and black cloth. But nonetheless, Rembrandt must have taken to heart the need to supply the quality-men with a painting in which their fastidious discernment was matched by his own exacting perfectionism. So even as he was battling bloodily with the problems surrounding the *Claudius Civilis*, he was taking infinite pains to get the *staalmeesters* right, both for his own satisfaction and for that of his patrons. It's the only group portrait for which a series of drawings survives, and to which (on the evidence of X-radiographs) he returned again and again, adjusting positions, stances, projections, and recessions. So this painting occupies a position in the body of his late work

Rembrandt, The Sampling Officials of the Drapers' Guild, *1662. Canvas, 191.5 × 279 cm. Amsterdam, Rijksmuseum*

quite different from that of the *Claudius Civilis*. Instead of aiming for a *coup de foudre*, a thunderbolt which would strike the beholder with irresistible force, Rembrandt aimed instead at a sophisticated technical solution to the problems of a traditional genre; one which respected the wish of individuals to be given their due, but which also tried to bind them together in a single composition.

Perhaps he was also thinking of where he had gone wrong; of concepts that might have overshot the expectations of his patrons; of the complaints that Hoogstraten says he received for *The Night Watch*, that it had been too dark, that the individuals had been forced to surrender too completely to the whole; of the evident difficulty the Town Hall had with the savage grandeur of his vision. So with the gentleman connoisseurs of the blue and black cloth, Rembrandt aims not to confound or to convert; not to revolutionize a genre but to perfect it. In all likelihood the parameters of the composition had been set by the *staalmeesters* themselves—the low angle of vision required by the intended hanging of the painting high on a wall of their meeting chamber; the number and personnel of the group; the inclusion of an account book and a money bag, their live-in steward Frans Bel, and the watchtower, emblematic of their own vigilance, painted on the wooden panel over the head of the right-most sampler. It was also the convention in such groups to show them arranged around a table, and they may have indicated this preference to Rembrandt as well.

But a table set parallel to the picture plane would have made for a dumbly monotonous composition, the rectangular row of figures aligned on a single axis that Rembrandt had always prided himself on avoiding. This horizontal axis had worked (so he had thought) for the repainted *Civilis*, but only because the Batavian gang of conspirators had been made up of a fantastically diverse cast of characters, from handsome youths to cackling old geezers. In this case, all Rembrandt had to work with were, as Joshua Reynolds succinctly put it, "six men dressed in black."[34] His solution borrowed from his own earlier work, especially *Cornelis Anslo and His Wife*, where he had also turned the corner of the table at an angle ninety degrees to the picture plane, so that we see it over a corner instead of along a side. This immediately disposes of the problem of having any of the figures seated with their backs to the viewer, but still keeps the essential sociability of the group, made up now of two facing pairs with the *voorzitter*, Willem van Doeyenburg, his right hand gesturing proudly to the account book, seated between the pairs, as was only right and proper for the chairman of the board.

A committee they might be, but Rembrandt was still able (as he was throughout the 1660s) to create an extraordinary sense of each of them as distinct individuals. The figure standing and leaning toward the chairman, almost in profile, is Volckert Jansz, a Mennonite whose eagle eye not only attested to his fitness to be a *staalmeester* but to the discrimination he had shown in creating a cabinet of curiosities and rarities in his house on the Nieuwendijk and which the ex-collector Rembrandt may well have wistfully envied. The figure on the far left (as we see it) is the Catholic cloth

merchant Jacob van Loon, who lived at the corner of the Dam and the Kalverstraat, and as befits the figure who was much the oldest of the group, Rembrandt has him seated wearing an old-fashioned tilted slouch hat and small fallen collar, very much the gentle patriarch. And within what was a necessarily limited range of gestures, Rembrandt also manages to extract the maximum vitality: Jochem van Neve, to the right of the *voorzitter,* establishing his share in the trustworthiness of the group by holding a page of the account book with his left hand; his neighbor grasping a money bag; the semistanding figure leaning on the edge of another book on the table; the Turkey rug on the table itself sumptuously figured and colored to set off the brown, black, and white that dominates the painting.

Finally, of course, there is the famous direction of the *staalmeesters'* gaze, which for generations led commentators into a realm of rich anecdotal fantasy. The table was on a dais or platform; the members of the board were addressing their "shareholders," one of whom had just interrupted the proceedings with a tricky question. Many years ago, the cultural historian Henri van de Waal dismissed all these imagined scenarios as so many fables. There was, he quite rightly insisted, no dais, no meeting of stockholders, no obstreperous questioner. All that there is here is, as an early nineteenth-century commentator put it (while declining to buy it for the Dutch state), "simply five gentlemen . . . sitting for their portrait."[35]

But van de Waal's brusque rejection that *anything* is happening, that there is *anyone* beyond the picture space, along with the old fairy tales, is just another instance of the overskeptical correction which has robbed Rembrandt, over the past thirty years, of so much of his extraordinary inventiveness. For contrary to van de Waal's denial of an extrapictorial presence, it is, in fact, quite *impossible* to look at the direction of the gazes of the individual *staalmeesters,* and for that matter also their steward, Bel, and *not* have the painting presuppose that some sort of person (us, of course) is being addressed in front of the picture. The best analogies are with Rembrandt's *Susanna* in The Hague, where the beholder is turned simultaneously into voyeur and rescuer, and perhaps, too, with a painting Rembrandt could not have known about, Velázquez's *Las meninas,* where the objects of the figures' attention (the King and Queen) are indicated in the mirror reflection at the back of the painting. Rembrandt, on form every bit Velázquez's equal in intellectual complexity and ingenuity, has, of course, no mirror precisely because the painting was meant to flatter all those who entered the room where it hung with the illusion that it was they who were being personally addressed by the ever-watchful *staalmeesters.* Once we grant that there is some sort of intended connection to be made between the figures on the inside of the painting and us on the outside, we can relax into the vivacious compositional dynamics of the picture—figures projecting, receding, standing, sitting, leaning, looking, holding, grasping, the wonderful ups and downs and backs and forths echoed by the rhythm of the wainscoting at their backs, and we can see yet again that even within the frame of what seems at first to be an entirely traditional painting, Rembrandt has done something startlingly modern, creating a pictorial pattern

that neither Vermeer nor Mondrian would have any difficulty in recognizing as an essentially musical composition: a contrapuntal arrangement of figures, lines, and colors.

Which did not mean that the unmodern men of the Sample House did not appreciate Rembrandt's immortalization. A group portrait hanging in the syndics' chamber could never have quite the same public impact as the monumental history in the Town Hall. But it was evidence, nonetheless, that Rembrandt's peculiar skills still appealed to at least some of the moneyed grandees of Amsterdam. None, after all, were grander, or richer (or more frightening), than the Trip dynasty, the ironmasters of Dordrecht who had built a global trading empire that extended from Russia to West Africa, from Sweden to Brazil. The Trips shipped Baltic grain and Guinea slaves, American silver and Polish saltpeter. But mostly they shipped guns. After all, there was war. It was none of their doing. But what was a Christian to do? If God had wished it otherwise, he would not have had them prosper. And so the Trips shipped guns, at first English guns, cannon, powder, and balls to the Germans, the French, the Dutch, and, in due course, back to the English, royalists, parliamentarians, to whoever had the price. And then, as the commanders of the killing fields needed bigger, heavier artillery to lay waste to men, horses, bastions, the Trips satisfied their customers with German and French guns and, finally, with a strong grip on Swedish ore, Swedish guns, more than a thousand cannon a year to different destinations of slaughter.

The Swedish connection had been made firm by the marriage alliance of one of the founding brothers, Jacob Trip, to the sister of the great entrepreneur Louis de Geer, who had virtually locked up a supply monopoly on Scandinavian metals. Five more members of the Trip family subsequently married five more de Geers, creating a shipping and industrial consortium that was, short of interfamily feuding (which duly came about), impregnable.

In the 1640s, the Trippen had sought out Rembrandt to paint Elias's widow, Aletta Adriaensdr., and their handsome daughter Maria, got up in fine ringlets and a dress of shiny black and gold. Back then, no one could touch him for the simultaneous impression of sumptuousness and sobriety, which was precisely how a Dutch plutocrat wished to have his rank and social virtue advertised. By the 1660s, though, many of the older inhibitions and anxieties about the display of wealth had passed, along with those who had originally accumulated it. The business was in the hands of Jacob's two sons, Hendrick and Louis, who, like many of their contemporaries, lived more like Venetian rentiers than frugal Calvinist entrepreneurs. (There was a third brother, Jacob Jr., who had been sent back to Dordrecht after a succession of failed speculations in Brazilian silver and other such follies.) Hendrick, on the other hand, had out-doged Venice by supplying the Serene Republic, at its own request, with a complete flotilla of six warships, delivery guaranteed in *six weeks* fully crewed, equipped, and armed. So the brothers Louis and Hendrick looked in a glass and saw the lords of

world trade and, like all millionaires, felt strongly, urgently, that they should say so in becoming masonry. In 1660 they commissioned the classicist architect Justus Vingboons to build them, on the Kloveniersburgwal, the most massive private house in the city; a true Amsterdam palazzo,[36] something which until recently would have been a contradiction in terms. But the only concession that the younger Trip brothers made to Dutch self-effacement were the two modest doors set on the façade, which somehow (as in the case of the equally modest seven arched doorways at the front of the Town Hall) only had the effect of making the rest of the building look even more imposing. Eight giant fluted Corinthian pilasters extended up three stories of the façade toward a pompously pedimented gable shamelessly ornamented with cannon, a device repeated in the roof chimneys, where massive stone mortars pointed over the city skyline as if threatening serious consequences to anyone presumptuous enough to suggest an attack of *folie de grandeur.*

While the family palazzo was going up on the Kloveniersburgwal, Hendrick Trip commissioned no fewer than four painters to make portraits of his father and mother for its interior. Two—Nicolaes Maes and Ferdinand Bol—were pupils of Rembrandt, but, more significant, were natives of Dordrecht, the dynasty's hometown. The third artist, the ubiquitous Bartholomeus van der Helst, was considered the nonpareil of contemporary portraiture, without whose contribution no fashionable collection could possibly be complete. So it was the fourth artist, Rembrandt van Rijn, soldiering on in his least ingratiating manner, with brown-black impasto trowelled onto the canvas relieved only by patches of lead-white heightening here and there, who was very much the odd man amidst the glossy virtuosi. But perhaps old Jacob Trip, before he died in 1661, or his widow Margaretha *wanted* a pair of portraits that presented them as survivors of the age of iron, patriarch and matriarch, solemn and monumental, rather than the comfortably elegant old gent with a fluffy white beard and benevolent smile that Maes had obligingly supplied for their descendants.

What they got, from Rembrandt, was a pair of portraits that were consciously old-fashioned in conception but uncompromisingly modern in execution; sharply faceted flint-faces, made a little less stony with artfully deployed shadows and selectively applied highlights. Both pictures are studies in endurance. Margaretha, who, had her husband been alive at the time of the painting, would have been slightly turned toward him as convention required, is now allowed a frontal pose in her widowhood. Her face, framed by the millstone ruff seen only on the most ancient tortoise necks of Amsterdam widows, is deeply carved by her years; the eyes red-rimmed and watery; her hands roped with bulging veins. Her portrait is the more elaborately worked and repainted of the two, Rembrandt fussing over the precise tilt of the ruff and painting out the lace trim that originally decorated her cuffs. His revisions suggest that he was trying to produce the most simplified image possible—literally without frills; the personification

FOLLOWING PAGES, LEFT: *Rembrandt, Portrait of Jacob Trip, c. 1661. Canvas, 130.5 × 97 cm. London, National Gallery*

RIGHT: *Rembrandt, Portrait of Margaretha de Geer, 1661. Canvas, 130.5 × 97.5 cm. London, National Gallery*

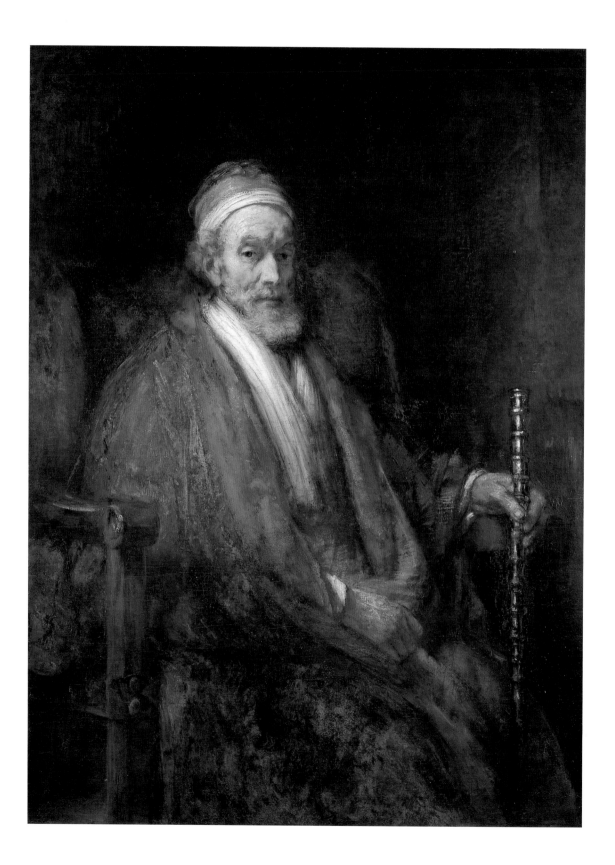

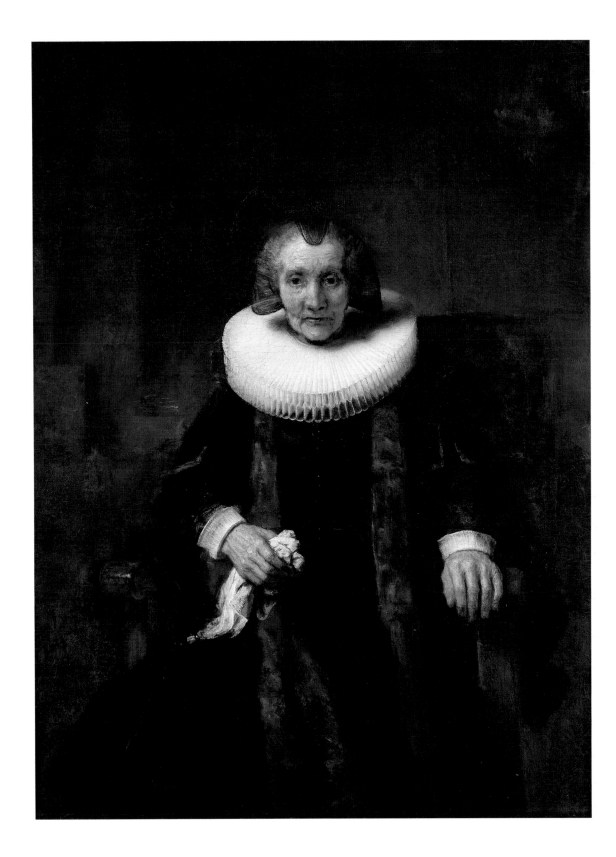

of rock-ribbed, matronly virtue: the character which the morality tracts celebrated as the unshakable foundation of their godly commonwealth. Even so, Margaretha's gaunt severity is relieved (a bit) by the shadows that model her cheeks, plumping them up below the bone to avoid an impression of flesh shrunk to the skull. Hard lines softened by delicate details and accents reappear throughout the picture as though revealing something about the widow's character: her gnarled hands, for example, holding a white handkerchief which Rembrandt has painted with the freest, gentlest touch of the brush.

Perhaps because Rembrandt was working from an existing, earlier likeness rather than a live model (since the old man lived out his last years in Dordrecht), Jacob Trip's portrait is a much looser, quicker piece of painting than that of his wife. The structure of the face is decisively sketched in, with thick impasto lights on the forehead and nose, but using animated, flickering brushwork to describe the tuft of hair over the old man's ear and his beard. Swiftly applied forceful strokes, with the bristles loaded with lead-white pigment, models both the headband of Trip's cap and the shawl-like collar of his shirt. But the rest of his costume, from the fur edge to the dark body of the tabard, is rendered in Rembrandt's broadest treatment, filling out its folds so that Trip himself seems not some sort of dour, fleshless ancient, rattling around in the remains of his grandeur, but a formidable patriarch ramrod-straight in the high, wing-backed throne.

This bulking-out process of the figure's authority is a matter not just of pose and position, but of the treatment of the paint surface itself, which Rembrandt has scuffed and scrambled to the point where, beyond the softer passages of the fur collar, the brushwork ceases to describe any kind of shape or contour at all and begins, instead, to lead its own independent existence; scratched and scrawled in some areas, scribbled and daubed and patched in others. Rembrandt has understood—and acted on—an optical principle which was beginning to be understood (though seldom practiced) but which would become a commonplace of modern painting, namely, that the rough surface engages with, and stimulates, the activity of the eye far more powerfully than a smooth surface. The rough and the smooth surface, in fact, presuppose quite different relationships between artist and spectator. The unequivocally completed, clear and polished work of art is an act of authority, presented to the spectator like a gift or a declaration, something requiring acceptance rather than an answering-back. The roughly fashioned, apparently unfinished painting, on the other hand, is more akin to an initiated conversation, a posed question, demanding an engaged response from the beholder for its completion. Smooth artists necessarily take pains to conceal to the utmost any of the revisions and alterations they might have made on the way to the finished object. Rough artists deliberately expose the working processes of composition as a way of pulling the spectator further into the image.

Roughness should never be confused with casualness. In Rembrandt's case, the rougher he became, the more wondrously elaborate he made the

paint layers, giving them a geologically tiered density. A painting like the *Portrait of Jacob Trip* used a whole range of material additives to the pigment, like charcoal, chalk, and silica, to give it a richly complicated and varied texture. Smalt, the blue pigment made from finely crushed cobalt particles which was notoriously fugitive when used as a surface color, has been discovered in the *underlayer* of this and

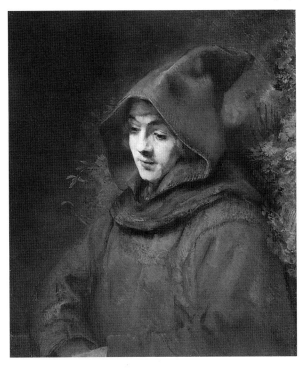

Rembrandt, Titus as St. Francis, *1660. Canvas, 79.5 × 67.5 cm. Amsterdam, Rijksmuseum*

other late paintings, used not for any discernible effect it might have on the eventual hue of passages of the picture, but for the gritty body and drying properties it lent to colors that ended up as red-brown (in Trip's cloak) or black (in the background).[37] Rembrandt is thinking and acting three-dimensionally here, but not in an effort to make the picture plane transparent, to make it a window into illusionistically manufactured space. On the contrary, he is blocking off that window with opaque, elaborately worked paint so that his third dimension is *in the paint itself.*

Rembrandt's technique for immortalizing a man of business had come a very long way from the quicksilver dynamism in which he had posed the fur trader Nicolaes Ruts thirty years before, where every sable hair and mercantile whisker had gleamed with light. Jacob Trip's eyes are without any sparkle, but light falls on his silver cane, which seems as potent as the staff of Moses, its owner transfigured into a kind of latter-day seer or sage. Around 1660–62 Rembrandt repeatedly painted figures who seem to inhabit *both* the scriptural and the modern world. For if Trip has been made pseudobiblical, a number of the saints whom he also painted three-quarter length in somber near monochrome have been given a disconcerting human immediacy, as though they might be encountered just around the corner in a marketplace or street crossing: apostles who sweat and grunt, tremble, pant, and snore. Titus, dressed as St. Francis, simply looks like a novice monk from some Flemish cloister, and St. Bartholomew, with his hair cut severely short and pulled back in a style that would be completely unknown until the late nineteenth and early twentieth centuries, seems to have stepped straight from behind a cashier's till or a lawyer's desk. Rembrandt's

Rembrandt, St.
Bartholomew, *1661.*
Canvas, 87.5 × 75
cm. Los Angeles,
J. Paul Getty
Museum

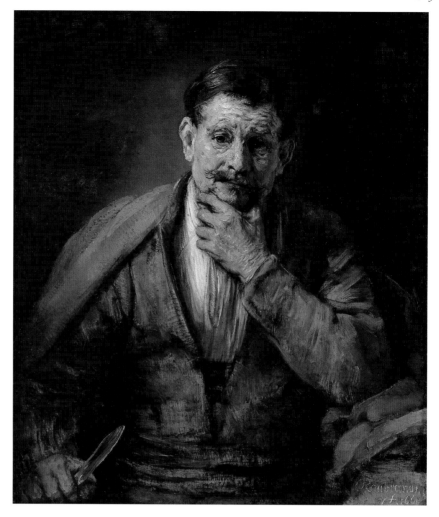

Rembrandt, St.
Bartholomew, *1661.*
Canvas, 87.5 × 75
cm. Los Angeles,
J. Paul Getty
Museum

most obvious technique here was to compress the usual attributes of the
saints into a euphemized or incidental object, almost unnoticed until
searched for by vigilant iconographers. Thus the scallop shell of the pilgrim
apostle, St. James the Greater, is nothing more conspicuous than the clasp
attaching his cloak to his coat. St. Bartholomew, who was skinned to death
by his tormentors and who usually appears with his shorn skin slung over
his shoulder, holds the flaying knife innocuously as if he were merely about
to give himself a close shave.

But painting the saints and apostles in the smart, businesslike 1660s,
when demand for this kind of picture was markedly on the wane, must
have meant something more to Rembrandt than merely producing a
euphemized version of their familiar identities, with the clutter of Catholic
iconography stripped away for Protestant consumption. It's hard to look
at the intensely wrought and self-contained images, in which the history
of their fervor is written less in their props than on their faces and bodies—
in the profile of St. James's enormous hands, or in the deep creases of

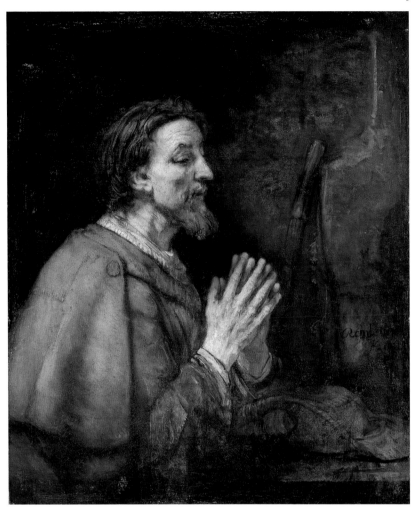

Rembrandt, St. James, *1661. Canvas, 90 × 78 cm. Private collection*

Bartholomew's brows—and not feel that Rembrandt is trying to establish their sanctity from their humanity, insisting not on the distance between the life of the holy man and that of the everyday sinner, but, on the contrary, on their close proximity.

This collapse of boundaries between saints and sinners happens most completely when the artist paints himself, in 1661, as St. Paul. Paul's emphasis, relentlessly prescribed, on salvation by grace alone had given him a kind of paramountcy among the saints and apostles in Calvinist culture. But two articles of the Pauline doctrine must have spoken to the aged Rembrandt, his face and fortunes crumpling into humility, with special power and eloquence. First, there was Paul's anathema on the law and his repeated reiteration not just that the law was irrelevant to salvation, but that its authority was a fraud and a curse, compared with the arbitration of the compassionate Almighty. With his bitter experience of institutions of one kind and another, this message must have had the force of vindication for Rembrandt. But at the same time, he must, in all honesty, have

Rembrandt, Self-portrait as St. Paul, *1661. Canvas, 91 × 77 cm. Amster-dam, Rijksmuseum*

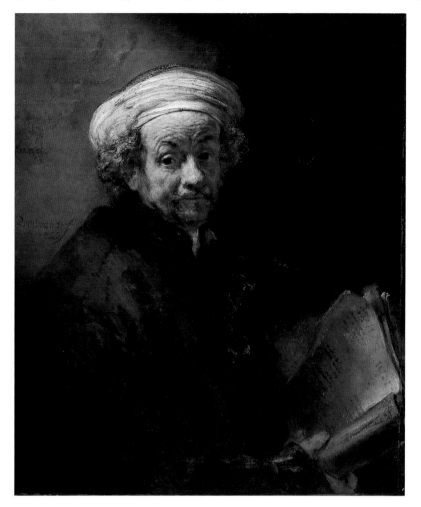

acknowledged that much of his troubles at the hands of the law had been self-inflicted. So the second part of Paul's message—of the unmerited nature of grace, of its bestowal upon even the most unworthy of men, or perhaps *especially* upon the most unworthy of men—may well have struck home.

Was there ever so unlikely, and yet so obvious, a Paul as this? Not the long-bearded pillar of self-righteousness whom Rembrandt had painted forty years before in disputes with the errant Peter, laying down the law, pointing to the irrefutable doctrine. Instead the quizzical, confessional Paul, eyebrows arched, as if slightly pained to admit the light of gospel truth, shoulders shrugged, brow crumpled, hapless yet not without hope; the author both of his blind folly and of his visionary wisdom; a vessel of sin and a receptacle of salvation; not a Paul of forbidding remoteness but a Paul of consoling humanity; a Paul for everyday sinners.

iii *Quietus*

In October 1662, when the chill Amsterdam nights were draining light from the afternoons, Rembrandt sold Saskia's grave. The buyer was the gravedigger at the Oude Kerk who made a little money from these transactions, acquiring lots from the hard-pressed and reselling them to those who needed space for the freshly deceased. With the plague raging again in the city, taking more victims than ever before, the market for grave space was brisk and prices high. So men with round-blade shovels came to the place in the chancel behind the organ and turfed out Saskia's bones to make room for the next lodger, one Hillegondt Willems.[38] It was not so very shocking. The fate of mortal remains was of no concern to the Church; nor did the site of their repose have any bearing on the salvation of souls, decided alone and from the beginning by the Almighty. One might be buried on a dung heap and still be received into the bosom of the Father.

God knows, Rembrandt needed the money. He did what he could to oblige the Heeren with portraits and pair portraits and self-portraits and apostles and it was never enough. He lived with just a few sticks of furniture, ate fish and cheese and hard bread and sour beer from plain pewter, and it was still too much. He pawned more, borrowed 537 guilders from Harmen Becker, who lived in grandeur in a stone-faced house on the Keizersgracht and who specialized in making loans to painters in difficulties and getting work from them as security. With a vulture's eye for the main chance, he now took over the note for 1,000 guilders that had begun with Jan Six's amicable loan and had made the long journey, through the hands of creditors and guarantors, down through the steep fall of Rembrandt's fortunes, ending up as another opportunity in the hands of Harmen Becker, the painters' loan shark. So Rembrandt now found himself binding over *nine* paintings (as well as two albums of etchings), for which he would get nothing but temporary relief on back debts. Hendrickje managed as best she could. But she had been ground down by their struggles and now her health was failing. The Jordaan, with its houses pressed close against each other and the refuse-clogged alleys between them a cozy home for *Rattus rattus*, was a nursery of infection. In 1660 Rembrandt painted Hendrickje, her skin the color of unrisen dough, dark eyes sunken into puffed-out cheeks. It was time for that perennial ritual in the Rembrandt household, the making of wills. This one needed to be especially careful, since once Hendrickje was gone, her seven-year-old heir and daughter, Cornelia, would, if not otherwise indicated, get a court-appointed guardian who might see to it that Rembrandt had no access at all to the inheritance. So the will spelled out Hendrickje's wish that Rembrandt be appointed Cornelia's sole guardian; that in the event of Cornelia predeceasing him,

Rembrandt, Lucretia, *1664. Canvas, 120 × 101 cm. Washington, D.C., National Gallery of Art*

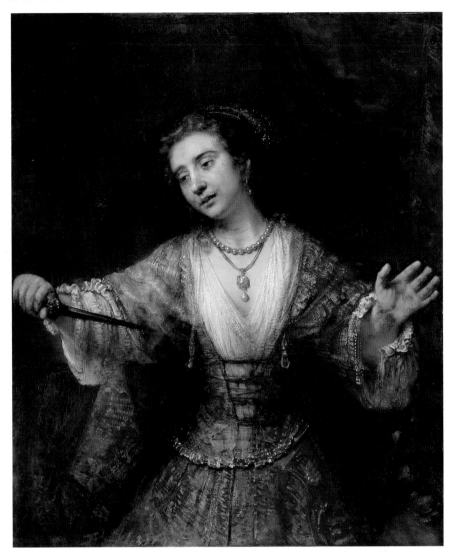

Titus should be her heir; and that the partnership she had formed with Titus to trade in works of art should, after her death, also be controlled by the aforesaid Rembrandt van Rijn. The painter would thus "receive the benefits [of Cornelia's legacy] and enjoyment thereof for his nourishment for the rest of his life."[39] When she died in the spring of 1663, one of the nine thousand taken by the bubonic plague that year in Amsterdam, Rembrandt set her in an unmarked grave in the Westerkerk which he rented for ten guilders and thirteen stuivers. Should the rent fall into arrears or lapse, the grave would be opened again for a new tenant. No one knows how long the body of Hendrickje Stoffels was left undisturbed.

Other women, then, had to model for Rembrandt's two paintings of the suicidal Lucretia, one on the point of thrusting a dagger into her body, the other with the weapon ripped back out, the wound's blood soaking her slit shirt. It is extraordinary that in the very last years of his life Rembrandt

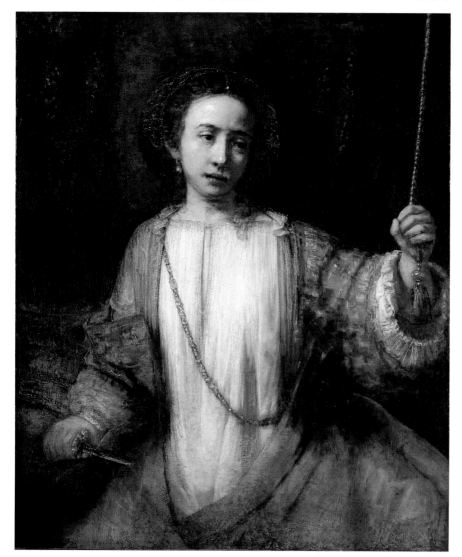

Rembrandt, Lucretia, *1666. Canvas, 105.1 × 92.3 cm. Minneapolis Institute of Arts*

should have wanted to paint another study in sexual tragedy. But ever since the *Susanna and the Elders* of 1634, he had brooded on the relationship between carnal aggression, virtue, and sacrifice; between the rapine stare and the fatal touch; between sex and history. Ten years before, he had posed Hendrickje/Bathsheba's undressed body in such a way as to provoke both desire and remorse, precoital greed and postcoital shame. Livy's famous history, set in the last days of the early Roman kingdom of the Tarquins, revisited many of those same dark themes that had long obsessed Rembrandt: a wife's innocent loyalty that itself inflamed lust; the malevolent abuse of princely sovereignty; an act of brutal possession that was repaid with political punishment.

Like King David's loyal Uriah, Lucretia's husband, Collatinus, was a soldier on campaign for his king, besieging the Ardeans, when he made the mistake of bragging of his wife's superior virtue. To test the boast, he and

his companions—among them Sextus Tarquinius, the son of the royal tyrant—rode back to Rome, only to find Lucretia at her spinning wheel, the very emblem of unimpeachable domesticity, while the other wives lounged about in dissipation. Days later, Sextus secretly returned to Lucretia's chamber, attempted to rape her and, when she resisted, threatened to kill both her and his own slave and leave them naked together in her bed. A double sacrifice followed. First Lucretia gives herself to her assailant. The following day she calls her father and husband, confesses her violation, and over their protests, and in their presence, takes a dagger to her heart. Over her corpse, father, husband, and companions (including Marcus Junius Brutus) swear a solemn oath not only to revenge her innocence but to rid Rome forever of the Tarquins. Lucretia's body becomes the altar of republican freedom.

The story, with its richly mingled bloodflow of sex and politics, had long been irresistible to history painters, who had depicted either the act of the rape itself or Lucretia's death in the presence of her friends and family. In both cases, opportunities offered themselves to expose the virtuous body either completely, as in the outrageously voluptuous nude of Giampetro Rizzi, or more conventionally, with a breast or at least a shoulder and the upper chest exposed. But to make us painfully conscious of the prior penetration of her body, Rembrandt has dressed her for death.[40]

The artist has made something crushingly weighty of these costumes, building the paint until it is as solid and impenetrable as the ironclad armor of the heroine's virtue. Yet it is an armor that has been pierced. The deep green impasto of the Washington National Gallery painting is especially worked and layered in the lower part of the painting where Lucretia's skirt is vainly girdled by a belt that circles her body just below the waist. But all this heavy casing of the paint layer is calculated to make the sense of the soft vulnerability of the body within—not just in the painfully delicate exposure of the flesh at her throat and between her breasts, but in the foreshortened left forearm at her opened sleeve—even more poignant. The fastenings of her bodice have been loosed and hang freely down to her waist. A teardrop pearl, the insignia of her virtue, is suspended just above the site where the dagger will rend the flimsy veil of her shift and into her heart. But her eyes are red with tears already shed, others gathering and brimming; her upper lip moist with misery.

In both paintings, Rembrandt, as was his habit, has removed the supporting cast, and with them any distractions that could disperse the concentrated force of the tragedy. But in the Washington painting (as in most past versions of the scene), there is a strongly implied sense of an audience, transferred to the spectator. Lucretia holds up her left hand, both in affirmation of her innocence and also to still the protests of her horrified household. But the Minneapolis version, painted two years later, around 1666, even though representing the subsequent scene where Livy makes the most of the gathered witnesses, effaces them even more completely, picturing Lucretia in the deepest solitude as her lifeblood leaches away. A genteel tradition has imagined that the heroine is holding on to a bell rope, to sum-

mon her friends and family. But this supposes her to be the doyenne of some country house in nineteenth-century Britain where the mistress rings for the servants by pulling on a cord that would ring in the downstairs parlor. Seventeenth-century Amsterdam knew no bell ropes. Lucretia is, in fact, both clinging (for support) and pulling on the cord which will open the concealing curtains of the canopy bed—the bed on which she has twice been violently penetrated, once in rape, once in atonement. She is at the moment of exposure, between private hurt and public grief.

There had never been a Lucretia like this (just as there had never been a Susanna or a Bathsheba like Rembrandt's), her face shiny and pallid with death, a painting of slits and gashes and apertures, where the torn, punctured body of the woman is made utterly naked by being ostensibly covered. The powerless belt slung across her hips in the Washington painting has, in the later work, become a slung sash extending from her right shoulder down to the left side of her waist and so travelling across the sites of her violation. It fixes our gaze, first on the deep V-shaped opening of her shirt and then on the terrible, spreading, soaking bloodstain that extends from her heart down toward her broad thighs. There is nothing like this bloodstain in all the countless martyrdoms of Baroque painting, in all of the spurting severed heads and severed breasts; nothing which pulses quietly and fatally out of an unseen wound. Rembrandt has even made the folds of Lucretia's shift hang forward on either side of the wound, while between them, in a saturated depression, as if rehearsing the site of her rape, the blood-soaked fabric clings wetly to her white skin.

Lucretia's stain had long created difficulties for the Christian tradition. The more severe authorities had thought her rape, whatever her personal virtue, a taint from which she could never be cleansed, and judged her suicide, an act abhorrent to God, as compounding rather than expiating the foulness. Calvinism, which placed the utmost emphasis on utter surrender to God's will, deemed self-murder a particularly horrifying defiance of divine dispensation, a complete forfeit of grace.

But then, Rembrandt is no orthodox Calvinist, no orthodox anything. His Lucretia has not taken arms against herself, much less against divine writ. Her pathos is of resignation. She has opened herself, bodily, to the possibility of mercy. Faultless, she has nonetheless sinned; spotless, she has become stained. But she hangs on to the cord, life ebbing from her, awaiting the embrace of compassion, the reception of grace.

The Lucretias are bathed in the cool tones of death: deep greens and shroud white; the complexion of flesh draining of its rosy bloom; swathes of gold torn away, chill solitude settling on the heroine like a thin covering of frost. But Rembrandt's last great suite of masterpieces are not, in fact, shadowed by bleakness, by the sense of a black void that would open for Goya or van Gogh on the lip of the grave. They are instead burning and radiant with vermilion and gold; the flesh in them is warm and glowing, and the figures are not isolated but reach out to each other, touch each other: enfold, caress, reassure, connect.

The fingertip touch of love is at the heart, *on* the heart, at the exact cen-

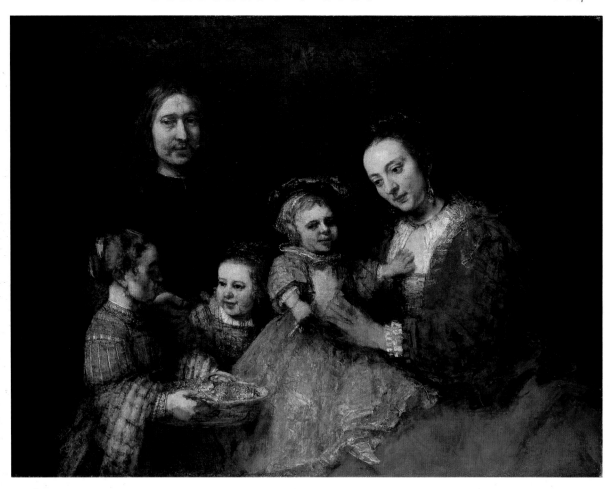

Rembrandt, A Family
Group, *c. 1666.*
Canvas, 126 × 167 cm.
Braunschweig, Herzog
Anton Ulrich-Museum

ter, not just of *The Jewish Bride* but also of the sublime *Family Group* in
Braunschweig. In fact, it is the *same* touch with a male hand laid on a
woman's breast, wife, mother; a gesture that seems to speak more pro-
foundly to the point of life than anything else in the canon of Western art.
For it speaks of passion and peace; of desire and rest; of nature and nur-
ture; of family feeling as the salve of loneliness, the redemption of selfish-
ness, the well of happiness. No one knows who these people are, and there
is no reason at all to assume that the couple are Jewish, except perhaps in
the scriptural sense, for they are certainly posing as Isaac and Rebecca.[41]
The couple had been obliged to masquerade as brother and sister, rather
than as husband and wife, but in a moment of unguarded freedom, Isaac,
so Genesis relates, is overseen by King Abimelech "sporting" with Rebecca
in a garden. A drawing plainly shows the garden background dimly
sketched in by Rembrandt, with Rebecca seated on her husband's lap and
his hand on her breast.

Yet it seems pedantic to call this a history, as if its entire purpose were
the illustration of a specific text. It's possible that a couple might have

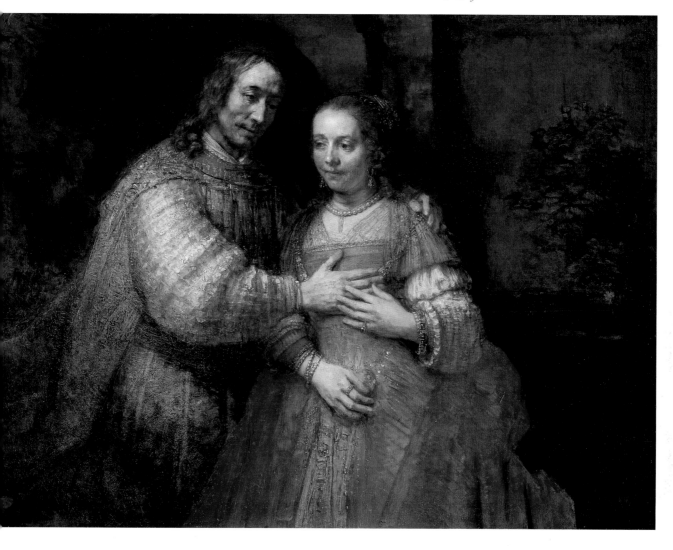

wanted a "historiated portrait" to celebrate their marriage, although the gesture that expresses their union would have been profoundly shocking to contemporary sensibilities (especially in the Jewish communities, then much exercised by the purity of morals). Nothing remotely like it exists, not merely in Dutch art but in the entire Western tradition to that point, save in low-life scenes of grabbing lust. But there is not a trace of coarseness about the touch of this hand; rather it is an act of purely instinctive tenderness. Its pressure is light; selfless, not cupping, stroking, or fondling the breast as if busily seeking hardening excitement, but the palm raised slightly, only the length and ends of the fingers laid flat across the gentle swelling; a solemn and reverent pleasure. It's important, too, that in both the Amsterdam and the Braunschweig paintings, the male hand is welcomed by the woman's response with her own, a displaced consummation: a love act celebrating the fertility of marriage, the blessed abundance of the woman's body. The

Rembrandt, The Jewish Bride: Isaac and Rebecca, *c. 1662. Canvas, 121.5 × 166.5 cm. Amsterdam, Rijksmuseum*

"Rebecca," after all, lays her right hand on the site of her womb, so that the places of procreation and of nurture are simultaneously hallowed.

So should we be surprised to find that particles of egg have been discovered in beads of paint taken from *The Jewish Bride*? The chain of life, its profound, organic mystery, its vital pulse arising as desire, enacted in passion, and ending in abiding trust and companionship, was the subject both Rubens and Rembrandt chose to portray as the essence of humanity at the end of their lives, returning again and again to the dwelling places of family affection (even when, in Rembrandt's case, his own household had been relentlessly depleted by sickness and death).

But the means by which the two artists expressed their vision of love's redemption could hardly have been more different. Rubens chose his lightest, most lyrical vein; brushes gripped painfully in his gout-tortured hands yet skimming over the surface of the canvas with the lithe agility of boyhood, the strokes silky, feathery, light, and delicate, something he might have learned from Titian. Rembrandt, of course, had taken his lessons from Titian, too. But in his last paintings, he set them aside. Instead of a broken manner, his love-painting has a massive, monumental quality; something as much hewn or graven as painted, the burning molten colors fused together into a solid block like some immense, glowing gem hardened in volcanic fire.

Modern painters have stood in front of *The Jewish Bride* raptly dumb-founded by its prophetic invention, as if a new world of painting is unfurled on its roughly woven canvas—a world in which the paint, as much as the subject, constitutes the composition; in which the paint seems to have been inseminated with vitality. In 1885 Vincent van Gogh, who as a child liked to go for walks looking at the world with his eyes half-shut, sat in front of the picture in the Rijksmuseum transfixed by its mesmerizing spell. "I should be happy to give ten years of my life," he told his friend Kersemakers, with whom he had visited the museum, "if I could go on sitting in front of this picture for ten days with only a dry crust of bread."[42] In the most prodigious passages of his last paintings, Rembrandt was indeed creating a kind of work that went realms beyond the most radical and broken inventions of Titian and even the startling patch-and-daub painting of Velázquez. In both those cases, and in his own earlier work, the loose or rough brushwork was meant to resolve itself at the right distance into a tightly cohering form. But in the heat of his urgent old age, Rembrandt was actually playing with paint in ways that precluded such resolution; that failed to describe anything except itself.

"Rough" or "broad" painting—the conventional art-historical terminology—is no longer adequate to characterize the revolutionary force and visionary courage of Rembrandt's last pictures. In some passages—in the lights on the glistening forehead of the "bride," for example, or the strands of lank hair across her partner's brow—he is still capable of creamily smooth painting, and precisely delineated forms, while still avoiding the stony coolness and hard glitter of fashionable taste in the 1660s. Else-

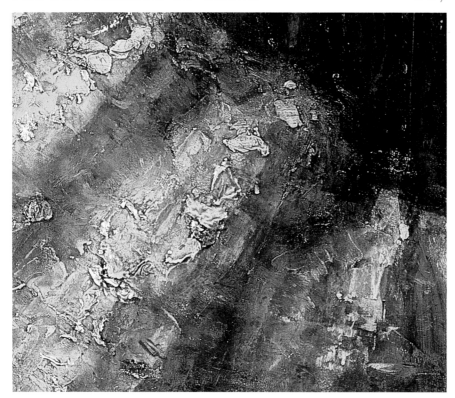

Rembrandt,
The Jewish Bride:
Isaac and Rebecca
(detail)

where, though, he ventures far beyond anything recognizable as conventional impasto laid on with a palette knife, creating, especially in the garments billowing from his figures, fantastic passages of sculpted pigment in which the ostensible shapes they are meant to describe—folds, pleats, swags, brocades—dissolve and collapse, actually seeming to occlude and obstruct, rather than assist, definition. The painting here is barely recognizable as brushwork at all, the tool of delivery by which it's been laid onto the canvas still completely unfathomable—neither brush nor palette knife, nor fingers dabbling in the oily pigment.[43] From zone to zone, it varies radically in feel and texture where Rembrandt was evidently experimenting with different rates of drying and layering. In some passages, like the back of the man's cape in *The Jewish Bride,* the paint seems first thickly laid on and then thinned out, by scouring, scraping, or combing, giving the upper layer a fibrous, stringily matted feel. In other areas, the paint is muddily coagulate, puddled, dripped, and caked; in other spots, more granular and abraded; in other places again, it seems clayey and bricklike, as though kiln-roasted, the colors parched or flame-licked, fired tiles of pigment laid down like tesserae. In still other passages, the paint surface is worked into a scarred and cratered ground like the valley floor of one of Seghers's moonscapes, pitted and pimply with gritty excrescences. And there are places where it resembles a raggedly quilted fabric, the pieces of work loosely stitched together.

It was as though Rembrandt, explorer, had navigated a storm-racked course, an odyssey to the outermost rim of the known world of painting. From suddenly still waters he was peering through a dust-coated telescope toward a hitherto unexplored artscape; a terra incognita where the relationship between seen objects and painted forms was different from anything that had been essayed since the invention of perspective. Dimly, he could see things blocked off from his contemporaries by their sharpness of focus, their crystal clarity. He could see the autonomy of paint. But his own sight was failing, his days running short. This other place was swimming on the mist-shrouded horizon. The winds were picking up. He would never arrive but there was, perhaps, his futurity. Even if Titus should not become a painter, he had been schooled by his father enough to understand for himself and perhaps explain to others what he had intended.

Now that Hendrickje was gone, Titus had shown himself eager to step into the breach as Rembrandt's interlocutor, loath to miss any opportunity to advertise his father's talents or to secure some gainful remuneration. If he should not turn out to be an artist, he was at least in possession of the future; he was in his middle twenties, vigorous, good-looking. And not without determination. The courts had ruled that Rembrandt's transfer of title to him was legal, and that Isaac van Hertsbeeck, the man who had lent Rembrandt 4,000 guilders before his insolvency and who had seized it back from the sale of the house, should now restore that money to Titus. Van Hertsbeeck had done nothing of the kind, instead making every possible appeal to the provincial high court and the High Court of Holland against the ruling. Titus and his guardian-lawyer, Louis Crayers, had then launched their own suit to have the ruling in their favor enforced. Van Hertsbeeck, seeing his loan to Rembrandt evaporate, did not take this kindly, becoming increasingly enraged and, at one point, hysterical, physically threatening harm to Titus if he dared to persist.[44] (A knife? A bloodied head one night on the canals?) But Titus did persist. He petitioned for, and received, his majority a few months early. In June 1665 he finally wrenched his 4,000 guilders from the fist of the incensed van Hertsbeeck. In August there was more good news—a little legacy, 800 guilders, inherited from the husband of his great-aunt. And in September he finally received the 6,900 guilders and 9 stuivers from the Breestraat sale.

Titus van Rijn had come into his own. It was to be expected now that he would seek, and find, a suitable match. There would be a dowry. The depleted family fortunes of the van Rijns would be replenished. The son would be a protector for the father, a Joseph to his Jacob, and the father would work on, shielded by Titus from the buzzing and biting of the importunate world.

iv Non-finito, *Summer 1667*

Somewhere far off, it seemed, out in the harbor, was a most tremendous tumult: a jubilation; the low thunder of guns sounded in triumph; and all round the city, from tower to tower, the *klokkenspelen* tolling the cannon of terrific self-righteousness. *Floreat Amstelodamum*; an empire in glory; the high-decked and haughty *Royal Charles* taken prize in the waters of the British King, a just recompense for the ingratitude of Charles Stuart, the complaisant son of a foolish father. In his distress and exile during the English wars, the benevolent Republic, at no little cost to itself, had given this stripling shelter as it had his French mother; had even sent him back to his throne with splendid and *pompeuze* ceremonies. Scant few years passed before this second Charles and his brother James had presumed to repay the courtesy by making free with Dutch ships and possessions, turning New Amsterdam into New York and prosperity into dearth and dismay. Now he had had his proper quittance. A justly affronted Jehovah had visited England with every manner of affliction, the fire and the pest, and had armed his servant Michiel de Ruyter, the seagoing Joshua, to scald them in the very entrails of their realm. He had sailed up the Medway and broken their iron chain thrown across the river as if it had been made of brittle kindling. The admiral had burned their ships, the hot cinders sent flying in the Kentish wind, and had taken the royal flagship back across the North Sea. Now it could be seen in its captive chains, its seventy guns spiked and silent, decently humbled in the Amsterdam docks, while de Ruyter was feted about the city: the *schutters* firing for him; pennants waving; anthems of thanksgiving sung in the Nieuwe Kerk, summer sunlight trickling through its high mullioned windows.

Never before had it been and never again would it be quite so fine to be an Amsterdammer as in 1667. In July the peace with England was signed at Breda. The fisheries were back in business, unmolested by English privateers: herring galore. Jan Vos's raptures hardly seemed hyperbole. It was, if not the new Rome, then surely the new Venice. Its fleets were invincible, its warehouses inexhaustible, its arts flourishing, its buildings handsome and extensive. The imperial crown granted by the Emperor Maximilian to the city's coat of arms and architecturally realized at the very top of the spire of the Westerkerk had never looked so fitting.

Rembrandt had only to step outside his house and look north down the Rozengracht to see that crown glinting yellow in the white sky. But his attention was elsewhere. He too had sketched the map of the round world, sliced in two down the center and opened like a pale-fleshed apple, on a wall in one of his paintings. But instead of Amsterdam poised between

them, there he was, staring back into the mirror, brushes, maulstick, and palette in hand. This was not a brag, at least not about his own world-mastery, about which he could have had few remaining illusions. Unlike the maps which appeared on the walls of the parlors and *kunstkamers* of the patriciate, Rembrandt had rendered those hemispheres at his back as empty circles wiped clean of detail: ciphers, exercises in pure freehand dexterity, as clean a line as he had given in his etching to the poor crazy Lieven Coppenol, the master calligrapher reduced in his dementia to writing poems in his own praise.[45] The painting, after all, was a demonstration, Rembrandt's last, of the vigor of his powers, the authority of his art. He was accused of slighting line, of botching drawing, was he? Very well then, he gave his critics (and his admirers) perfect circles, lines so cleanly and exactly done that they might have been made, as van Mander had related, by Giotto. But they were, of course, *non-finito,* circles whose completion had to be implied from the given trace. And once he had satisfactorily refuted those who supposed him incapable of classical geometries, Rembrandt returned to his chosen manner, where things were suggested rather than mechanically outlined. For all the attention paid by scholars to those enigmatic half-circles in the Kenwood self-portrait, very little has been given to the much more arresting passage of painting: his hands, rendered as a blurred whirl of paint, slathered and scribbled, with the brushes also crudely suggested with just a few summary lines. X-rays have revealed that originally Rembrandt had shown himself working on the canvas indicated by the vertical line at the extreme right. In the literal transcription of the mirror image, it had been his left hand which he had raised to that working surface, the right hand holding palette and brushes. But in the end, Rembrandt abandoned this mechanical transcription entirely and instead produced a manifesto of painterly freedom: his cap built higher with lashings of thick lead white, crowning the face still sovereign of his own studio, if not the world, the gray cloudlets of hair still curly with vigor; the pencil-line mustache in the fashion of the mid-1660s, drawing an elegant, faintly sardonic line across his broad but strongly modelled face; the black eyes deep, not sunken in the sockets; the whole face concentrated by a steady, piercing intelligence. In withering disregard for the niceties of formal classicism, Rembrandt has repeated, as if in unrepentant reassertion, in scratch marks incised into the white collar of his shirt, the fantastic, loopy scribble that suggests a hand in whirling motion. It's this extraordinary combination of the still, steady head and the whirling hand, the circle of thought and the circle of action, by which Rembrandt chooses to summarize himself in this the greatest of the late self-portraits. Two centuries later, Edouard Manet, another supreme personification of the union between a complex intellect and an adroit hand, would repeat precisely Rembrandt's motif of the painter's hand seen in flurried activity: unfixable, motile, restlessly alive.[46]

Was this the way he appeared to the twenty-five-year-old Cosimo de' Medici when he came calling at Rembrandt's house on December 29, 1667;

OPPOSITE: *Rembrandt,* Self-portrait, *c. 1662. Canvas, 114.3 × 95.2 cm. London, Kenwood House, Iveagh Bequest*

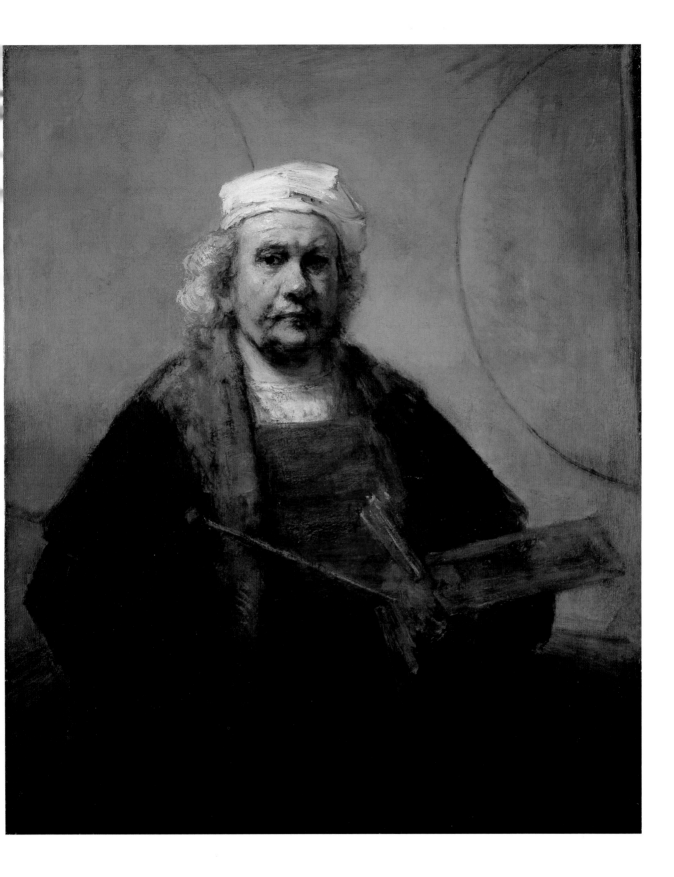

a prince of painting staring down a mere heir apparent to a grand duchy? Or was it the crumple-cheeked, testy, acidulous Rembrandt who appears in the aggressively graceless self-portrait, all jowls and scowls (and surely a copy), now in the Uffizi and acquired for the Medici gallery of Netherlandish self-portraits. That collection would eventually include much more ingratiating and self-flattering likenesses of Dutch painters, such as Gerard Dou, Caspar Netscher, Frans van Mieris the Elder, and Gerard ter Borch, all of them, Rembrandt conspicuously excepted, fancy practitioners of *fijnschilder* genre painting, brilliant with high gloss and satiny seduction. Odd man out, and becoming odder by the day, Rembrandt, *Reimbrand Vanrain, Reinbrent del Reno, Rembrant pittore famoso*, as his Tuscan visitors variously called him, was evidently still an obligatory stop on the reverse grand tour, north over the Alps, which, as Amsterdam's reputation as the greatest of all European cities spread, was becoming a less eccentric choice for educated Italian gentlemen.

The great-grandson of Duke Ferdinand, who had waylaid Rubens en route to his fateful mission to Spain in 1603, Cosimo, who would himself become Grand Duke in 1671, hardly fitted the profile of a Medici at all, being devout, scholastic, and somewhat ascetic in temper. Desperate to perpetuate the dynasty, his father Ferdinand II had made what at the time must have seemed a brilliant match for him with the cousin of Louis XIV, Marguerite Louise of Orléans. But the blood of the notorious cadet house of the French kings ran a little too richly in her veins and led her to prefer intense affairs with French soldiers to a life as the broodmare of the Medici, especially after she had done her duty by producing a baby, Ferdinando. Pregnant again in 1667, Marguerite expressed her opinion of her adopted family by attempting, in as many ways as possible—violent horseback riding, exhausting walks, energetic bouts of promiscuity, and finally self-starvation—to miscarry. Despite the campaign, Marguerite gave birth to an infant daughter, after which the Grand Duke judged it prudent to separate the ill-starred pair, sending Cosimo off on his long journey through Germany and the Netherlands.[47]

So with his usual retinue of secretaries, treasurer, confessor, physician, and tutelary *cavalieri*, including Filippo Corsini, who kept a journal of the trip, and the Florentine merchant based in Rotterdam, Francesco Feroni, Cosimo de' Medici, grandly attired (for all his relative austerity) and elaborately attended, showed up on Rembrandt's doorstep at the Rozengracht between Christmas and the Feast of Epiphany, when bean cakes were in the offing and skaters were out on the canals. Rembrandt was not his only stop. Feroni must have introduced him to the publisher and bookseller Pieter Blaeu, who arranged a little itinerary of studio visits around Amsterdam. The entourage called on the marine painter Willem van de Velde and proceeded to another artist known in Corsini's account only (and to this writer, tantalizingly) as "Scamus." And since nothing other than the bald fact of the visit is recorded in the Italian sources, one must imagine the Prince, shod in mules to avoid the notorious Amsterdam mud, stepping

from his carriage, cane in hand, and entering the little *voorhuis,* opposite Lingelbach's pleasure gardens, seating himself on one of Rembrandt's last remaining Spanish leather chairs, rising, and walking about the cramped spaces and plank floors of the house, bare of any of the conveniences one would have expected in the dwelling of the *pittore famoso,* even of much in the way of paintings themselves, and finding it hard to know what to make of the dough-faced old man with the mottled skin, unhealthily high color, puffball hair, and sagging belly who seemed to tolerate, rather than welcome, his presence, and after some uneasy minutes, with Feroni speaking to the son and then back to him and the exchange of a few constrained smiles and gestures, stepping back, in some relief, into the needle-sharp air.

Nothing came of it. The young prince from Florence descended from a carriage, condescended a while, and ascended back into his aristocratic *grandezza.* The whole episode must have been a painful disappointment for Titus, who had been attempting, since Hendrickje's death, to set his father's affairs on a more even keel. When he was granted the favor of coming into his majority and said to have *venia aetatis,* he finally had access to the remnant of his mother's legacy, much shrunk by his father's vicissitudes from the original 20,000 to less than 7,000 guilders.[48] But in the circumstances it must have seemed, nonetheless, a small and welcome fortune. It included a sum of 4,200 that had been taken by one of Rembrandt's creditors as a protest against the protective transfer of assets from father to son, and which the court now ordered restored to Titus. The young man must have felt that he was, at last, coming into his own. The odd work, including a drawing of *Atalanta and Meleager* which shows some grace, is even known from his hand, so that Titus was perhaps thinking of a future career like the van Uylenburghs', involving both the production and the trading of works of art. The challenge, of course, was either to find a way to convince customers of the continued excellence of his father's work or else to make his father (fat chance!) produce work of the kind generally considered, these days, excellent.

That same year, 1665, Titus seems to have become busy drumming up business for Rembrandt, though the scale of the commissions Titus van Rijn was now seeking on behalf of his father speaks sad volumes about the degree to which the painter had fallen from the ranks of the honored. He was in Leiden, acting as Rembrandt's agent, attempting to convince the bookseller Daniel van Gaesbeecq, over the latter's objections that the artist was known as an etcher, not an engraver, that he was certainly capable of engraving a portrait of the scholar Joan Antonides van der Linden. "My father engraves as well as anyone," said the son (before a notary); "just the other day he engraved a curious woman with a pap pot [*pap-potgen*] that gave everyone a pleasant surprise."[49] And when the bookman, evidently not completely persuaded, showed Titus an earlier effort from a different hand, on which an instruction had been written that the new print ought to be done better, Titus laughed out loud on seeing it, declaring it to be nothing compared to his father's work. In the end, though, the Leiden pub-

lisher's anxieties turned out to be entirely justified, since Rembrandt did indeed supply an etching, not an engraving, and embellished with drypoint, too, which may have improved the initial appearance but which made the plate unsuitable for the multiple impressions the bookseller evidently had in mind. It could not have helped that the original portrait of the Leiden scholar was by Abraham van den Tempel, the absolute epitome of the sleek, opulent, high-tone artist, who had supplied the city with allegorical portraits of its cloth trades in silky technicolors of ripe persimmon and robin's-egg blue, and who was, therefore, poles apart from Rembrandt's manner of offering plain and ruggedly executed truths. So if it was an innocuous little piece of flattery the bookseller and the professor were looking for, what they got was a large-faced scholar holding his book implausibly posed against a classical arch in an obscurely defined garden.

It was not exactly an auspicious beginning for Titus van Rijn, artist's agent and factotum. But with

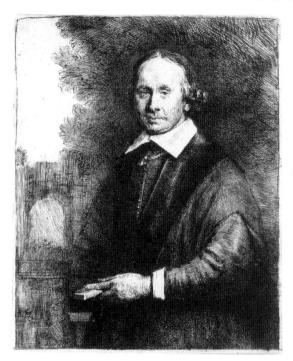

Rembrandt, Portrait of Joan Antonides van der Linden, *1665. Etching. Amsterdam, Museum het Rembrandthuis*

his money, he had prospects. In February 1668 he married Magdalena van Loo. The bride and groom were both twenty-six, Titus a few months older than Magdalena, and they must have known each other since childhood; they were distant relatives, for Magdalena was the niece of Saskia's older sister Hiskia van Uylenburgh. Rembrandt's wedding feast had been at the house of Hiskia and her husband, Gerrit van Loo, up in St. Annaparochie. His brother Jan van Loo, Magdalena's father, had been a silversmith, a member of a community of craftsmen where Rembrandt also had good friends, and had evidently been successful enough to live in a house called "the Moor's Head" in Amsterdam with his wife, Anna Huijbrechts, herself of an old family of goldsmiths originally from Bruges. Anna bore Jan thirteen children, of which nine, including Magdalena, survived into maturity. Jan van Loo died when the girl was a child, and she had grown up with her mother and the brood of siblings in another substantial house on the Singel opposite the Apple Market in the house known as "In the Gilded Herring Boat," or sometimes, from the little ornament set into its façade, as "the Gilded Scales."[50]

Considering the Gilded Scales, the sweetness must have outweighed the sadness. Rembrandt was left alone now with his old housekeeper Rebecca Willems and Cornelia, his daughter by Hendrickje, almost fourteen. But the marriage of Titus into the van Loo family could bring the old man nothing but good. On the practical side (which seems never to have been far from Rembrandt's mind), Hiskia van Loo had been listed among his creditors in 1656, and whatever the nature of that debt, it would surely be cancelled out by the alliance of the families. But the union of his son with a

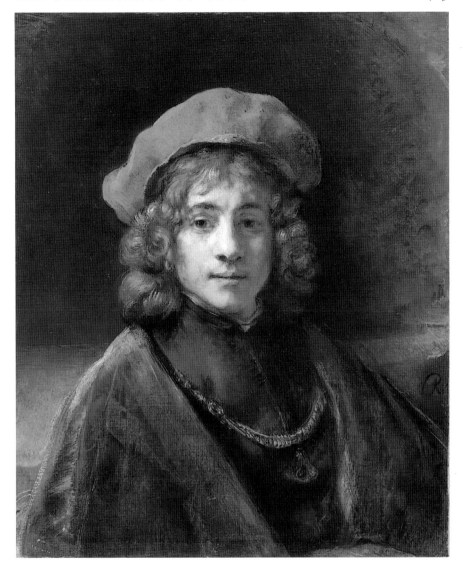

Rembrandt, Titus, *c. 1658. Canvas, 67.3 × 55.2 cm. London, Wallace Collection*

van Uylenburgh niece must also have seemed a moment of marvellously poetical felicity, the closing of another perfect circle like the orbs traced on the wall behind his self-portrait, a coming back and a setting forth, all at the same time.

And there would be issue. Magdalena became pregnant. But before the child could be born, and after just eight months of marriage, in September 1668, Titus died of the plague. Rembrandt had seen this before with Hendrickje, as with so many countless others in the city. Living in Amsterdam in the 1660s, it was impossible not to be aware of the endless harvest of death. By 1668 the toll was waning. But not soon enough. It must have been a lacerating cruelty to have his only son, on the verge of tasting the sweets of life, terrified, see the purple swellings appear, collapse into a wasting fever, be racked by the tearing, bloody cough, and be taken. Why not

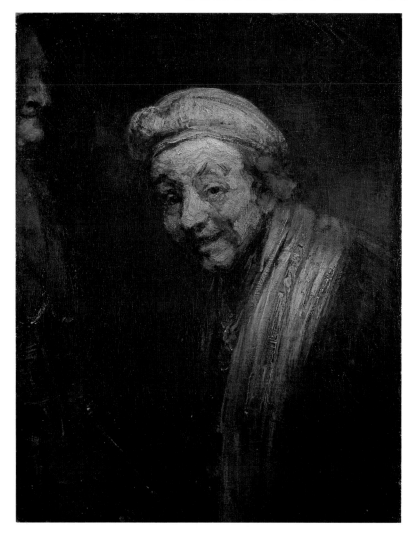

Rembrandt, Self-
portrait as Democritus,
*c. 1669. Canvas, 82.5 ×
65 cm. Cologne,
Wallraf-Richartz-
Museum*

me, Lord? he might have asked, like all fathers. Why not me?

Titus was buried on September 7, 1668, in a rented grave in the Westerkerk, where Hendrickje lay in a similarly leased accommodation. The van Loos had a family tomb in the church. But so many of them, the children and the children's children, had died since the last great sweep of the plague that there was no room for Magdalena's husband. It was intended that he would be moved, in due course, to a properly purchased grave by the family site, and an official deed for a new grave in the church was recorded on January 7, 1669. But the van Loos continued to fall to the plague faster than room could be made to contain their remains, Magdalena's mother, Anna, dying in 1669. Titus's body never was transferred, and when his wife, the mother of a little Titia, herself died, two weeks after Rembrandt, in October 1669, she was buried at the same site as her husband.

Now the biographer, I think, needs a sigh. Rembrandt, unobliging to the end, offers a toothless cackle. Cue, just in time, the iconographer. See the strange Roman-looking bust behind the painter. See the (later) painting by his last pupil, Arent de Gelder, likewise chortling as he paints a redoubtable matron. Rustle the pages. Scroll down the notes. Remember the story of Zeuxis the Greek who died of laughter while painting an old woman. Right, got it. The painter wants to sign off in a gust of black mirth as Zeuxis. The joke's on his patrons, not on him.

But it's never that straightforward, not with Rembrandt. For Zeuxis, of course, the master illusionist who painted grapes so lifelike that birds flew up to eat them, was also the epitome of discrimination, the master of fastidiousness, the artist who embodied most perfectly the classical ideal, taking only the best details of different models to blend them into a perfect, unreal whole.

Me? Zeuxis? The seeker after human perfection? The votary of the

form beautiful? says the tooth-
less grin at the end of the
ancient tortoise-head sticking
out from its cracked and leath-
ery shell. Don't make me laugh.

So perhaps this isn't Rem-
brandt pretending to be Zeuxis
after all. The de Gelder picture
does date from nearly twenty
years on. And the loosely
sketched figure at the artist's left
is implausible as some sort of
"old woman." It looks far more
like some sort of ancient wor-
thy, the kind of bust Rembrandt
himself had collected in his days
of fortune when he thought he
might own a little pantheon like
Rubens. In the Rozengracht,
according to Pieter van Brede-

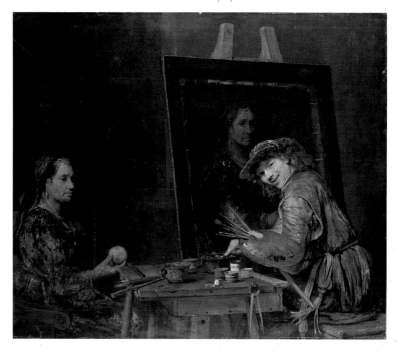

Arent de Gelder, Self-
portrait as Zeuxis, *1685.
Canvas. Frankfurt,
Städelsches Kunstinstitut*

rode, he still owned the bust of an "old philosopher," who Brederode
thought was a "Nazarene." But perhaps this was rather the Thracian sage
whose name was a byword for cheerful fortitude in the face of the incom-
prehensible absurdities of the world: Democritus. He was a far more com-
mon subject for painters in the seventeenth century than Zeuxis, invoked
by the likes of René Descartes and Thomas Hobbes when they wanted to
explain the necessity of laughter as a form of therapeutic ridicule, the oral
evacuation of black bile. Democritus, as Rubens had known, had looked
with sharp, clear eyes at the preposterous vanity of mankind, at the comical
disparity between self-image and truth, and had given voice to a wise bray-
ing, an expulsion of bitter mirth.[51]

Quite soon, though, even the hollow chuckle, as jarring as a stump of
chalk scratching on a slate, dies away altogether. Over Rembrandt's last
two self-portraits, both dated 1669, the year of his death, there hangs an
air of painful self-knowledge. Of course, Rembrandt could not have known
his own death was close. But he seems nonetheless to be divesting himself
of worldly pretensions and illusions; his dress is stark black or Franciscan
muddy-brown, the tone of his *doodverf,* his dead color. In the Kenwood
self-portrait, he is still very much in the midst of his work, the hand in busy
motion, the attitude commanding. In the strange, mildly grotesque
Cologne self-portrait, his work has become a barren joke. In the London
self-portrait, he had originally sketched himself with his hands open, one of
them holding a brush. In the end, though, he decided to relinquish the
brush, preferring instead the more passive, prayerlike gesture of his clasped
hands. It had been almost thirty years since he had pictured himself at the
same angle, body turned forty-five degrees to the picture plane, hand-

FOLLOWING PAGES,
LEFT: *Rembrandt*, Self-
portrait, *1669. Canvas,
86 × 70.5 cm. London,
National Gallery*

RIGHT: *Rembrandt*, Self-
portrait, *1669. Canvas,
63.5 × 57.8 cm. The
Hague, Mauritshuis*

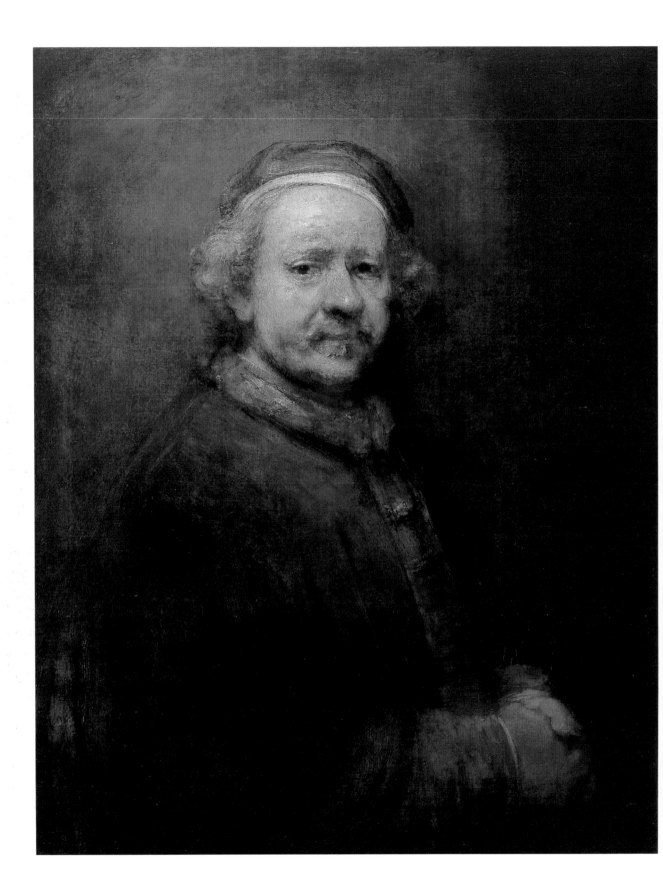

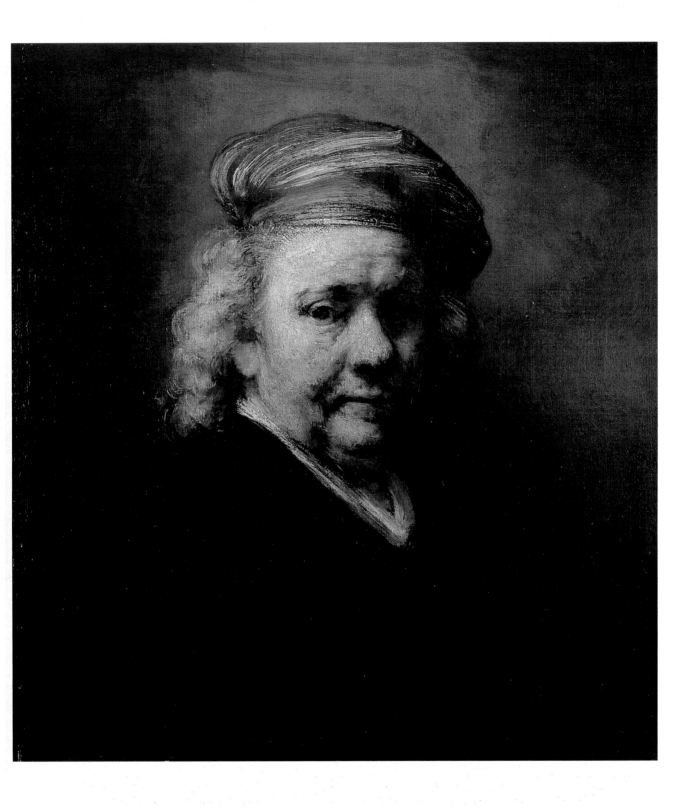

somely attired, the latter-day Renaissance man stealing poses from Raphael and Titian, posturing as poet, courtier, the heir to the greatest masters. Now these vanities had quite fallen away and Rembrandt is no longer much interested in pushing his body challengingly through the picture frame. The very same passages that were the most dashing advertisements for status and cultural pedigree—the flowing sleeve and nonchalant arm—are now the areas of the painting most deeply obscured. And his decision to give himself a simple close-fitting cap, rather than the higher and grander headgear he had initially chosen, also seems evidence of his wish to paint out any kind of pretension. Instead the paint is made to work in the service of simplicity and candor: in the soft collar and edge of his coat; and in the twisted and dragged brushwork that describes, without any kind of equivocation, Rembrandt's pitted, thickened face, locally dabbed impasto suggesting the loose flaps and folds of skin that hang below his eye and at his lower cheek. He works as industriously and as conscientiously as any makeup man, superimposing the features of an old man on the face of a young blood. But this is not makeup. This is the truth, and Rembrandt's face is lit only by the illumination of his unsparing frankness.

By the time Rembrandt painted the Mauritshuis self-portrait, his last, this process of dismantling his ego had gone much further. His face, sharply lit against the subdued background, is now a ruthlessly detailed map of time's attrition. The set of his jaw, still firm in the London painting, has slackened; the muscles elastic; his cheeks and chin flabby; the nose swollen and pulpy, its skin speckled with open, fatty pores; his hair a powdery gray cloud. Even so, there is nothing feebly submissive about the picture; rather it shows a lively contest between resignation and resolution. For the thick, boldly painted strokes, colored with the shades of autumn, that form his turban seem a refutation of decline, an affirmation with his last breath of the audacity and confidence in his hand. And he now made the opposite move from the London self-portrait. This time, he originally painted his hat close to the head but then decided after all to make it rise like a crown, offsetting the subsiding softness of his face. The conspicuously rubbed area above the turban suggests that it might once have risen still higher, like Civilis's regal tiara. Whatever the cruelty of his many disappointments, Rembrandt's is not a face wishing harm on a world that had betrayed him; that had not given him an old age like Rubens's, full of property and progeny. But the light that shines on the side of his face now seems overconcentrated, shakily dabbed or sprayed on, the white paint overlapping his hatband and extending down over his temples to the cheekbone, less a healthy glow than a kind of floury patina, a dusting of snow at Michaelmas. And the invading whiteness frames Rembrandt's deep-set black eyes, the brows raised a little as if accustomed to discomfort, ringed round and round again with puffy circles, wheels within wheels that speak of nights without sleep, of sorrows without end, of the crushing weight of life's travail.

October 2, 1669: the wind sear; the chill rains beginning; leaves on the

lindens and chestnuts dropping fast, piling up by the canal bridges; the pleasure gardens empty of pleasure. A man comes to the house on the Rozengracht, hunting curiosities. Pieter van Brederode, a shopkeeper and amateur genealogist, a heraldry buff, a fellow who likes to haunt old tombs and graveyards, scribble notes from stained-glass windows, pore over rusty suits of armor, has heard that the painter, something of a curiosity himself, he gathers, actually has a helmet said to have belonged to Gerard van Velsen, the knight redoubtable. He seems harmless enough, this van Brederode, and is let in to poke about among what remains of Rembrandt's cabinet of antiquities and rarities. He finds, apart from the medieval helm with eyelets "so narrow a sword could hardly pierce them," all sorts of odds and sods and makes sure to list them: the helmet of a "Roman commander"; a "Nazarene philosopher" (presumably as hairy as he was wise) "very old"; and not least those "four flayed arms and legs" purportedly anatomized by Vesalius.[52]

Three days later, on October 5, there were more comings and goings at that same house while a dead man lay covered in the back room. The sheriff's men had already been, fetched by the servant Rebecca Willems, and by Cornelia once she had seen her father, the day before, God rest his soul, dead and gone, not a breath about his mouth and his body, stone cold in the autumn light. Now there was a notary summoned to see to what the law required in the way of making inventories and suchlike, and then, pretty smartly, Magdalena van Loo arrived, resolved to take care of family matters. Since God had determined the appointed number of her father-in-law's days (and a fuller number it was than her husband's), she now must needs see that there were no damaging encumbrances upon her and her baby daughter left by the old man's misfortunes. She knew how he had been, owing here and there and promising this and that against the delivery of pictures, and now he was gone and there would be no more painting and she was certainly not going to be held accountable. A widow with a baby daughter, she could ill afford to be put at a disadvantage. Then there was Cornelia's guardian, the painter Christiaen Dusart, who was called by the girl and who was doing his part to make sure that Rembrandt's only surviving child was not spited of her own due portion.

It was hard to speak of such things, no doubt, with the girl in the parlor and her father in his shroud, but such matters needed to be settled directly. How was the burial to be paid for when they were all in such difficulties? Surely Rembrandt had kept some money about the house, Magdalena asked the servant, Rebecca, but she said no, he had been taking sums from Cornelia's legacy from Hendrickje just to make do for the housekeeping. Ah then, Magdalena was quick to get the key to Cornelia's cupboard (which must have been Hendrickje's cupboard brought from the Breestraat), and with Dusart standing right by (for he was a sharp one, too, make no mistake), she unlocked it and there was a money bag and inside that another bag, and at last some gold. Half of this is mine, she said, taking the bag right there and then, and not letting go of it until it was back

with her in the house of the Gilded Scales, though she had promised to return what she said was Cornelia's half in silver. And they agreed, Dusart and she, before notary Steeman and witnesses, that by the mercy of God the dead belonged to the earth and that they would accept money from the proceeds of the sale of possessions only if it were to be free of all obligations and thus provide for the expenses of the burial.[53]

The notary had finished making his list of the household things: four curtains of green lace; candlesticks, pewter, and pestle, brass; dishes, earthenware; neckties, old and new; pillowcases, six, and chairs, four, plain, and one mirror, old, with clothesrack. But that left, unlisted, a great deal of "rarities and antiquities" and "paintings and drawings" besides. They had been piled up in the three back rooms of the house, and once the notary had satisfied himself (as Magdalena van Loo insisted) that these were, in accordance with the law, the property of the infant, Titia van Rijn, and in the assigned charge of her duly appointed guardian the jeweller Bijlert, the notary so declared. He locked the room, sealing its effects within, and left the house on the Rozengracht, taking the keys with him.

That little money bag, with its pile of gold, sufficed for the work. On the eighth of October, the usual procession—sixteen pallbearers, the regular number for anyone but an absolute pauper—made its way up the Rozengracht to the Westerkerk. Not far, a few minutes at most, even in the slow tread stipulated for such occasions. When they had taken the burden off their shoulders and deposited the body in its assigned space in the Westerkerk, the men, none of whom had known Rembrandt but who had been hired by the gravedigger for the service, were paid their twenty guilders and money for the tankards of ale expected for their labors. Nothing particular marked the event. In those times of pestilence, it was a rare morning when a *huisvrouw* on her way to market with her servant would not come upon such a black little procession. There was no lengthy tolling of bells as there had been for Karel van Mander and Pieter Lastman; no outpouring of eulogies as there had been for Govert Flinck; no banquets, poems, chants of sorrow, or prayers said for the repose of the soul from one end of the city to the other as there had been for Peter Paul Rubens; just a box lowered into a rented hole in the church floor.

Inside the house on the Rozengracht, the sealed rooms kept their dusty silence, filled with the things dear to the painter, not the lion's pelts imagined by Jan Vos but surely some poor copies of Roman heads, a few pieces of ancient armor, perhaps an old piece of gold-colored cloth, stained and faded. Since he had been working until the end of his days, there would also have been the usual paraphernalia of his trade: a standing easel; a nail hammered into the wall to hang the palettes; other palettes, evidently in use, with the paint now caked and cracking, one of them with nothing but blacks and browns and a great gob of white, next to the thumbhole, gathered into a little peaked mound, the point fallen back on itself like the crest of a mountain; another palette with brighter pigment, ocher and red lakes; and beside them on a table piles of greasy rags, a smock much spotted, pots

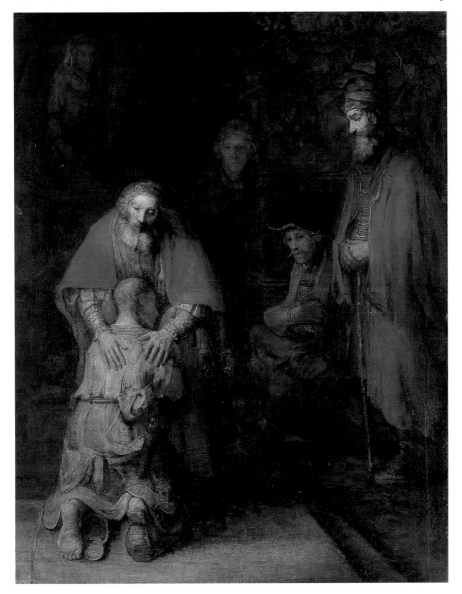

Rembrandt and follower, The Return of the Prodigal Son, *c. 1669. Canvas, 262 × 206 cm. St. Petersburg, Hermitage*

of linseed oil and pigment, unsized canvases, brushes standing with their bristles in the air. And scattered through the rooms thirteen paintings, which Steeman the notary evidently judged to be "unfinished." But then, how would he, or anyone else still alive, know?

Among those paintings was a *Prodigal Son* and a *Simeon in the Temple with the Christ Child*. At some point after Rembrandt's death, some well-intentioned soul made an effort to finish them. Perhaps Arent de Gelder, who continued to fly in the face of fashion by persevering in Rembrandt's late style, did what he could to give the faces a little more definition, to work up the onlooking figures from shadowy forms barely indicated in the painter's dead-color sketch.

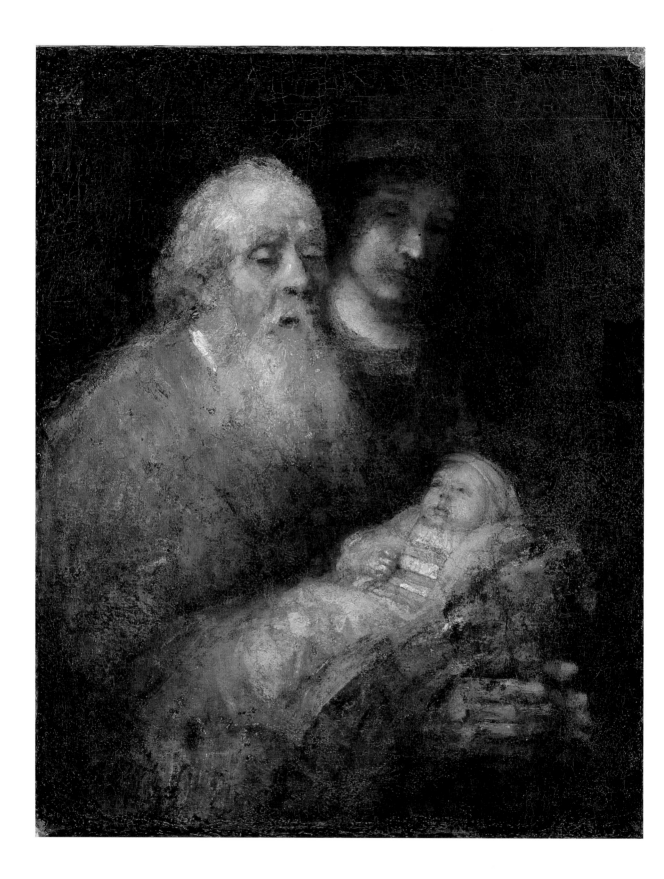

All this—the unhappy dab of highlight on the tip of the Virgin's nose; the oddly wooden bystanders (usually an indignant bunch of jealous brothers) staring at the prodigal and his father—needs to be banished from sight if we are to see the dying, phosphorescent flare of Rembrandt's deathbed vision in its proper incandescence. Stripped of the clumsy additions by later hands, the two pictures are virtually one and the same painting, both drawn from the Gospel of St. Luke, the patron saint of healers and painters, as if Rembrandt, at death's door, was wanting to say something to those close to him and to all of us, and wanting to repeat it so that we could not fail to comprehend him. But his utterance is broken, the message choked off; the hand strong at moments, at other times wavering, the clarity of the line ragged.

But we can see what he means: that there is a kind of vision denied the seeing eye but which may yet be apprehended by touch, and which may flood the inner eye with divine light. Neither of these old men has his eyes open, but they rather deliver and receive the balm of grace with their lids closed and their arms outstretched. Within their arms they cradle, in the one painting, the sinner; in the other, the savior. The face of the sinner, the prodigal, whom Rembrandt had etched and drawn and painted before, once with the features of a simian scapegrace, once with his own leering countenance, is turned away from us, his eyes shut, buried in the bosom of his forgiving father. In the print after Maerten van Heemskerck that provided Rembrandt with his formal source, the son has collapsed against his father, who has run to greet him, but his body is modelled like a Greek hero's, his handsome face crowned with curls, his feet unblemished, and he reappears in the fine raiments ordered by his father, complete with perky codpiece.[54] But Rembrandt's prodigal has been broken by his journey from transgression to atonement. The soles of his feet are lacerated and pierced, so that we understand that he has hobbled painfully home toward atonement. His finery hangs in pathetic rags and tatters from his emaciated frame. His head is shorn like a penitent's as he kneels in contrition. We can scarcely make out his features, so lightly has the artist drawn them, but we see enough to know this prodigal for Everyman, for the child who has taken all the sins of the world on his shoulders. The father, mantled in red, his brow shining with consummate peace, places his hands on those shoulders as if to lift the burden of his trespasses from them with his paternal blessing. But the gesture is even more than a rite of priestly healing: it is also an act of resurrection, a transformation of death into life. To the indignant righteous brother who protests against the fatted calf being killed for the prodigal, the father, godlike, retorts, "This thy brother was dead, and is alive again."[55] So the son kneels against the loins of the father, eyes shut, arms across his chest; they melt together in a single form, the pathetic shred of humanity returned to the boundlessly encompassing compassion of his creator.

There is another sacred mingling of red and gold, blood and light, in the *Simeon.* This, too, Rembrandt had painted many years before, in 1631 in the showy manner which caught Constantijn Huygens's eye, perhaps

OPPOSITE:
Rembrandt, Simeon
in the Temple with the
Christ Child, *c. 1669.
Canvas, 98 × 79 cm.
Stockholm, National-
museum*

inspired by Rubens's great painting for the wing of *The Descent from the Cross*. There was a darkened grandiose temple interior; a crowd of keenly observing rabbis; a theatrically costumed, gesticulating high priest and skeptically scowling Pharisees; and at the center the aged Simeon together with the kneeling Virgin, caught in a pool of supernal light, the "light to lighten the Gentiles," painted by Rembrandt as a nimbus of radiance pouring from the wide-eyed baby Jesus. Simeon's mouth is open, blessing God for allowing him to die now that he has beheld the Savior. Thirty years later, in March 1661, Rembrandt drew the same scene in the album of the minister Jacobus Heijblocq, reduced to just two priestly figures, heavily shadowed, leaning over Simeon, whose face and snowy beard are heightened with white body color, a strong line of the brush glancing down on his head as if struck by the Holy Spirit.[56] The drawing was arched at the top as if it were a framed devotional painting, and Simeon's eyes are closed, one of them rendered with a dark bister stroke, almost as if he were blind. In the painting found in the Rozengracht studio after Rembrandt's death, the old sage's eyes are likewise shut. Everything from the conventions of *Simeon in the Temple* pictures—rabbis; Temple columns; priests—has been effaced save Simeon himself, the Virgin, and the infant Messiah. The background is a shadowy void, but all three figures seem to swim in a luminous mist, a hazy penumbra of illumination that Rembrandt has contrived by making the paint granular, like finely pulverized crystal, applied not with the slapping force of his old age but with a filigree delicacy, as if with a sponge or finely spun gauze. The old man's cradling hands are immense, held rigid as if in deepest prayer. His face, closed off from the world in an ecstatic trance, glimmers with unearthly brilliance. Behind his heavy lids he has, at last, seen the light of salvation, and is able, at last, to declare, "Lord, now lettest thou thy servant depart in peace."[57]

PART SIX

Afterward

CHAPTER THIRTEEN · REMBRANDT'S
GHOST

i *Huygens's Eyes*

Two years after Rembrandt's death, in 1671, Constantijn Huygens, seventy-five years old, returns to Holland from London aboard the yacht of King Charles II. He is in a poor temper. The previous year he had followed the young Prince William III to England. Despite the two naval wars the Republic had fought with the British, Huygens still felt warmly about the country he had admired as a youth, and regretted the arguments that had had to be settled with so many poor souls sent into the sea. He was devoted now to the service of the latest Prince of Orange, a disconcertingly serious and inward young man who better merited the nickname of "Silent" than the first William. Now that there was so much discontent with the de Witts in the Republic, the Prince was again the cynosure of attention, spoken of as the needed captain, and so, over the protests of his old bones, he had gone with him to England to see if matters between him and his cousin, the King, could be made amicable. But after the usual polite ceremonies and amiable courtesies (this King being all amiability, an ease which made Huygens suspicious), the Prince had gone home, leaving him with the particularly unrewarding task of attempting to collect from the court and Parliament the moneys they still owed the House of Orange for support during their civil war. He had had more than his fill of this kind of labor. Sometimes, indeed, he felt he had had enough of life altogether and was tempted, in spite of the affront to the Almighty's wise dispensations, to ask God if He might not deliver him from its toils.

But he must not dwell on his own imagined hurts and weariness. He should think of others. So as the royal yacht bucks and dips through the slate-gray waves of the North Sea, Huygens keeps despondency at bay by writing a poem, another *Ooghen-troost*, a *Balm for the Eyes*. This time, it is addressed to his own sister Geertruyd, who is losing her sight to cataracts. His comfort is a little on the cold side.

As all approach their deaths, the eyesight falters first,
Those who have lived out more than threescore years and ten,
Die or are like to die and there is no gainsaying.
Is it untimely, strange, that eyesight should give way?[1]

No, really it isn't, he replies to his own rhetorical question. "Those who have stored up well can live on garnered sights." "Suppose that you could see ahead, it would be short / So short compared to what is past that you had / To see . . ."

But you and I have lived a multitude of years
Have outlived with our seeing the sight of many men;
This all we have surveyed, experienced in this world
Things worthy to be seen, and not worthy to be seen.
Insight alone remains, through which we fit ourselves
To search within ourselves and learn what is within
To learn the wisdom to confess to God alone
Where we stand most in need of his forgiving love.

Huygens's philosophical eyebright is of no avail. His sister goes blind. The poet-statesman-composer-patron lives on another sixteen years. The disarmingly affable King of England repays his obligations to the Dutch Republic by making a secret alliance against it with Louis XIV, designed to destroy it entirely as an independent state. In 1672 they attack the Republic by sea and land, with the Prince-Bishop of Münster joining in for the spoils. The French cross the Rhine. The country appears lost. Ministers mount the pulpits to declare that God has set a rod across their backs for all their countless sins and transgressions; that this Louis is their Tiglath-pileser, their Sargon, their Nebuchadnezzar, their Trajan. There are prayers and fasts, and there are riots and murders. William III is restored to the offices of his ancestors, is made Stadholder, captain, and admiral-general, while the Grand Pensionary Johan de Witt and his brother Cornelis are dismembered by a mob in The Hague, their cadavers mutilated, pieces of them sold around the city. The Catholic Mass is said in Utrecht Cathedral for the first time in a century.

It was also a hundred years since the country had had to summon the waters to its aid. The dikes are cut, flooding the countryside between the French lines and the inner heartland of Holland. At sea the fleets of the Republic hold off the British. The Fatherland is saved. But Huygens has little joy of it. He endures awhile, finding a degree of contentment only when he can be at his country villa, Hofwijk. Five years before his death, he writes an epitaph to his puppy, Geckie, "Little Fool."

This is my puppy's grave
No more than this be said
I'd wish (and were it so the world were none the worse)
My little dog alive, all the world's great ones dead.[2]

ii *Gérard's Eyes*

Gérard de Lairesse's eyes are sharply focussed on success. In the early months of 1672, he is to be found in Amsterdam painting a ceiling for the magnifico Andries de Graeff, the same patrician who, thirty-odd years before, had had some trouble with Rembrandt's portrait. De Graeff has had a new house built for himself in the grandest, most fashionable classical manner, and he has hired Lairesse to paint him an allegorical decoration celebrating the splendors of Amsterdam. The artist obliges by producing three paintings: Unity, Freedom of Commerce, and Security, together an *Allegory of the Blessings of the Peace of Breda*. The timing is a little unfortunate, seeing that the Dutch Republic is about to be thrown into the fight of its life.

No matter. The fickleness of history is not Lairesse's concern. So he supplies elegantly modelled, brilliantly lit images of the personifications enthroned on clouds attended by flights of winsome putti. Beauteous, helmeted Zekerheid, the security guard, has his sword out and sends a treacherous, snake-haired monster—whatever enemy you choose—tumbling from the vault into the abyss.[3] The painter's perspective is faultless; his colors limpid; his foreshortening immaculate. If old de Graeff can stretch his leathery neck and gaze at the ceiling, he will doubtless feel transported, a useful sensation when one is getting on in years. There could be no doubt of the painter's talent. Though he looked decidedly queer, with a snout for a nose like that of any bristly hog, plump lips, and goggling protuberant eyes, Lairesse was always handsomely dressed and luxuriantly coiffed and wigged, and he could be depended on to bring a distinctly grand aura, a classical tone, to any work he undertook, public or private. Hire Lairesse to cover the walls of your salons with allegorical grisailles, Roman virtues, mythological assemblages, and lo and behold a mere canal house could be transformed into a faux Pantheon and its owner into a latter-day Horace or Pliny.

The *rampjaar,* the year of calamity, scarcely checked the ascent of his star, although a story is told of Lairesse, who normally spoke French and who had learned Dutch relatively late in life, being set upon by a suspicious crowd in Amsterdam who mistook him for a French spy, and landing in prison for a few days. But since his father had already engraved the scene of William the Silent's assassination, it came naturally to Lairesse to turn into an enthusiast for the House of Orange. When the fires of the war had cooled and William III was hailed as its savior-Stadholder, Lairesse was established as his favored and serviceable painter. In 1672 he painted an allegory of the festivities attending the Prince's elevation to the stadholderate, and four years later he was taken to William's palace at Soestdijk to decorate the house.

Anonymous after Gérard de Lairesse, Self-portrait, c. 1665. Engraving. New York, Ursus Books and Prints

Very soon no artist was in greater demand for resplendent allegories and histories, and Lairesse became what no other painter in the whole of the seventeenth century had quite managed: the Dutch Republic's Rubens, a genuine virtuoso, even echoing the Flemish master by painting episodes from the *Aeneid*. For Protestant churches like the Westerkerk he could paint an organ case with *The Anointing of David* and *The Queen of Sheba Bearing Gifts*. For a Catholic cathedral like St.-Lambert back home in Liège, he would paint an *Assumption*. For another merchant patrician he would do *The Four Ages of Mankind* from golden through iron, and for the anatomist Bidloo he would design exquisite anatomical illustrations. He was not above painting rich clients like Bartholomeus Abba as Apollo if that was what Bartholomeus Abba wanted. He painted spectacular backdrops for the Amsterdam Theater and designed immense lunettes on *The Greatness of Amsterdam* for the Burgerzaal of the Town Hall. The exigencies of the war prevented funds from being available for their execution, but Lairesse did see installed in the High Court of Appeals of the Province of Holland in The Hague a suite of Roman histories including a painting of Horatio Cocles beating off the Etruscans, installed directly behind the Prince's chair when he presided over the tribunal, leaving no one in any doubt as to the identity of the modern Dutch Horatio. Lairesse became as valuable to the embattled Republic as Charles Le Brun was to the Sun King at Versailles: its panegyrist; a living refutation of the condescension of the French academicians that the Netherlanders were good for nothing other than low lifes and still lifes. This latest Dutch reincarnation of Apelles, his many admirers felt, was (unlike *some* to whom the honor had been carelessly applied) the true heir to Rubens and even to Raphael, indeed closer to the original Greek prototype: graceful, decorous, restrained, bookish; not only steeped in the classics but an impassioned advocate of their indispensable and enduring sublimity.

After a while, Lairesse stopped protesting and feigning modesty when agreeable comparisons were made with Poussin, even with Raphael. "My Apelles," William III called him, so Gérard obliged his princely patron with paintings of Alexander and his queen, Roxanne. And now it was *his* turn to sling his arm over a parapet, Titian-like, as Rembrandt had in 1640.

But then, in 1690, Gérard de Lairesse went quite blind. In his darkness, though, the artist professed to see something with new clarity. And what he now saw was mathematics.

Since he felt the need to describe this, to insist that mathematics, along with geometry, architecture, the ordered harmonics of the universe, was the foundation of all art, and the ideal which it must endeavor to approximate,

the blind Lairesse decided to give lectures. He held forth twice a week at his
house, on Tuesdays and Saturdays from six in the evening until eight, his
three sons and two brothers acting as teams of amanuenses (for Lairesse
had much to say), scribbling rapidly on slates, while another group tran-
scribed the slates to paper so that they could be wiped clean and refilled
with Wisdoms. And after ten years or so, there were enough of these notes
to make a large work which Lairesse published first as a manual for begin-
ning draftsmen in 1701, and then as his magnum opus, the two-volume
Groot schilderboeck (*The Great Book of Painting*) of 1707. And discern-
ing critics said that he had been transformed from Apelles into Homer,
blind yet truly visionary.

Even before his lights were snuffed out, Lairesse had held robust views
on the gravity of the distinction between vulgar and refined art and the
deplorable quality of Dutch painting through most of the seventeenth cen-
tury. He particularly despised its inexplicable attraction to coarse subject
matter and its repellent servitude to Nature. When he had come to Amster-
dam in the later 1660s, he had quickly attached himself to refined connois-
seurs and articulate men of letters who, in 1669, had formed a society that
called itself Nil Volentibus Arduum ("Nothing is too arduous for those
who truly want it"), which from 1676 to 1682 met in Lairesse's house on
the Oudezijds Achterburgwal, with its properly classical columns.[4] And
what they did want was to purge Dutch art of its gross vulgarities, both of
form and content. The entire purpose of art, the cultural crusaders of the
Nil all agreed, was to make visible Perfect and Ideal Forms, the kind of
thing that could only be appreciated by the cream of society, the cultivated
and the propertied, those who understood the eternal verities of the classi-
cal tradition. Andries Pels, the dramatist whose tragedy *Dido's Death* and
whose comedy *Julfus* were both illustrated by Lairesse's etchings, let it be
known in no uncertain terms that the redemption of art from the undigni-
fied and the commonplace was an urgent priority in the education of the
youth of the governing elite of the Republic. The pen and the brush, allies
in the reinstatement of the classical tradition, would henceforth be devoted
to Elevation and Refinement. For the dignity, the entire future of the
Republic demanded that they rescue the younger generation from dissipa-
tion in the whorehouses and gambling dens, the sure consequence of being
exposed to low art. Instead these young men would be steeped in noble lit-
erature and elevated, beautiful painting and would thus be disinfected of
everything common and base.

Especially to blame for the unhappy state of Holland's cultural conta-
mination were those artists, as Jan de Bisschop said in his *Paradigmata*
(supplied with a frontispiece by Lairesse and dedicated to the venerable
burgomaster-poet, Jan Six), who imagined that "whatever is unsightly in
reality is pleasing and praiseworthy in art. And that consequently a
deformed, wrinkled and tottering old man is more suitable for a painting
than a handsome and youthful one," or anyone who supposed that "the
marks of the garters on the legs" could possibly be reconciled with art's
striving for beauty.[5] And in case anyone was still in doubt as to who the

supreme embodiment of all these sins might be, Andries Pels specifically took to task "the great Rembrandt" as "the first heretic in painting." "What a shame for the sake of art," Pels went on, "that so able a hand made no better use of his inborn gifts. But ah! The nobler the man, the wilder he'll become if he fails to tie himself to a rein of rules."[6]

At the same time that they declared him the profligate squanderer of his talent and thus the Great Inferior, the academicians continued to be haunted by the spectral afterlife of Rembrandt van Rijn. He seemed like a ghostly guest who somehow materialized unwanted into polite company and then proceeded to disgrace himself by his boorish efforts to draw attention to himself with outlandish remarks, eccentric dress, and a simply dreadful indifference to table manners. And he would not go away. Worse, in some quarters, especially abroad, he continued to enjoy something of a reputation. They detested his posturing self-obsession; his want of emotional decorum; his slovenly brushwork; his dissolution of clear forms in murky obscurity; his porridge of pigment; his perverse pleasure in surveying the most unappetizing features of the human body and the most sordid rustic hovels; his peculiar attraction to the decrepit; and the common lewdness of his treatment of business between the sexes. And most of all, they hated Rembrandt's arrogant disregard for the elementary, time-honored principles of composition; his indifference to perspective; the effrontery of his mistaken notion that he, that anyone, could be set above the imperishable, divinely ordered Rules of Art. "I will not deny," wrote Lairesse, "that I used to have a particular weakness for his manner. But this was before I began to be aware of the infallible rules of painting. I later found myself obliged to concede my mistake and reject his art as based on nothing more than insubstantial imaginings."[7]

But then, of course, this kind of outlandishness was only to be expected from someone (as the legend already supposed) who came from common stock, miller's flour powdering his hair, and who, despite the favor and privilege of his betters, insisted on continuing to root about in the rank sty of humanity, consorting with the dregs of the common people: beggars, Jews, actors. As to his own notoriety, the procession of digraces that had soiled his career, it was better to pass that over in silence. But Lairesse was in no doubt, as he let it be known in the *Groot schilderboeck* (the title of which must have been seen as a deliberate attempt to recall and replace Karel van Mander's work), that the apprehension of beauty was conditional on the cultivation of virtue. To be truly elevated, to work on ceilings with lofty histories and poetic conceits, to lay down colors and lines in clarity and purity, the painter himself must needs be spotless and unstained.

He had lived so long, both sighted and blind, that no one seems to have thought to question Gérard de Lairesse's righteousness, still less to embarrass him with inconvenient recollection. In some quarters, he had a reputation for personal frugality and probity; it was said he would down no more than a pint of ale at dinner. In other circles, a more saturnalian explanation of his suspiciously syphilitic puglike nose was offered, reinforced perhaps

by the knowledge that after 1680 he was no longer living with his wife. Perhaps, by the time his book was published in 1707, when Prince William become King William III was himself dead and gone, there was no one left alive who remembered the season when Lairesse had first come to the Dutch Republic, in a not entirely unblemished condition.

For there had been a time when Gérard de Lairesse seemed the most improbable candidate for the position of the next Dutch Apelles; a time, in fact, when he had been a stone-broke fugitive from the law. And it was at that time that Rembrandt—the painter who, Lairesse would later say, should be avoided by all aspiring young artists for allowing his paint to "run down the surface of the canvas like *drek*," like shit—had painted his portrait.[8]

This other Gérard had been the brightest thing Liège had seen for generations. His father, Regnier Lairesse, was also a painter, much admired for his ability to imitate marble, and his two brothers Jan and Abraham also followed the family profession. But it was Gérard who was the prodigy, good enough to be apprenticed with Bertholet Flémalle, the one local artist in that little town who approximated to a cosmopolitan, with an education in Italy, work in Florence and Paris, and who could boast an extensive knowledge of the masters of the High Renaissance and the Roman Baroque. Doubtless Flémalle's talk was peppered with impressive familiarity with the likes of Poussin and Salvator Rosa. He certainly instructed Gérard to drink deep of the classics, to read Franciscus Junius's *De Pictura Veterum*, in which every conceivable Greco-Roman authority on painting had been anthologized, and perhaps also the standard works in French which promoted the virtues of cool restraint, edifying subject matter, and decorous harmony. In 1670 Flémalle would himself be rewarded for conscientiously adopting this manner by being commissioned to decorate Louis XIV's audience room (seldom used) in the Tuileries and by being admitted into the Académie de Peinture.

None of which, of course, prevented the young Lairesse from taking as his other great early model Peter Paul Rubens. Who else could possibly rival his mastery of pictorial drama, emotional drama, and glowing color? Living in the prince-bishopric of Liège, not far from Flanders, no young, gifted, and ambitious artist born in the year of Rubens's death, 1640, could fail to be impressed by the unparalleled fame, splendor, and wealth that the Antwerp master had achieved. Lairesse's first attempt to expand his horizons and his immediate circle of patrons beyond his native town took him to Cologne, where Henry Maximilian of Bavaria, the Prince-Bishop of Liège, also happened to be the Imperial Elector, and where, it was thought, Rubens had been born. Lairesse would have seen Rubens's *Martyrdom of St. Peter* installed over the high altar of the Church of St. Peter. And if his stay in Cologne seems not to have flung open the doors of patronage in the way Lairesse and his father had hoped, perhaps it was because his manner was excessively rigorous, insufficiently feeling in the Rubensian manner. So when he returned, Lairesse's grandest efforts like *The Baptism of St.*

Augustine made sure to include, along with austerely classical figures, unmistakably Rubensian ecstatics: St. Augustine's mother, the reformed drunk St. Monica, in a high old Rubensian state of rapture.

Barely into his twenties, Gérard de Lairesse was, at least in Liège, already reckoned a phenomenon. An independent master in 1660; the painter of a grandiose altarpiece for the cathedral of St.-Lambert in 1661, and of an *Orpheus in the Underworld* for the chimneypiece of Burgomaster de Selys in 1662. He was on his way. But Lairesse, it seems, had a little personality flaw which made it difficult for him to pose with much conviction as the ascetic votary of his art, living only for painting. For as his fellow Liègeois artist, Louis Abry, who for a time shared lodgings with him in Amsterdam, succinctly put it, "*Il aimoit le sexe.*"[9] He was hardly the only young painter to have acquired this reputation, but in Lairesse's case, his pursuit of women may, paradoxically, have been an attempt to triumph over facial disfigurement that was the result of being born a congenital syphilitic. So young Gérard, to his unaccountable delight, discovered between the sheets that his prodigious fame as "the Poussin of Liège" was the best cosmetic for his piggy nose and weak little chin. So Lairesse spent a great deal of time with women. There was a Polish adventuress of uncertain age. And then there were the sisters Marie and Catherine François, originally from nearby Maastricht, who lodged and worked in a tavern near Lairesse's house and earned money by modelling for him.

In the seventeenth century, when a young man of solid rank and auspicious prospects promised to marry a young woman of decidedly inferior station, there could only be one reason. So there must have been one modelling session that had ended in bed. Perhaps there were many such meetings. Perhaps there was even a pregnancy. For Gérard had indeed agreed to marry one of the handsome sisters François (it is not clear which), and had made the costly mistake of making that offer in writing. On hearing this intelligence, his aghast parents immediately produced an alternative, a cousin of Lairesse's brother-in-law and friend, the lawyer Nicolaes Delbrouck, called Marie Salme. She too, it seems, was *fort jolie*. And with the air of a man immune to misfortune, Gérard de Lairesse readily consented.

It was a spring afternoon, April 22, 1664, when he was made aware of the limitations of that immunity. The painter had just dined, and was walking back to the rooms he had taken at his brother-in-law Delbrouck's house to continue work on a picture. His route took him past the tavern where the François sisters worked, and he could not have been especially pleased to see them emerge from the establishment, clearly coming his way. Perhaps he even quickened his stride a little. If so, they certainly caught up to him, insisting, a little publicly, that he speak to them. Evidently the news of his betrothal to Marie Salme had reached them. How could it not, with the banns read? Just how unhappy they were with this information swiftly became apparent when one of the women, who had fallen back a little while her sister continued to berate the faithless artist, stuck a dagger into his neck, slicing clean through flesh and into his collarbone. With blood pouring from him, Lairesse managed to pull his sword from his scabbard,

only to discover that the sisters themselves had come heavily armed. He struck at his assailant, who had pulled another knife from her skirts, and then astonishingly found himself in an all-out duel with the other sister, sword on sword, in the middle of Liège, in broad daylight in the middle of the afternoon. For a short while, the girl held her own, but it was the young gentleman who had had the fencing lessons. Yet it took two deep sword thrusts, one below her breast, the other deep into what the notarized deposition described as "her shameful parts," before she would desist and was dragged away, doubtless screaming and bleeding effusively on the street. Lairesse was himself in need of urgent attention and was taken by his brother-in-law, who must have come rushing to the scene, and by Marie Salme, the fiancée, to an apothecary, who stanched the flow, saving the painter's life.

A warrant was out for his arrest. Two days later, when he was somewhat recovered, Lairesse made a statement of record to his brother-in-law that he had acted only in self-defense. This may have been so, but having stabbed a woman in the breast and groin, Lairesse was not confident enough of being treated benignly by the law to make his whereabouts known, and was instead secreted by Marie Salme in a Dominican monastery where he could claim refuge. On April 28, six days after the attack, Gérard and Marie left Liège together, getting rapid benefit of clergy in one of the city's suburbs from a priest who asked no difficult questions but pocketed coin for his services and blessed their union.

They crossed the border of the territories of the Prince-Bishop of Liège, travelling first to Aachen and then northwest to Utrecht. There, Gérard and Marie Salme found lodgings, the husband attempting to make some sort of living as a painter, perhaps hiring himself out to decorate burgher houses, as he had done in Liège. Most of the stories of this exile do not record a success. Completely ignorant of Dutch, with no reputation in Holland, Lairesse was reduced at one point to hanging one of his paintings outside his door as a trade sign.

And then, the story has it, one day it was seen by an Amsterdammer called Hooft who took it back to that city and showed it to the dealer Gerrit van Uylenburgh, Hendrick's son, who now had his own firm and was always interested in new and preferably undiscovered talent. Lairesse was summoned to Amsterdam and asked by van Uylenburgh to show what he could do. A blank canvas was set on an easel. Right, said van Uylenburgh. Paint me a Nativity. Lairesse stood immobile in front of the canvas, silent and in thought, and then surprised the company by pulling out a fiddle and playing a few airs before settling down to work. By the time he had sketched in a head of the Virgin, Joseph, and a good Dutch cow, it was apparent to van Uylenburgh that he did indeed have a painter on his premises (not to mention a musician).

Or so the story goes. It is, at any rate, certain that Lairesse got work from van Uylenburgh and that the dealer introduced the mysterious, oddlooking fellow with the snout and the large wet eyes to his wide circle of friends and painters in the city, young and old. One of them was the

Rembrandt, Portrait of
Gérard de Lairesse,
*1665. Canvas, 112.4 ×
87.6 cm. New York,
Metropolitan Museum
of Art*

famous, infamous, wide-renowned, widely overlooked, highly esteemed,
much discounted, admired, and despised Rembrandt van Rijn.

So there they were, across from one another in a room in Amsterdam:
the painter of awkward truth and the painter of graceful artifice; the terrible
old Tartar and the slightly soiled Young Turk. Suppose it had been the other
way about; suppose that Lairesse had been painting Rembrandt: would he
have made light of *his* innumerable imperfections, as he later wrote was
the duty of the responsible portraitist?[10] Would he have transformed the
dumpy, irascible, decomposing old face into the weathered countenance of
an ancient philosopher, more seer than sinner, a Paul, an Augustine, a
Homer, or a Democritus? But since it was he who was being carefully stud-

ied, Lairesse's emotions must have been in turmoil on that day in 1665: he must have been flattered that Rembrandt should have wanted to paint him at all yet deeply apprehensive that he might be made into an object of picturesque curiosity, or perhaps even worse, of pity and ridicule.

Just how much Lairesse's conviction that the mission of art was noble beautification was shaped by the painful consciousness of his own ugliness was later made apparent by the remarks he made in the *Schilderboeck* on the subject of the portraitist's responsibility to conceal any kind of defect or disfigurement. As for unfortunates who have a hunchback or a squint, "Nature itself rejects [the possibility] of taking any pleasure in the appearance of such persons. . . . A man with a squint can scarcely look at this defect in the mirror without pain and displeasure. It must always provoke an inner torment, especially for women who but for this are beautiful and well-formed. . . . How much more disgusting, then, for a Painting [to show such things]." It is entirely natural for us to want to show our best side, whether we sit or stand, speak or keep our silence, so that "if we have sore eyes, we pull our hat low over our face . . . if we have a rash or a boil on our cheek, we cover it with a plaster; if we have ugly teeth, we keep our mouth shut."[11] For a painter to expose rather than disguise such disfigurements was, Lairesse implies, an unspeakable act of cruelty masquerading as candor.

But of course Rembrandt would have taken one look at Lairesse and, with his acute grasp of human foibles, would have immediately observed the nervous self-consciousness behind the cocky self-confidence of the up-and-comer. And it would have been exactly this jarring discrepancy between the outward and the inner man that would have made Rembrandt warm to his subject, see him as yet another sympathetic specimen of the walking wounded. So the painting is the most affecting of all Rembrandt's late portraits, set down with no dissembling or euphemism, but also with not the slightest inclination to portray Lairesse as a grotesque. Instead Rembrandt, working with the free and flowing brushstrokes which his sitter would cite as the very worst kind of painting, depicts a young man whose literary pretensions (suggested by the paper he is holding) and social deportment (suggested by the hand thrust into the coat) have run ahead of his achievements; a man who still needs to grow into his clothes, with their gold trim and fancy lace; whose pinched little face needs to fit better between hat and collar; and whose enormous black intelligent eyes, with their heavily marked rims and excessively dilated pupils, suggest that something might not be quite right with Lairesse's vision.

As blemishes go, this is a pardonable imperfection. And in any case, for Rembrandt, imperfections are the norm of humanity. Which is why he will always speak across the centuries to those for whom art might be something other than the quest for ideal forms; to the unnumbered legions of damaged humanity who recognize, instinctively and with gratitude, Rembrandt's vision of our fallen race, with all its flaws and infirmities squarely on view, as a proper subject for picturing, and, more important, as worthy of love, of saving grace.

iii *Rembrandt's Eyes*

They were shut tight. As indeed you would expect from a baby christened just the day before in the Church of the Cross, with the tall steeple and the cherubim for decoration.

It was Sinterklaas Day, December 6, 1673. There were skipping children in the streets holding dolls and flying kites and munching on *koek* spiced with nutmeg and cinnamon. And if you were taken by a pang of homesickness, you might partly close your eyes and fancy you were in old, not new, Batavia. For there were, after all, tree-lined canals thirty feet wide, and step-gabled houses alongside them, and sidewalks paved in rosy brick; a copiously stocked Fish Market, and a handsome Town Hall where the *schepenen* met three times a week to deliberate on the public peace; and a sweeping bay studded with islands that broke the force of the tides so well that ships might almost lie at rest in the harbor without dropping anchor; and there was a Rope Alley, and a Cloth Hall, and a Flesh Hall to serve as slaughterhouse and butchers' mart.[12] And for the more Christian governance of the town there was an orphanage and a hospital, a Latin school, and even a spin house, its shutters close bolted, where whores and drunken women were brought to godly discipline.

But with your eyes wide open, you would note that the canals were called Tygers-Gracht and Rinoceros-Gracht, and the trees alongside them were palms, and if some of the bastions that looked out to the harbor were named Amsteldam and Rotterdam, Delft and Orange, others were called Diamond, Pearl, and Sapphire, names that would have raised eyebrows and hackles back home. And it was possible to raise good Holland cabbage in the rich wet soil here, and parsley, watercress, and asparagus, and radishes grew to prodigious size. But the beans were blue, the sorrel yellow, the beets white, and the ubiquitous fruit which newcomers began by calling apples and pears they soon called by the proper names of Tjamboes, Dap-Dap, Takkatak and Fokky-Fokky. And one needed whatever had been shipped in of Dutch temperance to withstand the temptation to gorge on fruit like the durian, wholesome and luscious in moderation, but if eaten to excess, likely to inflame the blood and bring on a welter of pimples about the face. The Company did bring in butter and bacon and stored it in places as dark and cool as possible, but it spoiled quickly in the tropical dampness and swelter. The staple of the place was, as at home, a wondrous abundance of fish. But the fishwives were Chinese, and the choice items were grunt-fish and baldpate, sand smelt, sea hedgehog, sea devil, sea porpoise, sea cat, turdfish, siapsiap, raven fish, Java gudgeon, and sucker. The crabs were mottled purple and white, the lobsters blue, and the mussels brown.

So it was not home; not really. But Cornelia van Rijn, like all good *huisvrouws* from Holland, doubtless did her best to make it seem so for

herself, her husband Cornelis, and their infant boy. And when all was said and done, what choice had she been offered? Scarce a few weeks had passed after her father's death when her half brother Titus's wife, Magdalena van Loo, had followed him to the grave in the Westerkerk. And then the mother Anna Huijbrechts gone, too, as if some mark had been laid upon all their kin. Truth to tell, with the fear of death all about them, there had been precious little affection parcelled out among the dwindling band of survivors, all struggling to keep their share of the remnant of their property. The orphan babe Titia had been looked after by her guardian, the jeweller Bijlert, and Cornelia had been the object of the tenderest solicitations of her guardian Christiaen Dusart. He had seen to it that she kept the portion of Hendrickje's legacy that was her due, and with it, he had found her a husband who might spare her from going unguarded and lonely in the wide world.

Sixteen years old, she was married, in 1670, to Cornelis van Suythof the painter, and soon after they had taken ship for Batavia, where the Company men vowed they might, with hard work and if God gave them good health to survive the fevers and contagions, make a little fortune for themselves.

But there was only so much work for painters in Batavia; only so many gentlemen in the fort and factory wanting *conterfeitsels* and landscapes to prettify their upriver summer-houses. So Suythof, like most others among the craftsmen in the colony, needed another line of work to keep his family in bread and clean linen. He became a jailor. The Artisans' House, where they were lodged, along with the silversmiths and pewterers and glassmakers, potters and masons, also served as a lockup where desperadoes who had committed especially wicked crimes were kept in chains and made to labor. So when he was not painting signboards or obliging the vanity of a merchant or officer of the Company's soldiery, Suythof kept watch on these men: lascars and Malay pirates; Timorese who wore nothing but a breechclout and who had sliced through some unsuspecting body with a sword made of sharpened sandalwood; mustachioed Amboinese and, in a separate quarter, the worst of the Europeans.

Two years later, Cornelia would have another child, whom she called Hendrick, and for a while at least, she and her husband survived the yellow fever and the distempers and the bloody fluxes of Batavia.

So let us imagine Cornelia on that December day in a shaded room in the Artisans' House rocking her swaddled firstborn, his cradle covered with a fine muslin gauze to protect him from the mosquitoes and biting flies, the blister-drawers, the frightening scorpions which lurked behind every heavy closet, and whatever demons the Indies could summon to beleaguer his little soul. Or perhaps, when the cool of the evening drew on, we might follow her to the gardens near the Governor's Castle and watch her, from a distance, seated beneath the broad, knotted tamarind tree pulling the thick perfume of the chapakka waterflowers into her nose, listening to the ill-matched choir of cockatoos and bullfrogs, and watching the first flittermice come swoop in the gathering dusk. And Cornelia might be thinking, as she

spied a lethal *kris* tucked into the silken belt of a passing Amboinese sol-
dier, or as she heard an elephant trumpet somewhere far beyond the walls,
that there was something here, beneath the flame-coral heavens, that an
enterprising artist could make something of.

And she would look at her child, eyes still shut, the delicate veins
visible on the pale, translucent lids which would now and then tremble
and flutter in his sleep, as if he were silently, seriously conversing with
himself as to how he had come to be baptized with so peculiar a name as
Rembrandt.

AUTHOR'S NOTE

BUT ARE THEY *REMBRANDTS*?

Rembrandt's Eyes is about the painter's long journey to singularity. It presupposes that only Rembrandt could have achieved a work of the complexity and virtuosity of the *Portrait of Jan Six* or *Jacob Blessing the Sons of Joseph*. These are the paintings which seem to me to proclaim Rembrandt's powers of invention and execution as of a different order from contemporaries and pupils. But not so very long ago there were literally hundreds of "Rembrandt-manner" paintings confidently given to the master, and which, in light of the much more exacting standards promoted by the Rembrandt Research Project, have been rejected from the *Corpus*. It's a measure of the success of the imposition of these more rigorous criteria that it's hard to look at the mass of paintings, many of them axiomatically given to Rembrandt by virtue of their superficial adoption of a rough, broad manner with extreme chiaroscuro, and not now feel surprised that they were ever taken seriously as works by Rembrandt's hand.

I have written about these issues in the pages of *The New Yorker* and the *Times Literary Supplement* and have deliberately chosen not to fill this book with complex issues of authenticity, not least because whatever authority I might claim to write a book about Rembrandt's life and work, it's certainly not that of the connoisseur, but simply the attentiveness of an engaged beholder. It would, though, be disingenuous if, after a decade and more of considering, writing, and sounding off about Rembrandt, I didn't own up to some views about authorship, especially since the *concept* of authorial agency remains stubbornly important to my way of looking. My views on the genuine article, then, may be inferred from the choice of paintings discussed and illustrated in the book. On *The Polish Rider* I have never had any doubts, an opinion I expressed in public during the period when the painting had been rejected by members of the Rembrandt Research Project.

Whatever reservations are in order about the categorical nature of the judgements handed down in the first three volumes of the project's monumental *A Corpus of Rembrandt Paintings*, like all my colleagues working in this field, I owe the projectors a debt of gratitude for their herculean labors, not least in the technical and material analysis of Rembrandt's paintings. And I look forward to the new and evidently more candidly interpretative style of analysis the

project promises to offer in further volumes of the *Corpus*.

Occasionally, though, I remain bemused by rushes to judgement and by the immediate deference to those judgements shown by museum curators. A recent case in point is the unarguably beautiful Mauritshuis 1629 *Self-portrait Wearing a Gorget*, which has recently been held to be a copy of the original in Nuremberg (see page 6), on the grounds that underdrawing discovered in the Hague painting is inconsistent with Rembrandt's habitual practice. And so it is. But inconsistency, of

itself, doesn't make for inadmissibility. Supposing that the Hague painting is indeed the work of a pupil, exactly which prodigy in 1629 is meant to have had the skill to execute something so stunning? The fourteen-year-old freshly apprenticed Gerard Dou? On the evidence of his early work, this is inconceivable. Isaac Jouderville? Almost as implausible. Not a pupil at all, then, but the unquestionably gifted Lievens? But we *have* Lievens's portrait of Rembrandt in a gorget, and it looks nothing remotely like the Mauritshuis painting. We are left, then, with only two options for assigning authorship: either some unknown pupil, whose astounding technical skill somehow wasn't enough to rescue him from complete oblivion, or else the possibility that *both* these heads are from Rembrandt's own hand, notwithstanding the underdrawing. For Rembrandt did, in fact, make near-identical versions of the same painting: for example, the Munich and Amsterdam *tronies* of his own face.

It is also said that the same artist could never have produced both a "rough" and a "smooth" version of the same head. But taking the rough with the smooth was precisely what Rembrandt was doing as a young man. He would go on doing it all his life.

NOTES

ABBREVIATIONS

Corpus *A Corpus of Rembrandt Paintings*, vol. 1, 1625–31, ed. Josua Bruyn et al. (The Hague, Boston, and London, 1982)

CR *Correspondance de Rubens et documents épistolaires concernant sa vie et ses oeuvres*, ed. Max Rooses and Charles Ruelens, 6 vols. (Antwerp, 1887–1909)

LPPR *The Letters of Peter Paul Rubens*, trans. and ed. Ruth Saunders Magurn (Evanston, Ill., 1991)

RD *The Rembrandt Documents*, ed. Walter L. Strauss and Marjon van der Meulen with the assistance of S. A. C. Dudok van Heel and P. J. M. de Baar (New York, 1979)

CHAPTER I: THE QUIDDITY

1. Jacob Smit, *De grootmeester van woord- en snarenspel: Het leven van Constantijn Huygens 1596–1687* (The Hague, 1980), 153.

2. Ibid., 155.

3. Lieuwe van Aitzema, *Historie of verhael van staet en oorlogh in, ende omtrent de verenigde Nederlanden* (The Hague, 1666–71), 2:883–84; see also Jonathan Israel, *The Dutch Republic and the Hispanic World* (Oxford, 1982), 177.

4. Smit, *De grootmeester van woord- en snarenspel*, 154.

5. J. J. Poelhekke, *Frederik Hendrik, Prins van Oranje: Een biographisch drieluik* (Zutphen, 1978), 285ff.

6. On Rembrandt's sense of the theater, see Svetlana Alpers, *Rembrandt's Enterprise: The Studio and the Market* (Chicago, 1988), 34–57.

7. Eelco Verwijs, ed., *Constantijn Huygens' kostelick mal en voor-hout* (Amsterdam, 1904).

8. The latest edition, translated from Latin into modern Dutch prose, is Constantijn Huygens, *Mijn jeugd*, trans. and ed. Chris L. Heesakkers (Amsterdam, 1987).

9. Henry Peacham, *The Compleat Gentleman: Fashioning Him Absolute in the Most Necessary and Commendable Qualities Concerning Minde or Bodie That May Be Required in a Noble Gentleman* (London, 1634).

10. I. Bergstrom, "Georg Hoefnagel, le dernier des grands miniaturistes flamands," *L'Oeil* 97 (1963): 2–9; M. L. Hendrix, "Joris Hoefnagel and the *Four Elements:* A Study in Sixteenth-Century Nature Painting," Ph.D. dissertation, Princeton University, 1981.

11. Huygens, *Mijn jeugd*, 71–72.

12. Hendrik Hondius, *Onderwijsinge in de perspecteve conste* (The Hague, 1623); idem, *Korte beschrijvinge ende af-beelding van de generale regelent der fortificatie* (The Hague, 1624). On Huygens's drawing lessons, see A. R. E. de Heer, "Het tekenonderwijs van Constantijn Huygens en zijn kinderen," in Victor Freijser, ed., *Leven en Leren op Hofwijck* (Delft, 1988), 43–63.

13. Peacham, *The Compleat Gentleman*, 129–30.

14. For detailed techniques of this kind of drawing and painting, see Edward Norgate, *Miniatura, or The Art of Limning*, ed. Martin Hardie (Oxford, 1919). The manuscript (Tanner 326) in the Bodleian Library, Oxford, was written as a copy shortly after Norgate's death in 1650. The original is likely to have been written between 1648 and 1650. Norgate was, among other things, drawing tutor to the children of the great English collector the Earl of Arundel and was personally familiar with both Rubens and Huygens.

15. Huygens, *Mijn jeugd*, 73.

16. Peacham, *The Compleat Gentleman*, 109.

17. See H. Perry Chapman, *Rembrandt's Self-portraits: A Study in Seventeenth-Century Identity* (Princeton, 1990), 44.

18. The best introduction to this flowering of painting in the northern Netherlands is Bob Haak, *The Golden Age: Dutch Painters of the Seventeenth Century*, trans. and ed. Elizabeth Willems-Treeman (New York, 1984), especially 77–161. For the immediately preceding period, see the superb exhibition catalogue *Dawn of the Golden Age: Northern Netherlandish Art, 1580–1620*, ed. Ger Luijten et al. (Amsterdam and Zwolle, 1993).

19. Huygens, *Mijn jeugd*, 79.

20. Ibid., 82.

21. Ibid., 84.

22. For a description of these brushes (albeit at the end of the seventeenth century), see Willem Beurs, *De groote waereld in't kleen geschildert, of Schilderagtig tafereel van 's weerelds schilderyen, kortelijk vervant in ses boeken: verklarende de hooftverwen, haare verscheide mengelingen in oly, en der zelver gebruik* (Amsterdam, 1692), p. 23.

23. On painting as alchemy, see James Elkins, *What Painting Is* (New York and London, 1998).

24. This is the theme of an important discussion by Ernst van de Wetering, *Rembrandt: The Painter at Work* (Amsterdam, 1997), especially 154–90.

25. For the material history and technical examination of the painting, see *Corpus*, 1:A18, 208–13.

26. In his fascinating discussion of the history of the palette, van de Wetering, *Rembrandt: The Painter at Work*, 132–52, argues that like other Dutch painters of his day, Rembrandt must have used separate palettes for distinct passages of painting: thus one for monochrome areas, say in black, gray, and earth tones like umber; another for brighter accents in lake, vermilion, or blue smalt. But there are instances of artists' self-portraits, not least that of Isaac Claesz. van Swanenburgh, the father of Rembrandt's teacher in Leiden, that show palettes with both bright and dark colors arranged on a single surface, lead white being by far the most commonly used and always placed conveniently close to the thumbhole. In *The Artist in His Studio*, Rembrandt makes the point moot by having the surface of the palette at a dead right angle to the picture plane, making it impossible to scan its contents.

27. Huygens, *Mijn jeugd*, 86.

28. When the painting surfaced in a private collection in 1925, before being acquired by the Boston Museum of Fine Arts, it was larger, at both the top and the bottom, making it an upright rather than horizontal painting and giving the impression of a much taller room in which the artist was standing. Although it's been argued by Seymour Slive that Rembrandt himself made these additions to the original panel, the distinctively darker paint of the additions makes it more likely that they were made and painted over at a later date, in a misguided attempt to give the painting the additional "grandeur" it, in fact, already had. For this physical history, see *Corpus*, 1:212; Seymour Slive, "Rembrandt's *Self-portrait in a Studio*," *Burlington Magazine* 106 (1964): 483–86.

29. For example, Victor I. Stoichita, *The Self-aware Image: An Insight into Early Modern Meta-painting*, trans. Anne-Marie Glasheen (Cambridge, 1997), 238–40; Mieke Bal, *Reading Rembrandt: Beyond the Word-Image Opposition* (Cambridge, 1991), 247–70. Both discussions make interesting analogies between Rembrandt's panel and Velázquez's *Las meninas*. But the artful back-wall image of the Spanish King and Queen which reveals them as beholders of the scene we witness in *Las meninas* is actually the exact opposite of Rembrandt's insistence on the absolute and unmediated absorption of the painter within his own work.

30. See illustration on p. 560.

31. Here, I'm very much in agreement with the general argument set out by van de Wetering, *Rembrandt: The Painter at Work*, 87–89, who quotes Karel van Mander, *Den grondt der edel vry schilder-const* (Haarlem, 1604), fol. 12, para. 4, to the effect that the most able painters "are used to drawing fluently by hand on their panels what they have already seen painted in their mind's eye."

32. Jan Emmens, *Rembrandt en de regels van de kunst* (Amsterdam, 1979), argues that at a number of points in his career, Rembrandt showed himself sensitive to the three different elements of the painterly vocation: *natura* (inborn talent); *exercitato* (disciplined practice); and *ingenium*, or inventiveness. *The Artist in His Studio* might certainly be taken as an example of this kind of thoughtfulness, but Emmens also believes that Rembrandt's attention to these principles, set out in Renaissance and contemporary art theory, made him generally obedient to "the rules of art" rather than any kind of experimenter. But one of the most striking aspects of *The Artist in His Studio* is precisely the unprecedented form in which Rembrandt chose to make his "conventional" points about the nature of painting—a form which brings practice and imaginative invention seamlessly together in a manner no other artist had yet anticipated.

33. See illustrations on pp. 549 and 570.

34. In this they were following Plato's discussion of artistic genius in the *Timaeus*: Martin Kemp, "The Super-Artist as Genius: The Sixteenth-Century View," in *Genius: The History of an Idea*, ed. P. Murray (Oxford, 1989), 45. I'm grateful to Professor Kemp for his kindness in bringing this important discussion to my attention. See also David Summers, *Michelangelo and the Language of Art* (Princeton, 1981), 171–76; Rudolf Wittkower, "Individualism in Art," *Journal of the History of Ideas* 22 (1961): 291–302.

35. This is Gary Schwartz's view: *Rembrandt: His Life, His Paintings* (London and New York, 1985), 55.

36. Kemp, "The Super-Artist as Genius," 38–39; see also Chapman, *Rembrandt's Self-portraits*, 26ff.

37. Norgate, *Miniatura*, 96. See also van de Wetering, *Rembrandt*, 51.

38. Van Mander, *Grondt*, fol. 25, para. 26. "Tizijn spieghelen des gheests / boden des herten / Die daer openbaren jonst / en benij den / Stadicheyt / beweghen / fachtmoedt / verblijven . . ."

39. Peacham, *The Compleat Gentleman*, 23.

40. Ibid.

41. On December 28, 1998, National Public Radio's "All Things Considered" reported an inadvertent archaeological find near the mouth of the Miami River in south Florida, the work of an as-yet-unknown prehistoric Floridian culture and consisting principally of a series of circles engraved in stone. (Similar circles have been discovered on pre-Aboriginal sites in the Northern Territory of Australia.) Amidst the circles was a form clearly making the basic shape of a human eye.

42. Giorgio Vasari, *La vita di Michelangelo nelle redazione del 1550 e del 1558*, ed. Paola Barocchi (Milan and Naples, 1962), 1:117–18; see also Kemp, "The Super-Artist as Genius," 46.

43. *RD*, 1628/1, 61.

44. Cited in Kemp, "The Super-Artist as Genius"; see also W. M. Conway, ed., *Literary Remains of Albrecht Dürer* (Cambridge, 1889), 244.

45. Pliny, *Natural History*, trans. H. Rackham (Cambridge, Mass., and London, 1952), 35:36:82–85, p. 323. I am grateful to David Freedberg, who, during our Rembrandt seminar at Columbia University in 1996, pointed out this possibility.

46. Giorgio Tonelli, "Genius from the Renaissance to 1770," in *Dictionary of the History of Ideas*, ed. P. P. Wiener (New York, 1973), 293–96.

47. Jan Emmens, "Rembrandt als genie," reprinted in *Kunst Historische Opstellen* (Amsterdam, 1981), 1:123–28.

48. This extraordinary story is told in Kees Bruin, *De echte Rembrandt: Verering van eeen genie in de twintigste eeuw* (The Hague, 1995), 65–86.

49. There is oddly little written directly on this relationship; see, though, Horst Gerson, "Rembrandt and the Flemish Baroque: His Dialogue with Rubens," *Delta* 12 (Summer 1969): 7–23; J. G. van Gelder, "Rubens in Holland in de zeventiende eeuw," *Nederlands Kunsthistorisch Jaarboek* 3 (1950–51): 103–50.

50. Karel van Mander, *The Lives of the Illustrious Netherlandish and German Painters from the First Edition of "The Schilder-boeck" (1603–4)*, ed. H. Miedema, trans. Michael Hoyle, J. Pennial-Boer, and Charles Ford, 4 vols. (Doornspijk, 1994), 1:180–1.

51. *RD*, 1633/1, 97; see also Schwartz, *Rembrandt*, 97.

52. For court life in The Hague, see Marika Keblusek and Jori Zijlmans, eds., *Princely Display: The Court of Frederik Hendrik and Amalia van Solms* (Zwolle, 1997).

53. See the biographical note in *Dawn of the Golden Age, Northern Netherlandish Art, 1580–1620*, ed. Ger Luiten et al. (Amsterdam and Zwolle, 1993), 307.

54. On Honthorst, see J. Richard Judson, *Gerrit van Honthorst: A Discussion of His Position in Dutch Art* (The Hague, 1959).

55. Smit, *De grootmeester van woord- en snarenspel*, 167.

56. For a detailed discussion of Rubens's painting, see pp. 160–5; for Rembrandt's response, pp. 291–2.

57. I follow much of the excellent discussion in Chapman, *Rembrandt's Self-portraits*, 59–61.

CHAPTER 2: JAN AND MARIA

1. ". . . de dire qui fut le premier il fault bien presumer, que je n'auroie jamais eu la hardiesse d'approacher si j'eusse eu crainte d'estre refuse." Cited in R. C. Bakhuizen van den Brink, "Het huwelijk van Willem van Oranje met Anna van Saxen," in *Historisch-Kritisch Onderzocht* (Amsterdam, 1853), 136.

2. On Jan Rubens's early education, see *CR*, 1:17.

3. For the background to the marriage and Anna's response to William's "courtship," see Bakhuizen van den Brink, "Huwelijk," 59.

4. C. V. Wedgwood, *William the Silent* (London, 1967), 51.

5. Ellen Scheuner, *Die Wirtschaftspolitik der Nassauer-Siegerland vom 16. bis 18. Jahrhundert* (Münster, 1926), 19–20.

6. On the revolt of the Netherlands, see G. Parker, *The Dutch Revolt* (London, 1977); Jonathan Israel, *The Dutch Republic: Its Rise, Greatness and Fall, 1477–1806* (Oxford and New York, 1995), 129–78; P. Geyl, *The Revolt of the Netherlands, 1555–1609*, rev. ed. (London, 1966). On the religious aspects of the revolt, see A. Duke, *Reformation and Revolt in the Low Countries* (London, 1990).

7. Phyllis Mack Crew, *Calvinist Preaching and Iconoclasm in the Netherlands, 1544–1569* (London and New York, 1978), 12.

8. Max Rooses, *Rubens*, trans. Harold Child (Philadelphia and London, 1904).

9. Mack Crew, *Calvinist Preaching and Iconoclasm*, 159.

10. On the iconoclasm, see David Freedberg, *Iconoclasm and Painting in the Revolt of the Netherlands, 1566–1609* (New York, 1987); also idem, "Art and Iconoclasm, 1525–1580: The Case of the Netherlands," in *Kunst voor de beeldenstorm: Noordnederlandse kunst, 1525–1580*, ed. Th. Kloek et al. (Amsterdam, 1986), 39–84; idem, *The Power of Images: Studies in the History and Theory of Response* (Chicago, 1989), 385–86.

11. On the Marys of Antwerp Cathedral, see Stefaan Grieten and Joke Bungeneers, eds., *De Onze-Lieve-Vrouwekathedraal van Antwerpen*, vol. 3 of *Inventaris van het kunstpatrimonium van de provincie Antwerpen* (Antwerp, 1995), 452ff.

12. Ibid., 363.

13. Mack Crew, *Calvinist Preaching and Iconoclasm*, 17.

14. Israel, *The Dutch Republic*, 157–58.

15. Geyl, *The Revolt of the Netherlands*, 102–3.

16. Quoted in Peter Sutton, "The Spanish Netherlands in the Age of Rubens," in *The Age of Rubens* (Boston, 1993–94), 122.

17. Rooses, *Rubens*, 4.

18. Ibid., 5.

19. Bakhuizen van den Brink, "Huwelijk," 59.

20. Their correspondence, as well as William's letters to his brothers and in-laws complaining about Anna, may be found in G. Groen van Prinsterer, *Archives, ou Correspondance inédite de la maison d'Orange-Nassau*, 1st ser. (Leiden, 1835–1847), 3:327–96.

21. Ibid., 327–31.

22. Ibid., 372.

23. For Maria Rubens, see W. Francken, *De moeder van Pieter Paulus Rubens* (Rotterdam, 1877), passim.

24. The letters are published in ibid., 15–21; also Bakhuizen van den Brink, "Huwelijk," 163–66. Translations throughout are mine.

25. Francken, *De moeder van Pieter Paulus Rubens*, 24.

26. Groen van Prinsterer, *Archives*, 3:393.

27. Ibid., 391.

28. Francken, *De moeder van Pieter Paulus Rubens*, 32; see also R. C. Bakhuizen van den Brink, *Les Rubens à Siegen* (The Hague, 1861), 4–5.

29. Bakhuizen van den Brink, *Les Rubens à Siegen*, 6.

30. Ibid., xii, 12.

31. Francken, *De moeder van Pieter Paulus Rubens*, 50.

CHAPTER 3: PIETRO PAOLO

1. For the cult of the saints in the Netherlands, see John B. Knipping, *Iconography of the Counter-Reformation in the Netherlands: Heaven on Earth* (Nieuwkoop and Leiden, 1974), 2:287ff; also David Freedberg, "The Representation of Martyrdoms During the Early Counter-Reformation in Antwerp," *Burlington Magazine* 118 (March 1976): 128–33.

2. See, for example, the prints produced by Jerome Wierix on the life of St. Bernard, ibid., 169.

3. L. Voet, *Antwerp: The Golden Age* (Antwerp, 1973), 202–3.

4. See J. Briels, *Du Zuidnederlandse immigratie, 1572–1630* (Haarlem, 1978), 12.

5. Ibid., 43–44.

6. Joachim von Sandrart, *L'academia todesca della architectura, scultura, ed pittura, oder, Teutsche Akademie*, 2 vols. (Nuremberg, 1675–80).

7. Fritz Lugt, "Rubens and Stimmer," *Art Quarterly* 6 (1943): 99–114.

8. Karel van Mander, *The Lives of the Illustrious Netherlandish and German Painters*, 1:226–7.

9. On Lampsonius's writings and influence, see the discussion in Walter S. Melion, *Shaping the Netherlandish Canon: Karel van Mander's "Schilder-boeck"* (Chicago and London, 1991), 143–72.

10. Francesco de Hollanda, *Four Dialogues on Paintings*, trans. A. F. G. Bell (Oxford and London, 1928), 16.

11. On this characteristic of seventeenth-century studio practice, as well as other issues related to Rubens's pre-Italian works, see Julius S. Held, "Thoughts on Rubens's Beginnings," *Ringling Museum of Art Journal* (1983): 14–27; also F. M. Haberditzl, "Die Lehrer der Rubens," *Jahrbuch der Kunsthistorischen der Allerhöchsten Kaiserhausen* 27 (Vienna), no. 5 (1908): 161–235.

12. Melion, *Shaping the Netherlandish Canon*, 153–56.

13. On Mantua at the beginning of the seventeenth century, see exhibition catalogue *Splendours of the Gonzaga*, Victoria and Albert Museum (London, 1981).

14. For a thorough discussion of Rubens's relationship to antiquity, see Marjon van der Meulen, *Rubens: Copies after the Antique*, 3 vols. (Antwerp and London, 1994).

15. Quoted in David Chambers and Jane Martineau, eds., *Splendours of the Gonzaga* (London, 1981), 80.

16. Ibid., 214.

17. For an exhaustive discussion of the importance of these copies to Rubens's later work, see Michael Jaffé, *Rubens and Italy* (Oxford, 1977).

18. See Wolfram Prinz, "*The Four Philosophers* by Rubens and the Pseudo-Seneca in Seventeenth-Century Painting," *Art Bulletin* 55 (1973): 410–28.

19. *CR*, 1:5–7.

20. Ibid., 62.

21. Ibid., 7.

22. Francis Huemer, *Rubens and the Roman Circle* (New York and London, 1996). Much of what follows in the account of Philip Rubens's stay in Italy is indebted to Dr. Huemer's study.

23. Ibid., 7.

24. Ibid., 8.

25. *CR*, 1:99.

26. March 29, 1603, *LPPR*, 27.

27. *CR*, 1:363.

28. *LPPR*, 30.

29. Ibid., 33.

30. For a discussion of this tradition and its implications for Rubens's painting, see Martin Warnke, *Kommentare zu Rubens* (Berlin, 1965), 3–8. Warnke's observations remain generally valid even though he was mistaken in supposing the *two* paintings, each of Heraclitus and Democritus, to be Rubens's work of 1603. Michael Jaffé was the first to identify the correct painting, presently in a private collection in Wales.

31. July 17, 1603, *LPPR*, 35.

32. *CR*, 1:175.

33. Ibid., 36.

34. See Walter Liedtke, *The Royal Horse and Rider: Painting, Sculpture, and Horsemanship, 1500–1800* (New York, 1989).

35. *LPPR*, 38.

36. Openmouthed sea monsters were a standard feature of Flemish marine painting; Rubens might well have known *The Sea Storm* (now in the Kunsthistorisches Museum, Vienna), for a long time attributed to Pieter Bruegel the Elder and now assigned to Joos de Momper. But similar creatures regularly appear in contemporary Flemish prints of the Jonah Scripture by Maarten de Vos and the Wierix brothers.

37. By Jaffé, *Rubens and Italy*, 70.

38. There are two versions of the painting: one in the Yale Art Gallery, New Haven, generally considered the original, bought by Rembrandt; and another, slightly larger copy in Dresden, now assigned to Rubens's workshop. For details of the provenance and literature, see the catalogue entry by Peter Sutton in *The Age of Rubens* (Boston, 1993–94), 225–27.

39. Rembrandt's wonderful painting was stolen, together with a double portrait attributed to Rembrandt and the great Vermeer *The Concert*, as well as a number of other works, from the Isabella Stewart Gardner Museum in Boston in 1990 (March 18). As of this writing, the paintings have not been recovered.

40. Because Aeneas himself does not prominently appear in the painting, not all authorities have agreed that the painting is, in fact, a scene from the *Aeneid*. For a view of the painting as a "simple" *Shipwreck*, see Lisa Vergara, *Rubens and the*

Poetics of Landscape (New Haven and London, 1982), 33–43.

41. Roger de Piles, *Abregé de la vie des peintres . . . et un traité du peintre parfait . . .* (Paris, 1699). See also Huemer, *Rubens and the Roman Circle*, 66–67; Vergara, *Rubens and the Poetics of Landscape*, 33–43; Lawrence Otto Goedde, *Tempest and Shipwreck in Dutch and Flemish Art* (University Park, Pa., 1989), 82–83.

42. See Vergara, *Rubens and the Poetics of Landscape*, 39. The painting is now in Dayton, Ohio.

43. *CR*, 1:239.

44. Ibid., 232–33.

45. Ibid., 67.

46. Huemer, *Rubens and the Roman Circle*, 41–42.

47. Ibid., 51–52.

48. For the tree-as-living-Cross tradition, see Simon Schama, *Landscape and Memory* (New York, 1995), 214–26.

49. "La casa di Pietro Paolo Rubens a Roma," *L'Opinione* 245 (September 6, 1887). See also the important article by Giuseppe Gabrieli, "Ricordi romani di P. P. Rubens," *Bolletino d'Arte del Ministero della Pubblica Istruzione* 1 (Milan and Rome) (July 1927): 596ff.

50. *LPPR*, 54.

51. Huemer, *Rubens and the Roman Circle*, 44.

52. Van der Meulen, *Rubens*, 96–112.

53. Rubens to Chieppio, December 2, 1606, *LPPR*, 39.

54. There is a substantial literature on the Chiesa Nuova commission. On the first *modello*, see Hans G. Evers, *Rubens und sein Werk: Neue Forschungen* (Brussels, 1943), 112–16; Michael Jaffé, "Peter Paul Rubens and the Oratorian Fathers," *Proporzioni* 4 (1963): 209–14; Julius S. Held, *Selected Drawings of Rubens* (London, 1959), 128; Justus Müller-Hofstede, "Rubens's First Bozzetto for S. Maria in Valicella," *Burlington Magazine* 106 (1964): 445; Sutton, *The Age of Rubens*, 228–31.

55. David Hugh Farmer, *Oxford Dictionary of Saints* (Oxford, 1992), 352.

56. Rubens to Chieppio, February 2, 1608, *LPPR*, 42.

57. I owe this point to the lyrical discussion offered in Huemer, *Rubens and the Roman Circle*, 229ff.: "The three phases of coloring in Rubens's painting of the Italian period . . ."

58. Rubens to Chieppio, February 2, 1608, *LPPR*, 42.

59. See P. Génard, *P. P. Rubens: Aantekeningen over den grooten meester en zijne bloedverwanten* (Antwerp, 1877), 371–76; also Held, "Thoughts on Rubens's Beginnings," 17.

CHAPTER 4: APELLES IN ANTWERP

1. *CR*, 2:20–24.

2. Jonathan Israel, *The Dutch Republic: Its Rise, Greatness and Fall, 1477–1806* (Oxford and New York, 1995), 400ff.

3. The canal was never built, owing to the resumption of the war in 1621, but it engaged the keen interest of all the Antwerp patriciate, including Rubens.

4. *LPPR*, 52.

5. Ibid.

6. *CR*, 2:7.

7. Rubens to Faber, January 14, 1611, *LPPR*, 53–54.

8. Roger de Piles, *Conversations sur la connaissance de la peinture* (Paris, 1677), 213–15; see also Christopher White, *Peter Paul Rubens: Man and Artist* (New Haven, 1987).

9. The painting, now in the National Gallery in London, has been the subject of controversy since it was suggested by an Egyptologist, Euphrosyne Doxiadis—largely on the basis of

discrepancies she claims to see in the brushwork—that it is a copy, rather than the original which hung over the fireplace in Rockox's house. Other critics, like Christopher Wright, have argued that the painting's "vulgarity" makes it suspect. But his charge of "vulgarity" makes suppositions about good and bad taste that would have been meaningless to Rubens, and in any case the allegedly objectionable details—Samson's torso, for instance—are clearly elements of the original painting seen in a *kunstkamer* painting of the interior of Rockox's house by Frans Francken the Younger.

10. See E. de Jongh, *Portretten van echt en trouw: Huwelijk en gezin in de Nederlandse kunst van de zeventiende eeuw* (Zwolle and Haarlem, 1986), 155–56.

11. On Rubens's attributes, see Zirka Filipczak, *Picturing Art in Antwerp, 1550–1700* (Princeton, 1987), 99.

12. One only has to look at Rubens's contemporary and very beautiful portrait of his friend Jan Bruegel and family, in the Courtauld collection in London, to see a more orthodox form of "burgher" dress, with Jan himself favoring the old-fashioned neck ruff.

13. Clara Serena herself only lived to her twelfth year, dying in 1623.

14. Rubens to Dupuy, July 15, 1626, *LPPR*, 135–36.

15. For details of Lipsius's own garden I am most grateful to Dr. Claudia Swan, whose 1997 Columbia University doctoral dissertation, "Jacques de Gheyn and the Representation of the Natural World in the Netherlands ca. 1600," deals extensively with Lipsian and Clusian botany. Jacques de Gheyn's now famous *vanitas* painting of 1603, in the Metropolitan Museum of Art, New York, prominently features a tulip as an emblem of both mortality and remembrance. On Lipsius and his importance for Rubens, see Mark Morford, *Stoics and Neostoics: Rubens and the Circle of Lipsius* (Princeton, 1991).

16. The model for Seneca in the Munich painting was provided by an antique statue that Rubens had sketched in Rome, later known as the *African Fisherman*. See Marjon van der Meulen, *Rubens: Copies after the Antique* (Antwerp and London, 1994), 2:34–40.

17. Thomas L. Glen, *Rubens and the Counter-Reformation: Studies in His Religious Paintings Between 1609 and 1620* (Garland Ph.D. Reprints, 1977), 19; see also John Rupert Martin, ed., *Rubens: The Antwerp Altarpieces* (New York, 1969).

18. Ibid., 20.

19. For these and many other aspects of the site and the painting, see Roger d'Hulst, Frans Baudouin, et al., *De kruisoprichting van Pieter Paul Rubens* (Bruges and Brussels, 1992). The Flemish-Dutch word *schip* is still used to mean either a ship or the nave of a church, but there was a long tradition going back to the Middle Ages of comparing the Church to a vessel.

20. Ibid., 53.

21. The Rembrandt painting, one of his most obvious variations on a Rubensian motif, was stolen from the Isabella Stewart Gardner Museum in Boston in 1990 and has not been recovered.

22. This was a princely, but not excessive, sum. Filipczak, *Picturing Art*, 78, points out that the fees paid for both *The Elevation of the Cross* and *The Descent from the Cross* were in line with the tariff calculated for earlier masters like Frans Floris, adjusted for inflation.

23. Glen, *Rubens and the Counter-Reformation*, 37–38.

24. For details on the cathedral's holdings of paintings, both preserved and destroyed, see Stefaan Grieten and Joke Bungeneers, eds., *De Onze-Lieve-Vrouwe Kathedraal van Antwerpen*, vol. 3 of *Inventaris van het kunstpatrimonium van de provincie Antwerpen* (Antwerp, 1995).

25. See G. Servière, "La Légende de Saint Christophe dans l'art," *Gazette des Beaux-Arts* 5 (1921): 3–63.

26. Max Rooses, *Rubens*, trans. Harold Child (Philadelphia and London, 1904), 164.

27. Glen, *Rubens and the Counter-Reformation*, 77.

28. For the importance of this theme, see the excellent discussion in Svetlana Alpers, *The Making of Rubens* (New Haven, 1995), 101ff.

29. Rooses, *Rubens*, 170.

30. The story is repeated (of "mine old Host at Arnhem") by Henry Peacham in *The Compleat Gentleman: Fashioning Him Absolute in the Most Necessary and Commendable Qualities Concerning Minde or Bodie That May Be Required in a Noble Gentleman* (London, 1634), 12.

31. See Filipczak, *Picturing Art*, 51–53.

32. Rooses, *Rubens*, 113.

33. The drawing of Floris's house is by Jacob van Croes and was made around 1714.

34. Rubens was too much of a bibliophile, and for that matter too interested in architectural theory, not to have been immersed in the work of Serlio, Scamozzi, and Palladio, and would certainly have taken seriously their advice on the construction of the modern villa.

35. Cited in Paul Huvenne, *The Rubens House*, Antwerpen (Antwerp, 1990), 4. Wowerius was referring to both Rubens's house and that of his friend Balthasar Moretus on the Vrijdagmarkt.

36. I am grateful to David Freedberg for showing me the library stamp of the Reichsführer SS of the Haus Germanien in Brussels on his copy of Hans G. Evers, *Rubens und sein Werk: Neue Forschungen* (Brussels, 1943).

37. Victor H. Miesel, "Rubens and Ancient Art," Ph.D. dissertation, University of Michigan, 1959, 317–18.

38. See Jeffrey M. Muller, *The Artist as Collector* (Princeton, 1989), 11ff.

39. Rubens owned two globes, and it is often suggested that these were prominently displayed as a symbol of his universalist temper and intellect. See ibid., 23.

40. Ibid., 150.

41. David de Wilhem, for example, shipped another mummy, first to third century B.C., to Otto Heurnius, a professor of anatomy at Leiden University. See *De wereld binnen handbereik: Nederlands kunst- en rariteitenverzamelingen, 1581–1735* (Amsterdam, 1992), 108–9.

42. For this interest, see Simon Schama, *Landscape and Memory* (New York, 1995), 282ff.; also J. R. Harris, ed., *The Legacy of Egypt* (Oxford, 1971).

43. Rubens to Carleton, April 28, 1618, *LPPR*, 61.

44. Rubens to Carleton, May 26, 1618, *LPPR*, 65.

45. For the inventory, see Muller, *The Artist as Collector*, 82–83.

46. Ibid., 32.

47. In *The Making of Rubens*, Svetlana Alpers chooses to reassert the fundamental importance of the sensual element in the artist's work, and to connect it with Virgilian notions of the fertility of the natural world. This seems to me an exceptionally important corrective to the dominant notion of Rubens as entirely governed by neo-Stoic asceticism.

48. Rubens to Sustermans, March 12, 1638, *LPPR*, 408–9.

49. May 1635, *LPPR*, 398; August 1635, *LPPR*, 400–401.

50. *LPPR*, 393.

51. Ibid.

52. *CR*, 12:45.

53. Ibid., 46.

54. Ibid., 53.

55. Ibid., 58.

56. Otto van Veen, *Q. Horatii Flacci Emblemata* (Antwerp, 1607), 138−9; see also Justus Müller-Hofstede, "Rubens und die Kunstlehre des Cinquecento: Zur Deutung eines theoretischen Skizzenblatts im Berliner Kabinett," in *Peter Paul Rubens* (Cologne, 1977), 55−56; Filipczak, *Picturing Art*, 32−34.

57. An earlier grisaille oil sketch by van Veen, now in the British Museum, made the two figures of poet and painter more precisely comparable by showing them both in full activity and the poet writing on his scroll, "Pictoribus atque poetis [semper fuit aecqua potestas] quid liet audendi" ("For painters and poets there has always been allowed equal license to attempt whatever they liked").

58. For the engravers as well as for other issues raised in these pages, see J. G. van Gelder, "Rubens in Holland in de zeventiende eeuw," *Nederlands Kunsthistorisch Jaarboek* 3 (1950−51): 103−50.

59. Ibid., 120.

60. After the debacle with Vorsterman, Rubens still went to the Dutch Republic rather than Flanders or Brabant for his engravers, in particular the Frisian Bolswert brothers.

61. Julius S. Held, "Rubens and Vorsterman," in *Rubens and His Circle*, ed. Julius S. Held (Princeton, 1982), 119.

62. *CR*, 2:466.

CHAPTER 5: RHL

1. The title of a *lofzang*, a celebratory song, hymning the virtues of Leiden, composed by the native composer and organist of the St. Pieterskerk, Cornelis Schuyt (1557−1616). It can be heard performed by the Ensemble dell' Anima Eterna, leader Jos van Immerseel, on the outstanding 1989 compilation *Muziek in de Nederlanden van 1100 tot heden*, disc 2, 1600−1700, track 5.

2. For the history of Rembrandt's family's mill ownership, see *RD*, 21ff.

3. J. R. ter Molen, A. P. E. Ruempol, and A. G. A. van Dongen, *Huisraad van een molenaarsweduwe: Gebruiksvoorwerpen uit een 16de eeuw boedelinventaris* (Rotterdam, 1986).

4. Ibid., p. 86.

5. Gerbrand Bredero, *De klucht van de molenaar* (Amsterdam, 1618).

6. H. van Oerle, "De rol van de schansen bij het beleg, 1572−74," in *Leiden '74: Leven in oorlogstijd in de tweede helft van de 16de eeuw* (Leiden, 1974), 32−50.

7. *RD*, 26−27. When her husband died, Lysbeth was left with four children, including Rembrandt's father, Harmen, then aged five or six.

8. Elisabeth de Bièvre, "The Urban Subconscious: The Art of Delft and Leiden," *Art History* 18 (June 1995): 230.

9. See the excellent discussion of these prints, albeit concentrating on the Alvaphobic images, by James Tanis and Daniel Horst in *De tweedracht verbeeld: Prentkunst als propaganda aan het begin van de Tachtigjarige Oorlog* (*Images of Discord: A Graphic Interpretation of the Opening Decades of the Eighty Years' War*) (Bryn Mawr, Pa., and Grand Rapids, Mich., 1993).

10. When I was in Leiden on October 3, 1995, herring and bread ("*met of zonder?* [with or without?]") chopped onions) was being offered, gratis, at the city railway station by the Dutch Railways in return for public patience while renovations were being made to the station and track. The lines were orderly, the fish delectable. No one cheated by coming back for seconds. I had the onions.

11. It would peak at around seventy thousand by the time of Rembrandt's death in 1669.

12. See J. K. S. Moes and B. M. A. de Vries, *Stofuit het Leidse verleden: Zeven eeuwen textielnijverheid* (Utrecht, 1991); also for general details about the city, see the great history chronicle by P. J. Blok, *Geschiedenis eener Hollandsche stad* (The Hague, 1910−18).

13. Ed Taverne, *In 't land van belofte: In de nieuwe stadt, aal en werkelijkheid van de stadsuitleg in de Republiek, 1580−1680* (Maarssen, 1978), 201f.

14. See the map of Leiden in 1600 by Pieter Bast; a detail can be found in *RD*, 44.

15. P. J. M. de Baar and Ingrid W. L. Moerman, "Rembrandt van Rijn en Jan Lievens, inwoners van Leiden," in *Rembrandt en Lievens in Leiden, "een jong en edel schildersduo,"* ed. Christiaan Vogelaar (Zwolle and Leiden, 1991), 26−27.

16. Esaias van de Velde made an extraordinary drawing of the scene. See the catalogue entry in *Dawn of the Golden Age: Northern Netherlandish Art, 1580−1620*, ed. Ger Luijten et al. (Amsterdam and Zwolle, 1993), 618−19.

17. J. G. van Gelder, "Rembrandt's vroegste ontwikkeling," *Mededelingen der Koninklijke Nederlandsche Akademie van Wetenschap, Afdeling Letterkunde* (1953): 34.

18. See Gary Schwartz, *Rembrandt: His Life, His Paintings* (London and New York, 1985), 21.

19. Jan Orlers, *Beschrijvinge der stadt Leyden: Inhoudende 't begin . . .* (Leiden, 1641).

20. See Rik Vos, *Lucas van Leyden* (Bentveld and Maarssen, 1978), 115−18.

21. For these inventories, see Th. H. Lunsingh Scheurleer, C. Willemijn Fock, and A. J. van Dissel, *Het Rapenburg: Geschiedenis van een Leidse gracht* (Leiden, 1996).

22. Ibid., 18.

23. *Geschildert tot Leyden anno 1626*, ed. R. E. O. Ekkert (Leiden, 1976), 17−18.

24. I have explored this theme elsewhere, especially in "Perishable Commodities: Dutch Still-Life Paintings and the Empire of Things," in *Consumption and the World of Goods*, ed. John Brewer (London, 1993), 478−88.

25. See the catalogue note in *Dawn of the Golden Age*, 544.

26. See Marten Jan Bok, "Art-Lovers and Their Paintings: Van Mander's *Schilder-boeck* as a Source for the History of the Art Market in the Netherlands," in *Dawn of the Golden Age*, 150.

27. See Simon Schama, *The Embarrassment of Riches: An Interpretation of Dutch Culture in the Golden Age* (New York, 1987), 104.

28. *RD*, 50.

29. See R. D. Harley, "Artist's Brushes: Historical Evidence from the Sixteenth to the Nineteenth Century," in *Conservation and Restoration of Pictorial Art*, ed. N. Brommelle and P. Smith (London, 1976), 123−29.

30. E. K. J. Reznicek, "Karel van Mander I," in the *Grove Dictionary of Art*, ed. Jane Turner (London and New York, 1996), 20:245. For the complete edited text, see Karel van Mander, *Den grondt der edel vry schilder-const*, ed. and trans. Hessel Miedema, 2 vols. (Utrecht, 1973).

31. Orlers, *Beschrijvinge der stadt Leyden*, 376.

32. There is no agreement on the exact period of Rembrandt's study with Lastman, specified by Orlers as six months, with authorities placing this as early as 1623 and as late as 1626. Since three of Rembrandt's own earliest works—*The Stoning of St. Stephen* (1625), the *"History Painting"* (1626), and *David Presenting the Head of Goliath to Saul* (1627)—are all

closely based on Lastman's own *Coriolanus*, dated 1625, they presuppose Rembrandt's having been in the Breestraat studio either that year or, at the earliest, late the previous year, when Lastman might have been laying in the basic composition for what was one of his most ambitious paintings. But Orlers also says that Rembrandt was in van Swanenburg's studio for three years before going to Amsterdam, which pushes the date of his original apprenticeship back to 1622—two years *after* he was supposed to have registered at, but then abruptly departed from, Leiden University.

Suppose, though, he did *not* drop out of the academy *immediately* (Orlers's text does not mandate such a reading, though it has become canonical in the literature) but spent a year or thereabouts as a student and took articles of apprenticeship with van Swanenburg in 1621. His three apprentice years would then have taken him to 1624, and come Michaelmas he could have made the trip, returning to Leiden in the late winter or early spring of 1625, having seen Lastman at work on the *Coriolanus* as well as other of the Amsterdammer's works—his *Balaam and the Ass*, *The Stoning of St. Stephen* (known to us only through a surviving drawing), and *The Baptism of the Eunuch*, which supplied both the subjects and to some extent the compositional templates for Rembrandt's own earliest histories.

33. For the details of Lastman's life and that of his parents, see Astrid Tümpel, Peter Schatborn, et al., *Pieter Lastman, leermeester van Rembrandt* (*Pieter Lastman, the Man Who Taught Rembrandt*) (Amsterdam and Zwolle, 1991).

34. On these influences as well as many other aspects of Lastman's work, see Kurt Bauch, *Der frühe Rembrandt und seine Zeit* (Berlin, 1960), 51–73.

35. J. G. van Gelder, "A Rembrandt Discovery," *Apollo* 77 (1963): 371–72; see also Martin Wurfbain, catalogue entry on Leiden's 1626 "*History Painting*," in *Geschildert tot Leyden* (1626), 66–68; Schwartz, *Rembrandt*, 37.

36. Bauch, *Der frühe Rembrandt*, 97–98, already recognized that the Leiden "*History Painting*" might be a scene from Tacitus's history, but wrongly identified the principal figure as the Roman general Cerealis, rather than Claudius Civilis. But a virtually identical figure, standing with a group of bearded elders and also holding a scepter, in an undated (though probably later) drawing now in the Morgan Library, has been correctly identified as "pertaining to the revolt of the Batavians." See *RD*, 600.

37. Tacitus, *Histories*, books 4–5, trans. John Jackson (Cambridge, Mass., and London, 1979), 31–33.

38. Ibid., 33.

39. Including himself in the painting may have been a kind of signature, following the precedent of some Italian artists who preferred it to a written signature.

40. Acts 6, 7:55–60.

41. Ibid., 8:26–40.

42. The other versions, in Berlin, Paris (Fondation Custodia-Lugt), and Munich (Alte Pinakothek), were painted in 1608, 1612, and 1620, respectively. See Christian Tümpel, *Rembrandt* (New York, 1993), 57–60.

43. For this iconographic tradition, see Simon Schama, *Landscape and Memory* (New York, 1995), 214.

44. See Franklin Robinson, "A Note on the Visual Tradition of Balaam and His Ass," *Oud Holland* 84 (1969): 167–96.

45. The essential text which makes this argument is Svetlana Alpers, *The Art of Describing* (Chicago, 1983). Alpers also isolates, in my view correctly, Rembrandt as an exception to this general rule.

46. On this theme and the Book of Tobit, see Julius S. Held, "Rembrandt and the Book of Tobit," in *Rembrandt Studies*

(Princeton, 1991), 118–43. Other scholars have also noted Rembrandt's fascination with the theme of blindness: Fritz Saxl, *Lectures* (London, 1957), 308; and most recently Mieke Bal, *Reading Rembrandt: Beyond the Word-Image Opposition* (Cambridge, 1991), especially chapter 9, "Blindness as Insight: The Powers of Horror," 326–60. While I don't altogether agree with Bal's psychoanalytic reading, I have learned an enormous amount from her brave and perceptive observations. The Book of Tobit also features prominently in the powerful and often moving essay written by Jacques Derrida for his exhibition in the "Parti Pris" series at the Louvre, *Mémoires d'aveugle: L'Autoportrait et autres ruines* (Paris, 1990).

47. See also Oswald Galbelkower, *Medecyn-boek*, trans. Carel van Baten (Dordrecht, 1599); also Jacques Guillemeau, *Traité des maladies de l'oeil* (Paris, 1610); Andreas Laurentius, *A Discourse on the Preservation of Sight*, trans. Richard Banister (Montpellier, 1599).

48. See Kahren Jones Hellerstedt, "The Blind Man and His Guide in Netherlandish Painting," *Simiolus* 13 (1983): 163–81.

CHAPTER 6: THE COMPETITION

1. Joaneath A. Spicer and Lynn Federle Orr, eds., *Masters of Light: Dutch Painters in Utrecht During the Golden Age* (New Haven and London, 1997), 379. In his biographical note on Hendrick ter Brugghen, Maarten Jan Bok cites Richard ter Brugghen's memoir of his father, published in 1707, in which the artist's son claims that Rubens said that "on all his travels in the Netherlands he had met only one real painter" (namely, ter Brugghen).

2. Joachim von Sandrart, *L'academia todesca della architectura, scultura, ed pittura, oder, Teutsche Academie* (Nuremberg, 1675–80), 1:291.

3. *LPPR*, 203.

4. Rubens to Dupuy, April 22, 1627, *LPPR*, 176.

5. Rubens to Dupuy, May 13, 1627, *LPPR*, 180.

6. May 28, 1627, *LPPR*, 185.

7. June 10, 1627, *LPPR*, 187.

8. On Catholic culture in Utrecht, see the essay by Benjamin Kaplan, "Confessionalism and Its Limits: Religion in Utrecht, 1600–1650," in Spicer and Orr, eds., *Masters of Light*, 60–71.

9. Sandrart, *Teutsche Akademie*, 1:291.

10. Ibid.

11. *LPPR*, 203.

12. September 23 and October 21, 1627, *LPPR*, 206, 209.

13. September 26, 1627, *LPPR*, 206.

14. Pliny, *Natural History*, trans. H. Rackham (Cambridge, Mass., and London, 1952), 35:36:80, p. 321.

15. Rudolf Dekker is currently working on the history of humor in the Dutch seventeenth century through the exploration of books of jokes, not many of which, it seems, have survived.

16. Karel van Mander, *Het schilder-boeck* (Haarlem, 1604), 104.

17. Jan Orlers, *Beschrijvinge der stadt Leyden: Inhoudende 't begin . . .* (Leiden, 1641), 376.

18. See Peter Schatborn, with contributions by Eva Ornstein–van Slooten, *Jan Lievens: Prints and Drawings* (Amsterdam, 1988).

19. See Victor I. Stoichita, *The Self-aware Image: An Insight into Early Modern Meta-painting*, trans. Anne-Marie Glasheen (Cambridge, 1997), especially 207–15.

20. Pliny, *Natural History*, 35:36:66, pp. 310–11.

21. The story of Rembrandt and Lievens sharing working space has long been dismissed as a legend, but Ernst van de Wetering, "De symbiose van Lievens en Rembrandt," in *Rembrandt en Lievens in Leiden*, "*een jong en edel schilders-duo*," ed. Christiaan Vogelaar (Zwolle and Leiden, 1991), 39–47, argues, in the end not quite convincingly, that it was a fact.

22. Christiaan Vogelaar et al., "Huygens over Rembrandt en Lievens," in Ernst van de Wetering, *Rembrandt en Lievens* (Leiden, 1641), 128–34.

23. Ibid., 134.

24. The translation is based principally on the reading given in ibid., 132–34. But since the English version is itself based on the Dutch version given in C. L. Heesakkers's edition of Constantijn Huygens, *Mijn jeugd* (Amsterdam, 1987), I have gone back to the Latin text for my own occasional amendments and translation suggestions.

25. On the two *Lazarus*es, see Richard Rand, "*The Raising of Lazarus*" *by Rembrandt* (Los Angeles, 1991).

26. For a discussion of the theological issues, see William H. Halewood, *Six Subjects of Reformation Art: A Preface to Rembrandt* (Toronto, 1982), 36–48; also Rand, "*The Raising of Lazarus*," especially 22–23; also Wolfgang Stechow, "Rembrandt's Representations of the Raising of Lazarus," *Los Angeles County Museum of Art Bulletin* 19 (1973): 6–11.

27. I am grateful, again, to Benjamin Binstock for noticing this compositional oddity.

28. This is the order proposed by Binstock, which I find persuasive.

29. See R. W. Scheller, "Rembrandt en de encyclopedische kunstkamer," *Oud Holland* 84 (1969): 81–147.

30. See the excellent account of the evolution of the painting in David Bomford et al., *Art in the Making: Rembrandt* (London, 1988), 36–41. See also C. H. Collins Baker, "Rembrandt's Thirty Pieces of Silver," *Burlington Magazine* 75 (1939): 179–80; Bob Haak, "Nieuwe licht op Judas en de zilverlingen van Rembrandt," in *Album Amicorum J. G. van Gelder* (The Hague, 1973), 155–58.

31. Vogelaar et al., "Huygens over Rembrandt en Lievens," 129, 133.

32. Ibid., 133.

33. P. J. M. de Baar and Ingrid W. L. Moerman, "Rembrandt van Rijn en Jan Lievens, inwoners van Leiden," in van de Wetering, *Rembrandt en Lievens*, 29 n. 33.

34. Karel van Mander, *Den grondt der edel vry schilder-const*, ed. and trans. H. Miedema (Utrecht, 1973), 2:178–9.

35. *Corpus*, 1:263. I have slightly altered the translation of the Latin text.

36. Hofman Hendrik Arie, *Constantijn Huygens (1596–1687): Een christelijk-humanistisch bourgeois-gentilhomme in dienst van het Oranjehuis* (Utrecht, 1983), 86.

37. See the excellent account of the "toleration debate" of the late 1620s in Jonathan Israel, *The Dutch Republic: Its Rise, Greatness and Fall, 1477–1806* (Oxford and New York, 1995), 499–505.

38. D. Nobbs, *Theocracy and Toleration* (Cambridge, 1938), 103–5.

39. Elisabeth de Bièvre, "The Urban Subconscious: The Art of Delft and Leiden," *Art History* 18 (June 1995): 230.

40. John Gregory, "*Two Old Men Disputing* and the Leiden Period," in *Rembrandt in the Collections of the National Gallery of Victoria* (Melbourne, 1988), 21–43.

41. *RD*, 205.

42. Christian Tümpel, *Rembrandt* (New York, 1993), 395; see also idem, "Studien zur Ikonographie der Historien Rem-

brandts. Deutung und Interpretation der Bildinhalte," in *Nederlands Kunsthistorisch Jaarboek* 20 (1969): 181–87.

43. Binstock has argued for Lievens as the author of the Melbourne painting on the stylistic grounds that the flat, indeterminately soft folds of Peter's robe argue more for Lievens than Rembrandt. But the figure of Peter is virtually identical to that of Joseph in the near contemporary *Simeon in the Temple with the Christ Child*, and many passages in the painting—the densely textured brilliant yellow tablecloth, the trace of a highlight along the edge of Paul's lower lip, and the extraordinarily vivid rendering of the chair arm with its exposed stud and another minute highlight falling on its upper edge—argue for the authenticity of Rembrandt's signature.

44. See Peter Schatborn, "Papieren kunst van Rembrandt en Lievens," in van de Wetering, *Rembrandt en Lievens*, especially 66ff.

45. Benjamin Binstock, "Becoming Rembrandt: National, Religious, and Sexual Identity in Rembrandt's History Paintings," Ph.D. dissertation, Columbia University, 1997, p. 248.

46. Jeremiah 52:11.

47. "Helden-Godes, Jeremias, de vroegpreiker," in *Vondel: Volledige dichtwerken en oorspronkelijke proze*, ed. Albert Verwey (Amsterdam, 1937), 120.

48. It's been suggested by Peter Davidson and Adriaan van der Weel that there was a *specific* constancy that Christiaan had in mind, namely, the loyalty of their native Breda to the House of Orange through all the vicissitudes of war and occupation, an argument I find completely persuasive.

49. Quoted in Gary Schwartz, *Rembrandt: His Life, His Paintings* (London and New York, 1985), 91.

50. *LPPR*, 357.

51. Ibid., 360.

52. Ibid.

53. Ibid., 383–84.

54. Ibid., 61.

55. On the Crucifixion paintings, see Kurt Bauch, "Rembrandt's *Christus am Kruez*," *Pantheon* 20 (1962): 137–44; M. Hours, "La Crucifixion du Mas-d'Agenais par Rembrandt," *Revue du Louvre et des Musées de France* 19 (1969): 157–60.

56. For the Tree of Life tradition in doctrine and iconography, see Simon Schama, *Landscape and Memory* (New York, 1995), 185–242. For the Catholic version, see John B. Knipping, *Iconography of the Counter-Reformation in the Netherlands: Heaven on Earth* (Nieuwkoop and Leiden, 1974), 2:465.

57. See, for example, Mary Crawford Volk et al., *Rubenism* (Providence, R.I., 1975), 58–59.

58. See the entry in the *Corpus*, 2:276–88.

59. When Rembrandt engraved his own version of the *Descent*, he changed the self-portrait figure from the John-supporter to the frowning figure halfway up the ladder.

60. There was one other artist who in his graphic work had made the analogy between the creation of art and the journeys of Everyman, and that was Pieter Bruegel the Elder, admired by both Rubens and Rembrandt.

61. H. Perry Chapman, *Rembrandt's Self-portraits: A Study in Seventeenth-Century Identity* (Princeton, 1990), is now the essential monograph on this crucial genre of the artist's output. Though it will be apparent that I don't always concur with all of her conclusions, the extent of my debt to her exceptionally perceptive and erudite discussion ought also to be abundantly clear.

62. Kenneth Clark, *An Introduction to Rembrandt* (London, 1978), 14.

63. Chapman, *Rembrandt's Self-portraits*, 30. For the dark side of artistic genius, see Rudolf and Margot Wittkower, *Born under Saturn: The Character and Conduct of Artists; A Documented History from Antiquity to the French Revolution* (New York and London, 1963); Martin Kemp, "The Super-Artist as Genius: The Sixteenth-Century View," in *Genius: The History of an Idea*, ed. P. Murray (Oxford, 1989), 45.

64. On face-reading, see the exceptionally interesting study by Vicki Bruce and Andy Young, *In the Eye of the Beholder: The Science of Face-Perception* (Oxford, New York, and Tokyo, 1998).

65. Joseph Leo Koerner, *The Moment of Self-portraiture in German Renaissance Art* (Chicago, 1993), especially chapter 5.

66. For such possible images, see the *Corpus*, 1:399ff.

67. Julius S. Held, "Rembrandt's Interest in Beggars," in *Rembrandt Studies* (Princeton, 1991), 153–63; see also Robert Baldwin, "Rembrandt's New Testament Prints: Artistic Genius, Social Anxiety, and the Marketed Calvinist Image," in *Impressions of Faith: Rembrandt's Biblical Etchings*, ed. Shelley K. Perlove (Dearborn, Mich., 1989), 24–71.

68. For the corrective treatment of the idle poor and vagrant, see Simon Schama, *The Embarrassment of Riches: An Interpretation of Dutch Culture in the Golden Age* (New York, 1987), 570–87; also Thorsten Sellin, *Pioneering in Penology: The Amsterdam Houses of Correction in the Sixteenth and Seventeenth Centuries* (Philadelphia, 1944).

69. See Jan van Hout, *Bienfaisance et répression au XVIe siècle: Deux textes néerlandais*, trans. P. Brachin (Paris, 1984).

70. James Howell, cited in John J. Murray, *Amsterdam in the Age of Rembrandt* (Norman, Okla., 1967), 54.

71. Adriaen van de Venne, *Tafereel der belacchende werelt* (The Hague, 1635); modern facsimile edition and annotations by M. van Vaeck (Gent, 1994). The catalogue of rogues appears on pp. 145–54 of the original and on pp. 461–70 of the van Vaeck edition.

72. For this genre, see Sheila Muller, *Charity in the Dutch Republic: Pictures of Rich and Poor for Charitable Institutions* (Ann Arbor, 1985).

73. Vogelaar et al., "Huygens over Rembrandt en Lievens," 135.

CHAPTER 7: AMSTERDAM ANATOMIZED

1. So at least one of the characters in *The Spanish Brabander*, Geeraert Pennyp, claimed.

2. William S. Heckscher, *Rembrandt's "Anatomy of Dr. Nicolaas Tulp"* (New York, 1958), 127 n. 21, cites the organists' contracts, which stipulated recitals outside normal church services as well as the use of churches as places of promenade in bad weather.

3. Twenty stuivers equalled one guilder or florin in most of the Republic's many currencies.

4. Some of this information, including this recipe, is taken from *De verstandige kok: Of sorghvuldige huyshoudster* (Amsterdam, 1683). See the translated edition by Peter Rose, *The Sensible Cook: Dutch Foodways in the Old and New World* (Syracuse, N.Y., 1989). Though this famous and important cookery book dates from much later in the seventeenth century, many of its recipes clearly owe their origins to earlier culinary traditions—more copiously seasoned, however, thanks to the accessibility of East Indian spices and American sugar.

5. Willem A. Brandenburg, "Market Scenes As Viewed by a Plant Biologist," in *Art in History, History in Art: Studies in Seventeenth-Century Dutch Culture*, ed. David Freedberg and Jan de Vries (Santa Monica, Calif., 1987), 69–70. See also, on related matters, Linda Stone-Ferrier, "Market Scenes As Viewed by an Art Historian," in idem, 29–57.

6. W. Th. Kloek, "Over Rembrandt's *Portret van Uyltenbogaert* nu in het Rijksmuseum," *Bulletin van het Rijksmuseum* 4 (1992): 346–52. On the Remonstrant patrons in Amsterdam, see S. A. C. Dudok van Heel, "De remonstrantse wereld van Rembrandt's opdrachtgever Abraham Anthonszn Recht," *Bulletin van het Rijksmuseum* 4 (1994): 334–46.

7. For an exceptionally acute discussion of the issues involved in the construction of portraits, see Richard Brilliant, *Portraiture* (Cambridge, 1991).

8. This was a commission that would cause all the parties involved some grief since Hals refused to go to Amsterdam for a prolonged period to complete the painting.

9. See Raymond H. Fisher, *The Russian Fur Trade, 1550–1700* (Berkeley and Los Angeles, 1943).

10. Ibid., 193.

11. Ibid., 192.

12. Rembrandt evidently needed to rework the contours of Ruts's body on its lower left side, where the line has been thickened, before he was satisfied with the crucial relationship between the figure and its surrounding space.

13. For a close examination of these techniques, see the superb essay by Ernst van de Wetering, "Rembrandt's Method: Technique in the Service of Illusion," in *Rembrandt: The Master and His Workshop* (New Haven and London, 1991), 1:12–30.

14. Ibid., 24–25.

15. In, for instance, the so-called Beresteyn portraits in the Metropolitan Museum in New York, where the treatment of the male figure conforms to virtually all of the standards set by indisputable Rembrandt portraits of this period, but in which the female figure has been widely judged to be awkwardly and formulaically designed and laboriously painted. There is, of course, the possibility that a pupil or assistant might have painted some or all of the woman's portrait.

16. *Corpus*, 2:51; see also H. d[e] l[a] F[ontaine] V[erwey], *Maandblad Amstelodamum* 56 (1969): 177–79.

17. A number of scholars have argued that the dissected arm represented in *The Anatomy Lesson of Dr. Tulp* was based on an illustration in an anatomical book, most probably Adriaen van den Spieghel's *De humani corporis fabrica libri decem*, illustrated by Giulio Casserio and published in Venice in 1627. But in fact, the closest illustration to the Tulp dissection actually shows a severed hand being worked on by the anatomist, and so might equally be invoked to suggest that Rembrandt produced his image from a combination of direct observation at an anatomy and examination of a preserved limb of the kind listed by van Brederode.

18. Heckscher, *Rembrandt's "Anatomy of Dr. Nicolaas Tulp,"* 65ff., argues that Tulp wished to be seen as the "Vesalius Redivivus," a view rejected, perhaps a little too categorically, by the otherwise brilliant and mostly persuasive analysis of William Schupbach, *The Paradox of Rembrandt's "Anatomy of Dr. Tulp"* (London, 1982).

19. I. C. E. Westdorp, "Nicolaes Tulp als medicur," in *Nicolaes Tulp: Leven en werk van een Amsterdams geneesheer en magistraat*, ed. T. Beijer et al. (Amsterdam, 1991), 35.

20. Roy Porter, *The Greatest Benefit to Mankind: A Medical History of Humanity* (London, 1997), 179.

21. For biographical details, see T. Beijer et al., *Nicolaes Tulp*, especially the essays by I. C. E. Westdorp on Tulp's

medical education and career and by S. A. C. Dudok van Heel on his family history and civic and political career.

22. Norbert Middelkoop, " 'Large and Magnificent Paintings, All Pertaining to the Chirurgeon's Art': The Art Collection of the Amsterdam Surgeons' Guild," in Norbert Middelkoop et al., *Rembrandt under the Scalpel: "The Anatomy Lesson of Dr. Nicolaes Tulp" Dissected* (The Hague, 1998), 9–38.

23. Dudok van Heel, "Dr. Nicolaes Tulp Alias Claes Pieterszn.," in Beijer et al., *Nicolaes Tulp*, 49 et seq.

24. Ibid., 59.

25. The authorship of *The Osteology Lesson of Dr. Sebastiaen Egbertsz.* (1619) has been in flux in recent Rembrandt literature, but in the latest publication on this theme, *Rembrandt under the Scalpel: "The Anatomy Lesson of Dr. Nicolaes Tulp" Dissected*, Norbert Middelkoop suggests (albeit tentatively) de Keyser as the more likely author. I agree with his reasoning.

26. Schupbach, *The Paradox of Rembrandt's "Anatomy of Dr. Tulp,"* insists, quite perversely in my view, on Rembrandt's *lack* of originality and his adherence to the double requirement established in the Pickenoy anatomy of Dr. Sebastiaen Egbertszoon (until recently attributed to Thomas de Keyser) that the scientific demonstration be accompanied by a moralizing gesture. But while Rembrandt—who I believe seldom or never deliberately meant to defy his patrons' wishes—certainly fulfilled that prescription in the case of Dr. Tulp, the *manner* in which he did so seems to me to be utterly original, as radical an innovation in the anatomies as Frans Hals's Haarlem militia pieces were in that genre. Here, I echo the exceptionally perceptive account given a century ago by W. Hastie, "Rembrandt's Lesson in Anatomy," *Contemporary Review* (August 1891): 271–7.

27. The classic analysis of Dutch group portraiture is still Alois Riegl, *Das holländische Gruppenporträt* (Vienna, 1931). See also the discussion by Margaret Iversen, *Alois Riegl: Art History and Theory* (Cambridge, Mass., and London, 1993), 93–123; and "Excerpts from the Dutch Group Portrait: Alois Riegl," trans. Benjamin Binstock; and Benjamin Binstock, "Postscript: Alois Riegl in the Presence of the Nightwatch," *October* 74 (Fall 1995): 3–44.

28. The more exclusive quality of the later anatomies may be because a fair number of the surgeons felt that they had already been depicted in earlier paintings.

29. Schupbach, *The Paradox of Rembrandt's "Anatomy of Dr. Tulp,"* 3.

30. I am deeply grateful to Gary Schwartz for pointing out this source.

31. Petria Noble and Jørgen Wadum, "The Restoration of the *Anatomy Lesson of Dr. Nicolaes Tulp,"* in Middelkoop et al., *Rembrandt under the Scalpel: "The Anatomy Lesson of Dr. Nicolaes Tulp" Dissected*, 69.

32. Schupbach's translation from the Latin seems to me a good deal more faithful than the version offered by Heckscher, *Rembrandt's "Anatomy of Dr. Nicolaas Tulp,"* 112–13.

33. After a lengthy (and to the medically unlearned) esoteric debate about the accuracy of Rembrandt's anatomical depiction, in which he had been accused of serious errors, M. P. Carpentier Alting and Tj. W. Waterbolk, "Nieuw licht op de anatomie van de *Anatomische les van Dr. Nicolaas Tulp,"* *Oud Holland* 92 (1978): 43–48, together with their colleagues at the Laboratory for Anatomy and Embryology at Groningen University, have conclusively proved that his representation is, in fact, anatomically correct. This makes a great deal more sense, as it would be difficult to imagine

Tulp, a notorious stickler for accuracy, who we know from van Meekeren (see above, note 19) often dissected the forearm, approving of the painting otherwise.

34. Here again I follow Schupbach's excellent translation, *The Paradox of Rembrandt's "Anatomy of Dr. Tulp,"* 49, with appendix, 85–89.

CHAPTER 8: BODY LANGUAGE

1. Another of Anthonie Coopal's subsequent titles was "Marquis of Antwerp," the title he requested from the Stadholder as the price for bringing about that city's surrender not through force of arms but by bribing the garrison.

2. The projection through the picture space may have owed something to Frans Hals's 1625 portrait of the Remonstrant scholar-historian Petrus Scriverius (or Jan van de Velde II's engraving of it), since Rembrandt had known Scriverius in Leiden.

3. Jan de Vries, *The Dutch Rural Economy in the Golden Age* (New Haven, 1974).

4. Gary Schwartz, *Rembrandt: His Life, His Paintings* (London and New York, 1985), 141.

5. H. F. Wijnman, *Uit de kring van Rembrandt en Vondel: Verzamelde studies over hun leven en omgeving* (Amsterdam, 1959), 5.

6. B. P. J. Broos, review of *RD*, *Simiolus* 12 (1981–82): 250.

7. Ibid., 142.

8. H. F. Wijnman, "Rembrandt als Huisgenoot van Hendrick Uylenburgh te Amsterdam (1631–1635): Was Rembrandt doopsgezind of libertijn?" in Wijnman, *Uit de kring*, 14. Wijnman also points out that van Uylenburgh's business was constantly cash-hungry. In 1640, when he was in serious financial straits, he made a notarized declaration that some eighteen persons had lent him funds for his business and dealership. Most of these were Mennonites to whom, not infrequently, van Uylenburgh offered works of art or etching plates either as collateral or in outright exchange for funds.

9. Filippo Baldinucci, *Notizie de' professori del desegno . . .* (Florence, 1728), 6:511.

10. *RD*, 1632/2, 87.

11. Arnold Houbraken, *De groote schouburgh der Nederlantsche konstchilders en schilderessen . . .* (Amsterdam, 1719), 2:19.

12. For Flinck, see J. W. von Moltke, *Govaert Flinck* (Amsterdam, 1965), and *Govert Flinck, der kleefsche Apelles, 1616–1660: Gemälde und Zeichnungen* (Cleve, 1965). For both Flinck's and Rembrandt's many other pupils, see the exhaustive catalogue and monograph study by Werner Sumowski, *Gemälde der Rembrandt-Schüler*, 5 vols. (Landau, 1983–90).

13. Much confusion has been caused by the fact that the date on which the wedding at St. Annaparochie was recorded was June 22, 1634. But Friesland still used the old Julian calendar, and according to the new Gregorian calendar used in Holland, the date would have been July 4.

14. *RD*, 1634, 11.

15. Donald Haks, *Huwelijk en gezin in Holland in de 17de en 18de eeuw* (Assen, 1982), 111–12. For similar practices in early modern Britain, see Lawrence Stone, *The Family, Sex and Marriage in England, 1500–1800* (New York, 1977).

16. Ernst van de Wetering, *Rembrandt: The Painter at Work* (Amsterdam, 1997), 47ff. Van de Wetering, p. 70, also points out that two other silverpoint drawings by Rembrandt survive—both roughly drawn landscapes, very much the kind of thing he might have done "on the road."

17. Karel van Mander, *Den grondt der edel vry schilder-const* (Haarlem, 1604), fol. 25, para. 28.

18. On the "red door," see Sebastian A. C. Dudok van Heel, *Dossier Rembrandt: Documenten, tekeningen en prenten* (*The Rembrandt Papers: Documents, Drawings and Prints*) (Amsterdam, 1987), 25.

19. Broos, review of *RD*, 255.

20. On the iconography of Flora, see Julius S. Held, "Flora, Goddess and Courtesan," in *De Artibus Opuscula XL: Essays in Honour of Erwin Panofsky*, ed. Millard Meiss (New York, 1961), 201–18.

21. In 1644 Constantijn Huygens published a rather snide poem complaining of Rembrandt's failure to portray a true likeness of his friend Jacques de Gheyn III. See p. 513.

22. M. Louttit, "The Romantic Dress of Saskia van Ulemborch: Its Pastoral and Theatrical Associations," *Burlington Magazine* 115 (April 1973): 317–26. See also, on pastoral dress and literature, Alison McNeil Kettering, "Rembrandt's *Flute Player*: A Unique Treatment of Pastoral," *Simiolus* 9 (1977): 19–44, especially 22–27.

23. Van Mander, *Grondt*, fol. 17, para. 32.

24. See the catalogue entry in *Dawn of the Golden Age: Northern Netherlandish Art, 1580–1620*, ed. Ger Luijten et al. (Amsterdam and Zwolle, 1993), no. 255, 583–84; also E. de Jongh, *Portretten van echt en trouw: Huwelijk en gezin in de Nederlandse Kunst van de zeventiende eeuw* (Zwolle and Haarlem, 1986), 270–71.

25. On the expected goals and purposes of marriage in the seventeenth-century Netherlands, see Haks, *Huwelijk en gezin*, 105ff.; see also Simon Schama, *The Embarrassment of Riches: An Interpretation of Dutch Culture in the Golden Age* (New York, 1987), chapter 6, especially 386–427.

26. On fans, gloves, and many other aspects of the pair portrait, see David R. Smith, *Masks of Wedlock: Seventeenth-Century Dutch Marriage Portraits* (Ann Arbor, 1982), especially chapters 4–6.

27. *Corpus*, 2:740–59.

28. Jacob Cats, *Houwelijck* (Amsterdam, 1625), 51–52; see also Schama, *Embarrassment of Riches*, 420–21.

29. In some cases, like the late-fifteenth-century *Portrait of the Unknown Couple* by the Amsterdam artist Dirk Jacobsz., worldly and unworldly roles are not allotted by gender but are nonetheless present in the work. In Jacobsz.'s painting, an hourglass sits on a table beside a pile of gold coins while the wife points conspicuously at another standard symbol of mortality, the scale. Her husband uses one hand to point to the hourglass, another to a background painting of a skull and landscape with the Crucifixion. See de Jongh, *Portretten van echt en trouw*, catalogue no. 11, 98–101.

30. Jane Campbell Hutchinson, "Quinten Metsys," in *Grove Dictionary of Art*, ed. Jane Turner (London and New York, 1996), 21:355.

31. The moral significance of the scales in Metsys's work seems reinforced by the fact that when Alexander van Fornenbergh saw the painting in its original frame in the collection of Pieter Stevens in Antwerp in 1658, it bore an inscription from Leviticus 19:36—"Just balances, just weights, a just ephah, and a just hin, shall ye have"—an allusion that could refer just as well to the division between worldly and unworldly matters as to the state of marriage itself, all themes that in turn had been intensely examined by Jan van Eyck, whose (lost) painting of 1440 of "a gentleman going over his accounts with an agent" may have been the starting point for Metsys as well as for other variants of the theme, such as Marinus van Reymerswaele's double studies of usurers and money changers. See L. Silver, *The Paintings of Quinten Massys with Catalogue Raisonné* (Montclair, N.J., 1984), 137–8.

32. *Corpus*, 2:373.

33. Ibid., 3:146.

34. I. Bergstrom, "Rembrandt's Double-Portrait of Himself and Saskia at the Dresden Gallery: A Tradition Transformed," *Nederlands Kunsthistorisch Jaarboek* 17 (1966): 143–69.

35. This is precisely what the guards in the Rijksmuseum *did* do in 1989–90, in the immediate aftermath of an acid attack, thereby averting a similar catastrophe.

36. See Tatiana Pavlovna Aleschina, "Some Problems Concerning the Restoration of Rembrandt's Painting *Danaë*," in *Rembrandt and His Pupils*, ed. Görel Cavalli-Björkman (Stockholm, 1993), 223–33. My own information about the vandalism and its aftermath, as well as the strategies of restoration, comes from conversations with Irina Alexeevna Sokolowa, the curator of Dutch paintings at the Hermitage, and the chief restorer, E. Gerassimov, who were both kind enough to let me inspect the painting in the laboratory before its return to public display. I am also most grateful to the director of the Hermitage, Professor Mikhail Pietrovsky, for granting me access to the painting.

37. Louis Viardot, *Les Musées d'Angleterre, de Belgique, de Hollande et de Russie* (Paris, 1860), 319.

38. Cited in David Freedberg, "Johannes Molanus on Provocative Paintings," *Journal of the Warburg and Courtauld Institutes* 34 (1971): 229–45.

39. In particular Christian Tümpel, *Rembrandt* (New York, 1993), 181–82, in turn quoting E. Kieser, "Über Rembrandts Verhältnis zur Antike," *Zeitschrift für Kunstgeschichte* 10 (1941–44): 129–62.

40. Erwin Panofsky, "Der gefesselte Eros: Zur Genealogie von Rembrandts *Danaë*," *Oud Holland* 50 (1933): 193–217; now translated by Peter Worstman as "Eros Bound: Concerning the Genealogy of Rembrandt's *Danaë*," in *German Essays on Art History*, ed. Gert Schiff (New York, 1988), 255–75. On this debate, see also Madlyn Millner Kahr, "*Danaë*: Virtuous, Voluptuous, Venal Woman," *Art Bulletin* 60 (1978): 43–55.

41. *Corpus*, 2:218.

42. Karel van Mander, *The Lives of the Illustrious Netherlandish and German Painters*, 1:376–9.

43. "Dees naakte kan een god bekoren." Joost van den Vondel, "Op Bleker's Danaë," in *Volledige dichtwerken en oorspronkelijk proza*, ed. Albert Verwey (Amsterdam, 1937), 942.

44. Joh. Episcopius [Jan de Bisschop], *Paradigmata Graphices Variorum Artificium: Voor-Beelden der teken-konst van verscheyde meesters* (The Hague, 1671). See also Seymour Slive, *Rembrandt and His Critics* (The Hague, 1953; reprint, New York, 1988), 83.

45. Pels's text is reproduced in its entirety in Slive, *Rembrandt and His Critics*, 210–11.

46. François-Edmé Gersaint, *Catalogue raisonné de toutes les pièces qui forment l'oeuvre de Rembrandt* (Paris, 1751), 156.

47. Kenneth Clark, *Rembrandt and the Italian Renaissance* (London, 1966), 10.

48. Pliny, *Natural History*, trans. H. Rackham (Cambridge, Mass., and London, 1952), 35:36: 64–5, pp. 308–9.

49. It seems, then, that Rubens's decision, in Christopher White's words (*Peter Paul Rubens: Man and Artist* [New Haven, 1987], 276), to provide Juno "with a more elegant pose and more graceful expression" only applied from the neck up.

50. *RD*, no. 239, 1656/12, 373.

51. Erik J. Sluijter, "Rembrandt's Early Paintings of the Female Nude: *Andromeda* and *Susanna*," in G. Cavalli-Björkman, *Rembrandt and His Pupils*, 31–54. I follow Dr. Sluijter's argument here. His discussion of voyeurism in Rembrandt's nudes coincides with my own set out in "Rembrandt and Women," *Bulletin of the American Academy of Arts and Sciences* 38 (April 1987): 21–47, as well as in my 1992 BBC television program, "Rembrandt: The Private Gaze."

52. See Christian Tümpel, "Studien zur Ikonographie der Historien Rembrandts: Deutung und Interpretation der Bildinhalte," *Nederlands Kunsthistorisch Jaarboek* 20 (1969): 160–63.

53. Sluijter, "Rembrandt's Early Paintings," 39.

54. Elizabeth McGrath, "Rubens's *Susanna and the Elders* and Moralizing Inscriptions on Prints," in *Wort und Bild, in der niederländischen Kunst und Literatur des 16 und 17 Jahrhunderts* (Erfstadt, 1984), 84.

55. Dirck Raphael Camphuyzen, translation of Geesteranus's *Idololenchus*, in Camphuyzen, *Stichtelyke rymen* (Amsterdam, 1644), 218.

56. Joost van den Vondel, "Op een Italiaanse schilderij van Susanne," in *Volledige dichtwerken*, 942.

57. Mieke Bal, *Reading Rembrandt: Beyond the Word-Image Opposition* (Cambridge, 1991), 141ff., apropos of another image, writes that Rembrandt "thematizes the issue of voyeurism without catering to it."

58. I am grateful to Talya Halkin for pointing out the two "self-struggles" proceeding simultaneously. See also Bal, *Reading Rembrandt*, 181ff. Bal argues that the direction of Joseph's "gaze" is backward, toward the proffered belly and vagina. But it seems to me more logical, and certainly more typical of Rembrandt's compositional cunning in this period, to read the gestures of Joseph's hands as *shielding* his eyes from the corrupting spectacle.

59. *Dawn of the Golden Age*, catalogue no. 7, 337–38; van Mander, *Grondt*, fol. 293 recto.

60. M. Roscam Abbing, "Houbraken's onbeholpen kritiek op de Rembrandt-ets *De Zondefal*," *Kroniek van het Rembrandthuis* 46 (1994): 14–23.

61. Gersaint, *Catalogue raisonné*, 18.

62. See John B. Knipping, *Iconography of the Counter-Reformation in the Netherlands: Heaven on Earth* (Nieuwkoop and Leiden, 1974), 1:63.

63. Albert Blankert, "Looking at Rembrandt, Past and Present," in *Rembrandt: A Genius and His Impact*, exhibition catalogue (Melbourne, Sydney, and Zwolle, 1997), 36–38.

64. See Richard Bernheimer, *Wild Men in the Middle Ages: A Study in Art, Sentiment and Demonology* (Cambridge, 1952); Timothy Husband, *The Wild Man: Medieval Myth and Symbolism* (New York, 1980); Simon Schama, *Landscape and Memory* (New York, 1995), 96–97.

65. The Royal Council, in its recommendation to the King, had specifically alluded to the honor done Titian. See White, *Rubens*, 24.

66. *CR*, 6:35; see also White, *Rubens*, 244.

67. Rubens to Peiresc, December 18, 1634, *LPPR*, 392–93.

68. For the detailed program, see John Rupert Martin, *The Decorations for the Pompa Introitus Ferdinandi (Corpus Rubenianum L. Burchard)*, vol. 16 (London, 1972).

69. December 18, 1634, *LPPR*, 393.

70. *CR*, 4:151; see also J. G. van Gelder, "Rubens in Holland in de zeventiende eeuw," *Nederlands Kunsthistorisch Jaarboek*, 1950–51, 3:142.

71. *Corpus*, 1:371. See also Julius S. Held, "Rembrandt and

the Classical World," in *Rembrandt after Three Hundred Years: A Symposium—Rembrandt and His Followers* (Chicago, 1973), 59; see also Clark, *Rembrandt and the Italian Renaissance*, 8.

72. The print is by Aegidius Sadeler.

73. See van Gelder, "Rubens in Holland," 103–50. For Rembrandt's debt to Caravaggio and other Italian antecedents, see J. Bruyn, "Rembrandt and the Italian Baroque," *Simiolus* 4 (1970), 28–48.

74. Vaenius [Otto van Veen], *Amoris Divini Emblemata* (Antwerp, 1615). See also Knipping, *Iconography*, 1:51–54.

75. For this interpretation and other elements of the iconography, see Margarita Russell, "The Iconography of Rembrandt's *Rape of Ganymede*," *Simiolus* 9 (1977): 5–18.

76. Clark, *Rembrandt and the Italian Renaissance*, 12.

77. Russell, "The Iconography of Rembrandt's *Rape of Ganymede*," 12–14.

78. Susan Donohue Kuretsky, "Rembrandt's *Good Samaritan* Etching: Reflections on a Disreputable Dog," in *Shop Talk: Studies in Honor of Seymour Slive Presented on His Seventy-fifth Birthday*, ed. C. P. Schneider et al. (Cambridge, 1995), 150–53.

79. Ibid., 151.

80. Peter Schatborn, "Over Rembrandt en kinderen," *Kroniek van het Rembrandthuis* 27 (1975): 9–19.

81. Jan Harmensz. Krul, *Wereld-hatende nootzakelijke* (Amsterdam, 1627). See also Schama, *Embarrassment of Riches*, 331–32.

82. *Dawn of the Golden Age*, 383–86.

83. Tümpel, "Studien zur Ikonographie," 163; for Huydecoper's inventory, see Schwartz, *Rembrandt*, 138.

84. See Bal, *Reading Rembrandt*, 286ff.; also Volker Manuth, "Die Augen des Sünders: Überlegungen zu Rembrandts *Blendung Simsons* von 1636 in Frankfurt," *Artibus et Historiae* 11 (1990): 90–169.

85. See the excellent discussion of pictorial violence and the *exemplum doloris* in Elizabeth Cropper and Charles Dempsey, *Nicolas Poussin: Friendship and the Love of Painting* (Princeton, 1996), 275ff.

86. Constantijn Huygens, *Mijn jeugd*, trans. and ed. C. L. Heesakkers (Amsterdam, 1987), 80.

87. On the *Prometheus*, see the catalogue entry by Peter Sutton in *The Age of Rubens* (Boston, 1993–94), 238–41; also idem, " 'Tutti finiti con amore': Rubens's *Prometheus Bound*," in *Essays in Northern European Art Presented to Egbert Haverkamp-Begemann* (Doornspijk, 1983), 270–75; Julius S. Held, "*Prometheus Bound*," *Philadelphia Museum of Art Bulletin* 59 (1963): 17–32; Charles Dempsey, "Euanthes Redivivus: Rubens's *Prometheus Bound*," *Journal of the Warburg and Courtauld Institutes* 30 (1967): 420–25.

88. Another possible source was Cornelis Cornelisz. van Haarlem's 1588 drawing of *Tityus*, or the copy made by Jan Muller. See *Dawn of the Golden Age*, 333–34.

89. See Ernst van de Wetering, "Rembrandt's Manner: Technique in the Service of Illusion," in the exhibition catalogue *Rembrandt: The Master and His Workshop* (New Haven and London, 1991), 1:32–33. Van de Wetering quotes Samuel van Hoogstraten, writing in 1678, to the effect that while the axiom that light passages advance and darker passages recede was still very much operative in the seventeenth century, there were, in fact, instances of the opposite perceptible in nature, as when, for example, the brilliance of the sun was perceived as distant, and the dark image of a fish beneath water appeared darker the closer it was to the surface. On this subject, see also Ernst Gombrich, "Light, Form and Texture in Fifteenth-Century Painting North and South

of the Alps," in *The Heritage of Apelles* (Oxford, 1976), 19–35.

90. H. Gerson, *Seven Letters by Rembrandt* (The Hague, 1961), 53–4.

91. Beneventus Grassus, *De Oculis Eorumque Egritudinibus et Curis*, ed. and trans. Casey A. Wood (Stanford and London, 1929), 59–60. First published in Ferrara in 1474, Beneventus's treatise was the model for subsequent ophthalmological manuals through the next two centuries and emphasized the relationship between a predisposition to melancholia (the artist's humor) and optical diseases, especially *muscae volitantes*, in which "the spirit of vision is unable to find its way to the eye and this obstruction shows itself as flies flying through the air," and *ungula*, which destroyed sight completely unless removed with silver needles inserted beneath the obstruction.

92. J. F. M. Sterck, "Charles de Trello en zijne dochter Lucretia," *Oud Holland* 5 (1887): 275–94. The most complete recent discussion of the poem is C. W. de Kruyter, *Constantijn Huygens' "Ooghentroost": Een interpretatieve studie* (Meppel, 1972).

93. An opposite view of Huygens, which places optical clarity and description at the heart of his concerns, can be found in Svetlana Alpers, *The Art of Describing* (Chicago, 1983), 1–4.

94. Quoted in Jacques Derrida, *Memoirs of the Blind: The Self-portrait and Other Ruins*, trans. P. Brault and M. Naas (Chicago, 1993), 131.

95. Joost van den Vondel, *Koning Edipus: Uit Sofokles treurspel* (Amsterdam, 1660); *Samson of heilige wraak* (Amsterdam, 1660).

96. John Milton, *Samson Agonistes* (London, 1671), lines 1686–91.

97. Ernst van de Wetering, *Rembrandt: The Painter at Work* (Amsterdam, 1997), 160, makes the important and marvelously paradoxical point that Rembrandt was in fact the founder of *both* the *fijnschilder* school of high-finish painting exemplified by his very first student, Gerard Dou, *and* its opposite: the broken-stroke, expressive, impasto-heavy manipulation of paint that he conspicuously favored (though not to the complete exclusion of smoother, more fluid passages) in his last decade.

98. Georg Bartisch, *Ophthalmoduleia: Das ist Augendienst*, 2d ed. (Dresden, 1583).

99. M. H. Heinemann and H. C. Pinelle-Staehle, "Rembrandt van Rijn and Cataract Surgery in Seventeenth-Century Amsterdam," *Historia Ophthalmologica Internationalis* 2 (1991): 118–43.

100. The classic discussion of Rembrandt's many treatments of the story is Julius S. Held, "Rembrandt and the Book of Tobit," in his *Rembrandt Studies* (Princeton, 1991), 118–43.

101. *RD*, 147. The site of the house, its view of the Amstel long obstructed by a row of houses built on land reclaimed from the river in 1660, is Zwanenburgerstraat 41.

102. On the Portuguese Jewish trade with Brazil, see Jonathan Israel, "The Economic Contribution of Dutch Sephardic Jews to Holland's Golden Age 1595–1713," *Tijdschrift voor Geschiedenis* 19 (1983): 505–35; Daniel M. Swetchinski, "Kinship and Commerce: The Foundations of Portuguese Jewish Life in the Seventeenth Century," *Studia Rosenthaliana* 15 (1981): 52–74; idem, *The Portuguese Jewish Merchants of Seventeenth-Century Amsterdam*, Ph.D. dissertation, Brandeis University, 1981.

103. A. M. Vaz-Dias, "Rembrandt en zijn Portugees-Joodsche Buren," *Amstelodamum* 19 (1932): 10; see also the excellent account of Vlooienburg in Steven M. Nadler, *Spinoza: A Life* (Cambridge, 1999). I am grateful to Professor Nadler for allowing me to see the manuscript of his book.

104. Elizabeth Cornwell, in a paper entitled "Rembrandt and Amsterdam's Jews: An Analysis of the Historical Record," written for the Rembrandt seminar at Columbia University taught by myself and David Freedberg in the spring of 1996, made this point at persuasive length. I am grateful to her for her insights on the subject.

105. Rembrandt's phrase was *"ruym half gedaen sijn,"* the operative word being *"ruym,"* which had a certain elasticity built into it and which could be understood as "around" *or* "at least." For the full text see *RD*, 1636/1, 129. The original letter is in the Houghton Library, Harvard University. See also (and for the other six letters to Huygens) H. Gerson, *Seven Letters by Rembrandt*, The Hague, 1961.

106. Van Gelder, "Rubens in Holland," art cit., 142–3. For Rubens's self-incorporation into his late love-imagery see the fine study by Svetlana Alpers, *The Making of Rubens* (New Haven, 1995).

107. *RD*, 1636/2, 133.

108. *Corpus*, 3:287.

109. Here, I obviously disagree with the account given by Gary Schwartz, *Rembrandt*, 117, who argues that Rembrandt behaved with "a minimum of consideration towards Huygens and the stadholder."

110. Schwartz, 116. See also Bomford, *Rembrandt: Art in the Making*, 66.

111. Ibid. Quoted by Christian Tümpel in *Gods, Saints and Heroes: Dutch Painting in the Age of Rembrandt*, exhibition catalogue, Rijksmuseum and National Gallery of Art, Amsterdam and Washington, D.C., 1980. I am grateful to Jackie Jung for bringing this reference to my attention.

112. John Gage, "Note on Rembrandt's *Meeste end die Natureelste Beweechgelijkheit*," *Burlington Magazine* 111 (1969): 381; see also *RD*, 162.

113. *RD*, 161.

114. Ibid., 165.

115. Ibid., 1639/3, 165.

116. Ibid., 1639/4, 167.

117. Ibid., 1639/5, 171 (author's translation).

118. Ibid., 1639/7, 173 (author's translation).

CHAPTER 9: CROSSING THE THRESHOLD

1. David Freedberg, *Peter Paul Rubens: Oil Paintings and Oil Sketches* (New York, 1996), 77–79.

2. On the productivity of Rubens's last years, see Christopher White, "Rubens and Old Age," *Allen Memorial Art Museum Bulletin* 35 (1977–78): 40–56.

3. *LPPR*, 413–14.

4. Ibid., 413.

5. Ibid., 411.

6. Ibid., 415.

7. Both paintings can be seen and compared in the Kunsthistorisches Museum in Vienna.

8. See pp. 558–62.

9. For the will, see E. Bonnaffe, "Documents inédits sur Rubens," *Gazette des Beaux-Arts* 6 (Paris, 1891): 204–210.

10. Max Rooses, *Rubens*, trans. Harold Child (Philadelphia and London, 1904), 619.

11. Quoted in Jonathan Brown, *Kings and Connoisseurs: Collecting in Seventeenth-Century Europe* (Princeton, 1995), 123.

12. Ibid.

13. Ibid., 629–30.

14. *LPPR*, 406.

15. I. H. van Eeghen, "Rubens en Rembrandt kopen van de familie Thijs," *Maandblad Amstelodamum* (May–June, 1977): 59–62; see also Gary Schwartz, *Rembrandt: His Life, His Paintings* (London and New York, 1985), 202–3.

16. John Michael Montias, *Artists and Artisans in Delft: A Socio-Economic Study of the Seventeenth Century* (Princeton, 1982), 120.

17. *RD*, 1639/1, 159.

18. Ibid., 1638/5, 153.

19. Ibid., 152. Rembrandt does not seem to have appeared in person to argue his case before the court in Leeuwarden, but was represented by another van Uylenburgh, Ulricus the lawyer. The case was, then, very much a battle of Mennonite in-laws. One feels for poor Hiskia, caught in the middle.

20. Philips Angel, *Lof der schilderkunst* (Leiden, 1642); see also *RD*, 1641/5, 211.

21. *RD*, 1656/12, 351. For the list of the contents of the house that follows, see the full inventory published in *RD*, 349–88.

22. On the importance of this competition, see Ernst van de Wetering, *Rembrandt: The Painter at Work* (Amsterdam, 1997), 82ff.

23. R. W. Scheller, "Rembrandt en de encyclopedische kunstkamer," *Oud Holland* 84 (1969): 81–147.

24. *RD*, 385.

25. Ibid., 367.

26. Scheller, "Rembrandt en de encyclopedische kunstkamer," 121–2.

27. The Callot examples included not only his *Beggars*, on which Rembrandt drew for his own studies in the early 1630s, but rarer and more specialized volumes like Bernardo Amico da Gallipoli's *Trattato delle plante & immagini de sacri edifizi di terra santa*, published in Florence in 1620 with forty-six prints by Callot.

28. S. A. C. Dudok van Heel, *Dossier Rembrandt: Documenten, tekeningen en prenten* (*The Rembrandt Papers: Documents, Drawings and Prints*) (Amsterdam, 1987), 77.

29. Not least by Giorgio Vasari. See Patricia Lee Rubin, *Giorgio Vasari: Art and History* (New Haven, 1995), 393.

30. The case that Rembrandt adapted the Titian *Ariosto* into a statement of painting's superiority over poetry is made by E. de Jongh in "The Spur of Wit: Rembrandt's Response to an Italian Challenge," *Delta* 12 (Summer 1969): 49–67.

31. For van den Valckert's *Portrait of a Man with a Ring*, see *Dawn of the Golden Age: Northern Netherlandish Art, 1580–1620*, ed. Ger Luijten et al. (Amsterdam and Zwolle, 1993), catalogue no. 267, 594–95. The Hals *Portrait of a Man with a Medal* is in the Brooklyn Museum, New York; the Gerrit Pietersz. in the Gemeentemuseum, The Hague.

32. On the issue of framing and its subversion, see the interesting discussion in Victor I. Stoichita, *The Self-aware Image: An Insight into Early Modern Meta-painting*, trans. Anne-Marie Glasheen (Cambridge, 1997), 30–63. Stoichita offers a number of examples from still-life painting and especially an astonishing Porcellis *Tempest*, now in Munich, in which painted frames serve to destabilize the assumed separation between spectator and representation.

33. Jan Emmens, "Ay Rembrant, maal Cornelis stem," reprinted in *Kunst Historische Opstellen* (Amsterdam, 1981), argued that Vondel was actually issuing a confrontational challenge on behalf of the poetic forces engaged in the perennial *paragone* with painting. It seems extremely unlikely, however, that Vondel or Rembrandt would have wanted to get into a serious dispute over which art better served the same patron.

34. J.-C. Klamt, "Ut Magis Luceat: Eine Miszelle zu Rembrandt's *Anslo*," *Jahrbuch der Berliner Museen* 17 (1975): 155–65.

35. For a full discussion of these problems, see *Corpus*, 3:346–55; also F. Schmidt-Degener, "Rembrandts *Eendracht van het land* opnieuw beschouwd," *Maandblad voor Beeldende Kunsten* 18 (1941): 161–73; J. D. M. Cornelissen, *Rembrandt's "Eendracht van het land"* (Nijmegen, 1941); J. G. van Gelder, "Rembrandt and His Time," in *Rembrandt after Three Hundred Years: A Symposium—Rembrandt and His Followers* (Chicago, 1973), 3–18.

36. Samuel van Hoogstraten, *Inleyding tot de hooge schoole der schilderkonst, anders De zichtbare werelt* (Rotterdam, 1678), 176. See also Celeste Brusati, *Artifice and Illusion: The Art and Writing of Samuel van Hoogstraten* (Chicago and London, 1995), 246–48; Egbert Haverkamp-Begemann, *Rembrandt: The Night Watch* (Princeton, 1982), 66–67.

37. Eugène Fromentin, *The Old Masters of Belgium and Holland* (translation of *Les Maîtres d'autrefois*), trans. Mary C. Robbins (Boston, 1883), 246.

38. Hoogstraten, *Inleyding tot de hooge schoole*, 190.

39. Ibid., 176.

40. Haverkamp-Begemann, *Rembrandt: The Night Watch*, 30.

41. Fromentin, *The Old Masters of Belgium and Holland*, 249.

42. Clement Greenberg, "Modernist Painting," in *Modernism with a Vengeance, 1957–1969*, vol. 4 of *Clement Greenberg: The Collected Essays and Criticism*, ed. John O'Brian (Chicago and London, 1993), 85–93.

43. Karel van Mander, *Den grondt der edel vry schilder-const* (Haarlem, 1604), 258–9.

44. For the gallery at the back of Rembrandt's house, see Dudok van Heel, *Dossier Rembrandt*, 48–51. Evidence for the gallery is provided in the contract of sale of the property to the rear of Rembrandt's house, transferred from the surgeon Adriaen Cornelisz. to a Portuguese Marrano, Diego Dias Brandão, in September 1643.

45. See the catalogue by B. J. P. Broos, no. 82, in *Rembrandt: A Genius and His Impact* (Melbourne, Sydney, and Zwolle, 1997), 348; also B. Bijtelaar, "Het graf van Saskia," *Maandblad Amstelodamum* 40 (1953): 50–52.

46. For the details of Rembrandt's mother's estate, see *RD*, 191–201.

47. Ecclesiastes 9:12.

48. E. de Jongh, "Erotica in vogelperspectief: De dubbelzinnigheid van een reeks 17de eeuwse genrevoorstellingen," *Simiolus* 3 (1968): 22–74.

49. *RD*, 223–25.

50. On the fifth of January 1642, the eve of the Feast of Epiphany. See the family album of Saskia's nephew, Rombertus Ockema, in *RD*, 225–27.

51. In 1647 Rembrandt did, in fact, make an inventory of Saskia's estate at the time of her death five years earlier. The valuation figure is known from a later document of 1659. See *RD*, 1647/6, 255.

52. For the complicated history of the Kassel *Portrait of Saskia*, see *Corpus*, 2:424–39.

CHAPTER 10: EXPOSURES

1. *A Selection of the Poems of Sir Constantijn Huygens* (1596–1687), ed. and trans. Peter Davidson and Adriaan van der Weel (Amsterdam, 1996), 93.

2. Constantijn Huygens, "Daghwerck" and "Huys-raedt," in ibid., 747–49, 753.

3. For discussions of the drawing, see Jan Emmens, *Rem-*

brandt en de regels van de kunst (Amsterdam, 1979), 202-8; Michiel Roscam Abbing, "De ezelsoren in Rembrandt's satire op de kunstkritiek," *Kroniek van het Rembrandthuis* 45 (1993): 18-21; and, most recently and most thoroughly, Ernst van de Wetering, "Rembrandt's *Satire on Art Criticism* Reconsidered," in *Shop Talk: Studies in Honor of Seymour Slive Presented on His Seventy-fifth Birthday*, ed. C. P. Schneider et al. (Cambridge, 1995), 264-70.

4. Pliny, *Natural History*, trans. H. Rackham (Cambridge, Mass., and London, 1952), 35:36: 85, p. 325.

5. Ernst van de Wetering, "Rembrandt's *Satire*," 266; Samuel van Hoogstraten, *Inleyding tot de hooge schoole der schilderkonst, anders De zichtbare werelt* (Rotterdam, 1678), 197-98.

6. Josua Bruyn, "Rembrandt's Workshop: Its Function and Production," in *Rembrandt: The Master and His Workshop* (New Haven and London, 1991), 1:79.

7. Arnold Houbraken, *De groote schouburgh der Nederlantsche konstschilders en schilderessen* (Amsterdam, 1719), 2:20-21.

8. Eva Ornstein-van Slooten and Peter Schatborn, *Bij Rembrandt in de leer (Rembrandt as Teacher)* (Amsterdam, 1984); see also Peter Schatborn, *Dutch Figure Drawings from the Seventeenth Century* (The Hague, 1981), especially 22ff.

9. Willem Goeree, *Inleydinge tot de al-ghemeene teyckenkonst* (Middelburg, 1668), 32.

10. Ibid., 25.

11. For some other examples of Renesse's drawings corrected by Rembrandt, see Eva Ornstein-van Slooten and Peter Schatborn, *Bij Rembrandt in de Leer*, 40-43.

12. Pliny, *Natural History*, 35:36, p. 339.

13. Roger de Piles, *Cours de peinture par principes* (Paris, 1708); see also Michiel Roscam Abbing, "On the Provenance of Rembrandt's *Girl at a Window*: Its First Owner and an Intriguing Anecdote," in *Paintings and Their Context IV; Rembrandt van Rijn: Girl at a Window* (London, n.d.), 19-24, especially 22-23.

14. For more on this revolutionary alteration of manner, see my essay "Culture as Foreground," in *Masters of Dutch Landscape Painting*, ed. Peter Sutton et al. (Boston, 1987); also Christopher Brown et al., *Dutch Landscape: The Early Years, Haarlem and Amsterdam, 1590-1650* (London, 1986).

15. On these paintings and Rembrandt's landscapes in general, see Cynthia P. Schneider, *Rembrandt's Landscapes: Drawings and Prints* (Washington, D.C., 1990).

16. On this tradition, see Walter S. Gibson, *"Mirror of the Earth": The World Landscape in Sixteenth-Century Flemish Painting* (Princeton, 1989).

17. Van Mander, *Lives*, 190-1.

18. See Egbert Haverkamp-Begemann, *Hercules Segers: The Complete Etchings* (Amsterdam, 1973); also J. G. van Gelder, "Hercules Segers, erbij en eraf," *Oud Holland* 65: 216-26.

19. Hoogstraten, *Inleyding tot de hooge schoole*, 312.

20. On these prints, see David Freedberg, *Dutch Landscape Prints of the Seventeenth Century* (London, 1980).

21. On pastoral culture in the Netherlands, see Alison McNeil Kettering, *The Dutch Arcadia: Pastoral Art and Its Audience in the Golden Age* (Totowa and Montclair, N.J., 1983).

22. I owe this observation, and many other acute insights on Rembrandt's landscape prints, to my former Harvard student H. Rodney Nevitt, and in particular to his paper "Rembrandt's Hidden Lovers."

23. On this point I'm clearly in disagreement with the interesting article by Linda Stone-Ferrier, "Rembrandt's Landscape Etchings: Defying Modernity's Encroachment," *Art History* 15 (December 1992): 403-33.

24. See Robert C. Cafritz, "Reverberations of Venetian Graphics in Rembrandt's Pastoral Landscapes," in idem et al., *Places of Delight: The Pastoral Landscape* (Washington, D.C., 1988), 131-47.

25. See Ernst van de Wetering, *Rembrandt: The Painter at Work* (Amsterdam, 1997), 70-73.

26. François-Edmé Gersaint, *Catalogue raisonné de toutes les pièces qui forment l'oeuvre de Rembrandt* (Paris, 1751), 162-63.

27. See B. P. J. Broos, "Hercules Segers," in the *Grove Dictionary of Art*, ed. Jane Turner (London and New York, 1996), 28:361.

28. The classic account of Rembrandt's experiments as an etcher is Christopher White, *Rembrandt as an Etcher: A Study of the Artist at Work*, 2 vols. (London, 1969). See also Clifford S. Ackley, *Printmaking in the Age of Rembrandt* (Boston, 1981); Schneider, *Rembrandt's Landscapes*.

29. Here I'm using modernism once more in the sense in which Clement Greenberg defined it, and which has always seemed to me to go to the heart of the matter: the exploration of the materials intrinsic to two-dimensional representation, to artistic form properly speaking, rather than the desire to make them disappear before the illusion of the represented object.

30. Pliny, *Natural History*, 35:36: 103-4, pp. 338-39.

31. Nevitt, "Rembrandt's Hidden Lovers."

32. *RD*, 1649/4, 269. See also J. Goudswaard, "Hendrickje Stoffels, jeugd en sterven," *Maandblad Amstelodamum* 43 (1956): 114-15, 163-64.

33. The story of Rembrandt's relationship with Geertje is told by Dirck Vis, with, however, a fair amount of undocumented speculation, in *Rembrandt en Geertje Dircx, de identiteit van Frans Hals's "Portret van een schilder en de vrouw van een kunstenaar"* (Haarlem, 1965). See also the review by I. H. van Eeghen, *Maandblad Amstelodamum* 52 (1965): 167.

34. For a discussion of the erotic calculation of these figures and the censorious reaction to them, see the important discussion in David Freedberg, *The Power of Images: Studies in the History and Theory of Response* (Chicago and London, 1989), 317-77.

35. Some of the jewels—specifically the ones subsequently pawned by Geertje—are listed in the deposition of the moneylender and barge skipper's wife, Giergtgen Nannings, in September 1656. *RD*, 1656/7, 390-91.

36. Ibid., 1648/2, 260-61.

37. Ibid., 1649/4, 269.

38. Ibid., 1649/7, 273-74.

39. Ibid., 1649/9, 276.

40. Ibid., 1656/2, 337-38; Vis, *Rembrandt en Geertje Dircx*, 332-34.

41. *RD*, 1656/4, 339; see also Vis, *Rembrandt en Geertje Dircx*, 75-76.

42. *RD*, 1656/5, 340-41.

43. Ibid., 1654/11, 318.

44. Ibid., 1654/15, 320.

45. 2 Samuel 11:27.

46. Joseph Leo Koerner, "Rembrandt's *David at Prayer*," in *Rembrandt's "David at Prayer"* (Jerusalem, 1997). See also Simon Schama, "Rembrandt's David," in the same publication.

47. 2 Samuel 11:4.

48. See, for example, David Bomford et al., *Art in the Making: Rembrandt* (London, 1988), 96.

49. Kenneth Clark, *The Nude* (New York and London, 1956), 439.

CHAPTER 11: THE PRICE OF PAINTING

1. Quoted in Gary Schwartz, *Rembrandt: His Life, His Paintings* (London and New York, 1985), 283.
2. S. Groenveld, "The English Civil Wars as a Cause of the First Anglo-Dutch War," *English Historical Review* 30 (1987): 561.
3. *RD*, 1653/9, 300–301.
4. S. A. C. Dudok van Heel, " 'Gestommel' in het huis van Rembrandt van Rijn: Bij twee nieuw Rembrandt-akten over het opvijzelen van het huis van zijn buurman Daniel Pinto in 1653," *Kroniek van het Rembrandthuis* 43 (1991): 3–13.
5. *RD*, 1654/3, 308–9.
6. Ibid., 1654/3, 610–11.
7. Ibid., 1654/5, 310.
8. See the biographical note by Nicolette Mout in *De wereld binnen handbereik: Nederlands kunst- en rariteitenverzamelingen, 1581–1735* (Amsterdam, 1992), 78. On Jan Six and Rembrandt, see also David Smith, " 'I Janus': Privacy and the Gentlemanly Ideal in Rembrandt's Portraits of Jan Six," *Art History* 11 (March 1988): 42–63; Clara Bille, "Rembrandt and the Burgomaster Jan Six: Conjectures as to Their Relationship," *Apollo* 85 (1967): 260–65; Luba Freedman, "Rembrandt's Portrait of Jan Six," *Artibus et Historiae* 12 (1985): 89–105.
9. See p. 534.
10. In, for example, the Dutch version of the Spanish play *Zabynaja*, performed in 1648 and in which Rembrandt's paintings were backhandedly complimented as being "eclipsed" by the heroine's needlework, "for she also paints with gold." *RD*, 1648/9, 265.
11. See Gary Schwartz, "Apollo, Apelles en de Third Man: schilderkunst, letterkunde en politiek rond 1650," *Zeventiende Eeuw* 11 (1995): 124–30.
12. See p. 149.
13. *De wereld binnen handbereik*, 117.
14. *RD*, 1653/11, 302.
15. Smith, " 'I Janus,' " 43.
16. *RD*, 1654/21, 322. The text of the *chronosticon* reads, "AonIDas teneris qVI sUM VeneratVs ab annis TaLIs ego IanUs SIXIVs ora tULI. op myn schildery."
17. On *houding*, see Paul Taylor, "The Concept of *Houding* in Dutch Art Theory," *Journal of the Warburg and Courtauld Institutes* 55 (1992): 210–32; see also Ernst van de Wetering, *Rembrandt: The Painter at Work* (Amsterdam, 1997), 160ff.
18. The hypothesis that the *Aristotle* in the Metropolitan Museum of Art in New York is, in fact, Apelles has been argued by Paul Crenshaw, who was kind enough to let me read the full text of his important study, "Rembrandt's *Aristotle*? Or Rembrandt's *Calumny*?" His richly supported analysis has persuaded me that the identity of the subject may well be Apelles, although I'm less convinced that Rembrandt specifically had in mind the calumny of Apelles, projected onto his own admittedly pressing problems in 1653.
19. For the documentary history of the Ruffo commissions, see Jeroen Giltaj, "Ruffo en Rembrandt: Over een Siciliaanse verzamelaar in de zeventiende eeuw die drie schilderijen bij Rembrandt bestelde," doctoral dissertation, Vrije Universiteit, Amsterdam, 1997. See also *RD*, 1654/10, 315.
20. On Baroque Messina, see Pietro Castiglione, *Storia di un declino: Il seicento siciliano* (Syracuse, 1987). I am grateful to Meredith Hale for this reference and for much other infor-

mation about seventeenth-century Messina and the Ruffo dynasty.
21. Giltaj, "Ruffo en Rembrandt," 44. See also O. Schutte, *Repertorium der Nederlandse vertegenwoordigers residerende in het buitenland, 1584–1810* (The Hague, 1986), 454–55. *A View of the Harbor at Messina* by Casembroot is in the Museo Nazionale di San Martino in Naples.
22. Crenshaw, "Rembrandt's *Aristotle*?" 2.
23. The bust Rembrandt used as a model for the painting was surely the one identified as a "Homer" in the inventory of his possessions taken in 1656. But like the pseudo-Seneca which Rubens and Rembrandt both owned, the "Homer" was a portrait-type commonly, but entirely speculatively, identified as the bard. There is no prima facie reason why Ruffo, who may have prided himself on his own connoisseurship, should have shared this common fantasy.
24. Crenshaw, "Rembrandt's *Aristotle*?" 35. Also *RD*, 317.
25. Giltaj, "Ruffo en Rembrandt," 37.
26. Julius S. Held, "Rembrandt's *Aristotle*," in *Rembrandt Studies* (Princeton, 1991), 28, n. 41.
27. Ibid., 17–58. For a quite different interpretation, see Margaret Deutsch Carroll, "Rembrandt's *Aristotle*: Exemplary Beholder," *Artibus et Historiae* 10 (1984): 35–56.
28. Richard Brilliant, *Portraiture* (Cambridge, 1991), 81.
29. Pliny, *Natural History*, trans. H. Rackham (Cambridge, Mass., and London, 1952), 35:36: 80, p. 321. I'm also struck by the significance of Apelles receiving "the price of the picture [of Alexander] by the *weight* of gold coin (line 92)—a theme that seems exemplified by the figure's gesture with his left hand.
30. Seymour Slive, *Rembrandt and His Critics* (The Hague, 1953; reprint, New York, 1988), 81.
31. *RD*, 1665/8, 546.
32. Giltaj, "Ruffo en Rembrandt," 49–56, argues, convincingly, that the date of 1655 on the Glasgow painting, visible under infrared spectroscopic examination, precludes any possibility of its being the *Alexander* sent to Ruffo in 1661, this being too soon after the *Aristotle* arrived. Why should Rembrandt have painted the *Alexander* and then waited six years to send it to Messina? Unless, of course, it was precisely an older painting that he refurbished with the addition of extra strips of canvas to make up the commission. The painting of a helmeted figure in the Gulbenkian Foundation, in Lisbon, could well be a portrait of Titus van Rijn, dressed as Alexander, since the helmet is embellished with a sculpture of an owl, often associated with the Macedonian prince. On the other hand, owls were, of course, also identified with Minerva, another possible subject of the painting. In any event, the dimensions of the Lisbon painting are far smaller than those cited by Rembrandt in his note attached to the invoice to Ruffo. Giltaj concludes that, in all likelihood, Ruffo's *Alexander* has been lost. For a different view, see the catalogue entry by Christopher Brown in *Rembrandt: The Master and His Workshop* (New Haven and London, 1991), 261.
33. *RD*, 1661/5, 485.
34. Ibid., 1662/11, 506–8.
35. Ibid., 1662/12, 509. I have altered the Strauss–van der Meulen translation from the Italian slightly.
36. Ibid., 1662/11, 506–8.
37. Schwartz, *Rembrandt*, 283–84.
38. Ibid., 283.
39. *RD*, 1653/12, 302.
40. Ibid., 1656/10, 345.
41. John Michael Montias, "A Secret Transaction in Seventeenth-Century Amsterdam," *Simiolus* 24 (1996): 5–18.

42. *RD*, 1655/6, 330–31.

43. This is Kenneth M. Craig's argument, "Rembrandt and *The Slaughtered Ox*," *Journal of the Warburg and Courtauld Institutes* 46 (1983): 235–39. See also Avigdor W. G. Poseq, "The Hanging Carcass Motif and Jewish Artists," *Jewish Art* 16–17 (1990–91): 139–56; Jan Emmens, "Reputation and Meaning of Rembrandt's *Slaughtered Ox*," *Museumjournaal voor Moderne Kunst* 12 (1967): 112; also in Emmens, *Kunsthistorische Opstellen* (Amsterdam, 1981), 2:133–38.

44. The authorship of *The Polish Rider* was attributed to Rembrandt's student Willem Drost (about whom very little is known) by Josua Bruyn in a review of Werner Sumowski, *Gemälde der Rembrandt-Schüler*, 5 vols. (London, 1983–90), in *Oud Holland* 98 (1984): 158. For the debate that followed, see Anthony Bailey, *Responses to Rembrandt: Who Painted "The Polish Rider"? A Controversy Reconsidered* (New York, 1994). Since Bailey's book, Ernst van de Wetering, the leader of the Rembrandt Research Project, announced at a symposium in Melbourne, Australia, in October 1997 that he considered the painting, after all, to be essentially, if not uniformly, by the hand of the master.

45. The most convincing arguments that the work was commissioned as a portrait have been set out by B. P. J. Broos, "Rembrandt's Portrait of a Pole and His Horse," *Simiolus* 7 (1974): 192–218. Colin Campbell, "Rembrandt's *Polish Rider* and the Prodigal Son," *Journal of the Warburg and Courtauld Institutes* 33 (1970): 292–303, presents a quite different view, and Julius S. Held, in his essay in *Rembrandt Studies* (Princeton, 1991), together with a postscript note, continues to believe that the painting is, primarily, an emblematic work. Gary Schwartz, *Rembrandt*, argued that the painting is an illustration of a scene from a contemporary play by Johannes Serwouter, which certainly did feature a horseback Tamerlaine. But neither the face of the rider nor his costume seems to correspond to the image, even a stage image, of the fearsome Mongol warrior-prince.

46. This is the argument, accepted by Broos and in my view absolutely convincing, set out in the article by Zdislaw Zygulski, Jr., "Rembrandt's *Lisowczyk*," *Bulletin du Musée National de Varsovie* 6 (1965): 43–67.

47. Filips von Zesen, *Beschreibung der Stadt Amsterdam* (Amsterdam, 1664), 232–33, mentions Polish as one of the prime components of the polylingual cacophony at the Beurs at one o'clock in the afternoon.

48. Broos, "Rembrandt's Portrait of a Pole," 208.

49. Ibid., 214.

50. Maccovius had remarried twice after Aantje van Uylenburgh's death in 1633, both eminently respectable matches. He himself died in 1644.

51. Broos, "Rembrandt's Portrait of a Pole," 216. See also W. B. S. Boeles, *Frieslands hoogeschool en het Rijks Athenaeum te Franeker* (Leeuwarden, 1878), 1:295.

52. Rembrandt could have pieced together this costume from actual items owned by the sitter or other Poles in Amsterdam. But as a number of scholars, including Held and Broos, have pointed out, he is also likely to have used the prints by Stefano della Bella of Polish cavalrymen, a number of which incorporate accurate details like the fur-trimmed *kutchma* cap, the Sigismund saber, and the decorative horse's tail hanging from the bridle.

53. Norbert Middelkoop, " 'Large and Magnificent Paintings, All Pertaining to the Chirurgeon's Art': The Art Collection of the Amsterdam Surgeons' Guild," in Norbert Middelkoop et al., *Rembrandt under the Scalpel: "The Anatomy Lesson of Dr. Nicolaes Tulp" Dissected* (The Hague, 1998), 25–26.

54. On this tradition, see Wolfgang Stechow, "Jacob Blessing the Sons of Joseph: From Early Christian Times to Rembrandt," *Gazette des Beaux-Arts* 85 (1943): 193–208.

55. Rembrandt had, in fact, made a drawing of that earlier scene from Genesis 27 in the 1640s, though no painting based on it has survived.

56. H. van de Waal, *Steps Towards Rembrandt* (Amsterdam, 1974), 115ff.

57. *RD*, 1657/8, 402–4.

58. Ibid., 1658/13, 420–21.

CHAPTER 12: THE SUFFICIENCY OF GRACE

1. I am grateful to David Freedberg for pointing out Rijckaert's famous disability to me.

2. I arrived at this conclusion myself, on purely speculative grounds, but am glad to note that new technical data suggest that the Frick self-portrait is indeed a pendant to the *Juno* in Los Angeles. L. J. Slatkes, "Rembrandt as Jupiter: The Frick *Self-portrait* and Its Pendant," lecture, Frick Collection, May 20, 1998.

3. Stylistically, the freest and roughest passages in the Hammer Collection *Juno* suggest a date in the middle 1660s, rather than circa 1658, when the Frick painting was completed. On the other hand, the smoothest and more defined passages—of the face and upper body—are consistent with a rather earlier date. So it may well be that Rembrandt returned to the painting (and perhaps his own self-portrait) and reworked them over a period of years.

4. Hazlitt, *The Complete Works of William Hazlitt* (London and Toronto, 1933), 18:61, cited in Christopher White, *Rembrandt in Eighteenth-Century England* (New Haven, 1983), 16.

5. The only other account of Rembrandt that comes close to arguing that the manipulated paint surface itself became the subject of his art is the first chapter of Svetlana Alpers's *Rembrandt's Enterprise: The Studio and the Market* (Chicago, 1988), "The Master's Touch," 14–33.

6. This is Christian Tümpel's view, *Rembrandt* (New York, 1993), 293, claiming to correct the earlier view of A. Heppner, "*Moses zeigt die Gesetzestafeln* bei Rembrandt," *Oud Holland* 52 (1935): 241–51, which, in my view, still remains much the more plausible interpretation.

7. The first documented reference to Bol's painting is not, in fact, until 1666. But both Joost van den Vondel and Jan Vos wrote poems in 1659 commemorating, and describing, just such a painting located in the Schepenkamer. It stretches the imagination somewhat to suppose that either of the poems would have been written in advance of the installation of the art, or that a *third* painting, neither Bol's nor Rembrandt's, was the occasion of the verses. On Bol's painting and its setting, see Albert Blankert, *Kunst als regeringzaak in Amsterdam in de 17de eeuw* (Amsterdam, 1975), 30–35; B. J. Buchbinder-Green, "The Painted Decorations of the Town Hall of Amsterdam," Ph.D. dissertation, Northwestern University, 150–58. For the political background of the "Moses and Aaron" motif, see Simon Schama, *The Embarrassment of Riches: An Interpretation of Dutch Culture in the Golden Age* (New York, 1987), 117–21.

8. For each of the offices, see Buchbinder-Green, "The Painted Decorations of the Town Hall," 106–81.

9. Pliny, *Natural History*, trans. H. Rackham (Cambridge, Mass., and London, 1952), 35:36: 90, pp. 327–28.

10. On the title page of the book, van Veen identifies himself specifically as a native of the purported ancient capital of the

Bataves, Leiden, calling himself "Othone Vaenio Lugduno-batavo." See H. van de Waal, "The Iconographical Background of Rembrandt's *Claudius Civilis*," in H. van de Waal, *Steps Towards Rembrandt* (Amsterdam, 1974), 28–43.

11. On trees and Germanic primitive liberty, see Simon Schama, *Landscape and Memory* (New York, 1995), 81–152. On the iconographic precedents, see van de Waal, "Iconographical Background," 28–43. For a political interpretation of Rembrandt's decisions, see Margaret Deutsch Carroll, "Civic Ideology and Its Subversion: Rembrandt's *Oath of Claudius Civilis*," *Art History* 9 (March 1986): 11–35.

12. Rembrandt had used this frontal approach to a grand theatrical platform on which to stage a great tragic drama in his etching of *Christ Presented to the People*, and to some extent for his *Anatomy of Dr. Jan Deyman* as well.

13. Tacitus, *Histories*, trans. Clifford H. Moore (Cambridge, 1979), 4:14, p. 27.

14. Svetlana Alpers, "Rembrandt's *Claudius Civilis*," in *Rembrandt and His Pupils*, ed. Görel Cavalli-Björkman (Stockholm, 1993), 17–18.

15. See Carroll, "Civic Ideology," 21–26.

16. Jonathan Israel, *The Dutch Republic: Its Rise, Greatness and Fall, 1477–1806* (Oxford and New York, 1995), 765.

17. Cited in Ernst van de Wetering, *Rembrandt: The Painter at Work* (Amsterdam, 1997), 156.

18. N. de Roever, "Het Nieuwe Doolhof 'in de Oranje Pot' te Amsterdam," *Oud Holland* 6 (1888): 103–12.

19. Ibid., 109.

20. *RD*, 1661/12, 491–92.

21. S. A. C. Dudok van Heel, "Het 'Schilderhuis' van Govert Flinck en de Kunsthandel van Uylenburgh aan de Lauriergracht te Amsterdam," *Jaarboek Amstelodamum* (1982): 70.

22. *RD*, 1660/20, 462–65.

23. For the long history of the Six loan, which remained unpaid at Rembrandt's death, see Gary Schwartz, *Rembrandt: His Life, His Paintings* (London and New York, 1985), 287.

24. *RD*, 1669/5, 586–89.

25. Dudok van Heel, "Het 'Schilderhuis,' " 74–75.

26. *RD*, 1666/3, 562.

27. Cornelis de Bie, *Het Gulden Cabinet van de Edele vry Schilder const* (Antwerp, 1661), 290.

28. For the beginnings of these controversies, see the excellent account given in Seymour Slive, *Rembrandt and His Critics* (The Hague, 1953; reprint, New York, 1988), 67ff.

29. Ibid., 70.

30. Jeremias de Decker, "Schaduw-Vrindschap," in *De Nederlandse poezie van de 17de en 18de eeuw in duizend en enige gedichten*, ed. Gerrit Komrij (Amsterdam, 1987), 321.

31. "Op d'afbeeldinge van den verreseb Christus en Maria Magdalena, geschildert door en uytnemenden Mr Rembrandt van Rijn, voor H. F. Waterloos," in *De Hollantsche Parnas, of versscheiden gedichten*, ed. Tobias van Domselaer (Amsterdam, 1669), 405; also included in Jeremias de Decker, *Rym-Oeffeningen* (Amsterdam, 1702), 85; see also Slive, *Rembrandt and His Critics*, 46–47.

32. Jan Vos, "Strydt tusschen de doodt en natuur, of zeege der schilderkunst," in *Alle de gedichten* (Amsterdam, 1726), 1:193–207.

33. Svetlana Alpers, "Rembrandt's *Claudius Civilis*," makes the direct, and to my mind persuasive, comparison between the composition of the two works, although the positioning of the table relative to the picture plane in the respective works is more striking in terms of contrast than similarity.

34. Sir Joshua Reynolds, *Literary Works* (London, 1819), 2:355–56.

35. Quoted in van de Waal, "The Syndics and Their Legend," in *Steps Towards Rembrandt*, 247–75.

36. R. Meischke and H. E. Reeser, eds., *Het Trippenhuis te Amsterdam* (Amsterdam, Oxford, and New York, 1983), passim.

37. David Bomford et al., *Art in the Making: Rembrandt* (London, 1988), 125.

38. *RD*, 1662/9, 505.

39. Ibid., 1661/6, 488–89.

40. My discussion of the Lucretias, especially in connection with the relationship between the rape and the suicide, owes much to the account offered in Mieke Bal, *Reading Rembrandt: Beyond the Word-Image Opposition* (Cambridge, 1991), 62ff.; and to Svetlana Alpers's emphasis on the importance of painterly touch in the representation of tragic weight, *Rembrandt's Enterprise*, 24–33. On the iconographic tradition, see Wolfgang Stechow, "Lucretiae Statua," in *Essays in Honor of Georg Swarzenski* (Chicago, 1951), 114; and Arthur Wheelock and George Keyes, *Rembrandt's Lucretias* (Washington, D.C., 1991).

41. Tümpel, *Rembrandt*, 355.

42. *The Complete Letters of Vincent van Gogh* (Greenwich, Conn., 1958), 2:446.

43. Van de Wetering, *Rembrandt: The Painter at Work*, 57.

44. *RD*, 1665/7, 543–44.

45. On the connection between the Coppenol etching and the Kenwood self-portrait, see B. P. J. Broos, "The 'O' of Rembrandt," *Simiolus* 4 (1971): 150–82. H. Perry Chapman, *Rembrandt's Self-portraits: A Study in Seventeenth-Century Identity* (Princeton, N.J., 1990), 98–101, reverts to the view argued by van de Waal and Kurt Bauch that the circles at the back of Rembrandt represent double-hemisphere maps common in better-off Dutch households, but that the painter also meant them to represent his universality. Jan Emmens, *Rembrandt en de regels van de kunst* (Amsterdam, 1979), 92, argued that the circles represented *ars* (theory) and *exercitatio* (disciplined practice), with Rembrandt's own person as the third and decisive force of *ingenium*, or invention, in the center.

46. I was reminded of this by the excellent discussion (which does not, however, include Rembrandt) by Gregory Galligan, "The Self Pictured: Manet, the Mirror and the Occupation of Realist Painting," *Art Bulletin* 80 (March 1998): 140–71.

47. On Cosimo de' Medici and his cultural world and European travels, see Eric Cochrane, *Florence in the Forgotten Centuries, 1527–1800* (Chicago and London, 1973), 259–62.

48. *RD*, 1665/13, 550.

49. Ibid., 1665/6, 541.

50. Ibid., 1668/2, 575; see also S. A. C. Dudok van Heel, "Anna Huibrechts en Rembrandt van Rijn," *Maandblad Amstelodamum* 64 (1977): 30–33.

51. On the complicated and fascinating history of laughter and jokes in golden-age Holland, see Rudolf Dekker, *Lachen in de Gouden Eeuw: Een geschiedenis van de Nederlandse humor* (Amsterdam, 1997). For the association with Zeuxis, see Albert Blankert, "Rembrandt, Zeuxis and Ideal Beauty," in *Album Amicorum J. G. van Gelder* (The Hague, 1973), 32–39. I owe my interpretation of this painting to the discussion of seventeenth-century and classical texts on laughter offered by Quentin Skinner in his Trilling seminar lecture "Ancient Laughter," given at Columbia University in March 1999.

52. *RD*, 1669/3, 583–85. Van Brederode's list describes the limbs as "*vier stuk gevilde armen en beenen door Vesalius anatomiseert*," which Strauss and van der Meulen translate as "anatomized according to Vesalius's *method*," but which,

in the spirit of van Brederode's enthusiast's curiosity and Rembrandt's tastes, might as easily be rendered as if they were actual survivors of the Paduan doctor's own practice.

53. The document recording the terms on which Magdalena and Dusart, on behalf of Cornelia, accepted sums from the estate was damaged by fire, but Strauss and van der Meulen's conclusion about the provisional nature of the agreement seems persuasive. *RD*, 1669/5, 586–89.

54. A Cornelis Anthonisz. woodcut may also have been one of Rembrandt's formal sources, particularly for the gesture of the father's hands on his son's shoulders. But the two bodies remain distinctly separate from each other. See I. V. Linnik, "Once More on Rembrandt and Tradition," in *Album Amicorum J. G. van Gelder*, 223–25.

55. Luke 15:32.

56. Otto Benesch, *Rembrandt as Draughtsman* (London, 1960), 163.

57. Luke 2:29.

CHAPTER 13: REMBRANDT'S GHOST

1. The translation is from *A Selection of the Poems of Sir Constantijn Huygens (1596–1687)*, trans. and ed. Peter Davidson and Adriaan van der Weel (Amsterdam, 1996), 186–87.

2. Ibid., 187.

3. D. P. Snoep, "Gérard de Lairesse als plafond- en kamerschilder," *Bulletin van het Rijksmuseum* 18 (December 1970): 159–220.

4. It seems that, initially at least, Lairesse was not actually a member of the society, even though he was extremely close to the inner core and became its host. See Lyckle de Vries, *Gérard de Lairesse: An Artist Between Stage and Studio* (Amsterdam, 1998), 7 n. 15.

5. Joh. Episcopius [Jan de Bisschop], *Paradigmata Graphices Variorum Artificium: Voor-Beelden der teken-konst van verscheyde meesters* (The Hague, 1671); also cited in Lyckle de Vries, *Gérard de Lairesse*, 80.

6. Pels's poem is given in full in S. Slive, *Rembrandt and His Circle*, appendix E, 210–11.

7. Gérard de Lairesse, *Het groot schilderboeck* (Amsterdam, 1707), 1:325.

8. Ibid., 324. On Rembrandt's painting, see also the catalogue entry by Walter Liedtke in "Rembrandt / Not Rembrandt," in *The Metropolitan Museum of Art: Aspects of Connoisseurship* (New York, 1996), vol. 2, *Paintings, Drawings and Prints: Art-Historical Perspectives*, 86–87.

9. J. J. M. Timmers, *Gérard de Lairesse* (Amsterdam and Paris, 1952), 7.

10. Lairesse, *Groot schilderboeck*, 2:13–14.

11. Ibid., 14.

12. The description of the architecture, institutions, and flora and fauna of Batavia are all drawn from the extremely detailed account given in Johan Nieuhof, a protégé of one of Rembrandt's patrons, Cornelis Witsen, *Remarkable Voyages and Travels to the East Indies, 1653–1670*, based on his visits during the 1650s and 1660s, originally published in Dutch in 1682 and in English in 1704. The *Voyages and Travels* have been reprinted in facsimile, with an excellent introduction by Anthony Reid (Oxford and New York, 1988). For Batavia, see pp. 264–321.

SELECT BIBLIOGRAPHY

The literature on Rembrandt and Rubens is, of course, immense. What follows makes no pretense at all to scholarly completeness, but is merely offered as guidance to the general reader as a way of further pursuing some of the themes addressed in this book. Reading on more specific subjects may be found in the notes.

SOURCES AND DOCUMENTS

RUBENS

Max Rooses and Charles Ruelens, eds., *Correspondance de Rubens et documents épistolaires concernant sa vie et ses oeuvres*, 6 vols., Antwerp, 1887–1909; Ruth Saunders Magurn, ed. and trans., *The Letters of Peter Paul Rubens*, Cambridge, Mass., 1955; repr. Evanston, Ill., 1991.

REMBRANDT

B. P. J. Broos, *Index to the Formal Sources of Rembrandt's Art*, Maarssen, 1977; Cornelis Hofstede de Groot, *Die Urkunden über Rembrandt (1575–1721)*, The Hague, 1906; Walter L. Strauss and Marjon van der Meulen, with S. A. C. Dudok van Heel and P. J. M. de Baar, *The Rembrandt Documents*, New York, 1979; H. Gerson, *Seven Letters by Rembrandt*, The Hague, 1961; S. A. C. Dudok van Heel, *The Rembrandt Papers: Documents, Drawings and Prints*, Amsterdam, 1987.

THE CORPUS

J. Bruyn et al., *A Corpus of Rembrandt Paintings*, 3 vols., The Hague, Boston, and London, 1982–1989. A drastically reconceived, more candidly interpretative continuation of the *Corpus*, eschewing definitive acceptances and rejections, and organized by genre rather than strictly chronologically, is promised under the editorial direction of E. van de Wetering, M. Franken, and P. G. T. Broekhoff.

BIOGRAPHIES AND STUDIES OF THE ARTISTS

RUBENS

Svetlana Alpers, *The Making of Rubens*, New Haven and London, 1995; Frans Baudouin, *P. P. Rubens*, trans. Elsie Callender, New York, 1980; Kristin Lohse Belkin, *Rubens*, London, 1998; Kerry Downes, *Rubens*, London, 1980; Hans Gerhard Evers, *Peter Paul Rubens*, Munich, 1942; Max

Rooses, *Rubens*, Philadelphia and London, 1904; Charles Scribner III, *Paul Rubens*, New York, 1989; Martin Warnke, *Rubens: His Life and Work*, trans. Donna Pedini Simpson, Woodbury, N.Y., 1980; idem, *Kommentare zu Rubens*, Berlin, 1965; Christopher White, *Peter Paul Rubens*, New Haven and London, 1987.

REMBRANDT

Two works have revolutionized Rembrandt studies since World War II: J. A. Emmens, "Rembrandt en de regels van de kunst," Ph.D. diss., University of Utrecht, 1964; repr. in idem, *Verzameld Werk*, vol. 2, Amsterdam, 1979 (see also David Freedberg's review in *Simiolus* 13 [1983]: 142–6; for my comments on the work and its influence, see chapter 1, pp. 24–25); and Gary Schwartz, *Rembrandt: His Life, His Paintings*, New York and London, 1985. By bringing an immense wealth of archival material to the account of Rembrandt's career and work, Schwartz established, more completely than anyone had before, the full social and political complexity of the historical milieu in which the painter's work was made possible. As an exhaustive history of Rembrandt's patrons and audiences, the book remains (and is likely to remain) unsurpassed.

Other important studies are Svetlana Alpers, *Rembrandt's Enterprise: The Studio and the Market*, Chicago and London, 1988; Mieke Bal, *Reading Rembrandt: Beyond the Word-Image Opposition*, Cambridge, 1991; Kenneth Clark, *Rembrandt and the Italian Renaissance*, London, 1966; H. Gerson, *Rembrandt Paintings*, Amsterdam, 1968; Bob Haak, *Rembrandt: His Life, His Work, His Time*, New York, 1969; Julius S. Held, *Rembrandt Studies*, Princeton, 1991; Seymour Slive, *Rembrandt and His Critics 1630–1730*, The Hague, 1953; Christian Tümpel (with chapters by Astrid Tümpel), *Rembrandt*, Antwerp, 1986, 1993; Christopher White, *Rembrandt*, London, 1984. Anthony Bailey, *Rembrandt's House*, Boston and London, 1978, is an engaging introduction to the artist's career.

WORKS

SPECIALIZED STUDIES ON THE EARLY STAGES OF RUBENS'S CAREER

K. Lohse Belkin, "Rubens und Stimmer," in *Tobias Stimmer*, exhibition catalogue, Basel, 1984, 201–22; C. Brown,

Rubens' Samson and Delilah, exhibition catalogue, National Museum, London, 1983; Zirka Zaremba Filipczak, *Picturing Art in Antwerp, 1550–1700*, Princeton, 1987; David Freedberg, "Painting and the Counter-Reformation in the Age of Rubens," in *The Age of Rubens*, ed. Peter Sutton, exhibition catalogue, Museum of Fine Arts and Toledo Museum of Art, Boston and Toledo, 1993, 131–45; T. L. Glen, *Rubens and the Counter-Reformation*, New York and London, 1977; Julius S. Held, "Thoughts on Rubens's Beginnings," in *Papers Presented at the International Rubens Symposium*, ed. William H. Wilson and Wendy McFarland, *Ringling Museum of Art Journal*, 1983, 14–35; idem, "Rubens and Vorsterman," in *Rubens and His Circle*, ed. idem, Princeton, 1982, 114–25; Frances Huemer, *Rubens and the Roman Circle: Studies of the First Decade*, New York, 1966; Roger d'Hulst et al., *De Kruisoprichting van Pieter Paul Rubens*, Brussels, 1993; Paul Huvenne, *The Rubens House, Antwerp*, Brussels, 1990; Michael Jaffé, *Rubens and Italy*, London, 1972; Elizabeth McGrath, "The Painted Decoration of Rubens's House," *Journal of the Warburg and Courtauld Institutes* 41 (1978): 245–77; idem, "Rubens, the Gonzaga and the *Adoration of the Trinity*," in *Splendours of the Gonzaga*, ed. David Chambers and Jane Martineau, exhibition catalogue, Victoria and Albert Museum, London, 1981, 214–21; John Rupert Martin, *The Antwerp Altarpieces*, New York, 1969; Mark Morford, *Stoics and Neo-Stoics*, Princeton, 1991; Jeffrey M. Muller, *Rubens: The Artist as Collector*, Princeton, 1989; W. Prinz, "The Four Philosophers by Rubens and the Pseudo-Seneca in Seventeenth Century Painting," *Art Bulletin* 55 (1973): 410–28; W. Stechow, *Rubens and the Classical Tradition*, Cambridge, Mass., 1968; Christopher White, "Rubens and Antiquity," in *The Age of Rubens*, ed. Peter Sutton, 147–57.

ON RUBENS'S INFLUENCE
IN THE NETHERLANDS
J. G. van Gelder, "Rubens in Holland in de Zeventiende Eeuw," *Nederlands Kunsthistorisch Jaarboek* 3 (1950–1951): 103–50; H. Gerson, "Rembrandt and the Flemish Baroque: His Dialogue with Rubens," *Delta*, 1969, 7–23.

REMBRANDT'S TECHNIQUE
M. Ainsworth, E. Haverkamp-Begemann, et al., *Art and Autoradiography: Insights into the Genesis of Paintings by Rembrandt, Van Dyck and Vermeer*, New York, 1982; David Bomford, Christopher Brown, and Ashok Roy, *Art in the Making: Rembrandt*, London, 1988; A. P. Laurie, *The Brushwork of Rembrandt and His School*, London, 1932; Ernst van de Wetering, *Rembrandt: The Painter at Work*, Amsterdam, 1997. The collection of essays by van de Wetering constitutes an exceptionally illuminating exploration of the relationship between the material and compositional techniques of the artist and the poetic effect his paintings have on their beholders.

REMBRANDT IN LEIDEN
P. J. M. de Baar et al., *Rembrandt en Lievens in Leiden "een jong en edel schildersduo,"* exhibition catalogue, Stedelijk Museum De Lakenhal, Leiden, 1992; K. Bauch, *Die Kunst des jungen Rembrandt*, Heidelberg, 1933; idem, *Der frühe Rembrandt und seine Zeit: Studien zur geschichtlichen Bedeutung seines Frühstils*, Berlin, 1960; idem, "Christus am Kreuz," *Pantheon* 20 (1962): 137–44; C. Bille, "Rembrandt and Burgomaster Jan Six," *Apollo* (1967): 160–65; B. P. J. Broos, "Rembrandt and Lastman's *Coriolanus*: The History Piece in the Seventeenth Century, Theory and Practice,"

Simiolus (1975): 199–228; C. Brown and J. Plesters, "Rembrandt's Portrait of Hendrickje Stoffels," *Apollo* (1977): 286–91; H. L. M. Defoer, "Rembrandt van Rijn, De doop van de kamerling," *Oud Holland* 91 (1977): 2–26; J. G. van Gelder, "A Rembrandt Discovery," *Apollo* 77 (1963): 371–72; H. Gerson, "La Lapidation de Saint Etienne peinte par Rembrandt en 1625," *Bulletin des musées et monuments lyonnais* (1962); B. Haak, "Nieuwe licht op Judas en de zilverlingen van Rembrandt," in *Album Amicorum J. G. van Gelder*, The Hague, 1973, 155–58; Franklin Robinson, "A Note on the Visual Tradition of Balaam and His Ass," *Oud Holland* 84 (1969): 167–96; S. Slive, "The Young Rembrandt," *Allen Memorial Art Museum Bulletin* 20 (1962): 120–49; E. van de Wetering, "Leidse schilders achter de ezels," in *Geschildert tot Leyden anno 1626*, exhibition catalogue, Leiden, 1976, 21–31.

PORTRAITS AND GROUP PORTRAITS
I. Bergstrom, "Rembrandt's Double-Portrait of Himself and Saskia at the Dresden Gallery," *Nederlands Kunsthistorisch Jaarboek* 17 (1966): 143–69; Richard Brilliant, *Portraiture*, Cambridge, Mass., 1991; H. Perry Chapman, *Rembrandt's Self-portraits: A Study in Seventeenth-Century Identity*, Princeton, 1990; S. A. C. Dudok van Heel, "Mr. Joannes Wtenbogaert (1608–1680): Een man uit Remonstrants milieu en Rembrandt van Rijn," *Jaarboek Amstelodamum* 70 (1978): 146–69; I. H. A. van Eeghen, "Baertje Martens en Herman Doomes," *Maandblad Amstelodamum* 43 (October 1956): 133–7; J. A. Emmens, "Ay, Rembrandt, maal Cornelis stem," in idem, *Kunsthistorische Opstelling*, vol. 1, Amsterdam, 1981, 20; L. J. Frederichs, "De schetsbladen van Rembrandt voor het schilderij van het echtpaar Anslo," *Maandblad Amstelodamum* 56 (Oct. 1969): 206–11; Luba Freedman, "Rembrandt's Portrait of Jan Six," *Artibus et Historiae* 12 (1985): 89–105; H. E. van Gelder, "Rembrandt's portretjes van M. Huygens en J. de Gheyn III," *Oud Holland* 68 (1953): 107; H. Gerson, "Rembrandt's portret van Amalia van Solms," *Oud Holland* (1984): 244–49; E. H. Gombrich, "The Mask and the Face: The Perception of Physiognomic Likeness in Life and Art," in *The Image and the Eye*, London, 1982, 104–36; Claus Grimm, *Rembrandt Selbst: Eine Neubewertung seiner Porträtkunst*, Stuttgart and Zurich, 1991; E. Haverkamp-Begemann, *Rembrandt: "The Night Watch,"* Princeton, 1982; W. S. Heckscher, *Rembrandt's "Anatomy of Dr. Nicolaas Tulp": An Iconological Study*, New York, 1958; E. de Jongh, "The Spur of Wit: Rembrandt's Response to an Italian Challenge," *Delta* 12 (1969): 49–67; Norbert Middelkoop et al., *Rembrandt under the Scalpel*, exhibition catalogue, Mauritshuis, The Hague, 1998; Alois Riegl, *Das holländische Gruppenporträt*, ed. L. Munz, 2 vols., Vienna, 1931; Cynthia P. Schneider, "Death by Interpretation: Rembrandt's *Girl with Dead Peacocks*," in *Rembrandt and His Pupils*, ed. Görel Cavalli-Björkman, Stockholm, 1993, 55–67; idem, "Rembrandt Reversed: Reflections on the Early Self-portrait Etchings," in *Shop Talk: Studies in Honour of Seymour Slive*, by Cynthia Schneider, William Robinson, and Alice Davies, Cambridge, Mass., 1995, 224–26; William Schupbach, *The Paradox of Rembrandt's "Anatomy of Dr. Tulp,"* London, 1982; Jan Six, "Jan Six aan het venster (Jan Six at the Window)," *Kroniek van het Rembrandthuis* 23 (1969): 34–36, 68–69; Seymour Slive, "Rembrandt's *Self-portrait in a Studio*," *Burlington Magazine* 106 (1964): 483–86; David R. Smith, "'I Janus': Privacy and the Gentlemanly Ideal in Rembrandt's Portraits of Jan Six," *Art History* 11 (Mar. 1988): 42–63; Victor I. Stoichita, *The Self-aware Image: An*

Insight into Early Modern Meta-painting, trans. Anne-Marie Glasheen, Cambridge, 1997; S. A. Sullivan, "Rembrandt's Self-portrait with Dead Bittern," Art Bulletin 62 (1980): 236–43; Christian Tümpel, "De Amsterdamse schutterstukken," in Schutters in Holland, by M. Carasso-Kok and J. Levy–van Halm, exhibition catalogue, Zwolle, 1988, 74–103; Arthur K. Wheelock, Jr., "Rembrandt Self-portraits: The Creation of a Myth," in Papers in Art History from the Pennsylvania State University 11 (1999): 3–35.

HISTORY PAINTINGS AFTER 1630
J. Bruyn, Rembrandt's keuze van Bijbelse onderwerpen, Utrecht, 1959; John Gage, "A Note on Rembrandt's Meeste Ende die Naetureelste Beweechgelickheijt," Burlington Magazine 111 (Mar. 1976): 128–38; W. H. Halewood, Six Subjects of Reformation Art: A Preface to Rembrandt, Toronto, 1982; Visser 't Hooft, Rembrandt and the Gospel, London, 1957; Ilse Manke, "Zu Rembrandts Jakobsegen in der Kasseler Galerie," Zeitschrift für Kunstgeschichte 23 (1960): 252–60; J. L. A. A. M. van Rijckevorsel, Rembrandt en de Traditie, Rotterdam, 1932; Margarita Russell, "The Iconography of Rembrandt's Rape of Ganymede," Simiolus (1977): 5–18; E. Kai Sass, "Comments on Rembrandt's Passion Paintings and Constantin Huygens' Iconography," Det kongelige danske videnskabernes selskab: Historisk-filosofiske skrifter 5.3 (Copenhagen, 1971); Seymour Slive, "Notes on the Relationship of Protestantism to Seventeenth-Century Dutch Painting," Art Quarterly 19 (1956): 2–15; W. Stechow, "Rembrandt's Representations of the 'Raising of Lazarus,'" Bulletin of the Los Angeles County Museum (1973): 7–11; A. Tümpel and C. Tümpel, Rembrandt legt die Bibel aus, Berlin, 1970; C. Tümpel, "Studien zur Ikonographie der Historien Rembrandts," Nederlands Kunsthistorisch Jaarboek 29 (1969): 107–98; Arthur K. Wheelock, Jr., "Rembrandt and the Rembrandt School," in Gods, Saints and Heroes: Dutch Painting in the Age of Rembrandt, ed. Albert Blankert et al., exhibition catalogue, National Gallery of Art, Detroit Institute of Arts, and Rijksmuseum, Washington D.C., Detroit, and Amsterdam, 1981, 137–82.

BLINDNESS
Mieke Bal, Reading Rembrandt: Beyond the Word-Image Opposition, Cambridge, 1991; Jacques Derrida, Memoirs of the Blind: The Self-portrait and Other Ruins, trans. Pascale-Anne Brault and Michael Naas, Chicago and London, 1973; M. H. Heinemann and H. C. Pinell-Staehle, "Rembrandt van Rijn and Cataract Surgery in Seventeenth-Century Amsterdam," Historia Ophthalmologica Internationalis 2 (1981): 85–93; Julius S. Held, "Rembrandt and the Book of Tobit," in Rembrandt Studies, Princeton, 1991, 118–43; Kahren Jones Hellerstedt, "The Blind Man and His Guide in Netherlandish Painting," Simiolus 13 (1983): 163–81; V. Manuth, "Die Augen des Sünders—Überlegungen zu Rembrandts Blendung Samsons von 1636 in Frankfurt," Artibus et Historiae 21 (1990): 169–98; Patrick Trevor-Roper, The World Through Blunted Sight, London, 1970.

THE NUDE
Ann Jensen Adams, ed., Rembrandt's "Bathsheba Reading King David's Letter," Cambridge, 1998; Tatiana Pavlovna Aleschina, "Some Problems Concerning the Restoration of Rembrandt's Painting Danaë," in Rembrandt and His Pupils, ed. Görel Cavalli-Björkman, Stockholm, 1993, 223–34; Kenneth Clark, The Nude: A Study in Ideal Form, New York, 1956; Colin Eisler, "Rembrandt and Bathsheba," in Essays in Northern European Art Presented to Egbert Haverkamp-Begemann on His Sixtieth Birthday, ed. Anne-Marie Logan, Doorspijk, 1983, 84–88; E. Panofsky, "Der gefesselte Eros: Zur Genealogie von Rembrandts Danaë," Oud Holland 50 (1933): 193–217; Simon Schama, "Rembrandt and Women," Bulletin of the American Academy of Arts and Sciences 38 (1985); Eric J. Sluiter, "Rembrandt's Early Paintings of the Female Nude: Andromeda and Susanna," in Rembrandt and His Pupils, ed. Görel Cavalli-Björkman, Stockholm, 1993, 31–54; Irina Sokolowa et al., Danaë, St. Petersburg, 1998.

LANDSCAPE AND GRAPHIC ART
Clifford S. Ackley, Printmaking in the Age of Rembrandt, exhibition catalogue, Museum of Fine Arts, Boston, 1981; K. G. Boon, Rembrandt: The Complete Etchings, 2 vols., London and New York, 1952; Robert C. Cafritz, "Reverberations of Venetian Graphics in Rembrandt's Pastoral Landscapes," in Places of Delight: The Pastoral Landscape, by idem, Lawrence Gowing, and David Rosand, exhibition catalogue, The Phillips Collection and National Gallery of Art, Washington, D.C., 1988, 130–47; David Freedberg, Dutch Landscape Prints, London, 1980; Alison McNeil Kettering, "Rembrandt's Flute Player: Unique Treatment of the Pastoral," Simiolus 9 (1977): 19–44; idem, The Dutch Arcadia: Pastoral Art and Its Audience in the Golden Age, Totowa and Montclair, N.J., 1983; F. Lugt, Mit Rembrandt in Amsterdam, Berlin, 1920; Cynthia Schneider et al., Rembrandt's Landscapes, New Haven and London, 1990; idem, Rembrandt's Landscapes: Drawings and Prints, exhibition catalogue, National Gallery of Art, Washington, D.C., 1990; Eric Jan Sluiter, "De entree van de amoureuze herdersidylle in de Noord-Nederlandse prent- en schilderkunst," in Het Gedroomde Land: Pastorale Schilderkunst in de Gouden Eeuw, ed. Peter van den Brink, Utrecht, 1993; Linda Stone-Ferrier, "Rembrandt's Landscape Etchings: Defying Modernity's Encroachments," Art History 15 (Dec. 1992): 403–33; Rembrandt: Experimental Etcher, exhibition catalogue, Museum of Fine Arts, Boston and New York, 1988; Christopher White, Rembrandt as Etcher: A Study of the Artist at Work, 2 vols., London, 1989.

REMBRANDT'S PUPILS
AND HIS "SCHOOL"
The vexed issue of differentiating works by Rembrandt's hand alone from those of his pupils, assistants, and imitators has been treated in a number of important recent exhibitions and their catalogues; see in particular: The Impact of a Genius: Rembrandt, His Pupils and Followers in the Seventeenth Century, Rijksmuseum, Gemäldegalerie, and Royal Academy, Amsterdam, Berlin, and London, 1983; Rembrandt: The Master and His Workshop, 2 vols., New Haven and London, 1991; essays by Görel Cavalli-Björkman, Albert Blankert, Walter Liedtke, Ernst van de Wetering, and Arthur Wheelock, in Rembrandt and His Pupils, ed. Görel Cavalli-Björkman, Stockholm, 1993; Hubert von Sonneburg and Walter Liedtke, Rembrandt/Not Rembrandt, 2 vols., Metropolitan Museum of Art, New York, 1995; Rembrandt: A Genius and His Impact, National Gallery of Victoria, Melbourne and Zwolle, 1997. See also H. Gerson, "Rembrandt's Workshop and Assistants," in Rembrandt after Three Hundred Years: A Symposium, Chicago, 1973, 19–31; Paul Huys Janssen and Werner Sumowski, The Hoogstede Exhibition of Rembrandt's Academy, Zwolle, 1992. The standard reference work for the "school" is W. Sumowski, Gemälde der Rembrandt-Schüler, vol. 1, Landau, 1983. A recent important contribution to the debate is

Walter Liedtke, "Reconstructing Rembrandt and His Circle: More on the Workshop Hypotheses," in *Papers in Art History from the Pennsylvania State University* 11 (1999): 38–60.

HISTORIES AND PORTRAITS
FROM THE 1650S AND 1660S
Svetlana Alpers, "Rembrandt's *Claudius Civilis*," in *Rembrandt and His Pupils*, ed. Görel Cavalli-Björkman, Stockholm, 1993, 14–30; Anthony Bailey, *Response to Rembrandt: Who Painted "The Polish Rider"? A Controversy Considered*, New York, 1994; Jan Biatostocki, "Rembrandt's *Eques Polonus*," *Oud Holland* 84 (1969): 163–76; Otto Benesch, "Wordly and Religious Portraits in Rembrandt's Late Art," *Art Quarterly* 19 (1956): 335–55; Albert Blankert, "Rembrandt, Zeuxis, and Ideal Beauty," in *Album Amicorum J. G. van Gelder*, The Hague, 1973, 32–39; B. P. J. Broos, "Rembrandt's Portrait of a Pole and His Horse," *Simiolus* 7 (1974): 192–218; Margaret Deutsch Carroll, "Civic Ideology and Its Subversion: Rembrandt's *Oath of Claudius Civilis*," *Art History* 9 (1986): 12–35; Ilse Manke, "Zu Rembrandt's *Jakobsegen* in der Kasseler Galerie," *Zeitschrift für Kunstgeschichte* 23 (1960): 252–60; C. Nordenfalk, *The Batavians' Oath of Allegiance*, Stockholm, 1982; Gary Schwartz, "Appelles, Apollo en the Third Man: Schilderkunst, letterkunde en politiek rond 1650," *De Zeventiende Eeuw* 11 (1995): 124–30; Wolfgang Stechow, "Jacob Blessing the Sons of Joseph: From Early Christian Times to Rembrandt," *Gazette des Beaux Arts* 23 (1943): 193–208; H. van de Waal, "The Staalmeesters and Their Legend," in van de Waal, *Steps Towards Rembrandt*, Amsterdam and London, 1974, 247–75.

ACKNOWLEDGEMENTS

Much of the argument of *Rembrandt's Eyes* was lengthily inflicted on patient audiences at Oxford University in the winter of 1996 as the Tanner Lectures on Human Values. I am grateful to Lord Windlesham, the principal of Brasenose College under whose auspices the lectures were delivered, and to the fellows of my old college for their generous hospitality. I should also like to thank Jonathan Israel, Martin Royalton-Kisch, Christopher White, and Joanna Woodall for their constructive criticism and comments in the seminar discussion which followed the lectures. Parts of the book were also delivered as seminars or lectures at Harvard University, the North Carolina Museum of Art, Stanford University, the University of California at Santa Barbara, the University of Washington, and the Grolier Society, New York.

Over many years of thinking and writing about Dutch art, I've shamelessly milked the kindness and wisdom of many friends, colleagues, and students in the field, in particular George Abrams, Ann Jensen Adams, Svetlana Alpers, Ronni Baer, Mieke Bal, Benjamin Binstock, Margaret Deutsch Carroll, Paul Crenshaw, Ivan Gaskell, Egbert Haverkamp-Begemann, Geraldine Johnson, Walter Liedtke, Otto Naumann, Rodney Nevitt, William Robinson, Seymour Slive, Peter Sutton, Amy Walsh, Ernst van de Wetering, Arthur Wheelock, and Michael Zell. My colleague David Freedberg deserves special thanks for continually provoking me to think harder and more subtly about Rubens and Rembrandt. The graduate seminar on Rembrandt, which we jointly taught at Columbia University in the spring of 1996 and which I taught solo in 1998, helped focus many of my ideas on the artist, and I owe a particular debt of thanks to Clare Gilman, Karen Green, Jackie Jung, Meredith Hale, and Margaret Sundell for helping stimulate fresh thinking on old topics. Meredith Hale has also been an indispensable help in all the later stages of preparing the book for publication: securing illustrations, checking references, and generally keeping a large and unwieldy manuscript (and its author) from spontaneous disintegration. I'm also grateful to Katie Nordine and Sonia Resika for assistance in finding and getting illustrations and running a tight but friendly ship in Fayerweather 523. I am most grateful to Ambassador William Luers and Dr. Mikhail Pietrowski for assistance during my visit to the Hermitage, and to Dr. Irina Sokolowa and her colleagues for allowing me to see the damaged *Danaë* before it was available for public viewing and for sharing with me their own account of the disaster and the work of restoration. At various stages of writing, Jill Slotover, Leon Wieseltier, and my agents Michael Sissons and Peter Matson were kind enough to read the manuscript and offer generous doses of calming guidance and reassurance. My editors Carol Brown Janeway and Stuart Proffitt both exercised their usual razor-sharp acumen on a sprawling manuscript and attempted to introduce some element of *houding* into the disorder. At Alfred A. Knopf, Debra Helfand, Iris Weinstein, and Tracy Cabanis were the heroic production team. Rachel Abram has been an invaluable help in securing illustrations and permissions. My wife, Ginny, and my children, Chloë and Gabriel, have administered the customary regulation doses of peace and love whenever Rembrandtian storms and stresses threatened shipwreck, and have sweetly indulged my obsession with dragging them in front of every conceivable and available painting by either Rubens or Rembrandt.

My greatest debt is to one of the book's dedicatees—my friend Gary Schwartz—who has been companion, critic, disputant, counsellor, for more than ten years, during which time I have struggled to come to terms with the painter he himself compassed in his own superb biography. At times we have resembled the *Two Old Men Disputing* in Rembrandt's great painting in Melbourne, with Gary, to be sure, the apostle with his finger on the right text. Notwithstanding our divergent approaches to Rembrandt, he has been kind enough to read the manuscript and save me from many errors. The errors which remain are, of course, my own responsibility.

Rembrandt's Eyes is also dedicated to John Brewer, with whom I've spoken not a word about Rembrandt, but with whom, over thirty years, I've shared virtually every other idea, fancy, opinion, and bloody-minded prejudice that has ever mattered. Through it all he has acted the part of the true friend: listened, said something wise, and poured us another glass of wine.

INDEX

Italicized page numbers refer to illustrations.

Winter Landscape (painting), 527, 528

Woman in a Doorway, 550, 551

Woman in North Holland Dress, 543

Woman on a Mound, 367, 389, 390, 391

Young Man at His Desk, 341, 341

Young Woman at an Open Door (with Hoogstraten), 523, 525

A Young Woman in Bed, 521, 523

Rembrandt with Pupils drawing from the Nude (Rembrandt pupil), 517, 517

Reni, Guido, 123, 464

Renialme, Johannes de, 596, 612

Repentant Judas Returning the Pieces of Silver (Rembrandt), 16, 265–8, 266

Resurrection (Lastman), 443

Resurrection of Christ, The (Rembrandt), 439–40, 441, 443–4, 444

Resurrection of Lazarus, The (Rembrandt), 259–60, 261, 443

Return of the Prodigal Son, The (Rembrandt, 1636), 427, 427, 443

Return of the Prodigal Son, The (Rembrandt, c. 1669), 683, 683, 685, 723n54

Reynolds, Joshua, 351, 352, 648

Richardot, Guillaume, 96, 97

Richardot, Jean, 76

Richardson, Jonathan, the Younger, 440

Richelieu, Cardinal, 404, 454

Riegl, Alois, 347

Rievelinck, Henricus, 207

Rihel, Frederik, 599

Rijckaert, Martin, 616–17, 620

Rijksen, Jan, 378–9, 378

Rizzi, Giampetro, 662

Rockox, Nicolaas, 141, 159, 160, 164, 452, 482

Roelofszoon, Gerrit, 198

Roncalli, Cristoforo, 123, 133

Rosa, Salvator, 24, 586, 594

roughness and smoothness in painting, 654–5

Rubens, Albert, 450–1, 452, 453, 455

Rubens, Bartholomeus (elder), 41

Rubens, Bartholomeus (younger), 69, 71, 121

Rubens, Blandina, 75, 76, 121

Rubens, Clara Serena, 144

Rubens, Constantina, 453

Rubens, Emilie, 71, 121

Rubens, Frans, 451

Rubens, Hendrik, 71, 121

Rubens, Jan, 76, 136

 Anna of Saxony and, 41, 59, 62

 banishment from the Netherlands, 70

 Cologne exile (1569), 59

Cologne residence (1581), 69

death of, 70–1

early years, 41–2

heresy charge against, 58

house arrest in Siegen, 67–9

imprisonment, 41, 62–7, 70

religious sensibility, 50

religious wars of the Netherlands, 50–1, 52, 54, 57–8

social standing, 42

Rubens, Jan-Baptiste, 121

Rubens, Maria, *see* Pypelincx, Maria

Rubens, Nicolaes, 450–1, 455

Rubens, Peter Paul, 11, 28, 35, 36, 59, 75, 98, 143, 147, 183, 213, 223, 232, 241, 258, 323, 367, 377, 395, 403, 450, 513, 561, 584, 588, 682

 Albert and Isabella's financial arrangement with, 138–9

 antiquities collection, 174–6, 182, 243–4

 appearance of, 76

 apprenticeship period, 79–82, 85–7

 artistic corporation, 188–9

 birth of, 69

 copyright concerns, 188–9

 courtier experience, 76–7, 79

 death and funeral, 455–6

 death-bed ruminations, 448–55

 diplomatic career, 27, 31, 270; Anglo-Spanish peace treaty, 179; mission to Spain on Gonzaga's behalf, 103–14; Netherlands religious wars, 242–8, 284–6, 404–5; retirement, 402

 Dutch Republic sojourn, 242–8

 education of, 76

 emotionalism of, 145–6

 English connections, 284

 engravers, dealings with, 185, 187, 189–90, 191

 gardening by, 182–3

 in Gonzaga's employ, 91, 93–5, 99–114, 117, 119–20, 125, 126, 129–33, 138–9

 harquebusiers and, 480–1

 Honthorst and, 30–1

 horsemanship of, 133

 Huygens and, 283–4, 285, 404, 436–8

 Italian sojourn, 91–103, 114–15, 117–18, 119–33

 knighthood for, 402

 Lairesse and, 695–6

 letters: to Chieppio, 104, 106, 108, 111, 114, 123, 130, 131, 133; to Dupuy, 145, 243, 244, 248; to Duquesnoy, 450; to Faber, 138, 139; to Fayd'herbe, 183, 451–2; to Gerbier, 247–8; to Gonzaga, 109, 111; to Peiresc, 181, 402, 403; to Sustermans, 180

 Lievens and, 332

 Lucas van Leyden and, 301

 master status, 87

nobility of, 11

personal regimen, 139

Raphael and, 466

Philip Rubens's relationship with, 95–6, 117–18, 120–2, 146, 148

self-image, 295

Spanish sojourn, 105–14

van Dyck and, 32–3

will of, 445

wives of, *see* Brant, Isabella; Fourment, Helena

workshop of, 402

see also Rubens, Peter Paul, works; Rubens, Peter Paul, works by title; Rubens House; Rubens-Rembrandt relationship

Rubens, Peter Paul, works

 antiquities, influence of, 94–5, 121

 apprentice-period paintings, 85–7

 Caravaggio's influence, 409–10

 ceremonial stages and arches, 402–4

 classicists' attitude toward, 643

 color values in, 165

 disposition of pieces in Rubens's possession after his death, 456–7

 engravings of, 185, 187, 189, 191, 286, 290–1

 first sketches, 77–9

 in gallery pictures, 166, 167–8

 Helena's appearance in history paintings, 453–4

 lion hunt paintings, 422

 love's redemption, vision of, 665–6

 macabre elements, 419–21

 Nazis' enthusiasm for, 172

 nudes, 390–1, 393, 396, 453

 portraits of Genoese princesses, 129

 restorations, 108, 111

 Rubens House faux frieze, 177–9

 sacred painting, Rubens's talent for, 150–1

 St. Peter's depiction in, 275

 self-portraits, 295, 300

 self-portrayal in history paintings, 294

 Stimmer's influence, 78–9

 storytelling in, 121

 Titian's influence, 165

 Torre de la Parada paintings, 437, 448, 452

 violence in, 177

Rubens, Peter Paul, works by title

 Adam and Eve, 86–7, 86, 113

 The Adoration of the Magi, 27, 139–41, 140, 153, 159, 294, 306

 Aeneas and His Family Departing from Troy, 116, 117

 Allegory of Sight (with Bruegel), 167–8, 168

 The Assumption of the Virgin, 158, 623

 The Baptism of Christ, 119, 120, 140, 153

 Bathsheba, 551

 Battle of the Amazons, 166, 167

Koninklijk Museum voor Schone Kunsten, Antwerp (België): pp. 120, 287 top

Copyright © Stichting Koninklijk Paleis, Amsterdam: pp. 623, 624, 626

Kunsthistorisches Museum, Vienna: pp. 403, 422, 570

Kupferstichkabinett Staatliche Museen zu Berlin, Preussischer Kulturbesitz, Berlin: pp. 364, 380, 414, 519

Erich Lessing/Art Resource, New York (Kunsthistorisches Museum, Vienna): pp. 454, 555

Los Angeles County Museum of Art: pp. 261 (Gift of H. F. Ahmanson and Company in memory of Howard F. Ahmanson), 338 (Gift of J. Paul Getty)

Musée du Louvre, Paris: pp. 132, 154 top, 241, 360, 362

Bildarchiv Foto Marburg: p. 457

Foto Marburg/Art Resource, New York: p. 100

Photograph copyright © Mauritshuis, The Hague: pp. 348–9 (inventory no. 146), 394 top right (inventory no. 707), 397 (inventory no. 147), 592 (inventory no. 584; Photograph by Daniël van de Ven), 679, 703 (inventory no. 148)

The Metropolitan Museum of Art, New York: pp. 21 (Rogers Fund, 1970 [1970.705]), 87 (The Jack and Belle Linsky Collection, 1982 [1982.60.24]), 303 (Gift of Henry Walters, 1917 [17.37.137]), 333 (Bequest of William K. Vanderbile, 1920 [20.155.2]), 356 (Sylmaris Collection, Gift of George Coe Graves, 1920 [20.46.19]), 373 left (H. O. Havemeyer Collection, Bequest of Mrs. H. O. Havemeyer, 1929 [29.100.3], 373 right (H. O. Havemeyer Collection, Bequest of Mrs. H. O. Havemeyer, 1929 [29.100.4]), 377 right (Gift of Helen Swift Neilson, 1943 [43.125]), 474, 475 (H. O. Havemeyer Collection, Bequest of Mrs. H. O. Havemeyer, 1929 [29.100.0]; Photograph by Malcolm Varon), 502 (Gift of Henry Walters by exchange, 1923 [23.57.2]), 515 (Robert Lehman Collection, 1975 [1975.1.799]), 554 (Gift of Harry G. Friedman, 1955 [55.632.9]), 585 (Purchase, special contributions and funds given or bequeathed by friends of the Museum, 1961 [61.198]), 640 (Bequest of Benjamin Altman, 1913 [14.40.618]), 698 (Robert Lehman Collection, 1975 [1975.1.140]; Photograph by Malcolm Varon)

The Minneapolis Institute of Arts: p. 661

The Pierpont Morgan Library/Art Resource, New York: title page, pp. 36 middle left, 304 left and right, 305, 323, 372, 400, 413, 415, 426 bottom, 427, 429, 446, 467, 477, 506, 534, 535, 536, 539 bottom, 540, 544 bottom, 545, 558, 559 top and bottom, 575, 576

Municipal Archive of Leiden: p. 196

Photographie Musée de Grenoble: p. 127

Musée des Beaux Arts de Lyon; p. 231

Musée Fabre, Ville de Montpellier: p. 125

Copyright © Photothèque des Musées de la Ville de Paris: pp. 237 bottom, 306

Musées Royaux des Beaux Arts de Belgique, Bruxelles—Koninklijke Musea voor Schone Kunsten van België, Brussel: pp. 236 (Photo Cussac), 392 (Photo Cussac), 473 left

Museum Boymans van Beuningen, Rotterdam: pp. 471 (Willem van der Vorm Foundation), 483, 503 bottom right, 610

Museum Catharijneconvent, Utrecht: p. 235 (Photograph by Ruben de Heer)

Museum der Bildenden Künste, Leipzig: p. 153 (Sammlung Maximilian Speck von Sternburg, Lützschena)

Museum of Fine Arts, Boston: pp. 13, 15, 20 bottom (Zoe Oliver Sherman Collection, given in memory of Lillie Oliver Poor), 374 left and right, 399 (Harvey D. Parker Collection, P417); Courtesy, Museum of Fine Arts, Boston. Reproduced with permission. Copyright © 1999 Museum of Fine Arts, Boston. All rights reserved.

Museum het Rembrandthuis, Amsterdam: pp. 224, 298, 299 top right and bottom left and right, 355, 390 top and bottom, 459, 549, 629, 674

Museum Wasserburg, Anholt/Artothek: p. 394 bottom

The National Gallery, London: pp. 141, 180, 339, 367 (Photograph copyright © by Erich Lessing), 417, 466, 468, 556, 557, 563, 652, 653, 678

Photograph copyright © 1998 Board of Trustees, National Gallery of Art, Washington, D.C.: pp. 354 (Widener Collection), 524 left, 660 (Andrew W. Mellon Collection)

The National Gallery of Ireland, Dublin: p. 225

National Gallery of Scotland, Edinburgh: p. 523 top

National Gallery of Victoria, Melbourne: p. 276 (Felton Bequest, 1934)

Nationalmuseum, Stockholm: pp. 503 middle right, 526, 593, 634–5, 684

Nimatallah/Art Resource, New York: p. 250 left

Philadelphia Museum of Art: pp. 186, 421 (Purchased with the W. P. Wilstach Fund)

Museo del Palazzo Ducale, Mantua: p. 101

Museo del Prado, Madrid: pp. 110, 140, 168, 182, 391; All rights reserved

Private collection, on loan to the Museum of Fine Arts, Boston: p. 655

Private collections: pp. 19 top, 212, 233, 257 top, 266, 277, 308–9, 375 left and right, 430, 587, 657

Rijksmuseum, Amsterdam: pp. 19 bottom, 33 left and right, 36 top, 190, 208, 218, 240, 251, 256, 259, 262 left and right, 282, 287 bottom, 296, 299 top left, 328, 344, 370 bottom, 394 top left, 472, 486 left and right, 487, 492–3, 497, 500, 504, 530, 531, 539 top, 544 top, 568, 603, 608, 611, 620, 628, 647, 655, 658, 665, 667

Photograph copyright © Réunion des Musées Nationaux (RMN): pp. 85, 379 (Daniel Arnaudet), 410, 426 top, 453 (H. Lewandowski), 464, 476 (C. Jean), 550, 553 (Jean Schormans), 598 (Gérard Blot)

The Royal Collection copyright © Her Majesty Queen Elizabeth II: pp. 31, 35, 378, 450, 473 right

The Royal Pavilion, Art Gallery and Museums, Brighton and Hove: p. 260

Copyright Rubenshuis, Antwerp: pp. 86, 167, 171, 178

Église St. Eustache, Paris: 250 right

Scala/Art Resource, New York: pp. 130, 366

Six Collection, Amsterdam: pp. 573, 574 right, 577 left and right, 579, 581

Staatliche Graphische Sammlung, Munich: p. 633

Staatliche Kunsthalle, Karlsruhe: pp. 128, 234

Staatsgalerie, Stuttgart: p. 280 right

Städelsches Kunstinstitut, Frankfurt/Artothek: pp. 272 (Mr. Jürgen Hinrichs), 420, 677

Stedelijk Museum De Lakenhal, Leiden; pp. 215, 227, 230 top, 255, 302 left

The Taft Museum, Cincinnati: p. 377 left (Bequest of Charles Phelps and Anna Sinton Taft)

Mr. A. Alfred Taubman: p. 449

By kind permission of the Marquess of Tavistock and the Trustees of the Bedford Estate: p. 523 bottom

Teylers Museum, Haarlem: p. 543

Board of the College, Trinity College, The University of Dublin: p. 226

Courtesy Ursus Books and Prints Ltd., New York: p. 692

Board of Trustees of the National Museums and Galleries on Merseyside, Walker Art Gallery, Liverpool: p. 29

Reproduced by permission of the trustees of the Wallace Collection, London: p. 675

Wallraf-Richartz-Museum, Köln/Rheinisches Bildarchiv, Cologne: pp. 97, 676

Yale University Art Gallery, New Haven: p. 115 (Gift of Susan Morse Hilles)